The Western Tradition

The Western Tradition

Third Edition

EUGEN WEBER
University of California
Los Angeles

From the Renaissance to the Present

D. C. HEATH AND COMPANY Lexington, Massachusetts Toronto

To the Mordlers

Copyright © 1972 by D. C. Heath and Company. Also copyright 1965, 1959 by D. C. Heath and Company; and 1956 by Eugen Weber.

All rights reserved. No part of this publication may be reproduced or transmitted in any form or by any means, electronic or mechanical, including photocopy, recording, or any information storage or retrieval system, without permission in writing from the publisher.

Published simultaneously in Canada.

Printed in the United States of America.

International Standard Book Number: 0-669-81141-6

Library of Congress Catalog Card Number: 72-172911

PREFACE

The passages gathered in this volume provide a reflection of the attitudes, ideas, or circumstances of the times which produced them. The choice was not an easy one, if only because every period is a complex collection of different attitudes, different tendencies, different problems, different men. The best one can do is to select documents that will throw light on the most typical or significant circumstances of an age. The selection must be arbitrary, and it is likely to slant in the direction of the editor's interests. In this case, I am trying to illustrate the developments and problems of Western Civilization from its remote origins to the present day. I can only hope that the following passages will put a little flesh on the bare bones of the textbook and give some body to the ghostly figures that parade too regularly through the pages of history books.

Readings are generally used in history courses as material for discussions complementing the lectures and as depositories for some of the great classic works or documents to which the courses refer. This book contains most of the classic texts to which teachers like to refer. It also contains passages which, in every section, lend themselves to discussion, argument, and various interpretations. In this connection, I have avoided cutting the ground from under the feet of teacher or student by the too copious introductions which, in some books, tend to furnish many ideas that the discussion itself should elicit and elucidate: my introductions try to be fairly noncommittal. In addition, the passages just mentioned are interspersed with more deliberately illustrative material, which throws an intimate light on the life and problems of a given time and place without necessarily lending itself to discussion. Thus, in his assignments, the teacher can pick and choose according to his purpose among passages that are illustrative or controversial, and I rather hope that such things as assignments omitted may catch the eve of the curious or the browsing, and lead, perhaps, to further reading.

This second revision of *The Western Tradition* has been undertaken in the wake of a book—A Modern History of Europe—which, roughly, deals with the last six centuries of European man. Inevitably, many passages reprinted here furnished fuel for those pages, while some of the things I read and thought while writing it are reflected here. There is always some risk in accumulations

such as this—above all, the spiritual desiccation of the reader in a hurry, with little time to waste,

And so the only books at which he looks Are books on books, and books on books.

Yet, even displaced, as if in a museum, these passages (or those of them that had it in them to begin with) still shine and still reflect their maker and their time. Acquaintance with them, even truncated, even compiled, is better than no acquaintance at all.

As with the second edition, the changes in the text consist more of addition than subtraction. Two figures make their entrance in the earlier part—St. Francis and Montaigne—without whom I cannot understand how the book thrived before. The most recent past (still very present) is reflected in sections on new orientations in the Christian churches and Christian belief; on the debates and tremors that living experience of communism has sparked among Marxists; and on the revolt of youth in different countries. Passages have been added here and there to show how people lived, as well as what they thought. Not least, an essay by Professor Trevor-Roper opens the discussion of what history is about, and what its relations are with social sciences. If the rest of the book offers the raw material of historical interpretation, Professor Trevor-Roper's essay shows what a lucid mind can do with it. In the ongoing argument of whether history is science or art, his pages prove that, however, "scientifically" approached, history can be an art.

Obviously, the same principles that went into this collection of readings and inspired its revisions must be applied in its use. This leaves me open to criticism for trying to cram in too much, ending with a grab bag difficult to cope with, let alone to read through in the space of an ordinary school year. But I would rather overrate than underrate my readers—rather ask too much than too little. It is bad enough that universities and colleges should devote so much time to what are in effect remedial courses designed to fill the gaps left in their students' schooling or, rather, to lay a groundwork which the schools have not bothered to provide. While this must be, there is yet no need to go overboard by trying to present the approach, and the understanding, of a vast, varied, and complex story as something easy and simple—leaving students with the impression that potted knowledge is as accessible and no more indigestible than potted shrimp.

CONTENTS

Introduction	XV
The Past and the Present	
Hugh Trevor-Roper: History and Sociology	xxiii
	-
The Making of the Modern World	
Fresh Fields and Pastures New	
Pico della Mirandola: Oration on the Dignity of Man	297
Niccolò Machiavelli: from The Prince	300
François Rabelais: from Gargantua and Pantagruel	313
Charles Dumoulin: from On Contracts and Usury	319
Paolo Toscanelli: Letter to Columbus	320
Christopher Columbus: from The Journal	323
Vasco da Gama: from A Journal of the First Voyage	325
John Cabot: Report to the Duke of Milan	329
Richard Hakluyt: from Divers Voyages Touching the Discovery of America	331
Space Theology	332
Reformation and Counter Reformation	
John Wycliffe: Conclusions	335
Reply to the Summons of the Pope	336
The Borgias: from The Life and Times of Niccolò Machiavelli	337
from Cronaca della Citta di Perugia dal 1492 al 1503	339
The Antiborgian Letter	340
Albert of Mainz: Instructions Concerning Indulgences	341
John Tetzel: A Sermon on Indulgences	343

viii CONTENTS

Martin Luther: The Ninety-five Theses	345
On the Babylonish Captivity of the Church	350
Peasant Revolt: The Twelve Articles	352
Thomas Bilney: Letter to the Bishop of London	355
John Calvin: from The Institutes of the Christian Church	358
Ignatius Loyola: from Spiritual Exercises	360
The Council of Trent: Decrees	363
Fr. Joachim Opser, S.J.: Letter to the Abbot of Saint-Gall	372
Papire Masson: from Historie de Charles IX	373
Political and Economic Changes	
Report of Venetian Ambassador: Power and Revenues of the States	
of Europe in 1423	374
Henry VIII: The Act of Supremacy	377
The Act of the Six Articles	378
Charles V: The Abdication of Charles V	379
The Library of Charles V at San Yuste	381
The Gold of the Indies	382
Revenues of the King of Spain	382
Henry VIII: Beggars Act of 1531	383
Elizabeth I: Poor Relief Act	386
Thomas More: from Utopia	390
Richard Hooker: from Preface to the Laws of Ecclesiastical Policy	394
Jean Bodin: from La République	399
Montaigne: Of Managing One's Will	402
The Seventeenth Century	
Hans Jacob von Grimmelshausen: from Simplicissimus	417
Muscovy	423
General Patrick Gordon: from The Diary of General Patrick Gordon	
of Auchleuchries	430
Thomas Mun: from England's Treasure by Foreign Trade	433
Daniel Defoe: from The Complete English Tradesman	442
René Descartes: from The Discourse Upon Method	448
Isaac Newton: from The Mathematical Principles of Natural Philosophy	458
John Locke: from An Essay Concerning Human Understanding	460
Witch Hunting: from The Witch-Persecutions at Trier	463
from The Witch-Persecution at Bamberg	464
The Methods of Witch-Persecutions	468

Combanto	
Contents	1X

The Political Debate	
Jacques Bénigne Bossuet: from On the Nature and Properties	
of Royal Authority	473
Thomas Hobbes: from The Leviathan	476
John Locke: from The Second Treatise on Government	488
A Time of Belief	
The Eighteenth Century	
경향 경향 기업 시간 사람이 없는 경기를 하셨다고 하는 것이다.	
James Boswell: from Life of Dr. Samuel Johnson	506
Montesquieu: from The Spirit of the Laws	510
Voltaire: from On English Commerce	515
On Presbyterians	516
Jean Jacques Rousseau: from The Social Contract	517
from Émile	526
Antoine Nicholas de Condorcet: from the Progress of the Human Mind	529
David Hume: from The Essay on Miracles	531
Enlightened Despotism	
Frederick the Great: from The Political Testament	535
from Forms of Government	536
Memoirs	546
Catherine II: from The Grand Instructions	552
Alexander Herzen: from Memoirs of Empress Catherine II	557
Mexander Herzen. John Memous of Empress Cumerine II	, , , , ,
A Dawn of Revolution	
A Dawn of Revolution	
The Declaration of Independence	558
The Federalist	561
Arthur Young: from Travels in France	567
Emmanuel Sieyès: from What Is the Third Estate?	583
French National Assembly: Decree Abolishing the Feudal System	586
The Declaration of the Rights of Man and Citizen	589
Letter of the Public Executioner	591
François Babeuf: The Manifesto of the Equals	592
Napoleon: Proclamation of 19th Brumaire	595

x CONTENTS

The Reaction

Edmund Burke: from Reflections on the French Revolution The Holy Alliance	598 606
Metternich: from Memoirs	608
Romantics and Romanticism	
Goethe: from Poetry and Truth	615
Friedrich Hölderlin: Hyperion	620
August-Wilhelm Schlegel: Classic Art and Romantic Art Letter to a French Friend	623 624
Madame de Staël: Romanticism	626
William Blake: Mock On, Mock On, Voltaire, Rousseau	627
The Tiger	627
London	628
William Wordsworth: The Tables Turned	628
London, 1802	629
Lord Byron: from Childe Harold's Pilgrimage	629
from Lara	630
Percy Bysshe Shelley: England in 1819 Final Chorus From Hellas	631 631
Economic Revolution	
John Stuart Mill: from Utilitarianism	634
from On Liberty	647
Samuel Romilly: from On the Old Criminal Law	653
The Sadler Committee: Evidence Given Before the Committee	656
An Independent Observer: Report on Factory Conditions	659
Lord Ashley's Mines Commission: Evidence Given Before Commission	660
Samuel Smiles: from Self Help	662
But Life Goes On	
A. W. Pugin: Chapels	667
Fr. Engels: Cheap Irish Labor	667
The Athenaeum: Panaceas	668
Blair: Catechism	668
The London Times: Charity	668
Charles Kingsley: The Trouble With the System	668
Letter from a working woman: Another View	669

Contents	s xi
Anonymous: Coming to Terms With Hardship Mrs. John Sandford: The Other Oppressed Alfred, Lord Tennyson: Order Established G. V. Cox: Order Threatened Jules Michelet: The Revolution of Cheap Calico	669 669 670 670
Liberalism, Nationalism, and 1848	
Joseph Mazzini: Conversion to Nationalism On the Duties of Man Louis Blanc: from Historical Revelations Alexis de Tocqueville: from Recollections Thomas Carlyle: Afterthought	673 675 678 687 693
A Time of Questioning	
The Rise of Social-Revolutionary Doctrines	
Peter Kropotkin: from Anarchism Karl Marx and Frederick Engels: from The Communist Manifesto Leo XIII: from Rerum Novarum	697 699 718
The Drift of Scientific Thought	
Augustus Comte: Positivistic Calendar Alfred Wallace: from Darwinism Thomas Huxley and Bishop Wilberforce: The Debate Ernst Haeckel: from The Riddle of the Universe Thomas Huxley: from Evolution and Ethics Leslie Stephen: An Agnostic's Apology Andrew Carnegie: from The Gospel of Wealth	729 734 737 740 743 746 748
Patterns of Change	
Prince Otto von Bismarck: from A Speech in the Prussian Budget Commission State Interference Universal Suffrage Parliamentary Debates: A Labor View on Old Age Pensions A Bishop's View of the Subject George Bernard Shaw: from A Manifesto Eduard Bernstein: from Evolutionary Socialism	752 753 754 757 758 759 760

xii CONTENTS

Lenin: Our Programme	766
Friedrich Nietzsche: We Homeless Ones—the Good Europeans	769
Our Outlook	770
The Wild Beast in Man	771
Life as Exploitation	771
Master-Morality and Slave-Morality	772
Nationalism and Imperialism	
Prince Otto von Bismarck: The Ems Telegram	776
The Triple Alliance	780
Houston Chamberlain: from The Foundations of the Nineteenth Century	782
German Attitudes: Living Space	784
How the New Germany Will Be Built	784
Germany's Manifest Destiny	784
Anglo-Saxon Attitudes: from The Sahibs	785
Rudyard Kipling: from The White Man's Burden	788
Arminius Vambery: from Western Culture in Eastern Lands	789
President McKinley: Attitude Toward the Philippines	791
Instructions to Peace Commissioners	792
War and Revolution	
Punch: Comments	793
Russian Socialist to the London Times: Letter	794
Woodrow Wilson: The Fourteen Points	795
The Treaty of Versailles	797
The Trenty of Ferentials	
Russia	
Meetings of the Council of Ministers: Report	800
Provisional Government, 1917: Formation and Program	801
The All-Russian Congress of Soviets: Invitation to the Congress	802
Clash between Moderates and Bolsheviks:	
Tseretselli's Speech	803
Lenin's Speech	805
Kerenski's Speech	807
The November Revolution: The Coup	808
The Petrograd Soviet Meets	809
Lenin's Speech	809
Editorial Comment	810
Brest-Litovsk: Accounts of the Conferences	811
Lenin: Writings and Speeches	819
3.44	

Contents	xiii
A Time of Fear	
Mussolini and Italian Fascism	
Francesco Nitti: Fascism: The Case for the Prosecution Antonio Cippico: The Case for the Defence Benito Mussolini: The Political and Social Doctrine of Fascism	829 831 834
National Socialism	
German Workers' Party: The Twenty-five Points of the Party Hitler: Mein Kampf State Department: Compilation on National Socialism	842 845 849
Appeasement	
Parliamentary Debates: Debate of 28 September, 1938 Chamberlain—Hitler Agreement: Peace in Our Time Parliamentary Debates: Debate of 3 October 1938 Debate of 5 October 1938	855 866 867 876
The Second World War	
Leon Poliakov: Harvest of Hate Nuernberg Trials: Slaves as Guinea Pigs Michel François: Against Oblivion United States Strategic Bombing Survey: Report	884 891 892 898
Another Postwar World	
K. P. Pobyedonostsev: from Reflections of a Russian Statesman Carl Becker: from A Discussion of Modern Democracy George Lichtheim: from The New Europe	910 912 924
Science and Social Change	
Bruce Stewart: Science and Social Change Julian Huxley: World Population George Lichtheim: Europe and Africa Alfred L. Malabre, Jr.: Automation Worry	933 940 953 959

xiv CONTENTS

Norbert Wiener: Cybernetics and Society	962
Margaret Mead: One Vote for This Age of Anxiety	968
A Sea Change in the Churches	
John XXIII: Pacem in Terris	972
Norman Goodall: The Ecumenical Movement	974
W. A. Viccer 't Hooft: The Mandate of the Ecumenical Movement	976
David E. Roberts: Existentialism in Religion	981
· ·	
Questions for Communism	
Quosiono 101 dominanto	
Wiktor Woroszylski: Materials for a Biography	988
Leon Trotsky: from The Revolution Betrayed	989
Kazimiers Brandys: Defense of Grenade	990
Jan Josef Lipski: Who Is Dr. Faul?	991
Stefan Kurowski: Apathy, or the Search for a Purpose	993
from: Resolution of the Central Committee of the Hungarian Workers' Party	994
Gyula Hay: The Problem of Truth	995
Manifesto of the Intellectuals	996
Czechoslovak Cultural Front: Manifesto	997
Charles and Caratar Front Francisco	331
The Revolt of Youth	
The Revolt of Touth	
The Student Revolt at Nanterre	1000
The Walls of 1968	1003
Fritz Teufel: Prophylactic Notes for the Self-Indictment of the Accused	1005
Tariq Ali: The Age of Permanent Revolution	_
rang mi. The rige of Lethunent nevolution	1013

INTRODUCTION

The story outlined in these pages is manifold and, of course, unfinished as history itself. It does, however, possess a certain internal coherence, for it reflects the gradual progress of Western man to greater self-consciousness and self-control, his repeated attempts to master not only himself but the world around him—aims in the pursuit of which he was never more than partially successful. The forty centuries on which we touch in these two volumes led man through a wide gamut of experience and experiment. Several times—as in Egypt, Greece, or Rome—he achieved types of civilization that seemed supremely satisfactory, and several times these collapsed or were destroyed, though leaving behind them a fund of techniques and thought and values that were eventually incorporated into subsequent societies in the way in which the stones and the statues of ancient Rome were incorporated into the buildings of the Renaissance.

The latest of these cultural structures began to rise after the disintegration of the Roman Empire in the West, and upon its ruins. The notion of a middle age seems to be the invention of certain fifteenth-century humanists who felt that only two historical periods really counted: the long-lost golden age of classical antiquity and their own, modern, Renaissance. The intervening period, across which these men saw themselves continuing a great tradition, was dark and useless, a time of chaos and terror better forgotten now that it was past and deserving no name, unless to describe its character—dark or Gothic (i.e., barbarous)—or its position in the middle. Yet, neither the bubbling buoyancy of the humanists nor their intellectual snobbery would have been possible without the foundations—economic, political, and scholarly —laid by their predecessors' long struggle against chaos and unreason—enemies of man and of civilization as much in his mind as in the world around him. Hence, much of this book concerns the slow and self-conscious efforts of Europeans, like fallen angels, trying to recover the heights of order, knowledge, and sophistication upon which men were thought to have stood in Augustan days. By the time of Louis XIV men believed that this had been achieved, that the ground lost during the "dark ages" had been regained, and that the Great Century, the seventeenth, had reached a cultural level no whit inferior to that of the ancients. It had been a long haul, but modern man had made it: the latest times had nothing to envy the past.

While Louis XIV and many of his contemporaries viewed history-and particularly modern history—as a long campaign to recapture lost and ancient glories, we can see that it was much more than that. On his trek, back to past heights as a humanist might have it, forward to new heights as others were soon to claim, man had picked up, invented, developed many things the ancients had not known. The court of Louis XIV was not the court of Titus or Trajan, still less that of Darius or Alexander. For one thing, it was Christian. For another, it rested on a social and economic structure the ancients had not known. And then, quite simply, it was not the court of an ancient prince because such princes and such courts had had their day and were no more except in tales. It was different because it came later, because the intervening times had taught and untaught a great deal, had discovered vast unsuspected realms and changed the face of Europe and also of the world. In other words, whatever they thought, men had not come back to a coveted golden-age starting point, but had gone on to something which, better or worse, was altogether different. Though Louis the Great might look backward to Cyrus and Apollo, his regime pointed forward to the Enlightened Despot and the modern state.

Yet what seemed to matter at the time were the new confidence and the slowly dawning feeling in some quarters that, now that he had made up the lost ground, nothing would stop man from going forward. Here was the feeling that foreshadowed the great hopes of the eighteenth century:

Go, wondrous creature! mount where science guides! Go, measure earth, weigh air, and state the tides; Instruct the planets in what orbs to run, Correct old Time and regulate the sun!

And behind it, ever present, was man himself, Homer's *Odysseus* or Swift's *Gulliver*, sly, enterprising, conceited, too clever by half and sometimes twice as foolhardy, taunting the Cyclops and sometimes the gods; feeling their wrath and surviving; hoisting himself, on the shoulders of his fellow men and too often at their expense, towards greater wisdom though never enough, towards his goal, though never attained.

First the eighteenth century, then the nineteenth, mark the high point of this optimism and the beginning of its decline. The nineteenth century opens with the echoes of 1789 still ringing in people's ears. To some they sound ominous; to others they carry promises of a better future. The twentieth century seems to realize both hopes and fears; as it advances through its second half there is expectation of discoveries greater than any before, yet much of the world lives in fear of the possibilities of a future grimly outlined in George Orwell's 1984 and already rendered almost out of date by later developments.

The latest moods and ideas always take time to percolate before they seriously affect public opinion. Long after scientists and scholars had begun to change their minds, ordinary men and women continued to believe that progress was inevitable—a law of nature and of history no less apparent in the long run than that of gravity. Thus the discovery that evil is part of the world order—

that man could not, apparently, by the mere use of his reason and will, build the good life uncorrupted—came as a shock to many in the twentieth century.

Once upon a time evil had seemed an integral part of creation. Though they feared and, at least theoretically, abhorred it, men reckoned with it. But the eighteenth and still more the nineteenth century had exorcised the Devil together, only too often, with God and encouraged the belief that in time evil and corruption could and would be eradicated from the world and from human nature. More and more things could be explained, adjusted, and improved. Utopia grew less utopian and more like the pattern of the better life that awaited us or our near descendants—the forward projection of improvements already implicit in present techniques and present thought. And yet it was seen that as the twentieth century advanced the reason of man seemed unable to prevent wars and revolutions, while his improved techniques served to make such conflicts vaster and bloodier than ever. Nor was the new order that followed upon them, at least in the eyes of many, an improvement on the old.

Even apparent successes were fraught with disillusion. One after another the panaceas from which so much had been expected in the past were tried or mistried, and found wanting: education and democracy, freedom of thought and of the press, parliamentary government, national self-determination, socialism and communism. All had been tried, and none had worked the miracles expected of them. Perhaps men had been mistaken in trusting to any formula to find perfection. At any rate, they felt increasingly nonplussed, disillusioned, disoriented. They had proved themselves capable of harnessing wind and water but not their own passions, and now they realized with horror not only that their improved techniques enabled them to inflict suffering and destruction upon themselves greater than ever before, but also that they lacked the standards or firm beliefs which might show how and to what purpose these vast and new-found powers should be used. They could not, indeed, decide whether tolerant indifference should be preferred to harsh, exclusive dogmas, or whether firm standards were better than none at all.

Most people, of course, live as they have always lived: from day to day, accepting without particular comment or examination whatever ideas happen to be entertained around them. Some can settle for this lowest common denominator and some cannot. They must investigate, question, criticize and, perhaps, hope. Between echoes of the past and echoes of the future, a future which is really the shadow which the present casts before it, the men of these centuries have lived and still live in very interesting times. But the Chinese have a saying that it were better if one's enemies alone lived in interesting times; for interesting times have a way of being uncomfortable times.

Certainly, there is no one way in which to read all this. The great French novelist Stendhal once suggested that the relationship between books and readers is like that between the bow and the violin it plays. The book is the bow; the violin that makes the sounds is the reader's soul, or, if you prefer, his personality. With certain reservations the same may be said about history and historical documents; and the most important of these reservations is bound to be

the fact that while the reader of a novel can make out pretty well with a bit of native intelligence and some imagination, the reader of history, like the violinist, does better if he knows how to wield the bow and read the notes. But even for those who come to it without preparation, without particular knowledge, with nothing but curiosity, history can offer both pleasure and form. True, it is we who endow it with the latter. Order and coherence are artificial creations of the human mind; we introduce them to make complicated subjects easier to grasp, easier to understand. If we really want more we must go beyond this into the realm of a reality which is never simple and try to perceive the underlying complexity of the whole. So, perhaps it is not history that suggests a pattern or form but we who endow it with one or with many. When we speak of pleasure, however, the issue is simpler. Though history has its uses, these are less important and more controversial than its pleasures. And these last, however intellectually valid they might be, rely in the final analysis on the fundamental nature of history, which is a vast, many-sided, sometimes passionate, often commonplace, diverse, monotonous, exciting, depressing, exhilarating, terrifying, inspiring, disillusioning, unending story.

From this follows the commonplace, but perhaps still necessary, reminder that while history as it happens is only partly connected with man, history as we write it—that is, the tale and interpretation of these happenings—is altogether of our making. The study of history may be, indeed should be, as scientific and scrupulous as possible; its telling can never be more than a work of art and the fact that it is so often botched means only that men are clumsy. The study of history is, of course, discovery. It is also a matter of selection and interpretation for which facts, whatever they might be, are only the raw material. Above all, perhaps, it is part of our constant struggle to understand ourselves and what makes us tick. We are products, we are part, of our place, and time, and class, all of which are themselves determined, affected—committed, so to speak—by previous and contemporary developments which they cannot escape any more than we can. If "know thyself" has any meaning, then history is analysis on a very vast scale.

In one sense the documents that follow are evidence in the case of a Western Tradition and how it developed. In another sense this evidence has been rigged—rigged by the editor's selection, of course; but, besides, by our natural inclination, when looking over the past, to pick only horses that have won and to read a pattern into what was in its own time unpredictable confusion. The events of a time very often seem chaotic at the time. Later they seem clear enough; their general lines appear evident and so do the principles of their development. And this may be because we, as it were, *invent* them and invest them with coherence. But it may be, too, because there really is such a thing as a general trend, a dominant tendency or climate of opinion at any one time, and that this only becomes apparent in the perspective lent by distance. Still, invented or perceived, history remains an artifact, the work of man's mind and his imagination.

This should warn us as nothing will to remember always the unselfcon-

scious character of so many historical developments, the remarkably unplanned, irrational fashion of human developments, the tremendous possibilities of alternative happenings, of things turning out differently. Naturally, we cannot stop again and again to consider what might have happened if Napoleon had failed to win the battle of Austerlitz, or if Luther had been burnt like Hus or allowed to die ineffectively like Wycliffe; our history is necessarily determined because it is the story of what has been, not of what might have been. And because the material with which we deal is so vast, we select what we know now are the significant developments, the ones with a future, the acts and the writings that are on the winning side, and we put them end to end to show just how coherently everything happened, that it was simply bound to happen, to create the world and the society we know, to shape countries like France or Spain within practically foreordained borders, and so forth.

It is because such thoughts are so tempting that it is healthy to remember that nothing, so far as we know, was foreordained; that men and countries and ideas fumbled for a long, long time against a background of reality that pointed to nowhere in particular or perhaps in the wrong direction as seen from today. In the fifteenth century the princess of Castile might have married the heir to the throne of Portugal instead of Ferdinand of Aragon, and the destinies of Spain, perhaps the destinies of the world, might have been different. And it is possible to argue in the same vein that for a long time the union of England, Scotland, Wales, and Ireland in one kingdom seemed no more natural and necessary than the union of Denmark, Iceland, Norway, and England in one kingdom under King Canute.

Thus, we ought to have some constant reminders of the unreality of deterministic history, in the same way as certain monastic Orders have constantly under their eyes the reminder that death lies at the end of life and to this purpose paint the words Memento Mori-Remember Death-on the walls of their refectories and on the doors of their cells. We ought to remember the infinite possibilities of what looks like sheer chance, or luck; and the fact that the patterns we see in history are conventions, artificially inserted like coat hangers, in what is really a shapeless garment—an otherwise shapeless mass of events. Such awareness is particularly important because we are forced to use these conventions—indeed, by the selective presentation of facts which we in particular consider significant, we have to create patterns in order to see our way through history at all. So there is nothing wrong with selective history, with deterministic history, with patterns of history like those that Toynbee, or Pirenne, or Marx, or the eschatology of Christian belief can present us with. They are, as a matter of fact, inescapable and necessary, and useful too, provided we remember that each offers one presentation of one aspect of a vaster truth which no one yet has managed to encompass and which it seems beyond the powers of a human being even to conceive.

Another thing worth bearing in mind is that documents of another age speak a language of their own, which may be understood at the price of great scholarship and self-exertion but which at the very least demands from us an effort of

sympathy and imagination. A document, of course, does not have to be written on paper or parchment to serve the historian: a gravestone, a shield, a golden necklace, or a cathedral is as much a document as a twelfth-century charter or the text of the Treaty of Versailles. Each is the product of attitudes and preconceptions peculiar to its time; each can provide—not only in itself but through its position in place and time-information precious to the historian. But though, to take one example, we can gape at a Gothic cathedral, marvel at the strength of the sculpture or the embroidery of its ornament, enjoy or admire it, the cathedral no more speaks our language than a dogmatic Hindu does. It belongs to another world, with different conventions and different beliefs; the feelings it inspires in us are not necessarily, or even probably, the feelings it inspired in the men who built it or worshiped in it at the time when it dominated the life as well as the architecture of its city. The cathedral and ourselves, today, carry on two monologues, what the French call a dialogue de sourds; and however brilliant the interlocutors may be, there is nothing they can do about this unless one crosses into the opposite camp and learns, indeed accepts, the language of the other.

The same thing is true about written documents. The poets, the philosophers, and the politicians whose writings we may study speak to a world that is not our world, that is very far from us, and very difficult to imagine, let alone to comprehend. The kinds of motives they appeal to, the kinds of values they refer to, are at times so strange that they can become irritating or incomprehensible. The *Song of Roland* or the political philosophy of Bossuet are only two instances to be found below in which our acceptance of the values and the motives of an age, the cause-and-effect relationships which these people

took for granted, may prove grudging and ill-natured.

And it is no good saying that a particular pattern of culture is that of a minority. Or, rather, it is important to know this, but also to know what it implies. Culture, after all, like all social influence, like political power in all ages, like belief, is the creation and often the preserve of a minority. Modern sociologists like to emphasize the obvious fact that the mass of people tends to follow and imitate certain "cultural" or "fashionable" leaders, whether individuals or groups. But one might say further that the character and climate of a society are set by the significant few, whether these are followed or not by the insignificant many. There is, after all, no need to actually share in the highest achievements of a form of art or thought in order to feel its influence. We can enjoy the works of Michelangelo or Beethoven even if we cannot perhaps soar as high as they, even if we cannot fully understand the conception behind them. More than that, the work of the men who pitched cathedral spires up into the skies just as much as that of the men who split the atom can be treated as a reflection—symbol or caricature—of certain important tendencies, moods, characteristics of a period, facets of it in which all men of that time must share even though they may be far from understanding, or appreciating, these works -sometimes even from knowing them. Many of the documents that follow represent the ideas and the doings of a single man or a very few; such activities probably did not touch the great majority of people and perhaps still do not today. And yet quantitatively feeble, statistically unimpressive, they cast their influence like a great shadow far, far from the solid mass.

Too little, also, has been said about the extremely important fact that a work of the mind is naturally allusive. Even if the author wants to give the most complete account of the subject, it is never possible for him to tell absolutely everything. He always knows more than he tells; he takes certain things for granted as he assumes that his readers will know them already. To people of the same period, to the members of the same society, there is no need to write everything. They share certain key ideas, you might say key words, which automatically evoke other ideas, emotions, reactions, if they are used to the right audience. Ali Baba found this out when his magic "Open sesame!" proved useless except in a given circumstance, in front of the particular cave where it got results. In the same way, an appeal to Jesus Christ, Democracy, National Feeling, Class, or Race would be effective only upon minds and societies familiar with these concepts and ready to react to them. Thus every work of the mind carries within itself the image of the public for which it is meant. This is what makes it a historical document for us, but it is also what demands the effort of understanding needed to consider it in its proper context.

The Past and the Present

Born in 1914, Hugh Trevor-Roper, Regius Professor of Modern History at Oxford since 1957, made his first scholarly mark in his twenties with the publication of a study of Archbishop Laud (1940), now considered a classic of seventeenth-century English history. Within a few years, he would put his experience as Intelligence Officer in the British Army to use in writing The Last Days of Hitler (1947), probably the first book to treat the dead dictator with historical objectivity. Since then, numerous works have reaffirmed his mastery of a field that runs from The Rise of Christian Europe (1965) through to the present age.

The lecture that follows was delivered on December 5, 1968, as the Annual Oration at the London School of Economics. It allows us to witness one of the major historians of our day explaining and defending the uses of history, the persistent bond between past and present, the inescapable need of the present to understand itself in terms of its understanding of the past.

Hugh Trevor-Roper: History and Sociology

When the Director of the London School of Economics invited me to speak here, he left me free to choose my subject; but on such an occasion I think that a man should speak of the subject which he has studied and on which he may be presumed, sometimes, to have thought. A historian, like other men, lives in the present; but his study is of the past; and coming as I do from Oxford, where some vestiges of past habits still remain, to this institution, which places emphasis rather on the immediate present, I shall venture to consider the relation, if any, between the two.

"If any . . ." Some indeed, I know, would say that there is none. The great

thing about the past, they tell us, is that it is past. Can we not then forget it and devote our limited span of time to the study of the present, in which we must live, or even of the future which, by our actions, however unconsciously, we determine? Historians, defending their own profession, may tell us that the historical process is continuous: that humanity is the same in all ages, and that therefore the lessons of the past may guide us even in the present. But even if this was true yesterday, is it necessarily true today? Is it not possible that, today, we live in a new age, a scientific, technological age, to which such lessons may be irrelevant —in which they may even be positively

World Copyright: The Past and Present Society, Corpus Christi College, Oxford. This article is reprinted with the permission of the Society and the author from Past and Present, a journal of historical studies, No. 42, February, 1969.

misleading? So we are told. Philosophers hitherto, said Marx, have sought to understand the world, but our task is to change it. History, said Mr. Henry Ford (who did change it), is bunk. "It is surely far more important," said our Minister of Education, addressing the Association of Education Committees last summer, "for young people to know all the facts about Vietnam than it is to know all the details of the Wars of the Roses." ¹

"All the facts about Vietnam . . ." This is a tall order. From whom are we to accept all these facts, how test them? Even to acquire these is an arduous task. Ought we not then to free our forwardlooking minds for the purpose, to clear away the incubus of the past, or at least to transform that incubus, from a real nightmare, into the innocent goblin of a fairy tale? It is easy to do this. All we have to do is to remove the study of history from the serious world into the Disnevland of fantasy, in which truth and falsehood do not matter. The temptation, I admit, is very strong. Some distinguished historians, in the weekly press, assure us that it is right to do so: that history has no function but to entertain. Skillful writers also are eager to oblige, ready to dress up the Muse of History in more fashionable, more highly colored clothes for this new occasion. Then, when she has gone, when she has been pushed off into the Light Programme, other graver persons come and bid us turn our serious attention to the new queen of sciences, sociology.

I am afraid that I do not agree, and here, in this home of sociology, I shall venture to defend my disagreement. I venture to suggest that, whether it is entertaining or not, the study of the past is, or can be, useful. Perhaps I would go further and maintain that it is necessary. To those who would say, with Marx, that it is more important to change than to understand the world, I would reply that, even so, without understanding we cannot rationally change it. To those who see the past as an incubus from which we must set ourselves free, I would reply, with Freud, that obsessions are purged only by understanding, not by repudiation. We cannot profitably look forward without also looking back.

Of course we must not be too ambitious. We must not expect too much from the study of history. The historical lens is not exact, and whether we look forward or backward through it, the image is quickly blurred, so that fine detail is often missed and precise parallels cannot be drawn. We cannot compare history with the exact sciences, like mathematics or engineering. Marxists indeed speak of "scientific history" and they have sometimes adjusted the recalcitrant details to fit the rules of their science. But I do not agree with them in this. If the phenomena do not obey the rules, I believe it is better to relax the rules in favour of the phenomena. History, I believe, has its rules, but they are not "scientific"; they are tentative and conditional, like the rules of life. There is an excellent historical periodical entitled, like this lecture, Past and Present. It began under Marxist control. The date of its escape from that control can be easily determined: it is the date (1959) when the sub-title was changed from "a journal of scientific history" to "a journal of historical studies."

But if the lessons of history elude easy formulation, they are none the less real, and they provide the reasons for its serious

¹ For the text of Mr. Short's speech, which seems to me a fine example of educational philistinism, see *Education*, 5 July 1968.

study. What then are these reasons?

First of all, I would suggest, there is a general reason: to avoid parochialism. We all agree that parochialism is a fault. By this we generally mean parochialism in space. But there is also parochialism in time. To understand our own country, we need to see it in its wider context of space, among other countries. Equally, to understand our own age, we need to see it in its wider context of time, among other ages. To study only our own time may seem, at first sight, proof of our modernity: it is a sign that we are concentrating on the real world. But in fact such concentration may easily be very superficial. It removes a whole dimension of thought, and so deprives us of the means of comparison. So much of our own contemporary history is hidden from us that we cannot hope to see it in full. It is so close to us that we cannot see it in correct proportion. It is not yet over, so that we cannot judge it by the result. Familiarity with the past can supply some of those defects. It can provide a standard of comparison. It can point to a known issue. By so doing, it can chasten our parochial arrogance.

Of course, to speak thus is to speak in generalities. To define is more difficult. Perhaps we can best define by opposition. In order to discover the advantages of studying history, we may consider the dangers of neglecting history. For both nations and individuals have sometimes made a virtue of neglecting history; and history has taken its revenge on them.

One instance of such historical revenge is the rise of nationalism in the nineteenth century. In many ways nationalism is the revolt of historically minded peoples against rulers who have thought in nonhistorical terms. In eighteenth-century Europe most enlightened men were cosmopolitan, international. They looked back at history and saw a "gothic" past from which they had emerged into the full light and freedom of the present; and they regarded "patriotism," national loyalty, national pride, as a vulgar relic of tribalism. How condescendingly the "enlightened" French Encyclopaedists looked at the literature of the past, of which one of them, D'Alembert, would have made a periodic bonfire! How contemptuously they dismissed the atavistic, irrational complaints of the bigoted, unenlightened Poles who squealed and squirmed in a most undignified fashion when their country was carved up and absorbed by the Enlightened Despots of Prussia, Russia and Austria! How impatiently, a generation later, the Bonapartist afrancesados of Spain looked down on the obscurantist bigots who resisted their rational reforms! But this triumph of Reason did not last. In the next century the nations revolted; and their revolt was nourished, everywhere, by history. It was the "historic nations," the nations which were conscious of their history—the Poles, Italians, Germans-which led the revolt; and all the nations in revolt began by discovering, or inventing, their history. No doubt the history which they discovered was not very good; the cosmopolitan historians of the eighteenth century were probably better as historians; but there was a large area of history which those historians had dangerously ignored and which now took its revenge.

We see the same process today in historic Asia and unhistoric Africa. In 1900 the colonial empires seemed "enlightened." Did they not bring material improvement, utility, modernity? The West was benevolent, cosmopolitan, the educator of the world. In 1940–41, Mr. Wendell Willkie, Franklin Roosevelt's defeat-

ed rival for the presidency of the United States, flew from country to country preaching the glowing message of "One World," and Vice-President Wallace afterwards further defined the new American ideal as "the century of the common man." I confess, I detest both these concepts of these two well-meaning men. I prefer variety and sophistication to such uniform banality. But quite apart from personal preference, such variety, I believe, is necessary. The variety of custom in the world is not merely the superficial diversity of a fundamentally uniform humanity. It has independent historic roots, and those roots will continue to thrust up shoots, after their kind: shoots which may be ignored, or cut, or fostered or distorted, but cannot be arbitrarily changed. This has been shown clearly in the past twenty years. Perhaps we would understand today's struggle in the Far East better if we knew less than "all the facts about Vietnam" and at least something about the Wars of the Roses.

This recrudescence of history, this periodic revenge of the past, which is my first reason for not forgetting it, is nowhere more obvious than in China today. Theoretically, the Chinese communist revolution is a repudiation of the millennial history of China. Communist China has broken decisively with its past, loudly and explicitly disowned its long and splendid history. The recent "cultural revolution" has emphasized and exaggerated that breach. The deposit of four thousand years has now been repudiated in its totality; everything that is old has been discarded; and all things, we are told, have been made new. But in fact, what has happened? The inheritance of the Kuomintang, of the Chinese Republic, has indeed been rejected, but the older inheritance of the Manchus, of the Chinese empire, has returned to fill the void. Today Peking is once again the capital of the Middle Kingdom. Chairman Mao, like the Son of Heaven, is to live for ten thousand years. The Europeans are again outer barbarians, whom the self-sufficient Celestial Empire has no need to know. The usages of international diplomacy, of the comity of nations, have been rejected; and foreign embassies provide the means not of negotiation but of tribute; of the enforced kowtow, of the sacked Legation, and of periodic humiliation by the officials of the vast, impervious, conformist bureaucracy.

Such is the revenge of history on those who ignore it. Expelled with a pitchfork, it nevertheless returns. How historical patterns thus reassert themselves, how historic continuity, even identity, persists below the apparent level of consciousness. is to me a mystery. Idealist historians speak of the spirit of a people, which they see no need to reduce into concrete terms. Perhaps the sociologists have some less airy formula. But in order to test any such formula, it must be studied against the dimension of time, that is, historically. No great political problem can be seen apart from its historical context. I well remember the debates that raged, in the 1930's, about the Spanish Civil War. To those who lived in their own time only, to the fashionable, ideologically committed commentators of the age, the Spanish Civil War was a war between international fascism and international communism, which was being fought out. almost by chance, in the Iberian peninsula. Superficially, of course, it was. But fundamentally, we all now realize, its causes lay deep in Spanish history. In that context alone could it be understood. General Franco was seen by foreigners as the creature of Hitler and Mussolini. He

saw himself, rather, as a hero of 1809. His opponents were seen, during the Civil War, as international communists. They were not. They were Spaniards, who looked back to an ancient peninsular tradition with which Marx had nothing whatever to do. The profoundest, most perceptive historian of that Civil War,-I refer to Mr. Gerald Brenan-once told me that he was provoked to write his account of it by the abysmal ignorance and folly of those Marxist crusaders who thought they could interpret, in the terms of twentieth-century international communism, a phenomenon which could only be understood in the terms of hitherto unstudied nineteenth—and pre-nineteenth —century Spain.

The same can be said, mutatis mutandis, of the Russian revolution, in which the Tsars have perhaps more long-term importance than Marx. The same can be said of modern Greece. And perhaps the War in the Far East would be better understood if it were interpreted with a little less of fashionable modern doctrine and a little more of unconsidered local history.

If past history—by whatever ducts and channels it flows—thus exercises a continuing force in human affairs, it is obvious that individuals also will greatly err who decline to consider its lessons. Once again I take an obvious instance from the 1930's. Neville Chamberlain, and those who supported him, were men of the twentieth century. They could not believe that Hitler, who was their contemporary, and who rose to power in a modern, highly industrial society, could be fundamentally different from themselves. He might be a vulgar demagogue; he might use extravagant language and

violent methods; but at bottom his aims must surely be limited by the shared rationality of the twentieth century, as they knew it, and ultimately, if only one could see past the violence and the vulgarity, it must be possible to reach agreement. But Hitler was not a man of the twentieth century. No man who concentrates in himself the claims of a whole nation is a man of his own century only. Winston Churchill, out of office, writing, in those very years, a great historical study of the seventeenth century, was in a better position to understand the true character of Nazism than those who, from whatever side, understood, however well, only the immediate problems of their own time.

The same error, I suspect, was made by Franklin Roosevelt in his relations with Stalin. He believed, and at one time frankly stated,2 that he could handle Stalin better than anyone else. At one time he would have constituted Stalin as an arbiter between Britain and America. He saw him, I suspect, as a political boss from another segment of Wendell Willkie's "one world": from Texas perhaps, or Huey Long's Louisiana, or Kentucky of the colonels: rough and ruthless, no doubt, but fundamentally "one of us." But Stalin was not one of us. Roosevelt and he might share, for a brief time, the responsibilities of a common war, just as Chamberlain and Hitler, for a brief time, held the balance of peace and war between them. But they did not, for that reason, live in the same context. Long years of Russian history, both conservative and revolutionary, formed the presuppositions and secret aims of Stalin. and those presuppositions and aims were not suspended by the war, or to be changed by personal diplomacy. Rather,

² See Winston Churchill, The Second World War (London, 1949-54), IV, p. 177.

the war was fought, by him, to secure those aims, and diplomacy consisted in temporarily concealing them.

But if past and present are thus continuous, so that the present cannot be fully understood in isolation from the past, can we be more particular? Can we use the past not merely to provide a general context within which the particular problems of the present may be better understood, but also to provide particular solutions to particular problems? Can we even, at least in theory—for this is logically entailed in that—use the past to predict the future?

Those who speak of "the science of history," "scientific history," would presumably answer yes. I would not go so far. Even if history were a science, I would remain basically sceptical: for there are sciences and sciences, and even in science we must never be too schematic, too quick to systematize: that is how sciences are not forwarded but arrested, frozen. And besides history, I believe, is not a science: it is an art in whose method several sciences are subsumed without making it thereby itself scientific.

At certain times, indeed, history itself has been declared scientific. It was scientific in the Middle Ages, and that scientific interpretation lasted, with the rest of the intellectual infrastructure of the Middle Ages, however damaged by heresy, until the mid-seventeenth century. In those centuries, History was understood to have both a beginning and an end. It began with the Creation and would end at the pre-ordained end of the world; and both dates could, theoretically at least, be scientifically determined with the perfection of astronomical tables and the clarification of sacred texts. Moreover, between those two terminal dates, which scientists were constantly making more precise,

the events of history could-again in theory at least—be exactly predicted; for God had already, by His Providence, determined them all and by His prophets and His occasional direct revelations had exposed—cryptically indeed, fragmentarily indeed, but not insolubly to the ingenious believer-both the general outline and a basic quota of particular details, from which the rest might be deduced. At one period-in the first half of the seventeenth century, when the astronomers and mathematicians had established the measurement of time and the theologians were refining the exact meaning of the Apocalypse—it seemed as if the last remaining problems were solved and the few still unfulfilled events of history could be exactly predicted, just ahead of time, before all came to an end in 1666. . . .

How remote it all seems now! Why should we trouble ourselves now with these exploded fantasies? Why indeed except to show a lesson of history, and learn humility thereby. The past is littered with the *débris* of ambitious historical systems, in which some of the greatest minds of the time—a Scaliger, a Napier, a Newton—have been invested. And why should later systems be any more durable? Are the doctrines of linear progress, or the continuing dialectic of the class struggle, or the withering away of the state, or the Yin and Yang any less metaphysical in their foundations?

History, I believe, is dependent on several sciences in its detail. Since the Renaissance, one new science after another has been subordinated to it, and refined within it. Textual scholarship has corrected its sources, cryptography has increased them, *Quellenkritik* has interpreted them. Chronology has provided a new spinal cord on which we can re-

connect the disjointed vertebrae of the remoter past. Sociology, authropology, have given new depth and breadth. But history itself, though resting on an ever more scientific base, remains itself too human a subject, too dependent on accident, too variable in the proportion even of its recurrent features, to be safely predictable. We may predict in detail, and conditionally, where we have the means of comparison, and such limited predictions may be scientifically, or at least empirically, tested and so justified and useful; but generally and absolutely there can be no prediction, only a guess; and a guess is, in the strict sense, worthless.

For instance, we may say that, according to the evidence of history, if there is a severe economic recession in a multi-racial society, there will be acute interracial tension, and we may say, according to the social pattern and ideological tendency of the time, what form that tension will take. We can use for this purpose the evidence of sixteenth- and seventeenthcentury Spain, which will, I believe, be of more value than any purely modern sociological theory. But we cannot say unconditionally that, by the law of history, the next generation shall see the end of the world, or a "time of troubles," or the rise of a new empire, or universal peace, or indeed, in those absolute terms, anything else.

When people ask me whether historians should not be able, ideally, to prophesy the future, I ask them a simple question. Let them place themselves at any date in past history and say honestly whether any man could rationally have prophesied the course of the next fifty

years. In 1900? Who could conceivably have forecast the convulsions of Europe or foreseen the total dissolution of the recently united German Reich? In 1950? Who would have supposed that America, the liberator of Europe, with its inherited cult of isolation and its public hatred of imperialism, would become the very type of imperialist power, fighting a long and bitter war in the Far East, and that a Democratic President would be denounced in Asia, however unjustly, as "the new Hitler"? I do not believe that any such prophecy would have been possible. If it had been made, it would have been not scientific but an inspired guess.

On the other hand, conditional prophecy is always possible, if the conditions are clearly understood, and the more we study history, and the more scientific its context becomes, and the more we respect its limits, the better we can prophesy. Jacob Burckhardt's prophecy, in the 1870's and 1880's, that the old monarchies would be pushed aside and a new race of Gewaltmenschen would rule as terrible dictators, beginning perhaps in Germany,3 was a rational, limited prophecv based on historical understanding: he saw that the new industrial power, if it became political, would be quite different from the old, and that it was most likely to take root where industry was heaviest and old "liberal" forms weakest. Similarly Sir Halford Mackinder's prophecv, before the first World War, that the struggle for mastery in the world would center on Eastern Europe and that Tsarist Russia would be the great power of the future,4 was not invalidated by the total ruin of Tsarist Russia, first in war, then

³ Burckhardt's prophecies are in his letters to Friedrich von Preen. See Jacob Burckhardt, Briefe, ed. Felix Kaphahn (Leipzig, 1935), esp. pp. 348–9, 355–6, 484–7.

⁴ Halford Mackinder's views were finally presented in *Democratic Ideas and Reality* (London, 1919); but they had been formulated and expressed by him earlier.

in revolution. Nor would it have been invalidated if Hitler had won his war. The essential condition was the control of the "Heartland." In fact, it was for that Heartland that Hitler and Stalin fought, and it was an ideological war, fought to the death, because both belligerents knew that the winner, whichever he was, would be the arbiter of Europe.

There are numerous such conditional laws of history; empirical rules which can be taken from a wide range of historical experience. Any of them may be applicable to the present, none of them provides a certain formula for the present. For one safe rule of history is that historical situations never exactly repeat themselves: there are too many variable ingredients in each situation for identical recurrence. Even if they should do so, the mere fact of repetition is a new ingredient which may alter the mixture.

I have often been asked, in the last twenty years, whether I could forecast an effective revival of Nazism in Germany. I have always answered, no; because I have never believed that the old doctrines could revive in the old form. They might survive, as a kind of dead deposit, in ageing minds. Elements of them would recur, here and there, in new situations: for some of the elements are permanent features of German history, and some are predictable responses to recurrent social pressures. But the fusion of all these elements in a particular dynamic pattern was caused, in the past, by the particular unrepeatable experience of one generation, and even if all the same circumstances should recur, in the same order (which is, inconceivable), the emotional content would not be communicable, unchanged, to another generation: the identical pattern of pressures and the same intellectual climate would not recur. For this reason, the new fascism, when it occurs, will occur with radical differences. Indeed, with such differences, it has already occurred. The arrogant cult of vouth, the nihilism, the intolerance of dissent, the rejection of rational argument, the deliberate invocation of force to justify counter-force—all these have recently been resumed.5 But they have been resumed in classes and circumstances very different from those of the 1920's and 1930's; and although a knowledge of the original fascism may help us to understand the new phenomenon, the precise form in which they have been resumed could not, I think, have been predicted.

This constant change of circumstance, and of "intellectual climate," is what makes the severance of the present from the past, in our studies, seem so dangerous. History is the empirical study of the past, which uses, or should use, all the sciences that are relevant to it. Sociology is the study—its advocates call it the scientific study: it is "social science"-of the present. Sociology entered historical study in the eighteenth century, with Montesquieu. It has remained within it, strengthening its position in it, ever since. Today, I cannot conceive of good history without a sociological dimension. But if sociology is essential to history, history, I believe, is no less essential to sociology. Sociological models tend to be static. Unless they are tested, they are necessarily dogmatic. But the test of a model is the

⁵ Since delivering this lecture, I have seen an issue of *The Beaver* (5 Dec. 1968), described as "The newspaper of the London School of Economics Union"; and I can add that the obscene and vindictive journalistic style of Julius Streicher's notorious anti-semitic periodical *der Stürmer* has also been resumed—though against other scapegoats.

way it works, as the test of a car is the way it runs; and the running of the sociological model is history.

This, I suspect, is sometimes forgotten by "social scientists" who construct and admire their models in the workshop only and do not test them by running them through the dimension of time. For once they are running, we see that they are not mechanical models only; they are organisms, with a biology, a metabolism of their own. They respond to circumstances, even to the circumstances which they may create. They engage, as it were. in dialogue with other "models," which are also organisms, and those other models change too. The very dialogue generates change, and it is the sum of these changes which is history.

Once, in 1950, I had a provocative experience. I was at a Congress in Berlin. It was the time of the outbreak of the Korean War, and feelings in that vulnerable, isolated city were running high. The Congress was being run by the American C.I.A. As I sat there, one distinguished speaker after another rose to speak. All of them were Marxist social scientists in their original intellectual formation, though by now they had put their convictions into reverse. They now declared that communist society and western society were immutable models, absolutely incompatible with each other, and that one must destroy the other. There was no alternative. Therefore, he who was not for us was necessarily against us in the holy war. As I listened to these remorseless speeches, historical analogies coursed through my head, and I saw, in past history, a very different lesson. I saw a succession of supposedly incompatible forms of society, sometimes indeed engaged in mutually destructive crusades, but sometimes also, behind their heavily fortified frontiers, competing with each other in less violent manner. Outmaneuvering each other, borrowing from each other, learning from each other, changing by contact with each other, until, with a change of generations, the crusading spirit (which was the product of a particular conjuncture) had evaporated, and the crusade itself, having been happily avoided, now seemed unnecessary. In order to expound my theme, I made several attempts to catch the chairman's eve, but somehow my attempts were never noticed: so I came home and wrote a short historical article which today, I hope, reads slightly better than those crusading speeches. It was an article on the co-existence of Christendom and the Turkish Empire; 6 but it could equally have been on other such ideological confrontations.

For instance, there is the ideological confrontation of Reformation and Counter-Reformation in sixteenth-century Europe. It is easy to construct abstract models of Protestant and Catholic societies, and having constructed them, to use them as permanent concepts. But although such models have their value, and at one particular time, or in one particular place, may even be true, we must always remember that they are abstractions, not realities: the historical reality is constantly changing. Some historians, misled by these abstractions, overlook the continual change, which caused the balance between the two societies to oscillate. Protestant or Marxist historians overlook the inhibiting ideological reaction in "reformed" societies and suppose that the intellectual supremacy of one period was

⁶ Reprinted in my Historical Essays (London, 1957), pp. 173-8.

necessarily, as part of the system, continued to another. Catholic historians similarly generalize from the temporary triumphs of the Counter-Reformation. But in fact intellectual or spiritual or economic superiority did not spring automatically from the "model," as applied. The reality was in constant process of adaptation. The very fact of competition quickened the process of adaptation—just as capitalist and communist society have transformed themselves out of recognition by their competition in the last forty years. Only a bigot of doctrine can fail, or refuse, to recognize this; and it is no doubt for that reason that, in communist countries today, history has been made to stand still and the social condition of England is permanently illustrated from the fossilized "model" supplied by the novels of Charles Dickens.

This debate between past and present, between history and "social science," is not new. It has an old ancestry. It is the debate between Machiavelli and the Churches in the sixteenth century, between Clarendon and Hobbes in the seventeenth, between Macaulay and the utilitarians in the nineteenth. Clarendon accused Hobbes of seeking to impose abstract "geometrical" models on society instead of taking advantage of the empirical lessons of history; and he urged him, though now at the advanced age of eightyeight, to go into politics and sit in parliament, and thereby correct the illusions bred by "his solitary cogitations, how deep soever, and his too peremptory adhering to some philosophical notions, and even rules of geometry." 7 Macaulay even more rudely excoriated the mean and abject

"sophisms," the "syllogisms," the scholastic deductions of James Mill, the illusion that "the science of government" could be derived "by short synthetical arguments" drawn from self-evident axioms about human nature. He extolled instead the empirical study of history whose best exponents, he too, like Clarendon, insisted, had been practical politicians—especially, of course, Whig politicians.8 Much the same point was put, in terser form, by Mr. Quintin Hogg to an academic sociologist who had the misfortune to meet him, a few months ago, on television. Both Clarendon and Macaulav, it must be admitted, in their more extended arguments, made some mistakes-which. since I am on their side, I shall leave decently unexposed; for they were not fundamental: they do not affect the general argument. Instead, I shall conclude by asking how we can follow their advice and study history in such a way that, without adopting the extreme course of going into Parliament, we can profit from it in the present and so avoid the reproaches of Mr. Short. I believe that there are at least two golden rules which Macaulay himself would sometimes have been well advised to follow.

First, we must not force the pace of history or seek to extract from it more precise lessons than it will yield. The very value of history lies in its general lessons, its complexity, its suggestions and analogies, and the highly conditional nature of its parallels, not in concrete lessons or dogmatic conclusions. I know that people want such conclusions, and when historians will not give them such conclusions, they sometimes, in their disappointment,

⁷ Edward Hyde, Earl of Clarendon, A Brief View of the Dangerous and Pernicious Errors . . . in Mr. Hobbes' book entitled Leviathan (Oxford, 1676).

⁸ Macaulay's views on Mill are expressed in his essays reviewing Mill's Essay on Government (1829) and Sir James Mackintosh's History of the Revolution in England (1835).

turn aside to the more positive (but not necessarily more helpful) assurances of the social scientists. But I insist that such precise conclusions are not warrantable, or valuable. All the greatest historians have refused to produce them, and those who have complied with the public demand by producing them, are quickly out of date. The great historians-Thucydides, Gibbon, Ranke-do not press an interpretation. The concessions that they make to the public are in form only: in style, in lucidity, in readability. They do not spell out crude lessons which can be neatly tabulated for busy readers by obliging epitomists. Therefore they are not always popular with those hasty students who wish to have their historical philosophy served up to them in a nutshell. The philosophy of the greatest historians cannot be quickly summarized. It is not crude. It is subtle; and in a long work it must be allowed gradually to emerge.

Secondly, we must, I believe, respect the independence of the past. All of us, living in our own time, tend to see the past on our own terms. We like to recognize, in past centuries, familiar problems, familiar faces: to see man looking towards us, not away from us. But this tendency, though natural, contains great dangers. It is right, I believe, to look for lessons in the past, to see its relevance to our own time, to observe the signs of continuity, connection and process. The past is not to be studied for its own sake. That is mere antiquarianism. But it is anachronistic, distorting, to judge the past as if it were subject to the present, as if the men of the eighteenth or the sixteenth or the tenth century had no right

to be independent of the twentieth. We exist in and for our own time: why should we judge our predecessors as if they were less self-sufficient: as if they existed for us and should be judged by us? Every age has its own intellectual climate, and takes it for granted, as we take ours. Because it was taken for granted, it is not explicitly expressed in the documents of the time: it has to be deduced and reconstructed. It also deserves respect. This is what the greatest of nineteenth-century historians, Leopold von Ranke, meant when he wrote that every age was "immediate to God," and implicitly blamed Macaulay for arraigning past ages before the tribunal of the present—the brief present of the midnineteenth century, which has now passed and may seem to us, in retrospect, a very partial tribunal.9 To discern the intellectual climate of the past is one of the most difficult tasks of the historian but it is also one of the most necessary. To neglect it-to use terms like "rational," "superstitious," "Progressive," "reactionary," as if only that was rational which obeyed our rules of reason, only that progressive which pointed to us—is worse than wrong: it is vulgar.

Finally, in studying history, I believe that while we must always appreciate its extent and variety, we must always study one part of it in detail. To study on too narrow a front deprives us of the chance of analogy; but to study too generally is not to study at all. We cannot penetrate below the surface all the time, or we shall never come up for air, never rise above the subject to survey and compare. But if we do not, at some point, penetrate below the surface, we shall fall into the opposite

⁹ Ranke's implied criticism of Macaulay is in his *History of England* (Engl. transl., Oxford, 1875), IV., p. 364.

error. We shall be obliged to take all our evidence at second-hand and shall end by believing, without testing, the fashionable orthodoxy of our time or place. Every age has its orthodoxy and no orthodoxy is ever right. It is changed, in due course, by those who approach the subject, whatever it is, with a certain humility and, above all, independence of mind. But those intellectual gifts need material on which to work, and that material, in history, must be raw material. In other words, the historian is amphibious: he must live some part of his time below the surface in order that, on emerging, he can usefully survey it from above. The historian who has specialized all his life may end as an antiquarian. The historian who has never specialized at all will end as a mere blower of froth. The antiquarian at least is useful to others.

I would have all historians specialize, for however short a space, on some part of their own history—for there they are at home: they can read the sources in their own language. This will prevent them from too easy generalization by

showing upon what uncertain and controversial foundations received opinions are often based. But having done this, I would have them read the history of other countries, knowing that they will then do so with a double advantage. From their specialist study of their own history they will know how to reserve judgment on general history where they have not penetrated so deeply; and from their general study of foreign history, thus qualified, they will learn that comparative method which will prevent them from too readily accepting one formula of historical causation: from assuming (for instance) that parliamentary democracy, or trades unions, or liberal catchwords, or any catchwords, are the only way of salvation. By this double process they may make the study of the past not only interesting but useful. It will not prove to be a science. It will produce no ready-made answers. It will not enable them to prophesy. But it will enlarge their views. It may bring independence of judgment. And so it may enable them to understand, and by understanding, to improve, the present.

The Making of the Modern World

- I. FRESH FIELDS AND PASTURES NEW
- II. REFORMATION AND COUNTER REFORMATION
- III. POLITICAL AND ECONOMIC CHANGES
- IV. THE SEVENTEENTH CENTURY
- V. THE POLITICAL DEBATE

There has been a great deal of debate as to the period to which the term Renaissance may legitimately be applied. Professor Haskins has pressed the claims of the twelfth century; Professor Butterfield has put forward those of the seventeenth. The case for each is strong; decision is difficult. A compromise between them would bring us back to the period favored by Michelet and Burckhardt; that is, to the fifteenth century. One point in favor of such an old-fashioned view is that the men of that time thought of themselves as living through a renaissance, a time of renewal which they contrasted with the dark and "gothic" barbarism of the past. They might well have written, with Shelley, that

The world's great age begins anew,
The golden years return,
The earth doth like a snake renew
Her winter weeds outworn:
Heaven smiles, and faiths and empires gleam
Like wrecks of a dissolving dream.

Certainly much that was new or, at least, refurbished, does seem to appear during this busy, bubbling period when in retrospect Heaven does seem to have smiled briefly upon Europe, even if the smile was only wryly ironical.

I. Fresh Fields and Pastures New

The documents that follow originated in the confused and busy period which we like to call the Renaissance. No period has only one aspect or mood, but in the long run every period can be defined in terms of the trend which proves to have been dominant or historically most significant. Thus, we can see these years as a time of questioning and reaffirmation, a rediscovery of forms and values which had been submerged since the barbarian invasions, a sense of emerging from the dark "gothic" ages into the sunlight of a new world—broadened by new discoveries, enriched by new enterprises, invested with a new significance. We may or may not agree, but to many intellectuals of the time—and to many nonintellectuals too—this seemed a better world to live in, a forward-looking world in which man, who had already accomplished so much, might be expected to accomplish yet more.

1. THE NEW MAN

Giovanni Pico della Mirandola (1463–1494) distinguished himself during his brief career by the precocity of his learning and the boldness of his ideas in philosophy and theology. His motto, *De omni re scibili* [Of all things that one can know], asserted that he knew all there was to be known; and though a doubt is permissible on that score, the claim itself seems to reflect a characteristic attitude of his time in which the borders between confidence and foolhardiness were very ill-defined.

Pico della Mirandola: Oration on the Dignity of Man

In the writings of the Arabs I have read, oh reverend Fathers [of the Church], that when someone asked the Saracen Abdalah what seemed to him the most wonderful thing in this theater of the world, he replied that nothing seemed more wonderful than man. The opinion of Mercury agrees with this: "What a miracle, oh Asclepius, is man!" As I was pondering the meaning of these words, the opinions which many had advanced about the greatness of human nature did not satisfy me—that man is the mediator

of all creatures, the servant of superior beings, the lord of inferior ones, that he is the interpreter of nature by the keenness of his senses, by rational inquiry, by the light of his intellect; the intermediary between time and eternity, and, as the Persians say, the nexus of the world, its very wedding song; according to David a little lower than the angels. These are great reasons, to be sure, but they are not the most important. It is not those which give man the privilege of unlimited admiration to men. Indeed, why not, there-

From Pico della Mirandola, Oration on the Dignity of Man (1486), tr. Dr. D. Weinstein; reprinted by courtesy of the translator.

fore admire the angels and the blessed heavenly choirs even more?

But at last it seems that I have understood why man is the most fortunate of creatures and therefore worthy of all admiration, and what is the position which has been granted him in the universal order, so that not only the beasts but even the stars and the other worldly intelligences envy him. Incredible and marvelous! And why not, if it is indeed for that that he is considered to be a great miracle and a wonderful creature? But what this position is, listen, oh Fathers, if you please, to my discourse and grant it a favorable hearing.

The most high Father, God the Creator, had wrought this worldly home which we see, this august temple of divinity, according to the laws of his secret wisdom. He furnished the supercelestial region with intelligences, the celestial sphere he provided with eternal souls, the filthy and disgusting parts of the lower world he populated with a great assortment of creatures of every species. But, when the work was finished, the Creator wanted some one to reflect upon the reason behind such a great creation, who might love its beauty and marvel over its grandeur. And therefore, when everything was finished, as Moses and Timaeus attest, he thought at last of creating man. However, there was not one model left by which he might fashion a new offspring; there was nothing left in the treasury with which he could endow this new son. There was no station in all the world where this contemplator of the universe could sit. All were full; everything had been distributed to the highest, the middle and the lowest orders. But it was not fitting of the paternal power to have been worn out in the last act of creation. It was not worthy of his wisdom to have been left perplexed

over an important problem. Nor was it fitting to his provident love that the creature who was to have praised his divine liberality to others was compelled to complain of the lack of it to himself. At last that excellent creator decided that he to whom he was to give nothing for his own could share everything which had been given individually to the others. Thus he took man as the product of an undetermined nature and placed him in the middle of the world and said to him: "I have not given you, oh Adam, a definite seat or a special appearance, or any function of your own. The seat or the appearance or the function which you want, you may have and keep by your own desire and your own counsel.

"The other creatures have a defined nature which is fixed within limits prescribed by me. You, unhampered, may determine your own limits according to your own will, into whose power I have placed you. I have set you in the center of the world: from there you can better see whatever is in the world. I have made vou neither heavenly nor terrestrial, neither mortal nor immortal, in order that, like a free and sovereign artificer, you can fashion your own form out of your own substance. You can degenerate to the lower orders of the brutes; you can, according to your own will, recreate yourself in those higher creatures which are divine."

Oh supreme generosity of God the Father! Oh supreme and wonderful felicity of man, to whom it is granted to have what he desires, to be what he wishes! The brutes receive all that they have from their mother's womb when they are born, as Lucullus says. The supreme spirits become either immediately or soon afterward that which they were destined to be for all eternity. At the time of man's

birth the Father plants every kind of seed and the germs of every kind of existence; and the ones which each man cultivates are the ones which will grow, and they will bear their fruit in him. If they are vegetative, he will be a plant; if animal, he will be a brute; if they are rational, he will become a celestial creature; if intellectual, he will be an angel and the son of God. But if, not content with the lot of any kind of creature, he draws into the center of his own unity, his spirit will become one with God. In the solitary darkness of the Father he who has been set above all things will stand above all things. Who will not admire our chameleon? Or rather, who will admire anything more? Of him Asclepius the Athenian said, with justice, that, in religious rites, because of his versatility and his changeable nature, he symbolized Proteus. Hence those famous metamorphoses among the Hebrews and the Pythagoreans. In fact, the esoteric theology of the Iews at one moment transforms St. Enoch into an angel of divinity. Then, others into other divine spirits. The Pythagoreans changed wicked men into beasts and (if Empedocles is to be believed) even into plants. In imitation of that Mahomet frequently repeated, and rightly, that he who retreated from the sacred law became a brute. For it is not the bark which makes the tree but the stupid and insensitive nature; not the hide which makes the mule but the brutish and sensual soul. It is not separation from the body that makes an angel, but spiritual intelligence. If you see someone who is a slave of his stomach, crawling on the ground, it is a plant that you see, not a man. If you see someone blinded like Callypso by vain illusions of fantasy and emprisoned by dark allurements, the slave of his senses, he is a brute, not a man. If he is a philosopher who looks at everything with reason, you will revere him: he is a heavenly creature, not an earthbound one. If he is a pure contemplative, unaware of his body, given over to mental perceptions, he is not an earthly nor a celestial creature, he is a more exalted spirit, surrounded by human flesh. And who would not admire the man who in the Old and New Testament is called, and rightly, first with the name of all flesh, then with the name of every creature, because he shapes, creates, and transforms himself into the appearance of every kind of flesh and into the nature of every kind of creature. So the Persian, Evantes writes, where he explains chaldaean theology, that man does not have any image of his very own but many exterior and foreign ones. Hence the saving of the Chaldeans that man is an animal of varying nature, multiform and inconstant. What of all this? It is that we may understand that from the time that we are born in this condition we are what we wish to be. We should take care that it be not said of us that, being honored, we did not realize we have become similar to brutes and foolish jackasses. Let rather the words of Asaph be repeated: "You are Gods, and you are all children of heaven," lest, abusing the indulgent generosity of the Father, we render harmful rather than salutary that choice liberty which he has given us. Let a sacred ambition enter our souls so that we do not satisfy ourselves with mediocre things, but aspire to the highest things, and strive with all our strength to reach them. From the moment that we wish it, we can. Let us despise earthly objects, let us disdain celestial ones, and leaving aside whatever is worldly, let us soar to that supramundane court which is close to the most high divinity. There, according to the sacred mysteries, the Seraphim, Cherubim, and Thrones have the primacy. Unable to give up, and impatient of second

place, let us emulate their dignity and glory and, if we desire it, we shall be in no way inferior to them.

2. THE NEW STATE

Niccolò Machiavelli (1469–1527) is one of the most interesting writers of the Italian Renaissance and one of the most controversial. Born in Florence, he engaged in the politics and the diplomacy of the powerful republic, wrote its history, found himself in exile when his opponents, the Medici, returned to power. The Prince (1513) is not a work of advice so much as of observation. Machiavelli does not offer his ideas of what is good, but his impressions or conclusions of what seems to work. It is just this amoral quality of the essay that has shocked so many of his readers, though it fascinated others. (Catherine de Médicis, Francis Bacon, Richelieu, Spinoza, Napoleon, count among his admirers.)

Machiavelli: from The Prince

OF NEW PRINCEDOMS ACQUIRED BY
THE AID OF OTHERS AND BY
GOOD FORTUNE

They who from a private station become Princes by mere good fortune, do so with little trouble, but have much trouble to maintain themselves. They meet with no hindrance on their way, being carried as it were on wings, but all their difficulties arise when they arrive. Of this class are those on whom States are conferred either in return for money or through the favour of him who confers them; as it happened to many who were made Princes by Darius in the Greek cities of Ionia and the Hellespont, so that they might hold them for his security and glory; and as happened in the case of those Emperors who, from privacy, attained the Imperial dignity by corrupting the army. Such Princes are wholly dependent on the favour and fortunes of those who have made them great, though

no supports could be less stable or less secure than these; and they lack both the knowledge and the power that would enable them to maintain their position. They lack the knowledge, because unless they have great parts and force of character, it is not to be expected that having always lived in a private station they should have learned how to command. They lack the power, since they cannot look for support from attached and faithful troops. Moreover, States suddenly acquired, like all else that is produced and grows up rapidly, can never have such root or hold as that the first storm that strikes them shall not overthrow them; unless, indeed, as I have said already, they who thus suddenly become Princes have a capacity for learning quickly how to defend what Fortune has placed in their lap, and can lay those foundations after their rise which by others are laid before.

Of each of these methods of becoming a Prince, namely by valour and by good

From Machiavelli, The Prince, adapted from the London edition of 1674.

fortune, I shall give you an example from times we can remember: the cases of Francesco Sforza and Cesare Borgia. By suitable measures and a great deal of ability, Francesco Sforza rose from privacy to be Duke of Milan, preserving with little trouble what it cost him infinite efforts to gain. On the other hand, Cesare Borgia, vulgarly spoken of as Duke Valentino, obtained his Princedom through the favourable fortunes of his father, and with these lost it, although, so far as in him lay, he used every effort and practised every expedient that a prudent and able man should, who desires to strike root in a State given him by the arms and fortune of another. For, as I have already said, he who does not lay his foundations at first, may if he be of great parts, succeed in laying them afterwards, though with inconvenience to the builder and risk to the building. And if we consider the various measures taken by Duke Valentino, we shall perceive how broad were the foundations he had laid whereon to rest his future power.

I do not think it superfluous to examine these, since I know not what lessons I could teach a new Prince more useful than the example of his actions. And if the measures taken by him did not profit him in the end, it was through no fault of his, but from the extraordinary and extreme malignity of Fortune.

In his efforts to aggrandize the Duke his son, Alexander VI had to face many difficulties, both immediate and remote. In the first place, he saw no way to make him Lord of any State which was not a State of the Church, while, if he sought to take for him a State belonging to the Church, he knew that the Duke of Milan and the Venetians would not consent:

saw that the arms of Italy, and those more especially whereof he might have availed himself, were in the hands of men who had reason to fear his aggrandizement, that is, of the Orsini, the Colonnesi, and their followers. These, therefore, he could not trust. It was consequently necessary that the existing order of things should be changed, and the States of Italy embroiled, in order that he might safely make himself master of some part of them; and this became easy for him when he found that the Venetians, moved by other causes, were plotting to bring the French once more into Italy. This design he accordingly did not oppose, but furthered by annulling the first marriage of the French King Con Con Will

King Louis, therefore, came into Italy at the instance of the Venetians and with the consent of Pope Alexander, and no sooner was he in Milan than the Pope got troops from him to aid him in his en, day terprise against Romagna, which Province, moved by the reputation of the French arms, at once submitted. After thus obtaining possession of Romagna, and defeating the Colonnesi, Duke Valentino wanted to follow up and extend his ¿conquests. Two causes, however, held him back, namely, the doubtful fidelity of his own forces, and the waywardness of France. For he feared that the Orsini, of whose arms he had made use, might let him down, and not merely prove a hin- 16- pl drance to further acquisitions, but take from him what he had gained, and that the King might do him the same turn. How little he could count on the Orsini was made plain when, after the capture of Faenza, he directed his arms against Bologna, and saw how reluctantly they took part in that enterprise. The King's mind he understood, when, after seizing on the Dukedom of Urbino, he was about

Louis made him desist. Whereupon the Duke resolved to depend no longer on the arms or fortune of others. His first step, therefore, was to weaken the factions of the Orsini and Colonnesi in Rome. Those of their following who were of good birth, he gained over by making them his own gentlemen, assigning them a liberal promands and appointments suited to their quality; so that in a few months their old partisan attachments died out, and the hopes of all rested on the Duke alone.

(50/1/05)

He then waited for a chance to crush ' the chiefs of the Orsini, for those of the house of Colonna he had already scattered, and a good opportunity presenting itself, he turned it to the best account. For when the Orsini came at last to see that the greatness of the Duke and the Church involved their ruin, they assembled a council at Magione in the Perugian territory, whence resulted the revolt of Urbino, commotions in Romagna, and an infinity of dangers to the Duke, all of which he overcame with the help of France. His credit thus restored, the Duke, trusting no longer to the French or to other foreign aid, that he might not have to confront them openly, resorted to stratagem, and was so well able to dissemble his designs, that the Orsini, through the mediation of Signor Paolo (whom he failed not to secure by every friendly attention, furnishing him with clothes, money, and horses) were so won over as to be drawn in their simplicity into his hands at Sinigaglia.1 The leaders thus disposed of, and their followers made his friends, the Duke had laid sufficiently good foundations for his future power, since he held all Romagna together with the Dukedom of Urbino, and had ingra-

¹ Where they were murdered.

to attack Tuscany; from which attempt, Etiated himself with the entire population of these States, more especially of Romagna, who now began to see that they were well off.

And since this part of his conduct mer its both attention and imitation, I shall not pass it over in silence. After the Duke had taken Romagna, finding that it had been ruled by feeble Lords, who thought vision, and conferring upon them com- more of plundering than correcting their subjects, and gave them more cause for division than for union, so that the country was overrun with robbery, riot, and every kind of outrage, he judged it necessary, with a view to render it peaceful and obedient to his authority, to provide it with a good government. Accordingly he set over it Messer Remiro d'Orca, a stern and prompt ruler, who being entrusted and with the fullest powers, in a very short time, and with much credit to himself, restored it to tranquillity and order. But afterwards apprehending that such unlimited authority might become odious, the Duke decided that it was no longer needed, and established in the centre of the Province a civil Tribunal, with an excellent President, in which every town was represented by its advocate. And knowing that past severities had created ill-feeling against himself, in order to purge the minds of the people and gain their goodwill, he tried to show them that any cruelty which had been done had not originated with him, but in the harsh character of his minister. Availing himself of the pretext this afforded, he one morning caused Remiro to be beheaded and exposed in the market place of Cesena with a block and bloody axe by his side—a savage spectacle which at once astounded متحمر كردن and satisfied the populace.

But, returning to the point from which we diverged, I say that the Duke, finding himself fairly strong and in a measure

secured against present dangers, being furnished with arms of his own choosing and having to a great extent got rid of those which, if left near him, might have caused him trouble, had to consider, if he desired to follow up his conquests, how he was to deal with France, since he saw he could expect no further support from King Louis, whose eyes were at last opened to his mistake. He therefore began to look about for new alliances, and to waver in his adherence to the French. then engaged in an expedition into the kingdom of Naples against the Spaniards, who were besieging Gaeta; his object being to secure himself against France; and in this he would soon have succeeded had Alexander lived.

Such was the line he took to meet present needs. As regards the future, he had to fear that a new Head of the Church might not be his friend, and might even seek to deprive him of what Alexander had given. This he thought to provide against in four ways. First, by exterminating all who were of kin to those Lords whom he had despoiled of their possessions, thereby leaving the new Pope no occasion for interference. Second, by gaining over all the Romans of good birth, so as to be able, as has been said, with their aid to hold the Pope in check. Third, by bringing the College of Cardinals, so far as possible, under his control. And fourth, by establishing his authority so firmly before his father's death, that he could by himself withstand the shock of a first onset.

Of these four objects, at the time when Alexander died, he had already effected three, and had almost carried out the fourth. For of the Lords whose possessions he had usurped, he had put to death all whom he could reach, and very few had escaped. He had gained over the Ro-

man nobility, and had the majority in the College of Cardinals on his side.

As to further acquisitions, his plan was to make himself master of Tuscany. He was already in possession of Perugia and Piombino, and had assumed the protectorate of Pisa, on which city he was about to spring, taking no heed of France, as indeed he no longer had occasion, since the French had been deprived of the kingdom of Naples by the Spaniards under conditions which made it necessary for both powers to buy his friendship. Pisa taken, Lucca and Siena must at once have yielded, partly through jealousy of Florence. partly through fear, and the position of the Florentines would then have been desperate.

If he had succeeded in these designs, as he was succeeding in that very year in which Alexander died, he would have won such power and reputation that he might afterwards have stood alone, relying on his own strength and resources, without being beholden to the forces and fortune of others. But Alexander died five years from the time he first unsheathed the sword, leaving his son with the State of Romagna alone consolidated, with all the rest unsettled, between two most powerful hostile armies, and sick almost to death. And yet such were the fire and courage of the Duke, he knew so well how men must either be conciliated or crushed, and so solid were the foundations he had laid in that brief period, that had these armies not been upon his back, or had he been in sound health, he must have surmounted every difficulty.

How strong his foundations were may be seen from this, that Romagna waited for him more than a month; and that although half dead, he remained in safety in Rome, where though the Baglioni, the Vitelli, and the Orsini came to attack him, they found no support. Moreover, since he was able if not to make whom he would Pope, at least to prevent the election of any whom he disliked, had he been in health at the time when Alexander died, all would have been easy for him. But he told me himself at the time when Julius II was created, that he had foreseen and provided for all else that could happen on his father's death, but had never anticipated that when his father died he too should be at death's door.

Taking all these actions of the Duke together, I can find no fault with him. It seems to me reasonable to put him forward, as I have done, as a pattern for all such as rise to power by good fortune and the help of others. For with his great spirit and high ambition he could not act otherwise than he did, and nothing but the shortness of his father's life and his own illness prevented the success of his designs. Whoever, therefore, on entering a new Princedom, judges it necessary to rid himself of enemies, to conciliate friends, to prevail by force or fraud, to make himself feared yet loved by his subjects, followed and revered by his soldiers, to crush those who can or ought to injure him, to introduce changes in the old order of things, to be at once severe and affable. magnanimous and liberal, to do away with a mutinous army and create a new one, to maintain relations with Kings and Princes on such a footing that they must see it is in their interest to aid him, and dangerous to offend, can find no brighter examples than in the actions of this Prince.

The one thing for which he may be blamed was the creation of Pope Julius II, in respect of whom he chose badly. Because, as I have said already, though he could not secure the election he desired, he could have prevented any other;

and he ought never to have consented to the creation of any one of those Cardinals whom he had injured, or who on becoming Pope would have reason to fear him; for fear is as dangerous an enemy as resentment. Those whom he had offended were, among others, San Pietro ad Vincula, Colonna, San Giorgio, and Ascanio; all the rest, excepting d'Amboise and the Spanish Cardinals (the latter from their being connected and under obligations, the former from the power he derived through his relations with the French Court), would on assuming the Pontificate have had reason to fear him. The Duke, therefore, ought, in the first place. to have laboured for the creation of a Spanish Pope; failing wherein, he should have agreed to the election of d'Amboise, but never to that of San Pietro ad Vincula. And he deceives himself who thinks that with the great, recent benefits cause old wrongs to be forgotten.

The Duke, therefore, erred in the part he took in this election; and his error was the cause of his ultimate downfall.

OF THOSE WHO BY CRIME COME TO BE PRINCES

But since from privacy a man may also rise to be a Prince in one or other of two ways, neither of which can be ascribed wholly either to valour or to fortune, it is fit that I note them here, though one of them may fail to be discussed more fully in treating of Republics.

The ways I speak of are, first, when the ascent to power is made by paths of wickedness and crime; and second, when a private person becomes ruler of his country by the favour of his fellow-citizens. The former method I shall make clear by two examples, one ancient the other modern, without entering further into the merits of the matter, for these, I think, should be enough for anyone who is constrained to follow them.

Agathocles the Sicilian came, not merely from a private station, but from the very dregs of the people, to be King of Syracuse. Son of a potter, through all the stages of his career he led an evil life. His vices, however, were conjoined with so much vigour both of mind and body, that enlisting as a common soldier, he rose through the various grades of the service to be Praetor of Syracuse. Established in that post, he resolved to make himself Prince, and to hold by violence and without obligation to others the authority which had been by consent entrusted to him. Accordingly, after imparting his design to Hamilcar, who with the Carthaginian armies was at that time waging war in Sicily, he one morning assembled the people and senate of Syracuse as though to consult with them on matters of public moment, and on a preconcerted signal caused his soldiers to put to death all the senators, and the wealthiest of the commons. These being thus disposed of, he seized and kept the sovereignty of the city without opposition from the people; and though twice defeated by the Carthaginians, and afterwards besieged, he was able not only to defend his city, but leaving a part of his forces for its protection, to invade Africa with the remainder, and so in a short time to raise the siege of Syracuse, reducing the Carthaginians to the utmost extremities, and forcing them to make terms whereby they resigned Sicily to him and confined themselves to Africa.

Whoever examines this man's actions and achievements will discover little or nothing in them that can be ascribed to chance, seeing, as has already been said, that it was not through the favour of any one but by the regular steps of the military service, gained at the cost of a thousand hardships and hazards, he reached the Princedom which he afterwards maintained by so many daring and dangerous exploits. Still, to slaughter fellow-citizens. to betray friends, to be devoid of honour, pity, and religion, cannot be counted as merits, for these are means that may lead to power, but confer no glory. Wherefore, if in respect of the valour with which he encountered and extricated himself from dangers, and the constancy of his spirit in supporting and conquering adverse fortune, there seems no reason to judge him inferior to the greatest captains that have ever lived, his unbridled cruelty and inhumanity, together with his countless other crimes, forbid us to number him with the greatest men; but, at any rate, we cannot attribute to luck or to merit what he accomplished without either.

In our own times, during the papacy of Alexander VI, Oliverotto of Fermo, who. left an orphan some years before, had been brought up by his maternal uncle Giovanni Fogliani, was sent while still a lad to serve under Paolo Vitelli, in order that a thorough training under that commander might qualify him for high rank as a soldier. After the death of Paolo, he served under his brother, Vitellozzo, and in a very short time, being quick-witted, hardy, and resolute, he became one of the first soldiers of his company. But he thought it beneath him to serve under others; so, with the support of the Vitelleschi and the connivance of certain citizens of Fermo who preferred the slavery to the freedom of their country, he planned to seize on that town.

He accordingly wrote to Giovanni Fogliani that after many years of absence from home, he desired to see him and his native city once more and to look a little into the condition of his patrimony; and as his one endeavour had been to make himself a name, in order that his fellow-citizens might see his time had not been wasted, he proposed to return honourably attended by a hundred horsemen from among his own friends and followers; and he begged Giovanni graciously to arrange for his reception by the citizens of Fermo with corresponding marks of distinction, as this would be creditable not only to himself, but also to the uncle who had brought him up.

Giovanni, accordingly, did not fail in any proper attention to his nephew, but caused him to be splendidly received by his fellow-citizens, and lodged him in his house; where Oliverotto having passed some days, and made the necessary arrangements for carrying out his wickedness, gave a sumptuous banquet, to which he invited his uncle and all the first men of Fermo. When the repast and the other entertainment proper to such an occasion had come to an end, Oliverotto artfully turned the conversation to matters of grave interest, by speaking of the greatness of Pope Alexander and Cesare his son, and of their enterprises; and when Giovanni and the others were replying to what he said, he suddenly rose, observing that these were matters to be discussed in a more private place, and so moved to another room; whither his uncle and the other citizens followed him, and where they had no sooner seated themselves. than soldiers rushing out from places of concealment slew Giovanni and all the others.

After this butchery, Oliverotto mounting his horse, rode through the streets, and besieged the chief magistrate in the place, so that all were forced by fear to submit and accept a government of which

he made himself the head. And all who from being disaffected, were likely to stand in his way, he put to death, while he strengthened himself with new ordinances, civil and military, to such effect, that for the space of a year during which he retained the Princedom, he not merely remained safe in Fermo, but grew formidable to all his neighbours. And it would have been as difficult to unseat him as to unseat Agathocles, had he not let himself be overreached by Cesare Borgia on the occasion when, as has already been told, the Orsini and Vitelli were entrapped at Sinigaglia; where he too being taken, one year after the commission of his parricidal crime, was strangled along with Vitellozzo, who had been his master in villainy as in valour.

It may be asked how it came that Agathocles and some like him, after numberless acts of treachery and cruelty, were able to live long in their own country in safety, and defend themselves from foreign enemies, without being conspired against by their fellow-citizens, whereas, many others, by reason of their cruelty. have failed to maintain their position even in peaceful times, not to speak of the perilous times of war. I believe that this results from cruelty being well or ill used. Those cruelties we may say are well used. if we may speak well of things evil, which are done once for all as necessary for your security, and are not afterwards persisted in, but so far as possible adapted to the advantage of the governed. Ill-used cruelties, on the other hand, are those which from small beginnings increase rather than diminish with time. Those who follow the first of these methods, may, by the grace of God and man, find, as Agathocles did, that their condition is not desperate; but by no possibility can the others maintain themselves.

Hence we may learn the lesson that on seizing a State, the usurper should plan ahead all the injuries he must inflict, and inflict them all at a stroke, that he may not have to renew them daily, but be enabled by their discontinuance to reassure men's minds and win them by benefits. Whosoever, either through timidity or from following bad counsels, acts otherwise, must keep the sword always drawn, and can put no trust in his subjects, who suffering from continued and constantly renewed severities can never feel sure of him. Injuries, therefore, should be inflicted all at once, that their ill savour being less lasting may less offend; whereas, benefits should be conferred little by little, that so they may be more fully relished.

But, before all things, a Prince should so live with his subjects that no vicissitude for better or worse shall cause him to alter his behaviour; for if the need to change come through adversity, it is too late to resort to severity; and any leniency you may then use will be wasted, since it will be seen to be compulsory and bring you no thanks.

OF THE QUALITIES FOR WHICH MEN, AND MOST OF ALL PRINCES, ARE PRAISED OR BLAMED

It now remains for us to consider what ought to be the conduct and bearing of a Prince in relation to his subjects and friends. And since I know that many have written on this subject, I fear it may be thought presumptuous in me to write of it also; the more so, because in my treatment of it, I depart widely from the views that others have taken.

But since it is my object to write what shall be useful to whosoever understands it, it seems to me better to follow the real truth of things than an imaginary view of them. For many Republics and Principalities have been imagined that were never seen or known to really exist. And the way in which we live, and that in which we ought to live, are things so wide apart, that he who leaves the one for the other is more likely to destroy than to save himself; since any one who would act up to a perfect standard of goodness in everything, must be ruined among so many who are not good. It is essential, therefore, for a Prince who would maintain his position, to have learned how to be other than good, and to use or not to use his goodness as necessity requires.

Laying aside, therefore, all fanciful notions concerning a Prince, and considering those only that are true. I say that all men when they are spoken of, and Princes more than others from their being set so high, are noted for certain of those qualities which attach either praise or blame. Thus one is accounted liberal, another miserly; one is generous, another greedy; one cruel, another tenderhearted; one is faithless, another true to his word; one effeminate and cowardly, another highspirited and courageous; one is courteous, another haughty; one lewd, another chaste; one upright, another crafty; one firm, another facile; one grave, another frivolous; one devout, another unbelieving; and the like. Everyone, I know, will admit that it would be most laudable for a Prince to be endowed with all of the above qualities that are reckoned good; but since it is impossible for him to possess or constantly practise them all, the conditions of human nature not allowing it, he must be discreet enough to know how to avoid the reproach of those vices that would deprive him of his government, and, if possible, be on his guard also against those which might not deprive him of it. Though if he cannot wholly restrain himself, he may with less scruple indulge in the latter. But he need never hesitate to incur the reproach of those vices without which his authority can hardly be preserved; for if he well considers the whole matter, he will find that there may be a line of conduct that looks like virtue, but which would ruin him; and that there may be another course that looks like vice on which his safety and well-being may depend.

OF LIBERALITY AND MISERLINESS

Beginning, then, with the first of the qualities above noticed, I say that it may be well to be reputed liberal but that liberality without a reputation for it is bad; since, though it be worthily and rightly used, still if it be not known, you escape not the reproach of its opposite vice. Thus, to have credit for liberality with the world at large, you must neglect no circumstance of sumptuous display; the result being that a Prince who would be thought liberal will consume his whole substance in things of this sort and after all be obliged, if he would maintain his reputation for liberality, to burden his subjects with extraordinary taxes and resort to confiscations and all the other shifts whereby money is raised. But in this way he becomes hateful to his subjects, and growing impoverished is held in little esteem by any. So that in the end, having by his liberality offended many and obliged few, he is no better off than when he began, and exposed to all his original dangers. Recognizing this, and trying to retrace his steps, he at once incurs the reproach of miserliness.

A Prince, therefore, since he cannot without injury to himself practise this virtue of liberality so that it may be known, will not, if he is wise, greatly concern himself though he be called miserly. Because in time he will come to be regarded as more and more liberal, when it is seen that through his parsimony his revenues are sufficient; that he is able to defend himself against any who make war on him; that he can engage in enterprises against others without burdening his subjects; and thus exercise liberality towards all from whom he does not take, whose number is infinite, while he is miserly in respect of those only to whom he does not give, whose number is small.

In our own days we have seen no Princes accomplish great results save those who have been accounted miserly. All others have been ruined. Pope Julius II, after using his reputation for liberality to arrive at the Papacy, made no effort to preserve that reputation when making war on the King of France but carried on all his many campaigns without levying from his subjects a single extraordinary tax, providing for the increased expenditure out of his long-continued savings. Had the present King of Spain been accounted liberal, he never could have engaged or succeeded in so many enterprises.

A Prince, therefore, if he is enabled thereby to avoid plundering his subjects, to defend himself, to escape poverty and contempt and the necessity of becoming rapacious, ought to care little about the reproach of miserliness, for this is one of those vices which enable him to reign.

And should any object that Caesar by his liberality rose to power and that many others have been advanced to the highest dignities from their having been liberal

and so reputed, I reply, "Either you are already a Prince or you seek to become one; in the former case liberality is hurtful, in the latter it is very necessary that you be thought liberal; Caesar was one of those who sought the sovereignty of Rome; but if after obtaining it he had lived on without retrenching his expenditure, he must have ruined the Empire." And if it be further urged that many Princes reputed to have been most liberal have achieved great things with their armies, I answer that a Prince spends either what belongs to himself and his subjects, or what belongs to others; and that in the former case he ought to be sparing but in the latter ought not to refrain from any kind of liberality. Because for a Prince who leads his armies in person and maintains them by plunder, pillage, and forced contributions, dealing as he does with the property of others, this liberality is necessary, since otherwise he would not be followed by his soldiers. "Of what does not belong to you or to your subjects you may, therefore, be a lavish giver, as were Cyrus, Caesar, and Alexander, for to be liberal with the property of others does not take from your reputation, but adds to it. What injures you is to give away what is your own." And there is no quality so selfdestructive as liberality; for while you practise it you lose the means whereby it can be practised, and become poor and despised, or else, to avoid poverty, you become rapacious and hated. For liberality leads to one or other of these two results, against which, beyond all others, a Prince should guard.

And hence it is wiser to put up with the name of being miserly, which breeds ignominy, but without hate, than be obliged, from the desire to be reckoned liberal, to incur the reproach of rapacity, which breeds both hate and ignominy.

OF CRUELTY AND CLEMENCY, AND WHETHER IT IS BETTER TO BE LOVED OR FEARED

Passing to the other qualities above mentioned, I say that every Prince should desire to be accounted merciful and not cruel. Nevertheless, he should be careful not to abuse this quality of mercy. Cesare Borgia was reputed cruel, yet his cruelty restored Romagna, united it, and brought it to order and obedience; so that if we look at things in their true light, it will be seen that he was in reality far more merciful than the people of Florence, who, to avoid the imputation of cruelty, suffered Pistoja to be destroyed by factions.

A Prince should therefore disregard the reproach of cruelty where it enables him to keep his subjects united and faithful. For he who puts down disorder by a minimum of striking examples, will in the end be more merciful than he who from excessive leniency suffers things to take their course and so result in rapine and bloodshed; for these hurt the entire State, whereas the severities of the Prince injure individuals only.

And for a new Prince, above all others, it is impossible to escape a name for cruelty, since new States are full of dangers. . . .

Nevertheless, the new Prince should not be too ready of belief, nor too easily influenced. Nor should he himself be the first to raise alarms; but should so temper prudence with kindliness that too great confidence in others shall not throw him off his guard, nor groundless distrust render him insupportable.

And here comes in the question whether it is better to be loved rather than feared, or feared rather than loved. It might be answered that we should wish to be both; but since love and fear can hard-

ly exist together, if we must choose between them, it is far safer to be feared than loved. For of men it may generally be said that they are thankless, fickle, false, studious to avoid danger, greedy of gain, devoted to you while you confer benefits upon them, and ready, as I said before, while the need is remote, to shed their blood and sacrifice their property, their lives, and their children for you; but when it comes near they turn against you. The Prince, therefore, who without otherwise securing himself builds wholly on what men say or promise is undone. For the friendships we buy with a price and not gain by greatness and nobility of character, though fairly earned, are not made good but fail us when we need them most.

Moreover, men are less careful how they offend him who makes himself loved than him who makes himself feared. For love is held by the tie of obligation, which, because men are a poor lot, is broken on every prompting of self-interest; but fear is bound by the apprehension of punishment which never loosens its grasp.

Nevertheless a Prince should inspire fear so that if he do not win love he may escape hate. For a man may very well be feared and vet not hated, as will always be the case so long as he does not intermeddle with the property or with the women of his citizens and subjects. And if forced to put any one to death, he should do so only when there is manifest cause or reasonable justification. But, above all, he must keep his hands off the property of others. For men will sooner forget the death of their father than the loss of their patrimony. Moreover, excuses for confiscation are never hard to find, and he who has once started to live by rapine always finds reasons for taking what is not his; whereas reasons for shedding blood are fewer and sooner exhausted.

But when a Prince is with his army, and has many soldiers under his command, he must wholly disregard the reproach of cruelty, for without such a reputation in its Captain, you cannot hold an army together, ready for every emergency. Among other things remarkable in Hannibal this has been noted, that having a very great army, made up of men of many different nations and brought to serve in a foreign country, no dissension ever arose among the soldiers themselves, nor any mutiny against their leader, either in his good or in his evil fortunes. This we can only ascribe to the tremendous cruelty, which, joined with numberless great qualities, rendered him at once wonderful and terrible in the eyes of his soldiers; for without this reputation for cruelty his other virtues would not have had the results they did.

Unreflecting writers, indeed, while praising his achievements, have condemned the chief cause of them; but that his other merits would not by themselves have been so useful we may see from the case of Scipio, one of the greatest Captains of all times, whose armies rose against him in Spain from no other cause than his excessive leniency in allowing them freedoms inconsistent with military discipline. With which weakness Fabius Maximus taxed him in the Senate House, calling him the corrupter of the Roman soldiery. Again, when the Locrians were shamefully outraged by one of his lieutenants, he neither avenged them nor punished the insolence of his officer; and this because he was so easy-going. So that it was said in the Senate by one who tried to excuse him, that there were many who knew better how to refrain from doing wrong themselves than how to correct the

wrong-doing of others. This temper, nowever, would in time have spoiled the name and fame even of Scipio, if he had continued in it, and retained his command. But living as he did under the control of the Senate, this hurtful quality was not merely veiled but came to be regarded as a glory.

Returning to the question of being loved or feared, I sum up by saying, that since his being loved depends upon his subjects, while his being feared depends upon himself, a wise Prince should build on what is his own and not on what rests with others. Only, as I have said, he must do his best to escape hatred.

HOW PRINCES SHOULD KEEP FAITH

Every one recognises how praiseworthy it is in a Prince to keep faith, and to act uprightly and not craftily. Nevertheless, we see from what has happened in our own days that Princes who have set little store by their word but have known how to overreach others by their cunning, have accomplished great things and in the end had the better of those who trusted to honest dealing.

It should be known, then, that there are two ways of acting, one in accordance with the laws, the other by force; the first of which is proper to men, the second to beasts. But since the first method is often ineffectual, it becomes necessary to resort to the second. A Prince should, therefore, understand how to use well both the man and the beast. And this lesson has been discreetly taught by the ancient writers, who relate how Achilles and many others of these old Princes were given over to be brought up and trained by Chiron the Centaur; since the only meaning of their having for teacher one who was half man

and half beast is, that it is necessary for a Prince to know how to use both natures and that the one without the other has no stability.

But since a Prince should know how to use the beast's nature wisely, he ought of beasts to choose both the lion and the fox; for the lion cannot guard himself from traps, nor the fox from wolves. He must therefore be a fox to discern traps, and a lion to drive off wolves.

To rely wholly on the lion is unwise: and for this reason a prudent Prince neither can nor ought to keep his word. when to keep it is hurtful to him and the causes which led him to give it are removed. If all men were good, this would not be good advice, but since they are dishonest and do not keep faith with you, you in return need not keep faith with them; and no Prince was ever at a loss for plausible reasons to cover a breach of faith. Of this infiniteness recent instances could be given, and it might be shown how many solemn treaties and engagements have been made empty and idle through want of faith in Princes and that he who has best known to play the fox has had the best success.

It is necessary, indeed, to put a good colour on this nature, and to be skillful in feigning and dissembling. But men are so simple and governed so absolutely by their present needs, that he who wishes to deceive will never fail in finding willing dupes. One recent example I will not omit. Pope Alexander VI had no care or thought but how to deceive, and always found material to work on. No man ever had a more effective manner of affirming things, or made promises with more solemn protestations, or observed them less. And yet, because he understood this side of human nature, his frauds always succeeded.

It is not essential, then, that a Prince should have all the good qualities I have enumerated above, but it is most essential that he should seem to have them. As a matter of fact I will venture to affirm that if he has and invariably practises them all, they are hurtful, whereas the appearance of having them is useful. Thus, it is well to seem merciful, faithful, humane, religious, and upright, and also to be so; but the mind should remain so balanced that were it needful not to be so, you should be able and know how to change to the contrary.

7

And you are to understand that a Prince, and most of all a new Prince, cannot observe all those rules of conduct in respect of which men are considered good; since he is often forced to act in opposition to good faith, charity, humanity, and religion in order to preserve his Princedom, he must therefore keep his mind ready to shift as the winds and tides of Fortune turn, and, as I have already said, ought not to leave good courses if he can help it but should know how to follow evil if he must.

A Prince should therefore be very careful that nothing ever escapes his lips which is not full of the five qualities above named, so that to see and hear him, one would think him the embodiment of mer-

cy, good faith, integrity, kindliness, and religion. And there is no virtue which it is more necessary for him to seem to possess than this last; because men in general judge rather by the eye than by the hand, for all can see but few can touch. Every one sees what you seem, but few know what you are, and these few dare not oppose themselves to the opinion of the many who have the majesty of the State to back them up.

Moreover, in the actions of all men, and most of all of Princes, where there is no tribunal to which we can appeal, we look to results. Wherefore if a Prince succeeds in establishing and maintaining his authority, the means will always be judged honourable and be approved by every one. For the vulgar are always taken by appearances and by results, and the world is made up of the vulgar, the few only finding room when the many have no longer ground to stand on.

A certain Prince of our own days, whom it is as well not to name, is always preaching peace and good faith, although he is the mortal enemy of both; and both, had he practised as he preaches, would, oftener than once, have lost him his kingdom and authority.

¹ Ferdinand of Aragon.

3. THE NEW EDUCATION

François Rabelais (1494–1553), Franciscan friar, Benedictine monk, doctor, professor of anatomy for a while, had a learned and inquisitive mind, representative of the best in French humanism. Quite a traveler, he was responsible for the introduction into western Europe of the Roman lettuce, but his surviving fame depends less on his medical studies or his culinary exploits than on the enduring popularity of the happy and lunatic world of giants and heroes he created in *Gargantua and Pantagruel*. The books describing their adventures have been banned repeatedly since the Sorbonne first placed *Pantagruel* on its *Index* in 1533. They are supposed to be coarse; they are certainly robust and rambunctious. But fundamentally Rabelais is a serious

man and a critic of society, and the fun he makes of the pretensions of his day often applies just as well to ours. The selections that follow reflect the contemporary debate between the old-fashioned techniques of education and the new ideas of the humanists.

Rabelais: from Gargantua and Pantagruel

THE STUDY OF GARGANTUA,
ACCORDING TO THE DISCIPLINE
OF HIS SCHOOLMASTERS THE
SOPHISTERS

The first day being thus spent and the bells put up again in their own place, the citizens of Paris, in acknowledgment of this courtesy, offered to maintain and feed his mare as long as he pleased, which Cargantua took in good part, and they sent her to graze in the forest of Bière. I think she is not there now. This done, he with all his heart submitted his study to the discretion of Ponocrates; who first of all appointed that he should do as he was accustomed, to the end it might be understood by what means, in so long time, his old masters had made him such a sot and puppy. He disposed therefore of his time in such fashion that ordinarily he did awake betwixt eight and nine o'clock, whether it was day or night (for so had his ancient governors ordained), alleging that which David saith, Vanum est vobis ante lucem surgere.1 Then did he tumble and toss, wag his legs, and wallow in the bed some time, the better to stir up and rouse his vital spirits, and appareled himself according to the season; but willingly he would wear a great long gown of thick frieze, furred with fox skins. Afterwards he combed his head with a comb de al-main, which is the four fingers and the thumb, for his preceptors had said

1 It is foolish to rise before light.

that to comb himself otherways, to wash and make himself neat, was to lose time in this world. Then he dunged, pissed, spued, belched, cracked, yawned, spitted, coughed, hawked, sneezed, and snotted himself like an archdeacon: and, to fortify against the fog and bad air, went to breakfast, having some good fried tripes, fair rashers on the coals, good gammons of bacon, store of good minced meat, and a great deal of sippet-brewis, made up of the fat of the beef-pot, laid upon bread, cheese, and chopped parsley strewed together.

Ponocrates showed him that he ought not to eat so soon after rising out of his bed, unless he had performed some exercise beforehand. Gargantua answered, "What! have not I sufficiently well exercised myself? I have wallowed and rolled myself six or seven turns in my bed, before I rose: is not that enough? Pope Alexander did so, by the advice of a Jew his physician, and lived till his dying day in despite of his enemies. My first masters have used me to it, saying, that to eat breakfast made a good memory; and therefore they drank first. I am very well after it, and dine but the better. And Master Tubal (who was the first licentiate at Paris) told me, that it was not enough to run apace, but to set forth betimes. So the total welfare of our humidity doth not depend upon drinking, switter-swatter like ducks, but in being at it early in the morning; hence the verse,

From Rabelais, Gargantua and Pantagruel (Chaps. XXI, XXIII), 1876.

To rise betimes is good for nothing, To drink betimes is meat and clothing."

After a good breakfast he went to church, and they carried to him in a great basket a huge breviary, weighing, what in grease, clasps, parchment, and cover, little more or less than eleven hundred and six pounds. There he heard six and twenty or thirty masses. This while, to the same place came his matin-mumbler, muffled up about the chin, round as a hoop, and his breath pretty well antidoted with the vine-tree sirrup. With him he mumbled all his kiriels, which he so curiously thumbed and fingered that there fell not so much as one bead of them to the ground. As he went from the church, they brought him, upon a dray drawn with oxen, a confused heap of patinotres of Saint Claude, every one of the bigness of a hat-block; and sauntering along through the cloisters, galleries, or garden, he riddled over more of them than sixteen hermits would have done. Then did he study some paltry half hour with his eyes fixed upon his book; but (as the comedy has it) his mind was in the kitchen. Pissing then a whole potful, he sat down at table; and because he was naturally phlegmatic, he began his meal with some dozens of gammons, dried neats' tongues, botargos, sausages, and such other forerunners of wine; in the meanwhile, four of his folks did cast into his mouth, one after another continually, mustard by the whole shovels full. Immediately after that, he drank a horrible draught of white wine for the comfort of his kidneys. When that was done, he ate according to the season, meat agreeable to his appetite; and then left off eating when his belly was like to crack for fulness. As for his drinking, he had in that neither end nor rule; for he was wont to say that the limits and bounds of drinking were, that a man might drink till the cork of his shoes swells up half a foot high.

HOW GARGANTUA WAS INSTRUCTED BY PONOCRATES, AND IN SUCH SORT DISCIPLINATED, THAT HE LOST NOT ONE HOUR OF THE DAY

When Ponocrates knew Gargantua's vicious manner of living, he resolved to bring him up in another way; but for a while bore with him, considering that Nature cannot endure a sudden change without great violence. Therefore, to begin his work the better he requested a learned physician of that time, called Master Theodore, seriously to ponder, if it were possible, how to bring Gargantua unto a better course; the said physician purged him canonically with Anticyrian hellebore, by which medicine he cleansed all that foulness and perverse habit of his brain. By this means, also, Ponocrates made him forget all that he had learned under his ancient preceptors, as Timotheus did to his scholars who had been instructed under other musicians: to do this the better they brought him into the company of learned men, who stirred in him an emulation and desire to whet his wit and improve his parts and to bend his study another way; so that the world might have a value for him. And afterwards he put himself into such a road, that he lost not any one hour in the day, but employed all his time in learning and honest knowledge. Gargantua awaked about four o'clock in the morning. Whilst they were rubbing him down, there was read unto him some chapter of the Holy Scripture aloud and clearly, with a pronunciation fit for the matter; and hereunto was appointed a young page, born in Basche, named Anagnostes. According to the purpose and argument of that lesson, he oftentimes gave himself to worship, adore, pray, and send up his supplications to that good God, whose word did shew his majesty and marvellous judgment. Then went he unto the secret places to make excretion of his natural digestions; there his master repeated what had been read, expounding unto him the most obscure and difficult points. In returning, they considered the face of the sky, if it were such as they had observed it the night before, and into what signs the sun was entering, as also the moon for that day. This done he was appareled, combed, curled, trimmed, and perfumed, during which time they repeated to him the lessons of the day before; he himself said them by heart, and upon them would ground some practical cases concerning the estate of man, which he would prosecute sometimes two or three hours. but ordinarily they ceased as soon as he was fully clothed. Then for three good hours he had a lecture read unto him: this done, they went forth, still conferring on the substance of the lecture, either unto a field near the University, called the Brack, or unto the meadows, where they played at the ball, tennis, and at the pelitrigone, most gallantly exercising their bodies, as before they had done their minds; all their play was but in liberty. for they left off when they pleased, and that was commonly when they did sweat over all their body, or were otherwise weary. Then were they very well wiped and rubbed, changed their shirts, and walking soberly, went to see if dinner was ready. Whilst they stayed for that, they did clearly and eloquently pronounce some sentences that they had retained of the lecture. In the meantime Master Appetite came, and then very orderly sat they down at table. At the beginning of the meal, there was read some pleasant history of the warlike actions of former times, until he had taken a glass of wine. Then (if they thought good) they continued reading, or began to discourse merrily together: speaking first of the virtue, propriety, efficacy, and nature of all that was served at the table: of bread, of wine, of water, of salt, of fleshes, fishes, fruits, herbs, roots, and of their dressing; by means whereof he learned, in a little time, all the passages competent for this, that were to be found in Pliny, Athenaeus, Dioscorides, Julius Pollux, Galen, Porphyry, Oppian, Polybius, Heliodorus, Aristotle, Elian, and others. Whilst they talked of these things many times, to be more certain they caused the very books to be brought to the table. And so well and perfectly did he in his memory retain the things above said, that in those days there was not a physician that knew half so much as he did. Afterwards they conferred of the lessons read in the morning, and ending their repast with some conserve or marmalade of quinces, he picked his teeth with mastic toothpickers; washed his hands and eyes with fair fresh water. and gave thanks unto God in some neat hymn, made in the praise of the divine bounty and munificence. This done they brought in cards, not to play, but to learn a thousand pretty tricks and new inventions, which were all grounded upon arithmetic. By this means he fell in love with that numerical science, and every day after dinner and supper he passed his time in it as pleasantly as he was wont to do at cards and dice; so that at last he

understood so well both the theory and practical part thereof, that Tunstall, the Englishman, who had written very largely to that purpose, confessed that verily, in comparison with him, he understood no more High Dutch.

And not only in that, but in the other mathematical science, as geometry, astronomy, and music. For, in waiting on the concoction, and attending the digestion of his food, they made a thousand pretty instruments and geometrical figures, and did in some measure practice the astronomical canons.

After this they recreated themselves with singing musically, in four or five parts, or upon a set theme or ground at random, as it best pleased them; in matter of musical instruments he learned to play upon the lute, the virginals, the harp, the all-man flute with nine holes, the viol, and the sackbut. This hour thus spent, and digestion finished, he did purge his body of natural excrements; then betook himself to his principal study for three hours together or more, as well to repeat his morning lectures, as to proceed in the book he had in hand, as also to write handsomely, to draw and form the antique and Roman letters. This being done they went abroad, and with them a young gentleman of Touraine, named the Esquire Gymnast, who taught him the art of riding. Changing then his clothes, he rode a Naples courser, a Dutch roussin, a Spanish gennet, a barded, or trapped steed, then a light fleet horse, unto whom he gave a hundred directions, made him try the high jumps, bounding in the air, clear the ditch with a skip, leap over a stile or pale, turn short in a ring both to the right and left hand. There he broke not his lance; for it is the greatest foolery in the world to say I have broken ten lances at tilt, or in fight; a carpenter can do even as much; but it is a glorious and praiseworthy action, with one lance to break and overthrow ten enemies: therefore with a sharp, stiff, strong, and wellsteeled lance would he usually force up a door, pierce a harness, beat down a tree, carry away the ring, lift up a cuirassier saddle, with the mail coat and gauntlet: all this he did in complete armour from head to foot. As for the prancing flourishes and smacking poppisms, for the better cherishing of the horse commonly used in riding, none did them better than he. The great vaulter of Ferrara was but an ape compared to him. He was singularly skilful in leaping nimbly from one horse to another, without putting foot to ground, and these horses were called desultories: he could likewise, from either side, with a lance in his hand, leap on horseback without stirrups, and rule the horse at his pleasure, without a bridle, for such things are useful in military engagements. Another day he exercised the battle-ax, which he so dexterously wielded both in the nimble, strong, and smooth management of that weapon, and in all the feats practisable by it, that he passed knight of arms in the field, and at all essays.

Then tossed he the pike, played with the two-handed sword, with the backsword, with the Spanish tuck, the dagger, poniard, armed or unarmed, with a buckler, with a cloak, with a target.

Then would he hunt the hart, the roebuck, the bear, the fallow deer, the wild boar, the hare, the pheasant, the partridge, and the bustard. He played at the baloon, and made it bound in the air, both with fist and foot.

He wrestled, ran, jumped, not at three steps and a leap, nor at the hare's leap, nor yet at the almanes; "for" said Gymnast, "these jumps are for the wars alto-

gether unprofitable and of no use;" but at one leap he would skip over a ditch, spring over a hedge, mount six paces upon a wall, ramp and grapple after this fashion up against a window, of the full height of a lance. He did swim in deep waters on his belly, on his back, sideways, with all his body, with his feet only, with one hand in the air, wherein he held a book, crossing thus the breadth of the River Seine without wetting it, and dragged along his cloak with his teeth, as did Julius Caesar; then, with the help of one hand he entered forcibly into a boat. from whence he cast himself again headlong into the water, sounded the depths, hollowed the rocks, and plunged into the pits and gulphs. Then turned he the boat about, governed it, led it swiftly or slowly with the stream and against the stream, stopped it in its course, guided it with one hand, and with the other laid hard about him with a huge great oar, hoisted the sail, hied up along the mast by the shrouds, ran upon the edge of the decks, set the compass in order, tackled the bowlines, and steered the helm. Coming out of the water, he ran furiously up against a hill, and with the same alacrity and swiftness ran down again; he climbed up trees like a cat, and leaped from one to the other like a squirrel; he did pull down the great boughs and branches like another Milo; then with two sharp, wellsteeled daggers and two tried bodkins, would he run up by the wall to the very top of a house, like a rat; then suddenly came down from the top to the bottom, with such an even composition of members, that by the fall he would catch no harm.

He did cast the dart, throw the bar, put the stone, practise the javelin, the boar-spear, or partisan, and the halbert; he broke the strongest bows in drawing, bended against his breast the greatest cross-bows of steel, took his aim by the eye with the hand-gun, and shot well, traversed, and planted the cannon, shot at butmarks, at the papgay from below upwards, from above downwards, then before him, sideways, and behind him, like the Parthians.

They tied a cable rope to the top of a high tower, by one end whereof hanging near the ground he wrought himself with his hands to the very top: then upon the same track came down so sturdily and firm that they could not, on a plain meadow, have run with more assurance. They set up a great pole, fixed upon two trees: there would he hang by his hands, and with them alone, his feet touching at nothing, would go back and forth along the aforesaid rope, with so great swiftness that hardly could one overtake him with running; and then, to exercise his breast and lungs, he would shout like all the devils in hell: I heard him once call Eudemon. from St. Victor's gate to Monmertre: Stentor had never such a voice at the siege of Troy.

Then, for the strengthening of his nerves or sinews, they made him two great sows of lead, each of them weighing eight thousand and seven hundred kintals, which they called *alteres*; those he took up from the ground, in each hand one, then lifted them up over his head, and held them without stirring three quarters of an hour or more, which was an inimitable force.

He fought at barriers with the stoutest and most vigorous champions; and when it came to the cope, he stood so sturdily on his feet that he abandoned himself to the strongest, in case they could remove him from his place, as Milo was wont to do of old; in whose imitation likewise he held a pomegranate in his hand, to give

it unto him that could take it from him. The time being thus bestowed, and himself rubbed, cleansed, wiped, and refreshed with other clothes, he returned fair and softly, and passing through certain meadows, or other grassy places, beheld the trees and plants, comparing them with what is written of them in the books of the ancients, such as Theophrast. Dioscorides, Marinus, Pliny, Nicander, Macer, and Galen, and carried home to the house great handfuls of them, whereof a young page, called Rhizotomos, had charge; together with little mattocks, pickaxes, grubbing hooks, cabbies, pruning knives, and other instruments requisite for gardening. Being come to their lodging whilst supper was making ready, they repeated certain passages of that which had been read, and then sat down at table. Here remark, that his dinner was sober and thrifty, for he did then eat only to prevent the gnawings of his stomach, but his supper was copious and large, for he took then as much as was fit to maintain and nourish him; which, indeed, is the true diet prescribed by the art of good and sound physic; although a rabble of logger-headed physicians, nuzzeled in the brabbling shop of Sophisters, counsel the contrary. During that repast, was continued the lesson read at dinner, as long as they thought good; the rest was spent in good discourse, learned and profitable.

After they had given thanks, he set himself to sing vocally, and play upon harmonious instruments, or otherwise passed his time at some pretty sports, made with cards or dice, or in practising the feats of legerdemain, with cups and balls. There they stayed some nights in frolicking thus, and making themselves merry till it was time to go to bed; and, on other nights they would go make visits unto learned men, or to such as had been travellers in strange and remote countries. When it was full night, before they retired themselves, they went unto the most open place of the house, to see the face of the sky, and there beheld the comets, if any were, as likewise the figures, situations, aspects, opposition, and conjunctions of both fixed stars and planets.

Then with his master did he briefly recapitulate, after the manner of the Pythagoreans, that which he had read, seen, learned, done, and understood, in the whole course of that day.

Then prayed they unto God the Creator, in falling down before him, and strengthening their faith towards him, and glorifying him for his boundless bounty; and giving thanks to him for the time that was past, they recommended themselves to his divine clemency for the future, which being done they went to bed, and betook themselves to their repose.

4. THE NEW ECONOMICS

Carolus Molineus, or Charles Dumoulin (1500–1566), was one of the greatest jurists of his time. His life was stormy, his character somewhat difficult, plentifully endowed with the self-satisfaction current among the men of the Renaissance, calculated to influence people but not to make too many friends. The views he expressed in his treatise On Contracts and Usury (1546) met with a tempest of abuse from ecclesiastical quarters; but, compared with current doctrine, which was still that of Aquinas, they were much better suited to the realities of the time.

Charles Dumoulin: from On Contracts and Usury

Scholastic theologians, as well as canonists and jurists, considering the letter rather than the spirit or intent and purpose of the divine law, have believed there was something peculiarly and inherently vicious about usury or usurious gains, more than in unjust, deceitful sales, or other similar kinds of fraud. And this, not because one's neighbor is more harmed thereby; but because in a loan something more than the principal is received; as if usury per se were more detestable and more wicked, or per se more unlawful. Thus some hold that, although usury may sometimes not be contrary to charity. as if it were harmful, still there is always something rather dishonorable about it; or again, that the prohibition of usury is so strict according to divine law that it cannot be modified by legislation, even in cases where it is a question of public utility and the common good, and the civil amity which nature has established among men. Hence they have fallen into the infinite evasions and numerous errors and fallacies with which their very confused books are filled; all because they have not considered the purpose of the divine law, which is charity, as Christ himself testifies: All things, therefore, whatsoever you would that men should do to you, do you also unto them. For this is the law and the prophets. That is to say, this is its purpose. And St. Paul (I Timothy): The end of the law is charity. Also Romans 13 and Galatians 5: He who loveth his neighbor hath fulfilled the law. Therefore, usury is not forbidden and unlawful according to divine law, except insofar as it is contrary to charity. Since, however,

usury is taken in many ways, that form alone is prohibited and condemned which offends against charity and love of one's neighbor. . . .

Suppose a merchant of means borrows money in order to make a profit from legitimate business, and promises to pay usury monthly or annually, instead of a portion of the expected profit: Should you say that the creditor, if unable to prove his claim to that much interest, or perhaps any interest at all, cannot lawfully contract for or receive such usury without injury to the debtor? Whatever all this crowd may have written, I see no harm in this, nothing contrary to divine or natural law; since nothing is done in it contrary to charity, but rather from mutual charity. It is plain that one grants the favor of a loan from his property; the other remunerates his benefactor with a part of the gain derived therefrom, without suffering any loss. Therefore the creditor lawfully receives more than his principal: and by the same reasoning, he may from the beginning covenant to this effect, within legitimate limits, however, and provided that the one who covenants does not plan any fraud against his neighbor, or demand usury unfairly. . . .

Just as the invention of money was necessary for the sake of exchange and the needs of men, so for a similar, though not so great, necessity, usury was invented and tolerated; for it is clear that people in business often need to use other people's money, nor is it expedient in all cases to arrange a partnership, a single man's industry being involved; and none are found who will lend for nothing. . . .

Reprinted by permission of the publishers from Arthur E. Monroe, editor Early Economic Thought: Selections from Economic Literature Prior to Adam Smith. Cambridge, Mass.: Harvard University Press, 1924.

320

Under these conditions [usury] is lawful, not only according to human law but also

according to all law, divine and natural. . . .

5. THE NEW WORLD

Early in the fifteenth century the thought occurred to some of the traders, the sailors, and the princes of Europe that the Italo-Arab hold on the rich Eastern trade might be broken by the discovery of another route to the Indies. The need for new trade routes which would permit western Europe to break the Italian monopoly on trade with Egypt and the Levant went along with the interest shown by contemporary humanists in the nature of the physical world, an interest which served to provide better maps that took account of the data provided in the works of the ancient Ptolemy and of travelers like Marco Polo, and by the experience of other recent explorers on land or sea.

Though some of the greatest sailors involved in the new adventures were Italians like Columbus, Cabot, and Amerigo Vespucci, their first patrons were the rulers of the rising Iberian kingdoms: Portugal, Aragon, and Castile. While the latter were still chiefly concerned through much of the fifteenth century with the reconquest of the peninsula from its remaining Moorish masters, the Portuguese had early started to send vessels along the coast of Africa and into the South Atlantic. Thus the direction of Portuguese enterprises was mostly to the south and the east, and they eventually reached India by turning the Cape of Good Hope. This is partly why the later, Spanish, explorers sailed due west. On their heels came the vessels of other nations, interested in the vast possibilities of the new lands.

Paolo Toscanelli

In the summer of 1474, the Florentine scientist and astronomer, Paolo Toscanelli, found his advice in great demand on the subject of the resources of the Indies and the best way of getting there. Here is a letter he wrote in July of that year.

Paul, the Physician, to Cristobal Colombo, greeting. I perceive your magnificent and great desire to find a way to where the spices grow, and in reply to your letter I send you the copy of another letter which I wrote some days ago to a friend and favorite of the most serene King of Portugal, in reply to another which, by direction of his Highness he wrote to me on the said subject, and I send you another sea chart like the one I

sent him, by which you will be satisfied respecting your enquiries: which copy is as follows:

"Paul the Physician, to Fernan Martins, Canon at Lisbon, greeting. It was pleasant to me to understand that your health was good, and that you are in the favor and intimacy with the most generous and most magnificent Prince, your King. I have already spoken with you respecting a shorter way to the places of

From The Journal of Christopher Columbus, tr. Clement R. Markham (London, 1893).

RESTORATION OF THE TOSCANELLI MAP

From The Journal of Christopher Columbus, tr. Clement R. Markham (London, 1893).

spices than that which you take by Guinea, by means of maritime navigation. The most serene King now seeks from me some statement, or rather a demonstration to the eye, by which the slightly learned may take in and understand that way. I know this can be shown from the spherical shape of the earth, yet to make the comprehension of it easier, and to facilitate the work, I have determined to show that way by means of a sailing chart. I, therefore, send his Majesty a chart made by my own hands, on which are delineated your coasts and islands, whence you must begin to make your journey always westward, and the places at which you should arrive, and how far from the pole or the equinoctial line you ought to keep, and through how much space or over how many miles you should arrive at those most fertile places full of all sorts of spices and jewels. You must not be surprised if I call the parts where the spices are west, when they usually call them east, because to those always sailing west, those parts are found by navigation on the under side of the earth. But if by land and by the upper side, they will always be found to the east. . . . It is asserted that none but merchants live on the islands. For there the number of navigators with merchandize is so great that in all the rest of the world there are not so many as in the most noble port called Zaitun. For they affirm that a hundred ships laden with pepper discharge their cargoes in that port in a single year, besides other ships bringing other spices. That country is very populous and very rich, with a multitude of provinces and kingdoms. and with cities without number, under one prince who is called the Great Kan, which name signifies King of Kings, whose seat and residence is generally in the province of Katay. His ancestors desired intercourse with Christians now 200 years ago. They sent to the Pope [he refers to the journey of Nicolo and Maffeo Polo. who reached the court of Kublai Khan in 1260, returned as his envoys in 1269. started east again in 1271, taking their nephew Marco with them] and asked for several persons learned in the faith that they might be enlightened, but those who were sent, being impeded in their journey. went back. Also in the time of Eugenius 1 one of them came, who affirmed their great kindness towards Christians, and I had a long conversation with him on many subjects, about the magnitude of their rivers in length and breadth, and on the multitude of cities on the banks of the rivers. He said that on one river there were near 200 cities with marble bridges great in length and breadth, and everywhere adorned with columns. This country is worth seeking by the Latins, not only because great wealth may be obtained from it, gold and silver, all sorts of gems and spices, which never reach us; but also on account of its learned men, philosophers and expert astrologers, and by what skill and art so powerful and magnificent a province is governed, as well as how their wars are conducted. This is for some satisfaction to his request, so far as the shortness of time and my occupations admitted: being ready in future more fully to satisfy his royal Majesty as far as he may wish. Given at Florence, June 24th, 1474."

From the city of Lisbon due west there are 26 spaces marked on the map, each of which has 250 miles, as far as the most noble and very great city of Quinsay [which Marco Polo calls the City of Heaven]. For it is a hundred miles in circumference and has ten bridges, and its name signifies the city of Heaven; many won-

¹ Pope Eugenius IV, 1431-1447.

ders being related concerning it, touching the multitude of its handicrafts and its resources. This space is almost a third part of the whole sphere. That city is . . . near the province of Katay, in which land is the royal residence. But from the island Antilia, known to you [a fabulous island, after which the West Indian islands were first named around 1500] to the most noble island of Cipan-

go there are ten spaces. For that island is most fertile in gold, pearls, and precious stones, and they cover the temples and palaces with solid gold. Thus the spaces of the sea to be crossed in the unknown part are not great. Many things might perhaps have been declared more exactly, but a diligent thinker will be able to clear up the rest for himself. Farewell, most excellent one.

Christopher Columbus from The Journal

Christopher Columbus (1451–1506) was born in Genoa. His beginnings are still obscure. The ideas which led to his great project of reaching China by sailing west were based on the belief, going back to the Middle Ages, that there were lands in the Atlantic—lands he presumed to be Cipango and Cathay. Rebuffed by the Portuguese, who had other fish to fry, he entered the service of Spain and eventually persuaded Queen Isabella of Castile to grant him command of the three ships with which he would discover the new world. Leaving Spain on August 2, 1492, he returned eight months later having effected landings in San Salvador, Cuba, and Haiti. A second voyage brought him to Guadeloupe, Puerto Rico, and Jamaica; a third enabled him, after touching Trinidad, to reach the continent and sail along the South American coast from the mouth of the Orinoco River to Caracas. On his fourth and last trip he explored the coast of Central America from Honduras to the Gulf of Darien; but he had, by then, lost his credit at court and after his return (1504) was left to die in relative poverty and disgrace.

In the name of our Lord Jesus Christ.

Because, O most Christian, and very high, very excellent and puissant Princes, King and Queen of the Spains and of the islands of the Sea, our Lords, in this present year of 1492, after your Highnesses had given an end to the war with the Moors who reigned in Europe, and had finished it in the very great city of Granada, where in this present year, on the second day of the month of January, by force of arms, I saw the royal banners of your Highnesses placed on the towers of Alhambra,

which is the fortress of that city, and I saw the Moorish King come forth from the gates of the city and kiss the royal hands of your Highnesses, and of the Prince my Lord, and presently in that same month, acting on the information that I had given to your Highnesses touching the lands of India, and respecting a Prince who is called Gran Can, which means in our language King of Kings, how he and his ancestors had sent to Rome many times to ask for learned men of our holy faith to teach him, and how the Holy Father had never complied, insomuch that many people believing in

From The Journal of Christopher Columbus, tr. Clement R. Markham (London, 1893).

idolatries were lost by receiving doctrine of perdition: YOUR HIGHNESSES, as Catholic Christians and Princes who love the holy Christian faith, and the propagation of it, and who are enemies to the sect of Mahomet and to all idolatries and heresies, resolved to send me, Cristobal Colon, to the said parts of India to see the said princes, and the cities and lands, and their disposition, with a view that they might be converted to our holy faith; and ordered that I should not go by land to the eastward, as had been customary, but that I should go by way of the west, whither up to this day we do not know for certain that any one has gone.

Thus, after having turned out all the Jews from all your kingdoms and lord-ships, in the same month of January, your Highnesses gave orders to me that with a sufficient fleet I should go to the said

parts of India. . . .

[The expedition left Palos on August 2, 1492; on October 12th,] at two hours after midnight, the land was sighted at a distance of two leagues. They shortened sail, and lay by under the mainsail without the bonnets. The vessels were hove to, waiting for daylight; and on Friday they arrived at a small island of the Lucayos [Columbus named it San Salvador; it is now Watling Island]. Presently they saw naked people. The Admiral went on shore in the armed boat, and Martin Alonzo Pinzon and Vicente Yañez, his brother, who was captain of the Nina. The Admiral took the royal standard, and the captains went with two banners of the green cross, which the Admiral took in all the ships as a sign, with an F and a Y and a crown over each letter, one on one side of the cross and the other on the other. Having landed, they saw trees very green, and much water, and fruits of diverse kinds. The Admiral called to the two captains and to the others who leaped on shore . . . and said that they should bear faithful testimony that he, in the presence of all, had taken, as he now took, possession of the said island for the King and for the Queen, his Lords making the declarations that are required. . . .

Presently many inhabitants of the island assembled. . . . I saw and knew (says the Admiral) that these people are without any religion, not idolaters but very gentle, not knowing what is evil, nor the sins of murder and theft, being without arms, and so timid that a hundred would fly before one Spaniard, although they joke with them. They, however, believe and know that there is a God in heaven, and say that we have come from heaven. At any prayer that we say, they repeat, and make the sign of the cross. Thus your Highnesses should resolve to make them Christians, for I believe that if the work was begun, in a little time the multitude of nations would be converted to our faith, with the acquisition of great lordships, peoples, and riches for Spain. Without doubt there is in this land a vast quantity of gold, and the Indians . . . do not speak without reason when they say that in these islands there are places where they dig out gold, and wear it on their necks, ears, arms and legs, the rings being very large. There are also precious stones, pearls, and an infinity of spices. . . . Here also there is a great quantity of cotton, and I believe it would have a good sale here without sending it to Spain, but to the cities of the Gran Can. which will be discovered without doubt, and many others ruled over by other lords, who will be pleased to serve your Highnesses, and whither will be brought other commodities of Spain and of the Eastern lands; but these are to the West as regards us.

They were to the west all right; but Columbus was never to enter into the land of Canaan that he had dreamed of for so long. Cuba was not Cipango; Katay he never found; and though the new world he discovered soon revealed other riches, it did not bring his masters the trade of the Indies. This was soon to fall into the hands of travelers following another route.

Vasco da Gama

The first half of the fifteenth century had seen the sailors of Portugal pushing south, along the African coast, in search of knowledge and gain. A series of expeditions, supported by the government, enabled Diego Cam to discover the Congo in 1484 and Bartholomeo Diaz to round the Cape of Good Hope in 1488. It was not for another ten years, however, that this discovery could be put to use by Vasco da Gama (c. 1469–1524) who set out in 1497 to reach India by rounding the Cape, and did actually reach Calecut, one of the chief trading ports of southern India, a year later. Vasco da Gama's voyage was the fount of Portugal's eastern empire, whose bases soon reached from Mozambique and the Persian Gulf to Canton; and the great explorer himself was appointed first Viceroy of the Indies.

In the year 1497 King Dom Manuel, the first of that name in Portugal, dispatched four vessels to make discoveries and go in search of spices. Vasco da Gama was the captain-major of these vessels.

FROM A JOURNAL OF THE FIRST VOYAGE OF VASCO DA GAMA

[On May 20, 1498] we anchored two leagues from the city of Calecut [in India]. The city . . . is inhabited by Christians. They are of a tawny complexion. Some of them have big beards and long hair, whilst others clip their hair short or shave the head, merely allowing a tuft to remain on the crown as a sign that they are Christians. They also wear mustaches. They pierce the ears and wear much gold in them. . . . The women of this country, as a rule, are ugly and of small stature. They wear many jewels of gold round the neck, numerous bracelets on their arms, and rings set with precious stones on their toes. All these

people are well disposed and apparently mild of temper. At first sight they seem covetous and ignorant. . . . On the following morning . . . the captain-major set out to speak to the king, and took with him thirteen men, of whom I was one. We put on our best attire, placed bombards in our boats, and took with us trumpets and many flags. On landing, the captainmajor was received by the alcalde, with whom were many men, armed and unarmed. The reception was friendly, as if the people were pleased to see us. . . . [On first arriving in Calecut] they took us to a large church [obviously a pagoda or temple] and this is what we saw: The body of the church is as large as a monastery, all built of stone and covered with tiles. . . . In the centre of the body of

From A Journal of the First Voyage of Vasco da Gama (London, 1898), E. J. Ravenstein, Ed.; from The Three Voyages of Vasco da Gama and His Viceroyalty, H. E. J. Stanley, Ed. 1869.

the church rose a chapel, all built of hewn stone, with a bronze door sufficiently wide for a man to pass, and stone steps leading up to it. Within this sanctuary stood a small image which they said represented Our Lady. Along the walls, by the main entrance, hung seven small bells. In this church the captain-major said his prayers, and we with him. . . . Many other saints were painted on the walls of the church, wearing crowns. They were painted variously, with teeth protruding an inch from the mouth, and four or five arms. . . .

The further we advanced in the direction of the king's palace, the more did the crowd increase in number. And when we arrived there, men of much distinction and great lords came out to meet the captain, and joined those who were already in attendance upon him. It was then an hour before sunset. When we reached the palace, we passed through a gate into a courtyard of great size and, before we arrived at where the king was, we passed four doors, through which we had to force our way, giving many blows to the people. When at last we reached the door where the king was, there came forth from it a little old man who holds a position resembling that of a bishop, and upon whose advice the king acts in all affairs of the church. This man embraced the captain when he entered the door. Several men were wounded at this door, and we only got in by the use of much force.

The king was in a small court, reclining upon a couch covered with a cloth of green velvet, above which was a good mattress, and upon this again a sheet of cotton stuff, very white and fine, more so than any linen. The cushions were after the same fashion. In his left hand the king held a very large golden spittoon, having a capacity of eight pints. At its

mouth this cup was 16 inches wide, and apparently it was massive. Into this cup the king threw the husks of a certain herb which is chewed by the people of this country for its soothing effects, and which they call betel nut. On the right side of the king stood a basin of gold, so large that a man might just encircle it with his arms: this contained the herbs. There were likewise many silver jugs. The canopy above the couch was all gilt. . . .

The king beckoned to the captain . . . to come nearer, but the captain did not approach him, for it is the custom of the country for no man to approach the king except only the servant who hands him the herbs, and when anyone addresses the king he holds his hand before his mouth, and remains at a distance. When the king beckoned to the captain he looked at us others, and ordered us to be seated on a stone bench near him, where he could see us. He ordered that water for our hands should be given us, also some fruit, one kind of which resembled a melon, except that its outside was rough and the inside sweet, whilst another kind of fruit resembled a fig and tasted very nice [apparently jack (a kind of breadfruit) and bananas].

And the captain told him he was the ambassador of a King of Portugal, who was Lord of many countries and the possessor of great wealth of every description, exceeding that of any king of these parts; that for a period of sixty years his ancestors had annually sent out vessels to make discoveries in the direction of India, as they knew that there were Christian kings like themselves. This, he said, was the reason which induced them to order this country to be discovered, not because they sought for gold or silver, for of this they had such an abundance that they needed not what was to be found in this

country. . . . The captains sent out traveled for a year or two, until their provisions became exhausted, and then returned to Portugal, without having succeeded in making the desired discovery. There reigned a king now whose name was Dom Manuel, who had ordered him to build three vessels . . . and not to return to Portugal until he should have discovered this king of the Christians, on pain of having his head cut off. . . . And, finally, he had been instructed to say by word of mouth that the King of Portugal desired to be his friend and brother. . . .

On Tuesday [May 29, 1498] the captain got ready the following things to be sent to the king [of Calecut], viz., twelve pieces of striped cloth, four scarlet hoods, six hats, four strings of coral, a case containing six washstand basins, a case of sugar, two casks of oil and two of honey. And as it is the custom not to send anything to the king without the knowledge

of the Moor, his factor, and of the bale [governor], the captain informed them of his intention. They came, and when they saw the present they laughed at it, saying that it was not a thing to offer to a king. that the poorest merchant from Mecca. or any other part of India, gave more, and that if he wanted to make a present it should be in gold, as the king would not accept such things. When the captain heard this he grew sad, and said that he had brought no gold; that, moreover, he was no merchant, but an ambassador; that he gave of that which he had, which was his own private gift, and not the king's; that if the king of Portugal ordered him to return he would intrust him with far richer presents. . . . Upon this they declared that they would not forward his presents, nor consent to his forwarding them himself. When they had gone, there came certain Moorish merchants and they all depreciated the present which the captain desired to be sent to the king. . . .

As a result of this and of other misunderstandings, relations between the Indians and the Portuguese got worse and worse. Nevertheless, the king of Calecut did let Vasco da Gama have a letter for his royal master, and the tenor of the letter was as follows:

Vasco da Gama, a gentleman of your household, came to my country, whereat I was pleased. My country is rich in cinnamon, cloves, ginger, pepper, and precious stones. That which I ask of you in exchange is gold, silver, corals, and scarlet cloth.

The survivors of the expedition reached Lisbon in July of 1499, and their reports greatly cheered the king; for that same month we find him writing to his neighbors, the King and Queen of Castile:

Most high and excellent Prince and Princess, most potent Lord and Lady!

Your Highnesses already know that we had ordered Vasco da Gama, a nobleman of our household, and his brother Paulo da Gama, with four vessels to make dis-

coveries by sea, and that two years have now elapsed since their departure. And as the principal motive of this enterprise has been, with our predecessors, the service of God our Lord, and our own advantage, it pleased Him in His mercy to speed them on their route. From a message which has now been brought to this city by one of the captains, we learn that they did reach and discover India and other kingdoms and lordships bordering upon it; that they entered and navigated its sea, finding large cities, large edifices and rivers, and great populations, among whom is carried on all the trade in spices and precious stones, which are forwarded in ships . . . to Mecca, and thence to Cairo, whence they are dispersed throughout the world. Of these spices, etc., they have brought a quantity, including cinnamon, cloves, ginger, nutmeg, and pepper, as well as other kinds, together with the boughs and leaves of the same; also many fine stones of all sorts, such as rubies and others. And they also came to a country in which there are mines of gold, of which, as of the spices and precious stones, they did not bring as much as they could have done, for they took no merchandise with them.

As we are aware that your Highnesses will hear of these things with pleasure and satisfaction, we thought well to give this information. And your Highnesses may believe, in accordance with what we have learnt concerning the Christian people whom these explorers reached, that it will be possible, notwithstanding that they are not as yet strong in the faith nor

possessed of a thorough knowledge of it, to do much in the service of God and the exaltation of the Holy Faith, once they shall have been converted and fully fortified in it. And when they shall thus have been fortified in the faith, there will be an opportunity for destroying the Moors of those parts. Moreover, we hope, with the help of God, that the great trade which now enriches the Moors of those parts, through whose hands it passes without the intervention of other persons or peoples, shall, in consequence of our regulations, be diverted to the natives and the ships of our own kingdom, so that henceforth all Christendom, in this part of Europe, shall be able, in a large measure, to provide itself with those spices and precious stones. This, with the help of God, who in his mercy thus ordained it, will cause our designs and intentions to be pushed with more ardor, especially as concerns the war upon the Moors of the territories conquered by us in these parts, which your Highnesses are so firmly resolved upon, and in which we are equally zealous.

And we pray your Highnesses, in consideration of this great favor, which, with much gratitude, we received from our Lord, to cause to be addressed to Him those praises which are His due.

But, while Manuel had reason to regard the discovery of India as a favor of God, and while Ferdinand and Isabella probably gnashed their teeth to see the Portuguese finding spices and jewels to the east, where their ships had found mostly savages to the west, the Indians themselves had no cause to praise the God of these arrogant interlopers. Back in India, once more, we find Gama up to his old tricks

He then ordered the boats to go and plunder the small vessels, which were sixteen, and the two ships in which they found rice, and many jars of butter, and many bales of stuffs. They then gathered all this together into the ships, with the crews of the two large ships, and he ordered the boats to get as much rice as they wanted, and they took that of four of the small vessels, which they emptied, for they did not want more. Then the captain-major commanded them to cut off the hands and noses of all the crews, and put all that into one of the small vessels, into which he ordered them to put the friar [a Brahmin envoy, dressed as a friar, who had come aboard under safe conduct), also without ears or nose or hands, which he had ordered to be strung up round his neck, with a palm leaf for the king, on which he told him to have a curry made to eat of what his friar brought with him. When all the Indians had been thus executed, he ordered their feet to be tied together, as they had no hands with which to untie them, and in order that they should not untie them with their teeth, he ordered men to strike upon their teeth with staves until they knocked them down their throats; and they were thus put on board, heaped up on top of each other, mixed up with the blood which streamed from them, and he ordered mats and dry leaves to be spread over them, and the sails to be set for the shore, and the vessel set on fire and there were more than eight hundred Moors. And the small vessel with the friar, with all the hands and ears, was also sent on shore under sail, without being fired. These vessels went at once on shore, where many people flocked together to put out the fire, and draw out those whom they found alive, upon which they made great lamentations.

John Cabot: Report to the Duke of Milan

In the meantime, the ruler of another Atlantic kingdom, the shrewd Henry VII of England, was taking a certain interest in the possibilities of the newly discovered lands and waters across the sea. The voyages of the Cabots, whom he sponsored in 1497 and 1498, reached Cape Breton Island, Newfoundland, Nova Scotia, and New England. Here is the account which a Milanese subject in England, Raimondo di Soncino, sent to the Duke of Milan in December 1497:

My most illustrious and most excellent Lord,

Perhaps amidst so many occupations of your Excellency it will not be unwelcome to learn how this Majesty has acquired a part of Asia without drawing his sword. In this kingdom there is a certain Venetian named Zoanne Caboto, of gentle disposition, very expert in navigation, who, seeing that the most serene Kings of Portugal and Spain had occupied unknown islands, meditated the achievement of a similar acquisition for the said Majesty. Having obtained royal privileges . . . he entrusted his fortune to

a small vessel with a crew of 18 persons, and set out from Bristol, a port in the western part of this kingdom. Having passed Ibernia, which is still further to the west, and then shaped a northerly course, he began to navigate to the eastern part, leaving the North Star on the right hand; and having wandered thus for a long time, at length he hit upon land, where he hoisted the royal standard, and took possession for this Highness and, having obtained various proofs of his discovery he returned. The said Messer Zoanne, being a foreigner and poor, would not have been believed if the crew, who are nearly all English and who be-

From The Journal of Christopher Columbus and Documents Relating to the Voyages of John Cabot and Gaspar Corte Real, tr. Clement R. Markham (London, 1893).

long to Bristol, had not testified that what he said was the truth. This Messer Zoanne has the description of the world on a chart, and also on a solid sphere which he has constructed, and on which he shows where he has been. . . .

The said Englishmen, his companions, say that they took so many fish that this kingdom will no longer have need of Iceland, from which country there is an immense trade in fish. . . . But Messer Zoanne has set his mind on higher things, for he thinks that, when that place has been occupied, he will keep on still further towards the east, where he will be opposite to an island called Cipango . . . where he believes that all the spices of the world, as well as the jewels, are found. He further says that he was once at Mecca, whither the spices are brought by caravans from distant countries; and having inquired from whence they were brought and where they grow, they answered that they did not know, but that such merchandize was brought from distant countries by other caravans to their home; and they further say that they are also conveyed from other remote regions. And he adduced this argument, that if the eastern people tell those in the south that these things come from a far distance from them, presupposing the rotundity of the earth, it must be that the last turn would be by the north towards the west; and it is said that in this way the route would not cost more than it costs now, and also I believe it. And what is more, this Majesty, who is wise and not prodigal, reposes such trust in him because of what he has already achieved. that he gives him a good maintenance, as Messer Zoanne himself told me. And it is said that before long his Majesty will arm some ships for him, and will give him all the malefactors to go to that country and form a colony, so that they hope to establish a greater depot of spices in London than there is in Alexandria.

The principal people in the enterprise belong to Bristol. They are great seamen, and now that they know where to go, they say that the trip there will not take more than 15 days after leaving Ibernia. I have also spoken to a Burgundian, who was a companion of Messer Zoanne, who affirms all this, and who wishes to return because the Admiral . . . has given him an island, and has given another to his barber of Castiglione, who is a Genoese, and both look upon themselves as Counts; nor do they look upon my Lord the Admiral as less than a Prince. I also believe that some poor Italian friars are going on this voyage, who have all had bishoprics promised to them. And if I had made friends with the Admiral when he was about to sail, I should have got an archbishopric at least; but I have thought that the benefits reserved for me by your Excellency will be more secure. I would venture to pray that, in the event of a vacancy taking place in my absence, I may be put in possession and that I may not be superseded by those who, being present, can be more diligent than I, who am reduced in this country to eating at each meal ten or twelve kinds of victuals, and to being three hours at table every day, two for love of your Excellency, to whom I humbly recommend myself.

Richard Hakluyt: from Divers Voyages Touching the Discovery of America

As the sixteenth century drew to a close, England had made little serious effort to colonize the new world. The Elizabethans were interested in discovery, pillage, and war, but few showed any enthusiasm for the hard, sustained work that would be involved in founding new communities on the North American shore. Sir Walter Raleigh was one of these few. Another was Richard Hakluyt (1553–1616), an Oxford man and preacher, whose *Principal Navigations*, *Voyages*, *Traffiques*, and *Discoveries of the English Nation* is, in H. A. L. Fisher's words, the prose epic of this age of adventures, though one devoted largely to recommending colonies as means of promoting trade and of ridding the country of its unprofitable members.

Hakluyt's propaganda led to the foundation in 1584 of a colony named, after the queen, Virginia; but the interest it generated was apparently insufficient to keep the new settlement alive. The colony was allowed to fade away without adequate support, and it had to be founded anew in 1607, under the succeeding reign of James I.

I marvel not a little (right worshipful) that since the first discovery of America (which is now full forescore and ten years), after so great conquests and plantings of the Spaniards and Portuguese there, that we of England could never have the grace to set fast footing in such fertile and temperate places as are left as yet unpossessed of them. But again, when I consider that there is a time for all men, and see the Portuguese time to be out of date, and that the nakedness of the Spaniards and their long hidden secrets are now at length espied, whereby they went about to delude the world, I conceive great hope that the time approaches and now is, that we of England may share and participate (if we will ourselves) both with the Spaniard and the Portuguese, in part of America and other regions, as yet undiscovered. And surely if there were in us that desire to advance the honor of our country which ought to be in every good man, we would not all this while have forborne [neglected] the possessing of those lands, which of equity

and right appertain unto us, as by the discourses that follow shall appear most plainly. Yea, if we would behold with the eye of pity how all our Prisons are pestered and filled with able men to serve their Country, which for small robberies are daily hanged up in great numbers, even twenty at a clap, out of one jail (as was seen at the last assizes at Rochester), we would hasten and further every man to his power the deducting of [conveying] to some Colonies of our superfluous people into those temperate and fertile parts of America, which, being within six weeks sailing of England, are yet unpossessed by any Christians: and seem to offer themselves unto us, stretching nearer unto her Majesty's Dominions than to any other part of Europe. We read that the Bees when they grow to be too many in their own hives at home, are wont to be led out by their Captains to swarm abroad and seek themselves a new dwelling place. If the examples of the Grecians and Carthaginians of old time and the practice of our age may not move us yet

From Divers Voyages Touching the Discovery of America (London, 1850).

let us learn wisdom of these small weak and unreasonable creatures. It chanced very lately that upon occasion I had great conference in matters of Cosmography with an excellent learned man of Portugal most privy to all the discoveries of his nation, who wondered that those blessed countries from the point of Florida northward were all this while unplanted by Christians, protesting with great affection and zeal, that if he were now as young as I (for at present he is three score years of age) he would sell all he had, being a man of no small wealth and honor, to furnish a convenient number of ships to sea for the inhabiting of those countries, and reducing those gentle people to Christianity. . . .

Space Theology

The first Christians dealing with the inhabitants of the unexpected Western Hemisphere faced the problem of the humanity of these people who had not been mentioned in the Gospels. Were they part of the human family? Had Christ also died for them? Or were they really a nonhuman species, to be treated and exploited as animals?

A similar problem arises today, and, while religious attitudes are less influential on the world of today, we can glimpse in the problems of contemporary theologians some of the much more acute problems of the fifteenth century, when everything made sense in terms of religion and when the unity of man was much more a unity of Christian men.

The first interplanetary padre, confronted by an antennaed Martian or flyeyed Venusian, will hardly know what to say about the Gospel. First he will have to find out how the space creature stands with God: Is he in an unfallen state like Adam and Eve before the apple? Is he fallen but redeemed and, if so, how? Is he under the Lordship of Christ, and should he be baptized?

Theological speculations along these lines, hotted up by space talk and Europe's recent rash of flying sauciness, are amusing continental Christian thinkers. Professor Eduard Stakemeier, Roman Catholic theologian at the Philosophical-Theological Academy at Paderborn, Germany, feels that planetary missionizing would be unwise.

"Christian teaching is indeed compatible with the assumption that there are

extra-earthly rational creatures similar to human beings," he writes in the Dusseldorf daily, *Rheinsche Post*. "The supreme world aim is the glorification of God through rational beings. . . . Should we assume there to be nothing but deserts in all these [other] worlds?

"The inhabitants of other worlds could be like us, but they could also be much superior to us in sense and will. And perhaps they also surpass us in gratitude to the Creator and in goodness and love to all that demands love and kindness [but] in principle we must say that the Christian order of redemption was realized by God for this world. . . . Only we, who are descended from Adam, are born in original sin, and God became man to redeem us. . . . His church and His sacraments are [not] valid for . . . other planets."

Courtesy Time; copyright Time, Inc., 1955.

Dr. Michael Schmaus, professor of Catholic dogma at the University of Munich, agrees that there is nothing in Christian teaching to deny the existence of unearthly rational beings. Christ, he writes, is certainly their head, for according to St. Paul, He is the head of the universe. But "the question remains open whether He also has the significance of Redeemer for them. That in turn depends on whether these rational creatures have sinned and whether, like mankind, they need redeeming. . . .

"If they, too, are to be redeemed through Christ, this does not mean that the heavenly Logos must appear amongst them as it did in the history of mankind. It could be that the redemption through Christ could be preached to them by some messenger of the faith without [Christ] making any visible appearance to them. But it is also possible that God did not give these creatures any supernatural goal and that He determined for them natural perfection. . . "

Italian theologians have not yet entered into space theology with the same gusto as the Germans. Jesuit Father Antonio Messineo, contributing editor of the fortnightly *Civiltà Cattolica*, favors a

wait-and-see attitude. "The question of an eventual missionary activity among the inhabitants of other planets," he said, "hinges on two fundamental questions: 1) is there spiritual and physical human life on planets, and 2) are the inhabitants still in the state of original grace, or have they fallen into sin?"

But Father Agostino Gemmelli, rector of Milan's Catholic University of the Sacred Heart, flatly denies the possibility of extraterrestrial life: the Scripture makes no mention of it. Says he: "If God had created other men on other planets, these men would not be derived from Adam and one would not be able to understand the logic of the Divine plan of man's salvation. . . . To admit that the divine plan of salvation is illogical is the same as not recognizing the infinite wisdom of God. It is fantastic to suppose that God would find place for such men on other planets. Remember that the world was created by God for God's glory. What glory would God derive from men deprived of supernatural gifts?"

In the face of the planetary emergency the Vatican maintained its calm. The whole question, said a spokesman, seemed as of this week "slightly premature."

II. Reformation and Counter Reformation

Movements for Church reform were nothing new in the Christian world. All through the Middle Ages the clergy were frequently attacked for failing to lead worthy lives; new doctrines were mooted; and attempts were made to replace the Latin Bible, incomprehensible to the vast majority of the laity and to a surprising number of the clergy, with translations in the local tongue. A look at the Wycliffite conclusions condemned by the Church, and at Wycliffe's letter to the Pope, shows defiance as rife in the fourteenth century as in the sixteenth.

When Luther tacked up his theses on the church door at Wittenberg, he did not think of himself as taking an original or revolutionary step. A feeling for Church reform was in the air, fostered by the studies and translations of Renaissance humanists like Erasmus and by the growth of a self-confident public opinion more critical of its religious leaders than of vore. But there was no need to think that reform would turn into revolt; nor would it have done so, perhaps, had German complaints been properly handled. However, once Luther and his supporters had been driven into open revolt, they benefited from economic and political circumstances which linked religious to political ideas. After 1521 there seems to have been no turning back; there would have to be reform, whether within the Church or outside it. In the event, there were both, with the "protestant" reform spurring the Church of Rome to put its house in order and reaffirm its doctrines. Thus, as the sixteenth century drew to a close, the unity of the Christian West had been shattered, but the divisions themselves created an intensity of religious concern and belief which had been unknown in Europe for a long time.

1. WYCLIFFE AND THE LOLLARDS

John Wycliffe (1324–1384) was born in Yorkshire, taught at Oxford and, on being expelled from the University in 1382, returned to his Leicestershire vicarage of Lutterworth where he lived quietly until his death. Wycliffe used his great knowledge and academic position at Oxford to attack the scandals and corruption in the Church of his time, protesting against much of its teaching and practice. He wanted preachers to preach in English, to base their preaching on the Scriptures, and to use an English Bible that would make the Scriptures available to all. The English Bible that bears his name was translated by his disciples, and preachers inspired by him spread the message throughout England. It also reached the University of Prague, where it led one of the professors, John Hus (1369–1415) to spread Wycliffe's doc-

trine that the Pope was to be obeyed only in so far as he acted in accordance with Scripture.

WYCLIFFITE CONCLUSIONS, TEN CONDEMNED AS HERETICAL AND FOURTEEN AS ERRONEOUS

I. That the material substance of bread and of wine remains, after the consecration, in the sacrament of the altar.

II. That the accidents do not remain without the subject, after the consecration, in the same sacrament.

III. That Christ is not in the sacrament of the altar identically, truly, and really in his proper corporal presence.

IV. That if a bishop or priest lives in mortal sin he does not ordain, or consecrate, or baptize.

V. That if a man has been truly repentant, all external confession is superfluous to him, or useless.

VI. Continually to assert that it is not founded in the gospel that Christ instituted the mass.

VII. That God ought to be obedient to the devil.

VIII. That if the Pope is foreordained to destruction and a wicked man, and therefore a member of the devil, no power has been given to him over the faithful of Christ by any one, unless perhaps by the Emperor.

IX. That since Urban the Sixth, no one is to be acknowledged as Pope; but all are to live, in the way of the Greeks, under their own laws.

X. To assert that it is against sacred scripture that men of the church should have temporal possessions.

XI. That no prelate ought to excommunicate any one unless he first knows that the man is excommunicated by God.

XII. That a person thus excommunicating is thereby a heretic or excommunicate.

XIII. That a prelate excommunicating a clerk who has appealed to the king, or to a council of the kingdom, on that very account is a traitor to God, the king, and the kingdom.

XIV. That those who neglect to preach, or to hear the word of God, or the gospel that is preached, because of the excommunication of men, are excommunicate, and in the day of judgment will be considered as traitors to God.

XV. To assert that it is allowed to any one, whether a deacon or a priest, to preach the word of God, without the authority of the apostolic see, or of a catholic bishop, or some other which is sufficiently acknowledged.

XVI. To assert that no one is a civil lord, no one is a bishop, no one is a prelate, so long as he is in mortal sin.

XVII. That temporal lords may, at their own judgment, take away temporal goods from churchmen who are habitually delinquent; or that the people may, at their own judgment, correct delinquent lords.

XVIII. That tithes are purely charity, and that parishioners may, on account of the sins of their curates, detain these and confer them on others at their will.

XIX. That special prayers applied to one person by prelates or religious persons, are of no more value to the same person than general prayers for others in a like position are to him.

XX. That the very fact that any one enters upon any private religion what-

From Translations and Reprints, Vol. 2, No. 5, E. P. Cheyney, Ed.

ever, renders him more unfitted and more incapable of observing the commandments of God.

XXI. That saints who have instituted any private religions whatever, as well of those having possessions as of mendicants, have sinned in thus instituting them.

XXII. That religious persons living in private religions are not of the Christian religion.

XXIII. That friars should be required to gain their living by the labor of their hands and not by mendicancy.

XXIV. That a person giving alms to friars, or to a preaching friar, is excommunicate; also the one receiving.

REPLY OF WYCLIFFE TO HIS SUMMONS BY THE POPE TO COME TO ROME, 1384

I have joyfully to tell what I hold, to all true men that believe and especially to the Pope; for I suppose that if my faith be rightful and given of God, the Pope will gladly confirm it; and if my faith be error, the Pope will wisely amend it.

I suppose over this that the gospel of Christ be heart of the corps of God's law; for I believe that Jesus Christ, that gave in his own person this gospel, is very God and very man, and by this heart passes all other laws.

I suppose over this that the Pope be most obliged to the keeping of the gospel among all men that live here; for the Pope is highest vicar that Christ has here in earth. For moreness of Christ's vicar is not measured by worldly moreness, but by this, that this vicar follows more Christ by virtuous living; for thus teacheth the gospel, that this is the sentence of Christ.

And of this gospel I take as believe,

that Christ for time that he walked here, was most poor man of all, both in spirit and in having; for Christ says that he had nought for to rest his head on. And Paul says that he was made needy for our love. And more poor might no man be, neither bodily nor in spirit. And thus Christ put from him all manner of worldly lordship. For the gospel of John telleth that when they would have made Christ king, he fled and hid him from them, for he would none such worldly highness.

And over this I take it as believe, that no man should follow the Pope, nor no saint that now is in heaven, but in as much as he follows Christ. For John and James erred when they coveted worldly highness; and Peter and Paul sinned also when they denied and blasphemed in Christ; but men should not follow them in this, for then they went from Jesus Christ. And this I take as wholesome counsel, that the Pope leave his worldly lordship to worldly lords, as Christ gave them, - and move speedily all his clerks to do so. For thus did Christ, and taught thus his disciples, till the fiend had blinded this world. And it seems to some men that clerks that dwell lastingly in this error against God's law, and fail to follow Christ in this, been open heretics, and their fautors been partners.

And if I err in this sentence, I will meekly be amended, yea, by the death, if it be skilful, for that I hope were good to me. And if I might travel in mine own person, I would with good will go to the Pope. But God has needed me to the contrary, and taught me more obedience to God than to men. And I suppose of our Pope that he will not be Antichrist, and reverse Christ in this working, to the contrary of Christ's will; for if he sum-

mon against reason, by him or by any of his, and pursue this unskilful summoning, he is an open Antichrist. And merciful intent excused not Peter, that Christ should not call him Satan; so blind intent and wicked counsel excuses not the Pope here; but if he ask of true priests that they travel more than they may, he is not excused by reason of God, that he should not be Antichrist. For our belief teaches

us that our blessed God suffers us not to be tempted more than we may; how should a man ask such service? And therefore pray we to God for our Pope Urban the Sixth, that his old holy intent be not quenched by his enemies. And Christ, that may not lie, says that the enemies of a man been especially his home family; and this is sooth of men and friends.

2. THE BORGIAS

The increasing worldliness of the Church and of its leading representatives sapped respect for the institution and spurred demands for reform. Among the most outrageous figures of Renaissance Italy were the Borgias, Pope Alexander VI (1492–1503) and his son Caesar (1475–1507), energetic and ruthless men whose efforts to break the power of the great Roman lords of the Orsini and Colonna clans and establish their power all over central Italy failed only after much bloodshed. Caesar, of course, is almost the hero of Machiavelli's *Prince*; but his father was just as unscrupulous and perhaps even more scandalous. And if none of his successors on the throne of St. Peter ever equalled his egregious performance, their political and financial activities continued to worry those who found them too worldly for the service of God.

The Predecessors

Sixtus IV, Innocent VIII, and Alexander VI are [the Popes] filling the most degraded period in papal history, and proving to what a state Italy was then reduced. The first of these men was a Genoese friar, who immediately after his election (1471) exhibited himself as a violent despot, devoid of all scruples and all decency. He needed money, and therefore put up to sale offices, benefices, and indulgences. He showed a downright mania for the advancement of his nephews, some of whom were, according to the general verdict, his own sons. One of these, Pietro Riario, was made Cardinal,

with an income of sixty thousand crowns, and plunged so desperately into luxury, dissipation, and debauchery of all kinds, that he soon died, worn out by his vices, and overwhelmed with debts. The other brother, Girolamo, as zealously patronized, led the same sort of life. The Pope's whole policy was ruled by his greed of fresh acquisitions for his sons and nephews. It was solely because Lorenzo dei Medici had crossed these designs that the conspiracy of the Pazzi was hatched in the Vatican, and that on its failure the Pope made war upon Florence, and launched a sentence of excommunication against that

From Pasquale Villari, The Life and Times of Niccolò Machiavelli, trans. Mme. L. Villari (London, 1898), pp. 51–55.

city. Later, he joined the Venetians in their expedition against Ferrara, always with the same object of snatching some province for his family. A general war was the result, in which even the Neapolitans took part, by making an attack upon Rome, where fresh feuds among the nobility quickly broke out. . . .

The palaces of the Riario were being sacked, the Orsini and the Colonna in arms, when the Cardinals hurriedly assembling in conclave succeeded in patching up a truce. Then began a most scandalous traffic in votes for election to the Papal chair, which was sold to the highest bidder. The fortunate purchaser was Cardinal Cibo, who was proclaimed Pope on 29th August 1484, under the name of Innocent VIII. . . .

During all this confusion, anarchy had again broken loose in Rome, nor was any way found to restrain it: no morning passed without corpses being found in the streets. Malefactors who could pay, obtained safe conducts; those who could not were hung. Every crime had its price, and all sums over 150 ducats went to Franceschetto Cibo, the Pope's son; smaller amounts to the Chamber. Parricide, rape, any sort of crime, could obtain absolution for money. . . .

Meanwhile, Innocent VIII passed his time in festivities. He was the first Pope who openly acknowledged his own children, and celebrated their wedding feasts. Franceschetto espoused Maddalena, daughter of Lorenzo dei Medici (1487), and by way of recompense her brother, Giovanni, was made a Cardinal at the age of fourteen. . . The Pope's sons and nephews made the town ring with the scandal of their daily life. Franceschetto Cibo lost 14,000 florins in a single night

at play with Cardinal Riario, whom he accused to the Pope of cheating at cards; the money, however, had already disappeared. The Eternal City had become a great market of offices and posts, often created only in order to be sold. And not only offices, but false bulls, indulgences to sinners, impunity for assassins could be had for money: a father, by payment of 800 ducats, obtained absolution for the murder of his two daughters. Every evening corpses found about the streets were thrown into the Tiber.

In the midst of these diabolical orgies, the Pope every now and then fell into a lethargy that was mistaken for death, and then his relations and his cardinals hurried to secure their treasures . . . and all Rome was in a tumult. The Pope would awake from his trance, and thereupon the merry-making went on as before, and assassination was once more the order of the day. At last a fresh attack of the Pope's malady left little room for hope. Anxious relations crowded round the bed of the dying man, who could take nothing but woman's milk; then, it was said, transfusion of blood was tried and three children sacrificed to the experiment.

But all was in vain and on the 25th of July, 1492—the same year in which Lorenzo dei Medici had died—Innocent VIII breathed his last at the age of sixty. At the death of Sixtus IV men had blessed the day that freed the world from so great a monster, and the following Pope was much worse than his predecessor. Nobody now believed that a worse than Innocent could be found, yet the infamy of the new Pope, Alexander VI, caused that of his predecessors to be totally forgotten.

The Son

Francesco Matarazzo, erudite philologist and secretary of the governor of Perugia, witnessed events which he later described in his Cronaca della Citta di Perugia dal 1492 al 1503.

[Cesare Borgia] was then the first captain of Italy, not so much by his great military science, but by treason and the power of gold; he had turned the art of war into the art of deception, which everybody learnt from him. After having destroyed all the lordships, he had the best of fighters on his side, all the most famous *condottieri*. Besides, wherever his soldiers went, he had them quartered free; thus they gained more in time of war than in time of peace and, thus,

he had a great number of soldiers with him.

He was also one of the happiest of men; he had picked up a greater quantity of treasure and objects than anyone else in Italy. And nowhere in Italy were the soldiers so well provided with horses and fine clothing. Captain and *Gonfaloniere* of the Church, he was esteemed by all the lords. . . . Astrologers and necromancers declared him to be the very son of Fortune.

The Father

The jubilee of 1500 and the crowds it brought to Rome helped spread abroad the rumors concerning the private lives, debauchery and crimes of the Borgia clan. In his *Diaries* (Venice: 1871–82), Mario Sanuto, a Venetian historiographer and a contemporary of the Borgias, notes that "daily one finds in Rome men murdered, four or five every night, even bishops, prelates and others; everyone in Rome trembles in fear of being murdered by the Duke."

Among Machiavelli's many correspondents, Agostino Vespucci, the brother of Amerigo, reflected the general opinion concerning the death of a Cardinal, one among many, whose inheritance fell to the Pope.

Here everyone holds it to have been due to poison and to not having been on sufficiently good terms with the great *Gonfaloniere*. One hears often, very often in Rome of deaths of this sort. . . .

The Pope seems to me very worried by these rumors concerning the Great Turk, rumors that get ever stronger; he begins to say with many sighs, "Alas! in what land, on what seas shall I find a haven?" He doubles the guard at his palace, night and day, shows himself only with the greatest difficulty, and yet still plays Sylla with his proscriptions. In

everybody's sight he deprives one of his property, another of his life, sends one into exile, another to forced labor, grabs the dwelling of another to install some rascal in it; and all this for the slightest motive, or for no motive at all. Besides, he lets his barons and his friends carry out every kind of outrage and crime, steal, ransack the shops and a thousand things of this sort. Here, benefices are for sale more readily than melons, waffles or drinking water in Florence. The courts of Rome are unemployed because all law rests in force and is in the hands

of these rascals: to the point that the Turk seems necessary, since the Christians do not arise to extirpate this blackguard from the human conclave; such is the unanimous language of all decent men.

I have still to tell you that every night, between the Angelus and the first hour, one sees twenty-five women and more who are brought to the pontifical palace, behind a few riders—without speaking of the Pope who, for his part, keeps his illicit herd permanently on the premises—to the point that the whole palace has become the bawdy-house of every turpitude . . .

The Antiborgian Letter

In November 1501, an anonymous letter, probably written by a member of the Colonna family and resuming the tale of Borgia crimes, was intercepted on its way to the court of the Emperor Maximilian. It was transcribed by the papal Master of Ceremonies, Burchard, and is now known from its contents as the "Antiborgian letter."

The Emperor and the other princes of the Roman Empire must be informed of the infamies that this ignoble beast [Caesar] perpetrates in the Christian world. They must know the abominable crimes which are committed, crimes which tend to the despising of God and the overturning of religion, crimes so atrocious, so frightful that the best informed must be stupefied by them. These things must be told in the councils of the princes. . . . They must be told that the time of Antechrist, so often announced by the prophets, has arrived, for there has never been a worse enemy of our faith and our religion; it is impossible to imagine a more declared enemy of God, a more determined destroyer of the faith and religion of Christ. . . .

O frightful times! How far we are from the holiness of the Sovereign Pontiffs of old! How far we are from justice!

Posterity will find it hard to believe in the fire which devours the peoples. And vet the Christian princes still think of spreading the domain of religion! How shall we make war on Turk and on Arab as long as this internal scourge has not disappeared? Once upon a time, glorious princes made the vow to use their arms to increase the religion of Christ and recover Jerusalem; many and glorious martyrs shed their blood for this cause. Have all these labors been undertaken so that a Rodrigo Borgia, the greatest rogue of all times, should gain the pontificate by a criminal deal and make nonsense out of every human and divine right?

Let then the princes come to the aid of religion in distress, let them bring the ship of St. Peter into port, let them restore to Rome justice and peace, let them banish from Rome this pest engendered by the loss of Christianity . . .

The End

The Pope would live another two years, but the conditions of his death (August 18, 1503) and the stories it evoked seemed to confirm his living reputation. In the papal palace as in the Basilica of St. Peter, chaos prevailed. Lackeys and soldiers struggled with the clergy for pillows, vestments and torches, too precious to waste in

burial. Soon, the corpse began to turn black, to decompose and to stink frightfully, developments to be expected in a Roman August but attributed at once to poison, to the devil, or to both. As the Marquis of Mantua wrote to his wife, Isabella d'Este: "After the death of Pope Innocent VIII, [his predecessor] during the conclave, [Borgia] made a pact with the devil, to whom he sold his soul in exchange for the papacy. . . . There are persons who affirm having seen, at the moment of death, seven devils in his room. After death, his body began to boil and the mouth to bubble like a cauldron on the fire. . . . He swelled so much that he had nothing of human form, and had become as broad as he was long. His burial was carried out with little ceremony. As everybody refused to touch him, a man dragged him by a rope tied to his feet, from his bed to a place where he was burnt."

3. THE MACHINERY OF INDULGENCES

The idea that the Pope could issue indulgences for the remission of sins was based on the theory that St. Peter and his successors had control of an inexhaustible treasury of merit which they could dispense to the faithful. This merit, due first to Christ and then to successive generations of good Christians, was seen as a store of spiritual wealth into which the Popes could dip at will for the benefit of the living and the dead. The Popes first began to use this power seriously as an inducement to pious activity, such as pilgrimages or crusades, but soon saw its pecuniary usefulness. As a rule, the administration of indulgences was accompanied by certain moral requirements—repentance, confession, etc. This is apparent in the instructions issued by the Archbishop of Mainz at the start of the great campaign of 1517, designed to raise money for the St. Peter's building fund. But such scrupulous instructions were not always obeyed.

Instructions Issued by Albert of Mainz

The first grace is the complete remission of all sins; and nothing greater than this can be named, since sinful man, deprived of the grace of God, obtains complete remission by these means and once more enjoys God's grace; moreover, through this remission of sins the punishment which one is obliged to undergo in purgatory on account of the affront to the Divine Majesty is all remitted, and the pains of purgatory completely blotted out. And although nothing is precious enough to be given in exchange for such a grace—since it is a free gift of God and grace

is beyond price—yet in order that Christian believers may be the more easily induced to procure the same, we establish the following rules, to wit:

In the first place, every one who is contrite in heart and has made oral confession, shall visit at least the seven churches indicated for this purpose, to wit, those in which the papal arms are displayed, and in each church shall say five Paternosters and five Ave Marias in honour of the five wounds of our Lord Jesus Christ, whereby our salvation is won, or one Miserere, which psalm is particularly well

From Documents of the Christian Church, ed. Henry Bettenson (Oxford, 1943), pp. 257–260. Reprinted by permission of Oxford University Press and Geoffrey Cumberlege.

adapted for obtaining forgiveness of sins. . . .

The method of contributing to the chest, for the construction of the said fabric of the Chief of the Apostles.

Firstly, the penitentiaries and confessors, after they have explained to those making confession the greatness of this kind of plenary remission and of these privileges, shall ask them for how large a contribution, in money or in other tem-

poral goods, they would wish, in good conscience, to be spared this method of full remission and privileges; and this is to be done that they may be more easily induced to contribute. And because the conditions of men, and their occupations, are so various and manifold, and we cannot consider and assess them individually, we have therefore decided that the rates can be determined thus, according to recognized classifications. . . .

Then follows a graded schedule of rates: kings and their families, bishops, etc., 25 Rhenish gold guilders; abbots, counts, barons, etc., 10; lesser nobles and ecclesiastics and others with incomes of 500, 6 guilders; citizens with their own income, 1 guilder; those with less, ½. Those with nothing shall supply their contribution with prayer and fasting, "for the kingdom of heaven should be open to the poor as much as the rich."

The second principal grace is a "confessional" [confessional letter] replete with the greatest, most important, and hitherto unheard of privileges. . . .

Firstly, the privilege of choosing a suitable confessor, even a regular of the mendicant orders. . . .

[The other privileges include the power given to this confessor to absolve in cases normally "reserved" for the Apostolic See.]

The third important grace is the participation in all the benefits of the Church universal; which consists in this, that contributors toward the said building, together with their deceased parents, who have departed this world in a state of grace, shall now and for eternity be partakers in all petitions, intercessions, alms, fastings, prayers, in each and every pilgrimage, even those to the Holy Land; furthermore, in the stations at Rome, in masses, canonical hours, mortifications, and all other spiritual benefits which have

been, or shall be, brought forth by the universal, most holy Church militant or by any of its members. Believers who purchase confessional letters may also become participants in all these things. Preachers and confessors must insist with great perseverance upon these advantages, and persuade believers not to neglect to acquire these benefits along with their confessional letter.

We also declare that in order to obtain these two most important graces, it is not necessary to make confession, or to visit the churches and altars, but merely to procure the confessional letter. . . .

The fourth important grace is for those souls which are in purgatory, and is the complete remission of all sins, which remission the pope brings to pass through his intercession, to the advantage of said souls, in this wise: that the same contribution shall be placed in the chest by a living person as one would make for himself. It is our wish, however, that our subcommissioners should modify the regula-

tions regarding contributions of this kind which are given for the dead, and that they should use their judgment in all other cases where, in their opinion, modifications are desirable.

It is, furthermore, not necessary that the persons who place their contributions in the chest for the dead should be contrite in heart and have orally confessed, since this grace is based simply on the state of grace in which the dead departed, and on the contribution of the living, as is evident from the text of the bull. Moreover preachers shall exert themselves to make this grace more widely known, since through the same, help will surely come to departed souls, and the construction of the church of St. Peter will be abundantly promoted at the same time. . . .

4. JOHN TETZEL

John Tetzel (c. 1465–1519) was a German Dominican friar blessed with the art of salesmanship and evident oratorical talents whose sermons on Indulgences, when delivered not far from Wittenberg, were the cause of Luther's ninety-five Theses. In this way the sale of Indulgences and Tetzel's exaggerations may be said to have touched off the Reformation.

A Sermon on Indulgences

Venerable Sir, I pray you that in your utterances you may be pleased to make use of such words as shall serve to open the eyes of the mind and cause your hearers to consider how great a grace and gift they have had and now have at their very doors. Blessed eyes indeed, which see what they see, because already they possess letters of safe conduct by which they are able to lead their souls through that valley of tears, through that sea of the mad world, where storms and tempests and dangers lie in wait, to the blessed land of Paradise. Know that the life of man upon earth is a constant struggle. We have to fight against the flesh, the world and the devil, who are always seeking to destroy the soul. In sin we are conceived,-alas! what bonds of sin encompass us, and how difficult and almost impossible it is to attain to the gate of salvation without divine aid; since He causes us to be saved, not by virtue of the good works which we accomplish, but through His divine mercy; it is necessary then to put on the armour of God.

You may obtain letters of safe conduct from the vicar of our Lord Jesus Christ, by means of which you are able to liberate your soul from the hands of the enemy, and convey it by means of contrition and confession, safe and secure from all pains of Purgatory, into the happy kingdom. For we know that in these letters are stamped and engraven all the merits of Christ's passion there laid bare. Consider, that for each and every mortal sin it is necessary to undergo seven years of penitence after confession and contrition, either in this life or in Purgatory.

How many mortal sins are committed in a day, how many in a week, how many in a month, how many in a year, how many in the whole course of life! They

From Translations and Reprints, Vol. 2, No. 6, J. H. Robinson, Ed.

are well-nigh numberless, and those that commit them must needs suffer endless punishment in the burning pains of Purgatory.

But with these confessional letters you will be able at any time in life to obtain full indulgence for all penalties imposed upon you, in all cases except the four reserved to the Apostolic See. Therefore throughout your whole life, whenever you wish to make confession, you may receive the same remission, except in cases reserved to the Pope, and afterwards, at the hour of death, a full indulgence as to all penalties and sins, and your share of all spiritual blessings that exist in the church militant and all its members.

Do you not know that when it is necessary for anyone to go to Rome, or undertake any other dangerous journey, he takes his money to a broker and gives a certain percent—five or six or ten—in order that at Rome or elsewhere he may receive again his funds intact, by means of the letter of this same broker? Are you not willing, then, for the fourth part of a florin, to obtain these letters, by virtue of which you may bring, not your money, but your divine and immortal soul safe and sound into the land of Paradise?

Wherefore I counsel, order, and by virtue of my authority as shepherd, I command that they shall receive together with me and other priests, this precious treas-

ure, especially those who were not confessed at the time of the holy Jubilee, that they may be able to obtain the same forever. For the time may come when you may desire, but yet be unable to obtain the least portion of the grace.

Also on the part of SS. D. N. the Pope and of the most Holy Apostolic See and of the most reverend sir, my legate, to each and every one who shall have profited by the sacred Jubilee and made confession, and to all who may profit by this present brief opportunity, and who shall have lent a helping hand to the construction of the aforesaid house of the Prince of the Apostles, they shall all be participants and sharers in all prayers, suffrages, alms, fasts, supplications, masses, canonical hours, disciplines, pilgrimages, papal stations, benedictions, and all other spiritual goods which now exist or may exist forever in the church militant, and in all of these, not only they themselves, but their relatives, kindred and benefactors who have passed away; and as they were moved by charity, so God, and SS. Peter and Paul, and all the saints whose bodies rest in Rome, shall guard them in peace in this vale, and conduct them through it to the heavenly kingdom. Give everlasting thanks in the aforesaid names and in mine to the reverend secular priests and prelates, etc.

5. MARTIN LUTHER

Martin Luther (1483–1546) was the son of a successful Saxon peasant-entrepreneur. He joined the order of Augustine friars to seek peace of mind and assurance of salvation—some kind of bridge between the wickedness of man and the goodness of God. Unable to visualize this bridge in the corrupt Church of his time, he found it at last in the faith that had also effected Augustine's salvation. If man had faith, he could be saved; in comparison to this supreme truth, "works" were of no avail, a priest's unction of no importance. Every baptized Christian was a priest.

These conclusions appear in the pamphlets he published (1520), all urging the laity to take a hand in the reformation of the Church. An excerpt of one is given below. But the success of such fighting works must be attributed in the first place to the original attack of 1517 upon those practical abuses of the Roman Church which most right-minded Germans regarded as shocking.

The Ninety-Five Theses

The theses were posted on the side door of the Castle church in Wittenberg on Halloween, 1517. Posting theses in a public place was the usual way of giving notice of the disputations which were a regular feature of academic life. So, there was nothing peculiar or revolutionary in the action. As a matter of fact, Luther thought the Pope would support his exposure of the evils of the indulgence trade.

In the desire and with the purpose of elucidating the truth, a disputation will be held on the underwritten propositions at Wittenberg, under the presidency of the Reverend Father Martin Luther, Monk of the Order of St. Augustine, Master of Arts and of Sacred Theology, and ordinary Reader of the same in that place. He therefore asks those who cannot be present and discuss the subject with us orally, to do so by letter in their absence. In the name of our Lord Jesus Christ. Amen.

- 1. Our Lord and Master Jesus Christ in saying "Repent ye" (poenitentiam agite), etc., intended that the whole life of believers should be penitence (poenitentia).
- 2. This word cannot be understood as sacramental penance (*poenitentia*), that is, of the confession and satisfaction which are performed under the ministry of priests.
- 3. It does not, however, refer solely to inward penitence (poenitentia); nay, such inward penitence is naught, unless it outwardly produces various mortifications of the flesh.
 - 4. The penalty (poena) thus contin-

- ues as long as the hatred of self (that is, true inward penitence); namely, till our entrance into the kingdom of heaven.
- 5. The pope has neither the will nor the power to remit any penalties except those which he has imposed by his own authority, or by that of the canons.
- 6. The Pope has no power to remit any guilt, except by declaring and warranting it to have been remitted by God; or at most by remitting cases reserved for himself; in which cases, if his power were despised, guilt would certainly remain.
- 7. Certainly God remits no man's guilt without at the same time subjecting him, humbled in all things, to the authority of his representative the priest.
- 8. The penitential canons are imposed only on the living, and no burden ought to be imposed on the dying, according to them.
- 9. Hence, the Holy Spirit acting in the Pope does well for us in that, in his decrees, he always makes exception of the article of death and of necessity.
- 10. Those priests act unlearnedly and wrongly who, in the case of the dying, reserve the canonical penances for Purgatory.

From Translations and Reprints, Vol. 2, No. 6, J. H. Robinson, Ed.

- 11. Those tares about changing the canonical penalty into the penalty of Purgatory seem surely to have been sown while the bishops were asleep.
- 12. Formerly the canonical penalties were imposed not after but before absolution, as tests of true contrition.
- 13. The dying pay all penalties by death, and are already dead to the canon laws, and are by right relieved from them.
- 14. The imperfect vigor or love of a dying person necessarily brings with it great fear, and the less it is, the greater the fear it brings.
- 15. This fear and horror is sufficient by itself, to say nothing of other things, to constitute the pains of Purgatory, since it is very near to the horror of despair.
- 16. Hell, Purgatory, and Heaven appear to differ as despair, almost despair, and peace of mind differ.
- 17. With souls in Purgatory it seems that it must needs be that as horror diminishes so love increases.
- 18. Nor does it seem to be proved by any reasoning or any Scriptures, that they are outside of the state of merit or of the increase of love.
- 19. Nor does this appear to be proved, that they are sure and confident of their own blessedness, at least all of them, though we may be very sure of it.
- 20. Therefore the Pope, when he speaks of the plenary remission of all penalties, does not mean really of all, but only of those imposed by himself.
- 21. Thus those preachers of indulgences are in error who say that by the indulgences of the Pope a man is freed and saved from all punishment.
- 22. For in fact he remits to souls in Purgatory no penalty which they would have had to pay in this life according to the canons.

- 23. If any entire remission of all penalties can be granted to any one it is certain that it is granted to none but the most perfect, that is to very few.
- 24. Hence, the greater part of the people must needs be deceived by this indiscriminate and high-sounding promise of release from penalties.
- 25. Such power over Purgatory as the Pope has in general, such has every bishop in his own diocese, and every parish priest in his own parish, in particular.
- 26. The Pope acts most rightly in granting remission to souls not by the power of the keys (which is of no avail in this case), but by the way of intercession.
- 27. They preach man who say that the soul flies out of Purgatory as soon as the money thrown into the chest rattles.
- 28. It is certain that, when the money rattles in the chest, avarice and gain may be increased, but the effect of the intercession of the Church depends on the will of God alone.
- 29. Who knows whether all the souls in Purgatory desire to be redeemed from it—witness the story told of Saints Severinus and Paschal?
- 30. No man is sure of the reality of his own contrition, much less of the attainment of plenary remission.
- 31. Rare as is a true penitent, so rare is one who truly buys indulgences—that is to say, most rare.
- 32. Those who believe that, through letters of pardon, they are made sure of their own salvation will be eternally damned along with their teachers.
- 33. We must especially beware of those who say that these pardons from the Pope are that inestimable gift of God by which man is reconciled to God.
- 34. For the grace conveyed by these pardons has respect only to the penalties

of sacramental satisfaction, which are of

human appointment.

35. They preach no Christian doctrine who teach that contrition is not necessary for those who buy souls (out of Purgatory) or buy confessional licenses.

36. Every Christian who feels true compunction has of right plenary remission of punishment and guilt even with-

out letters of pardon.

- 37. Every true Christian, whether living or dead, has a share in all the benefits of Christ and of the Church, given by God, even without letters of pardon.
- 38. The remission, however, imparted by the Pope is by no means to be despised, since it is, as I have said, a declaration of the divine remission.
- 39. It is a most difficult thing, even for the most learned theologians, to exalt at the same time in the eyes of the people the ample effect of pardons and the necessity of true contrition.
- 40. True contrition seeks and loves punishment; while the ampleness of pardons relaxes it, and causes men to hate it, or at least gives occasion for them to do so.
- 41. Apostolic pardons ought to be proclaimed with caution, lest the people should falsely suppose that they are placed before other good works of charity.
- 42. Christians should be taught that it is not the wish of the Pope that the buying of pardons should be in any way compared to works of mercy.
- 43. Christians should be taught that he who gives to a poor man, or lends to a needy man, does better than if he bought pardons.
- 44. Because by works of charity, charity increases, and the man becomes better; while by means of pardons, he does not become better, but only freer from punishment.
 - 45. Christians should be taught that

he who sees any one in need, and, passing him by, gives money for pardons, is not purchasing for himself the indulgences of the Pope but the anger of God.

- 46. Christians should be taught that, unless they have superfluous wealth, they are bound to keep what is necessary for the use of their own households, and by no means to lavish it on pardons.
- 47. Christians should be taught that while they are free to buy pardons they are not commanded to do so.
- 48. Christians should be taught that the Pope, in granting pardons, has both more need and more desire that devout prayer should be made for him than that the money should be readily paid.
- 49. Christians should be taught that the Pope's pardons are useful if they do not put their trust in them, but most hurtful if through them they lose the fear of God.
- 50. Christians should be taught that, if the Pope were acquainted with the exactions of the Preachers of pardons, he would prefer that the Basilica of St. Peter should be burnt to ashes rather than that it should be built up with the skin, flesh, and bones of his sheep.
- 51. Christians should be taught that as it would be the duty so would it be the wish of the Pope even to sell, if necessary, the Basilica of St. Peter, and to give of his own money to very many of those from whom the preachers of pardons extract money.
- 52. Vain is the hope of salvation through letters of pardon, even if a commissary—nay, the Pope himself—were to pledge his own soul for them.
- 53. They were enemies of Christ and of the Pope who, in order that the pardons may be preached, condemn the Word of God to utter silence in other churches.

- 54. Wrong is done to the Word of God when, in the same sermon, an equal or longer time is spent on pardons than on it.
- 55. The mind of the Pope necessarily is that, if pardons, which are a very small matter, are celebrated with single bells, single processions, and single ceremonies, the Gospel, which is a very great matter, should be preached with a hundred bells, a hundred processions, and a hundred ceremonies.
- 56. The treasures of the Church, whence the Pope grants indulgences, are neither sufficiently named nor known among the people of Christ.
- 57. It is clear that they are at least not temporal treasures, for these are not so readily lavished, but only accumulated, by means of the preachers.
- 58. Nor are they the merits of Christ and of the saints, for these, independently of the Pope, are always working grace to the inner man, and the cross, death, and hell to the outer man.
- 59. St. Lawrence said that the treasures of the Church are the poor of the Church, but he spoke according to the use of the term in his time.
- 60. We are not speaking rashly when we say that the keys of the Church, bestowed through the merits of Christ, are that treasure.
- 61. For it is clear that the power of the Pope is sufficient of itself for the remission of [canonical] penalties and of [reserved] cases.
- 62. The true treasure of the Church is the Holy Gospel of the glory and grace of God.
- 63. This treasure, however, is deservedly most hateful, because it makes the first to be last.
 - 64. While the treasure of indulgences

- is deservedly most acceptable, because it makes the last to be first.
- 65. Hence the treasures of the Gospel are nets, wherewith of old they fished for the men of riches.
- 66. The treasures of indulgences are nets, wherewith they now fish for the riches of men.
- 67. Those indulgences, which the preachers loudly proclaim to be the greatest graces, are seen to be truly such as regards the promotion of gain.
- 68. Yet they are in reality most insignificant when compared to the grace of God and the piety of the cross.
- 69. Bishops and parish priests are bound to receive the commissaries of apostolical pardons with all reverence.
- 70. But they are still more bound to see to it with all their eyes, and take heed with all their ears, that these men do not preach their own dreams in place of the Pope's commission.
- 71. He who speaks against the truth of apostolical pardons, let him be anathema and accursed.
- 72. But he, on the other hand, who exerts himself against the wantonness and license of speech of the preachers of pardons, let him be blessed.
- 73. As the Pope justly thunders against those who use any kind of contrivance to the injury of the traffic in pardons.
- 74. Much more is it his intention to thunder against those who, under the pretext of pardons, use contrivances to the injury of holy charity and of truth.
- 75. To think that the Papal pardons have such power that they could absolve a man even if—by an impossibility—he had violated the Mother of God, is madness.

- 76. We affirm on the contrary that Papal pardons cannot take away even the least of venial sins, as regards its guilt.
- 77. The saying that, even if St. Peter were now Pope, he could grant no greater graces, is blasphemy against St. Peter and the Pope.
- 78. We affirm on the contrary that both he and any other Pope has greater graces to grant, namely, the Gospel, powers, gifts of healing, etc. (I Cor. XII).
- 79. To say that the cross set up among the insignia of the Papal arms is of equal power with the cross of Christ, is blasphemy.
- 80. Those bishops, priests and theologians who allow such discourses to have currency among the people will have to render an account.
- 81. This license in the preaching of pardons makes it no easy thing, even for learned men, to protect the reverence due to the Pope against the calumnies, or at all events, the keen questioning of the laity.
- 82. As for instance: Why does not the Pope empty Purgatory for the sake of most holy charity and of the supreme necessity of souls—this being the most just of all reasons—if he redeems an infinite number of souls for the sake of that most fatal thing, money, to be spent on building a basilica—this being a very slight reason?
- 83. Again; why do funeral masses and anniversary masses for the deceased continue, and why does not the Pope return, or permit the withdrawal of, the funds bequeathed for this purpose, since it is a wrong to pray for those who are already redeemed?
- 84. Again; what is this new kindness of God and the Pope, in that, for money's

- sake, they permit an impious man and an enemy of God to redeem a pious soul which loves God, and yet do not redeem that same pious and beloved soul out of free charity on account of its own need?
- 85. Again; why is it that the penitential canons, long since abrogated and dead in themselves, in very fact and not only by usage, are yet still redeemed with money, through the granting of indulgences, as if they were full of life?
- 86. Again; why does not the Pope, whose riches are at this day more ample than those of the wealthiest of the wealthy, build the single Basilica of St. Peter with his own money rather than with that of poor believers?
- 87. Again; what does the Pope remit or impart to those who through perfect contrition have a right to plenary remission and participation?
- 88. Again; what greater good could the Church receive than if the Pope, instead of once, as he does now, were to bestow these remissions and participations a hundred times a day on any one of the faithful?
- 89. Since it is the salvation of souls, rather than money, that the Pope seeks by his pardons, why does he suspend the letters and pardons granted long ago, since they are equally efficacious?
- 90. To repress these scruples and arguments of the laity by force alone, and not to resolve them by giving reasons, is to expose the Church and the Pope to the ridicule of their enemies, and to make Christian men unhappy.
- 91. If then pardons were preached according to the spirit and mind of the Pope, all these questions would be resolved with ease; nay, would not exist.
 - 92. Away then with all those prophets

who say to the people of Christ: "Peace, peace," and there is no peace.

- 93. Blessed be all those prophets who say to the people of Christ: "The cross, the cross," and there is no cross.
 - 94. Christians should be exhorted to

strive to follow Christ their head through pains, deaths, and hells.

95. And thus trust to enter heaven through many tribulations, rather than in the security of peace.

On the Babylonish Captivity of the Church

OF ORDERS

Of this sacrament the Church of Christ knows nothing; it was invented by the church of the Pope. It not only has no promise of grace, anywhere declared, but not a word is said about it in the whole of the New Testament. Now it is ridiculous to set up as a sacrament of God that which can nowhere be proved to have been instituted by God. Not that I consider that a rite practised for so many ages is to be condemned; but I would not have human inventions established in sacred things, nor should it be allowed to bring in anything as divinely ordained, which has not been divinely ordained; lest we should be objects of ridicule to our adversaries. . . .

Which of the ancient Fathers has asserted that by these words priests were ordained? Whence then this new interpretation? It is because it has been sought by this device to set up a source of implacable discord, by which clergy and laity might be placed farther asunder than heaven and earth, to the incredible injury of baptismal grace and confusion of evangelical communion. Hence has originated that detestable tyranny of the clergy over the laity, in which, trusting to the corporal unction by which their hands are consecrated, to their tonsure, and to their vestments, they not only set themselves

above the body of lay Christians, who have been anointed with the Holy Spirit, but almost look upon them as dogs, unworthy to be numbered in the Church along with themselves. Hence it is that they dare to command, exact, threaten, drive, and oppress, at their will. In fine, the sacrament of orders has been and is a most admirable engine for the establishment of all those monstrous evils which have hitherto been wrought, and are yet being wrought, in the Church. In this way Christian brotherhood has perished; in this way shepherds have been turned into wolves, servants into tyrants, and ecclesiastics into more than earthly beings.

How if they were compelled to admit that we all, so many as have been baptized, are equally priests? We are so in fact, and it is only a ministry which has been entrusted to them, and that with our consent. They would then know that they have no right to exercise command over us, except so far as we voluntarily allow of it. Thus it is said: "Ye are a chosen generation, a royal priesthood, a holy nation." (I Pet. ii. 9.) Thus all we who are Christians are priests; those whom we call priests are ministers chosen from among us to do all things in our name; and the priesthood is nothing else than a ministry. . . .

From First Principles of the Reformation, tr. H. Wace and C. A. Buchheim (Philadelphia: Lutheran Publication Society, 1885).

As far then as we are taught from the Scriptures, since what we call the priesthood is a ministry, I do not see at all for what reason a man who has once been made priest cannot become a layman again, since he differs in no wise from a layman, except by his ministerial office. But it is so far from impossible for a man to be set aside from the ministry, that even now this punishment is constantly inflicted on offending priests, who are either suspended for a time, or deprived for ever of their office. For that fiction of an indelible character has long ago become an object of derision. I grant that the Pope may impress this character, though Christ knows nothing of it, and for this very reason the priest thus consecrated is the lifelong servant and bondsman, not of Christ, but of the Pope, as it is at this day. But, unless I deceive myself, if at some future time this sacrament and figment fall to the ground, the Papacy itself will scarcely hold its ground, and we shall recover that joyful liberty in which we shall understand that we are all equal in every right, and shall shake off the voke of tyranny and know that he who is a Christian has Christ, and he who has Christ has all things that are Christ's, and can do all things-on which I will write more fully and more vigorously when I find that what I have here said displeases my friends the papists.

6. THE PEASANT REVOLT, 1525

Once men had taken it upon themselves to interpret Scripture, it was only a matter of time before different interpretations would divide the reformers. Those who believed that ultimate sanction and authority were to be found in Scripture had no reason, besides their own judgment, to consider the authority of one interpreter superior to that of another. If Wittenberg was as good as Rome, then Zurich or Geneva, Münster, Canterbury, or Strasbourg need be no less. The ultimate appeal would always be to the Bible and to the believer's heart. But it is difficult to say in what proportion political motives mingled with religious ones in assuring the success of reformed ideas.

The serious peasant revolt which ravaged German lands in 1525 throws a lurid light on social and economic conditions in the area at the opening of the Reformation. The abuses against which the peasants rose were of long standing, and local revolts had punctuated the history of the Middle Ages. But the religious crisis helped fire the peasants' discontent into an explosion that threatened the princes, the cities, the whole social order, and even the Lutheran reform itself. As they rose, the peasants drafted their demands, of which there were many versions. The articles given below reflect the attitude of the least radical. Luther, who at first had appealed for peace, soon turned against the rebels and published his notorious plea to the German nobility, in which he asked them to "take pity on us poor people, and so kill, destroy, exterminate, drown in blood without mercy" the dangerous radicals.

The Twelve Articles of the Peasants

Peace to the Christian reader, and the Grace of God through Christ.

There are many evil writings put forth of late which take occasion on account of the assembling of the peasants, to cast scorn upon the Gospel, saying: Is this the fruit of the new teaching, that no one should obey but all should everywhere rise in revolt, and rush together to reform. or perhaps destroy entirely, the authorities, both ecclesiastical and lay? The articles below shall answer these godless and criminal fault-finders, and serve in the first place to remove the reproach from the word of God and, in the second place, to give a Christian excuse for the disobedience or even the revolt of the entire Peasantry. In the first place the Gospel is not the cause of revolt and disorder, since it is the message of Christ, the promised Messiah, the Word of Life, teaching only love, peace, patience and concord. Thus, all who believe in Christ should learn to be loving, peaceful, longsuffering and harmonious. This is the foundation of all the articles of the peasants (as will be seen) who accept the gospel and live according to it. How then can the evil reports declare the Gospel to be a cause of revolt and disobedience? That the authors of the evil reports and the enemies of the Gospel oppose themselves to these demands is due not to the Gospel but to the Devil, the worst enemy of the Gospel, who causes this opposition by raising doubts in the minds of his followers; and thus the word of God, which teaches love, peace and concord, is overcome. In the second place, it is clear that the peasants demand that this Gospel be taught them as a guide in life, and they ought not to be called disobedient or

disorderly. Whether God grant the peasants (earnestly wishing to live according to his word) their requests or no, who shall find fault with the will of the Most High? Who shall meddle in his judgments or oppose his majesty? Did he not hear the children of Israel when they called upon him and save them out of the hands of Pharaoh? Can he not save his own today? Yes, he will save them and that speedily. Therefore, Christian reader, read the following articles with care and then judge. Here follow the articles:

The First Article: First, it is our humble petition and desire, as also our will and resolution, that in the future we should have power and authority so that each community should choose and appoint a pastor, and that we should have the right to depose him should he conduct himself improperly. The pastor thus chosen should teach us the Gospel pure and simple, without any addition, doctrine or ordinance of man. For to teach us continually the true faith will lead us to pray God that through his grace this faith may increase within us and become a part of us. For if his grace work not within us we remain flesh and blood, which availeth nothing; since the Scripture clearly teaches that only through true faith can we come to God. Only through his mercy can we become holy. Hence such a guide and pastor is necessary, and in this fashion grounded upon the Scriptures.

The Second Article: According as the just tithe is established by the Old Testament and fulfilled in the New, we are ready and willing to pay the fair tithe of grain. The word of God plainly provides

From Translations and Reprints, Vol. II, No. 6, J. H. Robinson, Ed.

that in giving according to right to God and distributing to his people the services of a pastor are required. We will that for the future our church provost, whomsoever the community may appoint, shall gather and receive this tithe. From this he shall give to the pastor, elected by the whole community, a decent and sufficient maintenance for him and his [im und den seynen], as shall seem right to the whole community (or, with the knowledge of the community). What remains over shall be given to the poor of the place, as the circumstances and the general opinion demand. Should anything farther remain, let it be kept, lest anyone should have to leave the country from poverty. Provision should also be made from this surplus to avoid laying any land tax on the poor. In case one or more villages have themselves sold their tithes on account of want, and the village has taken action as a whole, the buyer should not suffer loss, but we will that some proper agreement be reached with him for the repayment of the sum by the village with due interest. But those who have tithes which they have not purchased from a village, but which were appropriated by their ancestors, should not, and ought not, to be paid anything farther by the village, which shall apply its tithes to the support of the pastors elected as above indicated, or to solace the poor, as is taught by the Scriptures. The small tithes, whether ecclesiastical or lay, we will not pay at all, for the Lord God created cattle for the free use of man. We will not, therefore, pay farther an unseemly tithe which is of man's invention.

The Third Article: It has been the custom hitherto for men to hold us as their own property, which is pitiable enough, considering that Christ has delivered and redeemed us all, without ex-

ception by the shedding of his precious blood, the lowly as well as the great. Accordingly, it is consistent with Scripture that we should be free and wish to be so. Not that we would wish to be absolutely free and under no authority. God does not teach us that we should lead a disorderly life in the lusts of the flesh, but that we should love the Lord our God and our neighbor. We would gladly observe all this as God has commanded us in the celebration of the communion. He has not commanded us not to obey the authorities, but rather that we should be humble, not only towards those in authority, but towards everyone. We are thus ready to yield obedience according to God's law to our elected and regular authorities in all proper things becoming to a Christian. We, therefore, take it for granted that you will release us from serfdom, as true Christians, unless it should be shown us from the Gospel that we are serfs.

The Fourth Article: In the fourth place it has been the custom heretofore, that no poor man should be allowed to touch venison or wild fowl, or fish in flowing water, which seems to us quite unseemly and unbrotherly, as well as selfish and not agreeable to the word of God. In some places the authorities preserve the game to our great annoyance and loss, recklessly permitting the unreasoning animals to destroy to no purpose our crops, which God suffers to grow for the use of man, and vet we must remain quiet. This is neither godly nor neighborly. For when God created man he gave him dominion over all the animals, over the birds of the air and over the fish in the water. Accordingly it is our desire if a man holds possession of waters that he should prove from satisfactory documents that his right has been unwittingly acquired by purchase. We do not wish to take it from him by force, but his rights should be exercised in a Christian and brotherly fashion. But whosoever cannot produce such evidence should surrender his claim with good grace.

The Fifth Article: In the fifth place we are aggrieved in the matter of woodcutting, for the noble folk have appropriated all the woods to themselves alone. If a poor man requires wood he must pay double for it, [or perhaps, two pieces of money]. It is our opinion in regard to a wood which has fallen into the hands of a lord, whether spiritual or temporal, that unless it was duly purchased it should revert again to the community. It should, moreover, be free to every member of the community to help himself to such firewood as he needs in his own home. Also, if a man requires wood for carpenter's purposes he should have it free, but with the knowledge of a person appointed by the community for that purpose. Should, however, no such forest be at the disposal of the community, let that which has been duly bought be administered in a brotherly and Christian manner. If the forest, although unfairly appropriated in the first instance, was later duly sold, let the matter be adjusted in a friendly spirit and according to the Scriptures.

The Sixth Article: Our sixth complaint is in regard to the excessive services demanded of us, which are increased from day to day. We ask that this matter be properly looked into so that we shall not continue to be oppressed in this way, and that some gracious consideration be given us, since our forefathers were required only to serve according to the word of God.

The Seventh Article: Seventh, we will not hereafter allow ourselves to be farther oppressed by our lords, but will let them demand only what is just and proper according to the word of the agreement between the lord and the peasant. The lord should no longer try to force more services or other dues from the peasant without payment, but permit the peasant to enjoy his holding in peace and quiet. The peasant should, however, help the lord when it is necessary, and at proper times, when it will not be disadvantageous to the peasant, and for a suitable payment.

The Eighth Article: In the eighth place, we are greatly burdened by holdings which cannot support the rent exacted from them. The peasants suffer loss in this way and are ruined; and we ask that the lords may appoint persons of honor to inspect these holdings, and fix a rent in accordance with justice, so that the peasant shall not work for nothing, since the laborer is worthy of his hire.

The Ninth Article: In the ninth place, we are burdened with a great evil in the constant making of new laws. We are not judged according to the offence, but sometimes with great ill will, and sometimes much too leniently. In our opinion we should be judged according to the old written law, so that the case shall be decided according to its merits, and not with partiality.

The Tenth Article: In the tenth place, we are aggrieved by the appropriation by individuals of meadows and fields which at one time belonged to a community. These we will take again into our own hands. It may, however, happen that the land was rightfully purchased, but when the land has unfortunately been purchased in this way, some brotherly arrangement should be made according to circumstances.

The Eleventh Article: In the eleventh place we will entirely abolish the due

called *Todfall* [i.e., heriot], and will no longer endure it, nor allow widows and orphans to be thus shamefully robbed against God's will, and in violation of justice and right, as has been done in many places, and by those who should shield and protect them. These have disgraced and despoiled us, and although they had little authority they assumed it. God will suffer this no more, but it shall be wholly done away with, and for the future no man shall be bound to give little or much.

Conclusion: In the twelfth place it is our conclusion and final resolution, that if one or more of the articles here set forth should not be in agreement with the word of God, as we think they are, such article we will willingly recede from, when it is proved really to be against the word of God by a clear explanation of the Scripture. Or if articles should now be conceded to us that are hereafter discovered to be unjust, from that hour they shall be dead and null and without force. Likewise, if more complaints should be discovered which are based upon truth and the Scriptures, and relate to offences against God and our neighbor, we have determined to reserve the right to present these also, and to exercise ourselves in all Christian teaching. For this we shall pray God, since he can grant this, and he alone. The peace of Christ abide with us all.

6. REFORMATION ECHOES IN ENGLAND

Thomas Bilney was an English parson who underwent a powerful religious experience of the sort not uncommon among the new reformed sects. Here is an attempt he made to justify himself in a letter to the Bishop of London (1527). Tried and sent to the Tower for his beliefs, Bilney delivered himself by making submission, but soon fell back into "heresy" and was finally executed for it in 1531, only three years before the final break between the English Church and that of Rome, one witness more to the dangers of being prematurely right.

To the reverend father in Christ, Cuthbert, bishop of London, Thomas Bilney wisheth health in Christ, with all submission due unto such a prelate:

In this behalf, most reverend father in Christ, I think myself most happy that it is my chance to be called to examination before your reverence, for that you are of such wisdom and learning, of such integrity of life, which all men do confess to be in you, that even yourself cannot choose (if you do not too lightly esteem God's gifts in you), as often as you

shall remember the great things which God hath done unto you, but straightways secretly in your heart, to his high praise say, "He that is mighty hath done great things unto me, and holy is his name." I rejoice, that I have now happened upon such a judge, and with all my heart give thanks unto God, who ruleth all things.

And albeit (God is my witness) I know not myself guilty of any error in my sermons, neither of any heresy or sedition, which divers do slander me of, seeking

From The Acts and Monuments of John Foxe, ed. Stephen R. Cattley, 7 vols. (London, 1837-1841), IV.

rather their own lucre and advantage, than the health of souls: notwithstanding I do exceedingly rejoice, that it is so foreseen by God's divine providence, that I should be brought before the tribunal seat of Tonstal, who knoweth as well as any other, that there will never be wanting a Jannes and a Jambres, who will resist the truth: that there shall never be lacking some Elymas, who will go about to subvert the straight ways of the Lord; and finally, that some Demetriuses, Pithonises, Balaams, Nicolaitans, Cains, and Ishmaels, will be always at hand, who will greedily hunt and seek after that which pertaineth unto themselves, and not that which pertaineth to Jesus Christ. . . .

But if any man seeketh to reduce those who were gone astray, into the fold of Christ, that is, the unity of faith, by and by there rise up certain against him, which are named pastors, but indeed are wolves; which seek no other thing of their flock, but the milk, wool, and fell, leaving both their own souls, and the souls of their flock, unto the devil.

These men, I say, rise up like unto Demetrius, crying out, "This heretic dissuadeth and seduceth much people every where, saying, that they are not gods, which are made with hands." These are they, these I say, most reverend father! are they, who, under the pretence of persecuting heretics, follow their own licentious lives: enemies unto the cross of Christ, who can suffer and bear anything rather than the sincere preaching of Christ crucified for our sins. These are they unto whom Christ threateneth eternal damnation, when he saith, "Wo be unto you scribes, Pharisees, and hypocrites! which shut up the kingdom of heaven before men, and you yourselves enter not in, neither suffer those which

would enter, to come in." These are they that have come in another way to the charge of souls, as it appeareth; "For if any man," saith Christ, "come in by me, he shall be saved; and shall come in, and go out, and find pasture." These men do not find pasture, for they never teach and draw others after them, that they should enter by Christ, who alone is the door whereby we must come unto the Father: but set before the people another way, persuading them to come unto God through good works, often times speaking nothing at all of Christ, thereby seeking rather their own gain and lucre, than the salvation of souls: in this point being worse than those who upon Christ (being the foundation) do build wood, hay, and straw. These men confess that they know Christ, but by their deeds they deny him.

These are those physicians upon whom that woman that was twelve years vexed with the bloody flux had consumed all that she had, and felt no help, but was still worse and worse, until such time as she came at last unto Christ; and after she had once touched the hem of his vesture, through faith she was so healed, that by and by she felt the same in her body. O mighty power of the most Highest! which I also, miserable sinner, have often tasted and felt, who, before I could come unto Christ, had even likewise spent all that I had upon those ignorant physicians, that is to say, unlearned hearers of confession; so that there was but small force of strength left in me (who of nature was but weak), small store of money. and very little wit or understanding; for they appointed me fastings, watching, buying of pardons and masses; in all things (as I now understand) they sought rather their own gain, than the salvation of my sick and languishing soul.

But at last I heard speak of Jesus, even

then when the New Testament was first set forth by Erasmus; which when I understood to be eloquently done by him, being allured rather by the Latin than by the word of God (for at that time I knew not what it meant), I bought it even by the providence of God, as I do now well understand and perceive: and at the first reading (as I well remember) I chanced upon this sentence of St. Paul (O most sweet and comfortable sentence to my soul!) in I Tim. i, "It is a true saying, and worthy of all men to be embraced, that Christ Iesus came into the world to save sinners: of whom I am the chief and principal." This one sentence, through God's instruction and inward working, which I did not then perceive, did so exhilarate my heart, being before wounded with the guilt of my sins, and being almost in despair, that immediately I felt a marvellous comfort and quietness, insomuch that my bruised bones leaped for jov.

After this, the Scripture began to be more pleasant unto me than the honey or the honey-comb; wherein I learned that all my travails, all my fasting and watching, all the redemption of masses and pardons, being done without trust in Christ, who only saveth people from their sins; these I say, I learned to be nothing else but even (as St. Augustine saith) a hasty and swift running out of the right way; or else much like to the vesture made of fig leaves, wherewithal Adam and Eve went about in vain to cover themselves, and could never before obtain quietness and rest, until they believed in the promise of God, that Christ, the seed of the woman, should tread upon the serpent's head: neither could I be relieved or eased of the sharp stings and bitings of my sins, before I was taught of God that lesson which Christ speaketh of in John iii: "Even as Moses exalted the serpent in the desert, so shall the Son of Man be exalted, that all which believe on him, should not perish, but have life everlasting." . . .

And therefore, with all my whole power I teach, that all men should first acknowledge their sins, and condemn them, and afterwards hunger and thirst for that righteousness whereof St. Paul speaketh, "The righteousness of God, by faith in Jesus Christ, is upon all them which believe in him; for there is no difference: all have sinned, and lack the glory of God, and are justified freely through his grace, by the redemption which is in Jesus Christ:" which whosoever doth hunger or thirst for, without doubt they shall at length so be satisfied, that they shall not hunger and thirst for ever.

But, forasmuch as this hunger and thirst were wont to be quenched with the fulness of man's righteousness, which is wrought through the faith of our own elect and chosen works, as pilgrimages, buying of pardons, offering of candles, elect and chosen fasts, and oftentimes superstitions; and finally all kind of voluntary devotions (as they call them), against which God's word speaketh plainly in Deut. iv, v. 2, saying, "Thou shalt not do that which seemeth good unto thyself; but that which I command thee for to do, that do thou, neither adding to, neither diminishing any thing from it." Therefore, I say, often times I have spoke of those works, not condemning them (as I take God to my witness), but reproving their abuse; making the lawful use of them manifest even unto children; exhorting all men not so to cleave unto them, that they, being satisfied therewith, should loathe or wax weary of Christ, as many do: in whom I bid your fatherhood most prosperously well to fare.

And this is the whole sum. If you will appoint me to dilate more at large the things here touched, I will not refuse to do it, so that you will grant me time (for

to do it out of hand I am not able for the weakness of my body); being ready always, if I have erred in anything, to be better instructed.

8. CALVINISM

John Calvin, born at Noyon in Picardy, 1509, died in 1564 at Geneva, where he had organized a Protestant republic. His religious system, known as Calvinism, has certain distinctive features: (1) the democratic origin which he attributes to religious authority; (2) the elimination of religious ceremonies; (3) the denial of any authority to tradition; (4) the dogma of predestination; (5) the reduction of the sacraments to two—baptism and communion. In France, the disciples of Calvin were also known as Huguenots, either after one of the Genevan leaders called Hugues or after the German word for fellows, Eidgenossen.

Founded upon very slender bases, Calvin's authority grew rapidly. A letter of the Venetian ambassador in Paris, written in 1561, informs the Doge: "Your Serenity will hardly believe the influence and power which the principal minister of Geneva, by name Calvin . . . possesses in this kingdom. He is a man of extraordinary authority, who by his mode of life, his doctrines, and his writings rises superior to all the rest." The French philosopher Renan explains this influence by saying that Calvin succeeded in an age and in a country that were hungry for Christianity, simply because he was the most Christian man of his generation. If Renan's reasoning is debatable, the prestige of Calvin and that which he reflected upon Geneva are not.

The Institutes of the Christian Church, 1559

The first edition of the *Institutio* was published in 1536, when Calvin was twenty-six. It was several times revised, but there was no development in Calvin's thought after the first edition. Calvin's genius was for organization rather than for theological speculation. (Bettenson's Note)

Book II. Chap. i. Therefore original sin is seen to be an hereditary depravity and corruption of our nature, diffused into all parts of the soul . . . wherefore those who have defined original sin as the lack of the original righteousness with which we should have been endowed, no doubt include, by implication, the whole fact of the matter, but they have not fully expressed the positive energy of this sin.

For our nature is not merely bereft of good, but is so productive of every kind of evil that it cannot be inactive. Those who have called it concupiscence have used a word by no means wide of the mark, if it were added (and this is what many do not concede) that whatever is in man, from intellect to will, from the soul to the flesh, is all defiled and crammed with concupiscence; or, to sum it up brief-

From Documents of the Christian Church, ed. Henry Bettenson (London, 1950). Reprinted by permission of Oxford University Press and Geoffrey Cumberlege.

ly, that the whole man is in himself nothing but concupiscence. . . .

Chap, iv. The old writers often shrink from the straight-forward acknowledgement of the truth in this matter, from motives of piety. They are afraid of opening to the blasphemers a window for their slanders concerning the works of God. While I salute their restraint. I consider that there is very little danger of this if we simply hold to the teaching of Scripture. Even Augustine is not always emancipated from that superstitious fear; as when he says (Of Predestination and Grace ss 4, 5) that "hardening" and "blinding" refer not to the operation of God, but to His foreknowledge. But there are so many savings of Scripture which will not admit of such fine distinctions: for they clearly indicate that God's intervention consists in something more than His foreknowledge. . . . In the same way their suggestions as to God's "permission" are too weak to stand. It is very often said that God blinded and hardened the reprobate, that he turned, inclined, or drove on their hearts . . . And no explanation of such statements is given by taking refuge in "foreknowledge" or "permission." We therefore reply that this [process of hardening or blinding] comes about in two ways. When His light is removed, nothing remains but darkness and blindness: when His Spirit is taken away, our hearts harden into stone: when His guidance ceases, we are turned from the straight path. And so He is rightly said to blind, to harden, to turn, those from whom He takes away the ability to see, to obey, to keep on the straight path. But the second way is much nearer the proper meaning of the words; that to carry out his judgements he directs their councils and excites their wills, in the direction which he has decided upon, through the agency of Satan, the minister of his wrath. . . .

Book III. chap xxi. No one who wishes to be thought religious dares outright to deny predestination, by which God chooses some for the hope of life, and condemns others to eternal death. But men entangle it with captious quibbles; and especially those who make foreknowledge the ground of it. We indeed attribute to God both predestination and foreknowledge; but we call it absurd to subordinate one to the other. When we attribute foreknowledge to God we mean that all things have ever been, and eternally remain, before his eyes; so that to his knowledge nothing is future or past, but all things are present; and present not in the sense that they are reproduced in imagination (as we are aware of past events which are retained in our memory), but present in the sense that He really sees and observes them placed, as it were, before His eyes. And this foreknowledge extends over the whole universe and over every creature. By predestination we mean the eternal decree of God, by which He has decided in His own mind what He wishes to happen in the case of each individual. For all men are not created on an equal footing, but for some eternal life is pre-ordained, for others eternal damnation. . . .

Book IV. chap xiv. Concerning Sacraments. . . . It is convenient first of all to notice what a Sacrament is. Now the following seems to me to be a simple and proper definition of a Sacrament. An external symbol by which the Lord attests in our consciences His promises of goodwill towards us to sustain the inferiority of our faith, and we on our part testify to our piety towards Him as well as in His presence and before the angels as in the sight of men. Another way of putting it, more condensed but equally valid, would

be: A testimony of God's grace to us confirmed by an external sign, with our answering witness of piety towards Him....

Chap. xvii. Concerning the Sacred Supper of Christ. That sacred communication of his own flesh and blood by which Christ pours his life into us, just as if he were to penetrate into the marrow of our bones, he witnesses and attests in the Supper. And that he does not by putting before us a vain or empty sign,

but offering there the efficacy of his Spirit, by which he fulfils his promise. And in truth he offers and displays the thing there signified to all who share that spiritual feast; though only by the faithful is it perceived and its fruits enjoyed. If it is true that the visible sign is offered to us to attest the granting of the invisible reality, then, on receiving the symbol of the body, we may be confident that the body itself is no less given to us.

9. THE COUNTEROFFENSIVE

The Protestant Revolution was spreading over northwestern Europe: in 1534 the English church broke from Rome; in 1536 Calvin began his work in Geneva; in 1537 Denmark, in 1539 Saxony and Brandenburg, in 1541 the Palatinate, turned toward reform. Meanwhile, in 1541 John Knox, the enthusiastic follower of Calvin, introduced the reform in Scotland. During this time, however, the Church had not remained inactive. New militant orders had been founded—Jesuits and Capuchins—to carry the fight into the enemy camp. The Inquisition had been reorganized on the Spanish model. For a few years after 1553 England had been reconciled to Rome. But above all, in the long-drawn-out Council of Trent (1545–1563) the Church put its own house in order and reaffirmed the fundamentals of Catholic doctrine.

The Jesuits

The Society of Jesus, founded by Ignatius Loyola (1491–1556), was skillfully organized into a great force for the conservation and propagation of the Roman Church. The Society started with six friends, in 1534, but it was not until 1540 that Pope Paul III could be induced to give his approval. The following extracts are given to show the spirit of obedience which served to make the Society such a mighty influence of propaganda. (Bettenson's Note)

Ignatius Loyola: Spiritual Exercises

A. RULES FOR THINKING WITH THE CHURCH

1. Always to be ready to obey with mind and heart, setting aside all judgment of one's own, the true spouse of Jesus Christ, our holy mother, our infallible and orthodox mistress, the Catholic Church, whose authority is exercised over us by the hierarchy.

2. To commend the confession of sins to a priest as it is practiced in the Church;

From *Documents of the Christian Church*, ed. Henry Bettenson (London, 1950). Reprinted by permission of Oxford University Press and Geoffrey Cumberlege.

the reception of the Holy Eucharist once a year, or better still every week, or at least every month, with the necessary preparation.

- 3. To commend to the faithful frequent and devout assistance at the holy sacrifice of the Mass, the ecclesiastical hymns, the divine office, and in general the prayers and devotions practiced at stated times, whether in public in the churches or in private.
- 4. To have a great esteem for the religious orders, and to give the preference to celibacy or virginity over the married state.
- 5. To approve of the religious vows of chastity, poverty, perpetual obedience, as well as the other works of perfection and supererogation. Let us remark in passing, that we must never engage by vow to take a state (such e.g. as marriage) that would be an impediment to one more perfect. . . .
- 6. To praise relics, the veneration and invocation of Saints: also the stations, and pious pilgrimages, indulgences, jubilees, the custom of lighting candles in the Churches, and other such aids to piety and devotion.
- 7. To praise the use of abstinence and fasts as those of Lent, of Ember Days, of Vigils, of Friday, of Saturday, and of others undertaken out of pure devotion: also voluntary mortifications, which we call penances, not merely interior, but exterior also.
- 8. To commend moreover the construction of Churches and ornaments; also images, to be venerated with the fullest right, for the sake of what they represent.
- 9. To uphold especially all the precepts of the Church, and not censure them in any manner; but, on the contrary, to defend them promptly, with reasons

drawn from all sources, against those who criticize them.

- 10. To be eager to commend the decrees, mandates, traditions, rites and customs of the Fathers in the Faith or our superiors. As to their conduct; although there may not always be the uprightness of conduct that there ought to be, yet to attack or revile them in private or in public tends to scandal and disorder. Such attacks set the people against their princes and pastors; we must avoid such reproaches and never attack superiors before inferiors. The best course is to make private approach to those who have power to remedy the evil.
- 11. To value most highly the sacred teaching, both the Positive and the scholastic, as they are commonly called. . . .
- 12. It is a thing to be blamed and avoided to compare men who are still living on the earth (however worthy of praise) with the Saints and Blessed, saying: This man is more learned than St. Augustine, etc. . . .
- 13. That we may be altogether of the same mind and in conformity with the Church herself, if she shall have defined anything to be black which to our eyes appears to be white, we ought in like manner to pronounce it to be black. For we must undoubtingly believe, that the spirit of our Lord Jesus Christ, and the Spirit of the Orthodox Church His Spouse, by which Spirit we are governed and directed to Salvation, is the same; . . .
- 14. It must also be borne in mind, that although it be most true, that no one is saved but he that is predestinated, yet we must speak with circumspection concerning this matter, lest perchance, stressing too much the grace or predestination of God, we should seem to wish to shut out the force of free will and the merits of good works; or on the other hand, at-

tributing to these latter more than belongs to them, we derogate meanwhile from the power of grace.

- 15. For the like reason we should not speak on the subject of predestination frequently; if by chance we do so speak, we ought so to temper what we say as to give the people who hear no occasion of erring and saying, "If my salvation or damnation is already decreed, my good or evil actions are predetermined"; whence many are wont to neglect good works, and the means of salvation.
- 16. It also happens not unfrequently, that from immoderate preaching and praise of faith, without distinction or explanation added, the people seize a pretext for being lazy with regard to any good works, which precede faith, or follow it when it has been formed by the bond of charity.
- 17. Nor any more must we push to such a point the preaching and inculcating of the grace of God, as that there may creep thence into the minds of the hearers the deadly error of denying our faculty of free will. We must speak of it as the glory of God requires . . . that we may not raise doubts as to liberty and the efficacy of good works.
- 18. Although it is very praiseworthy and useful to serve God through the motive of pure charity, yet we must also recommend the fear of God; and not only filial fear, but servile fear, which is very useful and often even necessary to raise man from sin. . . Once risen from the state, and free from the affection of mortal sin, we may then speak of that filial fear which is truly worthy of God, and

which gives and preserves the union of pure love.

B. OBEDIENCE OF THE JESUITS

Let us with the utmost pains strain every nerve of our strength to exhibit this virtue of obedience, firstly to the Highest Pontiff, then to the Superiors of the Society; so that in all things, to which obedience can be extended with charity, we may be most ready to obey his voice, just as if it issued from Christ our Lord . . . , leaving any work, even a letter, that we have begun and have not yet finished; by directing to this goal all our strength and intention in the Lord, that holy obedience may be made perfect in us in every respect, in performance, in will, in intellect; by submitting to whatever may be enjoined on us with great readiness, with spiritual joy and perseverance; by persuading ourselves that all things (commanded) are just; by rejecting with a kind of blind obedience all opposing opinion or judgment of our own; and that in all things which are ordained by the Superior where it cannot be clearly held (definiri) that any kind of sin intervenes. And let each one persuade himself that they that live under obedience ought to allow themselves to be borne and ruled by divine providence working through their Superiors exactly as if they were a corpse which suffers itself to be borne and handled in any way whatsoever; or just as an old man's stick which serves him who holds it in his hand wherever and for whatever purpose he wish to use it.

The Council of Trent

The chief act of the Counter Reformation issued from the Alpine city of Trent where, in three meetings held in 1545–1549, 1551–1552, and 1562–1563, the Church tackled the problems of Protestantism, the need for a more precise definition of Catholic faith, and ultimately the need for a new internal discipline. The loss of many Catholics who had left Rome for rival churches was thus compensated by raising the standards of religious life and by the reorganization and systematization of both doctrine and administration.

DECREE TOUCHING THE OPENING OF THE COUNCIL

Doth it please you,—unto the praise and glory of the holy and undivided Trinity, Father, and Son, and Holy Ghost; for the increase and exaltation of the Christian faith and religion; for the extirpation of heresies; for the peace and union of the Church; for the reformation of the Clergy and Christian people; for the depression and extinction of the enemies of the Christian name,—to decree and declare that the sacred and general council of Trent do begin, and hath begun?

They answered: It pleaseth us.

DECREE CONCERNING THE EDITION, AND THE USE OF THE SACRED BOOKS

Moreover, the same sacred and holy Synod,—considering that no small utility may accrue to the Church of God, if it be made known which out of all the Latin editions, now in circulation, of the sacred books, is to be held as authentic,—ordains and declares, that the said old and vulgate edition, which, by the lengthened usage of so many ages, has been approved of in the Church, be, in public lectures, disputations, sermons and expositions,

held as authentic; and that no one is to dare, or presume to reject it under any pretext whatever.

Furthermore, in order to restrain petulant spirits. It decrees, that no one, relying on his own skill, shall,—in matters of faith, and of morals pertaining to the edification of Christian doctrine, -wrestling the sacred Scripture to his own senses, presume to interpret the said sacred Scripture contrary to that sense which holy mother Church,—whose it is to judge of the true sense and interpretation of the holy Scriptures, -hath held and doth hold; or even contrary to the unanimous consent of the Fathers; even though such interpretations were never (intended) to be at any time published. Contraveners shall be made known by their Ordinaries, and be punished with the penalties by law established.

DECREE CONCERNING ORIGINAL SIN

That our Catholic faith, without which it is impossible to please God, may, errors being purged away, continue in its own perfect and spotless integrity, and that the Christian people may not be carried about with every wind of doctrine; whereas that old serpent, the perpetual enemy of mankind, amongst the very many evils

From The Canons and Decrees of the Sacred and Oecumenical Council of Trent, tr. J. Waterworth (London, 1848).

with which the Church of God is in these our times troubled, has also stirred up not only new, but even old, dissensions touching original sin, and the remedy thereof: the sacred and holy, oecumenical and general Synod of Trent,-lawfully assembled in the Holy Ghost, the three same legates of the Apostolic See presiding therein,—wishing now to come to the reclaiming of the erring, and the confirming of the wavering, -following the testimonies of the sacred Scriptures, of the holy Fathers, of the most approved councils, and the judgment and consent of the Church itself, ordains, confesses, and declares these things touching the said original sin:

- 1. If any one does not confess that the first man, Adam, when he had transgressed the commandment of God in Paradise, immediately lost the holiness and iustice wherein he had been constituted; and that he incurred, through the offense of that prevarication, the wrath and indignation of God, and consequently death, with which God had previously threatened him, and, together with death, captivity under his power who thenceforth had the empire of death, that is to say, the devil, and that the entire Adam, through that offense of prevarication, was changed, in body and soul, for the worse; let him be anathema.
- 2. If any one asserts, that the prevarication of Adam injured himself alone, and not his posterity; and that the holiness and justice, received of God, which he lost, he lost for himself alone, and not for us also; or that he, being defiled by the sin of disobedience, has only transfused death, and pains of the body, into the whole human race, but not sin also, which is the death of the soul; let him be anathema:—whereas he contradicts the apostle who says: By one man sin entered

into the world, and by sin death, and so death passed upon all men, in whom all have sinned.

3. If any one asserts, that this sin of Adam,—which in its origin is one, and being transfused into all by propagation, not by imitation, is in each one as his own, -is taken away either by the powers of human nature, or by any other remedy than the merit of the one mediator, our Lord Iesus Christ, who hath reconciled us to God in his own blood, made unto us justice, sanctification, and redemption; or if he denies that the said merit of Jesus Christ is applied, both to adults and to infants, by the sacrament of baptism rightly administered in the form of the Church; let him be anathema: For there is no other name under heaven given to men, whereby we must be saved. Whence that voice: Behold the lamb of God, behold him who taketh away the sins of the world; and that other: As many as have been baptized have put on Christ.

DECREE ON JUSTIFICATION

. . . No one, moreover, so long as he is in this mortal life, ought so far to presume as regards the secret mystery of divine predestination, as to determine for certain that he is assuredly in the number of the predestinate; as if it were true, that he that is justified, either cannot sin any more, or, if he do sin, that he ought to promise himself an assured repentance; for except by special revelation, it cannot be known whom God hath chosen unto Himself. . . .

DECREE ON THE SACRAMENTS IN GENERAL

Canon I. If any one saith, that the sacraments of the New Law were not all

instituted by Jesus Christ, our Lord; or, that they are more, or less, than seven, to wit, Baptism, Confirmation, the Eucharist, Penance, Extreme Unction, Holy Orders, and Matrimony; or even that any one of these seven is not truly and properly a sacrament; let him be anathema.

Canon IV. If any one saith, that the sacraments of the New Law are not necessary unto salvation, but superfluous; and that, without them, or without the desire thereof, men obtain of God, through faith alone, the grace of justification;—though all (the sacraments) are not indeed necessary for every individual; let him be anathema.

Canon V. If any one saith that these sacraments were instituted for the sake of nourishing faith alone; let him be anathema.

Canon VI. If any one saith, that the sacraments of the New Law do not contain the grace which they signify; or, that they do not confer that grace on those who do not place an obstacle thereunto; as though they were merely outward signs of grace or justice received through faith, and certain marks of the Christian profession, whereby believers are distinguished amongst men from unbelievers; let him be anathema.

Canon VII. If any one saith, that grace, as far as God's part is concerned, is not given through the said sacraments, always, and to all men, even though they receive them rightly, but (only) sometimes, and to some persons; let him be anathema.

Canon VIII. If any one saith, that by the said sacraments of the New Law grace is not conferred through the act performed, but that faith alone in the divine promise suffices for the obtaining of grace; let him be anathema.

Canon IX. If any one saith, that, in the three sacraments, Baptism, to wit, Confirmation, and Order, there is not imprinted in the soul a character, that is, a certain spiritual and indelible sign, on account of which they cannot be repeated; let him be anathema.

Canon X. If any one saith, that all Christians have power to administer the word, and all the sacraments; let him be anathema.

Canon XI. If any one saith, that, in ministers, when they effect, and confer the sacraments, there is not required the intention at least of doing what the Church does; let him be anathema.

Canon XII. If any one saith, that a minister, being in mortal sin,—if so be that he observe all the essentials which belong to the effecting, or conferring of, the sacrament,—neither effects, nor confers the sacrament; let him be anathema. . . .

DECREE CONCERNING THE MOST HOLY SACRAMENT OF THE EUCHARIST

deemer, declared that which He offered under the species of bread to be truly His own body, therefore has it ever been a firm belief in the Church of God, and this holy Synod doth now declare it anew, that, by the consecration of the bread and of the wine, a conversion is made of the whole substance of the body of Christ our Lord, and of the whole substance of the wine into the substance of His blood; which conversion is, by the holy Catholic Church, suitably and properly called Transubstantiation.

ON THE MOST HOLY SACRAMENT OF THE EUCHARIST

Canon I. If any one denieth, that, in the sacrament of the most holy Eucharist, are contained truly, really and substantially, the body and blood together with the soul and divinity of our Lord Jesus Christ, and consequently the whole Christ; but saith that He is only therein as in a sign, or in figure, or virtue; let him be anathema.

Canon II. If any one saith, that, in the sacred and holy sacrament of the Eucharist, the substance of the bread and wine remains conjointly with the body and blood of our Lord Jesus Christ, and denieth that wonderful and singular conversion of the whole substance of the bread into the Body, and of the whole substance of the wine into the Blood—the species only of the bread and wine remaining—which conversion indeed the Catholic Church most aptly calls Transubstantiation; let him be anathema.

Canon III. If any one denieth, that, in the venerable sacrament of the Eucharist, the whole Christ is contained under each species, and under every part of each species, when separated; let him be anathema.

Canon IV. If any one saith, that, after the consecration is completed, the body and blood of our Lord Jesus Christ are not in the admirable sacrament of the Eucharist, but (are there) only during the use, whilst it is being taken, and not either before or after; and that, in the hosts, or consecrated particles, which are reserved or which remain after communion, the true Body of the Lord remaineth not; let him be anathema.

Canon V. If any one saith, either that the principal fruit of the most holy Eucharist is the remission of sins, or, that other effects do not result therefrom; let him be anathema.

Canon VI. If any one saith, that, in the holy sacrament of the Eucharist, Christ, the only-begotten Son of God, is not to be adored with the worship, even external of latria; and is, consequently, neither to be venerated with a special festive solemnity, nor to be solemnly borne about in processions, according to the laudable and universal rite and custom of holy church; or, is not to be proposed publicly to the people to be adored, and that the adorers thereof are idolators; let him be anathema.

Canon VII. If any one saith, that it is not lawful for the sacred Eucharist to be reserved in the *sacrarium*, but that, immediately after consecration, it must necessarily be distributed amongst those present; or, that it is not lawful that it be carried with honour to the sick; let him be anathema.

Canon VIII. If any one saith, that Christ, given in the Eucharist, is eaten spiritually only, and not also sacramentally and really; let him be anathema.

Canon IX. If any one denieth, that all and each of Christ's faithful of both sexes are bound, when they have attained to years of discretion, to communicate every year, at least at Easter, in accordance with the precept of holy Mother Church; let him be anathema.

Canon X. If any one saith, that it is not lawful for the celebrating priest to communicate himself; let him be anathema.

Canon XI. If any one saith, that faith alone is a sufficient preparation for receiving the sacrament of the most holy Eucharist; let him be anathema. And for fear lest so great a sacrament may be received unworthily, and so unto death and condemnation, this holy Synod ordains and declares, that sacramental confession, when a confessor may be had, is of necessity to be made beforehand, by those whose conscience is burdened with mortal sin, how contrite even soever they may think themselves. But if any one shall presume to teach, preach, or obstinately to assert, or even in public disputation to defend the contrary, he shall be thereupon excommunicated.

ON THE SACRIFICE OF THE MASS

. . . . Canon I. If any one saith, that in the mass a true and proper sacrifice is not offered to God; or, that to be offered is nothing else but that Christ is given us to eat; let him be anathema.

Canon II. If any one saith, that by those words, Do this for the commemoration of me... Christ did not institute the apostles priests, or, did not ordain that they, and other priests should offer His own body and blood; let him be anathema.

Canon III. If any one saith, that the sacrifice of the mass is only a sacrifice of praise and of thanksgiving; or, that it is a bare commemoration of the sacrifice consummated on the cross, but not a propitiatory sacrifice; or, that it profits him only who receives; and that it ought not to be offered for the living and the dead for sins, pains, satisfactions, and other necessities; let him be anathema.

DECREE ON REFORMATION

And forasmuch as, though the habit does not make the monk, it is nevertheless fleedful that clerics always wear a dress suitable to their proper order, that by the decency of their outward apparel

they may show forth the inward correctness of their morals; but to such a pitch, in these days, have the contempt of religion and the rashness of some grown, as that, making but little account of their own dignity, and of the clerical honour, they even wear in public the dress of lavmen—setting their feet in different paths, one of God, the other of the flesh;-for this cause, all ecclesiastical persons, howsoever exempted, who are either in sacred orders or in possession of any manner of dignities, personates, or other offices, or benefices ecclesiastical; if, after having been admonished by their own bishop, even by a public edict, they shall not wear a becoming clerical dress, suitable to their order and dignity, and in conformity with the ordinance and mandate of the said bishop, they may, and ought to be, compelled thereunto, by suspension from their orders, office, benefice, and from the fruits, revenues, and proceeds of the said benefices; and also, if, after having been once rebuked, they offend again herein [they are to be coerced] even by deprivation of the said offices and benefices. . . .

Whereas too, he who has killed his neighbour on set purpose and by lying in wait for him, is to be taken away from the altar, because he has voluntarily commited a homicide; even though that crime have neither been proved by ordinary process of law, nor be otherwise public, but is secret, such a one can never be promoted to sacred orders; nor shall it be lawful to confer upon him any ecclesiastical benefices, even though they have no cure of souls; but he shall be forever excluded from every ecclesiastical order, benefice, and office. . . .

There is nothing that continually instructs others unto piety, and the service of God, more than the life and example of those who have dedicated themselves to the divine ministry. For as they are seen to be raised to a higher position, above the things of this world, others fix their eves upon them as upon a mirror, and derive from them what they are to imitate. Wherefore clerics called to have the Lord for their portion, ought by all means so to regulate their whole life and conversation, as that in their dress, comportment, gait, discourse, and all things else, nothing appear but what is grave, regulated, and replete with religiousness; avoiding even slight faults, which in them would be most grievous; that so their actions may impress all with veneration. Whereas, therefore, the more useful and decorous these things are for the Church of God, the more carefully also are they to be attended to; the holy Synod ordains, that those things which have been heretofore copiously and wholesomely enacted by sovereign pontiffs and sacred councils, -relative to the life, propriety of conduct, dress, and learning of clerics, and also touching the luxuriousness, feastings, dances, gambling, sports, and all sorts of crime whatever, as also the secular employments, to be by them shunned,—the same shall be henceforth observed, under the same penalties, or greater, to be imposed at the discretion of the Ordinary; nor shall any appeal suspend the execution hereof, as relating to the correction of manners. But if anything of the above shall be found to have fallen into desuetude, they shall make it their care that it be brought again into use as soon as possible, and be accurately observed by all, any customs to the contrary notwithstanding; lest they themselves may have, God being the avenger, to pay the penalty deserved by their neglect of the correction of those subject to them . . .

ON REFORMATION

. . . How shameful a thing, and how unworthy it is of the name of clerics who have devoted themselves to the service of God, to live in the filth of impurity, and unclean bondage, the thing itself doth testify, in the common scandal of all the faithful, and the extreme disgrace entailed on the clerical order. To the end, therefore, that the ministers of the Church may be recalled to that continency and integrity of life which becomes them; and that the people may hence learn to reverence them the more, that they know them to be more pure of life: the holy Synod forbids all clerics whatsoever to dare to keep concubines, or any other woman of whom any suspicion can exist, either in their own houses, or elsewhere, or to presume to have any intercourse with them: otherwise they shall be punished with the penalties imposed by the sacred canons, or by the statutes of the (several) churches. But if, after being admonished by their superiors, they shall not abstain from these women, they shall be ipso facto deprived of the third part of the fruits, rents, and proceeds of all their benefices whatsoever, and pensions; which third part shall be applied to the fabric of the church, or to some other pious place, at the discretion of the bishop. If, however, persisting in the same crime, with the same or some other woman, they shall not even yet have obeyed upon a second admonition, not only shall they thereupon forfeit all the fruits and proceeds of their benefices and pensions, which shall be applied to the places aforesaid, but they shall also be suspended from the administration of the benefices themselves, for as long a period as shall seem fit to the Ordinary, even as the delegate of the Apostolic See. And if,

having been thus suspended, they nevertheless shall not put away those women, or even if they shall have intercourse with them, then shall they be for ever deprived of their ecclesiastical benefices, portions, offices, and pensions of whatsoever kind, and be rendered thenceforth incapable and unworthy of any manner of honours, dignities, benefices and offices, until, after a manifest amendment of life, it shall seem good to their superiors, for a cause, to grant them a dispensation. But if, after having once put them away, they shall have dared to renew the interrupted connexion, or to take to themselves other scandalous women of this sort, they shall, in addition to the penalties aforesaid, be smitten with the sword of excommunication. Nor shall any appeal, or exemption, hinder or suspend the execution of the aforesaid; and the cognizance of all the matters above-named shall not belong to arch-deacons, or deans, or other inferiors, but to the bishops themselves, who may proceed without the noise and the formalities of justice, and by the sole investigation of the truth of the fact. . . .

ON THE SACRAMENT OF ORDER

Canon I. If any one saith, that there is not in the New Testament a visible and external priesthood; or that there is not any power of consecrating and offering the true body and blood of the Lord, and of forgiving and retaining sins; but only an office and bare ministry of preaching the Gospel; or, that those who do not preach are not priests at all; let him be anathema.

Canon II. If any one saith, that, besides the priesthood, there are not in the Catholic Church other orders, both greater and minor, by which, as by certain steps, advance is made unto the priesthood; let him be anathema. Canon III. If any one saith, that order, or sacred ordination, is not truly and properly a sacrament instituted by Christ the Lord; or, that it is a kind of human figment devised by men unskilled in ecclesiastical matters; or, that it is only a kind of rite for choosing ministers of the word of God and of the sacraments; let him be anathema.

Canon IV. If any one saith, that, by sacred ordination, the Holy Ghost is not given; and that vainly therefore do the bishops say, *Receive ye the Holy Ghost;* or, that a character is not imprinted by that ordination; or, that he who has once been a priest, can again become a layman; let him be anathema.

Canon V. If any one saith, that the sacred unction which the Church uses in holy ordination, is not only not required, but is to be despised and is pernicious, as likewise are the other ceremonies of Order; let him be anathema.

Canon VI. If any one saith, that in the Catholic Church there is not a hierarchy by divine ordination instituted, consisting of bishops, priests, and ministers; let him be anathema.

Canon VII. If any one saith, that bishops are not superior to priests; or, that they have not the power of confirming and ordaining; or, that the power which they possess is common to them and to priests; or, that orders, conferred by them, without the consent, or vocation of the people, or of the secular power, are invalid; or, that those who have neither been rightly ordained, nor sent, by ecclesiastical and canonical power, but come from elsewhere, are lawful ministers of the word and of the sacraments; let him be anathema.

Canon VIII. If any one saith, that the bishops, who are assumed by authority of

the Roman Pontiff, are not legitimate and true bishops, but are a human figment; let him be anathema.

ON THE SACRAMENT OF MATRIMONY

Canon IX. If any one saith, that clerics constituted in sacred orders, or Regulars, who have solemnly professed chastity, are able to contract marriage, and that being contracted it is valid, notwithstanding the ecclesiastical law or vow; and that the contrary is nothing else than to condemn marriage; and, that all who do not feel that they have the gift of chastity, even though they have made a vow thereof, may contract marriage; let him be anathema: seeing that God refuses not that gift to those who ask for it rightly, neither does He suffer us to be tempted above that which we are able.

ON THE INVOCATION, VENERATION, AND RELICS OF SAINTS AND ON SACRED IMAGES

The holy Synod enjoins on all bishops, and others who sustain the office and charge of teaching, that, agreeably to the usage of the Catholic and Apostolic Church, received from the primitive times of the Christian religion, and agreeably to the consent of the holy Fathers, and to the decrees of sacred Councils, they especially instruct the faithful diligently concerning the intercession and invocation of saints; the honour (paid) to relics; and the legitimate use of images: teaching them, that the saints, who reign together with Christ, offer up their own prayers to God for men; that it is good and useful suppliantly to invoke them, and to have recourse to their prayers, aid, (and) help for obtaining benefits from God, through

His Son, Jesus Christ our Lord, who is alone our Redeemer and Saviour; but that they think impiously, who deny that the saints, who enjoy eternal happiness in heaven, are to be invocated; or who assert either that they do not pray for men; or, that the invocation of them to pray for each of us even in particular, is idolatry; or, that it is repugnant to the word of God; and is opposed to the honour of the one mediator of God and men, Christ Jesus; or, that it is foolish to supplicate. vocally, or mentally, those who reign in heaven. Also, that the holy bodies of holy martyrs, and of others now living with Christ,—which bodies were the living members of Christ, and the temple of the Holy Ghost, and which are by Him to be raised unto eternal life, and to be glorified,—are to be venerated by the faithful; through which (bodies) many benefits are bestowed by God on men; so that they who affirm that veneration and honour are not due to the relics of saints; or, that these, and other sacred monuments, are uselessly honoured by the faithful; and that the places dedicated to the memories of the saints are in vain visited with the view of obtaining their aid; are wholly to be condemned, as the Church has already long since condemned, and now also condemns them.

Moreover, that the images of Christ, of the Virgin Mother of God, and of the other saints, are to be had and retained particularly in temples, and that due honour and veneration are to be given them; not that any divinity, or virtue, is believed to be in them, on account of which they are to be worshipped; or that anything is to be asked of them; or, that trust is to be reposed in images, as was of old done by the Gentiles who placed their hope in idols; but because the honour which is shown them is referred to the prototypes which those images represent; in such wise that by the images which we kiss, and before which we uncover the head and prostrate ourselves, we adore Christ; and we venerate the saints, whose similitude they bear; as, by the decrees of Councils, and especially of the second Synod of Nicaea, has been defined against the opponents of images. . . .

DECREE CONCERNING INDULGENCES

Whereas the power of conferring Indulgences was granted by Christ to the Church; and she has, even in the most ancient times, used the said power, delivered unto her of God; the sacred holy Synod teaches, and enjoins, that the use of Indulgences, for the Christian people most salutary, and approved of by the authority of sacred Councils, is to be retained in the Church; and It condemns with anathema those who either assert. that they are useless; or who deny that there is in the Church the power of granting them. In granting them, however, It desires that, in accordance with the ancient and approved custom in the Church. moderation be observed; lest, by excessive facility, ecclesiastical discipline be enervated. And being desirous that the abuses which have crept therein, and by occasion of which this honourable name of Indulgences is blasphemed by heretics, be amended and corrected, It ordains generally by this decree, that all evil gains for the obtaining thereof,—whence a most prolific cause of abuses amongst the Christian people has been derived,—be wholly abolished. But as regards the other abuses which have proceeded from superstition, ignorance, irreverence, or from whatever other source, since by reason of the manifold corruptions in the places and provinces where the said abuses are committed, they cannot conveniently be specially prohibited; It commands all bishops, diligently to collect, each in his own church, all abuses of this nature, and to report them in the first provincial Synod; that, after having been reviewed by the opinions of the other bishops also, they may forthwith be referred to the Sovereign Roman Pontiff, by whose authority and prudence that which may be expedient for the universal Church will be ordained; that thus the gift of holy Indulgences may be dispensed to all the faithful, piously, holily, and incorruptly. . . .

Amen.

10. THE MASSACRE OF ST. BARTHOLOMEW

The clash of two or more opposing views of truth, each claiming to be ultimate, each intolerant of every other view, would have been bitter enough. Matters were not improved when religious confession was enlisted in the service of rival political interests as it was, for instance, in France where protestantism became identified with the struggle of a section of the nobility against the growing power of central government. Throughout the second half of the sixteenth century, France was ravaged by savage struggles, the Wars of Religion, marked by a long series of plots and counterplots, murders, massacres and actual open warfare. The Catholic party was headed by the Lorraine family of Guise, the protestants by the Bourbons, supported by Admiral de Coligny. Both sides tried to secure control of the royal government which was in the hands of a widow-queen, Catherine de Médicis, and of her

rather unimpressive sons. In 1572, the marriage of Henri de Bourbon, King of Navarre, a protestant, to Catherine's daughter Margaret, a ceremony for which the flower of protestant nobility had gathered in Paris, seemed to offer the Catholic party a chance to decapitate the enemy by one master stroke. The result was the massacre of St. Bartholomew's night, which, ordered by the King and enthusiastically carried out by the ultra-Catholic population of Paris, made some 3000 victims in the capital—as well as a good many in the provinces.

Philip II of Spain and the Court of Rome rejoiced greatly. It is said that the news of the massacre made Philip laugh for the only time in his life. The Pope, for his part, ordered a *Te Deum*, declaring that the news pleased him more than fifty victories of Lepanto (against the Turks). Such joy, however, proved somewhat premature and the massacre only one more bloody incident in a conflict which dragged out another twenty years. France would remain Catholic, though tolerant of protestants, but Henri of Navarre became its king—first of the Bourbons who were to rule the country for two centuries. More important, far from declining as its opponents had hoped, royal power grew, the anarchy of half a century's civil war bringing grist to the mill of central authority.

Letter of Fr. Joachim Opser, S.J., sub-prior of Clermont College to the Abbot of Saint-Gall, August 26, 1572.

I think I shall not bore you if I mention in detail an event as unexpected as it is useful to our cause, and which not only delights the Christian world with admiration, but brings it to a peak of rejoicing. Concerning this you will hear what the Captain has to say [the Captain commanding the detachment of the King's Swiss Mercenaries that broke into the house of the Huguenot leader, Admiral Coligny, and murdered the Admiral]. Rejoice in advance, but do not for that disdain or reject as superfluous the lines I write with more satisfaction perhaps than seems quite proper, for I affirm nothing I have not got from authoritative sources.

The Admiral has perished miserably on August 24, with all the heretical French nobility. (One can say it without exaggeration.) What immense car-

nage! I shuddered at the sight of this river [the Seine] full of naked and horribly mutilated corpses. Up to the present, the King has spared none but the King of Navarre [the future Henry IV]. In effect, today August 26, towards one o'clock, the King of Navarre attended Mass with the King Charles, so that all conceive the greatest hopes of seeing him change religion. . . Everyone agrees in praising the prudence and magnanimity of the King who, after having by his kindness and indulgence fattened, as it were, the heretics like cattle, has suddenly had them slaughtered by his soldiers. . . . All heretical book-sellers that one could find have been massacred and cast naked into the river. Ramus, who had jumped out of his bedroom, quite high up, still lies naked on the river bank, pierced by numerous dagger-

From Bulletin de la Société de l'Histoire du Protestantisme français, Vol. XIII (Paris, 1882), pp. 243-247.

blows. In a word, there is no one (even women not excepted) who has not been either killed or wounded.

One more thing as concerns the massacre of the Admiral; I hold these details from the man who gave him the third blow with his battle axe, from that Conrad Burg who used to be groom at Steward Joachim Waldemann's at Wyl. When the Swiss, under the orders of the Duc d'Anjou, had broken in the doors, Conrad, followed by Leonhard Grunenfelder of Glaris and Martin Koch of Fribourg, reached the Admiral's room which was the third in the house. The servant was killed first. The Admiral was in a dressing gown and none at first wanted

to lay hands on him; but Martin Koch, more daring than the others, struck the wretch with his halberd; Conrad gave him the third blow, and at the seventh at last he fell dead against the chimney of his room. By order of the Duc de Guise his corpse was thrown out of the window and, after tying a rope round his neck as is the way with criminals, he was offered in display for all the people by dragging him to the Seine. Such was the end of that pernicious man, who not only brought a great many to the brink [of perdition] in his lifetime, but who, dying, swept a crowd of heretical nobles into hell with him.

Papire Masson, the King's Historiographer, notes in his Histoire de Charles IX:

This carnage arrived in the sight of the King, who watched it from the Louvre with much pleasure. Few days later, he went himself to the gallows of Montfaucon to see the corpse of Coligny which was hanging by its feet; and as some of his suite feigned reluctance to step near because of the corpse's stink: "The smell of a dead foe," said he, "is sweet and pleasant."

On September 8, 1572, Rome celebrated the massacre's success with a Mass of Thanks in the Church of Saint-Louis-des-Français, "for the great grace received of God."

All-powerful God, who stands against the proud and grants grace to the humble, we offer you the tribute of our most fervent praise for that, caring for the faith of your servants, you have granted them a brilliant triumph over the perfidious opponents of the Catholic people and we humbly beseech you to continue in your mercy that which you have begun in your constancy, for the glory of your name which is invoked in our midst. In the name of Christ, grant us our prayer!

III. Political and Economic Changes

Cultural developments take place against a political and economic background. The fifteenth and sixteenth centuries witnessed very profound changes in the political and economic structure of the West. New worlds had been discovered, new powers had risen, old powers had waned, the trickle of goods and bullion from overseas was growing into a stream. The Muslims, expelled from the Iberian Peninsula, had made great strides at the other end of Europe, where Hungary had fallen in 1526 and Vienna itself was for the first time besieged in 1529.

Hard pressed by changing realities, the old feudal order of society had decayed but had not yet been replaced by a new order. Hence, this is a period of transition, with all the suffering and the disorder that follow social changes as yet uncomprehended and, therefore, unmastered. The Reformation too had created political problems which princes and statesmen strove to handle as best they could: what should be the relationship between church and state, whence comes the prince's right to rule, can more than one religious belief be tolerated in the state? These issues were to be threshed out in the course of the sixteenth century, and the answers proposed would be very different in tenor from those which the prereformation world might have found acceptable.

1. THE POWER AND REVENUES OF THE STATES OF EUROPE IN 1423

The document below is given in order to facilitate comparison with later developments. It appears in a fifteenth-century life of the Venetian Doge, Mocenigo. The Venetian Ambassadors were the best intelligence agents of their time and kept their government informed as to the doings of foreign powers by a system of regular reports.

Income of all the Christian powers and what they are able to do. The king of France with all his force and the feudal services of princes, dukes, marquises, counts, barons, knights, bishops, abbots, canons, priests, and citizens, can in his own country raise 30,000 horsemen skilled in arms. If desiring to send them out of the country the said realm could not, since the costs would be doubled,

send more than 15,000 horse. Before the war with their own countrymen, it could have raised 100,000, for that war destroyed both Church and revenues. In the total therefore 15,000 horse. The king of England with the power of his revenues, and the feudal services of princes and others as above could, paying them every month, raise at home 30,000 horsemen skilled in arms. In making the test of war

From Translations and Reprints, Vol. 3, No. 2, R. P. Falkner, Ed.

these powers are equal. They have always been powerful in their undertakings. And if one of these forces had been greater than the other, one would have been destroved. The English were overcome, after the division occurred in England, and they could not make provision for their forces. This was before 1414. They had 40,000 horse. Wars have weakened these countries, their men and their revenues, so that now wishing to send a force out of the country it is agreed that they have the half, i.e., 15,000 horsemen. The king of Scotland is lord of a great country, and of a people of so great poverty that he would not be able to maintain with his revenues and the taxes and dues of the clergy and laity, 10,000 horsemen skilled in arms in his own country; outside of the country on account of the great cost, 5000 horse. The king of Norway who is lord of a great country, and a people equally poor could not maintain at home with his revenues and the taxes and dues of clergy and laity 10,000 horsemen skilled in arms, abroad 5000 horse. The king of Spain with all his revenues and feudal dues of clergy and laity, with all his forces 30,000 horsemen skilled in arms. In 1414 he paid for 20,000. Wishing to maintain them out of the country at double cost they would be 15,000 horsemen. The king of Portugal with all his revenues from clergy and laity, with all his force, would have, if he paid every month, at home 6000 horsemen skilled in arms, abroad 3000 horse. The king of Brittany with all his revenues and feudal dues of clergy and laity, paying every month could maintain at home 8000 horsemen skilled in arms, abroad 4000. The master of St. James with all his force of men skilled in arms, at home 4000 horsemen, abroad 2000. The duke of Burgundy with all his force as above at home 3000 cavalry. In 1414 he held 1000. But war has destroyed the country. Abroad 5000 men. The king René (of Provence) with all his revenues would be able to raise at home 6000 horse, abroad 3000. The duke of Savoy with all his revenues would be able to raise at home 8000 horse, abroad 4000. The marguis of Montferrat would be able to hold 2000 horse at home, 1000 abroad. The count Francesco Sforza, duke of Milan, with all his force could hold as mercenaries 10,000 horse at home and 5000 abroad. The signory of Venice can, with all its force pay for 10,000 horsemen skilled in arms at home. and 5000 abroad. The marquis of Ferrara at home 2000 horsemen, abroad 1000. The marguis of Mantua, at home 2000, abroad 1000. The signory of Bologna 2000 at home, 1000 abroad. The community of Siena at home 2000, abroad 1000. The Signory of Florence with all its revenues of 1414 could place 1000. At present through the wars it can place 4000 horsemen at home and 2000 abroad.

The Pope with all his revenues of his States of the Church, and with the profits of churches which he receives, was able in 1414 to raise 8000 horsemen; at present at home 6000 horsemen, abroad 3000. The king of Aragon in the Realm of Naples can raise with all his revenues 12,000 horsemen at home and 6000 abroad. The princes of the Realm are able with all their revenues to raise 4000 horsemen at home, 2000 abroad. The Community of Genoa were able in 1414 to maintain 5000 horsemen. But through their present dissension and the wars they are only able to maintain at present 2000. The Barcelonians with all the community and the lord of Catalonia, counting citizens and knights, can at home every month maintain 12,000 horsemen,

and abroad 6000. All Germany with the lords temporal and spiritual, the free and the other cities, north and south Germany, and the Emperor who is German, can raise with all their resources and revenues 60,000 horsemen at home and 30,000 abroad. The king of Hungary, with all the dukes, lords, princes, barons, prelates, clergy and laity, and with all his resources and revenues can raise at home 80,000 horsemen, abroad 40,000. The grand master of Prussia with all his revenues, 30,000 horsemen. In 1414 he had 50,-000. But war has weakened him. Abroad 15,000 horsemen. The king of Poland with all his revenues, with dukes, marquises, barons, cities and boroughs can raise at home 50,000 horsemen, abroad 25,000. The Wallachians with all their revenues and feudal service, at home 20,-000 horsemen, abroad 10,000. Morea with its resources of 1414 could raise 50.-000 horsemen. War has weakened them. At present at home 20,000, abroad 10,-000. All Albania, Croatia, Slavonia, Servia, Russia, and Bosnia with all their revenues at home 30,000, abroad 15,000. The king of Cyprus with all his revenues can raise in the Island 2000. abroad 1000. The duke of Nicea in the Archipelago with all his power can pay for 2000 horsemen at home, 1000 abroad. The grand master of Rhodes with all his revenues and feudal dues of his liegemen, clergy and laity of the island. would be able to raise 4000 horsemen at home, 2000 abroad. The lord of Mitylene 2000 horsemen, abroad 1000. The emperor of Trebizonde with all his power could raise at home 25,000 horsemen. abroad 15,000. The king of Georgia with his revenues of 1414 could raise 30,000 horsemen. At present he can raise at home 10,000 horsemen, abroad 5000.

Power of the Infidel Monarchs. The Turk can in all his dominions raise 40,-000 horsemen, valiant men to defend him against the Christians. The Caraman with all his power can raise at home 60,000 horsemen, abroad 30,000. Ussun Cassan with all his power can raise at home 20,000 horsemen in the service of Mahomet, abroad 10,000. The Caraifan with all his resources at home 20,000, abroad 10,000. Tamerlane with all his Tartar power can raise at home 1.000,-000 horsemen, abroad 500,000. The king of Tunis, of Granada and the other cities of Barbary who have galleys and boats to the injury of Christians, at home are 100,000 horsemen, abroad 50,000.

Revenues of some Christian princes in the year 1423. The king of France in the year 1414 had 2,000,000 ducats ordinary revenues. But the wars which have continued for forty years have reduced the ordinary revenues to 1,000,000 ducats. The king of England had 2,000,000 ducats ordinary revenue. The continued wars have desolated the island. At the present time he has 700,000 ducats revenue. The king of Spain had in 1410, 3,-000,000 ducats ordinary revenue, but the continued wars have reduced it to 800,000 ducats. The king of Portugal had in 1410, 200,000 ducats revenue. By the wars it is reduced to 140,000 ducats. The king of Brittany in 1414 had 200,000 ducats revenue. By the wars it is reduced to 140,000 ducats. The duke of Burgundy had in 1400, 3,000,000 ducats. By the wars it is reduced to 900,-000 ducats. The duke of Savoy as a free country has 150,000 ducats revenue. The marquis of Montferrat as a free country has 150,000 ducats revenue. Count Francesco, duke of Milan [in 1423 duke Filippo Maria Visconti of Milan had

1,000,000 ducats revenue] Count Francesco has at present on account of the wars only 500,000 ducats. The signory of Venice had in 1423, 1,100,000 ducats ordinary revenue. By reason of great wars which have destroyed commerce it has 800,000 ducats ordinary revenue. The marquis of Ferrara had in 1423, 70,000 ducats ordinary revenue. Through the Italian wars he has by remaining at peace 150,000 ducats. The Marquis of Montferrat had in 1423, 150,000 ducats, to-day 60,000 ducats. The Bolognese

had in 1423, 400,000 ducats ordinary revenue. But by the wars it has come to 200,000 ducats. Florence in 1423 had a revenue of 400,000 ducats. But since then, through the great wars it is reduced to 200,000 ducats. The pope, though formerly he had none, has 400,000 ducats ordinary revenue. The Genoese through the great division among them are reduced to 130,000 ducats. The king of Aragon, in all his realm with Sicily, though at first he had considerably more, has a revenue of 310,000 ducats.

2. HENRY VIII

In an age of forceful figures, Henry VIII stands out as one of the most conspicuous. His popular fame seems to rest primarily on half a dozen wives, but the historian sees him as the central figure and dominating force in England during the whole of his long reign (1509–1547)—fighting hard to establish a secure succession for the Tudor dynasty that his father, Henry VII, had founded on Bosworth Field (1485); beginning the English Reformation; and gathering in his hands powers and loyalties for which Church and Crown had vied a long time.

The Act of Supremacy, 1534

An Act concernynge the Kynges Highness to be supreme heed of the Churche of Englande and to have auctoryte to reforme and redresse all errours, heresyes and abuses yn the same.

Albeit the Kynges Majestie justely and rightfully is and oweth to be the supreme heed of the Churche of England, and so is recognysed by the clergy of this Realme in theyr convocacions; yet neverthelesse for corroboracion and confirmacion thereof, and for increase of vertue in Cristis Religion within this Realme of England, and to represse and extirpe all errours, heresies and other enormyties and abuses heretofore used in the same. Be it enacted by auctority of this present Parliament

that the Kyng our Soveraign Lorde, his heires and successours Kynges of this Realme shall be takyn, acceptyd, and reputed the onely supreme heed in erthe of the Churche of England callyd Anglicana Ecclesia, and shall have and enjoye annexed and unyted to the Ympervall Crowne of this Realme as well the title and style thereof, as all Honours Dignyties prehemynences jurisdiccions privileges auctorities ymunyties profitis and commodities to the said dignyties of supreme heed of the same Churche belongyng and apperteyning: And that our said Soveraigne Lorde his heires and successours Kynges of this Realme shall have full power and auctorite from tyme to

From Translations and Reprints, Vol. 1, No. 1, E. P. Cheyney, Ed.

tyme to visite represse redresse reforme order correct restrayne and amende all suche errours heresies abuses offences contemptes and enormyties whatsoever they be whiche by any maner spirituall auctoryte or juristiccion ought or maie lawfullye be reformyd repressyd ordred redressyd correctyd restrayned or amendyd,

most to the pleasure of almyghtie God the increase of vertue yn Chrystis Religion and for the conservacy of the peace unyte and tranquylyte of this Realme: Any usage custome foreyne laws foreyne auctoryte prescripcion or anye other thinge or thinges to the contrarie hereof notwithstandinge.

The Act of the Six Articles, 1539

AN ACT ABOLISHING DIVERSITY IN OPYNIONS

Where the Kinges most excellent Majestie is by Gods lawe supreme head ymmediately under him of this hole churche and congregation of Englande intendinge the conservacion of the same Churche and congregation in a true syncere and unyforme doctrine of Christ's Religion.

Forasmuche as in the saide parliament synode and convacacion there were certen articles, matters and questions proponed and set forth touchinge Christen Religion.

The Kinges most Royal Majestie most prudently ponderinge and consideringe that by occasion of variable and sundrie opinions and judgements of the saide articles, greate discorde and variance hathe arisen as well amongest the clergie of this his Realme as amongest a great number of vulgar people his lovinge subjects of the same, and beinge in a full hope and truste that a full and perfect resolucion of the saide articles should make a perfecte concorde and unyte generally amonge all his lovinge and obedient subjects; of his most excellent goodness not only commanded that the saide articles shoulde deliberately and advisedly by his saide Archbisshops Bishopps and other

lerned men of his clergie be debated argued and reasoned, and their opinions therein to be understood declared and knowne, but also most graciously vouchsaved in his owne princelie person to discend and come into his said highe Courte of Parliament and Counsaile and there like a Prince of most highe Prudence and noe lesse lernynge opened and declared many things of highe lerning and great knowledge touchinge the said articles matters and questions, for an unytye to be had in the same; whereupon, after a greate and longe deliberate and advised disputacion and consultacion had and made concerning the saide articles, as well by the consent of the Kinges Highness as by the assent of the Lordes spirituall and temporall and other lerned men of his clergie in their convacacion, and by the consent of the Commons in this present parliament assembled, it was and is fynally resolved accorded and agreed in manner and forme following, that is to say: First, that in the most blessed Sacrament of the aulter, by the strengthe and efficacy of Christs myghtie worde, it beinge spoken by the prest, is present really, under the forme of bread and wyne, the naturale bodye and bloode of our Saviour Jesu Crist, conceyved of the Virgin Marie, and after the consecracion there remayneth noe substance of

From Translations and Reprints, Vol. 1, No. 1, E. P. Cheyney, Ed.

bread or wyne, nor any other substance but the substance of Criste, God and man; secondly, that Comunion in bothe kinds is not necessarie ad salutem [for salvation] by the lawe of God to all persons; and that it is to be believed and not doubted of, but that in the fleshe under forme of bread is the verie blode, and withe the blode under forme of wyne is the verie fleshe, as well aparte as thoughe they were bothe together; thirdly, that Priests after the order of Presthode receyved as afore may not marye by the lawe of God; fourthlye, that vowes of chastitye and wydowhood by man or woman made to God advisedly

ought to be observed by the lawe of God, and that it exempteth them from other libertyes of Cristen people, which without that they myght enjoye; fyftly, that it is mete and necessarie that private masses be contynued and admytted in this the Kings English Churche and congregacion as whereby good Cristen people orderinge them selfes accordingly doe receyve bothe godly and goodly consolacions and benefyttes and it is agreable also to Gods lawe; sixtly, that auricular confession is expedient and necessarie to be retayned and contynued used and frequented in the Churche of God.

3. CHARLES V

Where Henry VIII appears as the type of the new king of the new nation-state, his contemporary, Charles V (1500–1558), may almost be said to close the medieval tradition in which the prince's authority, derived from God, was not necessarily connected with local or national attachments. The Emperor tried to be a "parfit, gentil," and, of course, Christian knight; but, though his revenues were very great and though his writ ran from Bohemia to the Indies, he met with disappointment and in the weariness of failure retired to the Spanish monastery of San Yuste to end his life in relative peace. But perhaps it is the anachronism he represents which explains the frustration of his attempts to hold together his vast and disconnected realm—the failure Charles expressed in his abdication speech below.

The Abdication of Charles V, Brussels, 1555

Although Philibert has fully explained to you, my friends, the causes which have determined me to surrender these states and leave them to my son Don Philip, in order that he may possess and rule them, yet I wish to say certain things with my own mouth. You will remember that upon the 5th of February of this year there had elapsed forty years since my grandfather the emperor Maximilian, in the same place and at the same hour declared my majority at the age of fifteen, withdrew

me from the guardianship under which I had remained up to that time and made me master of myself. The following year, which was my sixteenth, king Ferdinand died, my mother's father and my grandfather, in the kingdom over which I then commenced to reign, because my beloved mother, who has but lately died, was left, after the death of my father, with disordered judgment and never sufficiently recovered her health to become mistress of herself.

From Translations and Reprints, Vol. 3, No. 3, E. P. Cheyney, Ed.

At that time I went to Spain, by way of the sea. Soon came the death of my grandfather Maximilian, in my 19th year, and although I was still young they conferred upon me in his stead the imperial dignity. I had no inordinate ambition to rule a multitude of kingdoms, but merely sought to secure the welfare of Germany, to provide for the defence of Flanders, to consecrate my forces to the safety of Christianity against the Turk and to labor for the extension of the Christian religion. But although such zeal was mine, I was unable to show so much of it as I might have wished, on account of the troubles raised by the heresies of Luther and the other innovators of Germany, and on account of serious war into which the hostility and envy of neighboring princes had driven me, and from which I have safely emerged, thanks to the favor of God.

This is the fourth time that I go to Spain, there to bury myself. I wish to say to you that nothing I have ever experienced has given me so much pain or rested so heavily upon my soul as that which I experience in parting from you to-day, without leaving behind me that peace and quiet which I so much desired. My sister Mary, who in my absence has governed you so wisely and defended you so well, has explained to you, in the last assembly, the reasons for my determination. I am no longer able to attend to my affairs without great bodily fatigue and consequent detriment to the affairs of the state. The cares which so great a responsibility involves; the extreme dejection which it causes; my health already ruined; all these leave me no longer the strength sufficient for governing the states which God has confided to me. The little strength that remains to me is rapidly disappearing. So I should long ago have put down the burden, if my son's immaturity and my mother's incapacity had not forced both my spirit and my body to sustain its weight until this hour.

The last time that I went to Germany I had determined to do what you see me do to-day, but I could not bring myself to do it when I saw the wretched condition of the Christian state, a prey to such a multitude of disturbances, of innovations, of singular opinions as to faith, of worse than civil wars, and fallen finally into so many lamentable disorders. I was turned from my purpose because my ills were not yet so great, and I hoped to make an end of all these things and restore the peace. In order that I might not be wanting in my duty I risked my strength, my goods, my repose and my life for the safety of Christianity and the defence of my subjects. From this struggle I emerged with a portion of the things I desired. But the king of France and certain Germans, failing to preserve the peace and amity they had sworn, marched against me and were upon the point of seizing my person. The king of France took the city of Metz, and I, in the dead of winter, exposed to intense cold, in the midst of snow and blood, advanced with a powerful army raised at my own expense to retake the city and restore the Empire. The Germans saw that I had not yet laid aside the imperial crown and had no disposition to allow its majesty to be diminished.

I have carried out what God has permitted, since the outcome of our efforts depends upon the will of God. We human beings act according to our powers, our strength, our spirit, and God awards the victory and permits defeat. I have ever done as I was able, and God has aided me. I return to Him boundless thanks for having succored me in my greatest trials and in all my dangers.

To-day I feel so exhausted that I should not be of any aid to you, as you see yourselves. In my present state of dejection and weakness, I should have to render a great and serious account to God and man, if I did not lay aside authority, as I have resolved to do, since my son, king Philip, is of an age sufficiently advanced to be able to govern you, and he will be, I hope, a good prince to all my beloved subjects.

I am determined then to retire to Spain, to yield to my son Philip the possession of all my states, and to my brother, the king of the Romans, the Empire. I particularly commend to you my son, and I ask you only in remembrance of me, that you extend to him the love which you have always borne towards me; moreover I ask you to preserve among yourselves the same affection and harmony. Be obedient towards justice, zealous in the observance of the laws, preserve respect for all that merits it, and do not refuse to grant to

authority the support of which it stands in need.

Above all, beware of infection from the sects of neighboring lands. Extirpate at once the germs, if they appear in your midst, for fear lest they may spread abroad and utterly overthrow your state, and lest you may fall into the direst calamities. As to the manner in which I have governed you I confess that I have been more than once deceived, led astray by the inexperience of youth, by the hasty conclusions of young manhood, or by some other fault of human weakness. Nevertheless I make bold to assert, that never of my knowledge or by my will has wrong or violence been done to any of my subjects. If any can complain of having suffered such, I aver that it is unknown to me and against my will: I declare before all the world that I regret it from the bottom of my heart, and I beseech all present, and those who are not here as well, to wish me well and to pardon me.

The Library of Charles V at San Yuste (1555-1558)

The Almagestus, the great astronomical work of Ptolemy.

The Imperial Astronomy, by Santa Cruz, who had given lessons in mathematics to Charles V.

Caesar's Commentaries, in Italian (Tuscan).

History of Spain, ancient and mediaeval, edited by Florian de Ocampo.

The Consolations of Boethius, of which there were several copies, in French, Italian and Latin.

Commentaries upon the German War, by the Grand Commander of Alcantara.

Caballero Determinado, a poetical romance.

Meditations of St. Augustine and two other books of pious meditations.

The works of Doctor Constantin Ponce de la Fuente, and of Father Pedro de Soto upon Christian Doctrine.

Sum of Christian Mysteries, by Tilleman.

Two breviaries, a missal, two illuminated psalters, the commentary of Father Thomas de Portocarrero upon the Psalm: "In te, Domine, speravi."

Selected prayers from the Bible.

Though after 1855 the Imperial crown passed to the German branch of the Habsburg family, Philip II (1527–1598) was probably the most powerful prince of his time. For his policy and his almost continuous wars he could draw upon the resources of a vast realm upon which the sun never set. Not the least part of his wealth

derived from Spain's American colonies where important silver deposits were discovered in Mexico and Peru, the most famous, at Cerro de Potosi, being opened in 1545. Yet it would appear that, even so, the king lived well beyond his income. A great and growing amount of bullion found its way into Europe, to pay the king's debts to foreign bankers and the wages of his soldiers. War and mismanagement drained Spain of its wealth, decimated its manpower, and contributed to the inflation so characteristic of the period. In 1617, we shall find the Castilian Cortes complaining that the treasure from America "immediately goes to foreign kingdoms, leaving this one in extreme poverty."

The Gold of the Indies, 1559

From New Spain are obtained gold and silver, cochineal [little insects like flies], from which crimson dye is made, leather, cotton, sugar and other things; but from Peru nothing is obtained except minerals. The fifth part of all that is produced goes to the king, but since the gold and silver is brought to Spain and he has a tenth part of that which goes to the mint and is refined and coined, he eventually gets one-fourth of the whole sum, which fourth does not exceed in all four or five hundred thousand ducats, although it is reckoned not alone at millions, but at millions of pounds. Nor is it likely that it will long remain at this figure, because great quantities of gold and silver are no longer found upon the surface of the earth, as they have been in past years; and to penetrate into the bowels of the earth requires greater effort, skill and outlay, and the Spaniards are not willing to do the work themselves, and the natives cannot be forced to do so, because the Emperor has freed them from all obligation of service as soon as they accept the Christian religion. Wherefore it is necessary to acquire negro slaves, who are brought from the coasts of Africa, both within and without the Straits, and these are selling dearer every day, because on account of their natural lack of strength and the change of climate, added to the lack of discretion upon the part of their masters in making them work too hard and giving them too little to eat, they fall sick and the greater part of them die.

Revenues of the King of Spain, 1559

From these his realms his majesty receives every year an income of five millions of gold in times of peace: one and one-half millions from Spain; a half-million from the Indies; one from Naples and Sicily, and another from Flanders and the Low Countries. But his expenses are six millions, and this excess is covered by extraordinary taxes according to his pleasure, whence it appears that he could control only a small amount of

money for special undertakings, since he consumes for his ordinary needs everything that he derives from his realms. But looked at from another point of view, the Emperor, his father, although he had the same burdens, was nevertheless able to carry on extensive wars and enterprises in Italy and outside of Italy, both by land and sea, and the same king was able in these later years to maintain great armies in Flanders, in Piedmont, in Lombardy

and in the kingdom, and many soldiers in Africa against the Turk. So that we may calculate that he spent more than ten millions of gold; wherefore it may be put down as a fact that although expenses may exceed income, yet a way is not wanting to great princes, whereby they may find large sums of money in times of great need, particularly in the case of the king of Spain, not so much on account of the mines which are found in Spain and the Indies, of which the Spanish nation, according to its custom, makes no great account, as from the fact that he has so many states and so many subjects and

nearly all are rich, and from them he has had so much aid, not through force or violence, but for the most part with common consent of the people, persuaded that public and private interest demanded such a policy.

It would appear that the great results which the Spaniards have accomplished are not to be ascribed to the financial strength derived from the mines, because you see on one side France and the Turk, extremely rich without mines, and on the other the Emperor, with more mines in his realms than all the rest of Europe possesses, always in need.

4. HENRY VIII: BEGGARS ACT OF 1531

One of the first tasks the rulers of the new nation-states had to face was the establishment of order in their territories. Prosperity meant power, but order meant prosperity; and to that end new legislation was needed and it had to be enforced. Throughout Europe the problem of beggars, rogues, and vagabonds was one of the first that princes had to tackle. Ignoring the economic causes of the evils that plagued them, they did their best to cope with them by means of laws and decrees which sought to cauterize ills they could neither prevent nor cure. Yet one law was never enough, for law enforcement was difficult and unemployment even then turned numbers of unsettled and often violent men and women into potential sources of trouble.

An Act Concerning Punishment of Beggars and Vagabonds (1531)

Where in all places throughout this realm of England vagabonds and beggars have of long time increased and daily do increase in great and excessive numbers, by the occasion of idleness, mother and root of all vices, whereby hath insurged and sprung and daily insurgeth and springeth continual thefts, murders, and other heinous offences and great enormities, to the high displeasure of God, the inquietation and damage of the King's people, and to the marvellous disturbance of the common weal of this realm. And

whereas many and sundry good laws, strait statutes and ordinances, have been before this time devised and made, as well by the King our Sovereign Lord as also by divers his most noble progenitors, kings of England, for the most necessary and due reformation of the premises, yet that, notwithstanding, the said numbers of vagabonds and beggars be not seen in any party to be diminished, but rather daily augmented and increased into great routs and companies, as evidently and manifestly it doth and may appear; be it

From Statutes of the Realm, III, 328.

therefore enacted. . . . That the Justices of the Peace . . . shall from time to time, as often as need shall require, by their discretions divide themselves within the said shires (etc. . . .) and so being divided shall make diligent search and enquiry of all aged, poor, and impotent persons which live or of necessity be compelled to live by alms of the charity of the people that be or shall be hereafter abiding . . . within the limits of their division, and after and upon such search made the said Justices of Peace . . . shall have power and authority by their discretions to enable to beg, within such . . . limits as they shall appoint, such of the said impotent persons which they shall find and think most convenient within the limits of their division to live of the charity and alms of the people, and to give in commandment to every such aged and impotent beggar (by them enabled) that none of them shall beg without the limits to them so appointed, and shall also register and write the names of every such impotent beggar (by them appointed) in a bill or roll indented, the one part thereof to remain with themselves and the other part by them to be certified before the Justices of Peace at the next Sessions . . . there to remain under the keeping of the Custos Rotulorum; And that the said Justices of Peace . . . shall make and deliver to every such impotent person by them enabled to beg, a letter containing the name of such impotent person and witnessing that he is authorized to beg and the limits within which he is appointed to beg, the same letter to be sealed within such . . . seals as shall be engraved with the name of the limit wherein such impotent person so authorized to beg do beg in any other place than within such limits that he shall be assigned unto, that then the Justices of

Peace . . . shall by their discretions punish all such persons by imprisonment in the stocks by the space of 2 days and 2 nights, giving them but only bread and water, and after that cause every such impotent person to be sworn to return again without delay to the (limits . . .) where they be authorized to beg in.

II. And be it enacted, that no such impotent person (as is above said) . . . shall beg within any part of this realm except he be authorized by writing under seal as is above said. And if any such impotent person . . . be vagrant and go a-begging having no such letter under seal as is above specified, that then the constables and all other inhabitants within such town or parish where such person shall beg shall cause every such beggar to be taken and brought to the next Justice of Peace or High Constable of the Hundred; and thereupon the said Justice of Peace or High Constable shall command the said constables and other inhabitants of the town or parish which shall bring before him any such beggar that they shall strip him naked from the middle upward and cause him to be whipped within the town where he was taken, or within some other town where the same Justice or High Constable shall appoint . . . : And if not, then to command such beggar to be set in the stocks in the same town or parish where he was taken by the space of 3 days and 3 nights, there to have only bread and water; and thereupon the said Justice or High Constable afore whom such beggar shall be brought shall limit to him a place to beg in, and give to him a letter under seal in form above remembered, and swear him to depart and repair thither immediately after his punishment to him executed.

III. And be it further enacted . . . That if any person or persons being whole

and mighty in body and able to labour, . . . or if any man or woman being whole and mighty in body and able to labour having no land, master, nor using any lawful merchandise, craft, or mystery, whereby he might get his living . . . be vagrant and can give none reckoning how he doth lawfully get his living, that then it shall be lawful to the constables and all other the King's officers, ministers, and subjects of every town, parish and hamlet to arrest the said vagabonds and idle persons and them to bring to any of the Justices of Peace of the same shire or liberty . . . and that every such Justice of Peace . . . shall cause every such idle person so to him brought to be had to the next market town or other place where the said Justices of Peace . . . shall think most convenient, . . . and there to be tied to the end of a cart naked and be beaten with whips throughout the same market town or other place till his body be bloody by reason of such whipping; and after such punishment and whipping had, the person so punished . . . shall be enjoined upon his oath to return forthwith without delay in the next and straight way to the place where he was born, or where he last dwelled before the same punishment by the space of 3 years, and there put himself to labour like as a true man oweth to do; and after that done, every such person so punished and ordered shall have a letter sealed with the seal of the hundred, rape, wapentake, city, borough, town, liberty, or franchise wherein he shall be punished, witnessing that he hath been punished according to this Estatute, and containing the day and place of his punishment, and the place whereunto he is limited to go, and by what time he is limited to come thither, within which time he may lawfully beg by the way, shewing the same letter, and oth-

erwise not; And if he do not accomplish the order to him appointed by the said letter, then to be eftsoons taken and whipped till he be repaired where he was born or where he last dwelled by the space of three years, and there put his body to labour for his living or otherwise truly get his living without begging as long as he is able so to do; And if the person so whipped be an idle person and no common beggar, then after such whipping he shall be kept in the stocks till he hath found surety to go to service or else to labour after the discretion of the said Justice of Peace . . . afore whom any such idle person being no common beggar shall be brought, . . . or else to be ordered and sworn to repair to the place where he was born or where he last dwelled by the space of three years, and to have like letter and such further punishment, if he eftsoons offend this Estatute as is above appointed to and for the common, strong, and able beggars, and so from time to time to be ordered and punished till he put his body to labour or otherwise gets his living truly according to the law: And that the Justices of the Peace of every shire . . . shall have power and authority within the limits of their Commissions to enquire of all majors, bailiffs, constables, and other officers and persons that shall be negligent in executing of this Act: And if the constables and inhabitants within any town or parish . . . be negligent . . . that then the township or parish . . . shall lose and forfeit for every such impotent beggar . . . 3s. 4d., and for every strong beggar, . . . 6s. 8d. . . . And that all Justices of Peace . . . shall have full power and authority as well to hear and determine every such default by presentment as by such bill of information, and upon every presentment afore them and upon every such bill of information to make process by distress against the inhabitants of every such town and parish. . . .

IV. And be it enacted . . . that scholars of the Universities of Oxford and Cambridge that go about begging, not being authorized under the seal of the said Universities by the Commissary, Chancellor, or Vice-Chancellor of the same, and all and singular shipmen pretending losses of their ships and goods of the sea going about the country begging without sufficient authority witnessing the same, shall be punished and ordered in manner and form as is above rehearsed of strong beggars; and that all proctors and pardoners going about in any country or countries or abiding in any city, borough, or town, some of them using divers and subtile crafty and unlawful games and plays, and some of them feigning themselves to have knowledge of physic, faces, palmistry, or other crafty sciences, whereby they delude people that they can tell their destinies, deceases, and fortunes, and such other like fantastical imaginations, to the great deceit of the King's subjects, shall upon examination had before two Justices of Peace, whereof the one shall be of the Quorum, if he by provable witness be found guilty of any such deceits, be punished by whipping at two days together after the manner above rehersed: And if he eftsoons offend in the said offence or any like offence, then to be scourged two days and the third day to be put upon the pillory from 9 of the clock till 11 before noon of the same day, and to have one of his ears cut off; and if he offend the third time, to have like punishment with whipping, standing on the pillory, and to have his other ear cut off; and that Justices of Peace have like authority in every liberty and franchise within their shires where they be Justices of Peace for the execution of this Act in every part thereof as they shall have without the liberty or franchise.

5. ELIZABETH I: POOR RELIEF ACT OF 1598

The first English statute specifically directed "for the provision and relief of the poor" dates back to 1552; this sort of legislation was strengthened in 1563 by introducing the principle of compulsion to the collection of funds for poor relief. The English Poor Law reached its final stages with the Acts of 1598 and 1601, the second patterned on the first, whose main features obtained until the nineteenth century. In the Act of 1598, given below, we find the principle of poor relief recognized as a public concern and put to the charge of the community.

An Act for the Relief of the Poor (1598)

Be it enacted by the authority of this present Parliament, That the Churchwardens of every parish, and four substantial householders there . . . who shall be nominated yearly in Easter week, under the hand and seal of two or more

Justices of the Peace in the same county, whereof one to be of the Quorum, dwelling in or near the same parish, shall be called Overseers of the Poor of the same parish; and they or the greater part of them shall take order from time to time

From Statutes of the Realm, IV, 896.

by and with the consent of two or more Justices of Peace for setting to work of the children of all such whose parents shall not by the said persons be thought able to keep and maintain their children. And also all such persons married or unmarried as having no means to maintain them use no ordinary and daily trade of life to get their living by; and also to raise weekly or otherwise (by taxation of every inhabitant and every occupier of lands in the said parish in such competent sum and sums of money as they shall think fit) a convenient stock of flax, hemp, wool, thread, iron, and other necessary ware and stuff to set the poor on work, and also competent sums of money for and towards the necessary relief of the lame, impotent, old, blind, and such other among them being poor and not able to work, and also for the putting out of such children to be apprentices, to be gathered out of the same parish according to the ability of the said parish; and to do and execute all other things, as well for disposing of the said stock as otherwise concerning the premises, as to them shall seem convenient: Which said Churchwardens, and Overseers so to be nominated, or such of them as shall not be prevented by sickness or other just excuse to be allowed by such two Justices of Peace or more, shall meet together at the least once every month in the church of the said parish, upon the Sunday in the afternoon after divine service, there to consider of some good course to be taken and of some meet orders to be set down in the premises; and shall within four days after the end of their year, and after other overseers nominated as aforesaid, make and yield up to such two Justices of Peace a true and perfect account of all sums of money by them received, or rated and cessed and not received, and also of such stock as shall be in their hands or in the hands of any of the poor to work, and of all other things concerning their said office, and such sum or sums of money as shall be in their hands shall pay and deliver over to the said Churchwardens and Overseers newly nominated and appointed as aforesaid: upon pain that every one of them absenting themselves without lawful cause as aforesaid from such monthly meeting for the purpose aforesaid, or being negligent in their office or in the execution of the orders aforesaid being made by and with the assent of the said Justices of Peace, to forfeit for every such default twenty shillings.

II. And be it also enacted. That if the said Justices of Peace do perceive the inhabitants of any parish are not able to levy among themselves sufficient sums of money for the purposes aforesaid, That then the said Justices shall and may tax, rate, and assess as aforesaid any other of other parishes, or out of any parish within the hundred where the said parish is, to pay such sum and sums of money to the Churchwardens and Overseers of the said poor parish for the said purposes as the said Justices shall think fit, according to the intent of this law; And if the said hundred shall not be thought to the said Justices able and fit to relieve the said several parishes nor able to provide for themselves as aforesaid, then the Justices of Peace at their general Quarter Sessions, or the greater number of them, shall rate and assess as aforesaid, . . . other parishes . . . as in their discretion shall seem fit.

III. And that it shall be lawful for the said Churchwardens and Overseers or any of them, by warrant from any such two Justices of Peace, to levy as well the said sums of money of every one that shall refuse to contribute according as they shall

be assessed, by distress and sale of the offender's goods, as the sums of money or stock which shall be behind upon any account to be made as aforesaid, rendering to the party the overplus; and in defect of such distress, it shall be lawful for any such two Justices of the Peace to commit him to prison, there to remain without bail or mainprize till payment of the said sum or stock; and the said Justices of Peace or any one of them to send to the House of Correction such as shall not employ themselves to work being appointed thereunto as aforesaid; And also any two such Justices of Peace to commit to prison every one of the said Churchwardens and Overseers which shall refuse to account, there to remain without bail or mainprize till he have made a true account and satisfied and paid so much as upon the said account shall be remaining in his hands.

IV. And be it further enacted. That it shall be lawful for the said Churchwardens and Overseers or the greater part of them, by the assent of any two Justices of the Peace, to bind any such children as aforesaid to be apprentices where they shall see convenient, till such man-child shall come to the age of four and twenty years, and such woman-child to the age of one and twenty years; the same to be as effectual to all purposes as if such child were of full age and by indenture of covenant bound him or herself.

V. And to the intent that necessary places of habitation may more conveniently be provided for such poor impotent people. Be it enacted by the authority aforesaid. That it shall and may be lawful for the said Churchwardens and Overseers or the greater part of them, by the leave of the lord or lords of the manor whereof any waste or common within their parish is or shall be parcel . . . to erect, build, and set up in fit and convenient places of habitation in such waste or common, at the general charges of the parish or otherwise of the hundred or county as aforesaid, to be taxed, rated, and gathered in manner before expressed, convenient Houses of Dwelling for the said impotent poor; And also to place inmates or more families than one in one cottage or house. . . .

VI. Provided always, That if any person or persons shall find themselves grieved with any cess or tax or other act done by the said Churchwardens and other persons or by the said Justices of Peace, that then it shall be lawful for the Justices of Peace at their general Quarter Sessions, or the greater number of them. to take such order therein as to them shall be thought convenient, and the same to conclude and bind all the said parties.

VII. And be it further enacted, That the parents or children of every poor, old, blind, lame, and impotent person, or other poor person not able to work, being of sufficient ability, shall at their own charges relieve and maintain every such poor person in that manner and according to that rate as by the Justices of Peace of that county where such sufficient persons dwell, or the greater number of them, at their general Quarter Sessions shall be assessed; upon pain that every one of them forfeit 20s. for every month which they shall fail therein.

X. And be it further enacted by the authority aforesaid, That . . . no person or persons whatsoever shall go wandering abroad and beg in any place whatsoever, by licence or without, upon pain to be esteemed, taken, and punished as a rogue: Provided always, That this present Act shall not extend to any poor people which shall ask relief of victuals only in the same parish where such poor people do dwell . . .

XII. And forasmuch as all begging is forbidden by this present Act; Be it further enacted by the authority aforesaid, That the Justices of Peace of every county or place corporate, or the more part of them, in their general Sessions to be holden next after the end of this session of Parliament, or in default thereof at the Ouarter Sessions to be holden about the Feast of Easter next, shall rate every parish to such a weekly sum of money as they shall think convenient, so as no parish be rated above the sum of 6 pence nor under the sum of an halfpenny weekly to be paid, and so as the total sum of such taxation of the parishes in the said county; which sums so taxed shall be yearly assessed by the agreement of the parishioners within themselves, or in default thereof by the Churchwardens and Constables of the same parish or the more part of them, or in default of their agreement by the order of such Justice or Justices of Peace as shall dwell in the same parish or (if none be there dwelling) in the parts next adjoining; And if any person shall refuse or neglect to pay any such portion of money so taxed, it shall be lawful for the said Churchwardens and Constables, or in their default for the Justices of the Peace, to levy the same by sale of the goods of the party so refusing or neglecting or to commit such person to prison, there to abide without bail till he have paid the same.

XIII. And be it also enacted, That the said Justices of the Peace at their general

Quarter Sessions to be holden at the time of such taxation, shall set down what competent sum of money shall be sent quarterly out of every county or place corporate for the relief of the poor prisoners of the King's Bench and Marshalsea, and also of such hospitals and alms-houses as shall be in the said county, . . .

XVI. Provided always nevertheless, That every soldier being discharged of his service or otherwise lawfully licensed to pass into his country, and not having wherewith to relieve himself in his travel homewards, and every seafaring man landing from sea not having wherewith to relieve himself in his travel homewards. having a testimonial under the hand of some one Justice of Peace of or near the place where he was landed or was discharged, setting down therein the place and time where and when he landed or was discharged, and the place of the party's dwellingplace or birth unto which he is to pass, and a convenient time to be limited therein for his passage, shall and may, without incurring the danger or penalty of this Act, in the usual ways directly to the place unto which he is directed to pass and within the time in such his testimonial limited for his passage, ask and receive such relief as shall be necessary in and for his passage; This Act or anything therein contained to the contrary notwithstanding.

XVII. Provided always, That this Act shall endure no longer than to the end of the next Session of Parliament.

6. THOMAS MORE

Sir Thomas More was born in London (1478), the son of a Justice of the King's Bench. At sixteen he was placed, according to the custom of his time, in the household of the Archbishop of Canterbury, there to learn the ways of a gentleman by serving a gentleman. The Archbishop thought highly of the lad, for whom he pre-

dicted a great future; More in turn never lost his early respect for his first master, whom he brings into the passage below. The young man's education was perfected at Oxford, where he became the friend of men like Erasmus and John Colet and drank deep of the new learning of the time. Brilliant lawyer and parliament man, he was much against his will appointed Lord Chancellor of England after Wolsey's fall, disapproved of Henry VIII's ecclesiastical policy, and finally resigned his office in 1532. His conscience forcing him to refuse the Oath of Supremacy, he was imprisoned in the Tower and beheaded in 1535, to the shock and indignation of all Catholic Europe. He had written a number of works of controversy and two histories; but his reputation rests on the *Utopia*, two books written in Latin—the first in 1515, the second in 1516—which were immediately popular and soon translated (into German, 1524; French, 1530; Italian, 1548; English, 1551). In the following passage from Book I, the speaker presents some views on the England of his day.

From Utopia

I pray you, Sir (quoth I) have you been in our country?

Yes, indeed (quoth he) and there I tarried for four or five months not long after the Cornish insurrection of 1497. In the meantime, I was much indebted to the right reverend father, John Morton, Archbishop and Cardinal of Canterbury, and at that time also Lord Chancellor of England: a man, Master Peter (for Master More already knows what I will say) not more honorable for his authority than for his prudence and virtue. He was of small stature, and though stricken in age vet carried his body upright. In his face there shone such amiable reverence as was pleasant to behold; he was gentle in his talk, and yet earnest and sage. Often he enjoyed speaking sharply to those about him, to find out, but without harm, what prompt wit and what bold spirit were in every man. He took great delight in these, as being virtues much agreeing with his own inclinations, provided they were not combined with impudence. And those who lived up to such standards he would lovingly embrace as able and deserving of a post in the public service. In his speech he was fine, eloquent and pithy. In the law he had profound knowledge, in wit he was incomparable, and in memory wonderfully excellent. These qualities which were inborn to him, he had made perfect by learning and practice. The king put much trust in his counsel, and when I was there you might say that in a sense the public weal depended upon him. He had been taken from school into the court while still very young, and there he had passed all his time in much trouble and business, being continually tumbled and tossed in the waves of diverse misfortunes and adversities. And so, through many and great dangers, he had learned the experience of the world, something that cannot be easily forgotten when it has been learned in this manner.

It happened on a certain day, when I sat at his table, there was present a certain layman, well versed in the laws of your country. I cannot tell how the occasion arose, but this man began diligently and earnestly to praise that strict and rigorous justice which at that time was being executed upon felons who, as he said, were mostly being hanged twenty

at a time upon one gallows. And, seeing that so few escaped punishment, he said he could not help but greatly wonder and marvel how, and by what evil luck, it should be that in spite of this thieves were nevertheless so rife and rank everywhere. Nay, Sir, quoth I (for I dared boldly speak my mind before the Cardinal) do not marvel at this: for this punishment of thieves passes the limits of justice, and is also very hurtful to the public weal. For it is too extreme and cruel a punishment for theft, and vet not sufficient to refrain and withhold men from theft. For simple theft is not so great an offence that it ought to be punished with death. Neither is there any punishment so horrible that it can keep men from stealing who have no other skill or craft by which to earn their living. Therefore on this point, not you alone but also most people in the world are like bad schoolmasters who are readier to beat than to teach their pupils. For great and horrible punishments are appointed for thieves, whereas much rather provision should have been made that there should be some means by which they could get their living, so that no man should be driven to this extreme necessity, first to steal, then to die.

Yes (quoth he) but for this there is quite enough provision already. There are handicrafts, there is husbandry for people to get their living by if they would not willingly be nought. No, I said, you cannot get away with this: for first of all, I shall say nothing of those that return from the wars, maimed and lame—as not long ago out of Blackheath Field [where the Cornishmen's rebellion was crushed], and a little before that out of the wars in France: such, I say, as put their lives in jeopardy for the public weal or for the king's sake, and then by reason of weak-

ness or lameness are not able to take up their old crafts anew, and too old to learn new ones—of them I will say nothing, forasmuch as this is all we can expect from wars. But let us consider those things that happen daily before our eyes.

First there is a great number of gentlemen, who cannot be content to live idle themselves on that which others have labored for: I mean their tenants whom they squeeze and shave to the quick, by raising their rents (for this is the only point of frugality they use, to bring other men to beggary through their lavishness and prodigal spending). These gentlemen, I say, do not only live in idleness themselves, but also carry about with them at their tails a great flock or train of idle and loitering servingmen who never learned any craft whereby to get their living. These men, as soon as their master is dead, or they themselves fall ill, are at once thrust out of doors. For gentlemen would rather keep idlers than sick men, and many times the dead man's heir is not able to maintain as great a house and keep as many servingmen as his father did. Then, in the meantime, those who are thus out of work either starve or else manfully play the thieves. For what would you have them do? When they have wandered about so long that they have worn their clothing threadbare and also impaired their health, then gentlemen, because of their pale and sickly faces and their patched coats, will not take them into their service. And farmers do not dare to give them a job, knowing well enough that the sort of man who has been idly and daintily pampered up in idleness and pleasure, who used to swagger through the street with a bragging look, a sword and buckler by his side, and think himself too good to be any man's mate, is not fit to do true and faithful

service to a poor man with a spade and a mattock, for small wages and hard fare.

Nay, by Saint Mary, Sir (quoth the lawyer) that is not so. For this kind of men we must make the most of. For in them, as men of stouter stomachs, bolder spirits, and manlier courage than handicraftsmen and ploughmen are, in them consists the whole power and strength of our army when we must fight in battle.

Forsooth, Sir, you might as well say (quoth I) that for war's sake you must cherish thieves. For surely you shall never lack thieves whilst you have them. And thieves are far from being the most false and fainthearted soldiers, and soldiers are far from being the most cowardly of thieves: so well do these two crafts agree together. But faulty argument, though it is much used among you, in England, yet is not peculiar to you only, but common almost to all nations. Yet France, besides this, is troubled and infected with a much sorer plague. The whole kingdom is filled and besieged with hired soldiers in peacetime (if that be peace) which are brought in under the same color and pretence that has persuaded you to keep these idle servingmen. For these wise fools and very arch-dolts thought that the wealth of their country depended on there always being in readiness a strong and sure garrison, especially of old practised soldiers—for they put no trust at all in untrained men. And therefore they are forced to look for war, so that they may always have trained soldiers and cunning manslayers, lest their hands and their minds should wax dull through idleness or lack of exercise. But how pernicious and pestilent a thing it is to maintain such beasts, the Frenchmen have learnt from their own sufferings, and the examples of the Romans, Carthaginians, Syrians, and many other countries do manifestly declare. For not only the empire, but also the fields and the cities of all these, on different occasions have been overrun and destroyed by their own army which they had been keeping up. Now how unnecessary a thing [this sort of standing army] is, may be seen from this: that the French soldiers who from their youth have been trained and inured to feats of arms, do not flatter themselves to have often got the upper hand and mastery over your new made and untrained soldiers.

But I will not talk too much on this point, lest I should seem to flatter you. But you can also argue that these same handicraftsmen in your cities, or the rude and uplandish ploughmen of the country, are not supposed to be greatly afraid of vour gentlemen's idle servingmen, unless their stature does not correspond to their courage, or their bold stomachs have been discouraged through poverty. Thus you may see that it is not to be feared lest they should be effeminated if those whose stout and sturdy bodies (for gentlemen bother to corrupt and spoil only picked and chosen men) have been weakened by rest and idleness were brought up in good crafts and laborsome works. Truly, howsoever the case stands, I do not think it is much to the public weal that you should, for the sake of war-which you never have but when you will yourselves-keep and maintain an innumerable flock of that sort of men, that are so troublesome and useless in the peacetime of which you ought to have a thousand times more regard than of war. But yet this is not the only cause of stealing. There is another, which, I suppose, is proper and peculiar to Englishmen alone.

What is that? quoth the Cardinal. Forsooth, my lord, quoth I, your sheep that

used to be so meek and tame, and such small eaters, now, as I hear say, have become such great devourers and so wild that they eat up and swallow up the very men themselves. They consume, destroy and devour whole fields, houses and cities. For notice that in those parts of the realm whence comes the finest and therefore the dearest wool, there noblemen and gentlemen, and indeed certain abbots, holy men no doubt, not contenting themselves with the yearly revenues and profits that their lands gave their forefathers and predecessors, nor being content that they live in peace and pleasure contributing nothing to the public weal but rather hurting it, leave no ground for tillage. They enclose all pastures; they pull down the houses, they pluck down towns, and leave nothing standing except for the church to be made into a sheephouse. And, as though you lost no small quantity of ground by forests, chases, lands and parks, those good holy men turn all dwelling places and all glebe land into desolation and wilderness.

Therefore in order that one covetous and insatiable cormorant and very plague of his native country may compass about and enclose many thousand acres of ground together within one pale or hedge, the farmers are thrust out of their own, or else by constraint and fraud, or by violent oppression they are done out of it, or by wrongs and injuries they are so wearied that they are compelled to sell everything. Therefore, by one means or by another, by hook or by crook, they are forced to move away, poor, silly, wretched souls, men, women, husbands, wives, fatherless children, widows, woefull mothers with their young babes and their whole household, small in substance but great in numbers as farming requires many hands. Away they trudge, I say, out of their known and accustomed houses, finding no place to rest in. All their household stuff is worth very little, though there is no reason why it need be sold: vet, being suddenly thrust out, they are constrained to sell it for almost nothing. And when they have wandered about until that has been spent, what else can they do then but steal, and then, by God, be justly hanged, or go about a-begging? And yet even in that case they are cast into prison as vagabonds, because they wander and work not: yet no man will put them to work, though they may offer themselves to do it ever so willingly.

For one shepherd or herdsman is enough to eat up with his cattle that ground for which many hands were need ed when it was used for farming. And this is also the cause why foodstuffs are now dearer in many places. And besides this, the price of wool has risen so that poor folks, who used to work it and make cloth thereof, are no longer able to buy any at all. And by this means very many are forced to give up working and give themselves to idleness. For after so much ground had been enclosed for pasture, a great number of sheep died of the sheeprot that God would have done better to send upon the sheepmasters' own heads. And though the number of sheep is once more increasing fast, yet the price does not fall one mite, because there are so few sellers. For the sheep have almost all come into a few rich men's hands, who have no need to sell before they want, and they do not want before they can sell as dear as they want.

7. RICHARD HOOKER

As the sixteenth century drew to a close, it became increasingly clear in western Europe that concern for the spiritual welfare and unity of a nation might well harm its political welfare and unity. Long-drawn-out religious conflicts had torn France and had traced their bloody marks across the face of England. Statesmen and philosophers began to suggest that tolerance is not necessarily sin and that an uncompromising religious attitude might be more hindrance than help in the politics of this world. These men who put the visible welfare of the community above its spiritual salvation were known as the *Politiques*.

Richard Hooker (1554–1600) was an English theologian who undertook to show that religious extremism, either Catholic or Puritan, was undesirable. His fundamental idea is that law is the manifestation of the divine order of the universe, and the sovereign who administers the law must preserve and enforce this divine order.

Preface to the Laws of Ecclesiastical Policy

One example herein may serve for many, to shew that false opinions, touching the will of God to have things done, are wont to bring forth mighty and violent practices against the hinderances of them: and those practices new opinions more pernicious than the first, yea most extremely sometimes opposite to that which the first did seem to intend. Where the people took upon them the reformation of the Church by casting out popish superstition, they having received from their pastors a general instruction "that whatsoever the heavenly Father hath not planted must be rooted out," proceeded in some foreign places so far that down went oratories and the very temples of God themselves. For as they chanced to take the compass of their commission stricter or larger, so their dealings were accordingly more or less moderate. Amongst others there sprang up presently one kind of men, with whose zeal and forwardness the rest being compared were thought to be marvellous cold and dull. These grounding themselves on rules more general; that whatsoever the law of Christ

commandeth not, thereof Antichrist is the author: and that whatsoever Antichrist or his adherents did in the world, the true professors of Christ are to undo; found out many things more than others had done, the extirpation whereof was in their conceit as necessary as of any thing before removed. Hereupon they secretly made their doleful complaints everywhere as they went, that albeit the world did begin to profess some dislike of that which was evil in the kingdom of darkness, yet fruits worthy of a true repentance were not seen; and that if men did repent as they ought, they must endeavor to purge the earth of all manner of evil, to the end there might follow a new world afterward, wherein righteousness only should dwell. Private repentance they said must appear by every man's fashioning his own life contrary unto the customs and orders of this present world, both in greater things and in less. To this purpose they had always in their mouths those greater things, charity, faith, the true fear of God, the cross, the mortification of the flesh. All their exhortations were to set

From R. Hooker, Works, 3 vols., 7th ed. (Oxford, 1888).

light of the things in this world, to count riches and honours vanity, and in token thereof not only to seek neither, but if men were possessors of both, even to cast away the one and resign the other, that all men might see their unfeigned conversion unto Christ. They were solicitors of men to fasts, too often meditations of heavenly things, as it were conferences in secret with God by prayers, not framed according to the frozen manner of the world, but expressing such fervent desires as might even force God to hearken unto them. Where they found men in diet, attire, furniture of house, or any other way, observers of civility and decent order, such they reproved as being carnally and earthly minded. Every word otherwise than severely and sadly uttered seemed to pierce like a sword through them. If any man were pleasant, their manner was presently with deep sighs to repeat those words of our Saviour Christ, "Woe be to you which now laugh, for ye shall lament." So great was their delight to be always in trouble, that such as did quietly lead their lives, they judged of all other men to be in most dangerous case. They so much affected to cross the ordinary custom in every thing, that when other men's use was to put on better attire, they would be sure to shew themselves openly abroad in worse: the ordinary names of the days in the week they thought it a kind of profaneness to use, and therefore accustomed themselves to make no other distinction than by numbers, the First, Second, Third day.

From this they proceeded unto public reformation, first ecclesiastical, and then civil. Touching the former, they boldly avouched that themselves only had the truth, which thing upon peril of their lives they would at all times defend; and that since the Apostles lived, the same was never before in all points sincerely taught. Wherefore that things might again be brought to that ancient integrity which Jesus Christ by his word requireth. they began to control the ministers of the gospel for attributing so much force and virtue unto the scriptures of God. . . . The Book of God they notwithstanding for the most part so admired, that other disputation against their opinions than only by allegation of Scripture they would not hear; besides it they thought no other writings in the world should be studied: insomuch as one of their great prophets exhorting them to cast away all respects unto human writings, so far to his motion they condescended, that as many as had any books save the Holy Bible in their custody, they brought and set them publicly on fire. When they and their Bibles were alone together, what strange fantastical opinion soever at any time entered into their heads, their use was to think the Spirit taught it them. Their phrenesies concerning our Saviour's incarnation, the state of souls departed, and such-like, are things needless to be rehersed. And forasmuch as they were of the same suite with those of whom the Apostle speaketh, saving, "They are still learning, but never attain to the knowledge of truth," it was no marvel to see them every day broach some new thing, not heard of before. Which restless levity they did interpret to be their growing to spiritual perfection, and a proceeding from faith to faith. The differences amongst them grew by this mean in a manner infinite, so that scarcely was there found any one of them, the forge of whose brain was not possessed with some special mystery. Whereupon, although their mutual contentions were most fiercely prosecuted amongst themselves, yet when they came to defend the cause common to them all against the adversaries of their faction, they had ways to lick one another whole; the sounder in his own persuasion excusing the dear brethren, which were not so far enlightened, and professing a charitable hope of the mercy of God towards them notwithstanding their swerving from him in some things. Their own ministers they highly magnified as men whose vocation was from God; the rest their manner was to term disdainfully Scribes and Pharisees, to account their calling a human creature, and to detain the people as much as might be from hearing them. . . .

The pretended end of their civil reformation was that Christ might have dominion over all; that all crowns and sceptres might be thrown down at his feet; that no other might reign over Christian men but he, no regiment keep them in awe but his discipline, amongst them no sword at all be carried besides his, the sword of spiritual excommunication. For this cause they laboured with all their might in overturning the seats of magistracy, because Christ hath said, "Kings of nations"; in abolishing the execution of justice, because Christ hath said, "Resist not evil"; in forbidding oaths, the necessary means of judicial trial, because Christ hath said, "Swear not at all": finally, in bringing in community of goods, because Christ by his Apostles hath given the world such example, to the end that men might excel one another not in wealth the pillar of secular authority, but in virtue.

These men at the first were only pitied in their error, and not much withstood by any; the great humility, zeal, and devotion, which appeared to be in them, was in all men's opinion a pledge of their harmless meaning. . . . Luther made request unto Frederick duke of Saxony, that within his dominion they might be

favourably dealt with and spared, for that (their error exempted) they seemed otherwise right good men. By means of which merciful toleration they gathered strength, much more than was safe for the state of the commonwealth wherein they lived. They had their secret corner-meetings and assemblies in the night, the people flocked unto them by thousands. . . .

In all these things being fully persuaded, that what they did, it was obedience to the will of God, and that all men should do the like; there remained, after speculation, practice, whereby the whole world thereunto (if it were possible) might be framed. This they saw could not be done but with mighty opposition and resistance; against which to strengthen themselves, they secretly entered into league of association. And peradventure considering, that although they were many, yet long wars would in time waste them out; they began to think whether it might not be that God would have them do, for their speedy and mighty increase, the same which sometime God's own chosen people, the people of Israel, did. Glad and fain they were to have it so; which very desire was itself apt so to breed both an opinion of possibility, and a willingness to gather arguments of likelihood, that so God Himself would have it. Nothing more clear unto their seeming, than that a new Jerusalem being often spoken of in Scripture, they undoubtedly were themselves that new Jerusalem, and the old did by way of a certain figurative resemblance signify what they should both be and do. Here they drew in a sea of matter, by applying all things unto their own company, which are any where spoken concerning divine favours and benefits bestowed upon the old commonwealth of Israel: concluding that as Israel was delivered out of Egypt, so they spirit-

ually out of the Egypt of this world's servile thraldom unto sin and superstition; as Israel was to root out the idolatrous nations, and to plant instead of them a people which feared God; so the same Lord's good will and pleasure was now, that these new Israelites should, under the conduct of other Ioshuas, Samsons, and Gideons, perform a work no less miraculous in casting out violently the wicked from the earth, and establishing the kingdom of Christ with perfect liberty: and therefore, as the cause why the children of Israel took unto one man many wives, might be lest the casualties of war should any way hinder the promise of God concerning their multitude from taking effect in them; so it was not unlike that for the necessary propagation of Christ's kingdom under the Gospel the Lord was content to allow as much.

Now whatsoever they did in such sort collect out of Scripture, when they came to justify or persuade it unto others, all was the heavenly Father's appointment, his commandment, his will and charge. Which thing is the very point, in regard whereof I have gathered this declaration. For my purpose herein is to show, that when the minds of men are once erroneously persuaded that it is the will of God to have those things done which they fancy, their opinions are as thorns in their sides, never suffering them to take rest till they have brought their speculations into practice. The lets and impediments of which practice their restless desire and study to remove leadeth them every day forth by the hand into other more dangerous opinions, sometimes quite and clean contrary to their first pretended meanings; so what will grow out of such errors as go masked under the cloak of divine authority, impossible it is that ever the wit of man should imagine, till time have

brought forth the fruits of them; for which cause it behoveth wisdom to fear the sequels thereof, even beyond all apparent cause of fear. These men, in whose mouths at the first sounded nothing but only mortification of the flesh, were come at the length to think they might lawfully have their six or seven wives apiece; they which at the first thought judgment and justice itself to be merciless cruelty, accounted at the length their own hands sanctified with being embrued in Christian blood; they who at the first were wont to beat down all dominion, and to urge against poor constables, "Kings of nations;" had at the length both consuls and kings of their own erection amongst themselves: finally, they which could not brook at the first that any man should see, no not by law, the recovery of goods injuriously taken or withheld from him, were grown at the last to think they could not offer unto God more acceptable sacrifice, than by turning their adversaries clean out of house and home, and by enriching themselves with all kinds of spoil and pillage: which thing being laid to their charge, they had in a readiness their answer, that now the time was come, when according to our Saviour's promise, "the meek ones must inherit the earth"; and that their title hereunto was the same which the righteous Israelites had unto goods ofthe wicked tians. . . .

Wherefore if we anything respect their error, who being persuaded even as you are have gone further upon that persuasion than you allow; if we regard the present state of the highest governor placed over us, if the quality and disposition of our nobles, if the orders and laws of our famous universities, if the profession of the civil or the practice of the common law amongst us, if the mis-

chiefs whereinto even before our eyes so many others have fallen headlong from no less plausible and fair beginnings than yours are: there is in every of these considerations most just cause to fear lest our hastiness to embrace a thing of so perilous consequence should cause posterity to feel those evils, which as yet are more easy for us to prevent than they would be for them to remedy.

The best and safest way for you therefore, my dear brethren, is, to call your deeds past to a new reckoning, to reexamine the cause ve have taken in hand, and to try it even point by point, argument by argument, with all the diligent exactness ve can; to lay aside the gall of that bitterness wherein your minds have hitherto over-abounded, and with meekness to search the truth. Think ye are men, deem it not impossible for you to err; sift unpartially your own hearts, whether it be force of reason or vehemency of affection, which hath bred and still doth feed these opinions in you. If truth do any where manifest itself, seek not to smother it with glosing delusions, acknowledge the greatness thereof, and think it your best victory when the same doth prevail over you. . . .

Far more comfort it were for us (so small is the joy we take in these strifes) to labour under the same yoke, as men that look for the same eternal reward of their labours, to be joined with you in bands of indissoluble love and amity, to live as if our persons being many our souls were but one, rather than in such dismembered sort to spend our few and wretched days in a tedious prosecuting of wearisome contentions: the end where-of, if they have not some speedy end,

will be heavy even on both sides. Brought already we are even to that estate . . . whereby all parts are entered into a deadly war amongst themselves, and that little remnant of love which was, is now consumed to nothing. The only godliness we glory in, is to find out somewhat whereby we may judge others to be ungodly. Each other's faults we observe as matter of exprobration and not of grief. . . . With the better sort of our own our fame and credit is clean lost. The less we are to marvel if they judge vilely of us, who although we did well would hardly allow thereof. On our backs they also build that are lewd, and what we object one against another, the same they use to the utter scorn and disgrace of us all. This we have gained by our mutual home-dissensions. This we are worthily rewarded with, which are more forward to strive than becometh men of virtuous and mild disposition.

But our trust in the Almighty is, that with us contentions are now at their highest float, and that the day will come (for what cause of despair is there?) when the passions of former enmity being allayed. we shall with ten times redoubled tokens of our unfeignedly reconciled love, shew ourselves each towards other the same which Joseph and the brethren of Joseph were at the time of their interview in Egypt. Our comfortable expectation and most thirsty desire whereof what man soever amongst you shall any way help to satisfy (as we truly hope there is no one amongst you but some way or other will) the blessings of the God of peace, both in this world and in the world to come, be upon him more than the stars of the firmament in number.

8. JEAN BODIN

Jean Bodin (1530–1596) was a French magistrate and political writer. Concerned with the waste and destruction brought to France by the religious struggles between Huguenots and Catholics, he put his faith in a central power that would be a monarchy tempered by the popular will as expressed by the States-General. His great work on the *Republic*, published in 1576, only four years after the Massacre of Saint Bartholomew, with the deliberate purpose of strengthening the position of the king as a source of national unity above rival sects and political parties, achieved a great reputation in its own day especially in those moderate circles which, wanting to separate politics from theology, saw in the royal power a mainstay of peace and order.

From La République, 1576

Since an impetuous tempest has tormented the ship of our Republic with such violence that the captain himself and the pilots are engaged in continual labor, it is needful that the passengers themselves lend a hand with the sails, with the ropes, and with the anchor; as well as to those who have not enough strength. [It is needful] that they give some good advice or that they present their suggestions plainly to those who can command the weather and appease the tempests, because all together run the same danger, one which does not affect our enemies which are on certain ground and who take a singular pleasure at the wreck of our Republic; who run amongst the debris and who enrich themselves by the precious things which are constantly manufactured in order to save the kingdom. [The kingdom] which once upon a time possessed all the empires of Germany, of Hungary, of Spain and of Italy and all the possessions of the Gauls just until the Rhine and which were under the rule of its laws. . . .

That is why for myself, not being able to do anything better, I have undertaken

to talk of the Republic in popular language because the sources of the Latin language have practically dried up . . . [since Plato] those who have written speak of the affairs of the world without any knowledge of the laws, and even of public law, which has been forgotten beneath conclusions which one has drawn especially out of the profound and sacred mysteries of political philosophy a thing which has given occasion of trouble and tribulation [for] good states. We have, for example, Machiavelli, who has been the vogue amongst tyrants, and whom Paul Iove, having put him among the outstanding men, nevertheless calls an atheist and ignorant of all literature. As to atheism, he has glorified it by his writings. As to knowledge, I think that those who are in the know [and] who talk softly and learnedly and resolve subtly the high affairs of state are in agreement that he has never gotten to the bottom of political science which does not lie in the tricks of tyrants which he has brought together from all the corners of Italy and which like a soft poison run through his book on the Prince. . . .

From Bodin, Les six livres de la république (Lyon, 1593), tr. George L. Mosse in Europe in Review (New York, 1957), pp. 67-69; by permission of Rand McNally & Co.

Sovereignty is the absolute and perpetual power of a republic which the Romans called majestas . . . the Republic is a legal government of several families and that which they have in common with sovereignty added. I have said that this [sovereign] power is perpetual. . . . It is possible to give sovereign power to one or to many for a limited time. . . . [such men] are nothing better than subjects, and when they are in power they cannot call themselves sovereign princes because they are nothing but administrators and trustees of that power until it pleases the people or the prince to revoke it . . . The People are continually invested of it [the power]. They can give power and authority to judge or to command for a certain time, or for so long and so much a time as pleases them. . . . That is why the law says that the governor of a province . . . after his time has expired, gives the power back to those depositories.

Let us perceive now another part of our definition and see what the words "absolute power" actually mean. The people are the rulers of a Republic. [They can] give pure and simple perpetual power to someone to dispose of their goods and persons, or of all the state at his pleasure, and to let him do as he likes, just as the property owner can give his goods pure and simple without any other reason than his liberality. That is a true gift which has no strings attached once it has been made and accepted, in contrast with other gifts which have conditions and qualifications and which [therefore] are not true gifts . . . So the sovereignty or absolute power. It must be that the conditions imposed in the creation of a prince conform, however, to the laws of God and of nature. . . .

In this we can recognize the power and

majesty of a true sovereign prince: When the estates of the people are assembled, persons request and supplicate to their prince in all humility without [however having any power to command, disclaim, or to deliberate, [or] to declare laws, edicts and ordinances [unless] it pleases the king to consent or to dissent, to command or to defend. And those . . . who have written of the duty of magistrates and others have gone out of their way to argue that the estates of the people are more illustrious than the prince; a thing which revolts true subjects in the obedience which they owe to their sovereign monarch. There is neither reason nor any foundation whatsoever for such an opinion. . . .

The prince is not held to ordinances and edicts unless these edicts and ordinances coincide with natural justice. . . . It is divine and natural law to obey the edicts and ordinances of him to whom God has given the power over us, if these edicts are not directly opposed to the rule of God who is above all princes. . . . The subject owes obedience to his sovereign prince against all, saving the majesty of God who is the absolute ruler of all the princes of the world. From this axiom we can draw a rule of state: that is to know that the sovereign prince is held to 'the contracts which he has made, be it with his subjects [or] be it with strangers, because he is the guardian for the subjects of [those] mutual conventions and obligations which they have made one with the other. . . .

There is no crime more detestable in a prince [than] perjury. . . . Also, it is badly spoken to say that the sovereign prince has the power to steal the goods of anyone and to do evil . . . because that connotes weakness, feebleness and laxness of heart. Moreover, the sovereign

prince does not have the power to infringe the law of nature which God, of Whom it is the image, has instituted. He [the prince] cannot, therefore, take the goods of anyone without just and reasonable cause, be it by buying or exchange, or legitimate confiscation, or [by] making a treaty with the enemy which he cannot conclude otherwise than by taking the goods of particular or private persons for the preservation of the state. . . . For natural law decrees that the public good is above all individuals and that subjects surrender not only their injuries and vengeances, but also their goods for the well being of the republic. . . . Because there is nothing higher on earth after God than sovereign princes, and as they are established by Him as His lieutenants to command men, it is necessary to be aware of their station, to respect them and to revere their majesty in all obedience, to talk to them with all honor; because he who abuses his sovereign prince abuses God of Whom he is the image on earth. . . . In order that one can recognize him who is . . . the sovereign prince, one has to know his qualities which are not common to other subjects; because if they were common they could not be any part of a sovereign prince. . . .

He who has no [earthly] sovereign is he who gives law to all his subjects, who makes peace and war, who gives power to all the offices and magistrates of his country, who levies taxes, [who] enfranchises him who seems worthy, and who gives pardon to him who had deserved death: What more power could one desire in a sovereign prince? These are always the

marks of sovereign power. . . . Just as the great sovereign God cannot create a god who is His equal because He is infinite, so we can say that the princes whom we have described as the image of God cannot elevate a subject to his station because then his [the prince's] power would no longer exist. . . .

Because this is so, it follows that the prime mark of sovereignty is not to give justice, because that is common to the prince and to the subjects, just as is [the power] to institute or to abolish offices. because the prince and the subject [both] may share that power-especially as respects the officers serving justice or the police, or war or finance . . . [nor] is it the prime mark of sovereignty to give rewards to them who have merited them, because that is common to the prince and the magistrates, because the magistrates may receive that power from the prince; also, it is not a prime mark of sovereignty to take counsel of the affairs of a state, because that may be the charge of the privy council or the senate of the Republic. . . . We might say the same thing as regards the law [which] the magistrates can give to them who are within the power of their jurisdiction, but he [the magistrate] can do nothing against the edicts and ordinances of his sovereign prince and to make this point clearer, we must presuppose that the word of the law signifies the right command of him, or of those who have power over all others without exception of person; and to go further, . . . there is no one but the sovereign prince who can give law to all his subjects without exception, be it in general or in particular.

9. MONTAIGNE

"If you can keep your head, when all about you are losing theirs . . ." Michel Eyquem de Montaigne (1533–1592) was one of the few who did. Counsellor in the Parlement (High Court) of Bordeaux, near which his estate lay; eventually mayor of the great port; he soon left the public life to which his rank had led him for the peace of his manor at Montaigne, where he read books and composed the Essays whose publication, beginning in 1580, would make him famous. Unusual in trying to take no side in the religious wars then tearing France apart, Montaigne was more unusual still in that he felt no hatred for his enemies—at least, no more than circumstances required. His humorous scepticism and his detachment would be recognized as subversive when his book was placed on the Index in 1676. In his own lifetime, though, he lived as a conformist and died as a Catholic, appreciated by his king (Henry IV), by his neighbors and, even, by his (sometimes nagging) wife.

"We are great fools. 'He has spent his life in idleness,' we say. 'I have done nothing today.' What, have you not lived? That is not only the fundamental but the most illustrious of your occupations. 'If I had been placed in a position to manage great affairs, I would have shown what I could do.' Have you been able to think out and to manage your own life? You have done the greatest task of all. . . . Our great and glorious masterpiece is to live appropriately. All other things—ruling, building, hoarding up treasure—are only little appendages and props, at most." We can consider this a fitting epitaph for the man whose tomb now stands in the hall-way of what was once the University of Bordeaux.

The following essay, one of his most famous, reflects the wide reading of a Renaissance man, greedy like many of his contemporaries for the wisdom of the ancients, ready to quote them at the drop of a quill, but also ready to assimilate this wisdom into a stoic epicureanism of his own: moderate, good-humored, and philosophical in the best sense of that word.

Of Managing One's Will

Few things, in comparison of what commonly affect other men, move, or, to say better, possess me; for 'tis but reason they should concern a man, provided they do not take possession of him. I am very solicitous, both by study and reasoning, to enlarge this privilege of insensibility, which is naturally raised to a pretty high degree in me; so that consequently I espouse or am very much moved with

very few things. I have my sight clear enough, but I fix it upon very few objects; my sense delicate and tender enough, but an apprehension and application stubborn and negligent. I am very unwilling to engage myself; as much as in me lies, I employ myself wholly upon myself; and in this very subject should rather choose to curb and restrain my affection from plunging itself over head

From William Hazlitt, ed. and trans., The Complete Works of Michael de Montaigne (Philadelphia, 1879), pp. 490–501.

and ears into it, it being a subject that I possess at the mercy of others, and over which fortune has more right than I: so that even so much as to health, which I so much value, it were necessary for me not so passionately to cover and desire it as to find diseases insupportable. A man ought to moderate himself betwixt the hatred of pain and the love of pleasure, and Plato sets down a middle path of life betwixt both. But against such affections as wholly carry me away from myself and fix me elsewhere, against these, I say, I oppose myself with my utmost force and power. 'Tis my opinion that a man should lend himself to others, and only give himself to himself. Were my will easy to lend itself out, and to be swaved, I should not stick there; I am too tender, both by nature and custom:

Born and bred up in negligence and ease, I fly from business as from disease.

(Ovid)

The hot and obstinate disputes wherein my adversary would at last have the better, the issue that would render my heat and obstinacy disgraceful, would perhaps vex me to the last degree. Should I set myself to it at the rate that others do, my soul would never have the force to bear the emotions and alarms that attend those who pursue and grasp at so much; it would immediately be disordered by this inward agitation. If sometimes I have been put upon the management of other men's affairs, I have promised to take them in hand, but not into my lungs and liver; to take them upon me, not to incorporate them; to take pains for, but not to be impassioned about, them. I have a care of them, but I will not brood upon them. I have enough to do to order and govern the domestic tumults that I have in my own veins and bowels, without introducing a crowd of other men's affairs, and am sufficiently concerned about my own proper and natural business, without meddling with the concerns of others. Those who know how much they owe to themselves, and how many offices they are bound to of their own, find that nature has given them this commission, full enough to keep them from being ever idle: "Thou hast business enough at home, look to that."

Men let themselves out to hire; their faculties are not for themselves, but to be employed for those to whom they have enslaved themselves: their hirers are in their houses, not themselves. This common humour pleases not me. We must be thrifty of the liberty of our souls, and never let them out but upon just occasions, which are very few, if we judge aright. Do but observe such as have accustomed themselves to be at every one's call, they do it indifferently upon all, as well upon little as upon great occasions, in that which nothing concerns them, as much as in what imports them most; they intrude themselves indifferently wherever there is business and obligation, and are without life, when not in the bustle of affairs: "they only seek business for business sake" (Seneca). It is not so much that they will go, as that they cannot stand still: like a rolling stone that does not stop till it can go no farther. Business, by a certain sort of men, is thought a mark of capacity and honour; their souls seek repose in motion, as children do by being rocked in a cradle; they may pronounce themselves as serviceable to their friends, as troublesome to themselves. No one distributes his money to others, but every one distributes his time and his life. There is nothing of which we are so prodigal as of these two things, of which to be thrifty would be both commendable and useful. I am of a quite contrary humour; I look to myself, and commonly covet with no great ardour what I do desire, and desire little, and employ and busy myself but rarely and temperately in the same way. Whatever they take in hand, they do it with their utmost power and vehemence. There are so many dangerous steps, that, for the more safety, we must a little lightly and superficially slide through the world, and not rush through it. Pleasure itself is painful in its depth:

Thou upon glowing coals dost tread,

Under deceitful ashes hid.

(Horace)

The citizens of Bordeaux chose me mayor of their city at a time when I was at a distance from France, and still more remote from any such thought. I begged to be excused, but I was told that I had committed an error in so doing, and the greater because the king had moreover interposed his command in the affair. 'Tis an office that ought to be looked upon so much more honourable, as it has no other pay nor advantage than the bare honour of its execution. It continues two years but may be extended by a second election, which very rarely happens. It was so to me, and had never been so but twice before, some years ago to Monsieur Lanssac, and lately to Monsieur de Biron, marshal of France, in which place I succeeded, and left mine to Monsieur de Matignon, marshal of France also. Proud of so noble a fraternity.

Both fit for governing in peace and war.
(Virgil)

Fortune would have a hand in my promotion, by this particular circumstance, which she put in of her own, not altogether vain; for Alexander disdained the ambassadors of Corinth, who came to make him a tender of the burgess-ship of their city; but when they proceeded to lay before him that Bacchus and Hercules were also in the register, he thankfully accepted the offer.

At my arrival, I faithfully and conscientiously represented myself to them for such as I find myself to be; a man without memory, without vigilance, without experience, and without vigour; but withal without hatred, without ambition, without avarice, and without violence. That they might be informed and know what they were to expect from my service, and being that the knowledge they had had of my father, and the honour they had for his memory, had been the only motives to confer this upon me, I plainly told them that I should be very sorry any thing should make so great an impression upon me, as their affairs and the concerns of their city had done upon him, whilst he had the same government to which they had preferred me. I very well remember, when a boy, to have seen him in his old age, tormented with and solicitous about the public affairs, neglecting the soft repose of his own house, to which the declension of his age had attached him for several years before, the management of his own affairs, and his health, and certainly despising his own life, which was in great danger of being lost, by being engaged in long and painful journeys on their behalf. Such was he, and this humour of his proceeded from a marvelous goodness of nature. Never was there a more charitable and popular spirited man. Yet this which I commend in others, I do not love to follow myself, and am not without excuse.

He had heard that a man must forget himself for his neighbour, and that particular individuals were in no manner of consideration in comparison with the general concern. Most of the rules and precepts of this world run this way, to drive us out of ourselves into the world, for the benefit of public society: they thought to do a great feat, to divert us from ourselves, presuming we were but too much fixed at home, and by a too natural inclination, and have said all they could to that purpose; for 'tis no new thing for wise men to preach things as they serve, not as they are. Truth has its obstructions, inconveniences, and incompatibilities with us: we must be often deceived, that we may not deceive ourselves, and shut our eyes, and stupefy our understandings, to redress and amend them: "For the ignorant judge, and therefore are oft to be deceived, lest they should err" (Quintilian). When they prescribe us to love three, four, fifty degrees of things above ourselves, they do like archers who, to hit the mark, take their aim a great deal higher than the butt: to set a crooked stick straight, we bend it the contrary way. . . .

The principal charge we have is, to every one his own conduct, and 'tis for this that we are here. As he who should forget to live a virtuous and holy life, and should think he acquitted himself of his duty in instructing and training up others to it, would be a fool; even so he who abandons his own particular healthful and pleasant living to serve others, takes, in my opinion, a wrong and an unnatural course.

I would not that men should refuse, in the employments they take upon them, their attention, pains, their eloquence, and their sweat and blood, in time of need . . . but 'tis only as a loan, and incidentally; his mind being always in repose and in health not without action, but without vexation, without passion. To be simply doing costs him so little that he acts even sleeping; but he must set on the motion with discretion; for the body receives the offices imposed upon it, just according to what they are; the mind often extends, and makes them heavier at its own expense, giving them what measure it pleases. Men perform like things with several sorts of endeavour, and different contentions of the will: the one does well enough without the other: for how many people hazard themselves every day in war, without any concern which way it goes, and thrust themselves into the dangers of battles, the loss of which will not break their next night's sleep? And such a man may be at home, out of danger, which he durst not have looked upon, who is more passionately concerned for the issue of this war, and whose soul is more anxious about events. than the soldier who stakes his life and blood in the quarrel. I could have engaged myself in public employments, without quitting myself a nail's breadth, and have given myself to others without abandoning myself. This sharpness and violence of desires more hinders than it advances the execution of what we undertake, fills us with impatience against slow or contrary events, and with heat and suspicion against those with whom we have to do. We never carry on that thing well by which we are prepossessed and led:

For overheat doth carry on things ill.

He who therein employs only his judgment and address proceeds more cheerfully: he counterfeits, he gives way, he defers all things at his ease, according to the necessities of occasions; he fails in his attempts, without trouble and affliction, ready and entire for a new effort; he always rides bridle in hand. In him

who is drunk with violent and tyrannic intention, we see of necessity much imprudence and injustice: the impetuosity of his desire carries him away; these are rash motions, and, if fortune does not very much assist, of very little fruit. Philosophy wills that in the revenge of injuries received we should strip ourselves of choler, not that the chastisement should be less, but, on the contrary, that the revenge may be the better and more heavy, which it conceives will be by this impetuosity hindered. For anger does not only trouble, but of itself does also weary, the arm of those who chastise; this fire benumbs and wastes their force: as in precipitation, "haste fetters itself." For example, according to what I commonly see, avarice has no greater impediment than itself; the more bent and vigorous it is, the less it rakes together, and commonly sooner grows rich, when disguised in a vizor of liberality. . . .

Do but consider that, even in vain and frivolous actions, as at chess, tennis, and the like, this eager and ardent engaging with an impetuous desire immediately throws the mind and members into indirection and disorder; a man confounds and hinders himself; he that carries himself the most moderately, both towards gain and loss, has always his wits about him; the less peevish and passionate he is at play, he plays much more advantageously and surely.

As to the rest, we hinder the mind's seizure and hold, in giving it so many things to seize upon: some things we are only to offer to it, to tie others to it, and others to incorporate with it: it can feel and discern all things, but ought to feed on nothing but itself, and should be instructed in what properly concerns itself, that is properly of its own having and substance. The laws of nature teach us ex-

actly what we need. After the sages have told us that, according to nature, no one is indigent, and that every one is so according to opinion, they very subtly distinguish betwixt the desires that proceed from her and those that proceed from the disorder of our own fancy: those of which we can see the end are hers; those that fly before us, and of which we can see no end, are our own. Want of goods is easily repaired; poverty of soul is irreparable:

If what's for man enough enough could be It were enough: but as we plainly see That won't suffice, how can I e'er believe That any wealth my mind content can give? (Lucilius)

Socrates seeing a great quantity of riches, jewels, and furniture of great value, carried in pomp through the city: "How many things," said he, "do I not desire!" Metrodorus lived on twelve ounces a day; Epicurus upon less; Metrocles slept in winter abroad among sheep; in summer in the cloisters of churches. Cleanthes lived by the labour of his own hands, and boasted, "That Cleanthes, if he would, could maintain yet another Cleanthes."

If that which nature exactly and originally requires of us for the conservation of our being be too little, let us dispense with a little more; let us call every one of our habits and conditions nature; let us tax and treat ourselves by this measure; let us stretch our appurtenances and accounts so far; for so far I fancy we have some excuse. Custom is a second nature, and no less powerful. What is wanting to my custom I hold to be wanting to me: and I should be almost as well content that they took away my life, as take me far from the way wherein I have so long lived. I am no more in a condition for any great change, nor to put myself into a new and unwonted course, though

never so much to my advantage. 'Tis past the time for me to become other than what I am; and as I should complain of any great adventure that should now befall me, that it came not in time to be enjoyed:

For what are fortune's gifts, if I'm denied Their cheerful use? (Horace)

so should I complain of any inward acquest. It were almost better never, than so late, to become an honest man, and well understanding in living, when a man has no longer to live. I, who am going, would readily resign to any new-comer all the wisdom I have acquired for the world's commerce: "after meat comes mustard." I want no goods of which I can make no use; of what use is knowledge to him that has lost his head? 'Tis adding insult to injury for fortune to offer us presents that will only inspire us with a just despite that we had them not in their due season. Guide me no more, I can no longer go. Of so many parts as make a perfect man, patience suffices. Give an excellent treble to a chorister that has rotten lungs, and eloquence to a hermit exiled in the deserts of Arabia. There needs no art to further a fall: the end finds itself of itself, at the conclusion of every affair. My world is at an end, my form expired: I belong to the past, and am bound to authorise it, and to conform my end to it. I will here mention, by way of example, that the recent eclipse by the pope of ten days,* has taken me so low that I cannot well get used to it; I belong to the years wherein we kept another kind of account. So ancient and so long a custom challenges and calls me back to it: I am constrained to be somewhat heretical in this point: impatient of any even though a corrective innovation. My imagination, in spite of my teeth, always pushes me ten days forward or backward. and is ever murmuring in my ears, "This rule concerns those who are going to be." If health itself, sweet as it is, returns to me by fits, 'tis rather to give me cause of regret than fruition of itself; I have no place left to keep it in. Time leaves me, without which nothing can be possessed. Oh, what little account should I make of those great elective dignities that I see in such esteem in the world, that are never conferred but upon men who are taking leave of it, in whom they do not so much regard how well he will discharge his trust, as how short his administration will be; from the very entry they look at the exit. In short, I am about to finish this man, and not to rebuild another. By long habit this form is, in me, turned into substance, and fortune into nature.

I say, therefore, that every one of us feeble creatures is excusable in thinking that to be his own which is comprised under this measure: but withal, beyond these limits, 'tis nothing but confusion; 'tis the largest extent we can grant to our own claim. The more business we create ourselves, the more we amplify our possession, so much more do we expose ourselves to the blows and adversities of fortune. The career of our desires ought to be circumscribed, and restrained to a short limit of near and contiguous conveniences; and ought moreover, to perform their course, not in a right line, that ends elsewhere, but in a circle, of which the two points by a short wheel meet and terminate in ourselves. Actions that are carried on without this reflection (a near

^{*} The introduction of the Gregorian calendar, 1582.

and essential reflection I mean), such as those of ambitious and avaricious men, and many more who run point blank, and whose career always carries them before themselves, such actions, I say, are erroneous and sickly.

Most of our business is farce: "All the world's a stage, and all the men and women merely players" (Petronius). We must play our part well, but withal as the part of a borrowed personage; we must not make a real essence of a mask and outward appearance, nor of a strange person our own; we cannot distinguish the skin from the shirt; 'tis enough to meal the face without mealing the breast. I see some who transform and transubstantiate themselves into as many new shapes and new beings as they undertake employments, and who prelate themselves even to the heart and liver, and carry their office along with them, even to the close stool; I cannot make them distinguish the salutations that are made to them from those made to their commission, their train, or their mule: "They so much give themselves up to fortune as even to forget nature" (Petronius); they swell and puff up their souls and their natural way of speaking, according to the height of their magisterial place. The mayor of Bordeaux and Montaigne have ever been two by very manifest separation. To be an advocate or a treasurer, a man must not be ignorant of the knavery of such callings; an honest man is not accountable for the vice or folly of his business, and yet ought not to refuse to take the calling upon him; 'tis the custom of his country, and there is money to be got by it; a man must live by the world, and make his best of it, such as it is. But the judgment of an emperor ought to be above his empire, and view and consider it as an accident; and he ought to know

how to enjoy himself apart from it, and to communicate himself as James and Peter, to himself at least.

I cannot engage myself so deep and so entire; when my will gives me to a party, 'tis not with so violent an obligation that my judgment is infected with it. In the present broils of this kingdom, my interest in the one side has not made me forget either the laudable qualities of some of our adversaries, nor those that are reproachable in my own party. People generally adore all of their own side; for my part I do not so much as excuse most things in those of mine; a good book has never the worse grace for being written against me. The knot of the controversy excepted, I have always kept myself in equanimity and pure indifference: "And have no express hatred beyond the necessity of war" (Quintus Curtius); for which I am pleased with myself, and the more, because I see others commonly fail in the contrary way. Such as extend their anger and hatred beyond the dispute in question, as most men do, show that they spring from some other occasion and particular cause; like one who, being cured of an ulcer, has yet a fever remaining, by which it appears that the ulcer had another more concealed beginning. It is because they are not concerned in the common cause, because it is wounding to the state and common interest, but are only nettled by reason of their private and particular concern: this is why they are so especially animated, beyond justice and public reason: "Every one was not so much angry against things in general as against those that particularly concerned himself" (Livy). I would have matters go well on our side; but if they do not, I shall not run mad. I am heartily for the right party; but I do not affect to be taken notice of for an especial enemy to others, and beyond the general quarrel. I am a mortal enemy to this vicious form of censure: "He is of the league because he admires the Duke of Guise. He is astonished at the king of Navarre's valour and diligence, and therefore he is a Huguenot. He finds such and such faults in the king, and therefore he is seditious in his heart;" and I would not grant to the magistrate that he did well in condemning a book, because it had placed a heretic among the best poets of the time. Shall we not dare to say of a thief that he has a handsome leg? Because a woman is a strumpet, must it needs follow that she has a stinking breath? . . . If they take a hatred against an advocate, he will not be allowed the next day to be eloquent. I have elsewhere spoken of the zeal that pushes on worthy men to the like faults. For my part I can say: "such an one does this ill, and that well and virtuously." So, in the prognostics or sinister events of affairs, they will have every one, in his own party, blind or a blockhead; and our persuasion and judgment be subservient, not to truth, but to the project of our desires. I should rather incline towards the other extreme, so much do I fear being suborned by my desire; to which may be added, that I am a little tenderly distrustful of things that I wish.

I have in my time seen wonders in the way of an indiscreet and prodigious facility in people to suffer their hopes and belief to be led and governed which way has best pleased and served their leaders, through a hundred mistakes one upon another, and through dreams and phantasms. I no more wonder at those who have been blinded and led by the nose by the ape's tricks of Apollonius and Mahomet. Their sense and understanding is absolutely taken away by their passion: their discretion has no longer any other

choice than that which smiles upon them, and supports their cause. I principally observed that in the beginning of our intestine distempers: this other, which is sprung up since, in imitation, has surpassed it: by which I am satisfied that it is a quality inseparable from popular errors: after the first that sets out, opinions drive on one another like waves with the wind: you are not part of the body, if you utter a word of objection, and do not follow the common run. But doubtless they wrong the just side, when they go about to assist it with fraud; I have ever been against that practice: 'tis only fit to work upon weak heads; for the sound, there are surer and more honest ways to keep up their courage, and to excuse adverse accidents. . . .

We must not precipitate ourselves so headlong after our affections and interest. As, when I was young, I opposed the progress of love, which I perceived to advance too fast upon me, and had a care lest it should at last become so pleasing as to force, captivate, and wholly reduce me to its mercy, so I do the same upon all other occasions, where my will is running on with too warm an appetite; I lean opposite to the side it inclines to, as I find it going to plunge and make itself drunk with its own wine: I evade nourishing its pleasure so far, that I cannot recover it without infinite loss. Souls that, through their own stupidity, only discern things by halves, have this happiness, that they smart the less with hurtful things: 'tis a spiritual leprosy that has some show of health, and such a health as philosophy does not altogether contemn; but yet we have no reason to call it wisdom, as we often do. And after this manner a man mocked Diogenes, who, in the depth of winter, and stark naked, went hugging an image of snow for a trial of his patience; seeing him in this exercise: "Art thou very cold?" said he; "Not at all," replied Diogenes; "Why, then," said the other, "what great and exemplary thing dost thou think thou art doing now?" To estimate a man's firmness, we must know what his suffering is.

But souls that are to meet with adverse events, and the injuries of fortune in their depth and sharpness, that are to weigh and taste them according to their natural weight and sharpness, let such show their skill in avoiding the causes and diverting the blow. What did King Cotys do? He paid liberally for the rich and beautiful service of porcelain that had been brought him; but, seeing it was exceedingly brittle he immediately broke it, in order to prevent so easy a matter of displeasure against his servants. In like manner, I have willingly avoided all confusion in my affairs, and never coveted to have my estate contiguous to those of my relations, and those with whom I desired a strict friendship; whence matter of unkindness and fallings-out often proceed. I formerly loved cards and dice, but have long since left them off, only for this reason, that though I carry my losses as handsomely as another, I was not quiet within. Let a man of honour, who ought to be sensible of the lie, and who will not take a scurvy excuse for satisfaction, avoid occasions of dispute. I shun melancholic and sournatured men as I would the plague; and in matters I cannot talk of without emotion and concern, I never meddle, if not compelled by duty: "'Tis better not to begin, than to desist" (Seneca). The surest way, then, is to prepare one's-self before the occasion.

I know very well that some wise men have taken another way, and have not feared to grapple and engage to the utmost upon several subjects: these are confident of their own strength, under cover of which they protect themselves in all ill successes, making their patience wrestle and contend with disaster. . . . Let us never attempt these examples; we shall never come up to them. They set themselves resolutely, and without trouble, to behold the ruin of their country, to which all the good they can contrive or perform is due: this is too much and too rude for our common souls to undergo. Cato gave up the noblest life that ever was upon this account; but it is for us smaller men to fly from the storm as far as we can; we ought to shun pain, instead of cultivating patience, and dip under the blows we cannot parry. Zeno seeing Chremonides, a young man whom he loved, draw near to sit down by him, suddenly started up, and Cleanthes asking the reason why he did so: "I hear," said he, "that physicians especially order repose, and forbid emotion, in all excitements." Socrates does not say: "Do not surrender to the charms of beauty; stand your ground, and do your utmost to oppose it." "Fly it," says he, "shun the sight and encounter of it, as of a powerful poison, that darts and wounds at a distance" (Xenophon). And the Holy Spirit, in like manner: "Lead us not into temptation" (Matt. 6:13). We do not pray that our reason may not be combated and overcome by concupiscence, but that it should not be so much as tried by it; that we should not be brought into a state wherein we should have so much as to suffer the approaches, solicitations, and temptations of sin; and we beg of Almighty God to keep our consciences quiet, fully and perfectly delivered from all commerce of evil.

Such as say that they have reason for their avenging passion, or any other sort of troublesome agitation of mind, do often say true, as things now are, but not as they were; they speak to us when the causes of their error are nourished and advanced by themselves: but look back, recall these causes to their beginning, and there you will put them to a nonplus. Will they have their fault less, for being of longer continuance; think they of an unjust beginning the sequel can be just? Whoever desires the good of his country, as I do, without fretting and pining, will be troubled, but will not swoon to see it threatened either with its own ruin, or a not less ruinous continuance: poor vessel, that the waves, the wind, and the pilot toss and steer to so contrary designs! He who does not gape after the favour of princes, as after a thing he cannot live without, does not much concern himself at the coldness of their reception and countenance, nor at the inconstancy of their wills. He who does not brood over his children or his honours with a slavish propension, ceases not to live commodiously enough after their loss. He who does good principally for his own satisfaction will not be much troubled to see men judge of his actions contrary to his merit. A quarter of an ounce of patience will provide sufficiently against such inconveniences. I find ease in this receipt, redeeming myself in the beginning as cheap as I can; and find that by this means I have escaped much trouble and many difficulties. With very little effort I stop the first sally of my emotions, and quit the subject that begins to be troublesome, before it carries one away. He who stops not the start will hardly ever be able to stop the career: he who cannot keep them out will never get them out, when they are once in; he who cannot crush them at the beginning, will never do it after; nor ever keep himself from falling, if he cannot recover himself when first he begins to totter. . . .

How often have I done myself a manifest injustice, to avoid the hazard of having vet a worse done me by the judges, after an age of vexations, dirty and vile practices, more enemies to my nature than fire or the rack? "A man should be an enemy to all contention as much as he lawfully may, and I know not whether or not something more: for 'tis not only handsome, but sometimes also advantageous too, a little to recede from one's right" (Cicero). Were we wise, we ought to rejoice and boast, as I one day heard a young gentleman of a good family very innocently do, that his mother had lost her suit, as if it had been a cough, a fever, or something very troublesome to keep. Even the favours that fortune might have given me through relationship, or acquaintance with those who have sovereign authority in our affairs, I have conscientiously waived, and very carefully avoided employing them to the prejudice of others, and of advancing my pretensions above their true right. In fine, I have so much prevailed by my endeavours (happy 'tis for me I can say), that I am to this day a virgin from all suits at law, though they have made me very fair offers, and with very just ground, would I have hearkened to them; and a virgin from quarrels too; I have almost passed over a long life without any offence of moment, either active or passive, or without ever hearing myself called by a worse word than my own name; a rare favour of heaven!

Our greatest agitations have ridiculous motives and causes; and I have in my time seen the wisest heads in this kingdom assembled with great ceremony, and at the public expense, about treaties and agreements, of which the real decision in the mean time absolutely depended upon the ladies' cabinet council, and the inclina-

tion of some woman body. The poets very well understood this, when they put all Greece and Asia to fire and sword for an apple. Enquire why that man hazards his life and honour upon the fortune of his rapier and dagger: let him acquaint you with the occasion of the quarrel; he cannot do it without blushing, 'tis so idle and frivolous!

A little thing will engage you in't, but being once embarked, all cords draw; greater considerations are then required, more hard and more important. How much easier is it not to enter in, than it is to get out? We should proceed contrary to the reed, which at its first spring produces a long and straight shoot, but afterwards, as if tired and out of breath, runs into thick and frequent joints and knots, as so many pauses, which demonstrate that it has no more its first vigour and constancy: 'twere better to begin fair and calmly, and to keep a man's breath and vigour for the weight and stress of the business. We guide and govern affairs in their beginnings, and have them then in our own power; but afterwards, when they are once at work, 'tis they that guide and govern us, and we have to follow them.

Yet do I not pretend by this to say that this plan has relieved me of all difficulty. and that I have not often had enough to do to curb and restrain my passions; they are not always to be governed according to the measure of occasions, and often have their entries very sharp and violent. Yet good fruit and profit may thence be reaped, except by those who in well-doing are not satisfied with any benefit, if reputation be wanting; for, in truth, such an effect is of no account, but by every one in himself; you are better contented, but no more esteemed, seeing you reformed yourself before you came into play, or that any vice was discovered in you. Yet

not in this only, but in all other duties of life also, the way of those who aim at honour is very different from that they proceed by, who propose to themselves order and reason. I find some who rashly and furiously rush into the lists, and cool in the race. As Plutarch says, that as those who, through awkwardness, are soft and facile to grant whatever is desired of them, are afterwards as frail to break their word and to recant: so likewise he who enters lightly into a quarrel, is subject to run as lightly out of it. The same difficulty that keeps me from entering into it would, when once hot and engaged in it, incite me to maintain it with resolution. 'Tis, perhaps, wrong; but when a man is once engaged, he must go through with it or die. "Undertake coldly," said Bias, "but pursue with ardour" (Laertius). For want of prudence, men fall into want of courage, which is still more intolerable.

Most accommodations of our quarrels now-a-days are discreditable and false: we only seek to save appearances, and in the mean time betray and disayow our true intentions; we salve over the fact. We know very well how we said the thing, and in what sense we spoke it, and all the company, and all our friends with whom we would appear to have the advantage, understand it well enough too; 'tis at the expense of our frankness, and the honour of our courage, that we disown our thoughts, and seek subterfuge in falsehood to make friends; we give ourselves the lie, to excuse the lie we have given another. You are not to consider whether your word or action may admit of another interpretation; 'tis your own real and sincere interpretation, your real meaning, that you are thenceforward to maintain. whatever it cost you. Men address themselves to your virtue and your conscience, which are neither of them to be disguised:

let us leave these pitiful ways and expedients to the tricksters of the law. The excuses and satisfactions that I see every day made and given to repair indiscretion, seem to me more scandalous than the indiscretion itself. It were better to affront your adversary a second time, than to offend yourself by giving him such satisfaction. You have braved him in your heat and anger and you go to appease him in your cooler and better sense; and by that means lay vourself lower, and at his feet, whom before you pretended to overtop. I do not find anything a gentleman can say so rude and vicious in him, as unsaying what he has said is infamous, when that unsaying is authoritatively extracted from him; forasmuch as obstinacy is more excusable in him than pusillanimity. Passions are as easy for me to evade, as they are hard for me to moderate: "'Tis easier to tear them altogether from the mind, than to moderate them" (Seneca). He who cannot attain unto that noble stocial impassibility, let him secure himself in the bosom of this popular stupidity of mine: what those great souls performed by their virtue, I inure myself to do by complexion. The middle region harbours storms and tempests; the two extremes of philosophers and rustics concur in tranquillity and happiness:

How blest the sage! whose mind can pierce each cause

Of changeful nature, and her wond'rous laws;

Who tramples fear beneath his foot, and braves

Fate, and stern death, and hell's resounding waves!

Blest too, who knows each god that guards the swain,

Pan, old Sylvanus, and the Dryad train.
(Virgil)

The birth of all things is weak and ten-

der; and therefore we are to have an eye to beginnings; for as then, in their infancy, the danger is not perceived, so, when it is grown up, neither is the remedy to be found. I had every day encountered a million of crosses, harder to digest, in the progress of ambition, than it has been difficult for me to curb the natural propension that inclined me to it:

For well might I be shy, To raise my head so high. (Horace)

All public actions are subject to various and uncertain interpretations, for too many heads judge of them. Some say of this city employment of mine (and I am willing to say a word of it, not that it is worth so much, but to exhibit my conduct in such things), that I have behaved myself in it like a man not easy to be moved. and with a languishing affection; and they have some colour for what they say. I endeavour to keep my mind and my thoughts in repose: "As being always quiet by nature, so also now by age" (Cicero); and if they sometimes lash out on some rude and sensible impression, 'tis in truth, without my advice. Yet, from this natural heaviness of mine, men ought not to conclude a total inability in me (for want of care and want of sense are two very different things), and much less any ingratitude towards that city, who employed the utmost means they had in their power to oblige me, both before they knew me and after, and did much more for me in choosing me anew, than conferring that honour upon me at first. I wish them all the good that can befall them, and certainly had occasion offered, there is nothing I would have spared for their service. I did for them as I would have done for myself. 'Tis a good, warlike, and generous people, but capable of obedience and discipline, and of whom

the best use may be made, if well guided. They say also that my administration was passed over without mark or thing worthy of record. Very good! They accuse my cessation in a time when every body almost was convicted of doing too much. I am impatient to be doing where my will spurs me on; but this point is an enemy to perseverance. Let whoever will make use of me according to my own way, employ me in affairs where vigour and liberty are required; where a direct, short, and moreover a hazardous conduct is necessary; I may do something: but if it must be long, subtle, laborious, artificial, and intricate, they would do better to call in somebody else. All important offices are not hard: I came prepared to work a little more, had there been great occasion; for it is in my power to do something more than I do, or than I love to do; I did not to my knowledge omit any thing that my duty really required. I easily forget those offices that ambition mixes with duty, and shelters under that title; these are they that, for the most part, fill the eyes and ears, and give men the most satisfaction: not the thing, but the appearance contents them; they think men sleep, if they hear no noise. My humour is no friend to tumult; I could appease a riot without emotion, and chastise a disorder without alteration. If I stand in need of anger and inflammation, I borrow it and put it on; my manners are heavy, rather faint than sharp. I do not condemn a magistrate that sleeps, provided the people under his charge sleep as well as he: the laws in that case sleep too. For my part I commend a gliding, quiet, and silent life, "neither abject nor overbearing:" my fortune will have it so. I am descended from a family that has lived without lustre or tumult, and time out of mind, particularly ambitious

of the character of truth and honesty.

Our people now-a-days are so bred up to bustle and ostentation, that goodness, moderation, equability, and such quiet and obscure qualities, are no more regarded: rough bodies make themselves the smooth are imperceptibly handled; sickness is felt; health little, or not at all; no more than the oils that foment us, in comparison of the pain for which we are fomented. 'Tis acting for a man's reputation and particular profit, not for the public good, to refer that to be done in the public place which a man may as well do in the council-chamber, and to noon-day what might have been done the night before; and to be jealous to do that himself which his colleague can do as well as he. So some surgeons of Greece used to perform their operations upon scaffolds, in the sight of the people, to draw more practice and profit. They think that good orders cannot be understood but by the sound of trumpet. Ambition is not a vice of little people and of so mean abilities as ours. One said to Alexander: "Your father will leave you a great dominion, easy and pacific," but this youth was envious of his father's victories, and the justice of his government, and would not have enjoyed the empire of the world in ease and peace. Alcibiades, in Plato, had rather die young, beautiful, rich, noble, and learned, and all this par excellence, than stop in the state of such a condition; this disease is perhaps excusable in so strong and so full a soul. When these wretched and dwarfish little souls gull and deceive themselves, and think to spread their fame, for having given right judgment in some affair, or kept up the discipline of the guard of the city gate, the more they think to exalt their heads, the more they show their tails. This little well-doing has neither body nor life; it

vanishes in the first month, and goes no farther than from one street to another. Talk of it, in God's name, to your son or your servant; like that old fellow who, having no other auditor of his praises. nor approver of his valour, boasted to his chambermaid, crying out: "O, Peretta, what a brave man hast thou as thy master!" At the worst, talk of it to yourself; like a counsellor of my acquaintance, who, having disgorged a whole cart-load of paragraphs with great heat, and as great folly, coming out of the councilchamber to make water, was heard very conscientiously to mutter betwixt his teeth: "Not unto us, O Lord, not unto us, but unto thy name, be the glory" (Psalm 113). He who can get it of nobody else. let him pay himself out of his own purse.

Fame is not prostituted at so cheap a rate: rare and exemplary actions, to which it is due, would not endure the company of this prodigious crowd of little everyday performances. Marble may exalt your titles as much as you please, for having repaired a rod of a ruinous wall, or cleansed a public sewer, but not men of sense. Renown does not follow all good deeds, if novelty and difficulty be not conjoined; nay, so much as mere estimation, according to the Stoics, is not due to every action that proceeds from virtue; neither will they allow him bare thanks who, out of temperance, forbears to meddle with any old blear-eved hag. We have pleasures suitable to our fortunes: let us not usurp those of grandeur. Our own are more natural, and by so much more solid and sure, as they are more low. If not for that of conscience, yet at least for ambition's sake, let us reject ambition; let us disdain that thirst of honour and renown, so low and mendicant, that it makes us beg it of all sorts of people. "What praise is that which is to be got in the market, by abject means, and at what cheap rate soever" (Cicero)? 'Tis dishonour to be so honoured. Let us learn to be no more greedy of honour than we are capable of it. To be puffed up with every action that is innocent, or of use, is only for such with whom such things are extraordinary and rare; they will value it as it costs them. How much the more a good effect makes a noise, so much I abate of the goodness of it, as I enter into suspicion that it was more performed for notice than upon the account of goodness: being exposed upon the stall, it is half sold. Those actions have much more grace and lustre that slip from the hand of him that does them negligently and without noise, and that some honest man after chooses out and raises from the shade, to produce it to the light upon its own account: "All things, truly, seem more laudable to me that are performed without ostentation and without testimony of the people," says the most vainglorious man in the world (Cicero).

I had no care but to conserve and to continue, which are silent and insensible effects. Innovation is of great lustre, but 'tis interdicted in this time, when we are pressed upon, and have nothing to defend ourselves from but novelties. To forbear doing is often as noble as to do; but 'tis less in the light: and the little good I have in me is almost all of this kind. In fine, occasions in this employment of mine have been confederate with my humour, and I thank them for it. Is there any one who desires to be sick that he may see his physician at work? And would not that physician deserve to be whipped who should wish the plague amongst us, that he might put his art in practice? I have never been of that wicked, though common enough, humour, to desire that the trouble and disorders of this city

should elevate and honour my government: I have ever willingly contributed all I could to their tranquillity and ease. He who will not thank me for the order, gentle and silent calm, that has accompanied my administration, cannot, however, deprive me of the share that belongs to me by the title of my good fortune. And I am of such a composition that I would as willingly be happy as wise; and had rather owe my successes purely to the favour of Almighty God than to any industry or operation of my own. I had sufficiently published to the world my unfitness for such public offices. But I have something in me vet worse than incapacity, which is that I am not much displeased at it, and that I do not much

go about to cure it, considering the course of life that I have proposed to myself. Neither have I satisfied myself in this employment, but I have very near arrived at what I expected from myself, and have much surpassed what I promised them with whom I had to do; for I am apt to promise something less than what I am able to do, and than what I hope to make good. I am sure that I have left no impressions of offence or hatred behind me; and as to leaving regret or desire of me amongst them, I at least know very well that I never much affected it:

Wouldst thou I should a quiet sea believe, To this inconstant monster credit give? (Virgil)

IV. The Seventeenth Century

War, economic activity, and a far-reaching revolution in scientific thought characterized the seventeenth century. It is worth insisting on the last two, since the economic activity ensured the rise of a newly significant social class which owed its position to trade rather than to traditional rank or prowess and which left its mark on the political thought of the time when it introduced the notion of contract into the search for social authority. At the same time, the new scientific activity stressed a rational approach which had been somewhat ignored for centuries past. But just because the seventeenth century was a time of scientific revolution, this does not mean that superstition was dead. On the contrary, this was the golden age of witches, when witch-hunters lit their pyres all over Europe and the shadow of the Black Mass hung even over the court of Louis XIV.

1. THE THIRTY YEARS' WAR: SIMPLICISSIMUS

Hans Jacob Christopher von Grimmelshausen was a German writer (c. 1620–1676) who spent part of his life soldiering on various sides during the Thirty Years' War. In the picaresque novel which he published in 1668, he has left us fascinating descriptions of German life during this period and also a document concerning some of the directions taken during these years by the speculations of some. For most of Germany they were difficult years, in which towns and countryside were occupied successively by Catholics and Protestants, Danes, Swedes, French and Saxons, mercenaries of Wallenstein or Tilly, devastated by men, famines and epidemics, all seeming to vie with each other in their destructiveness. This was the country over which the young Grimmelshausen marched, now with the Imperial soldiers, now with the Swedes, and over which he carries his hero.

THE FATE OF A FARM

When these horsemen took over my father's smoky house, the first thing they did was to bring in their horses; then each one started to destroy everything and tear everything to pieces. Some were killing the cattle, and broiling or roasting the carcasses; others were going through

the house, determined not to miss any thing good there might be for them to find; even the privy was not safe from their investigations, as if we had hidden there Jason's Golden Fleece. Others were making great bundles of linen and clothes and all sorts of stuff, as if they were going to open a flea market someplace, and what they weren't going to carry away

Tr. by the editor from chaps. 4, 15, 16 of Simplicius Simplicissimus (1669).

with them they pulled to pieces. Some shoved their swords through the piles of straw or hay as if they hadn't had enough pigs to kill; others shook the feathers out of the mattresses and filled them with bacon and salt meat and other things as if they expected to sleep on them better that way. Others were breaking down the stoves and the window panes, as if they thought that summer was going to last forever. They were smashing the tableware and carrying away with them these useless pieces of copper or pottery or pewter. They burnt beds, and the tables, and the chairs, and the benches, when they could have found plenty of dry fire-wood in the yard. Of pots and of pans they shattered the lot; either because they didn't want to eat anything but roast meat any more, or because they only planned to stay with us for one single meal. Our maid underwent such treatment in the stables that she could hardly walk coming out. Is it not shameful to have such things happening? As for the groom, they laid him on the ground, they put a funnel into his mouth, and they poured in a whole tubful of foul matter. They called this "a little drink in the Swedish manner"; but he didn't find it at all to his taste. They also forced him to guide them on another raid, where they captured both people and cattle whom they brought into our yard. Among them they got my father, and my mother, and my sister Ursula.

Then they started to take the flints out of the cocks of the pistols in order to use them as thumbscrews, and to torture the poor beggars as if they were sorcerers who needed to be punished before being burnt. As a matter of fact, the soldiers had already shoved one of the captured peasants into the oven and they were trying to keep him warm in there (so he would tell

them the hiding place of his little hoard). They had tied a cord around the head of another, and they were tightening the cord with a garrot, so that with every turn they gave it, the blood gushed out of his mouth, his nose and his ears. In short, each man was busy working out some new kind of torture for the peasants and so each victim had his own particular kind of torment.

However it seemed to me at the time that my father was the luckiest of them all, because he admitted with roars of laughter what the others were forced to reveal in the midst of sufferings and fearful plaints.

This kind of honor was his, no doubt, because he was the head of the family. The soldiers put him before a great fire, they tied him so that he couldn't move his arms or his legs, and they rubbed the soles of his feet with damp salt; then they had our old goat lick it off. He was so tickled by this that he nearly died of laughter. It all seemed to me so pleasant and so silly—I had never seen nor heard my father laugh so long-that, either because his laughter was contagious, or else because I couldn't understand what was going on, I had to laugh too. That is how my father told the raiders what they wanted to know, and revealed the hiding place of his treasure which consisted of gold and pearls and jewels; a much richer hoard than one would have expected a peasant to own.

I cannot say anything about the treatment of the women, the maids, and the young girls who had been captured, because the soldiers didn't let me see what they were doing to them. I know only that one heard sighs and groans in various corners, and I thought that my mother and my sister Ursula were probably no better off than the others.

THE DREAM OF SIMPLICISSIMUS

Lost in these thoughts, discouraged, shivering, hunger hugging my stomach, I went to sleep. In my dream I thought I saw that all the trees which surrounded my dwelling place had suddenly changed, and taken on another aspect. On top of each tree there was a gentleman, and the branches were covered, instead of leaves, by all sorts of people: Some had their long lances, others had muskets, carbines, halberds, standards, and also fifes and drums. It was an amusing sight, for all these people were arranged in an orderly manner, each one in his proper place according to his rank. The roots of the tree were made of little people, artisans, workmen, and especially peasants and other unimportant folk. And yet it was they who lent the tree its strength and its life, and who renewed its vitality as it ran out. They also replaced the fallen leaves and they furnished others in their place from among their numbers, not without loss and inconvenience for themselves. You could hear them groaning under the weight of those who were sitting on the tree; because everything rested on them, and pressed them so hard that they sweated even the silver from their purses. And when the silver was not forthcoming, the quartermasters knocked them about so harshly, with great broomsticks, that they drew great sighs from their hearts, tears from their eyes, blood from under their nails, and the marrow from their bones. In spite of this there were a certain number of jolly fellows amongst them who didn't seem to care and who accepted everything with a smile; overwhelmed by oppression, they sought and found consolation in their merriment.

So the roots of these trees were resigned to spending their lives in pain and in sighing, but the people who sat on the lowest branches had to endure even worse trouble and torments. And yet they were always gayer than the first. They were also insolent, tyrannical, impious for the most part, and for the roots they made a load so heavy as to be almost unbearable. As the wind passed through them you could hear them singing the following song:

To endure horror, thirst, and pain and strife:

To work or to starve as things might be; To be violent and unjust; that is our life, For fighting men at arms are we.

And these words were perfectly true and conformed to their activities. In effect, the life and the pastime of these men consisted in eating and drinking too much, enduring hunger and thirst, living in debauchery, rattling the dice and gambling, killing and being killed, shooting and being shot, torturing and being tortured, hunting and being hunted, terrorizing and being terrorized, robbing and being robbed, frightening and being frightened, sowing evil and desolation wherever they went; in one word, of carrying everywhere destruction, ruin and death, while being themselves exposed to these evils. Neither the winter nor the summer, neither snow nor ice, neither heat nor cold, neither wind nor rain, nor the mountains, nor the valleys, or the fields or the marshes, or the mountain passes or the sea, or great walls or waters, or fire or ramparts, or the dangers that threaten body, soul, or conscience; not the laws of their life or heaven, or anything else whatever its reason, whatever its name—none of these could stop them. They continued with great enthusiasm to carry out all their villainies until in some battle or siege or assault, or even in billets (which we know

are a soldier's paradise, especially if he can get himself quartered on some nice fat peasant whom he can exploit) they end by finding their death. Only a few could survive such a life and they, if they had not been successful in their thefts and rapine, became beggars and miserable vagabonds in their old age.

Immediately above these miserable beings there sat a number of old chicken thieves, who had been living on the lower branches for several years but who now, by dint of the greatest risks, had made a success of their thievery, and were living on its proceeds. These looked like serious, solid people and rather more honest than those below them, if only because they overtopped them.

Above them yet again you could find the people who were rather better off, but who also had rather higher pretensions because they commanded those of inferior degree. These carried the title of lickspittles: they bustled about among the lowest of the lancers and cursed them, and beat them with sticks to make them go forward. They furnished the musketeers with the oil they needed to grease their weapons, but carried neither weapons nor themselves into battle.

Above them there was an empty space on the trunk of the tree, a breach in continuity. It was a piece of trunk without any branches, and greased with a soap of disfavor. This was there so that no soldier, unless he should be of noble birth, could climb higher, either by his courage or by his merit or by his wisdom, whatever his skill in climbing might be. This part was more slippery than a column of polished marble or a mirror of steel.

Above it the ensigns were set; some were young, others were already middle-aged. The young had risen by nepotism; the old had got there themselves, either

by climbing the golden ladder of corruption, or by some other means offered them by chance.

Yet higher in a more elevated position I saw others who had also their troubles, their worries and their tribulations: but they had the advantage of being able to grease their skillets and their purses with bacon which they cut out of the roots with a knife they called "war contribution." They showed their particular skill whenever a commissary arrived who emptied a barrelful of silver over the tree in order to give it new life. Sitting on top as they did, the ensigns caught most of the silver and let hardly any of it get by them to the lower reaches of the tree, so that those on the lower branches died rather of hunger than by the enemy's blows, while those on top seemed to be safe from both these dangers. This is why I could see everybody in ceaseless movement trying to get up the tree; for each one wanted to conquer for himself a place in the happy, higher regions. Only a few ne'erdo-wells, lazy and debauched, unworthy even of the rations they were drawing, didn't care about rising higher. They reckoned they had enough trouble where they were.

The ambitious ones below looked forward to the fall of their leaders in order to take their places, but when one in ten thousand actually managed to obtain so lofty a place, he only reached it at that miserable age when one is better off sitting by the fire, than fighting against the enemy.

If some man, in any position, honestly carried out his task and bore himself bravely in the midst of danger, he only roused the jealousy of others, or else some deadly or unexpected blow of fate deprived him at the same time of his post and of his life.

Nowhere was the pressure greater than at this particular part of the tree trunk: whoever had a good sergeant or a good quarter-master would not want to lose him and he would necessarily be lost once he got a commission. That is why the old experienced soldiers always lacked preferment and the ones who got on were the paperscratchers, the potmen, the old page-boys, the ruined nobles, the poor relations, the parasites or starvelings, who kept the bread out of the mouths of the men who really deserved promotions. These were the ones who could aspire to an ensign's commission.

Such injustice so discontented an old sergeant major that he started grumbling furiously; but Adelhold, representative of the nobility, addressed him thus:

"Don't you know that everywhere and always military command is entrusted to nobles, because they are better fitted to such functions than anybody else? It is not the old graybeards who defeat the enemy-otherwise we could enroll a company of billygoats. Tell me, my veteran friend, are not the officers of noble birth more respected by the soldiery than those who started out in the ranks? And what kind of military discipline can you get that isn't based on respect? Can not a general more legitimately trust a gentleman than the son of a peasant who has deserted the plow of his father, and never rendered his own parents any service? A nobleman of integrity would rather die than soil his name by treason, desertion, or any other crime. All preference is due to the nobility. . . . Even if one of you is a good soldier, unafraid of the smell of gun powder, able always to strike great blows, he is not able, just because of that. to command others and act with prudence: on the contrary, these qualities are inbred in a nobleman, or else he learns them from his early youth. . . . Besides, the noble has more means than a peasant and these he can use to pay his subordinates, and reinforce the undermanned companies in his command. And if we may believe a current proverb, it would not do at all to set a peasant above a nobleman. In any case the peasant would become much too proud if he were suddenly to be dubbed 'Lord'; for you know it is commonly said:

'No one ever knows a sharper sword Than that of a peasant become a great Lord.'

"If the peasants, by reason of long tradition or honest habit, held in their hands the charges or the commands of war, they would surely not allow the nobles a share in their honors. Why should we be more magnanimous? And then, however well disposed one may be towards you soldiers of fortune, however much one may wish to help you to conquer the highest ranks, you are, as a rule, already so decrepit when you are judged worthy of a better fate, that one necessarily thinks twice before promoting you. For then the ardor of youth is dead within you and you have only one thought in your head: To spare this sickly body that so many tribulations have used and which is no longer much good for war, and to care for it well. By then what do you care who fights and who gathers glory for himself? After all, doesn't a young dog go hunting more gaily than an old lion?"

The sergeant major answered:

"But who would be stupid enough to serve in the army and risk death all the time if he cannot hope to obtain promotion by his good conduct, and to see his loval services rewarded? To hell with this kind of warfare! From this point of view it doesn't matter whether a soldier behaves well or badly; whether he advances bravely to the enemy's fire or runs away! I have often heard our old colonel say that he did not want any soldier in his regiment who did not firmly believe that he could become a general by his good conduct; all the world has to admit that the nations which favor the promotion of common, but loyal soldiers, and which reward their bravery, are generally victorious."

"When one sees real qualities in a brave man they certainly receive recognition," Adelhold answered. "Thus we find men today who, after having handled the plow, the needle, the shoemaker's last, have taken sword in hand, have shown themselves to be outstanding by their exemplary conduct, by their heroism, by their bravery, by their enormous intrepidity and, thus overtaking the common or garden nobles, have raised themselves to the dignity of counts and barons. After all, what were John de Werd, the Imperial general; and the Swedish general, Stallhans, and the Hessian colonel, Jacob Mercier, and Saint-André, who commanded the city of Lipstadt, and a lot of others whom I do not want to name in order to be brief? Thus it is no novelty in our times that humble men but brave ones can attain by war to the highest honors. And this was the case in olden times. Tamerlane was a powerful king, and he terrorized the whole world, even though he only started out by guarding pigs; Agathocles, the tyrant of Syracuse, was the son of a potter; the father of the Emperor Valentinian was a ropemaker; Hugues Capet, son of a butcher, later became king of France; Pizarro, who conquered Peru, also started out guarding pigs, but he became ruler of the Western Indies and handled gold by the hundredweight."

"All this is very well," rejoined the old soldier. "But what's the use! I see very clearly that the way to this or that honor is closed to men of my sort by the nobility. The squire and the gentleman can get a good job as soon as he leaves his shell, and they fill posts that we could never aspire to; even though we have done more than this or that nobleman who struts about today and calls himself a colonel.

"Among the peasants more than one good mind goes to waste because lack of means has kept it from any studies. In the same way more than one brave soldier grows old under the musket, who would do better, and would be more justly employed commanding a regiment; and in such a position would know how to render great services to his general."

I simply could not listen any longer to the grumbles of this old ass. His complaints sounded hollow, when you could see that he himself often struck the poor soldiers like dogs. I looked again towards the trees that covered the countryside, and I saw them move and charge each other. The soldiers on the branches were thrown to the ground, sometimes in bunches, and there they died at once. In the blink of an eye they passed from life to death; in less time than I need to say it, one lost an arm, another a leg, a third his very head. And, looking better, I thought I saw that all these trees before me were really only one tree, on top of which sat enthroned Mars, the god of War, and whose branches spread through the length and breadth of Europe. It seemed as if this tree could have covered the whole world with its shade. But envy

and hatred, suspicion and injustice, pride, vanity and ambition, and other beautiful virtues of the same sort, blew hard upon it, as did the bitter northern winds, so that the great tree seemed rickety and threadbare, and almost transparent.

2. A NEW WORLD

With central Europe in the throes of war, another world was rising to its east, still barbarous, still in some eyes almost colonial territory, but offering vast opportunities for trade and for the skills of the west. Between 1633 and 1639, the Duke of Holstein sent two embassies to Muscovy and beyond it into Asia, to sound out the possibilities of these lands. The reports they brought back leave the impression of places whose evolution was several centuries behind that of the west, the language of the Holsteiners reminding one of that which we can find in the chronicles of nine-teenth century African explorers and exploiters.

Even while the good Germans wrote, however, the lands which they had scouted out were being forged into a powerful state by the rulers of the Romanov family. Halting legal and administrative reforms would only begin to show after the accession of Peter I in 1689; but his predecessors already encouraged the westernization if not of the country, at least of its army and technology. Foreigners were encouraged to enter the service of the Tsar, not least officers like Patrick Gordon of Auchleuchries, whose memoirs suggest that Russian attitudes to visitors have not changed too much in 300 years.

Muscovy

Livonia is, in all parts, very fertile, and particularly in wheat. For though it hath suffered much by the *Muscovites*, yet it is now more and more reduc'd to tillage, by setting the Forests afire, and sowing in the ashes of the burnt Wood and Turf, which for three or four years produce excellent good Wheat, and with great increase, without any Dung. . . . There is also abundance of Cattel, and Fowl so cheap, that many times we bought a young Hare for four pence; a Heath-Cock for six, and accordingly others, so that it is much cheaper living there than in *Germany*.

The Inhabitants were a long time Heathens, it being in the 12 age that the rayes of the Sun of righteousness began to break in upon them, occasion'd by the frequentation of certain Merchants of Bremen, and the Commerce they were desirous to establish in those parts. About the year 1158 one of their Ships having been forc'd by a Tempest into the Gulf of Riga, which was not yet known, the Merchants agreed so well with the Inhabitants of the Country, that they resolv'd to continue their Traffick there, having withall, this satisfaction, that, the people being very simple, they thought it would be no hard matter to reduce them to Christianity. Menard, a Monk of Segeberg, was the first that preach'd the Gospel to them, and was made first Bishop of Livonia, by Pope Alexander III in the year 1170. Menard was suc-

From The Voyages and Travells of the Ambassadors Sent by Frederick Duke of Holstein, to the Great Duke of Muscovy, and the King of Persia (London, 1669).

ceeded in the Bishoprick of Livonia, by Bertold, a Monk, of the Order of white Friers; but he, thinking to reduce those people rather by Arms than the word of God, met with a success accordingly, for having incens'd them, they kill'd him in the year 1186 and with him 11000 Christians. Albert, a Canon of Bremen, succeeded Bertold, in the Bishoprick. He laid the first foundations of the City of Riga, and of the Order of the Friers of the short sword, by authority from Pope Innocent the third, and by vertue of a power he had given them, to allow them the third part of that they should Conquer from the Barbarians. . . . This Religious Profession was . . . iovn'd to the Order of St. Mary of Jerusalem, in the person of Herman Balk, Grand-Master of Prussia, in the year 1238. And it is since that time that the Master of Livonia had a dependence on the Grand-Master of Prussia. . . .

All the Champain Countrey, of the two Provinces of Letthie and Esthonie, is to this day people with these Barbarians. who have nothing of their own, but are slaves, and serve the Nobility in the Countrey, and the Citizens in Cities. They are called Unteutche, that is, not-Germans, because their language was not understood by the Germans, who went to plant in those quarters; though that of Letthie hath nothing common with that of Esthonie, no more than there is between them, as to their Cloaths and manner of Life. The Women of Esthonie wear their Petticoats very narrow, and without any folds, like sacks, adorn'd above on their backs with many little brass Chains, having at the ends Counters of the same metal, and below set out with a certain lacing of yellow glass. Those who would express a greater bravery, have about their Necks a Necklace

of plates of silver of the bigness of a Crown, or half-Crown, and upon the breast, one as big as a round Trencher, but not much thicker than the back of a knife.

Maids wear nought on their heads, Summer nor Winter, and cut their hair as the men do, letting it fall negligently down about the head. Both Men and Women are clad with a wretched stuff made of Wool, or a coarse Linnen. They are yet unacquainted with Tannage, so that, in Summer, they have barks of Trees about their feet, and in the Winter, raw Leather of a Cow's hide. Both Men and Women do ordinarily carry all the Wealth they have about them.

Their Ceremonies of marriage are very odd. When a Country fellow marries a Lass out of another Village, he goes a hors-back to fetch her, sets her behind him, and makes her embrace him with the right hand. He hath in his hand a stick cleft at the top, where he puts a piece of brass money, which he gives to him who opens the wicket, through which he is to pass. Before, rides a man that playes upon the Bag-pipe, as also two of his friends, who, having naked swords in their hands, give two stroaks therewith, cross the Door of the House, where the marriage is to be consummated, and then they thrust the point of one of the swords into a beam, over the Bridegroom's head, which is done to prevent Charms, which, they say, are ordinary in that Country. 'Tis to the same end that the Bride scatters little pieces of Cloath, or red Serge by the way, especially where cross-ways meet, near Crosses, and upon the Graves of little Children dead without baptism, whom they bury in the Highways. She hath a Veil over her face while she is at the Table, which is not long; for, as soon almost as the Guests

are set down, the married couple rise, and go to bed. About two hours after they get up, and are brought to sit down at the Table. Having drunk and danc'd till such time as they are able to stand no longer, they fall down on the floor, and sleep altogether like so many Swine.

We said the Gospel was preach'd in Livonia in the 12 age; but the Livonians are never the better Christians for it. Most of them are only such in name, and can hardly vet abstain from their Heathenish Superstitions. For though they are Lutherans, by profession, and that there is hardly a Village but hath its Church and Minister; yet are they so poorly instructed, and so far from regeneration, that it may be said, Baptism excepted, they have not any Character of Christianity. They very seldom go to Sermons, and never almost Communicate. They excuse their backwardness in frequenting the Sacraments, by alleging the great slavery they are in, which, they say, is so insupportable, that they have not time to mind their Devotions. If they go at any time to Sermon, or to the Communion, it is by force, or upon some other particular accompt. . . . 'Tis true, the gross and inexcusable ignorance of most of the Pastors in those quarters, who might well come to be Catechiz'd themselves, hath contributed much to the obduration of those poor people: but the late King of Sueden hath taken order, therein enjoyning, by a severe Ordinance, the Bishop of the Province, who hath his residence in the Cathedral Church of Reuel, to convocate a Synod once a year, for the regulation of Church affairs, and then to examine, not only the Recipiendaries, but also the Pastors themselves, thereby to oblige them to apply themselves to the constant study of the Holy Scripture.

It must be acknowledg'd, the slavery these people are in is great, and indeed insupportable; but it is true withall; that upon the least liberty given them, they would break out into any extravagance. For being perswaded that the Predecessors have been Masters of the Country, and that only force hath enslav'd them to the Germans, they cannot forbear their resentments of it, and discovering, especially in their drink, if any opportunity of regaining their liberty should offer it self, a readiness to prosecute it. Of which they gave an evident example, when, upon the irruption of Colonel Bot, the Peasants would side with the Enemy, and head together, to secure their Masters and deliver them up to the Polanders.

They believe there is another life after this; but their imaginations of it are very extravagant. A *Livonian* woman, being present at her husband's burial, put a Needle and Thread into the Grave, giving this reason for it, that, her husband being to meet, in the other World, with persons of good Rank, she was asham'd he should be seen with his Cloaths rent. . . .

These customs favour of their antient Idolatry. The Ministers do all they can to weed it out of them by little and little; to which end we saw, at Narva, the Catechism, Epistles, and Gospels, with their explications, which Henry Stahl, Superintendent of Ecclesiastical affairs in those parts (a person much esteem'd for his Learning and pains in instructing those Barbarians) had caused to be translated and Printed in their Language, to give them some apprehentions of Christian Religion. But Idolatry and Superstition are too deeply rooted in them, and their stupidity and stubborness too great to give way to any hope, that they will ever be susceptible of instruction. They do their

devotions commonly upon hills, or neer a tree they make choice of to that purpose, and in which they make several incisions, bind them up with some red stuff, and there say their prayers, wherein they desire only temporal blessings. Two leagues from Kunda, between Reuel and Narva, there is an old ruin'd Chapel, whither the Peasants go once a year on Pilgrimage, upon the day of our Lady's Visitation. Some put off their cloaths; and in that posture having kneel'd by a great stone that is in the midst of the Chapel, they afterwards leap about it, and offer it Fruits and Flesh, recommending the preservation of themselves and their Cattel to it for that year. This piece of devotion is concluded with eating and drinking, and all kind of licentiousness, which seldom end without quarrels, murthers, and the like disorders.

They have such an inclination to Sorcery, and think it so necessary for the preservation of their Cattel, that Fathers and Mothers teach it their Children, so that there is scarce any Peasant but is a Sorcerer. They all observe certain superstitious Ceremonies, by which they think to elude the affects of it, upon which accompt it is, that they never kill any Beast, but they cast somewhat of it away, nor never make a Brewing, but they spill some part of it, that the Sorcery may fall upon that. They have also a custome of rebaptizing their Children, when, during the first six weeks after their birth, they chance to be sick or troubled with fits, whereof they think the cause to be, that the name, given them at their baptism, is not proper for them. Wherefore they give them another; but in regard this is not only a sin, but a crime which the Magistrate severely punishes in that Country, they conceal it.

As they are stubborn in their superstitions, so are they no less in the exact ob-

servation of their Customs. To which purpose we had a very pleasant, but true, story, related to us at Colonel de la Barr's, concerning an old Country fellow. Being condemn'd, for faults enormous enough, to lye along upon the ground, to receive his punishment, and Madam de la Barre, pittving his almost decrepit age, having so far interceded for him, as that his corporal punishment should be chang'd into a pecuniary mulct of about 15. or 16. pence, he thank'd her for her kindness, and said, that, for his part, being an old man, he would not introduce any novelty, nor suffer the Customs of the Country to be alter'd, but was ready to receive the chastisement which his Predecessors had not thought much to undergo, put off his cloaths, layd himself upon the ground, and receiv'd the blows according to his condemnation.

This is accounted no punishment, but an ordinary chastisement in Livonia. For, the people, being of an incorrigible nature, must be treated with that severity, which would elsewhere be insupportable. They are not permitted to make any purchase, and to prevent their so doing, they have only so much ground to manage, as will afford them a subsistence. Yet will they venture to cut down wood in some places of the Forests, and, having order'd the ground, sow wheat in it, which they hide in pits under ground, to be secretly sold. When they are taken in this, or any other fault, they make them strip themselves naked down to the hips, and to lye down upon the ground, or are ty'd to a post, while one of their Camerades beats them with a Switch, or Hollywand, till the blood comes of all sides; especially when the Master says "Beat him till the skin falls from the flesh."

Nor are they suffer'd to have any money; for as soon as it is known they have any, the Gentlemen and their Officers, who are paid by the Peasantry, take it from them, nav force them to give what they have not. Which cruelty of the Masters puts these poor people many times into despair, whereof there happened a sad example. A Peasant press'd by his Officer to pay what he neither had, not ought, and being depriv'd of the means whereby he should maintain his Family, strangled his Wife and Children, and when he had done hung himself up by them. The Officer coming the next day to the house, thinking to receive the mony, struck his head against the man's feet that was hanging, and so perceiv'd the miserable execution, whereof he was the cause.

MOSCOW

But it were not handsome to leave Moscou without giving some account of that great City, the Metropolis of all Muscovy, to which it gives the name, as it takes its own from the River Moska. This River, which passes through, and divides all the rest of the City, from that quarter of it which is called Strelitz a Slaueda, rises out of the Province of Tuere, and having joyn'd its waters with those of the Occa, near Columna, it falls together with the other, about half a league thence, into the Wolga. The City is elevated 55 degr. 36 min. its longitude 66 degrees, in the midst of all the Country, and almost at an equal distance from all the Frontiers, which is above 120 German leagues. It is about three leagues about, and, no doubt, hath been heretofore bigger than it is now. Mathius de Michou, a Canon of Cracovia, who flourish'd at the beginning of the last age, says, that, in his time, it was twice as big as the City of Prague. The Tartars of Crim and Precop, burnt it in the year 1571. and the Poles set it a-fire in the year 1611. so as that there was nothing left of it but the Castle; and yet now there are numbred in it above 40000 houses, and it is out of all controversie one of the greatest Cities in *Europe*.

'Tis true, that, the Palaces of great Lords, and the Houses of some rich Merchants excepted, which are of Brick or Stone, all the rest are of Wood, are made up of beams, and cross-pieces of Firr laid one upon another. They cover them with barks of trees, upon which they sometimes put another covering of Turfes. The carelesness of the Muscovites, and the disorders of their housekeeping are such, that there hardly passes a moneth, nay not a week, but some place or other takes fire, which, meeting with what is very combustible, does in a moment reduce many houses, nay, if the wind be any thing high, whole streets into ashes. Some few days before our arrival, the fire had consumed the third part of the City; and about 5 or 6 years since, the like accident had near destroy'd it all. To prevent this, the Strelits of the Guard, and the Watch, are enjoyn'd, in the night time to carry Poleaxes, wherewith they break down the houses adjoyning to those which are afire, by which means they hinder the progress of it, with much better success than if they attempted the quenching of it. And that it may not fasten on other more solid structures, the doors and windows are very narrow, having shutters of Lattin, to prevent the sparks and flashes from getting in. Those who have their houses burnt, have this comfort withall, that they may buy houses ready built, at a market for that purpose, without the white-Wall, at a very easy rate, and have them taken down, transported, and in a short time set up in the same place where the former stood.

The streets of *Moscou* are handsome, and very broad, but so dirty, after rain hath ever so little moisten'd the ground, that it were impossible to get out of the dirt, were it not for the great Posts, which set together make a kind of bridge, much like that of the *Rhin*, near *Strasbourg* which bridges, in foul weather, serve for a kind of pavement.

The City is divided into four quarters, or circuits, whereof the first is called Cataygorod, that is, the mid-City, as being in the midst of the others. This quarter is divided from the rest by a brickwall, which the Muscovites call crasne stenna, that is, red stone. The Moska passes on the South-side of it, and the River Neglina, which joyns with the other behind the Castle, on the North side. The Great Duke's Palace, called Cremelena, and which is of greater extent than many other ordinary Cities, takes up almost one half of it, and is fortify'd with three strong walls, and a good ditch, and very well mounted with Canon. In the midst of the Castle are two Steeples, one very high, and cover'd with Copper gilt, as all the other Steeples of the Castle are. This Steeple is called Juan Welike, that is, the Great John. The other is considerable only for the Bell within it, made by the Great Duke Boris Gudenou, weighing 33600 pounds. It is not toll'd, but upon great Festivals, or to honour the entrance and audience of Ambassadors: but to stir it there must be 24 men, who pull it by a Rope that comes down into the Court, while some others are above to help it on by thrusting. The Great Duke's Palace stands towards the further side of the Castle, with that of the Patriarch, and appartements for several Bojares, who have places at

Court. There is also lately built a very fair Palace of stone, according to the *Italian* Architecture, for the young Prince; but the Great Duke continues still in his wooden Palace, as being more healthy than stone-structures. The Exchequer, and the Magazine of Powder and provisions are also within the Castle.

There are also within it two fair Monasteries, one for men, the other for women, and above fifty Churches and Chapels, all built of stone; among others, those of the *B. Trinity, St. Mary's, St. Michael's*, wherein are the Sepulchres of the Great Dukes, and *St. Nicholas's*.

At the Castle-Gate, but without the Walls, on the South-side, is a fair Church Dedicated to the *B. Trinity*, and commonly called *Jerusalem*. When it was finish'd, the Tyrant *John Basilouits*, thought it so magnificent a structure, that he caus'd the Architect's eyes to be put out, that he might not afterwards do any thing that should be comparable to that. Near this Church are two great pieces of Canon, with the mouths towards that street by which the *Tartars* were wont to make their irruptions; but these pieces are now dismounted, and useless.

In the spacious place, before the Castle, is the chief Market of the City kept; all day it is full of people, but especially slaves, and idle persons. All the Marketplace is full of Shops, as also all the street abutting upon it: but every Trade hath a station by it self, so as the Mercers intermingle not with the Linnen or Wollen-Drapers, nor Goldsmiths with Sadlers, Shoemakers, Taylors, Furriers, and the like, but every Profession and Trade hath its proper street: which is so much the greater convenience, in that a man does, of a sudden, cast his eye on all he can desire. Sempstresses have their shops in the midst of the Market, where

there is also another fort of Women Traders, who have Rings in their mouths, and, with their Rubies and Turquoises, put off another commodity which is not seen in the Market. There is a particular street where are sold the Images of their Saints. 'Tis true, these go not under the name of Merchandise, among the *Muscovites*, who would make some difficulty to say they had *bought* a Saint; but they say, they receive them by way of Exchange or Trucking, for money: and so when they buy, they make no bargain, but lay down what the Painter demands.

There is yet another place, in this quarter, called the *Hairmarket*, because the Inhabitants go thither to be trimm'd, by which means the place comes to be so cover'd with hair, that a man treads as softly as if it were on a Feather-bed. Most of the principal *Goses*, or Merchants, as also many *Knez* and *Muscovian* Lords have their houses in this first circuit.

The second quarter is called Czaargorod, that is, Czaar's Citie, or the Citie-Royal, and includes the former as it were in a Semi-circle. The little River Neglina passes through the midst of it, and it hath its particular Wall, called Biola stenna, that is, the white Wall. In this quarter is the Arsenal, and the place, where Guns and Bells are cast, which is called Pogganabrut, the management whereof the Great Duke hath bestow'd on a very able man, one John Valk, born at Nuremberg, whom he sent for out of Holland, for this reason, that he was the first who found a way to discharge a Bullet of sixteen pound weight with five pound of pouder. The Muscovites who have-wrought under this man, have so well learnt the mystery of founding that now they are as expert at it as the most experienc'd Germans.

In this quarter also there live many *Knez*, Lords, *Sinbojares*, or Gentlemen, and a great number of Merchants, who drive a Trade all the Countrey over, and Trades-men, especially Bakers. There are also some Butchers shambles, and Tipling-houses, which sell Beer, Hydromel, and Strong-water, Store-Houses of Wheat, Meal shops, and the Great Duke's stables.

The third quarter is called Skoradom. and includes the quarter called Czaargorod, from the East, along the Northside, to the West. The Muscovites affirm, that this quarter was five German Leagues about, before the City was burnt by the Tartars, in the year 1571. The little River Jagusas passes through it, and in its way falls into the Mosca. In this quarter is the Market for Wood and Houses before mentioned; where you may have Houses ready made, which may be taken asunder, transported thence, and set up any where else, in a short time, and with little pains and charge, since they consist only of beams, and posts, set one upon the other, and the vacuities are fill'd up with Mosse.

The fourth quarter is called Strelitz a Slauoda, because of the Strelits, or Musketiers of the Great Duke's Guard, who live in it. It is situated towards the South of Cataygorod, on the other side of the Mosca, upon the Avenues of the Tartars. Its Ramparts and Bastions are of Wood. The Great Duke Basili Juanouits, father of Basilouits, who built this quarter, design'd it for the quarters of such Soldiers, as were strangers, as Poles, Germans, and others, naming that place Naeilki, or, the quarter of Drunkards, from the word Nali, which signifies, powre out: for, these strangers being more inclin'd to drunkenness than the Muscovites, he would not have his own people, who were apt enough to debauch themselves, to become so much the worse by the others bad example. Besides the Soldiery, the poorer sort of the people have their habitations in this quarter.

There is, in the City and Suburbs of Moscou, a very great number of Churches, Monasteries and Chapels. In the former Impression of these Travels, we said, there were above fifteen hundred; but whereas John Lewis Godefrey, Author of the Archontologia Cosmica, thinks that number so excessive, that he sticks not to speak of it as a thing not likely to be true, I must indeed needs acknowledge, that I was much mistaken, and, now

affirm for certain, that where I said there were 1500 there are above 2000. No *Muscovite* that hath liv'd at *Moscou*, nay no stranger, any thing acquainted with that City, but will confirm this truth, as knowing, there is no Lord but hath his private Chapel, nor any Street but hath many of them. 'Tis true, they are most of them very small ones, and but fifteen foot square; nay, before the Patriarch commanded they should be built of Stone, they were all of Wood: but that hinders not, but that the number of them may amount to what we have said.

Passages from the Diary of General Patrick Gordon of Auchleuchries

September 9, 1661

On Monday, it was ordered that I should be enrolled for major, Pawl Menezes for captaine, William Hay for lievtennant, and John Hamilton for ensignie, to foot, under the regiment of Colonell Daniell Crawfuird, and a gratuity for our comeing in or welcome to the countrey, being to me twenty fyve rubles in money, and as much in sables, foure ells of cloth, and eight ells of damask: the rest accordingly, and our monthly pay equall with others of these charges. But the chancellour, [That is, as Gordon immediately afterwards calls him, the dyak, or scribe.] being a most corrupt fellow, delayed us from day to day in expectation of a bribe, which is not only usuall here, but, as they think, due; whereof I haveing no information, after expostulateing with him twice or thrice, and receiving no satisfactory answers, I went to the Boyar and complained; who, with a light check, ordered him againe,

which incensing the Diack more, he delayed us still. But when, after a second complaint and order wee received no satisfaction, I went a third tyme to the Boyar, and very confidently told him, I knew not whether he or the Diack had the greatest power, seeing he did not obey his so many orders. Whereat, the Boyar, being vexed, caused stop his coach (he being on his way out of the towne to his countrey house) and caused call the Diack; whom, being come, he tooke by the beard and shak'd him three or foure tymes, telling him, if I complained againe, he would cause knute him. The Boyar being gone, the Diack came to me, and began to scold; and I, without any respect (whereof they gett but ever too much here), paved him home in his owne coyne, telling him that I cared not whither they gave me any thing or no, if they would but permitt me to go out of the countrey againe. With which resolution I went to the

From The Diary of General Patrick Gordon of Auchleuchries (Aberdeen, 1859).

Slobod, and now began in good earnest to consider how I might ridd myself of this countrey, so farr short of my exspectation, and disagreeing with my humour. For, haveing served in such a countrey [Poland and Sweden] and amongst such people, where strangers had great respect and were in great reputation, and even more trust as the natives themselves; and where a free passage, for all deserving persons, lay open to all honour, military and civill; and where, in short tyme, by good husbandry and industry, an estate might be gained; and, in marrying, no scruple or difference was made betwixt the natives and strangers, whereby many have attained to great fortunes, governements, and other honourable and profitable commands; as indigenation, also, being usually conferred on well qualifyed and deserving persons; where a dejected countenance or submissive behaviour is noted for cowardice and faintheartednes. and a confident, majestick, yet unaffected, comportment for virtuous generosity; the peoples high mindednes being accompanied and qualifyed with courteousnes and affability, wherein, meeting with the lyke humours, they contend for transandency. Whereas, on the contrary, I perceived strangers to be looked upon as a company of hirelings, and, at the best (as they say of women) but necessaria mala; no honours or degrees of preferment to be exspected here but military, and that with a limited command, in the attaining whereof a good mediator or mediatrix, and a piece of money or other bribe, is more availeable as the merit or sufficiency of the person; a faint heart under faire plumes, and a cuckoe in gay cloths, being as ordinary here as a counterfeited or painted visage; no marrying with natives, strangers being looked upon by the best sort as scarcely Christians, and by the plebevans as meer pagans; no indigenation without ejeration of the former religion and embraceing theirs; the people being morose and niggard, and vet overweening and valuing themselves above all other nations; and the worst of all, the pay small, and in a base copper coyne, which passed at foure to one of silver, so that I foresaw an impossibility of subsistance, let be of enriching my self, as I was made beleeve I should, befor I came from Polland. These, and many other reasons were but too sufficient to setle my self for disengageing my self of this place. The only difficulty was, how to attaine to it, which troubled me very much; every one, of whom I asked advice, alleadging it impossible. However I resolved to try and not to take any of their money, albeit I had gotten at Plesko and Novogrod some for expenses on the way.

Hearing that the Boyar was to stay a weeke out of the citty, I resolved not to go to the prikase untill he should returne, and then give up a petition or request for my dismission; bringing in for my reasons, that the ambassadour Zamiaty Fiodorovits Leontiuf, with whom I capitulated in Polland, had promised me to be paid in silver or other equivalent coine, which I found farr otherwise now, and that I found the constitution of my body not agreeable with this climate. But the Diack, getting notice of my intentions, and fearing the wrath of the Boyar at his returne, colluded with my Colonell to entice me into the towne; so that I being come one morning to pay my respects to my Colonnel, he desired me to accompany him to the towne, which after some tergiversation I did; and being come and takeing a walke on the piazza, a writer, with a couple of catch-

poles with him, came to me and desired me to come into the prikase, which I refused. He told me, that he had order to force me, if I would not come fairely. Being come into the chieffe writer. Tichon Fiodorovits Motiakin received me very courteously, desireing me to sitt downe; and then, after some very civill discourse, presented me with orders to diverse offices for money, sables, damask, and cloth for me and those who came with me: which I absolutely refused, telling him that I would stay untill the Boyar returned, with whom I hoped to prevaile and procure my dismission out of the countrey. This writer, being a courteous person, began to reason with me very civilly, showing me many reasons to divert me from such resolutions; and haveing sent for my Colonell (who was not farr to seeke) they both tooke me aside, and among other reasons told me, that it would be my ruine to desire out of the countrey, because the Russe would presume that comeing from such a countrey, with which they were in open warr, and being a Roman Catholick, I was come to spy out their countrey only. and then returne; and that, if I mentioned any such thing, they would not only not dismiss me, but send me to Sibiria or some remote place, and that they would never trust me thereafter. This, indeed, did startle me, considering the nature of the people; so that, with great reluctancy, I consented to accept of the orders for our comeing into the countrev.

September 17.

I got orders to receive from a Russe seven hundred men, who were to be in our regiment, being runneway sojours out of severall regiments, and fetched back from diverse places. Haveing received these, I marched through the Sloboda of the strangers to Crasna Cella, [The German editors explain *cella* or *selo* to be a village with a church—what in Scotland, would have been known to Gordon as a *kirktown*.] where wee gott our quarters, and exercized these souldiers twice a day in fair weather. I received money, twenty fyve rubles, for my welcome; and the next day, sables, and two dayes thereafter, damask and cloth.

September 25

I received a months meanes, in cursed copper money, as did these who came along with me.

About thirty officers, most whereof I had bespoke in Riga, came to Mosko, most of them being our countreymen, as Walter Airth, William Guild, Georg Keith, Andrew Burnet, Andrew Calderwood, Robert Stuart, and others, most whereof were enrolled in our regiment.

October

I marched, by order, into the utmost great towne, and to the Sloboda Zagrodniky, and tooke up my quarters.

At the first, some contentions did fall out betwixt the officers and sojours, with the rich burgesses, who would not admitt them into their houses. Amongst the rest, a merchant, by whom my quarters were taken up, whilst my servants were cleansing the inner room, he breake downe the oven in the utter roome, which served to warme both, so that I was forced to go to another quarter. But, to teach him better manners, I sent the profos [Profos, that is, provost—the provost marshal.] to quarter by him, with twenty prisoners and a corporalship of sojours, who, by connivence, did grievously plague him a

weeke; and it cost him near a hundred dollers, befor he could procure an order out of the right office to have them removed, and was well laught at besides for his uncivility and obstinacy.

3. MERCANTILISM AND OTHER NOVELTIES

With growing economic activity, the seventeenth century developed an intense and novel economic awareness. Trade was seen to play such an important part in the wealth—and hence the power—of all countries, that statesmen and publicists considered it with more attention than ever before. Repeated attempts were made to attract bullion, to secure the greatest possible share of the profits of the carrying trade, to attract craftsmen whose skills were expected to improve the country's industrial position. The economic ideal for a country was seen as self-sufficiency at home, combined with a vigorous export trade which would bring bullion (i.e., riches) into the country; and a great deal of legislation tried to implement the ideal. These mercantilistic ideas, as they are called, would alter and develop with time; but the economic activity with which they were connected also encouraged the growth of a numerous and increasingly self-confident bourgeoisie. The rising class would soon make its presence felt, and its down-to-earth rationalism would affect cultural attitudes in time to come.

Thomas Mun

The mercantilist theory of national wealth appears very clearly in the following passage from Thomas Mun's book, England's Treasure by Foreign Trade (1664). Mun (1571–1641), who was a director of the English East India Company, was not interested in the crude mercantilism that concentrated on getting as much gold and silver as possible and had no idea of the real meaning of a country's import-export balance. He believed that England's real wealth lay in trade, in the volume and the profits of her exports, and he put his ideas in the little book that was not published until some years after his death.

THE MEANS TO ENRICH THE KINGDOM, AND TO INCREASE OUR TREASURE

Although a Kingdom may be enriched by gifts received, or by purchase taken from some other Nations, yet these are things uncertain and of small consideration when they happen. The ordinary means therefore to increase our wealth and treasure is by Foreign Trade, wherein we must ever observe this rule: to sell more to strangers yearly than we consume of theirs in value. For suppose that when this Kingdom is plentifully served with the Cloth, Lead, Tin, Iron, Fish and other native commodities, we do yearly export the overplus to foreign Countries to the

From Thomas Mun, England's Treasure by Foreign Trade (New York, 1895), pp. 7-27.

value of twenty two hundred thousand pounds; by which means we are enabled beyond the Seas to buy and bring in foreign wares for our use and Consumptions, to the value of twenty hundred thousand pounds; by this order duly kept in our trading, we may rest assured that the Kingdom shall be enriched yearly two hundred thousand pounds, which must be brought to us in so much Treasure; because that part of our stock which is not returned to us in wares must necessarily be brought home in treasure.

For in this case it cometh to pass in the stock of a Kingdom, as in the estate of a private man; who is supposed to have one thousand pounds yearly revenue and two thousand pounds of ready money in his Chest: If such a man through excess shall spend one thousand five hundred pounds per annum, all his ready money will be gone in four years; and in the like time his said money will be doubled if he take a Frugal course to spend but five hundred pounds per annum; which rule never faileth likewise in the Commonwealth, but in some cases (of no great moment) which I will hereafter declare, when I shall shew by whom and in what manner this balance of the Kingdom's account ought to be drawn up yearly, or so often as it shall please the State to discover how much we gain or lose by trade with foreign Nations. But first I will say something concerning those ways and means which will increase our exportations and diminish our importations of wares; which being done, I will then set down some other arguments both affirmative and negative to strengthen that which is here declared, and thereby to shew that all the other means which are commonly supposed to enrich the Kingdom with Treasure are altogether insufficient and mere fallacies.

THE PARTICULAR WAYS AND MEANS
TO INCREASE THE EXPORTATION
OF OUR COMMODITIES, AND TO
DECREASE OUR CONSUMPTION
OF FOREIGN WARES

The revenue or stock of a Kingdom by which it is provided of foreign wares is either Natural or Artificial. The Natural wealth is so much only as can be spared from our own use and necessities to be exported unto strangers. The Artificial consists in our manufactures and industrious trading with foreign commodities, concerning which I will set down such particulars as may serve for the cause we have in hand.

- 1. First, although this Realm be already exceeding rich by nature, yet might it be much increased by laying the waste grounds (which are infinite) into such employments as should no way hinder the present revenues of other manured lands, but hereby to supply ourselves and prevent the importations of Hemp, Flax, Cordage, Tobacco, and divers other things which we fetch from strangers to our great impoverishing.
- 2. We may likewise diminish our importations, if we would soberly refrain from excessive consumption of foreign wares in our diet and rayment, with such often change of fashions as is used so much the more to increase the waste and charge; which vices at this present are more notorious amongst us than in former ages. Yet might they easily be amended by enforcing the observation of such good laws as are strictly practiced in other Countries against the said excesses: where likewise by commanding their own manufactures to be used, they prevent the coming in of others, without prohibition, or offense to strangers in their mutual commerce.

3. In our exportations we must not only regard our own superfluities, but also we must consider our neighbors' necessities, that so upon the wares which they cannot want, nor yet be furnished thereof elsewhere, we may (besides the vent of the Materials) gain so much of manufacture as we can, and also endeavor to sell them dear, so far forth as the high price cause not a less vent in the quantity. But the superfluity of our commodities which strangers use, and may also have the same from other Nations, or may abate their vent by the use of some such like wares from other places, and with little inconvenience: we must in this case strive to sell as cheap as possible we can, rather than to lose the utterance of such wares. For we have found of late years by good experience, that being able to sell our Cloth cheap in Turkey, we have greatly increased the vent thereof, and the Venetians have lost as much in the utterance of theirs in those Countrys. because it is dearer. And on the other side a few years past, when by the excessive price of Wools our Cloth was exceeding dear, we lost at the least half our clothing for foreign parts, which since is no otherwise (well near) recovered again than by the great fall of price for Wools and Cloth. We find that twenty five in the Hundred less in the price of these and some other wares, to the loss of private mens revenues, may raise above fifty upon the hundred in the quantity vented to the benefit of the publique. For when Cloth is dear, other Nations do presently practice clothing, and we know they want neither art nor materials to this performance. But when by cheapness we drive them from this employment, and so in time obtain our dear price again, then do they also use their former remedy. So that by these alterations we learn, that it is in vain to expect a greater revenue of our wares than their condition will afford, but rather it concerns us to apply our endeavors to the times with care and diligence to help ourselves the best we may, by making our cloth and other manufactures without deceit, which will increase their estimation and use.

4. The value of our exportations likewise may be much advanced when we perform it ourselves in our own ships. For then we get not only the price of our wares as they are worth here, but also the Merchants gains, the charges of insurance, and freight to carry them bevond the seas. As for example, if the Italian Merchants should come hither in their own shipping to fetch our Corn, our red Herrings or the like, in this case the Kingdom should have ordinarily but 25 s. for a quarter of Wheat, and 20 s. for a barrel of red herrings, whereas if we carry there wares ourselves into Italy upon the said rates, it is likely that we shall obtain fifty shillings for the first, and forty shillings for the last, which is a great difference in the utterance or vent of the Kingdoms stock. And although it is true that the commerce ought to be free to strangers to bring in and carry out at their pleasure, yet nevertheless in many places the exportation of victuals and munition are either prohibited, or at least limited to be done only by the people and Shipping of those places where they abound.

5. The frugal expanding likewise of our own natural wealth might advance much yearly to be exported unto strangers; and if in our payment we will be prodigal, yet let this be done with our own materials and manufactures, as Cloth, Lace, Embroideries, Cutworks and the like, where the excess of the rich may be the employment of the poor, whose labours notwithstanding of this kind, would be more

profitable for the Commonwealth, if they were done to the use of Strangers.

- 6. The Fishing in his Majesties seas of England, Scotland, and Ireland is our natural wealth, and would cost nothing but labour, which the Dutch bestow willingly and thereby draw yearly a very great profit to themselves by serving many places of Christendom with our Fish, for which they return and supply their wants both of foreign Wares and Money, besides the multitudes of Mariners and Shipping, which hereby are maintain'd, whereof a long discourse might be made to shew the particular management of this important business. Our Fishing plantation likewise in New England, Virginia, Greenland, the Summer Islands and the Newfoundland, are of the like nature, affording much wealth and employments to maintain a great number of poor, and to increase our decaying trade.
- 7. A Staple or Magazine for foreign Corn, Indigo, Spices, Raw silks, Cotton, Wool or any other commodity whatsoever, to be imported will increase Shipping, Trade, Treasure, and the Kings customs, by exporting them again where need shall require, which course of Trading hath been the chief means to raise Venice, Genoa, the low Countrys, with some others; and for such a purpose England stands most commodiously, wanting nothing to this performance but our own diligence and endeavor.
- 8. Also we ought to esteem and cherish those trades which we have in remote or far Countrys, for besides the increase of Shipping and Mariners thereby, the wares also sent thither and receiv'd from thence are far more profitable unto the kingdom than by our trades neer at hand; As for example; suppose Pepper to be worth here two Shillings the pound constantly, if then it be brought from the

Dutch at Amsterdam, the Merchant may give there twenty pence the pound and gain well by the bargain, but if he fetch this Pepper from the East Indies, he must not give above three pence the pound at the most, which is a mighty advantage, not only in that part which serveth for our own use, but also for the great quantity which (from hence) we transport vearly unto divers other Nations to be sold at a higher price: whereby it is plain, that we make a far greater stock by gain upon these Indian Commodities, than those Nations do where they grow, and to whom they properly appertain, being the natural wealth of their Countries. But for the better understanding of this particular, we must ever distinguish between the gain of the Kingdom, and the profit of the Merchant; for although the Kingdom payeth no more for this Pepper than is before supposed, nor for any other commodity bought in foreign parts more than the Stranger receiveth from us for the same, yet the Merchant payeth not only that price, but also the freight, insurance, customs, and other charges which are exceeding great in these long voyages; but vet all these in the Kingdoms accompt are but commutations among ourselves, and no privation of the Kingdoms stock, which being duly considered, together with the support also of our other trades in our best Shipping to Italy, France, Turkey, the East Countries and other places, by transporting and venting the wares which we bring yearly from the East Indies. It may well stire up our utmost endeavors to maintain and enlarge this great and noble business, so much importing the Publique wealth, Strength, and Happiness. Neither is there less honour and judgment by growing rich (in this manner) upon the stock of other Nations, than by an industrious increase of

our own means, especially when this later is advanced by the benefit of the former, as we have found in the East Indies by sale of much of our Tin, Cloth, Lead and other Commodities, the vent whereof doth daily increase in those Countries which formerly had no use of our wares.

9. It would be very beneficial to export money as well as wares, being done in trade only, it would increase our Treasure; but of this I write more largely in the next Chapter to prove it plainly.

10. It were policy and profit for the State to suffer manufactures made of foreign Materials to be exposed custom-free, as Velvets and all other wrought Silks, Fustians, thrown Silks and the like, it would employ very many poor people, and much increase the value of our stock yearly issued into other Countries, and it would (for this purpose) cause the more foreign Materials to be brought in, to the improvement of His Majesties Customes. I will here remember a notable increase in our manufacture of winding and twisting only of foreign raw Silk, which within 35 years to my knowledge did not employ more than 300 people in the City and suburbs of London, where at this present time it doth set on work above fourteen thousand souls, as upon diligent inquiry hath been credibly reported unto his Majesties Commissioners for Trade. And it is certain, that if the said foreign Commodities might be exported from hence, free of custome, this manufacture would yet increase very much, and decrease as fast in Italy and the Netherlands. But if any man allege the Dutch proverb, "Live and let others live"; I answer, that the Dutchmen notwithstanding their own Proverb, do not only in these Kingdoms, encroach upon our livings, but also in other foreign parts of our trade (where they have power)

they do hinder and destroy us in our lawful course of living, hereby taking the bread out of our mouth, which we shall never prevent by plucking the pot from their nose, as of late years too many of us do practice to the great hurt and dishonour of this famous Nation; We ought rather to imitate former times in taking sober and worthy courses more pleasing to God and suitable to our ancient reputation.

11. It is needful also not to charge the native commodities with too great customes, lest by indearing them to the strangers use, it hinder their vent. And especially foreign wares brought in to be transported again should be favoured, for otherwise that manner of trading (so much importing the good of the Commonwealth) cannot prosper nor subsist. But the consumption of such foreign wares in the Realm may be the more charged, which will turn to the profit of the Kingdom in the Balance of the Trade, and thereby also enable the King to lay up the more Treasure out of his yearly incomes. As of this particular I intend to write more fully in his proper place, where I shall shew how much money a Prince may conveniently lay up without the hurt of his subjects.

12. Lastly, in all things we must endeavour to make the most we can of our own, whether it be Natural or Artificial; And forasmuch as the people which live by the Arts are far more in number than they who are masters of the fruits, we ought the more carefully to maintain those endeavors of the multitude, in whom doth consist the greatest strength and riches both of King and Kingdom: for where the people are many, and the arts good, there the traffique must be great, and the Country rich. The Italians employ a greater number of people, and

get more money by their industry and manufactures of the raw Silks of the Kingdom of Cicilia, than the King of Spain and his Subjects have by the revenue of this rich commodity. But what need we fetch the example so far, when we know that our own natural wares do not yield us so much profit as our industry? For Iron ore in the Mines is of no great worth, when it is compared with the employment and advantage it yields being digged, tried, transported, bought, sold, cast into Ordnance, Muskets, and many other instruments of war for offense and defense, wrought into Anchors, bolts, spikes, Hayles and the like, for the use of Ships, Houses, Carts, Coaches, Ploughs, and other instruments for Tillage. Compare our Fleece-wools with our Cloth, which requires shearing, washing, carding, spinning, weaving, fulling, dying, dressing and other trimmings, and we shall find these Arts more profitable than the natural wealth, whereof I might instance other examples, but I will not be more tedious, for if I would amplify upon this and the other particulars before written, I might find matter sufficient to make a large volume, but my desire in all is only to prove what I propound with brevity and plainness.

THE EXPORTATION OF OUR MONEYS IN TRADE OF MERCHANDISE IS A MEANS TO INCREASE OUR TREASURE

This Position is so contrary to the common opinion, that it will require many and strong arguments to prove it before it can be accepted of the Multitude, who bitterly exclaim when they see any moneys carried out of the Realm; affirming thereupon that we have absolutely lost so much Treasure, and that this is an act directly against the long continued laws made and confirmed by the wisdom of this Kingdom in the High Court of Parliament, and that many places, nay Spain itself which is the Fountain of Money, forbids the exportation thereof, some cases only excepted. To all which I might answer that Venice, Florence, Genoa, the Low Countries and divers other places permit it, their people applaud it, and find great benefit by it; but all this makes a noise and proves nothing, we must therefore come to those reasons which concern the business in question.

First, I will take for granted which no man of judgment will deny, that we have no other means to get Treasure but by foreign trade, for Mines we have none which do afford it, and how this money is gotten in the managing of our said Trade I have already shewed, that it is done by making our commodities which are exported yearly to over balance in value the foreign wares which we consume; so that it resteth only to shew how our moneys may be added to our commodities, and being jointly exported may so much the more increase our Treasure.

We have already supposed our yearly consumptions of foreign wares to be for the value of twenty hundred thousand pounds, and our exportations to exceed that two hundred thousand pounds, which sum we have thereupon affirmed is brought to us in treasure to balance the accompt. But now if we add three hundred thousand pounds more in ready money unto our former exportations in wares, what profit can we have (will some men say) although by this means we should bring in so much ready money more than we did before, seeing that we have carried out the like value.

To this the answer is, that when we have prepared our exportations of wares, and sent out as much of everything as we can spare or vent abroad; It is not therefore said that then we should add our money thereunto to fetch in the more money immediately, but rather first to enlarge our trade by enabling us to bring in more foreign wares, which being sent out again will in due time much increase our Treasure.

For although in this manner we do yearly multiply our importations to the maintenance of more Shipping and Mariners, improvement of His Majesties Customs and other benefits; yet our consumption of those foreign wares is no more than it was before; so that all the said increase of commodities brought in by the means of our ready money sent out as afore written, doth in the end become an exportation unto us of far greater value than our said moneys were, which is proved by three several examples following.

- 1. For I suppose that 100,000 Pounds being sent in our Shipping to the East Countries, will buy there one hundred thousand quarters of wheat clear aboard the Ships, which after being brought into England and housed, to export the same at the best time for vent thereof in Spain or Italy, it cannot yield less in those parts than two hundred thousand pounds to make the Merchant but a saver, yet by this reckoning we see the Kingdom hath doubled that Treasure.
- 2. Again this profit will be far greater when we trade thus in remote Countries, as for example, if we send one hundred thousand pounds into the East Indies to buy Pepper there, and bring it hither, and from hence send it for Italy or Turkey, it must yield seven hundred thousand pounds at least in those places, in regard

of the excessive charge which the Merchant disburseth in those long voyages in Shipping, Wages, Victuals, Insurance, Interest, Customes, Imposts, and the like, all which notwithstanding the King and the Kingdom gets.

3. But where the voyages are short and the wares rich, which therefore will not employ much Shipping, the profit will be far less. As when another hundred thousand pounds shall be employed in Turkey in raw Silks, and brought hither to be after transported from hence into France, the Low Countries, or Germany, the Merchant shall have good gain, although he sell it there but for one hundred and fifty thousand pounds: and thus take the voyages altogether in their Medium, the moneys exported will be returned unto us more than Trebled. But if any man will yet object, that these returns come to us in wares, and not really in money as they were issued out.

The answer is (keeping our first ground) that if our consumption of foreign wares be no more yearly than is already supposed, and that our exportations be so mightily increased by this manner of Trading with ready money as is before declared: it is not then possible but that all the over-balance or difference should return either in money or in such wares as we must export again, which, as is already plainly shewed will be still a greater means to increase our Treasure.

For it is in the stock of the Kingdom as in the estates of private men, who having store of ware, do not therefore say that they will not venture out or trade with their money (for this were ridiculous) but do also turn that into wares, whereby they multiply their Money, and so by a continual and orderly change of one into the other grow rich, and when they please turn all their estates into

Treasure; for they that have Wares cannot want money.

Neither is it said that Money is the Life of Trade, as if it could not subsist without the same; for we know that there was great trading by way of commutation or barter when there was little money stirring in the world. The Italians and some other Nations have such remedies against this want, that it can neither decay nor hinder their trade, for they transfer bills of debt, and have Banks both public and private, wherein they do assign their credits from one to another daily for very great sums with ease and satisfaction by writings only, whilst in the mean time the Mass of Treasure which gave foundation to these credits is employed in Foreign Trade as a Merchandise, and by the said means they have little other use of money in those countries more than for their ordinary expenses. It is not therefore the keeping of our money in the Kingdom; but the necessity and use of our wares in foreign Countries. and our want of their commodities which causeth the vent and consumption on all sides, which makes a quick and ample Trade. If we were once poor, and now having gained some store of money by trade with resolution to keep it still in the Realm; shall this cause other Nations to spend more of our commodities than formerly they have done, whereby we might say that our trade is Quickened and Enlarged? No verily it will produce no such good effect: but rather according to the alteration of times by their true causes we may expect the contrary; for all men do consent that plenty of money in a Kingdom doth make the native commodities dearer, which as it is to the profit of some private men in their revenues, so is it directly against the benefit of the Publique in the quantity of the trade; for

as plenty of money makes wares dearer, so dear wares decline their use and consumption as hath been already plainly shewed in the last Chapter upon that particular of our cloth; And although this is a very hard lesson for some great landed men to learn, yet I am sure it is a true lesson for all the land to observe, lest when we have gained some store of money by trade, we lose it again by not trading with our money. I knew a Prince in Italy (of famous memory) Ferdinando the first, great Duke of Tuscanie, who being very rich in Treasure, endevoured therewith to enlarge his trade by issuing out to his Merchants great sums of money for very small profit; I myself had forty thousand crowns of him gratis for a whole year, although he knew that I would presently send it away in Specie for the parts of Turkey to be employed in wares for his Countries, he being well assured that in this course of trade it would return again (according to the old saying) with a Duck in the mouth. This noble and industrious Prince by his care and diligence to countenance and favour Merchants in their affairs, did so increase the practice thereof, that there is scarce a Nobleman or Gentleman in all his dominions that doth not Merchandise either by himself or in partnership with others, whereby within these thirty years the trade to his port of Leghorn is so much increased, that of a poor little town (as I myself knew it) it is now become a fair and strong City, being one of the most famous places for trade in all Christendom. And yet it is worthy our observation, that the multitude of Ships and wares which come hither from England, the Low Countries, and other places, have little or no means to make their returns from thence but only in ready money, which they may and do carry away freely at all times, to the incredible advantage of the said great Duke of Tuscanie and his subjects, who are much enriched by the continual great concourse of Merchants from all the States of the neighbor Princes, bringing them plenty of money daily to supply their wants of the said wares. And thus we see that the current of Merchandise which carries away their Treasure, becomes a flowing stream to fill them again in a greater measure with money.

There is yet an objection or two as weak as all the rest: that is, if we trade with our Money we shall issue out the less wares; as if a man should say, those Countries which heretofore had occasion to consume our Cloth, Lead, Tin, Iron, Fish and the like, shall now make use of our moneys in the place of these necessaries, which were most absurd to affirm, or that the Merchant had not rather carry out wares by which there is ever some gains expected, than to export money which is still but the same without any increase.

But on the contrary there are many Countries which may yield us very profitable trade for our money, which otherwise afford us no trade at all, because they have no use of our wares, as namely the East Indies for one in the first beginning thereof, although since by industry in our commerce with those Nations we have brought them into the use of much of our Lead, Cloth, Tin, and other things, which is a good addition to the former vent of our commodities.

Again, some men have alleged that those Countries which permit money to be carried out, do it because they have few or no wares to trade withall: but we have great store of commodities, and therefore their action ought not to be our example.

To this the answer is briefly, that if we have such a quantity of wares as doth fully provide us of all things needful from beyond the seas: why should we then doubt that our moneys sent out in trade, must not necessarily come back again in treasure; together with the great gains which it may procure in such manner as is before set down? And on the other side. if those Nations which send out their moneys do it because they have but few wares of their own, how come they then have so much Treasure as we ever see in those places which suffer it freely to be exported at times and by whomsoever? I answer, even by trading with their Moneys: for by what other means can they get it, having no Mines of Gold or Silver?

Thus may we plainly see, that when this weighty business is duly considered in his end, as all our humane actions ought well to be weighed, it is found much contrary to that which most men esteem thereof, because they search no further than the beginning of the work, which mis-informs their judgments, and leads them into error: For if we only behold the actions of the husbandman in the seed-time when he casteth away much good corn into the ground, we will rather accompt him a mad man than a husbandman: but when we consider his labours in the harvest which is the end of his endeavors, we find the worth and plentiful increase of his actions. . . .

4. THE RISE OF THE BOURGEOISIE

Daniel Defoe (c. 1659–1731), novelist and political pamphleteer, has left us some excellent descriptions of the events of his time. In *The Complete English Tradesman*, however, he is concerned to show the respectability, indeed the prestige, of trade and its connection with England's strength and prosperity. Chapter 24 of the book gives a long list of intermarriages between nobles and bourgeois, purporting to show "how some families owe their rise to trade, and others their descent and fortunes to prudent alliances with the families of citizens." Chapter 25, given below, is more down to earth.

The instances which we have given in the last chapter, abundantly make for the honour of the British traders; and we may venture to say, at the same time, are very far from doing dishonour to the nobility who have from time to time entered into alliance with them; for it is very well known, that besides the benefit which we reap by being a trading nation, which is our principal glory, trade is a very different thing in England than it is in many other countries, and is carried on by persons who, both in their education and descent, are far from being the dregs of the people.

King Charles II, who was perhaps the prince of all the kings that ever reigned in England, who best understood the country and the people he governed, used to say, that the tradesmen were the only gentry in England. His majesty spoke it merrily, but it had a happy signification in it, such as was peculiar to the bright genius of that prince, who, though he was not the best governor, was the best acquainted with the world of all the princes of his age, if not of all the men in it; and I make no scruple to advance these three points in honour of our country; viz.—

1. That we are the greatest trading country in the world, because we have

the greatest exportation of the growth and product of our land, and of the manufacture and labour of our people; and the greatest importation and consumption of the growth, product, and manufactures of other countries from abroad, of any nation in the world.

- 2. That our climate is the best and most agreeable to live in, because a man can be more out of doors in England than in other countries.
- 3. That our men are the stoutest and best, because, strip them naked from the waist upwards, and give them no weapons at all but their hands and heels, and turn them into a room or stage, and lock them in with the like number of other men of any nation, man for man, and they shall beat the best men you shall find in the world.

As so many of our noble and wealthy families, as we have shown, are raised by and derived from trade, so it is true, and indeed it cannot well be otherwise, that many of the younger branches of our gentry, and even of the nobility itself, have descended again into the spring from whence they flowed, and have become tradesmen; and thence it is that, as I said above, our tradesmen in England are not, as it generally is in other countries, always of the meanest of our people. Nor

From Daniel Defoe, The Complete English Tradesman (London, 1724), Chap. XXV.

is trade itself in England, as it generally is in other countries, the meanest thing the men can turn their hand to; but, on the contrary, trade is the readiest way for men to raise their fortunes and families; and therefore it is a field for men of figure and of good families to enter upon.

Having thus done a particular piece of justice to ourselves, in the value we put upon trade and tradesmen in England, it reflects very much upon the understandings of those refined heads who pretend to depreciate that part of the nation which is so infinitely superior in wealth to the families who call themselves gentry, and so infinitely more numerous.

As to the wealth of the nation, that undoubtedly lies chiefly among the trading part of the people; and though there are a great many families raised within few years, in the late war, by great employments and by great actions abroad, to the honour of the English gentry, yet how many more families among the tradesmen have been raised to immense estates. even during the same time, by the attending circumstances of the war; such as the clothing, the paying, the victualling and furnishing, &c., both army and navy. And by whom have the prodigious taxes been paid, the loans supplied, and money advanced upon all occasions? By whom are the banks and companies carried on, and on whom are the customs and excises levied? Have not the trade and tradesmen borne the burden of the war? And do they not still pay four millions a year interest for the public debts? On whom are the funds levied, and by whom the public credit supported? Is not trade the inexhausted fund of all funds, and upon which all the rest depend?

As is the trade, so in proportion are the tradesmen; and how wealthy are

tradesmen in almost all the several parts of England, as well as in London? How common is it to see a tradesman go off the stage, even but from mere shopkeeping, with from ten to forty thousand pounds' estate to divide among his family! When, on the contrary, take the gentry in England, from one end to the other. except a few here and there, what with excessive high living, which is of late grown so much into a disease, and the other ordinary circumstances of families, we find few families of the lower gentry, that is to say from six or seven hundred a year downwards, but they are in debt, and in necessitous circumstances, and a great many of greater estates also.

On the other hand, let any one who is acquainted with England, look but abroad into the several counties, especially near London, or within fifty miles of it; how are the ancient families worn out by time and family misfortunes, and the estates possessed by a new race of tradesmen, grown up into families of gentry, and established by the immense wealth gained, as I may say, behind the counter; that is, in the shop, the warehouse, and the counting-house.

How many noble seats, superior to the palaces of sovereign princes, in some countries, do we see erected within few miles of this city by tradesmen, or the sons of tradesmen, while the seats and castles of the ancient gentry, like their families, look worn out and fallen into decay!

Again; in how superior a port do our tradesmen live, to what the middling gentry either do or can support! An ordinary tradesman now, not in the city only, but in the country, shall spend more money by the year, than a gentleman of four or five hundred pounds a year too; whereas the gentleman shall at the best stand stock

still just where he began, nay, perhaps, decline: and as for the lower gentry, from a hundred pounds a year to three hundred, or thereabouts, though they are often as proud and high in their appearance as the other; as to them, I say, a shoemaker in London shall keep a better house, spend more money, clothe his family better, and yet grow rich too. It is evident where the difference lies; an estate's a pond, but trade's a spring: the first, if it keeps full, and the water wholesome, by the ordinary supplies and drains from the neighbouring grounds, it is well, and it is all that is expected; but the other is an inexhausted current, which not only fills the pond, and keeps it full, but is continually running over, and fills all the lower ponds and places about it.

This being the case in England, and our trade being so vastly great, it is no wonder that the tradesmen in England fills the lists of our nobility and gentry; no wonder that the gentlemen of the best families marry tradesmen's daughters, and put their vounger sons apprentices to tradesmen; and how often do these younger sons come to buy the elder sons' estates, and restore the family, when the elder and head of the house, proving rakish and extravagant, has wasted his patrimony, and is obliged to make out the blessing of Israel's family, where the younger son bought the birthright, and the elder was doomed to serve him!

Trade is so far here from being inconsistent with a gentleman, that, in short, trade in England makes gentlemen, and has peopled this nation with gentlemen; for, after a generation or two, the tradesman's children, or at least their grand-children, come to be as good gentlemen, statesmen, parliamentmen, privy-counsellors, judges, bishops, and noblemen, as those of the highest birth and the most

ancient families; as we have shown. Nor do we find any defect either in the genius or capacities of the posterity of tradesmen, arising from any remains of mechanic blood, which, it is pretended, should influence them; but all the gallantry of spirit, greatness of soul, and all the generous principles that can be found in any of the ancient families, whose blood is the most untainted, as they call it, with the low mixtures of a mechanic race, are found in these; and, as is said before, they generally go beyond them in knowledge of the world, which is the best education.

We see the tradesmen of England, as they grow wealthy, coming every day to the herald's office to search for the coats of arms of their ancestors, in order to paint them upon their coaches, and grave them upon their plate, embroider them upon their furniture, or carve them upon the pediments of their new houses; and how often do we see them trace the registers of their families up to the prime nobility, or the most ancient gentry of the kingdom!

In this search we find them often qualified to raise new families, if they do not descend from old; as was said of a certain tradesman of London, that if he could not find the ancient race of gentlemen, from which he came, he would begin a new race, who should be as good gentlemen as any that went before him.

Thus, in the late wars between England and France, how was our army full of excellent officers, who went from the shop, and behind the counter, into the camp, and who distinguished themselves there by their merits and gallant behaviour! And several such came to command regiments, and even to be general officers, and to gain as much reputation in the service as any; as Colonel Pierce, Wood,

Richards, and several others that may be named.

All this confirms what I have said before, viz., that trade in England neither is or ought to be compared with what it is in other countries; or the tradesman depreciated as they are abroad, and as some of our gentry would pretend to do in England; but that as many of our best families rose from trade, so many branches of the best families in England, under the nobility, have stooped so low as to be put apprentices to tradesmen in London, and to set up and follow those trades when they have come out of their times, and have thought it no dishonour to their blood.

To bring this once more home to the ladies, who are scandalized at that mean step, which they call it, of marrying a tradesman, it may be told them, for their humiliation, that, however they think fit to act, sometimes those tradesmen come of better families than their own; and oftentimes, when they have refused them to their loss, those very tradesmen have married ladies of superior fortune to them, and have raised families of their own, who, in one generation, have been superior to those nice ladies both in dignity and estate; and have, to their great mortification, been ranked above them upon all public occasions.

The word "tradesmen," in England, does not sound so harsh as it does in other countries; and to say a gentleman-tradesman, is not so much nonsense as some people would persuade us to reckon it; and, indeed, the very name of an English tradesman, will and does already obtain in the world; and as our soldiers, by the late war, gained the reputation of being some of the best troops in the world; and our seamen are at this day, and very justly too, esteemed the best

sailors in the world; so the English tradesman may be allowed to rank with the best gentlemen in Europe.

And hence it is natural to ask, whence comes all this to be so? How is it produced? War has not done it; no, nor so much as helped or assisted to it; it is not by any martial exploits; we have made no conquests abroad, added no new kingdoms to the British empire, reduced no neighbouring nations, or extended the possession of our monarchs into the properties of others; we have gained nothing by war and encroachment; nay, we have lost all the dominions which our ancient kings for some hundreds of years held in France; and, instead of being enriched by war and victory, on the contrary, we have been torn in pieces by civil wars and rebellions, and that several times, to the ruin of our richest families, and the slaughter of our nobility and gentry.

These things prove abundantly that the greatness of the British nation is not owing to war and conquests, to enlarging its dominions by the sword, or subjecting the people of other countries to our power; but it is allowing to trade, to the increase of our commerce at home, and the extending it abroad.

It is owing to trade, that new discoveries have been made in lands unknown, and new settlements and plantations made, new colonies planted, and new governments formed, in the uninhabited islands, and the uncultivated continent of America; and those plantings and settlements have again enlarged and increased the trade, and thereby the wealth and power of the nation by whom they were discovered and planted; we have not increased our power, or the number of our subjects, by subduing the nations which possess those countries, and incorporating them into our own; but have entirely

planted our colonies, and peopled the countries with our own subjects, natives of this island; and, excepting the negroes, which we transport from Africa to America as slaves to work in the sugar and to-bacco plantations, all our colonies, as well in the islands as on the continent of America, are entirely peopled from Great Britain and Ireland, and chiefly the former; the natives having either removed further up into the country, or, by their own folly and treachery raising war against us, been destroyed and cut off.

As trade has thus extended our colonies abroad, so it has (except those colonies) kept our people at home, where they are multiplied to that prodigious degree, and do still continue to multiply in such a manner, that, if it goes on so, time may come that all the lands in England will do little more than serve for gardens for them and to feed their cows, and their corn and cattle be supplied from Scotland and Ireland.

What is the reason that we see numbers of French, and of Scots, and Germans, in all the foreign nations in Europe, and especially filling up their armies and courts, and that you see few or no English there?

What is the reason that, when we want to raise armies, or to man navies, in England, we are obliged to press the seamen, and to make laws, and empower the justices of peace and magistrates of towns, to force men to go for soldiers, and enter into the service, or allure them by giving bounty-money as an encouragement to men to list themselves; whereas the people of other nations, and even the Scots and Irish, travel abroad and run into all the neighbour-nations, to seek service and to be admitted into their pay?

What is it but trade, the increase of business at home, and the employment of the poor in the business and manufactures of this kingdom, by which the poor get so good wages, and live so well, that they will not list for soldiers; and have so good pay in the merchants' service, that they will not serve on board the ships of war, unless they are forced to do it?

What is the reason that, in order to supply our colonies and plantations with people, besides the encouragement given in those colonies to all people that will come hither to plant and to settle, we are obliged to send away thither all our petty offenders, and all the criminals that we think fit to spare from the gallows, besides that we formerly called the kidnapping trade, that is to say, the arts made use of to wheedle and draw away young, vagrant, and indigent people, and people of desperate fortunes, to sell themselves, that is, bind themselves for servants, the number of which are very great?

It is poverty fills armies, mans navies, and peoples colonies; in vain the drums beat for soldiers to serve in the armies for fivepence a day, and the king's captains invite seamen to serve in the royal navy for twenty-three shillings per month, in a country where the ordinary labourer can have nine shillings a week for his labour, and the manufacturers earn from twelve to sixteen shillings a week for their work; and while trade gives thirty shillings per month wages to the seamen on board merchant-ships, men will always stay or go, as the pay gives them encouragement; and this is the reason why it has been so much more difficult to raise and recruit armies in England, than it has been in Scotland and Ireland. France and Germany.

The same trade that keeps our people at home, is the cause of the well-living of the people here; for as frugality is not the national virtue of England, so the people

that get much, spend much; and as they work hard, so they live well, eat and drink well, clothe warm, and lodge soft: in a word, the working manufacturing people of England, eat the fat, drink the sweet, live better, and fare better, than the working poor of any other nation in Europe; they make better wages of their work, and spend more of the money upon their backs and bellies than in any other country. This expense of the poor, as it causes a prodigious consumption both of the provisions and of the manufactures of our country at home, so two things are undeniably the consequence of that part.

- 1. The consumption of provisions increases the rent and value of the lands; and this raises the gentlemen's estates, and that again increases the employment of people, and consequently the numbers of them, as well those that are employed in the husbandry of land, breeding and feeding of cattle, &c., as of servants to the gentlemen's families, who as their estates increase in value, so they increase their families and equipages.
- 2. As the people get greater wages, so they, I mean the same poorer part of the people, clothe better, and furnish better; and this increases the consumption of the

very manufactures they make; then that consumption increases the quantity made; and this creates what we call inland trade, by which innumerable families are employed, and the increase of the people maintained; and by which increase of trade and people the present growing prosperity of this nation is produced.

The whole glory and greatness of England then being thus raised by trade, it must be unaccountable folly and ignorance in us to lessen that one article in our own esteem, which is the only fountain from whence we all, take us as a nation, are raised, and by which we are enriched and maintained. The Scripture says, speaking of the riches and glory of the city of Tyre, which was indeed at that time the great port or emporium of the world for foreign commerce, from whence all the silks and fine manufactures of Persia and India were exported all over the western world, "that her merchants were princes," and in another place, "by thy traffic thou hast increased thy riches." Certain it is, that our traffic has increased our riches; and it is also certain, that the flourishing of our manufacture is the foundation of all our traffic, as well our merchandise as our inland trade.

5. THE NEW SCIENCE

The "scientific revolution" is usually associated with the sixteenth and seventeenth centuries, although, of course, its origins may be traced a long way back. But for a technique or an idea to be historically significant, mere existence is not enough: acceptance and practice are needed and success is, to some extent, measured quantitatively. This is why the seventeenth century seems crucial to that revolution which, in the words of Herbert Butterfield (*The Origins of Modern Science*, London, 1949), "overturned the authority in science not only of the middle ages but of the ancient world." To Professor Butterfield this change of techniques and attitudes is the most important event since the rise of Christianity, more important by far than Renaissance or Reformation: "Since it changed the character of men's habitual mental operations

even in the conduct of the non-material sciences, while transforming the whole diagram of the physical universe and the very texture of human life itself, it looms so large as the real origin both of the modern world and of the modern mentality that our customary periodisation of European history has become an anachronism and an encumbrance."

Quite apart from the new interpretations and perspectives these words suggest, it is interesting to see that such tremendous changes came about in the first place and quite literally as changes of *mind*. In other words, not as a result of new discoveries, new facts, new observations, but of new ways of looking at evidence which had been available for quite some time. What we find in the work of Descartes or Newton, as in that of William Harvey or Galileo, is "the art of handling the same bundle of data as before, but placing them in a new system of relations with one another by giving them a new framework." It was a system that would prepare the minds of men for Darwin's *Origin of Species* two centuries later.

Descartes: from The Discourse upon Method

René Descartes (1596–1650) was a versatile French philosopher and mathematician. Not only did he crisscross Europe as a soldier during some of the campaigns connected with the Thirty Years' War, but we owe him several important scientific discoveries. His meditations ruined the medieval scholastic methods and founded modern philosophy by suggesting a new principle for the use of reason in metaphysical matters. This method, generally known as "Cartesianism," is summarized as follows: "In order to get at truth, we must at least once in a lifetime get rid of all received [accepted] opinions, and reconstruct completely afresh, from the ground up, all the systems of our knowledge."

Descartes' work reflects a newly critical attitude to evidence and to ideas. Doubt had existed before: a hundred years earlier, Montaigne had represented the amiable but unconstructive doubt of the worldly-wise skeptic. But now doubt was to be used rationally, according to critical rules of evidence which would serve as an instrument of knowledge. This was the time when scientific attitudes were born, with William Harvey in medicine, Richard Simon in Biblical exegesis, Mabillon in historical criticism, presenting the typical attitudes of the future.

PART FIRST

the method which everyone must follow for the right direction of his understanding, but merely to show how I have attempted to conduct my own. Those who take it upon themselves to give precepts

to others must assume that they are themselves better instructed than those to whom they give them, and if they make the least error, they are answerable for it. But as I offer this production merely as a piece of personal history, or of fiction, if you please, in which, among some examples which may well be imitated, there

From The Philosophy of Descartes, tr. Henry A. P. Torrey (New York, 1892), pp. 37-49.

will be found, perhaps, many others also which one might reasonably decline to follow, I hope that it may prove useful to some and harmful to none, and that all will take my frankness kindly.

I was brought up to letters from my childhood, and because I was led to believe that by means of them clear and certain knowledge of all that was useful in life might be acquired, I had an extreme desire for learning. But no sooner had I completed the whole course of studies at the end of which it is customary for one to be received into the circle of the learned, than I changed my opinion entirely. For I found myself involved in 30 many doubts and errors, that it seemed to me that I had derived no other advantage from my endeavors to instruct myself but only to find out more and more how ignorant I was. And yet I was in one of the most celebrated schools in Europe, where I thought there must be learned men if there were any such in the world. I had acquired all that others learned there, and more than that, not being content with the sciences which were taught us, I ran through all the books I could get hold of which treated of matters considered most curious and rare. Moreover, I knew what others thought about me, and I did not perceive that they considered me inferior to my fellow-students, albeit there were among them some who were destined to fill the places of our masters. And finally, our time appeared to me to be as flourishing and as prolific of good minds as any preceding time had been. Such considerations emboldened me to judge all others by myself, and served to convince me that there did not exist in the world any such wisdom as I had been led to hope for. However, I did not cease to think well of scholastic pursuits. I knew that the languages taught in the schools were indispensable for the understanding of the ancient books; that light and graceful stories stimulate the mind: that the memorable deeds of history exalt it, and that when read with discretion they help to form the judgment; that the reading of all good books is like conversation with the noble men of bygone times—a studied conversation, even, in which only their best thoughts are disclosed. . . . But I thought I had already given time enough to languages and to the literature of the ancients, to their histories and to their fables. To talk with men of other times is like traveling. It is well to know something of the manners of foreign peoples, in order that we may judge our own more wisely, and that we may not suppose that what is different from our own habits is ridiculous and contrary to reason, as those do who have not seen the world. But if one spends too much time in traveling in foreign countries, he becomes at last a stranger in his own; and when one is too curious to know what has been done in past ages, he is liable to remain ignorant of what is going on in his own time. Moreover, fiction represents many events as possible which are not so; and even the most faithful histories, if they do not deviate from truth nor dignify events to make them more impressive, at least they almost always omit the meaner and the less illustrious incidents, so that it comes about that the rest is not what it really was, and those who govern their conduct by the examples there furnished are liable to fall into the extravagances of the paladins of our romances, and to conceive designs which surpass their ability. . . .

Above all I was delighted with the mathematics, on account of the certainty and evidence of their demonstrations, but I had not as yet found out their true use, and although I supposed that they were of

service only in the mechanic arts, I was surprised that upon foundations so solid and stable no loftier structure had been raised: while, on the other hand, I compared the writings of the ancient moralists to palaces very proud and very magnificent, but which are built on nothing but sand or mud. . . . I revered our theology, and, as much as anyone, I strove to gain heaven; but when I learned, as an assured fact, that the way is open no less to the most ignorant than to the most learned, and that the revealed truths which conduct us thither lie beyond the reach of our intelligence, I did not presume to submit them to the feebleness of my reasonings, and I thought that, to undertake the examination of them and succeed in the attempt, required extraordinary divine assistance and more than human gifts. I had nothing to say of philosophy, save that, seeing it had been cultivated by the best minds for many ages, and still there was nothing in it which might not be brought into dispute, and which was, therefore, not free from doubt, I had not the presumption to hope for better success therein than others; and considering how many diverse opinions may be held upon the same subject and defended by the learned, while not more than one of them can be true, I regarded as pretty nearly false all that was merely probable. Then, as to the other sciences which derive their principles from philosophy, I judged that nothing solid could be built upon foundations so unstable; and neither the fame nor the emolument they promised me were sufficient to induce me to acquire them; for, thanks to a kind Providence, I did not find myself in a condition of life which required me to make science a profession for the bettering of my estate; and although I did not profess to despise fame,

like a cynic, still I thought very little of that which I could not hope to acquire except on false pretenses. And finally, as for the pseudo-sciences, I thought I was already sufficiently acquainted with their value to be proof against the promises of the alchemist, the predictions of the astrologer, the impostures of the magician, the artifices and vain boasting of those who profess to know more than they actually do know.

For these reasons, so soon as I was old enough to be no longer subject to the control of my teachers, I abandoned literary pursuits altogether, and, being resolved to seek no other knowledge than that which I was able to find within myself or in the great book of the world, I spent the remainder of my youth in traveling, in seeing courts and armies, in mingling with people of various dispositions and conditions in life, in collecting a variety of experiences, putting myself to the proof in the crises of fortune, and reflecting on all occasions on whatever might present itself, so as to derive from it what profit I might. For it appeared to me that 1 might find a great deal more of truth in reasonings such as everyone carries on with reference to the affairs which immediately concern himself, and where the issue will bring speedy punishment if he make a mistake, than in those which a man of letters conducts in his private study with regard to speculations, which have no other effect and are of no further consequence to him than to tickle his vanity the less they are understood by common people, and the more they require wit and skill to make them seem probable. And I always had an extreme desire to learn how to distinguish the true from the false, so that I might see clearly and proceed with assurance in the affairs of this present life.

It is true that while I employed myself only in observing the manners of foreigners, I found very little to establish my mind, and saw as much diversity here as I had seen before in the opinions of philosophers. So that the principal benefit I derived from it was that, observing many things which, although they appear to us to be very extravagant and ridiculous, are vet commonly received and approved by other great peoples, I gradually became emancipated from many errors which tend to obscure the natural light within us, and make us less capable of listening to reason. But after I had spent some years thus in studying in the book of the world, and trying to gain some experience. I formed one day the resolution to study within myself, and to devote all the powers of my mind to choosing the paths which I must thereafter follow; a project attended with much greater success, as I think, than it would have been had I never left my country nor my books.

PART SECOND

I was then in Germany, whither the wars, which were not yet ended there, had summoned me; and when I was returning to the army, from the coronation of the emperor, the coming on of the winter detained me in a quarter where, finding no one I wished to talk with, and fortunately having no cares nor passions to trouble me, I spent the whole day shut up in a room heated by a stove, where I had all the leisure I desired to hold converse with my own thoughts. One of the first thoughts to occur to me was that there is often less completeness in works made up of many parts and by the hands of different masters than in those upon which only one has labored. Thus we see that buildings which a single architect has undertaken and erected are usually much more beautiful and symmetrical than those which many have tried to reconstruct, using old walls which were built for other purposes.

. . . And so I thought that the sciences contained in books, at least those in which the proofs were merely probable and not demonstrations, being the gradual accumulation of opinions of many different persons, by no means come so near the truth as the plain reasoning of a man of good sense in regard to the matters which present themselves to him.

And I thought still further that, because we all have been children before we were men, and for a long time of necessity were under the control of our inclinations and our tutors, who were often of different minds, and none of whom perhaps gave us the best of counsels, it is almost impossible that our judgments should be as free from error and as solid as they would have been if we had had the entire use of our reason from the moment of our birth, and had always been guided by that alone. . . .

As for all the opinions which I had accepted up to that time, I was persuaded that I could do no better than get rid of them at once, in order to replace them afterward with better ones, or perhaps with the same, if I should succeed in making them square with reason. And I firmly believed that in this way I should have much greater success in the conduct of my life than if I should build only on the old foundations, and should rely only on the principles which I had allowed myself to be persuaded of in my youth, without ever having examined whether they were true. . . .

My design has never reached further than the attempt to reform my own opinions, and to build upon a foundation altogether my own. But although I am well enough pleased with my work to present you here a sketch of it, I would not on that account advise anyone to imitate me. . . . The simple resolution to strip one's self of all that he has hitherto believed is not an example for everyone to follow. . . .

But having discovered while at college that there is nothing whatever so strange or incredible that has not been said by some philosopher; and afterward, in my travels, having observed that not all those who cherish opinions quite contrary to our own are therefore barbarians or savages, but that many of these peoples use their reason as well or better than we do; and having considered how differently the same man, with the same mind, would turn out, if he were brought up from infancy among the French or the Germans, from what he would if he alwavs lived among the Chinese or with cannibals; and observing how, even in fashions of dress, the same thing which pleased us ten years ago, and, it may be, will please us again ten years hence, appears to us now extravagant and ridiculous; so that it is rather custom and example than certain knowledge which persuades us; and yet a plurality of votes is no proof that a thing is true, especially where truths are difficult of discovery, in which case it is much more likely that a man left to himself will find them out sooner than people in general—taking all these things into consideration, and not being able to select anyone whose opinions seemed to me to be preferable to those of others, I found myself, as it were, compelled to take myself as my guide. But like a man who walks alone and in the dark, I resolved to go so slowly and to use so much caution in everything, that, even if 1 did not get on very far, I should at least keep from falling. Likewise I was unwilling at the start to reject summarily any opinion which might have insinuated itself into my belief without having been introduced there by reason, but I would first spend time enough to draw up a plan of the work I was undertaking and to discover the true method for arriving at the knowledge of whatever my mind was capable of.

I had studied, in earlier years, of the branches of philosophy, logic, and in mathematics, geometrical analysis and algebra, three arts or sciences which seemed likely to afford some assistance to my design. But on examination of them I observed, in respect to logic, that its syllogisms and the greater part of its processes are of service principally in explaining to another what one already knows himself, or, like the art of Lully, they enable him to talk without judgment on matters in which he is ignorant, rather than help him to acquire knowledge of them; and while it contains in reality many very true and very excellent precepts, there are nevertheless mixed with these many others which are either harmful or superfluous, and which are almost as difficult to separate from the rest as to draw forth a Diana or a Minerva from a block of marble which is not yet rough-hewn. . . . For this reason I thought that some other method should be sought out which, comprising the advantages of these three, should be exempt from their defects. And as a multiplicity of laws often furnishes excuses for vices, so that a state is best governed which has but few and those strictly obeyed; in like manner, in place of the multitude of precepts of which logic is composed, I believed I should find the four following rules quite sufficient, provided I should firmly and

steadfastly resolve not to fail of observing them in a single instance.

The first rule was never to receive anything as a truth which I did not clearly know to be such; that is, to avoid haste and prejudice, and not to comprehend anything more in my judgments than that which should present itself so clearly and so distinctly to my mind that I should have no occasion to entertain a doubt of it.

The second rule was to divide every difficulty which I should examine into as many parts as possible, or as might be required for resolving it.

The third rule was to conduct my thoughts in an orderly manner, beginning with objects the most simple and the easiest to understand, in order to ascend as it were by steps to the knowledge of the most composite, assuming some order to exist even in things which did not appear to be naturally connected.

The last rule was to make enumerations so complete, and reviews so comprehensive, that I should be certain of omitting nothing.

Those long chains of reasoning, quite simple and easy, which geometers are wont to employ in the accomplishment of their most difficult demonstrations. led me to think that everything which might fall under the cognizance of the human mind might be connected together in a similar manner, and that, provided only one should take care not to receive anvthing as true which was not so, and if one were always careful to preserve the order necessary for deducing one truth from another, there would be none so remote at which he might not at last arrive, nor so concealed which he might not discover. . . .

And I am free to say that the exact observance of these few rules which I had laid down gave me such facility in solving all the questions to which these two sciences apply, that in the two or three months which I spent in examining them, having begun with the simplest and most general, and each truth that I discovered being a rule which was of service to me afterward in the discovery of others, not only did I arrive at many which formerly I had considered very difficult, but it seemed to me, toward the end, that I was able to determine even in those matters where I was ignorant by what means and how far it would be possible to resolve them. In this I shall not appear to you to be very vain, perhaps, if you will only consider that there is, in respect to each case, but one truth, and that he who finds it knows as much about it as anyone can know; as, for example, a child, who has learned arithmetic, when he has made an addition according to the rules, can be assured that he has found out, in respect to the sum that he has computed, all that it is possible for the human mind to discover. Because, in a word, the method which shows one how to follow the true order, and to take account exactly of all the circumstances of the subject under investigation, contains all that which gives certitude to the rules of arithmetic. But that which pleased me most in this method was the fact that by means of it I was using my reason in everything, if not perfectly, yet in a manner the very best in my power. . . .

PART FOURTH

I am in doubt as to the propriety of making my first meditations in the place

From Descartes, Discourse on Method, tr. John Veitch (Edinburgh, 1850), pp. 74-82.

above mentioned a matter of discourse: for these are so metaphysical, and so uncommon, as not, perhaps, to be acceptable to every one. And yet, that it may be determined whether the foundations that I have laid are sufficiently secure, I find myself in a measure constrained to advert to them. I had long before remarked that, in relation to practice, it is sometimes necessary to adopt, as if above doubt, opinions which we discern to be highly uncertain, as had been already said; but as I then desired to give my attention solely to the search after truth, I thought that a procedure exactly the opposite was called for, and that I ought to reject as absolutely false all opinions in regard to which I could suppose the least ground for doubt, in order to ascertain whether after that there remained aught in my belief that was wholly indubitable. Accordingly, seeing that our senses sometimes deceive us, I was willing to suppose that there existed nothing really such as they presented to us: and because some men err in reasoning, and fall into paralogisms, even on the simplest matters of Geometry. I, convinced that I was as open to error as any other, rejected as false all the reasonings I had hitherto taken for demonstrations; and finally, when I considered that the very same thoughts [presentations] which we experience when awake may also be experienced when we are asleep, while there is at that time not one of them true, I supposed that all the objects [presentations] that had ever entered into my mind when awake, had in them no more truth than the illusions of my dreams. But immediately upon this I observed that, whilst I thus wished to think that all was false, it was absolutely necessary that I, who thus thought, should be somewhat; and as I observed that this truth, I think, hence I am, was so certain

and of such evidence, that no ground of doubt, however extravagant, could be alleged by the Sceptics capable of shaking it, I concluded that I might, without scruple, accept it as the first principle of the Philosophy of which I was in search.

In the next place, I attentively examined what I was, and as I observed that I could suppose that I had no body, and that there was no world nor any place in which I might be; but that I could not therefore suppose that I was not; and that, on the contrary, from the very circumstance that I thought to doubt of the truth of other things, it most clearly and certainly followed that I was; while, on the other hand, if I had only ceased to think, although all the other objects which I had ever imagined had been in reality existent, I would have had no reason to believe that I existed; I thence concluded that I was a substance whose whole essence or nature consists only in thinking, and which, that it may exist, has need of no place, nor is dependent on any material thing; so that "I," that is to say, the mind by which I am what I am, is wholly distinct from the body, and is even more easily known than the latter, and is such, that although the latter were not, it would still continue to be all that it is.

After this I inquired in general into what is essential to the truth and certainty of a proposition; for since I had discovered one which I knew to be true, I thought that I must likewise be able to discover the ground of this certitude. And as I observed that in the words I think, hence I am, there is nothing at all which gives me assurance of their truth beyond this, that I see very clearly that in order to think it is necessary to exist, I concluded that I might take, as a general rule, the principle, that all the things which we very clearly and distinctly con-

ceive are true, only observing, however, that there is some difficulty in rightly determining the objects which we distinctly conceive.

In the next place, from reflecting on the circumstance that I doubted, and that consequently my being was not wholly perfect, (for I clearly saw that it was a greater perfection to know than to doubt,) I was led to inquire whence I had learned to think of something more perfect than myself; and I clearly recognised that I must hold this notion from some Nature which in reality was more perfect. As for the thoughts of many other objects external to me, as of the sky, the earth, light, heat, and a thousand more, I was less at a loss to know whence these came; for since I remarked in them nothing which seemed to render them superior to myself, I could believe that, if these were true, they were dependencies on my own nature, in so far as it possessed a certain perfection, and, if they were false, that I held them from nothing, that is to say, that they were in me because of a certain imperfection of my nature. But this could not be the case with the idea of a Nature more perfect than myself; for to receive it from nothing was a thing manifestly impossible; and, because it is not less repugnant that the more perfect should be an effect of, and dependence on the less perfect, than that something should proceed from nothing, it was equally impossible that I could hold it from myself: accordingly, it but remained that it had been placed in me by a Nature which was in reality more perfect than mine, and which even possessed within itself all the perfections of which I could form any idea: that is to say, in a single word, which was God. And to this I added that, since I knew some perfections which I did not possess, I was not the only being in existence, (I will here, with your permission, freely use the terms of the schools): but, on the contrary, that there was of necessity some other more perfect Being upon whom I was dependent, and from whom I had received all that I possessed; for if I had existed alone, and independently of every other being, so as to have had from myself all the perfection, however little, which I actually possessed, I should have been able, for the same reason, to have had from myself the whole remainder of perfection, of the want of which I was conscious, and thus could of myself have become infinite, eternal, immutable, omniscient, all-powerful, and, in fine, have possessed all the perfections which I could recognise in God. For in order to know the nature of God. (whose existence has been established by the preceding reasonings,) as far as my own nature permitted, I had only to consider in reference to all the properties of which I found in my mind some idea, whether their possession was a mark of perfection; and I was assured that no one which indicated any imperfection was in him. and that none of the rest was wanting. Thus I perceived that doubt, inconstancy, sadness, and such like, could not be found in God, since I myself would have been happy to be free from them. Besides, I had ideas of many sensible and corporeal things; for although I might suppose that I was dreaming, and that all which I saw or imagined was false, I could not, nevertheless, deny that the ideas were in reality in my thoughts. But, because I had already very clearly recognised in myself that the intelligent nature is distinct from the corporeal, and as I observed that all composition is an evidence of dependency, and that a state of dependency is manifestly a state of imperfection, I therefore determined that it could not be a perfection in God to be compounded of these two natures, and that consequently he was not so compounded; but that if there were any bodies in the world, or even any intelligences, or other natures that were not wholly perfect, their existence depended on his power in such a way that they could not subsist without him for a single moment.

I was disposed straightway to search for other truths; and when I had represented to myself the object of the geometers, which I conceived to be a continuous body, or a space indefinitely extended in length, breadth, and height or depth, divisible into divers parts which admit of different figures and sizes, and of being moved or transposed in all manner of ways, (for all this the geometers suppose to be in the object they contemplate,) I went over some of their simplest demonstrations. And, in the first place, I observed, that the great certitude which by common consent is accorded to these demonstrations, is founded solely upon this, that they are clearly conceived in accordance with the rules I have already laid down. In the next place, I perceived that there was nothing at all in these demonstrations which could assure me of the existence of their object: thus, for example, supposing a triangle to be given, I distinctly perceived that its three angles were necessarily equal to two right angles, but I did not on that account perceive anything which could assure me that any triangle existed: while, on the contrary, recurring to the examination of the idea of a Perfect Being, I found that the existence of the Being was comprised in the idea in the same way that the equality of its three angles to two right angles is comprised in the idea of a triangle, or as in the idea of a sphere, the equidistance of all points on its surface from the centre,

or even still more clearly; and that consequently it is at least as certain that God, who is this Perfect Being, is, or exists, as any demonstration of Geometry can be.

But the reason which leads many to persuade themselves that there is a difficulty in knowing this truth, and even also in knowing what their mind really is, is that they never raise their thoughts above sensible objects, and are so accustomed to consider nothing except by way of imagination, which is a mode of thinking limited to material objects, that all that is not imaginable seems to them not intelligible. The truth of this is sufficiently manifest from the single circumstance. that the philosophers of the Schools accept as a maxim that there is nothing in the Understanding which was not previously in the Senses, in which however it is certain that the ideas of God and of the soul have never been; and it appears to me that they who make use of their imagination to comprehend these ideas do exactly the same thing as if, in order to hear sounds or smell odours, they strove to avail themselves of their eves; unless indeed that there is this difference, that the sense of sight does not afford us an inferior assurance to those of smell or hearing; in place of which, neither our imagination nor our senses can give us assurance of anything unless our Understanding intervene.

Finally, if there be still persons who are not sufficiently persuaded of the existence of God and of the soul, by the reasons I have adduced, I am desirous that they should know that all the other propositions, of the truth of which they deem themselves perhaps more assured, as that we have a body, and that there exist stars and an earth, and such like, are less certain; for, although we have a moral assurance of these things, which is so strong

that there is an appearance of extravagance in doubting of their existence, yet at the same time no one, unless his intellect is impaired, can deny, when the question relates to a metaphysical certitude, that there is sufficient reason to exclude entire assurance, in the observation that when asleep we can in the same way imagine ourselves possessed of another body and that we see other stars and another earth, when there is nothing of the kind. For how do we know that the thoughts which occur in dreaming are false rather than those other which we experience when awake, since the former are often not less vivid and distinct than the latter? And though men of the highest genius study this question as long as they please, I do not believe that they will be able to give any reason which can be sufficient to remove this doubt, unless they presuppose the existence of God. For, in the first place, even the principle which I have already taken as a rule, viz., that all the things which we clearly and distinctly conceive are true, is certain only because God is or exists, and because he is a Perfect Being, and because all that we possess is derived from him: whence it follows that our ideas or notions, which to the extent of their clearness and distinctness are real, and proceed from God, must to that extent be true. Accordingly, whereas we not unfrequently have ideas or notions in which some falsity is contained, this can only be the case with such as are to some extent confused and obscure, and in this proceed from nothing, [participate of negation, that is, exist in us thus confused because we are not wholly perfect. And it is evident that it is not less repugnant that falsity or imperfection, in so far as it is imperfection, should proceed from God, than that truth or perfection should proceed from nothing. But if we did not know that all which we possess of real and true proceeds from a Perfect and Infinite Being, however clear and distinct our ideas might be, we should have no ground on that account for the assurance that they possessed the perfection of being true.

But after the knowledge of God and of the soul has rendered us certain of this rule, we can easily understand that the truth of the thoughts we experience when awake, ought not in the slightest degree to be called in question on account of the illusions of our dreams. For if it happened that an individual, even when asleep, had some very distinct idea, as, for example, if a geometer should discover some new demonstration, the circumstance of his being asleep would not militate against its truth; and as for the most ordinary error of our dreams, which consists in their representing various objects in the same way as our external senses, this is not prejudicial, since it leads us very properly to suspect the truth of the ideas of sense; for we are not unfrequently deceived in the same manner when awake; as when persons in the jaundice see all objects yellow, or when the stars or bodies at a great distance appear to us much smaller than they are. For, in fine, whether awake or asleep, we ought never to allow ourselves to be persuaded of the truth of anything unless on the evidence of our Reason. And it must be noted that I say of our Reason, and not of our imagination or of our senses: thus, for example, although we very clearly see the sun, we ought not therefore to determine that it is only of the size which our sense of sight presents; and we may very distinctly imagine the head of a lion joined to the body of a goat, without being therefore shut up to the conclusion that a chimæra exists: for it is not a dictate of Reason that what we thus see or imagine is in reality existent; but it plainly tells us that all our ideas or notions contain in them some truth; for otherwise it could not be that God, who is wholly perfect and veracious, should have placed them in us. And because our reasonings are never so clear or so complete during sleep as when we are awake, although some-

times the acts of our imagination are then as lively and distinct, if not more so than in our waking moments, Reason further dictates that, since all our thoughts cannot be true because of our partial imperfection, those possesing truth must infallibly be found in the experience of our waking moments rather than in that of our dreams.

Newton: from The Mathematical Principles of Natural Philosophy

Isaac Newton (1642–1727) was perhaps the most illustrious all-round man of the early eighteenth century. Mathematician, physicist, astronomer, philosopher, and amateur theologian, he discovered the laws of universal gravity and of the decomposition of light, and he disputed with Leibnitz the priority of the differential calculus. The prevailing veneration of the great scientist appears in Pope's couplet intended for Newton's tomb in Westminster Abbey:

Nature and Nature's laws lay hid in night; God said, "Let Newton be," and all was light.

For our purpose, we can find no better brief expression of the new scientific approach than in the definition of scientific method that he laid down in the great *Philosophiae Naturalis Principia Mathematica* of 1687.

RULES OF REASONING IN PHILOSOPHY

Rule I

We are to admit no more causes of natural things than such as are both true and sufficient to explain their appearances.

To this purpose the philosophers say that Nature does nothing in vain, and more is in vain when less will serve; for Nature is pleased with simplicity, and affects not the pomp of superfluous causes.

Rule II

Therefore to the same natural effects we must, as far as possible, assign the same causes.

As to respiration in a man and in a beast; the descent of stones in Europe and in America; the light of our culinary fire and of the sun; the reflection of light on the earth, and in the planets.

Rule III

The qualities of bodies, which admit neither intension nor remission of degrees, and which are found to belong to all bodies within the reach of our experiments, are to be esteemed the universal qualities of all bodies whatsoever.

For since the qualities of bodies are only known to us by experiments, we are to hold for universal all such as universally agree with experiments and such as are not liable to diminution can never be

From Isaac Newton, The Mathematical Principles of Natural Philosophy, 2 vols. (London, 1803), II, 160-162.

quite taken away. We are certainly not to relinquish the evidence of experiments for the sake of dreams and vain fictions of our own devising; nor are we to recede from the analogy of Nature, which uses to be simple, and always consonant to itself. We no other way know the extension of bodies than by our senses, nor do these reach it in all bodies; but because we perceive extension in all that are sensible, therefore we ascribe it universally to all others also. That abundance of bodies are hard, we learn by experience; and because the hardness of the whole arises from the hardness of the parts, we therefore justly infer the hardness of the undivided particles not only of the bodies we feel but of all others. That all bodies are impenetrable, we gather not from reason, but from sensation. The bodies which we handle we find impenetrable, and thence conclude impenetrability to be an universal property of all bodies whatsoever. That all bodies are moveable, and endowed with certain powers (which we call the vires inertiae) of persevering in their motion, or in their rest, we only infer the like properties observed in the bodies which we have seen. The extension, hardness, impenetrability, mobility, and vis inertiae of the whole, result from the extension, hardness, impenetrability, mobility, and vires inertiae of the parts; and thence we conclude the least particles of all bodies to be also all extended, and hard, and impenetrable, and moveable, and endowed with their proper vires inertiae. And this is the foundation of all philosophy. Moreover, that the divided but contiguous particles of bodies may be separated from one another, is matter of observation; and, in the particles that remain undivided, our minds are able to distinguish yet lesser parts, as is mathematically demonstrated. But whether the parts so distinguished and not yet divided, may, by the powers of Nature, be actually divided and separated from one another, we cannot certainly determine. Yet had we the proof of but one experiment that any undivided particle, in breaking a hard and solid body, suffered a division, we might by virtue of this rule conclude that the undivided as well as the divided particles may be divided and actually separated to infinity.

Lastly, if it universally appears, by experiments and astronomical observations, that all bodies about the earth gravitate towards the earth, and that in proportion to the quantity of matter which they severally contain; that the moon likewise, according to the quantity of its matter, gravitates towards the earth; that, on the other hand, our sea gravitates towards the moon; and all the planets mutually one towards another; and the comets in like manner towards the sun; we must, in consequence of this rule, universally allow that all bodies whatsoever are endowed with a principle of mutual gravitation. For the argument from the appearances concludes with more force for the universal gravitation of all bodies than for their impenetrability; of which, among those in the celestial regions, we have no experiments, nor any manner of observation. Not that I affirm gravity to be essential to bodies: by their vis infita I mean nothing but their vis inertiae. This is immutable. Their gravity is diminished as they recede from the earth.

Rule IV

In experimental philosophy we are to look upon propositions collected by general induction from phaenomena as accurately or very nearly true, notwithstanding any contrary hypotheses that may be imagined, till such time as other phaenomena occur, by which they may either be made more accurate, or liable to exceptions.

This rule must follow, that the argument of induction may not be evaded by hypotheses.

Locke: from An Essay Concerning Human Understanding

John Locke (1632–1704) was not only a scholar but also a doctor, a civil servant, and an amateur diplomat. Attached to the powerful Ashley family (Lords Shaftesbury) he met some of the greatest men in contemporary English politics (Buckingham, Halifax) and was the tutor of the second and the third Lords Shaftesbury. At one time he produced a constitution for the newly founded American colony of Carolina. In exile with his patron in Holland from 1682 to 1688, he returned in the fleet of William of Orange and set himself to provide a philosophical explanation for the dispossession of James II. Two *Treatises on Government* resulted, and part of one is given on page 423 below. His fame, however, rests chiefly on his philosophical writings, chief of which is the *Essay Concerning Human Understanding*, published in 1690. It is divided into four books: the first discusses innate ideas and concludes that they do not exist, the second deals with the origin of ideas, the third with language, the fourth lays down the limits of human understanding. Only two brief passages from books one and four are given below.

OF IDEAS IN GENERAL, AND THEIR ORIGIN

1. Idea is the object of thinking. -Every man being conscious to himself, that he thinks, and that which his mind is applied about, whilst thinking, being the ideas that are there, it is past doubt that men have in their mind several ideas, such as are those expressed by the words, "whiteness, hardness, sweetness, thinking, motion, man, elephant, army, drunkenness," and others. It is in the first place then to be inquired, How he comes by them? I know it is a received doctrine, that men have native ideas and original characters stamped upon their minds in their very first being. This opinion I have at large examined already; and, I suppose, what I have shown whence the understanding may get all the ideas it has, and

by what ways and degrees they may come into the mind; for which I shall appeal to every one's own observation and experience.

2. All ideas come from sensation or reflection.—Let us then suppose the mind to be, as we say, white paper, void of all characters, without any ideas; how comes it to be furnished? Whence comes it by that vast store, which the busy and bound less fancy of man has painted on it with an almost endless variety? Whence has it all the materials of reason and knowledge? To this I answer, in one word, From experience: in that all our knowledge is founded, and from that it ultimately derives itself. Our observation, employed either about external sensible objects, or about the internal operations of our minds, perceived and reflected on by ourselves, is that which supplies our

From John Locke, An Essay Concerning Human Understanding (London, 1881), pp. 59-61; 424.

understandings with all the materials of thinking. These two are the fountains of knowledge, from whence all the ideas we have, or can naturally have, do spring.

- 3. The object of sensation one source of ideas. - First, Our senses, conversant about particular sensible objects, do convev into the mind several distinct perceptions of things, according to those various ways wherein those objects do affect them: and thus we come by those ideas we have of vellow, white heat, cold, soft, hard, bitter, sweet, and all those which we call sensible qualities; which when I say the senses convey into the mind, I mean they from external objects convey into the mind what produces there those perceptions. The great source of most of the ideas we have, depending wholly upon our senses, and derived by them to the understanding, I call "sensation."
- 4. The operations of our minds the other source of them. - Secondly. The other fountain, from which experience furnisheth the understanding with ideas, is the perception of the operations of our own minds within us, as it is employed about the ideas it has got; which operations, when the soul comes to reflect on and consider, do furnish the understanding with another set of ideas which could not be had from things without; and such are perception, thinking, doubting, believing, reasoning, knowing, willing, and all the different actings of our own minds; which we, being conscious of, and observing in ourselves, do from these receive into our understanding as distinct ideas, as we do from bodies affecting our senses. This source of ideas every man has wholly in himself; and though it be not sense as having nothing to do with external objects, yet it is very like it, and might properly enough be called "internal sense." But as I call the other "sensation." so I

call this "reflection," the ideas it affords being such only as the mind gets by reflecting on its own operations within itself. By reflection, then, in the following part of this discourse, I would be understood to mean that notice which the mind takes of its own operations, and the manner of them, by reason whereof there come to be ideas of these operations in the understanding. These two, I say, viz., external material things as the objects of sensation, and the operations of our own minds within as the objects of reflection, are, to me, the only originals from whence all our ideas take their beginnings. The term "operations" here, I use in a large sense, as comprehending not barely the actions of the mind about its ideas, but some sort of passions arising sometimes from them, such as is the satisfaction or uneasiness arising from any thought.

5. All our ideas are of the one or the other of these.—The understanding seems to me not to have the least glimmering of any ideas which it doth not receive from one of these two. External objects furnish the mind with the ideas of sensible qualities, which are all those different perceptions they produce in us; and the mind furnishes the understanding with ideas of its own operations.

These, when we have taken a full survey of them, and their several modes, combinations, and relations, we shall find to contain all our whole stock of ideas; and that we have nothing in our minds which did not come in one of these two ways. Let any one examine his own thoughts, and thoroughly search into his understanding, and then let him tell me, whether all the original ideas he has there, are any other than of the objects of his senses, or of the operations of his mind considered as objects of his reflection; and how great a mass of knowledge

soever he imagines to be lodged there, he will, upon taking a strict view, see that he has not any idea in his mind but what one of these two hath imprinted, though perhaps with infinite variety compounded and enlarged by the understanding, as we shall see hereafter. . . .

OF KNOWLEDGE IN GENERAL

- 1. Our knowledge conversant about our ideas.—Since the mind, in all its thoughts and reasonings, hath no other immediate object but its own ideas, which it alone does or can contemplate, it is evident that our knowledge is only conversant about them.
- 2. Knowledge is the perception of the agreement or disagreement of two ideas.

 —Knowledge then seems to me to be nothing but the perception of the connection and agreement or disagreement and

repugnancy, of any of our ideas. In this alone it consists. Where this perception is, there is knowledge; and where it is not, there, though we may fancy, guess, or believe, yet we always come short of knowledge. For, when we know that white is not black, what do we else but perceive that these two ideas do not agree? When we possess ourselves with the utmost security of the demonstration that the three angles of a triangle are equal to two right ones, what do we more but perceive that equality to two right ones does necessarily agree to, and is inseparable from the three angles of a triangle?

3. This agreement fourfold.—But to understand a little more distinctly, wherein this agreement or disagreement consists, I think we may reduce it all to these four sorts: (1.) Identity, or diversity. (2.) Relation. (3.) Co-existence, or necessary connection. (4.) Real existence. . . .

6. WITCH HUNTING

As mentioned earlier, the high intellectual caliber of the era did nothing to banish the prevalence of witches which seems to have troubled Europe since the high Middle Ages. Superstition was rife, but superstition was coterminous with faith. As the eminent seventeenth-century divine, Joseph Glanvill, had pointed out, if you do not believe in witches you do not believe in spirits; if you do not believe in spirits, you do not believe in angels; if you do not believe in angels, you do not believe in God. Since all believed in God, all believed in devils and their fellow-traveling witches. The persecution of the devil's fifth column on earth culminated in a series of semi-hysterical panics that terrorized western Europe from Scotland to Bohemia, and even impinged on the attention of Cardinal de Richelieu (see A. Huxley, *The Devils of Loudun*) and Louis XIV, one of whose mistresses, Mme. de Montespan, was involved in a lurid and complicated scandal.

Persecutions for witchcraft continued to take place through most of the eighteenth century too. In England the last execution for this crime seems to have been carried out in 1684, but in Scotland a woman was burnt for it as late as 1727. European countries were slower to lose the habit; in 1749, a high-born nun was executed for witchcraft at Würzburg; six years later a young adventurer called Casanova was imprisoned by the Inquisition at Venice on a charge of magic, but escaped. He was luckier than the two witches burnt at Glarus, Switzerland, in 1782 and the two who suffered a similar fate in Poland eleven years later, when the Revolution had already triumphed in France. But these were the last it would seem; witches and the fear of witches endured, but the growth of skepticism meant that the law and authorities no longer countenanced superstition. John Wesley had foreseen the dire consequences of such skeptical tolerance: "It is true," he noted in his Journal (Vol. V, p. 375, 1768), "that the English have given up all accounts of witches and apparitions as mere old wives' fables. I am sorry for it. . . . Infidels have hooted witchcraft out of the world. . . . They well know (whether Christians know it or not) that the giving up of witchcraft is in effect giving up the Bible." However, we know that such dangerous skepticism did not long endure and, like the poor, witches of one sort or another are always with us.

The first and briefest of the selections below relates to the witch hunts which took place in the second half of the sixteenth century in the Rhenish domains of the Elector-Archbishop of Trier. The subsequent selections are self-explanatory.

The Witch-Persecution at Trier

Inasmuch as it was popularly believed that the continued sterility of many years was caused by witches through the malice of the Devil, the whole country rose to exterminate the witches. This movement was promoted by many in office, who hoped for wealth from the persecution. And so, from court to court throughout the towns and villages of all the diocese, scurried special accusers, inquisitors, notaries, jurors, judges, constables, dragging to trial and torture human beings of both sexes and burning them in great numbers. Scarcely any of those who were accused escaped punishment. Nor were there spared even the leading men in the city of Trier. For the Judge, with two Burgomasters, several Councilors and Associate Judges, canons of sundry collegiate churches, parish-priests, rural deans, were swept away in this ruin. So far, at length, did the madness of the furious populace and of the courts go in this thirst for blood and booty that there was scarcely anybody who was not smirched by some suspicion of this crime.

Meanwhile notaries, copyists, and innkeepers grew rich. The executioner rode a blooded horse, like a noble of the court, and went clad in gold and silver; his wife vied with noble dames in the richness of her array. The children of those convicted and punished were sent into exile; their goods were confiscated; plowman and vintner failed—hence came sterility. A direr pestilence or a more ruthless invader could hardly have ravaged the territory of Trier than this inquisition and persecution without bounds: many were the reasons for doubting that all were really guilty. This persecution lasted for several years; and some of those who presided over the administration of iustice gloried in the multitude of the stakes, at each of which a human being had been given to the flames.

At last, though the flames were still unsated, the people grew impoverished,

All of witch-hunting documents from Translations and Reprints, Vol. 3, No. 4, G. L. Burr, Ed.

rules were made and enforced restricting the fees and costs of examinations and examiners, and suddenly, as when in war

funds fail, the zeal of the persecutors died out.

The Witch-Persecution at Bamberg

On Wednesday, June 28, 1628, was examined without torture, Johannes Junius, Burgomaster at Bamberg, on the charge of witchcraft: how and in what fashion he had fallen into that vice. Is fifty-five years old, and was born at Niederwaysich in the Wetterau. Says he is wholly innocent, knows nothing of the crime, has never in his life renounced God; says that he is wronged before God and the world, would like to hear of a single human being who has seen him at such gatherings [as the witch-sabbaths].

Confrontation of Dr. Georg Adam Haan. Tells him to his face he will stake his life on it [er wolle darauf leben und sterben], that he saw him, Junius, a year and a half ago at a witch-gathering in the electoral council-room, where they ate and drank. Accused denies the same wholly.

Confronted with Hopffens Elsse. Tells him likewise that he was on Haupts-moor at a witch-dance; but first the holy wafer was desecrated. Junius denies. Hereupon he was told that his accomplices had confessed against him and was given time for thought.

On Friday, June 30, 1628, the aforesaid Junius was again without torture exhorted to confess, but again confessed nothing, whereupon, . . . since he would confess nothing, he was put to the torture, and first the

Thumb-screws were applied. Says he has never denied God his Savior nor suffered himself to be otherwise baptized; will again stake his life on it; feels no pain in the thumb-screws.

Leg-screws. Will confess absolutely nothing; knows nothing about it. He has never renounced God; will never do such a thing; has never been guilty of this vice; feels likewise no pain.

Is stripped and examined; on his right side is found a bluish mark, like a clover leaf, is thrice pricked therein, but feels no pain and no blood flows out.

Strappado. He has never renounced God; God will not forsake him; if he were such a wretch he would not let himself be so tortured; God must show some token of his innocence. He knows nothing about witchcraft . . .

On July 5, the above named Junius is without torture, but with urgent persuasions, exhorted to confess, and at last begins and confesses:

When in the year 1624 his law-suit at Rothweil cost him some six hundred florins, he had gone out, in the month of August, into his orchard at Friedrichsbronnen; and, as he sat there in thought, there had come to him a woman like a grass-maid, who had asked him why he sat there so sorrowful; he had answered that he was not despondent, but she had led him by seductive speeches to yield him to her will. . . . And thereafter this wench had changed into the form of a goat, which bleated and said, "Now you see with whom you have had to do. You must be mine or I will forthwith break your neck." Thereupon he had been frightened, and trembled all over for fear. Then the transformed spirit had seized him by the throat and demanded that he

should renounce God Almighty, whereupon Junius said, "God forbid," and thereupon the spirit vanished through the power of these words. Yet it came straightway back, brought more people with it, and persistently demanded of him that he renounce God in Heaven and all the heavenly host, by which terrible threatening he was obliged to speak this formula: "I renounce God in Heaven and his host, and will henceforward recognize the Devil as my God."

After the renunciation he was so far persuaded by those present and by the evil spirit that he suffered himself to be otherwise baptized in the evil spirit's name. The Morhauptin had given him a ducat as dower-gold, which afterward became only a potsherd.

He was then named Krix. His paramour he had to call Vixen. Those present had congratulated him in Beelzebub's name and said that they were now all alike. At this baptism of his there were among others the aforesaid Christiana Morhauptin, the young Geiserlin, Paul Glaser, [and others]. After this they had dispersed.

At this time his paramour had promised to provide him with money, and from time to time to take him to other witchgatherings. . . . Whenever he wished to ride forth [to the witch-sabbath] a black dog had come before his bed, which said to him that he must go with him, whereupon he had seated himself upon the dog and the dog had raised himself in the Devil's name and so had fared forth.

About two years ago he was taken to the electoral council-room, at the left hand as one goes in. Above at a table were seated the Chancellor, the Burgomaster Neydekher, Dr. Georg Haan, (and many others). Since his eyes were not good, he could not recognize more persons.

More time for consideration was now given him. On July 7, the aforesaid Junius was again examined, to know what further had occurred to him to confess. He confesses that about two months ago, on the day after an execution was held, he was at a witch-dance at the Black Cross, where Beelzebub had shown himself to them all and said expressly to their faces that they must all be burned together on this spot, and had ridiculed and taunted those present. . . .

Of crimes. His paramour had immediately after his seduction demanded that he should make away with his youngest son Hans Georg, and had given him for this purpose a gray powder; this, however, being too hard for him, he had made away with his horse, a brown, instead.

His paramour had also often spurred him on to kill his daughter. . . . and because he would not do this he had been maltreated with blows by the evil spirit.

Once at the suggestion of his paramour he had taken the holy wafer out of his mouth and given it to her. . . .

A week before his arrest as he was going to St. Martin's church the Devil met him on the way in the form of a goat, and told him that he would soon be imprisoned, but that he should not trouble himself-he would soon set him free. Besides this, by his soul's salvation, he knew nothing further; but what he had spoken was the pure truth; on that he would stake his life. On August 6, 1628, there was read to the aforesaid Junius this his confession, which he then wholly ratified and confirmed, and was willing to stake his life upon it. And afterward he voluntarily confirmed the same before the court.

So ended the trial of Junius, and he was accordingly burnt-at the stake. But it so happens that there is also preserved in Bamberg a letter, in quivering hand, secretly written by him to his daughter while in the midst of his trial (July 24, 1628):

Many hundred thousand good nights, dearly beloved daughter Veronica. Innocent have I come into prison, innocent have I been tortured, innocent must I die. For whoever comes into the witch prison must become a witch or be tortured until he invents something out of his head-and God pity him-bethinks him of something. I will tell you how it has gone with me. When I was the first time put to the torture, Dr. Baum, Dr. Kotzendorffer, and two strange doctors were there. Then Dr. Braun asks me, "Kinsman, how come you here?" I answer, "Through falsehood, through misfortune." "Hear, you," he says, "You are a witch; will you confess it voluntarily? If not, we'll bring in witnesses and the executioner for you." I said, "I am no witch. I have a pure conscience in the matter: if there are a thousand witnesses, I am not anxious, but I'll gladly hear the witnesses." Now the Chancellor's son was set before me . . . and afterward Hopffens Elsse. She had seen me dance on Haupts-moor. . . . I answered: "I have never renounced God, and will never do it-God graciously keep me from it. I'll rather bear whatever I must." And then came also-God in highest Heaven have mercy—the executioner, and put the thumb-screws on me, both hands bound together, so that the blood ran out at the nails and everywhere, so that for four weeks I could not use my hands, as you can see from the writing. . . . Thereafter they first stripped me, bound my hands behind me, and drew me up in the torture. Then I thought heaven

and earth were at an end; eight times did they draw me up and let me fall again, so that I suffered terrible agony. . . .

And this happened on Friday, June 30, and with God's help I had to bear the torture. . . . When at last the executioner led me back into the prison, he said to me: "Sir, I beg you, for God's sake confess something, whether it be true or not. Invent something, for you cannot endure the torture which you will be put to; and, even if you bear it all, yet you will not escape, not even if you were an earl, but one torture will follow after another until you say you are a witch. Not before that," he said, "will they let you go, as you may see by all their trials, for one is just like another." . . .

And so I begged, since I was in wretched plight, to be given one day for thought and a priest. The priest was refused me, but the time for thought was given. Now, my dear child, see in what hazard I stood and still stand. I must say that I am a witch, though I am not,-must now renounce God, though I have never done it before. Day and night I was deeply troubled, but at last there came to me a new idea. I would not be anxious, but, since I had been given no priest with whom I could take counsel, I would myself think of something and say it. It were surely better that I just say it with mouth and words, even though I had not really done it; and afterwards I would confess it to the priest, and let those answer for it who compel me to do it. . . . And so I made my confession, as follows; but it was all a lie.

Now follows, dear child, what I confessed in order to escape the great anguish

and bitter torture, which it was impossible for me longer to bear.

Here follows his confession, substantially as it is given in the minutes of his trial. But he adds:

Then I had to tell what people I had seen [at the witch-sabbath]. I said that I had not recognized them. "You old rascal, I must set the executioner at you. Say-was not the Chancellor there?" So I said yes. "Who besides?" I had not recognized anybody. So he said: "Take one street after another; begin at the market, go out on one street and back on the next." I had to name several persons there. Then came the long street. I knew nobody. Had to name eight persons there. Then the Zinkenwert—one person more. Then over the upper bridge to the Georgthor, on both sides. Knew nobody again. Did I know nobody in the castle-whoever it might be, I should speak without fear. And thus continuously they asked me on all the streets, though I could not and would not say more. So they gave me to the executioner, told him to strip me, shave me all over, and put me to the torture. "The rascal knows one on the market-place, is with him daily, and yet won't name him." By that they meant Dietmeyer: so I had to name him too.

Then I had to tell what crimes I had committed. I said nothing. . . . "Draw

the rascal up!" So I said that I was to kill my children, but I had killed a horse instead. It did not help. I had also taken a sacred wafer, and had desecrated it. When I had said this, they left me in peace.

Now, dear child, here you have all my confession, for which I must die. And they are sheer lies and made-up things, so help me God. For all this I was forced to say through fear of the torture which was threatened beyond what I had already endured. For they never leave off with the torture till one confesses something; be he never so good, he must be a witch. Nobody escapes, though he were an earl. . . .

Dear child, keep this letter secret so that people do not find it, else I shall be tortured most piteously and the jailers will be beheaded. So strictly is it forbidden. . . . Dear child, pay this man a dollar. . . . I have taken several days to write this: my hands are both lame. I am in a sad plight.

Good night, for your father Johannes Junius will never see you more. July 24, 1628.

And on the margin of the letter he added:

Dear child, six have confessed against me at once: the Chancellor, his son, Neudecker, Zaner, Hoffmaisters Ursel, and Hopffens Elsse—all false, through compulsion, as they have all told me, and begged my forgiveness in God's name before they were executed. . . . They know nothing but good of me. They were forced to say it, just as I myself was. . . .

The Methods of the Witch-Persecutions

It was in Franconia, during the persecutions just above described, that the noble Jesuit poet, Friedrich von Spee, was made the confessor of those sentenced to death for witchcraft and was thus inspired to write (though anonymously) the book whose eloquent protest gave the persecution throughout Europe its first effective check. Not till long afterward did the philosopher Leibnitz reveal its authorship, on the authority of his friend Johann Philipp von Schonborn, Archbishop of Mainz, who as a boy at Würzburg had known and loved Father Spee and had learned from him the whole story in answer to a question as to the young father's whitened hair. The last of the fifty-one doubts into which Spee's Cautio criminalis (Rintein, 1631) is divided runs thus (Burr's note):

WHAT, NOW, IS THE OUTLINE AND METHOD OF THE TRIALS AGAINST WITCHES TO-DAY IN GENERAL USE? — A THING WORTHY OF GERMANY'S CONSIDERATION.

I answer: . . .

- 1. Incredible among us Germans and especially (I blush to say it) among Catholics are the popular superstition, envy, calumnies, backbitings, insinuations, and the like, which, being neither punished by the magistrates nor refuted by the pulpit, first stir up suspicion of witchcraft. All the divine judgments which God has threatened in Holy Writ are now ascribed to witches. No longer do God or nature do aught, but witches everything.
- 2. Hence it comes that all at once everybody is clamoring that the magistrates proceed against the witches—those witches whom only their own clamor has made seem so many.
- 3. Princes, therefore, bid their judges and counselors to begin proceedings against the witches.
- 4. These at first do not know where to begin, since they have no testimony or proofs, and since their conscience clearly tells them that they ought not to proceed in this rashly.

- 5. Meanwhile they are a second time and a third admonished to proceed. The multitude clamors that there is something suspicious in this delay; and the same suspicion is, by one busybody or another, instilled into the ear of the princes.
- 6. To offend these, however, and not to defer at once to their wishes, is in Germany a serious matter: most men, and even clergymen, approve with zeal whatever is but pleasing to the princes, not heeding by whom these (however good by nature) are often instigated.
- 7. At last, therefore, the judges yield to their wishes, and in some way contrive at length a starting-point for the trials.
- 8. Or, if they still hold out and dread to touch the ticklish matter, there is sent to them a commissioner [Inquisitor] especially deputed for this. And, even if he brings to his task something of inexperience or of ardor, as is wont to happen in things human, this takes on in this field another color and name, and is counted only zeal for justice. This zeal for justice is no whit diminished by the prospect of gain, especially in the case of a commissioner of slender means and avaricious, with a large family, when there is granted him as salary so many dollars per head for each witch burned.

besides the fees and assessments which he is allowed to extort at will from the peasants.

- 9. If now some utterance of a demoniac or some malign and idle rumor then current (for proof of the scandal is never asked) points especially to some poor and helpless Gaia, she is the first to suffer.
- 10. And yet, lest it appear that she is indicted on the basis of rumor alone, without other proofs, as the phrase goes, lo a certain presumption is at once obtained against her by posing the following dilemma: Either Gaia has led a bad and improper life, or she has led a good and proper one. If a bad one, then, say they, the proof is cogent against her; for from malice to malice the presumption is strong. If, however, she has led a good one, this also is none the less a proof; for thus, they say, are witches wont to cloak themselves and try to seem especially proper.
- 11. Therefore it is ordered that Gaia be haled away to prison. And lo now a new proof is gained against her by this other dilemma: Either she then shows fear or she does not show it. If she does show it (hearing forsooth of the grievous tortures wont to be used in this matter), this is of itself a proof; for conscience, they say accuses her. If she does not show it (trusting forsooth in her innocence), this too is a proof; for it is most characteristic of witches, they say, to pretend themselves peculiarly innocent and wear a bold front.
- 12. Lest, however, further proofs against her should be lacking, the Commissioner has his own creatures, often depraved and notorious, who question into all her past life. This, of course, cannot be done without coming upon some saying or doing of hers which evil-minded

men can easily twist or distort into ground for suspicion of witchcraft.

- 13. If, too, there are any who have borne her ill will, these, having now a fine opportunity to do her harm, bring against her such charges as it may please them to devise; and on every side there is a clamor that the evidence is heavy against her.
- 14. And so, as soon as possible, she is hurried to the torture, if indeed she be not subjected to it on the very day of her arrest, as often happens.
- 15. For in these trials there is granted to nobody an advocate or any means of fair defense, for the cry is that the crime is an expected one, and whoever ventures to defend the prisoner is brought into suspicion of the crime—as are all those who dare to utter a protest in these cases and to urge the judges to caution; for they are forthwith dubbed patrons of the witches. Thus all mouths are closed and all pens blunted, lest they speak or write.
- 16. In general, however, that it may not seem that no opportunity of defense has been given to Gaia, she is brought out and the proofs are first read before her and examined—if examination it can be called.
- 17. But, even though she then denies these and satisfactorily makes answer to each, this is neither paid attention to nor even noted down: all the proofs retain their force and value, however perfect her answer to them. She is only ordered back into prison, there to bethink herself more carefully whether she will persist in her obstinacy—for, since she has denied her guilt, she is obstinate.
- 18. When she has bethought herself, she is next day brought out again, and there is read to her the sentence of torture—just as if she had before answered

nothing to the charges, and refuted nothing.

- 19. Before she is tortured, however, she is led aside by the executioner, and lest she may by magical means have fortified herself against pain, she is searched, her whole body being shaved, . . . although up to this time nothing of the sort was ever found. . . .
- 21. Then, when Gaia has thus been searched and shaved, she is tortured that she may confess the truth, that is to say, that she may simply declare herself guilty; for whatever else she may say will not be the truth and cannot be.
- 22. She is, however, tortured with the torture of the first degree, i.e., the less severe. This is to be understood thus: that, although in itself it is exceeding severe, yet, compared with others to follow, it is lighter. Wherefore, if she confesses, they say and noise it abroad that she has confessed without torture.
- 23. Now, what prince or other dignitary who hears this can doubt that she is most certainly guilty who thus voluntarily without torture confesses her guilt?
- 24. Without any scruples, therefore, after this confession she is executed. Yet she would have been executed, nevertheless, even though she had not confessed; for when once a beginning has been made with the torture, the die is already cast—she cannot escape, she must die.
- 25. So, whether she confesses or does not confess, the result is the same. If she confesses, the thing is clear, for, as I have said and as is self-evident, she is executed: all recantation is in vain, as I have shown above. If she does not confess, the torture is repeated—twice, thrice, four times: anything one pleases is permissible, for in an excepted crime there is no limit of duration or severity or repetition of the tortures. As to this, think the

- judges, no sin is possible which can be brought up before the tribunal of conscience.
- 26. If now Gaia, no matter how many times tortured, has not yet broken silence, —if she contorts her features under the pain, if she loses consciousness, or the like, then they cry that she is laughing or has bewitched herself into taciturnity, and hence deserves to be burned alive, as lately has been done to some who though several times tortured would not confess.
- 27. And then they say—even clergymen and confessors—that she died obstinate and impenitent, that she would not be converted or desert her paramour, but kept rather her faith with him.
- 28. If, however, it chances that under so many tortures one dies, they say that her neck has been broken by the Devil.
- 29. Wherefore justly, forsooth, the corpse is dragged out by the executioner and buried under the gallows.
- 30. But if, on the other hand, Gaia does not die and some exceptionally scrupulous judge hesitates to torture her further without fresh proofs or to burn her without a confession, she is kept in prison and more harshly fettered, and there lies for perhaps an entire year to rot until she is subdued.
- 31. For it is never possible to clear herself by withstanding and thus to wash away the aspersion of crime, as is the intention of the laws. It would be a disgrace to her examiners if when once arrested she should thus go free. Guilty must she be, by fair means or foul, whom they have once but thrown into bonds.
- 32. Meanwhile, both then and earlier, they send to her ignorant and headstrong priests, more importunate than the executioners themselves. It is the business of these to harass in every wise the wretched

creature to such a degree that, whether truly or not, she will at last confess herself guilty; unless she does so, they declare, she simply cannot be saved, nor share in the sacraments.

33. The greatest care is taken lest there be admitted to her priests more thoughtful and learned, who have aught of insight or kindliness; as also that nobody visits her prison who might give her counsel or inform the ruling princes. For there is nothing so much dreaded by any of them as that in some way the innocence of any of the accused should be brought to light. . .

34. In the meantime, while Gaia, as I have said, is still held in prison, and is tormented by those whom it least behooves, there are not wanting to her industrious judges clever devices by which they not only find new proofs against Gaia, but by which moreover they so convict her to her face (an 't please the gods!) that by the advice of some university faculty she is then at last pronounced to deserve burning alive. . . .

35. Some, however, to leave no stone unturned, order Gaia to be exorcised and transferred to a new place, and then to be tortured again, in the hope that by this exorcism and change of place the bewitchment of taciturnity may perhaps be broken. But, if not even this succeeds. then at last they commit her alive to the flames. Now in Heaven's name, I would like to know, since both she who confesses and she who does not, perish alike, what way of escape there is for any, however innocent? O unhappy Gaia, why hast thou rashly hoped? why hast thou not, at first entering prison, declared thyself guilty? why, O foolish woman and mad, wilt thou die so many times when thou mightst die but once? Follow my counsel, and before all pain declare thyself guilty and die. Thou wilt not escape; for this were a disgrace to the zeal of Germany.

36. If, now, any under stress of pain has once falsely declared herself guilty, her wretched plight beggars description. For not only is there in general no door for her escape, but she is also compelled to accuse others, of whom she knows no ill, and whose names are not seldom suggested to her by her examiners or by the executioner, or of whom she has heard as suspected or accused or already once arrested and released. These in their turn are forced to accuse others, and these still others, and so it goes on: who can help seeing that it must go on without end?

37. Wherefore the judges themselves are obliged at last either to break off the trials and so condemn their own work or else to burn their own folk, aye themselves and everybody: for on all soon or late false accusations fall, and, if only followed by the torture, all are proved guilty.

- 38. And so at last those are brought in question who at the outset most loudly clamored for the constant feeding of the flames; for they rashly failed to foresee that their turn, too, must inevitably come—and by a just verdict of heaven, since with their pestilent tongues they created us so many witches and sent so many innocent to the flames.
- 39. But now gradually many of the wiser and more learned begin to take notice of it, and, as if aroused from deep sleep, to open their eyes and slowly and cautiously to bestir themselves. . . .
- 46. From all which there follows this corollary, worthy to be noted in red ink: that, if only the trials be steadily pushed on with, there is nobody in our day, of whatsoever sex, fortune, rank or dignity who is safe, if he have but an enemy and slanderer to bring him into suspicion of witchcraft. . .

V. The Political Debate

In the great orderly pattern of seventeenth-century thought, one thing still remained to be settled: the nature and justification of political authority. In the Middle Ages this had rested with God and been shared equally between God's representatives on earth—the Pope and the Prince. With the Reformation, this ideal equilibrium had been broken: where only one pope had reigned before, now there were several, each claiming ultimate religious authority for his version of God's will and revelation. The result of this was a growth in the power of princes at the expense of the Church. Where, once upon a time, religious authority had provided the sanction of political power, under the new dispensation political authority guaranteed and reinforced this or that form of religion. By a natural evolution, it came to be argued that the prince was the ultimately significant representative of God on earth, ruling his country by divine right and dispensation. This was the thesis of Bossuet, but it was challenged by a rival theory based on a justification more immediate and worldly than the will of God: the contract.

The contract theory of government, which appealed to the common sense of an increasingly businesslike public, presented society as the result of an agreement between its members, and the political form of society, its system of government, as arising out of a similar agreement. The contract theory was not necessarily more liberal than that of divine right: the king of Hobbes is a less restrained and probably a harsher ruler than that of Bossuet. But, in the hands of Locke, the logical implications of contractual relationships were carried to revolutionary conclusions: a contract was seen for what it had always been—an undertaking with mutual obligations binding on both parties and sanctions for failure to carry out its terms—and the new view severely shook the firm, unquestioned basis of monarchial power.

1. BOSSUET

Jacques Bénigne Bossuet (1627–1704), bishop of Meaux, was one of the great orators and polemicists of the reign of Louis XIV. Appointed tutor to the Dauphin, the King's heir, Bossuet wrote for his edification a series of works expounding the divine rights and God-appointed duties of kings. The following passages are taken from one of these, the *Treatise on Politics*, Based on the Verv Words of Holy Writ, most of which was composed in 1678.

On the Nature and the Properties of Royal Authority

Firstly, royal authority is sacred; secondly, it is paternal; thirdly, it is absolute; fourthly, it is subject to reason.

God establishes kings as his ministers, and reigns through them over the peoples. We have already seen that all power comes from God. The Prince, adds Saint Paul, "is a minister of God to thee for good. But if thou do that which is evil, be afraid; for he beareth not the sword in vain: for he is a minister of God. an avenger for wrath to him that doeth evil." So princes act as ministers of God and his lieutenants on earth. It is through them that He rules His empire. This is why we have seen that the royal throne is not the throne of a man, but the throne of God Himself. Nor is it peculiar to the Iews alone to have kings appointed by God. . . . He governs all peoples, and gives kings to all.

It appears from all this that the person of the king is sacred, and that it is a sacrilege to attack him. God has His prophets anoint them with a sacred unction, as He has His pontiffs and His altars anointed. But, even without the external application of this unction, their charge renders them sacred, as being the representatives of the divine majesty, delegated by His providence to the execution of His designs. It is thus that God Himself speaks of Cyrus as His anointed-"his right hand I have holden to subdue nations before him." The title of Christ is given to kings; and everywhere we see them called the Christ, or the anointed of the Lord.

Translated by the editor.

Kings must be guarded as being sacred; and he who neglects to guard them deserves to die. He who guards the life of the prince, places his own in the safe-keeping of God.

Saint Paul, after having said that the prince is the minister of God, concludes thus: "Wherefore Ye must needs be in subjection, not only because of the wrath, but also for conscience's sake." . . . And again, "servants, obey in all things your temporal masters and whatsoever Ye do, do it heartily as to the Lord, and not as unto men." If the apostle speaks thus of servitude, which is an unnatural condition: what should we think of legitimate subjection to princes and to the magistrates who are the protectors of public liberty? This is why Saint Peter says, "submit yourselves to every ordinance of man for the Lord's sake: whether it be to the king as supreme, or unto governors, as unto them that are sent by him for the punishment of evildoers and for the praise of them that do well." And, even if they did not carry out their duty, we must respect in them their charge and their ministry. "Servants, be subject to your masters with all fear; not only to the good and gentle, but also to the froward and unjust." There is thus a religious character about the respect we show to the prince. The service of God and the respect for kings are one; and Saint Peter puts these two duties together: "Fear God; honor the king." . . . Indeed, God has infused something of divinity into princes: "I have said Ye are Gods; and all of you are children of the Most High."

The kings must respect their own power and use it only to the public good.

Their power coming from above, as we have said, they must not believe that it belongs to them to be used as they please; but they must use it with fear and restraint, as a thing which comes from God and for which God will call them to account. Kings should therefore tremble when using the power that God has given them, and think how horrible is the sacrilege of misusing a power which comes from God.

THE ROYAL AUTHORITY IS PATERNAL, AND ITS INHERENT CHARACTER IS GOODNESS

We have seen that kings take the place of God, who is the true father of all mankind. We have also seen that the first idea of power arrived at by men is that of paternal power; and that kings have been made on the model of fathers. Also, everybody agrees that the obedience which is due to the public power is to be found, in the Ten Commandments, in the commandment which obliges men to honor their parents. From all this, it follows that the title of king is the title of a father, and that goodness is the most natural characteristic of kings.

Because God is great and sufficient unto Himself, He turns, so to speak, entirely towards doing good to men, according to the word: "As is His greatness, so is His compassion." He places an image of His greatness in kings in order to force them to imitate His goodness. He raises them to a level where they have nothing more to desire for themselves. We have heard David saying: "What can Your servant add to all the greatness with which You have clothed him?"

THE ROYAL AUTHORITY IS ABSOLUTE

In order to render this idea odious and unbearable, many pretend to confuse absolute government with arbitrary government. But there are no two more dissimilar things. . . . The prince need render no account to anyone for the orders he gives. "I counsel thee to keep the king's commandment and that in regard to the oath of God. Be not hasty to go out of his sight: stand not in an evil thing; for he does whatsoever pleases him. Where the word of a king is, there is power; and who may say unto him, What dost thou?" Without this absolute authority the king can do no good, nor punish evil; his power must be such that no one can hope to escape it.

Men must therefore obey princes as they obey justice itself, without which there can be no order or purpose in things. They are Gods, and share in a fashion the divine independence: "I have said Ye are Gods. . . ." There is only God who can judge their judgements and their persons. "God standeth in the congregation of the mighty; He judgeth among the Gods."

THE ROYAL AUTHORITY MUST BE INVINCIBLE

If there is in a State any authority which can stand in the path of public power and embarrass it in its exercise, no one is safe.

If the prince himself, who is the judge of judges, fears powerful men, what stability could there be in the State? It is therefore necessary that authority should be invincible, and that nothing should be able to breach the rampart behind which the public peace and private weal are safe.

OF MAJESTY

Majesty is the reflection of the greatness of God in the prince. God is infinite, God is all. The prince, as a prince, is not regarded as a private individual: he is a public figure, the whole State rests in him: the will of the whole people is comprehended in his. Just as all perfection and all virtue are concentrated in God. so all the power of private individuals is concentrated in the person of the prince. What greatness, that one man should carry so much! The power of God makes itself felt in an instant from one end of the world to the other: the royal power acts in the same way throughout the whole kingdom. It keeps the whole kingdom in being, as God keeps the whole world. If God were to withdraw His hand, the world would fall back into nothingness: if authority ceased in the kingdom, everything would be confusion.

Now, put together all the great and august things that we have said on the subject of royal authority. See a great people united in one person: see this sacred, paternal, and absolute power: see the secret purpose which governs the whole body of the State comprehended in one head: you see the image of God in the kings; and you get an idea of royal majesty. . . . God is holiness itself, goodness itself, power itself, reason itself. The majesty of God is in these things. The majesty of the prince is in the image of these things. This majesty is so great that its source cannot be in the prince; it is borrowed from God who gives it to him for the good of the peoples, for whom it is salutary that they should be held in by a superior power.

There is something divine about a prince, which inspires the peoples with fear.

Therefore, use your power boldly, oh, kings! For it is divine and salutary to mankind; but use it with humility. You are endowed with it from outside. Fundamentally, it leaves you weak; it leaves you mortal; it leaves you sinners; and burdens you with greater responsibility towards God.

ON THE OBEDIENCE DUE TO THE PRINCE

The subjects owe unlimited obedience to the prince. If the prince is not punctually obeyed, the public order is over-thrown and there is no more unity, and consequently no more cooperation or peace in a State.

Open godlessness, and even persecution, do not absolve the subjects from the obedience they owe to princes. The character of royalty is holy and sacred, even in infidel princes; and we have seen that Isaiah calls Cyrus "the anointed of the Lord." Nebuchadnezzar was godless, and proud to the point of wanting to equal God and put to death those who refused him a sacrilegious worship; and nevertheless Daniel addresses him thus: "You are the king of kings: and the God of Heavens has given you the kingdom and the power and the empire and the glory."

The subjects may oppose to the violence of princes only respectful remonstrances, without murmurs or rebellion, and prayers for their conversion. If God does not hearken to the prayers of His faithful; if in order to try and chasten His children He permits their persecution to grow worse, they must then remember that Jesus Christ has "sent them as lambs in the midst of wolves." Here is a truly holy doctrine, truly worthy of Jesus Christ and of His disciples.

6

ON THE DUTIES OF THE PRINCE

The purpose of government is the welfare and conservation of the State. . . .

The good constitution of the body of the State consists in two things: religion and justice. These are the internal and constitutive principles of States. By the one we render to God what is owed to Him, and by the other we render to men that which they deserve. . . The prince must employ his authority to destroy false religion in his State.

The prince is the minister of God: "He beareth not the sword in vain: for he is a revenger to execute wrath upon him that doeth evil." He is the protector of the public peace which is based upon religion; and he must maintain his throne, of which, as we have seen, religion is the foundation. Those who will not suffer the prince to act strictly in religious matters, because religion should be free, make an impious error. Otherwise, one would have to tolerate in all the subjects and in all the country idolatry, mohammedanism, judaism, any false religions; blasphemy, even atheism, and the greatest crimes would be the least punished.

2. HOBBES: THE LEVIATHAN

Thomas Hobbes (1588–1679) was born and brought up an Elizabethan and died at ninety-one under the Restoration. As tutor to the noble Cavendish family and as a scholar in his own right, he traveled widely, meeting many of the greatest minds of his time. Friend of Ben Jonson, Bacon, and Galileo, he knew and argued with Descartes. The troubles of the Civil War drove him to Paris, where he lived from 1641 to 1652. In 1647 he was appointed tutor to the Prince of Wales, but the future Charles II had to break the relationship when the publication of *The Leviathan* in 1651 shocked too many people. It nevertheless remains one of the most thorough—and perhaps, therefore, thoroughly depressing—analyses of the motives and patterns of political behavior.

The extreme authoritarianism of Hobbes has been attributed to the natural timidity of a man whose mother may have been frightened by the Spanish Armada, and whom the Civil War persuaded that anything was better than disorder.

OF THE NATURAL CONDITION OF MANKIND AS CONCERNING THEIR FELICITY AND MISERY

Nature hath made men so equal, in the faculties of the body and mind; as that though there be found one man sometimes manifestly stronger in body, or of quicker mind than another, yet when all is reckoned together, the difference between man and man, is not so considerable, as that one man can thereupon

From Thomas Hobbes, The Leviathan (London, n. d.), pp. 63-65, 82-88.

claim to himself any benefit, to which another may not pretend, as well as he. For as to the strength of body, the weakest has strength enough to kill the strongest, either by secret machination, or by confederacy with others, that are in the same danger with himself.

And as to the faculties of the mind, setting aside the arts grounded upon words, and especially that skill of proceeding upon general and infallible rules, called science; which very few have, and but in few things; as being not a native faculty, born with us; nor attained, as prudence, while we look after somewhat else, I find yet a greater equality amongst men than that of strength. For prudence is but experience; which equal time equally bestows on all men, in those things they equally apply themselves unto. That which may perhaps make such equality incredible, is but a vain concept of one's own wisdom, which almost all men think they have in a greater degree than the vulgar; that is, than all men but themselves, and a few others, whom by fame or for concurring with themselves, they approve. For such is the nature of men, that howsoever they may acknowledge many others to be more witty, or more eloquent, or more learned; yet they will hardly believe there be many so wise as themselves; for they see their own wit at hand, and other men's at a distance. But this proveth rather that men are in that point equal, than unequal. For there is not ordinarily a greater sign of the equal distribution of anything, than that every man is contented with his share.

From this equality of ability, ariseth equality of hope in the attaining of our ends. And therefore if any two men desire the same thing, which nevertheless they cannot both enjoy, they become enemies; and in the way to their end,

which is principally their own conservation, and sometimes their delectation only, endeavour to destroy or subdue one another. And from hence it comes to pass, that where an invader hath no more to fear than another man's single power; if one plant, sow, build, or possess a convenient seat, others may probably be expected to come prepared with forces united, to dispossess and deprive him, not only of the fruit of his labour, but also of his life or liberty. And the invader again is in the like danger of another.

And from this diffidence of one another, there is no way for any man to secure himself, so reasonable, as anticipation; that is, by force, or wiles, to master the persons of all men he can, so long, till he see no other power great enough to endanger him: and this is no more than his own conservation requireth, and is generally allowed. Also because there be some, that taking pleasure in contemplating their own power in the acts of conquest, which they pursue farther than their security requires; if others, that otherwise would be glad to be at least within modest bounds, should not by invasion increase their power, they would not be able, long time, by standing only on their defence, to subsist. And by consequence, such augmentation of dominion over men being necessary to a man's conservation, it ought to be allowed him.

Again, men have no pleasure, but on the contrary, a great deal of grief, in keeping company, where there is no power able to overawe them all. For every man looketh that his companion should value him, at the same rate he sets upon himself: and upon all signs of contempt, or undervaluing, naturally endeavours, as far as he dares (which amongst them that have no common power to keep them in quiet, is far enough to make them destroy each other), to extort a greater value from his contemners, by damage; and from others, by the example.

So that in the nature of man we find three principal causes of quarrel. First, competition; second, diffidence; thirdly, glory.

The first maketh men invade for gain; the second, for safety; and the third, for reputation. The first use violence, to make themselves masters of other men's persons, wives, children, and cattle; the second, to defend them; the third, for trifles, as a word, a smile, a different opinion, and any other sign of undervalue, either direct in their persons, or by reflection in their kindred, their friends, their nation, their profession, or their name.

Hereby it is manifest, that during the time men live without a common power to keep them all in awe, they are in that condition which is called war; and such a war, as is of every man, against every man. For "war" consisteth not in battle only, or the act of fighting, but in a tract of time, wherein the will to contend by battle is sufficiently known; and therefore the notion of "time" is to be considered in the nature of war, as it is in the nature of weather. For as the nature of foul weather lieth not in a shower or two of rain, but in an inclination thereto of many days together; so the nature of war consisteth not in actual fighting, but in the known disposition thereto during all the time there is no assurance to the contrary. All other time is "peace."

Whatsoever therefore is consequent to a time of war, where every man is enemy to every man, the same is consequent to the time wherein men live without other security than what their own strength and their own invention shall furnish them withal. In such condition there is no place for industry, because the fruit thereof is uncertain, and consequently no culture of the earth; no navigation, nor use of the commodities that may be imported by sea; no commodious building; no instruments of moving and removing such things as require much force; no knowledge of the face of the earth; no account of time; no arts; no letters; no society; and, which is worst of all, continual fear and danger of violent death; and the life of man, solitary, poor, nasty, brutish, and short.

It may seem strange to some man, that has not well weighed these things, that Nature should thus dissociate, and render men apt to invade, and destroy one another; and he may therefore, not trusting to this inference made from the passions, desire perhaps to have the same confirmed by experience. Let him therefore consider with himself, when taking a journey, he arms himself, and seeks to go well accompanied; when going to sleep, he locks his doors: when even in his house, he locks his chests; and this when he knows there be laws, and public officers, armed. to revenge all injuries shall be done him; what opinion he has of his fellow-subjects, when he rides armed: of his fellow citizens, when he locks his doors; and of his children and servants, when he locks his chests. Does he not there as much accuse man's nature in it? The desires and other passions of man are in themselves no sin. No more are the actions that proceed from those passions, till they know a law that forbids them; which till laws be made they cannot know, nor can any law be made till they have agreed upon the person that shall make it.

It may peradventure be thought there was never such a time nor condition of war as this; and I believe it was never generally so, over all the world, but there

are many places where they live so now. For the savage people in many places of America, except the government of small families, the concord whereof dependeth on natural lust, have no government at all, and live at this day in that brutish manner, as I said before. Howsoever, it may be perceived where there were no common power to fear, by the manner of life which men that have formerly lived under a peaceful government, use to degenerate into a civil war.

But though there had never been any time, wherein particular men were in a condition of war one against another; vet in all times, kings, and persons of sovereign authority, because of their independency, are in continual jealousies, and in the state and posture of gladiators; having their weapons pointing, and their eves fixed on one another; that is, their forts, garrisons, and guns upon the frontiers of their kingdoms; and continual spies upon their neighbours; which is a posture of war. But because they uphold thereby the industry of their subjects; there does not follow from it that misery which accompanies the liberty of particular men.

To this war of every man, against every man, this also is consequent; that nothing can be unjust. The notions of right and wrong, justice and injustice, have there no place. Where there is no common power, there is no law: where no law, no injustice. Force and fraud are in war the two cardinal virtues. Justice and injustice are none of the faculties neither of the body nor mind. If they were, they might be in a man that were alone in the world. as well as his senses, and passions. They are qualities that relate to men in society, not in solitude. It is consequent also to the same condition, that there be no propriety, no dominion, no "mine" and "thine" distinct; but only that to be every man's, that he can get; and for so long, as he can keep it. And thus much for the ill condition, which man by mere nature is actually placed in; though with a possibility to come out of it, consisting partly in the passions, partly in his reason.

The passions that incline men to peace, are fear of death; desire of such things as are necessary to commodious living; and a hope by their industry to obtain them. And reason suggesteth convenient articles of peace, upon which men may be drawn to agreement. These articles are they which otherwise are called the Laws of Nature. . . .

OF THE CAUSES, GENERATION AND DEFINITION OF A COMMONWEALTH

The final cause, end, or design of men, who naturally love liberty, and dominion over others, in the introduction of that restraint upon themselves, in which we see them live in commonwealths, is the foresight of their own preservation, and of a more contented life thereby; that is to say, of getting themselves out from that miserable condition of war, which is necessarily consequent, as hath been shown above to the natural passions of men, when there is no visible power to keep them in awe, and tie them by fear of punishment to the performance of their covenants, and observation of those laws of Nature. . . .

For the laws of Nature, as "justice," "equity," "modesty," "mercy," and in sum, "doing to others, as we would be done to," of themselves, without the terror of some power, to cause them to be observed are contrary to our natural passions, that

carry us to partiality, pride, revenge, and the like. And covenants, without the sword, are but words, and of no strength to secure a man at all. Therefore notwithstanding the laws of Nature, which every one hath then kept, when he has the will to keep them, when he can do it safely, if there be no power erected, or not great enough for our security; every man will, and may lawfully rely on his own strength and art, for caution against all other men. And in all places, where men have lived by small families, to rob and spoil one another, has been a trade, and so far from being reputed against the law of Nature, that the greater spoils they gained, the greater was their honour; and men observed no other laws therein, but the laws of honour: that is, to abstain from cruelty, leaving to men their lives, and instruments of husbandry. And as small families did then; so now do cities and kingdoms, which are but greater families, for their own security, enlarge their dominions, upon all pretences of danger, and fear of invasion, or assistance that may be given to invaders, and endeavour as much as they can, to subdue, or weaken their neighbours, by open force and secret arts, for want of other caution, justly; and are remembered for it in after ages with honour.

Nor is it the joining together of a small number of men, that gives them this security; because in small numbers, small additions on the one side or the other, make the advantage of strength so great, as is sufficient to carry the victory; and therefore gives encouragement to an invasion. The multitude sufficient to confide in for our security, is not determined by any certain number, but by comparison with the enemy we fear; and is then sufficient, when the odds of the enemy is not of so visible and conspicuous mo-

ment, to determine the event of war, as to move him to attempt.

And be there never so great a multitude: vet if their actions be directed according to their particular judgments and particular appetites, they can expect thereby no defence, nor protection, neither against a common enemy, nor against the injuries of one another. For being distracted in opinions concerning the best use and application of their strength, they do not help but hinder one another; and reduce their strength by mutual opposition to nothing; whereby they are easily, not only subdued by a very few that agree together: but also when there is no common enemy, they also make war upon each other, for their particular interests. For if we could suppose a great multitude of men to consent in the observation of justice, and other laws of Nature, without a common power to keep them all in awe, we might as well suppose all mankind to do the same; and then there neither would be, nor need to be any civil government or commonwealth at all; because there would be peace without subjection.

Nor is it enough for the security, which men desire should last all the time of their life, that they be governed and directed by one judgment, for a limited time: as in one battle, or one war. For though they obtain a victory by their unanimous endeavour against a foreign enemy; yet afterwards, when either they have no common enemy, or he that by one part is held for an enemy, is by another part held for a friend, they must needs by the difference of their interests dissolve, and fall again into a war amongst themselves.

It is true that certain living creatures, as bees and ants, live sociably one with another, which are therefore by Aristotle numbered amongst political creatures; and yet have no other direction than their particular judgments and appetites; nor speech, whereby one of them can signify to another, what he thinks expedient for the common benefit: and therefore some man may perhaps desire to know, why mankind cannot do the same. To which I answer,

First, that men are continually in competition for honour and dignity, which these creatures are not; and consequently amongst men there ariseth on that ground, envy and hatred, and finally war; but amongst these not so.

Secondly, that amongst these creatures, the common good differeth not from the private, and being by nature inclined to their private, they procure thereby the common benefit. But man, whose joy consisteth in comparing himself with other men, can relish nothing but what is eminent.

Thirdly, that these creatures, having not, as man, the use of reason, do not see, nor think they see any fault in the administration of their common business; whereas amongst men, there are very many that think themselves wiser, and abler to govern the public, better than the rest; and these strive to reform and innovate, one this way, another that way; and thereby bring it into distraction and civil war.

Fourthly, that these creatures, though they have some use of voice, in making known to one another their desires and other affections; yet they want that art of words, by which some men can represent to others that which is good in the likeness of evil; and evil in the likeness of good; and augment or diminish the apparent greatness of good and evil; discontenting men, and troubling their peace at their pleasure.

Fifthly, irrational creatures cannot dis-

tinguish between "injury" and "damage"; and therefore as long as they be at ease, they are not offended with their fellows, whereas man is then most troublesome, when he is most at ease; for then it is that he loves to show his wisdom, and control the actions of them that govern the commonwealth.

Lastly, the agreement of these creatures is natural; that of men is by covenant only, which is artificial: and therefore it is no wonder if there be somewhat else required, besides covenant, to make their agreement constant and lasting; which is a common power, to keep them in awe, and to direct their actions to the common benefit.

The only way to erect such a common power, as may be able to defend them from the invasion of foreigners, and the injuries of one another, and thereby to secure them in such sort, as that by their own industry, and by the fruits of the earth, they may nourish themselves and live contentedly, is, to confer all their power and strength upon one man, or upon one assembly of men, that may reduce all their wills, by plurality of voices, unto one will: which is as much as to say, to appoint one man, or assembly of men, to bear their person; and every one to own, and acknowledge himself to be author of whatsoever he that so beareth their person, shall act, or cause to be acted, in those things which concern the common peace and safety; and therein to submit their wills, every one to his will, and their judgments, to his judgment. This is more than consent, or concord; it is a real unity of them all, in one and the same person, made by covenant of every man, in such manner, as if every man should say to every man, "I authorize and give up my right of governing myself, to this man, or to this assembly of men, on this condition, that thou give up thy right to him, and authorize all his actions in like manner." This done, the multitude so united in one person is called a "commonwealth," in Latin civitas. This is the generation of that great LEVIATHAN, or rather, to speak more reverently, of that "mortal god," to which we owe under the "immortal God," our peace and defence. For by this authority, given him by every particular man in the commonwealth, he hath the use of so much power and strength conferred on him, that by terror thereof, he is enabled to perform the wills of them all, to peace at home, and mutual aid against their enemies abroad. And in him consisteth the essence of the commonwealth; which, to define it, is one person of whose acts a great multitude, by mutual covenants one with another, have made themselves every one the author, to the end he may use the strength and means of them all, as he shall think expedient, for their peace and common defence.

And he that carrieth this person is called "sovereign," and is said to have "sovereign power"; and every one besides, his "subject."

The attaining to this sovereign power is by two ways. One, by natural force; as when a man maketh his children to submit themselves and their children to his government, as being able to destroy them if they refuse; or by war subdueth his enemies to his will, giving them their lives on that condition. The other is, when men agree amongst themselves to submit to some man, or assembly of men, voluntarily, on confidence to be protected by him against all others. This latter may be called a political commonwealth, or commonwealth by "institution"; and the former, a commonwealth by "acquisition." And first, I shall speak of a commonwealth by institution.

OF THE RIGHTS OF SOVEREIGNS BY INSTITUTION

A "commonwealth" is said to be "insituted," when a "multitude" of men do agree, and "covenant, every one, with every one," that to whatsoever "man," or "assembly of men," shall be given by the major part, the "right" to "represent" the person of them all, that is to say, to be their "representative"; every one, as well he that "voted for it," as he that "voted against it," shall "authorize" all the actions and judgments, of that man, or assembly of men, in the same manner, as if they were his own, to the end, to live peaceably amongst themselves, and be protected against other men.

From this institution of a commonwealth are derived all the "rights" and "faculties" of him, or them, on whom sovereign power is conferred by the consent of the people assembled.

First, because they covenant, it is to be understood, they are not obliged by former covenant to anything repugnant hereunto. And consequently they that have already instituted a commonwealth, being thereby bound by covenant, to own the actions and judgments of one, cannot lawfully make a new covenant, amongst themselves, to be obedient to any other, in anything whatsoever, without his permission. And therefore, they that are subjects to a monarch, cannot without his leave cast off monarchy, and return to the confusion of a disunited multitude: nor transfer their person from him that beareth it, to another man, or other assembly of men: for they are bound, every man to every man, to own, and be reputed author of all, that he that already is their sovereign, shall do, and judge fit to be done; so that one man dissenting, all the rest should break their covenant made to that man, which is injustice: and they have also every man given the sovereignty to him that beareth their person; and therefore if they depose him, they take from him that which is his own, and so again it is injustice. Besides, if he that attempteth to depose his sovereign, be killed, or punished by him for such attempt, he is author of his own punishment, as being by the institution, author of all his sovereign shall do: and because it is injustice for a man to do anything for which he may be punished by his own authority, he is also upon that title unjust. And whereas some men have pretended for their disobedience to their sovereign, a new covenant, made not with men, but with God; this also is unjust: for there is no covenant with God but by mediation of somebody that representeth God's person; which none doth but God's lieutenant, who hath the sovereignty under God. But this pretence of covenant with God, is so evident a lie, even in the pretenders' own consciences, that it is not only an act of an unjust, but also of a vile and unmanly disposition.

Secondly, because the right of bearing the person of them all, is given to him they make sovereign, by covenant only of one to another, and not of him to any of them; there can happen no breach of covenant on the part of the sovereign: and consequently none of his subjects, by any pretence of forfeiture, can be freed from his subjection. That he which is made sovereign maketh no covenant with his subjects before hand, is manifest; because either he must make it with the whole multitude, or one party to the covenant; or he must make a several covenant with every man. With the whole, as one party; it is impossible; because as yet they are not one person and if he make so many several covenants as there be men, those

covenants after he hath the sovereignty are void; because what act soever can be pretended by any one of them for breach thereof, is the act both of himself and of all the rest, because done in the person and by the right of every one of them in particular. Besides, if any one or more of them pretend a breach of the covenant made by the sovereign at his institution; and others, or one other of his subjects, or himself alone, pretend there was no such breach, there is in this case no judge to decide the controversy; it returns therefore to the sword again; and every man recovereth the right of protecting himself by his own strength, contrary to the design they had in the institution. It is therefore in vain to grant sovereignty by way of precedent covenant. The opinion that any monarch receiveth his power by covenant, that is to say, on condition, proceedeth from want of understanding this easy truth, that covenants being but words and breath, have no force to oblige, contain, constrain, or protect any man, but what it has from the public sword; that is, from the united hands of that man, or assembly of men that hath the sovereignty, and whose actions are avouched by them all, and performed by the strength of them all, in him united. But when an assembly of men is made sovereign, then no man imagineth any such covenant to have passed in the institution; for no man is so dull as to say, for example, the people of Rome made a covenant with the Romans, to hold the sovereignty on such or such conditions; which not performed, the Romans might lawfully depose the Roman people. That men see not the reason to be alike in a monarchy, and in a popular government, proceedeth from the ambition of some, that are kinder to the government of an assembly, whereof they may hope to participate, than of monarchy, which they despair to enjoy.

Thirdly, because the major part hath by consenting voices declared a sovereign; he that dissented must now consent with the rest; that is, be contented to avow all the actions he shall do, or else justly be destroyed by the rest. For if he voluntarily entered into the congregation of them that were assembled, he sufficiently declared thereby his will, and therefore tacitly covenanted to stand to what the major part should ordain: and therefore if he refuse to stand thereto, or make protestation against any of their decrees, he does contrary to his covenant, and therefore unjustly. And whether he be of the congregation or not; and whether his consent be asked or not, he must either submit to their decrees, or be left in the condition of war he was in before; wherein he might without injustice be destroyed by any man whatsoever.

Fourthly, because every subject is by this institution author of all the actions and judgments of the sovereign instituted, it follows, that whatsoever he doth it can be no injury to any of his subjects, nor ought he to be by any of them accused of injustice. For he that doth anything by authority from another doth therein no injury to him by whose authority he acteth: but by this institution of a commonwealth every particular man is author of all the sovereign doth; and consequently, he that complaineth of injury from his sovereign complaineth of that whereof he himself is author, and therefore ought not to accuse any man but himself; no, nor himself of injury; because to do injury to one's self is impossible. It is true that they that have sovereign power may commit iniquity, but not injustice or injury in the proper signification.

Fifthly, and consequently to that

which was said last, no man that hath sovereign power can justly be put to death, or otherwise in any manner by his subjects punished. For seeing every subject is author of the actions of his sovereign, he punisheth another for the actions committed by himself.

And because the end of this institution is the peace and defence of them all; and whosoever has right to the end has right to the means; it belongeth of right to whatsoever man or assembly that hath the sovereignty to be judge both of the means of peace and defence, and also of the hindrances and disturbances of the same, and to do whatsoever he shall think necessary to be done, both beforehand, for the preserving of peace and security, by prevention of discord at home and hostility from abroad; and, when peace and security are lost, for the recovery of the same. And therefore,

Sixthly, it is annexed to the sovereignty to be judge of what opinions and doctrines are averse and what conducing to peace; and consequently, on what occasions, how far, and what men are to be trusted withal, in speaking to multitudes of people, and who shall examine the doctrines of all books before they be published. For the actions of men proceed from their opinions, and in the wellgoverning of opinions consisteth the wellgoverning of men's actions, in order to their peace and concord. And though in matter of doctrine nothing ought to be regarded but the truth; yet this is not repugnant to regulating the same by peace. For doctrine repugnant to peace can be no more true than peace and concord can be against the law of Nature. It is true that in a commonwealth, where, by the negligence or unskilfulness of governors and teachers, false doctrines are by time generally received; the contrary truths

may be generally offensive. Yet the most sudden and rough bursting in of a new truth that can be, does never break the peace, but only sometimes awakes the war. For those men that are so remissly governed, that they dare take up arms to defend or introduce an opinion, are still in war; and their condition not peace, but only a cessation of arms for fear of one another; and they live, as it were, in the precincts of battle continually. It belongeth therefore to him that hath the sovereign power to be judge, or constitute all judges of opinions and doctrines, as a thing necessary to peace, thereby to prevent discord and civil war.

Seventhly, is annexed to the sovereignty, the whole power of prescribing the rules, whereby every man may know what goods he may enjoy, and what actions he may do, without being molested by any of his fellow subjects; and this is it men call "propriety." For before constitution of sovereign power, as hath already been shown, all men had right to all things, which necessarily causeth war: and therefore this propriety, being necessary to peace, and depending on sovereign power, is the act of that power, in order to the public peace. These rules of propriety, or meum and tuum, and of "good," "evil," "lawful," and "unlawful" in the actions of subjects, are the civil laws; that is to sav, the laws of each commonwealth in particular; though the name of civil law be now restricted to the ancient civil laws of the city of Rome, which being the head of a great part of the world, her laws at that time were in these parts the civil law.

Eighthly, is annexed to the sovereignty, the right of judicature; that is to say, of hearing and deciding all controversies, which may arise concerning law, either civil or natural, or concerning fact. For without the decision of controversies, there is no protection of one subject against the injuries of another; the laws concerning *meum* and *tuum* are in vain, and to every man remaineth, from the natural and necessary appetite of his conservation, the right of protecting himself by his private strength, which is the condition of war, and contrary to the end for which every commonwealth is instituted.

Ninthly, is annexed to the sovereignty, the right of making war and peace with other nations and commonwealths; that is to say, of judging when it is for the public good, and how great forces are to be assembled, armed, and paid for that end: and to levy money upon the subjects to defray the expenses thereof. For the power by which the people are to be defended consisteth in their armies, and the strength of an army, in the union of their strength under one command, which command the sovereign instituted, therefore hath; because the command of the "militia," without other institution, maketh him that hath it sovereign. And therefore whosoever is made general of an army, he that hath the sovereign power is always generalissimo.

Tenthly, is annexed to the sovereignty, the choosing of all counsellors, ministers, magistrates, and officers, both in peace and war. For seeing the sovereign is charged with the end, which is the common peace and defence, he is understood to have power to use such means as he shall think most fit for his discharge.

Eleventhly, to the sovereign is committed the power of rewarding with riches or honour, and of punishing with corporal or pecuniary punishment, or with ignominy, every subject according to the law he hath formerly made, or if there be no law made, according as he shall judge most to conduce to the encouraging of men to serve the commonwealth, or de-

terring of them from doing disservice to the same.

Lastly, considering what value men are naturally apt to set upon themselves; what respect they look for from others; and how little they value other men; from whence continually arise amongst them, emulation, quarrels, factions, and at last war, to the destroying of one another, and diminution of their strength against a common enemy; it is necessary that there be laws of honour, and a public rate of the worth of such men as have deserved, or are able to deserve well of the commonwealth: and that there be force in the hands of some or other, to put those laws in execution. But it hath already been shown, that not only the whole "militia," or forces of the commonwealth, but also the judicature of all controversies, is annexed to the sovereignty. To the sovereign therefore it belongeth also to give titles of honour; and to appoint what order of place and dignity each man shall hold; and what signs of respect, in public or private meetings, they shall give to one another. . .

OF THE SEVERAL KINDS OF COMMONWEALTH BY INSTITUTION, AND OF SUCCESSION TO THE SOVEREIGN POWER

The difference of commonwealths consisteth in the difference of the sovereign, or the person representative of all and every one of the multitude. And because the sovereignty is either in one man, or in an assembly of more than one; and into that assembly either every man hath right to enter, or not every one, but certain men distinguished from the rest; it is manifest, there can be but three kinds of commonwealth. For the representative

must needs be one man, or more: and if more, when it is the assembly of all that will come together, then it is a "democracy," or popular commonwealth: when an assembly of a part only, then it is called an "aristocracy." Other kind of commonwealth there can be none: for either one or more, or all, must have the sovereign power, which I have shown to be indivisible, entire.

There be other names of government in the histories and books of policy, as "tyranny," and "oligarchy": but they are not the names of other forms of government, but of the same forms misliked. For they that are discontented under "monarchy," call it "tyranny"; and they that are displeased with "aristocracy," call it "oligarchy": so also they which find themselves grieved under a "democracy," call it "anarchy," which signifies want of government: and vet I think no man believes that want of government is any new kind of government: nor by the same reason ought they to believe that the government is of one kind when they like it, and another when they dislike it, or are oppressed by the governors.

It is manifest, that men who are in absolute liberty may, if they please, give authority to one man to represent them every one; as well as give such authority to any assembly of men whatsoever; and consequently may subject themselves, if they think good, to a monarch as absolutely as to any other representative. Therefore, where there is already erected a sovereign power, there can be no other representative of the same people, but only to certain particular ends, by the sovereign limited. For that were to erect two sovereigns; and every man to have his person represented by two actors, that by opposing one another, must needs divide that power, which, if men will live in

peace, is indivisible, and thereby reduce the multitude into the condition of war, contrary to the end for which all sovereignty is instituted. And therefore as it is absurd to think that a sovereign assembly, inviting the people of their dominion to send up their deputies, with power to make known their advice, or desires, should therefore hold such deputies rather than themselves, for the absolute representatives of the people; so it is absurd also to think the same in a monarchy. And I know not how this so manifest a truth should of late be so little observed; that in a monarchy, he that had the sovereignty from a descent of six hundred years, was alone called sovereign, had the title of Majesty from every one of his subjects, and was unquestionably taken by them for their king, was notwithstanding never considered as their representative; the name without contradiction passing for the title of those men, which at his command were sent up by the people to carry their petitions, and give him, if he permitted it, their advice. Which may serve as an admonition, for those that are the true and absolute representative of a people, to instruct men in the nature of that office, and to take heed how they admit of any other general representation upon any occasion whatsoever, if they mean to discharge the trust committed to them.

The difference between these three kinds of commonwealth, consisteth not in the difference of power; but in the difference of convenience, or aptitude to produce the peace and security of the people; for which end they were instituted. And to compare monarchy with the other two, we may observe; first, that whosoever beareth the person of the people, or is one of that assembly that bears it, beareth also his own natural person. And though he

be careful in his politic person to procure the common interest; yet he is more or no less careful to procure the private good of himself, his family, kindred, and friends; and for the most part, if the public interest chance to cross the private, he prefers the private: for the passions of men are commonly more potent than their reason. From whence it follows, that where the public and private interest are most closely united, there is the public most advanced. Now in monarchy, the private interest is the same with the public. The riches, power, and honour of a monarch, arise only from the riches, strength, and reputation of his subjects. For no king can be rich, nor glorious, nor secure, whose subjects are either poor, or contemptible, or too weak through want or dissension, to maintain a war against their enemies: whereas in a democracy, or aristocracy, the public prosperity confers not so much to the private fortune of one that is corrupt, or ambitious, as doth many times a perfidious advice, a treacherous action, or a civil war.

Secondly, that a monarch receiveth counsel of whom, when, and where he pleaseth; and consequently may hear the opinion of men versed in the matter about which he deliberates, of what rank or quality soever, and as long before the time of action, and with as much secrecy, as he will. But when a sovereign assembly has need of counsel, none are admitted but such as have a right thereto from the beginning; which for the most part are of those who have been versed more in the acquisition of wealth than of knowledge; and are to give their advice in long discourses, which may and do commonly excite men to action, but not govern them in it. For the "understanding" is by the flame of the passions, never enlightened, but dazzled. Nor is there any place, or time, wherein an assembly can receive counsel with secrecy, because of their own multitude.

Thirdly, that the resolutions of a monarch are subject to no other inconstancy, than that of human nature; but in assemblies, besides that of Nature, there ariseth an inconstancy from the number. For the absence of a few, that would have the resolution once taken, continued firm, which may happen by security, negligence, or private impediments, or the diligent appearance of a few of the contrary opinion, undoes to-day all that was concluded yesterday.

Fourthly, that a monarch cannot disagree with himself, out of envy or interest; but an assembly may; and that to such a height, as may produce a civil war.

Fifthly, that in monarchy there is this inconvenience; that any subject, by the power of one man, for the enriching of a favorite or flatterer, may be deprived of

all he possesseth; which I confess is a great and inevitable inconvenience.

But the same may as well happen, where the sovereign power is an assembly: for their power is the same; and they are as subject to evil counsel, and to be seduced by orators, as a monarch by flatterers; and becoming one another's flatterers, serve one another's covetousness and ambition by turns. And whereas the favorites of monarchs are few, and they have none else to advance but their own kindred; the favorites of an assembly are many; and the kindred much more numerous than of any monarch. Besides there is no favorite of a monarch, which cannot as well succour his friends as hurt his enemies: but orators, that is to say, favorites of sovereign assemblies, though they have great power to hurt, have little to save. For to accuse, requires less eloquence, such is man's nature, than to excuse; and condemnation, than absolution more resembles justice.

3. LOCKE

Locke's treatises on government have generally been considered as offered in justification of the English Revolution of 1688. Such justification is provided by the philosopher largely by arguing that government and society exist in order to preserve the individual's rights, and that a ruler's failure to abide by this fundamental stipulation calls for his removal. The assumptions of this theory that explains society in terms of individual interests were outlined in a description of the "state of nature" and conclusions drawn from its implications, which were quite different from those of Hobbes and far more influential.

From: The Second Treatise on Government

OF THE STATE OF NATURE

To understand political power aright, and derive it from its original, we must

consider what estate all men are naturally in, and that is, a state of perfect freedom to order their actions, and dispose of their possessions and persons as they think fit,

From John Locke, Treatise on Government (London, 1690), Book 2.

within the bounds of the law of nature, without asking leave or depending upon the will of any other man.

A state also of equality, wherein all the power and jurisdiction is reciprocal, no one having more than another, there being nothing more evident than that creatures of the same species and rank, promiscuously born to all the same advantages of nature, and the use of the same faculties, should also be equal one amongst another without subordination or subjection, unless the lord and master of them all should, by any manifest declaration of his will, set one above another, and confer on him, by an evident and clear appointment, an undoubted right to dominion and sovereignty. . . .

But though this be a state of liberty, vet it is not a state of license; though man in that state have an uncontrollable liberty to dispose of his person or possessions, yet he has not liberty to destroy himself, or so much as any creature in his possession, but where some nobler use than its bare preservation calls for it. The state of nature has a law of nature to govern it, which obliges every one, and reason, which is that law, teaches all mankind who will but consult it, that being all equal and independent, no one ought to harm another in his life, health, liberty or possessions. For men being all the workmanship of one omnipotent and infinitely wise Maker-all the servants of one sovereign Master, sent into the world by his order and about his business-they are his property, whose workmanship they are, made to last during his, not one another's pleasure. And, being furnished with like faculties, sharing all in one community of nature, there cannot be supposed any such subordination among us that may authorize us to destroy one another, as if we were made for one another's uses, as the inferior ranks of creatures are for ours. Every one as he is bound to preserve himself, and not to quit his station willfully, so by the like reason, when his own preservation comes not in competition, ought he as much as he can, to preserve the rest of mankind, and not unless it be to do justice on an offender, take away, or impair the life or what tends to be the preservation of the life, the liberty, health, limb, or goods of another.

OF THE BEGINNINGS OF POLITICAL SOCIETIES

Men, being, as has been said, by nature all free, equal, and independent, no one can be put out of this estate and subjected to the political power of another without his own consent. The only way whereby anyone divests himself of his natural liberty and puts on the bonds of civil society, is by agreeing with other men, to join and unite into a community for their comfortable, safe and peaceable living one amongst another, in a secure enjoyment of their properties, and a greater security against any that are not of it. This any number of men may do, because it injures not the freedom of the rest; they are left, as they were, in the liberty of the state of nature. When any number of men have so consented to make one community or government, they are thereby presently incorporated, and make one body politic, wherein the majority have a right to act and conclude the rest. . . .

And thus every man, by consenting with others to make one body politic under one government, puts himself under an obligation to every one of that society to submit to the determination of the majority, and to be concluded by it; or

else this original compact whereby he with others incorporates into one society, would signify nothing. . . .

For if the consent of the majority shall not, in reason be received as the act of the whole, and conclude every individual; nothing but the consent of every individual can make anything to be the act of the whole; but such a consent is next to impossible ever to be had. . . .

OF THE ENDS OF POLITICAL SOCIETY AND GOVERNMENT

If man in the state of nature be so free as has been said, if he be absolute lord of his own person and possessions, equal to the greatest and subject to nobody, why will he part with his freedom? Why will he give up this empire, and subject himself to the dominion and control of any other power? To which it is obvious to answer, that though in the state of nature he hath such a right, yet the enjoyment of it is very uncertain and constantly exposed to the invasion of others; for all being kings as much as he, every man his equal, and the greater part no strict observers of equity and justice, the enjoyment of the property he has in this state is very unsafe, very insecure. This makes him willing to quit this condition which, however free, is full of fears and continual dangers; and it is not without reason that he seeks out and is willing to join in society with others who are already united. or have a mind to unite for the mutual preservation of their lives, liberties and estates, which I call by the general name -property.

The great and chief end, therefore, of men uniting into commonwealths, and putting themselves under government, is the preservation of their property; to

which in the state of nature there are many things wanting.

First, There wants an established, settled, known law, received and allowed by common consent to be the standard of right and wrong, and the common measure to decide all controversies between them. For though the law of nature be plain and intelligible to all rational creatures, yet men, being biased by their interest, as well as ignorant for want of study of it, are not apt to allow of it as a law binding to them in the application of it to their particular cases.

Secondly. In the state of nature there wants a known and indifferent judge, with authority to determine all differences according to the established law. For every one in that state, being both judge and executioner of the law of nature, men being partial to themselves, passion and revenge is very apt to carry them too far, and with too much heat in their own cases, as well as negligence and unconcernedness, make them too remiss in other men's.

Thirdly, In the state of nature there often wants power to back and support the sentence when right, and to give it due execution. They who by any injustice offend will seldom fail where they are able by force to make good their injustice. Such resistance many times makes the punishment dangerous, and frequently destructive to those who attempt it.

Thus mankind, notwithstanding all the privileges of the state of nature, being but in an ill condition while they remain in it, are quickly driven into society. Hence it comes to pass, that we seldom find any number of men live any time together in this state. The inconveniences that they are therein exposed to by the irregular and uncertain exercise of the power every man has of punishing the

transgressions of others, make them take sanctuary under the established laws of government, and therein seek the preservation of their property. It is this makes them so willingly give up every one his single power of punishing to be exercised by such alone as shall be appointed to it amongst them, and by such rules as the community, or those authorized by them to that purpose, shall agree on. And in this we have the original right and rise of both the legislative and executive power as well as of the governments and societies themselves.

For in the state of nature, to omit the liberty he has of innocent delights, a man has two powers.

The first is to do whatsoever he thinks fit for the preservation of himself and others within the permission of the law of nature, by which law, common to them all, he and all the rest of mankind are of one community, make up one society, distinct from all other creatures. And were it not for the corruption and viciousness of degenerate men there would be no need of any other, no necessity that men should separate from this great and natural community, and associate into lesser combinations.

The other power a man has in the state of nature is the power to punish the crimes committed against that law. Both these he gives up when he joins in a private, if I may so call it, or particular political society, and incorporates into any commonwealth separate from the rest of mankind.

The first power—viz., of doing whatsoever he thought fit for the preservation of himself and the rest of mankind, he gives up to be regulated by laws made by the society, so far forth as the preservation of himself and the rest of that society shall require; which laws of the society in many things confine the liberty he had by the law of nature.

Secondly, The power of punishing he wholly gives up, and engages his natural force (which he might before employ in the execution of the law of nature, by his own single authority, as he thought fit), to assist the executive power of the society as the law thereof shall require. For being now in a new state, wherein he is to enjoy many conveniences from the labor, assistance, and society of others in the same community, as well as protection from its whole strength, he is to part also with as much of his natural liberty, in providing for himself, as the good, prosperity, and safety of the society shall require, which is not only necessary but just, since the other members of the society do the like.

But though men when they enter into society give up the equality, liberty, and executive power they had in the state of nature into the hands of the society, to be so far disposed of by the legislative as the good of the society shall require, yet it being only with an intention in every one the better to preserve himself, his liberty and property (for no rational creature can be supposed to change his condition with an intention to be worse). the power of the society or legislative constituted by them can never be supposed to extend farther than the common good, but is obliged to secure every one's property by providing against those three defects above mentioned that made the state of nature so unsafe and uneasy. And so, whoever has the legislative or supreme power of any commonwealth, is bound to govern by established standing laws, promulgated and known to the people, and not by extemporary decrees; by indifferent and upright judges, who are to decide controversies by those laws; and to employ the force of the community at home only in the execution of such laws, or abroad to prevent or redress foreign injuries and secure the community from inroads and invasion. And all this to be directed to no other end, but the peace, safety, and public good of the people.

OF THE EXTENT OF THE LEGISLATIVE POWER

The great end of men's entering into society being the enjoyment of their properties in peace and safety, and the great instrument and means of that being the laws established in that society, the first and fundamental positive law of all commonwealths is the establishing of the legislative power. . . . This legislative is not only the supreme power of the commonwealth, but sacred and unalterable in the hands where the community have once placed it. Nor can any edict of anybody else, in what form soever conceived. or by what power soever backed, have the force and obligation of a law which has not its sanction from that legislative which the public has chosen and appointed. . . .

Though the legislative . . . be the supreme power in every commonwealth; yet,

First, it is not, nor can possibly be, absolutely arbitrary over the lives and fortunes of the people. . . . For nobody can transfer to another more power than he has in himself, and nobody has an absolute arbitrary power over himself, or over any other, to destroy his own life, or take away the life or property of another. A man, as has been proved, cannot subject himself to the arbitrary power of another; and having, in the state of na-

ture, no arbitrary power over the life, liberty, or possession of another, but only so much as the law of nature gave him for the preservation of himself and the rest of mankind, this is all he doth, or can give up to the commonwealth, and by it to the legislative power, so that the legislative can have no more than this. Their power in the utmost bounds of it is limited to the public good of the society. It is a power that hath no other end but preservation, and therefore can never have a right to destroy, enslave, or designedly to impoverish the subjects. The obligations of the law of nature cease not in society, but only in many cases are drawn closer, and have, by human laws, known penalties annexed to them to enforce their observation. Thus the law of nature stands as an external rule to all men, legislators as well as others. The rules that they make for other men's actions must, as well as their own and other men's actions, be conformable to the law of nature-i.e., to the will of God, of which that is a declaration, and the fundamental law of nature, being the preservation of mankind, no human sanction can be good or valid against it.

Secondly, the legislative or supreme authority cannot assume to itself a power to rule by extemporary arbitrary decrees, but is bound to dispense justice and decide the rights of the subject by promulgated standing laws, and known authorized judges. For the law of nature being unwritten, and so nowhere to be found but in the minds of men, they who, through passion or interest, shall miscite or misapply it, cannot so easily be convinced of their mistake where there is no established judge. To avoid these inconveniences which disorder men's properties in the state of nature, men unite into societies that they may have the united strength of

the whole society to secure and defend their properties, and may have standing rules to bound it by which every one may know what is his. To this end it is that men give up all their natural power to the society they enter into, and the community put the legislative power into such hands as they think fit, with this trust, that they shall be governed by declared laws, or else their peace, quiet, and property will still be at the same uncertainty as it was in the state of nature.

Absolute arbitrary power, or governing without settled standing laws, can neither of them consist with the ends of society and government. . . . And, therefore, whatever form the commonwealth is under, the ruling power ought to govern by declared and received laws, and not by extemporary dictates and undetermined resolutions. . . . For all the power the government has, being only for the good of the society, as it ought not to be arbitrary and at pleasure, so it ought to be exercised by established and promulgated laws, that both the people may know their duty, and be safe and secure within the limits of the law, and the rulers, too, kept within their due bounds, and not tempted by the power they have in their hands to employ it to purposes, and by such measures as they would not have known, and own not willingly.

Thirdly, the supreme power cannot take from any man any part of his property without his own consent. For the preservation of property being the end of government, and that for which men enter into society, it necessarily supposes and requires that the people should have property, without which they must be supposed to lose that by entering into society, which was the end for which they entered into it; too gross an absurdity for any man to own. Men, therefore, in so-

ciety having property, they have such a right to the goods, which by the law of the community are theirs, that nobody hath a right to take them, or any part of them, from them without their own consent; without this they have no property at all. For I have truly no property in that which another can by right take from me when he pleases against my consent. Hence it is a mistake to think that the supreme or legislative power of any commonwealth can do what it will, and dispose of the estates of the subject arbitrarily, or take any part of them at pleasure. This is not much to be feared in governments where the legislative consists wholly or in part in assemblies which are variable, whose members upon the dissolution of the assembly are subjects under the common laws of their country, equally with the rest. But in governments where the legislative is in one man as in absolute monarchies, there is danger still, that they will think themselves to have a distinct interest from the rest of the community, and so will be apt to increase their own riches and power by taking what they think fit from the people. For a man's property is not at all secure, though there be good and equitable laws to set the bounds of it between him and his fellow-subjects, if he who commands those subjects have power to take from any private man what part he pleases of his property, and use and dispose of it as he thinks good.

But government into whosesoever hands it is put, being as I have before showed, entrusted with this condition, and for this end, that men might have and secure their properties, the prince or senate, however it may have power to make laws for the regulating of property between the subjects one amongst another, yet can never have a power to take

to themselves the whole, or any part of the subjects' property, without their own consent; for this would be in effect to leave them no property at all. And to let us see that even absolute power, where it is necessary, is not arbitrary by being absolute, but is still limited by that reason, and confined to those ends which required it in some cases to be absolute, we need look no farther than the common practice of martial discipline. For the preservation of the army, and in it of the whole commonwealth, requires an absolute obedience to the command of every superior officer, and it is justly death to disobey or dispute the most dangerous or unreasonable of them; but yet we see that neither the sergeant that could command a soldier to march up to the mouth of a cannon, or stand in a breach where he is almost sure to perish, can command that soldier to give him one penny of his money; nor the general that can condemn him to death for deserting his post, or not obeying the most desperate orders, cannot yet with all his absolute power of life and death dispose of one farthing of that soldier's estate, or seize one jot of his goods: whom yet he can command anything, and hang for the least disobedience. Because such a blind obedience is necessary to that end for which the commander has his power-viz., the preservation of the rest, but the disposing of his goods has nothing to do with it.

It is true governments cannot be supported without great charge, and it is fit every one who enjoys his share of the protection should pay out of his estate his proportion for the maintenance of it. But still it must be with his own consent—i.e., the consent of the majority, giving it either by themselves or their representatives chosen by them; for if any one shall claim a power to lay and levy taxes on the

people by his own authority, and without such consent of the people, he thereby invades the fundamental law of property, and subverts the end of government. For what property have I in that which another may by right take when he pleases to himself?

Fourthly, The legislative cannot transfer the power of making laws to any other hands, for it being but a delegated power from the people, they who have it cannot pass it over to others. The people alone can appoint the form of the commonwealth, which is by constituting the legislative, and appointing in whose hands that shall be. And when the people have said, "We will submit, and be governed by laws made by such men, and in such forms," nobody else can say other men shall make laws for them; nor can they be bound by any laws but such as are enacted by those whom they have chosen and authorized to make laws for them

These are the bounds which the trust that is put in them by the society and the law of God and nature have set to the legislative power of every commonwealth, in all forms of government.

First: They are to govern by promulgated established laws, not to be varied in particular cases, nor to have one rule for rich and poor, for the favorite at court, and the countryman at plough.

Secondly: These laws also ought to be designed for no other end ultimately but the good of the people.

Thirdly: They must not raise taxes on the property of the people without the consent of the people given by themselves or their deputies. . . .

Fourthly: The legislative neither must nor can transfer the power of making laws to anybody else, or place it anywhere but where the people have.

OF THE SUBORDINATION OF THE POWERS OF THE COMMONWEALTH

Though in a constituted commonwealth . . . there can be but one supreme power, which is the legislative, to which all the rest are and must be subordinate, yet the legislative being only a fiduciary power to act for certain ends, there remains still in the people a supreme power to remove or alter the legislative, when they find the legislative act contrary to the trust reposed in them. For all power given with trust for the attaining an end being limited by that end; whenever that end is manifestly neglected or opposed, the trust must necessarily be forfeited, and the power devolve into the hands of those that gave it, who may place it anew where they shall think best for their safety and security. And thus the community perpetually retains a supreme power of saving themselves from the attempts and designs of anybody, even of their legislators, whenever they shall be so foolish or so wicked as to lay and carry on designs against the liberties and properties of the subject. For no man or society of men having a power to deliver up their preservation, or consequently the means of it, to the absolute will and arbitrary dominion of another, whenever any one shall go about to bring them into such a slavish condition, they will always have a right to preserve what they have not a power to part with, and to rid themselves of those who invade this fundamental, sacred, and unalterable law of self-preservation for which they entered into society. And thus the community may be said in this respect to be always the supreme power, but not as considered under any form of government, because this power of the people can never take place till the government be dissolved.

In all cases whilst the government subsists, the legislative is the supreme power. For what can give laws to another must needs be superior to him. . . .

It may be demanded here, what if the executive power, being possessed of the force of the commonwealth, shall make use of that force to hinder the meeting and acting of the legislative, when the original constitution or the public exigencies require it? I say, using force upon the people, without authority, and contrary to the trust put in him that does so, is a state of war with the people, who have a right to reinstate their legislative in the exercise of their power. . . . In all states and conditions the true remedy of force without authority is to oppose force to it. The use of force without authority always puts him that uses it into a state of war as the aggressor, and renders him liable to be treated accordingly. . . .

OF TYRANNY

As usurpation is the exercise of power which another hath a right to, so tyranny is the exercise of power beyond right, which nobody can have a right to; and this is making use of the power any one has in his hands, not for the good of those who are under it, but for his own private, separate advantage. When the governor, however entitled, makes not the law but his will the rule, and his commands and actions are not directed to the preservation of the properties of his people, but the satisfaction of his own ambition, revenge, covetousness, or any other irregular passion [that is tyranny]. . . .

It is a mistake to think this fault is proper only to monarchies. Other forms of government are liable to it as well as that; for wherever the power that is put in any hands for the government of the people and the preservation of their properties is applied to other ends, and made use of to impoverish, harass, or subdue them to the arbitrary and irregular commands of those that have it, there it presently becomes tyranny, whether those that thus use it are one or many. Thus we read of the thirty tyrants at Athens, as well as one at Syracuse; and the intolerable dominion of the Decemviri at Rome was nothing better.

Wherever law ends, tyranny begins, if the law be transgressed to another's harm; and whosoever in authority exceeds the power given him by the law, and makes use of the force he has under his command to compass that upon the subject which the law allows not, ceases in that to be a magistrate, and acting without authority may be opposed, as any other man who by force invades the right of another. This is acknowledged in subordinate magistrates. He that hath authority to seize my person in the street may be opposed as a thief and a robber if he endeavors to break into my house to execute a writ, notwithstanding that I know he has such a warrant and such a legal authority as will empower him to arrest me abroad. And why this should not hold in the highest, as well as in the most inferior magistrate, I would gladly be informed. Is it reasonable that the eldest brother, because he has the greatest part of his father's estate, should thereby have a right to take away any of his younger brothers' portions? Or, that a rich man, who possessed a whole country, should from thence have a right to seize, when he pleased, the cottage and garden of his poor neighbor? The being rightfully possessed of great power and riches, exceedingly beyond the greatest part of the sons of Adam, is so far from being an excuse,

much less a reason for rapine and oppression, which the endamaging another without authority is, that it is a great aggravation of it. For the exceeding the bounds of authority is no more a right in a great than a petty officer, no more justifiable in a king than a constable.

May the commands, then, of a prince be opposed? May he be opposed? May he be resisted, as often as any one shall find himself aggrieved, and but imagine he has not right done him? This will unhinge and overturn all politics, and instead of government and order, leave nothing but anarchy and confusion.

To this I answer: That force is to be opposed to nothing but to unjust and unlawful force. Whoever makes any opposition in any other case draws on himself a just condemnation, both from God and man, and no such danger or confusion will follow, as is often suggested.

OF THE DISSOLUTION OF GOVERNMENT

He that will, with any clearness, speak of the dissolution of government, ought in the first place to distinguish between the dissolution of the society and the dissolution of the government. That which makes the community, and brings men out of the loose state of nature into one politic society, is the agreement which everyone has with the rest to incorporate and act as one body, and so be one distinct commonwealth. The usual, and almost only way whereby this union is dissolved. is the inroad of foreign force making a conquest upon them. . . . The world is too well instructed in, and too forward to allow of this way of dissolving of governments, to need any more to be said of it. . . .

There is, therefore, secondly, another way whereby governments are dissolved, and that is, when the legislative, or the prince, either of them act contrary to their trust.

First: the legislative acts against the trust reposed in them when they endeavor to invade the property of the subject, and to make themselves, or any part of the community, masters or arbitrary disposers of the lives, liberties, or fortunes of the

people.

. . . Whensoever, therefore, the legislative shall transgress this fundamental rule of society, and either by ambition, fear, folly, or corruption, endeavor to grasp themselves, or put into the hands of any other, an absolute power over the lives, liberties, and estates of the people; by this breach of trust they forfeit the power the people had put into their hands for quite contrary ends; and it devolves to the people, who have a right to resume their original liberty, and by the establishment of a new legislative (such as they shall think fit), provide for their own safety and security, which is the end for which they are in society. What I have said here concerning the legislative in general holds true also concerning the supreme executor, who having a double trust put in him, both to have a part in the legislative and the supreme execution of the law, acts against both, when he goes about to set up his own arbitrary will as the law of the society. He acts also contrary to his trust when he employs the force, treasure, and offices of the society to corrupt the representatives, and gain them to his purposes, when he openly preengages the electors, and prescribes, to their choice, such whom he has, by solicitation, threats, promises, or otherwise, won to his designs, and employs them to bring in such who have promised beforehand what to vote and what to enact. Thus to regulate candidates and electors, and new model the ways of election, what is it but to cut up the government by the roots, and poison the very fountain of public security?

To this, perhaps it will be said that the people being ignorant and always discontented, to lay the foundation of government in the unsteady opinion and uncertain humor of the people, is to expose it to certain ruin; and no government will be able long to subsist if the people may set up a new legislative whenever they take offense at the old one. To this I answer, quite the contrary. People are not so easily got out of their old forms as some are apt to suggest. They are hardly to be prevailed with to amend the acknowledged faults in the frame they have been accustomed to. And if there be any original defects, or adventitious ones introduced by time or corruption, it is not an easy thing to get them changed, even when all the world sees there is an opportunity for it. This slowness and aversion in the people to quit their old constitutions has in the many revolutions that have been seen in this kingdom, in this and former ages, still kept us to, or after some interval of fruitless attempts, still brought us back again to, our old legislative of kings, lords, and commons; and whatever provocations have made the crown be taken from some of our princes' heads, they never carried the people so far as to place it in another line.

But it will be said this hypothesis lays a ferment for further rebellion. To which I answer:

First: no more than any other hypothesis. For when the people are made miserable, and find themselves exposed to the ill usage or arbitrary power, cry up their governors as much as you will for sons of

Jupiter, let them be sacred and divine, descended or authorized from Heaven; give them out for whom or what you please, the same will happen. The people generally ill treated, and contrary to right, will be ready upon any occasion to ease themselves of a burden that sits heavy upon them. They will wish and seek for the opportunity, which in the change, weakness, and accidents of human affairs, seldom delays long to offer itself. He must have lived but a little while in the world, who has not seen examples of this in his time; and he must have read very little who cannot produce examples of it in all sorts of governments in the world

Secondly: I answer, such revolutions happen not upon every little mismanagement in public affairs. Great mistakes in the ruling part, many wrong and inconvenient laws, and all the slips of human frailty will be borne by the people without mutiny or murmur. But if a long train of abuses, prevarications, and artifices, all tending the same way, make the design visible to the people, and they cannot but feel what they lie under, and see whither they are going, it is not to be wondered that they should then rouse themselves, and endeavor to put the rule into such hands which may secure to them the ends for which government was at first erected, and without which, ancient names and specious forms are so far from being better, that they are much worse than the state of nature or pure anarchy; the inconveniences being all as great and as near, but the remedy farther off and more difficult

Thirdly: I answer, that this . . . power in the people of providing for their safety anew by a new legislative when their legislators have acted contrary to their trust by invading their property, is

the best fence against rebellion, and the probablest means to hinder it. For rebellion being an opposition, not to persons, but authority, which is founded only in the constitutions and laws of the government; those, whoever they be, who by force break through, and by force justify their violation of them, are truly and properly rebels. For when men, by entering into society and civil government, have excluded force, and introduced laws for the preservation of property, peace, and unity amongst themselves, those who set up force again in opposition to the laws, do rebellare—that is, bring back again the state of war, and are properly rebels. which they who are in power (by the pretence they have to authority, the temptation of force they have in their hands, and the flattery of those about them), being likeliest to do, the properest way to prevent the evil is to show them the danger and injustice of it who are under the greatest temptation to run into it. . . .

But if they who say it lays a foundation for rebellion mean that it may occasion civil wars or intestine broils to tell the people they are absolved from obedience when illegal attempts are made upon their liberties or properties, and may oppose the unlawful violence of those who were their magistrates when they invade their properties, contrary to the trust put in them, and that, therefore, this doctrine is not to be allowed, being so destructive to the peace of the world; they may as well say, upon the same ground, that honest men may not oppose robbers or pirates, because this may occasion disorder or bloodshed. If any mischief come in such cases, it is not to be charged upon him who defends his own right, but on him that invades his neighbor's. If the innocent honest man must quietly quit all he has for peace's sake to him who will lay

violent hands upon it, I desire it may be considered what a kind of peace there will be in the world which consists only in violence and rapine, and which is to be maintained only for the benefit of robbers and oppressors. Who would not think it an admirable peace betwixt the mighty and the mean, when the lamb, without resistance, yielded his throat to be torn by the imperious wolf?

The end of government is the good of mankind; and which is best for mankind, that the people should be always exposed to the boundless will of tyranny, or that the ruler should be sometimes liable to be opposed when they grow exorbitant in the use of their power, and employ it for the destruction, and not the preservation, of

the properties of their people?

Nor let any one say that mischief can arise from hence as often as it shall please a busy head or turbulent spirit to desire the alteration of the government. It is true such men stir whenever they please, but it will be only to their own just ruin and perdition. For till the mischief be grown general, and the ill designs of the rulers become visible, or their attempts sensible to the greater part, the people who are more disposed to suffer than right themselves by resistance, are not apt to stir. The examples of particular injustice or oppression of here and there an unfortunate man moves them not. But if they universally have a persuasion grounded upon manifest evidence that designs are carrying on against their liberties, and the general course and tendency of things cannot but give them strong suspicions of the evil intention of their governors, who is to be blamed for it? Who can help it if they, who might avoid it, bring themselves into this suspicion? Are the people to be blamed if they have the sense of rational creatures, and can think of things no otherwise than as they find and feel them? And is it not rather their fault who put things in such a posture that they would not have them thought as they are? I grant that the pride, ambition, and turbulency of private men have sometimes caused great disorders in commonwealths, and factions have been fatal to states and kingdoms. But whether the mischief hath oftener begun in the people's wantonness, and a desire to cast off the lawful authority of their rulers, or in the rulers' insolence and endeavors to get and exercise an arbitrary power over their people, whether oppression or disobedience gave the first rise to the disorder, I leave it to impartial history to determine. This I am sure, whoever, either ruler or subject, by force goes about to invade the rights of either prince or people, and lays the foundation for overturning the constitution and frame of any just government, he is guilty of the greatest crime I think a man is capable of, being to answer for all those mischiefs of blood, rapine, and desolation. which the breaking to pieces of governments brings on a country; and he who does it is justly to be esteemed the common enemy and pest of mankind; and is to be treated accordingly. . . .

Here it is like, the common question will be made, Who shall be judge whether the prince or legislative act contrary to their trust? . . . To this I reply, The people shall be judge; for who shall be judge whether his trustee or deputy acts well and according to the trust reposed in him, but he who deputes him and must, by having deputed him, have still a power to discard him when he fails in his trust? If this be reasonable in particular cases of private men, why should it be otherwise in that of the greatest moment, where the welfare of millions is concerned and also where the evil, if not

prevented, is greater, and the redress very difficult, dear, and dangerous? . . .

If a controversy arise betwixt a prince and some of the people in a matter where the law is silent or doubtful, and the thing be of great consequence, I should think the proper umpire in such a case should be the body of the people. For in cases where the prince hath a trust reposed in him, and is dispensed from the common, ordinary rules of the law, there, if any men find themselves aggrieved, and think the prince acts contrary to, or beyond that trust, who so proper to judge as the body of the people (who at first lodged that trust in him) how far they meant it should extend? But if the prince, or whoever they be in the administration. decline that way of determination, the appeal then lies nowhere but to Heaven; force between either persons who have no known superior on earth, or which permits no appeal to a judge on earth, being properly a state of war, wherein the appeal lies only to Heaven; and in that state the injured party must judge for himself when he will think fit to make use of that appeal and put himself upon it.

To conclude: The power that every individual gave the society when he entered into it can never revert to the individuals again, as long as the society lasts, but will always remain in the community; because without this there can be no community -no commonwealth, which is contrary to the original agreement; so also when the society hath placed the legislative in any assembly of men, to continue in them and their successors, with direction and authority for providing such successors, the legislative can never revert to the people whilst that government lasts; because, having provided a legislative with power to continue forever, they have given up their political power to the legislative and cannot resume it. But if they have set limits to the duration of their legislative, and made this supreme power in any person or assembly only temporary; or else, when, by the miscarriages of those in authority it is forfeited; upon the forfeiture of their rules, or at the determination of the time set, it reverts to the society, and the people have a right to act as supreme. and continue the legislative in themselves or place it in a new form, or new hands, as they think good.

A Time of Belief

- I. THE EIGHTEENTH CENTURY
- II. ENLIGHTENED DESPOTISM
- III. A DAWN OF REVOLUTION
- IV. THE REACTION
- V. ROMANTICS AND ROMANTICISM
- VI. ECONOMIC REVOLUTION
- VII. BUT LIFE GOES ON
- VIII. LIBERALISM, NATIONALISM, AND 1848

The temptation to select one characteristic of a period and arbitrarily proclaim its dominance over all others is always strong and always dangerous. But the temptation becomes a necessity when one seeks a principle of unity in a period as full of diversity as the one which runs from the death of Louis XIV to the revolutions of 1848: enlightened despotism, constitutional monarchy, revolution, Jacobin terror, liberalism and reaction, the dreams of the Romantic poets and the no less exalted dreams of industrialists and economists—these make an ill-matched company. Yet they all have one thing in common—the same self-confidence, the same belief that by following their particular recipe the world could be made a better place, indeed, quite likely, a perfect place.

This is why the years between the birth of Frederick the Great and the death of the Second Republic in France are a time of belief, in which the failure of one panacea merely brings more grist to the mill of the others; belief which is shared by all the most typical representatives of the time . . . except for Metternich. And if Metternich had no particular faith in the future, he had a prodigious faith in himself, which makes him more a man of his time than of our own.

I. The Eighteenth Century

As the seventeenth century draws to a close, many of the lines for future development have been laid down. But they are much clearer to the historian with the advantage of hindsight than to the men of the time. It is in the eighteenth century that the decisive steps are taken towards establishing the institutions and the attitudes of our own age; and, while it is wrong to see these as disconnected from the trends and the thinking which had gone before, it would be even more difficult to gain an understanding of events after 1789 without knowing their eighteenth-century background.

More than any other century, perhaps, the thought of the eighteenth is preoccupied by order and by the use of reason which can, if properly utilized, discover and establish order even in this apparently chaotic world. Educated men generally accepted the advice of that most passionately reasonable poet, Alexander Pope, who opened his *Essay on Man* (1733) with the admonition:

Let us (since Life can little more supply Than just to look about us and to die) Expatiate free o'er all this scene of Man; A mighty maze! but not without a plan.

Certainly the men of the eighteenth century loved to expatiate—mostly in French—but for the benefit of all mankind, which would naturally be included in the universal plan; a plan, reasonable and accessible to reason, which would make sense of the mighty maze about them. This lust for a beneficial (re?)ordering of the world was expressed on the international scene in the policies of the so-called Enlightened Despots, the most articulate of whom was Frederick of Prussia. On the intellectual plane, the place of rationalism is harder to determine, and perhaps on reflection the age may as justly be called one of Faith as of Reason. It is, at any rate, tempting to compare the mood of the Enlightenment with that of Renaissance humanism: similarities and differences are both significant. But in the end the question remains: what exactly do we mean by "Enlightenment"? Just how enlightened, for instance, were the Enlightened Despots?

1. SAMUEL JOHNSON

Samuel Johnson (1709–1784), moralist, essayist, lexicographer, dominated London literary society after 1755, when his great *Dictionary* appeared. He has come down to us mainly in the account of James Boswell, who seems to have spent the years between 1763 and 1784 drinking in and noting down the great man's sayings. As a matter of fact many of them were well worth noting, both for themselves and as illustrations of what an intelligent and articulate English conservative might think in the second half of the eighteenth century.

From: Life of Dr. Samuel Johnson

He talked in his usual style with a rough contempt for popular liberty. "They make a rout about universal liberty, without considering that all that is to be valued, or indeed can be enjoyed by individuals, is private liberty. Political liberty is good only so far as it produces private liberty. Now, Sir, there is the liberty of the press, which you know is a constant topic. Suppose you and I and two hundred more were restrained from printing our thought: what then? What proportion would that restraint upon us bear to the private happiness of the nation?"

This mode of representing the inconveniences of restraint as light and insignificant, was a kind of sophistry in which he delighted to indulge himself, in opposition to the extreme laxity for which it has been fashionable for too many to argue, when it is evident, upon reflection, that the very essence of government is restraint; and certain it is, that as government produces rational happiness, too much restraint is better than too little. But when restraint is unnecessary, and so close as to gall those who are subject to it, the people may and ought to demonstrate; and, if relief is not granted, to resist. Of this manly and spirited principle, no man was more convinced than Johnson himself. . . .

I told him that Mrs. Macaulay said, she wondered how he could reconcile his political principles with his moral; his notions of inequality and subordination with wishing well to the happiness of all mankind, who might live so agreeably, had they all their portions of land, and none to domineer over another. JOHNSON. "Why, Sir, I reconcile my principles very well, because mankind are happier in a state of inequality and subordination. Were they to be in this state of equality, they would soon degenerate into brutes; -they would become Monboddo's nation:-their tails would grow. Sir, all would be losers were all to work for all: -they would have no intellectual improvement. All intellectual improvement arises from leisure; all leisure arises from one working for another."

I introduced the subject of toleration. Johnson. "Every society has a right to preserve public peace and order, and therefore has a good right to prohibit the propagation of opinions which have a dangerous tendency. To say the magistrate has this right, is using an inadequate word; it is the society for which the magistrate is agent. He may be morally or theologically wrong in restraining the propagation of opinions which he thinks dangerous, but he is politically right."

MAYO. "I am of opinion, Sir, that every man is entitled to liberty of conscience in religion; and that the magistrate cannot restrain that right." JOHNSON. "Sir, I agree with you. Every man has a right to liberty of conscience, and with that the magistrate cannot interfere. People confound liberty of thinking with liberty of talking; nay, with liberty of preaching. Every man has a physical right to think as he pleases; for it cannot be discovered how he thinks. He has not a moral right, for he ought to inform himself, and think justly. But, Sir, no member of a society has a right to teach any doctrine contrary to what the society holds to be true. The magistrate, I say, may be wrong in what he thinks: but while he thinks himself right, he may and ought to enforce what he thinks." MAYO. "Then, Sir, we are to remain always in error, and truth never can prevail; and the magistrate was right in persecuting the first Christians." JOHNSON. "Sir, the only method by which religious truth can be established is by martyrdom. The magistrate has a right to enforce what he thinks; and he who is conscious of the truth has a right to suffer. I am afraid there is no other way of ascertaining the truth, but by persecution on the one hand and enduring it on the other." GOLD-SMITH. "But how is a man to act, Sir? Though firmly convinced of the truth of his doctrine may he not think it wrong to expose himself to persecution? Has he a right to do so? Is it not, as it were, committing voluntary suicide?" JOHNSON. "Sir, as to voluntary suicide, as you call it, there are twenty thousand men in an army who will go without scruple to be shot at, and mount a breach for five-pence a day," GOLDSMITH. "But have they a moral right to do this?" JOHNSON. "Nay, Sir, if you will not take the universal opinion of mankind, I have nothing to say. If

mankind cannot defend their own way of thinking, I cannot defend it. Sir, if a man is in doubt whether it would be better for him to expose himself to martyrdom or not, he should not do it. He must be convinced that he has a delegation from heaven." GOLDSMITH. "I would consider whether there is the greater chance of good or evil upon the whole. If I see a man who had fallen into a well, I would wish to help him out; but if there is greater probability that he shall pull me in; than that I shall pull him out, I would not attempt it. So were I to go to Turkey, I might wish to convert the Grand Signor to the Christian faith; but when I considered that I should probably be put to death without effectuating my purpose in any degree, I should keep myself quiet." JOHNSON. "Sir, you must consider that we have perfect and imperfect obligations. Perfect obligations, which are generally not to do something, are clear and positive; as, 'thou shalt not kill.' But charity, for instance, is not definable by limits. It is a duty to give to the poor; but no man can say how much another should give to the poor, or when a man has given too little to save his soul. In the same manner it is a duty to instruct the ignorant, and of consequence to convert infidels to Christianity; but no man in the common course of things is obliged to carry this to such a degree as to incur the danger of martyrdom, as no man is obliged to strip himself to the shirt in order to give charity. I have said, that a man must be persuaded that he has a particular delegation from heaven." GOLDSMITH. "How is this to be known? Our first reformers, who were burnt for not believing bread and wine to be Christ"-JOHNSON. (Interrupting him,) "Sir, they were not burnt for not believing bread and wine to be Christ, but for insulting those who did

believe it. And Sir, when the first reformers began, they did not intend to be martyred: as many of them ran away as could." BOSWELL. "But, Sir, there was your countryman, Elwal, who you told me challenged King George with his blackguards, and his red-guards." JOHNSON. "My countryman, Elwal, Sir, should have been put in the stocks: a proper pulpit for him: and he'd have had a numerous audience. A man who preaches in the stocks will always have hearers enough." Bos-WELL. "But Elwal thought himself in the right." JOHNSON. "We are not providing for mad people; there are places for them in the neighbourhood." (Meaning Moorfields.) MAYO. "But, Sir, is it not very hard that I should not be allowed to teach my children what I really believe to be the truth?" JOHNSON. "Why, Sir, you might contrive to teach your children extra scandalum; but, Sir, the magistrate, if he knows it, has a right to restrain you. Suppose you teach your children to be thieves?" MAYO. "This is making a joke of the subject." JOHNSON. "Nay, Sir, take it thus: - that you teach them the community of goods; for which there are as many plausible arguments as for most erroneous doctrines. You teach them that all things at first were in common, and that no man had a right to any thing but as he laid his hands upon it; and that this still is, or ought to be, the rule amongst mankind. Here, Sir, you sap a great principle in society, - property. And don't you think the magistrate would have a right to prevent you? Or, suppose you should teach your children the notion of the Adamites, and they should run naked into the streets, would not the magistrate have a right to flog 'em into their doublets?" MAYO. "I think the magistrate has no right to interfere till there is some overt act." BOSWELL. "So, Sir, though he

sees an enemy to the state charging a blunderbuss, he is not to interfere till it is fired off?" MAYO. "He must be sure of its direction against the state." JOHNSON. "The magistrate is to judge of that.—He has no right to restrain your thinking, because the evil centers in yourself. If a man were sitting at this table, and chopping off his fingers, the magistrate, as guardian of the community, has no authority to restrain him; however he might do it from kindness as a parent.-Though, indeed, upon more consideration, I think he may; as it is probable, that he who is chopping off his own fingers, may soon proceed to chop off those of other people. If I think it right to steal Mr. Dilly's plate, I am a bad man; but he can say nothing to me. If I make an open declaration that I think so, he will keep me out of his house. If I put forth my hand, I shall be sent to Newgate. This is the gradation of thinking, preaching, and acting: if a man thinks erroneously, he may keep his thoughts to himself, and nobody will trouble him; if he preaches erroneous doctrine, society may expel him; if he acts in consequence of it, the law takes place, and he is hanged." MAYO. "But, Sir, ought not Christians to have liberty of conscience?" JOHNSON. "I have already told you so, Sir. You are coming back to where you were." BOSWELL. "Dr. Mayo, like other champions for unlimited toleration, has got a set of words. Sir, it is no matter, politically, whether the magistrate be right or wrong. Suppose a club were to be formed to drink confusion to King George the Third, and a happy restoration to Charles the Third, this would be very bad with respect to the State; but every member of that club must either conform to its rules, or be turned out of it. Old Baxter, I remember, maintains that the magistrate should 'tolerate all

things that are tolerable.' This is no good definition of toleration upon any principle; but it shews that he thought some things were not tolerable." TOPLADY. "Sir, you have untwisted this difficult subject with great dexterity."

During this argument, Goldsmith sat in restless agitation, from a wish to get in and shine. Finding himself excluded, he had taken his hat to go away, but remained for some time with it in his hand, like a gamester, who at the close of a long night, lingers for a little while, to see if he can have a favourable opening to finish with success. Once when he was beginning to speak, he found himself overpowered by the loud voice of Johnson, who was at the opposite end of the table, and did not perceive Goldsmith's attempt. Thus disappointed of his wish to obtain the attention of the company, Goldsmith in a passion threw down his hat, looking angrily at Johnson, and exclaiming in a bitter tone, "Take it." When Toplady was going to speak, Johnson uttered some sound, which led Goldsmith to think that he was beginning again, and taking the words from Toplady. Upon which, he seized this opportunity of venting his own envy and spleen, under the pretext of supporting another person: "Sir, (said he to Johnson,) the gentleman has heard you patiently for an hour; pray allow us now to hear him." JOHNSON. (Sternly,) "Sir, I was not interrupting the gentleman. I was only giving him a signal of my attention. Sir. vou are impertinent." Goldsmith made no reply, but continued in the company for some time.

A gentleman present ventured to ask Dr. Johnson if there was not a material difference as to toleration of opinions which lead to action, and opinions merely speculative; for instance, would it be wrong in the magistrate to tolerate those

who preach against the doctrine of the Trinity? Johnson was highly offended, and said, "I wonder, Sir, how a gentleman of your piety can introduce this subject in a mixed company." He told me afterwards that the impropriety was, that perhaps some of the company might have talked on the subject in such terms as might have shocked him; or he might have been forced to appear in their eyes a narrowminded man. The gentleman, with submissive deference, said, he had only hinted at the question from a desire to hear Dr. Johnson's opinion upon it. JOHNSON. "Why then, Sir, I think that permitting men to preach any opinion contrary to the doctrine of the established church tends, in a certain degree, to lessen the authority of the church, and consequently, to lessen the influence of religion." "It may be considered, (said the gentleman,) whether it would not be politic to tolerate in such a case." JOHNSON. "Sir, we have been talking of right: this is another question. I think it is not politic to tolerate in such a case." . . .

Patriotism having become one of our topics, Johnson suddenly uttered, in a strong determined tone, an apophthegm, at which many will start: "Patriotism is the last refuge of a scoundrel." But let it be considered, that he did not mean a real and generous love of our country, but that pretended patriotism which so many, in all ages and countries, have made a cloak for self-interest. I maintained, that certainly all patriots were not scoundrels. Being urged, (not by Johnson,) to name one exception, I mentioned an eminent person, whom we all greatly admired. IOHNSON. "Sir, I do not say that he is not honest; but we have no reason to conclude from his political conduct that he is honest. Were he to accept a place from this ministry, he would lose that character of firmness which he has, and might be turned out of his place in a year. This ministry is neither stable, nor grateful to their friends, as Sir Robert Walpole was, so that he may think it more for his interest to take his chance of his party coming in."

2. MONTESQUIEU

Charles de Secondat, baron de Montesquieu (1689–1755), came from a good family of lawyers and judges, and himself presided over the Parliament Court of Bordeaux. He made his name by a brilliant satire, *The Persian Letters*, containing descriptions of contemporary life and ways produced by a supposed Persian visitor to France. He then established his reputation with *The Spirit of the Laws* in which he discussed in detail, with great learning and sometimes also with great tediousness, the nature of the state, its laws, and the factors that affected them. Of all the forerunners of the revolutions that marked the last quarter of the eighteenth century, Montesquieu is probably the one with the broadest views and the one whose ideas were most fertile in practical results.

From: The Spirit of the Laws (1748)

OF LAWS IN GENERAL

Laws, in their most general signification, are the necessary relations arising from the nature of things. In this sense, all beings have their laws, the Deity his laws, the material world its laws, the intelligences superior to man their laws, the beasts their laws, man his laws. . . .

There is then a primitive reason; and laws are the relations subsisting between it and different beings, and the relations of these to one another.

God is related to the universe as creator and preserver: the laws by which he created all things are those by which he preserves them. He acts according to these rules, because he knows them; he knows them, because he made them; and he made them, because they are relative to his wisdom and power.

Since we observe that the world,

though formed by the motion of matter, and void of understanding, subsists through so long a succession of ages, its motions must certainly be directed by invariable laws: and, could we imagine another, it must also have constant rules, or it would inevitably perish.

Thus the creation, which seems an arbitrary act, supposeth laws as invariable as those of the fatality of the atheists. It would be absurd to say, that the Creator might govern the world without those rules, since without them it could not subsist. . . .

Particular intelligent beings may have laws of their own making; but they have some likewise which they never made. Before there were intelligent beings, they were possible; they had therefore possible relations, and consequently possible laws. Before laws were made, there were relations of possible justice. To say that there

From The Complete Works of M. de Montesquieu (London, 1777).

is nothing just or unjust, but what is commanded or forbidden by positive laws, is the same as saying that, before the describing of a circle, all the radii were not equal.

We must therefore acknowledge relations of justice antecedent to the positive law by which they are established. . . .

Man, as a physical being, is, like other bodies, governed by invariable laws. . . . Such a being might every instant forget his Creator; God has therefore reminded him of his duty by the laws of religion. Such a being is liable every moment to forget himself; philosophy has provided against this by the laws of morality. Formed to live in society, he might forget his fellow-creatures; legislators have, therefore, by political and civil laws, confined him to his duty. . . .

Law in general is human reason, inasmuch as it governs all the inhabitants of the earth; the political and civil laws of each nation ought to be only the particular cases in which human reason is applied.

They should be adapted in such a manner to the people for whom they are framed, that it is a great chance if those of one nation suit another.

They should be relative to the nature and principle of each government; whether they form it, as may be said of political laws; or whether they support it, as in the case of civil institutions.

They should be relative to the climate of each country, to the quality of its soil, to its situation and extent, to the principal occupation of the natives, whether husbandmen, huntsmen, or shepherds: they should have a relation to the degree of liberty which the constitution will bear, to the religion of the inhabitants, to their manners, and customs. In fine, they have inclinations, riches, numbers, commerce,

relations to each other, as also origin, to the intent of the legislate and to the order of things on which they are established; in all which different lights they ought to be considered.

This is what I have undertaken to perform in the following work. These relations I shall examine, since all these together constitute what I call the Spirit of Laws.

OF POLITICAL LIBERTY AND THE CONSTITUTION OF ENGLAND

Democratic and aristocratic states are not in their own nature free. Political liberty is to be found only in moderate governments; and even in these it is not always found. It is there only when there is no abuse of power: but constant experience shows us that every man invested with power is apt to abuse it, and to carry his authority as far as it will go. Is it not strange, though true, to say, that virtue itself has need of limits?

To prevent this abuse, it is necessary, from the very nature of things, power should be a check to power. A government may be so constituted as no man shall be compelled to do things to which the law does not oblige him, nor forced to abstain from things which the law permits. . . .

The political liberty of the subject is a tranquility of mind arising from the opinion each person has of his safety. In order to have this liberty, it is requisite the government be so constituted as one man need not be afraid of another.

When the legislative and executive powers are united in the same person, or in the same body of magistrates, there can be no liberty; because apprehensions may arise, lest the same monarch or senate should enact tyrannical laws, to execute them in a tyrannical manner.

Again, there is no liberty if the judiciary power be not separated from the legislative and executive. Were it joined with the legislative, the life and liberty of the subject would be exposed to arbitrary control; for the judge would be then the legislator. Were it joined to the executive power, the judge might behave with violence and oppression.

There would be an end of everything, were the same man, or the same body, whether of the nobles or of the people, to exercise those three powers, that of enacting laws, that of executing the public resolutions, and of trying the causes of individuals.

The judiciary power ought not to be given to a standing senate; it should be exercised by persons taken from the body of the people, at certain times of the year, and consistently with a form and manner prescribed by law, in order to erect a tribunal that should last only so long as necessity requires.

By this method, the judicial power, so terrible to mankind, not being annexed to any particular state or profession, becomes, as it were, invisible. People have not then the judges continually present to their view; they fear the office, but not the magistrate. . . .

But though the tribunals ought not to be fixed, the judgments ought; and to such a degree, as to be ever conformable to the letter of the law. Were they to be the private opinion of the judge, people would then live in society without exactly knowing the nature of their obligations.

As, in a country of liberty, every man who is supposed a free agent ought to be his own governor, the legislative power should reside in the whole body of the people. But, since this is impossible in large states, and in small ones is subject to many inconveniences, it is fit the people should transact by their representatives what they cannot transact by themselves.

The inhabitants of a particular town are much better acquainted with its wants and interests than with those of other places; and are better judges of the capacity of their neighbours than of that of the rest of their countrymen. The members, therefore, of the legislature should not be chosen from the general body of the nation; but it is proper, that in every considerable place, a representative should be elected by the inhabitants.

The great advantage of representatives is their capacity of discussing public affairs. For this, the people collectively are extremely unfit, which is one of the chief inconveniences of a democracy. . . .

All the inhabitants of the several districts ought to have a right of voting at the election of a representative, except such as are in so mean a situation as to be deemed to have no will of their own.

In such a state, there are always persons distinguished by their birth, riches, or honours; but, were they to be confounded with the common people, and to have only the weight of a single vote, like the rest, the common liberty would be their slavery, and they would have no interest in supporting it, as most of the popular resolutions would be against them. The share they have, therefore, in the legislature ought to be proportioned to their other advantages in the state; which happens only when they form a body that has a right to check the licentiousness of the people, as the people have a right to oppose any encroachment of theirs.

The legislative power is, therefore, committed to the body of the nobles, and

to that which represents the people; each having their assemblies and deliberations apart, each their separate views and interests. . . .

The body of the nobility ought to be hereditary. In the first place, it is so in its own nature; and, in the next, there must be a considerable interest to preserve its privileges: privileges, that, in themselves, are obnoxious to popular envy, and of course, in a free state, are always in danger.

But, as an hereditary power might be tempted to pursue its own particular interests, and forget those of the people, it is proper, that, where a singular advantage may be gained by corrupting the nobility, as in the laws relating to supplies, they should have no other share in the legislation than the power of rejecting, and not that of resolving.

The executive power ought to be in the hands of a monarch, because this branch of government, having need of dispatch, is better administered by one than by many: on the other hand, whatever depends on the legislative power, is oftentimes better regulated by many than by a single person. . . .

Were the legislative body to be a considerable time without meeting, this would likewise put an end to liberty. For, of two things, one would naturally follow; either that there would be no longer any legislative resolutions, and then the state would fall into anarchy; or that these resolutions would be taken by the executive power, which would render it absolute. . . .

But, if the legislative power, in a free state, has no right to stay the executive, it has a right, and ought to have the means, of examining in what manner its laws have been executed; an advantage which this government has over that of Crete and Sparta, where the Cosmi and the Ephori gave no account of their administration.

But, whatever may be the issue of that examination, the legislative body ought not to have a power of arraigning the person, nor, of course, the conduct of him who is entrusted with the executive power. His person should be sacred, because, as it is necessary, for the good of the state, to prevent the legislative body from rendering themselves arbitrary, the moment he is accused or tried there is an end of liberty.

In this case, the state would be no longer a monarchy, but a kind of republic, though not a free government. But, as the person, entrusted with the executive power, cannot abuse it without bad counsellors, and such as hate the laws as ministers, though the laws protect them as subjects, these men may be examined and punished: an advantage which this government has over that of Gnidus, where the law allowed of no such thing as calling the Amymones to account, even after their administration; and therefore the people could never obtain any satisfaction for the injuries done to them. . . .

The executive power, pursuant to what has been already said, ought to have a share in the legislature by the power of rejecting; otherwise it would soon be stripped of its prerogative. But, should the legislative power usurp a share of the executive, the latter would be equally undone.

If the prince were to have a part in the legislature by the power of resolving, liberty would be lost. But, as it is necessary he should have a share in the legislature for the support of his own prerogative, this share must consist in the power of rejecting. . . .

514

Were the executive power to determine the raising of public money otherwise than by giving its consent, liberty would be at an end; because it would become legislative in the most important point of legislation. . . .

To prevent the executive power from being able to oppress, it is requisite that the armies with which it is entrusted should consist of the people, and have the same spirit as the people, as was the case at Rome till the time of Marius. To obtain this end, there are only two ways; either that the persons employed in the army should have sufficient property to answer for their conduct to their fellowsubjects, and be enlisted only for a year, as was customary at Rome; or, if there should be a standing-army composed chiefly of the most despicable part of the nation, the legislative power should have a right to disband them as soon as it pleased; the soldiers should live in common with the rest of the people; and no separate camp, barracks, or fortress, should be suffered.

In perusing the admirable treatise of Tacitus on the manners of the Germans, we find it is from that nation the English have borrowed the idea of their political government. This beautiful system was invented first in the woods. . . .

It is not my business to examine whether the English actually enjoy this liberty, or not. Sufficient it is for my purpose to observe, that it is established by their laws; and I inquire no farther.

Neither do I pretend by this to undervalue other governments, nor to say that this extreme political liberty ought to give uneasiness to those who have only a moderate share of it. How should I have any such design; I who think that even the highest refinement of reason is not always desirable, and that mankind generally find their account better in mediums than in extremes?

3. VOLTAIRE

François Marie Arouet, better known as Voltaire (1694–1778), is probably the most characteristic, certainly the most brilliant, figure of the Enlightenment. Born in Paris, son of a notary, endowed with a daring, supple, and inquiring mind, and a great gift for writing in prose or verse, he produced plays, poems, pamphlets, histories, novels, encyclopedia articles and journalistic ones in tremendous profusion. He spent most of his life in a long but effective private war against prejudice, intolerance, superstition, and their embodiment in the Catholic Church and the ancien régime. His rationalism, however, did not lead him to share the optimism common to his time. In several satires he held up to scorn the idea that "Whatever is, is right," and it would be a dull man who did not bother to read at least his Candide, which is not included here because selection proved impossible: too much of it is too good to leave out.

One of the best translations of his works is also the earliest, that of Tobias Smollett, and that is the one used below.

On English Commerce

Carthage, Venice, and Amsterdam were undoubtedly powerful; but their conduct has been exactly like that of merchants grown rich by traffic, who afterwards purchase lands that carry with them the dignity of lordship. Neither Carthage, Venice, nor Holland have, from a warlike and even conquering beginning, ended in a commercial nation. The English are the only people in existence who have done this; they were for a long time warriors before they learned to cast accounts. They were entirely ignorant of numbers when they won the battles of Agincourt, Crécy, and Poitiers, and were also ignorant that it was in their power to become corn merchants and woollen drapers, two things that would certainly turn to much better account than winning battles. This science alone has rendered the nation at once populous, wealthy, and powerful. London was a poor country town when Edward III conquered one half of France; and it is wholly owing to this that the English have become merchants; that London exceeds Paris in extent and number of inhabitants; that they are able to equip and man two hundred sail of ships of war, and keep the kings who are their allies in pay. The Scots are born warriors, and, from the purity of their air, inherit good sense. Whence comes it then that Scotland, under the name of a Union, has become a province of England? It is because Scotland has scarcely any other commodity than coal, and that England has fine tin, excellent wool, and abounds in corn, manufactures, and trading companies.

Even the younger son of a peer of the realm is not above trading. Lord Townshend, secretary of state, has a brother

who is satisfied with being a merchant in the city. At the time when Lord Oxford ruled all England, his younger brother was a trader at Aleppo, whence he could never be prevailed on to return, and where he died. This custom which is now unhappily dving out, appears monstruous to a German, whose head is full of the coats of arms and the pageants of his family. They can never conceive how it is possible that the son of an English peer should be no more than a rich and powerful citizen, when in Germany they are all princes. I have known more than thirty highnesses of the same name, whose whole fortune and estate put together amounted to a few coats of arms, and the starving pride they inherited from their ancestors.

In France everybody is a marquis; and a man just come from the obscurity of some remote province, with money in his pocket and a name that ends in "ac" or "ille," may give himself airs, and usurp such phrases as "A man of my quality and rank"; and hold merchants in the most sovereign contempt. The merchant again, by dint of hearing his profession despised on all occasions, at last is fool enough to blush at his condition. I will not, however, take it upon me to say which is the most useful to his country, and which of the two ought to have the preference; whether the powdered lord, who knows to a minute when the king rises or goes to bed, perhaps to stool, and who gives himself airs of importance while playing the part of a slave in the antechamber of a minister; or the merchant, who enriches his country, and from his counting house sends his orders into Surat or Cairo, thereby contributing to the happiness and convenience of human nature.

Another interesting aspect of English institutions, not unconnected with the first and one which Voltaire obviously thought his countrymen might well imitate, was religious tolerance. He describes it below in characteristically striking terms:

On Presbyterians

To the Presbyterians is owing the sanctification of Sunday in the three kingdoms. People are forbidden to work or take any recreation on that day, which is being twice as severe as the Church of Rome. No operas, plays, or concerts are allowed in London on Sundays; and even cards are so expressly forbidden that none but persons of quality, and those we call genteel, play on that day; the rest of the nation go either to church, to the tavern, or to a kept mistress.

Though the Episcopal and Presbyterian sects are the two prevailing ones in Great Britain, yet all others are very welcome to come and settle in it, and they live very sociably together, though most of their preachers hate one another almost as cordially as a Jansenist damns a Jesuit.

Take a view of the Royal Exchange in London, a place more venerable than many courts of justice, where the representatives of all nations meet for the benefit of mankind. There the Jew, the

Mahometan, and the Christian transact business together, as though they were all of the same religion, and give the name of Infidels to none but the bankrupts; there the Presbyterian confides in the Anabaptist, and the Churchman depends upon the Quaker's word. At the breaking up of this pacific and free assembly, some withdraw to the synagogue, others go to drink. This man goes to be baptized in a great tub in the name of the Father, Son and Holy Ghost; that man has his son's foreskin cut off and has Hebrew words mumbled over him which he does not understand himself; others retire to their churches and there await the inspiration of heaven with their hats on their heads; and all are satisfied.

If one religion only were allowed in England, the government would very possibly become arbitrary; if there were but two, the people would cut one another's throats; but as there is such a multitude, they all live happy and in peace.

4. ROUSSEAU

Jean Jacques Rousseau (1712–1778) was born in Geneva, Switzerland, the odd and adventurous son of an odd and adventurous watchmaker—dancing master. Orphaned at an early age, he never ceased his wanderings. Something of a musician and literary jack-of-all-trades, he basked for a while in the searing glory of the Paris salons, contributed to the Encyclopedia, quarreled with the Encyclopedists, lived some time in England where he quarreled with the philosopher Hume, and in Germany where he quarreled with nearly everybody, became more and more difficult and embittered until he died, a melancholy and rather mad old man, at Ermenonville, near Paris.

He reacted to the excessive rationalism of his time by re-emphasizing instinct against reason, unspoilt virtue against corrupt society, inspiration against discipline, nature against artifice. But he also reminded his readers that man is a member of society and that, since he is a social animal, he should be concerned to reorganize society and life in it according to sensible, virtuous, and natural rules. Society is corrupt because it has moved too far from nature; hence man in society is corrupt too. Hope, however, lies for man in education and for society in political reorganization; and Rousseau tried to present his prescriptions for a healthier, saner approach to these in *Emile* and in the essay on *The Social Contract*, both of which appeared in 1762. His ideas not only made him the prophet of the Romantic movement which was going to dominate European literature during the early nineteenth century but also the inspiration of terroristic democrats like Robespierre.

From: The Social Contract INTRODUCTORY NOTE

I wish to enquire whether, taking men as they are and laws as they can be made, it is possible to establish some just and certain rule of administration in civil affairs. In this investigation I shall always strive to reconcile what right permits with what interest prescribes, so that justice and utility may not be severed. . . .

CHAPTER I

Man is born free, and everywhere he is in chains. Many a one believes himself the master of others, and yet he is a greater slave than they. How has this change come about? I do not know. What can render it legitimate? I believe that I can settle this question.

If I considered only force and the results that proceed from it, I should say that so long as a people is compelled to obey and does obey, it does well; but that, so soon as it can shake off the yoke and does shake it off, it does better; for, if men recover their freedom by virtue of the same right by which it was taken away, either they are justified in resuming it, or there was no justification for depriving them of it. But the social order is

a sacred right which serves as a foundation for all others. This right however, does not come from nature. It is therefore based on conventions. The question is to know what these conventions are. Before coming to that, I must establish what I have just laid down.

THE RIGHT OF THE STRONGEST

The strongest man is never strong enough to be always master, unless he transforms his power into right, and obedience into duty. Hence the right of the strongest—a right apparently assumed in irony, and really established in principle. But will this phrase never be explained to us? Force is a physical power; I do not see what morality can result from its effects. To yield to force is an act of necessity, not of will; it is at most an act of prudence. In what sense can it be a duty?

Let us assume for a moment this pretended right. I say that nothing results from it but inexplicable nonsense; for if force constitutes right, the effect changes with the cause, and any force which overcomes the first succeeds to its rights. As soon as men can disobey with impunity, they may do so legitimately; and since the

From Rousseau, The Social Contract, tr. Henry J. Tozer (London, 1895).

strongest is always in the right, the only thing is to act in such a way that one may be the strongest. But what sort of a right is it that perishes when force ceases? If it is necessary to obey by compulsion, there is no need to obey from duty; and if men are no longer forced to obey, obligation is at an end. We see, then, that this word "right" adds nothing to force; it here means nothing at all.

Obey the powers that be. If that means, Yield to force, the precept is good but superfluous; I reply that it will never be violated. All power comes from God, I admit; but every disease comes from him too; does it follow that we are prohibited from calling in a physician? If a brigand should surprise me in the recesses of a wood, am I bound not only to give up my purse when forced, but am I also morally bound to do so when I might conceal it? For, in effect, the pistol which he holds is a superior force.

Let us agree, then, that might does not make right, and that we are bound to obey none but lawful authorities. Thus my original question ever recurs.

THE SOCIAL PACT

I assume that men have reached a point at which the obstacles that endanger their preservation in the state of nature overcome by their resistance the forces which each individual can exert with a view to maintaining himself in that state. Then this primitive condition can no longer subsist, and the human race would perish unless it changed its mode of existence.

Now, as men cannot create any new forces, but only combine and direct those that exist, they have no other means of self-preservation than to form by aggregation a sum of forces which may overcome the resistance, to put them in action by a single motive power, and to make them work in concert.

This sum of forces can be produced only by the combination of many; but the strength and freedom of each man being the chief instruments of his preservation, how can he pledge them without injuring himself, and without neglecting the cares which he owes to himself? This difficulty, applied to my subject, may be expressed in these terms:

"To find a form of association which may defend and protect with the whole force of the community the person and property of every associate, and by means of which each, coalescing with all, may nevertheless obey only himself, and remain as free as before." Such is the fundamental problem of which the social contract furnishes the solution.

The clauses of this contract are so determined by the nature of the act that the slightest modification would render them vain and ineffectual; so that, although they have never perhaps been formally enunciated, they are everywhere the same, everywhere tacitly admitted and recognised, until, the social pact being violated, each man regains his original rights and recovers his natural liberty, whilst losing the conventional liberty for which he renounces it.

These clauses, rightly understood, are reducible to one only, viz. the total alienation to the whole community of each associate with all rights; for, in the first place, since each gives himself up entirely, the conditions are equal for all; and, the conditions being equal for all, no one has any interest in making them burdensome to others.

Further, the alienation being made without reserve, the union is as perfect as it can be, and an individual associate can no longer claim anything; for, if any rights were left to individuals, since there would be no common superior who could judge between them and the public, each being on some point his own judge, would soon claim to be so on all; the state of nature would still subsist, and the association would necessarily become tyrannical or useless.

In short, each giving himself to all, gives himself to nobody; and as there is not one associate over whom we do not acquire the same rights which we concede to him over ourselves, we gain the equivalent of all that we lose, and more power to preserve what we have.

If, then, we set aside what is not of the essence of the social contract, we shall find that it is reducible to the following terms: "Each of us puts in common his person and his whole power under the supreme direction of the general will; and in return we receive every member as an indivisible part of the whole."

Forthwith, instead of the individual personalities of all the contracting parties, this act of association produces a moral and collective body, which is composed of as many members as the assembly has voices, and which receives from this same act its unity, its common self, its life, and its will. This public person, which is thus formed by the union of all the individual members, formerly took the name of "city" and now takes that of "republic" or "body politic," which is called by its members "State" when it is passive, "sovereign" when it is active, "power" when it is compared to similar bodies. With regard to the associates, they take collectively the name of "people," and are called individually "citizens," as participating in the sovereign power, and "subjects," as subjected to the laws of the State. But these terms are often confused and are mistaken one for another; it is sufficient to know how to distinguish them when they are used with complete precision.

THE SOVEREIGN

We see from this formula that the act of association contains a reciprocal engagement between the public and individuals, and that every individual, contracting so to speak with himself, is engaged in a double relation, viz. as a member of the sovereign towards individuals, and as a member of the State towards the sovereign. But we cannot apply here the maxim of civil law that no one is bound by engagements made with himself: for there is a great difference between being bound to oneself and to a whole of which one forms part.

We must further observe that the public resolution which can bind all subjects to the sovereign in consequence of the two different relations under which each of them is regarded cannot, for a contrary reason, bind the sovereign to itself; and that accordingly it is contrary to the nature of the body politic for the sovereign to impose on itself a law which it cannot transgress. As it can only be considered under one and the same relation it is in the position of an individual contracting with himself: whence we see that there is not, nor can be, any kind of fundamental law binding upon the body of the people, not even the social contract. This does not imply that such a body cannot perfectly well enter into engagements with others in what does not derogate from this contract; for, with regard to foreigners, it becomes a simple being, an individual.

But the body politic or sovereign, deriving its existence only from the sanctity of the contract, can never bind itself, even

to others, in anything that derogates from the original act, such as alienation of some portion of itself, or submission to another sovereign. To violate the act by which it exists would be to annihilate itself; and what is nothing produces nothing.

So soon as the multitude is thus united in one body, it is impossible to injure one of the members without attacking the body, still less to injure the body without the members feeling the effects. Thus duty and interest alike oblige the two contracting parties to give mutual assistance; and the men themselves should seek to combine in this twofold relationship all the advantages which are attendant on it.

Now, the sovereign, being formed only of the individuals that compose it, neither has nor can have any interest contrary to theirs; consequently the sovereign power needs no guarantee towards its subjects, because it is impossible that the body should wish to injure all its members; and we shall see hereafter that it can injure no one as an individual. The sovereign, for the simple reason that it is so, is always everything that it ought to be.

But this is not the case as regards the relation of subjects to the sovereign, which, nothwithstanding the common interest, would have no security for the performance of their engagements, unless it found means to ensure their fidelity.

Indeed, every individual may, as a man, have a particular will contrary to, or divergent from, the general will which he has as a citizen; his private interest may prompt him quite differently from the common interest; his absolute and naturally independent existence may make him regard what he owes to the common cause as a gratuitous contribution, the loss

of which will be less harmful to others than the payment of it will be burdensome to him; and, regarding the moral person that constitutes the State as an imaginary being because it is not a man, he would be willing to enjoy the rights of a citizen without being willing to fulfil the duties of a subject. The progress of such injustice would bring about the ruin of the body politic.

In order, then, that the social pact may not be a vain formulary, it tacitly includes this engagement, which can alone give force to the others,—that whoever refuses to obey the general will shall be constrained to do so by the whole body; which means nothing else than that he shall be forced to be free; for such is the condition which, uniting every citizen to his native land, guarantees him from all personal dependence, a condition that ensures the control and working of the political machine, and alone renders legitimate civil engagements, which, without it, would be absurd and tyrannical, and subject to the most enormous abuses.

THE CIVIL STATE

The passage from the state of nature to the civil state produces in man a very remarkable change, by substituting in his conduct justice for instinct, and by giving his actions the moral quality that they previously lacked. It is only when the voice of duty succeeds physical impulse, and law succeeds appetite, that man, who till then had regarded only himself, sees that he is obliged to act on other principles, and to consult his reason before listening to his inclinations. Although, in this state, he is deprived of many advantages that he derives from nature, he acquires equally great ones in return; his faculties are exercised and developed; his

ideas are expanded; his feelings are ennobled; his whole soul is exalted to such a degree that, if the abuses of this new condition did not often degrade him below that from which he has emerged, he ought to bless without ceasing the happy moment that released him from it for ever, and transformed him from a stupid and ignorant animal into an intelligent being and a man.

Let us reduce this whole balance to terms easy to compare. What man loses by the social contract is his natural liberty and an unlimited right to anything which tempts him and which he is able to attain; what he gains is civil liberty and property in all that he possesses. In order that we may not be mistaken about these compensations, we must clearly distinguish natural liberty, which is limited by the general will; and possession, which is nothing but the result of force or the right of first occupancy, from property, which can be based only on a positive title.

Besides the preceding, we might add to the acquisitions of the civil state moral freedom, which alone renders man truly master of himself; for the impulse of mere appetite is slavery, while obedience to a self-prescribed law is liberty. But I have already said too much on this head, and the philosophical meaning of the term "liberty" does not belong to my present subject.

WHETHER THE GENERAL WILL CAN ERR

It follows from what precedes that the general will is always right and always tends to the public advantage; but it does not follow that the resolutions of the people have always the same rectitude. Men always desire their own good, but do not

always discern it; the people are never corrupted, though often deceived, and it is only then that they seem to will what is evil.

There is often a great deal of difference between the will of all and the general will; the latter regards only the common interest, while the former has regard to private interests, and is merely a sum of particular wills; but take away from these same wills the pluses and minuses which cancel one another, and the general will remains as the sum of the differences.

If the people came to a resolution when adequately informed and without any communication among the citizens, the general will would always result from the great number of slight differences, and the resolution would always be good. But when factions, partial associations, are formed to the detriment of the whole society, the will of each of these associations becomes general with reference to its members, and particular with reference to the State; it may then be said that there are no longer as many voters as there are men, but only as many voters as there are associations. The differences become less numerous and yield a less general result. Lastly, when one of these associations becomes so great that it predominates over all the rest, you no longer have as the result a sum of small differences, but a single difference; there is then no longer a general will, and the opinion which prevails is only a particular opinion.

It is important, then, in order to have a clear declaration of the general will, that there should be no partial association in the State, and that every citizen should express only his own opinion. Such was the unique and sublime institution of the great Lycurgus. But if there are partial associations, it is necessary to multiply their number and prevent inequality, as Solon, Numa, and Servius did. These are the only proper precautions for ensuring that the general will may always be enlightened, and that the people may not be deceived.

THE LIMITS OF THE SOVEREIGN POWER

If the State or city is nothing but a moral person, the life of which consists in the union of its members, and if the most important of its cares is that of self-preservation, it needs a universal and compulsive force to move and dispose every part in the manner most expedient for the whole. As nature gives every man an absolute power over all his limbs, the social pact gives the body politic an absolute power over all its members; and it is this same power which, when directed by the general will, bears, as I said, the name of sovereignty.

But besides the public person, we have to consider the private persons who compose it, and whose life and liberty are naturally independent of it. The question, then, is to distinguish clearly between the respective rights of the citizens and of the sovereign, as well as between the duties which the former have to fulfil in their capacity as subjects and the natural rights which they ought to enjoy in their character as men.

It is admitted that whatever part of his power, property, and liberty each one alienates by the social compact is only that part of the whole of which the use is important to the community; but we must also admit that the sovereign alone is judge of what is important.

All the services that a citizen can render to the State he owes to it as soon as the sovereign demands them; but the sovereign, on its part, cannot impose on its subjects any burden which is useless to the community; it cannot even wish to do so, for, by the law of reason, just as by the law of nature, nothing is done without a cause.

The engagements which bind us to the social body are obligatory only because they are mutual; and their nature is such that in fulfilling them we cannot work for others without also working for ourselves. Why is the general will always right, and why do all invariably desire the prosperity of each, unless it is because there is no one but appropriates to himself this word "each" and thinks of himself in voting on behalf of all? This proves that equality of rights and the notion of justice that it produces are derived from the preference which each gives to himself, and consequently from man's nature; that the general will, to be truly such, should be so in its object as well as in its essence; that it ought to proceed from all in order to be applicable to all; and that it loses its natural rectitude when it tends to some individual and determinate object, because in that case, judging of what is unknown to us, we have no true principle of equity to guide us.

From this we must understand that what generalises the will is not so much the number of voices as the common interest which unites them; for, under this system, each necessarily submits to the conditions which he imposes on others—an admirable union of interest and justice, which gives to the deliberations of the community a spirit of equity that seems to disappear in the discussion of any private affair, for want of a common interest to unite and identify the ruling principle of the judge with that of the party.

By whatever path we return to our

principle we always arrive at the same conclusion, viz. that the social compact establishes among the citizens such an equality that they all pledge themselves under the same conditions and ought all to enjoy the same rights. Thus, by the nature of the compact, every act of sovereignty, that is, every authentic act of the general will, binds or favours equally all the citizens; so that the sovereign knows only the body of the nation, and distinguishes none of those that compose it.

What, then, is an act of sovereignty properly so called? It is not an agreement between a superior and an inferior, but an agreement of the body with each of its members; a lawful agreement, because it has the social contract as its foundation: equitable, because it is common to all; useful, because it can have no other obiect than the general welfare; and stable, because it has the public force and the supreme power as a guarantee. So long as the subjects submit only to such conventions, they obey no one, but simply their own will; and to ask how far the respective rights of the sovereign and citizens extend is to ask up to what point the latter can make engagements among themselves, each with all and all with each.

Thus we see that the sovereign power, wholly absolute, wholly sacred, and wholly inviolable as it is, does not, and cannot, pass the limits of general conventions, and that every man can fully dispose of what is left to him of his property and liberty by these conventions; so that the sovereign never has a right to burden one subject more than another, because then the matter becomes particular and his power is no longer competent.

These distinctions once admitted, so untrue is it that in the social contract

there is on the part of individuals any real renunciation, that their situation, as a result of this contract, is in reality preferable to what it was before, and that, instead of an alienation, they have only made an advantageous exchange of an uncertain and precarious mode of existence for a better and more assured one, of natural independence for liberty, of the power to injure others for their own safety. and of their strength, which others might overcome. for a right which the social union renders inviolable. Their lives, also, which they have devoted to the State, are continually protected by it; and in exposing their lives for its defence, what do they do but restore what they have received from it? What do they do but what they would do more frequently and with more risk in the state of nature, when, engaging in inevitable struggles, they would defend at the peril of their lives their means of preservation? All have to fight for their country in case of need, it is true; but then no one ever has to fight for himself. Do we not gain, moreover, by incurring, for what ensures our safety, a part of the risks that we should have to incur for ourselves individually, as soon as we were deprived of it?

GOVERNMENT IN GENERAL

I warn the reader that this chapter must be read carefully, and that I do not know the art of making myself intelligible to those that will not be attentive.

Every free action has two causes concurring to produce it; the one moral, viz. the will which determines the act; the other physical, viz. the power which executes it. When I walk towards an object, I must first will to go to it; in the second place, my feet must carry me to it. Should a paralytic wish to run, or an ac-

tive man not wish to do so, both will remain where they are. The body politic has the same motive powers; in it, likewise, force and will are distinguished, the latter under the name of "legislative power," the former under the name of "executive power." Nothing is, or ought to be, done in it without their co-operation.

We have seen that the legislative power belongs to the people, and can belong to it alone. On the other hand, it is easy to see from the principles already established, that the executive power cannot belong to the people generally as legislative or sovereign, because that power is exerted only in particular acts, which are not within the province of the law, nor consequently within that of the sovereign, all the acts of which must be laws.

The public force, then, requires a suitable agent to concentrate it and put it in action according to the directions of the general will, to serve as a means of communication between the State and the sovereign, to effect in some manner in the public person what the union of soul and body effects in a man. This is, in the State, the function of the government, improperly confounded with the sovereign of which it is only the minister.

What, then, is the government? An intermediate body established between the subjects and the sovereign for their mutual correspondence, charged with the execution of the laws and with the maintenance of liberty both civil and political.

The members of this body are called magistrates or kings, that is, governors; and the body as a whole bears the name of Prince. Those therefore who maintain that the act by which a people submits to its chiefs is not a contract are quite right. It is absolutely nothing but a commission, an employment, in which, as

simple officers of the sovereign, they exercise in its name the power of which it has made them depositaries, and which it can limit, modify, and resume when it pleases. The alienation of such a right, being incompatible with the nature of the social body, is contrary to the object of the association.

Consequently, I give the name "government" or "supreme administration" to the legitimate exercise of the executive power, and that of "Prince" or "magistrate" to the man or body charged with that administration.

It is in the government that are found the intermediate powers, the relations of which constitute the relation of the whole to the whole, or of the sovereign to the State. This last relation can be represented by that of the extremes of a continued proportion, of which the mean proportional is the government. The government receives from the sovereign the commands which it gives to the people; and in order that the State may be in stable equilibrium, it is necessary, everything being balanced, that there should be equality between the product or the power of the government taken by itself, and the product or the power of the citizens, who are sovereign in the one aspect and subjects in the other.

Further, we could not alter any of the three terms without at once destroying the proportion. If the sovereign wishes to govern, or if the magistrate wishes to legislate, or if the subjects refuse to obey, disorder succeeds order, force and will no longer act in concert, and the State being dissolved falls into despotism or anarchy. Lastly, as there is but one mean proportional between each relation, there is only one good government possible in a State; but as a thousand events may change the relation of a people, not only

may different governments be good for different peoples, but for the same people at different times. . . .

MEANS OF PREVENTING USURPATIONS OF THE GOVERNMENT

From these explanations it follows, . . . that the act which institutes the government is not a contract, but a law; that the depositaries of the executive power are not the masters of the people, but its officers; that the people can appoint them and dismiss them at pleasure; that for them it is not a question of contracting, but of obeying; and that in undertaking the functions which the State imposes on them, they simply fulfil their duty as citizens, without having in any way a right to discuss the conditions.

When, therefore, it happens that the people institute a hereditary government, whether monarchical in a family or aristocratic in one order of citizens, it is not an engagement that they make, but a provisional form which they give to the administration, until they please to regulate it differently.

It is true that such changes are always dangerous, and that the established government must never be touched except when it becomes incompatible with the public good; but this circumspection is a maxim of policy, not a rule of right; and the State is no more bound to leave the civil authority to its chief men than the military authority to its generals.

Moreover, it is true that in such a case all the formalities requisite to distinguish a regular and lawful act from a seditious tumult, and the will of a whole people from the clamours of a faction, cannot be too carefully observed. It is especially in this case that only such concessions

should be made as cannot in strict justice be refused; and from this obligation also the Prince derives a great advantage in preserving its power in spite of the people, without their being able to say that it has usurped the power; for while appearing to exercise nothing but its rights, it may very easily extend them, and, under pretext of maintaining the public peace, obstruct the assemblies designed to re-establish good order; so that it takes advantage of a silence which it prevents from being broken or of irregularities which it causes to be committed, so as to assume in its favour the approbation of those whom fear renders silent and punish those that dare to speak. It is in this way that the Decemvirs, having at first been elected for one year, and then kept in office for another year, attempted to retain their power in perpetuity by no longer permitting the "comitia" to assemble; and it is by this easy method that all the governments in the world, when once invested with the public force, usurp sooner or later the sovereign authority.

The periodical assemblies of which I have spoken before are fitted to prevent or postpone this evil, especially when they need no formal convocation; for then the Prince cannot interfere with them, without openly proclaiming itself a violator of the laws and an enemy of the State.

These assemblies, which have as their object the maintenance of the social treaty, ought always to be opened with two propositions, which no one should be able to suppress, and which should pass separately by vote.

The first: "Whether it pleases the sovereign to maintain the present form of government."

The second: "Whether it pleases the people to leave the administration to those at present entrusted with it."

I presuppose here that I believe that I have proved, viz. that there is in the State no fundamental law which cannot be revoked, not even the social compact; for if all the citizens assembled in order to break this compact by a solemn agreement, no one can doubt that it would be quite legitimately broken. Grotius even

thinks that each man can renounce the State of which he is a member, and regain his natural freedom and his property by quitting the country. Now it would be absurd if all the citizens combined should be unable to do what each of them can do separately.

From: Emile

BOOK III

The man and the citizen, whichever he may be, has no other property to give to society except himself, all his other property being there without his will; and when a man is rich, either he does not enjoy his wealth, or the public enjoys it also. In the first case he steals from others that of which he deprives himself; and in the second case, he gives them nothing. Thus the whole indebtedness to society remains with him, so long as he pays only with his property. "But," you may say, "my father, in gaining this property, served society." Very well, then; he has paid his own debt, but not yours. You owe more to others than if you had been born without property; because you were favored at birth. It is not just that what one man has done for society should discharge the obligation of another; because each owing his entire self, can pay only for himself, and no father can transmit to his son the right of being useless to his kind; yet it is just that which he does, according to you, when he transmits to him his wealth, which is the evidence and the reward of labor. He who eats in idleness that which he himself has not earned, steals it; and a capitalist whom the state pays for doing nothing differs little in my eyes from a brigand, who lives

at the expense of passers-by. Outside of society, an isolated man, owing nothing to any one, has a right to live as it pleases him: but in society, where he necessarily lives at the expense of others, he owes them in labor the price of his maintenance; there is no exception to this rule. To work is then an indispensable duty to the social man. Rich or poor, powerful or weak, every idle citizen is a rogue.

Now of all occupations which can furnish subsistence to man, that which most nearly approaches to the state of nature is manual labor; of all conditions the most independent of chance and of men is that of the artisan. The artisan depends only upon his labor; he is as free as the husbandman is enslaved; for the latter is dependent upon his field, whose crop is at the discretion of others. The enemy, the prince, a powerful neighbor, a suit at law may take from him his field; through this field they may harass him in a thousand ways. But wherever they wish to harass the artisan, his luggage is soon packed; he goes, taking his strong arms with him. Nevertheless agriculture is the first of human employments; it is the most honest, the most useful, and consequently the noblest that he can practice. I do not say to Emile: "Learn agriculture"; he knows it. All forms of rustic labor are familiar to him; he began with them, and

From Translations and Reprints, VI, No. 1, M. Whitcomb, Ed.

to them he is ever returning. I say to him then: "Cultivate the heritage of your fathers. But if you lose this heritage, or if you have none, what will you do? Learn a trade."

"A trade for my son! My son an artisan! My dear sir, are you serious?" More serious than you, madam, who would make it impossible for him to be other than a lord, a marquis, a prince, and perhaps some day less than nothing; as for me, I wish to give him a position that he cannot lose, a position that will honor him at all times. I wish to elevate him to man's estate, and whatever you may say, he will have fewer equals with this title than with all those which he may derive from you.

The letter kills and the spirit makes alive. It is a matter of learning a trade less for the purpose of knowing a trade than to overcome the prejudices which tend to treat it with contempt. You think that you will never be reduced to work for a living. Ah! so much the worse—so much the worse for you! But never mind, do not work from necessity, work for glory. Lower yourself to the splendor of the artisan in order to be above your own. In order to put fortune and things under your control, begin by making yourself independent of them. In order to rule by opinion, commence by ruling over it.

Remember that it is by no means an accomplishment that I ask of you; it is a trade, a true trade, a purely mechanical art, where the hands work more than the head, which does not lead to fortune, but with which one can be independent of it. In families far above the danger of wanting bread, I have seen fathers push foresight to the point of joining to the labor of instructing their children that of providing them with a knowledge with which, in any event, they might gain their

living. These provident fathers believe they are accomplishing much; but they are doing nothing, because the resources which they believe they are providing for their children depend upon the very fortune which they desire to make themselves independent of. So that with all these fine accomplishments, unless he who possesses them finds himself in circumstances favorable for their employment, he will perish as if he had none of them.

Since it is a question of management and intrigue, it is as necessary to employ these means to maintain yourself in abundance as to regain, from the depths of misery the means of re-ascending to your former estate. If you cultivate the arts whose success depends upon the reputation of the artist, if you turn your attention to those employments which are obtained only by favor, of what use will it all be to you, when rightly disgusted with the world, you disdain the means without which you cannot hope to succeed? You have studied diplomacy and the interests of princes? Good; but what will you do with this knowledge, unless you know how to conciliate the ministers. the ladies of the court, the heads of the bureaus; unless you possess the secret of pleasing them; unless all find in you the rascal that suits their purposes? You are an architect or painter? Good; but it is necessary that you should make your talent known. Do you expect to go straightway and exhibit your work at the salon? Alas! that doesn't happen so easily! It is necessary to be in the Academy; it is necessary to be a favorite in order to obtain even a dark corner of the wall. Give up your model and your brush, take a cab and go from door to door; it is in this way that you will acquire celebrity. But you ought to know that all these illustrious doors have Swiss or porters who understand only motions, and whose ears are in their hands. Do you wish to impart what you have learned, and become a teacher of geography, or mathematics, or languages, or music, or drawing? For that it is necessary to find pupils, and consequently somebody to recommend you. Remember, it contributes more toward success to be plausible than to be able, and that, if you know no trade but your own, you will never be anything but a dunce.

See then how little solidity all these brilliant resources possess, and how many other resources are necessary in order to derive any advantage from them. And then, what will become of you in this cowardly abasement? Reverses, instead of instructing you, debase you. More than ever the creature of public opinion, how will you elevate yourself above those prejudices, arbiters of your lot? How will you despise baseness and the vices of which you have need for your subsistence? You were dependent only on wealth, and now you are dependent on wealth; you have only deepened your slavery and surcharged it with your poverty. You are poor without becoming free; it is the worst state into which a man can fall.

But instead of resorting for a liveli-

hood to those high knowledges which are made for nourishing the soul and not the body, if you resort, in time of need, to your hands and the use which you know how to make of them, all difficulties vanish, all artifices become useless. Your resources are always ready at the moment their use is required; probity and honor are no longer an obstacle to living; you have no need to be a coward and a liar before the great, to bend and cringe before rascals, a vile pander to all the world, a borrower or a thief, which are almost the same thing when one has nothing. The opinion of others concerns you not; you have your court to make to no one, no fool to flatter, no Swiss to knuckle to, no courtier to fee, or what is worse, to worship. That rogues manage the affairs of the great is of no consequence to you. That does not prevent you in your obscure life from being an honest man and having bread. You enter the first shop whose trade you have learned: "Master, I need work." "Journeyman, go there and get to work." Before the dinner hour arrives you have earned your dinner. If you are diligent and sober, before eight hours have passed you will have wherewith to live eight hours more. You will have lived free, sound, true, industrious and just. To gain it thus it not to lose one's time.

5. CONDORCET

Antoine Nicholas de Condorcet (1743–1794) was a philosopher and mathematician very typical of his "enlightened" generation, its dreams, and its fall. Perpetual Secretary of the French Academy under the monarchy, member of the Convention during the Revolution, he poisoned himself during the Terror in order to escape the guillotine. A burning faith, which he thought scientific, supported his belief that great possibilities of infinite progress lay before mankind. Even in hiding from his Jacobin enemies shortly before his death he labored to finish his great historical survey of *The Progress of the Human Mind*.

From: The Progress of the Human Mind

And now we arrive at the period when philosophy, the most general and obvious effects of which we have before remarked, obtained an influence on the thinking class of men, and these on the people and their governments, that, ceasing any longer to be gradual, produced a revolution in the entire mass of certain nations, and gave thereby a secure pledge of the general revolution one day to follow that shall embrace the whole human species.

After ages of error, after wandering in all the mazes of vague and defective theories, writers upon politics and the law of nations at length arrived at the knowledge of the true rights of man, which they deduced from this simple principle: that he is a being endowed with sensation, capable of reasoning upon and understanding his interests, and of acquiring moral ideas.

They saw that the maintenance of his rights was the only object of political union, and that the perfection of the social art consisted in preserving them with the most entire equality, and in their fullest extent. They perceived that the means of securing the rights of the individual, consisting of general rules to be laid down in every community, the power of choosing these means, and determining these rules, could vest only in the majority of the community: and that for this reason, as it is impossible for any individual in this choice to follow the dictates of his own understanding without subjecting that of others, the will of the majority is the only principle which can be followed by all, without infringing upon the common equality.

Each individual may enter into a previous engagement to comply with the will of the majority, which by this engagement becomes unanimity; he can however bind nobody but himself, nor can he bind himself except so far as the majority shall not violate his individual rights, after having recognized them.

Such are at once the rights of the majority over individuals, and the limits of these rights; such is the origin of that unanimity, which renders the engagement of the majority binding upon all; a bond that ceases to operate when, by the change of individuals, this species of unanimity ceases to exist. There are objects, no doubt, upon which the majority would pronounce perhaps oftener in fayour of error and mischief, than in favour of truth and happiness; still the majority and the majority only, can decide what are the objects which cannot properly be referred to its own decision; it can alone determine as to the individuals whose judgment it resolves to prefer to its own, and the method which these individuals are to pursue in the exercise of their judgment; in fine, it has also an indispensable authority of pronouncing whether the decisions of its officers have or have not wounded the rights of all.

From these simple principles men discovered the folly of former notions respecting the validity of contracts between a people and its magistrates, which it was supposed could only be annulled by mutual consent, or by a violation of the conditions by one of the parties; as well as of another opinion, less servile, but equally absurd, that would chain a people for ever to the provisions of a constitution when once established, as if the right of changing it were not the security of every other right, as if human institutions, necessarily

From Condorcet, The Progress of the Human Mind (Philadelphia, 1796).

defective, and capable of improvement as we become enlightened, were to be condemned to an eternal monotony. Accordingly the governors of nations saw themselves obliged to renounce that false and subtle policy, which, forgetting that all men derive from nature an equality of rights, would sometimes measure the extent of those which it might think proper to grant by the size of territory, the temperature of the climate, the national character, the wealth of the people, the state of commerce and industry; and sometimes cede them in unequal portions among the different classes of society, according to their birth, their fortune, or their profession, thereby creating contrary interests and jarring powers, in order afterwards to apply correctives, which, but for these institutions, would not be wanted, and which, after all, are inadequate to the end.

It was now no longer practicable to divide mankind into two species, one destined to govern, the other to obey, one to deceive, the other to be dupes: the doctrine was obliged universally to be acknowledged, that all have an equal right to be enlightened respecting their inter-

ests, to share in the acquisition of truth, and that no political authorities appointed by the people for the benefit of the people, can be entitled to retain them in ignorance and darkness.

These principles, which were vindicated by the generous Sydney at the expense of his blood, and to which Locke gave the authority of his name, were afterwards developed with greater force, precision, and extent by Rousseau, whose glory it is to have placed them among those truths henceforth impossible to be forgotten or disputed. . . .

Hence it appears to be one of the rights of man that he should employ his faculties, dispose of his wealth, and provide for his wants in whatever manner he shall think best. The general interest of the society, so far from restraining him in this respect, forbids, on the contrary, every such attempt; and in this department of public administration, the care of securing to every man the rights which he derives from nature, is the only sound policy, the only control which the general will can exercise over the individuals of the community.

6. DAVID HUME: ON MIRACLES

The pursuit of critical thought to whatever realms it might lead proved a powerful dissolvent. Analytical tinkering with established beliefs, customs, institutions was deeply subversive of the existing order, whose foundations it shook in the minds not of the general public only, but of the very men who ruled, profited from and preserved that order. Belief, said David Hume, must be proportioned to the evidence; reason must be the ultimate test—even of religion, as can be seen from the essay on miracles which the Scottish philosopher (1711–1776) included in his Inquiry into Human Understanding (1748).

But reason exercised upon itself, investigating its own processes, produced results even more subversive than at first suspected. Applied to reasoning itself, Hume's philosophical scepticism suggested that no belief could be rationally grounded: "All probable reasoning is nothing but a species of sensation. 'Tis not solely in poetry and music we must follow our taste and sentiment, but likewise

in philosophy. When I am convinced of any principle, 'tis only an idea, which strikes more strongly upon me. When I give the preference to one set of arguments above another, I do nothing but decide from my feeling concerning the superiority of their influence." This disastrous suggestion of the impossibility of positive thought provoked the violent anger of Rousseau as it did the reactions of a great many others, including Kant and Hegel, who never quite succeeded in refuting Hume's arguments. There was no way of doing so, except in the irrational terms of a later, much later, generation. Meanwhile, the sceptic himself indicated scepticism as to the effects his arguments might achieve: "This sceptical doubt, both with respect to reason and the senses, is a malady, which can never be radically cured, but must return upon us every moment, however we may chase it away, . . . Carelessness and inattention alone can afford us any remedy. For this reason I rely entirely upon them; and take it for granted, whatever may be the reader's opinion at this present moment, that an hour hence he will be persuaded [of whatever he wishes to believe]."

A miracle is a violation of the laws of nature; and as a firm, an unalterable experience has established these laws, the proof against a miracle, from the very nature of the fact, is as entire as any argument from experience can possibly be imagined. Why is it more than probable, that all men must die; that lead cannot, of itself, remain suspended in the air; that fire consumes wood, and is extinguished by water: unless it be, that these events are found agreeable to the laws of nature, and there is required a violation of these laws, or in other words a miracle to prevent them? Nothing is esteemed a miracle, if it ever happened in the common course of nature. It is no miracle that a man, seemingly in good health, should die on a sudden: because such a kind of death, though more unusual than any other, has yet been frequently observed to happen. But it is a miracle, that a dead man should come to life; because that has never been observed in any age or country. There must, therefore, be a uniform experience against every miraculous event, otherwise the event would not merit that appellation. And as a uniform experience amounts to a proof, there is here a direct and full *proof*, from the nature of the fact, against the existence of any miracle; nor can such a proof be destroyed, or the miracle rendered credible, but by an opposite proof, which is superior.

The plain consequence is (and it is a general maxim worthy of our attention), "That no testimony is sufficient to establish a miracle, unless the testimony be of such a kind, that its falsehood would be more miraculous than the fact which it endeavours to establish: and even in that case there is a mutual destruction of arguments, and the superior only gives us an assurance suitable to that degree of force, which remains, after deducting the inferior." When anyone tells me, that he saw a dead man restored to life, I immediately consider with myself whether it be more probable, that this person should either deceive or be deceived, or that the fact, which he relates, should really have happened. I weigh the one miracle against the other; and according to

From The Essay on Miracles (1741).

the superiority, which I discover, I pronounce my decision, and always reject the greater miracle. If the falsehood of his testimony would be more miraculous than the event which he relates; then, and not till then, can he pretend to command my belief or opinion.

In the foregoing reasoning we have supposed, that the testimony, upon which a miracle is founded, may possibly amount to an entire proof, and that the falsehood of that testimony would be a real prodigy: But it is easy to show, that we have been a great deal too liberal in our concessions, and that there never was a miraculous event established on so full an evidence.

For first, there is not to be found, in all history, any miracle attested by a sufficient number of men, of such unquestioned good sense, education, and learning, as to secure us against all delusion in themselves: of such undoubted integrity, as to place them beyond all suspicion of any design to deceive others; of such credit and reputation in the eves of mankind, as to have a great deal to lose in case of their being detected in any falsehood; and at the same time, attesting facts performed in such a public manner and in so celebrated a part of the world, as to render the detection unavoidable: All which circumstances are requisite to give us a full assurance in the testimony of men.

Secondly. We may observe in human nature a principle which, if strictly examined, will be found to diminish extremely the assurance which we might, from human testimony, have in any kind of prodigy. The maxim, by which we commonly conduct ourselves in our reasonings, is, that the objects of which we have no experience, resemble those of which we have; that what we have found to be most usual is always most probable; and that where there is an opposition of

arguments, we ought to give the preference to such as are founded on the greatest number of past observations. But though, in proceeding by this rule, we readily reject any fact which is unusual and incredible in an ordinary degree; yet in advancing further, the mind observes not always the same rule; but when anything is affirmed utterly absurd and miraculous, it rather the more readily admits of such a fact, upon account of that very circumstance, which ought to destroy all its authority. The passion of surprise and wonder, arising from miracles, being an agreeable emotion, gives a sensible tendency towards the belief of those events, from which it is derived. And this goes so far, that even those who cannot enjoy this pleasure immediately, nor can believe those miraculous events, of which they are informed, yet love to partake of the satisfaction at second hand or by rebound, and place a pride and delight in exciting the admiration of others.

With what greediness are the miraculous accounts of travellers received, their descriptions of sea and land monsters, their relations of wonderful adventures, strange men, and uncouth manners? But if the spirit of religion join itself to the love of wonder, there is an end of common sense; and human testimony, in these circumstances, loses all pretensions to authority. A religionist may be an enthusiast, and imagine he sees what has no reality: he may know his narrative to be false, and yet persevere in it, with the best intentions in the world, for the sake of promoting so holy a cause: or even where this delusion has not place, vanity, excited by so strong a temptation, operates on him more powerfully than on the rest of mankind in any other circumstances; and self-interest with equal force. His auditors may not have, and commonly have not, sufficient judgment to canvass his evidence: what judgment they have, they renounce by principle, in this sublime and mysterious subject: or if they were ever so willing to employ it, passion and a heated imagination disturb the regularity of its operations. Their credulity increases his impudence: and his impudence overpowers their credulity.

Eloquence, when at its highest pitch, leaves little room for reason or reflection; but addressing itself entirely to the fancy or the affections, captivates the willing hearers, and subdues their understanding. Happily, this pitch it seldom attains. But what a Tully or a Demosthenes could scarcely effect over a Roman or Athenian audience, every Capuchin, every itinerant or stationary teacher can perform over the generality of mankind, and in a higher degree, by touching such gross and vulgar passions.

The many instances of forged miracles, and prophecies, and supernatural events, which, in all ages, have either been detected by contrary evidence, or which detect themselves by their absurdity, prove sufficiently the strong propensity of mankind to the extraordinary and the marvellous, and ought reasonably to beget a suspicion against all relations of this kind. . . .

Thirdly. It forms a strong presumption against all supernatural and miraculous relations, that they are observed chiefly to abound among ignorant and barbarous nations; or if a civilized people has ever given admission to any of them, that people will be found to have received them from ignorant and barbarous ancestors, who transmitted them with that inviolable sanction and authority which always attend received opinions. When we peruse the first histories of all nations, we are apt to imagine ourselves transported into some new world; where the whole frame of nature is disjointed, and every

element performs its operations in a different manner from what it does at present. Battles, revolutions, pestilence, famine and death, are never the effect of those natural causes, which we experience. Prodigies, omens, oracles, judgments, quite obscure the few natural events that are intermingled with them. But as the former grow thinner every page, in proportion as we advance nearer the enlightened ages, we soon learn, that there is nothing mysterious or supernatural in the case, but that all proceeds from the usual propensity of mankind towards the marvellous, and that, though this inclination may at intervals receive a check from sense and learning, it can never be thoroughly extirpated from human nature.

It is strange, a judicious reader is apt to say, upon the perusal of these wonderful historians, that such prodigious events never happen in our days. But it is nothing strange, I hope, that men should lie in all ages. You must surely have seen instances enough of that frailty. You have vourself heard many such marvellous relations started, which, being treated with scorn by all the wise and judicious, have at last been abandoned even by the vulgar. Be assured, that those renowned lies, which have spread and flourished to such a monstrous height, arose from like beginnings; but being sown in a more proper soil, shot up at last into prodigies almost equal to those which they relate. . . .

The advantages are so great, of starting an imposture among an ignorant people, that, even though the delusion should be too gross to impose on the generality of them (which, though seldom, is sometimes the case), it has a much better chance for succeeding in remote countries, than if the first scene had been laid in a city renowned for arts and knowledge. The most ignorant and barbarous

of these barbarians carry the report abroad. None of their countrymen have a large correspondence, or sufficient credit and authority to contradict and beat down the delusion. Men's inclination to the marvellous has full opportunity to display itself. And thus a story, which is universally exploded in the place where it was first started, shall pass for certain at a thousand miles distance.

I may add as a fourth reason, which diminishes the authority of prodigies, that there is no testimony for any, even those which have not been expressly detected, that is not opposed by an infinite number of witnesses; so that not only the miracle destroys the credit of testimony, but the testimony destroys itself. To make this the better understood, let us consider that, in matters of religion, whatever is different is contrary; and that it is impossible the religions of ancient Rome, of Turkey, of Siam, and of China, should, all of them, be established on any solid foundation. Every miracle, therefore, pretended to have been wrought in any of these religions (and all of them abound in miracles), as its direct scope is to establish the particular system to which it is attributed: so has it the same force, though more indirectly, to overthrow every other system. In destroying a rival system, it likewise destroys the credit of those miracles on which that system was established; so that all the prodigies of different religions are to be regarded as contrary facts, and the evidences of these prodigies, whether weak or strong, as opposite to each other. According to this method of reasoning, when we believe any miracle of Mahomet or his successors, we have for our warrant the testimony of a few barbarous Arabians. And on the other hand, we are to regard the authority of Titus Livius, Plutarch, Tac-

itus, and, in short, of all the authors and witnesses, Grecian, Chinese, and Roman-Catholic, who have related any miracle in their particular religion; I say, we are to regard their testimony in the same light as if they had mentioned that Mahometan miracle, and had in express terms contradicted it, with the same certainty as they have for the miracle they relate. This argument may appear oversubtle and refined; but it is not in reality different from the reasoning of a judge. who supposes, that the credit of two witnesses, maintaining a crime against anvone, is destroyed by the testimony of two others, who affirm him to have been two hundred leagues distant, at the same instant when the crime is said to have been committed. . . .

Upon the whole, then, it appears that no testimony for any kind of miracle has ever amounted to a probability, much less to a proof; and that, even supposing it amounted to a proof, it would be opposed by another proof, derived from the very nature of the fact which it would endeavor to establish. It is experience only which gives authority to human testimony; and it is the same experience which assures us of the laws of nature. When, therefore, these two kinds of experience are contrary, we have nothing to do but to subtract the one from the other, and embrace an opinion either on one side or the other, with that assurance which arises from the remainder. But according to the principle here explained, this subtraction with regard to all popular religions amounts to an entire annihilation; and therefore we may establish it as a maxim, that no human testimony can have such force as to prove a miracle, and make it a just foundation for any such system of religion.

II. Enlightened Despotism

The spirit of the Enlightenment and the influence of the *philosophes* were reflected in the policies of the second half of the eighteenth century—policies of reform designed to secure the more efficient administration of the state and the greater prosperity of its subjects. The chief protagonists of this "enlightened despotism" were not to be found in the more advanced West but among the rulers of less developed countries, princes, and their ministers who sought to increase their power by increasing the productivity and the resources of their lands and the efficiency of the governmental machine: Emperor Joseph II of Austria (1765–1790), Empress Catherine II of Russia (1762–1796) and, above all, King Frederick II of Prussia (1740–1786).

1. FREDERICK THE GREAT

Frederick II of Brandenburg-Prussia (1712–1786) was born in Berlin, the son of a boor, nicknamed the Sergeant King because of his delight in soldiers, beer, to-bacco, and barrack-room manners. Father and son never got on and, in consequence, Frederick's youth was far from happy; but when in 1740 he succeeded to the throne, he found that his father had left him an excellent military establishment. This the young king proceeded to use in a series of wars which, combined with his skillful diplomacy and firm administrative policy, raised Prussia to the rank of a first-rate power.

But Frederick was not only a great soldier and statesman; he was also a friend of literature and of the arts, a sensitive and not untalented dilettante in the field of music and letters. His long and temperamental flirtation with Voltaire is one of the more fascinating stories of the eighteenth century, and his palace at Sans Souci attracted a cosmopolitan crowd of scientists, philosophers, and artists.

From: The Political Testament of Frederick II (1752)

Politics is the science of always using the most convenient means in accord with one's own interests. In order to act in conformity with one's interests one must know what these interests are, and in order to gain this knowledge one must study their history and application. . . . One must attempt, above all, to know the

special genius of the people which one wants to govern, in order to know if one must treat them leniently or severely, if they are inclined to revolt . . . to intrigue. . . .

[The Prussian nobility] has sacrificed its life and goods for the service of the state, its loyalty and merit have earned it

From Die politischen Testamente Friedrichs des Grossen (Berlin, 1920), tr. George L. Mosse, in Europe in Review (New York, 1957), pp. 110-112. By permission of Rand McNally and Co.

the protection of all its rulers, and it is one of the duties [of the ruler] to aid those [noble] families which have become impoverished, in order to keep them in possession of their lands: for they are to be regarded as the pedestals and the pillars of the state. In such a state no factions or rebellions need be feared . . . it is one goal of the policy of this state to preserve the nobility.

A well conducted government must have an underlying concept so well integrated that it could be likened to a system of philosophy, all actions taken must be well reasoned, and all financial, political and military matters must flow towards one goal: which is the strengthening of the state and the furthering of its power. However, such a system can flow but from a single brain, and this must be that of the sovereign. Laxness, hedonism, and imbecility, these are the causes which restrain Princes in working at the noble task of bringing happiness to their subjects. . . . A sovereign is not elevated to his high position, supreme power has not been confided to him, in order that he may live in lazy luxury, enriching himself by the labour of the people, being happy while everyone else suffers. The sovereign is the first servant of the state. He is well paid in order that he may sustain the dignity of his office, but one demands that he work efficiently for the good of the state, and that he, at the very least, pay personal attention to the most important problems. . . .

You can see, without doubt, how important it is that the King of Prussia govern personally. Just as it would have been

impossible for Newton to arrive at his system of attractions if he had worked in harness with Leibnitz and Descartes, so a system of politics cannot be arrived at and continued, if it has not sprung from a single brain. . . . All parts of the government are inexorably linked with each other. Finance, politics and military affairs are inseparable; it does not suffice that one be well administered; they must all be . . . A Prince who governs personally, who has formed his [own] political system, will not be handicapped when occasions arise where he has to act swiftly: for he can guide all matters towards the end which he has set for himself.

Catholics, Lutherans, Reformed, Jews, and other Christian sects live in this state, and live together in peace: if the sovereign, actuated by a mistaken zeal, declares himself for one religion or another, parties will spring up, heated disputes ensue, little by little persecutions will commence and, in the end, the religion persecuted will leave the fatherland and thousands of subjects will enrich our neighbours by their skill and industry.

It is of no concern in politics whether the ruler has a religion or whether he has none. All religions, if one examines them, are founded on superstitious systems, more or less absurd. It is impossible for a man of good sense, who dissects their contents, not to see their error; but these prejudices, these errors and mysteries were made for men, and one must know enough to respect the public and not to outrage its faith, whatever religion be involved.

Forms of Government (1781)

If we look back into the most remote antiquity, we shall find that the people From *The Posthumous Works of Frederick II, King of Prussia*, tr. Thomas Holcroft (London, 1789).

whose history has descended to us led pastoral lives, and did not form social bodies. What the book of Genesis relates of the history of the Patriarchs is sufficient proof. Previous to this small Jewish nation, the Egyptians must in like manner have been dispersed over those countries which the Nile did not submerge; and many ages no doubt passed away before the vanquished river would permit the people to assemble in small towns. From the Grecian history we learn the names of founders of states, and of those legislators who first assembled the Greeks in bodies. This nation was long in a savage state, as well as all the nations of the globe. Had the annals of the Etruscans, and those of the Samnite, Sabine and other tribes, come down to us, we should assuredly have learnt that they lived in distinct families, before they were assembled and united.

The Gauls were forming into societies at the time they were conquered by Julius Cesar; but it appears Great Britain had not attained this point of perfection, when the conqueror first passed into that island with his Roman legions. In the age of this great man, the Germans could only be compared with what the Iroquois and Algonquins, or some equally savage people, are at present. . . .

We are astonished at imagining the human race so long existing in a brutal state, and without forming itself into societies. Reasons are accordingly suggested, such as might induce people like these to unite in bodies. It must have been the violence and pillage which existed, among neighboring hordes, that could have first inspired such savage families with the wish of uniting, that they might secure their possessions by mutual defence. Hence laws took birth, which taught those societies to prefer the general to individual

good. From that time, no person durst seize on the effects of another, because of the dread of chastizement. The life, the wife, and the wealth of a neighbor were sacred; and, if the whole society were attacked, it was the duty of the whole to assemble for its defence. The grand truth "That we should do unto others as they should do unto us" became the principle of laws and of the social compact. Hence originated the love of our country, which was regarded as the asylum of happiness.

But, as these laws could neither be maintained nor executed unless some one should incessantly watch for their preservation, magistrates arose out of this necessity, whom the people elected, and to whom they subjected themselves. Let it be carefully remembered that the preservation of the laws was the sole reason which induced men to allow of, and to elect, a superior: because this is the true origin of sovereign power. The magistrate, thus appointed, was the first servant of the state. When rising states had anything to fear from their neighbors, the magistrate armed the people and flew to the defence of the citizens.

That general instinct in men which leads them to procure for themselves the greatest possible happiness, occasioned the creation of the various forms of government. . . .

But, however sage the legislators, and those who first assembled the people in bodies were, however good their intentions might be, not one of these governments is found to have maintained its perfect integrity. And why? Because men are imperfect, consequently so are their works: because the citizens, employed by the prince, were blinded by individual interest, which always overthrows the general good: and, in fine, because there is no stability on earth.

In aristocracies, the abuse which the principal members of the society make of their authority is the general cause of succeeding revolutions. The Roman democracy was destroyed by the people themselves. The blind multitude of the Plebeians suffered themselves to be corrupted by ambitious citizens, by whom they were afterward deprived of their liberty and enslaved. This is what England has to dread, if the lower house of parliament should not prefer the true interest of the nation to that infamous corruption by which it is degraded. . . .

With respect to the true monarchical government, it is the best or the worst of all others, according to how it is administered.

We have remarked that men granted preeminence to one of their equals, expecting that he should do them certain services. These services consisted in the maintenance of the laws: a strict execution of justice; and employment of his whole powers to prevent any corruption of manners; and defending the state against its enemies. It is the duty of this magistrate to pay attention to agriculture; it should be his care that provisions for the nation should be in abundance, and that commerce and industry should be encouraged. He is a perpetual sentinel, who must watch the acts and the conduct of the enemies of the state. His foresight and prudence should form timely alliances, which should be made with those who might most conduce to the interest of the association.

By this short abstract, the various branches of knowledge, which each article in particular requires, will be perceived. To this must be added a profound study of the local situation of the country, which it is the magistrate's duty to govern, and a perfect knowledge of the genius of the nation; for the sovereign who sins through ignorance is as culpable as he who sins through malice: the first is the guilt of idleness, the latter of a vicious heart; but the evil that results to society is the same.

Princes and monarchs, therefore, are not invested with supreme authority that they may, with impunity, riot in debauchery and voluptuousness. They are not raised by their fellow citizens in order that their pride may pompously display itself, and contemptuously insult simplicity of manners, poverty and wretchedness. Government is not intrusted to them so that they may be surrounded by a crowd of useless people, whose idleness engenders every vice.

The ill administration of monarchical government originates in various causes. the source of which is the character of the sovereign. Thus a prince addicted to women suffers himself to be governed by his mistresses, and his favourites, who abuse the ascendancy they have over his mind, commit injustice, protect the most vicious, sell places, and are guilty of other similar acts of infamy. If the prince, through debility, should abandon the helm of the state to mercenary hands, I mean to ministers, in that case, each having different views, no one proceeds on general plans: the new minister fritters away what he finds already established, however excellent that may be, to acquire the character of novelty, and execute his own schemes, generally to the detriment of the public good. His successors do the like; they destroy and overturn with equal want of understanding, so that they may be supposed to possess originality. Hence that succession of change and variation which allows no project time to take root; hence confusion, disorder, and every vice of a bad administration. Prevaricators

have a ready excuse; they shelter their turpitude under these perpetual changes.

Men attach themselves to that which appertains to them, and the state does not appertain to these ministers, for which reason they have not its real good at heart; business is carelessly executed, and with a kind of stoic indifference; and hence results the decay of justice, and the ill administration of the finances and the military. From a monarchy, as it was, the government degenerates into a true aristocracy, in which ministers and generals conduct affairs according to their own fancies. There is no longer any comprehensive system; each pursues his own plans, and the central point, the point of unity, is lost. As all the wheels of a watch correspond to effect the same purpose, which is that of measuring time, so ought the springs of government to be regulated. that all the different branches of administration may equally concur to the greatest good of the state; an important object, of which we ought never to lose sight.

We may add, the personal interest of the ministers and generals usually occasions them to counteract each other without ceasing, and sometimes to impede the execution of the best plans because they have not been conceived by themselves. But the evil is at its utmost when perverse minds are able to persuade the sovereign that his welfare and the public good are two separate things. The monarch then becomes the enemy of his people, without knowing why; is severe, rigorous, inhuman, from mistake; for, the principle on which he acts being false, the consequences must necessarily be the same.

The sovereign is attached by indissoluble ties to the body of the state; hence it follows that he, by repercussion, is sensible to all the ills which afflict his subjects; and the people, in like manner, suf-

fer from the misfortunes which affect their sovereign. There is but one general good, which is that of the state. If the monarch loses his provinces, he is no longer able to assist his subjects as before. If misfortune should oblige him to contract debts, they must be liquidated by the poor citizens; and, in return, if the people are not numerous, and if they are oppressed by poverty, the sovereign is destitute of all resource. These are truths so incontestable that there is no need to insist on them further.

I once more repeat, the sovereign represents the state; he and his people form but one body, which can only be happy as far as united by concord. The prince is to the nation he governs what the head is to the man; it is his duty to see, to think, and act for the whole community, so that he may procure it every advantage of which it is capable. . . . He must be active, possess integrity, and collect his whole powers, that he may be able to run the course he has commenced. Here follow my ideas concerning his duties.

He ought to procure exact and circumstantial information of the strength and weakness of his country, as well relative to pecuniary resources as to population, finance, trade, laws, and the genius of the nation whom he is appointed to govern. If the laws are good, they will be clear in their definitions; otherwise, chicanery will seek to elude their spirit to its advantage, and arbitrarily and irregularly determine on the fortunes of individuals. Law suits ought to be as short as possible, to prevent the ruin of the appellants who consume in useless expenses what is justly and duly their right. This branch of government cannot be too carefully watched, so that every possible barrier may be opposed to the avidity of judges and counsellors. Every person is kept within the limits of their duty, by occasional visits into the provinces. Whoever imagines himself to be injured will venture to make his complaints to the commission; and those who are found to be prevaricators ought to be severely punished. It is perhaps superfluous to add that the penalty ought never to exceed the crime; that violence never ought to supersede law; and that it were better that the sovereign should be too merciful than too severe.

As every person who does not proceed on principle is inconsistent in his conduct, it is still more necessary that the magistrate who watches over the public good should act from a determinate system of politics, war, finance, commerce and law. Thus, for example, a people of mild manners ought not to have severe laws, but such as are adapted to their character. The basis of such systems ought always to be correspondent to the greatest good society can receive. Their principles ought to be conformable to the situation of the country, to its ancient customs, if they are good, and to the genius of the nation.

As an instance, it is a known truth in politics that the most natural allies, and consequently the best, are those whose interests concur, and who are not such near neighbors as to be engaged in any contest respecting frontiers. It sometimes happens that strange accidents give place to extraordinary alliances. We have seen, in the present times, nations that had always been rivals and even enemies, united under the same banners. But these are events that rarely take birth, and which never can serve as examples. Such connections can be no more than momentary; whereas the other kind, which are contracted from a unity of interests, are alone capable of exertion. In the present situation of Europe, when all her princes are armed, and among whom preponderating powers rise up capable of crushing the feeble, prudence requires alliances should be formed with other powers, as well to secure aid in case of attack, as to repress the dangerous projects of enemies, and to sustain all just pretensions by the succour of such allies in opposition to those by whom they are controverted.

Nor is this sufficient. It is necessary to have among our neighbors, especially among our enemies, eyes and ears which shall be open to receive and report with fidelity what they have seen and heard. Men are wicked. Care must especially be taken not to suffer surprise, because whatever surprises intimidates and terrifies, which never happens when preparations are made, however vexatious the event may be which there is reason to expect. European politics are so fallacious, that the most sage may become dupes, if they are not always alert and on their guard.

The military system ought, in like manner, to rest on good principles, which from experience are known to be certain. The genius of the nation ought to be understood: of what it is capable, and how far its safety may be risked by leading it against the enemy. The warlike customs of the Greeks and Romans are interdicted in our times. The discovery of gunpowder has entirely changed the mode of making war. A superiority of fire at present decides the day. Discipline, rules and tactics have all been changed, in order that they may conform to the new custom; and the recent and enormous abuse of numerous trains of artillery, which incumber armies, obliges others in like manner to adopt this method; as well to maintain themselves in their posts as to attack the foe in those positions which they shall occupy. . . . So many new refinements have therefore so much changed the art of war that it would, at present, be unpardonable temerity in a general who, in imitation of Turenne, Condé, or Luxembourg, should risk a battle according to the dispositions made by those great commanders in the age in which they lived. Victory then was carried by valor and strength: it is at present decided by artillery; and the art of the general consists in his near approach to the army of the enemy, without suffering his own troops to be destroyed before the attack. To gain this advantage, it is necessary to silence the fire of the enemy by the superiority of that with which it is opposed. . . .

There are states which, from their situation and constitution, must be maritime powers: such are England, Holland, France, Spain and Denmark. They are surrounded by the sea, and the distant colonies which they possess oblige them to keep a navy, to maintain communication and trade between the mother country and these detached members. There are other states, such as Austria, Poland, Prussia, and even Russia, some of which may well do without shipping; and others that would commit an unpardonable fault in politics were they to divide their forces by employing a part of their troops at sea, of the services of which they indispensably stand in need on land.

The number of troops which a state maintains ought to be in proportion to the troops maintained by its enemies. Their force should be equal, or the weakest is in danger of being oppressed. It may perhaps be objected that a king ought to depend on the aid of his allies. The reasoning would be good were allies what they ought to be. But their zeal is only lukewarm; and he who shall depend upon another as on himself will most certainly be deceived. If frontiers can be defended by fortresses, there must be no neglect in

building, nor any expense spared to bring them to perfection. Of this France has given an example, and she has found the advantage of it on different occasions.

But neither politics nor the army can prosper if the finances are not kept in the greatest order, and if the prince himself be not a prudent economist. Money is like the wand of the magician, for by its aid miracles are performed. Grand political views, the maintenance of soldiers, and the best conceived plans for the welfare of the people, will all remain in a lethargic state if not animated by money. The economy of the sovereign is the more useful to the public good, because if he have not sufficient funds in reserve, either to supply the expenses of war without loading his people with extraordinary taxes, or to succour citizens in times of public calamity, all these burdens will fall on the subjects, who will be without resource in such unhappy times, just when they need it most.

No government can exist without taxation, which is equally necessary to the republic and to the monarchy. The sovereign who labors in the public cause must be paid by the public; the judge the same, that he may have no need to prevaricate. The soldier must be supported so that he may commit no violence for lack of having whereon to subsist. In like manner, it is necessary that those persons who are employed in collecting the finances should receive such salaries as may not put them under any temptation to rob the public. These various expenses demand very considerable sums, and to these must still be added money that should be saved to serve only in the most extraordinary emergencies. This money must all be necessarily levied on the people; and the grand art consists in levying so as not to oppress. That taxes may be

equally and not arbitrarily imposed, surveys and registers should be made by which, if the people are properly classified, the money will be proportionate to the income of the persons paying. This is a thing so necessary that it would be an unpardonable fault in finance if ill imposed taxes should disgust the husbandman of his labors. Having performed his duties, it is afterwards necessary that he and his family should live in a certain degree of ease. Far from oppressing the nursing fathers of the state, they ought to be encouraged in the cultivation of the lands; for in this cultivation the true wealth of a country is to be found.

The earth furnishes the most necessary part of subsistence, and those who till it are, as we have already said, the true nursing fathers of society. I shall perhaps be answered that Holland subsists, although the land does not yield a hundredth part of what the people consume. To this I reply, Holland is a small state, in which trade is the substitute for agriculture; but the more vast any government is, the more ought rural economy to be encouraged.

Excise is another species of tax, levied on cities, and this must be managed by able persons; otherwise, those provisions which are most necessary to life, such as bread, small beer, meat, etc., will be overtaxed; and the weight will fall on the soldier, the laborer, and the artisan. The result will be, unhappily for the people, that the price of labor will be raised: consequently merchandize will become so dear as not to be saleable in foreign markets. Such is at present the case in Holland and in England. These two nations, having contracted immensely heavy debts in the last wars, have imposed new taxes to pay the interest; but, having very un-

advisedly taxed labor, they have almost ruined their manufactures. Hence, all things having become dearer in Holland, the Dutch are obliged to purchase their cloths from Verviers and Liège [in the Austrian Netherlands]; and England has lost a very considerable sale of her woollens in Germany. To obviate such inconveniences, the sovereign ought frequently to remember the condition of the poor, to imagine himself in the place of the peasant or the manufacturer, and then to say "Were I born one among the class of citizens whose labors constitute the wealth of the state, what should I require from the king?" The answer which, on such a supposition, good sense would suggest, it is his duty to put in practice.

In most of the kingdoms of Europe there are provinces in which the peasants are attached to the glebe, or are serfs to their lords. This, of all conditions, is the most unhappy, and that at which humanity most revolts. No man certainly was born to be the slave of his equal. We reasonably detest such an abuse; and it is supposed that nothing more than will is needed to abolish so barbarous a custom. But this is not true: it is held on ancient tenures, and contracts made between the landholders and colonists. Tillage is regulated according to the service performed by the peasantry; and whoever should suddenly desire to abolish this abominable administration would entirely overthrow the mode of managing estates, and would be obliged, in part, to indemnify the nobility for the losses which their rents must suffer.

The state of manufactures and of trade, an article no less important, next presents itself. For the country to be preserved in prosperity, it is indubitably necessary that the balance of trade should

be in its favor. If it pay more for importation than it gains by exportation, the result will be that it will be annually impoverished. Let us suppose a purse in which there are a hundred ducats, from which let us daily take one, and put none in, and everybody will allow that in a hundred days the purse will be empty. The means to avoid incurring any such loss are to work up all the raw materials of which the country is in possession, and to manufacture foreign raw materials, so that the price of labor may be gained, in order to procure a foreign market.

Three things are to be considered in respect to commerce: first the surplus of native products which are exported; next the products of foreign states, which enrich those by whom they are carried; and thirdly foreign merchandize, which home consumption obliges the state to import. The trade of any kingdom must be regulated according to these three articles, for of these only is it susceptible, according to the nature of things. England, Holland, France, Spain and Portugal, have possessions in the two Indies, and more extensive resources for their merchant ships than other kingdoms. To profit by such advantages as we are in possession of, and to undertake nothing beyond our strength. is the advice of wisdom.

We have now to speak of what are the most proper means invariably to maintain those provinces in abundance, of which society stands in absolute need, that it may continue flourishing. The first is to be careful that the lands are well cultivated; to clear such grounds as are capable of tillage; to increase the breed of sheep and cattle, so that the more may be gained by milk, butter, cheese and manure; afterwards to obtain an exact statement of the quantity of the various species

of corn, grown in good, indifferent, and bad seasons, and to subtract the quantity consumed, so that from the result information may be gained of the surplus, and the point at which exportation ought to stop; or of the deficiency in consumption, and of the consequently necessary importation. Every sovereign actuated by the public good is obliged to keep storehouses abundantly furnished, that supplies may be ready when the harvest is bad and famine prevented. During the scarcity of the years 1771 and 1772, Germany beheld the miseries with which Saxony and the provinces of the empire were afflicted, because this very useful precaution had not been taken. The people pounded oak bark, on which they fed, and this wretched food did but accelerate death. Numerous families perished unsuccoured, and the desolation was universal. The survivors were pale, livid, and lean, and fled from their country to seek food elsewhere. The sight of them excited compassion: they would have been pitied by a heart of iron. What were the reproaches with which their governors ought to have loaded themselves, spectators as they were of such calamities and unable to afford any relief!

We shall now speak of another article, which perhaps is equally interesting. There are few countries in which the people are all of one religious opinion; they often totally differ. There are some who are called sectaries. The question then is stated—Is it requisite that the people should all think alike, or may each one be allowed to think as he pleases? Gloomy politicians will tell us everybody ought to be of the same opinion, so that there may be no division among the citizens. The priest will add "whoever does not think like me is damned, and it is by

no means proper that my king should be the king of the damned." The inevitable deduction is that they must be destroyed in this world, so that they may be the more prosperous in the next.

To this is answered that all the members of one society never thought alike: that, among Christian nations, the majority are anthropomorphites; that among the Catholics, most of the people are idolaters, for I shall never be persuaded that a clown is capable of distinguishing between Latria and Hyperdulia. He firmly and really adores the image he invokes. Therefore there are a number of heretics in all Christian sects. What is more, each man believes that which appears to him to be the truth. A poor wretch may be forced to pronounce a certain form of prayer, although he inwardly refuses his consent. His persecutor consequently has gained nothing. But, if we revert to the origin of all society, it will be found evident that the sovereign has no right to interfere in the belief of the subject. Would it not be madness to imagine men who have said to another man, their equal, "We raise you to be our superior, because we are in love with slavery; and we bestow on you the power of directing our thoughts, according to your will"? On the contrary, they have said "We have need of you for the maintenance of those laws which we are willing to obey, and that we may be wisely governed and defended; but we also require that you should respect our freedom." This is the sentence pronounced, and it is without appeal. Nay, tolerance is itself so advantageous, to the people among whom it is established, that it constitutes the happiest of states. As soon as there is that perfect freedom of opinion, the people are all at peace; whereas persecution has

given birth to the most bloody civil wars, and such as have been the most inveterate and the most destructive. The least evil that results from persecution is to occasion the persecuted to emigrate. The population of France has suffered in certain provinces, and those provinces still are sensible of the revocation of the edict of Nantes.

Such are in general the duties imposed upon a prince, from which, in order that he may never depart, he ought often to recollect that he himself is but a man, like the least of his subjects. If he be the first general, the first minister of the realm, it is not so that he should shelter in the shadow of authority, but that he should fulfil the duties of such titles. He is only the first servant of the state, who is obliged to act with probity and prudence; and to remain as totally disinterested as if he were each moment liable to render an account of his administration to his fellow citizens.

Thus is he culpable, if he be prodigal of the money of the people, dispersing the produce of the taxes in luxury, pomp, or licentiousness. It is for him to watch over morals, which are the guardians of the laws, and to improve the national education, and not pervert it by ill examples. One of the most important objects is the preservation of good morals, in all their purity; to which the sovereign may greatly contribute by distinguishing and rewarding those citizens who have performed virtuous actions, and testifying his contempt for such as are so deprayed as not to blush at their own disorders. The prince ought highly to disapprove of every dishonest act, and refuse distinctions to men who are incorrigible.

There is another interesting object which ought not to be lost sight of, and

which, if neglected, would be of irreparable prejudice to good morality; which is that princes are liable too highly to notice persons who are possessed of no other merit than that of great wealth. Honours so undeservedly bestowed, confirm the people in the vulgar prejudice that wealth only is necessary to gain respect. Interest and cupidity will then break forth from the curb by which they are restrained. Each will wish to accumulate riches; and, to acquire these, the most iniquitous means will be employed. Corruption increases, takes root, and becomes general. Men of abilities and virtue are despised, and the public honor none but the bastards of Midas, who dazzle by their excessive dissipation and their pomp. To prevent national manners from being perverted to an excess so horrible, the prince ought to be incessantly attentive to distinguish nothing but personal merit, and to show his contempt for that opulence which is destitute of morals and virtue.

As the sovereign is properly the head of a family of citizens, the father of his people, he ought on all occasions to be the last refuge of the unfortunate; to be the parent of the orphan, and the husband of the widow; to have as much pity for the lowest wretch as for the greatest courtier; and to shed his benefactions over those who, deprived of all other aid, can only find succour in his benevolence.

Such, according to the principles which we established at the beginning of this Essay, is the most accurate conception we can form of the duties of a sovereign, and the only manner which can render monarchical government good and advantageous. Should the conduct of many princes be found different, it must

be attributed to their having reflected but little on their institution, and its derivatory duties. They have borne a burthen with the weight and importance of which they were unacquainted, and have been misled from the want of knowledge; for in our times ignorance commits more faults than vice. Such a sketch of sovereignty will perhaps appear to the censorious the archetype of the Stoics; an ideal sage, who never existed except in imagination, and to whom the nearest approach was Marcus Aurelius. If we, with this feeble Essay, were capable of forming men like Marcus Aurelius, it would be the highest reward we could possibly expect, at the same time that it would conduce to the good of mankind.

We ought however to add that the prince who should pursue the laborious route which we have indicated, would never attain absolute perfection; because, with all possible good will, he might be deceived in the choice of the persons whom he should employ in the administration. Incidents might be depicted under false colors; his orders might not be punctually executed; iniquitous might be so concealed as never to arrive at his knowledge; and his ministers, rigorous and consequential, might be too severe, too haughty in their exactions. In fine, it is impossible a monarch should be everywhere in an extensive kingdom. Such therefore is and must be the destiny of earthly affairs, that the degree of perfection which the happiness of the people requires, as far as it depends on government, never can be attained. Therefore, in this as in everything else, we must of necessity remain satisfied with that which is the least defective.

Memoirs

In this account of how his devastated country was restored after the Seven Years' War ended in 1763, Frederick expresses the major practical concern of his fellow-despots: power founded on prosperity, prosperity founded on industry, industry encouraged by government intervention.

OF THE FINANCES

Princes should resemble the spear of Achilles, which gave the wound and afforded the cure. They bring evil upon nations: and the evil they cause it is their duty to redress. A war of seven years, against most of the powers of Europe, had nearly exhausted the treasures of the state. Prussia, the provinces on the Rhine, and those of Westphalia, as well as East Friesland, not having been defended, had fallen into the enemy's power. Their loss occasioned a deficiency of three millions four hundred thousand crowns in the revenue; while Pomerania, the electorate of Brandenbourg, and the confines of Silesia, had been occupied, during a part of the war, by the Russians, the Austrians, and the Swedes; so that they were unable to pay in their contributions. This embarrassing situation obliged the king, during the war, to have recourse to the most exact economy, and to all that the most determined valour could suggest, that he might bring it to a happy conclusion. Those resources of which there was an urgent necessity were found in the contributions levied on Saxony, in the subsidies of England, and in the adulteration of the coin; the last was a remedy as violent as prejudicial, but the only one by which, under such circumstances, the state could be supported. These means, well managed, annually supplied the royal treasury with the advances necessary for the expenses of the campaign, and the pay of the army.

1763. Such was the state of the finances when the peace of Hubertsburg was concluded. The supplies were in the treasury; the magazines formed for the campaign were stored; and the horses for the army, the train of artillery, and the provisions, were all complete and in good condition. These resources that were destined for the continuation of war, became still more useful for the recovery of the provinces.

In order to obtain a clear idea of the general subversion of the country, and to represent to ourselves the desolation and discouragement of the people, it is necessarv we should imagine countries entirely ravaged, where the traces of former habitations were scarcely discoverable; towns almost erased from the earth; others half consumed by the flames; thirteen thousand houses no vestige of which remained; fields lying fallow; the inhabitants destitute of the corn requisite for their support; the farmers in want of sixty thousand horses for the plough; and a diminution of five hundred thousand inhabitants, since the year 1756; a very considerable number in a population of only four millions five hundred thousand. The noble and the peasant had been pillaged, ransomed, and foraged, by so many different armies that nothing was left them, except life, and the miserable rags by which their nakedness was concealed. They had not sufficient credit even to satisfy the daily wants of nature. There

From The Posthumous Works of Frederick II, King of Prussia, tr. Thomas Holcroft (London, 1789).

was no longer any police in the towns. To a spirit of equity and regularity base interest, disorder, and anarchy had succeeded. The colleges of justice and of finance had been rendered inactive, by the frequent invasions of such numerous enemies. The slumber of the laws produced a licentiousness of spirit in the public, and hence avidity, and the desire of rapacious gain, took birth. The noble, the merchant, the farmer, the labourer, the manufacturer, all strove who should set the highest price on their commodities, their provisions, and their industry; and only seemed active to effect their mutual ruin.

Such was the fatal spectacle which so many provinces that had lately been so flourishing presented, at the conclusion of the war. There is no description, however pathetic, that can possibly approach the deep, the affecting, the mournful impression which the sight of them produced.

In a situation thus deplorable, courage must be opposed to adversity. This was not a time to despair, but to resolve to soften the evil, and endeavour to reestablish the state. A new creation must be undertaken. The treasury furnished supplies for the rebuilding of the towns and villages: the corn that was necessary for the subsistence of the people, and to sow the lands, was supplied by the stores found in the magazines. The horses that had been destined for the use of the artillery, the baggage waggons, and provisions, were employed in agriculture. Silesia was relieved from contributions for six months. Pomerania and the New Marche for two years. Relief was given to the provinces by a grant of the sum of two millions three hundred and thirtynine thousand crowns, with which they acquitted the debts they had contracted, to pay their contributions, and to gratify those impositions which the vagrant enemy had exacted.

However great this expense was, still it was necessary, or rather it was indispensable. The state of these provinces, after the peace of Hubertsburg, recalled to mind the condition of Brandenbourg, after the famous war of thirty years. The electorate, at that time, remained in want of succour; because of the inability of the great elector to assist his people. And what was the consequence? An entire age passed away before his successors had again rebuilt the towns and cultivated the desolated countries.

An example so striking made the king determine not to lose a moment, under circumstances thus afflicting; but, by prompt and ample aid, to repair the public calamity. Multiplied largesses restored courage to the poor inhabitants, who had begun to despair amidst their sufferings. The means that were thus supplied inspired new hope; the citizens acquired renovated life; industry, encouraged, reproduced activity; the people were again inspired with patriotism; and from that time the lands were cultivated anew. manufactures recovered animation, and the re-established police successively corrected those vices which had taken root during a state of anarchy.

During the war, the most aged counsellors, and all the ministers of the grand directory, had died in succession; and, in times of such trouble, it was impossible properly to fill up the vacancies. It was difficult to find persons capable of these different offices. The provinces were searched, in which men of talents were as uncommon as in the capital. At length, M. von Blumenthal, M. von Massow, M. von Hagen, and general Wedel, were chosen to fill these important posts.

The beginnings of administration were rigorous and oppressive; there were deficiencies in all the receipts: it was nevertheless necessary exactly to acquit the burthens of the state. Although, after its reduction, the army had been fixed, in time of peace, at a hundred and fifty thousand men, it was difficult to find the supplies necessary for the pay of the troops. During the war, all persons who did not appertain to the military had been paid in notes; and this was likewise a debt which must be discharged, and which, beside other necessary payments, was productive of much inconvenience. The king, however, the first year after the peace, found means to satisfy all the creditors of the state: and every incumbrance which had been incurred by the war was liquidated.

It might have been supposed that the devastations which war had occasioned were vet insufficient to ruin and overwhelm the kingdom. Scarcely was it terminated before frequent fires produced almost as much mischief as even the conflagrations of the enemy. Between the year 1765 and the year 1769 the city of Königsberg was twice reduced to ashes; a like destiny in Silesia destroyed the towns of Freystaedtel, Ober-Glogau, Parchwitz, Haynau, Naumburg Oueis, and Goldberg; Nauen in the Electorate; Calies, and a part of Landsberg in the New Marche; and Belgard and Tempelburg in Pomerania.

To repair these misfortunes, additional expenses were continually incurred; and, in order to supply so many extraordinary wants, it was necessary to imagine new resources: for, beside money exacted for the renovation of the provinces, very considerable sums were expended on the new fortifications, and the founding of other trains of artillery; but of these we shall speak in their place. Industry exerted all

her efforts. The revenues of the tolls and the excise were not exactly administered. because there wanted superintendents to watch over the collectors. That this important branch of the revenues of the crown might be established on a more permanent basis, those who had been at the head of this department having died during the war, the king found himself obliged to have recourse to foreigners, and took some Frenchmen into his service. who had long been in the routine of this kind of business. These duties were not farmed on leases, but were subjected to a directory, as the preferable mode; by aid of which the collectors might be prevented from pillaging the people, an abuse which we see but too frequently practised in France. The tax on corn was lowered, and the price of beer underwent some little advance, that there might be a compensation. By this new arrangement, the produce of the taxes was augmented; especially that of the tolls, which introduced foreign money into the kingdom.

But the greatest good which resulted from the regulation was that of diminishing contraband trade, so prejudicial to countries that are in possession of manufactures. When a country has but few products to export, and is obliged to have recourse to the industry of its neighbours, the balance of trade must necessarily be unfavourable to such a country; it must pay more money to foreigners than it receives; and, if the practice be continued, it will necessarily, after a certain number of years, find itself destitute of specie. If money be daily taken out of a purse into which money is not again returned it must soon be emptied. Sweden may serve us as an example in support of this remark.

To obviate the inconveniency there were no other means than those of increasing the manufactures. The peculiar products of any country are wholly gain,

and the price of workmanship, at the least, is gained from foreigners. These maxims, as true as they are palpable, served as principles to the government, and according to these were all the operations of trade directed. Thus, in the year 1773, there were two hundred and sixtyfour new manufactories. Among others, there was a porcelain manufactory established at Berlin, the workmanship of which, while it afforded subsistence to five hundred persons, soon surpassed the Saxon porcelain. A snuff manufactory was formed, which was put under the direction of a company. This company had warehouses in all the provinces, which supplied the consumption of those provinces, and gained by the sale the leaf tobacco, which must have been purchased from Virginia, from foreigners. The revenues of the crown were increased, and the proprietors were paid ten per cent for their capitals.

War had rendered the course of exchange disadvantageous to the Prussian commerce, although the adulterated coin had been immediately melted down, after the peace, and restored to its former value. To erect a bank was the only means that could be taken to obviate this inconveniency. Persons who were enslaved by prejudices, because they had not sufficiently considered the subject, affirmed that no bank could be supported, except under republican governments; for that monied men would never place any confidence in a bank that should be established in a monarchy. The assertion was false; there is a bank at Copenhagen, another at Rome, and a third at Vienna. Men were therefore suffered to reason as they thought proper, but the project was put in execution. After having attentively compared these various banks and regulations, in order to examine what might be best adapted to the nature of the country, it was found that a giro bank, combined with a lombard, would be the most convenient. The court disbursed eight hundred thousand crowns for its establishment, which sum was to serve as a fund on which to form its operations. At the beginning the bank suffered some losses, either through ignorance or from the knavery of those to whose direction it was committed. But since it has been under the administration of M. von Hagen, exactitude and order have been established. No bills have been issued till funds were first realized for their payment.

Beside the advantage which this establishment procured the country, by facilitating commerce, there still was another. In preceding times, it had been the custom for the money of wards of chancery to be deposited with the court, and these wards, instead of deriving any advantage from their capitals, while any suits at law continued, were obliged to pay one per cent per annum. Such money was afterward deposited at the bank, for which the minor received three per cent; so that, in effect, including what had formerly been paid into court, their real gain was four per cent.

The bankruptcy of Neuville, and other foreign merchants, occasioned some Prussian traders to fail. Credit would have suffered had it not been for the establishment of the bank, by which such traders were supported in their business. The course of exchange was presently at par, and the commercial world began then to be convinced, by the effects that followed. that this was a useful establishment, and necessary to trade. The bank soon had offices in all the great towns of the kingdom, and houses in every commercial city of Europe. By these means the circulation of money was expedited, as were the payments of the provinces, at the same time that the lombard [The Lombards were originally a kind of pawnbrokers, as bankers still in some degree are. Hence the term.] prevented usurers from ruining the poor manufacturer, who could not sell the produce of his industry with sufficient promptitude. Exclusive of the good which resulted to the public, the court prepared for itself, by the credit of the bank, resources for the grand necessities of the state.

Princes, like private persons, while they may amass with one hand, are under the necessity of expending with the other. The good husbandman cuts channels for the rivulets that, by their aid, he may water his thirsty lands, which otherwise, wanting humidity, would remain unproductive. On the same principle government augmented its revenues, that they might be employed in works of utility to the public. Nor did it content itself with restoring that which war had destroyed: it was desirous of perfecting whatever was capable of perfection. It therefore proposed to profit by every kind of foil, by draining the marshes, improving the lands by an augmentation of cattle, and even to render the barren sands useful, by planting them with trees. Although we relate circumstances that may be thought minute, we still flatter ourselves they will be deemed such as must interest posterity.

The first work of this nature regarded the Netze and the Wartha, the banks of which were cleared, after having drained off the stagnant waters by different channels, which, in different directions, carried these waters toward the Oder. The expense amounted to seven hundred and fifty thousand crowns, and three thousand five hundred families were settled in these countries. The nobility, and the towns in the vicinity of the above-named rivers, found a very considerable increase

of riches. The work was finished in 1773, and population from that time there increased to fifteen thousand souls.

The marshes which extend to Friedberg were afterward drained, and four hundred foreign families were there settled.

The lakes of the Madua and of Leba were drained in Pomerania, by which labor the nobility gained thirty thousand acres of meadow land. Similar works in like manner took place in the environs of Stargard, of Cammin, of Treptow, of Rugenwalde, and of Colberg.

In the Marche, the marshes of the Havel were drained; those of the Rhine, toward Fehrbellin; and those of the Finow, between Ratenow, and Ziesar; without enumerating the money that was employed in the amelioration of the lands of the nobility, which amounted to considerable sums.

Mounds were at the same time thrown up in Friesland, in the Dollart, by which the land that had been overflowed by the sea, in 1724, was gradually recovered.

In the province of Magdeburg two thousand new families were settled. Their labor was the more necessary there inasmuch as, formerly, the peasants of Thuringia were accustomed to come and help to gather in the harvest. This was afterward done without their aid.

The crown possessed too many farms. More than a hundred and fifty were changed into villages; and, for its loss of revenue, it was richly rewarded by the increase of population. A farm seldom contained more than six people; and as soon as they were converted into villages they each contained thirty inhabitants, at the least.

However industrious the late king had been in his endeavors to repeople Prussia, which, in the year 1709, had been desolated by the plague, he had not restored it to the flourishing state in which it was previous to that destructive scourge; but the king was unwilling that Prussia should remain in a comparative state of inferiority; after the death of his father, he had there settled thirteen thousand additional families; and, if hereafter it be not neglected, its population may be increased by more than a hundred thousand souls.

Silesia no less merited attention and efforts for its re-establishment than did the other provinces: nor was it thought sufficient to restore affairs to their former state: an endeavour was made to obtain greater perfection. The priests themselves were rendered useful, by obliging all the rich abbots to establish manufactures. In some of these the workmen were employed in fabricating table linen; at others in oil mills. Here they were tanners, and there they worked in copper, iron, or wire, according as best suited the place, and the products of the country. The number of husbandmen was likewise augmented in Lower Silesia, by four thousand families. It will perhaps afford surprise that such an increase might take place in that class, recollecting that no field of the country remained uncultivated. The reason was many lords, that they might increase their domains, had imperceptibly appropriated to themselves the land of their subjects. Had this abuse been tolerated, many fee-farms would, in time, have been vacated; and the land, wanting laborers for tillage, would have been less productive; till at length each village would have had its lord, without having any fee-farmers. We know that the possession of property attaches men to their country. Those who have no property can have no reason for remaining in states where they have nothing to lose. These reasons having been alleged to the manor lords, their own advantage induced them to consent to restore their peasants to their former privileges.

In return, the king aided the nobility by very considerable loans, that their credit, which was totally on the decline, might be recovered. Numerous families, indebted before, or by the war, were in danger of becoming bankrupts. The law granted them letters of credit, for two years, in order that, having time again to till their lands and render them productive, they might be in a situation to pay at least the interest of the money. These letters completely ruined the credit of the nobility. The king, who took a pleasure and made it a duty to assist the first and most splendid order of the state, paid three hundred thousand crowns of the debts of the nobility; but the sum total which had been borrowed on the lands amounted to twenty-five millions of crowns, and it was necessary to resort to means more efficacious. The nobles were assembled, and, as forming an assembly of the states, pledged themselves to pay the debts contracted. Notes to the amount of twenty millions were issued, which being put into circulation, aided by two hundred thousand crowns, which the king advanced to realize the payments that were most pressing, soon re-established credit; and four hundred of the most distinguished families are indebted for their preservation to these salutary measures.

In Pomerania and the New Marche, as in Silesia, the nobility were in like manner ruined. The government paid a part of their debts, to the amount of five hundred thousand crowns; adding five hundred thousand more that were to be expended in putting their lands into a proper state of tillage.

The towns that had suffered most by the war were in like manner relieved. Landshut received two hundred thousand crowns: Striegau forty thousand; Halle forty thousand; Crossen twenty-four thousand; Reppen six thousand; Halberstadt forty thousand; Minden twenty thousand; Bielefeld fifteen thousand; and those of the county of Hohenstein, thirteen thousand crowns.

These expenses were all necessary: it was requisite to be prompt in dispersing

money through the provinces, that they might be re-established as hastily as possible. Had rigid economy been attended to, under such circumstances, a century perhaps would have passed away before the kingdom would again have flourished; but, by the celerity that was employed on the occasion, more than a hundred thousand persons returned to their country.

2. CATHERINE II

In 1768, Empress Catherine of Russia, good friend of the French *philosophes*, issued her "Grand Instructions to the Commissioners appointed to frame a new code of laws for the Russian Empire," a document typical of an age when good intentions often took precedence over practice. Though urged by the Empress to spare no pains "in bringing this great Work to a Conclusion, that Our Age might soon enjoy the happy Fruits of those Seeds which are now planted," the Commissioners seem to have made haste rather slowly. Meanwhile, however, the Empress was interested in profiting from the propaganda value of her progressive gesture. Aware of the value of publicity, she had already bought Diderot's private library on condition that it continued in his possession until his death, thus securing the goodwill of a master publicist and of his circle of friends. Now, she had her "Grand Instructions" translated and published in all of Europe's major cities, another eloquent witness to her enlightened views.

Catherine's Constitution

O Lord my God, hearken unto me, and instruct me; that I may administer Judgment unto thy People; as thy sacred Laws direct to judge with Righteousness!

THE INSTRUCTIONS TO THE
COMMISSIONERS FOR COMPOSING
A NEW CODE OF LAWS

- 1. The Christian Law teaches us to do mutual Good to one another, as much as possibly we can.
- 2. Laying this down as a fundamental Rule prescribed by that Religion, which

has taken, or ought to take Root in the Hearts of the whole People; we cannot but suppose, that every honest Man in the Community is, or will be, desirous of seeing his native Country at the very Summit of Happiness, Glory, Safety, and Tranquillity.

3. And that every Individual Citizen in particular must wish to see himself protected by Laws, which should not distress him in his Circumstances, but, on the Contrary, should defend him from all Attempts of others, that are repugnant to

From The Grand Instructions to the Commissioners Appointed to Frame a New Code of Laws for the Russian Empire: Composed by Her Imperial Majesty Catherine II, Empress of all the Russias, Trans. Michael Tatischeff (London, 1768).

this fundamental Rule.

4. In order therefore to proceed to a speedy Execution of what *We* expect from such a general Wish, *We*, fixing the Foundation upon the above first-mentioned Rule, ought to begin with an Inquiry into the natural Situation of this Empire.

5. For those Laws have the greatest Conformity with Nature, whose particular Regulations are best adapted to the Situation and Circumstances of the People, for whom they are instituted.

This natural Situation is described in the three following Chapters.

CHAPTER I

6. Russia is an European State.

7. This is clearly demonstrated by the following Observations: The Alterations which Peter the Great undertook in Russia succeeded with the greater Ease, because the Manners, which prevailed at that Time, and had been introduced amongst us by a Mixture of different Nations, and the Conquest of foreign Territories, were quite unsuitable to the Climate. Peter the First, by introducing the Manners and Customs of Europe among the European People in his Dominions, found at that Time such Means as even he himself was not sanguine enough to expect.

CHAPTER II

8. The Possessions of the Russian Empire extend upon the terrestrial Globe to 32 Degrees of Latitude, and to 165 of Longitude.

The Sovereign is absolute; for there is no other Authority but that which centers in his single Person, that can act with a Vigour proportionate to the Extent of such a vast Dominion.

10. The Extent of the Dominion requires an absolute Power to be vested in that Person who rules over it. It is expedient so to be, that the quick Dispatch of Affairs, sent from distant Parts, might make ample Amends for the Delay occasioned by the great Distance of the Places.

11. Every other Form of Government whatsoever would not only have been prejudicial to Russia, but would even have proved its entire Ruin.

12. Another Reason is; That it is better to be subject to the Laws under one Master, than to be subservient to many.

13. What is the true End of Monarchy? Not to deprive People of their natural Liberty; but to correct their Actions, in order to attain the *Supreme Good*.

14. The Form of Government, therefore, which best attains this End, and at the same Time sets less Bounds than others to natural Liberty, is that which coincides with the Views and Purposes of rational Creatures, and answers the End, upon which we ought to fix a stedfast Eye in the Regulations of civil Polity.

15. The Intention and the End of Monarchy, is the Glory of the Citizens, of the State, and of the Sovereign.

16. But, from this Glory, a Sense of Liberty arises in a People governed by a Monarch; which may produce in these States as much Energy in transacting the most important Affairs, and may contribute as much to the Happiness of the Subjects, as even Liberty itself.

CHAPTER III

17. Of the Safety of the Institutions of Monarchy.

- 18. The intermediate Powers, subordinate to, and depending upon the supreme Power, form the essential Part of monarchical Government.
- 19. I have said, that the intermediate Powers, subordinate and depending, proceed from the supreme Power; as in the very Nature of the Thing the Sovereign is the Source of all imperial and civil Power.
- 20. The Laws, which form the Foundation of the State, send out certain Courts of Judicature, through which, as through smaller Streams, the Power of the Government is poured out, and diffused.
- 21. The Laws allow these Courts of Judicature to remonstrate, that such or such an Injunction is unconstitutional, and prejudicial, obscure, and impossible to be carried into Execution; and direct, beforehand, to which Injunction one ought to pay Obedience, and in what Manner one ought to conform to it. These Laws undoubtedly constitute the firm and immoveable Basis of every State.

CHAPTER IV

- 22. There must be a political Body, to whom the Care and strict Execution of these Laws ought to be confided.
- 23. This Care, and strict Execution of the Laws, can be no where so properly fixed as in certain Courts of Judicature, which announce to the People the newlymade Laws, and revive those, which are forgotten, or obsolete.
- 24. And it is the Duty of these Courts of Judicature to examine carefully those Laws which they receive from the Sovereign, and to remonstrate, if they find any Thing in them repugnant to the fundamental Constitution of the State, &c.

- which has been already remarked above in the third Chapter, and twenty-first Article.
- 25. But if they find nothing in them of that Nature, they enter them in the Code of Laws already established in the State, and publish them to the whole Body of the People.
- 26. In Russia the Senate is the political Body, to which the Care and due Execution of the Laws is confided.
- 27. All other Courts of Judicature may, and ought to remonstrate with the same Propriety, to the Senate, and even to the Sovereign himself, as was already mentioned above.
- 28. Should any One inquire, wherein the Care and due Execution of the Laws consists? I answer, That the Care, and due Execution of the Laws, produces particular Instructions; in consequence of which, the before-mentioned Courts of Judicature, instituted to the End that, by their Care, the Will of the Sovereign might be obeyed in a Manner comformable to the fundamental Laws and Constitution of the State, are obliged to act, in the Discharge of their Duty, according to the Rules prescribed.
- 29. These Instructions will prevent the People from transgressing the Injunctions of the Sovereign with impunity; but, at the same Time, will protect them from the Insults, and ungovernable Passions of others.
- 30. For, on the one Hand, they justify the Penalties prepared for those who transgress the Laws; and, on the other, they confirm the Justice of that Refusal to enter Laws repugnant to the good Order of the State, amongst those which are already approved of, or to act by those Laws in the Administration of Justice, and the general Business of the whole Body of the People.

CHAPTER V

- 31. Of the Situation of the People in general.
- 32. It is the greatest Happiness for a Man to be so circumstanced, that, if his Passions should prompt him to be mischievous, he should still think it more for his Interest not to give Way to them.
- 33. The Laws ought to be so framed, as to secure the Safety of every Citizen as much as possible.
- 34. The Equality of the Citizens consists in this; that they should all be subject to the same Laws.
- 35. This Equality requires Institutions so well adapted, as to prevent the Rich from oppressing those who are not so wealthy as themselves, and converting all the Charges and Employments intrusted to them as Magistrates only, to their own private Emolument.
- 36. General or political Liberty does not consist in that licentious Notion, That a Man may do whatever he pleases.
- 37. In a State or Assemblage of People that live together in a Community, where there are Laws, Liberty can only consist in doing that which every One ought to do, and not to be constrained to do that which One ought not to do.
- 38. A Man ought to form in his own Mind an exact and clear Idea of what Liberty is. Liberty is the Right of doing whatsoever the Laws allow: And if any one Citizen could do what the Laws forbid, there would be no more Liberty; because others would have an equal Power of doing the same.
- 39. The political Liberty of a Citizen is the Peace of Mind arising from the Consciousness, that every Individual enjoys his peculiar Safety; and in order that the People might attain this Liberty, the Laws ought to be so framed, that no one

Citizen should stand in Fear of another; but that all of them should stand in Fear of the same Laws.

CHAPTER VI

- 40. Of Laws in general.
- 41. Nothing ought to be forbidden by the Laws, but what may be prejudicial, either to every Individual in particular, or to the whole Community in general.
- 42. All Actions, which comprehend nothing of this Nature, are in nowise cognizable by the Laws; which are made only with the View of procuring the greatest possible Advantage and Tranquillity to the People, who live under their Protection.
- 43. To preserve Laws from being violated, they ought to be so good, and so well furnished with all Expedients, tending to procure the greatest possible Good to the People; that every Individual might be fully convinced, that it was his Interest, as well as Duty, to preserve those Laws inviolable.
- 44. And this is the most exalted Pitch of Perfection which we ought to labour to attain to.
- 45. Many Things rule over Mankind. Religion, the Climate, Laws, the Maxims received from Government, the Example of past Ages, Manners, and Customs.
- 46. Hence results a general Sense in the People, similar to these Causes.
- 47. For Instance, Nature and Climate domineer almost alone over the savage People.
 - 48. Customs govern the Chinese.
- 49. The Laws tyrannise with savage Ferocity over the Japonese.
- 50. Manners heretofore took the Lead amongst the Lacedemonians.
- 51. Maxims of Government, and their ancient Manners bore the Sway at Rome.

- 52. The different Characters of Nations are blended with Virtues and Vices, with good and bad Qualities.
- 53. That Composition, or Admixture, might be pronounced happy, from which many and great Blessings spring; though, we frequently cannot even conjecture the Cause, from whence they should issue.
- 54. To prove this, I here produce in Evidence different Examples of different Facts. The Spaniards were at all Times remarkably eminent for their Good Faith. History furnishes us with remarkable Instances of their Fidelity in keeping a Pledge intrusted to their Care: They frequently submitted to Death, rather than betray their Trust, and they still retain this Fidelity, for which they were formerly so renowned. All Nations, who trade in Cadiz intrust their Fortunes to the Spaniards; and, hitherto, have had no Reason to repent of their Confidence. But this amazing Quality, blended with their Laziness, forms such a strange Medly, as produces Effects prejudicial to themselves. The other European Nations carry on all that Trade, before their very Eyes, which belongs properly to their Monarchy only.
- 55. The Character of the Chinese is of a different Complexion, and forms a Contrast which is the very Reverse of that of the Spaniards. The Precariousness of their Lives (arising from the very Nature of their Soil and Climate) produces in them an Activity almost inconceivable; and so immoderate a Fondness for Gain, that no trading Nation can trust them. This known Perfidy of theirs, has preserved to them the sole Trade of Japon. Not one of the European Merchants durst ever venture to engage in the Japon Trade under their Names, though they might have done it with great Ease through their maritime Provinces.

- 56. By what I have here advanced, I meant not, in the least, to abridge that infinite Distance which must ever subsist between Vices and Virtues. God forbid! My Intention was only to shew, that all the political Vices are not moral Vices; and that all the moral Vices are not political Ones. This Distinction ought to be known and carefully attended to, that in making the Laws nothing may be introduced in them which is contrary to the general Sense of a Nation.
- 57. The Legislation ought to adapt its Laws to the general Sense of a Nation. We do nothing so well as what we do freely and uncontrouled, and following the natural Bent of our own Inclinations.
- 58. In order to introduce better Laws, it is essentially necessary to prepare the Minds of the People for their Reception. But that it may never be pleaded in Excuse, that it is impossible to carry even the most useful Affairs into Execution, because the Minds of the People are not yet prepared for it; you must, in that Case, take the Trouble upon yourselves to prepare them; and, by these Means, you will already have done a great Part of the Work.
- 59. Laws are the peculiar and distinct Institutions of the Legislator; but Manners and Customs are the Institutions of the whole Body of the People.
- 60. Consequently, if there should be a Necessity of making great Alterations amongst the People for their greater Benefit, that must be corrected by Laws, which has been instituted by Laws, and that must be amended by Custom, which has been introduced by Custom; and it is extreme bad Policy to alter that by Law, which ought to be altered by Custom.
 - 61. There are Means of preventing

the Growth of Crimes, and these are the Punishments inflicted by the Laws. At the same Time there are Means for introducing an Alteration in Customs, and these are Examples.

62. Besides, the more a People have an Intercourse with one another, the more easy it is for them to introduce a Change in their Customs.

63. In a Word, every Punishment, which is not inflicted through Necessity,

is tyrannical. The Law has not its Source merely from Power. Things indifferent in their Nature, do not come under the Cognizance of the Laws.

CHAPTER VII

64. Of the Laws in particular.

65. Laws carried to the Extremity of Right, are productive of the Extremity of Evil.

A Footnote

The gesture was impressive. The reality less so. This is what Alexander Herzen, a Russian liberal, would write in 1858 in his preface to the Memoirs of Empress Catherine II (London, 1859), pp. xiv-xv:

In reading these memoirs one is surprised that one thing is constantly forgotten, to the point of being nowhere mentioned,—it is *Russia* and *the people*. And this is the characteristic trait of the period.

The Winter Palace, with its administrative and military machinery, was a world apart. Like a ship floating on the water's surface, the only intercourse it had with the inhabitants of the Ocean was to eat them. It was the State for the State's sake. Organized in the German fashion, it imposed itself upon the people as a victor would. In this monstrous barracks, in this enormous chancellery,

there was a dry sort of rigidity, as in a camp. The ones gave or transmitted the orders, the others obeyed in silence. There was only one point where human passions reappeared, stormy and agitated, and this point was, in the Winter Palace, the domestic focus not of the nation but of the State. Behind the triple line of guards, in these heavily ornate salons, a feverish life fermented with its intrigues and its struggles, its drama and its tragedies. It was there that Russia's destinies were plotted in the obscurity of the alcove, in the midst of orgies, beyond the reach of police and spies.

III. A Dawn of Revolution

The idea that natural laws existed which not even kings could transgress with impunity was one which the eighteenth century had learned from the seventeenth. This was now blended with the belief that society was perfectible. Dr. Johnson, pessimistically swimming against the contemporary tide, had reminded his age that

Of all the ills that human hearts endure How few that kings or laws can cause or cure.

But this was not the accepted attitude; on the contrary, men were thought able to forge their fates, shape the societies in which they lived according to the laws of nature and reason, and cure a great many of the ills that human hearts endure. These hopes erupted in the last quarter of the century in two great revolutions, one in America and one in France. The documents that follow give some idea of the motives and results of the two and of the reactions which they called forth.

1. THE AMERICAN REVOLUTION

About a year after the second Continental Congress began its work, Richard Henry Lee of Virginia introduced a resolution which stated that "These united Colonies are and of right ought to be, free and independent States." In two other resolutions he called for confederation and foreign alliances. Thomas Jefferson, John Adams, Benjamin Franklin, Roger Sherman, and Robert R. Livingston were appointed a committee to draw up a declaration of independence. Thomas Jefferson was the principal author of the draft which the Second Continental Congress approved on July 4, 1776.

The Declaration of Independence

In Congress, July 4, 1776. The Unanimous Declaration of the Thirteen United States of America

When in the course of human events, it becomes necessary for one people to dissolve the political bands which have connected them with another, and to assume among the Powers of the earth, the separate and equal station to which the Laws

of Nature and of Nature's God entitle them, a decent respect to the opinions of mankind requires that they should declare the causes which impel them to the separation.

We hold these truths to be self-evident, that all men are created equal, that they are endowed by their Creator with certain unalienable Rights, that among these are Life, Liberty and the pursuit of Happi-

ness. That to secure these rights, Governments are instituted among Men, deriving their just powers from the consent of the governed. That whenever any Form of Government becomes destructive of these ends, it is the Right of the People to alter or to abolish it, and to institute a new Government, laying its foundation on such principles and organizing its powers in such form, as to them shall seem most likely to effect their Safety and Happiness. Prudence, indeed, will dictate that Governments long established should not be changed for light and transient causes: and accordingly all experience hath shown, that mankind are more disposed to suffer, while evils are sufferable, than to right themselves by abolishing the forms to which they are accustomed. But when a long train of abuses and usurpations, pursuing invariably the same Object, evinces a design to reduce them under absolute Despotism, it is their right, it is their duty, to throw off such Government, and to provide new Guards for their future security. - Such has been the patient sufferance of these Colonies; and such is now the necessity which constrains them to alter their former Systems of Government. The history of the present King of Great Britain is a history of repeated injuries and usurpation, all having in direct object the establishment of an absolute Tyranny over these States. To prove this, let Facts be submitted to a candid world.

He has refused his Assent to Laws, the most wholesome and necessary for the

public good.

He has forbidden his Governors to pass Laws of immediate and pressing importance, unless suspended in their operation till his Assent should be obtained; and when so suspended, he has utterly neglected to attend to them.

He has refused to pass other Laws for the accommodation of large districts of people, unless those people would relinquish the right of Representation in the Legislature, a right inestimable to them and formidable to tyrants only.

He has called together legislative bodies at places unusual, uncomfortable, and distant from the depository of their Public Records, for the sole purpose of fatiguing them into compliance with his measures.

He has dissolved Representative Houses repeatedly, for opposing with manly firmness his invasions on the rights of the people.

He has refused for a long time, after such dissolutions, to cause others to be elected; whereby the Legislative Powers, incapable of Annihilation, have returned to the People at large for their exercise: the State remaining in the meantime exposed to all the dangers of invasion from without, and convulsions within.

He has endeavoured to prevent the population of these States; for that purpose obstructing the Laws for Naturalization of Foreigners; refusing to pass others to encourage their migration hither, and raising the conditions of new Appropriations of Lands.

He has obstructed the Administration of Justice, by refusing his Assent to Laws for establishing Judiciary Powers.

He has made Judges dependent on his Will alone, for the tenure of their offices, and the amount and payment of their salaries.

He has erected a multitude of New Offices, and sent hither swarms of Officers to harass our People, and eat out their substance.

He has kept among us, in time of peace, Standing Armies without the Consent of our legislature.

560

He has affected to render the Military independent of and superior to the Civil Power.

He has combined with others to subject us to a jurisdiction foreign to our constitution, and unacknowledged by our laws; giving his Assent to their acts of pretended Legislation:

For quartering large bodies of armed

troops among us:

For protecting them, by a mock Trial, from Punishment for any Murders which they should commit on the Inhabitants of these States:

For cutting off our Trade with all parts of the world:

For imposing Taxes on us without our Consent:

For depriving us in many cases, of the benefits of Trial by Jury:

For transporting us beyond Seas to be tried for pretended offences:

For abolishing the free System of English Laws in a Neighbouring Province, establishing therein an Arbitrary government, and enlarging its boundaries so as to render it at once an example and fit instrument for introducing the same absolute rule into these Colonies:

For taking away our Charters, abolishing our most valuable Laws, and altering fundamentally the Forms of our Governments:

For suspending our own Legislatures, and declaring themselves invested with Power to legislate for us in all cases whatsoever.

He has abdicated Government here, by declaring us out of his Protection and waging War against us.

He has plundered our seas, ravaged our Coasts, burnt our towns, and destroyed the Lives of our people.

He is at this time transporting large Armies of foreign Mercenaries to complete the works of death, desolation and tyranny, already begun with circumstances of Cruelty & perfidy scarcely paralleled in the most barbarous ages, and totally unworthy the Head of a civilized nation.

He has constrained our fellow Citizens taken Captive on the high Seas to bear Arms against their Country, to become the executioners of their friends and Brethren, or to fall themselves by their Hands. He has excited domestic insurrections amongst us, and has endeavoured to bring on the inhabitants of our frontiers the merciless Indian Savages, whose known rule of warfare is an undistinguished destruction of all ages, sexes, and conditions.

In every stage for these Oppressions we have Petitioned for Redress in the most humble terms: Our repeated petitions have been answered only by repeated injury. A Prince, whose character is thus marked by every act which may define a Tyrant, is unfit to be the ruler of a free People.

Nor have we been wanting in attention to our British brethren. We have warned them from time to time of attempts by their legislature to extend an unwarrantable jurisdiction over us. We have reminded them of the circumstances of our emigration and settlement here. We have appealed to their native justice and magnanimity, and we have conjured them by the ties of our common kindred to disavow these usurpations, which would inevitably interrupt our connections and correspondence. They too have been deaf to the voice of justice and of consanguinity. We must, therefore, acquiesce in the necessity, which denounces our Separation, and hold them, as we hold the rest of mankind, Enemies in War, in Peace Friends.

We, therefore, the Representatives of the United States of America, in General Congress Assembled, appealing to the Supreme Judge of the world for the rectitude of our intentions, do, in the Name, and by Authority of the good People of these Colonies, solemnly publish and declare, That these United Colonies are, and of Right ought to be Free and Independent States; that they are Absolved from all Allegiance to the British Crown, and that all political connection between

them and the State of Great Britain, is and ought to be totally dissolved; and that as Free and Independent States, they have full power to levy War, conclude Peace, contract Alliances, establish Commerce, and to do all other Acts and Things which Independent States may of right do. And for the support of this Declaration, with a firm reliance on the protection of Divine Providence, we mutually pledge to each other our lives, our Fortunes and our sacred Honor.

The Federalist

The Federalist was the title given to a series of articles published in the New York press between October 1787 and August 1788, expounding and defending the proposed new Constitution of the United States, which had just emerged from the discussions of the Federal Convention at Philadelphia. The authors, Alexander Hamilton and John Jay of New York, and James Madison of Virginia, were trying to persuade the public, and especially the electors of New York State, to vote in favor of ratification. Incidentally to this purpose they produced a very clear-sighted study of government and politics, which is still worth our attention.

NUMBER 10 (MADISON)

Among the numerous advantages promised by a well constructed Union, none deserves to be more accurately developed than its tendency to break and control the violence of faction. The friend of popular governments, never finds himself so much alarmed for their character and fate, as when he contemplates their propensity to this dangerous vice. He will not fail, therefore, to set a due value on any plan which, without violating the principles to which he is attached, provides a proper cure for it. The instability, injustice, and confusion, introduced into the public councils have, in truth, been the mortal diseases under which popular governments have everywhere perished; as they continue to be the favourite and fruitful topics from which the adversaries to liberty derive their most specious declamations. The valuable improvements made by the American constitutions on the popular models, both ancient and modern, cannot certainly be too much admired: but it would be an unwarrantable partiality, to contend that they have as effectually obviated the danger on this side, as was wished and expected. Complaints are everywhere heard from our most considerate and virtuous citizens, equally the friends of public and private faith, and of public and personal liberty, that our governments are too unstable; that the public good is disregarded in the conflicts of rival parties; and that measures are too often decided, not according to the rules of justice, and the rights of the minor party, but by the superior force

of an interested and overbearing majority. However anxiously we may wish that these complaints had no foundation, the evidence of known facts will not permit us to deny that they are in some degree true. It will be found, indeed, on a candid review of our situation, that some of the distresses under which we labour, have been erroneously charged on the operation of our governments; but it will be found, at the same time, that other causes will not alone account for many of our heaviest misfortunes; and, particularly, for that prevailing and increasing distrust of public engagements, and alarm for private rights, which are echoed from one end of the continent to the other. These must be chiefly, if not wholly, effects of the unsteadiness and injustice, with which a factious spirit has tainted our public administrations.

By a faction, I understand a number of citizens, whether amounting to a majority or minority of the whole, who are united and actuated by some common impulse of passion, or of interest, adverse to the rights of other citizens, or to the permanent and aggregate interests of the community.

There are two methods of curing the mischiefs of faction. The one, by removing its causes; the other, by controlling its effects.

There are again two methods of removing the causes of faction: The one, by destroying the liberty which is essential to its existence; the other, by giving to every citizen the same opinions, the same passions, and the same interests.

It could never be more truly said, than of the first remedy, that it was worse than the disease. Liberty is to faction what air is to fire, an aliment, without which it instantly expires. But it could not be a less folly to abolish liberty, which is essential to political life because it nourishes faction, than it would be to wish the annihilation of air, which is essential to animal life, because it imparts to fire its destructive agency.

The second expedient is as impracticable, as the first would be unwise. As long as the reason of man continues fallible, and he is at liberty to exercise it, different opinions will be formed. As long as the connection subsists between his reason and his self-love, his opinions and his passions will have a reciprocal influence on each other; and the former will be objects to which the latter will attach themselves. The diversity in the faculties of men, from which the rights of property originate, is not less an insuperable obstacle to an uniformity of interests. The protection of those faculties is the first object of government. From the protection of different and unequal faculties of acquiring property, the possession of different degrees and kinds of property immediately results; and from the influence of these on the sentiments and views of the respective proprietors, ensues a division of the society into different interests and parties.

The latent causes of faction are thus sown in the nature of man; and we see them everywhere brought into different degrees of activity, according to the different circumstances of civil society. A zeal for different opinions concerning religion, concerning government, and many other points, as well of speculation as of practice; an attachment to different leaders, ambitiously contending for pre-eminence and power; or to persons of other descriptions, whose fortunes have been interesting to the human passions, have, in turn, divided mankind into parties, inflamed them with mutual animosity, and rendered them much more disposed to vex and oppress each other, than to co-operate

for their common good. So strong is this propensity of mankind, to fall into mutual animosities, that where no substantial occasion presents itself, the most frivolous and fanciful distinctions have been sufficient to kindle their unfriendly passions, and excite their most violent conflicts. But the most common and durable source of factions has been the various and unequal distribution of property. Those who hold, and those who are without property, have ever formed distinct interests in society. Those who are creditors, and those who are debtors, fall under a like discrimination. A landed interest, a manufacturing interest, a mercantile interest, a moneyed interest, with many lesser interests, grow up of necessity in civilized nations, and divide them into different classes, actuated by different sentiments and views. The regulation of these various and interfering interests forms the principal task of modern legislation, and involves the spirit of party and faction in the necessary and ordinary operations of government.

No man is allowed to be a judge in his own cause; because his interest will certainly bias his judgment, and, not improbably, corrupt his integrity. With equal, nay, with greater reason, a body of men are unfit to be both judges and parties at the same time; yet what are many of the most important acts of legislation, but so many judicial determinations, not indeed concerning the rights of single persons, but concerning the rights of large bodies of citizens? and what are the different classes of legislators, but advocates and parties to the causes which they determine? Is a law proposed concerning private debts? It is a question to which the creditors are parties on one side, and the debtors on the other. Justice ought to hold the balance between them. Yet the parties are, and must be, themselves the judges: and the most numerous party, or, in other words, the most powerful faction, must be expected to prevail. Shall domestic manufactures be encouraged. and in what degree, by restrictions on foreign manufactures? are questions which would be differently decided by the landed and the manufacturing classes; and probably by neither with a sole regard to justice and the public good. The apportionment of taxes, on the various descriptions of property, is an act which seems to require the most exact impartiality; yet there is, perhaps, no legislative act, in which greater opportunity and temptation are given to a predominant party, to trample on the rules of justice. Every shilling, with which they overburden the inferior number, is a shilling saved to their own pockets.

It is in vain to say, that enlightened statesmen will be able to adjust these clashing interests, and render them all subservient to the public good. Enlightened statesmen will not always be at the helm: nor, in many cases, can such an adjustment be made at all, without taking into view indirect and remote considerations, which will rarely prevail over the immediate interest which one party may find in disregarding the rights of another, or the good of the whole.

The inference to which we are brought is, that the *causes* of faction cannot be removed; and that the relief is only to be sought in the means of controlling its *effects*.

If a faction consists of less than a majority, relief is supplied by the republican principle, which enables the majority to defeat its sinister views, by regular vote. It may clog the administration, it may convulse the society; but it will be unable to execute and mask its violence under

the forms of the constitution. When a majority is included in a faction, the form of popular government, on the other hand, enables it to sacrifice to its ruling passion or interest, both the public good and the rights of other citizens. To secure the public good, and private rights, against the danger of such a faction, and at the same time to preserve the spirit and the form of popular government, is then the great object to which our inquiries are directed.

NUMBER 51 (HAMILTON OR MADISON)

To what expedient then shall we finally resort, for maintaining in practice the necessary partition of power among the several departments, as laid down in the constitution? The only answer that can be given is, that as all these exterior provisions are found to be inadequate, the defect must be supplied, by so contriving the interior structure of the government, as that its several constituent parts may, by their mutual relations, be the means of keeping each other in their proper places. Without presuming to undertake a full development of this important idea, I will hazard a few general observations, which may, perhaps, place it in a clearer light, and enable us to form a more correct judgment of the principles and structure of the government planned by the convention.

In order to lay a due foundation for that separate and distinct exercise of the different powers of government, which, to a certain extent, is admitted on all hands to be essential to the preservation of liberty, it is evident that each department should have a will of its own; and consequently should be so constituted, that the members of each should have as

little agency as possible in the appointment of the members of the others. Were this principle rigorously adhered to, it would require that all the appointments for the supreme executive, legislative, and judiciary magistracies, should be drawn from the same fountain of authority, the people, through channels, having no communication whatever with one another. Perhaps such a plan of constructing the several departments, would be less difficult in practice, than it may in contemplation appear. Some difficulties, however, and some additional expense, would attend the execution of it. Some deviations, therefore, from the principle must be admitted. In the constitution of the judiciary department in particular, it might be inexpedient to insist rigorously on the principle, first, because peculiar qualifications being essential in the members, the primary considerations ought to be to select that mode of choice, which best secures these qualifications; secondly, because the permanent tenure by which the appointments are held in that department, must soon destroy all sense of dependence on the authority conferring them.

It is equally evident, that the members of each department should be as little dependent as possible on those of the others, for the emoluments annexed to their offices. Were the executive magistrate, or the judges, not independent of the legislature in this particular, their independence in every other, would be merely nominal.

But the great security against a gradual concentration of the several powers in the same department, consists in giving to those who administer each department, the necessary constitutional means, and personal motives, to resist encroachments of the others. The provision for defence

must in this, as in all other cases, be made commensurate to the danger of attack. Ambition must be made to counteract ambition. The interest of the man must be connected with the constitutional rights of the place. It may be a reflection on human nature, that such devices should be necessary to control the abuses of government. But what is government itself, but the greatest of all reflections on human nature? If men were angels, no government would be necessary. If angels were to govern men, neither external nor internal controls on government would be necessary. In framing a government, which is to be administered by men over men, the great difficulty lies in this: You must first enable the government to control the governed; and in the next place, oblige it to control itself. A dependence on the people is, no doubt, the primary control on the government; but experience has taught mankind the necessity of auxiliary precautions.

This policy of supplying by opposite and rival interests, the defect of better motives, might be traced through the whole system of human affairs, private as well as public. We see it particularly displayed in all the subordinate distributions of power; where the constant aim is, to divide and arrange the several offices in such a manner, as that each may be a check on the other; that the private interest of every individual, may be a sentinel over the public rights. These inventions of prudence cannot be less requisite to the distribution of the supreme powers of the state.

But it is not possible to give to each department an equal power of self-defence. In republican government, the legislative authority necessarily predominates. The remedy for this inconveniency is, to divide the legislature into different

branches; and to render them by different modes of election, and different principles of action, as little connected with each other, as the nature of their common functions, and their common dependence on the society will admit. It may even be necessary to guard against dangerous encroachments, by still further precautions. As the weight of the legislative authority requires that it should be thus divided, the weakness of the executive may require, on the other hand, that it should be fortified. An absolute negative on the legislature, appears, at first view, to be the natural defense with which the executive magistrate should be armed. But perhaps it would be neither altogether safe, nor alone sufficient. On ordinary occasions, it might not be exerted with the requisite firmness; and on extraordinary occasions, it might be perfidiously abused. May not this defect of an absolute negative be supplied by some qualified connexion between this weaker department, and the weaker branch of the stronger department, by which the latter may be led to support the constitutional rights of the former, without being too much detached from the rights of its own department?

If the principles on which these observations are founded be just, as I persuade myself they are, and they be applied as a criterion to the several state constitutions, and to the federal constitution, it will be found, that if the latter does not perfectly correspond with them, the former are infinitely less able to bear such a test. . . .

There are, moreover, two considerations particularly applicable to the federal system of America, which place it in a very interesting point of view.

First. In a single republic, all the power surrendered by the people is submitted to the administration of a single government; and the usurpations are guarded against, by a division of the government into distinct and separate departments. In the compound republic of America, the power surrendered by the people is first divided between two distinct governments, and then the portion allotted to each subdivided among distinct and separate departments. Hence a double security arises to the rights of the people. The different governments will control each other; at the same time each will be controlled by itself.

Second. It is of great importance in a republic, not only to guard the society against the oppression of its rulers; but to guard one part of the society against the injustice of the other part. Different interests necessarily exist in different classes of citizens. If a majority be united by a common interest, the rights of the minority will be insecure. There are but two methods of providing against this evil: The one by creating a will in the community independent of the majority, that is, of the society itself; the other by comprehending in the society so many separate descriptions of citizens, as will render an unjust combination of a majority of the whole very improbable, if not impracticable. The first method prevails in all governments possessing an hereditary or self-appointed authority. This, at best, is but a precarious security; because a power independent of the society may as well espouse the unjust views of the major, as the rightful interests of the minor party, and may possibly be turned against both parties. The second method will be exemplified in the federal republic of the United States. Whilst all authority in it will be derived from, and dependent on the society, the society itself will be broken into so many parts, interests, and classes of citizens, that the rights of indi-

viduals, or of the minority, will be in little danger from interested combinations of the majority. In a free government, the security for civil rights must be the same as that for religious rights. It consists in the one case in the multiplicity of interests, and in the other, in the multiplicity of sects. The degree of security in both cases will depend on the number of interests and sects; and this may be presumed to depend on the extent of country and number of people comprehended under the same government. This view of the subject must particularly recommend a proper federal system, to all the sincere and considerate friends of republican government: since it shows that, in exact proportion, as the territory of the union may be formed into more circumscribed confederacies, or states, oppressive combinations of a majority will be facilitated. the best security under the republican form, for the rights of every class of citizens, will be diminished; and consequently, the stability and independence of some member of the government, the only other security must be proportionably increased. Justice is the end of government. It is the end of civil society. It ever has been, and ever will be pursued, until it be obtained, or until liberty be lost in the pursuit. In a society under the forms of which the stronger faction can readily unite and oppress the weaker, anarchy may as truly be said to reign, as in a state of nature where the weaker individual is not secured against the violence of the stronger: And as in the latter state even the stronger individuals are prompted by the uncertainty of their condition, to submit to a government, which may protect the weak as well as themselves: so in the former state, will the more powerful factions be gradually induced by a like motive to wish for a government which will

protect all parties, the weaker as well as the more powerful. It can be little doubted, that if the state of Rhode Island was separated from the confederacy, and left to itself, the insecurity of rights under the popular form of government within such narrow limits, would be displayed by such reiterated oppressions of factious majorities, that some power altogether independent of the people, would soon be called for by the voice of the very factions whose misrule had proved the necessity of it. In the extended republic of the United States, and among the great variety of interests, parties and sects, which it embraces, a coalition of a majority of the whole society could seldom take place upon any other principles, than those of justice and the general good: Whilst there being thus less danger to a minor from the will of the major party, there must be less pretext also, to provide for the security of the former, by introducing into the government a will not dependent on the latter: or, in other words, a will independent of the society itself. It is no less certain that it is important, notwithstanding the contrary opinions which have been entertained, that the larger the society, provided it lie within a practicable sphere, the more duly capable it will be of self-government. And happily for the republican cause, the practicable sphere may be carried to a very great extent by a judicious modification and mixture of the federal principle.

2. THE FRENCH REVOLUTION

Arthur Young (1741–1820), the son of a Suffolk clergyman, was best known in his time as a practical farmer and as a writer on agricultural subjects. To us, however, he is interesting as one of the most intelligent and readable diarists of his time. The notes he kept as he traveled through Europe in the eighties of the eighteenth century contain clear-sighted descriptions of the circumstances and mood of the people he observed and mixed with. Here are some of his experiences in France between 1787 and 1789.

Arthur Young: from Travels in France

August 3, 1787 At Mirepoix they are building a most magnificent bridge of seven flat arches, each of 64 feet span, which will cost 1,800,000 livres (gold); it has been 12 years erecting, and will be finished in two more. The weather for several days has been as fine as possible, but very hot; today the heat was so disagreeable, that I rested from 12 to 3 at Mirepoix; and found it so burning, that it was an effort to go half a quarter of a mile to view the bridge. The myriads of flies were ready to devour me, and I could hardly

support any light in the room. Riding fatigued me, and I inquired for a carriage of some sort to carry me, while these great heats should continue; I had done the same at Carcassonne; but nothing like a cabriolet of any sort was to be had. When it is recollected that that place is one of the most considerable manufacturing towns in France, containing 15,000 people, and that Mirepoix is far from being a mean place, and yet not a voiture of any kind to be had, how will an Englishman bless himself for the universal conven-

From Arthur Young, Travels in France (London, 1890).

iences that are spread through his own country, in which I believe there is not a town of 1500 people in the kingdom where post chaises and able horses are not to be had at a moment's warning? What a contrast! This confirms the fact deducible from the little traffic on the roads even around Paris itself. Circulation is stagnant in France.—The heat was so great that I left Mirepoix disordered with it: this was by far the hottest day that I ever felt. The hemisphere seemed almost in a flame with burning rays that rendered it impossible to turn ones eyes within many degrees of the radiant orb that now blazed in the heavens.-Cross another fine new bridge of three arches; and come to a woodland, the first I have seen for a great distance. Many vines about Pamiers, which is situated in a beautiful vale, upon a fine river. The place itself is ugly, stinking, and ill built; with an inn! Adieu, Monsieur Gacit; if fate sends me to such another house as thine—be it an expiation for my sins!-28 miles.

August 4, 1787 Leaving Amous, there is the extraordinary spectacle of a river issuing out of a cavern in a mountain of rock; on crossing the hill you see where it enters by another cavern.—It pierces the mountain. Most countries, however, have instances of rivers passing under ground. At St. Geronds go to the Croix Blanche Inn, the most execrable receptacle of filth, vermin, impudence, and imposition that ever exercised the patient, or wounded the feelings of a traveller. A withered hag, the daemon of beastliness, presides there. I laid, not rested, in a chamber over a stable, whose effluviae through the broken floor were the least offensive of the perfumes afforded by this hideous place. —It could give me nothing but two stale eggs, for which I paid, exclusive of all other charges, 20 francs. Spain brought

nothing to my eyes that equalled this sink, from which an English hog would turn with disgust. But the inns all the way from Nismes are wretched, except at Lodève, Gange, Carcassonne, and Mirepoix. St. Geronds must have, from its appearance, four or five thousand people. Pamiers near twice that number. What can be the circulating connection between such masses of people and other towns and countries, that can be held together and supported by such inns? There have been writers who look upon such observations as rising merely from the petulance of travellers, but it shews their extreme ignorance. Such circumstances are political data. We cannot demand all the books of France to be opened in order to explain the amount of circulation in that kingdom: a politician must therefore collect it from such circumstances as he can ascertain; and among these, traffic on the great roads, and the convenience of the houses prepared for the reception of travellers, tell us both the number and the condition of those travellers; by which term I chiefly allude to the natives, who move on business or pleasure from place to place; for if they are not considerable enough to cause good inns, those who came from a distance will not, which is evident from the bad accommodations even in the high road from London to Rome. On the contrary, go in England to towns that contain 1500, 2000, or 3000 people, in situations absolutely cut off from all dependence on, or almost the expectation of, what are properly called travellers, yet you will meet with neat inns, well dressed and clean people keeping them, good furniture, and a refreshing civility; your senses may not be gratified, but they will not be offended; and if you demand a post chaise and a pair of horses, the cost of which is not less than 80

pounds in spite of a heavy tax, it will be ready to carry you whither you please. Are no political conclusions to be drawn from this amazing contrast? It proves that such a population in England have connections with other places to the amount of supporting such houses. The friendly clubs of the inhabitants, the visits of friends and relations, the parties of pleasure, the resort of farmers, the intercourse with the capital and with other towns, form the support of good inns; and in a country where they are not to be found, it is a proof that there is not the same quantity of motion; or that it moves by means of less wealth, less consumption, and less enjoyment. In this journey through Languedoc, I have passed an incredible number of splendid bridges, and many superb causeways. But this only proves the absurdity and oppression of government. Bridges that cost 70 or 80,-000 pounds and immense causeways to connect towns, that have no better inns than such as I have described, appear to be gross absurdities. They cannot be made for the mere use of the inhabitants, because one-fourth of the expense would answer the purpose of the real utility. They are therefore objects of public magnificence, and consequently for the eye of travellers. But what traveller, with his person surrounded by the beggarly filth of an inn, and with all his senses offended, will not condemn such inconsistencies as folly, and will not wish for more comfort and less appearance of splendour?-30 miles.

August 23, 1787 Pass a rich and highly cultivated vale to Aguillon; much hemp, and every woman in the country employed on it. Many neat well built farmhouses on small properties, and all the country very populous. View the chateau of the Duc d'Aguillon, which, being in

the town, is badly situated, according to all rural ideas; but a town is ever an accompanyment of a chateau in France, as it was formerly in most parts of Europe; it seems to have resulted from a feudal arrangement, that the Grand Seigneur might keep his slaves the nearer to his call, as a man builds his stables near his house. This edifice is a considerable one, built by the present duke; began about twenty years ago, when he was exiled here during eight years. And, thanks to that banishment, the building went on nobly; the body of the house done, and the detached wings almost finished. But as soon as the sentence was reversed, the duke went to Paris, and has not been here since, consequently all now stands still. It is thus that banishment alone will force the French nobility to execute what the English do for pleasure—reside upon and adorn their estates. There is one magnificent circumstance, namely, an elegant and spacious theatre; it fills one of the wings. The orchestra is for twenty-four musicians, the number kept, fed, and paid, by the duke when here. This elegant and agreeable luxury, which falls within the compass of a very large fortune, is known in every country in Europe except England: the possessors of great estates here preferring horses and dogs very much before any entertainment a theatre can yield. To Tonnance. -25 miles.

August 24, 1787 Many new and good country seats, of gentlemen, well built, and set off with gardens, plantations, etc. These are the effects of the wealth of Bordeaux. These people, like other Frenchmen, eat little meat; in the town of Levrac five oxen only are killed in a year; whereas an English town with the same population would consume two or three oxen a week.

October 13, 1787 There has been much rain to-day; and it is almost incredible to a person used to London, how dirty the streets of Paris are, and how horribly inconvenient and dangerous walking is without a footpavement. We had a large party at dinner, with politicians among them, and some interesting conversation on the present state of France. The feeling of every body seems to be that the King's minister, Loménie de Brienne, will not be able to do any thing towards exonerating the state from the burthen of its present situation; some think that he has not the inclination; others that he has not the ability. By some he is thought to be attentive only to his own interest; and by others, that the finances are too much deranged to be within the power of any system to recover, short of the states-general of the kingdom; and that it is impossible for such an assembly to meet without a revolution in the government ensuing. All seem to think that something extraordinary will happen; and a bankruptcy is an idea not at all uncommon. But who is there that will have the courage to make it?

October 14, 1787 To the benedictine abbey of St. Germain, to see pillars of African marble, etc. It is the richest abbey in France: the abbot has 300,000 liv. a year. I lose my patience at such revenues being thus bestowed; consistent with the spirit of the tenth century, but not with that of the eighteenth. What a noble farm would the fourth of this income establish! what turnips, what cabbages, what potatoes, what clover, what sheep, what wool! -Are not these things better than a fat ecclesiastic? If an active English farmer was mounted behind this abbot, I think he would do more good to France with half the income than half the abbots of the kingdom with the whole of theirs. Pass the Bastile; another pleasant object to make agreeable emotions vibrate in a man's bosom. I search for good farmers, and run my head at every turn against monks and state prisoners.

October 17, 1787 Dined to-day with a party, whose conversation was entirely political. Mons. de Calonne's "Request to the King" is come over, and all the world are reading and disputing on it. It seems, however, generally agreed that, without exonerating himself from the charge of the speculation, he has thrown no inconsiderable load on the shoulders of Loménie, the present premier, who will be puzzled to get rid of the attack. But both these ministers were condemned on all hands in the lump; as being absolutely unequal to the difficulties of so arduous a period. One opinion pervaded the whole company, that they are on the eve of some great revolution in the government: that every thing points to it: the confusion in the finances great; with a deficit impossible to provide for without the statesgeneral of the kingdom, yet no ideas formed of what would be the consequence of their meeting: no minister existing, or to be looked to in or out of power, with such decisive talents as to promise any other remedy than palliative ones: a prince on the throne, with excellent dispositions, but without the resources of a mind that could govern in such a moment without ministers: a court buried in pleasure and dissipation; and adding to the distress, instead of endeavouring to be placed in a more independent situation: a great ferment amongst all ranks of men, who are eager for some change, without knowing what to look to, or to hope for: and a strong leaven of liberty, increasing every hour since the American revolution: altogether form a combination of circumstances that promise e'er long to ferment

into motion, if some master hand, of very superior talents, and inflexible courage, is not found at the helm to guide events, instead of being driven by them. It is very remarkable, that such conversation never occurs, but a bankruptcy is a topic: the curious question on which is, would a bankruptcy occasion a civil war, and a total overthrow of the government? The answers that I have received to this question, appear to be just: such a measure, conducted by a man of abilities, vigour, and firmness, would certainly not occasion either one or the other. But the same measure, attempted by a man of a different character, might possibly do both. All agree, that the states of the kingdom cannot assemble without more liberty being the consequence; but I meet with so few men that have any just ideas of freedom, that I question much the species of this new liberty that is to arise. They know not how to value the privileges of THE PEOPLE: as to the nobility and the clergy, if a revolution added anything to their scale, I think it would do more mischief than good.

October 20, 1787 To the Ecole Militaire, established by Louis XV for the education of 140 youths, the sons of the nobility; such establishments are equally ridiculous and unjust. To educate the son of a man who cannot afford the education himself, is a gross injustice, if you do not secure a situation in life answerable to that education. If you do secure such a situation, you destroy the result of the education, because nothing but merit ought to give that security. You educate the children of men, who are well able to give the education themselves, you tax the people who cannot afford to educate their children, in order to ease those who can well afford the burthen; and in such institutions, this is sure to be the case. At night to l'Ambigu Comique, a pretty little theatre, with plenty of rubbish on it. Coffee-houses on the boulevards, music, noise, and whores without end; every thing but scavengers and lamps. The mud is a foot deep; and there are parts of the boulevards without a single light.

October 22, 1787 To the bridge of Neuilie, said to be the finest in France. It is by far the most beautiful one I have any where seen. It consists of five vast arches; flat, from the Florentine model; and all of equal span; a mode of building incomparably more elegant, and more striking than our system of different sized arches. To the machine at Marly; which ceases to make the least impression. Madame du Barry's residence, Lusienne, is on the hill just above this machine; she has built a pavilion on the brow of the declivity, for commanding the prospect, fitted up and decorated with much elegance. There is a table of Sèvres porcelain, exquisitely done. I forget how many thousand louis d'ors it cost. The French, to whom I spoke of Lusienne, exclaimed against mistresses and extravagance, with more violence than reason in my opinion. Who, in common sense, would deny a king the amusement of a mistress, provided he did not make a business of his plaything? "Look at Frederic the Great!" they say. "Did he have a mistress? Did he build her mansions? Did he waste his money furnishing them with porcelain?" No: but he had that which was fifty times worse: a king had better make love to a handsome woman than to one of his neighbour's provinces. The king of Prussia's mistress cost an hundred millions sterling, and the lives of 500,000 men; and before the reign of that mistress is over, may yet cost as much more. The greatest genius and talents are lighter than a feather, weighed philosophically,

if rapine, war, and conquest, are the effects of them.

October 25, 1787 This great city appears to be in many respects the most ineligible and inconvenient for the residence of a person of small fortune of any that I have seen; and vastly inferior to London. The streets are very narrow, and many of them crouded, nine tenths dirty, and all without foot-pavements. Walking, which in London is so pleasant and so clean, that ladies do it every day, is here a toil and a fatigue to a man, and an impossibility to a well dressed woman. The coaches are numerous and, what are much worse, there are an infinity of one-horse cabriolets, which are driven by young men of fashion and their imitators, alike fools, with such rapidity as to be real nuisances, and render the streets exceedingly dangerous, without an incessant caution. I saw a poor child run over and probably killed, and have been myself many times blackened with the mud of the kennels. This beggarly practice, of driving a one-horse booby hatch about the streets of a great capital, flows either from poverty or wretched and despicable economy; nor is it possible to speak of it with too much severity. If young noblemen at London were to drive their chaises in streets without foot-ways, as their brethren do at Paris, they would speedily and justly get very well threshed, or rolled in the kennel. This circumstance renders Paris an ineligible residence for persons, particularly families that cannot afford to keep a coach; a convenience which is as dear as at London. The fiacres, hackneycoaches, are much worse than at that city; and chairs there are none, for they would be driven down in the streets. To this circumstance also it is owing, that all persons of small or moderate fortune, are forced to dress in black, with black stock-

ings; the dusky hue of this in company is not so disagreeable a circumstance as being too great a distinction; too clear a line drawn in company between a man that has a good fortune, and another that has not. With the pride, arrogance, and ill temper of English wealth this could not be borne; but the prevailing good humour of the French eases all such untoward circumstances. Lodgings are not half so good as at London, yet considerably dearer. If you do not hire a whole suite of rooms at an hotel, you must probably mount three, four, or five pair of stairs, and in general have nothing but a bed-chamber. After the horrid fatigue of the streets, such an elevation is a delectable circumstance. You must search with trouble before you will be lodged in a private family, as gentlemen usually are at London, and pay a higher price. Servants' wages are about the same as at that city. It is to be regretted that Paris should have these disadvantages, for in other respects I take it to be a most eligible residence for such as prefer a great city. The society for a man of letters, or who has any scientific pursuit, cannot be exceeded. The intercourse between such men and the great, which if it is not upon an equal footing, ought never to exist at all, is respectable. Persons of the highest rank pay an attention to science and literature, and emulate the character they confer. I should pity the man who expected, without other advantage of a very different nature, to be well received in a brilliant circle at London, because he was a fellow of the Royal Society. But this would not be the case with a member of the Academy of Sciences at Paris; he is sure of a good reception every where. Perhaps this contrast depends in a great measure on the difference of the governments of the two countries. Politics are too much attended to in

England to allow a due respect to be paid to anything else; and should the French establish a freer government, academicians will not be held in such estimation, when rivalled in the public esteem by the orators who hold forth liberty and property in a free parliament.

August 13, 1788 Rouen is dearer than Paris, and therefore it is necessary for the pockets of the people that their bellies should be wholesomely pinched. At the table d'hôte, at the Pinecone Hotel we sat down, sixteen, to the following dinner, a soup, about 3 lb. of stew, one fowl, one duck, a small fricassee of chicken. roast of veal, of about 2 lb. and two other small plates with a sallad: the price 45 francs and 29 francs more for a pint of wine; at an ordinary of 20d.1 a head in England there would be a piece of meat which would, literally speaking, outweigh this whole dinner! The ducks were swept clean so quickly, that I moved from table without half a dinner. Such table d'hôtes are among the cheap things of France! Of all sombre and triste meetings a French table d'hôte is foremost; for eight minutes a dead silence, and as to the politeness of addressing a conversation to a foreigner, he will look for it in vain. Not a single word has any where been said to me unless to answer some question: Rouen not singular in this. The parliamenthouse here is shut up, and its members exiled a month past to their country seats, because they would not register the edict for a new land-tax. I inquired much into the common sentiments of the people, and found that the King personally from having been here, is more popular than the parliament, to whom they attribute the general dearness of everything.

September 2, 1788, Brittany. Rennes

is well built, and it has two good squares; that particularly of Louis XV, where is his statue. The parliament being in exile. the house is not to be seen. The Benedictines garden, called the Tabour, is worth viewing. But the object at Rennes most remarkable at present is a camp, with a marshal of France (de Stainville). and four regiments of infantry, and two of dragoons, close to the gates. The discontents of the people have been double, first on account of the high price of bread and secondly for the banishment of the parliament. The former cause is natural enough, but why the people should love their parliament was what I could not understand, since the members, as well as of the states, are all noble, and the distinction between the nobles and commoners no where stronger, more offensive, or more abominable than in Bretagne. They assured me, however, that the populace have been blown up to violence by every art of deception, and even by money distributed for that purpose. The commotions rose to such a height before the camp was established, that the troops here were utterly unable to keep the peace. Mon. Argentaise, to whom I had brought letters, had the goodness, during the four days I was here, to shew and explain every thing to be seen. I find Rennes very cheap; and it appears the more so to me just come from Normandy, where every thing is extravagantly dear. The table d'hôte, at the grand maison, is well served; they give two courses, containing plenty of good things, and a very ample regular dessert: the supper one good course, with a large joint of mutton, and another good dessert; each meal, with the common wine, 40 francs and for 20 more you have very good wine, instead of the

¹ 20 pence = in those days, about 30 cents. There are 20 shillings in one pound, 12 pence in one shilling. Five shillings were about one dollar; the franc was two for a penny.

ordinary sort: 30 francs for the horse: thus, with good wine, it is no more than 6 liv. 10 francs a day, or 5s. 10d. Yet a camp which they complain has raised prices enormously.

September 5, 1788 To Montauban. The poor people seem poor indeed; the children terribly ragged, if possible worse clad than if with no cloaths at all; as to shoes and stockings they are luxuries. A beautiful girl of six or seven years playing with a stick, and smiling under such a bundle of rags as made my heart ache to see her: they did not beg, and when I gave them any thing seemed more surprised than obliged. One third of what I have seen of this province seems uncultivated, and nearly all of it in misery. What have kings, and ministers, and parliaments, and states, to answer for their prejudices, seeing millions of hands that would be industrious, idle and starving, through the execrable maxims of despotism, or the equally detestable prejudices of a feudal nobility. Sleep at the Lion d'or, at Montauban, an abominable hole. -20 miles.

September 6, 1788 The same inclosed country to Brooms; but near that town improves to the eye, from being more hilly. At the little town of Lamballe, there are above fifty families of noblesse that live in winter, who reside on their estates in the summer. There is probably as much foppery and nonsense in their circles, and for what I know as much happiness, as those of Paris. Both would be better employed in cultivating their lands, and rendering the poor industrious.

1789 My two preceding journeys had crossed the whole western half of France, in various directions; and the information I had received in making them, had made me as much a master of the general husbandry, the soil, management and pro-

ductions, as could be expected, without penetrating in every corner, and residing long in various stations; a method of surveying such a kingdom as France, that would demand several lives instead of years. The eastern part of the kingdom remained. The great mass of country, formed by the triangle, whose three points are Paris, Strasbourg and Moulins, and the mountainous region S. E. of the last town, presented in the map an ample space, which it would be necessary to pass before I could have such an idea of the kingdom as I had planned the acquisition; I determined to make this third effort, in order to accomplish a design which appeared more and more important, the more I reflected on it; and less likely to be executed by those whose powers are better adapted to the undertaking than mine. The meeting of the States General of France also, who were now assembled. made it the more necessary to lose no time; for in all human probability, that assembly will be the epoch of a new constitution, which will have new effects. and, for what I know, attended with a new agriculture; and to have the regal sun in such a kingdom, both rise and set without the territory being known, must of necessity be regretted by every man solicitous for real political knowledge. The events of a century and half, including the brilliant reign of Louis XIV, will for ever render the sources of the French power interesting to mankind, and particularly that its state may be known previous to the establishment of an improved government, as the comparison of the effects of the old and new system will be not a little curious in future.

June 8, 1789, Paris. To my friend Lazowski, to know where were the lodgings I had written him to hire me, but my good dutchess d'Estissac would not allow him

to execute my commission. I found an apartment in her house 'prepared for me. Paris is at present in such a ferment about the States General, now holding at Versailles, that conversation is absolutely absorbed by them. Not a word of any thing else talked of. Every thing is considered, and justly so, as important in such a crisis of the fate of four-and-twenty millions of people. It is now a serious contention whether the representatives are to be called the Commoners or Tiers Etat; they call themselves steadily the former, while the court and the great lords reject the term with a species of apprehension, as if it involved a meaning not easily to be fathomed. But this point is of little consequence, compared with another, that has kept the states for sometime in inactivity, the verification of their power separately or in common. The nobility and the clergy demand the former, but the Commons steadily refuse it; the reason why a circumstance, apparently of no great consequence, is thus tenaciously regarded, is that it may decide their sitting for the future in separate houses or in one. Those who are warm for the interest of the people declare that it will be impossible to reform some of the grossest abuses in the state, if the nobility, by sitting in a separate chamber, shall have a negative on the wishes of the people: and that to give such a veto to the clergy would be still more preposterous; if therefore, by the verification of their powers in one chamber, they shall once come together, the popular party hope that there will remain no power afterwards to separate. The nobility and clergy foresee the same result, and will not therefore agree to it. In this dilemma it is curious to remark the feelings of the moment. It is not my business to write memoirs of what passes, but I am intent to catch, as well as I can, the

opinions of the day most prevalent. While I remain at Paris, I shall see people of all descriptions, from the coffee-house politicians to the leaders in the estates: and the chief object of such rapid notes as I throw on paper, will be to catch the ideas of the moment; to compare them afterwards with the actual events that shall happen, will afford amusement at least. The most prominent feature that appears at present is, that an idea of common interest and common danger does not seem to unite those, who, if not united, may find themselves too weak to oppose the common danger that must arise from the people being sensible of a strength the result of their weakness. The king, court, nobility, clergy, army, and parliament, are nearly in the same situation. All these consider, with equal dread, the ideas of liberty, now afloat; except the first, who, for reasons obvious to those who know his character, troubles himself little, even with circumstances that concern his power the most intimately. Among the rest, the feeling of danger is common, and they would unite, were there a head to render it easy, in order to do without the states at all. That the commons themselves look for some such hostile union as more than probable, appears from an idea which gains ground, that they will find it necessary should the other two orders continue to refuse to unite with them in one chamber, to declare themselves boldly the representatives of the kingdom at large, calling on the nobility and clergy to take their places—and to enter upon deliberations of business without them, should they refuse it. All conversation at present is on this topic, but opinions are more divided than I should have expected. There seem to be many who hate the clergy so cordially, that rather than permit them to form a distinct chamber

576

would venture on a new system, dangerous as it might prove.

June 9, 1789 The business going forward at present in the pamphlet shops of Paris is incredible. I went to the Palais Royal to see what new things were published, and to procure a catalogue of all. Every hour produces something new. Thirteen came out today, sixteen vesterday, and ninety-two last week. We think sometimes that book shops at London are crouded, but they are mere deserts, compared to Desein's, and some others here, in which one can scarcely squeeze from the door to the counter. The price of printing two years ago was from 27 liv. to 30 liv. per sheet, but now it is from 60 liv. to 80 liv. This spirit of reading political tracts, they say, spreads into the provinces, so that all the presses of France are equally employed. Nineteen-twentieths of these productions are in favour of liberty, and commonly violent against the clergy and nobility; I have to-day bespoke many of this description, that have reputation; but enquiring for such as had appeared on the other side of the question, to my astonishment I find there are but two or three that have merit enough to be known. Is it not wonderful, that while the press teems with the most levelling and even seditious principles, that if put in execution would overturn the monarchy, nothing in reply appears, and not the least step is taken by the court to restrain this extreme licentiousness of publication. It is easy to conceive the spirit that must thus be raised among the people. But the coffee-houses in the Palais Royal present yet more singular and astonishing spectacles; they are not only crouded within, but other expectant crouds are at the doors and windows, listening open-mouthed to certain orators, who from chairs or tables harangue each

his little audience: the eagerness with which they are heard, and the thunder of applause they receive for every sentiment of more than common hardiness or violence against the present government, cannot easily be imagined. I am all amazement at the ministry permitting such nests and hotbeds of sedition and revolt, which disseminate amongst the people, every hour, principles that by and by must be opposed with vigour, and therefore it seems little short of madness to allow the propagation at present.

June 10, 1789 Every thing conspires to render the present period in France critical: the want of bread is terrible: accounts arrive every moment from the provinces of riots and disturbances, and calling in the military, to preserve the peace of the markets. The prices reported are the same as I found at Abbeville and Amiens: 5 francs (2½ d.) a pound for white bread, and 31/2 francs to 4 francs for the common sort, eaten by the poor: these rates are beyond their faculties, and occasion great misery. At Meudon, the police, that is to say the intendant, ordered that no wheat should be sold on the market without the person taking at the same time an equal quantity of barley. What a stupid and ridiculous regulation, to lay obstacles on the supply, in order to be better supplied; and to shew the people the fears and apprehensions of government, creating thereby an alarm, and raising the price at the very moment they wish to sink it. I have had some conversation on this topic with well informed persons, who have assured me that the price is, as usual, much higher than the proportion of the crop demanded, and there would have been no real scarcity if Mr. Necker would have let the corn-trade alone: but his edicts of restriction, which have been mere comments on his book on

the legislation of corn, have operated more to raise the price than all other causes together. It appears plain to me, that the violent friends of the commons are not displeased at the high price of corn, which seconds their views greatly, and makes any appeal to the common feeling of the people more easy, and much more to their purpose than if the price was low. Three days past, the chamber of the clergy contrived a cunning proposition; it was to send a deputation to the commons, proposing to name a commission from the three orders to take into consideration the misery of the people, and to deliberate on the means of lowering the price of bread. This would have led to the deliberation by order, and not by heads, consequently must be rejected, but unpopularly so from the situation of the people: the commons were equally dextrous; in their reply, they prayed and conjured the clergy to join them in the common hall of the states to deliberate, which was no sooner reported at Paris than the clergy became doubly an object of hatred; and it became a question with the politicians of the Caffé de Foy, whether it was not lawful for the commons to decree the application of their estates towards easing the distress of the people.

June 11, 1789 I have been in much company all day, and cannot but remark, that there seem to be no settled ideas of the best means of forming a new constitution. Yesterday the Abbé Sieyès made a motion in the house of commons, to declare boldly to the privileged orders, that if they will not join the commons, the latter will proceed in the national business without them; and the house decreed it, with a small amendment. This causes much conversation on what will be the consequence of such a proceeding; and on the contrary, on what may flow from

the nobility and clergy continuing steadily to refuse to join the commons, and should they so proceed, to protest against all they decree, and appeal to the King to dissolve the states, and recall them in such a form as may be practicable for business. In these most interesting discussions, I find a general ignorance of the principles of government; a strange and unaccountable appeal, on one side, to ideal and visionary rights of nature; and, on the other, no settled plan that shall give security to the people for being in future in a much better situation than hitherto; a security absolutely necessary. But the nobility, with the principles of great lords that I converse with, are most disgustingly tenacious of all old rights, however hard they may bear on the people; they will not hear of giving way in the least to the spirit of liberty, beyond the point of paying equal land-taxes, which they hold to be all that can with reason be demanded. The popular party, on the other hand, seem to consider all liberty as depending on the privileged classes being lost, and outvoted in the order of the commons, at least for making the new constitution; and when I urge the great probability, that should they once unite, there will remain no power of ever separating them; and that in such a case, they will have a very questionable constitution, perhaps a very bad one; I am always told, that the first object must be for the people to get the power of doing good; and that it is no argument against such a conduct to urge that an ill use may be made of it. But among such men, the common idea is, that anything tending towards a separate order, like our house of lords, is absolutely inconsistent with liberty; all which seems perfectly wild and unfounded.

June 15, 1789 This has been a rich

578

day, and such an one as ten years ago none could believe would ever arrive in France; a very important debate being expected on what, in our house of commons, would be termed the state of the nation. My friend Mons. Lazowski and myself were at Versailles by eight in the morning. We went immediately to the hall of the states to secure good seats in the gallery; we found some deputies already there, and a pretty numerous audience collected. The room is too large; none but stentorian lungs, or the finest clearest voices can be heard; however, the very size of the apartment, which admits 2000 people, gave a dignity to the scene. It was indeed an interesting one. The spectacle of the representatives of twentyfive millions of people, just emerging from the evils of 200 years of arbitrary power, and rising to the blessings of a freer constitution, assembled with open doors under the eve of the public, was framed to call into animated feelings every latent spark, every emotion of a liberal bosom. To banish whatever ideas might intrude of their being a people too often hostile to my own country,-and to dwell with pleasure on the glorious idea of happiness to a great nation—of felicity to millions vet unborn.

In regard to their general method of proceeding, there are two circumstances in which they are very deficient: the spectators in the galleries are allowed to interfere in the debates by clapping their hands, and other noisy expressions of approbation: this is grossly indecent; it is also dangerous; for, if they are permitted to express approbation, they are, by parity of reason, allowed expressions of dissent; and they may hiss as well as clap; which it is said, they have sometimes done:—this would be, to over-rule the debate and influence the deliberations. Another cir-

cumstance, is the want of order among themselves; more than once today there were a hundred members on their legs at a time, and the President, Monsieur Bailly absolutely without power to keep order.

July 9, 1789 To Châlons, through a poor country and poor crops. M. de Broussonet had given me a letter to Mons. Sabbatier, secretary to the academy of sciences, but he was absent. A regiment passing to Paris, an officer at the inn addressed me in English: —He had learned, he said. in America, damme!—He had taken lord Cornwallis, damme!-Maréchal Broglie was appointed to command an army of 50,000 men near Paris—it was necessary —the third estate were running mad and wanted some wholesome correction: —they want to establish a republic—absurd! Pray, Sir, what did you fight for in America? To establish a republic. What was so good for the Americans, is it so bad for the French? Aye, damme! that is the way the English want to be revenged. It is, to be sure, no bad opportunity. Can the English follow a better example? He then made many inquiries about what we thought and said upon it in England: and I may remark, that almost every person I meet has the same idea—The English must be very well contented at our confusion. They feel pretty pointedly what they deserve. - 121/2 miles.

July 14, 1789 They have a reading room at Metz, and they admit any person to read or go in and out for a day, on paying 4 francs. To this I eagerly resorted, and the news from Paris, both in the public prints, and by the information of a gentleman, I found to be interesting. Versailles and Paris are surrounded by troops: 35,000 men are assembled, and 20,000 more on the road, large trains of

artillery collected, and all the preparations of war. The assembling of such a number of troops has added to the scarcity of bread; and the magazines that have been made for their support, are not easily by the people distinguished from those they suspect of being collected by monopolists. This has aggravated their evils almost to madness; so that the confusion and tumult of the capital are extreme. A gentleman of an excellent understanding. and apparently of consideration, from the attention paid him, with whom I had some conversation on the subject, lamented in the most pathetic terms, the situation of his country; he considers a civil war as impossible to be avoided. There is not, he added, a doubt but the court, finding it impossible to bring the National Assembly to terms, will get rid of them; a bankruptcy at the same moment is inevitable: the union of such confusion must be a civil war; and it is now only by torrents of blood that we have any hope of establishing a freer constitution: yet it must be established; for the old government is rivetted to abuses that are insupportable. He agreed with me entirely, that the propositions of the royal sitting, though certainly not sufficiently satisfactory, yet, were the ground for a negotiation, that would have secured by degrees all even that the sword can give us, let it be as successful as it will. The purse —the power of the purse is everything; skilfully managed, with so necessitous a government as ours, it would, one after another, have gained all we wished. As to a war, Heaven knows the event; and if we have success, success itself may ruin us; France may have a Cromwell in its bosom, as well as England.

July 20, 1789 To Strasbourg, through one of the richest scenes of soil and cultivation to be met with in France, and

rivalled only by Flanders, which however, exceeds it. I arrived there at a critical moment, which I thought would have broken my neck; a detachment of horse, with their trumpets on one side, a party of infantry, with their drums beating on the other, and a great mob hallooing, frightened my French mare; and I could scarcely keep her from trampling on Messrs. the tiers état. On arriving at the inn, hear the interesting news of the revolt of Paris. —The French Guards joining the people: the little dependence on the rest of the troops; the taking the Bastile; and the institution of the bourgeois militia: in a word, of the absolute overthrow of the old government. Everything being now decided, and the kingdom absolutely in the hands of the assembly, they have the power to make a new constitution, such as they think proper; and it will be a great spectacle for the world to view, in this enlightened age, the representatives of twenty-five millions of people sitting on the construction of a new and better order and fabric of liberty, than Europe has vet offered. It will now be seen, whether they will copy the constitution of England, freed from its faults, or attempt, from theory, to frame something absolutely speculative: in the former case, they will prove a blessing to their country; in the latter they will probably involve it in inextricable confusions and civil wars, perhaps not in the present period, but certainly at some future one. I hear nothing of their removing from Versailles; if they stay there under the control of an armed mob, they must make a government that will please the mob; but they will, I suppose, be wise enough to move to some central town Tours, Blois, or Orléans, where their deliberations may be free. But the Parisian spirit of commotion spreads quickly; it is here; the troops that were near breaking my neck, are employed, to keep an eye on the people who show signs of an intended revolt. They have broken the windows of some magistrates that are no favourites; and a great mob of them is at this moment assembled demanding clamourously to have meat at 5 franc a pound. They have a cry among them that will conduct them to good lengths,—No taxes and long live the estates!

July 21, 1789 I have spent some time this morning at the reading room, reading the gazettes and journals that give an account of the transactions at Paris: and I have had some conversation with several sensible and intelligent men on the present revolution. The spirit of revolt is gone forth into various parts of the kingdom; the price of bread has prepared the populace every where for all sorts of violence; at Lyons there have been commotions as furious as at Paris, and the same at a great many other places: Dauphiné is in arms: and Bretagne in absolute rebellion. The idea is, that the people will, from hunger, be driven to revolt; and when once they find any other means of subsistence than that of honest labour, every thing will be to be feared. Of such consequence it is to a country, and indeed to every country, to have a good police of corn; a police that shall by securing a high price to the farmer, encourage his culture enough to secure the people at the same time from famine. . . . Night . . . I have been witness to a scene curious to a foreigner; but dreadful to Frenchmen that are considerate. Passing through the square of the city hall, the mob were breaking the windows with stones, notwithstanding an officer and a detachment of horse was in the square. Perceiving that their numbers not only increased, but that they grew bolder and bolder every moment, I thought it worth staying to see what it would end in, and clambered on to the roof of a row of low stalls opposite the building, against which their malice was directed. Here I beheld the whole commodiously. Perceiving that the troops would not attack them, except in words and menaces, they grew more violent, and furiously attempted to beat the door in pieces with iron crows: placing ladders to the windows. In about a quarter of an hour, which gave time for the assembled magistrates to escape by a back door, they burst all open, and entered like a torrent with a universal shout of the spectators. From that minute a shower of casements, sashes, shutters. chairs, tables, sophas, books, papers, pictures, etc., rained incessantly from all the windows of the house, which is seventy or eighty feet long, and which was then succeeded by tiles, skirting boards, bannisters, frame-work, and every part of the building that force could detach. The troops, both horse and foot, were quiet spectators. They were at first too few to interpose, and, when they became more numerous, the mischief was too far advanced to admit of any other conduct than guarding every avenue around, permitting none to go to the scene of action, but letting every one that pleased retire with his plunder; guards being at the same time placed at the doors of the churches, and all public buildings. I was for two hours a spectator at different places of the scene, secure myself from the falling furniture, but near enough to see a fine lad of about 14 crushed to death by something as he was handing plunder to a woman, I suppose his mother, from the horror pictured in her countenance. I remarked several common soldiers, with their white cockades, among the plunderers, and instigating the mob even in sight of the officers of the detachment. There were amongst them, people so decently dressed, that I regarded them with no small surprise:—they destroyed all the public archives; the streets for some way around strewed with papers; this has been a wanton mischief; for it will be the ruin of many families unconnected with the magistrates.

July 26, 1789 For twenty miles to Lisle sur Daube, the country nearly as before; but after that, to Baume les Dames. It is all mountainous and rock, much wood, and many pleasing scenes of the river flowing beneath. The whole country is in the greatest agitation; at one of the little towns I passed, I was questioned for not having a cockade of the Third Estate. They said it was ordained by the Third, and, if I was not a Seigneur, I ought to obey. But suppose I am a Seigneur, what then, my friends?-What then? they replied sternly, why, be hanged; for that most likely is what you deserve. It was plain this was no moment for joking, the boys and girls began to gather, whose assembling has every where been the preliminaries of mischief; and if I had not declared myself an Englishman, and ignorant of the ordinance, I had not escaped very well. I immediately bought a cockade, but the hussey pinned it into my hat so loosely, that before I got to Lisle it blew into the river, and I was again in the same danger. My assertion of being English would not do. I was a Seigneur, perhaps in disguise, and without a doubt a great rogue. At this moment a priest came into the street with a letter in his hand: the people immediately collected around him, and he then read aloud a detail from Belfort giving an account of M. Necker's passing, with some general features of news from Paris, and assurances that the condition of the people would be improved. When he had finished, he ex-

horted them to abstain from all violence; and assured them, they must not indulge themselves with any ideas of impositions being abolished; which he touched on as if he knew that they had got such notions. When he retired, they again surrounded me, who had attended to the letter like others; were very menacing in their manner; and expressed many suspicions: I did not like my situation at all, especially on hearing one of them say that I ought to be secured till somebody would give an account of me. I was on the steps of the inn, and begged they would permit me a few words; I assured them, that I was an English traveller, and to prove it, I desired to explain to them a circumstance in English taxation, which would be a satisfactory comment on what the priest had told them, to the purport of which I could not agree. He had asserted, that the impositions must be paid was certain, but not as heretofore, as they might be paid as they were in England. Gentlemen, we have a great number of taxes in England, which you know nothing of in France; but the Third Estate, the poor do not pay them; they are laid on the rich; every window in a man's house pays; but if he has no more than six windows, he pays nothing; the rich for their horses, their carriages, and their servants, and even for liberty to kill their own partridges, but the poor farmer nothing of all this: and what is more, we have in England a tax paid by the rich for the relief of the poor; hence the assertion of the priest, that because taxes existed before they must exist again, did not at all prove that they must be levied in the same manner; our English method seemed much better. There was not a word of this discourse, they did not approve of; they seemed to think that I might be an honest fellow, which I confirmed, by crying: "Long live the Third

Estate and down with taxes," when they gave me a bit of a huzza, and I had no more interruption from them. My miserable French was pretty much on a par with their own patois. I got, however, another cockade, which I took care to have so fastened as to lose it no more. I do not half like travelling in such an unquiet and fermenting moment; one is not secure for a hour beforehand.—35 miles.

July 27, 1789 To Besançon; the country mountain, rock, and wood, above the river: some scenes are fine. I had not arrived an hour before I saw a peasant pass the inn on horseback, followed by an officer of the bourgeois militia, of which there are 1200 here, and 200 under arms, and his party-coloured detachment. and those by some infantry and cavalry. I asked, why the militia took the place of the King's troops. For a very good reason, they replied, the troops would be attacked and knocked on the head, but the populace will not resist the milice. This peasant, who is a rich proprietor, applied for a guard to protect his house, in a village where there is much plundering and burning. The mischiefs which have been perpetrated in the country, towards the mountains and Vesoul, are numerous and shocking. Many chateaus have been burnt, others plundered, the seigneurs hunted down like wild beasts, their wives and daughters ravished, their papers and titles burnt, and all their property destroyed: and these abominations not inflicted on marked persons, who were odious for their former conduct or principles, but an indiscriminating blind rage for the love of plunder. Robbers, galleyslaves, and villains of all denominations, have collected and instigated the peasants to commit all sorts of outrages. Some gentlemen at the table informed me, that letters were received from the Mâconois, the

Lyonois, Auvergne, Dauphiné, etc. and that similar commotions and mischiefs were perpetrating every where; and that it was expected they would pervade the whole kingdom. The backwardness of France is beyond credibility in every thing that pertains to information. From Strasbourg hither, I have not been able to see a newspaper. Here I asked for the Reading Room. None. The gazettes? At the coffee-house. Very easily replied; but not so easily found. Nothing but the Gazette de France; for which at this period, a man of common sense would not give one cent. To four other coffee-houses; at some no paper at all, not even the Mercure; at the Caffé Militaire, the Courier de l'Europe a fortnight old; and well dressed people are now talking of the news of two or three weeks past, and plainly by their discourse know nothing of what is passing. The whole town of Besancon has not been able to afford me a sight of the Journal de Paris, nor of any paper that gives a detail of the transactions of the states; yet it is the capital of a province, large as half a dozen English counties, and containing 25,000 souls,—with strange to say! the post coming in but three times a week. At this eventful moment, with no license, nor even the least restraint on the press, not one paper established at Paris for circulation in the provinces, with the necessary steps taken by poster, or placard, to inform the people in all the towns of its establishment. For what the country knows to the contrary, their deputies are in the Bastile, instead of the Bastile being razed: so the mob plunder, burn, and destroy, in complete ignorance: and yet, with all these shades of darkness, these clouds of tenebrity, this universal mass of ignorance, there are men every day in the states, who are puffing themselves off for the FIRST NATION IN EUROPE! the GREATEST PEOPLE IN THE UNI-VERSE! as if the political juntos, or literary circles of a capital constituted a people; instead of the universal illumination of knowledge, acting by rapid intelligence on minds prepared by habitual energy of reasoning to receive, combine, and comprehend it. That this dreadful ignorance of the mass of the people, of the events that most intimately concern them, is owing to the old government, no one can doubt; it is however curious to remark, that if the nobility of other provinces are hunted like those of Franche Comté, of which there is little reason to doubt, that whole order of men undergo a proscription, suffer like sheep, without making the least effort to resist the attack. This appears marvellous, with a body that have an army of 150,000 men in their hands; for though a part of those troops would certainly disobey their leaders, yet let it be remembered, that out of the 40,000 or possibly 100,000 noblesse of France, they might, if they had intelligence and union

amongst themselves, fill half the ranks of more than half the regiments of the kingdom, with men who have fellow-feelings and fellow-sufferings with themselves; but no meetings, no associations among them; no union with military men; no taking refuge in the ranks of regiments to defend or avenge their cause; fortunately for France they fall without a struggle and die without a blow. That universal circulation of information, which in England transmits the least vibration of feeling or alarm, with electric sensibility, from one end of the kingdom to another, and which unites in bands of connection men of similar interests and situations, has no existence in France. Thus it may be said, perhaps with truth, that the fall of the king, courts, lords, nobles, army, church, and parliaments is owing to a want of information being quickly circulated, consequently is owing to the very effects of that thraldom in which they held the people: it is therefore a retribution rather than a punishment. - 18 miles

Sieyès: from What Is the Third Estate?

Emmanuel Joseph Sieyès was born at Fréjus, May 3, 1748. He was educated at a Jesuit school, became a licentiate of canon law, and was appointed vicar-general by the bishop of Chartres. He first came into prominence with the publication of his pamphlet entitled "Qu'est-ce que le tiers état?" In 1789 he was elected delegate to the States-General from Paris and in the preliminary struggle for organization was made spokesman of the third estate. The policy indicated in his pamphlet was that which was actually carried out in the conservative period of the Revolution. As the Revolution progressed Sieyès dropped out of sight and had the good fortune to escape destruction. When asked at a later period what he had done during the Terror, he summed up his whole experience in the words: "I survived." In 1795 he again came forward and was appointed member of a commission to draft a new constitution. His views did not obtain prominence in the constitution of 1795, and he refused to accept a position in the *Directoire*.

Sieyès took part with Napoleon in the coup d'état of the 18th Brumaire and made one of the provisional consulate with Napoleon and Ducos. Later on he was made a count of the Empire and given extensive estates as a reward for his services

to France. This marks Sieyès' final retirement from public life. He fled to Brussels on the second return of the Bourbons, returned after the revolution of 1830, and died in Paris on June 20, 1836.

What is necessary that a nation should subsist and prosper? Individual effort and public functions.

All individual efforts may be included in four classes: 1. Since the earth and the waters furnish crude products for the needs of man, the first class, in logical sequence, will be that of all families which devote themselves to agricultural labor. 2. Between the first sale of products and their consumption or use, a new manipulation, more or less repeated, adds to these products a second value more or less composite. In this manner human industry succeeds in perfecting the gifts of nature, and the crude product increases two-fold, ten-fold, one hundred-fold in value. Such are the efforts of the second class. 3. Between production and consumption, as well as between the various stages of production, a group of intermediary agents establish themselves, useful both to producers and consumers; these are the merchants and brokers: the brokers who, comparing incessantly the demands of time and place, speculate upon the profit of retention and transportation; merchants who are charged with distribution, in the last analysis, either at wholesale or at retail. This species of utility characterizes the third class. 4. Outside of these three classes of productive and useful citizens, who are occupied with real objects of consumption and use, there is also need in a society of a series of efforts and pains, whose objects are directly useful or agreeable to the individual. This fourth class embraces all those who stand between the most distinguished and

liberal professions and the less esteemed services of domestics.

Such are the efforts which sustain society. Who puts them forth? The Third Estate.

Public functions may be classified equally well, in the present state of affairs, under four recognized heads; the sword, the robe, the church and the administration. It would be superfluous to take them up one by one, for the purpose of showing that everywhere the Third Estate attends to nineteen-twentieths of them, with this distinction; that it is laden with all that which is really painful, with all the burdens which the privileged classes refuse to carry. Do we give the Third Estate credit for this? That this might come about, it would be necessary that the Third Estate should refuse to fill these places, or that it should be less ready to exercise their functions. The facts are well known. Meanwhile they have dared to impose a prohibition upon the order of the Third Estate. They have said to it: "Whatever may be your services, whatever may be your abilities, you shall go thus far; you may not pass beyond!" Certain rare exceptions, properly regarded, are but a mockery, and the terms which are indulged in on such occasions, one insult the more.

If this exclusion is a social crime against the Third Estate; if it is a veritable act of hostility, could it perhaps be said that it is useful to the public weal? Alas! who is ignorant of the effects of monopoly? If it discourages those whom it rejects, is it not well known that it

tends to render less able those whom it favors? Is it not understood that every employment from which free competition is removed, becomes dearer and less effective?

In setting aside any function whatsoever to serve as an appanage for a distinct class among citizens, is it not to be observed that it is no longer the man alone who does the work that it is necessary to reward, but all the unemployed members of that same caste, and also the entire families of those who are employed as well as those who are not? Is it not to be remarked that since the government has become the patrimony of a particular class, it has been distended beyond all measure; places have been created, not on account of the necessities of the governed, but in the interests of the governing, etc., etc.? Has not attention been called to the fact that this order of things, which is basely and-I even presume to say-beastly respectable with us, when we find it in reading the History of Ancient Egypt or the accounts of Voyages to the Indies, is despicable, monstrous, destructive of all industry, the enemy of social progress; above all degrading to the human race in general, and particularly intolerable to Europeans, etc., etc.? But I must leave these considerations, which, if they increase the importance of the subject and throw light upon it, perhaps, along with the new light, slacken our progress.

It suffices here to have made it clear that the pretended utility of a privileged order for the public service is nothing more than a chimera; that with it all that which is burdensome in this service is performed by the Third Estate; that without it the superior places would be infinitely better filled; that they naturally ought to be the lot and the recompense of

ability and recognized services, and that if privileged persons have come to usurp all the lucrative and honorable posts, it is a hateful injustice to the rank and file of citizens and at the same time a treason to the public weal.

Who then shall dare to say that the Third Estate has not within itself all that is necessary for the formation of a complete nation? It is the strong and robust man who has one arm still shackled. If the privileged order should be abolished, the nation would be nothing less, but something more. Therefore, what is the Third Estate? Everything; but an everything shackled and oppressed. What would it be without the privileged order? Everything, but an everything free and flourishing. Nothing can succeed without it, everything would be infinitely better without the others.

It is not sufficient to show that privileged persons, far from being useful to the nation, cannot but enfeeble and injure it; it is necessary to prove further that the noble order does not enter at all into the social organization; that it may indeed be a burden upon the nation, but that it cannot of itself constitute a nation.

In the first place, it is not possible in the number of all the elementary parts of a nation to find a place for the caste of nobles. I know that there are individuals in great number whom infirmities, incapacity, incurable laziness, or the weight of bad habits render strangers to the labors of society. The exception and the abuse are everywhere found beside the rule. But it will be admitted that the less there are of these abuses, the better it will be for the State. The worst possible arrangement of all would be where not alone isolated individuals, but a whole class of citizens should take pride in re-

maining motionless in the midst of the general movement, and should consume the best part of the product without bearing any part in its production. Such a class is surely estranged to the nation by its indolence.

The noble order is not less estranged from the generality of us by its civil and political prerogatives.

What is a nation? A body of associates, living under a common law, and represented by the same legislature, etc.

Is it not evident that the noble order has privileges and expenditures which it dares to call its rights, but which are apart from the rights of the great body of citizens? It departs there from the common order, from the common law. So its civil rights make of it an isolated people in the midst of the great nation. This is truly *imperium in imperio*.

In regard to its political rights, these also it exercises apart. It has its special representatives, which are not charged with securing the interests of the people. The body of its deputies sit apart; and when it is assembled in the same hall with the deputies of simple citizens, it is none the less true that its representation is essentially distinct and separate: it is a stranger to the nation, in the first place, by its origin, since its commission is not derived from the people; then by its object, which consists of defending not the general, but the particular interest.

The Third Estate embraces then all that which belongs to the nation; and all that which is not the Third Estate, cannot be regarded as being of the nation. What is the Third Estate? It is the whole.

Decree of the National Assembly Abolishing the Feudal System, August 11, 1789

The abolition of the Feudal System, which took place during the famous night session of August 4 and 5, 1789, was caused by the reading of a report on the misery and disturbances in the provinces, and was carried in a fervor of enthusiasm and excitement which made some later revision necessary. The decree here given was drawn up during the following days, and contains some alterations and important amplifications of the original provisions as passed in the early morning of August 5. (Robinson's note)

I. The National Assembly hereby completely abolishes the feudal system. It decrees that, among the existing rights and dues, both feudal and censual (perpetual), all those originating in or representing real or personal serfdom (mainmorte) or personal servitude, shall be abolished without indemnification. All other dues are declared redeemable, the terms and mode of redemption to be fixed by the National Assembly. Those of the said dues which are not extinguished by

this decree shall continue to be collected until indemnification shall take place.

II. The exclusive right to maintain pigeon-houses and dovecotes is abolished. The pigeons shall be confined during the seasons fixed by the community. During such periods they shall be looked upon as game, and every one shall have the right to kill them upon his own land.

III. The exclusive right to hunt and to maintain unenclosed warrens is likewise abolished, and every land owner

From Translations and Reprints, I, No. 5, J. H. Robinson, Ed.

shall have the right to kill or to have destroyed on his own land all kinds of game, observing, however, such police regulations as may be established with a view to the safety of the public.

All hunting captainries, including the royal forests, and all hunting rights under whatever denomination, are likewise abolished. Provision shall be made, however, in a manner compatible with the regard due to property and liberty, for maintaining the personal pleasures of the king.

The president of the assembly shall be commissioned to ask of the King the recall of those sent to the galleys or exiled, simply for violations of the hunting regulations, as well as for the release of those at present imprisoned for offences of this kind, and the dismissal of such cases as are now pending.

IV. All manorial courts are hereby suppressed without indemnification. But the magistrates of these courts shall continue to perform their functions until such time as the National Assembly shall provide for the establishment of a new judicial system.

V. Tithes of every description, as well as the dues which have been substituted for them, under whatever denomination they are known or collected (even when compounded for), possessed by secular or regular congregations, by holders of benefices, members of corporations (including the Order of Malta and other religious and military orders), as well as those devoted to the maintenance of churches, those impropriated to lay persons and those substituted for the portion congrue, are abolished, on condition, however, that some other method be devised to provide for the expenses of divine worship, the support of the officiating clergy, for the assistance of the poor, for repairs and rebuilding of churches and parsonages, and for the maintenance of all institutions, seminaries, schools, academies, asylums, and organizations to which the present funds are devoted. Until such provision shall be made and the former possessors shall enter upon the enjoyment of an income on the new system, the National Assembly decrees that the said tithes shall continue to be collected according to law and in the customary manner.

Other tithes, of whatever nature they may be, shall be redeemable in such manner as the Assembly shall determine. Until such regulation shall be issued, the National Assembly decrees that these, too, shall continue to be collected.

VI. All perpetual ground rents, payable either in money or in kind, of whatever nature they may be, whatever their origin and to whomsoever they may be due, as to members of corporations, holders of the domain or appanages or to the Order of Malta, shall be redeemable. No due shall in the future be created which is not redeemable.

VII. The sale of judicial and municipal offices shall be suppressed forthwith. Justice shall be dispensed gratis. Nevertheless, the magistrates at present holding such offices shall continue to exercise their functions and to receive their emoluments until the Assembly shall have made provision for indemnifying them.

VIII. The fees of the country priests are abolished, and shall be discontinued so soon as provision shall be made for increasing the minimum salary of the parish priests and the payment to the curates. A regulation shall be drawn up to determine the status of the priests in the towns.

IX. Pecuniary privileges, personal or real, in the payment of taxes are abolished forever. Taxes shall be collected from all the citizens, and from all property, in the same manner and in the same form. Plans shall be considered by which the taxes shall be paid proportionally by all, even for the last six months of the current year.

X. Inasmuch as a national constitution and public liberty are of more advantage to the provinces than the privileges which some of these enjoy, and inasmuch as the surrender of such privileges is essential to the intimate union of all parts of the realm, it is decreed that all the peculiar privileges, pecuniary or otherwise, of the provinces, principalities, districts, cantons, cities and communes, are once for all abolished and are absorbed into the law common to all Frenchmen.

XI. All citizens, without distinction of birth, are eligible to any office or dignity, whether ecclesiastical, civil or military; and no profession shall imply any derogation.

XII. Hereafter no remittances shall be made for annates or for any other purpose to the court of Rome, the vice-legation at Avignon, or to the nunciature at Lucerne. The clergy of the diocese shall apply to their bishops in regard to the filling of benefices and dispensations, the which shall be granted gratis without regard to reservations, expectancies and papal months, all the churches of France enjoying the same freedom.

XIII. The rights of Peter's pence, and other dues of the same kind, under whatever denomination, established in favor of bishops, archdeacons, archpresbyters, chapters, and regular congregations which formerly exercised priestly functions, are abolished, but appropriate provision shall be made for those benefices of archdeacons and archpresbyters which are not sufficiently endowed.

XIV. Pluralities shall not be permitted

hereafter in cases where the revenue from the benefice or benefices held shall exceed the sum of three thousand livres. Nor shall any individual be allowed to enjoy several pensions from benefices, or a pension and a benefice, if the revenue which he already enjoys from such sources exceeds the same sum of three thousand livres.

XV. The National Assembly shall consider, in conjunction with the King, the report which is to be submitted to it relating to pensions, favors and salaries, with a view to suppressing all such as are not deserved and reducing those which shall prove excessive; and the amount shall be fixed which the King may in the future disburse for this purpose.

XVI. The National Assembly decrees that a medal shall be struck in memory of the recent grave and important deliberations for the welfare of France, and that a Te Deum shall be chanted in gratitude in all the parishes and the churches of France.

XVII. The National Assembly solemnly proclaims the King, Louis XVI, the Restorer of French Liberty.

XVIII. The National Assembly shall present itself in a body before the King, in order to submit to him the decrees which have just been passed, to tender to him the tokens of its most respectful gratitude and to pray him to permit the Te Deum to be chanted in his chapel, and to be present himself at this service.

XIX. The National Assembly shall consider, immediately after the constitution, the drawing up of the laws necessary for the development of the principles which it has laid down in the present decree. The latter shall be transmitted without delay by the deputies to all the provinces, together with the decree of the

tenth of this month, in order that it may be printed, published, announced from the parish pulpits, and posted up whereever it shall be deemed necessary.

The Declaration of the Rights of Man and Citizen

The resolutions passed on the night of August 4 had, in the words of the decree that made them final, "entirely destroyed the feudal regime." With the ground thus prepared, the National Assembly proceeded to lay down what it considered the fundamental rights of men and citizens. The final text, voted on August 26, 1789, proclaimed its belief in liberty, equality, and national sovereignty. It was appended to the Constitution of 1791. Though several times revised, the statement contains the basic principles of the Revolution, inspired by English and American experience, and might well be considered the death certificate of the old regime destroyed by the popular revolution.

The representatives of the French people, organized in National Assembly, considering that ignorance, forgetfulness, or contempt of the rights of man, are the sole causes of the public miseries and of the corruption of governments, have resolved to set forth in a solemn declaration the natural, inalienable and sacred rights of man, in order that this declaration, being ever present to all the members of the social body, may unceasingly remind them of their rights and duties; in order that the acts of the legislative power and those of the executive power may be each moment compared with the aim of every political institution and thereby may be more respected: and in order that the demands of the citizens, grounded henceforth upon simple and incontestable principles, may always take the direction of maintaining the constitution and the welfare of all.

In consequence, the National Assembly recognizes and declares, in the presence and under the auspices of the Supreme Being, the following rights of man and citizen.

1. Men are born and remain free and equal in rights. Social distinctions can be based only upon public utility.

2. The aim of every political association is the preservation of the natural and imprescriptible rights of man. These rights are liberty, property, security and resistance to oppression.

3. The source of all sovereignty is essentially in the nation; no body, no individual can exercise authority that does not proceed from it in plain terms.

- 4. Liberty consists in the power to do anything that does not injure others; accordingly, the exercise of the natural rights of each man has no limits except those that secure to the other members of society the enjoyment of these same rights. These limits can be determined only by law.
- 5. The law has the right to forbid only such actions as are injurious to society. Nothing can be forbidden that is not interdicted by the law, and no one can be constrained to do that which it does not order.
 - 6. Law is the expression of the gen-

From F. M. Anderson, Constitutions and Other Select Documents Illustrative of the History of France (Minneapolis, 1908).

eral will. All citizens have the right to take part personally, or by their representatives, in its formation. It must be the same for all whether it protects or punishes. All citizens, being equal in its eyes, are equally eligible to all public dignities, places, and employments, according to their capacities, and without other distinction than that of their virtues and their talents.

- 7. No man can be accused, arrested, or detained, except in the cases determined by the law and according to the forms that it has prescribed. Those who procure, expedite, execute, or cause to be executed arbitrary orders ought to be punished; but every citizen summoned or seized in virtue of the law ought to render instant obedience; he makes himself guilty by resistance.
- 8. The law ought to establish only penalties that are strictly and obviously necessary, and no one can be punished except in virtue of a law established and promulgated prior to the offence and legally applied.
- 9. Every man being presumed innocent until he has been pronounced guilty; if it is thought indispensable to arrest him, all severity that may not be necessary to secure his person ought to be strictly suppressed by law.
- 10. No one should be disturbed on account of his opinions, even religious, provided their manifestation does not derange the public order established by law.

- 11. The free communication of ideas and opinions is one of the most precious of the rights of man; every citizen then can freely speak, write and print, subject to responsibility for the abuse of this freedom in the cases determined by law.
- 12. The guarantee of the rights of man and citizen requires a public force; this force then is instituted for the advantage of all and not for the personal benefit of those to whom it is entrusted.
- 13. For the maintenance of the public force and for the expenses of administration a general tax is indispensable; it ought to be equally apportioned among all the citizens according to their means.
- 14. All the citizens have the right to ascertain by themselves or by their representatives, the necessity of the public tax, to consent to it freely, to follow the employment of it, and to determine the quota, the assessment, the collection, and the duration of it.
- 15. Society has the right to call for an account of his administration from every public agent.
- 16. Any society in which the guarantee of rights is not secured, or the separation of powers not determined, has no constitution at all.
- 17. Property being a sacred and inviolable right, no one can be deprived of it, unless a legally established public necessity evidently demands it, under the condition of a just and prior indemnity.

Terror

The revolutionaries sought liberty and equality for all. Yet, if equality were to be established, liberty had to be restricted. And if men were to be educated to their new rights in a new world, misleading or corrupting influences had to be eliminated and obstacles to their forward march thrust out of the way. The Revolution, made to assert the rights of man, therefore began by restraining them and by proscribing those whom it counted as its enemies. The monarchy was abolished in 1792, the

King and Queen executed in 1793. The strains of internal dissension, foreign war and the struggle for power between rival revolutionary factions made the years between 1792 and 1794 a period of terror, whose symbol remains less the tricolor flag than the guillotine, named after a medical member of the Constituent Assembly, the Professor of Anatomy in the University of Paris, Dr. Joseph Guillotin (1738–1814).

For the sake of greater humanity, Dr. Guillotin argued, current methods of execution should be replaced by an enlightened Assembly which could introduce the simple, expeditious and far less messy process of decapitation. This could be carried out efficiently by means of a machine already employed in parts of Italy, but recently perfected by a Frenchman, Dr. Louis. Guillotin's proposition was adopted and the machine, first called *louisette*, was put into use on April 25, 1792. It was destined to a brilliant future.

PUBLIC EXECUTIONER SANSON
TO THE ATTORNEY GENERAL
OF THE DEPARTMENT
OF THE SEINE.
AUGUST 6, 1792

Sir,

It is very respectfully that I have the honor to put before you the position in which I find myself. It is such that I beg you, Sir, to give it a moment of your attention.

The kind of execution practised today easily triples costs when compared to the old expenses, and this besides the rise in prices of all necessities of life.

The service and the number of criminal courts force me to keep a number of persons ready to carry out the orders I receive. I cannot personally be everywhere at once. I need dependable people. For the public still wants to see us do a decent job. I have to pay for that.

To have proper people for this work, they want twice the pay of previous years. And just last Saturday they have come to warn me that without at least a twenty-five per cent raise they could not do their work any longer. The present circumstances have forced me to promise.

The abolition of prejudices seemed to have eased my problem in finding help. On the contrary, I find it has merely made disappear all those in the class of which I could recruit, by the ease with which they now can find domestic service or some other job, or join the army.

It is therefore necessary, if one wishes to find help, to chain them by the hope of gain.

I have fourteen persons to feed every day, of whom eight are on salary, three horses, three carts, and accessories. . . .

An enormous rent, which should be paid by the state (the executioner has always been lodged by the King).

The extra expenses of execution, very common daily, other family responsibilities, like relatives and sick old servants who have sacrificed their lives in this service, and who have a right to humanity.

My present request, Sir, is that eight

Jules Antoine Tachereau, Revue rétrospective, vol. II, tr. Eugen Weber (Paris, 1834), pp. 142-44.

months have passed since I submitted an account of expenses and costs to the Office of Judicial Costs, which have always in the past been paid me at the price of the tariff I provided, and now I cannot get my bills paid. Yet I have very carefully kept to the prices of the tariff; I have even personally made rebates on certain articles.

I had the honor, Sir, to present you a request concerning this matter last June 11, without receiving an answer. I am faced with financial embarrassment, even in debt, if I may say so, not knowing any more where to turn for funds. And unable to address myself to creditors whom I cannot repay if I am not paid.

I have no recourse but you, Sir, to

order the payment of what is owed me, without which, after the sacrifice I have made to manage up to date to carry out my duties conscientiously, will cause the total subversion of my existence and inevitable ruin in forcing me to abandon my post and my family after forty-two years of faithful service.

Since my position is pressing, I beg you, Sir, to have the kindness to have a trustworthy person inform you of the facts I have the honor to submit.

I have the honor to be with the most profound respect, Sir, your very humble and obedient servant.

Sanson

Executor of Criminal Judgments in Paris

Babeuf: The Manifesto of the Equals

François Émile Babeuf (1710–1797) was employed as a land commissioner at the outbreak of the Revolution. Adopting the surname of "Gracchus," he joined the extreme wing of the Jacobins and held certain minor posts during the Terror. Imprisoned after the reaction of Thermidor (1794), on his release he became the central figure in a movement calling for economic and political equality and for the fulfillment of the Revolution in socialism. The Pantheon Society, as it was named, incorporated too many radical Jacobins and enemies of the Directory in general; so, in February 1796, Barras ordered its dissolution and General Bonaparte carried out the decree. The Society's leaders reacted by hatching "the conspiracy of the equals," designed to overthrow the Directory. They also distributed a manifesto which gives a good brief statement of their aims. The conspiracy was uncovered, Babeuf arrested, tried, and executed; but his ideas survived him to inspire later apostles of social reform.

People of France! During fifteen centuries you have lived as slaves, and in consequence unhappily. It is scarcely six years that you have begun to breathe, in the expectation of independence, happiness, equality! The first demand of nature, the first need of man, and the chief

knot binding together all legitimate association! People of France! you have not been more favored than other nations who vegetate on this unfortunate growth! Always and everywhere the poor human race, delivered over to more or less adroit cannibals, has served as a plaything for

From Ernest Belfort Bax, The Last Episode of the French Revolution (London, 1911), pp. 107-113. By permission of the Richards Press Ltd.

all ambitions, as a pasture for all tyrannies. Always and everywhere men have been lulled by fine words; never and nowhere have they obtained the thing with the word. From time immemorial it has been repeated, with hypocrisy, that MEN ARE EQUAL; and from time immemorial the most degrading and the most monstrous inequality ceaselessly weighs upon the human race. Since the dawn of civil society this noblest appanage of man has been recognised without contradiction, but has on no single occasion been realised; equality has never been anything but a beautiful and sterile fiction of the law. Today, when it is demanded with a stronger voice, they reply to us: "Be silent, wretches! Equality of fact is nought but a chimera; be contented with conditional equality; you are all equal before the law. Canaille, what do you want more?" What do we want more? Legislators, governors, rich proprietors, listen in your turn! We are all equal, are we not? This principle remains uncontested. For, unless attacked by madness, no one could seriously say that it was night when it was day.

Well! We demand henceforth to live and to die equal, as we have been born equal. We demand real equality or death; that is what we want.

And we shall have it, this real equality, it matters not at what price! Woe betide those who place themselves between us and it! Woe betide him who offers resistance to a vow thus pronounced!

The French Revolution is but the forerunner of another, and a greater, and more solemn revolution, and which will be the last!

The People has marched over the bodies of kings and priests who coalesced against it: it will be the same with the new tyrants, with the new political hypo-

crites, seated in the place of the old ones! What do we want more than equality of rights? We want not only the equality transcribed in the declaration of the Rights of Man and the Citizen: we will have it in the midst of us, under the roof of our houses. We consent to everything for its sake; to make a clear board, that we may hold to it alone. Perish, if it must be, all the arts, provided real equality be left us! 1 Legislators and governors, who have neither genius nor good faith; rich proprietors without bowels of compassion, you will try in vain to neutralise our holy enterprise by saving that it does no more than reproduce that agrarian law already demanded more than once before! Calumniators! be silent in your turn and, in the silence of confusion, listen to our demands, dictated by nature and based upon iustice!

The agrarian law, or the partition of lands, was the immediate aim of certain soldiers without principles, of certain people moved by their instinct rather than by reason. We aim at something more sublime and more equitable: the common good, or the community of goods. No more individual property in land; the land belongs to no one. We demand, we would have, the communal enjoyment of the fruits of the earth, fruits which are for everyone!

We declare that we can no longer suffer, while the enormous majority of men labor in the service and for the good pleasure of a small minority! Enough and too long have less than a million individuals disposed of that which belongs to more than twenty millions of their kind!

Let this great scandal that our grandchildren will hardly be willing to believe in, cease!

Let disappear, once and for all, the re-

¹ This was one of the sentences objected to by other members of the committee.

volting distinction of rich and poor, of great and small, of masters and valets, of governors and governed! ²

Let there be no other difference between human beings than those of age and sex. Since all have the same needs and the same faculties, let there be one education for all, one food for all. We are contented with one sun and one air for all. Why should the same portion and the same quality of nourishment not suffice for each of us? But already the enemies of an order of things the most natural that can be imagined, declaim against us. Disorganisers and factious persons, say they, you only seek massacre and plunder. People of France! we shall not waste our time in replying to them, but we shall tell you: the holy enterprise which we organise has no other aim than to put an end to civil dissensions and to public misery.

Never has a vaster design been conceived or put into execution. From time to time some men of genius, some sages, have spoken of it in a low and trembling voice. Not one of them has had the courage to tell the whole truth.

The moment for great measures has come. The evil is at its height. It covers the face of the earth. Chaos, under the name of politics, reigns there throughout too many centuries. Let everything return once more to order and reassume its just place!

At the voice of equality, let the elements of justice and wellbeing organise themselves! The moment has arrived for founding the Republic of the Equals, that grand refuge open to all men. The days of general restitution have come. Families groaning in misery, come and seat yourselves at the common table prepared by nature for all her children! People of

France! the purest form of all glory has been reserved for thee! Yes, it is you who may first offer to the world this touching sight!

Ancient customs, antiquated conventions, would again raise an obstacle to setting up the Republic of the Equals. The organisation of real equality, the only kind that answers all needs without making victims, without costing sacrifices, will not perhaps please everybody at first sight. The egoist, the ambitious man, will tremble with rage. Those who possess unjustly will cry aloud against such injustice. Exclusive enjoyments, solitary pleasures, personal ease, will cause sharp regrets on the part of individuals who have fattened on the labor of others. The lovers of absolute power, the vile supporters of arbitrary authority, will scarcely bend their arrogant heads to the level of real equality. Their narrow view will penetrate with difficulty, it may be, the near future of common wellbeing. But what can a few thousand malcontents do against a mass of men, all of them happy, and surprised to have sought so long for a happiness which they had beneath their hands?

The day after this true revolution, they will say with astonishment: What? the common wellbeing was to be had for so little? We had only to will it. Ah! why did we not will it sooner? Why had we to be told about it so many times? Yes, doubtless, with one man on earth richer, more powerful than his neighbors, than his equals, the equilibrium is broken, crime and misery are already in the world. People of France! by what sign ought you to exercise the excellence of a constitution from now on? That which rests entirely on an equality of fact is the only one that can benefit you and satisfy all your wants.

² The idea of abolishing governors and governed was also objected to by some members of the committee.

The aristocratic charters of 1791 to 1795 have only riveted your bonds instead of rending them. That of 1793 was a great step indeed towards real equality, and never before had it been approached so closely; but yet, it did not achieve the aim and did not touch the

common wellbeing, of which, nevertheless, it solemnly consecrated the great principle.

People of France! open your eyes and your heart to the fulness of happiness. Recognize and proclaim with us the "Republic of the Equals"!

Proclamation of 19th Brumaire, 11 O'clock P.M.

Although the Equals had been effectively dealt with, the relatively moderate Directorate (1795–1799), caught between the specter of a new Jacobin terror and the more concrete threat of a right-wing restoration, was unable to rule constitutionally. Perhaps it did not really want to do so. At any rate, having once called in the generals to eliminate their political opponents, it was only a matter of time before an enterprising general took it into his head to eliminate them. That time came on 19th Brumaire (November 9), 1799, when General Bonaparte, who had returned in haste from his unsuccessful Egyptian expedition, dispersed the assemblies, liquidated the Directorate, and replaced it with a consular regime that was to be the prelude to his imperial rule.

To the People:

Frenchmen, on my return to France I found division reigning among all the authorities. They agreed only on this single point, that the constitution was half destroyed and was unable to protect liberty.

Each party in turn came to me, confided to me their designs, imparted their secrets, and requested my support. But I refused to be the man of any party.

The Council of Elders appealed to me. I answered their appeal. A plan of general restoration had been conspired at by men whom the nation has been accustomed to regard as the defenders of liberty, equality, and property. This plan required calm deliberation, free from all influence and all fear. The Elders therefore resolved upon the removal of the legislative bodies to St. Cloud. They placed at my disposal the force necessary to secure their independence. I was bound, in duty to my

fellow-citizens, to the soldiers perishing in our armies, and to the national glory acquired at the cost of so much blood, to accept the command. The Council assembled at St. Cloud. Republican troops guaranteed their safety from without, but assassins created terror within. Many deputies in the Council of Five Hundred, armed with stilettos and pistols, spread the menace of death around them.

The plans which ought to have been developed were withheld. The majority of the Council was disorganized, the boldest orators were disconcerted, and the futility of submitting my salutary proposition was quite evident.

I proceeded, filled with indignation and chagrin, to the Council of the Elders. I besought them to carry their noble designs into execution. I directed their attention to the evils of the nation, which were their motives for conceiving those

From J. H. Robinson and C. A. Beard, Readings in Modern European History, 2 vol. (Boston, 1908), I, 322-323.

designs. They concurred in giving me new proofs of their unanimous good will.

I presented myself before the Council of the Five Hundred alone, unarmed, my head uncovered, just as the Elders had received and applauded me. My object was to restore to the majority the expression of its will and to secure to it its power.

The stilettos which had menaced the deputies were instantly raised against their deliverer. Twenty assassins rushed upon me and aimed at my breast. The grenadiers of the legislative body, whom I had left at the door of the hall, ran forward and placed themselves between me and the assassins. One of these brave grenadiers had his clothes pierced by a stiletto. They bore me out.

At the same moment cries of "Outlaw him!" were raised against the defender of the law. It was the horried cry of assassins against the power destined to repress them. They crowded around the president, uttering threats. With arms in their hands, they commanded him to declare me outlawed. I was informed of this. I ordered him to be rescued from their fury, and six grenadiers of the legislative body charged the hall and cleared it.

The seditious, thus intimidated, dispersed and fled. The majority, freed from their assailants, returned freely and peaceably into the hall, listened to the propositions for the public safety, deliberated, and drew up the salutary resolution which will become the new provisional law of the republic.

Frenchmen, you will doubtless recognize in this conduct the zeal of a soldier of liberty, of a citizen devoted to the republic. Conservative, judicial, and liberal ideas resumed their sway upon the dispersion of those seditious persons who had domineered in the councils and who proved themselves the most odious and contemptible of men.

Bonaparte.

IV. The Reaction

It was inevitable that the subversive ideas and world-shattering events outlined above should generate a reaction. One aspect of the reaction, when it came, was reflected in the profoundly Romantic ideas of Burke, who felt that the good society was equivalent to the natural society, natural in so far as it is the product of organic development and growth. For Rousseau and some of his followers such ideas had suggested that the existing society and social order which had deviated from a healthy, natural form should be pulled down and replaced by something better. Burke, on the contrary, saw in the very existence of social forms and institutions a proof of their healthy organic nature and an argument against their elimination in favor of artificial products of the human mind—theories or systems which could never fit the needs of society as well as the traditional norms and forms it had evolved in the course of many years. A brilliant pamphleteer rather than a consistent political thinker, Burke suggests ideas that are sometimes pragmatic but often also ambiguous, and he has only himself to blame for being frequently misunderstood.

About Metternich's ideas, on the other hand, there was little ambiguity. The man knew what he wanted: to preserve the status quo. His difficulty was that he had to work with men who were far less single-minded than he. He preserved the old world, his world, for over thirty years after the Congress of Vienna, but only by fighting a continuous battle on two fronts—one, against the rising powers of nationalism and liberalism; the other, against the masters and associates whom he had to persuade of the rightness of his views. Though he seemed to have lost his battles in 1848, his uncompromising brand of conservatism lived on for a long time and may be found today in the clubs and last ditches where it still holds out.

1. EDMUND BURKE

Edmund Burke (1729–1797), statesman, orator, and political philosopher, was born in Dublin the son of a Protestant father and a Catholic mother. Trained to be a lawyer like his father, he went into pamphleteering and politics instead. As member of Parliament he took the side of the insurgent American colonists but opposed the French revolutionaries in his Reflections on the French Revolution, published in 1790. He felt that violent breaks with tradition could only harm men whose life and society were like part of a tree with roots in the past. Revolution, the cutting of the roots, can only kill or maim society. Reform, change, as a natural development on

historical foundations, are the only healthy ways of bringing about changes in conformity with the real character and needs of a nation. Burke's ideas carried far, but their real effects were not felt until the nineteenth century.

Reflections on the French Revolution

THE ROAD TO EMINENCE

I do not, my dear sir, conceive you to be of that sophistical, captious spirit, or of that uncandid dulness, as to require for every general observation or sentiment, an explicit detail of the correctives and exceptions, which reason will presume to be included in all the general propositions which come from reasonable men. You do not imagine, that I wish to confine power, authority, and distinction to blood, and names, and titles. No, sir. There is no qualification for government but virtue and wisdom, actual or presumptive. Wherever they are actually found, they have, in whatever state, condition, profession or trade, the passport of heaven to human place and honour. Woe to the country which would madly and impiously reject the service of the talents and virtues, civil, military or religious, that are given to grace and to serve it; and would condemn to obscurity everything formed to diffuse lustre and glory around a state. Woe to that country too, that, passing into the opposite extreme, considers a low education, a mean contracted view of things, a sordid, mercenary occupation, as a preferable title to command. Everything ought to be open; but not indifferently to every man. No rotation; no appointment by lot; no mode of election operating in the spirit of sortation, or rotation, can be generally good in a government conversant in extensive objects. Because they have no tendency, direct or indirect, to select the man with a view to the duty, or to accommodate the one to the other. I do not hesitate to say that the road to eminence and power, from obscure condition, ought not to be made too easy, nor a thing too much of course. If rare merit be the rarest of all rare things, it ought to pass through some sort of probation. The temple of honour ought to be seated on an eminence. If it be opened through virtue, let it be remembered too that virtue is never tried but by some difficulty and some struggle.

Nothing is a due and adequate representation of a state that does not represent its ability, as well as its property. But as ability is a vigorous and active principle, and as property is sluggish, inert and timid, it never can be safe from the invasions of ability, unless it be, out of all proportion, predominant in the representation. It must be represented too in great masses of accumulation, or it is not rightly protected. The characteristic essence of property, formed out of the combined principles of its acquisition and conservation, is to be unequal. The great masses therefore which excite envy, and tempt rapacity, must be put out of the possibility of danger. Then they form a natural rampart about the lesser properties in all their gradations. The same quantity of property, which is by the natural course of things divided among many, has not the same operation. Its defensive power is weakened as it is diffused. In this diffusion each man's portion is less than what,

From The Works of the Right Honourable Edmund Burke, 2 vol. (London, 1834), I.

in the eagerness of his desires, he may flatter himself to obtain by dissipating the accumulations of others. The plunder of the few would indeed give but a share inconceivably small in the distribution to the many. But the many are not capable of making this calculation; and those who lead them to rapine never intend this distribution.

The power of perpetuating our property in our families is one of the most valuable and interesting circumstances belonging to it, and that which tends the most to the perpetuation of society itself. It makes our weakness subservient to our virtue; it grafts benevolence even upon avarice. The possessors of family wealth, and of the distinction which attends hereditary possession, (as most concerned in it.) are the natural securities for this transmission. With us the House of Peers is formed upon this principle. It is wholly composed of hereditary property and hereditary distinction; and made therefore the third of the legislature; and in the last event, the sole judge of all property in all its subdivisions. The House of Commons too, though not necessarily, vet in fact, is always so composed, in the far greater part. Let those large proprietors be what they will, and they have their chance of being among the best, they are, at the very worst, the ballast in the vessel of the commonwealth. For though hereditary wealth, and the rank which goes with it, are too much idolized by creeping sycophants, and the blind, abject admirers of power, they are too rashly slighted in shallow speculations of the petulant, assuming, short-sighted coxcombs of philosophy. Some decent, regulated pre-eminence, some preference (not exclusive appropriation), given to birth, is neither unnatural, nor unjust, nor impolitic.

It is said, that twenty-four millions ought to prevail over two hundred thousand. True: if the constitution of a kingdom be a problem of arithmetic. This sort of discourse does well enough with the lamp-post for its second: to men who may reason calmly, it is ridiculous. The will of the many, and their interest, must very often differ; and great will be the difference when they make an evil choice. A government of five hundred country attorneys and obscure curates is not good for twenty-four millions of men, though it were chosen by eight and forty millions; nor is it the better for being guided by a dozen of persons of quality, who have betraved their trust in order to obtain that power. At present, you seem in everything to have straved out of the high road of nature. The property of France does not govern it. Of course property is destroyed, and rational liberty has no existence. All you have got for the present is a paper circulation, and a stock-jobbing constitution: and, as to the future, do you seriously think that the territory of France, upon the republican system of eighty-three independent municipalities (to say nothing of the parts that compose them), can ever be governed as one body, or can ever be set in motion by the impulse of one mind? When the National Assembly has completed its work, it will have accomplished its ruin.

THE RIGHTS OF MEN

Far am I from denying in theory, full as far is my heart from withholding in practice (if I were of power to give or to withhold) the *real* rights of men. In denying their false claims of right, I do not mean to injure those which are real, and are such as their pretended rights would totally destroy. If civil society be made

for the advantage of man, all the advantages for which it is made become his right. It is an institution of beneficence: and law itself is only beneficence, acting by a rule. Men have a right to live by that rule; they have a right to do justice; as between their fellows, whether their fellows are in politic function or in ordinary occupation. They have a right to the fruits of their industry; and to the means of making their industry fruitful. They have a right to the acquisitions of their parents; to the nourishment and improvement of their offspring; to instruction in life, and to consolation in death. Whatever each man can separately do, without trespassing upon others, he has a right to do for himself; and he has a right to a fair portion of all which society, with all its combinations of skill and force, can do in his favour. In this partnership all men have equal rights: but not to equal things. He that has but five shillings in the partnership, has as good a right to it as he that has five hundred pounds has to his larger proportion. But he has not a right to an equal dividend in the product of the joint stock; and as to the share of power, authority, and direction which each individual ought to have in the management of the state, that I must deny to be amongst the direct original rights of man in civil society; for I have in my contemplation the civil social man, and no other. It is a thing to be settled by convention.

If civil society be the offspring of convention, that convention must be its law. That convention must limit and modify all the descriptions of constitution which are formed under it. Every sort of legislature, judicial, or executory power, are its creatures. They can have no being in any other state of things; and how can any man claim, under the conventions of civil

society, rights which do not so much as suppose its existence?—rights which are absolutely repugnant to it? One of the first motives to civil society, and which becomes one of its fundamental rules, is, that no man should be judge in his own cause. By this each person has at once divested himself of the first fundamental right of uncovenanted man, that is, to judge for himself and to assert his own cause. He abdicates all right to be his own governor. He inclusively, in a great measure abandons the right of self-defence, the first law of nature. Men cannot enjoy the rights of an uncivil and of a civil state together. That he may obtain justice, he gives up his right of determining what it is in points the most essential to him. That he may secure some liberty, he makes a surrender in trust of the whole of it.

Government is not made in virtue of natural rights, which may and do exist in total independence of it; and exist in much greater clearness, and in a much greater degree of abstract perfection; but their abstract perfection is their practical defect. By having a right to everything, they want everything. Government is a contrivance of human wisdom to provide for human wants. Men have a right that these wants should be provided for by this wisdom. Among these wants is to be reckoned the want, out of civil society, of a sufficient restraint upon their passions. Society requires not only that the passions of individuals should be subjected, but that even in the mass and body, as well as in the individuals, the inclinations of men should frequently be thwarted, their will controlled, and their passions brought into subjection. This can only be done by a power out of themselves; and not, in the exercise of its function, subject to that will and to those passions which it is

its office to bridle and subdue. In this sense the restraints on men, as well as their liberties, are to be reckoned among their rights. But as the liberties and the restrictions vary with times and circumstances, and admit of infinite modifications, they cannot be settled upon any abstract rule; and nothing is so foolish as to discuss them upon that principle.

The moment you abate anything from the full rights of men, each to govern himself, and suffer any artificial, positive, limitation upon those rights, from that moment the whole organization of government becomes a consideration of convenience. This it is which makes the constitution of a state, and the due distribution of its powers, a matter of the most delicate and complicated skill. It requires a deep knowledge of human nature and human necessities, and of the things which facilitate or obstruct the various ends, which are to be pursued by the mechanism of civil institutions. The state is to have recruits to its strength, and remedies to its distempers. What is the use of discussing a man's abstract right to food or medicine? The question is upon the method of procuring and administering them. In that deliberation I shall always advise to call in the aid of the farmer and the physician, rather than the professor of metaphysics.

The science of constructing a commonwealth, or renovating it, or reforming it, is, like every other experimental science, not to be taught *a priori*. Nor is it a short experience that can instruct us in that practical science; because the real effects of moral causes are not always immediate; but that which in the first instance is prejudicial may be excellent in its remoter operation; and its excellence may arise even from the ill effects it produces in the beginning. The reverse also happens; and very plausible schemes, with very pleasing commencements, have often shameful and lamentable conclusions. In states there are often some obscure and almost latent causes, things which appear at first view of little moment, on which a very great part of its prosperity or adversity may most essentially depend. The science of government being therefore so practical in itself, and intended for such practical purposes, a matter which requires experience, and even more experience than any person can gain in his whole life, however sagacious and observing he may be, it is with infinite caution that any man ought to venture upon pulling down an edifice, which has answered in any tolerable degree for ages the common purposes of society, or on building it up again, without having models and patterns of approved utility before his eyes.

These metaphysic rights entering into common life, like rays of light which pierce into a dense medium, are, by the laws of nature, refracted from their straight line. Indeed, in the gross and complicated mass of human passions and concerns, the primitive rights of men undergo such a variety of refractions and reflections, that it becomes absurd to talk of them as if they continued in the simplicity of their original direction. The nature of man is intricate; the objects of society are of the greatest possible complexity: and therefore no simple disposition or direction of power can be suitable either to man's nature, or to the quality of his affairs. When I hear the simplicity of contrivance aimed at and boasted of in any new political constitutions, I am at no loss to decide that the artificers are grossly ignorant of their trade, or totally negligent of their duty. The simple governments are fundamentally defective, to say no worse of them. . . . If you were to contemplate society in but one point of view, all these simple modes of polity are infinitely captivating. In effect each would answer its single end much more perfectly than the more complex is able to attain all its complex purposes. But it is better that the whole should be imperfectly and anomalously answered, than that, while some parts are provided for with great exactness, others might be totally neglected, or perhaps materially injured, by the overcare of a favourite member.

The pretended rights of these theorists are all extremes: and in proportion as they are metaphysically true, they are morally and politically false. The rights of men are in a sort of middle, incapable of definition, but not impossible to be discerned. The rights of men in governments are their advantages; and these are often in balances between differences of good; in compromises sometimes between good and evil, and sometimes between evil and evil. Political reason is a computing principle; adding, subtracting, multiplying, and dividing, morally and not metaphysically, or mathematically, true moral denominations.

By these theorists the right of the people is almost always sophistically confounded with their power. The body of the community, whenever it can come to act, can meet with no effectual resistance; but till power and right are the same, the whole body of them has no right inconsistent with virtue, and the first of all virtues, prudence. Men have no right to what is not reasonable, and to what is not for their benefit.

EFFECTS OF REVOLUTION

It is now sixteen or seventeen years since I saw the queen of France, then the

dauphiness, at Versailles; and surely never lighted on this orb, which she hardly seemed to touch, a more delightful vision. I saw her just above the horizon, decorating and cheering the elevated sphere she just began to move in, -glittering like the morning-star, full of life, and splendour, and joy. Oh! what a revolution! and what a heart must I have to contemplate without emotion that elevation and that fall! Little did I dream when she added titles of veneration to those of enthusiastic, distant respectful love, that she should ever be obliged to carry the sharp antidote against disgrace concealed in that bosom: little did I dream that I should have lived to see such disasters fallen upon her in a nation of gallant men; in a nation of men of honour and of cavaliers. I thought ten thousand swords must have leaped from their scabbards to avenge even a look that threatened her with insult. But the age of chivalry is gone. That of sophisters, economists, and calculators, has succeeded; and the glory of Europe is extinguished for ever. Never, never more shall we behold that generous loyalty to rank and sex, that proud submission, that dignified obedience, that subordination of the heart, which kept alive, even in servitude itself, the spirit of an exalted freedom. The unbought grace of life, the cheap defense of nations, the nurse of manly sentiment and heroic enterprise, is gone. It is gone, that sensibility of principle, that chastity of honour, which felt a stain like a wound, which inspired courage whilst it mitigated ferocity, which ennobled whatever it touched, and under which vice itself lost half its evil, by losing all its grossness.

This mixed system of opinion and sentiment had its origin in the ancient chivalry; and the principle, though varied in its appearance by the varying state of human affairs, subsisted and influenced through a long succession of generations, even to the time we live in. If it should ever be totally extinguished, the loss I fear will be great. It is this which has given its character to modern Europe. It is this which has distinguished it under all its forms of government, and distinguished it to its advantage, from the states of Asia, and possibly from those states which flourished in the most brilliant periods of the antique world. It was this which, without confounding ranks, had produced a noble equality, and handed it down through all the gradations of social life. It was this opinion which mitigated kings into companions, and raised private men to be fellows with kings. Without force or opposition, it subdued the fierceness of pride and power; it obliged sovereigns to submit to elegance, and made a dominating vanquisher of laws to be subdued by manners.

But now all is to be changed. All the pleasing illusions, which made power gentle and obedience liberal, which harmonized the different shades of life, and which, by a bland assimilation, incorporated into politics the sentiments which beautify and soften private society, are to be dissolved by this new conquering empire of light and reason. All the decent drapery of life is to be rudely torn off. All the superadded ideas, furnished from the wardrobe of a moral imagination, which the heart owns, and the understanding ratifies, as necessary to cover the defects of our naked, shivering nature, and to raise it to dignity in our own estimation, are to be exploded as a ridiculous, absurd, and antiquated fashion.

On this scheme of things, a king is but a man, a queen is but a woman; a woman is but an animal, and an animal not of the highest order. All homage paid to the sex in general as such, and without distinct view, is to be regarded as romance and folly. Regicide, and parricide, and sacrilege, are but fictions of superstition, corrupting jurisprudence by destroying its simplicity. The murder of a king, or a queen, or a bishop, or a father, are only common homicide; and if the people are by any chance, or in any way, gainers of it, a sort of homicide much the most pardonable, and into which we ought not to make too severe a scrutiny.

On the scheme of this barbarous philosophy, which is the offspring of cold hearts and muddy understandings, and which is as void of solid wisdom as it is destitute of all taste and elegance, laws are to be supported only by their own terrors, and by the concern which each individual may find in them from his own private speculations, or can spare to them from his own private interests. In the groves of their academy, at the end of every vista, you see nothing but the gallows. Nothing is left which engages the affections on the part of the commonwealth. On the principles of this mechanic philosophy, our institutions can never be embodied, if I may use the expression, in persons; so as to create in us love, veneration, admiration, or attachment. But that sort of reason which banishes the affections is incapable of filling their place. These public affections, combined with manners, are required sometimes as supplements, sometimes as correctives, always as aids to law. . . .

But power, of some kind or other, will survive the shock in which manners and opinions perish; and it will find other and worse means for its support. The usurpation which, in order to subvert ancient institutions, has destroyed ancient principles, will hold power by arts similar to those by which it has acquired it. 604

When the old feudal and chivalrous spirit of *fealty*, which, by freeing kings from fear, freed both kings and subjects from the precautions of tyranny, shall be extinct in the minds of men, plots and assassinations will be anticipated by preventive murder and preventive confiscation, and that long roll of grim and bloody maxims, which form the political code of all power, not standing on its own honour, and the honour of those who are to obey it. Kings will be tyrants from policy, when subjects are rebels from principle.

When ancient opinions and rules of life are taken away, the loss cannot possibly be estimated. From that moment we have no compass to govern us; nor can we know distinctly to what port we steer. Europe, undoubtedly, taken in a mass, was in a flourishing condition the day on which your revolution was completed. How much of that prosperous state was owing to the spirit of our old manners and opinions is not easy to say; but as such causes cannot be indifferent in their operation, we must presume, that, on the whole, their operation was beneficial.

We are but too apt to consider things in the state in which we find them, without sufficiently adverting to the causes by which they have been produced, and possibly may be upheld. Nothing is more certain, than that our manners, our civilization, and all the good things which are connected with manners and with civilization, have, in this European world of ours, depended for ages upon two principles; and were indeed the result of both combined; I mean the spirit of a gentleman, and the spirit of religion. The nobility and the clergy, the one by profession, the other by patronage, kept learning in existence, even in the midst of arms and confusions, and whilst governments

were rather in their causes, than formed. Learning paid back what it received to nobility and to priesthood; and paid it with usury by enlarging their ideas, and by furnishing their minds. Happy if they had all continued to know their indissoluble union, and their proper place! Happy if learning, not debauched by ambition, had been satisfied to continue, the instructor, and not aspired to be the master! Along with its natural protectors and guardians, learning will be cast into the mire, and trodden down under the hoofs of a swinish multitude.

If, as I suspect, modern letters owe more than they are always willing to own to ancient manners, so do other interests which we value full as much as they are worth. Even commerce, and trade, and manufacture, the gods of our economical politicians, are themselves perhaps but creatures; are themselves but effects, which, as first causes, we choose to worship. They certainly grew under the same shade in which learning flourished. They too may decay with their natural protecting principles. With you, for the present at least, they will threaten to disappear together. Where trade and manufactures are wanting to a people, and the spirit of nobility and religion remains, sentiment supplies, and not always ill supplies, their place; but if commerce and the arts should be lost in an experiment to try how well a state may stand without these old fundamental principles, what sort of a thing must be a nation of gross, stupid. ferocious, and, at the same time, poor and sordid, barbarians, destitute of religion, honour, or manly pride, possessing nothing at present, and hoping for nothing hereafter?

I wish you may not be going fast, and by the shortest cut, to that horrible and disgustful situation. Already there appears a poverty of conception, a coarseness and vulgarity, in all the proceedings of the Assembly and of all their instructors. Their liberty is not liberal. Their science is presumptuous ignorance. Their humanity is savage and brutal. . . .

THE ENGLISH SCENE

We are not the converts of Rousseau; we are not the disciples of Voltaire; Helvetius has made no progress amongst us. Atheists are not our preachers; madmen are not our lawgivers. We know that we have made no discoveries; and we think that no discoveries are to be made, in morality; nor many in the great principles of government, nor in the ideas of liberty, which were understood long before we were born, altogether as well as they will be after the grave has heaped its mould over our presumption, and the silent tomb shall have imposed its law on our pert loquacity. In England we have not yet been completely embowelled of our natural entrails: we still feel within us, and we cherish and cultivate, those inbred sentiments which are the faithful guardians, the active monitors of our duty, the true supporters of all liberal and manly morals. We have not been drawn and trussed, in order that we may be filled, like stuffed birds in a museum, with chaff and rags and paltry blurred sheets of paper about the rights of man. We preserve the whole of our feelings still native and entire, unsophisticated by pedantry and infidelity. We have real hearts of flesh and blood beating in our bosoms. We fear God; we look up with awe to kings; with affection to parliaments; with duty to magistrates; with reverence to priests; and with respect to nobility. Why? Because when such ideas are brought before our minds, it is natural to be so affected; because all other feelings are false and spurious, and tend to corrupt our minds, to vitiate our primary morals, to render us unfit for rational liberty; and by teaching us a servile, licentious, and abandoned insolence, to be our low sport for a few holidays, to make us perfectly fit for, and justly deserving of, slavery, through the whole course of our lives.

You see, Sir, that in this enlightened age I am bold enough to confess that we are generally men of untaught feelings; that instead of casting away all our old prejudices, we cherish them to a very considerable degree; and, to take more shame to ourselves, we cherish them because they are prejudices; and the longer they have lasted and the more generally they have prevailed, the more we cherish them. We are afraid to put men to live and trade each on his own private stock of reason; because we suspect that this stock in each man is small, and that the individuals would do better to avail themselves of the general bank and capital of nations and of ages. Many of our men of speculation, instead of exploding general prejudices, employ their sagacity to discover the latent wisdom which prevails in them. If they find what they seek, and they seldom fail, they think it more wise to continue the prejudice, with the reason involved, than to cast away the coat of prejudice, and to leave nothing but the naked reason; because prejudice, with its reason, has a motive to give action to that reason, and an affection which will give it permanence. Prejudice is of ready application in the emergency; it previously engages the mind in a steady course of wisdom and virtue, and does not leave the man hesitating in the moment of decision, sceptical, puzzled, and unresolved. Prejudice renders a man's virtue his habit; and not a series of unconnected acts. Through just prejudice, his duty becomes a part of his nature.

Your literary men, and your politicians, and so do the whole clan of the enlightened among us, essentially differ in these points. They have no respect for the wisdom of others; but they pay it off by a very full measure of confidence in their own. With them it is a sufficient motive to destroy an old scheme of things, because it is an old one. As to the new, they are in no sort of fear with regard to the duration of a building run up in haste; because duration is no object to those who think little or nothing has been done before their time, and who place all their hopes in discovery. They conceive, very systematically, that all things which give perpetuity are mischievous, and therefore they are at inexpiable war with all establishments. They think that government may vary like modes of dress, and with as

little ill effect: that there need be no principle of attachment, except a sense of present conveniency, to any constitution of the state. They always speak as if they were of opinion that there is a singular species of compact between them and their magistrates, which binds the magistrate, but which has nothing reciprocal in it, but that the majesty of the people has a right to dissolve it without any reason, but its will. Their attachment to their country itself is only so far as it agrees with some of their fleeting projects: it begins and ends with that scheme of polity which falls in with their momentary opinion.

These doctrines, or rather sentiments, seem prevalent with your new statesmen. But they are wholly different from those on which we have always acted in this country.

2. THE HOLY ALLIANCE

When Napoleon had been defeated for a second and final time, the Tzar, the Austrian Emperor, and the King of Prussia signed the famous treaty known as The Holy Alliance in September 1815. In time other European monarchs adhered to it. Only the Pope and the Prince Regent, the future George IV of England, steadfastly refused to sign it. The alliance has been mistakenly regarded as the chief bond of union between the conservative powers in their struggle against a revival of liberal ideas. It was really signed chiefly in order to humor Alexander I of Russia with whom the idea originated, and it functioned effectively only in terms of other, more concrete policies and interests which may be followed in the memoranda of Metternich.

In the Name of the very Holy and Indivisible Trinity.

Their majesties, the Emperor of Austria, the King of Prussia and the Emperor of Russia, in view of the great events which the last three years have brought to pass in Europe and in view especially of the benefits which it has

pleased Divine Providence to confer upon those states whose governments have placed their confidence and their hope in Him alone, having reached the profound conviction that the policy of the powers, in their mutual relations, ought to be guided by the sublime truths taught by the eternal religion of God our Saviour, solemnly declare that the present act has

From Translations and Reprints, I, No. 3, J. H. Robinson, Ed.

no other aim than to manifest to the world their unchangeable determination to adopt no other rule of conduct, either in the government of their respective countries or in their holy religion, than the precepts of justice, charity and peace. These, far from being applicable exclusively to private life, ought on the contrary directly to control the resolutions of princes and to guide their steps as the sole means of establishing human institutions and of remedying their imperfections. Hence their majesties have agreed upon the following articles:

Article I. Conformably to the words of Holy Scripture which command all men to look upon each other as brothers, the three contracting monarchs will continue united by the bonds of a true and indissoluble fraternity, and regarding themselves as compatriots, they will lend aid and assistance to each other on all occasions and in all places; viewing themselves, in their relations to their subjects and to their armies, as fathers of families, they will direct them in that spirit of fraternity by which they are animated, for the protection of religion, peace and justice.

Article II. Hence the sole principle of conduct, be it between the said governments or their subjects, shall be that of rendering mutual service, and testifying by unceasing good-will, the mutual affection with which they should be animated. Considering themselves all as members of one great Christian nation, the three al-

lied princes look upon themselves as delegates of Providence called upon to govern three branches of the same family, viz: Austria, Russia and Prussia. They thus confess that the Christian nation, of which they and their people form a part, has in reality no other sovereign than He alone to whom belongs by right the power, for in Him alone are to be found all the treasures of love, of knowledge and of infinite wisdom, that is to say God, our Divine Saviour, Jesus Christ, the word of the most High, the word of life. Their majesties recommend, therefore, to their peoples, as the sole means of enjoying that peace which springs from a good conscience and is alone enduring, to fortify themselves each day in the principles and practice of those duties which the Divine Saviour has taught to men.

Article III. All those powers who wish solemnly to make avowal of the sacred principles which have dictated the present act, and who would recognize how important it is to the happiness of nations, too long agitated, that these truths should hereafter exercise upon human destiny all the influence belonging to them, shall be received into this Holy Alliance with as much cordiality as affection.

Engrossed in three copies and signed at Paris, year of grace 1815, Septem-

ber $\frac{14}{26}$. Signed: Francis

Frederick William Alexander

3. METTERNICH

Clement-Wenceslas, Prince Metternich (1773–1859), was born at Coblenz, in the Rhineland, but entered the service of the house of Habsburg, married the daughter of Kaunitz, the trusted Chancellor of Empress Maria Theresa and, after Kaunitz' death, managed the destinies of the Austrian Empire through the Napole onic period until his overthrow in the revolution of 1848. It was Metternich who ar-

ranged the marriage between Napoleon and the Austrian Archduchess Marie Louise, but after Napoleon's fall he became the leading influence in the Austro-Prussian-Russian alliance which dominated Europe at least until 1830, and the chief supporter of reactionary policies designed to wipe out all traces of the revolutionary tide which had advanced over Europe only a short while before.

From: Memoirs

CONFESSION OF FAITH
PRESENTED AS A
SECRET MEMORANDUM TO
EMPEROR ALEXANDER I
OF RUSSIA ON
DECEMBER 15, 1820

Having now cast a rapid glance over the first causes of the present state of society, it is necessary to point out in a more particular manner the evil which threatens to deprive it, at one blow, of the real blessings, the fruits of genuine civilization, and to disturb it in the midst of its enjoyments. This evil may be described in one word: presumption; the natural effect of the rapid progression of the human mind towards the perfecting of so many things. This it is which at the present day leads so many individuals astray, for it has become an almost universal sentiment.

Religion, morality, legislation, economy, politics, administration, all have become common and accessible to everyone. Knowledge seems to come by inspiration; experience has no value for the presumptuous man; faith is nothing to him; he substitutes for it a pretended individual conviction, and to arrive at this conviction dispenses with all inquiry and with all study; for these means appear too trivial to a mind which believes itself strong enough to embrace at one glance all questions and facts. Laws have no value for

him, because he has not contributed to make them. . . . Power resides in himself; why should he submit himself to that which was only useful for the man deprived of light and knowledge? . . . Presumption makes of every man the guide of his own belief, the arbiter of laws according to which he is pleased to govern himself, or to allow some one else to govern him and his neighbors; it makes him, in short, the sole judge of his own faith, his own actions, and the principles according to which he guides them. . . .

We look upon it as a fundamental truth, that for every disease there is a remedy, and that the knowledge of the real nature of the one should lead to the discovery of the other. Few men, however, stop thoroughly to examine a disease which they intend to combat. There are hardly any who are not subject to the influence of passion, or held under the voke of prejudice; there are a great many who err in a way more perilous still, on account of its flattering and often brilliant appearance; we speak of l'esprit de système; that spirit always false but indefatigable, audacious and irrepressible, is satisfactory to men imbued with it (for they live and govern a world created by themselves), but it is so much the more dangerous for the inhabitants of the real world, so different from that created by l'esprit de système.

There is another class of men who, judging of a disease by its outward ap-

From Metternich, Memoirs, 5 vol. (New York, 1880-1881), I, 458-475; III, 655.

pearance, confound the accessory manifestations with the root of the disease, and, instead of directing their efforts to the source of the evil, content themselves with subduing some passing symptoms.

It is our duty to try and avoid both of these dangers.

The evil exists and it is enormous. We do not think we can better define it and its cause at all times and in all places than we have already done by the word "presumption," that inseparable companion of the half-educated, that spring of an unmeasured ambition, and yet easy to satisfy in times of trouble and confusion.

It is principally the middle classes of society which this moral gangrene has affected, and it is only among them that the real heads of the party are found.

Men in the higher classes of society who join the revolution are either falsely ambitious men, or, in the widest acceptation of the word, lost spirits. Their career, moreover, is generally short! They are the first victims of political reforms, and the part played by the small number among them who survive is mostly that of courtiers despised by upstarts, their inferiors, promoted to the first dignities of the State; and of this France, Germany, Italy, and Spain furnish a number of living examples. . . .

In all four countries the agitated classes are principally composed of wealthy men—real cosmopolitans, securing their personal advantage at the expense of any order of things whatever—paid State officials, men of letters, lawyers, and the individuals charged with the public education. To these classes may be added that of the falsely ambitious, whose number is never considerable among the lower orders, but is larger in the higher ranks of society.

There is besides scarcely any epoch which does not offer a rallying cry to some particular fashion. This cry, since 1815, has been Constitution. But do not let us deceive ourselves: this word, susceptible of great latitude of interpretation, would be but imperfectly understood if we supposed that the factions attached quite the same meaning to it under the different regimes. Such is certainly not the case. In pure monarchies it is qualified by the name of "national representation." In countries which have lately been brought under the representative regime it is called "development," and promises charters and fundamental laws. In the only State which possesses an ancient national representation it takes "reform" as its object. Everywhere it means change and trouble.

In pure monarchies it may be paraphrased thus: "The level of equality shall pass over your heads; your fortunes shall pass into other hands; your ambitions which have been satisfied for centuries, now shall give place to our ambitions, which have been hitherto repressed."

In the States under a new regime they say: "The ambitions satisfied yesterday must give place to those of the morrow, and this is the morrow for us."

Lastly, in England, the only place in the third class, the rallying cry—that of Reform—combines the two meanings.

The Governments having lost their balance, are frightened, intimidated, and thrown into confusion by the cries of the intermediary class of society, which, placed between the Kings and their subjects, breaks the sceptre of the monarch, and usurps the cry of the people—that class so often disowned by the people, and nevertheless too much listened to, caressed and feared by those who could

with one word reduce it again to nothingness.

We see this intermediary class abandon itself with a blind fury and animosity which proves much more its own fears than any confidence in the success of its enterprises, to all the means which seem proper to assuage its thirst for power, applying itself to the task of persuading Kings that their rights are confined to sitting upon a throne, while those of the people are to govern, and to attack all that centuries have bequeathed as holy and worthy of man's respect-denying, in fact, the value of the past, and declaring themselves, the masters of the future. We see this class take all sorts of disguises, uniting and subdividing as occasion offers, helping each other in the hour of danger, and the next day depriving each other of all their conquests. It takes possession of the press, and employs it to promote impiety, disobedience to the laws of religions and the State, and goes so far as to preach murder as a duty of those who desire what is good.

We are convinced that society can no longer be saved without strong and vigorous resolutions on the part of the Governments still free in their opinions and actions. We are also convinced that this may yet be, if the Governments face the truth, if they free themselves from all illusion, if they join their ranks and take their stand on a line of correct, unambiguous, and frankly announced principles.

By this course the monarchs may fulfil the duties imposed upon them by Him, who by entrusting them with power, has charged them to watch over the maintenance of justice, and the rights of truth. Placed beyond the passions which agitate society, it is in days of trial chiefly that they are called upon to despoil realities of their false appearances, and to show themselves as they are, fathers invested with the authority belonging by right to the heads of families, to prove that, in days of mourning, they know how to be just, wise, and therefore strong, and that they will not abandon the people whom they ought to govern to be the sport of factions, to error and its consequences, which must involve the loss of society. The moment in which we are putting our thoughts on paper is one of these critical moments. The crisis is great; it will be decisive to the part we take or do not take.

There is a rule of conduct common to individuals and to States, established by the experience of centuries as by that of everyday life. This rule declares "that one must not dream of reformation while agitated by passion; wisdom directs that at such moments we should limit ourselves to maintaining."

Let the monarchs vigorously adopt this principle; let all their resolutions bear the impression of it. Let their actions, their measures, and even their words announce and prove to the world this determination -they will find allies everywhere. The Governments, in establishing the principle of stability, will in no wise exclude the development of what is good, for stability is not immobility. But it is for those who are burdened with the heavy task of government to augment the well-being of their people! It is for Governments to regulate it according to necessity and to suit the times. It is not by concessions, which the factious strive to force from legitimate power, and which they have neither the right to claim nor the faculty of keeping within just bounds, that wise reforms can be carried out. That all the good possible should be done is our most ardent wish: but that which is not good must never be confounded with that which is, and even real good should be done only by those who unite to the right of authority the means of enforcing it. Such should be also the sincere wish of the people, who know by sad experience the value of certain phrases and the nature of certain caresses. . . .

The first principle to be followed by the monarchs, united as they are by the coincidence of their desires and opinions, should be that of maintaining the stability of political institutions against the disorganized excitement which has taken possession of men's minds; the immutability of principles against the madness of their interpretation; and respect for laws actually in force against a desire for their destruction.

The hostile faction is divided into two very distinct parties. One is that of the Levellers; the other, that of the Doctrinaires. United in times of confusion, these men are divided in times of inaction. It is for Governments to understand and estimate them at their just value.

In the class of Levellers there are found men of strong will and determination. The Doctrinaires can count none such among their ranks. If the first are more to be feared in action, the second are more dangerous in that time of deceitful calm which precedes it; as with physical storms, so with those of social order. Given up to abstract ideas inapplicable to real wants, and generally in contradiction to those very wants, men of this class unceasingly agitate the people by their imaginary or simulated fears, and disturb Governments in order to make them deviate from the right path. The world desires to be governed by facts and according to justice, not by phrases and theories; the first need of society is to be maintained by strong authority (no authority without real strength deserves the name) and not

to govern itself. In comparing the number of contests between parties in mixed Governments, and that of just complaints caused by aberrations of power in a Christian State, the comparison would not be in favor of the new doctrines. The first and greatest concern for the immense majority of every nation is the stability of the laws, and their uninterrupted action -never their change. Therefore let the Governments govern, let them maintain the groundwork of their institutions, both ancient and modern: for if it is at all times dangerous to touch them, it certainly would not now, in the general confusion, be wise to do so.

Let them announce this determination to their people, and demonstrate it by facts. Let them reduce the Doctrinaires to silence within their States, and show their contempt for them abroad. Let them not encourage by their attitude or actions the suspicion of being favorable or indifferent to error; let them not allow it to be believed that experience has lost all its rights to make way for experiments which at the least are dangerous. Let them be precise and clear in all their words, and not seek by concessions to gain over those parties who aim at the destruction of all power but their own, whom concessions will never gain over, but only further embolden in their pretensions to power.

CIRCULAR SENT FROM VERONA
BY AUSTRIA, RUSSIA,
AND PRUSSIA TO THEIR
AMBASSADORS AT THE OTHER
COURTS (VERONA, DECEMBER,
1822)

You were informed on the conclusion of the Laibach Conferences in May 1821, that the allied Monarchs and their Cabinets would meet in the course of 1822 on the proposal of the Courts of Naples and Turin, and with the concurrence of the other Italian Courts, to arrange as to the continuance of the measures which had been adopted for the maintenance of peace in the Peninsula after the sad events of 1820 and 1821.

This meeting has now taken place, and it is our present purpose to make known to you its results.

By the Convention, signed July 24, 1821, at Novara, the provisional formation of a military line in Piedmont by a corps of auxiliaries for one year was arranged, with the reservation to decide at the meeting in the year 1822 whether the condition of the country required the longer continuance of this measure, or whether it might be repealed.

The plenipotentiaries of those Courts which had signed the Convention of Novara, together with the plenipotentiaries of his Majesty the King of Sardinia, entered upon this investigation, and it was decided that the presence of an auxiliary force was no longer necessary to preserve peace in Piedmont. The King of Sardinia himself pointed out the mode in which the gradual retreat of the auxiliaries should be effected; and it was determined by a new convention that the departure of the troops from Piedmont should begin on December 31 and conclude on September 30, 1823, with the evacuation of the fortress of Alessandria.

His Majesty the King of the Two Sicilies, who had taken part in the Convention at Naples on October 18, also declared to the three Courts that the present condition of his country permitted him to propose a reduction in the number of the auxiliaries stationed at different places. The allied sovereigns have had no hesitation in acting on this proposal, and the

auxiliary forces stationed in the Two Sicilies will be as quickly as possible reduced to seventeen thousand men.

Everything therefore goes on according to the wishes of the monarchs as expressed by them at the conclusion of the Congress of Laibach, when they declared "that, far from desiring to extend their intervention in the affairs of Italy beyond the limits of stern necessity, they cherished the desire that the state of things which imposed this painful duty upon them would soon pass away never to return." Thus disappeared the false alarms, hostile constructions, and gloomy prophecies which have been disseminated over Europe by ignorance or perfidy, to mislead the people as to the pure and noble intentions of the monarchs. No secret scheme, no ambition, no calculation of their own advantage united them in the determination which an imperious necessity alone had dictated to them in 1821. To make a stand against revolutions, to overcome the disorders, troubles, and crimes which had overspread Italy, and restore this country to peace and order; to afford to legitimate Governments the protection to which they had a rightthese were the objects to which the thoughts and the efforts of the monarchs were solely directed. In proportion as those objects are attained they have withdrawn and will continue to withdraw the assistance which necessity alone called for and justifies. They think themselves happy to be able to leave the security and peace of the people to the care of the Princes whom Providence has entrusted with it, thus taking away the last pretext for the calumny which cast a doubt on the independence of the Italian sovereigns.

This object of the Congress of Verona, assigned to it by a definite Convention,

was fulfilled by the resolutions passed for the relief of Italy. But the allied sovereigns and their Cabinets cannot but glance at two great difficulties with the progress of which they have been much occupied since the Congress of Laibach.

An event of great importance took place before the conclusion of the Congress; what the spirit of revolution began in the Western Peninsula, what was attempted in Italy, has succeeded in the East of Europe. At the very moment when the rebels in Naples and Turin were retiring at the approach of legitimate power, a rebellious firebrand was cast into the Ottoman Empire. The coincidence of the events leaves no doubt as to the similarity of their origin. The outbreak of the evil at so many different points, everywhere conducted in the same manner and using the same language, unmistakably betrays the common focus from whence they all issue. The instigators of this movement flattered themselves that the counsels of the Powers would be embarrassed by dissensions and their forces neutralized by the cry of new dangers in different parts of Europe. The hope was vain. The monarchs, determined to refute the maxims of rebellion in whatever place and under whatever form they might appear, at once declared their unanimous decision. They will pursue the objects of their common care with unremitting attention, withstanding every consideration which might turn them from their path; they will follow the voice of conscience and duty, and uphold the cause of humanity in behalf of the victims of an enterprise as rash as it is criminal.

During this period—one of the most remarkable in the history of their alliance —numerous confidential communications took place between the five Courts, which had established such a satisfactory understanding in regard to the Eastern question that when they met at Verona the results only of that understanding had to be set forth, and the Powers friendly with Russia hope by common effort to put aside every obstacle to the entire fulfillment of her wishes.

Other events have called the attention of the monarchs to the pitiable condition of the Western Peninsula.

Spain is now undergoing the fate which awaits all States unfortunate enough to speak for what is good in a way in which it can never be found. It is passing through the fateful circle of its revolution, a revolution which deluded or evildisposed men represent as a benefit, or indeed a triumph, of the enlightened century. All Governments are witnesses of the zeal with which these men seek to persuade their comrades that this revolution is the necessary and wholesome fruit of advanced civilization, and the means by which it acts and is supported the noblest flight of enthusiastic love for the fatherland. If civilization can have for its aim the destruction of human society, and if it were possible to admit that the armed force which is only meant for the preservation of peace in the kingdom can seize the Government of that kingdom unpunished, certainly the Spanish revolution may claim the admiration of the age, and the military rising in Leon may serve as a pattern for reformers. But truth has soon asserted her rights, and Spain only presents another sad example (at the cost of her happiness and her fame) of the inevitable consequences of such transgressions of the eternal laws of the world.

Legitimate power fettered and turned into an instrument for the overthrow of all rights and all lawful liberty; all classes of people drawn into the stream of revo-

lutionary agitation; caprice and oppression exercised under the guise of laws; a whole kingdom given up to disorders and confusions of every kind; rich colonies preparing to set themselves free by the same maxims with which the mother has built up its public rights, and which it vainly condemns in another hemisphere; the last resources of the country destroyed by civil war—this is the picture which Spain now presents, these are the vexations with which a noble people worthy of a better fate is afflicted; lastly, these are the grounds of the just anxiety which such a concurrence of the elements of discontent and confusion must awake in the countries contiguous to the Peninsula. If ever a Power was raised in the very heart of civilization hostile to the principles of conservation, to the principles on which the European confederation rests, that Power is Spain in its present state of decomposition.

Can the monarchs look with equanimity on the evils heaped on one country which are accompanied with so many dangers for others? Dependent only on

their own judgment and their own conscience in this grave juncture of affairs, they must ask themselves whether it can be longer permitted to remain quiet spectators of calamities which daily threaten to become more dangerous and more horrible, or even by the presence of their representatives to give the false appearance of a silent consent to the measures of a faction ready to do anything to maintain and support their pernicious power. The decision of the monarchs cannot be doubtful. Their ambassadors have received orders to leave the Peninsula.

Whatever may be the result of this step, the monarchs declare before Europe that nothing can move them to waver in a resolution approved by their most heartfelt convictions. The greater the friendship they entertain for the King of Spain, the livelier their interest in the well-being of a nation which has ever been distinguished for its virtues and its grandeur, the more strongly do they feel the necessity of taking the measure on which they have decided, and which they will know how to maintain.

V. Romantics and Romanticism

Late in the eighteenth century a reaction against the straitness and the formalism of the dominant classical style encouraged the rise of a new style and attitude which we know as Romantic. It is the antithesis of everything the eighteenth century appreciated in Pope and in Voltaire; it spurns order, reason, impersonality, in favor of impulse, fantasy, dreams, mystery, and originality. Inspiration is found, not in classical models of perfection, but in varied, vital nature and in the observation of nature rather than its merely reasonable interpretation in the vast generalities dear to the heart of an earlier period.

The new fashion was popularized by the writings of Samuel Richardson (Pamela, 1740), J. J. Rousseau (The New Héloïse, 1761), and Goethe (Werther, 1774), but only became culturally dominant in the 'twenties of the following century. It is during these years that an older generation of Romantic writers (Goethe, Wordsworth, Chateaubriand) coincides with a younger (Byron, Shelley, Hugo, Vigny) that is much more turbulent. However, the general characteristics of the Romantic mood should be readily apparent from the following passages.

1. GOETHE

Wolfgang von Goethe (1749–1832) is certainly the most accomplished man that Germany ever produced. Poet, scientist, dramatist, and statesman, he started his career in the seventies with a verse play, Götz von Berlichingen, and a novel presented as a series of letters, The Sorrows of Young Werther, which turned him into a symbol and leader of the angry and inspired young men of the German "Storm and Stress" movement. He never managed to outlive or equal his early fame, though he still had two-thirds of his life to live and his greatest work still to write in, for instance, Faust and Wilhelm Meister. He is more of a transitional figure than a pure romantic, and yet the remarks below well reflect a characteristic romantic attitude.

From: Poetry and Truth

had grown old, along with the literature of which, for nearly a century, he had been the animating and ruling spirit. By his side there still existed many littérateurs, vegetating in a more or less active and happy old age, and then disappearing

in their turn one by one. The influence of society upon authors increased more and more; for the best society, consisting of persons of birth, rank, and property, chose literature as one of their chief recreations, making it entirely social and genteel in tone. Persons of rank and liter-

From Goethe, Poetry and Truth, tr. M. S. Smith (London: G. Bell & Sons, Ltd., 1908), II, 33-40, 301-303. By permission of the publisher.

ary men mutually cultivated and of necessity mutually perverted one another; for the genteel is naturally exclusive; that is what French criticism became, negative, detracting, and fault-finding. The upper classes applied this kind of criticism to authors; the authors, with somewhat less decorum, used the same procedure towards each other, and even towards their patrons. If the public was not to be awed, they endeavoured to take it by surprise, or to persuade it by humility; and thusapart from the movements which shook church and state to their inmost corethere arose such a literary ferment, that Voltaire himself had to strain to the utmost all the resources of his activity, and of his literary dictatorship, to keep himself afloat above the torrent of universal censure. As it was, he was openly called an old self-willed child; his indefatigable endeavours were regarded as the vain efforts of decrepit age; those principles, for which he had stood all his life, and to the spread of which he had devoted his days, were no longer held in honour or esteem: nay, that very Deity he acknowledged, and so continued to declare himself free from atheism, was discredited: and thus he himself, the venerable patriarch, was forced, like his youngest competitor, to watch the present moment, to sue for fresh favours—to show too much love to his friends, too much hate to his enemies; and under the appearance of a passionate striving after truth, to act deceitfully and falsely. Was it worth while to have led such a great and active life, if it was to end in greater dependence than it had begun? His high spirit, his delicate sensitiveness, felt only too keenly the galling nature of such a position. He often relieved himself by swift onslaughts, gave the reins to his humour, and exceeded all bounds, -at which both

friends and enemies showed themselves indignant; for everyone thought himself capable of gauging him, though none could equal him. A public which hears only the judgment of old men, becomes over-wise too soon; and nothing is more unsatisfactory than a mature judgment adopted by an immature mind.

We young men, with our German love of truth and nature, considered honesty towards ourselves and others as the best guide in life and art; hence Voltaire's factious dishonesty and his constant perversion of noble subjects became more and more distasteful to us, and our aversion to him grew daily. He seemed never to have done with degrading religion and the Holy Scriptures on which it rests, for the sake of injuring priestcraft, as they called it, and had thereby awakened in me feelings of irritation. But when I now learned that, to weaken the tradition of a deluge, he had denied the existence of all fossilized shells, and admitted them only as lusus naturae, he entirely lost my confidence; for my own eyes had shown me on the Bastberg, plainly enough, that I stood on what had been the floor of an ancient sea, among the exuviae of its original inhabitants. These mountains had certainly been once covered with waves, whether before or during the deluge did not concern me; it was enough that the valley of the Rhine had been one vast lake, a bay extending further than eye could see: no amount of talk could shake me in this conviction. I hoped, rather to extend my knowledge of lands and mountains, let the result be what it would. . . .

What I have here tried to state connectedly and in a few words was, at the time I speak of, the cry of the moment, a perpetual discord in our ears, unconnected and uninstructive. Nothing was heard but the praise of those who had gone be-

fore. The demand was continually for something good and new; yet the newest never found favour. . . .

If we heard the encyclopedists mentioned, or opened a volume of their colossal work, we felt as if we were moving amidst the innumerable whirling spools and looms of a great factory, where, what with the mere creaking and rattling—what with all the mechanism, bewildering both to eyes and brain—what with the mere impossibility of understanding how the various parts fit in and work with one another—what with the contemplation of all that is necessary to prepare a single piece of cloth, we felt disgusted with the very coat we wore upon our backs.

Diderot was sufficiently akin to us, as, indeed, in all the points for which the French blame him, he is a true German. But even his point of view was too lofty, his range of vision too wide for us to be able to rise to his height and place ourselves at his side. Yet the children of nature he continued to produce and to ennoble by his great rhetorical art delighted us: we were enchanted with his brave poachers and smugglers; and this rabble throve later only too well on the German Parnassus. He, too, like Rousseau, by diffusing a disgust of social life, unobtrusively paved the way for those monstrous world-wide changes, in which all that had hitherto existed seemed to be swallowed up.

However, we should now put aside these considerations, and observe what influence these two men have had upon art. Here, too, they pointed to nature and urged us to turn from art and follow her.

The highest problem of all art is to produce by illusion the semblance of a higher reality. But it is a false endeavour to push the realization of the illusion so far that at last only a commonplace reality remains. . . .

We had neither desire nor inclination to be enlightened or advanced by the aid of philosophy; on religious subjects we thought we had sufficiently enlightened ourselves, and therefore looked on with comparative indifference at the violent contest between the French philosophers and the priesthood. Prohibited books condemned to the flames, of which so much was heard at the time, produced no effect upon us. I mention as a typical instance, the Système de la Nature [of Holbach] which we looked into out of curiosity. We did not understand how such a book could be dangerous. It seemed to us so gloomy, so Cimmerian, so deathlike, that we found it difficult to endure its presence, and shuddered at it as at a spectre. The author fancies he is giving his book a great recommendation, when he declares in his preface, that as a decrepit old man, just sinking into the grave, he is anxious to announce the truth to his contemporaries and to posterity.

We laughed at him; for we thought we had observed that old people are incapable of appreciating whatever is good and loveable in the world. "Old churches have dark windows.-To know how cherries and berries taste, we must ask children and sparrows." These were our gibes and maxims; and so that book, as the very quintessence of senility, seemed to us insipid, or even offensive. "All had of necessity to be," so said the book, "and therefore there was no God." But could not God also exist of necessity? we asked. We did indeed admit, at the same time, that we could not escape from the necessities of day and night, the seasons, the influence of climate, and from physical and animal conditions; but nevertheless we felt within us something that seemed like perfect freedom of will, and again something which sought to counter-balance this freedom.

We could not give up the hope of becoming more and more rational, of making ourselves more and more independent of external things, and even of ourselves. The word freedom has so fair a sound, that we cannot dispense with it, even though it designates an error.

None of us had read the book through; for it had disappointed the expectation with which we opened it. It had announced a system of nature; and we had. therefore, hoped really to learn something of nature-of this idol of ours. Physics and chemistry, descriptions of heaven and earth, natural history and anatomy, with much besides, had now for years, and up to this very moment, constantly pointed us to the great world and its wealth of beauty; and we would fain have heard more, both in particular and in general, of suns and stars, planets and moons, mountains, valleys, rivers and seas, with all that live and move in them. That in the course of such an exposition much must occur which would appear to the common man as pernicious, to the clergy as dangerous, and to the state as inadmissible, we had no doubt; and we hoped that the small volume had not unworthily undergone the fiery ordeal. But how hollow and empty did we feel this melancholy, atheistic half-night to be, where earth vanished with all its creatures, heaven with all its stars. Matter was supposed to have existed and to have been in motion from all eternity, and to this motion, to right and to left and in every direction, were attributed the infinite phenomena of existence. We might have allowed even so much to pass, if the author, out of his matter in motion, had really built up the

world before our eyes. But he seemed to know as little about nature as we did; for, after simply propounding some general ideas, he forthwith disregards them in order to change what seems above nature, or a higher nature within nature, into matter with weight and motion but without aim or shape—and by this he fancies he has gained much.

If this book did us any harm at all, it was in giving us a hearty and lasting dislike to all philosophy, and especially to metaphysics; while, on the other hand, we threw ourselves into living knowledge, experience, action, and poetry, with all the more zeal and ardour.

Thus, on the very borders of France, we had at one blow got rid of everything French about us. The French way of life was too definite and too genteel for us, their poetry cold, their criticism annihilating, their philosophy abstruse, and yet unsatisfying. . . .

In the course of this biography we have shown in detail how the child, the boy, the youth, sought by various ways to approach the supernatural; first, looking with strong inclination to a religion of nature; then, clinging with love to a positive one; and, finally, concentrating himself in the trial of his own powers and joyfully giving himself up to a general faith. Whilst he wandered to and fro, seeking and looking about him, in the intervals which lay between these several phases, he met with much that would not fit into any of them, and he seemed to realize more and more clearly the desirability of turning his thoughts away from the immense and incomprehensible.

He thought he could detect in nature—both animate and inanimate, with soul and without soul—something which manifested itself only in contradictions, and which, therefore, could not be com-

prehended under any idea, still less under one word. It was not godlike, for it seemed without reason; nor human, for it had no understanding; nor devilish, for it was beneficent; nor angelic, for it often betrayed a malicious pleasure. It resembled chance, for it evinced no succession; it was like Providence, for it hinted at connection. It semed to penetrate all that limits us; it seemed to deal arbitrarily with the necessary elements of our existence; it contracted time and expanded space. In the impossible alone did it appear to find pleasure, while it rejected the possible with contempt.

To this principle, which seemed to come in between all other principles and separate them, and yet link them together, I gave the name of Daemonic, after the example of the ancients and others with similar experiences. I sought to escape from this terrible principle, by taking refuge, according to my wont, in a creation of the imagination.

Among the parts of history which I had particularly studied, were the events that made the countries which subsequently became the United Netherlands so famous. I had diligently examined the original sources, and had endeavoured, as far as possible, to get my facts at first hand, and to bring the whole period vividly before me. The situations it presented appeared to me to be in the highest degree dramatic, while Count Egmont, whose greatness as a man and a hero most captivated me, seemed to me a suitable central figure round whom the others might be grouped with happiest effect.

But for my purpose it was necessary to convert him into a character marked by such peculiarities as would grace a youth better than a man in years, and an unmarried man better than the father of a family; a man leading an independent life, rather than one, who, however free in thought, is nevertheless restrained by the various relations of life.

Having then, in my conception of Egmont's character, made him youthful, and freed him from all fettering restraints, I gave him unlimited love of life, boundless self-reliance, a gift of attracting all men, enabling him to win the favour of the people, the unspoken attachment of a princess, the avowed passion of a child of nature, the sympathy of a shrewd politician, and even the loving admiration of the son of his greatest adversary. The personal courage which distinguishes the hero is the foundation upon which his whole character rests, the ground whence it springs. He knows no danger, and is blind to the greatest peril when it confronts him.

When surrounded by enemies, we may, at need, cut our way through them; the meshes of state policy are harder to break. The Daemonic element, which plays a part on both sides, in conflict with which what is loveable falls while what is hated triumphs; further the prospect that out of this conflict will spring a third element, and fulfil the wishes of all men;this perhaps is what has gained for the piece (not, indeed, on its first appearance, but later and in due time), the fayour which it still enjoys. Here, therefore, for the sake of many dear readers, I will forestall myself, and as I do not know when I shall have another opportunity, will express a conviction, which did not become clear to me till a later date.

Although this Daemonic element manifests itself in all corporeal and incorporeal things, and even expresses itself most distinctly in animals, yet it is primarily in its relation to man that we observe its mysterious workings, which represent a force, if not antagonistic to the moral or-

der, yet running counter to it, so that the one may be regarded as the warp, and the other as the woof.

For the phenomena which result there are innumerable names; for all philosophies and religions have sought in prose and poetry to solve this enigma and to read once for all the riddle; and may they still continue to seek.

But the most fearful manifestation of the Daemonic is when it is seen predominating in some individual character. During my life I have observed several instances, either closely or at a distance. Such persons are not always the most eminent men, either in intellect or special

gifts, and they are seldom distinguished by goodness of heart; a tremendous energy seems to emanate from them, and they exercise a wonderful power over all creatures, and even over the elements: and. indeed, who shall say how much further such influence may extend? All the moral powers combined are of no avail against them; in vain does the more enlightened portion of mankind attempt to throw suspicion upon them as dupes or as deceivers—the masses are attracted by them. Seldom if ever do they find their equals among their contemporaries; nothing can vanquish them but the universe itself, with which they have begun the fray.

2. FRIEDRICH HÖLDERLIN

Though little known outside Germany, Johann Christian Friedrich Hölderlin (1770–1843) provides one of the major links between the classical and romantic schools of literature in that country. Influenced by the poetry of Schiller and of the ancient Greeks, his work was lyrical and highly subjective, though the themes often referred to classical times.

As a young man, Hölderlin earned his living as a private tutor. An unhappy love affair deranged his high-strung mind. He would live to the age of 73, but the last forty years of his life were passed in an advanced state of schizophrenia, with brief recoveries during which his poetry was as magnificent as ever. *Hyperion*, written before this disaster, between 1797 and 1799, is a strange elegiac novel about a Grecian hermit sage and his considerations on the ways of the world. The penultimate letter of the book, translated below, vents certain uncomplimentary views on his German countrymen.

Hyperion

I do not know who once said that the virtues of the ancients are nothing but brilliant vices; but it is truer to say that their faults themselves are virtues, for a spirit of youth and beauty is still alive in them and, without this spirit, they

would not have accomplished all that they have. The virtues of the Germans, on the other hand, are the brilliant reverse of a vice, and nothing more; for they are of necessity, forcibly drawn from the desert of the heart, in heavy

Translated by Eugen Weber from the Letters of Hyperion to Bellarmin (Leipzig, 1822), the penultimate letter.

slavery, by a fear born of cowardice. The pure soul, which would so wish to find its nourishment in beauty, they leave it without consolation. Alas! used as it is to the sacred harmony of all noble natures, it cannot endure the cacophony that breaks out everywhere throughout the dead order of these humans.

I tell you this: there is nothing sacred which is not profaned, in this people, not lowered to sordidly utilitarian ends; and even that which, most of the time, savages maintain pure and divine these barbarians, who are accountants above all, deal with as if it were a trade. What else could they do? Since, with them, hardly has a man grown up than he has to serve a useful purpose and earn money; no more enthusiasm, God save us! and no more dreams: settled, besotted, that is how he remains even in his rejoicings, his loves, his prayers. Even in the graces of spring, in the time of universal reconciliation and freedom from care. when even the guilty heart miraculously rediscovers its first innocence and when. under the caress of the sun's warm rays, the merry slave comes to forget his chains, when even misanthropists, disarmed by the divine breath of the breeze, become sweet as children-yea, when even caterpillars find wings and the hive swarms, the German, for his part, stays in his place, shut up, keeps to his specialty and gives not a hoot for the weather!

But you, Holy Nature, shall judge him! For this humanity could at least be modest enough not to impose its law on the best among it! It could at least avoid denouncing that which it is not and, at the very least, not blaspheme God in its denigrations.

For is it not the divine which you mock and hold to be without a soul? And the air on which you feed, is it not better

than all your chatter? Has not the sunshine a greater price and a higher nobility than all your clever men? The springs of the earth and the dew refresh your meadows; can you do as much? Alas! to kill them, that you know how, but not to revivify them as love does, love which does not come from you, which you have not discovered. Your care and effort are to escape Destiny, when your childish arts—you will not understand it—are no use; and meanwhile, up there, the serene constellations accomplish their course. You degrade and ravage patient nature in the very places where it bears you; and yet its life continues in its endless youth, and you cannot abolish its spring or fall, nor soil its immaculate air.

O divine, how divine she must be for you to ravage her thus, yet without her ever growing old, and how splendid, despite you, remains her beauty!

It is a heartbreaking sight, also, to see your poets and artists and all those who still feel respect for Genius, still love and are devoted to Beauty. Poor miserable creatures! They are in the world like strangers in their own house, alike in every way to the patient Ulysses as he sat, in beggar's garb, before the gate of his own palace, the insolent suitors noisily asking: who brought us this tramp?

See them growing, filled with hope and love and intelligence, the young disciples of the Muse among this German people. But see them seven years later: they move like shadows, silent and frozen, and see them altogether like those arid lands which the enemy has sown with salt so that not the slightest blade of grass should ever grow on them again; or if they speak, woe to him who hears them! for he can only behold, in the unleashing of this titanic force, the changing and protean forms of the great and desperate

struggle that a troubled spirit leads against the barbarians with whom he deals.

Nothing perfect here on earth, is the Germans' old song. But may someone come to tell these damned people, once for all, that if all is so imperfect with them it is because nothing pure exists which they do not soil, nothing sacred which they do not profane, with their big paws; and that nothing prospers with them because the root and providence of all success, which is divine nature, receives no respect from them; that life with them is altogether insipid, crushed down with cares, wholly the prev of cold and secret discord, because of the way in which they despise Genius-that Genius which introduces nobility and virtue into the human condition, serenity into suffering, communion and love into cities and homes.

And that is why they fear death so much, yes, that is why, in order to lead this life of molluscs, they suffer every infamy. They know nothing more sublime than the dreary shoddy works turned out by the hands of saboteurs.

Ah! Bellarmin, if only a people has the love of Beauty, if it may express, through its artists, devotion and reverence for Genius, then a spirit moves in it, the universal spirit, like a breath of life at whose

touch heretofore intimidated personalities bloom, before which self-satisfied presumption retreats: and all hearts ripen to piety, to grandeur; enthusiasm flowers and heroes are born. Such a nation is the fatherland of all mankind and the stranger likes to draw out his stay there. But where, on the contrary, divine nature and its artists are so outraged, nothing of the best, nothing of joy of life remains, alas! and then my other planet is a better abode than this earth! Ever more desolate and arid become the men who vet are all born of equally noble origin; and one can see a servile mentality develop, a lackeyspirit, and with it the pride of the bully; drunkenness grows together with anxiety, and along with opulence hunger and fear of want increase: the benediction of every season turns to malediction, and all gods flee.

Indeed, woe to the stranger whom love of travel has brought as far as this nation, and woe, O! three times woe, to him who, like myself, moved by a great sorrow, has come to this people!

But enough! Knowing me, Bellarmin, you will not take this ill. I have spoken in your name too, as I have spoken for all those who are here, in this country, and who suffer in it as I have suffered myself.

3. AUGUST-WILHELM SCHLEGEL

August-Wilhelm Schlegel, 1767–1845, the elder of two brothers who have left their mark on German letters, was responsible for initiating Madame de Staël to German literature and thus, perhaps, the French public to romanticism. More important, he naturalized Shakespeare in Germany by his great translation of the poet's works and also introduced German readers to Ariosto, Tasso, Petrarch, Camoens, the Ramayana and the great plays of the Spanish theater. Quarrelling with his younger brother when the latter turned to Catholicism, as other members of the romantic generation were doing, he ended his life publishing his works only in French.

Classic Art and Romantic Art

It is evident that the imperishable spirit of poesy acquires a different guise every time it reappears in the human race, and that in every age the habits and ideas of the different centuries provide it with a new and peculiar existence. The forms of poesy must change with the direction that the peoples' poetic imagination may take, and when one wants to apply the names of the old styles and their old rules to new compositions, to judge them according to these ideas, this is an ill-conceived usage of classical authority. None should be judged in a court under whose jurisdiction he does not come.

Ancient art and poetry never admitted the mixture of heterogeneous styles; the romantic spirit, on the contrary, enjoys a continual juxtaposition of the most diverse things. All the antinomies: nature and art, poetry and prose, seriousness and joking, memory and foreboding, abstract ideas and concrete sensations, the earthly and the divine, life and death, become one in the closest and most intimate union. . . . If ancient poesy, ancient art as a whole, are . . . a harmonious and regular revelation of the legislation forever fixed for an ideal world reflecting the eternal types of things, romantic poetry, on the contrary, is the expression of a mysterious secret aspiration towards the chaos that ever labors to conceive ever new and more wondrous things-that chaos which always subsists beneath the harmonious creation and hides even in its breast. Here the vivifying breath of the original love still floats above the waters.

The inspiration of the ancients was

simple, clear, more alike to nature in its most isolated and most perfect works. The romantic genius, despite its fragmentary aspect and its apparent disorder, is yet nearer the mystery of the universe; for if *intelligence* can never grasp in every isolated thing more than a part of truth, *feeling* on the contrary, embracing everything, perceives and penetrates all in all.

To return to the dramatic style under discussion, one may compare ancient tragedy to the group in sculpture: in one and the other art equally, each figure corresponds to a character, and the action lies in the manner in which they are grouped: the characters and the action, it is solely on these two elements that attention is directed, since this alone is represented. As for romantic drama, one must present it as a painted scene, where there appear not only figures in the most varied attitudes and forming groups endowed with the richest, most diverse movements, but also objects surrounding the characters and even perspectives upon the distant horizon, so that the whole is bathed in a magic light which, precisely, determines and orients its singular effect.

Such a painting would be less circumscribed, less clearly framed than the plastic group because it is, in effect, something like a fragment of the universal perspective. Nevertheless, by the framework within which he encloses his foreground, by the light which he focuses upon it, by still other means, the artist can attract and hold the beholder's gaze and avoid its being distracted or dissatisfied.

From the thirteenth lesson of the Course on Dramatic Literature, delivered at Vienna, 1808; translated by Eugen Weber from the Collected Works of August-Wilhelm Schlegel, Course on Dramatic Literature (Leipzig, 1876).

Painting cannot match sculpture in the reproduction of form, since it reproduces it only with the aid of an illusion and from only one point of view; but by means of color it gives this imitation more life, and its figures, by means of facial expression, express the most diverse feelings to their most delicate nuances. By the expression of a gaze, which sculpture can indicate only very imperfectly, painting can let us read far more profoundly in the heart and can reveal its most subtle movements. Above all, the peculiar charm of painting is to reveal those most immaterial aspects of material objects: light and air.

It is exactly this kind of beauty that is

Letter to a French friend

At the time of my entry into the literary career, we carried on, my friends and I, an active campaign against the prosaic and negative tendencies of the time. We awakened the remembrance of the middle ages, of those centuries so vigorous and at the same time so full of faith. We brought back into poetry the Christian subjects which had gone so completely out of fashion. Protestantism does not lend itself at all to this sort of thing: witness Milton and Klopstock. Dante, whom I had studied thoroughly, and Calderon, whom I discovered later, are of quite a different nature. So one could not help drawing upon the traditions of the Roman Church. All the world admires the great painters who glorified the cosmogony and the patriarchal history of the Jews, ennobled the humble garments of the Scriptures, and veiled the absurdities of the legend. I retranslated, so to speak, into words some of the most beautiful picturesque subjects. It was an artist's predilection; and this connection is even more clearly marked in my poem: "The

peculiar to romantic drama. To the contrary of ancient tragedy, the romantic play does not rigorously isolate the tragic element and the action of the elements of vital life: it resumes the whole show in its total variety and with its surroundings; and while it may seem to reproduce only fortuitously juxtaposed details, in fact it satisfies the unconscious rights of our imagination, and plunges us into a contemplative, meditative mood, by giving us the feeling of wonderful harmony and of the profound meaning connected with it, by the mixture and the bizarre appearance of its imitation of life. It lends, so to speak, a soul to the perspectives of appearance.

Alliance of the Church with the Fine Arts."

Among my friends, Novalis, audacious thinker, prophetic dreamer, visionary in the end, gave himself wholly over to the Christian faith, as a migratory bird, tired by its flight over an immense ocean, falls on to a small green island and there forgets the land whence it came and the vast spaces it had hoped to reach. However, he did not change confession; his father had been a member of the Society of Moravian Brethren, and one could notice a hereditary tinge in the piety of his son. He died soon after.

I wanted to get to know the mystics, those exploring divers of consciousness and sensibility who sometimes bring back pearls from the bottom of the sea, and the theosophists, who discern the imprint of Christian doctrines throughout the whole of nature. And it is true that there are grains of gold in their writings, but in such strange company that, when they want to pass all this off as pure gold, it looks more like an alchemist's trick.

Written in French from Bonn, August 13, 1838.

Returns to the old religion were becoming ever more frequent. Among painters, especially, abjuration at Rome had become almost an epidemic. One would be mistaken in thinking that I had any influence upon this.

For my part, I never seriously entertained the idea of contracting a solemn engagement, although I did not lack for solicitations. On the contrary, to the degree that my brother, Frédéric, was moving forward, I was drawing back. I can only blame myself for overmuch indulgence; but I expiated it by one of my life's bitterest sorrows. It was the divorce of the souls. Revolted by the role he played

since 1819, as writer and as ally of the Jesuits, I ended by an open declaration of hostility, in the manner of the ancient Romans.

Let us admit that what we have seen in Europe since the peace [of 1815] does not encourage a new union with one of the two Christian communities. On one side, frightful reactions, efforts to submit mankind once more to the priestly yoke; on the other side, intolerance, separation, a pedantic morality which tries to pass itself off for holiness, finally all sorts of sects, one more extravagant than the other. It all surpasses belief, but the facts are there. I speak only of Germany.

4. MADAME DE STAËL

The mother of Madame de Staël, Suzanne Curchod, daughter of a Swiss country parson, was reputed the most accomplished maiden of her province. Courted by Edward Gibbon, she eventually married a great Genevan banker, Jacques Necker, who soon took her to Paris where she presided over his literary and philosophical salon, while he presided over the finances of the monarchy. It was in that salon that little Germaine (1766-1817) first discovered the art of conversation and all the games that could be played with it. Words, she would explain on one occasion, are not just "a means to communicate ideas, feelings and needs, but an instrument one likes to play and which revives the spirit, just as does music in some nations, and strong liquors in others." Conversation, at its best, was "a certain way in which people act upon one another, a quick give-and-take of pleasure, a way of speaking as soon as one thinks, of rejoicing in oneself in the immediate present, of being applauded without making an effort, of displaying one's intelligence by every nuance of intonation, gesture and look — in short the ability to produce at will a kind of electricity which, emitting a shower of sparks, relieves the excess of liveliness in some and rouses others from their painful apathy."

Coming from a literary family, the young woman wrote, and she wrote well, all of her books having been talked before they were written. Talking a bit too much, she got on the wrong side of Napoleon, who exiled her from Paris. One result of this rather benign relegation was a trip to Germany which gave, in 1810, her book Concerning Germany (promptly banned by Napoleon). As a contemporary observed, there was more light in the book than there was clarity; but the chapters on literature and philosophy presented its readers (first in England where it was published in 1813, and only later in France and elsewhere) with a loaded but suggestive picture of a romantic country and a romantic climate.

Romanticism

The word *romantic* has been lately introduced in Germany, to designate that kind of poetry which is derived from the songs of the Troubadours; that which owes its birth to the union of chivalry and Christianity. If we do not admit that the empire of literature has been divided between paganism and Christianity, the north and the south, antiquity and the middle ages, chivalry and the institutions of Greece and Rome, we shall never succeed in forming a philosophical judgment of ancient and modern taste.

Some French critics have asserted that German literature is still in its infancy; this opinion is entirely false: men who are best skilled in the knowledge of languages, and the works of the ancients, are certainly not ignorant of the defects and advantages attached to the species of literature which they either adopt or reject; but their character, their habits, and their modes of reasoning have led them to prefer that which is founded on the recollection of chivalry, on the wonders of the middle ages, to that which has for its basis the mythology of the Greeks. The literature of romance is alone capable of further improvement, because, being rooted in our own soil, that alone can continue to grow and acquire fresh life: it expresses our religion; it recalls our history; its origin is ancient, although not of classical antiquity. Classic poetry, before it comes home to us, must pass through our recollections of paganism: that of the Germans is the Christian era of the fine arts; it employs our personal impressions to excite strong and vivid emotions; the genius by which it is inspired addresses itself immediately to our hearts, and seems to call forth the spirit of our own

lives, of all phantoms at once the most powerful and the most terrible.

It is said there are persons who discover springs, hidden under the earth, by the nervous agitation which they cause in them: in German poetry, we often think we discover that miraculous sympathy between man and the elements. The German poet comprehends nature not only as a poet, but as a brother; and we might almost say that the bonds of family union connect him with the air, the water, flowers, trees—in short, all the primary beauties of the creation.

When I began the study of German literature, it seemed as if I was entering on a new sphere, where the most striking light was thrown on all that I had before perceived only in a confused manner. For some time past, little has been read in France except memoirs and novels, and it is not wholly from frivolity that we are become less capable of more serious reading, but because the events of the revolution have accustomed us to value nothing but the knowledge of men and things: we find in German books, even on the most abstract subjects, that kind of interest which confers their value upon good novels, and which is excited by the knowledge which they teach us of our own hearts. The peculiar character of German literature, is to refer everything to an interior existence; and as that is the mystery of mysteries, it awakens an unbounded curiosity.

The new school maintains the same system in the fine arts as in literature, and affirms that Christianity is the source of all modern genius; the writers of this school also characterize, in a new manner, all that in Gothic architecture agrees with the religious sentiments of Christians. It does not follow however from this, that the moderns can and ought to construct Gothic churches; neither art nor nature admit of repetition: it is only of consequence to us, in the present silence of genius, to lay aside the contempt

which has been thrown on all the conceptions of the middle ages; it certainly does not suit us to adopt them, but nothing is more injurious to the development of genius, than to consider as barbarous everything that is original.

5. WILLIAM BLAKE

William Blake (1757–1827) was from the first a dreamer and a seer of visions. These he sought to reproduce in poems and plays of great simplicity and directness. His work, original and intense, was neglected and misunderstood by all but a few; but in the verses that follow, he reflects as well as anyone the anti-French, anti-rationalist reaction of the age.

Mock on, mock on, Voltaire, Rousseau

(written between 1800 and 1810)

Mock on, mock on, Voltaire, Rousseau; Mock on, mock on; 'tis all in vain! You throw the sand against the wind, And the wind blows it back again.

And every sand becomes a gem Reflected in the beams divine;

The Tiger

(published in 1794)

Tiger! Tiger! burning bright
In the forests of the night,
What immortal hand or eye
Could frame thy fearful symmetry?

In what distant deeps or skies Burnt the fire of thine eyes? On what wings dare he aspire? What the hand dare seize the fire?

And what shoulder, and what art, Could twist the sinews of thy heart? And when thy heart began to beat, What dread hand? and what dread feet? Blown back they blind the mocking eye But still in Israel's path they shine.

The Atoms of Democritus And Newton's Particles of Light Are sands upon the Red Sea shore Where Israel's tents do shine so bright.

What the hammer? what the chain? In what furnace was thy brain? What the anvil? what dread grasp Dare its deadly terrors clasp?

When the stars threw down their spears, And watered heaven with their tears, Did he smile his work to see? Did he who made the Lamb make thee?

Tiger! Tiger! burning bright
In the forests of the night,
What immortal hand or eye
Dare frame thy fearful symmetry?

London

(published in 1794)

I wander through each chartered street,
Near where the chartered Thames does
flow,
And mark in every face I meet

And mark in every face I meet
Marks of weakness, marks of woe.

In every cry of every Man, In every Infant's cry of fear, In every voice, in every ban, The mind-forged manacles I hear. How the Chimney-sweeper's cry Every blackening Church appalls; And the hapless Soldier's sigh Runs in blood down Palace walls.

But most through midnight streets I hear How the youthful Harlot's curse Blasts the new born Infant's tear, And blights with plagues the Marriage hearse.

6. WILLIAM WORDSWORTH

William Wordsworth (1770–1850) lived most of his life in the hills and dales of the English Lake District. His boyhood was rather poor and wild, and he says of himself at the time that he showed "a stiff, moody, and violent temper." A visit to France in 1790 filled him with enthusiastic sympathy for the Revolution, but this ebbed away in a few years. His reputation as a poet grew with time, and he was mellowed by recognition both pecuniary and critical. Wordsworth settled at Grasmere where he led a tranquil and fruitful life crowned by his appointment as Poet Laureate a few years before his death.

The Tables Turned

(published in 1798)

Up! up! my Friend, and quit your books; Or surely you'll grow double: Up! up! my Friend, and clear your looks; Why all this toil and trouble?

The sun, above the mountain's head, A freshening lustre mellow Through all the long green fields has spread, His first sweet evening yellow.

Books! 'tis a dull and endless strife: Come, hear the woodland linnet, How sweet his music! on my life, There's more of wisdom in it. And hark! how blithe the throstle sings! He, too, is no mean preacher:
Come forth into the light of things,
Let Nature be your teacher.

She has a world of ready wealth, Our minds and hearts to bless— Spontaneous wisdom breathed by health, Truth breathed by cheerfulness.

One impulse from a vernal wood May teach you more of man, Of moral evil and of good, Than all the sages can. Sweet is the lore which Nature brings; Our meddling intellect Mis-shapes the beauteous forms of things: We murder to dissect. Enough of Science and of Art; Close up those barren leaves; Come forth, and bring with you a heart That watches and receives.

London, 1802

Milton! thou shouldst be living at this hour:

England hath need of thee: she is a fen

Of stagnant waters: altar, sword, and pen,

Fireside, the heroic wealth of hall and bower,

Have forfeited their ancient English dower Of inward happiness. We are selfish men; Oh! raise us up, return to us again; And give us manners, virtue, freedom, power.

Thy soul was like a Star, and dwelt apart; Thou hadst a voice whose sound was like the sea:

Pure as the naked heavens, majestic, free, So didst thou travel on life's common way, In cheerful godliness; and yet thy heart The lowliest duties on herself did lay.

7. LORD BYRON

George Gordon, sixth Lord Byron (1788–1824), appears as very much the type of volcanic Romantic hero. The misery of lameness, a violent and capricious mother, and an extravagant youth (one of his escapades consisted of keeping a bear cub in his rooms at Trinity College, Cambridge) helped form the spirit of revolt which was his lifelong characteristic. The first two cantos of *Childe Harold*, published in 1812, met with acclamation. In his own words, he awoke one morning and found himself famous. But, though lionized, his marital difficulties, his temper, and his refusal to conform kept him out of English society and out of England for most of the rest of his life. It was in Italy that he wrote many of his later poems and in Greece that he died, of malarial fever, having gone there to fight for Hellenic independence against the Turks.

From: Childe Harold's Pilgrimage

CANTO III (1816)

But quiet to quick bosoms is a hell, And there hath been thy bane; there is a fire

And motion of the soul which will not dwell
In its own narrow being, but aspire
Beyond the fitting medium of desire;
And, but once kindled, quenchless evermore,

Preys upon high adventure, nor can tire Of aught but rest; a fever at the core, Fatal to him who bears, to all who ever bore.

This makes the madmen who have made men mad

By their contagion; Conquerors and Kings,

Founders of sects and systems, to whom add

Sophists, Bards, Statesmen, all unquiet things

Which stir too strongly the soul's secret springs,

And are themselves the fools to those they fool;

Envied, yet how unenviable! what stings Are theirs! One breast laid open were a school

From: Lara, Canto I, 1814

There was in him a vital scorn of all:
As if the worst had fall'n which befall,
He stood a stranger in this breathing world,
An erring spirit from another hurl'd;
A thing of dark imaginings, that shaped
By choice the perils he by chance escaped;
But 'scaped in vain, for in their memory yet
His mind would half exult and half regret:
With more capacity for love than earth
Bestows on most of mortal mould and birth,
His early dreams of good outstripp'd the
truth,

And troubled manhood followed baffled youth;

With thought of years in phantom chase misspent,

And wasted powers for better purpose lent; And fiery passions that had poured their wrath

In hurried desolation o'er his path,
And left the better feelings all at strife
In wild reflection o'er his stormy life;
But haughty still, and loth himself to blame,
He call'd on Nature's self to share the
shame.

And charged all faults upon the fleshly form She gave to clog the soul, and feast the worm:

Till he at last confounded good and ill, And half mistook for fate the acts of will: Too high for common selfishness, he could Which would unteach mankind the lust to shine or rule:

Their breath is agitation, and their life A storm whereon they ride, to sink at last, And yet so nursed and bigoted to strife, That should their days, surviving perils past, Melt to calm twilight, they feel overcast With sorrow and supineness, and so die; Even as a flame unfed, which runs to waste With its own flickering, or a sword laid by, Which eats into itself, and rusts ingloriously.

At times resign his own for others' good,
But not in pity, not because he ought,
But in some strange perversity of thought,
That sway'd him onward with a secret pride
To do what few or none would do beside;
And this same impulse would, in tempting
time,

Mislead his spirit equally to crime; So much he soar'd beyond, or sunk beneath, The men with whom he felt condemn'd to breathe,

And long'd by good or ill to separate Himself from all who shared his mortal state;

His mind abhorring this, had fix'd her throne

Far from the world, in regions of her own: Thus coldly passing all that pass'd below, His blood in temperate seeming now would flow:

Ah! happier if it ne'er with guilt had glow'd, But ever in that icy smoothness flow'd! 'Tis true, with other men their path he walk'd,

And like the rest in seeming did and talk'd, Nor outraged Reason's rules by flaw nor start,

His madness was not of the head, but heart;

And rarely wander'd in his speech, or drew His thoughts so forth as to offend the view.

8. PERCY BYSSHE SHELLEY

Percy Bysshe Shelley (1792–1822), the son of a Sussex country gentleman, was educated at Eton and expelled from Oxford for writing a pamphlet on *The Necessity of Atheism*. At odds with his disapproving family, the ensuing years of wandering produced some beautiful verses, an unfortunate first marriage, and an elopement to Italy with Mary Wollstonecraft Godwin, the daughter of the radical philosopher William Godwin and famous in her own right for the novel *Frankenstein* (1818). Shelley was able to marry Mary in 1816, when his former wife had drowned herself. He too lived the last years of his life in Italy, where he made friends with Byron and where he was drowned in the course of a boating expedition.

England in 1819

An old, mad, blind, despised, and dying king,—

Princes, the dregs of their dull race, who flow

Through public scorn,—mud from a muddy spring,—

Rulers who neither see, nor feel, nor know, But leech-like to their fainting country cling, Till they drop, blind in blood, without a blow,—

A people starved and stabbed in the untilled field,—

An army, which liberticide and prey
Makes as a two-edged sword to all who
wield

Golden and sanguine laws which tempt and slay;

Religion Christless, Godless—a book sealed; A Senate,—Time's worst statute unrepealed,—

Are graves, from which a glorious Phantom may

Burst, to illumine our tempestuous day.

Final Chorus from Hellas, 1822

The world's great age begins anew,
The golden years return,
The earth doth like a snake renew
Her winter weeds outworn:
Heaven smiles, and faiths and empires
gleam,

A brighter Hellas rears its mountains From waves serener far; A new Peneus rolls his fountains Against the morning star. Where fairer Tempes bloom, there sleep Young Cyclads on a sunnier deep.

Like wrecks of a dissolving dream.

A loftier Argo cleaves the main, Fraught with a later prize; Another Orpheus sings again, And loves, and weeps, and dies. A new Ulysses leaves once more Calypso for his native shore.

Oh, write no more the tale of Troy, If earth Death's scroll must be!
Nor mix with Laian rage the joy
Which dawns upon the free:
Although a subtler Sphinx renew
Riddles of death Thebes never knew.

Another Athens shall arise,
And to remoter time
Bequeath, like sunset to the skies,
The splendour of its prime;
And leave, if nought so bright may live,
All earth can take or Heaven can give.

632 A TIME OF BELIEF

Saturn and Love their long repose Shall burst, more bright and good Than all who fell, then One who rose, Than many unsubdued: Not gold, not blood, their altar dowers, But votive tears and symbol flowers. Oh, cease! must hate and death return? Cease! must men kill and die? Cease! drain not to its dregs the urn Of bitter prophecy.

The world is weary of the past, Oh, might it die or rest at last!

VI. Economic Revolution

In political and economic matters the dominant doctrine of the nineteenth century was liberalism, which stood in general terms for constitutional government, private enterprise, and free trade. In England much of this liberal doctrine was based on ideas first formulated by Adam Smith (1723-1790) and Ieremy Bentham (1748-1832). to the effect that individual self-interest intelligently pursued is bound to redound to the good of society as a whole. In his Inquiry into the Nature and Causes of the Wealth of Nations (1776), the former analyzed the sources of society's economic well-being and concluded that specialization of labor on the one hand, free enterprise on the other, were the most important of these. As he saw it: "Every individual is continually exerting himself to find out the most advantageous employment of whatever capital he can command. It is his own advantage, indeed, and not that of the society, which he has in view. But the study of his own advantage naturally, or rather necessarily, leads him to prefer that employment which is most advantageous to the society."

Bentham, for his part, expounded his ideas in a series of works sadly deficient in clarity or ease of reading, which were saved from obscurity largely through the efforts of several talented and enthusiastic disciples, interpreters, and translators. Yet, in the first chapter of his *Introduction to the Principles of Morals and Legislation*, privately printed in 1780 but first published only in 1789, we may find a working definition of the new creed.

Nature has placed mankind under the governance of two sovereign masters, pain and pleasure. It is for them alone to point out what we ought to do, as well as to determine what we shall do. On the one hand the standard of right and wrong, on the other the chain of causes and effects, are fastened to their throne. They govern us in all we do, in all we say, in all we think: every effort we can make to throw off our subjection will serve but to demonstrate and confirm it. In words a man may pretend to abjure their empire: but in reality he will remain subject to it all the while. The principle of utility recognizes this subjection, and assumes it for the foundation of that system, the object of which is to rear the fabric of felicity by the hands of reason and law. Systems which attempt to question it, deal in caprice instead of reason, in darkness instead of light. . . . By the principle of utility is meant that principle which approves or disapproves of every action whatsoever, according to the tendency which it appears to

have to augment or diminish the happiness of the party whose interest is in question: or, what is the same thing in other words, to promote or to oppose that happiness. I say of every action whatsoever; and therefore not only of every action of a private individual, but of every measure of government.

Based upon these views, the Utilitarian philosophy, so-called, became tremendously influential in legislation, business, and economic thought.

1. JOHN STUART MILL

A good presentation of the new economic doctrines is furnished by John Stuart Mill (1806–1873), the son of one of Bentham's most devoted followers. The Essay on Utilitarianism is made up of a series of articles which he had written in 1854 and which he refurbished into one volume in 1860. In it he attempts to reconcile the principle of individual self-regard with the greatest happiness of the greatest number. By the time he is through, little is left of Bentham's original ideas, but the groundwork has been prepared for what might be called liberal collectivism. As might be expected, Mill himself soon left the straight and narrow path of undiluted Utilitarianism. He respected individual liberty and thought that this was threatened rather by majority than by minority pressures; this led him to write the famous Essay on Liberty (1859). But a growing feeling that individual liberty might be more in danger from the jungle laws of free enterprise than from some form of defensive organization, drove him in his later years toward Socialism. A man of tremendous intelligence and almost equal sensitiveness, he has left us a fascinating and rather frightening Autobiography.

From: Utilitarianism

GENERAL REMARKS

There are few circumstances among those which make up the present condition of human knowledge, more unlike what might have been expected, or more significant of the backward state in which speculation on the most important subjects still lingers, than the little progress which has been made in the decision of the controversy respecting the criterion of right and wrong. From the dawn of philosophy, the question concerning the *sum-*

mum bonum, or, what is the same thing, concerning the foundation of morality, has been accounted the main problem in speculative thought, has occupied the most gifted intellects, and divided them into sects and schools, carrying on a vigorous warfare against one another. And after more than two thousand years the same discussions continue, philosophers are still ranged under the same contending banners, and neither thinkers nor mankind at large seem nearer to being unanimous on the subject, than when the youth Soc-

From J. S. Mill, "Utilitarianism," in Fraser's Magazine, October and November, 1861.

rates listened to the old Protagoras, and asserted (if Plato's dialogue be grounded on a real conversation) the theory of utilitarianism against the popular morality of the so-called sophist.

It is true that similar confusion and uncertainty, and in some cases similar discordance, exist respecting the first principles of all the sciences, not excepting that which is deemed the most certain of them, mathematics; without much impairing, generally indeed without impairing at all, the trustworthiness of the conclusions of those sciences. An apparent anomaly, the explanation of which is, that the detailed doctrines of a science are not usually deduced from, nor depend for their evidence upon, what are called its first principles. Were it not so, there would be no science more precarious, or whose conclusions were more insufficiently made out, than algebra; which derives none of its certainty from what are commonly taught to learners as its elements, since these, as laid down by some of its most eminent teachers, are as full of fictions as English law, and of mysteries as theology. The truths which are ultimately accepted as the first principles of a science, are really the last results of metaphysical analysis, practiced on the elementary notions with which the science is conversant; and their relation to the science is not that of foundations to an edifice, but of roots to a tree, which may perform their office equally well though they be never dug down to and exposed to light. But though in science the particular truths precede the general theory, the contrary might be expected to be the case with a practical art, such as morals or legislation. All action is for the sake of some end, and rules of action, it seems natural to suppose, must take their whole character and color from the end to which they are subservient. When we engage in a pursuit, a clear and precise conception of what we are pursuing would seem to be the first thing we need, instead of the last thing we are to look forward to. A test of right and wrong must be the means, one would think, of ascertaining what is right or wrong, and not a consequence of having already ascertained it.

The difficulty is not avoided by having recourse to the popular theory of a natural faculty, a sense or instinct, informing us of right and wrong. For-besides that the existence of such a moral instinct is itself one of the matters in dispute—those believers in it who have any pretensions to philosophy, have been obliged to abandon the idea that it discerns what is right or wrong in the particular case in hand, as our other senses discern the sight or sound actually present. Our moral faculty, according to all those of its interpreters who are entitled to the name of thinkers, supplies us only with the general principles of moral judgments; it is a branch of our reason, not of our sensitive faculty; and must be looked to for the abstract doctrines of morality, not for perception of it in the concrete. The intuitive, no less than what may be termed the inductive, school of ethics, insists on the necessity of general laws. They both agree that the morality of an individual action is not a question of direct perception, but of the application of a law to an individual case. They recognize also, to a great extent, the same moral laws; but differ as to their evidence, and the source from which they derive their authority. According to the one opinion, the principles of morals are evident a priori, requiring nothing to command assent, except that the meaning of the terms be understood. According to the other doctrine, right and wrong, as well as truth, and falsehood, are questions

of observation and experience. But both hold equally that morality must be deduced from principles; and the intuitive school affirm as strongly as the inductive, that there is a sense of morals. Yet they seldom attempt to make out a list of the a priori principles which are to serve as the premises of the science; still more rarely do they make any effort to reduce those various principles to one first principle, or common ground of obligation. They either assume the ordinary precepts of morals as of a priori authority, or they lay down as the common groundwork of those maxims, some generality much less obviously authoritative than the maxims themselves, and which has never succeeded in gaining popular acceptance. Yet to support their pretensions there ought either to be some one fundamental principle or law, at the root of all morality, or if there be several, there would be a determinate order of precedence among them; and the one principle, or the rule for deciding between the various principles when they conflict, ought to be self-evident.

To inquire how far the bad effects of this deficiency have been mitigated in practice, or to what extent the moral beliefs of mankind have been vitiated or made uncertain by the absence of any distinct recognition of an ultimate standard, would imply a complete survey and criticism of past and present ethical doctrine. It would, however, be easy to show that whatever steadiness or consistency these moral beliefs have attained, has been mainly due to the tacit influence of a standard not recognized. Although the non-existence of an acknowledged first principle has made ethics not so much a guide as a consecration of men's actual sentiments, still, as men's sentiments, both of favor and of aversion, are greatly

influenced by what they suppose to be the effects of things upon their happiness, the principle of utility, or as Bentham latterly called it, the greatest happiness principle, has had a large share in forming the moral doctrines even of those who most scornfully reject its authority. Nor is there any school of thought which refuses to admit that the influence of actions on happiness is a most material and even predominant consideration in many of the details of morals, however unwilling to acknowledge it as the fundamental principle of morality, and the source of moral obligation. I might go much further, and say that to all those a priori moralists who deem it necessary to argue at all, utilitarian arguments are indispensable. It is not my present purpose to criticize these thinkers; but I cannot help referring, for illustration, to a systematic treatise by one of the most illustrious of them, the Metaphysics of Ethics, by Kant. This remarkable man, whose system of thought will long remain one of the landmarks in the history of philosophical speculation, does, in the treatise in question, lay down a universal first principle as the origin and ground of moral obligation; it is this: -"So act, that the rule on which thou actest would admit of being adopted as a law by all rational beings." But when he begins to deduce from this precept any of the actual duties of morality, he fails, almost grotesquely, to show that there would be any contradiction, any logical (not to say physical) impossibility, in the adoption by all rational beings of the most outrageously immoral rules of conduct. All he shows is that the consequences of their universal adoption would be such as no one would choose to incur.

On the present occasion, I shall, without further discussion of the other theories, attempt to contribute something to-

wards the understanding and appreciation of the Utilitarian or Happiness theory, and towards such proof as it is susceptible of. It is evident that this cannot be proof in the ordinary and popular meaning of the term. Ouestions of ultimate ends are not amenable to direct proof. Whatever can be proved to be good, must be so by being shown to be a means to something admitted to be good without proof. The medical art is proved to be good by its conducing to health; but how is it possible to prove that health is good? The art of music is good, for the reason, among others, that it produces pleasure, but what proof is it possible to give that pleasure is good? If, then, it is asserted that there is a comprehensive formula, including all things which are in themselves good, and that whatever else is good, is not so as an end, but as a mean, the formula may be accepted or rejected, but is not a subject of what is commonly understood by proof. We are not, however, to infer that its acceptance or rejection must depend on blind impulse, or arbitrary choice. There is a larger meaning of the word proof, in which this question is as amenable to it as any other of the disputed questions of philosophy. The subject is within the cognisance of the rational faculty and neither does that faculty deal with it solely in the way of intuition. Considerations may be presented capable of determining the intellect either to give or withhold its assent to the doctrine; and this is equivalent to proof.

We shall examine presently of what nature are these considerations; in what manner they apply to the case, and what rational grounds, therefore, can be given for accepting or rejecting the utilitarian formula. But it is a preliminary condition of rational acceptance or rejection, that

the formula should be correctly understood. I believe that the very imperfect notion ordinarily formed of its meaning, is the chief obstacle which impedes its reception; and that could it be cleared. even from only the grosser misconceptions, the question would be greatly simplified, and a large proportion of its difficulties removed. Before, therefore I attempt to enter into the philosophical grounds which can be given for assenting to the utilitarian standard. I shall offer some illustrations of the doctrine itself. with the view of showing more clearly what it is, distinguishing it from what it is not, and disposing of such of the practical objections to it as either originate in or are closely connected with mistaken interpretations of its meaning. Having thus prepared the ground, I shall afterwards endeavour to throw such light as I can upon the question considered as one of philosophical theory.

WHAT UTILITARIANISM IS

A passing remark is all that needs be given to the ignorant blunder of supposing that those who stand up for utility as the test of right and wrong, use the term in that restricted and merely colloquial sense in which utility is opposed to pleasure. An apology is due to the philosophical opponents of utilitarianism, for even the momentary appearance of confounding them with any one capable of so absurd a misconception: which is the more extraordinary, inasmuch as the contrary accusation, of referring everything to pleasure, and that too in its grossest form, is another of the common charges against utilitarianism; and, as has been pointedly remarked by an able writer, the same sort of persons, and often the very same per-

sons, denounce the theory "as impracticably dry when the word pleasure precedes the word utility." Those who know anything about the matter are aware that every writer, from Epicurus to Bentham, who maintained the theory of utility, meant by it, not something to be contradistinguished from pleasure, but pleasure itself, together with exemption from pain; and instead of opposing the useful to the agreeable or the ornamental, have always declared that the useful means these, among other things. Yet the common herd, including the herd of writers, not only in newspapers and periodicals, but in books of weight and pretension, are perpetually falling into this shallow mistake. Having caught up the word utilitarian, while knowing nothing whatever about it but its sound, they habitually express by it the rejection, or the neglect, of pleasure in some of its forms; of beauty, or ornament, or of amusement. Nor is the term thus ignorantly misapplied solely in disparagement, but occasionally in compliment; as though it implied superiority to frivolity and the mere pleasures of the moment. And this perverted use is the only one in which the word is popularly known, and the one from which the new generation are acquiring their sole notion of its meaning. Those who introduced the word, but who had for many years discontinued it as a distinctive appellation, may well feel themselves called upon to resume it, if by doing so they can hope to contribute anything towards rescuing it from this utter degradation.

The creed which accepts as the foundation of morals, Utility, or the Greatest Happiness Principle, holds that actions are right in proportion as they tend to promote happiness, wrong as they tend to produce the reverse of happiness. By

happiness is intended pleasure, and the absence of pain; by unhappiness, pain, and the privation of pleasure. To give a clear view of the moral standard set up by the theory, much more requires to be said; in particular, what things it includes in the ideas of pain and pleasure; and to what extent this is left an open question. But these supplementary explanations do not affect the theory of life on which this theory of morality is grounded-namely, that pleasure, and freedom from pain, are the only things desirable as ends; and that all desirable things (which are as numerous in the utilitarian as in any other scheme) are desirable either for the pleasure inherent in themselves, or as means to the promotion of pleasure and the prevention of pain.

Now, such a theory of life excites in many minds, and among them in some of the most estimable in feeling and purpose, inveterate dislike. To suppose that life has (as they express it) no higher end than pleasure—no better and nobler object of desire and pursuit—they designate as utterly mean and grovelling; as a doctrine worthy only of swine, to whom the followers of Epicurus were, at a very early period, contemptuously likened; and modern holders of the doctrine are occasionally made the subject of equally polite comparisons by its German, French, and English assailants.

When thus attacked, the Epicureans have always answered, that it is not they, but their accusers, who represent human nature in a degrading light; since the accusation supposes human beings to be capable of no pleasures except those of which swine are capable. If this supposition were true, the charge could not be gainsaid, but would then be no longer an imputation; for if the sources of pleasure were precisely the same to human beings

and to swine, the rule of life which is good enough for the one would be good enough for the other. The comparison of the Epicurean life to that of beasts is felt as degrading, precisely because a beast's pleasures do not satisfy a human being's conceptions of happiness. Human beings have faculties more elevated than the animal appetites, and when once made conscious of them, do not regard anything as happiness which does not include their gratification. I do not, indeed, consider the Epicureans to have been by any means faultless in drawing out their scheme of consequences from the utilitarian principle. To do this in any sufficient manner, many Stoic as well as Christian elements require to be included. But there is no known Epicurean theory of life which does not assign to the pleasures of the intellect, of the feelings and imagination, and of the moral sentiments, a much higher value as pleasures than to those of mere sensation. It must be admitted, however, that utilitarian writers in general have placed the superiority of mental over bodily pleasures chiefly in the greater permanency, safety, uncostliness, etc., of the former—that is, in their circumstantial advantages rather than in their intrinsic nature. And on all these points utilitarians have fully proved their case; but they might have taken the other, and, as it may be called, higher ground, with entire consistency. It is quite compatible with the principle of utility to recognize the fact, that some kinds of pleasure are more desirable and more valuable than others. It would be absurd that while, in estimating all other things, quality is considered as well as quantity, the estimation of pleasures should be supposed to depend on quantity alone.

Now it is an unquestionable fact that those who are equally acquainted with,

and equally capable of appreciating and enjoying, both, do give a most marked preference to the manner of existence which employs their higher faculties. Few human creatures would consent to be changed into any of the lower animals, for a promise of the fullest allowance of a beast's pleasures; no intelligent human being would consent to be a fool, no instructed person would be an ignoramus. no person of feeling and conscience would be selfish and base, even though they should be persuaded that the fool, the dunce, or the rascal is better satisfied with his lot than they are with theirs. They would not resign what they possess more than he for the most complete satisfaction of all the desires which they have in common with him. If they ever fancy they would, it is only in cases of unhappiness so extreme, that to escape from it they would exchange their lot for almost any other, however undesirable in their own eves. A being of higher faculties requires more to make him happy, is capable probably of more acute suffering, and certainly accessible to it at more points, than one of an inferior type; but in spite of these liabilities, he can never really wish to sink into what he feels to be a lower grade of existence. We may give what explanation we please of this unwillingness; we may attribute it to pride, a name which is given indiscriminately to some of the most and to some of the least estimable feelings of which mankind are capable: we may refer it to the love of liberty and personal independence, an appeal to which was with the Stoics one of the most effective means for the inculcation of it; to the love of power, or to the love of excitement, both of which do really enter into and contribute to it: but its most appropriate appellation is a sense of dignity, which all human beings possess in one form or oth-

er, and in some, though by no means in exact, proportion to their higher faculties, and which is so essential a part of the happiness of those in whom it is strong, that nothing which conflicts with it could be, otherwise than momentarily, an object of desire to them. Whoever supposed that this preference takes place at a sacrifice of happiness—that the superior being, in anything like equal circumstances. is not happier than the inferior—confounds the two very different ideas, of happiness, and content. It is indisputable that the being whose capacities of enjoyment are low, has the greatest chance of having them fully satisfied; and a highly endowed being will always feel that any happiness which he can look for, as the world is constituted, is imperfect. But he can learn to bear its imperfections, if they are at all bearable; and they will not make him envy the being who is indeed unconscious of the imperfections, but only because he feels not at all the good which those imperfections qualify. It is better to be a human being dissatisfied than a pig satisfied; better to be Socrates dissatisfied than a fool satisfied. And if the fool, or the pig, are of a different opinion, it is because they only know their own side of the question. The other party to the comparison knows both sides.

It may be objected, that many who are capable of the higher pleasures, occasionally, under the influence of temptation, postpone them to the lower. But this is quite compatible with a full appreciation of the intrinsic superiority of the higher. Men often, from infirmity of character, make their election for the nearer good, though they know it to be the less valuable; and this no less when the choice is between two bodily pleasures, than when it is between bodily and mental. They pursue sensual indulgences to the injury

of health, though perfectly aware that health is the greater good. It may be further objected, that many who begin with youthful enthusiasm for everything noble, as they advance in years sink into indolence and selfishness. But I do not believe that those who undergo this very common change, voluntarily choose the lower description of pleasures in preference to the higher. I believe that before they devote themselves exclusively to the one, they have already become incapable of the other. Capacity for the nobler feelings is in most natures a very tender plant, easily killed, not only by hostile influences, but by mere want of sustenance: and in the majority of young persons it speedily dies away if the occupations to which their position in life has devoted them, and the society into which it has thrown them, are not favorable to keeping that higher capacity in exercise. Men lose their high aspirations as they lose their intellectual tastes, because they have not time or opportunity for indulging them; and they addict themselves to inferior pleasures, not because they deliberately prefer them but because they are either the only ones to which they have access, or the only ones which they are any longer capable of enjoying. It may be questioned whether any one who has remained equally susceptible to both classes of pleasures, ever knowingly and calmly preferred the lower; though many, in all ages, have broken down in an ineffectual attempt to combine both.

From this verdict of the only competent judges, I apprehend there can be no appeal. On a question which is the best worth having of two pleasures, or which of two modes of existence is the most grateful to the feelings, apart from its moral attributes and from its consequences, the judgment of those who are

qualified by knowledge of both, or, if they differ, that of the majority among them, must be admitted as final. And there needs be the less hesitation to accept this judgment respecting the quality of pleasures, since there is no other question of quantity. What means are there of determining which is the acutest of two pains. or the intensest of two pleasurable sensations, except the general suffrage of those who are familiar with both? Neither pains nor pleasures are homogeneous, and pain is always heterogeneous with pleasure. What is there to decide whether a particular pleasure is worth purchasing at the cost of a particular pain, except the feelings and judgment of the experienced? When, therefore, those feelings and judgments declare the pleasures derived from the higher faculties to be preferable in kind, apart from the question of intensity, to those of which the animal nature, disjoined from the higher faculties, is susceptible, they are entitled on this subject to the same regard.

I have dwelt on this point, as being a necessary part of a perfectly just conception of Utility or Happiness, considered as the directive rule of human conduct. But it is by no means an indispensable condition to the acceptance of the utilitarian standard; for that standard is not the agent's own greatest happiness, but the greatest amount of happiness altogether; and if it may possibly be doubted whether a noble character is always the happier for its nobleness, there can be no doubt that it makes other people happier, and that the world in general is immensely a gainer by it. Utilitarianism, therefore, could only attain its end by the general cultivation of nobleness of character, even if each individual were only benefited by the nobleness of others, and his own, so far as happiness is concerned, were a sheer deduction from the benefit. But the bare enunciation of such an absurdity as this last, renders refutation superfluous.

OF THE ULTIMATE SANCTION OF THE PRINCIPLE OF UTILITY

The question is often asked, and properly so, in regard to any supposed moral standard-What is its sanction? what are the motives to obey it? or more specifically, what is the source of its obligation? whence does it derive its binding force? It is a necessary part of moral philosophy to provide the answer to this question; which, though frequently assuming the shape of an objection to the utilitarian morality, as if it had some special applicability to that above others, really arises in regard to all standards. It arises, in fact, whenever a person is called on to adopt a standard, or refer morality to any basis on which he has not been accustomed to rest it. For the customary morality, that which education and opinion have consecrated, is the only one which presents itself to the mind with the feeling of being in itself obligatory; and when a person is asked to believe that this morality derives its obligation from some general principle round which custom has not thrown the same halo, the assertion is to him a paradox: the supposed corollaries seem to have a more binding force than the original theorem; the super-structure seems to stand better without, than with, what is represented as its foundation. He says to himself. I feel that I am bound not to rob or murder, betray or deceive; but why am I bound to promote the general happiness? If my own happiness lies in something else, why may I not give that the preference?

If the view adopted by the utilitarian philosophy of the nature of the moral sense be correct, this difficulty will always present itself, until the influences which form moral character have taken the same hold of the principle which they have taken of some of the consequences, —until, by the improvement of education, the feeling of unity with our fellowcreatures shall be (what it cannot be denied that Christ intended it to be) as deeply rooted in our character, and to our own consciousness as completely a part of our nature, as the horror of crime is in an ordinarily well brought up young person. In the meantime, however, the difficulty has no peculiar application to the doctrine of utility, but is inherent in every attempt to analyze morality and reduce it to principles; which, unless the principle is already in men's minds invested with as much sacredness as any of its applications, always seems to divest them of a part of their sanctity.

The principle of utility either has, or there is no reason why it might not have, all the sanctions which belong to any other system of morals. Those sanctions are either external or internal. Of the external sanctions it is not necessary to speak at any length. They are, the hope of favor and the fear of displeasure, from our fellow-creatures or from the Ruler of the Universe, along with whatever we may have of sympathy or affection for them, or of love and awe of Him, inclining us to do his will independently of selfish consequences. There is evidently no reason why all these motives for observance should not attach themselves to the utilitarian morality, as completely and as powerfully as to any other. Indeed, those of them which refer to our fellow-creatures are sure to do so, in proportion to the amount of general intelligence; for wheth-

er there be any other ground of moral obligation than the general happiness or not, men do desire happiness; and however imperfect may be their own practice, they desire and commend all conduct in others towards themselves, by which they think their happiness is promoted. With regard to the religious motive, if men believe, as most profess to do, in the goodness of God, those who think that conduciveness to the general happiness is the essence, or even only the criterion of good, must necessarily believe that it is also that which God approves. The whole force therefore of external reward and punishment, whether physical or moral, and whether proceeding from God or from our fellow men, together with all that the capacities of human nature admit of disinterested devotion to either, become available to enforce the utilitarian morality, in proportion as that morality is recognized; and the more powerfully, the more the appliances of education and general cultivation are bent to the purpose.

So far as to external sanctions. The internal sanction of duty, whatever our standard of duty may be, is one and the same—a feeling in our own mind; a pain, more or less intense, attendant on violation of duty, which in properly cultivated moral natures rises, in the more serious cases, into shrinking from it as an impossibility. This feeling, when disinterested, and connecting itself with the pure idea of duty, and not with some particular form of it, or with any of the merely accessory circumstances, is the essence of Conscience; though in that complex phenomenon as it actually exists, the simple fact is in general all encrusted over with collateral associations, derived from sympathy, from love, and still more from fear; from all the forms of religious feeling; from the recollections of childhood

and of all our past life; from self-esteem, desire of the esteem of others, and occasionally even self-abasement. This extreme complication is, I apprehend, the origin of the sort of mystical character, which, by a tendency of the human mind of which there are many other examples, is apt to be attributed to the idea of moral obligation, and which leads people to believe that the idea cannot possibly attach itself to any other objects than those which, by a supposed mysterious law, are found in our present experience to excite it. Its binding force, however, consists in the existence of a mass of feeling which must be broken through in order to do what violates our standard of right, and which, if we do nevertheless violate that standard, will probably have to be encountered afterwards in the form of remorse. Whatever theory we have of the nature or origin of conscience, this is what essentially constitutes it.

The ultimate sanction, therefore, of all morality (external motives apart) being a subjective feeling in our own minds, I see nothing embarrassing to those whose standard is utility, in the question, what is the sanction of that particular standard? We may answer, the same as of all other moral standards—the conscientious feelings of mankind. Undoubtedly this sanction has no binding efficacy on those who do not possess the feelings it appeals to; but neither will these persons be more obedient to any other moral principle than to the utilitarian one. On them morality of any kind has no hold but through the external sanctions. Meanwhile the feelings exist, a fact in human nature, the reality of which, and the great power with which they are capable of acting on those in whom they have been duly cultivated, are proved by experience. No reason has ever been shown why they may not be cultivated to as great intensity in connection with the utilitarian, as with any other rule of morals.

There is, I am aware, a disposition to believe that a person who sees in moral obligation a transcendental fact, an objective reality belonging to the province of "Things in themselves," is likely to be more obedient to it than one who believes it to be entirely subjective, having its seat in human consciousness only. But whatever a person's opinion may be on this point of Ontology, the force he is really urged by is his own subjective feeling, and is exactly measured by its strength. No one's belief that duty is an objective reality is stronger than the belief that God is so: yet the belief in God, apart from the expectation of actual reward and punonly operates on conduct through, and in proportion to, the subjective religious feeling. The sanction, so far as it is disinterested, is always in the mind itself; and the notion therefore of the transcendental moralists must be, that this sanction will not exist in the mind unless it is believed to have its root out of the mind: and that if a person is able to say to himself, this which is restraining me, and which is called my conscience, is only a feeling in my own mind, he may possibly draw the conclusion that when the feeling ceases the obligation ceases, and that if he find the feeling inconvenient, he may disregard it, and endeavour to get rid of it. But is this danger confined to the utilitarian morality? Does the belief that moral obligation has its seat outside the mind make the feeling of it too strong to be got rid of? The fact is so far otherwise, that all moralists admit and lament the ease with which, in the generality of minds, conscience can be silenced or stifled. The question, Need I obey my conscience? is quite as often put to themselves by persons who never heard of the principle of utility, as by its adherents. Those whose conscientious feelings are so weak as to allow of their asking this question, if they answer it affirmatively, will not do so because they believe in the transcendental theory, but because of the external sanctions.

It is not necessary, for the present purpose, to decide whether the feeling of duty is innate or implanted. Assuming it to be innate, it is an open question to what objects it naturally attaches itself; for the philosophic supporters of that theory are now agreed that the intuitive perception is of principles of morality and not of the details. If there be anything innate in the matter. I see no reason why the feeling which is innate should not be that of regard to the pleasures and pains of others. If there is any principle of morals which is intuitively obligatory, I should say it must be that. If so, the intuitive ethics would coincide with the utilitarian. and there would be no further quarrel between them. Even as it is, the intuitive moralists, though they believe that there are other intuitive moral obligations, do already believe this to be one; for they unanimously hold that a large portion of morality turns upon the consideration due to the interests of our fellow-creatures. Therefore, if the belief in the transcendental origin of moral obligation gives any additional efficacy to the internal sanction, it appears to me that the utilitarian principle has already the benefit of it.

On the other hand if, as is my own belief, the moral feelings are not innate, but acquired, they are not for that reason the less natural. It is natural to man to speak, to reason, to build cities, to cultivate the ground, though these are acquired faculties. The moral feelings are not indeed a part of our nature, in the

sense of being in any perceptible degree present in all of us; but this, unhappily, is a fact admitted by those who believe the most strenuously in their transcendental orgin. Like the other acquired capacities above referred to, the moral faculty, if not a part of our nature, is a natural outgrowth from it; capable, like them, in a certain small degree, of springing up spontaneously; and susceptible of being brought by cultivation to a high degree of development. Unhappily it is also susceptible, by a sufficient use of the external sanctions and of the force of early impressions, of being cultivated in almost any direction: so that there is hardly anything so absurd or so mischievous that it may not, by means of these influences, be made to act on the human mind with all the authority of conscience. To doubt that the same potency might be given by the same means to the principle of utility. even if it had no foundation in human nature, would be flying in the face of all experience.

But moral associations which are wholly of artificial creation, when intellectual culture goes on, yield by degrees to the dissolving force of analysis: and if the feeling of duty, when associated with utility, would appear equally arbitrary; if there were no leading department of our nature, no powerful class of sentiments. with which that association would harmonize, which would make us feel it congenial, and incline us not only to foster it in others (for which we have abundant interested motives), but also to cherish it in ourselves; if there were not, in short. a natural basis of sentiment for utilitarian morality, it might well happen that this association also, even after it had been implanted by education, might be analyzed away.

But there is this basis of powerful nat-

ural sentiment; and this it is which, when once the general happiness is recognized as the ethical standard, will constitute the strength of the utilitarian morality. This firm foundation is that of the social feelings of mankind; the desire to be in unity with our fellow-creatures, which is already a powerful principle in human nature, and happily one of those which tend to become stronger even without express inculcation, from the influences of advancing civilization. The social state is at once so natural, so necessary, and so habitual to man, that, except in some unusual circumstances or by an effort of voluntary abstraction, he never conceives himself otherwise than as a member of a body; and this association is riveted more and more, as mankind are further removed from the state of savage independence. Any condition, therefore, which is essential to a state of society, becomes more and more an inseparable part of every person's conception of the state of things which he is born into, and which is the destiny of a human being. Now, society between human beings, except in the relation of master and slave, is manifestly impossible on any other footing than that the interests of all are to be consulted. Society between equals can only exist on the understanding that the interests of all are to be regarded equally. And since in all states of civilization, every person except an absolute monarch, has equals, everyone is obliged to live on these terms with somebody; and in every age some advance is made towards a state in which it will be impossible to live permanently on other terms with anybody. In this way people grow up unable to conceive as possible to them a state of total disregard of other people's interests. They are under a necessity of conceiving themselves as at least abstaining from all

the grosser injuries, and (if only for their own protection) living in a state of constant protest against them. They are also familiar with the fact of co-operating with others; there is at least a temporary feeling that the interests of others are their own interests. Not only does all strengthening of social ties, and all healthy growth of society, give to each individual a stronger personal interest in practically consulting the welfare of others; it also leads him to identify his feelings more and more with their good, or at least with an even greater degree of practical consideration for it. He comes, as though instinctively, to be conscious of himself as a being who of course pays regard to others. The good of others becomes to him a thing naturally and necessarily to be attended to, like any of the physical conditions of our existence. Now, whatever amount of this feeling a person has, he is urged by the strongest motives both of interest and of sympathy to demonstrate it, and to the utmost of his power encourage it in others; and even if he has none of it himself, he is as greatly interested as any one else that others should have it. Consequently the smallest germs of the feeling are laid hold of and nourished by the contagion of sympathy and the influences of education; and a complete web of corroborative association is woven round it, by the powerful agency of the external sanctions. This mode of conceiving ourselves and human life, as civilization goes on, is felt to be more and more natural. Every step in political improvement renders it more so, by removing the sources of opposition of interest, and levelling those inequalities of legal privilege between individuals or classes, owing to which there are large portions of mankind whose happiness it is still practicable to disregard. In an improving

state of the human mind, the influences are constantly on the increase, which tend to generate in each individual a feeling of unity with all the rest; which, if perfect, would make him never think of, or desire, any beneficial condition for himself, in the benefits of which they are not included. If we now suppose this feeling of unity to be taught as a religion, and the whole force of education, of institutions, and of opinion, directed, as it once was in the case of religion, to make every person grow up from infancy surrounded on all sides both by the profession and the practice of it, I think that no one, who can realize this conception, will feel any misgiving about the sufficiency of the ultimate sanction for the Happiness morality. To any ethical student who finds the realization difficult, I recommend, as a means of facilitating it, the second of M. Comte's two principal works, the Traité de Politique Positive. I entertain the strongest objections to the system of politics and morals set forth in that treatise; but I think it has superabundantly shown the possibility of giving to the service of humanity, even without the aid of belief in a Providence, both the psychological power and the social efficacy of a religion; making it take hold of human life, and colour all thought, feeling, and action, in a manner of which the greatest ascendancy ever exercised by any religion may be but a type and foretaste; and of which the danger is, not that it should be insufficient, but that it should be so excessive as to interfere unduly with human freedom and individuality.

Neither is it necessary to the feeling which constitutes the binding force of the utilitarian morality on those who recognize it, to wait for those social influences which would make its obligation

felt by mankind at large. In the comparatively early state of human advancement in which we now live, a person cannot indeed feel that entireness of sympathy with all others, which would make any real discordance in the general direction of their conduct in life impossible: but already a person in whom the social feeling is at all developed, cannot bring himself to think of the rest of his fellowcreatures as struggling rivals with him for the means of happiness, whom he must desire to see defeated in their object in order that he may succeed in his. The deeply rooted conception which every individual even now has of himself as a social being, tends to make him feel it one of his natural wants that there should be harmony between his feelings and aims and those of his fellow-creatures. If differences of opinion and of mental culture make it impossible for him to share many of their actual feelings-perhaps make him denounce and defy those feelingshe still needs to be conscious that his real aim and theirs do not conflict: that he is not opposing himself to what they really wish for, namely their own good, but is, on the contrary, promoting it. This feeling in most individuals is much inferior in strength to their selfish feelings, and is often wanting altogether. But to those who have it, it possesses all the characters of a natural feeling. It does not present itself to their minds as a superstition of education, or a law despotically imposed by the power of society, but as an attribute which it would not be well for them to be without. This conviction is the ultimate sanction of the greatest happiness morality. This it is which makes any mind, of well-developed feelings, work with, and not against, the outward motives to care for others, afforded by what I have called the external sanctions; and

when those sanctions are wanting, or act in an opposite direction, constitutes in itself a powerful internal binding force, in proportion to the sensitivities and thoughtfulness of the character; since few but those whose mind is a moral blank, could bear to lay out their course of life on the plan of paying no regard to others except so far as their own private interest compels.

From: On Liberty

The subject of this Essay is not the so-called Liberty of the Will, so unfortunately opposed to the misnamed doctrine of Philosophical Necessity; but Civil, or Social Liberty: the nature and limits of the power which can be legitimately exercised by society over the individual. A question seldom stated, and hardly ever discussed, in general terms, but which profoundly influences the practical controversies of the age by its latent presence, and is likely soon to make itself recognized as the vital question of the future. It is so far from being new, that, in a certain sense, it has divided mankind, almost from the remotest ages; but in the stages of progress into which the more civilized portions of the species have now entered, it presents itself under new conditions, and requires a different and more fundamental treatment.

The struggle between Liberty and Authority is the most conspicuous feature in the portions of history with which we are earliest familiar, particularly in that of Greece, Rome, and England. But in old times this contest was between subjects, or some classes of subjects, and the Government. By liberty, was meant protection against the tyranny of the political rulers. The rulers were conceived (except in some of the popular governments of Greece) as in a necessarily antagonistic position to the people whom they ruled. They consisted of a governing One, or a governing tribe or caste, who derived

their authority from inheritance or conquest, who, at all events, did not hold it at the pleasure of the governed, and whose supremacy men did not venture, perhaps did not desire, to contest, whatever precautions might be taken against its oppressive exercise. Their power was regarded as necessary, but also as highly dangerous; as a weapon which they would attempt to use against their subjects, no less than against external enemies. To prevent the weaker members of the community from being preved upon by innumerable vultures, it was needful that there should be an animal of prev stronger than the rest, commissioned to keep them down. But as the king of the vultures would be no less bent upon preving on the flock than any of the minor harpies, it was indispensable to be in a perpetual attitude of defence against his beak and claws. The aim, therefore, of patriots was to set limits to the power which the ruler should be suffered to exercise over the community; and this limitation was what they meant by liberty. It was attempted in two ways. First, by obtaining a recognition of certain immunities, called political liberties or rights, which it was to be regarded as a breach of duty in the ruler to infringe, and which, if he did infringe, specific resistance, or general rebellion, was held to be justifiable. A second, and generally a later expedient, was the establishment of constitutional checks, by which the consent of the com-

From Mill, On Liberty (London, 1859), chap. 1.

munity, or of a body of some sort, supposed to represent its interests, was made a necessary condition to some of the more important acts of the governing power. To the first of these modes of limitation, the ruling power, in most European countries, was compelled, more or less, to submit. It was not so with the second; and, to attain this, or when already in some degree possessed, to attain it more completely, became everywhere the principal object of the lovers of liberty. And so long as mankind were content to combat one enemy by another, and to be ruled by a master, on condition of being guaranteed more or less efficaciously against his tyranny, they did not carry their aspirations beyond this point.

A time, however, came, in the progress of human affairs, when men ceased to think it a necessity of nature that their governors should be an independent power, opposed in the interest to themselves. It appeared to them much better that the various magistrates of the State should be their tenants or delegates, revocable at their pleasure. In that way alone, it seemed, could they have complete security that the powers of government would never be abused to their disadvantage. By degrees this new demand for elective and temporary rulers became the prominent object of the exertions of the popular party, wherever any such party existed; and superseded, to a considerable extent, the previous efforts to limit the power of rulers. As the struggle proceeded for making the ruling power emanate from the periodical choice of the ruled, some persons began to think that too much importance had been attached to the limitation of the power itself. That (it might seem) was a resource against rulers whose interests were habitually opposed to those of the people. What was now wanted was,

that the rulers should be identified with the people; that their interest and will should be the interest and the will of the nation. The nation did not need to be protected against its own will. There was no fear of its tyrannizing over itself. Let the rulers be effectually responsible to it, promptly removable by it, and it could afford to trust them with power of which it could itself dictate the use to be made. Their power was but the nation's own power, concentrated, and in a form convenient for exercise. This mode of thought, or rather perhaps of feeling, was common among the last generation of European liberalism, in the continental section of which it still apparently predominates. Those who admit any limit to what a government may do, except in the case of such governments as they think ought not to exist, stand out as brilliant exceptions among the political thinkers of the continent. A similar tone of sentiment might by this time have been prevalent in our own country, if the circumstances which for a time encouraged it, had continued unaltered.

But, in political and philosophical theories, as well as in persons, success discloses faults and infirmities which failure might have concealed from observation. The notion, that the people have no need to limit their power over themselves, might seem axiomatic, when popular government was a thing only dreamed about. or read of as having existed at some distant period of the past. Neither was that notion necessarily disturbed by such temporary aberrations as those of the French Revolution, the worst of which were the work of an usurping few, and which, in any case, belonged not to the permanent working of popular institutions, but to a sudden and convulsive outbreak against monarchical and aristocratic despotism.

In time, however, a democratic republic came to occupy a large portion of the earth's surface, and made itself felt as one of the most powerful members of the community of nations; and elective and responsible government became subject to the observations and criticisms which wait upon a great existing fact. It was now perceived that such phrases as "selfgovernment," and "the power of the people over themselves," do not express the true state of the case. The "people" who exercise the power are not always the same people with those over whom it is exercised; and the "self-government" spoken of is not the government of each by himself, but of each by all the rest. The will of the people, moreover, practically means the will of the most numerous or the most active part of the people; the majority, or those who succeed in making themselves accepted as the majority; the people, consequently, may desire to oppress a part of their number; and precautions are as much needed against this as against any other abuse of power. The limitation, therefore, of the power of government over individuals loses none of its importance when the holders of power are regularly accountable to the community, that is, to the strongest party therein. This view of things, recommending itself equally to the intelligence of thinkers and to the inclination of those important classes in European society to whose real or supposed interests democracy is adverse, has had no difficulty in establishing itself; and in political speculations "the tyranny of the majority" is now generally included among the evils against which society requires to be on its guard.

Like other tyrannies, the tyranny of the majority was at first, and is still, vulgarly, held in dread, chiefly as operating

through the acts of the public authorities. But reflecting persons perceive that when society is itself the tyrant—society collectively, over the separate individuals who compose it—its means of tyrannizing are not restricted to the acts which it may do by the hands of its political functionaries. Society can and does execute its own mandates: and if it issues wrong mandates instead of right, or any mandates at all in things with which it ought not to meddle, it practises a social tyranny more formidable than many kinds of political oppression, since, though not usually upheld by such extreme penalties, it leaves fewer means of escape, penetrating much more deeply into the details of life, and enslaving the soul itself. Protection, therefore, against the tyranny of the magistrate is not enough: there needs protection also against the tyranny of the prevailing opinion and feeling; against the tendency of society to impose, by other means than civil penalties, its own ideas and practices as rules of conduct on those who dissent from them; to fetter the development, and, if possible, prevent the formation, of any individuality not in harmony with its ways, and compel all characters to fashion themselves upon the model of its own. There is a limit to the legitimate interference of collective opinion with individual independence: and to find that limit, and maintain it against encroachment, is as indispensable to a good condition of human affairs, as protection against political despotism.

But though this proposition is not likely to be contested in general terms, the practical question, where to place the limit—how to make the fitting adjustment between individual independence and social control—is a subject on which nearly everything remains to be done. All that makes existence valuable to anyone,

depends on the enforcement of restraints upon the actions of other people. Some rules of conduct, therefore, must be imposed, by law in the first place and by opinion on many things which are not fit subjects for the operation of law. What these rules should be, is the principal question in human affairs; but if we except a few of the most obvious cases, it is one of those which least progress has been made in resolving. No two ages, and scarcely any two countries, decided it alike; and the decision of one age or country is a wonder to another. Yet the people of any given age and country no more suspect any difficulty in it than if it were a subject on which mankind had always been agreed. The rules which obtain among themselves appear to them selfevident and self-justifying. This all but universal illusion is one of the examples of the magical influence of custom, which is not only, as the proverb says, a second nature, but is continually mistaken for the first. The effect of custom, in preventing any misgiving respecting the rules of conduct which mankind impose on one another, is all the more complete because the subject is one on which it is not generally considered necessary that reasons should be given, either by one person to others, or by each to himself. People are accustomed to believe, and have been encouraged in the belief by some who aspire to the character of philosophers, that their feelings, on subjects of this nature, are better than reasons, and render reasons unnecessary. The practical principle which guides them to their opinions on the regulation of human conduct, is the feeling in each person's mind that everybody should be required to act as he, and those with whom he sympathizes, would like them to act. No one, indeed, acknowledges to himself that his standard of

judgment is his own liking; but an opinion on a point of conduct, not supported by reasons, can only count as one person's preference; and if the reasons, when given, are a mere appeal to a similar preference felt by other people it is still only many people's liking instead of one. To an ordinary man, however, his own preference, thus supported, is not only a perfectly satisfactory reason, but the only one he generally has for any of his notions of morality, taste, or propriety, which are not expressly written in his religious creed; and his chief guide in the interpretation even of that. Men's opinions, accordingly, on what is laudable or blameable, are affected by all the multifarious causes which influence their wishes in regard to the conduct of others, and which are as numerous as those which determine their wishes on any other subject. Sometimes their reason—at other times their prejudices or superstitions: often their social affections, not seldom their anti-social ones, their envy or jealousy, their arrogance or contemptuousness: but most commonly, their desires or fears for themselves—their legitimate or illegitimate self-interest. Wherever there is an ascendant class, a large portion of the morality of the country emanates from its class-interests, and its feelings of class superiority. The morality between Spartans and helots, between planters and negroes, between princes and subjects, between nobles and roturiers, between men and women, has been for the most part the creation of these class interests and feelings: and the sentiments thus generated, react in turn upon the moral feelings of the members of the ascendant class, in their relations among themselves. Where, on the other hand, a class, formerly ascendant, has lost its ascendancy, or where its ascendancy is un-

popular, the prevailing moral sentiments frequently bear the impress of an impatient dislike of superiority. Another grand determining principle of the rules of conduct, both in act and forbearance. which have been enforced by law or opinion, has been the servility of mankind towards the supposed preferences or aversions of their temporal masters, or of their gods. This servility, though essentially selfish, is not hypocrisy; it gives rise to perfectly genuine sentiments of abhorrence; it made men burn magicians and heretics. Among so many baser influences, the general and obvious interests of society have of course had a share, and a large one, in the direction of the moral sentiments: less, however, as a matter of reason, and on their own account, than as a consequence of the sympathies and antipathies which grew out of them: and sympathies and antipathies which had little or nothing to do with the interests of society, have made themselves felt in the establishment of moralities with quite as great force.

The likings and dislikings of society, or of some powerful portion of it, are thus the main thing which has practically determined the rules laid down for general observance under the penalties of law or opinion. And in general, those who have been in advance of society in thought and feeling, have left this condition of things unassailed in principle, however they may have come into conflict with it in some of its details. They have occupied themselves rather in inquiring what things society ought to like or dislike, than in questioning whether its likings or dislikings should be a law to individuals. They prefer endeavouring to alter the feelings of mankind on the particular points on which they were themselves heretical, rather than make common cause

in defence of freedom, with heretics generally. The only case in which the higher ground has been taken on principle and maintained with consistency, by any but an individual here and there, is that of religious belief: a case instructive in many ways, and not least so as forming a most striking instance of the fallibility of what is called the moral sense: for the odium theologicum, in a sincere bigot, is one of the most unequivocal cases of moral feeling. Those who first broke the voke of what called itself the Universal Church. were in general as little willing to permit difference of religious opinion as that church itself. But when the heat of the conflict was over, without giving a complete victory to any party, and each church or sect was reduced to limit its hopes to retaining possession of the ground it already occupied; minorities seeing that they had no chance of becoming majorities, were under the necessity of pleading to those whom they could not convert for permission to differ. It is accordingly on this battlefield, almost solely, that the rights of the individual against society have been asserted on broad grounds of principle, and the claim of society to exercise authority over dissentients, openly controverted. The great writers to whom the world owes what religious liberty it possesses, have mostly asserted freedom of conscience as an indefeasible right, and denied absolutely that a human being is accountable to others for his religious beliefs. Yet so natural to mankind is intolerance in whatever they really care about, that religious freedom has hardly anywhere been practically realised, except where religious indifference, which dislikes to have its peace disturbed by theological quarrels, has added its weight to the scale. In the minds of almost all religious persons, even in the most tolerant countries, the duty of toleration is admitted with tacit reserves. One person will bear with dissent in matters of church government, but not of dogma; another can tolerate everybody, short of a Papist or a Unitarian; another, everyone who believes in revealed religion; a few extend their charity a little further, but stop at the belief in a God and in a future state. Wherever the sentiment of the majority is still genuine and intense, it is found to have abated little of its claim to be obeyed.

In England, from the peculiar circumstances of our political history, though the voke of opinion is perhaps heavier, that of law is lighter than in most other countries of Europe; and there is considerable iealousy of direct interference, by the legislative or executive power, with private conduct; not so much from any just regard for the independence of the individual, as from the still subsisting habit of looking on the government as representing an opposite interest to the public. The majority have not yet learned to feel the power of the government their power, or its opinions their opinions. When they do so, individual liberty will probably be as much exposed to invasion from the government, as it already is from public opinion. But, as yet, there is a considerable amount of feeling ready to be called forth against any attempt of the law to control individuals in things in which they have not hitherto been accustomed to be controlled by it; and this with very little discrimination as to whether the matter is, or is not, within the legitimate sphere of legal control; insomuch that the feeling, highly salutary on the whole, is perhaps quite as often misplaced as well grounded in the particular instances of its application. There is, in fact, no recognized principle by which the propriety or im-

propriety of government interference is customarily tested. People decide according to their personal preferences. Some, whenever they see any good to be done. or evil to be remedied, would willingly instigate the government to undertake the business; while others prefer to bear almost any amount of social evil, rather than add one to the departments of human interests amenable to governmental control. And men range themselves on one or the other side in any particular case, according to this general direction of their sentiments; or according to the degree of interest which they feel in the particular thing which it is proposed that the government should do, or according to the belief they entertain that the government would, or would not, do it in the manner they prefer; but very rarely on account of any opinion to which they consistently adhere, as to what things are fit to be done by a government. And it seems to me that in consequence of this absence of rule or principle, one side is at present as often wrong as the other; the interference of government is, with about equal frequency, improperly invoked and improperly condemned.

The object of this Essay is to assert one very simple principle, as entitled to govern absolutely the dealings of society with the individual in the way of compulsion and control, whether the means used be physical force in the form of legal penalties, or the moral coercion of public opinion. That principle is, that the sole end for which mankind are warranted, individually or collectively, in interfering with the liberty of action of any of their number, is self-protection. That the only purpose for which power can be rightfully exercised over any member of a civilised community, against his will, is to prevent harm to others. His own good, either

physical or moral, is not a sufficient warrant. He cannot rightfully be compelled to do or forbear because it will be better for him to do so, because it will make him happier, because, in the opinions of others, to do so would be wise, or even right. These are good reasons for remonstrating with him, or reasoning with him, or persuading him, or entreating him, but not for compelling him, or visiting him with any evil in case he do otherwise. To jus-

tify that, the conduct from which it is desired to deter him, must be calculated to produce evil to someone else. The only part of the conduct of anyone, for which he is amenable to society, is that which concerns others. In the part which merely concerns himself, his independence is, of right, absolute. Over himself, over his own body and mind, the individual is sovereign.

2. SAMUEL ROMILLY

Sir Samuel Romilly (1757–1815) was one of a group of members of Parliament who led the agitation for reform of the prisons and the penal code. Perhaps his most signal success came in 1808, when he persuaded the House of Commons to accept transportation for life, instead of hanging, as a punishment for picking pockets. Most of his other endeavors failed against the opposition of bishops and lords, and wider changes had to wait for Robert Peel's reforms in the 1820's and 1830's.

On the Old Criminal Law

I have always considered it a very great defect in the Criminal Code of this Country, that Capital Punishments should be so frequent; that they have been appointed, I cannot say inflicted, for so many crimes. For no principle seems to me more clear than this, that it is the certainty, much more than the severity of punishments, which renders them efficacious. This has been acknowledged, I believe, ever since the publication of the works of the Marquis Beccaria. The impression, however, which was made in this Country by his writings, has hitherto proved unavailing; for it has not produced a single alteration in our Criminal Law; although in many other states of Europe various amendments have taken place. Indeed, if we were to take the very reverse of the principle to which I have alluded, it would be a faithful description of the English law, in its enactments and administration. It is notorious how few of those, who are condemned, actually suffer punishment. From returns which are to be found in the Secretary of State's office. it appears, that in the year 1805, there were 350 persons who received the sentence of death, of whom only 68 were executed, not quite a fifth part of the number. In the year 1806, 325 received sentence of death, of whom 57 were executed; and in 1807, the number was 343, of whom there were executed 63. If we deduct from this number all those who received sentence of death for crimes which are never, or very rarely pardoned, it will, perhaps, be found, that out of 20 persons condemned to die, not more than one suffers death.

The question, therefore, is, whether the execution of the Law is to be the rule

From The Speeches of Sir Samuel Romilly in the House of Commons (London, 1820).

or the exception to be observed in the administration of justice; whether a code shall continue to exist in theory, which has been lately described (in language which one would rather have expected to hear from the lips of a Satirist, than from a seat of Judgment) "as almost abrogated in practice by the astuteness of Judges, the humanity of Juries, and the mercy of the Crown." I am far from being disposed either to censure or regret this relaxation of the Law; I am only inquiring whether Statutes so dispensed with can be deemed any longer essential to the well-being of the State.

Such is the general view which I have taken of the subject. But my more immediate purpose is to call the attention of the House to one class only of these severe Statutes, which have, from a change of circumstances, acquired a rigour not originally intended by their framers; Statutes, in which the capital part of the charge depends, not on the mode or season in which the offence has been committed, but on the value of the property stolen; such as the Act of Elizabeth, which punishes with death the stealing privately from the person of another to the value of twelve pence; that of William and Mary, which makes privately stealing in a shop, to the amount of five shillings, a capital Felony; and other Statutes of the same nature. So great an alteration has taken place in the value of money since those Statutes passed, that it is astonishing that the letter of the Law should have been suffered to remain unaltered to the present day, the offences, in the mean time, having become altogether so different. Perhaps there is no case which renders more striking the truth of Lord Bacon's observation, that Time is the greatest of all innovators; for, in proportion as every thing that contributes to the support, the comfort, and the luxuries of life has grown dearer, life itself has become cheaper and of less account.

There are many mischievous consequences, resulting from such a state of things, which do not strike the mind at first, but which become more evident, on reflection. Such Laws cannot be executed. Juries are placed in the painful situation of violating one of two duties; they are reduced to the alternative of violating their oaths, or what they are sometimes mistakenly induced to think more binding on them—the dictates of humanity. Often, against the plainest evidence, Juries have reduced the property stolen to less than half of its lowest value, in order to dispense with the capital part of the punishment. And this is now considered (as Blackstone has somewhere expressed it) "a pious perjury"-words, which I regret, should ever have been put together; since nothing has a more immoral tendency than for men to familiarize themselves with the disregard of their judicial oaths! The law ought not to remain so; it causes offenders to be acquitted against the clearest evidence; and thus, by a necessary consequence, defeats its own ends, and becomes the abettor of its own violation.

The same benevolence and humanity, understood in a more confined or a more enlarged sense, will determine one Judge to pardon and another to punish. It has often happened, it necessarily must have happened, that the very same circumstance which is considered by one Judge as a matter of extenuation, is deemed by another a high aggravation of the crime. The former good character of the delinquent, his having come into a country in which he was a stranger to commit the offense, the frequency or the novelty of

the crime, are all circumstances which have been upon some occasions considered by different Judges in those opposite lights; and it is not merely the particular circumstances attending the crime, it is the crime itself, which different Judges sometimes consider in quite different points of view.

Not a great many years ago, upon the Norfolk Circuit, a larceny was committed by two men in a poultry-yard, but only one of them was apprehended; the other having escaped into a distant part of the country had eluded all pursuit. At the next Assizes the apprehended thief was tried and convicted; but Lord Loughborough, before whom he was tried, thinking the offense a very slight one, sentenced him to a few months' imprisonment. The news of this sentence having reached the accomplice in his retreat, he immediately returned and surrendered himself to take

his trial at the next Assizes. The next Assizes came; but, unfortunately for the prisoner, it was a different Judge who presided; and still more unfortunately. Mr. Justice Gould, who happened to be the Judge, though of a very mild and indulgent disposition, had observed, or thought he had observed, that men who set out with stealing fowls, generally ended by committing the most atrocious crimes; and building a sort of system upon this observation, had made it a rule to punish this offense with very great severity: and he accordingly, to the astonishment of this unhappy man, sentenced him to be transported. While one was taking his departure for Botany Bay, the term of the other's imprisonment had expired; and what must have been the notions which that little Public, who witnessed and compared these two examples, formed of our system of Criminal Jurisprudence?

3. CONDITIONS IN INDUSTRY

Liberal economics seemed an integral part of the booming activity and prosperity of the times. But behind the façade of the industrial revolution were hundreds of thousands of people torn by economic and social dislocation. They were the displaced persons of the revolution: law, industry, society, seemed to operate without regard for them as human beings. And though opportunity gleamed golden above the grim and grimy mills, and though Samuel Smiles and others provided good advice on how a man could save and grow rich—hence respectable—the new industrial proletariat was too harassed and brutalized, too busy coping with the tremendous task of merely keeping alive from one day to another, to lift its eyes too high above the hopeless present. This task was undertaken by reformers—many of them manufacturers themselves, many of them Tories-who spoke, wrote, and fought on its behalf; by independent observers like Dr. Gaskell, whose opinion as a medical man appears on p. 659, and by parliamentary commissions of inquiry, like those headed by Michael Sadler or by Anthony Ashley Cooper, the future seventh Earl of Shaftesbury. The evidence these men produced shocked public opinion and led to measures regulating conditions of labor in factories and mines and restricting the hours of work of women and children.

Evidence Given before the Sadler Committee

Mr. Matthew Crabtree, called in; and Examined

What age are you?—Twenty-two.
What is your occupation?—A blanket
manufacturer.

Have you ever been employed in a factory?—Yes.

At what age did you first go to work in one?—Eight.

How long did you continue in that occupation?—Four years.

Will you state the hours of labor at the period when you first went to the factory, in ordinary times?—From 6 in the morning to 8 at night.

Fourteen hours?—Yes.

With what intervals for refreshment and rest?—An hour at noon.

When trade was brisk what were your hours?—From 5 in the morning to 9 in the evening.

Sixteen hours?—Yes.

With what intervals at dinner?—An hour.

How far did you live from the mill?—About two miles.

Was there any time allowed for you to get your breakfast in the mill?—No.

Did you take it before you left your home?—Generally.

During those long hours of labor could you be punctual; how did you awake?— I seldom did awake spontaneously; I was most generally awoke or lifted out of bed, sometimes asleep, by my parents.

Were you always in time?—No.

What was the consequence if you had been too late?—I was most commonly beaten.

Severely?—Very severely, I thought. In those mills is chastisement towards

the latter part of the day going on perpetually?—Perpetually.

So that you can hardly be in a mill without hearing constant crying?—Never an hour, I believe.

Do you think that if the overlooker were naturally a human person it would still be found necessary for him to beat the children, in order to keep up their attention and vigilance at the termination of those extraordinary days of labor?—Yes: the machine turns off a regular quantity of cardings, and of course they must keep as regularly to their work the whole of the day; they must keep with the machine, and therefore however human the slubber may be, as he must keep up with the machine or be found fault with, he spurs the children to keep up also by various means; but that which he commonly resorts to is to strap them when they become drowsy.

At the time when you were beaten for not keeping up with your work, were you anxious to have done it if you possibly could?—Yes; the dread of being beaten if we could not keep up with our work was a sufficient impulse to keep us to it if we could.

When you got home at night after this labor, did you feel much fatigued?— Very much so.

Had you any time to be with your parents, and to receive instructions from them?—No.

What did you do?—All that we did when we got home was to get the little bit of supper that was provided for us and to go to bed immediately. If the supper had not been ready directly, we should have gone to sleep while it was preparing.

Did you not, as a child, feel it a very grievous hardship to be roused so soon in the morning?—I did.

Were the rest of the children similarly circumstanced?—Yes, all of them; but they were not all of them so far from their work as I was.

And if you had been too late you were under the apprehension of being cruelly beaten?—I generally was beaten when I happened to be too late, and when I got up in the morning the apprehension of that was so great, that I used to run, and cry all the way as I went to the mill.

Elizabeth Bentley, called in; and Examined

What age are you?—Twenty-three. Where do you live?—At Leeds.

What time did you begin to work at a factory?—When I was six years old.

At whose factory did you work?—Mr. Busk's.

What kind of mill is it?—Flax-mill.

What was your business in that mill?
—I was a little doffer.

What were your hours of labor in that mill?—From 5 in the morning till 9 at night, when they were thronged.

For how long a time together have you worked that excessive length of time?—
For about half a year.

What were your usual hours of labor when you were not so thronged?—From 6 in the morning till 7 at night.

What time was allowed for your meals?
—Forty minutes at noon.

Had you any time to get your breakfast or drinking?—No, we got it as we could.

And when your work was bad, you had hardly any time to eat it at all?—No; we were obliged to leave it or take it home, and when we did not take it, the overlooker took it, and gave it to his pigs.

Do you consider doffing a laborious employment?—Yes.

Explain what it is you had to do?— When the frames are full, they have to stop the frames, and take the flyers off, and take the full bobins off, and carry them to the roller; and then put empty ones on, and set the frame going again.

Does that keep you constantly on your feet?—Yes, there are so many frames, and they run so quick.

Your labor is very excessive?—Yes; you have not time for any thing.

Suppose you flagged a little, or were too late, what would they do?—Strap us.

Are they in the habit of strapping those who are last in doffing?—Yes.

Constantly?—Yes.

Girls as well as boys?—Yes.

Have you ever been strapped?—Yes. Severely?—Yes.

Could you eat your food well in that factory?—No, indeed, I had not much to eat, and the little I had I could not eat it, my appetite was so poor, and being covered with dust; and it was no use to take it home, I could not eat it, and the overlooker took it, and gave it to the pigs.

You are speaking of the breakfast?—Yes.

How far had you to go for dinner?— We could not go home to dinner.

Where did you dine?—In the mill.

Did you live far from the mill?—Yes, two miles.

Had you a clock?—No, we had not.

Supposing you had not been in time enough in the morning at these mills, what would have been the consequence?

—We should have been quartered.

What do you mean by that?—If we were a quarter of an hour too late, they would take off half an hour; we only got a penny an hour, and they would take a halfpenny more.

The fine was much more considerable than the loss of time?—Yes.

Were you also beaten for being too late?—No, I was never beaten myself, I have seen the boys beaten for being too late.

Were you generally there in time?—Yes, my mother has been up at 4 o'clock in the morning, and at 2 o'clock in the morning; the colliers used to go to their work about 3 or 4 o'clock, and when she heard them stirring she has got up out of her warm bed, and gone out and asked them the time, and I have sometimes been at Hunslet Car at 2 o'clock in the morning, when it was streaming down with rain, and we have had to stay till the mill was opened.

Peter Smart, called in; and Examined

You say you were locked up night and day?—Yes.

Do the children ever attempt to run away?—Very often.

Were they pursued and brought back again?—Yes, the overseer pursued them and brought them back.

Did you ever attempt to run away?—Yes, I ran away twice.

And you were brought back?—Yes, and I was sent up to the master's loft, and thrashed with a whip for running away.

Were you bound to this man?—Yes, for six years.

By whom were you bound?—My mother got 15s. for the six years.

Do you know whether the children were, in point of fact, compelled to stop during the whole time for which they were engaged?—Yes, they were.

By law?—I cannot say by law; but they were compelled by the master; I never saw any law used there but the law of their own hands.

To what mill did you next go?—To

Mr. Webster's, at Battus Den, within eleven miles of Dundee.

In what situation did you act there?

—I acted as an overseer.

At 17 years of age?—Yes.

Did you inflict the same punishment that you yourself had experienced?—I went as an overseer; not as a slave, but as a slave-driver.

What were the hours of labor in that mill?—My master told me that I had to produce a certain quantity of yarn; the hours were at that time fourteen; I said that I was not able to produce the quantity of yarn that was required; I told him if he took the timepiece out of the mill I would produce that quantity, and after that time I found no difficulty in producing the quantity.

How long have you worked per day in order to produce the quantity your master required?—I have wrought nineteen hours.

Was this a water-mill?—Yes, water and steam both.

To what time have you worked?—I have seen the mill going till it was past 12 o'clock on the Saturday night.

So that the mill was still working on the Sabbath morning?—Yes.

Were the workmen paid by the piece, or by the day?—No, all had stated wages.

Did not that almost compel you to use great severity to the hands then under you?—Yes; I was compelled often to beat them, in order to get them to attend to their work, from their being overwrought.

Were not the children exceedingly fatigued at that time?—Yes, exceedingly fatigued.

Were the children bound in the same way in that mill?—No; they were bound from one year's end to another, for twelve months.

Did you keep the hands locked up in the same way in that mill?—Yes; we locked up the mill; but we did not lock the bothy.

Did you find that the children were unable to pursue their labor properly to that extent?—Yes; they have been brought to that condition, that I have gone and fetched up the doctor to them,

to see what was the matter with them, and to know whether they were able to rise or not able to rise; they were not at all able to rise; we have had great difficulty in getting them up.

When that was the case, how long have they been in bed, generally speaking?—Perhaps not above four or five hours in their beds.

An Independent Observer

Any man who has stood at twelve o'clock at the single narrow doorway. which serves as the place of exit for the hands employed in the great cottonmills, must acknowledge that an uglier set of men and women, of boys and girls, taking them in the mass, it would be impossible to congregate in a smaller compass. Their complexion is sallow and pallidwith a peculiar flatness of feature, caused by the want of a proper quantity of adipose substance to cushion out the cheeks. Their stature low—the average height of four hundred men, measured at different times and different places, being five feet six inches. Their limbs, slender, and playing hadly and ungracefully. A very general bowing of the legs. Great numbers of girls and women walking lamely or awkwardly, with raised chests and spinal flexures. Nearly all have flat feet, accompanied with a down-tread, differing very widely from the elasticity of action in the foot and ankle, attendant upon perfect formation. Hair thin and straight-many of the men having but little beard, and that in patches of a few hairs, much resembling its growth among the red men of America. A spiritless and dejected air, a sprawling and wide action of the legs, and an appearance, taken as a whole, giving the world but "little assurance of a man," or if so, "most sadly cheated of his fair proportions. . . ."

Factory labor is a species of work, in some respects singularly unfitted for children. Cooped up in a heated atmosphere, denied the necessary exercise, remaining in one position for a series of hours, one set or system of muscles alone called into activity, it cannot be wondered at that its effects are injurious to the physical growth of a child. Where the bony system is still imperfect, the vertical position it is compelled to retain, influences its direction; the spinal column bends beneath the weight of the head, bulges out laterally, or is dragged forward by the weight of the parts composing the chest, the pelvis yields beneath the opposing pressure downwards, and the resistance given by the thigh-bones; its capacity is lessened, sometimes more and sometimes less; the legs curve, and the whole body loses height, in consequence of this general yielding and bending of its parts.

From P. Gaskell, The Manufacturing Population of England (London, 1833).

660

Evidence Given before Lord Ashley's Mines Commission of 1842

Sarah Gooder, aged 8 years

I'm a trapper in the Gawber pit. It does not tire me, but I have to trap without a light and I'm scared. I go at four and sometimes half past three in the morning, and come out at five and half past. I never go to sleep. Sometimes I sing when I've light, but not in the dark; I dare not sing then. I don't like being in the pit. I am very sleepy when I go sometimes in the morning. I go to Sundayschools and read Reading made Easy. She knows her letters and can read little words. They teach me to pray. She repeated the Lord's Prayer, not very perfectly, and ran on with the following addition: - "God bless my father and mother, and sister and brother, uncles and aunts and cousins, and everybody else, and God bless me and make me a good servant. Amen. I have heard tell of Jesus many a time. I don't know why he came on earth, I'm sure, and I don't know why he died, but he had stones for his head to rest on. I would like to be at school far better than in the pit."

Thomas Wilson, Esq., of the Banks, Silkstone, owner of three collieries

The employment of females of any age in and about the mines is most objectionable, and I should rejoice to see it put an end to; but in the present feeling of the colliers, no individual would succeed in stopping it in a neighborhood where it prevailed, because the men would immediately go to those pits where their daughters would be employed. The only way effectually to put an end to this and other evils in the present colliery system is to elevate the minds of the men; and the

only means to attain this is to combine sound moral and religious training and industrial habits with a system of intellectual culture much more perfect than can at present be obtained by them.

I object on general principles to government interference in the conduct of any trade, and I am satisfied that in mines it would be productive of the greatest injury and injustice. The art of mining is not so perfectly understood as to admit of the way in which a colliery shall be conducted being dictated by any person. however experienced, with such certainty as would warrant an interference with the management of private business. I should also most decidedly object to placing collieries under the present provisions of the Factory Act with respect to the education of children employed therein. First, because, if it is contended that coal-owners, as employers of children, are bound to attend to their education, this obligation extends equally to all other employers, and therefore it is unjust to single out one class only; secondly, because, if the legislature asserts a right to interfere to secure education, it is bound to make that interference general; and thirdly, because the mining population is in this neighborhood so intermixed with other classes, and is in such small bodies in any one place, that it would be impossible to provide separate schools for them.

Isabella Read, 12 years old, coal-bearer

Works on mother's account, as father has been dead two years. Mother bides at home, she is troubled with bad breath, and is very weak in her body from early labor. I am wrought with sister and brother, it is very sore work; cannot say how

From Parliamentary Papers (London, 1842), XV-XVII, Appendix 1; Appendix 2.

many rakes or journeys I make from pit's bottom to wall face and back, thinks about 30 or 25 on the average; the distance varies from 100 to 250 fathom.

I carry about 1 cwt. and a quarter on my back; have to stoop much and creep through water, which is frequently up to the calves of my legs. When first down, fell frequently asleep while waiting for coal from heat and fatigue.

I do not like the work, nor do the lassies, but they are made to like it. When the weather is warm there is difficulty in breathing, and frequently the lights go out.

Isabel Wilson, 38 years old, coal-putter

When women have children thick [fast] they are compelled to take them down early, I have been married 19 years and have had 10 bairns; seven are in life. When on Sir John's work was a carrier of coals, which caused me to miscarry five times from the strains, and was ill after each. Putting is not so oppressive; last child was born on Saturday morning, and I was at work on the Friday night.

Once met with an accident; a coal brake my cheek-bone, which kept me idle some weeks.

I have wrought below 30 years, and so has the guid man; he is getting touched in the breath now.

None of the children read; as the work is not regular. I did read once, but not able to attend to it now; when I go below lassie 10 years of age keeps house and makes the broth or stir-about.

Nine sleep in two bedsteads; there did not appear to be any beds, and the whole of the other furniture consisted of two chairs, three stools, a table, a kail-pot and a few broken basins and cups. Upon asking if the furniture was all they had, the guid wife said, furniture was of no use, as it was so troublesome to flit with.

Patience Kershaw, aged 17

My father has been dead about a year; my mother is living and has ten children, five lads and five lasses; the oldest is about thirty, the youngest is four; three lasses go to mill; all the lads are colliers, two getters and three hurriers; one lives at home and does nothing; mother does nought but look after home.

All my sisters have been hurriers, but three went to the mill. Alice went because her legs swelled from hurrying in cold water when she was hot. I never went to day-school; I go to Sunday-school, but I cannot read or write; I go to pit at five o'clock in the morning and come out at five in the evening; I get my breakfast of porridge and milk first; I take my dinner with me, a cake, and eat it as I go; I do not stop or rest any time for the purpose; I get nothing else until I get home, and then have potatoes and meat, not every day meat. I hurry in the clothes I have now got on, trousers and ragged jacket; the bald place upon my head is made by thrusting the corves; my legs have never swelled, but sisters' did when they went to mill; I hurry the corves a mile and more under ground and back; they weigh 300 cwt.; I hurry 11 a day; I wear a belt and chain at the workings to get the corves out; the getters that I work for are naked except their caps; they pull off all their clothes; I see them at work when I go up; sometimes they beat me, if I am not quick enough, with their hands; they strike me upon my back; the boys take liberties with me; sometimes they pull me about; I am the only girl in the pit; there are about 20 boys and 15 men; all the men are naked; I would rather work in mill than in coal-pit.

(This girl is an ignorant, filthy, ragged, and deplorable-looking object, and such a one as the uncivilized natives of the prairies would be shocked to look upon.)

Mary Barrett, age 14, June 15

I have worked down in pit five years; father is working in next pit; I have 12 brothers and sisters—all of them but one live at home; they weave, and wind, and hurry, and one is a counter, one of them can read, none of the rest can, or write;

they never went to day-school, but three of them go to Sunday-school; I hurry for my brother John, and come down at seven o'clock about; I go up at six, sometimes seven; I do not like working in pit, but I am obliged to get a living; I work always without stockings, or shoes, or trousers; I wear nothing but my chemise; I have to go up to the headings with the men; they are all naked there; I am got well used to that, and don't care now much about it; I was afraid at first, and did not like it; they never behave rudely to me; I cannot read or write.

4. SAMUEL SMILES

Samuel Smiles (1812–1904), whose real name was Samuel Smiles, studied medicine at Edinburgh, took to journalism, and thence to biography and inspirational writings. Self Help, his most popular work, was published in 1859; it was tremendously successful and before long had been translated into seventeen languages. It was followed by books on Character (1871), Thrift (1875), and Duty (1880). He also wrote biographies of worthy men, mostly engineers, received an honorary degree (LL.D.) from the University of Edinburgh in 1878, and died replete with honors and years, having reaped the rewards of adherence to the recipe he had proposed so enthusiastically to others.

Self Help

"Heaven helps those who help themselves," is a well-worn maxim, embodying in a small compass the results of vast human experience. The spirit of self-help is the root of all genuine growth in the individual; and, exhibited in the lives of many, it constitutes the true source of national vigor and strength. Help from without is often enfeebling in its effects, but help from within invariably invigorates. Whatever is done for men or classes, to a certain extent takes away the stimulus and necessity of doing for themselves; and where men are subjected to overguidance and over-government, the inevitable tendency is to render them comparatively helpless.

Even the best institutions can give a man no active aid. Perhaps the utmost they can do, is, to leave him free to develop himself and improve his individual condition. But in all times men have been prone to believe that their happiness and well-being were to be secured by means of institutions rather than by their own conduct. Hence the value of legislation as an agent in human advancement has always been greatly over-estimated. To con-

From S. Smiles, Self Help (Boston, 1860).

stitute the millionth part of a legislature, by voting for one or two men once in three or five years, however conscientiously this duty may be performed, can exercise but little active influence upon any man's life and character. Moreover, it is every day becoming more clearly understood, that the function of government is negative and restrictive, rather than positive and active; being resolvable principally into protection, - protection of life, liberty and property. Hence the chief "reforms" of the last fifty years have consisted mainly of abolitions and disenactments. But there is no power of law that can make the idle man industrious, the thriftless provident, or the drunken sober; though every individual can be each and all of these if he will, by the exercise of his own free powers of action and selfdenial. Indeed, all experience serves to prove that the worth and strength of a state depend far less upon the form of its institutions than upon the character of its men. For the nation is only the aggregate of individual conditions, and civilization itself is but a question of personal improvement.

National progress is the sum of individual industry, energy, and uprightness, as national decay is of individual idleness. selfishness, and vice. What we are accustomed to decry as great social evils, will, for the most part, be found to be only the outgrowth of our own perverted life; and though we may endeavour to cut them down and extirpate them by means of law, they will only spring up again with fresh luxuriance in some other form, unless the individual conditions of human life and character are radically improved. If this view be correct, then it follows that the highest patriotism and philanthropy consist, not so much in altering laws and modifying institutions, as in helping and stimulating men to elevate and improve themselves by their own free and independent action as individuals.

Practical industry, wisely and vigorously applied, never fails of success. It carries a man onward and upward, brings out his individual character, and powerfully stimulates the action of others. All may not rise equally, yet each, on the whole, very much according to his deserts. "Though all cannot live on the piazza," as the Tuscan proverb has it, "every one may feel the sun."

We have already referred to some illustrious Commoners raised from humble to elevated positions by the power of application and industry; and we might point to even the peerage itself as affording equally instructive examples. One reason why the peerage of England has succeeded so well in retaining its vigor and elasticity, arises from the fact that, unlike the peerages of other countries, it has been fed from time to time by the best industrial blood of the country—the very "liver, heart, and brain of Britain." . . .

The great bulk of our peerage is comparatively modern, so far as the titles go; but it is not the less noble in that it has been recruited to so large an extent from the ranks of honorable industry. In olden times, the wealth and commerce of London, conducted as it was by energetic and enterprising men, was a prolific source of peerages. Thus, the earldom of Cornwallis was founded by Thomas Cornwallis, the Cheapside merchant; that of Essex by William Capel, the draper; and that of Craven by William Craven, the merchant tailor. The modern Earl of Warwick is not descended from "the Kingmaker," but from William Greville, the woolstapler; whilst the modern dukes of Northumberland find their head, not in the Percies, but in Hugh Smithson, a respectable London apothecary.

It is will, force of purpose, that enables a man to do or be whatever he sets his mind on being or doing. A holy man was accustomed to say, "Whatever you wish, that you are: for such is the force of our will, joined to the Divine, that whatever we wish to be, seriously, and with a true intention, that we become. No one ardently wishes to be submissive, patient, modest, or liberal, who does not become what he wishes." The story is told of a working carpenter, who was observed one day planing a magistrate's bench, which he was repairing, with more than usual carefulness, and when asked the reason, he replied, "Because I wish to make it easy against the time when I come to set upon it myself." And singularly enough, the man actually lived to sit upon that very bench as a magistrate.

Whatever theoretical conclusions logicians may have formed as to the freedom of the will, each individual feels that practically he is free to choose between good and evil,—that he is not like a mere straw thrown upon the water to mark the direction of the current, but that he has within him the power of a strong swimmer, and is capable of striking out for himself, of buffeting with the waves, and directing to a great extent his own independent course. There is no absolute constraint upon our volitions, and we feel and know that we are not bound, as by a spell, with reference to our actions. It would paralyze all desire of excellence were we to think otherwise. The entire business and conduct of life, with its domestic rules, its social arrangements, and its public institutions, proceed upon the practical conviction that the will is free,

Without this where would be responsibility?—and what the advantage of teaching, advising, preaching, reproof, and correction? What were the use of laws, were it not the universal belief, as it is the universal fact, that men obey them or not, very much as they individually determine? In every moment of our life, conscience is proclaiming that our will is free. It is the only thing that is wholly ours, and it rests solely with ourselves individually, whether we give it the right or the wrong direction. Our habits or our temptations are not our masters, but we of them. Even in yielding, conscience tells us we might resist; and that were we determined to master them, there would not be required for that purpose a stronger resolution than we know ourselves to be capable of exercising.

Any class of men that lives from hand to mouth will ever be an inferior class. They will necessarily remain impotent and helpless, hanging on to the skirts of society, the sport of times and seasons. Having no respect for themselves, they will fail in securing the respect of others. In commercial crises, such men must inevitably go to the wall. Wanting that husbanded power which a store of savings, no matter how small, invariably gives them, they will be at every man's mercy, and, if possessed of right feelings, they cannot but regard with fear and trembling the future possible fate of their wives and children. "The world," once said Mr. Cobden to the working men of Huddersfield, "has always been divided into two classes, -those who saved, and those who have spent,—the thrifty and the extravagant. The building of all the houses, the mills, the bridges, and the ships, and the accomplishment of all

other great works which have rendered man civilized and happy, has been done by the savers, the thrifty; and those who have wasted their resources have always been their slaves. It has been the law of nature and of Providence, that this should be so; and I were an imposter if I promised any class that they would advance themselves if they were improvident, thoughtless, and idle."

Equally sound was the advice given by Mr. Bright to an assembly of working men at Rochdale, in 1847, when, after expressing his belief that "so far as honesty was concerned, it was to be found in pretty equal amount among all classes," he used the following words: "There is only one way that is safe for any man, or any number of men, by which they can maintain their present position if it be a good one, or raise themselves above it if it be a bad one,—that is, by the practice of the virtues of industry, frugality, temperance, and honesty. There is no royal road by which men can raise themselves from a position which they feel to be uncomfortable and unsatisfactory, as regards their mental or physical condition, except by the practice of those virtues by which they find numbers amongst them are continually advancing and bettering themselves. What is it that has made, that has in fact created, the middle class in this country, but the virtues to which I have alluded? There was a time when there was hardly any class in England, except the highest, that was equal in condition to the poorest class at this moment. How is it that the hundreds of thousands of men, now existing in this our country, of the middle class, are educated, comfortable, and enjoying an amount of happiness and independence, to which our forefathers were wholly unaccustomed? Why,

by the practice of those very virtues; for I maintain that there has never been in any former age as much of these virtues as is now to be found amongst the great middle class of our community. When I speak of the middle class, I mean that class which is between the privileged class, the richest, and the very poorest in the community; and I would recommend every man to pay no attention whatever to public writers or speakers, whoever they may be, who tell them that this class or that class, that this law or that law, that this government or that government, can do all these things for them. I assure you, after long reflection and much observation, that there is no way for the working classes of this country to improve their condition but that which so many of them have already availed themselves of,—that is, by the practice of those virtues, and by reliance upon themselves."

Many popular books have been written for the purpose of communicating to the public the grand secret of making money. But there is no secret whatever about it, as the proverbs of every nation abundantly testify. "Many a little makes a meikle." -"Take care of the pennies and the pounds will take care of themselves."-"A penny saved is a penny gained."-"Diligence is the mother of good-luck." -"No pains no gains."-"No sweat no sweet."—"Sloth, the key of poverty."— "Work, and thou shalt have."-"He who will not work, neither shall he eat."-"The world is his, who has patience and industry."—"It is too late to spare when all is spent."-"Better go to bed supperless than rise in debt."—"The morning hour has gold in its mouth."-"Credit keeps the crown of the causeway." Such are specimens of the poverbial philosophy,

embodying the hoarded experience of many generations, as to the best means of thriving in the world. They were current in people's mouths long before books were invented; and like other popular proverbs, they were the first codes of popular morals. Moreover they have stood the test of time and the experience of every day still bears witness to their accuracy, force, and soundness.

VII. But Life Goes On

1. IN ENGLAND

At a more pedestrian level than that of parliaments and banks, everyday life carried on with its petty concerns, its rationalizations and its cares. The brief selections that follow reflect some of the more commonplace attitudes and reactions of mid-nineeenth-century England: the first European country to enter the new industrial world and try to adjust to the changes it implied.

Chapels*

[Chapels] are erected by men who ponder between a mortgage, a railroad or a chapel, as the best investment of their money, and who, when they have resolved on relying on the persuasive eloquence of a cushion-thumping, popular preacher, erect four walls with apertures for windows, cram the same full of seats, which they readily let; and so greedy after self are these chapel-raisers, that they form dry and spacious vaults underneath which are soon occupied at a good rent by some wine and brandy merchant.

Cheap Irish Labor †

The rapid extension of English industry could not have taken place if England had not possessed in the numerous and impoverished population of Ireland a reserve at command. The Irish had nothing to lose at home, and much to gain in England; and from the time when it became known in Ireland that the East side of St. George's Channel offered steady work and good pay for strong arms, every year has brought armies of the Irish hither. It has been calculated (in 1840) that more than a million have already immigrated, and not far from 50,000 still come every year. . . . These people having grown up almost without civilization, accustomed from youth to every sort of priva-

tion, rough, intemperate and improvident, bring all their brutal habits with them among a class of the English population which has, in truth, little inducement to cultivate education and morality. . . . These Irishmen who migrate for 4-pence, to England, on the deck of a steamship on which they are often packed like cattle, insinuate themselves everywhere. The worst dwellings are good enough for them; their clothing causes them little trouble, so long as it holds together by a single thread; shoes they know not; their food consists of potatoes and potatoes only; whatever they earn beyond these needs they spend on drink. What does such a race want with high wages?

^{*} From A. W. Pugin, Contrasts, Second Edition (London, 1841), p. 41.

[†] From Fr. Engels, The Condition of the Working Classes in England in 1844 (London, 1844).

Panaceas*

A Society for the Distribution of Religious Prints amongst the Middle Classes, the Poor and Charity Schools With Lord John Russell as a Patron.

Catechism †

- Q. What are the classes of society?
- A. Proprietors, money-dealers, farmers, manufacturers, traders, professions, servants and labourers. . . .
- Q. What are money-dealers?
- Persons who live on the interest of money, by lending it on some security.

Charity ‡

The anniversary of the [Ladies' Sanitary] association was held yesterday at the Hanover Square Rooms. The Bishop of Oxford, who presided, advocated the claims of the association upon the several grounds of religion, humanity and selfinterest, showing the effect of its operations in making it possible for the poor to become religious and respectable, reducing the amount of disease and death, and lowering the taxation of the country. The association did this in the most direct manner by teaching the poor to help themselves, and the promotion of such objects had a tendency to lessen the separation which gradually grew up between the rich and the poor and between different classes of religionists, in proportion to the increase of wealth and of the intensity of Christian principle. Mr. Thomas Hughes, author of Tom Brown's Schooldays, proposed the first resolution, which was seconded by Dr. Lankester, who dwelt with

considerable warmth upon the duty of lessening the mortality of the population by disseminating information as to the laws of life and health, a knowledge of which, he considered should not by a false delicacy be withheld from females, for it was their ignorance of the subject that caused a vast number of deaths, which could as easily be prevented as deaths from accidents upon railways. . . .

The Bishop of London said there was, no doubt, a great want of sanitary knowledge, but there was a greater want of sanitary belief; the poor needed the importance of cleanliness to be brought home to them; and if they were saved from an epidemic, for instance, by means of the brushes and whitewash which he was glad to find the missionaries of the association carried with them, they would see there was something practical in what was told them by the lecturer.

^{*} From an advertisement in London Athenaeum, November 18, 1848, p. 1138.

[†] From Blair's First or Mother's Catechism, 124th edition (London, 1856), p. 39.

From The London Times, April 24, 1861.

The Trouble with the System*

When any [Manchester manufacturer] boasts to me that the earnings of his workpeople average 16s. a week, woman, man, and child, I am inclined to answer so much the worse for them. It is a very great question whether such high wages are a benefit, without a corresponding high education. You must know well . . . that most of them do not know what to do with their money, and waste it on drink, on rich food, on finery, etc. God knows, I do not grudge it them; but the waste, and the temptation to coarse self-indulgence, is extreme. . .

Another great evil of our system is, that the children earn wages too nearly equal to those of their parents. Hence the family is broken up, the children are independent too early, boys and girls go off and live in lodgings of their own, and so a great deal of fearful profligacy is engendered. . . .

Another great evil, by the masters' own account, is that mill labour effeminates the men and renders them unfit for any other sort of labour. . . That large bodies of men should be employed in exclusively performing, day after day, the same minute mechanical operation till their whole intellect is concentrated on it, and their fingers kept delicate for the purpose, is to me shocking.

Another View

12 May. While reading in the herald to Day on the subject on shorter houers of Labour I was Reminded of A cercomstance that came under my hone notis when the 10 hours sistom Began in the cotton mills in Lancashire. . . . I was Minding a masheen with 30 treds in it I was then maid to mind 2 of 30 treds each with one shilling Advance of wages wich was 5s. for one and 6s. for tow with an increes of speed and with improved mecheens in A few years I was minding tow mecheens with two 100 treds each and Dubel speed for 9s. perweek so that in our

improved condation we had to turn out some 100 weght per day and we went as if the Devel was After us for 10 houers per day and with that comparetive small Advance in money and the feemals have often Been carred out fainting what with the heat and hard work and those that could not keep up must go and make room for another and all this is Done in Christian England and then we are tould to be content in the station of Life to wich the Lord as places us But I say the Lord never Did place us there so we have no Right to Be content. . . .

Coming to Terms with Hardship ‡

The author recommends grey paper for the drawing-room, with inscriptions from the book of Job such as "Man is born unto travail, as the sparks fly upward" painted in black letters in diagonal lines.

^{*} From Ch. Kingsley; His Letters and Memories (London, 1863), Volume II, p. 148.

[†] Letter from a working woman, quoted in J. Ruskin, Fors Clavigera (London, 1873), XXVIII, 65.

From Anon., A Plea for Art in the Home (London, n.d.), p. 39.

The Other Oppressed*

The sentiment for woman has undergone a change. The romantic passion, which once almost deified her, is on the decline; and it is by intrinsic qualities that she must now inspire respect.

A woman may make a man's home delightful, and may thus increase his motives for virtuous exertion. She may refine and tranquilize his mind—may turn away his anger, or allay his grief. Where want of congeniality impairs domestic comfort, the fault is generally chargeable on the female side; for it is for woman, not for man, to make the sacrifice, especially in indifferent matters. She must, in a certain degree, be plastic herself, if she would mould others, and this is one reason why very good women are sometimes very uninfluential. They do a great deal, but they yield nothing. . . .

In everything that women attempt, they should show their consciousness of dependence. There is something so unpleasant in female self-sufficiency, that it not infrequently prejudices instead of persuading.

Their sex should ever teach them to be subordinate; and they should remember that, by them, influence is to be obtained, not by assumption, but by a delicate appeal to affection or principle. Women, in this respect, are something like children: the more they show their need of support, the more engaging they are.

The bas bleu [Bluestocking] is eager for notoriety, and avails herself of her requirement only to secure it. She does all she can to sustain her claims; she accumulates around her the materials of learning, and her very boudoir breathes an academic air. Its decorations are sufficient to proclaim her character; its shelves are filled with books of every tongue; its tables are strewed with the apparatus of science; the casket of jewels is displaced for the cabinet of stones, and the hammer and alembic occupy the stand allotted for the work-box. One niche glooms with a quartered skull; another is enriched by a classic statue; the easel stands in the background, and the harp is admitted to complete the picturesque. And she herself is in accordance with all this paraphernalia; and her conversation, dress and manner equally attest her eagerness to make good her pretensions to literary notoriety.

Order Established †

Man for the field and woman for the hearth; Man for the sword and for the needle she; Man with the head and woman with the heart;

Man to command and woman to obey; All else confusion.

^{*} From Mrs. John Sandford, Woman in her Social and Domestic Character (1837).

[†] From Alfred, Lord Tennyson, The Princess (1847).

Order Threatened*

November, 1859. In chronicling the striking incidents and varying shades of Oxford life, it is but fair to mention the following notice, by the Vice-Chancellor and Proctors, as a proof of a growing neglect of manners, the natural accompaniment of a rougher bearing and a coarser

external: "Whereas complaints have been made that some undergraduate members of the University are in the habit of smoking at *public entertainments* and other wise creating annoyance, they are hereby cautioned against the repetition of such ungentlemanlike conduct."

2. FRANCE FOLLOWS SUIT

Where the England of the 1840's was already industrialized, continental countries like France were only beginning their industrial revolution. In 1846, the great historian Jules Michelet (1798–1874), himself the son of a poor printer, interrupted his historical writings to pen a pamphlet on the condition of the popular masses in France. Well aware that machines enslaved and demeaned their serfs, he noticed nevertheless that machine products improved the general condition of the laboring poor, among whom peasants and artisans were still much more numerous than industrial workers. This improvement in material conditions could lead to a rise in self-respect and help to integrate into the nation classes heretofore politically irrelevant and socially dangerous.

Michelet: The Revolution of Cheap Calico †

There used to be in the past, admission tolls apart, another barrier that drove the peasant from the towns and kept him from turning workman. This barrier was the difficulty of entering a trade, the length of apprenticeship, the exclusive spirit of guilds and corporations. Industrial families took few apprentices, most often their own children whom they exchanged among themselves. Today, new trades have been created, which require no apprenticeship and accept any man. The true worker in these trades is the machine; man needs neither much strength nor skill; he is there only to survev and help that iron worker.

This miserable population enslaved to the machines includes four hundred thousand souls or a little more.¹ That is about one fifteenth of our workers. All who do not know how to do anything come to offer themselves to the machines, to serve the machines. The more they come, the lower the wages, the more miserable they are. On the other hand, the merchandise thus turned out at low cost falls within reach of the poor, so that the misery of the workman-machine slightly lessens the misery of the [other] workers and peasants who are probably seventy times more numerous.

This is what we saw in 1842. The

^{*} From G. V. Cox, Recollections of Oxford (1868), 428.

[†] From Jules Michelet, The People (Paris, 1946), part I, ch. 2. Translated by Eugen Weber.

¹ The census of 1846 found French population to stand at 34,400,000.

spinning industry was in a desperate condition. It was choking; the warehouses were bursting; there were no sales. The manfacturer, terrified, dared neither work nor cease work with his devouring machines; usury knows no standstill: he worked half-time and crowded his crowded stores still further. Prices fell, in vain: new reductions followed, until cotton had fallen to six farthings. There, something unexpected happened. This word, six farthings, was an awakening. Millions of buyers, poor people who never bought anything, set themselves in motion. That was when one saw what an immense and powerful consumer the people is, when it takes a hand. The shops were emptied at one go. The machines went furiously back to work; the chimneys smoked again. It was a revolution in France, little noticed, but great; revolution in cleanliness, sudden improvement in the poor household; body linen, bed and table linen. curtains: whole classes came to have them that had never had them since the beginning of the world.

It is easy to understand, no other example is needed: the machine, which seems a wholly aristocratic force by the centralization of capital that it implies, is nevertheless, by the cheapness and the vulgarization of its products, a very powerful agent of democratic progress. It places within reach of the poorest a host

of useful objects, and even of luxury goods and artifacts, to which they never before had access. Wool, thank God, has come down to the people, and warms it. Silk begins to adorn it. But the great and capital revolution has been calico. The combined efforts of science and art were needed to force a rebellious, uncomfortable fabric, cotton, to undergo every day so many brilliant transformations; then, thus transformed, to spread it everywhere, to place it within grasp of the poorest purse. Once upon a time, every woman wore a single blue or black gown that she kept ten years without washing, for fear that it would fall to shreds. Today, her husband, poor working man, for one day's wages, covers her with a garment of flowers. All this multitude of women that turns our street into a dazzling manycolored rainbow, was once in mourning.

These changes that one considers futile have an immense bearing. Here are no mere material improvements. This is a progress of the people in externals and appearance, upon which men judge each other; it is, so to speak, *visible equality*. From this, the people rises to new ideas which otherwise it would not reach; fashion and taste are for it an initiation to art. Add, more momentous still, that dress impresses even the wearer; he wants to be worthy of it, and seeks to live up to it by his moral bearing.

VII. Liberalism, Nationalism, and 1848

Of the many political developments that sprang from the travail of the French Revolution, the most important were the ideas of popular sovereignty and national self-determination. After the French had sown these ideas and reaped the whirlwind in their own defeat, attempts were made to restore regimes based on different values, with no constitutional way to express the people's will, and sometimes, as in Italy, involving alien occupation of lands which wanted to determine their own future. But such regimes were given no peace by constitutionalist or nationalist liberals, and sooner or later they all either came to grief or learned to adapt themselves to the temper of the times.

1. JOSEPH MAZZINI

Joseph Mazzini (1805–1872), the anticlerical son of a Genoese doctor, was a typical liberal nationalist of the mid-nineteenth century. A prophet of the *Risorgimento*, an admirer of Dante rather than of Machiavelli, he spent his life preaching the doctrine of the Italian republic, one and indivisible. What he wanted was a regenerated republic, linked in perpetual and pacific bonds with free republics all over the world, and this may have been a chimerical dream. It certainly appeared so when the short-lived Roman Republic of 1848, which he had been elected to head, was crushed—of all things—by French troops (June 30, 1849). Thereafter he spent most of his life in exile, propagandizing the Italian masses and plotting the overthrow of Austrian rule in Italy. In spite of his apparent personal failure, the moral fervor of the Italian national movement was largely due to him and to his passionate preaching.

Mazzini's Conversion to Nationalism

One Sunday in April 1821, while I was yet a boy, I was walking in the Strada Nuova of Genoa with my mother, and an old friend of our family named Andrea Gambini. The Piedmontese insurrection had just been crushed; partly by Austria, partly through treachery, and partly through the weakness of its leaders.

The revolutionists, seeking safety by sea, had flocked to Genoa, and, finding

themselves distressed for means, they went about seeking help to enable them to cross into Spain, where the revolution was yet triumphant. The greater number of them were crowded in S. Pier d'Arena, waiting a chance to embark; but not a few had contrived to enter the city one by one, and I used to search them out from amongst our own people, detecting them either by their general appearance,

by some peculiarity of dress, by their warlike air, or by the signs of a deep and silent sorrow on their faces.

The population were singularly moved. Some of the boldest had proposed to the leaders of the insurrection—Santarosa and Ansaldi, I think—to concentrate themselves in, and take possession of the city, and organize a new resistance; but Genoa was found to be deprived of all means of successful defense; the fortresses were without artillery, and the leaders rejected the proposition, telling them to preserve themselves for a better fate.

Presently we were stopped and addressed by a tall black-bearded man, with a severe and energetic countenance, and a fiery glance that I have never since forgotten. He held out a white handkerchief towards us, merely saying, for the refugees of Italy. My mother and friend dropped some money into the handkerchief, and he turned from us to put the same request to others. I afterwards learned his name. He was one Rini, a captain in the National Guard, which had been instituted at the commencement of the movement. He accompanied those for whom he had thus constituted himself collector, and, I believe, died-as so many of ours have perished—for the cause of liberty in Spain.

That day was the first in which a confused idea presented itself to my mind—
I will not say of country, or of liberty—
but an idea that we Italians could and therefore ought to struggle for the liberty of our country. I had already been unconsciously educated in the worship of equality by the democratic principles of my parents, whose bearing toward high or low was ever the same. Whatever the position of the individual, they simply regarded the man and sought only the honest man. And my own natural aspirations towards

liberty were fostered by constantly hearing my father and the friend already mentioned speak of the recent republican era in France; by the study of the works of Livy and Tacitus, which my Latin master had given me to translate; and by certain old French newspapers, which I discovered half-hidden behind my father's medical books. Amongst these last were some numbers of the *Chronique du Mois*, a Girondist publication belonging to the first period of the French Revolution.

But the idea of an existing wrong in my own country, against which it was a duty to struggle, and the thought that I too must bear my part in that struggle, flashed before my mind on that day for the first time, never again to leave me. The remembrance of those refugees, many of whom became my friends in after life, pursued me wherever I went by day, and mingled with my dreams by night. I would have given I know not what to follow them. I began collecting names and facts, and studied, as best I might, the records of that heroic struggle, seeking to fathom the causes of its failure.

They had been betrayed and abandoned by those who had sworn to concentrate every effort in the movement; the new king [Carlo Felice] had invoked the aid of Austria; part of the Piedmontese troops had even preceded the Austrians at Novara; and the leaders had allowed themselves to be overwhelmed at the first encounter, without making an effort to resist. All the details I succeeded in collecting led me to think that they might have conquered, if all of them had done their duty; then why not renew the attempt?

This idea ever took stronger possession of my soul, and my spirit was crushed by the impossibility I then felt of even conceiving by what means to reduce it to action. Upon the benches of the University (in those days there existed a course of Belles Lettres, preparatory to the courses of law and medicine, to which even the very young were admitted,) in the midst of the noisy tumultuous life of the students around me, I was sombre and absorbed, and appeared like one suddenly grown old. I childishly determined to

dress always in black, fancying myself in mourning for my country. Jacopo Ortis happened to fall into my hands at this time, and the reading of it became a passion with me. I learned it by heart. Matters went so far that my poor mother became terrified lest I should commit suicide.

On the Duties of Man

Your first duties-first as regards importance—are, as I have already told you, towards Humanity. You are men before you are either citizens or fathers. If you do not embrace the whole human family in your affection, if you do not bear witness to your belief in the Unity of that family, consequent upon the Unity of God, and in that fraternity among the peoples which is destined to reduce that unity to action; if, wheresoever a fellowcreature suffers, or the dignity of human nature is violated by falsehood or tyranny -you are not ready, if able, to aid the unhappy, and do not feel called upon to combat, if able, for the redemption of the betrayed or oppressed—you violate your law of life, you comprehend not that Religion which will be the guide and blessing of the future.

But, you tell me, you cannot attempt united action, distinct and divided as you are in language, customs, tendencies, and capacity. The individual is too insignificant, and Humanity too vast. The mariner of Brittany prays to God as he puts to sea: Help me, my God! my boat is so small and thy ocean so wide! And this prayer is the true expression of the condition of each one of you, until you find the means of infinitely multiplying your forces and powers of action.

This means was provided for you by God when he gave you a country; when, even as a wise overseer of labour distributes the various branches of employment according to the different capacities of the workmen, he divided Humanity into distinct groups or nuclei upon the face of the earth, thus creating the germ of Nationalities. Evil governments have disfigured the divine design. Nevertheless you may still trace it, distinctly marked out —at least as far as Europe is concerned —by the course of the great rivers, the direction of the higher mountains, and other geographical conditions. They have disfigured it by their conquests, their greed, and their jealousy even of the righteous power of others; disfigured it so far that, if we except England and France—there is not perhaps a single country whose present boundaries correspond to that design.

These governments did not, and do not, recognize any country save their own families or dynasty, the egotism of caste. But the Divine design will infallibly be realized. Natural divisions, and the spontaneous, innate tendencies of the peoples, will take the place of the arbitrary divisions sanctioned by evil governments. The map of Europe will be redrawn. The countries of the Peoples, defined by the

From Emilie A. Venturi, Joseph Mazzini: A Memoir (London, 1875).

vote of free men, will arise upon the ruins of the countries of kings and privileged castes, and between these countries harmony and fraternity will exist. And the common work of Humanity, of general amelioration and the gradual discovery and application of its Law of life, being distributed according to local and general capacities, will be wrought out in peaceful and progressive development and advance. Then may each one of you, fortified by the power and the affection of many millions, all speaking the same language, gifted with the same tendencies, and educated by the same historical tradition, hope, even by your own single effort. to be able to benefit all Humanity.

O my brothers, love your Country! Our country is our Home, the house that God has given us, placing therein a numerous family that loves us, and whom we love; a family with whom we sympathise more readily, and whom we understand more quickly than we do others; and which, from its being centred around a given spot, and from the homogeneous nature of its elements, is adapted to a special branch of activity. Our country is our common workshop, whence the products of our activity are sent forth for the benefit of the whole world: wherein the tools and implements of labour we can most usefully employ are gathered together: nor may we reject them without disobeying the plan of the Almighty, and diminishing our own strength.

In labouring for our own country on the right principle, we labour for Humanity. Our country is the fulcrum of the lever we have to wield for the common good. If we abandon that fulcrum, we run the risk of rendering ourselves useless not only to humanity but to our country itself. Before men can associate with the nations of which humanity is composed, they must have a National existence. There is no true association except among equals. It is only through our country that we can have a recognized collective existence.

Humanity is a vast army advancing to the conquest of lands unknown, against enemies both powerful and astute. The peoples are the different corps, the divisions of that army. Each of them has its post assigned to it, and its special operation to execute; and the common victory depends upon the exactitude with which those distinct operations shall be fulfilled. Disturb not the order of battle. Forsake not the banner given you by God. Wheresoever you may be, in the centre of whatsoever people circumstances may have placed you, be ever ready to combat for the liberty of that people should it be necessary, but combat in such wise that the blood you shed may reflect glory, not on yourselves alone, but on your country. Say not I, but we. Let each man among you strive to incarnate his country in himself. Let each man among you regard himself as a guarantee, responsible for his fellow-countrymen, and learn so to govern his actions as to cause his country to be loved and respected through him. Your country is the sign of the mission God has given you to fulfill towards Humanity. The faculties and forces of all her sons should be associated in the accomplishment of that mission. The true country is a community of free men and equals, bound together in fraternal concord to labour towards a common aim. You are bound to make it and to maintain it such. The country is not an aggregation, but an association. There is therefore no true country without an uniform right. There is no true country where the

uniformity of that right is violated by the existence of castes, privilege, and inequality. Where the activity of a portion of the powers and faculties of the individual is either cancelled or dormant; where there is not a common Principle, recognized, accepted, and developed by all, there is no true nation, no People; but only a multitude, a fortuitous agglomeration of men whom circumstances have called together. and whom circumstances may again divide. In the name of the love you bear your country you must peacefully but untiringly combat the existence of privilege and inequality in the land that gave you life.

There is but one sole legitimate privilege, the privilege of Genius when it reveals itself united with virtue. But this is a privilege given by God, and when you acknowledge it and follow its inspiration, you do so freely, exercising your own reason and your own choice. Every privilege which demands submission from you in virtue of power, inheritance, or any other right than the Right common to all, is a usurpation and a tyranny which you are bound to resist and destroy.

Be your country your Temple. God at the summit; a people of equals at the base.

Accept no other formula, no other moral law, if you would not dishonour alike your country and yourselves. Let all secondary laws be but the gradual regulation of your existence by the progressive application of this supreme law. And in order that they may be such, it is necessary that all of you should aid in framing them. Laws framed only by a single fraction of the citizens, can never, in the very nature of things, be other than the mere expression of the thoughts, aspirations, and desires of that fraction; the representation, not of the Country, but of a

third or fourth part, of a class or zone of the country.

The laws should be the expression of the universal aspiration, and promote the universal good. They should be a pulsation of the heart of the nation. The entire nation should, either directly or indirectly, legislate.

By yielding up this mission into the hands of a few, you substitute the egotism of one class for the Country, which is the union of all classes.

Country is not a mere zone or territory. The true country is the Idea to which it gives birth; it is the Thought of love, the sense of communion which unites in one all the sons of that territory.

So long as a single one amongst your brothers has no vote to represent him in the development of the national life, so long as there is one left to vegetate in ignorance where others are educated, so long as a single man, able and willing to work, languishes in poverty through want of work to do, you have no country in the sense in which country ought to exist—the country of all and for all.

Education, labour, and the franchise, are the three main pillars of the nation. Rest not until you have built them strongly up with your own labour and exertions.

Never deny your sister nations. Be it yours to evolve the life of your country in loveliness and strength; free from all servile fears or sceptical doubts; maintaining as its basis the People; as its guide the consequences of the principles of its Religious Faith, logically and energetically applied; its strength, the united strength of all; its aim, the fulfilment of the mission given to it by God.

And so long as you are ready to die for Humanity, the life of your country will be immortal.

2. 1848

The eighteenth century had demonstrated that the status quo could be changed by force, and the nineteenth century proceeded to apply this lesson at every opportunity. But every revolution, though it might be successful in solving some of the problems that had caused it, also revealed new ones. And, especially in 1848, political and social claims which had been telescoped early in the year came to clash when those satisfied with purely political reforms were challenged by others who wanted more—work, food, and a redistribution of property. The two accounts of the French revolutions of 1848 which follow are by one of the leaders of the Left, Louis Blanc, and by the foremost liberal thinker of the time, Alexis de Tocqueville.

Louis Blanc

Louis Blanc (1811–1882) was one of the leading writers of the French Left under the July Monarchy of Louis Philippe. His popularity led to his designation as a member of the temporary government set up in February 1848 after the fall of the king. There, Louis Blanc persuaded his colleagues to abolish the death penalty and to found National Workshops which, he hoped, would help solve the problems of unemployed and hungry labor. Soon, however, his activities hindered by official suspicion, his safety endangered by the counter-revolution in May, the radical leader had to seek refuge in England whence he returned only after Napoleon III's fall in 1870. He was then immediately elected deputy of Paris to the new National Assembly. His account of the events of 1848 was written during his English years of exile.

From: Historical Revelations

HOW THE PROVISIONAL GOVERNMENT WAS ESTABLISHED

Louis Philippe was a prince gifted with many good qualities. His domestic virtues were such as to command respect. He was by no means wanting in enlightened perceptions. Both from a disposition naturally merciful, and from a philosophical notion of the value of human life, he was so averse to shedding blood, that his ministers were sure to meet with an almost desperate resistance on his part, whenever they asked him to affix his signature to a sentence of death. Upon the whole, he was a man of remarkably sober character. Nor did Liberty, under his

From Louis Blane, 1848. (London, 1858).

reign, receive any mortal wound. In times of foreign and internal difficulties, he succeeded in warding off imminent dangers, and the middle classes were indebted to him for the repose they so dearly prized.

Still, when the hour of his doom struck, no wish was expressed for his crown's preservation; no helping hand was held out to him; the moneyed classes kept aloof; the soldiers either refused to fight or fought reluctantly; for the first time, the shopkeepers seemed to have forgotten that revolutions are bad for trade; the most active part of the National Guard actually countenanced the insurrection; the old King, looking around him, and seeing nothing but a dreary solitude, be-

came disheartened, and a government which had lasted no less than seventeen years was overthrown by a touch.

How is such a phenomenon to be accounted for? In my "History of Ten Years," the reader will find the causes explained and the result foretold. Of these causes, the most effective lay in Louis Philippe's utter inability to comprehend all that was chivalrous and elevated in the genius of France. To the meaner principles of action he applied for support. Bribery was his principal engine of government. He fostered the blind fears of the bourgeoisie, and took pleasure in nursing selfishness. His policy was systematically inimical to anything like a generous hope or a noble impulse. Not only did he struggle against all efforts originating in the spirit of improvement, but it was his constant endeavour to make the nation. if possible, after his own image; that is, greedy of gain, true only to the debasing worship of the cash-box, heedless of the past, and faithless in the future. Even what happened to be good in his policy was done through objectionable means, and everyone knows that it was only by wounding beyond measure in the heart of the French the feeling of national selfimportance, that he succeeded in averting the calamities of war. So completely had he stifled around him all promptings of devotedness and disinterested attachment, that these supreme resources proved wanting when needed; so that he may verily be said to have been the sole artificer of his own ruin.

The fact is, that, two months before the downfall of Louis Philippe, it had become quite certain that the Democratic party was about to appear, in its turn, on the public stage, and to take possession of it exclusively.

This was made obvious by the "ban-

quet de Dijon," whose news spread all over France with the rapidity of lightning. There, in an immense hall, decorated with flags and devices symbolic of liberty, in the presence of thirteen hundred guests —operatives, manufacturers, tradesmen, magistrates—words reverberated; which M. de Lamartine, seized with short-sighted terror, termed the "tocsin of opinion." At Lille, M. Ledru Rollin had previously said:

"Sometimes, the stagnant pools of the dried-up Nile, and the detritus in a state of decomposition on its banks, engender epidemics; but let the flood return, the river, in its impetuous course, will sweep away all these impurities, and will deposit on its borders germs of fecundity and reawakened life."

These audacious allusions were repeated by MM. Ledru Rollin and Flocon at the "banquet de Dijon" without exciting surprise, so thoroughly was the idea of an impending revolution present to every mind. And, for the same reason, no one took exception to this passage of my speech—prophecy and menace:

"The power which but yesterday seemed so vigorous, sinks under its own weight, without even being pushed. An invisible will goes on its way through the highest regions of society, sowing degrading catastrophes. Unexpected acts of insanity, shameful disasters, unaccountable suicides, crimes to make the hair stand on end, come, one after another, stunning public opinion into stupor. Then, that Society, apparently so prosperous, becomes agitated: it wonders at the mysterious virus which it feels running through its veins. 'Corruption' is the cry of the day; and everyone exclaims: 'That such things should last any longer, is impossible; what will tomorrow bring?' Gentlemen, when the fruit is rotten, it only needs a breath of wind to shake it from the tree."

This was said towards the end of December; and at the end of February, hardly two months after, the blast had come which blew down the monarchy.

The circumstances connected with the downfall of Louis Philippe being generally known, I will enter at once upon my subject by explaining how the Provisional Government was established.

At that period, the Republican party, numerically inferior in the provinces, was prevalent in Paris. Its accredited organs were the *National* and the *Reforme*; the latter paper being more acceptable to the workmen, on account of its social tendencies, whilst the other, merely political, had a stronger hold on the middle classes. . . .

The situation was one of extraordinary enthusiasm mingled with dangerous excitement. The passions let loose by the struggle were still burning. The aspect of Paris was terrible. Here and there infuriated groups were seen emerging from behind the barricades boastful of the blood which stained their dress, flourishing muskets, swords, hatchets, or pikes, and shouting fiercely: "A bas les Bourbons!" The palace of the Tuileries had just been invaded, amidst an unparalleled tempest formed by the threatening clamours of the combatants, the uproar of the rushing multitudes, the beating of drums, the shots incessantly fired, the fits of laughing and the loud jests in which, on any such occasion, the gamins de Paris are wont to indulge. As to the particulars which marked the invasion of the royal abode, I know nothing more than what any one could, at the time, pick up from flying reports. But it is a matter of public notoriety that some sat down at card-tables

and began in joke to bet the millions of the Civil list; that many a jolly fellow delighted in putting on the rich velvet dressing gowns which had been worn by princely personages; that two insurgents whose firelocks lay beside them on the ground, were noticed playing at chess with a fixed look and uninterrupted attention, despite the deafening turmoil. "Marquis," asked a facetious companion of a youth who held in his hands a plan of Neuilly, "What are you about?" "Viscount," replied the lad, "I am examining the plan of my estates." By superficial minds, these apparently trifling incidents may be deemed to have no other import than to show the levity so complacently ascribed to the French. But those who do not judge of the inside by the outside will easily perceive through all this the deeprooted love of equality which is the true characteristic of the French nation.

Under such circumstances, M. Martin (of Strasbourg) and I concurred in thinking that this was not the proper time for handling the abstruse questions which the Revolution was likely to start. The main point was to insure the triumph of the Republic by baffling the intrigues of petty parliamentary coteries on one hand, and by preventing, on the other, the wild confusion into which the general rush towards the unknown could not fail to plunge everything, in the absence of all regular direction. Two great evils were to be averted: despotism and anarchy, for anarchy is nothing better than a tumultuous despotism. An immediate selection of united leaders was therefore required; and although the republicanism of M. de Lamartine, a new convert, seemed somewhat unsteady; although rumours had already become current about the support which M. Garnier Pagès might possibly be disposed to give to the Regency of the

Duchess of Orleans, the influence of such men over the middle classes certainly deserved to be taken into serious consideration. Subsequent events have shown, indeed, that alliances of this kind are fraught with impediments and perils. But it must be borne in mind that the republican party, however strong in Paris, was far from being able to get the mastery in the provinces. The middle classes contained a considerable number of republicans, sincere though timid, whom it was impolitic to frighten out of our ranks. Moreover, the situation was dreadfully unsettled, and the morrow overcast with clouds. To bring a man like M. de Lamartine to commit himself irrevocably in the service of the Republic was considered a stroke of sound policy, and even now, I do not think the step we took would have proved a fatal one, had it not been made so by an astounding concurrence of unfavourable circumstances. which it was then impossible for any one to foresee.

So, it was determined that M. de Lamartine should rank with the republican leaders.

The exertions of M. Martin (of Strasbourg) and my own having been attended with full success, the two leading papers of the republican party came to an understanding, the result of which was the adoption in common of a list to be presented to the people.

It is singular—and this is one of the most peculiar features of the Parisians—how an intuitive perception of the necessity of order combines in their character with occasional outbursts of turbulence. One may think it wonderful, still, it is perfectly true, that Paris never witnessed a rising in which the insurgents did not preserve, all through, a sense of discipline, and an almost uneasy preoccupa-

tion of the immediate consequences. In June, for instance, in those formidable days of June, the fact was ascertained that the insurgents, while fighting desperately, were busy writing down, on the very stones of the barricades stained with their blood, the names of a Provisional Government.

So, on the 24th of February, scarcely was the fight at an end, when the people flocked from every quarter to the offices of both Republican papers, in quest of a central direction.

An immense crowd surrounded the office of the Reforme, the smallest part of which was pent up to suffocation in the court of the Hotel Buillon, while the rest overflowed the neighbouring streets, and more especially the street of Iean Jacques Rousseau. A sort of considerate anxiety was visible in everyone's countenance. The only shout sent forth was "Vive la Republique!"-a shout which grew tremendous, but gradually dwindled into solemn silence, when I made my appearance at a window, holding a paper in my hand. Then it was that I read the following list, which had been agreed to by the Reforme and the National:

Dupont (de L'Eure)
François Arago
Ledru Rollin
Flocon
Marie
Armand Marrast
Crémieux
Garnier Pagès
Lamartine
Louis Blanc

The utterance of these names was hailed with loud acclamations, quickly succeeded by a general cry: Albert! Albert!

Albert had never been considered as a

political leader. Still less had he ever entertained any hope or desire of being chosen as such. He was a mechanic. Amongst us, he was but little known personally. For my part, I had never seen him. But his uprightness, both of heart and mind, his unbounded devotion to the cause of the people, the disinterested fervour of his convictions, his unassuming manners, his courage, had endeared him to the workmen. To them the presence of a man of that stamp in the Provisional Government was a token that no measure would be taken without being anxiously scrutinised, and, if prejudicial to their interests, strenuously opposed. Moreover, what could be better calculated to mark the commencement of a new era-what could inaugurate in a more striking way the official acknowledgment of the rights of labour, than this previously unheard of rising of a workman to a post of the highest eminence? I took up a pen; I wrote down the name of Albert with a feeling of deep emotion, and, hastening to the office of the National, I had there no difficulty in getting the name added to the list, which was immediately circulated all over Paris, and happened, as regards the other names, to agree with those which emanated from every other popular centre of action, save that on some the name of M. Recurt, afterwards Minister of the Interior, and very popular then in the Faubourg St. Antoine, figured in the place of the names of Crémieux or Garnier Pagès.

THE INTELLECTUAL EFFERVESCENCE OF THE TIME

Home policy, foreign policy, taxation, emancipation of working men, the improvement of the condition of poor wom-

en, gratuitous national education, the union of peoples,-what questions were there not raised and discussed in these ardent laboratories of public opinion? [the clubs] Oh, how swift was the march of life then! How each man's heart beat quicker! and what swift wings the imagination lent to the mind's conceptions! So intense was the life of society, moved to its very depths, that in a few days the number of the clubs rose to 300; and though immense halls had been placed at the disposal of these popular meetings in various public buildings, yet, from these halls, crammed every night to suffocation, intellectual excitement overflowed into the streets, spread from man to man, and finally, penetrating into those miserable haunts, where the most noble faculties of man had been hitherto asleep, awakened a powerful and impassioned curiosity.

Add to this, the incessant action of a crowd of new journals, to which the abolition of the stamp-duty had largely contributed; and the combative character of literature, as represented by such writers as MM. Victor Hugo, Eugène Sue, Félix Pyat, and Madame George Sand.

I need hardly say, that in the midst of this vast mixture of aspirations and feelings, all of which were permitted, without exception, to express and justify themselves, the Provisional Government praised by some, was the object of vehement and repeated attacks from others; if allowance was made for the difficulty of its task in the club of Barbès, it was criticized with ever-increasing severity in the club of Blanqui. If the majority of the council was supported by the National, whose views had undergone no change, and if the minority found an advocate in the Reforme, edited by M. Ribeyrolles in the most brilliant manner, how many were

the journals that indiscriminately attacked, and even flung their invectives at the whole Provisional Government? Not one of our acts escaped the bitterest scrutiny from M. Émile de Girardin, chief editor of the Presse. Not a single thing we did which was not cited by M. Proudhon, editor of the Représentant du Peuple, as a proof that all governments, be they what they might, ought to be suppressed, and that the only thing which should be left standing was anarchy, or to use the orthography of Proudhon, an-archy. M. de Lamennais, too, who a little later, came over to Socialism, opposed it at that time, from not having sufficiently studied it. and his journal, Le Peuple Constituant, waged active war against the Luxembourg.

Thus lashed by every wave of this agitated and roaring sea, what course did the Provisional Government take? Were they to be seen, doing what Louis Bonaparte and his supporters do at this very hourinterdicting discussion, reducing their adversaries to silence, trembling at the least appearance of criticism, growing pale before the mere shadow of an allusion, seeking their safety and force in darkness? No. The Provisional Government were so convinced of their moral strength, so bold from the consciousness of their good intentions, and so confiding in the spontaneous support of a free people, that far from fearing the light—a fear that should be left to malefactors—they spread their special protection over the liberty of their most violent enemies. The printing-house of M. Émile de Girardin having been menaced by a crowd of people exasperated at the excess to which he carried his systematic attacks upon the official agents of the Republic, M. Caussidière at once despatched his Montagnards to keep the crowd in order, and M. Ledru Rollin went

himself to assist personally in preserving unscathed that liberty which M. de Girardin was so remorselessly using at our expense. A farce like this took place at the Luxembourg. Some delegates having come and told me that the people were irritated at our persistence in suffering the Constitutionnel to pour its venom every morning on the Luxembourg, and that a great number of workmen were assembled at that very moment in the court, intending to go and bring it to account for its calumnies, I instantly went out to them, and turned them from their purpose by words whose extreme vehemence disarmed them.

There survives, moreover, an official and decisive testimony to the confidence of the Provisional Government in the sympathies of the nation. I allude to the Proclamation they published on the 20th of April, concerning the Clubs. It begins with these words: "The Republic lives by discussion and liberty," and finishes thus: "The best safe-guard of liberty, is liberty."

Let the people of England compare the principles so openly professed by the Provisional Government, with those that are now directing the policy of Louis Bonaparte, and then let them say, if, for Great Britain, an alliance with the Republic would not have been more natural, more reasonable, more certain, than an alliance with the Empire?

After all, the license given to the Clubs and to the newspapers had, together with some of the drawbacks inseparable from all human things, advantages which will not be lost to the future. The question under discussion alarmed and irritated egotists of every kind, all who live by abuses; factitious agitation was encouraged; the tendency to innovation sometimes manifested itself under ridiculous forms; there was much declamation; and

the allurements offered to public curiosity were not always wholesome or substantial. But problems of a high interest were proposed, and their solution matured; the attention of the people was keenly aroused on points on which the light of knowledge was cast for the first time: true working ideas sprang up amongst others that were vain and chimerical; in a word, the soil was ploughed in all directions, and seed was thrown into it, which nothing hereafter can destroy, which even at this moment is germinating silently, and which, when the winter shall have passed away, that is, on the morrow of the day when despotism shall have vanished, will vield a harvest whose rich abundance will be the astonishment of Europe.

THE JUNE DAYS

Out of doors, the people continued to cry: Du Pain ou du Plomb!—bread or lead.

But as if to stifle those words of woe, it was not enough to load guns with grape, to set infantry and cavalry in movement, to reinforce the National Guard with troops of the line, and the republican guard with the Garde Mobile,-the aid of calumny was called to their support. In a circular addressed to the municipalities of the twelve arrondissements, M. Marrast dared to represent this insurgent army of hunger as a horde of brigands in foreign pay. He dared to write these words, speaking of the chiefs of the insurrection: "It is not only civil war that they would light up among us, it is PIL-LAGE that they prepare."

No doubt the parties that wore the legitimist and imperial liveries had, crowded into their ranks, men ready to instigate disorder in the hope of abetting the

triumph of their conspiracies; and these men were in effect the active agents of disorder. But to confound the instigations of conspirators like these, who scarcely dared to show their faces or their objects, with the true cause which was then arming thousands of fellowmen; to pretend that the barricades were being reared against the Republic, and that PILLAGE was the object of men driven to despair, and hurrying to death, -a more audacious calumny, I say, was never published. Yet it had the success of audacious calumny. Sincere Republicans believed that the Republic was in peril: false Republicans affected to believe that it was attacked: there was an immense uncertainty, and an immense confusion. The insurgents continued crying, as they marched to the combat, DU PAIN OU DU PLOMB!

Whether the insurrection might not have been prevented from the firstwhether barricades need have been quietly left to boys to construct—whether, in short, General Cavaignac, by letting the insurrection pass, reserved to himself the sinister honour of suppressing it,—these are questions for History to solve. For the present, I will only state this fact, that, at four o'clock in the afternoon, on the 23rd of June, in the Faubourg St. Marceau, although it was in full insurrection, the circulation was still free, and that it would have been perfectly easy for either the civil or the military authorities to ascertain that many of the barricades were guarded by men incompletely armed, and utterly without ammunition of any kind. I have ample evidence in my possession to produce, when the proper time arrives for doing justice to all.

It is worthy of remark that this insurrection, so general in its causes and in its spirit, assumed at almost every point the character of a local protest. In many districts, the inhabitants reserved to themselves exclusively the guard of their own barricades, rejected the assistance of strangers, and after closing all access to their streets, refused to cooperate in the general attack. After the capture of the Eighth and Ninth Mairies, for instance, when preparations were making for storming the Hôtel de Ville—a very strong position, strongly defended—scarcely a few hundred combatants could be got together at the bottom of the Rue St. Antoine.

Reinforcements were demanded from the Faubourgs, where the barricades could easily have spared numbers of men, but in vain. Not but that among the combatants there were many who knew well that an insurrection which stands still. or does not go forward, is lost; but that there was a total want of unity of direction, and many of the insurgents were paralyzed by the sense of their inferiority in the use of their weapons. Fifty thousand men had taken up arms: how many in that number were utterly unable to use them! Some, who might have vigorously defended a barricade, were more than inefficient for any other purpose. And whilst in the rich quarters of the town there were thousands of isolated combatants, who were on the look out for a loop-hole to pass over to the insurgents, there was probably a reserve of twenty thousand men in the Faubourgs, whose strength might have changed the fate of the battle.

Another cause of the unwillingness of the combatants to venture far beyond their barricades was the want of ammunition. The gunpowder was manufactured by the insurgents, and from this fact we may determine their chances of success against regular troops, amply furnished with all the resources of war. Yet, in spite of the inadequacy of the ammunition for offensive warfare, of the want of chiefs to concentrate their movements, of means to prolong the combat, the indomitable energy of the insurgents was astounding. The regular troops and National Guards fought well, as Frenchmen always fight; but those who were least liable to suspicion of sympathy with the insurgents, confessed that their prodigious resolution and audacity would have sufficed, under an able general, for the conquest of the world!

Besides, thanks to M. Marie, the Atéliers Nationaux had received a military organization, and had been divided into brigades, squadrons, and companies, comprising the men of the same arrondissement, of the same quarter, of the same street; and, in a war of barricades, in which every man resolved to fight and die at his own door, for the bread of his own household, such an organization lent a certain ensemble to the resistance, although the resistance was a local one.

The movement had continued to spread from point to point, until all Paris was in arms. It was not until Friday evening that the Société des Droits de l'Homme was enabled to hold a meeting; and the communications were already interrupted in so many places, that it was impossible to give the sections anything like uniformity of operation. Having at their head men of ardour and decision. the sectionaries of the eighth arrondissement took an active part in the attack of the Place des Vosges. In the offices of the Socialist journals, a poignant uncertainty prevailed amidst the contradictory rumours arriving every moment from the scene of conflict. A list of names for a new Government came from a barricade in the Faubourg St. Marceau, containing the name of M. de Lamartine, together with other names then more dear to the people.

Overwhelming as the forces of the Government appeared, the end was still doubtful. At some points, the desperation of the insurgents was incredibly triumphant. In the Faubourg du Temple, where General Cavaignac had reconnoitred the fortresses, the fight assumed gigantic proportions. At the attack of the barricade Saint Maure, the troops suffered terrible loss, and were repulsed. When the darkness of night enveloped the streets, the insurgents were completely masters of that portion of the city.

Terrible was that night—a night of expectation and grief! On the following morning, the heavy guns began to thunder once more against the Faubourg, without gaining the least advantage over the insurgents, while the troops advanced, retreated, and advanced again, with alternate wrath and discouragement. Until Sunday evening, the blood of countrymen and fellow-citizens was flowing in disastrous rivalry. What was most lamentable of all, was the inexorable fury of the fight between the working-men and the Garde Mobile-between fathers on one side, and sons on the other! Everybody knows now, that when insurrection began, the Garde Mobile was more disposed to join than to attack the insurgents. But it had been so pertinaciously asserted that the insurrection was against the Republic. that one more terrible misunderstanding was added to the history of civil conflicts. . . .

That night passed without any fresh attack by the troops; it was not until the following (Monday) morning, about eight or nine o'clock, that the Faubourg was completely invested. The insurgents beat a retreat, but did not cease to fire until they had expended their last cart-

ridge. At five o'clock in the evening, La Villette was taken: that was the end of the bloody tragedy.

An eye-witness assured me that after that final struggle, a National Guard shot a man for the simple reason that he wore a red comforter round his throat.

I had myself a narrow escape from some of the party of order. Going home when the insurrection had just been put down, in company with several of my colleagues, I was set upon by a number of National Guards crying out: "Here is the contriver of the national workshops. Down with him!" Not satisfied with threatening to kill me, one of them clapped his pistol to my temple; but the weapon, being fortunately struck up by one of my companions, went off in the air. Others rushed upon me with their sabres; and I should have been killed in this cowardly way, had not my fellowrepresentatives on the spot, and some respectable National Guards come to my defense, and succeeded, after a desperate struggle, in rescuing me from my murderous assailants, by forcing me into the Café Frascati, which I soon after left under the protection of two worthy citizens, M. Bouillon, the lieutenant-colonel of the second legion, and one of my colleagues, M. Dutier. The latter gentleman's tilbury was waiting for him on the boulevard; he put me into it, and we drove to the Assembly. Two shots were fired at me, from behind!

After the victory the reprisals were terrible. Prisoners huddled together in the vaults beneath the terrace, in the garden of the Tuileries, which faces the Seine, were shot at random through the air-holes in the wall: others were shot in masses in the Plaine de Grenelle, in the cemetery of Mont Parnasse, in the quarries of Montmartre, in the cloister of Saint Be-

noît, in the court of the Hôtel de Cluny. Wretched men, whom General Cavaignac in his proclamation of the 23rd of June had addressed in these words—"Come to us, the Republic opens her arms to you"—were dragged before Councils of War to be judged by the men they had fought: and the vanquished, whom General Cavaignac had promised not to treat as victims, were despatched en masse, without trial. In short, a horrible and humiliating terror spread over the devastated city for many days. A single episode will complete the picture.

On the 3rd of July a considerable number of prisoners were taken out of the cellars of the École Militaire to be re-

moved to the Prefecture of Police, and thence to the forts. They were bound four and four with cords very tightly drawn. As these poor wretches, exhausted by hunger, could hardly drag their limbs along, porringers filled with coarse soup were placed before them. Having their hands tied, they were obliged to lie down on their stomachs, and to drag themselves to the porringers like animals, amidst shouts of laughter from the officers of the escort, who called it "Socialism in practice."-I heard this from one of the unfortunate victims of this punishment, which no Indian savage could ever have invented.

Alexis de Tocqueville

Alexis de Tocqueville (1805–1859), trained as a lawyer and magistrate, made his name when, in 1835, he published his famous essay on *Democracy in America*. The admired friend of men like J. S. Mill, Tocqueville was elected to the Chamber of Deputies in 1839 and to the French Academy in 1841, and came to be regarded as an outstanding man, liberal but detached. Opposing the extremism both of Left and Right, Tocqueville, who had briefly served as Foreign Minister of the Second Republic (1849), retired from public life after Louis Napoleon's *coup* of 1851 and spent his remaining years in writing history and compiling his own *Recollections*, from which the following passages are taken.

From: Recollections

And so the Monarchy of July was fallen, fallen without a struggle, and before rather than beneath the blows of the victors, who were as astonished at their triumph as were the vanquished at their defeat, I have often, since the Revolution of February, heard Mr. Guizot and even M. Molé and M. Thiers declare that this event should only be attributed to a surprise and regarded as a mere accident, a bold and lucky stroke and nothing more. I have always felt tempted to answer them

in the words which Molière's Misanthrope used to Oronte: "To judge as you do, you have your own reasons"; for these three men had conducted the affairs of France, under the guidance of King Louis-Philippe, during eighteen years, and it was difficult for them to admit that it was the King's bad government which had prepared the catastrophe which hurled him from the Throne.

As for me, I have not the same motives for forming an opinion, and I could hard-

From Alexis de Tocqueville, Recollections, tr. Alexander Teixeira de Mattos (New York, 1896).

ly persuade myself to be of theirs. I am not prepared to say that accidents played no part in the Revolution of February; on the contrary, they played a great one; but they were not the only thing.

I have come across men of letters, who have written history without taking part in public affairs, and politicians, who have only concerned themselves with producing events without thinking of describing them. I have observed that the first are always inclined to find general causes, whereas the others, living in the midst of disconnected daily facts, are prone to imagine that everything is attributable to particular incidents, and that the wires which they pull are the same that move the world. It is to be presumed that both are equally deceived.

For my part, I detest these absolute systems, which represent all the events of history as depending upon great first causes linked by the chain of fatality, and which, as it were, suppress men from the history of the human race. They seem narrow, to my mind, under their pretence of broadness, and false beneath their air of mathematical exactness. I believe (pace the writers who have invented these sublime theories in order to feed their vanity and facilitate their work) that many important historical facts can only be explained by accidental circumstances, and that many others remain totally inexplicable. Moreover, chance, or rather that tangle of secondary causes which we call chance, for want of the knowledge how to unravel it, plays a great part in all that happens on the world's stage; although I firmly believe that chance does nothing that has not been prepared beforehand. Antecedent facts, the nature of institutions, the cast of minds and the state of morals are the materials of which

are composed those impromptus which astonish and alarm us.

The Revolution of February, in common with all other great events of this class, sprang from general causes, impregnated, if I am permitted the expression, by accidents; and it would be as superficial a judgment to ascribe it necessarily to the former or exclusively to the latter.

The industrial revolution which, during the past thirty years, had turned Paris into the principal manufacturing city of France and attracted within its walls an entire new population of workmen (to whom the works of the fortifications had added another population of labourers at present deprived of work) tended more and more to inflame this multitude. Add to this the democratic disease of envy, which was silently permeating it; the economical and political theories which were beginning to make their way and which strove to prove that human misery was the work of laws and not of Providence, and that poverty could be suppressed by changing the conditions of society; the contempt into which the governing class. and especially the men who led it, had fallen, a contempt so general and so profound that it paralyzed the resistance even of those who were most interested in maintaining the power that was being overthrown; the centralization which reduced the whole revolutionary movement to the overmastering of Paris and the seizing of the machinery of government, and lastly, the mobility of all things, institutions, ideas, men and customs, in a fluctuating state of society which had, in less than sixty years, undergone the shock of seven great revolutions, without numbering a multitude of smaller, secondary upheavals. These were the general causes without which the Revolution of February would have been impossible. The principal accidents which led to it were the passions of the dynastic Opposition, which brought about a riot in proposing a reform; the suppression of this riot, first over-violent, and then abandoned; the sudden disappearance of the old Ministry, unexpectedly snapping the threads of power, which the new ministers, in their confusion, were unable either to seize upon or to reunite: the mistakes and disorder of mind of these ministers, so powerless to re-establish that which they had been strong enough to overthrow; the vacillation of the generals; the absence of the only Princes who possessed either personal energy or popularity; and above all, the senile imbecility of King Louis-Philippe, his weakness, which no one could have foreseen, and which still remains almost incredible. after the event has proved it.

I have sometimes asked myself what could have produced this sudden and unprecedented depression in the King's mind. Louis-Philippe had spent his life in the midst of revolutions, and certainly lacked neither experience, courage, nor readiness of mind, although these qualities all failed him so completely on that day. In my opinion, his weakness was due to his excessive surprise; he was overwhelmed with consternation before he had grasped the meaning of things. The Revolution of February was unforeseen by all, but by him more than any other; he had been prepared for it by no warning from the outside, for since many years his mind had withdrawn into that sort of haughty solitude into which in the end the intellect almost always settles down of princes who have long lived happily, and who, mistaking luck for genius, refuse to listen to anything, because they think there is nothing left for them to learn from anybody. Besides, Louis-Philippe had been deceived, as I have already said that his ministers were, by the misleading light cast by antecedent facts upon present times. One might draw a strange picture of all the errors which have thus been begotten, one by the other. without resembling each other. We see Charles I driven to tyranny and violence at the sight of the progress which the spirit of opposition had made in England during the gentle reign of his father; Louis XVI determined to suffer everything because Charles I had perished by refusing to endure anything; Charles X provoking the Revolution, because he had with his own eyes beheld the weakness of Louis XVI; and lastly, Louis-Philippe. who had more perspicacity than any of them, imagining that, in order to remain on the Throne, all he had to do was to observe the letter of the law while violating its spirit, and that, provided he himself kept within the bounds of the Charter, the nation would never exceed them. To warp the spirit of the Constitution without changing the letter; to set the vices of the country in opposition to each other; gently to drown revolutionary passion in the love of material enjoyment; such was the idea of his whole life. Little by little, it had become, not his leading, but his sole idea. He had wrapped himself in it, he had lived in it; and when he suddenly saw that it was a false idea, he became like a man who is awakened in the night by an earthquake, and who, feeling his house crumbling in the darkness, and the very ground seeming to vawn beneath his feet, remains distracted amid this unforeseen and universal ruin.

I am arguing very much at my ease today concerning the causes that brought about the events of the 24th of February [1848]; but on the afternoon of that day I had many other things in my head: I was thinking of the events themselves, and sought less for what had produced them than for what was to follow.

I returned slowly home. I explained in a few words to Madame de Tocqueville what I had seen, and sat down in a corner to think. I cannot remember ever feeling my soul so full of sadness. It was the second revolution I had seen accomplish itself, before my eyes, within seventeen years!

On the 30th of July 1830, at daybreak, I met the carriages of King Charles X on the outer boulevards of Versailles, with damaged escutcheons, proceeding at a foot pace, in Indian file, like a funeral, and I was unable to restrain my tears at the sight. This time my impressions were of another kind, but even keener. Both revolutions had afflicted me; but how much more bitter were the impressions caused by the last! I had until the end felt a remnant of hereditary affection for Charles X; but that King fell for having violated rights that were dear to me, and I had every hope that my country's freedom would be revived rather than extinguished by his fall. But now this freedom seemed dead; the Princes who were fleeing were nothing to me, but I felt that the cause I had at heart was lost.

I had spent the best days of my youth amid a society which seemed to increase in greatness and prosperity as it increased in liberty; I had conceived the idea of a balanced, regulated liberty, held in check by religion, custom and law; the attractions of this liberty had touched me; it had become the passion of my life; I felt that I could never be consoled for its loss, and that I must renounce all hope of its recovery.

I had gained too much experience of

mankind to be able to content myself with empty words; I knew that, if one great revolution is able to establish liberty in a country, a number of succeeding revolutions make all regular liberty impossible for very many years.

I could not yet know what would issue from this last revolution, but I was already convinced that it could give birth to nothing that would satisfy me; and I foresaw that, whatever might be the lot reserved for our prosperity, our own fate was to drag on our lives miserably amid alternate reactions of licence and oppression.

I began to pass in review the history of our last sixty years, and I smiled bitterly when I thought of the illusions formed at the conclusion of each period in this long revolution; the theories on which these illusions had been fed; the sapient dreams of our historians, and all the ingenious and deceptive systems by the aid of which it had been endeavoured to explain a present which was still incorrectly seen, and a future which was not seen at all.

The Constitutional Monarchy had succeeded the Ancient Regime; the Republic, the Monarchy; the Empire, the Republic; the Restoration, the Empire; and then came the Monarchy of July. After each of these successive changes it was said that the French Revolution, having accomplished what was presumptuously called its work, was finished; this had been said and it had been believed. Alas! I myself had hoped it under the Restoration, and again after the fall of the Government of the Restoration; and here is the French Revolution beginning over again, for it is still the same one. As we go on, its end seems farther off and shrouded in greater darkness. Shall we ever-as we are assured by other prophets, perhaps as delusive as their predecessors—shall we ever

attain a more complete and more farreaching social transformation than our fathers foresaw and desired, and than we ourselves are able to foresee; or are we not destined simply to end in a condition of intermittent anarchy, the well-known chronic and incurable complaint of old races? As for me, I am unable to say; I do not know when this long voyage will be ended; I am weary of seeing the shore in each successive mirage, and I often ask myself whether the *terra firma* we are seeking does really exist, and whether we are not doomed to rove upon the seas forever.

I spent the rest of the day with Ampère, who was my colleague at the Institute, and one of my best friends. He came to discover what had become of me in the affray, and to ask himself to dinner. I wished at first to relieve myself by making him share my vexation; but I soon perceived that his impression was not the same as mine, and that he looked differently upon the revolution which was in progress. Ampère was a man of intelligence and, better still, a man full of heart, gentle in manner, and reliable. His good nature caused him to be liked; and he was popular because of his versatile, witty, amusing, good-humoured conversation, in which he made many remarks that were at once entertaining and agreeable to hear but too shallow to remember. Unfortunately, he was inclined to carry the spirit of the salons into literature and the spirit of literature into politics. What I call literary spirit in politics consists in seeking for what is novel and ingenious rather than for what is true; in preferring the showy to the useful; in showing one's self very sensible to the playing and elocution of the actors, without regard to the results of the play; and lastly, in judging by impressions rather than reasons. I need not say that this eccentricity exists among others besides Academicians. To tell the truth, the whole nation is a little inclined that way, and the French Public very often takes a man-of-letters' view of politics. Ampère held the fallen Government in great contempt, and its last actions had irritated him greatly. Moreover, he had witnessed many instances of courage, disinterestedness, and even generosity among the insurgents; and he had been bitten by the popular excitement.

I saw that he not only did not enter into my view, but that he was disposed to take quite an opposite one. Seeing this, I was suddenly impelled to turn against Ampère all the feelings of indignation, grief and anger that had been accumulating in my heart since the morning; and I spoke to him with a violence of language which I have often since recalled with a certain shame, and which none but a friendship so sincere as his could have excused. I remember saying to him, *inter alia*:

"You understand nothing of what is happening; you are judging like a poet or a Paris cockney. You call this the triumph of liberty, when it is its final defeat. I tell you that the people which you so artlessly admire has just succeeded in proving that it is unfit and unworthy to live a life of freedom. Show me what experience has taught it! Where are the new virtues it has gained, the old vices it has laid aside? No, I tell you, it is always the same, as impatient, as thoughtless, as contemptuous of law and order, as easily led and as cowardly in the presence of danger as its fathers were before it. Time has altered it in no way, and has left it as frivolous in serious matters as it used to be in trifles."

After much vociferation we both ended by appealing to the future, that enlightened and upright judge who always, alas! arrives too late.

I come at last to the insurrection of June, the most extensive and the most singular that has occurred in our history, and perhaps in any other; the most extensive, because, during four days, more than a hundred thousand men were engaged in it; the most singular, because the insurgents fought without a war-cry, without leaders, without flags, and yet with a marvellous harmony and an amount of military experience that astonished the oldest officers.

What distinguished it also, among all the events of this kind which have succeeded one another in France for sixty years, is that it did not aim at changing the form of government, but at altering the order of society. It was not, strictly speaking, a political struggle, in the sense which until then we had given to the word, but a combat of class against class, a sort of Servile War. It represented the facts of the Revolution of February in the same manner as the theories of Socialism represented its ideas; or rather it issued naturally from these ideas, as a son does from his mother. We behold in it nothing more than a blind and rude. but powerful, effort on the part of the workmen to escape from the necessities of their condition, which had been depicted to them as one of unlawful oppression, and to open up by main force a road towards that imaginary comfort with which they had been deluded. It was this mixture of greed and false theory which first gave birth to the insurrection and then made it so formidable. These poor people had been told that the wealth of the rich was in some way the product of a theft practiced upon themselves. They had been assured that the

inequality of fortunes was as opposed to morality and the welfare of society as it was to nature. Prompted by their needs and their passions, many had believed this obscure and erroneous notion of right, which, mingled with brute force, imparted to the latter an energy, a tenacity and a power which it would never have possessed unaided.

It must also be observed that this formidable insurrection was not the enterprise of a certain number of conspirators, but the revolt of one whole section of the population against another. Women took part in it as well as men. While the latter fought, the former prepared and carried ammunition; and when at last the time had come to surrender, the women were the last to yield. These women went to battle with, as it were, a housewifely ardour: they looked to victory for the comfort of their husbands and the education of their children. They took pleasure in this war as they might have taken pleasure in a lottery.

As to the strategic science displayed by this multitude, the warlike nature of the French, their long experience of insurrections, and particularly the military education which the majority of the men of the people have in turn received, suffice to explain it. Half of the Paris workmen have served in our armies, and they are always glad to take up arms again. Generally speaking, old soldiers abound in our riots. On the 24th of February when Lamoricière was surrounded by his foes, he twice owed his life to insurgents who had fought under him in Africa, men in whom the recollection of their military life had been stronger than the fury of civil war.

As we know, it was the closing of the national workshops that occasioned the rising. Dreading to disband this formida-

ble soldiery at one stroke, the Government had tried to disperse it by sending part of the workmen into the country. They refused to leave. On the 22nd of June, they marched through Paris in troops, singing in cadence, in a monotonous chant, "We won't be sent away, we won't be sent away. . . ." Their dele-

gates waited upon the members of the Committee of the Executive Power with a series of arrogant demands, and on meeting with a refusal, withdrew with the announcement that next day they would have recourse to arms. Everything, indeed, tended to show that the long-expected crisis had come.

Thomas Carlyle: Afterthought

All Europe exploded, boundless, uncontrollable, and we had the year 1848, one of the most singular, disastrous, amazing and on the whole humiliating years the European world ever saw. Not since the irruption of the Northern Barbarians has there been the like. Everywhere immeasurable democracy rose monstrous, loud, blatant, inarticulate as the voice of chaos. . . . Universal democracy, what-

ever one may think of it, has declared itself as an inevitable fact of the days in which we live; and he who has any chance to instruct, or lead, in his days, must begin by admitting that: new streetbarricades, and new anarchies, still more scandalous, if still less sanguinary, must return and again return, till governing persons everywhere know and admit that.

A Time of Questioning

- I. THE RISE OF SOCIAL-REVOLUTIONARY DOCTRINES
- II. THE DRIFT OF SCIENTIFIC THOUGHT
- III. PATTERNS OF CHANGE
- IV. NATIONALISM AND IMPERIALISM
- V. WAR AND REVOLUTION
- VI. RUSSIA

After 1848 the certainty of a better world waiting at the end of the road begins to pale and the unity of method by which it was to have been reached disintegrates. The better world is no longer built to a universal pattern thought acceptable to all; henceforth we have several versions of it as imagined by the bourgeoisie, the proletariat, the nationalist, perhaps also the scientist. Existing standards are questioned no longer in the name of one supreme value, that of reason, but in the name of many different ones put forward by contending churches and anti-churches, classes and nations, whose interests cannot fit together in any harmony in a shattered world.

The divisive tendency which we could follow since the Reformation now rises to a peak, with every interest and world view challenging every other, struggling to impose its values and its patterns against all others, as in a great match of catch-as-catch-can. National revolutions stress the piecemeal quality of a world whose rising barriers are in turn emphasized by ever more complicated hindrances to the free movement of men, money, and goods. Social revolution, or its doctrines, continues the pattern of fragmentation at the national level so that class rears against class while nation rears against nation. And successful scientific revolutions shake the prevailing conception of reality and create doubt whether an understandable pattern of the world order so much as exists.

The great war of 1914–1918 and the Russian Revolution simply complete this process. The inability of politicians to solve their problems without war, the carnage and lunacy of the hostilities, the prodigious lies of the contending propaganda machines, the collapse of Tsarist rule and survival of the Bolshevik regime, these taken together sapped all remaining belief in the sanity or the rationality or the coherence of the western world. The long years of questioning had done their work, but the distracted lack of self-confidence to which they testified did not seem exactly unfounded.

I. The Rise of Social-Revolutionary Doctrines

After 1830, and even more after 1848, it seemed very clear that the erstwhile bourgeois allies of the lower classes were determined to keep the profits of reforms and revolutions for themselves without serious thought for the interests of the propertyless and the poor. Revolution had not removed oppression but merely replaced one oppressor with a more vigorous and determined one who would manipulate in his own interest the forces of organized society which he now controlled. This revelation was followed by two reactions. One, embodied in Anarchism, hoped for the removal of coercive authority which would leave men free to act and cooperate unconstrained. The other, most powerfully expressed by Karl Marx, relied on the organization of the oppressed classes to oppose and defeat the forces of their oppressors.

1. KROPOTKIN: ANARCHISM

Prince Pietr Alexander Alexeyevitch Kropotkin, Russian anarchist, geographer, naturalist, and explorer, was born in Moscow in 1842 and died there in 1921. In the meantime he had served as an army officer in Siberia, as a convict in Russia and France, and had come to be regarded as the intellectual head of Anarchism. In July 1917 Kropotkin—who had endorsed the war "against German imperialism"—returned to Russia, where he supported Kerensky, rejected the Communist dictatorship after the October Revolution, but stayed on in the country unmolested, probably in view of his prestige and advanced age. His birthplace in Moscow is today a Kropotkin Museum.

Educated men—"civilized," as Fourier used to say with disdain—tremble at the idea that society might some day be without judges, police, or gaolers.

But, frankly, do you need them as much as you have been told in musty books! Books written, be it noted, by scientists who generally know well what has been written before them, but, for the most part, absolutely ignore the people and their every-day life.

If we can wander, without fear, not only in the streets of Paris, which bristle with police, but especially in rustic walks where you rarely meet passers by, is it to the police that we owe this security? Or rather to the absence of people who care to rob or murder us? I am evidently not speaking of the one who carries millions about him. That one—a recent trial tells us—is soon robbed, places where there are as lamp-posts. No, I speak of the man who fears for his life and not for his purse filled with ill-gotten sovereigns. Are his fears real?

From Peter Kropotkin, Anarchism: Its Philosophy and Ideal (San Francisco, 1898).

Besides, has not experience demonstrated quite recently that Jack the Ripper performed his exploits under the eye of the London police—a most active force—and that he only left off killing when the population of Whitechapel itself began to give chase to him?

And in our every-day relations with our fellow-citizens, do you think that it is really judges, gaolers, and the police that hinder anti-social acts from multiplying? The judge, ever ferocious, because he is a maniac of law, the accuser, the informer, the police spy, all those interlopers that live from hand to mouth around the Law Courts, do they not scatter demoralization far and wide into society? Read the trials, glance behind the scenes, push your analysis further than the exterior facade of law courts, and you will come out sickened.

Have not prisons—which kill all will and force of character in man, which enclose within their walls more vices than are met with on any other spot of the globe—always been universities of crime? Is not the court of a tribunal a school of ferocity? And so on.

When we ask for the abolition of the State and its organs we are always told that we dream of a society composed of men better than they are in reality. But no; a thousand times, no. All we ask is that men should not be made worse than they are, by such institutions!

Once a German jurist of great renown, Lhering, wanted to sum up the scientific work of his life and write a treatise in which he proposed to analyze the factors that preserve social life in society. Purpose in Law (der Zweck im Rechte), such is the title of that book, which enjoys a well-deserved reputation.

He made an elaborate plan of his treatise, and, with much erudition, discussed both coercive factors which are used to maintain society: wagedom, and the different forms of coercion which are sanctioned by law. At the end of his work, he reserved two paragraphs only to mention the two noncoercive factors—the feeling of duty and the feeling of mutual sympathy—to which he attached very little importance, as might be expected from a writer in law.

But what happened? As he went on analyzing the coercive factors, he realized their insufficiency. He consecrated a whole volume to their analysis, and the result was to lessen their importance! When he began the last two paragraphs, when he began to reflect upon the noncoercive factors of society, he perceived, on the contrary, their immense, outweighing importance; and instead of two paragraphs, he found himself obliged to write a second volume, twice as large as the first, on these two factors: voluntary restraint and mutual help; and yet he analyzed but an infinitesimal part of these latter-those which result from social institutions.

Well, then, leave off repeating the formulae which you have learned at school; meditate on this subject; and the same thing that happened to Lhering will happen to you. You will recognize the infinitesimal importance of coercion, as compared to the voluntary assent, in society.

On the other hand, if by following the very old advice given by Bentham you begin to think of the fatal consequences—direct, and especially indirect—of legal coercion, like Tolstoy, like us, you will begin to hate the use of coercion, and you will begin to say that society possesses a thousand other means for preventing antisocial acts. If it neglects those means today, it is because, being educated by

Church and State, our cowardice and apathy of spirit hinder us seeing clearly on this point. When a child has committed a fault, it is so easy to hang a man —especially when there is an executioner
who is paid so much for each execution
—and it dispenses us from thinking of
the cause of crimes.

2. MARXIAN COMMUNISM

Karl Marx (1818–1883) was born in Prussia, the son of a Jewish lawyer. He himself studied law at Bonn and Berlin. By 1842 he had begun his long battle against the accepted ideas of society when he published his radical views in a liberal journal of which he became editor. Within six months the paper was suppressed by the Prussian government. Virtually a political exile, Marx lived in Paris and Brussels, finally settling in London, where his major lifework was done. Engels (1820–1895) was also born in Prussia, the son of a wealthy manufacturer. From 1842, Engels worked in a commercial house in Manchester and at the same time studied British conditions. In 1844 he met Marx in Paris and from then on the two were close friends, jointly developing the theories which afterward became known as Marxism.

From: The Communist Manifesto

PREFACE TO THE ENGLISH EDITION OF 1888

The Manifesto was published as the platform of the Communist League, a workingmen's association, first exclusively German, later on international, and, under the political conditions of the Continent before 1848, unavoidably a secret society. At a Congress of the League, held in London in November, 1847, Marx and Engels were commissioned to prepare for publication a complete theoretical and practical party programme. Drawn up in German, in January, 1848, the manuscript was sent to the printer in London a few weeks before the French revolution of February 24th. A French translation was brought out in Paris, shortly before the insurrection of June, 1848. The first English translation, by Miss Helen Macfarlane, appeared in George Julian Harney's *Red Republic*, London, 1850. A Danish and a Polish edition had also been published.

The defeat of the Parisian insurrection of June, 1848,—the first great battle between proletariat and bourgeoisie—drove again into the background, for a time, the social and political aspirations of the European working class. Thenceforth, the struggle for supremacy was again, as it had been before the revolution of February, solely between different sections of the propertied class; the working class was reduced to a fight for political elbowroom, and to the position of extreme wing of the middle-class Radicals. Wherever independent proletarian movements continued to show signs of life, they were ruthlessly hunted down. Thus the Prussian police hunted out the Central Board of the Communist League then located in Cologne. The members were arrested,

From Karl Marx and Frederick Engels, The Communist Manifesto (London, 1888).

700

and, after eighteen months' imprisonment, they were tried in October, 1852. This celebrated "Cologne Communist Trial" lasted from October 4th till November 12th: seven of the prisoners were sentenced to terms of imprisonment in a fortress, varying from three to six years. Immediately after the sentence, the League was formally dissolved by the remaining members. As to the Manifesto, it seemed thenceforth to be doomed to oblivion

When the European working class had recovered sufficient strength for another attack on the ruling classes, the International Workingmen's Association 1 sprang up. But this association, formed with the express aim of welding into one body the whole militant proletariat of Europe and America, could not at once proclaim the principles laid down in the Manifesto. The International was bound to have a programme broad enough to be acceptable to the English trades unions, to the followers of Proudhon 2 in France, Belgium, Italy and Spain, and to the Lassalleans * in Germany. Marx, who drew up this programme to the satisfaction of all parties, entirely trusted to the intellectual development of the working class, which was sure to result from combined action and mutual discussion. The very events and vicissitudes of the struggle against capital, the defeats even more than the victories, could not help bringing home to men's minds the insufficiency of their various favourite nostrums, and prepar-

ing the way for a more complete insight into the true conditions of working-class emancipation. And Marx was right. The International, on its breaking up in 1874, left the workers quite different men from what it had found them in 1864. Proudhonism in France, Lassalleanism in Germany were dving out, and even the conservative English trades unions, though most of them had long since severed their connection with the International, were gradually advancing towards that point at which, last year at Swansea, their president could say in their name "Continental Socialism had lost its terrors for us." In fact, the principles of the Manifesto had made considerable headway among the working men of all countries.

The Manifesto itself thus came to the front again. Since 1850 the German text had been reprinted several times in Switzerland, England and America. In 1872, it was translated into English in New York, where the translation was published in Woodhull and Calftin's Weekly. From this English version, a French one was made in Le Socialiste of New York. Since then at least two more English translations, more or less mutilated, have been brought out in America, and one of them has been reprinted in England. The first Russian translation, made by Bakunin,8 was published at Herzen's 4 Kolokol office in Geneva, about 1863; a second one, by the heroic Vera Zasulich,5 also in Geneva in 1882. A new Danish edition is to be found in Socialdemokratisk Bibliothek.

1 Now known as the First International.

² P. J. Proudhon (1809-1865)—French anarchist who disagreed with Marx.

⁵ Vera Zasulich (1849-1919), shot the governor of St. Petersburg in 1878. Later a member of the first Russian Marxist organization.

³ Bakunin (1814-1876), Russian anarchist; at first a supporter, then an opponent of Marx. ⁴ Herzen (1812-1870), Russian liberal and socialist. His newspaper, Kolokol ("The Bell"), published mostly in London, was smuggled regularly into Tsarist Russia.

^{*} Lasalle personally, to us, always acknowledged himself to be a disciple of Marx, and, as such, stood on the ground of the Manifesto. But in his public agitation, 1862-64, he did not go beyond demanding co-operative workshops supported by State credit. - F. E.

Copenhagen, 1885; a fresh French translation in Le Socialiste, Paris, 1886. From this latter, a Spanish version was prepared and published in Madrid, in 1886. The German reprints are not to be counted; there have been twelve altogether at the least. An Armenian translation, which was to be published in Constantinople some months ago, did not see the light, I am told, because the publisher was afraid of bringing out a book with the name of Marx on it, while the translator declined to call it his own production. Of further translations into other languages I have heard, but have not seen them. Thus the history of the Manifesto reflects, to a great extent, the history of the modern working-class movement; at present it is undoubtedly the most widespread, the most international production of all Socialist literature, the common platform acknowledged by millions of working men from Siberia to California.

Yet, when it was written, we could not have called it a Socialist manifesto. By Socialists, in 1847, were understood, on the one hand, the adherents of the various Utopian systems; Owenites 6 in England, Fourierists 7 in France, both of them already reduced to the position of mere sects, and gradually dying out; on the other hand, the most multifarious social quacks, who by all manner of tinkering professed to redress, without any danger to capital and profit, all sorts of social grievances; in both cases men outside the working-class movement, and looking rather to the "educated" classes for support. Whatever portion of the working class had become convinced of the insufficiency of mere political revolutions,

and had proclaimed the necessity of a total social change, called itself Communist. It was a crude, rough-hewn, purely instinctive sort of Communism; still it touched the cardinal point and was powerful enough amongst the working class to produce the Utopian Communism of Cabet in France, and of Weitling in Germany.8 Thus, in 1847, Socialism was a middle-class movement, Communism a working-class movement. Socialism was, on the Continent at least, "respectable"; Communism was the very opposite. And as our notion, from the very beginning, was that "the emancipation of the working class must be the act of the working class itself," there could be no doubt as to which of the two names we must take. Moreover, we have, ever since, been far from repudiating it.

The Manifesto being our joint production, I consider myself bound to state that the fundamental proposition which forms its nucleus, belongs to Marx. That proposition is: That in every historical epoch, the prevailing mode of economic production and exchange, and the social organization necessarily following from it, form the basis upon which is built up, and from which alone can be explained. the political and intellectual history of that epoch; that consequently the whole history of mankind (since the dissolution of primitive tribal society, holding land in common ownership) has been a history of class struggles, contests between exploiting and exploited, ruling and oppressed classes; that the history of these class struggles forms a series of evolutions in which, nowadays, a stage has been reached where the exploited and op-

⁶ Owenites were followers of Robert Owen (1771–1858). ⁷ Fourierists, followers of Charles Fourier (1772–1858).

⁸ E. Cabet (1788-1856), French writer and lawyer with utopian ideas. Weitling (1808-1871), German tailor, who wrote the first German socialist work in 1842.

pressed class—the proletariat—cannot attain its emancipation from the sway of the exploiting and ruling class—the bourgeoisie—without, at the same time, and once and for all, emancipating society at large from all exploitation, oppression, class distinctions and class struggles.

This proposition, which, in my opinion, is destined to do for history what Darwin's theory has done for biology, we both of us had been gradually approaching for some years before 1845. How far I had independently progressed towards it is best shown by my Condition of the Working Class in England in 1844. But when I again met Marx at Brussels, in spring, 1845, he had it already worked out, and put it before me, in terms almost as clear as those in which I have stated it here.

From our joint preface to the German edition of 1872, I quote the following: "However much the state of things may have altered during the last 25 years, the general principles laid down in this Manifesto are, on the whole, as correct today as ever. Here and there some detail might be improved. The practical application of the principles will depend, as the Manifesto itself states, everywhere and at all times, on the historical conditions for the time being existing; and for that reason, no special stress is laid on the revolutionary measures proposed at the end of Section II. That passage would, in many respects, be very differently worded today. In view of the gigantic strides of modern industry since 1848, and of the accompanying improved and extended organization of the working class, in view of the practical experience gained, first in the February Revolution, and then, still more, in the Paris Commune,

where the proletariat for the first time held political power for two whole months, this programme has in some details become antiquated. One thing especially was proved by the Commune, viz., that 'the working class cannot simply lay hold of the ready-made State machinery, and wield it for its own purposes.' (See The Civil War in France; Address of the General Council of the International Workingmen's Association, 1871, where this point is further developed.) Further, it is self-evident that the criticism of Socialist literature is deficient in relation to the present time, because it comes down only to 1847; also, that the remarks on the relation of the Communists to the various opposition parties (Section IV), although in principle still correct, yet in practice are antiquated, because the political situation has been entirely changed, and the progress of history has swept from off the earth the greater portion of the political parties there enumerated.

But then, the *Manifesto* has become a historical document which we have no longer any right to alter.

The present translation is by Mr. Samuel Moore, the translator of the greater portion of Marx's *Capital*. We have revised it in common, and I have added a few notes explanatory of historical allusions.

Frederick Engels London, January 30th, 1888

INTRODUCTION

A spectre is haunting Europe—the spectre of Communism. All the powers of old Europe have entered into a holy alliance to exorcise this spectre: Pope and Czar, Metternich and Guizot,⁹

⁹ Guizot (1787-1784), French Premier under Louis Philippe.

French Radicals and German political police.

Where is the party in opposition that has not been decried as communistic by its opponents in power? Where is the Opposition that has not hurled back the branding reproach of Communism, against the more advanced opposition parties as well as against its reactionary adversaries?

Two things result from this fact:

- 1. Communism is already acknowledged by all European powers to be itself a power.
- 2. It is high time that Communists should openly, in the face of the whole world, publish their views, their aims, their tendencies, and meet this nursery tale of the spectre of Communism with a manifesto of the party itself.

To this end, Communists of various nationalities have assembled in London, and sketched the following manifesto, to be published in the English, French, German, Italian, Flemish and Danish languages.

CHAPTER I BOURGEOIS AND PROLETARIANS*

The history of all hitherto existing society ** is the history of class struggles.

Freeman and slave, patrician and plebeian, lord and serf, guild-master *** and journeyman, in a word, oppressor and oppressed, stood in constant opposition to one another, carried on an uninterrupted, now hidden, now open fight, a fight that each time ended, either in a revolutionary reconstitution of society at large, or in the common ruin of the contending classes.

In the earlier epochs of history, we find almost everywhere a complicated arrangement of society into various orders, a manifold gradation of social rank. In ancient Rome we have patricians, knights, plebeians, slaves; in the Middle Ages, feudal lords, vassals, guildmasters, journeymen, apprentices, serfs; in almost all of these classes, again, subordinate gradations.

The modern bourgeois society that has sprouted from the ruins of feudal society has not done away with class antagonisms. It has but established new classes, new conditions of oppression, new forms of struggle in place of the old ones.

Our epoch, the epoch of the bourgeoisie, possesses, however, this distinctive feature: it has simplified the class antagonisms. Society as a whole is more and more splitting up into two great hostile camps, into two great classes directly fac-

* By bourgeoisie is meant the class of modern capitalists, owners of the means of social production and employers of wage-labour. By proletariat, the class of modern wage-labourers who, having no means of production of their own, are reduced to selling their labour power in order to live.— F. E.

** That is, all written history. In 1847, the pre-history of society, the social organization existing previous to recorded history, was all but unknown. Since then Haxthausen (August von, 1792–1866) discovered common ownership of land in Russia, Maurer (Georg Ludwig von, 1790–1872) proved it to be the social foundation from which all Teutonic races started in history, and, by and by, village communities were found to be, or to have been, the primitive form of society everywhere from India to Ireland. The inner organization of this primitive communistic society was laid bare, in its typical form, by Morgan's (Henry, 1818–1881) crowning discovery of the true nature of the gens and its relation to the tribe. With the dissolution of these primeval communities, society begins to be differentiated into separate and finally antagonistic classes. I have attempted to retrace this process of dissolution in Der Ursprung der Familie, des Privateigenthums und des Staats, 2nd edition, Stuttgart, 1886. (The Origin of the Family, Private Property and the State.)

—F. E.

*** Guild-master, that is a full member of a guild, a master within, not a head of a guild.—

F. E

ing each other—bourgeoisie and proletariat.

From the serfs of the Middle Ages sprang the chartered Burghers of the earliest towns. From these burgesses the first elements of the bourgeoisie were devel-

oped.

The discovery of America, the rounding of the Cape, opened up fresh ground for the rising bourgeoisie. The East-Indian and Chinese markets, the colonization of America, trade with the colonies, the increase in the means of exchange and in commodities generally, gave to commerce, to navigation, to industry, an impulse never before known, and thereby, to the revolutionary element in the tottering feudal society, a rapid development.

The feudal system of industry, in which industrial production was monopolized by closed guilds, now no longer sufficed for the growing wants of the new markets. The manufacturing system took its place. The guild-masters were pushed aside by the manufacturing middle class; division of labour between the different corporate guilds vanished in the face of division of labour in each single workshop.

Meantime the markets kept ever growing, the demand ever rising. Even manufacture no longer sufficed. Thereupon, steam and machinery revolutionized industrial production. The place of manufacture was taken by the giant, modern industry, the place of the industrial middle class by industrial millionaires, the leaders of whole industrial armies, the modern bourgeois.

Modern industry has established the world market, for which the discovery of America paved the way. This market has given an immense development to commerce, to navigation, to communication by land. This development has, in its turn, reacted on the extension of industry; and in proportion as industry, commerce, navigation, railways extended, in the same proportion the bourgeoisie developed, increased its capital, and pushed into the background every class handed down from the Middle Ages.

We see, therefore, how the modern bourgeoisie is itself the product of a long course of development, of a series of revolutions in the modes of production and of exchange.

Each step in the development of the bourgeoisie was accompanied by a corresponding political advance of that class. An oppressed class under the sway of the feudal nobility, an armed and self-governing association in the medieval commune; * here independent urban republic (as in Italy and Germany), there taxable "third estate" of the monarchy (as in France); afterwards, in the period of manufacture proper, serving either the semi-feudal or the absolute monarchy as a counterpoise against the nobility, and, in fact, corner-stone of the great monarchies in general, the bourgeoisie has at last, since the establishment of modern industry and of the world market, conquered for itself, in the modern parliamentary State, exclusive political sway. The executive of the modern State is but a committee for managing the common affairs of the whole bourgeoisie.

The bourgeoisie, historically, has played a most revolutionary part.

The bourgeoisie, wherever it has got

^{* &}quot;Commune" was the name taken, in France, by the nascent towns even before they had conquered from their feudal lords and masters local self-government and political rights as "the Third Estate." Generally speaking, for the economical development of the bourgeoisie, England is here taken as the typical country, for its political development, France.—F. E.

the upper hand, has put an end to all feudal, patriarchal, idvllic relations. It has pitilessly torn asunder the motley feudal ties that bound man to his "natural superiors," and has left no other nexus between man and man than naked self-interest, than callous "cash payment." It has drowned the most heavenly ecstasies of religious fervour, of chivalrous enthusiasm, of Philistine sentimentalism, in the icy water of egotistic calculation. It has resolved personal worth in exchange value and in place of the numberless indefeasible chartered freedoms has set up that single, unconscionable freedom-Free Trade. In one word, for exploitation veiled by religious and political illusions it has substituted naked, shameless, direct, brutal exploitation.

The bourgeoisie has stripped of its halo every occupation hitherto honoured and looked up to with reverent awe. It has converted the physician, the lawyer, the priest, the poet, the man of science, into its paid wage-labourers.

The bourgeoisie has torn away from the family its sentimental veil, and has reduced the family relation to a mere money relation.

The bourgeoisie has disclosed how the brutal display of vigour in the Middle Ages, which reactionaries so much admire, found its fitting complement in the most slothful indolence. It has been the first to show what man's activity can bring about. It has accomplished wonders far surpassing Egyptian pyramids, Roman aqueducts, and Gothic cathedrals; it has conducted expeditions that put in the shade all former Exoduses of nations and crusades.

The bourgeoisie cannot exist without constantly revolutionising the instruments of production, and thereby the relations of production, and with them the whole re-

lations of society. Conservation of the old modes of production in unaltered form, was, on the contrary, the first condition of existence for all earlier industrial classes. Constant revolutionising of production, uninterrupted disturbance of all social conditions, everlasting uncertainty and agitation distinguish the bourgeois epoch from all earlier ones. All fixed, fastfrozen relations, with their train of ancient and venerable prejudices and opinions, are swept away, all new-formed ones become antiquated before they can ossify. All that is privileged and established melts into air, all that is holy is profaned, and man is at last compelled to face with sober senses his real conditions of life and his relations with his kind.

The need of a constantly-expanding market for its products chases the bourgeoisie over the whole surface of the globe. It must get a footing everywhere, settle everywhere, establish connections everywhere.

The bourgeoisie has through its exploitation of the world market given a cosmopolitan character to production and consumption in every country. To the great chagrin of reactionaries, it has drawn from under the feet of industry the national ground on which it stood. Old established national industries have been destroyed and are still being destroyed every day. They are dislodged by new industries, whose introduction becomes a life and death question for all civilized nations, by industries that no longer work up indigenous raw material, but raw material drawn from the remotest zones; industries whose products are consumed, not only at home, but in every quarter of the globe. In place of the old wants, satisfied by the production of the country, we find new wants, requiring for their satisfaction the products of distant lands and climes. In place of the old local and national seclusion and self-sufficiency, we have exchange in every direction, universal interdependence of nations. And as in material, so also in intellectual production. The intellectual creations of individual nations become common property. National onesidedness and narrow-mindedness become more and more impossible, and from the numerous national and local literatures there arises a world literature.

The bourgeoisie, by the rapid improvement of all instruments of production, by the immensely facilitated means of communication, draws all, even the most barbarian, nations into civilization. The cheap prices of its commodities are the heavy artillery with which it batters down all Chinese walls, with which it forces the barbarians' intensely obstinate hatred of foreigners to capitulate. It compels all nations, on pain of extinction, to adopt the bourgeois mode of production; it compels them to introduce what it calls civilization into their midst, i.e., to become bourgeois themselves. In one word, it creates a world after its own image.

The bourgeoisie has subjected the country to the rule of the towns. It has created enormous cities, has greatly increased the urban population as compared with the rural, and has thus rescued a considerable part of the population from the idiocy of rural life. Just as it has made the country dependent on the towns, so it has made barbarian and semibarbarian countries dependent on the civilized ones, nations of peasants on nations of bourgeois, the East on the West.

The bourgeoisie keeps more and more doing away with the scattered state of the population, of the means of production, and of property. It has agglomerated population, centralized means of production, and has concentrated property in a few hands. The necessary consequence of this was political centralization. Independent, or but loosely connected provinces, with separate interests, laws, governments and local dues, became lumped together into one nation, with one government, one code of laws, one national class interest, one frontier and one customs tariff.

The bourgeoisie, during its class rule of scarce one hundred years, has created more massive and more colossal productive forces than have all preceding generations together. Subjection of Nature's forces to man, machinery, application of chemistry to industry and agriculture, steam-navigation, railways, electric telegraphs, clearing of whole continents for cultivation, making rivers navigable, whole populations conjured out of the ground—what earlier century had even a presentiment that such productive forces slumbered in the lap of social labour?

We see then: the means of production and of exchange, on whose foundation the bourgeoisie built itself up, were generated in feudal society. At a certain stage in the development of these means of production and of exchange, the conditions under which feudal society produced and exchanged, the feudal organization of agriculture and manufacturing industry, in one word, the feudal relations of property, became no longer compatible with the already developed productive forces: they hindered production instead of promoting it; they became so many fetters. They had to be burst asunder; they were burst asunder.

Into their place stepped free competition, accompanied by a social and political constitution adapted to it, and by the economical and political sway of the bourgeois class.

A similar movement is going on before our own eyes. Modern bourgeois society with its relations of production, of exchange and of property, a society that has conjured up such gigantic means of production and of exchange, is like the sorcerer who is no longer able to control the powers of the nether world whom he has called up by his spells. For many a decade past the history of industry and commerce is but the history of the revolt of modern productive forces against modern conditions of production, against the property relations that are the conditions for the existence of the bourgeoisie and of its rule. It is enough to mention the commercial crises that by their periodical return put the existence of the entire bourgeois society on its trial, each time more threateningly. In these crises a great part, not only of the existing products, but also of the previously-created productive forces, are periodically destroyed. In these crises there breaks out an epidemic that, in all earlier epochs, would have seemed an absurdity-the epidemic of over-production. Society suddenly finds itself put back into a state of momentary barbarism; it appears as if a famine, a universal war of devastation, had cut off the supply of every means of subsistence; industry and commerce seem to be destroyed. And why? Because there is too much civilization, too much means of subsistence, too much industry, too much commerce. The productive forces at the disposal of society no longer tend to promote bourgeois civilization and bourgeois property; on the contrary, they have become too powerful for these relations, by which they are fettered, and so soon as they overcome these fetters, they bring disorder into the whole of bourgeois society, endanger the existence of bourgeois property. The conditions of bourgeois society are too narrow

to contain the wealth created by them. And how does the bourgeoisie get over these crises? On the one hand by enforced destruction of a mass of productive forces; on the other, by the conquest of new markets, and by the more thorough exploitation of the old ones. That is to say, by paving the way for more extensive and more destructive crises, and by diminishing the means whereby crises are prevented.

The weapons with which the bourgeoisie felled feudalism to the ground are now turned against the bourgeoisie itself.

But not only has the bourgeoisie forged the weapons that bring death to itself; it has also called into existence the men who are to wield those weapons—the modern working class—the proletarians.

In proportion as the bourgeoisie, i.e., capital, is developed, in the same proportion is the proletariat developed—the modern class of workers, who live only so long as they find work, and who find work only so long as their labour increases capital. These workmen, who must sell themselves piecemeal, are a commodity, like every other article of commerce, and are consequently exposed to all the vicissitudes of competition, to all the fluctuations of the market.

Owing to the extensive use of machinery and to division of labour, the work of the proletarians has lost all independent character, and, consequently, all charm for the workman. He becomes a mere appendage of the machine, and it is only the most simple, most monotonous, and most easily acquired knack, that is required of him. Hence, the cost of production of a workman is restricted, almost entirely, to the means of subsistence that he requires for his maintenance, and for the propagation of his race. But the price of

a commodity, and therefore also of labour, is equal to its cost of production. ¹⁰ In proportion, therefore, as the repulsiveness of the work increases, the wage decreases. Nay, more, in proportion as the use of machinery and division of labour increases, in the same proportion the burden of toil also increases, whether by prolongation of the working hours, by increase of the work exacted in a given time, or by increased speed of the machinery, etc.

Modern industry has converted the little workshop of the patriarchal master into the great factory of the industrial capitalist. Masses of labourers, crowded into the factory, are organized like soldiers. As privates of the industrial army they are placed under the command of a perfect hierarchy of officers and sergeants. Not only are they slaves of the bourgeois class, and of the bourgeois State; they are daily and hourly enslaved by the machine, by the overlooker, and, above all, by the individual bourgeois manufacturer himself. The more openly this despotism proclaims gain to be its end and aim, the more petty, the more hateful and the more embittering it is.

The less the skill and exertion of strength implied in manual labour, in other words, the more modern industry becomes developed, the more is the labour of men superseded by that of women. Differences of age and sex have no longer any distinctive social validity for the working class. All are instruments of labour, more or less expensive to use, according to their age and sex.

No sooner is the exploitation of the labourer by the manufacturer so far at an end that he receives his wages in cash, than he is set upon by the other portions of the bourgeoisie, the landlord, the shop-keeper, the pawnbroker, etc.

The former lower strata of the middle class—the small manufacturers, traders and persons living on small incomes, the handicraftsmen and peasants—all these sink gradually into the proletariat, partly because their diminutive capital does not suffice for the scale on which modern industry is carried on and is swamped in the competition with the large capitalists, partly because their specialized skill is rendered worthless by new methods of production. Thus the proletariat is recruited from all classes of the population.

The proletariat goes through various stages of development. With its birth begins its struggle with the bourgeoisie. At first the contest is carried on by individual labourers, then by the workpeople of a factory, then by the operatives of one trade, in one locality, against the individual bourgeois who directly exploits them. They direct their attacks not only against the bourgeois conditions of production, but against the instruments of production themselves; they destroy imported wares that compete with their labour, they smash to pieces machinery, they set factories ablaze, they seek to restore by force the vanished status of the workman of the Middle Ages.

At this stage the labourers still form an incoherent mass scattered over the whole country, and broken up by their mutual competition. If anywhere they unite in greater masses, this is not yet the consequence of their own active union, but of the union of the bourgeoisie, which class, in order to attain its own political ends, is compelled to set the whole proletariat in motion, and is moreover yet, for a time, able to do so. At this stage, therefore, the

¹⁰ According to Marx and Engels, the worker sells to the capitalist, not his labor, but his labor power.

proletarians do not fight their enemies, but the enemies of their enemies, the remnants of absolute monarchy, the land-owners, the non-industrial bourgeois, the petty bourgeoisie. Thus the whole historical movement is concentrated in the hands of the bourgeoisie; every victory so obtained is a victory for the bourgeoisie.

But with the development of industry the proletariat not only increases in number; it becomes concentrated in greater masses, its strength grows, and it feels that strength more. The various interests and conditions of life within the ranks of the proletariat are more and more equalized, in proportion as machinery obliterates all distinctions of labour, and nearly everywhere reduces wages to the same low level. The growing competition among the bourgeois, and the resulting commercial crises, make the wages of the workers ever more fluctuating. The unceasing improvement of machinery, ever more rapidly developing, makes their livelihood more and more precarious; the collisions between individual workmen and individual bourgeois take more and more the character of collisions between two classes. Thereupon the workers begin to form combinations against the bourgeois; they club together in order to keep up the rate of wages; they themselves found permanent associations in order to make provision beforehand for these occasional revolts. Here and there the contest breaks out into riots. Now and then the workers are victorious, but only for a time. The real fruit of their battles lies, not in the immediate result, but in the ever-expanding union of the workers. This union is helped on by the improved means of communication that are created by modern industry and that place the workers of different localities in contact with one another. It was just this contact that was needed to centralize the numerous local struggles, all of the same character, into one national struggle between classes. But every class struggle is a political struggle. And that union, to attain which the burghers of the Middle Ages, with their miserable highways, required centuries, the modern proletarians, thanks to railways, achieve in a few years.

This organization of the proletarians into a class, and consequently into a political party, is continually being upset again by the competition between the workers themselves. But it ever rises up again, stronger, firmer, mightier. It compels legislative recognition of particular interests of the workers, by taking advantage of the divisions among the bourgeoisie itself. Thus the ten-hours' bill in England was carried.

Altogether, collisions between the classes of the old society further in many ways the course of development of the proletariat. The bourgeoisie finds itself involved in a constant battle. At first with the aristocracy; later on, with those portions of the bourgeoisie itself, whose interests have become antagonistic to the progress of industry; at all times with the bourgeoisie of foreign countries. In all these battles it sees itself compelled to appeal to the proletariat, to ask for its help, and thus, to drag it into the political arena. The bourgeoisie itself, therefore, supplies the proletariat with its own elements of political and general education, in other words, it furnishes the proletariat with weapons for fighting the bourgeoi-

Further, as we have already seen, entire sections of the ruling classes are, by the advance of industry, precipitated into the proletariat, or are at least threatened in their conditions of existence. These

also supply the proletariat with fresh elements of enlightenment and progress.

Finally, in times when the class struggle nears the decisive hour, the process of dissolution going on within the ruling class, in fact within the whole range of old society, assumes such a violent, glaring character, that a small section of the ruling class cuts itself adrift, and joins the revolutionary class, the class that holds the future in its hands. Just as, therefore, at an earlier period, a section of the nobility went over to the bourgeoisie, so now a portion of the bourgeoisie goes over to the proletariat, and in particular, a portion of the bourgeois ideologists who have raised themselves to the level of comprehending theoretically the historical movement as a whole.

Of all the classes that stand face to face with the bourgeoisie today, the proletariat alone is a really revolutionary class. The other classes decay and finally disappear in the face of modern industry; the proletariat is its special and essential product.

The lower middle class, the small manufacturer, the shopkeeper, the artisan, the peasant, all these fight against the bourgeoisie, to save from extinction their existence as fractions of the middle class. They are therefore not revolutionary, but conservative. Nay, more, they are reactionary, for they try to roll back the wheel of history. If by chance they are revolutionary, they are so only in view of their impending transfer into the proletariat; they thus defend not their present, but their future interests; they desert their own standpoint to place themselves at that of the proletariat.

The "dangerous class," the social scum, that passively rotting mass thrown off by the lowest layers of old society, may, here and there, be swept into the movement by a proletarian revolution; its conditions of life, however, prepare it far more for the part of a bribed tool of reactionary intrigue.

In the conditions of the proletariat, those of old society at large are already virtually swamped. The proletarian is without property; his relation to his wife and children has no longer anything in common with the bourgeois family relations; modern industrial labour, modern subjection to capital, the same in England as in France, in America as in Germany, has stripped him of every trace of national character. Law, morality, religion, are to him so many bourgeois prejudices, behind which lurk in ambush just as many bourgeois interests.

All the preceding classes that got the upper hand sought to fortify their already-acquired status by subjecting society at large to their conditions of appropriation. The proletarians cannot become masters of the productive forces of society except by abolishing their own previous mode of appropriation, and thereby also every other previous mode of appropriation. They have nothing of their own to secure and to fortify; their mission is to destroy all previous securities for, and insurances of, individual property.

All previous historical movements were movements of minorities, or in the interest of minorities. The proletarian movement is the self-conscious, independent movement of the immense majority, in the interest of the immense majority. The proletariat, the lowest stratum of our present society, cannot stir, cannot raise itself up, without the whole superincumbent strata of official society being sprung into the air.

Though not in substance, yet in form, the struggle of the proletariat with the bourgeoisie is at first a national struggle. The proletariat of each country must, of course, first of all settle matters with its own bourgeoisie.

In depicting the most general phases of the development of the proletariat, we traced the more or less veiled civil war, raging within existing society, up to the point where that war breaks out into open revolution, and where the violent overthrow of the bourgeoisie lays the foundation for the sway of the proletariat.

Hitherto, every form of society has been based, as we have already seen, on the antagonism of oppressing and oppressed classes. But in order to oppress a class, certain conditions must be assured to it under which it can, at least, continue its slavish existence. The serf, in the period of serfdom, raised himself to membership in the commune, just as the petty bourgeois, under the yoke of feudal absolutism, managed to develop into a bourgeois. The modern labourer, on the contrary, instead of rising with the progress of industry, sinks deeper and deeper below the conditions of existence of his own class. He becomes a pauper, and pauperism develops more rapidly than population and wealth. And here it becomes evident that the bourgeoisie is unfit to rule because it is incompetent to assure an existence to its slave within his slavery, because it cannot help letting him sink into such a state that it has to feed him, instead of being fed by him. Society can no longer live under this bourgeoisie; in other words, its existence is no longer compatible with society.

The essential condition for the existence and for the sway of the bourgeois class is the accumulation of wealth in the hands of private individuals, the formation and augmentation of capital; the condition for capital is wage-labour. Wagelabour rests exclusively on competition between the labourers. The advance of industry, whose involuntary promoter is the bourgeoisie, replaces the isolation of the labourers, due to competition, by their revolutionary combination, due to association. The development of modern industry, therefore, cuts from under the feet of the bourgeoisie the very foundation on which it produces and appropriates products. What the bourgeoisie therefore produces, above all, are its own grave-diggers. Its fall and the victory of the proletariat are equally inevitable.

CHAPTER II PROLETARIANS AND COMMUNISTS

In what relation do the Communists stand to the proletarians as a whole?

The Communists do not form a separate party opposed to other working-class parties.

They have no interests separate and apart from those of the proletariat as a whole.

They do not set up any sectarian principles of their own, by which to shape and mould the proletarian movement.

The Communists are distinguished from the other working-class parties by this only: 1. In the national struggles of the proletarians of the different countries, they point out and bring to the front the common interests of the entire proletariat, independently of all nationality. 2. In the various stages of development which the struggle of the working class against the bourgeoisie has to pass through, they always and everywhere represent the interests of the movement as a whole.

The Communists, therefore, are on the one hand, in their practice, the most advanced and resolute section of the working-class parties of every country, that

section which pushes forward all others; on the other hand, theoretically, they have over the great mass of the proletariat the advantage of clearly understanding the line of march, the conditions, and the ultimate general results of the proletarian movement.

The immediate aim of the Communists is the same as that of all the other proletarian parties: formation of the proletariat into a class, overthrow of the bourgeois supremacy, conquest of political power by the proletariat.

The theoretical conclusions of the Communists are in no way based on ideas or principles that have been invented, or discovered, by this or that would-be universal reformer.

They merely express, in general terms, actual relations springing from an existing class struggle, from an historical movement going on under our very eyes. The abolition of existing property relations is not at all a distinctive feature of Communism.

All property relations in the past have continually been subject to historical change consequent upon the change in historical conditions.

The French revolution, for example, abolished feudal property in favour of bourgeois property.

The distinguishing feature of Communism is not the abolition of property generally, but the abolition of bourgeois property. But modern bourgeois private property is the final and most complete expression of the system of producing and appropriating products that is based on class antagonisms, on the exploitation of some by others.

In this sense, the theory of the Communists may be summed up in the single sentence: Abolition of private property.

We Communists have been reproached

with the desire of abolishing the right of personally acquiring property as the fruit of a man's own labour, which property is alleged to be the groundwork of all personal freedom, activity and independence.

Hard-won, self-acquired, self-earned property! Do you mean the property of the petty artisan and of the small peasant, a form of property that preceded the bourgeois form? There is no need to abolish that; the development of industry has to a great extent already destroyed it, and is still destroying it daily.

Or do you mean modern bourgeois private property?

But does wage-labour create any property for the labourer? Not a bit. It creates capital, i.e., that kind of property which exploits wage-labour, and which cannot increase except upon condition of begetting a new supply of wage-labour for fresh exploitation. Property, in its present form, is based on the antagonism of capital and wage-labour. Let us examine both sides of this antagonism.

To be a capitalist is to have not only a purely personal, but a social, status in production. Capital is a collective product, and only by the united action of many members, nay, in the last resort, only by the united action of all members of society, can it be set in motion.

Capital is therefore not a personal, it is a social power.

When, therefore, capital is converted into common property, into the property of all members of society, personal property is not thereby transformed into social property. It is only the social character of the property that is changed. It loses its class character.

Let us now take wage-labour.

The average price of wage-labour is the minimum wage, i.e., that quantum of the means of subsistence which is absolutely requisite to keep the labourer in bare existence as a labourer. What, therefore, the wage-labourer appropriates by means of his labour, merely suffices to prolong and reproduce a bare existence. We by no means intend to abolish this personal appropriation of the products of labour, an appropriation that is made for the maintenance and reproduction of human life, and that leaves no surplus wherewith to command the labour of others. All that we want to do away with is the miserable character of this appropriation, under which the labourer lives merely to increase capital, and is allowed to live only in so far as the interest of the ruling class requires it.

In bourgeois society, therefore, the past dominates the present; in Communist society, the present dominates the past. In bourgeois society capital is independent and has individuality, while the living person is dependent and has no individuality.

And the abolition of this state of things is called by the bourgeois, abolition of individuality and freedom! And rightly so. The abolition of bourgeois individuality, bourgeois independence, and bourgeois freedom is undoubtedly aimed at.

By freedom is meant, under the present bourgeois conditions of production, free trade, free selling and buying.

But if selling and buying disappear, free selling and buying disappear also. This talk about free selling and buying, and all the other "brave words" of our bourgeoisie about freedom in general, have a meaning, if any, only in contrast with restricted selling and buying, with the fettered traders of the Middle Ages, but have no meaning when opposed to the Communist abolition of buying and selling, of the bourgeois conditions of production, and of the bourgeoisie itself.

You are horrified at our intending to do away with private property. But in your existing society, private property is already done away with for nine-tenths of the population; its existence for the few is solely due to its non-existence in the hands of those nine-tenths. You reproach us, therefore, with intending to do away with a form of property, the necessary condition for whose existence is the non-existence of any property for the immense majority of society.

In one word, you reproach us with intending to do away with your property. Precisely so: that is just what we intend.

From the moment when labour can no longer be converted into capital, money, or rent, into a social power capable of being monopolized, i.e., from the moment when individual property can no longer be transformed into bourgeois property, into capital, from that moment, you say, individuality vanishes.

You are, therefore, confessing that by "individual" you mean no other person than the bourgeois, than the owner of bourgeois property. This person must, indeed, be swept out of the way, and made impossible.

Communism deprives no man of the power to appropriate the products of society; all that it does is to deprive him of the power to subjugate the labour of others by means of such appropriation. It has been objected, that upon the abolition of private property all work will cease, and universal laziness will overtake us.

According to this, bourgeois society ought long ago to have gone to the dogs through sheer idleness; for those of its members who work acquire nothing, and those who acquire anything do not work. The whole of this objection is but another expression of the tautology: There can no

longer be any wage-labour when there is no longer any capital.

All objections urged against the Communistic mode of producing and appropriating material products, have, in the same way, been urged against the Communistic modes of producing and appropriating intellectual products. Just as to the bourgeois the disappearance of class property is the disappearance of production itself, so the disappearance of class culture is to him identical with the disappearance of all culture.

That culture, the loss of which he laments, is for the enormous majority, a mere training to act as a machine.

But don't wrangle with us so long as you apply, to our intended abolition of bourgeois property, the standard of your bourgeois notions of freedom, culture, law, etc. Your very ideas are but the outgrowth of the conditions of your bourgeois production and bourgeois property, just as your jurisprudence is but the will of your class elevated into a law, a will whose essential character and direction are determined by the material conditions of existence of your class.

The selfish conception that induces you to transform into eternal laws of nature and of reason the relations springing from your present mode of production and form of property—historical relations that rise and disappear in the progress of production—this conception you share with every ruling class that has preceded you. What you see clearly in the case of ancient property, what you admit in the case of feudal property, you are of course forbidden to admit in the case of your own bourgeois form of property.

Abolition of the family! Even the most radical flare up at this infamous proposal of the Communists.

On what foundation is the present family, the bourgeois family, based? On capital, on private gain. In its completely developed form this family exists only among the bourgeoisie. But this state of things finds its complement in the enforced absence of the family among the proletarians, and in public prostitution.

The bourgeois family will vanish as a matter of course when its complement vanishes, and both will vanish with the vanishing of capital.

Do you charge us with wanting to stop the exploitation of children by their parents? To this crime we plead guilty. But, you will say, we destroy the most hallowed of relations, when we replace home education by social.

And your education! Is not that also social, and determined by the social conditions under which you educate, by the intervention, direct or indirect, of society, by means of schools, etc? The Communists have not invented the intervention of society in education; they do but seek to alter the character of that intervention, and to rescue education from the influence of the ruling class.

The bourgeois claptrap about the family and education, about the hallowed relation of parent and child, becomes all the more disgusting, the more, by the action of modern industry, all family ties among the proletarians are torn asunder, and their children transformed into simple articles of commerce and instruments of labour.

But you Communists would introduce community of women, screams the whole bourgeoisie in chorus.

The bourgeois sees in his wife a mere instrument of production. He hears that the instruments of production are to be exploited in common, and, naturally, can

come to no other conclusion than that the lot of being common to all will likewise fall to the women.

He has not even a suspicion that the real point aimed at is to do away with the status of women as mere instruments of production.

For the rest, nothing is more ridiculous than the virtuous indignation of our bourgeois at the community of women which, they pretend, is to be openly and officially established by the Communists. The Communists have no need to introduce community of women; it has existed almost from time immemorial.

Our bourgeois, not content with having the wives and daughters of their proletarians at their disposal, not to speak of common prostitutes, take the greatest pleasure in seducing each other's wives.

Bourgeois marriage is in reality a system of wives in common, and thus, at the most, what the Communists might possibly be reproached with is that they desire to introduce, in substitution for a hypocritically concealed, an openly legalized community of women. For the rest, it is self-evident that the abolition of the present system of production must bring with it the abolition of the community of women springing from that system, i.e., of prostitution both official and unofficial.

The Communists are further reproached with supposedly desiring to abolish fatherland and nationality.

The working men have no country. We cannot take from them what they have not got. Since the proletariat must first of all acquire political supremacy, must rise to be the leading class of the nation, must constitute itself the nation, it is, so far, itself national, though not in the bourgeois sense of the word.

National differences and antagonisms

between peoples are daily more and more vanishing, owing to the development of the bourgeoisie, to freedom of commerce, to the world market, to uniformity in the mode of production and in the conditions of life corresponding thereto.

The supremacy of the proletariat will cause them to vanish still faster. United action, of the leading civilized countries at least, is one of the first conditions for the emancipation of the proletariat.

In proportion as the exploitation of one individual by another is put an end to, the exploitation of one nation by another will also be put an end to. In proportion as the antagonism between classes within the nation vanishes, the hostility of one nation to another will come to an end.

The charges against Communism made from a religious, a philosophical and, generally, from an ideological standpoint, are not deserving of any more detailed examination.

Does it require deep intuition to comprehend that man's ideas, views, and conceptions, in one word, man's consciousness, change with every change in the conditions of his material existence, in his social relations and in his social life?

What else does the history of ideas prove, than that intellectual production changes its character in proportion as material production is changed? The ruling ideas of each age have been only the ideas of its ruling class.

When people speak of ideas that revolutionize society, they do but express the fact that, within the old society, the elements of a new one have been created, and that the dissolution of the old ideas keeps even pace with the dissolution of the old conditions of existence.

When the ancient world was in its last throes, the ancient religions were overcome by Christianity. When Christian ideas succumbed in the 18th century to rationalist ideas, feudal society fought its death battle with the then revolutionary bourgeoisie. The ideas of religious liberty and freedom of conscience merely gave expression to the sway of free competition within the domain of knowledge.

"Undoubtedly," it will be said, "religious, moral, philosophical, political and juridical ideas have been modified in the course of historical development. But religion, morality, philosophy, political science, and law, constantly survived this change."

"There are, besides, eternal truths, such as Freedom, Justice, etc., that are common to all states of society. But Communism abolishes eternal truths, it abolishes all religion and all morality, instead of constituting them on a new basis; it therefore acts in contradiction to all past historical experience."

What does this assertion reduce itself to? The history of all past society has developed through class antagonisms, antagonisms that assumed different forms at different epochs.

But whatever form they may have taken, one fact is common to all past ages, viz., the exploitation of one part of society by the other. No wonder, then, that the social consciousness of past ages, despite all the multiplicity and variety it displays, moves within certain common forms, or general ideas, which cannot completely vanish except with the total disappearance of class antagonisms.

The Communist revolution is the most radical rupture with traditional property relations; no wonder that its development involves the most radical rupture with traditional ideas.

But let us have done with the bourgeois objections to Communism.

We have seen above that the first step in the revolution by the working class is to raise the proletariat to the position of ruling class, to win the battle for democracy.

The proletariat will use its political supremacy to wrest, by degrees, all capital from the bourgeoisie, to centralize all instruments of production in the hands of the State, i.e., of the proletariat organized as the ruling class; and to increase the total of productive forces as rapidly as possible.

Of course, in the beginning, this cannot be effected except by means of despotic inroads on the rights of property, and on the conditions of bourgeois production; by means of measures, therefore, which appear economically insufficient and provisional, but which in the course of the movement, outstrip themselves, necessitate further inroads upon the old social order, and are unavoidable as a means of entirely revolutionizing the mode of production.

These measures will of course be different in different countries.

Nevertheless, in the most advanced countries, the following will be pretty generally applicable.

- 1. Abolition of property in land and application of all rents of land to public purposes.
- 2. A heavy progressive or graduated income tax.
 - 3. Abolition of all right of inheritance.
- Confiscation of the property of all emigrants and rebels.
- 5. Centralization of credit in the hands of the State, by means of a national bank with State capital and an exclusive monopoly.
- 6. Centralization of the means of communication and transport in the hands of the State.

- 7. Extension of the number of State factories and instruments of production: the bringing into cultivation of waste lands, and the improvement of the soil generally in accordance with a common plan.
- 8. Equal obligation of all to work. Establishment of industrial armies, especially for agriculture.
- 9. Combination of agriculture with manufacturing industries; gradual abolition of the distinction between town and country, by a more equable distribution of the population over the country.
- 10. Free education for all children in public schools. Abolition of children's factory labour in its present form. Combination of education with industrial production, etc.

When, in the course of development, class distinctions have disappeared, and all production has been concentrated in the hands of a vast association of the whole nation, the public power will lose its political character. Political power, properly so called, is merely the organized power of one class for oppressing another.

If the proletariat during its contest with the bourgeoisie is compelled, by the force of circumstances, to organize itself as a class; if, by means of a revolution, it makes itself the ruling class, and as such sweeps away by force the old conditions of production, then it will, along with these conditions, have swept away the conditions for the existence of class antagonisms and of classes generally, and will thereby have abolished its own supremacy as a class.

In place of the old bourgeois society, with its classes and class antagonisms, we shall have an association, in which the free development of each is the condition for the free development of all. . . .

The Communists disdain to conceal their views and aims. They openly declare that their ends can be attained only by the forcible overthrow of all existing social conditions. Let the ruling classes tremble at a Communist revolution. In it the proletarians have nothing to lose but their chains. They have a world to win.

WORKING MEN OF ALL COUNTRIES, UNITE!

3. RERUM NOVARUM

The social problem also came to the attention of the Church, which had every reason to intervene in questions involving Christian charity as well as justice. In 1864 Pius IX, who had never recovered from his disillusion with liberalism in 1848, had published a *Syllabus of Errors* to be avoided by Catholics. Among the errors were the following: "That every man is free to embrace and profess the religion he shall believe true, guided by the light of reason," "That eternal salvation may be hoped for by those who are not in the true Church of Christ," "That it is allowable to refuse obedience to legitimate princes or rise in insurrection against them." Socialism and Biblical societies were lumped together as "pests." The idea of secular popular schools, open to children of all classes, merited the same opprobrium as that which suggested "that, in the present day, it is no longer necessary that the Catholic religion be held as the only religion of the State, to the exclusion of all other modes of worship." Finally, it was denied "that the Roman pontiff can and ought to, reconcile himself to, and agree with, progress, liberalism, and modern civilization."

With this fine flourish, Pio Nono had begun what many regarded as a retreat to the Middle Ages, deplored even by many pious Catholics. On May 15, 1891, Pope Leo XIII reverted to a great and more progressive tradition when he published his Encyclical Letter, *De Rerum Novarum*, which remains today the most important recent papal pronouncement on the social question.

Once the passion for revolutionary change was aroused-a passion long disturbing governments—it was bound to follow sooner or later that eagerness for change would pass from the political sphere over into the related field of economics. In fact, new developments in industry, new techniques striking out on new paths, changed relations of employer and employee, abounding wealth among a very small number and destitution among the masses, increased self-reliance on the part of the workers as well as a closer bond of union with one another, and, in addition to all this, a decline in morals, have caused conflict to break forth.

The momentous nature of the questions involved in this conflict is evident from the fact that it keeps men's minds in anxious expectation, occupying the talents of the learned, the discussions of the wise and experienced, the assemblies of the people, the judgment of the law-makers, and the deliberations of rulers, so that now no topic more strongly holds men's interests.

Therefore, Venerable Brethren, with the cause of the Church and the common welfare before Us, We have thought it advisable, following Our custom on other occasions when We issued to you the Encyclicals On Political Power, On Human Liberty, On the Christian Constitution of States, and others of similar nature, which seemed opportune to refute erroneous opinions, that We ought to do the same now, and for the same reasons, On the Condition of Workers. We have on occasion touched more than once upon this subject. In this Encyclical, however, consciousness of Our Apostolic office admonishes Us to treat the entire question thoroughly, in order that the principles may stand out in clear light, and the conflict may thereby be brought to an end as required by truth and equity.

The problem is difficult to resolve and is not free from dangers. It is hard indeed to fix the boundaries of the rights and duties within which the rich and the proletariat—those who furnish material things and those who furnish work—ought to be restricted in relation to each other. The controversy is truly dangerous, for in various places it is being twisted by turbulent and crafty men to pervert judgment as to truth and seditiously to incite the masses.

In any event, We see clearly, and all are agreed that the poor must be speedily and fittingly cared for, since the great majority of them live undeservedly in miserable and wretched conditions.

After the old trade guilds had been destroyed in the last century, and no protection was substituted in their place, and when public institutions and legislation had cast off traditional religious teaching, it gradually came about that the present age handed over the workers, each alone and defenseless, to the inhumanity of employers and the unbridled greed of competitors. A devouring usury, although of-

The complete text of the Encyclical Letter may be found in the American Catholic Review, July 1891.

ten condemned by the Church, but practiced nevertheless under another form by avaricious and grasping men, has increased the evil; and in addition the whole process of production as well as trade in every kind of goods has been brought almost entirely under the power of a few, so that a very few rich and exceedingly rich men have laid a yoke almost of slavery on the unnumbered masses of nonowning workers.

To cure this evil, the Socialists, exciting the envy of the poor toward the rich, contend that it is necessary to do away with private possession of goods, and in its place to make the goods of individuals common to all, and that the men who preside over a municipality or who direct the entire State should act as administrators of these goods. They hold that, by such a transfer of private goods from private individuals to the community, they can cure the present evil through dividing wealth and benefits equally among the citizens.

But their program is so unsuited for terminating the conflict that it actually injures the workers themselves. Moreover, it is highly unjust, because it violates the rights of lawful owners, perverts the functions of the State, and throws governments into utter confusion.

Clearly the essential reason why those who engage in any gainful occupation undertake labor, and at the same time the end to which workers immediately look, is to procure property for themselves and to retain it by individual right as theirs and as their very own. When the worker places his energy and his labor at the disposal of another, he does so for the purpose of getting the means necessary for livelihood. He seeks in return for the work done, accordingly, a true and full right not only to demand his wage but

to dispose of it as he sees fit. Therefore, if he saves something by restricting expenditures and invests his savings in a piece of land in order to keep the fruit of his thrift more safe, a holding of this kind is certainly nothing else than his wage under a different form; and on this account land which the worker thus buys is necessarily under his full control as much as the wage which he earned by his labor. But, as is obvious, it is clearly in this that the ownership of movable and immovable goods consists. Therefore, inasmuch as the Socialists seek to transfer the goods of private persons to the community at large, they make the lot of all wage earners worse, because in abolishing the freedom to dispose of wages they take away from them by this very act the hope and the opportunity of increasing their property and of securing advantages for themselves.

But, what is of more vital concern, they propose a remedy openly in conflict with justice, inasmuch as nature confers on man the right to possess things privately as his own. . . .

The fact that God gave the whole human race the earth to use and enjoy cannot indeed in any manner serve as an objection against private possessions. For God is said to have given the earth to mankind in common, not because He intended indiscriminate ownership of it by all, but because He assigned no part to anyone in ownership, leaving the limits of private possessions to be fixed by the industry of men and the institutions of peoples. Yet, however the earth may be apportioned among private owners, it does not cease to serve the common interest of all, inasmuch as no living being is sustained except by what the fields bring forth. Those who lack resources supply labor, so that it can be truly affirmed that the entire scheme of securing a livelihood consists in the labor which a person expends either on his own land or in some working occupation, the compensation for which is drawn ultimately from no other source than from the varied products of the earth and is exchanged for them.

For this reason it also follows that private possessions are clearly in accord with nature. The earth indeed produces in great abundance the things to preserve and, especially, to perfect life, but of itself it could not produce them without human cultivation and care. Moreover, since man expends his mental energy and his bodily strength in procuring the goods of nature, by this very act he appropriates that part of physical nature to himself which he has cultivated. On it he leaves impressed, as it were, a kind of image of his person, so that it must be altogether just that he should possess that part as his very own and that no one in any way should be permitted to violate his right. . . .

It is a most sacred law of nature that the father of a family see that his offspring are provided with all the necessities of life, and nature even prompts him to desire to provide and to furnish his children, who, in fact reflect and in a sense continue his person, with the means of decently protecting themselves against harsh fortune in the uncertainties of life. He can do this surely in no other way than by owning fruitful goods to transmit by inheritance to his children. As already noted, the family like the State is by the same token a society in the strictest sense of the term, and it is governed by its own proper authority, namely, by that of the father. Wherefore, assuming, of course, that those limits be observed which are fixed by its immediate purpose, the family assuredly possesses rights, at

least equal with those of civil society, in respect to choosing and employing the things necessary for its protection and its just liberty. We say "at least equal" because, inasmuch as domestic living together is prior both in thought and in fact to uniting into a polity, it follows that its rights and duties are also prior and more in conformity with nature. But if citizens. if families, after becoming participants in common life and society, were to experience injury in a commonwealth instead of help, impairment of their rights instead of protection, society would be something to be repudiated rather than to be sought for.

To desire, therefore, that the civil power should enter arbitrarily into the privacy of homes is a great and pernicious error. If a family perchance is in such extreme difficulty and is so completely without plans that it is entirely unable to help itself, it is right that the distress be remedied by public aid, for each individual family is a part of the community. Similarly, if anywhere there is a grave violation of mutual rights within the family walls, public authority shall restore to each his right: for this is not usurping the rights of citizens, but protecting and confirming them with just and due care. Those in charge of public affairs, however, must stop here: nature does not permit them to go beyond these limits. Paternal authority is such that it can be neither abolished nor absorbed by the State, because it has the same origin in common with that of a man's own life. "Children are a part of their father," and, as it were, a kind of extension of the father's person; and, strictly speaking, not through themselves, but through the medium of the family society in which they are begotten, they enter into and participate in civil society. And for the very

reason that children "are by nature part of their father . . . before they have the use of free will, they are kept under the care of their parents." Inasmuch as the Socialists, therefore, disregard care by parents and in its place introduce care by the State, they act against natural justice and dissolve the structure of the home.

And apart from the injustice involved, it is also only too evident what turmoil and disorder would obtain among all classes; and what a harsh and odious enslavement of citizens would result! The door would be open to mutual envy, detraction, and dissension. If incentives to ingenuity and skill in individual persons were to be abolished, the very fountains of wealth would necessarily dry up; and the equality conjured up by the Socialist imagination would, in reality, be nothing but uniform wretchedness and meanness for one and all, without distinction.

From all these considerations, it is perceived that the fundamental principle of Socialism which would make all possessions public property is to be utterly rejected because it injures the very ones whom it seeks to help, contravenes the natural rights of individual persons, and throws the functions of the State and public peace into confusion. Let it be regarded, therefore, as established that in seeking help for the masses this principle before all is to be considered as basic, namely that private ownership must be preserved inviolate.

It is a capital evil with respect to the question we are discussing to take for granted that the one class of society is of itself hostile to the other, as if nature had set rich and poor against each other to fight fiercely in implacable war. This is so abhorrent to reason and truth that the exact opposite is true; for just as in the

human body the different members harmonize with one another, whence arises that disposition of parts and proportion in the human figure rightly called symmetry, so likewise nature has commanded in the case of the State that the two classes mentioned should agree harmoniously and should properly form equally balanced counterparts to each other. Each needs the other completely: neither capital can do without labor, nor labor without capital. Concord begets beauty and order in things. Conversely, from perpetual strife there must arise disorder accompanied by bestial cruelty. But for putting an end to conflict and for cutting away its very roots, there is wondrous and multiple power in Christian institutions.

And first and foremost, the entire body of religious teaching and practice, of which the Church is the interpreter and guardian, can pre-eminently bring together and unite the rich by recalling the two classes of society to their mutual duties, and in particular to those duties which derive from justice.

Among these duties the following concern the poor and the workers: To perform entirely and conscientiously whatever work has been voluntarily and equitably agreed upon; not in any way to injure the property or to harm the person of employers; in protecting their own interests, to refrain from violence and never to engage in rioting; not to associate with vicious men who craftily hold out exaggerated hopes and make huge promises, a course usually ending in vain regrets and in the destruction of wealth.

The following duties, on the other hand, concern rich men and employers: Workers are not to be treated as slaves; justice demands that the dignity of human personality be respected in them, en-

nobled as it has been through what we call the Christian character. If we hearken to natural reason and to Christian philosophy, gainful occupations are not a mark of shame to man, but rather of respect, as they provide him with an honorable means of supporting life. It is shameful and inhuman, however, to use men as things for gain and to put no more value on them than what they are worth in muscle and energy. Likewise it is enjoined that the religious interests and the spiritual well-being of the workers receive proper consideration. Wherefore, it is the duty of employers to see that the worker is free for adequate periods to attend to his religious obligations; not to expose anyone to corrupting influences or the enticements of sin, and in no way to alienate him from care for his family and the practice of thrift. Likewise, more work is not to be imposed than strength can endure, nor that kind of work which is unsuited to a worker's age or sex.

Among the most important duties of employers the principal one is to give every worker what is justly due him. Assuredly, to establish a rule of pay in accord with justice, many factors must be taken into account. But, in general, the rich and employers should remember that no laws, either human or divine, permit them for their own profit to oppress the needy and the wretched or to seek gain from another's want. To defraud anyone of the wage due him is a great crime that calls down avenging wrath from Heaven. "Behold, the wages of the laborers . . . which have been kept back by you unjustly, cry out: and their cry has entered into the ears of the Lord of Hosts." Finally, the rich must religiously avoid harming in any way the savings of the workers either by coercion, or by fraud, or by the arts of usury; and the more for this reason, that the workers are not sufficiently protected against injustices and violence, and their property, being so meagre, ought to be regarded as all the more sacred. Could not the observance alone of the foregoing laws remove the bitterness and the causes of conflict? . . .

Those who lack fortune's goods are taught by the Church that, before God as Judge, poverty is no disgrace, and that no one should be ashamed because he makes his living by toil. And Jesus Christ has confirmed this by fact and by deed, Who for the salvation of men, "being rich, became poor"; and although He was the Son of God and God Himself, vet He willed to seem and to be thought the son of a carpenter; nay, He even did not disdain to spend a great part of his life at the work of a carpenter. "Is not this the carpenter, the Son of Mary?" Those who contemplate this Divine example will more easily understand these truths: True dignity and excellence in men resides in moral living, that is, in virtue; virtue is the common inheritance of man, attainable equally by the humblest and the mightiest, by the rich and the poor; and the reward of eternal happiness will follow upon virtue and merit alone, regardless of the person in whom they may be found. Nav. rather the favor of God Himself seems to incline more toward the unfortunate as a class; for Jesus Christ calls the poor blessed, and He invites most lovingly all who are in labor or sorrow to come to Him for solace, embracing with special love the lowly and those harassed by injustice. At the realization of these things the proud spirit of the rich is easily brought down, and the downcast heart of the afflicted is lifted up; the former are moved toward kindness, the latter, toward reasonableness in their demands. Thus the distance between the classes which

pride seeks is reduced, and it will easily be brought to pass that the two classes, with hands clasped in friendship, will be united in heart.

Such is the economy of duties and rights according to Christian philosophy. Would it not seem that all conflict would soon cease wherever this economy were

to prevail in civil society?

Finally, the Church does not consider it enough to point out the way of finding the cure, but she administers the remedy herself. For she occupies herself fully in training and forming men according to discipline and doctrine; and through the agency of bishops and clergy, she causes the health-giving streams of this doctrine to be diffused as widely as possible. Furthermore, she strives to enter into men's minds and to bend their wills so that they may suffer themselves to be ruled and governed by the discipline of the divine precepts. And in this field, which is of first and greatest importance because in it the whole substance and matter of benefits consists, the Church indeed has a power that is especially unique. For the instruments which she used to move souls were given her for this very purpose by Jesus Christ, and they have an efficacy implanted in them by God. Such instruments alone can properly penetrate the inner recesses of the heart and lead man to obedience, to duty, to govern the activities of his self-seeking mind, to love God and his neighbors with a special and sovereign love, and to overcome courageously all things that impede the path of virtue. . . .

But it is now in order to inquire what portion of the remedy should be expected from the State. By State here We understand not the form of government which this or that people has, but rather that form which right reason in accordance with nature required and the teachings of Divine wisdom approve . . .

Therefore those governing the State ought primarily to devote themselves to the service of individual groups and of the whole commonwealth, and through the entire scheme of laws and institutions to cause both public and individual wellbeing to develop spontaneously out of the very structure and administration of the State. For this is the duty of wise statesmanship and the essential office of those in charge of the State. Now, States are made prosperous especially by wholesome morality, properly ordered family life. protection of religion and justice, moderate imposition and equitable distribution of public burdens, progressive development of industry and trade, thriving agriculture, and by all other things of this nature, which the more actively they are promoted, the better and happier the life of the citizens is destined to be. Therefore, by virtue of these things, it is within the competence of the rulers of the State that, as they benefit other groups, they also improve in particular the condition of the workers. Furthermore, they do this with full right and without laying themselves open to any charge of unwarranted interference. For the State is bound by the very law of its office to serve the common interest. And the richer the benefits which come from this general providence on the part of the State, the less necessary it will be to experiment with other measures for the well-being of workers.

This ought to be considered, as it touches the question more deeply, namely, that the State has one basic purpose for existence, which embraces in common the highest and the lowest of its members. Non-owning workers are unquestionably citizens by nature in virtue of the same

right as the rich, that is, true and vital parts whence, through the medium of families, the body of the State is constituted; and it hardly need be added that they are by far the greatest number in every urban area. Since it would be quite absurd to look out for one portion of the citizens and to neglect another, it follows that public authority ought to exercise due care in safeguarding the well-being and the interests of non-owning workers. Unless this is done, justice, which commands that everyone be given his own. will be violated. Wherefore St. Thomas says wisely: "Even as part and whole are in a certain way the same, so too that which pertains to the whole pertains in a certain way to the part also." Consequently, among the numerous and weighty duties of rulers who would serve their people well, this is first and foremost, namely, that they protect equitably each and every class of citizens, maintaining inviolate that justice especially which is called distributive.

Although all citizens, without exception, are obliged to contribute something to the sum-total of common goods, some share of which naturally goes back to each individual, yet all can by no means contribute the same amount and in equal degree. Whatever the vicissitudes that occur in the forms of government, there will always be those differences in the condition of citizens without which society could neither exist nor be conceived. It is altogether necessary that there be some who dedicate themselves to the service of the State, who make laws, who dispense justice, and finally, by whose counsel and authority civil and military affairs are administered. These men, as is clear, play the chief role in the State, and among every people are to be regarded as occupying first place, because they work for the

common good most directly and preeminently. On the other hand, those engaged in some calling benefit the State, but not in the same way as the men just mentioned, nor by performing the same duties; yet they, too, in a high degree, although less directly, serve the public weal. Assuredly, since social good must be of such a character that men through its acquisition are made better, it must necessarily be founded chiefly on virtue.

Nevertheless, an abundance of corporeal and external goods is likewise a characteristic of a well constituted State, "the use of which goods is necessary for the practice of virtue." To produce these goods the labor of the workers, whether they expend their skill and strength on farms or in factories, is most efficacious and necessary. Nay, in this respect, their energy and effectiveness are so important that it is incontestable that the wealth of nations originates from no other source than from the labor of workers. Equity therefore commands that public authority show proper concern for the worker so that from what he contributes to the common good he may receive what will enable him, housed, clothed, and secure, to live his life without hardship. Whence, it follows that all those measures ought to be favored which seem in any way capable of benefiting the condition of workers. Such solicitude is so far from injuring anyone, that it is destined rather to benefit all. because it is of absolute interest to the State that those citizens should not be miserable in every respect from whom such necessary goods proceed.

It is not right, as We have said, for either the citizen or the family to be absorbed by the State; it is proper that the individual and the family should be permitted to retain their freedom of action, so far as this is possible without jeopardizing the common good and without injuring anyone. Nevertheless, those who govern must see to it that they protect the community and its constitutent parts: the community, because nature has entrusted its safeguarding to the sovereign power in the State to such an extent that the protection of the public welfare is not only the supreme law, but is the entire cause and reason for sovereignty; and the constituent parts, because philosophy and Christian faith agree that the administration of the State has from nature as its purpose, not the benefit of those to whom it has been entrusted, but the benefit of those who have been entrusted to it. And since the power of governing comes from God and is a participation, as it were, in His supreme sovereignty, it ought to be administered according to the example of the Divine power, which looks with paternal care to the welfare of individual creatures as well as to that of all creation. If, therefore, any injury has been done to or threatens either the common good or the interests of individual groups, which injury cannot in any other way be repaired or prevented, it is necessary for public authority to intervene.

It is vitally important to public as well as to private welfare that there be peace and good order: likewise, that the whole regime of family life be directed according to the ordinances of God and the principles of nature, that religion be observed and cultivated, that sound morals flourish in private and public life, that justice be kept sacred and that no one be wronged with impunity by another, and that strong citizens grow up, capable of supporting, and if necessary, of protecting the State. Wherefore, if at any time disorder should threaten because of strikes or concerted stoppages of work, if the natural bonds of family life should be relaxed among the poor, if religion among the workers should be outraged by failure to provide sufficient opportunity for performing religious duties, if in factories danger should assail the integrity of morals through the mixing of the sexes or other pernicious incitements to sin, or if the employer class should oppress the working class with unjust burdens or should degrade them with conditions inimical to human personality or to human dignity, if health should be injured by immoderate work and such as is not suited to sex or age-in all these cases, the power and authority of the law, but of course within certain limits, manifestly ought to be employed. And these limits are determined by the same reason which demands the aid of the law, that is, the law ought not undertake more, nor go farther, than the remedy of evils or the removal of danger requires.

Rights indeed, by whomsoever possessed, must be religiously protected; and public authority, in warding off injuries and punishing wrongs, ought to see to it that individuals may have and hold what belongs to them. In protecting the rights of private individuals, however, special consideration must be given to the weak and the poor. For the nation, as it were, of the rich, is guarded by its own defenses and is in less need of governmental protection, whereas the suffering multitude, without the means to protect itself, relies especially on the protection of the State. Wherefore, since wage workers are numbered among the great mass of the needy, the State must include them under its special care and foresight.

But it will be well to touch here expressly on certain matters of special importance. The capital point is this, that private property ought to be safeguarded by the sovereign power of the State and

through the bulwark of its laws. And especially, in view of such a great flaming up of passion at the present time, the masses ought to be kept within the bounds of their moral obligations. For while justice does not oppose our striving for better things, on the other hand, it does forbid anyone to take from another what is his and, in the name of a certain absurd equality, to seize forcibly the property of others; nor does the interest of the common good itself permit this. Certainly, the great majority of working people prefer to secure better conditions by honest toil, without doing wrong to anyone. Nevertheless, not a few individuals are found who, imbued with evil ideas and eager for revolution, use every means to stir up disorder and incite to violence. The authority of the State, therefore, should intervene and, by putting restraint upon such disturbers, protect the morals of workers from their corrupting arts and lawful owners from the danger of spoliation.

Labor which is too long and too hard and the belief that pay is inadequate not infrequently give workers cause to strike and become voluntarily idle. This evil, which is frequent and serious, ought to be remedied by public authority, because such interruption of work inflicts damage not only upon employers and upon the workers themselves, but also injures trade and commerce and the general interest of the State; and, since it is usually not far removed from violence and rioting, it very frequently jeopardizes public peace. In this matter it is more effective and salutary that the authority of the law anticipate and completely prevent the evil from breaking out by removing early the causes from which it would seem that conflict between employers and workers is bound to arise.

And in like manner, in the case of the worker, there are many things which the power of the State should protect; and, first of all, the good of his soul. For however good and desirable mortal life be. yet it is not the ultimate goal for which we are born, but a road only and a means for perfecting, through knowledge of truth and love of good, the life of the soul. The soul bears the express image and likeness of God, and there resides in it that sovereignty through the medium of which man has been bidden to rule all created nature below him and to make all lands and all seas serve his interest. "Fill the earth and subdue it, and rule over the fishes of the sea and the fowls of the air and all living creatures that move upon the earth." In this respect all men are equal, and there is no difference between rich and poor, between masters and servants, between rulers and subjects: "For there is the same Lord of all." No one may with impunity outrage the dignity of man, which God Himself treats with great reverence, nor impede his course to that level of perfection which accords with eternal life in heaven. Nav. more, in this connection a man cannot even by his own free choice allow himself to be treated in a way inconsistent with his nature, and suffer his soul to be enslaved; for there is no question here of rights belonging to man, but of duties owed to God, which are to be religiously observed.

Hence follows necessary cessation from toil and work on Sundays and Holy Days of Obligation. Let no one, however, understand this in the sense of greater indulgence of idle leisure, and much less in the sense of that kind of cessation from work, such as many desire, which encourages vice and promotes wasteful spending of money, but solely in the sense of a

repose from labor made sacred by religion. Rest combined with religion calls man away from toil and the business of daily life to admonish him to ponder on heavenly goods and to pay his just and due homage to the Eternal Deity. This is especially the nature and this the cause. of the rest to be taken on Sundays and Holy Days of Obligation, and God has sanctioned the same in the Old Testament by a special law: "Remember thou keep holy the Sabbath Day," and He Himself taught it by His own action: namely the mystical rest taken immediately after He had created man: "He rested on the seventh day from all His work which He had done."

Now as concerns the protection of corporeal and physical goods, the oppressed workers above all, ought to be liberated from the savagery of greedy men, who inordinately use human beings as things of gain. Assuredly, neither justice nor humanity can countenance the exaction of so much work that the spirit is dulled from excessive toil and that along with it the body sinks crushed from exhaustion. The working energy of a man, like his entire nature, is circumscribed by definite limits beyond which it cannot go. It is developed indeed by exercise and use, but only on condition that a man cease from work at regular intervals and rest. With respect to daily work, therefore, care ought to be taken not to extend it beyond the hours that human strength warrants. The length of rest intervals ought to be decided on the basis of the varying nature of the work, of the circumstances of time and place, and of the physical condition of the workers themselves. Since the labor of those who quarry stone from the earth, or who mine iron, copper, and other underground materials, is much more severe and harmful to health, the working period for such men ought to be correspondingly shortened. The seasons of the year also must be taken into account; for often a given kind of work is easy to endure in one season but cannot be endured at all in another, or not without the greatest difficulty.

Finally, it is not right to demand of a woman or a child what a strong adult man is capable of doing or would be willing to do. Nay, as regards children, special care ought to be taken that the factory does not get hold of them before age has sufficiently matured their physical, intellectual, and moral powers. For budding strength in childhood, like greening verdure in spring, is crushed by premature harsh treatment; and under such circumstances all education of the child must needs be foregone. Certain occupations likewise are less fitted for women. who are intended by nature for work of the home—work indeed which especially protects modesty in women and accords by nature with the education of children and the well-being of the family. Let it be the rule everywhere that workers be given as much leisure as will compensate for the energy consumed by toil, for rest from work is necessary to restore strength consumed by use. In every obligation which is mutually contracted between employers and workers, this condition, either written or tacit, is always present, that both kinds of rest be provided for; nor would it be equitable to make an agreement otherwise, because no one has the right to demand of, or to make an agreement with, anyone to neglect those duties which bind a man to God or to himself.

II. The Drift of Scientific Thought

The political debate which went on in public was accompanied by another whose results would be just as far-reaching. Darwin's publication of *The Origin of Species* in 1859, and the scientific arguments which immediately sprang up around it, affected accepted ideas and fundamentally altered the pattern of reality. The new scientific revelations persuaded a great many men that all the secrets of a mechanically determined world awaited eventual discovery by scientific processes which were ultimately infallible. They also persuaded some more skeptical thinkers that, until adduction of proof, doubt—even on religious questions—was at least as reasonable and worthy of respect as affirmation. Lastly, when vulgarized and (mis)interpreted, they seemed to endorse the current doctrines of free enterprise and the idea that survival and success went to the fittest in human society as, apparently, they did in nature.

1. COMTE

It is not surprising that at a time when science seemed to challenge established religion and cast serious doubts on any divine sanction for morality, men should turn toward a religion of science, an attempt to explain the world (and hence lay down rules for behavior in it) in positive—scientific—terms. One of these men was Auguste Comte (1798–1857), the French mathematician and philosopher, founder of positivism, whose Course of Positive Philosophy was one of the century's most influential works. His philosophical system was completed by a religion of humanity which would be inculcated, in part, by the use of a new and original calendar designed to express a "positive" hierarchy of values, a theory of historical progress culminating in the "positive" scientific achievements of the nineteenth century.

Comte published the calendar that follows in his Positivistic Catechism of 1852. It purports to reflect the progress of humanity from a relatively primitive organization of society and stage of civilization, to the heights attained in his time. It also divides the year into thirteen months, each of four weeks of seven days. Each month edifyingly symbolizes a stage in humanity's advance from the initial theocracy, incarnated in Moses, to the revelations of modern science, represented by Bichat, a French anatomist and physiologist of the eighteenth century (1771–1802), who has long been forgotten together with his once-much-admired magnum opus, the Anatomie Générale.

Absurd though all this may seem today, it affords precious evidence on the values and ideas of an exceptional though eccentric man; and it remains, when all is said and done, no more ridiculous than any other schematic interpretation of history.

POSITIVISTIC CALENDAR

for any given year

or A CONCRETE TABLE OF HUMAN PREPARATION

First Month MOSES THE INITIAL THEOCRACY		MOSES	Second Month HOMER ANCIENT POETRY	Third Month ARISTOTLE ANCIENT PHILOSOPHY
Mon. Tues. Wed. Thurs. Fri. Sat. Sun.	3 4 5 6	Prometheus Hercules Theseus Orpheus Ulysses Lycurgus Romulus NUMA	Hesiod Tyrteus Sapho Anacreon Pindarus Sophocles Euripides Theocritus Longus ESCHYLUS	Anaximander Anaximenes Heraclitus Anaxagoras Democritus Leucippus Herodotus THALES
		Belus Semiramis Sesostris Manus Cyrus Zoroaster The Druids Ossian BUDDHA	Scopas Zeuxis Ictinus Praxiteles Lysippus Apelles PHIDIAS	Solon Xenophanes Empedocles Thucydides Archytas Philolaus Apollonius of Tyana PYTHAGORAS
	15 16 17 18 19 20 21	Fo-Hi Lao-Tse Meng-Tse The theocrats of Tibet The theocrats of Japan Manco-Capac CONFUCIUS	Esopus Plautus Terence Menander Phedra Juvenal Lucian ARISTOPHANES	Aristippus Antisthenes Zeno Cicero Pliny the Younger Epictetus Arius Tacitus SOCRATES
	22 23 24 25 26 27 28	Isaiah St. John the Baptist	Ennius Lucretius Horace Tibullus Ovid Lucan VIRGIL	Xenocrates Philo of Alexandria St. John the Evangelist St. Justin St. Ireneus St. Clement of Alexandria Origen Tertullian PLATO

Fourth Month ARCHIMEDES ANCIENT SCIENCE	Fifth Month CESAR MILITARY CIVILISATION	Sixth Month ST. PAUL CATHOLICISM
Theophrastus Hierophilus Erasistratus Celsius Galen Avicenna Averrhoes HIPPOCRATES	Miltiades Leonidas Aristides Cimon Xenophon Phocion Epaminondas THEMISTOCLES	St. Luke St. Cyprian St. Athanasius St. Jerome St. Ambrose St. Monica ST. AUGUSTIN
Euclid Aristeus Theodosius of Bythinia Hero Clesibius Pappus Diophantes APOLLONIUS	Pericles Philip Demosthenes Ptolemeus Lagus Philopoemen Polybius ALEXANDER	Constantine Theodosius St. Chrysostom St. Basil St. Pulcheria Marcian St. Genevieve of Paris St. Gregory the Great HILDEBRAND
Eudoxius Pytheas Nearchus Aristarchus Berosius Eratosthenes Ptolemeus Albategnius Nasr-ed-Din HIPPARCHUS	Junius Brutus Camillus Cincinnatus Fabricius Regulus Hannibal Paulus-Emilius Marius The Gracchi SCIPIO	St. Benedict St. Anthony St. Boniface St. Isidore of Seville St. Bruno Lanfranc St. Anselm Heloïse Beatrice The medieval architects ST. BERNARD
Varro Columella Vitruvius Strabo Frontinus Plutarch PLINIUS THE ELDER	Augustus Mecenas Vespasian Titus Hadrian Nerva Antoninus Marcus-Aurelius Papinian Ulpian Alexander Severus TRAJAN	St. Francis Xavier St. Ig. Loyola St. Charles Borromeus St. Theresa St. Catherine of Sienna St. Vincent de Paul Bourdaloue Claude Fleury W. Penn G. Fox BOSSUET

Seventh Month CHARLEMAGNE FEUDAL CIVILISATION	Eighth Month DANTE THE MODERN EPIC	Ninth Month GUTEMBERG MODERN INDUSTRY
Theodoric the Great Pelagius Otto the Great Henry the Fowler St. Henry Villiers La Valette Don Juan of Lepanto Jan Sobieski KING ALFRED	The Troubadours Boccacio Chaucer Rabelais Cervantes La Fontaine De Foe Smith ARIOSTO	Marco Polo Jacques Cœur Gama Gresham Magellan Neper Lacaille Cook Delambre Delambre Tasman
Charles Martel Le Cid Tancred Richard Lion Heart Saladdin Joan of Arc Albuquerque Walter Raleigh Bayard GODEFROI DE BOUILLON	Leonardo Titian Michelangelo Veronese Holbein Rembrandt Poussin Lesueur Velasques Alonzo Cano Teniers Rubens Raphael	Benvenuto Cellini Amontons Wheatstone Harrison Pierre Leroy Dollond Graham Arkwright Jacquart Conté VAUCANSON
St. Leo the Great Leo IV Gerbert Peter Damian Peter the Hermit Abbot Suger St. Eloï Alexander III Thomas Becket St. Francis of Assisi St. Dominic INNOCENT III	Froissart Joinville Camoens The Spanish Romanceros Chateaubriand Walter Scott Cooper Manzoni TASSO	Stevin Torricelli Mariotte R. Boyle Papin Worcester Black Jouffroy Fulton Dalton Thilorier WATT
St. Clotilda St. Bathilda St. Matthew of Tuscany St. Stephen of Hungary Matthias Corvinus St. Elizabeth of Hungary Blanche of Castile St. Ferdinand III Alphonse X SAINT LOUIS	Petrarch Thomas a'Kempis Mme. de Lafayette Mme. de Staël Fénelon St. Francis of Sales Klopstock Gessner Byron Elisa Mercoeur MILTON	Bernard Palissy Guglielmini Riquet Duhamel du Monceau Saussure Bouguer Coulomb Borda Carnot Vauban MONTGOLFIER

Tenth Month SHAKESPEARE Modern Drama	Eleventh Month DESCARTES Modern Philosophy	Twelfth Month FREDERIC Modern Politics
Lope de Vega	Albert the Great	Molina
	John of Salisbury	
Moreto Guillen de Castro	Roger Bacon Raimond Lulle	Cosimo Medici the Older
Rojas Guevara	St. Bonaventura Joachim	Comines Guicciardina
Otway	Ramus Card. of Cusa	Isabel of Castile
Lessing	Montaigne Erasmus	Charles V Sixtus V
Goethe	Campanella Thomas More	Henry IV
CALDERON	ST. THOMAS AQUINAS	LOUIS XI
	A CONTRACTOR OF THE CONTRACTOR	and the state of t
Tirso	HobbesSpinoza	Coligny de l'Hôpital
Vondel	Hobbes Spinoza Pascal Giordano Bruno	Barneveldt de i Hopital
Racine	Locke Malebranche	Gustavus-Adolphus
Voltaire	Vauvenargues Wateoranche	De Witt
Voltaire	Mme. de Lambert	De Witt
Metastasio Alfieri	Diderot Destutt de Tracy	Ruyter
Schiller Atjust	Cabanis Georges Leroy	William III of Orange
CORNEILLE	CHANCELLOR BACON	WILLIAM THE SILENT
CORNEILLE	CHANCELLOR BACON	WILLIAM THE SILENT
Alarcon	Grotius Cujas	Ximenes
Mme. de Motteville Mme. Roland	Fontenelle Maupertuis	Sully Oxenstierna
Mme. de Sévigné Lady Montague	Vico Herder	Colbert Louis XIV
Lesage Sterne	Fréré Winckelmann	Walpole Mazarin
Mme. de Staël	Montesquieu d'Aguesseau	d'ArandaPombal
Miss Edgeworth		
Fielding Richardson	Buffon Oken	Turgot Campomanes
MOLIÈRE	LEIBNITZ	RICHELIEU
Develope Deleting	D-b-star	C'1
Pergolese Palestrina Sachini Grétry	Robertson Gibbon	Sidney Lambert
	Adam Smith Dunoyer	Franklin
	Kant Fichte	Washington Kosciusko
Beethoven Handel Rossini Weber	Condorcet Ferguson	Jefferson
ROSSIII Weber	Joseph de Maistre Bonald	Bolivar
Dallini Dani u	II	Toussaint l'Ouverture
Bellini Donizetti	Hegel Sophie Germain	Francia
MOZART	HUME	CROMWELL

Thirteenth Month BICHAT Modern Science

Copernicus ... Tycho Brahe
Kepler ... Halley
Huyghens ... Varignou
Jacques Bernoulli ... Jean Bernoulli
Bradley ... Roëmer
Volta ... Sauveur
GALILEO

Viète ... Harriott
Wallis ... Fermat
Clairaut ... Poinsot
Euler ... Monge
D'Alembert ... Daniel Bernoulli
Lagrange ... Joseph Fourier
NEWTON

Bergmann ... Scheele
Priestley ... Davy
Cavendish
Guyton-Morveau ... Geoffroy
Berthollet
Berzelius ... Ritter
LAVOISIER

Harvey
Boërhaave
Linneus
Haller
Lamarck
Broussais
GALL

... Charles Bell
... Stahl
... Bernard de Jussieu
... Vicq-d'Azyr
... Blainville
... Morgagni

One complementary day dedicated to a UNIVERSAL FESTIVAL OF THE DEAD.

On leap years, the extra day is to be devoted to the solemn reprobation of the two main regressive figures in the history of humanity — Julian the Apostate and Napoleon Bonaparte — but this only during the first half-generation. Thus, after the first four celebrations of this festival of reprobates, this exceptional day will be used for its normal purpose of celebrating the Cult of the Absolute.

2. WALLACE

Alfred Russel Wallace (1823–1913), one of the founders of zoological geography, was a Scottish naturalist and interpreter of Darwin. While Darwin was still working on his theory, Wallace, thinking upon Malthus' Essay on Population, hit upon the idea of the survival of the fittest and wrote to Darwin about it. The coincidence has caused him to be coupled with Darwin as one of the originators of the theory of natural selection. There is, however, no indication of this in the following extract which provides a luminous account of Darwin's theory and its effect on current scientific thought.

From: Darwinism

THE CHANGE OF OPINION EFFECTED BY DARWIN

The point I wish especially to urge is this. Before Darwin's work appeared, the great majority of naturalists, and almost without exception the whole literary and scientific world, held firmly to the belief that species were realities, and had not been derived from other species by any process accessible to us; the different species of crow and of violet were believed to have been always as distinct and separate as they are now, and to have originated by some totally unknown process so far removed from ordinary reproduction that it was usually spoken of as "special creation." There was, then, no question of the origin of families, orders, and classes, because the very first step of all, the "origin of species," was believed to be an insoluble problem. But now this is all changed. The whole scientific and literary world, even the whole educated public, accepts, as a matter of common knowledge, the origin of species from other allied species by the ordinary process of natural birth. The idea of special creation or any altogether exceptional mode of production is absolutely extinct! Yet more: this is held also to apply to many

higher groups as well as to the species of a genus, and not even Mr. Darwin's severest critics venture to suggest that the primeval bird, reptile, or fish must have been "specially created." And this vast, this totally unprecedented change in public opinion has been the result of the work of one man, and was brought about in the short space of twenty years! This is the answer to those who continue to maintain that the "origin of species" is not yet discovered; that there are still doubts and difficulties; that there are divergencies of structure so great that we cannot understand how they had their beginning. We may admit all this, just as we may admit that there are enormous difficulties in the way of a complete comprehension of the origin and nature of all the parts of the solar system and of the stellar universe. But we claim for Darwin that he is the Newton of natural history, and that, just so surely as that the discovery and demonstration by Newton of the law of gravitation established order in place of chaos and laid a sure foundation for all future study of the starry heavens, so surely has Darwin, by his discovery of the law of natural selection and his demonstration of the great principle of the preservation of useful variations in the struggle for life,

From Alfred Russel Wallace, Darwinism (London, 1889).

not only thrown a flood of light on the process of development of the whole organic world, but also established a firm foundation for all future study of nature.

In order to show the view Darwin took of his own work, and what it was that he alone claimed to have done, the concluding passage of the introduction to the Origin of Species should be carefully considered. It is as follows: "Although much remains obscure, and will long remain obscure. I can entertain no doubt, after the most deliberate and dispassionate judgment of which I am capable, that the view which most naturalists until recently entertained and which I formerly entertained-namely, that each species has been independently created—is erroneous. I am fully convinced that species are not immutable; but that those belonging to what are called the same genera are lineal descendants of some other and generally extinct species, in the same manner as the acknowledged varieties of any one species are the descendants of that species. Furthermore, I am convinced that Natural Selection has been the most important, but not the exclusive, means of modification."

It should be especially noted that all which is here claimed is now almost universally admitted, while the criticisms of Darwin's works refer almost exclusively to those numerous questions which, as he himself says, "will long remain obscure."

THE DARWINIAN THEORY

The theory of natural selection rests on two main classes of facts which apply to all organised beings without exception, and which thus take rank as fundamental principles or laws. The first is, the power of rapid multiplication in a geometrical progression; the second, that the offspring always vary slightly from the parents, though generally very loosely resembling them. From the first fact or law there follows, necessarily, a constant struggle for existence; because, while the offspring always exceed the parents in number, generally to an enormous extent, vet the total number of living organisms in the world does not, and cannot, increase year by year. Consequently every year, on the average, as many die as are born, plants as well as animals; and the majority die premature deaths. They kill each other in a thousand different ways; they starve each other by some consuming the food that others want; they are destroyed largely by the powers of nature —by cold and heat, by rain and storm, by flood and fire. There is thus a perpetual struggle among them which shall live and which shall die; and this struggle is tremendously severe, because so few can possibly remain alive-one in five, one in ten, often only one in a hundred or even one in a thousand.

Then comes the question, Why do some live rather than others? If all the individuals of each species were exactly alike in every respect, we could only say it is a matter of chance. But they are not alike. We find that they vary in many different ways. Some are stronger, some swifter, some hardier in constitution, some more cunning. An obscure colour may render concealment more easy for some, keener sight may enable others to discover prev or escape from an enemy better than their fellows. Among plants the smallest differences may be useful or the reverse. The earliest and strongest shoots may escape the slug; their greater vigour may enable them to flower and seed earlier in a wet autumn; plants best armed with spines or hairs may escape being devoured; those whose flowers are most conspicuous may be soonest fertilised by insects. We cannot doubt that, on the whole, any beneficial variations will give the possessors of it a greater probability of living through the tremendous ordeal they have to undergo. There may be something left to chance, but on the whole the fittest will survive.

THE ETHICAL ASPECT OF THE STRUGGLE FOR EXISTENCE

Our exposition of the phenomena presented by the struggle for existence may be fitly concluded by a few remarks on its ethical aspect. Now that the war of nature is better known, it has been dwelt upon by many writers as presenting so vast an amount of cruelty and pain as to be revolting to our instincts of humanity, while it has proved a stumbling-block in the way of those who would fain believe in an all-wise and benevolent ruler of the universe. Thus, a brilliant writer says: "Pain, grief, disease, and death, are these the inventions of a loving God? That no animal shall rise to excellence except by being fatal to the life of others, is this the law of a kind Creator? It is useless to say that pain has its benevolence, that massacre has its mercy. Why is it so ordained that bad should be the raw material of good? Pain is not the less pain because it is useful; murder is not less murder because it is conducive to development. Here is blood upon the hand still, and all the perfumes of Arabia will not sweeten it."

Even so thoughtful a writer as Professor Huxley adopts similar views. In a recent article on "The Struggle for Existence" he speaks of the myriads of generations of herbivorous animals which "have been tormented and devoured by carnivores"; of the carnivores and herbivores alike "subject to all the miseries incidental to old age, disease, and over-multiplication"; and of the "more or less enduring suffering," which is the meed of both vanquished and víctor. And he concludes that, since thousands of times a minute, were our ears sharp enough, we should hear sighs and groans of pain like those heard by Dante at the gate of hell, the world cannot be governed by what we call benevolence.

Now there is, I think, good reason to believe that all this is greatly exaggerated; that the supposed "torments" and "miseries" of animals have little real existence, but are the reflection of the imagined sensations of cultivated men and women in similar circumstances; and that the amount of actual suffering caused by the struggle for existence among animals is altogether insignificant. . . .

We have a horror of all violent and sudden death, because we think of the life full of promise cut short, of hopes and expectations unfulfilled, and of the grief of mourning relatives. But all this is quite out of place in the case of animals, for whom a violent and a sudden death is in every way the best. Thus the poet's picture of "Nature red in tooth and claw With ravine" is a picture the evil of which is read into it by our imaginations, the reality being made up of full and happy lives, usually terminated by the quickest and least painful of deaths.

On the whole, then, we conclude that the popular idea of the struggle for existence entailing misery and pain on the animal world is the very reverse of the truth. What it really brings about, is, the maximum of life and of the enjoyment of life with the minimum of suffering and pain. Given the necessity of death and reproduction—and without these

there could have been no progressive development of the organic world,—and it is difficult even to imagine a system by which a greater balance of happiness could have been secured. And this view was evidently that of Darwin himself, who thus concludes his chapter on the

struggle for existence: "When we reflect on this struggle, we may console ourselves with the full belief that the war of nature is not incessant, that no fear is felt, that death is generally prompt, and that the vigorous, the healthy, and the happy survive and multiply."

3. HUXLEY AND WILBERFORCE

The kind of ruckus which surrounded the emergence of Darwinian ideas appears below in Leonard Huxley's account of the debate between his celebrated father and the bishop of Oxford, Dr. Wilberforce. Such exchanges reflected the high feelings aroused by the controversy that surged around *The Origin of Species* and that, incidentally, furnished it further publicity.

The Debate between Thomas Huxley and Bishop Wilberforce

The famous Oxford Meeting of 1860 was of no small importance in Huxley's career. It was not merely that he helped to save a great cause from being stifled under misrepresentation and ridicule—that he helped to extort for it a fair hearing; it was not that he first made himself known in popular estimation as a dangerous adversary in debate—a personal force in the world of science which could not be neglected. From this moment he entered the front fighting line in the most exposed quarter of the field.

Most unluckily, no contemporary account of his own exists of the encounter. Indeed, the same cause which prevented his writing home the story of the day's work nearly led to his absence from the scene. It was known that Bishop Wilberforce, whose first class in mathematics gave him, in popular estimation, a right to treat on scientific matters intended to "smash Darwin"; and Huxley, expecting that the promised debate would be merely an appeal to prejudice in a mixed audience, before which the scientific argu-

ments of the Bishop's opponents would be at the utmost disadvantage, intended to leave Oxford that very morning and join his wife at Hardwicke, near Reading, where she was staying with her sister. But in a letter, quoted below, he tells how, on the Friday afternoon, he chanced to meet Robert Chambers, the reputed author of the *Vestiges of Creation*, who begged him "not to desert them." Accordingly he postponed his departure; but seeing his wife next morning, had no occasion to write a letter.

Several accounts of the scene are already in existence: one in the Life of Darwin (vol. ii, p. 320), another in the 1892 Life, p. 236 sq.; a third that of Lyell (vol. ii, p. 335), the slight difference between them representing the difference between individual recollections of eye-witnesses. In addition to these I have been fortunate enough to secure further reminiscences from several other eye-witnesses.

Two papers in Section D, of no great importance in themselves, became histori-

From Leonard Huxley, Life and Letters of Thomas Henry Huxley, 2 vol. (New York, 1900).

cal as affording the opponents of Darwin their opportunity of making an attack upon his theory which should tell with the public. The first was on Thursday, June 28. Dr. Daubeny of Oxford made a communication to the Section, "On the final causes of the sexuality of plants, with particular reference to Mr. Darwin's work on the *Origin of Species*." Huxley was called upon to speak by the President, but tried to avoid a discussion, on the ground "that a general audience, in which sentiment would unduly interfere with intellect, was not the public before which such a discussion should be carried on."

This consideration, however, did not stop the discussion; it was continued by Owen. He said he "wished to approach the subject in the spirit of the philosopher," and declared his "conviction that there were facts by which the public could come to some conclusion with regard to the probabilities of the truth of Mr. Darwin's theory." As one of these facts, he stated that the brain of the gorilla "presented more differences, as compared with the brain of man, than it did when compared with the brain of the very lowest and most problematical of the Quadrumana."

Now this was the very point, as said above, upon which Huxley had made special investigations during the last two years, with precisely opposite results, such as, indeed, had been arrived at by previous investigators. Hereupon he replied, giving these assertions a "direct and unqualified contradiction," and pledging himself to "justify that unusual procedure elsewhere,"—a pledge which was amply fulfilled in the pages of the *Natural History Review* for 1861.

Accordingly it was to him, thus marked out as the champion of the most debatable thesis of evolution, that, two days later,

the Bishop addressed his sarcasms, only to meet with a withering retort. For on the Friday there was peace; but on the Saturday came a yet fiercer battle over the "Origin," which loomed all the larger in the public eye, because it was not merely the contradiction of one anatomist by another, but the open clash between Science and the Church. It was, moreover, not a contest of bare fact or abstract assertion, but a combat of wit between two individuals, spiced with the personal element which appeals to one of the strongest instincts of every large audience.

It was the merest chance . . . that Huxley attended the meeting of the section that morning. Dr. Draper of New York was to read a paper on the "Intellectual Development of Europe considered with reference to the views of Mr. Darwin." "I can still hear," writes one who was present, "the American accents of Dr. Draper's opening address when he asked 'Are we a fortuitous concourse of atoms?" However, it was not to hear him but the eloquence of the Bishop, that the members of the Association crowded in such numbers into the Lecture Room of the Museum, that this, the appointed meeting-place of the section, had to be abandoned for the long west room, since cut in two by a partition for the purposes of the library. It was not term time, nor were the general public admitted; nevertheless the room was crowded to suffocation long before the protagonists appeared on the scene, 700 persons or more managing to find places. The very windows by which the room was lighted down the length of its west side were packed with ladies, whose white handkerchiefs, waving and fluttering in the air at the end of the Bishop's speech, were an unforgettable factor in the acclamation of the crowd.

The clergy, who shouted lustily for the Bishop, were massed in the middle of the room; behind them in the north-west corner a knot of undergraduates (one of these was T. H. Green, who listened but took no part in the cheering) had gathered together beside Professor Brodie, ready to lift their voices, poor minority though they were, for the opposite party. Close to them stood one of the few men among the audience already in Holy Orders, who joined in—and indeed led—the cheers for the Darwinians.

So "Dr. Draper droned out his paper, turning first to the right hand and then to the left, of course bringing in a reference to the *Origin of Species* which set the ball rolling."

An hour or more that paper lasted, and then discussion began. The President "wisely announced in limine that none who had not valid arguments to bring forward on one side or the other would be allowed to address the meeting; a caution that proved necessary, for no fewer than four combatants had their utterances burked by him, because of their indulgence in vague declamation."

First spoke (writes Professor Farrar) a layman from Brompton, who gave his name as being one of the Committee of the (newly formed) Economic section of the Association. He, in a stentorian voice, let off his theological venom. Then jumped up Richard Greswell with a thin voice, saying much the same, but speaking as a scholar; but we did not merely want any theological discussion, so we shouted them down. Then a Mr. Dingle got up and tried to show that Darwin would have done much better if he had taken him into consultation. He used the blackboard and began a mathematical demonstration on the question-"let this point A be man, and let that point B be the mawnkey." He got no further; he was shouted down with cries of "mawnkey." None of these had spoken more than three minutes. It was when these were shouted down that Henslow said he must demand that the discussion should rest on scientific grounds only.

Then there were calls for the Bishop, but he rose and said he understood his friend Professor Beale had something to say first. Beale, who was an excellent histologist, spoke to the effect that the new theory ought to meet with fair discussion, but added, with great modesty, that he himself had not sufficient knowledge to discuss the subject adequately. Then the Bishop spoke the speech that you know, and the question about his mother being an ape, or his grandmother.

From the scientific point of view, the speech was of small value. It was evident from his mode of handling the subject that he had been "crammed up to the throat," and knew nothing at first hand; he used no argument beyond those to be found in his Quarterly article, which appeared a few days later, and is now admitted to have been inspired by Owen. "He ridiculed Darwin badly and Huxley savagely; but," confesses one of his strongest opponents, "all in such dulcet tones, so persuasive a manner, and in such well turned periods, that I who had been inclined to blame the President for allowing a discussion that could serve no scientific purpose, now forgave him from the bottom of my heart."

The Bishop spoke thus "for full half an hour with inimitable spirit, emptiness and unfairness." "In a light, scoffing tone, florid and fluent, he assured us there was nothing in the idea of evolution; rockpigeons were what rock-pigeons had always been. Then, turning to his antagonist with a smiling insolence, he begged

to know, was it through his grandfather or his grandmother that he claimed his descent from a monkey?"

This was the fatal mistake of his speech. Huxley instantly grasped the tactical advantage which the descent to personalities gave him. He turned to Sir Benjamin Brodie, who was sitting beside him, and emphatically striking his hand upon his knee, exclaimed, "The Lord hath delivered him into mine hands." The bearing of the exclamation did not dawn upon Sir Benjamin until after Huxley had completed his "forcible and eloquent" answer to the scientific part of the Bishop's argument, and proceeded to make his famous retort.

On this (continues the writer in Macmillan's Magazine) Mr. Huxley slowly and deliberately arose. A slight, tall figure, stern and pale, very quiet and very grave, he stood before us and spoke those tremendous words—words which no one seems sure of now, nor, I think, could remember just after they were spoken, for their meaning took away our breath, though it left us in no doubt as to what it was. He was not ashamed to have a monkey for his ancestor; but he would be

ashamed to be connected with a man who used great gifts to obscure the truth. No one doubted his meaning, and the effect was tremendous. One lady fainted and had to be carried out; I, for one, jumped out of my seat.

The fullest and probably most accurate account of these concluding words is the following, from a letter of the late John Richard Green, then an undergraduate, to his friend, afterwards Professor Boyd Dawkins:

I asserted-and I repeat-that a man has no reason to be ashamed of having an ape for his grandfather. If there were an ancestor whom I should feel shame in recalling it would rather be a man-a man of restless and versatile intellect-who. not content with an equivocal success in his own sphere of activity, plunges into scientific questions with which he has no real acquaintance, only to obscure them by an aimless rhetoric, and distract the attention of his hearers from the real point at issue by eloquent digressions and skilled appeals to religious prejudice.

4. HAECKEL

Ernst Haeckel (1834–1919), the German biologist and one of Darwin's most devoted propagandists, was one of many who tried to apply the doctrine of evolution to philosophical and religious problems. His philosophy, called *Monism*, sees organic and inorganic nature as one, and life as deriving from carbon.

From: The Riddle of the Universe

THE LAW OF SUBSTANCE

The supreme and all-pervading law of nature, the true and only cosmological law, is, in my opinion, the law of sub-

stance; its discovery and establishment is the greatest intellectual triumph of the nineteenth century, in the sense that all other known laws of nature are subordinate to it. Under the name of "law of

From Ernst Haeckel, The Riddle of the Universe, tr. Joseph McCabe (New York, 1900).

substance" we embrace two supreme laws of different origin and age—the older is the chemical law of the "conservation of matter," and the younger is the physical law of the "conservation of energy." . . .

The law of the "persistence" or "indestructibility of matter," established by Lavoisier in 1789, may be formulated thus: The sum of matter, which fills infinite space, is unchangeable. A body has merely changed its form, when it seems to have disappeared. When coal burns, it is changed into carbonic-acid gas by combination with the oxygen of the atmosphere; when a piece of sugar melts in water, it merely passes from the solid to the fluid condition. In the same way, it is merely a question of change of form in the cases where a new body seems to be produced. A shower of rain is the moisture of the atmosphere cast down in the form of drops of water; when a piece of iron rusts, the surface layer of the metal has combined with water and with atmospheric oxygen, and formed a "rust," or oxyhydrate of iron. Nowhere in nature do we find an example of the production, or "creation," of new matter; nowhere does a particle of existing matter pass entirely away. This empirical truth is now the unquestionable foundation of chemistry: . . .

We may formulate the "law of the persistence of force" or "conservation of energy" thus: The sum of force, which is at work in infinite space and produces all phenomena, is unchangeable. When the locomotive rushes along the line, the potential energy of the steam is transformed into the kinetic or actual energy of the mechanical movement; . . . The whole marvelous panorama of life that spreads over the surface of our globe is, in the last analysis, transformed sunlight. It is well known how the remarkable progress

of technical science has made it possible for us to convert the different physical forces from one form to another; heat may be changed into molar movement, or movement of mass; this in turn into light or sound, and then into electricity, and so forth. Accurate measurement of the quantity of force which is used in this metamorphosis has shown that it is "constant" or unchanged. No particle of living energy is ever extinguished; no particle is ever created anew.

The sum-total of force or energy in the universe remains constant, no matter what changes take place around us; it is eternal and infinite, like the matter on which it is inseparably dependent. The whole drama of nature apparently consists in an alternation of movement and repose; yet the bodies at rest have an inalienable quantity of force, just as truly as those that are in motion. . . .

Once modern physics had established the law of substance as far as the simpler relations of inorganic bodies are concerned, physiology took up the story, and proved its application to the entire province of the organic world. It showed that all the vital activities of the organismwithout exception-are based on a constant "reciprocity of force" and a correlative change of material, or metabolism, just as much as the simplest processes in "lifeless" bodies. Not only the growth and the nutrition of plants and animals, but even their functions of sensation and movement, their sense-action and psychic life, depend on the conversion of potential into kinetic energy, and vice versa. This supreme law dominates also those elaborate performances of the nervous system which we call, in the higher animals and man, "the action of the mind."

Our monistic view, that the great cos-

mic law applies throughout the whole of nature, is of the highest moment. For it not only involves, on its positive side, the essential unity of the cosmos and the causal connection of all phenomena that come within our cognizance, but it also, in a negative way, marks the highest intellectual progress, in that it definitely rules out the three central dogmas of metaphysics—God, freedom, and immortality. In assigning mechanical causes to phenomena everywhere, the law of substance comes into line with the universal law of causality.

In the philosophy of history—that is, in the general reflections which historians make on the destinies of nations and the complicated course of political evolution —there still prevails the notion of a "moral order of the universe." Historians seek in the vivid drama of history a leading design, an ideal purpose, which has ordained one or other race or state to a special triumph, and to dominion over the others. This teleological view of history has recently become more strongly contrasted with our monistic view in proportion as monism has proved to be the only possible interpretation of inorganic nature. Throughout the whole of astronomy, geology, physics, and chemistry there is no question to-day of a "moral order," or a personal God, whose "hand hath disposed all things in wisdom and understanding." And the same must be said of the entire field of biology, the whole constitution and history of organic nature, if we set aside the question of man for the moment. Darwin has not only proved by his theory of selection that the orderly processes in the life and structure of animals and plants have arisen by mechanical laws without any preconceived design, but he has shown us in the "struggle for life" the powerful natural force which has exerted supreme control over the entire course of organic evolution for millions of years. It may be said that the struggle for life is the "survival of the fittest" or the "victory of the best": that is only correct when we regard the strongest as the best (in a moral sense). Moreover, the whole history of the organic world goes to prove that, besides the predominant advance towards perfection, there are at all times cases of retrogression to lower stages. Even Baer's notion of "design" has no moral feature whatever.

Do we find a different state of things in the history of peoples, which man, in his anthropocentric presumption, loves to call "the history of the world"? Do we find in every phase of it a lofty moral principle or a wise ruler, guiding the destinies of nations? There can be but one answer in the present advanced stage of natural and human history: No. The fate of those branches of the human familv, those nations and races which have struggled for existence and progress for thousands of years, is determined by the same "eternal laws of iron" as the history of the whole organic world which has peopled the earth for millions of years.

5. HUXLEY

Thomas Henry Huxley (1825–1895) was recognized as the foremost English biologist of the sixties and seventies and was elected President of the Royal Society in 1883. His insistence on a strictly scientific approach, as distinguished from the meta-

physical or theological, earned him many enemies and much opposition; but the ethical attitude reflected in his lecture on *Evolution and Ethics* seems far from the ruthlessness of contemporary materialists.

From: Evolution and Ethics

As no man fording a swift stream can dip his foot twice into the same water, so no man can, with exactness, affirm of anything in the sensible world that it is. As he utters the words, nay, as he thinks them, the predicate ceases to be applicable: the present has become the past; the "is" should be "was." And the more we learn of the nature of things, the more evident is it that what we call rest is only unperceived activity; that seeming peace is silent but strenuous battle. In every part, at every moment, the state of the cosmos is the expression of a transitory adjustment of contending forces; a scene of strife, in which all the combatants fall in turn. What is true of each part, is true of the whole. Natural knowledge tends more and more to the conclusion that "all the choir of heaven and furniture of the earth" are the transitory forms of parcels of cosmic substance wending along the road of evolution, from nebulous potentiality, through endless growths of sun and planet and satellite; through all varieties of matter; through infinite diversities of life and thought; possibly, through modes of being of which we neither have a conception, nor are competent to form any, back to the indefinable latency from which they arose. Thus the most obvious attribute of the cosmos is its impermanence. It assumes the aspect not so much of a permanent entity as of a changeful process, in which naught endures save the flow of energy and the rational order which pervades it.

We are more than sufficiently familiar with modern pessimism. . . . We also know modern speculative optimism, with its perfectibility of the species, reign of peace, and lion and lamb transformation scenes: but one does not hear so much of it as one did forty years ago; indeed, I imagine it is to be met with more commonly at the tables of the healthy and wealthy, than in the congregations of the wise. The majority of us, I apprehend, profess neither pessimism nor optimism. We hold that the world is neither so good, nor so bad, as it conceivably might be: and, as most of us have reason, now and again, to discover that it can be. Those who have failed to experience the joys that make life worth living are, probably, in as small a minority as those who have never known the griefs that rob existence of its sayour and turn its richest fruits into mere dust and ashes.

Further, I think I do not err in assuming that, however diverse their views on philosophical and religious matters, most men are agreed that the proportion of good and evil in life may be very sensibly affected by human action. I never heard anybody doubt that the evil may be thus increased, or diminished; and it would seem to follow that good must be similarly susceptible of addition or subtraction. Finally, to my knowledge, nobody professes to doubt that, so far forth as we possess a power of bettering things, it is our paramount duty to use it and to train all our intellect and energy to this supreme service of our kind.

Hence the pressing interest of the question, to what extent modern progress in natural knowledge, and, more especially, the general outcome of that progress in the doctrine of evolution, is competent to help us in the great work of helping one another?

The propounders of what are called the "ethics of evolution," when the "evolution of ethics" would usually better express the object of their speculations, adduce a number of more or less interesting facts and more or less sound arguments, in favour of the origin of the moral sentiments, in the same way as other natural phenomena, by a process of evolution. I have little doubt, for my own part, that they are on the right track; but as the immoral sentiments have no less been evolved, there is, so far, as much natural sanction for the one as the other. The thief and the murderer follow nature just as much as the philanthropist. Cosmic evolution may teach us how the good and the evil tendencies of man may have come about; but, in itself, it is incompetent to furnish any better reason why what we call good is preferable to what we call evil than we had before. Some day, I doubt not, we shall arrive at an understanding of the evolution of the aesthetic faculty; but all the understanding in the world will neither increase nor diminish the force of the intuition that this is beautiful and that is ugly.

There is another fallacy which appears to me to pervade the so-called "ethics of evolution." It is the notion that because, on the whole, animals and plants have advanced in perfection of organization by means of the struggle for existence and the consequent "survival of the fittest"; therefore men in society, men as ethical beings, must look to the same process to help them towards perfection. I suspect

that this fallacy has arisen out of the unfortunate ambiguity of the phrase "survival of the fittest," "Fittest" has a connotation of "best"; and about "best" there hangs a moral flavour. In cosmic nature, however, what is "fittest" depends upon the conditions. Long since, I ventured to point out that if our hemisphere were to cool again, the survival of the fittest might bring about, in the vegetable kingdom, a population of more and more stunted and humbler and humbler organisms, until the "fittest" that survived might be nothing but lichens, diatoms, and such microscopic organisms as those which give red snow its colour; while, if it became hotter, the pleasant valleys of the Thames and Isis might be uninhabitable by any animated beings save those that flourish in a tropical jungle. They, as the fittest, the best adapted to the changed conditions, would survive.

Men in society are undoubtedly subject to the cosmic process. As among other animals, multiplication goes on without cessation, and involves severe competition for the means of support. The struggle for existence tends to eliminate those less fitted to adapt themselves to the circumstances of their existence. The strongest, the most self-assertive, tend to tread down the weaker. But the influence of the cosmic processes on the evolution of society is the greater the more rudimentary its civilization. Social progress means a checking of the cosmic process at every step and the substitution for it of another, which may be called the ethical process; the end of which is not the survival of those who may happen to be the fittest, in respect of the whole of the conditions which obtain, but of those who are ethically the best.

As I have already urged, the practice of that which is ethically best—what we

call goodness or virtue—involves a course of conduct which, in all respects, is opposed to that which leads to success in the cosmic struggle for existence. In place of ruthless self-assertion it demands self-restraint; in place of thrusting aside, or treading down, all competitors, it requires that the individual shall not merely respect, but shall help his fellows; its influence is directed, not so much to the survival of the fittest, as to the fitting of as many as possible to survive. It repudiates the gladiatorial theory of existence. It demands that each man who enters into the enjoyment of the advantages of a polity shall be mindful of his debt to those who have laboriously constructed it; and shall take heed that no act of his weakens the fabric in which he has been permitted to live. Laws and moral precepts are directed to the end of curbing the cosmic process and reminding the individual of his duty to the community, to the protection and influence of which he owes. if not existence itself, at least the life of something better than a brutal savage.

It is from neglect of these plain considerations that the fanatical individualism of our time attempts to apply the analogy of cosmic nature to society. Once more we have a misapplication of the stoical injunction to follow nature; the duties of the individual to the state are forgotten, and his tendencies to self-assertion are dignified by the name of rights. It is seriously debated whether the members of a community are justified in using their combined strength to constrain one of their number to contribute his share to the maintenance of it; or even to prevent him from doing his best to destroy it. The

struggle for existence, which has done such admirable work in cosmic nature, must, it appears, be equally beneficent in the ethical sphere. Yet if that which I have insisted upon is true; if the cosmic process has no sort of relation to moral ends; if the imitation of it by man is inconsistent with the first principles of ethics; what becomes of this surprising theory?

Let us understand, once for all, that the ethical progress of society depends, not on imitating the cosmic process, still less in running away from it, but in combating it. It may seem an audacious proposal thus to pit the microcosm against the macrocosm and to set man to subdue nature to his higher ends; but I venture to think that the great intellectual difference between the ancient times with which we have been occupied and our day, lies in the solid foundation we have acquired for the hope that such an enterprise may meet with a certain measure of success.

Ethical nature may count upon having to reckon with a tenacious and powerful enemy as long as the world lasts. But, on the other hand. I see no limit to the extent to which intelligence and will, guided by sound principles of investigation, and organized in common effort, may modify the conditions of existence, for a period longer than that now covered by history. And much may be done to change the nature of man himself. The intelligence which has converted the brother of the wolf into the faithful guardian of the flock ought to be able to do something towards curbing the instincts of savagery in civilized men.

6. STEPHEN

The following extract from Leslie Stephen's Agnostic's Apology explains the very moderate attitude of an earnest and thoughtful man who left holy orders and resigned his fellowship in Cambridge when he lost faith in Christianity. Stephen lived to marry one of Thackeray's daughters, edit the Dictionary of National Biography, climb the Matterhorn, and be knighted; but he never saw any reason to change his mind or abandon the opposition to religious dogma which he had expressed in this article, first published in the London Fortnightly Review, in 1876.

An Agnostic's Apology

The name Agnostic, originally coined by Professor Huxley about 1869, has gained general acceptance. It is sometimes used to indicate the philosophical theory which Mr. Herbert Spencer, as he tells us, developed from the doctrine of Hamilton and Mansel. Upon that theory I express no opinion. I take the word in a vaguer sense, and am glad to believe that its use indicates an advance in the courtesies of controversy. The old theological phrase for an intellectual opponent was Atheist-a name which still retains a certain flavour as of the stake in this world and hell-fire in the next, and which, moreover, implies an inaccuracy of some importance. Dogmatic Atheism —the doctrine that there is no God, whatever may be meant by God-is, to say the least, a rare phase of opinion. The word Agnosticism, on the other hand, seems to imply a fairly accurate appreciation of a form of creed already common and daily spreading. The Agnostic is one who asserts-what no one denies-that there are limits to the sphere of human intelligence. He asserts, further, what many theologians have expressly maintained, that those limits are such as to exclude at least what Lewes called "metempirical" knowledge. But he goes further, and asserts, in opposition to theologians, that theology lies within this for-

bidden sphere. This last assertion raises the important issue; and, though I have no pretension to invent an opposition nickname, I may venture, for the purposes of this article, to describe the rival school as Gnostics.

The Gnostic holds that our reason can, in some sense, transcend the narrow limits of experience. He holds that we can attain truths not capable of verification, and not needing verification, by actual experiment or observation. He holds, further, that a knowledge of those truths is essential to the highest interests of mankind, and enables us in some sort to solve the dark riddle of the universe. A complete solution, as everyone admits, is beyond our power. But some answer may be given to the doubts which harass and perplex us when we try to frame any adequate conception of the vast order of which we form an insignificant portion. We cannot say why this or that arrangement is what it is; we can say, though obscurely, that some answer exists, and would be satisfactory, if we could only find it. Overpowered, as every honest and serious thinker is at times overpowered, by the sight of pain, folly, and helplessness, by the jarring discords which run through the vast harmony of the universe. we are yet enabled to hear at times a whisper that all is well, to trust to it as

coming from the most authentic source, and to know that only the temporary bars of sense prevent us from recognising with certainty that the harmony beneath the discords is a reality and not a dream. This knowledge is embodied in the central dogma of theology. God is the name of the harmony; and God is knowable. Who would not be happy in accepting this belief, if he could accept it honestly? Who would not be glad if he could say with confidence: "the evil is transitory, the good eternal: our doubts are due to limitations destined to be abolished, and the world is really an embodiment of love and wisdom, however dark it may appear to our faculties"? And yet, if the so-called knowledge be illusory, are we not bound by the most sacred obligations to recognise the facts? Our brief path is dark enough on any hypothesis. We cannot afford to turn aside after every ignis fatuus without asking whether it leads to sounder footing or to hopeless quagmires. Dreams may be pleasanter for the moment than realities; but happiness must be won by adapting our lives to the realities. And who, that has felt the burden of existence, and suffered under wellmeant efforts to consolation, will deny that such consolations are the bitterest of mockeries? Pain is not an evil; death is not a separation; sickness is but a blessing in disguise. Have the gloomiest speculations of avowed pessimists ever tortured sufferers like those kindly platitudes? Is there a more cutting piece of satire in the language than the reference in our funeral service to the "sure and certain hope of a blessed resurrection"? To dispel genuine hopes might be painful, however salutary. To suppress these spasmodic efforts to fly in the face of facts would be some comfort, even in the distress which they are meant to alleviate.

Besides the important question whether the Gnostic can prove his dogmas, there is, therefore, the further question whether the dogmas, if granted, have any meaning. Do they answer our doubts, or mock us with the appearance of an answer? The Gnostics rejoice in their knowledge. Have they anything to tell us? They rebuke what they call the "pride of reason" in the name of a still more exalted pride. The scientific reasoner is arrogant because he sets limits to the faculty in which he trusts, and denies the existence of any other faculty. They are humble because they dare to tread in the regions which he declares to be inaccessible. But without bandying such accusations, or asking which pride is the greatest, the Gnostics are at least bound to show some ostensible justification for their complacency. Have they discovered a firm resting-place from which they are entitled to look down in compassion or contempt upon those who hold it to be a mere edifice of moonshine? If they have diminished by a scruple the weight of one passing doubt, we should be grateful: perhaps we should be converts. If not, why condemn Agnosticism?

7. CARNEGIE

The Darwinian theories and the speculations which followed them could also lead to other conclusions concerning the purpose of life and, hence, man's attitude to life and to his fellow men. The apparently stern inferences of the doctrine of the survival of the fittest were drawn by the English philosopher Herbert Spencer (1820–

1903). To a generation that no longer sought its spiritual guidance from the churches, Spencer offered a confident creed grounded on natural knowledge. He saw society passing from a military and despotic to an industrial and democratic phase, condemned state interference with the healthy struggle for survival, and preached a robust individualism that appealed especially to the middle class. Some of his basic ideas may be found below in the words of one of his most successful disciples, the Scottish-American steel magnate and philanthropist, Andrew Carnegie (1835–1919).

From: The Gospel of Wealth

The problem of our age is the proper administration of wealth, that the ties of brotherhood may still bind together the rich and poor in harmonious relationship. The conditions of human life have not only been changed, but revolutionized, within the past few hundred years. In former days there was little difference between the dwelling, dress, food, and environment of the chief and those of his retainers. . . . The contrast between the palace of the millionaire and the cottage of the laborer with us to-day measures the change which has come with civilization. This change, however, is not to be deplored, but welcomed as highly beneficial. It is well, nay, essential for the progress of the race that the houses of some should be homes for all that is highest and best in literature and the arts, and for all the refinements of civilization. rather than that none should be so. Much better this great irregularity than universal squalor. Without wealth there can be no Maecenas. The "good old times" were not good old times. Neither master nor servant was as well situated then as to-day. A relapse to old conditions would be disastrous to both—not the least so to him who serves—and would sweep away civilization with it. But whether the change be for good or ill, it is upon us, beyond our power to alter, and therefore,

to be accepted and made the best of. It is a waste of time to criticize the inevitable. . . .

The price we pay for this salutary change is, no doubt, great. We assemble thousands of operatives in the factory. and in the mine, of whom the employer can know little or nothing, and to whom he is little better than a myth. All intercourse between them is at an end. Rigid castes are formed, and, as usual, mutual ignorance breeds mutual distrust. Each caste is without sympathy with the other. and ready to credit anything disparaging in regard to it. Under the law of competition, the employer of thousands is forced into the strictest economies, among which the rates paid to labor figure prominently, and often there is friction between the employer and the employed, between capital and labor, between rich and poor. Human society loses homogeneity.

The price which society pays for the law of competition, like the price it pays for cheap comforts and luxuries, is also great; but the advantages of this law are also greater still than its cost—for it is to this law that we owe our wonderful material development, which brings improved conditions in its train. But, whether the law be benign or not, we must say of it, as we say of the change in the conditions of men to which we have

From Andrew Carnegie, The Gospel of Wealth (New York: North American Review, 1889).

referred: It is here; we cannot evade it; no substitutes for it have been found; and while the law may be sometimes hard for the individual, it is best for the race, because it insures the survival of the fittest in every department. We accept and welcome, therefore, as conditions to which we must accommodate ourselves, great inequality of environment; the concentration of business, industrial and commercial, in the hands of a few; and the law of competition between these, as being not only beneficial, but essential to the future progress of the race. . . . Nor is there any middle ground which such men can occupy, because the great manufacturing or commercial concern which does not earn at least interest upon its capital soon becomes bankrupt. It must either go forward or fall behind; to stand still is impossible. It is a condition essential to its successful operation that it should be thus far profitable, and even that, in addition to interest on capital, it should make profit. It is a law, as certain as any of the others named, that men possessed of this peculiar talent for affairs, under the free play of economic forces must, of necessity, soon be in receipt of more revenue than can be judiciously expended upon themselves; and this law is as beneficial for the race as the others.

Objections to the foundations upon which society is based are not in order, because the condition of the race is better with these than it has been with any other which has been tried. Of the effect of any new substitutes proposed we cannot be sure. The Socialist or Anarchist who seeks to overturn present conditions is to be regarded as attacking the foundation upon which civilization itself rests, for civilization took its start from the day when the capable, industrious workman said to his incompetent and lazy fellow, "If thou

dost not sow, thou shalt not reap," and thus ended primitive Communism by separating the drones from the bees. One who studies this subject will soon be brought face to face with the conclusion that upon the sacredness of property civilization itself depends—the right of the laborer to his hundred dollars in the savings-bank, and equally the legal right of the millionaire to his millions. . . . To those who propose to substitute Communism for this intense Individualism. the answer therefore is: The race has tried that. All progress from that barbarous day to the present time has resulted from its displacement. Not evil, but good, has come to the race from the accumulation of wealth by those who have had the ability and energy to produce it. But even if we admit for a moment that it might be better for the race to discard its present foundation, Individualism that it is a nobler ideal that man should labor, not for himself alone, but in and for a brotherhood of his fellows, and share with them all in common, . . . even admit all this, and a sufficient answer is, This is not evolution, but revolution. It necessitates the changing of human nature itself-a work of eons, even if it were good to change it, which we cannot know.

It is not practicable in our day or in our age. Even if desirable theoretically, it belongs to another and long-succeeding sociological stratum. Our duty is with what is practicable now—with the next step possible in our day and generation. It is criminal to waste our energies in endeavoring to uproot, when all we can profitably accomplish is to bend the universal tree of humanity a little in the direction most favorable to the production of good fruit under existing circumstances. We might as well urge the de-

struction of the highest existing type of man because he failed to reach our ideal as to favor the destruction of Individualism, Private Property, the Law of Accumulation of Wealth, and the Law of Competition; for these are the highest result of human experience, the soil in which society, so far, has produced the best fruit. Unequally or unjustly, perhaps, as these laws sometimes operate, and imperfect as they appear to the Idealist, they are, nevertheless, like the highest type of man, the best and most valuable of all that humanity has yet accomplished. . . .

Poor and restricted are our opportunities in this life, narrow our horizon, our best work most imperfect; but rich men should be thankful for one inestimable boon. They have it in their power during their lives to busy themselves in organizing benefactions from which the masses of their fellows will derive lasting advantage, and thus dignify their own lives. The highest life is probably to be reached, not by such imitation of the life of Christ as Count Tolstoi gives us, but, while animated by Christ's spirit, by recognizing the changed conditions of this age, and adopting modes of expressing this spirit suitable to the changed conditions under which we live, still laboring for the good of our fellows, which was the essence of his life and teaching, but laboring in a different manner.

This, then, is held to be the duty of the man of wealth: To set an example of modest, unostentatious living, shunning display or extravagance; to provide moderately for the legitimate wants of those dependent upon him; and, after doing so, to consider all surplus revenues which come to him simply as trust funds, which he is called upon to administer, and strictly bound as a matter of duty to administer in the manner which, in his judgment, is best calculated to produce the most beneficial result for the community—the man of wealth thus becoming the mere trustee and agent for his poorer brethren, bringing to their service his superior wisdom, experience, and ability to administer, doing for them better than they would or could do for themselves. . . .

One of the serious obstacles to the improvement of our race is indiscriminate charity. It were better for mankind that the millions of the rich were thrown into the sea than so spent as to encourage the slothful, the drunken, the unworthy. Of every thousand dollars spent in so-called charity today, it is probable that nine hundred and fifty dollars is unwisely spent—so spent, indeed, as to produce the very evils which it hopes to mitigate or cure. A well-known writer of philosophic books admitted the other day that he had given a quarter of a dollar to a man who approached him as he was coming to visit the house of his friend. He knew nothing of the habits of this beggar, knew not the use that would be made of this money, although he had every reason to suspect that it would be spent improperly. This man professed to be a disciple of Herbert Spencer; yet the quarter-dollar given that night will probably work more injury than all the money will do good which its thoughtless donor will ever be able to give in true charity. He only gratified his own feelings, saved himself from annoyance-and this was probably one of the most selfish and very worst actions of his life, for in all respects he is most worthy.

In bestowing charity, the main consideration should be to help those who will help themselves; to provide part of the means by which those who desire to

improve may do so; to give those who desire to rise the aids by which they may rise: to assist, but rarely or never to do all. Neither the individual nor the race is improved by almsgiving. Those worthy of assistance, except in rare cases, seldom require assistance. The really valuable men of the race never do, except in case of accident or sudden change. Every one has, of course, cases of individuals brought to his own knowledge where temporary assistance can do genuine good, and these he will not overlook. But the amount which can be wisely given by the individual for individuals is necessarily limited by his lack of knowledge of the circumstances connected with each. He is the only true reformer who is as careful and as anxious not to aid the unworthy as he is to aid the worthy, and, perhaps, even more so, for in almsgiving more injury is probably done by rewarding vice than by relieving virtue.

Thus is the problem of rich and poor to be solved. The laws of accumulation will be left free, the laws of distribution free. Individualism will continue, but the millionaire will be but a trustee for the poor, intrusted for a season with a great part of the increased wealth of the community, but administering it for the community far better than it could or would have done for itself. The best minds will thus have reached a stage in the development of the race in which it is clearly seen that there is no mode of disposing of surplus wealth creditable to thoughtful and earnest men into whose hands it flows, save by using it year by year for the general good. This day already dawns.

III. Patterns of Change

The variety of views quoted below bears witness to the variety of the patterns of change at this time. A striking point they all have in common is the pragmatism they express. Exceptions like the approach attempted by the Bishop of Ripon (p. 660) merely prove the rule. Of the political thinkers of the time, those who think to some purpose think in terms of the possible and use principles only in the service of limited and practical ends. This is a territory upon which Bismarck and Bernstein, Fabians and Lenin can meet and it seems to foreshadow the democratic politics of a twentieth century for which a platform is made to run on, not to stand on.

1. BISMARCK

Prince Otto von Bismarck (1815–1898), something of a stormy petrel in his youth, became First Minister of Prussia in 1862 and forged German unity around and under Prussian rule. In 1864 he achieved the conquest of Schleswig from Denmark, in 1866 the defeat of Austria which established Prussia's predominant place in Germany, and in 1870 his final aim, the proclamation of a German Empire under the rule of the Prussian king. Henceforth his policy as imperial Chancellor was devoted to the maintenance of peace both at home and abroad. Until his dismissal from office in 1890 by the young William II, the old Prince remained the dominant figure of European affairs—not only a great statesman but also a very smart operator. He found it useful to accept and use some of the progressive ideas of his time in order to strengthen the power of the monarchy he served; and he never scrupled about the means he used in order to achieve his ends. As he saw it, the end justified the means; as contemporaries saw it, success justified Bismarck.

FROM: A SPEECH IN THE PRUSSIAN BUDGET COMMISSION

Germany is not looking to Prussia's liberalism, but to her power; Bavaria or Würtemberg or Baden may choose to be

liberal, but no one is going to expect of them what they expect of Prussia. Prussia must gather up her strength and hold it ready for the moment of opportunity—an opportunity we have already missed several times. Prussia's borders since the Treaty of Vienna, have not been the sort

From a speech delivered by Bismarck in the Budget Commission of the Prussian Lower Chamber, 30 Sept. 1862; in Hohlfeld, Deutsche Reichsgeschichte in Dokumenten (Berlin, 1927).

that a healthy state needs; the great questions of the day are not decided by speeches and by the votes of the majority—that was the great mistake of 1848 and 1849. They are decided by blood and iron.

STATE INTERFERENCE

Herr Richter has called attention to the responsibility of the State for what it does. But it is my opinion that the State can also be responsible for what it does not do. I do not think that doctrines like "Laissez-faire, laissez-aller," those of "Pure Manchesterdom in politics," "Jeder sehe, wie er's treibe, Jeder sehe, wo er bleibe," "He who is not strong enough to stand must be knocked down, and trodden to the ground," "To him that hath shall be given, and from him that hath not shall be taken away even that which he hath"—that doctrines like these should be applied in the State, and especially in a monarchically, paternally governed State. On the other hand, I believe that those who profess horror at the intervention of the State for the protection of the weak lay themselves open to the suspicion that they are desirous of using their strength—be it that of capital, that of rhetoric, or whatever it be-for the benefit of a section, for the oppression of the rest, for the introduction of party domination, and that they will be chagrined as soon as this design is disturbed by any action of the government.

I ask you what right had I to close the way to the throne against these people? The kings of Prussia have never been by preference kings of the rich. Frederick the Great said when Crown Prince:

"Quand je serai roi, je serai un vrai roi des gueux." He undertook to be the protector of the poor, and this principle has been followed by our later kings. At their throne suffering has always found a refuge and a hearing. . . .

Our kings have secured the emancipation of the serfs, they have created a thriving peasantry, and they may possibly be successful—the earnest endeavour exists, at any rate—in improving the condition of the working classes somewhat. To have refused access to the throne to the complaints of these operatives would not have been the right course to pursue, and it was, moreover, not my business to do it. The question would afterwards have been asked: "How rich must a deputation be in order to insure its reception by the King?" . . .

I am not antagonistic to the rightful claims of capital; I am far from wanting to flourish a hostile flag; but I am of opinion that the masses, too, have rights which should be considered.

I wish we could immediately create a few hundred millionaires. They would expend their money in the country, and this expenditure would act fruitfully on labour all round. They could not eat their money themselves; they would have to spend the interest on it. Be glad, then, when people become rich with us. The community at large, and not only the tax authority, is sure to benefit.

The large land-owner who lives in the country is not the worst evil; the worst is the large land-owner who lives in town, be it Paris, Rome, or Berlin, and who only requires money from his estates and agents, who does not represent his estates in the Reichstag or Land-tag, and does not even know how it fares with them.

Therein lies the evil of large estates. Large estates whose owners live in the country are under certain circumstances a great blessing, and very useful. . . . I regard the large land-owners who are really farmers, and buy land from a predilection for this industry, as a blessing for our country, and especially for the provinces where I live. And if you succeed in destroying this race, you would see the result in the palsying of our entire economic and political life. . . . But so long as God is still minded to preserve the German Empire and the Kingdom of Prussia, this war of yours against landed proprietorship will not succeed, however many allies you may obtain.

Give the working-man the right to work as long as he is healthy; assure him care when he is sick; assure him maintenance when he is old. If you do that, and do not fear the sacrifice, or cry out at State Socialism directly the words "Provision for old age" are uttered, -if the State will show a little more Christian solicitude for the working-man, then I believe that the gentlemen of the Wyden (Social-Democratic) programme will sound their birdcall in vain, and that the thronging to them will cease as soon as workingmen see that the Government and legislative bodies are earnestly concerned for their welfare.

Yes, I acknowledge unconditionally a right to work, and I will stand up for it as long as I am in this place. But here I do not stand upon the ground of Socialism, which is said to have only begun with the Bismarck Ministry, but on that of the Prussian common law. . . . Was not the right to work openly proclaimed at the time of the publication of the common law? Is it not established in all our social arrangements that the man who comes before his fellow-citizens and says,

"I am healthy, I desire to work, but can find no work," is entitled to say also, "Give me work," and that the State is bound to give him work?

I will further every endeavour which positively aims at improving the condition of the working classes. . . . As soon as a positive proposal comes from the Socialists for fashioning the future in a sensible way, in order that the lot of the workingman might be improved, I would not at any rate refuse to examine it favourably, and I would not even shrink from the idea of State help for the people who would help themselves.

The establishment of the freedom of the peasantry was Socialistic; Socialistic, too, is every expropriation in favour of railways: Socialistic to the utmost extent is the aggregation of estates—the law exists in many provinces—taking from one and giving to another, simply because this other can cultivate the land more conveniently; Socialistic is expropriation under the Water Legislation, on account of irrigation, etc., where a man's land is taken away from him because another can farm it better; Socialistic is our entire poor relief, compulsory school attendance, compulsory construction of roads, so that I am bound to maintain a road upon my lands for travellers. That is all Socialistic. and I could extend the register further; but if you believe that you can frighten any one or call up spectres with the word "Socialism," you take a standpoint which I abandoned long ago, and the abandonment of which is absolutely necessary for our entire imperial legislation.

UNIVERSAL SUFFRAGE

Looking to the necessity, in a fight against an overwhelming foreign Power,

of being able, in extreme need, to use even revolutionary means, I had had no hesitation whatever in throwing into the frying-pan, by means of the circular dispatch of June 10, 1866, the most powerful ingredient known at that time to liberty-mongers, namely, universal suffrage, so as to frighten off foreign monarchies from trying to stick a finger into our national omelette. I never doubted that the German people would be strong and clever enough to free themselves from the existing suffrage as soon as they realized that it was a harmful institution. If it cannot, then my saving that Germany can ride when once she has got into the saddle was erroneous. The acceptance of universal suffrage was a weapon in the war against Austria and other foreign countries, in the war for German Unity, as well as a threat to use the last weapons in a struggle against coalitions. In a war of this sort, when it becomes a matter of life and death, one does not look at the weapons that one seizes; nor at the value of what one destroys in using them: one is guided at the moment by no other thought than the issue of the war, and the preservation of one's external independence; the settling of affairs and reparation of the damage has to take place after the peace. Moreover, I still hold that the principle of universal suffrage is a just one, not only in theory but also in practice, provided always that voting be not secret, for secrecy is a quality that is indeed incompatible with the best characteristics of German blood.

The influence and the dependence on others that the practical life of man brings in its train are God-given realities which we cannot and must not ignore. If we refuse to transfer them to political life, and base that life on a faith in the secret insight of everybody, we fall into a contradiction between public law and the realities of human life which practically leads to constant frictions, and finally to an explosion, and to which there is no theoretical solution except by way of the insanities of social-democracy, the support given to which rests on the fact that the judgment of the masses is sufficiently stultified and undeveloped to allow them, with the assistance of their own greed, to be continually caught by the rhetoric of clever and ambitious leaders.

The counterpoise to this lies in the influence of the educated classes which would be greatly strengthened if voting were public, as for the Prussian Diet. It may be that the greater discretion of the more intelligent classes rests on the material basis of the preservation of their possessions. The other motive, the struggle for gain, is equally justifiable; but a preponderance of those who represent property is more serviceable for the security and development of the state. A state, the control of which lies in the hands of the greedy, of the new rich, and of orators who have in a higher degree than others the capacity for deceiving the unreasoning masses, will constantly be doomed to a restlessness of development, which so ponderous a mass as the commonwealth of the state cannot follow without injury to its organism. Ponderous masses, and among these the life and development of great nations must be reckoned, can only move with caution, since the road on which they travel to an unknown future has no smooth iron rails. Every great state-commonwealth that loses the prudent and restraining influence of the propertied class, whether that influence rests on material or moral grounds, will always end by being rushed along at

From Bismarck, His Reflections and Reminiscences, tr. A. J. Butler, 2 vol. (London, 1898).

a speed which must shatter the coach of state, as happened in the development of the French Revolution. The element of greed has the preponderance arising from large masses which in the long run must make its way. It is in the interests of the great mass itself to wish decision to take place without dangerous acceleration of the speed of the coach of state, and without its destruction. If this should happen, however, the wheel of history will revolve again, and always in a proportionately shorter time, to dictatorship, to despotism. to absolutism, because in the end the masses yield to the need of order; if they do not recognize this need a priori, they always realize it eventually after manifold arguments ad hominem; and in order to purchase order from a dictatorship and Caesarism they cheerfully sacrifice that justifiable amount of freedom which ought to be maintained, and which the political society of Europe can endure without ill-health.

I should regard it as a serious misfortune, and as an essential weakening of our security in the future, if we in Germany are driven into the vortex of this French cycle. Absolutism would be the ideal form of government for an European political structure were not the King and his officials ever as other men are to whom it is not given to reign with superhuman wisdom, insight and justice. The most experienced and well-meaning absolute rulers are subject to human imperfections, such as overestimation of their own wisdom, the influence and eloquence of favourites, not to mention petti-

coat influence, legitimate and illegitimate. Monarchy and the most ideal monarch, if in his idealism he is not to be a common danger, stand in need of criticism; the thorns of criticism set him right when he runs the risk of losing his way. Joseph II is a warning example of this.

Criticism can only be exercised through the medium of a free press and parliaments in the modern sense of the term. Both correctives may easily weaken and finally lose their efficacy if they abuse their powers. To avert this is one of the tasks of a conservative policy, which cannot be accomplished without a struggle with parliament and press. The measurement of the limits within which such a struggle must be confined, if the control of the government, which is indispensable to the country, is neither to be checked nor allowed to gain a complete power, is a question of political tact and judgment.

It is a piece of good fortune for his country if a monarch possess the judgment requisite for this-a good fortune that is temporary, it is true, like all human fortune. The possibility of establishing ministers in power who possess adequate qualifications must always be granted in the constitutional organism; but also the possibility of maintaining in office ministers who satisfy these requirements in face of occasional votes of an adverse majority and of the influence of courts and camarillas. This aim, so far as human imperfections in general allow its attainment, was approximately reached under the government of William I.

2. PARLIAMENTARY DEBATES

Other conservatives were slower than Bismarck to realize that moderate reforms prevented revolution and that a welfare state directed by the Right could do much to steal the Left's thunder. However, as conditions gradually improved and reforms alleviated the utter despair of midcentury, the progressive Left found itself divided between supporters of gradual reform by constitutional means and those who believed that only cataclysmic change offered hope of the millennium. The former was the view encouraged by such reforms as those introduced by the Liberal government which had come to power in England after the general elections of 1906. Herbert Asquith, first Chancellor of the Exchequer, then in 1908 Prime Minister, introduced as one of his first reform proposals that of old age pensions to be provided by the State. The following passages are taken from the parliamentary debates that raged around the proposals.

A LABOR VIEW ON OLD AGE PENSIONS

I once said, and I repeat, that no man should sit in this House without having served first for ten years as a Poor Law guardian. He would then know something about human nature. It is not perfect. There are a good many sides to it, but most people who apply for relief are very human, and I do not think that they very much object to these inquisitorial examinations as to their character. We were challenged by the Hon. Member for Preston (Mr. Harold Cox), who said, "Would you go on any public platform and declare that you are in favour of giving a pension of 5s. [approx. \$1] per week to a drunken, thriftless, worthless man or woman?" My reply is very prompt to that. A man of seventy with nothing in the world to keep him is going to cut a pretty shine on 5s. per week, whether his character be good or bad. What could he do with it? It is not enough to keep him in decency, and he would be well punished for not taking care when he had the opportunity if he had to live on 5s. per

week. Who are you, to be continually finding fault? Who amongst you has such a clear record as to be able to point to the iniquity and wickedness of an old man of seventy? I said before, and I repeat, if a man is foolish enough to get old, and if he has not been artful enough to get rich, you have no right to punish him for it. It is no business of yours. It is sufficient for you to know he has grown old.

After all, who are these old men and women? Let me appeal to the noble Lord the Member for Marylebone (Lord Robert Cecil). They are the veterans of industry. people of almost endless toil, who have fought for and won the industrial and commercial supremacy of Great Britain. Is their lot and end to be the Bastille of the everlasting slur of pauperism? We claim these pensions as a right. Ruskin, I think, read you a little homily on the subject-"Even a laborer serves his country with his spade and shovel as the statesman does with his pen, or the soldier with his sword." He has a right to some consideration from the State. Here in a country rich beyond description there are people poverty-stricken beyond description.

From Parliamentary Debates. 4th Series, Vol. 192, 9 July 1908.

There can be no earthly excuse for the condition of things which exists in this country today. If it be necessary to have a strong Army and Navy to protect the wealth of the nation, do not let us forget that it is the veterans of industry who have created that wealth; and let us accept this as an installment to bring decency and comfort to our aged men and women.

A BISHOP'S VIEW OF THE SUBJECT

The Lord Bishop of Ripon: . . . My Lords, there is something in nations which is of more importance to them than mere financial prosperity. The accumulation of the power of wealth which enables nations to raise a considerable revenue through taxation, gives the stamp, as it were, of prosperity, but the best asset of a nation is a manly, vigorous, and numerous race, and the best asset of the race is that the character of its men and women shall never be impaired. A Frenchman once wrote a book concerning what he called the superiority of the Anglo-Saxon race, and in the course of that book he pointed out what he believed to be the one essential factor which contributed to that superiority. He said that in all the history of English life one spirit had prevailed, and that was the spirit of selfreliance. He turned to his countrymen and said, "The danger which we are in today is that we are not rearing our population to self-reliant habits." He drew the picture of the little farmer in Normandy who would stint himself and live in an unclean and even unwholesome dwelling in order that he might leave a sufficient sum to his children. He pointed then to the English farmer who, he said, so far from crippling himself in order that his sons may be well started in the world, takes the strong and independent line and says, "I made my way in the world and I expect my sons to do the same." "In other words," said the French writer, "the race across the Channel has educated its children in the habits of self-reliance, and to this habit is largely due the superiority and the strength of that race. . . ."

I speak not of those of seventy years of age who are to receive the benefit of this measure. Their characters are formed. their conditions are settled. We are going forward tonight and saying: "Let us help them, let us give to them something which will ease their later years, and if a few have not deserved well, we will at any rate with large-heartedness forget those who were weak and deal largely and generously with this matter before us, for all these men or women of seventy naturally appeal to the pity and sympathy of our hearts." But when I look beyond and ask whether it is conceivable that we may begin so to hold out the thought that men may be able to receive from the State that which in olden days they won by their own strong labors, self-denial, and thrift, then I am apprehensive lest we should, in attempting to do a good, do a great and grievous wrong, robbing ourselves and our children of that which is the best inheritance, the inheritance of a sturdy, strong, self-reliant manhood, that will take upon itself the responsibilities of life and be equal, therefore, to the responsibilities of Empire. I think none of us can shut our eyes to the fact that there are among us people who are very ready to shirk responsibility, and I, for one, would feel that the whole system and condition of English life had lost its meaning and value if once we should act in such fashion

From Parliamentary Debates, 4th Series, Vol. 192, 20 July 1908.

as to remove responsibility, and the sense of responsibility, from the people of this country. We are in this world for responsibility; through responsibility we grow and rise to the height of character which Divine Providence intended us to reach. Let us not, by any action of ours, weaken that which is the best thing we can preserve, the character of the population, for out of that, and out of that alone, will spring the strength and the stability of the nation.

3. THE FABIAN SOCIETY

The Fabian Society was set up in 1883 to propagate a non-Marxian, evolutionary Socialism. Its leading personalities were Sidney and Beatrice Webb, George Bernard Shaw, and later for a while H. G. Wells. Their principle of cautious advance, which would leave its mark on the British Labour Party, was implied in the Society's name, derived from Quintus Fabius Cunctator, the circumspect Roman general whose tactics had worn down Hannibal's first victorious impetus.

From: A Manifesto

The Fabians are associated for spreading the following opinions held by them and discussing their practical consequences.

That under existing circumstances wealth cannot be enjoyed without dishonor or foregone without misery.

That it is the duty of each member of the State to provide for his or her wants by his or her own Labor.

That a life interest in the Land and Capital of the nation is the birthright of every individual born within its confines and that access to this birthright should not depend upon the will of any private person other than the person seeking it.

That the most striking result of our present system of farming out the national Land and Capital to private persons has been the division of Society into hostile classes, with large appetites and no dinners at one extreme and large dinners and no appetites at the other.

That the practice of entrusting the Land of the nation to private persons in the hope that they will make the best of it has been discredited by the consistency with which they have made the worst of it; and that Nationalization of the Land in some form is a public duty.

That the pretensions of Capitalism to encourage Invention and to distribute its benefits in the fairest way attainable, have been discredited by the experience of the nineteenth century.

That, under the existing system of leaving the National Industry to organize itself Competition has the effect of rendering adulteration, dishonest dealing and inhumanity compulsory.

That since Competition amongst producers admittedly secures to the public the most satisfactory products, the State should compete with all its might in every department of production.

That such restraints upon Free Competition as the penalties for infringing the Postal monopoly, and the withdrawal of workhouse and prison labor from the markets, should be abolished.

From G. B. Shaw, A Manifesto, Fabian Tract No. 2 (London, 1884).

That no branch of Industry should be carried on at a profit by the central administration.

That the Public Revenue should be levied by a direct Tax; and that the central administration should have no legal power to hold back for the replenishment of the Public Treasury any portion of the proceeds of Industries administered by them.

That the State should compete with private individuals—especially with parents—in providing happy homes for children, so that every child may have a refuge from the tyranny or neglect of its natural custodians.

That Men no longer need special po-

litical privileges to protect them against Women and that the sexes should henceforth enjoy equal political rights.

That no individual should enjoy any Privilege in consideration of services rendered to the State by his or her parents or other relation.

That the State should secure a liberal education and an equal share in the National Industry to each of its units.

That the established Government has no more right to call itself the State than the smoke of London has to call itself the weather.

That we had rather face a Civil War than such another century of suffering as the present one has been.

4. BERNSTEIN

The economic changes of the late nineteenth century and the improvement in the condition of the proletariat persuaded Socialist thinkers that some revision of Marxian theory and tactics was required. Eduard Bernstein was a prominent intellectual of the German Socialist party, who argued that Socialists should now stress evolution and cooperation rather than revolution and class conflict. Bernstein's revisionism or reformism found favor with many Socialist leaders in the West, but was bitterly criticized by men like Kautsky and Lenin who saw gradual reforms as drops in a bucket, and compromise only as a dangerous corrupting force.

From: Evolutionary Socialism

PREFACE

It has been maintained in a certain quarter that the practical deductions from my treatises would be the abandonment of the conquest of political power by the proletariat organised politically and economically. That is quite an arbitrary deduction, the accuracy of which I altogether deny.

I set myself against the notion that we have to expect shortly a collapse of the bourgeois economy, and that social democracy should be induced by the prospect of such an imminent, great, social catastrophe to adapt its tactics to that assumption. That I maintain most emphatically.

The adherents of this theory of a catastrophe, base it especially on the conclusions of the *Communist Manifesto*. This is a mistake in every respect.

The theory which the Communist Manifesto sets forth of the evolution of

From Eduard Bernstein, Evolutionary Socialism, tr. E. C. Harvey (London, 1909). Reprinted by permission of Independent Labour Party, 6 Endsleigh Street, London, W. C.1.

modern society was correct as far as it characterised the general tendencies of that evolution. But it was mistaken in several special deductions, above all in the estimate of the time the evolution would take. The last has been unreservedly acknowledged by Friedrich Engels, the joint author with Marx of the Manifesto in his preface to the Class War in France. But it is evident that if social evolution takes a much greater period of time than was assumed, it must also take upon itself forms and lead to forms that were not foreseen and could not be foreseen then.

Social conditions have not developed to such an acute opposition of things and classes as is depicted in the *Manifesto*. It is not only useless, it is the greatest folly to attempt to conceal this from ourselves. The number of members of the possessing classes is to-day not smaller but larger. The enormous increase of social wealth is not accompanied by a decreasing number of large capitalists but by an increasing number of capitalists of all degrees. The middle classes change their character but they do not disappear from the social scale.

The concentration in productive industry is not being accomplished even today in all its departments with equal thoroughness and at an equal rate. In a great many branches of production it certainly justifies the forecasts of the socialist critic of society; but in other branches it lags even to-day behind them. The process of concentration in agriculture proceeds still more slowly. Trade statistics show an extraordinarily elaborated graduation of enterprises in regard to size. No rung of the ladder is disappearing from it. The significant changes in the inner structure of these enterprises and their inter-relationship cannot do away with this fact.

In all advanced countries we see the

privileges of the capitalist bourgeoisie vielding step by step to democratic organisations. Under the influence of this, and driven by the movement of the working classes which is daily becoming stronger, a social reaction has set in against the exploiting tendencies of capital, a counteraction which, although it still proceeds timidly and feebly, yet does exist, and is always drawing more departments of economic life under its influence. Factory legislation, the democratising of local government, and the extension of its area of work, the freeing of trade unions and systems of co-operative trading from legal restrictions, the consideration of standard conditions of labour in the work undertaken by public authorities—all these characterise this phase of the evolution.

But the more the political organisations of modern nations are democratised the more the needs and opportunities of great political catastrophes are diminished. He who holds firmly to the catastrophic theory of evolution must, with all his power, withstand and hinder the evolution described above, which, indeed, the logical defenders of that theory formerly did. But is the conquest of political power by the proletariat simply to be by a political catastrophe? Is it to be the appropriation and utilisation of the power of the State by the proletariat exclusively against the whole non-proletarian world?

He who replies in the affirmative must be reminded of two things. In 1872 Marx and Engels announced in the preface to the new edition of the Communist Manifesto that the Paris Commune had exhibited a proof that "the working classes cannot simply take possession of the ready-made State machine and set it in motion for their own aims." And in 1895 Friedrich Engels stated in detail in the preface to War of the Classes that the

762

time of political surprises, of the "revolutions of small conscious minorities at the head of unconscious masses" was to-day at an end, that a collision on a large scale with the military would be the means of checking the steady growth of social democracy and of even throwing it back for a time-in short, that social democracy would flourish far better by lawful than by unlawful means and by violent revolution. And he points out in conformity with this opinion that the next task of the party should be "to work for an uninterrupted increase of its votes" or to carry on a slow propaganda of parliamentary activity.

Thus Engels, who, nevertheless, as his numerical examples show, still somewhat over-estimated the rate of process of the evolution! Shall we be told that he abandoned the conquest of political power by the working classes, because he wished to avoid the steady growth of social democracy secured by lawful means being interrupted by a political revolution?

If not, and if one subscribes to his conclusions, one cannot reasonably take any offence if it is declared that for a long time yet the task of social democracy is, instead of speculating on a great economic crash, "to organise the working classes politically and develop them as a democracy and to fight for all reforms in the State which are adapted to raise the working classes and transform the State in the direction of democracy."

That is what I have said in my impugned article and what I still maintain in its full import. As far as concerns the question propounded above it is equivalent to Engel's dictum, for democracy is, at any given time, as much government by the working classes as these are capable of practising according to their intellectual ripeness and the degree of social

development they have attained. Engels, indeed, refers at the place just mentioned to the fact that the *Communist Manifesto* has "proclaimed the conquest of the democracy as one of the first and most important tasks of the fighting proletariat."

In short, Engels is so thoroughly convinced that the tactics based on the presumption of a catastrophe have had their day, that he even considers a revision of them necessary in the Latin countries where tradition is much more favourable to them than in Germany. "If the conditions of war between nations have altered," he writes, "no less have those for the war between classes." Has this already been forgotten?

No one has questioned the necessity for the working classes to gain the control of government. The point at issue is between the theory of a social cataclysm and the question whether, with the given social development in Germany and the present advanced state of its working classes in the towns and the country, a sudden catastrophe would be desirable in the interest of the social democracy. I have denied it and deny it again, because in my judgment a greater security for lasting success lies in a steady advance than in the possibilities offered by a catastrophic crash.

And as I am firmly convinced that important periods in the development of nations cannot be leapt over I lay the greatest value on the next tasks of social democracy, on the struggle for the political rights of the working man, on the political activity of working men in town and country for the interests of their class, as well as on the work of the industrial organisation of the workers.

In this sense I wrote the sentence that the movement means everything for me and that what is usually called "the final

aim of socialism" is nothing; and in this sense I write it down again to-day. Even if the word "usually" had not shown that the proposition was only to be understood conditionally, it was obvious that it could not express indifference concerning the final carrying out of socialist principles, but only indifference-or, as it would be better expressed, carelessness as to the form of the final arrangement of things. I have at no time had an excessive interest in the future, beyond general principles; I have not been able to read to the end any picture of the future. My thoughts and efforts are concerned with the duties of the present and the nearest future, and I only busy myself with the perspectives beyond so far as they give me a line of conduct for suitable action now.

The conquest of political power by the working classes, the expropriation of capitalists, are no ends in themselves but only means for the accomplishment of certain aims and endeavours. As such they are demands in the programme of social democracy and are not attacked by me. Nothing can be said beforehand as to the circumstances of their accomplishment: we can only fight for their realisation. But the conquest of political power necessitates the possession of political rights; and the most important problem of tactics which German social democracy has at the present time to solve, appears to me to be to devise the best ways for the extension of the political and economic rights of the German working classes.

The following work has been composed in the sense of these conclusions. I am fully conscious that it differs in several important points from the ideas to be found in the theory of Karl Marx and Engels—men whose writings have ex-

ercised the greatest influence on my socialist line of thought, and one of whom —Engels—honoured me with his personal friendship not only till his death but who showed beyond the grave, in his testamentary arrangements, a proof of his confidence in me.

This deviation in the manner of looking at things certainly is not of recent date; it is the product of an inner struggle of years and I hold in my hand a proof that this was no secret to Friedrich Engels, and moreover I must guard Engels from the suspicion that he was so narrow-minded as to exact from his friends an unconditional adherence to his views. Nevertheless, it will be understood from the foregoing why I have till now avoided as much as possible giving to my deviating points of view the form of a systematic and detailed criticism of the Marx-Engels doctrine. This could the more easily be avoided up till now because as regards the practical questions with which we were concerned Marx and Engels in the course of time considerably modified their views.

All that is now altered. I have now a controversy with socialists who, like me, have sprung from the Marx-Engels school; and I am obliged, if I am to maintain my opinions, to show them the points where the Marx-Engels theory appears to me especially mistaken or to be self-contradictory. .

EVOLUTIONARY SOCIALISM

Unfortunately for the scientific socialism of Plekhanov, the Marxist propositions on the hopelessness of the position of the worker have been upset in a book which bears the title, Capital: A Criticism of Political Economy. There we read of

the "physical and moral regeneration" of the textile workers in Lancashire through the Factory Law of 1847, which "struck the feeblest eye." A bourgeois republic was not even necessary to bring about a certain improvement in the situation of a large section of workers! In the same book we read that the society of to-day is no firm crystal, but an organism capable of change and constantly engaged in a process of change, that also in the treatment of economic questions on the part of the official representatives of this society an "improvement was unmistakable." Further that the author had devoted so large a space in his book to the results of the English Factory Laws in order to spur the Continent to imitate them and thus to work so that the process of transforming society may be accomplished in ever more humane forms. All of which signifies not hopelessness but capability of improvement in the condition of the worker. And, as since 1866, when this was written, the legislation depicted has not grown weaker but has been improved, made more general, and has been supplemented by laws and organisations working in the same direction, there can be no more doubt to-day than formerly of the hopefulness of the position of the worker.

Now, it can be asserted against me that Marx certainly recognized those improvements, but that the chapter on the historical tendency of capitalist accumulation at the end of the first volume of *Capital* shows how little these details influenced his fundamental mode of viewing things. To which I answer that as far as that is correct it speaks against that chapter and not against me.

One can interpret this chapter in very different kinds of ways. I believe I was the first to point out, and indeed repeatedly, that it was a summary characterisation of the tendency of a development which is found in capitalist accumulation, but which in practice is not carried out completely and which therefore need not be driven to the critical point of the antagonism there depicted.

One can, however, understand this chapter differently. One can conceive it in this way, that all the improvements mentioned there, and some possibly ensuing, only create temporary remedies against the oppressive tendencies of capitalism, that they signify unimportant modifications which cannot in the long run effect anything substantially against the critical point of antagonisms laid down by Marx, that this will finally appear-if not literally yet substantiallyin the manner depicted, and will lead to catastrophic change by violence. This interpretation can be founded on the categoric wording of the last sentences of the chapter, and receives a certain confirmation because at the end reference is again made to the Communist Manifesto.

According to my view, it is impossible simply to declare the one conception right and the other absolutely wrong. To me the chapter illustrates a dualism which runs through the whole monumental work of Marx, and which also finds expression in a less pregnant fashion in other passages—a dualism which consists in this, that the work aims at being a scientific inquiry and also at proving a theory laid down long before its drafting; a formula lies at the basis of it in which the result to which the exposition should lead is fixed beforehand. The return to the Communist Manifesto points here to a real residue of Utopianism in the Marxist system. Marx had accepted the solution of the Utopians in essentials, but had recognised their means and proofs as inadequate. He therefore undertook a revision of them, and this with the zeal, the critical acuteness, and love of truth of a scientific genius. He suppressed no important fact, he also forebore belittling artificially the importance of these facts as long as the object of the inquiry had no immediate reference to the final aim of the formula to be proved. To that point his work is free of every tendency necessarily interfering with the scientific method.

For the general sympathy with the strivings for emancipation of the working classes does not in itself stand in the way of the scientific method. But, as Marx approaches a point when that final aim enters seriously into the question, he becomes uncertain and unreliable. Such contradictions then appear as were shown in the book under consideration, for instance, in the section on the movement of incomes in modern society. It thus appears that this great scientific spirit was,

in the end, a slave to a doctrine. To express it figuratively, he has raised a mighty building within the framework of a scaffolding he found existing, and in its erection he kept strictly to the laws of scientific architecture as long as they did not collide with the conditions which the construction of the scaffolding prescribed, but he neglected or evaded them when the scaffolding did not allow of their observance. Where the scaffolding put limits in the way of the building, instead of destroying the scaffolding, he changed the building itself at the cost of its right proportions and so made it all the more dependent on the scaffolding. Was it the consciousness of this irrational relation which caused him continually to pass from completing his work to amending special parts of it? However that may be. my conviction is that wherever that dualism shows itself the scaffolding must fall if the building is to grow in its right proportions. In the latter, and not in the former, is found what is worthy to live in Marx.

5. LENIN

Vladimir Ilyitch Ulianov, better known as Lenin, was born in 1870 at Simbirsk, the son of a local teacher and educational official of some talent; he died in Moscow in 1924, first head of the Union of Soviet Socialist Republics, which he had helped to create. Entering revolutionary activity after his brother had been executed by the Tsar's government, Lenin spent several years of exile in Siberia, and far more in the usual wanderings of the political exile abroad. He soon became a leader of the left wing of the Russian Social-Democratic Party, preaching the necessity of an independent Socialist party which would contain no "opportunists," make no opportunistic compromises, and maintain a clear revolutionary policy. Naturally, he attacked those who, like Bernstein, concentrated on the possibilities of gradual reform and failed to put revolutionary activity first. Our Programme was written in this connection, in 1899, but did not appear in print at the time (not, as a matter of fact, until after his death) because police interference prevented its publication while it was still relevant. But Lenin stuck tirelessly to the theme the essay announced and this even-

tually, in 1903, led to the party's split between the Bolshevik (majority) faction, which followed Lenin, and the more moderate Menshevik (minority) faction under Martoff.

Our Programme

International social democracy is at present going through a period of theoretical vacillations. Up to the present the doctrines of Marx and Engels were regarded as a firm foundation of revolutionary theory—nowadays voices are raised everywhere declaring these doctrines to be inadequate and antiquated. Anyone calling himself a social-democrat and having the intention to publish a social-democratic organ, must take up a definite attitude as regards this question, which by no means concerns German social-democrats alone.

We base our faith entirely on Marx's theory; it was the first to transform socialism from a Utopia into a science, to give this science a firm foundation and to indicate the path which must be trodden in order further to develop this science and to elaborate it in all its details. It discovered the nature of present-day capitalist economy and explained the way in which the employment of workers—the purchase of labour power—the enslavement of millions of those possessing no property by a handful of capitalists, by the owners of the land, the factories, the mines, etc., is concealed. It has shown how the whole development of modern capitalism is advancing towards the large producer ousting the small one, and is creating the prerequisites which make a socialist order of society possible and necessary. It has taught us to see, under the disguise of ossified habits, political intrigues, intricate laws, cunning theories, the class struggle, the struggle between,

on the one hand, the various species of the possessing classes, and, on the other hand, the mass possessing no property, the proletariat, which leads all those who possess nothing. It has made clear what is the real task of a revolutionary socialist party-not to set up projects for the transformation of society, not to preach sermons to the capitalists and their admirers about improving the position of the workers, not the instigation of conspiracies, but the organisation of the class struggle of the proletariat, and the carrying on of this struggle, the final aim of which is the seizure of political power by the proletariat and the organisation of a socialist society.

We now ask: What new elements have the touting "renovators" introduced into this theory, they who have attracted so much notice in our day and have grouped themselves round the German socialist Bernstein? Nothing, nothing at all; they have not advanced by a single step the science which Marx and Engels adjured us to develop; they have not taught the proletariat any new methods of fighting; they are only marching backwards in that they adopt the fragments of antiquated theories and are preaching to the proletariat not the theory of struggle but the theory of submissiveness—submissiveness to the bitterest enemies of the proletariat, to the governments and bourgeois parties who never tire of finding new methods of persecuting socialists. Plekhanov, one of the founders and leaders of Russian social-democracy, was perfectly right when

From The Communist (Petrograd), July 1928.

he subjected to merciless criticism the latest "Criticism" of Bernstein, whose views have now been rejected even by the representatives of the German workers at the 1899 Party Congress in Hanover.

We know that on account of these words we shall be drenched with a flood of accusations; they will cry out that we want to turn the Socialist Party into a holy order of the "orthodox," who persecute the "heretics" for their aberrations from the "true dogma," for any independent opinion, etc. We know all these nonsensical phrases which have become the fashion nowadays. Yet there is no shadow of truth in them, no iota of sense. There can be no strong socialist party without a revolutionary theory which unites all socialists, from which the socialists draw their whole conviction, which they apply in their methods of fighting and working. To defend a theory of this kind, of the truth of which one is completely convinced, against unfounded attacks and against attempts to debase it, does not mean being an enemy of criticism in general. We by no means regard the theory of Marx as perfect and inviolable; on the contrary, we are convinced that this theory has only laid the foundation stones of that science on which the socialists must continue to build in every direction, unless they wish to be left behind by life. We believe that it is particularly necessary for Russian socialists to work out the Marxist theory independently, for this theory only gives general precepts, the details of which must be applied in England otherwise than in France, in France otherwise than in Germany, and in Germany otherwise than in Russia. For this reason we will willingly devote space in our paper to articles about theoretical questions, and we call upon all comrades openly to discuss the matters in dispute.

What are the main questions which arise in applying the common programme of all social-democrats to Russia?

We have already said that the essence of this programme consists in the organisation of the class struggle of the proletariat and in carrying on this struggle, the final aim of which is the seizure of political power by the proletariat and the construction of a socialist society. The class struggle of the proletariat is divided into: The economic fight (the fight against individual capitalists, or against the individual groups of capitalists by the improvement of the position of the workers), and the political fight (the fight against the Government for the extension of the rights of the people, i.e., for democracy, and for the expansion of the political power of the proletariat). Some Russian social-democrats regard the economic fight as incomparably more important and almost go so far as to postpone the political fight to a more or less distant future. This standpoint is quite wrong. All social-democrats are unanimous in believing that it is necessary to carry on an agitation among the workers on this basis. i.e., to help the workers in their daily fight against the employers, to direct their attention to all kinds and all cases of chicanery, and in this way to make clear to them the necessity of unity. To forget the political for the economic fight would. however, mean a digression from the most important principle of international social-democracy; it would mean forgetting what the whole history of the Labour movement has taught us. Fanatical adherents of the bourgeoisie and of the Government which serves it, have indeed repeatedly tried to organise purely economic unions of workers and thus to deflect them from the "politics" of socialism. It is quite possible that the Russian Government will also be clever enough to do something of the kind, as it has always endeavoured to throw some largesse or other sham presents to the people in order to prevent them becoming conscious that they are oppressed and without rights.

No economic fight can give the workers a permanent improvement of their situation, it cannot, indeed, be carried on on a large scale unless the workers have the free right to call meetings, to join in unions, to have their own newspapers and to send their representatives to the National Assembly as do the workers in Germany and all European countries (with the exception of Turkey and Russia). In order, however, to obtain these rights, a political fight must be carried on. In Russia, not only the workers but all the citizens are deprived of political rights. Russia is an absolute monarchy. The Tsar alone promulgates laws, nominates officials and controls them. For this reason it seems as though in Russia the Tsar and the Tsarist Government were dependent on no class and cared for all equally. In reality, however, all the officials are chosen exclusively from the possessing class, and all are subject to the influence of the large capitalists who obtain whatever they want—the Ministers dance to the tune the large capitalists play. The Russian worker is bowed under a double yoke; he is robbed and plundered by the capitalists and the landowners, and, lest he should fight against them, he is bound hand and foot by the police, his mouth is gagged and any attempt to defend the rights of the people is followed by persecution. Any strike against a capitalist results in the military and police being let loose on the workers. Every economic fight of necessity turns into a political fight, and socialdemocracy must indissolubly combine the economic with the political fight into a united class struggle of the proletariat.

6. NIETZSCHE

Friedrich Nietzsche (1844–1900) was perhaps the most original thinker of his time. Professor of Classical Philology at the University of Basle at the age of twenty-four, admiring friend and then bitter critic of Richard Wagner, thinker and writer of tremendous power, he was to spend the last twelve years of his life in hopeless insanity.

More than that of most philosophers, his work has suffered from misinterpretation and misrepresentation, and large chunks of it have been quoted out of context not only by Nazis who had an axe to grind but also by men from whom he might have expected better understanding. Certainly his ideas cannot be grasped from any brief or superficial reading and, to this extent, the passages that follow, compiled by Thomas Common (London, 1901), may merely accentuate the confusion. Even so, they will serve their purpose if they provide an idea of the impression they would create when tossed, like bombs, into the self-satisfied intellectual world of the late nineteenth century.

In the last generation, Nietzsche was regarded as a prophet of totalitarianism and race hatred. Today, however, we can see him as a rebel against a society whose complacent mediocrity he abhorred, and against democratic conformity which he

despised. His "will to power" aspires to power over oneself. And his insistence on individualism, self-assertion, and self-transcendence reveals him rather as a forerunner, not the least important, of contemporary existentialist thought.

From: The Gay Science, 1882, #377

WE HOMELESS ONES— THE GOOD EUROPEANS

Among the Europeans of today there are not lacking those who may call themselves, in a contrasting and honoring sense, homeless ones; it is precisely by them that my secret wisdom and gava scienza is to be laid to heart. For their lot is hard, their hope uncertain; it is an artifice to devise consolation for them. But what does it matter! We children of the future, how could we be at home in the present? We are unfavorable to all ideals which would make us feel at home in this frail, broken-down, transition period; and as regards the "realities" thereof, we do not believe in their endurance. The ice which still carries has become very thin; the thawing wind blows; we ourselves, we homeless ones, help to break the ice and the other too thin "realities". We "conserve" nothing, nor would we return to any past age; we are not at all "liberal", we do not labor for "progress", we do not need first to stop our ears to the song of the market-place sirens of the future—what they sing: "equal rights", "free society", "no longer either lords or slaves", does not allure us!-we do not by any means think it desirable that the kingdom of righteousness and peace should be established on earth (because under any circumstances it would be the kingdom of the profoundest mediocrity and chinoiserie); we rejoice in everything which, like ourselves, loves danger, war and adventure, which does not make compromises, nor let itself be captured, conciliated or defaced; we count ourselves among the conquerors; we ponder over the need of a new order of things, even of a new slavery—for the strengthening and elevation of the type "man" always involves a new form of slavery. Is it not obvious that with all this we must feel ill at ease in an age which claims the honor of being the most humane, gentle and just on which the sun has shone? It is bad enough, isn't it, that precisely in connection with these fine words our innermost thoughts are the more unpleasant; that we see therein only the expression-or even the masquerade—of profound weakening, exhaustion, age, and declining power? What does it matter to us with what kind of tinsel a sick person decks out his weakness! He may parade it as his virtue; there is certainly no doubt that weakness makes people gentle, ah, so gentle, so just, so inoffensive, so "humane"! The "religion of sympathy" to which people would like to persuade us-ves, we know the hysterical mannikin and girl sufficiently well, who need precisely this religion at present for a cloak and adornment!

We are no humanitarians; we should not dare to speak of our "love for mankind"; for that, a person of our stamp is not enough of an actor! . . . Mankind! Was there ever a more hideous old crone among all the old crones (unless perhaps it were "the truth": a question for philosophers)? No, we do not love mankind! Nor, on the other hand, are we nearly German enough (in the sense in which the word "German" is current at present)

to advocate nationalism and race-hatred, or take delight in the national heart-itch and blood-poisoning, on account of which the nations in Europe are at present bounded off and secluded from one another as by quarantines. We are too unprejudiced for that, too perverse, too fastidious: also too well informed, too much "travelled". We prefer much rather to live on mountains, apart, "unseasonable", in past or coming centuries, in order merely to spare ourselves the silent rage to which we know we should be condemned as witnesses of politics which make the German nation barren by making it vain, and which are petty politics besides. . . . We homeless ones are too diverse and mixed as regards race and descent to be "modern men". . . . We are, in a word -and it shall be our title of honor!-

From: #343

OUR OUTLOOK

The Greatest modern event—that God is dead, that the belief in the Christian God has become unworthy of belief-has now begun to cast its first shadows over Europe. To the few, at least, whose eve. whose suspecting glance is strong enough and subtle enough for a spectacle, a sun seems to have set to them, some old profound truth seems to have changed into doubt; our ancient world must every day seem to them "older", stranger, more unreliable, more vespertine. In the main, however, one may say that the event itself is far too great, too much beyond the power of apprehension of many people, for even the report of it to have reached them, to say nothing of their capacity for knowing what is really involved and what must all collapse, now that this belief has been undermined-by being built thereon, by

good Europeans, the heirs of Europe, the rich, over-wealthy heirs, also the too greatly obligated heirs, of milleniums of European thought: as such we have also outgrown Christianity, and are disinclined to it—and precisely because we have sprung from it, because our forefathers were Christians uncompromising in their Christian integrity, who willingly sacrificed possessions and positions, blood and fatherland, for the sake of their belief. We-do the same? For what, then? For our unbelief? For all sorts of unbelief? Nay, ye know better than that, my friends! The hidden Yea in you is stronger than all the Nays and Perhapses, of which you and your age are sick; and when ye are obliged to put out to sea, ye emigrants, it is-a belief which forces vou also thereto.

being buttressed thereby, by being engrafted therein; for example, our entire European morality. The prolonged excess and continuation of demolition, ruin and overthrow which is now impending-who has vet understood it sufficiently to be obliged to stand up as the teacher and herald of such tremendously frightful logic, as the prophet of such an overshadowing, of such a solar eclipse as has probably never happened on earth before? Even we, the born riddle-readers, who, as it were, wait on the mountains, posted betwixt today and tomorrow, and engirt by the contradiction between today and tomorrow, we, the firstlings and premature births of the coming century, to whom especially the shadows which must forthwith envelop Europe should already have come to sight—how is it that even we, without genuine sympathy for this over-shadowing, contemplate its advent without personal solicitude or fear? Are we still perhaps too much under the immediate effects of the event—and are these effects, especially as regards ourselves, perhaps the reverse of what was to be expected—not at all sad and depressing, but rather like a new and difficultly describable variety of light, happiness, alleviation, enlivenment, encouragement and rosy dawn? In fact, we philosophers and "free spirits" feel ourselves irradiated as by a new rosy dawn by the

report that "the old God is dead"; our hearts thereby overflow with gratitude, astonishment, presentiment and expectation. At last the horizon seems once more unobstructed, granting even that it is not bright; our ships can at last start on their voyages once more, in face of every danger; every risk is again permitted to the knowing ones; the sea, our sea, again lies open before us; perhaps there never was such an open sea.

From: Genealogy of Morals, 1887, I, 11

THE WILD BEAST IN MAN

At the bottom of all distinguished races the beast of prey is not to be mistaken, the magnificent blond beast, roaming wantonly in search of prey and victory. It requires from time to time the discharge of this hidden source of its nature the animal must again show itself, it must again go back into the wilderness. Roman, Arabic, German and Japanese nobles, Homeric heroes, Scandinavian vikings—they are all alike in this requirement. . . . The same men who are held in such strict bonds by usage, reverence,

custom, gratitude and, still more, by mutual watching and jealousy *inter pares* (while, at the same time, they show themselves so ingenious in deference, self-command, delicacy, fidelity, pride and friendship in relation to one another), these same men are not much better than wild beasts let loose towards the outside world, where what is unfamiliar, unfamiliar *people* commence. They there enjoy freedom from all social constraint; . . . like exulting monsters, they go back into the condition of innocent conscience of the beast of prey.

From: Beyond Good and Evil, 1886, #259

LIFE AS EXPLOITATION

Life itself is essentially appropriating, injuring and vanquishing of what is foreign and weak: it is suppression, severity, obtrusion of its own forms, incorporation and, at least, putting it most mildly, exploitation; but why should one for ever use precisely these words on which for ages a disreputable significance has been stamped? Even an organization within

which individuals deal with one another on equal terms (it is so in every healthy aristocracy) must, if it is a living and not a dying organization, act hostilely towards other organizations in all matters wherein the several individuals restrain themselves in their dealings with one another; it must be the embodied Will to Power, it has to seek to grow, it has to endeavor to gain ground, obtain advantage and acquire ascendancy—not on account of any

772

morality or immorality whatsoever, but because it *lives*, and because life itself *is* Will to Power.

There is nothing, however, on which the ordinary consciousness of Europeans is more unwilling to be corrected than on this matter; at present people rave everywhere, even under the guise of science, about coming conditions of society in which "the exploiting character" will be absent: that sounds to me as if they proposed to invent a mode of life which should not exercise organic functions. "Exploitation" does not belong to a depraved or an imperfect and primitive state of society; it belongs to the *essence* of living beings, as a fundamental organic function; it is a consequence of the intrinsic Will to Power, which is just the Will to Life. Granting that as a theory this is an innovation, as a reality it is the original fact of history.

From: Beyond Good and Evil, #260

MASTER-MORALITY AND SLAVE-MORALITY

In strolling through the many finer and coarser forms of morality which have hitherto prevailed or yet prevail on the earth, I found certain characteristics recurring regularly in connection with one another, until at last two fundamental types betrayed themselves to me, and a fundamental distinction was brought to light. There is Master-morality and Slavemorality. I would at once add, however, that in all higher and compound civilizations one finds attempts at the reconciliation of the two systems, while still oftener one finds their confusion and mutual misunderstanding; in fact, sometimes their close juxtaposition-even in the same man, in the same soul. The distinctions of moral worth have arisen either in a ruling caste, agreeably conscious of being distinct from the ruled; or among the ruled themselves, the slaves and dependents of all classes. In the first case, when it is the ruling caste that determines the conception "good", it is the exalted, proud disposition which is regarded as distinguishing and decisive as to the degree of rank. The noble type of man separates from himself those in whom the opposite of this is exalt-

ed, proud disposition displays itself—he despises them. (Let it be noted that in this first kind of morality the antithesis "good" and "bad" signifies practically the same as "noble" and "contemptible"; the antithesis "good" and "evil" has a different origin.) The despised ones are the cowards, the timid, the insignificant, those thinking merely of narrow utility, and moreover the distrustful with their constrained glances, the self-abasing, the dog-species of men who allow themselves to be misused, the mendacious flatterers and, above all, the liars-it is a fundamental belief of all aristocrats that the common people are deceitful; "we true ones", the nobility of ancient Greece called themselves.

It is obvious that the designations of moral worth everywhere were at first applied to men, and were only derivatively and at a later period applied to actions. It is a bad mistake, therefore, when historical moralists start with questions such as—"Why have sympathetic actions been praised?" The noble type of man regards himself as the determiner of worth, it is not necessary for him to be approved of, he passes the judgment—"What is injurious to me is injurious in itself"; he recognizes that it is he himself only that

confers honor on things—he is a creator of worth, of values. The type of man in question honors whatever qualities he recognizes in himself: his morality is selfglorification. In the foreground there is the feeling of plenitude and power which seeks to overflow, the happiness of high tension, the consciousness of riches which would fain give and bestow; the noble man also helps the unfortunate, not (or scarcely) out of sympathy, but rather out of an impulse produced by the superabundance of power. The noble man honors the powerful one in himself, and also him who has self-command, who knows how to speak and keep silence, who joyfully exercizes strictness and severity over himself and reverences all that is strict and severe. "Wotan has put a hard heart in my breast" says the hero of an old Scandinavian saga: the idea is thus expressed right out of the heart of a proud viking. Such a type of man is in fact proud of not being made for sympathy; the hero of the saga therefore adds by way of warning: "He who has not had a hard heart when young, will never have a hard heart." The noble and brave who think thus are furthest removed from the morality which sees precisely in sympathy, in acting for the good of others, or in disinterestedness, the characteristic of morality; a belief in oneself, a pride in oneself, a fundamental hostility and irony with respect to "selflessness", belong as distinctly to the higher morality as do careless scorn and precaution in presence of sympathy and the "warm heart". It is the powerful who know how to honor: it is their art, their domain, their invention. The profound reverence for age and tradition-all law rests on this double reverence—the belief and prejudice in favor of ancestors and unfavorable to newcomers, is typical of the morality of the powerful; and if, reversely, men of "modern ideas" believe almost instinctively in "progress" and "the future", and are more and more lacking in respect for the old, the ignoble origin of these "ideas" complacently betrays itself thereby.

The morality of the ruling class, however, is more especially foreign and irritating to the taste of the present day, owing to the sternness of the principle that one has only obligations to one's equals, that one may act towards beings of a lower rank, and towards all that is foreign to one, according to discretion, or "as the heart desires", and in any case "beyond Good and Evil". It is here that sympathy and similar sentiments like to have a place. The capacity and obligation for prolonged gratitude and prolonged revenge-both only among equals-artfulness in retaliation, refinement of ideas in friendship, a certain necessity to have enemies (as outlets for the passions of quarrelsomeness, arrogance—in fact, in order to be a good friend): these are all typical characteristics of the noble morality, which, as we have indicated, is not the morality of "modern ideas", and on that account is at present difficult to realise, and also difficult to unearth and disclose.

It is different with the second type of morality, Slave-morality. Supposing that the misused, the oppressed, the suffering, the enslaved, the weary and those uncertain of themselves should moralise, what will be the common element in their estimates of moral worth? Probably a pessimistic suspicion with regard to the whole situation of man will find expression, perhaps a condemnation of man together with his situation. The slave contemplates with disapproval the virtues of the powerful; he has a thorough skepticism and distrust, a refinement of dis-

774

trust, of everything "good" that is there honored; he would like to persuade himself that the very happiness there is not genuine. On the other hand, those qualities are brought into prominence and into the light which tend to alleviate the existence of sufferers; it is here that the kind helping hand, the warm heart, along with sympathy, patience, diligence, submissiveness and friendliness attain to honor; for these are the most useful qualities here, and almost the only expedients for supporting the burden of existence. Slavemorality is essentially the morality of utility. This is the seat of the origin of the celebrated antithesis "good" and "evil"; the notion of power and dangerousness is introduced into the evil, the ideas of dreadfulness, subtlety and strength, which do not admit of being despised. According to slave-morality, the "evil" man also excites fear; according to master-morality, it is precisely the "good" man who excites fear and seeks to excite it, while the "bad" man is regarded as the contemptible being. The contrast attains its maximum when, according to the logical consequences involved, a tinge of depreciation attaches itself to the "good" man of slave-morality; because in any case he has to be the safe man: he is good-natured, easily-deceived, perhaps a little stupid, un bonhomme. Wherever slave-morality gets the upper hand, language shows a tendency to approximate the significations of the words "good" and "stupid".

A last fundamental distinction: the desire for *liberty*, the instinct for happiness, and the refinements of the feeling of freedom, belong as necessarily to the domain of slave-morals and slave morality, as enthusiasm and art in reverence and devotion are the regular symptoms of an aristocratic mode of thinking and valuing.

IV. Nationalism and Imperialism

There is no necessary connection between nationalism and imperialism, for one is an ideological, almost mythological phenomenon, while the other is a policy which can be carried out by an individual like Alexander the Great, by a dynasty like the Habsburgs, a city-state like Athens or Rome, or even, figuratively, by a great business enterprise.

It is, however, true that the forty years before 1914 saw the conjunction of these two forces, the great nations of the West engaging in economic and territorial enterprises of an imperialistic nature and using nationalistic arguments in their support—nationalism being the use or misuse of patriotism for political ends. There was a great deal of idealism mixed with the various national conceptions of manifest destiny which often sincere writers, politicians, and crackpots expressed in every country. It would appear, however, that in the long run the ideals either served to cover the interests of skilful pragmatists or else carried politicians and public both into policies which had little to do with reason, logic, or the real interests of the nation.

The tale of this modern imperialism must be traced back at least to the policies of Bismarck which achieved the unification of Germany as a Prussian-dominated realm by defeating three successive enemies-Danes, Austrians, French—in three successive wars, each a put-up job. Having achieved his aim with the defeat of France in 1871, Bismarck devoted the rest of his career to securing the international stability without which he feared his new structure might be destroyed. But he had set in motion forces which he could not long control. His very success persuaded the Germans that they were destined to rule Europe . . . and the world; and "scientific" theories succeeded in proving the point. Nor, as we shall see, were the Germans alone in their illusions of grandeur. The Anglo-Saxon peoples too had been advancing in seven-league boots and had come to believe that their achievements were only a promise of greater ones to come. It would be only a matter of time before such expansive tendencies, mystic in part but expressed in concrete economic and territorial interests, would clash on the international plane.

1. BISMARCK

As we have seen already, for Bismarck the end justified the means, and these means might be either dubious or respectable, provided they served the interests of Germany. His own account of the events preceding the outbreak of war with France in 1870 affords an instance of his readiness to claim responsibility even for acts of

doubtful propriety provided they succeeded in serving the national cause. On a different tack, the Triple Alliance was also a part of his work—of his striving, once German unity had been achieved, to preserve European peace and a balance of power favorable to the newly created Empire.

The Ems Telegram

On July 12 I decided to hurry off from Varzin to Ems to discuss with his Majesty about summoning the Reichstag for the purpose of the mobilization. As I passed through Wussow my friend Mulert, the old clergyman, stood before the parsonage door and warmly greeted me; my answer from the open carriage was a thrust in carte and tierce in the air, and he clearly understood that I believed I was going to war. As I entered the courtyard of my house at Berlin, and before leaving the carriage, I received telegrams from which it appeared that the King was continuing to treat with Benedetti, even after the French threats and outrages in parliament and in the press, and not referring him with calm reserve to his ministers. During dinner, at which Moltke and Roon were present, the announcement arrived from the embassy in Paris that the Prince of Hohenzollern had renounced his candidature in order to prevent the war with which France threatened us. My first idea was to retire from the service, because, after all the insolent challenges which had gone before I perceived in this extorted submission a humiliation of Germany for which I did not desire to be responsible. This impression of a wound to our sense of national honour by the compulsory withdrawal so dominated me that I had already decided to announce my retirement at Ems. I considered this humiliation before France and her swaggering demonstrations as worse than that of Olmütz, for which the previous history on both sides, and our want of preparation for war at the time, will always be a valid excuse. I took it for granted that France would lay the Prince's renunciation to her account as a satisfactory success, with the feeling that a threat of war, even though it had taken the form of international insult and mockery, and though the pretext for war against Prussia had been dragged in by the head and shoulders, was enough to compel her to draw back, even in a just cause; and that even the North German Confederation did not feel strong enough to protect the honour and independence against French arrogance. I was very much depressed, for I saw no means of repairing the corroding injury I dreaded to our national position from a timorous policy, unless by picking quarrels clumsily and seeking them artificially. I saw by that time that war was a necessity, which we could no longer avoid with honour. I telegraphed to my people at Varzin not to pack up or start, for I should be back again in a few days. I now believed in peace; but as I would not represent the attitude by which this peace had been purchased, I gave up the journey to Ems and asked Count Eulenburg to go thither and represent my opinion to his Majesty. In the same sense I conversed with the Minister of War, von Roon: we had got our slap in the face from France, and had been reduced, by our complai-

From Bismarck, The Man and the Statesman, tr. A. J. Butler, 2 vol. (New York, 1899), II, Chaps. 22, 29.

sance, to look like seekers of a quarrel if we entered upon war, the only way in which we could wipe away the stain. My position was now untenable. . . .

Having decided to resign, in spite of the remonstrances which Roon made against it, I invited him and Moltke to dine with me alone on the 13th, and communicated to them at table my views and projects for doing so. Both were greatly depressed, and reproached me indirectly with selfishly availing myself of my greater facility for withdrawing from service. I maintained the position that I could not offer up my sense of honour to politics, that both of them, being professional soldiers and consequently without freedom of choice, need not take the same point of view as a responsible Foreign Minister. During our conversation I was informed that a telegram from Ems in cipher, was being deciphered. When the copy was handed to me it showed that Abeken had drawn up and signed the telegram at his Majesty's command, and I read it out to my guests, whose dejection was so great that they turned away from food and drink.

The telegram, handed in at Ems on July 13, 1870, at 3:50 P.M. and received in Berlin at 6:09, ran as deciphered:

"His Majesty writes to me: 'Count Benedetti spoke to me on the promenade, in order to demand from me, finally in a very importunate manner, that I should authorize him to telegraph at once that I bound myself for all future time never again to give my consent if the Hohenzollerns should renew their candidature. I refused at last somewhat sternly, as it is neither right nor possible to undertake engagements of this kind à tout jamais. Naturally I told him that I had as yet received no news, and as he was earlier

informed about Paris and Madrid than myself, he could clearly see that my government once more had no hand in the matter.' His Majesty has since received a letter from the Prince. His Majesty having told Count Benedetti that he was awaiting news from the Prince, has decided, with reference to the above demand, upon the representation of Count Eulenburg and myself, not to receive Count Benedetti again, but only to let him be informed through an aide-decamp: That his Majesty had now received from the Prince confirmation of the news which Benedetti had already received from Paris, and had nothing further to say to the ambassador. His Majesty leaves it to your Excellency whether Benedetti's fresh demand and its rejection should not be at once communicated both to our ambassadors and to the press."

On a repeated examination of the document I lingered upon the authorization of his Majesty, which included a command, immediately to communicate Benedetti's fresh demand and its rejection both to our ambassadors and to the press. I put a few questions to Moltke as to the extent of his confidence in the state of our preparations, especially as to the time they would still require in order to meet this sudden risk of war. He answered that if there was to be war he expected no advantage to us by deferring its outbreak; and even if we should not be strong enough at first to protect all the territories on the left bank of the Rhine against French invasion, our preparation would nevertheless soon overtake those of the French, while at a later period this advantage would be diminished; he regarded a rapid outbreak as, on the whole, more favourable to us than delay.

In view of the attitude of France, our national sense of honour compelled us, in my opinion, to go to war; and if we did not act according to the demands of this feeling, we should lose, when on the way to its completion, the entire impetus towards our national development won in 1866, while the German national feeling south of the Main, aroused by our military successes in 1866, and shown by the readiness of the southern states to enter the alliances, would have to grow cold again. The German feeling, which in the southern states lived along with the individual and dynastic state feeling, had, up to 1866, silenced its political conscience to a certain degree with the fiction of a collective Germany under the leadership of Austria, partly from South German preference for the old imperial state, partly in the belief of her military superiority to Prussia. After events had shown the incorrectness of that calculation, the very helplessness in which the South German states had been left by Austria at the conclusion of peace was a motive for the political Damascus that lay between Varnbuler's "Vae victis" and the willing conclusion of the offensive and defensive alliance with Prussia. It was confidence in the Germanic power developed by means of Prussia, and the attraction which is inherent in a brave and resolute policy if it is successful, and then proceeds within reasonable and honourable limits. This nimbus had been won by Prussia; it would have been lost irrevocably, or at all events for a long time, if in a question of national honour the opinion gained ground among the people that the French insult, La Prusse cane, had a foundation in fact.

In the same psychological train of thought in which during the Danish war in 1864 I desired, for political reasons, that precedence should be given not to the old Prussian, but to the Westphalian

battalions, who so far had no opportunity of proving their courage under Prussian leadership, and regretted that Prince Frederick Charles had acted contrary to my wish, did I feel convinced that the gulf, which diverse dynastic and family influences and different habits of life had in the course of history created between the south and north of the Fatherland, could not be more effectually bridged over than by a joint national war against the neighbour who had been aggressive for many centuries. I remembered that even in the short period from 1813 to 1815, from Leipzig and Hanau to Belle-Alliance, the joint victorious struggle against France had rendered it possible to put an end to the opposition between a vielding Rhine-Confederation policy and the German national impetus of the days between the Vienna congress and the Mainz commission of enquiry, days marked by the names of Stein, Gorres, Jahn, Wartburg, up to the crime of Sand. The blood shed in common, from the day when the Saxons came over at Leipzig down to their participation at Waterloo under English command, had fostered a consciousness before which the recollections of the Rhine-Confederation were blotted out. The historical development in this direction was interrupted by the anxiety aroused by the over-haste of the national craving for the stability of stateinstitutions.

This retrospect strengthened me in my conviction, and the political considerations in respect to the South German states proved applicable likewise, *mutatis mutandis*, to our relations with the populations of Hanover, Hesse, and Schleswig-Holstein. That this view was correct is shown by the satisfaction with which, at the present day, after a lapse of twenty years, not only the Holsteiners, but like-

wise the people of the Hanse towns remember the heroic deeds of their sons in 1870. All these considerations, conscious and unconscious, strengthened my opinion that war could be avoided only at the cost of the honour of Prussia and of the national confidence in it. Under this conviction I made use of the royal authorization communicated to me through Abeken, to publish the contents of the telegram; and in the presence of my two guests I reduced the telegram by striking out words, but without adding or altering, to the following form: "After the news of the renunciation of the hereditary Prince of Hohenzollern had been officially communicated to the imperial government of France by the royal government of Spain, the French ambassador at Ems further demanded of his Majesty the King that he would authorize him to telegraph to Paris that his Majesty the King bound himself for all future time never again to give his consent if the Hohenzollerns should renew their candidature. His Majesty the King thereupon decided not to receive the French ambassador again, and sent to tell him through the aide-decamp on duty that his Majesty had nothing further to communicate to the ambassador." The difference in the effect of the abbreviated text of the Ems telegram as compared with that produced by the original was not the result of stronger words but of the form, which made this announcement appear decisive, while Abeken's version only would have been regarded as a fragment of a negotiation still pending, and to be continued at Berlin.

After I had read out the concentrated edition to my two guests, Moltke re-

marked: "Now it has a different ring; it sounded before like a parley; now it is like a flourish in answer to a challenge." I went on to explain: "If in execution of his Majesty's order I at once communicate this text, which contains no alteration in or addition to the telegram, not only to the newspapers, but also by telegraph to all our embassies, it will be known in Paris before midnight, and not only on account of its contents, but also on account of the manner of its distribution, will have the effect of a red rag upon the Gallic bull. Fight we must if we do not want to act the part of the vanquished without a battle. Success, however, essentially depends upon the impression which the origination of the war makes upon us and others; it is important that we should be the party attacked, and this Gallic overweening and touchiness will make us, if we announce in the face of Europe, so far as we can without the speaking-trumpet of the Reichstag, that we fearlessly meet the public threats of France."

This explanation brought about in the two generals a revulsion to a more joyous mood, the liveliness of which surprised me. They had suddenly recovered their pleasure in eating and drinking and spoke in a more cheerful vein. Roon said: "Our God of old lives still and will not let us perish in disgrace." Moltke so far relinquished his passive equanimity that, glancing up joyously towards the ceiling and abandoning his usual punctiliousness of speech, he smote his hand upon his breast and said: "If I may but live to lead our armies in such a war, then the devil may come directly afterwards and fetch away the 'old carcass.' "

The Triple Alliance

The triple alliance which I originally sought to conclude after the peace of Frankfort, and about which I had already sounded Vienna and St. Petersburg, from Meaux, in September 1870, was an alliance of the three Emperors with the further idea of bringing into it monarchical Italy. It was designed for the struggle which, as I feared, was before us; between the two European tendencies which Napoleon called Republican and Cossack, and which I, according to our present ideas, should designate on the one side as the system of order on a monarchical basis, and on the other as the social republic to the level of which the anti-monarchical development is wont to sink, either slowly or by leaps and bounds, until the conditions thus created become intolerable. and the disappointed populace are ready for a violent return to monarchical institutions in a Cesarean form. I consider that the task of escaping from this vicious circle or, if possible, of sparing the present generation and their children an entrance into it, ought to be more closely incumbent upon the strong existing monarchies, those monarchies which still have a vigorous life, than any rivalry over the fragments of nations which people the Balkan peninsula. If the monarchical governments have no understanding of the necessity for holding together in the interests of political and social order, but make themselves subservient to the chauvinistic impulses of their subjects, I fear that the international revolutionary and social struggles which will have to be fought out will be all the more dangerous. and take such a form that the victory on the part of monarchical order will be more difficult. Since 1871 I have sought for the most certain assurance against

these struggles in the alliance of the three Emperors, and also in the effort to impart to the monarchical principle in Italy a firm support in that alliance. I was not without hope of a lasting success when the meeting of the three Emperors took place at Berlin in September 1872, and this was followed by the visits of my Emperor to St. Petersburg in May, of the king of Italy to Berlin in September, and of the German Emperor to Vienna in October of the next year. The first clouding over of that hope was caused in 1875 by the provocations of Prince Gortchakoff, who spread the lie that we intended to fall upon France before she had recovered from her wounds. . . .

It is explicable that for the Russian policy there is a limit beyond which the importance of France in Europe must not be decreased. That limit was reached, as I believe, at the peace of Frankfort—a fact which in 1870 and 1871 was not so completely realized at St. Petersburg as five years later. I hardly think that during our war the Russian cabinet clearly foresaw that, when it was over, Russia would have as neighbour so strong and consolidated a Germany. In 1875 I had the impression that some doubt prevailed on the Neva as to whether it had been prudent to let things go so far without interfering in their development. The sincere esteem and friendship of Alexander II for his uncle concealed the uneasiness already felt in official circles. . . .

Count Suvaloff was perfectly right when he said that the idea of coalition gave me nightmares. We had waged victorious wars against two of the European Great Powers; everything depended on inducing at least one of the two mighty foes whom we had beaten in the field to renounce the anticipated designs of uniting with the other in a war of revenge. To all who know history and the character of the Gallic race, it was obvious that that Power could not be France, and if a secret treaty of Reichstadt was possible without consent, without our knowledge, so also was a renewal of the old coalition—Kaunitz's handiwork—of France, Austria, and Russia, whenever the elements which it represented, and which beneath the surface were still present in Austria, should gain the upper hand there.

This situation demanded an effort to limit the range of the possible anti-German coalition by means of treaty arrangements which would place our relations with at least one of the Great Powers upon a firm footing. The choice could only lie between Austria and Russia, for the English constitution does not admit of alliances of assured permanence, and a union with Italy alone did not promise an adequate counterpoise to a hostile coalition. The choice could therefore be narrowed till only the alternative remained which I have indicated.

In point of material force I held a union with Russia to have the advantage. I had also been used to regard it as safer, because I have placed more reliance on traditional dynastic friendship, on community of conservative monarchical instincts, on the absence of indigenous political division, than on the fits and starts of public opinion among the Hungarian, Slav, and Catholic population of the Habsburg Monarchy. Complete reliance could be placed upon the lasting quality of neither union, whether one estimated the strength of the dynastic bond with Russia, or of the German sympathies of the Hungarian populace. If the balance of opinion in Hungary were always determined by sober political calculations, this brave and independent people, isolated in the broad ocean of Slav populations, and comparatively insignificant in numbers, would remain constant to the conviction that its position can only be secured by the support of the German element in Austria and Germany. But the Kossuth episode, and the suppression in Hungary itself of the German elements that remained loyal to the Empire, along with other symptoms, showed that among Hungarian hussars and lawvers self-confidence is apt at critical moments to get the better of political calculation and selfcontrol. Even in quiet times many a Magyar will get the Gypsies to play him the song that goes "The German is a blackguard."

2. CHAMBERLAIN

The ideas of Houston Stewart Chamberlain, an Englishman naturalized a German subject, reflect the nationalist thinking current at the turn of the century and had a strong influence upon Hitler and the theory to which the National-Socialists subscribed. Here are three short passages from his book, The Foundations of the Nineteenth Century first published in 1899. Notice the way in which the appeal to common sense is combined with assertions quite unsupported by fact. In this case the writer boosts the Teuton, but similar farragoes of mystic nonsense could be cited which glorify the national vanity and sense of Manifest Destiny of every other country in the world. Nevertheless, we have to admit that Mr. Chamberlain and his fatherin-law, Richard Wagner, did particularly well in this line.

From: The Foundations of the Nineteenth Century

Seldom have the consciousness of race. national feeling, and suspicious safeguarding of the rights of personality been so active and vigorous as in our time; a phase of feeling is passing over the nations at the close of the nineteenth century which reminds one of the dull cry of the hunted animal, when the noble creature at bay suddenly turns, determined to fight for its life. And in our case resolution means victory. For the great attractiveness of every Universalist idea is due to the weakness of men; the strong man turns from it and finds in his own breast, in his own family, in his own people, the Limitless, which we would not surrender for the whole cosmos with its countless stars. Now from the nation-building Teutons of former generations we can learn that there is a higher enjoyment than to surrender, and that is to assert ourselves. . . . Our Teutonic culture is a result of toil and pain and faith—not ecclesiastical but religious faith. If we go lovingly through those annals of our ancient forbears, which tell us so little and yet so much, what will strike us most is the almost incredible strength of the developed sense of duty; for the worst cause, as for the best, every one yields up his life unquestioningly. Did these men know what they wanted? I scarcely think so. But they knew what they did not want, and that is the beginning of all practical wisdom.

Wherever the reader casts his eyes, he will find examples to prove the fact that the present civilization and culture of Europe are specifically Teutonic, fundamentally distinct from all the un-Aryan ones and very essentially different from the In-

dian, the Hellenic and the Roman, directly antagonistic to the halfbreed ideal of the anti-national Imperium and the socalled "Roman" system of Christianity. The matter is so perfectly clear that further discussion would surely be superfluous. . . . This one fact had first to be laid down. For our world of today is absolutely new, and in order to comprehend it and form an estimate of its rise and present condition, the first fundamental question is: Who has created it? The new world was created by the same Teuton who after such an obstinate struggle discarded the old. He alone possessed that "wild willing" of which I spoke at the end of the last chapter, the determination not to surrender, but to remain true to self. . . . Will this be censured as empty pride? Surely it is only the recognition of a manifest fact. Will the objection be offered that no mathematical proof is possible? Surely from all sides this fact is borne in upon us with the same certainty as that twice two makes four.

Nothing is more instructive in this connection than a reference to the manifest significance of purity of race. How feebly throbs today the heart of the Slav, who had entered history with such boldness and freedom: though highly gifted, he is losing his real informing power and the constancy to carry through whatever he undertakes. Anthropology solves the riddle, for it shows us that by far the greater number of Slavs today have, by mingling with another human race, lost the physical—and naturally also the moral—characteristics of their ancestors, who were identical with the ancient Teutons. And yet there is still in these nations so

From H. S. Chamberlain, The Foundations of the Nineteenth Century, tr. John Lees, 2 vol. (London: John Lane The Bodley Head Limited, 1912), II, 180-181, 196-197, 222-223. By permission of the publishers.

much Teutonic blood that they form one of the greatest civilizing forces in the continuous subjection of the world by Europe.

If we then free ourselves from the delusion of there being such a thing as a humanity, and content ourselves with the realization of the fact that our culture is specifically North European, i.e. Teutonic, we shall at once gain a sure standard by which to judge our own past and our present, and at the same time a very useful standard to a future which has yet to come. For nothing Individual is limitless. So long as we regard ourselves as the responsible representatives of all humanity, the more clearsighted among us must be driven to despair by our poverty and obvious incapacity to pave the way for a golden age; at the same time, however, all shallow-brained phrase-makers turn us from those earnest aims which we might attain, and undermine what I should like to call historical morality, in that, shutting their eyes, blind to our universal limitations, and totally failing to realize the value of our specific talents, they dangle before our eyes the Impossible, the Absolute: natural rights, eternal peace, universal brotherhood, mutual fusion, etc. But if we know that we Northern Europeans are a definite individuality, responsible not for humanity but certainly for our own personality, we shall love and value our work as something individual, we shall recognize the fact that it is by no means complete, but still very defective, and, above all, far from being sufficiently independent; no vision of an "absolute" perfection will mislead us but we shall, as Shakespeare wished, remain true to ourselves and be satisfied with doing our very best within the limits of the Teuton's power of achievement; we shall deliberately defend ourselves against the un-Teutonic, and seek not only to extend our empire farther and farther over the surface of the globe and over the powers of nature, but, above all, unconditionally to subject the inner world to ourselves by mercilessly overthrowing and excluding those who are alien to us, and who, nevertheless, would fain gain mastery over our thought. It is often said that politics can know no scruples: nothing at all can know scruples; scruples are a crime against self. Scruple is the soldier who in battle takes to his heels, presenting his behind as a target to the enemy. The most sacred duty of the Teuton is to serve the Teutonic cause. This fact supplies us with an historical standard of measurement. In all spheres that man and that deed will be glorified as great and most important which most successfully advance specific Teutonism or have most vigorously supported its supremacy. Thus and thus only do we acquire a limiting, organising, absolutely positive principle of judgment.

3. GERMAN ATTITUDES

Prior to 1914 a strong German imperialist movement arose, aiming at uniting all German-speaking people in a common empire and also at German expansion abroad. Its program included the conquest of territories in Eastern Europe, colonial expansion, and a big navy for Germany. The pan-Germans also evolved racial and anti-Semitic doctrines, and their doctrines and demands foreshadowed those of Nazism.

LIVING SPACE

A people needs land for its activities, land for its nourishment. No people needs it as much as the German people which is increasing so rapidly and whose old boundaries have become dangerously narrow. If we do not soon acquire new territories, we are moving towards a frightful catastrophe. It matters little whether it be in Brazil, in Siberia, in Anatolia or in South Africa, as long as we can once again move full of freedom and fresh energy, as long as we can once more offer our children wholesome light and air in plenty. Once more, as 2000 years ago when the Cimbri and the Teutons were hammering at the gates of Rome, sounds the cry, now full of anguish and unappeased desires, now arrogant and full of confidence—sounds more and more strongly the cry "We must have lands, new lands!"

HOW THE NEW GERMANY WILL BE BUILT

The manner in which Germany will realize the aggrandizement of its territory poses a problem difficult to solve, because it is a practical one. (sic) This problem is closely bound to the necessities which the peculiar characteristics of the germanic race impose. Where the idea of racial unity is concerned, the division of the germanic race into different peoples and different states can raise an obstacle. And outside difficulties become more important for the Germans because they incline them towards particularism. How-

ever, these difficulties are easier to overcome than one might think at first. In effect, the moment the belief should appear in the dominant German states that a closer political union of certain germanic elements in Europe is both necessary and possible, the situation appears at once to be similar to that at the time when the (Holy Roman) Empire was founded. The most powerful state of Germany must seize the hegemony, and the little states must sacrifice that part of their autonomy that is needed to establish a lasting unity for the new Empire.

It is unimportant whether armed force can or cannot be done without. The essential thing is that the state which aspires to the hegemony should dispose of sufficient moral, economic and military power to reach the end which must be attained and never forgotten. What could this state be if not the (present) German Empire engaged on a quest for fresh territories? No one can doubt it, seeing what we have said about the other great powers. All will depend on the submission of France. Germany must rule in Central and Western Europe. She must annex simultaneously, or shortly afterwards, the German provinces of Austria, in conformity with the purposes of the germanic race. The pressure exerted by the new Empire will be so great that, willy-nilly, the little germanic states will be forced to join us on terms that we shall have to lay down.1

GERMANY'S MANIFEST DESTINY

There is no need to state concerning the German idea, as of the Roman idea,

From A. Wirth, The Race and World Power in History (Berlin, 1904); quoted in C. Andler, Le Pangermanisme philosophique (Paris, 1917), p. 178.

Condensed from J. L. Reimer, A Pangerman Germany (Berlin, 1905), pp. 121-122.

¹ Remember that countries like Holland, Luxemburg, Switzerland were considered "germanic" by the Pangermans.

that it can only be mistress of the world or not be at all. But we can press the comparison further and say: she will only conquer and dominate as the auxiliary of universal civilization, or not at all. It is easy to state the reasons for this. The Anglo-American element has today grown to such an extraordinary extent that, based on those countries belonging to it, on its means of action and on its internal power, it seems on the way to establish its dominion over the world's civilization. Russia, the greatest and most numerous of political communities after the Anglo-Americans, appears to us stripped of its old hopes of a world policy because of its internal barbarism and its fragile structure. France has of its own accord renounced competition in the future with the other world powers. By the side of the Anglo-Americans, only the German nation has developed in such a fashion that she now appears sufficiently numerous and strong internally for its national thought to claim its formal right of a share in the shaping of the future. How can we understand this? We must know that we can only preserve our energy and our strength by an endless increase of the German idea. For us there can be no halt, no immobility. We cannot give up, even for a moment, the widening of our living space. We have only the choice between the alternative of relapsing into the ranks of the territorial peoples (bound by narrow boundaries) and that of conquering by force a place beside the Anglo-Americans (on the world scale).

4. ANGLO-SAXON ATTITUDES

Many things affected imperialists and colonialists, of which a feeling of manifest destiny was only one. Economic enterprise, missionary activity, the selfish but natural pursuit of private interest, all entered into it. The following extracts from a recent anthology may illuminate some of these motives and the extent to which such aims were fulfilled.

From: The Sahibs

LETTERS FROM MADRAS, 1836

Every horse has a man and a maid to himself—the maid cuts grass for him; and every dog has a boy. I inquired whether the cat had any servants, but I found that she was allowed to wait upon herself; and, as she seemed the only person in the establishment capable of so doing, I respected her accordingly. . . .

Notwithstanding their numbers, they are dreadfully slow. I often tire myself with doing things for myself rather than wait for their dawdling; but Mrs. Staunton laughs at me, and calls me a "griffin" [green, or new], and says that I must learn to have patience and save my strength. The real Indian ladies lie on a sofa and, if they drop their handkerchief, they just lower their voices and say "Boy!" in a very gentle tone, and then creeps in, perhaps, some old wizen, skinny brownie, looking like a superannuated threadpaper, who twiddles after them for a little while, and then creeps out again as softly as a black cat, and sits down cross-legged in

Condensed from P. Rohrbach, The German Idea in the World (Berlin, 1912), p. 6. From The Sahibs, ed. Hilton Brown (London: William Hodge & Company Limited, 1948), pp. 68-69, 96, 212, 224, 228. By permission of the publishers.

the verandah till "Mistress please to call again."

LETTERS OF MISS EDEN, 1836-1840

I wish you could see my passage sometimes. The other day when I set off to pay George a visit I could not help thinking how strange it would have seemed at home. It was a rainy day, so all the servants were at home. The two tailors were sitting in one window, making a new gown for me, and Rosina by them chopping up her betel-nut; at the opposite window were my two Dacca embroiderers working at a large frame, and the sentry, in an ecstasy of admiration mounting guard over them. There was the bearer standing upright, in a sweet sleep, pulling away at my punkah. My own five servants were sitting in a circle, with an English spelling-book, which they were learning by heart; and my jemadar, who, out of compliment to me, has taken to draw, was sketching a bird. Chance's (Miss Eden's dog) servant was waiting at the end of the passage for his "little excellency" to go out walking, and a Chinese was waiting with some rolls of satin that he had brought to show.

RUSSELL, MY DIARY OF INDIA, 1857-1858

"Who is that in the smart gharry, with servants in livery?" "That is the chaplain of the station, who marries and baptises, and performs services for the Europeans." "Does he go among the natives?" "Not he; he leaves that to the missionaries, of whom there are lots here." . . .

"Well: and who comes next along the drive, in that very smart buggy with the grey mare?" "That is the doctor of the station. He attends the sick Europeans. He also gets, under certain circumstances, head-money for every native soldier in garrison." "Does he attend them?" "I should think not! Why, how on earth could he attend a lot of niggers?" "But why is he paid for them?" "Ah, that is another matter. You must understand our system a little better before you can comprehend things of this sort."

LETTERS FROM MADRAS, 1838

We had heard that two Missionaries were established there (in Narsapoor), and we wanted to see them, and learn how they went on, and whether there was anything we could do to make them more comfortable. They were English shoemakers, Mr. Bowden and Mr. Beer, dissenters of Mr. Grove's class, but good, innocent, zealous creatures, and in the way to be very useful. They have two pretty, young English wives, as simple as themselves. They are living completely among the natives, teaching and talking to them, and distributing books. One of them is a man of great natural talent, strong-headed, and clear and sensible in his arguments; if he had been educated, he would probably have turned out a very superior person. They complained much of the difficulties of the language; but A- says that the two men spoke it really much better than the general run of Missionaries. One of the wives said to me very innocently, "It is pertickly difficult to us, ma'am, on account of our never having learnt any language at all. I don't know what to make of the grammar." I advised her not to trouble herself with the grammar but just to try and learn to speak the language so as to converse with the natives -to learn it, in short, as a child learns

to talk. At her age, and without any education, it was next to impossible for her to learn the grammar of an Oriental language; but I do not suppose she will follow my advice, as she had a great notion of studying, Moonshees, and so on. They live almost like the natives, without either bread or meat, but they have rice, fish, fowls, and vegetables, and they say, "The Lord has brought down our appetites to what he gives us to feed them on."

LADY FALKLAND, CHOW CHOW, 1848

Shortly before we left India, the railroad at Bombay was completed to a short distance beyond Tannah.

This was the first railroad opened in India. It can well be imagined what astonishment and excitement it caused among the natives, as well as what surprise it occasioned to many Europeans; for there were Anglo-Indians at Bombay, who had not been in Europe for many years, and who, therefore, had not seen a railroad.

A very handsome new temple had been commenced before the railroad was contemplated, and was on the verge of completion when the latter was opened. A railway station and a Hindoo temple in juxtaposition—the work of the rulers and

the ruled. Could one possibly imagine buildings more opposite in their purposes, or more indicative of the character of the races? the last triumphs of science side by side with the superstitions of thousands of years ago.

THE CIVILIAN'S SOUTH INDIA, 1915

What in the name of all that is wonderful are we doing in India at all? What indeed? The Civilian cannot tell you, for he does not know, but he does think we are doing something. He thinks this because of a letter he saw the other day in the papers. It was a letter signed by a number of Indian gentlemen, and they asked that their District which had had an Indian Collector for some years past might be given a European Collector for a change. Now, if there is anything in Self-Government for India at all, an Indian Collector ought to be its finest product, and the raising of Indians to be Collectors should be India's noblest aim. The Civilian is, moreover, competent to state that the Indian Collector in question was a first-class man and an able. But they wanted a European. There you are, and the Civilian leaves you to make of it what you can. He himself, frankly, is beaten.

5. KIPLING

The concept of Manifest Destiny in another guise appears with the idea of the White Man's Burden, which may be simply the idea of "Noblesse Oblige" translated into modern terms but no less typically presumptuous for all that. Its classic expression is to be found in the poem by Rudyard Kipling which is given below and which was written as an invitation to the Americans to help shoulder the burden. Kipling wrote these lines while the United States was engaged in the Spanish-American War. They appeared in the London *Times* on February 4, 1899, and in the New York *Sun* and *Tribune* on the following day. On February 6, the United States Senate voted to take over the administration of the Philippines.

From: The White Man's Burden

Take up the White Man's burden—Send forth the best ye breed—Go bind your sons to exile
To serve your captives' need;
To wait in heavy harness,
On fluttered folk and wild—Your new-caught, sullen peoples,
Half-devil and half-child.

Take up the White Man's burden—In patience to abide,
To veil the threat of terror
And check the show of pride;
By open speech and simple,
An hundred times made plain
To seek another's profit,
And work another's gain.

Take up the White Man's burden—
The savage wars of peace—
Fill full the mouth of Famine
And bid the sickness cease;
And when your goal is nearest
The end for others sought,
Watch sloth and heathen Folly
Bring all your hopes to nought.

Take up the White Man's burden— No tawdry rule of kings, But toil of serf and sweeper— The tale of common things. The ports ye shall not enter, The roads ye shall not tread, Go make them with your living, And mark them with your dead.

Take up the White Man's burden—And reap his old reward:
The blame of those ye better,
The hate of those ye guard—
The cry of hosts ye humour
(Ah, slowly!) toward the light:—
"Why brought he us from bondage,
Our loved Egyptian night?"

Take up the White Man's burden—Ye dare not stoop to less—
Nor call too loud on Freedom
To cloke your weariness;
By all ye cry or whisper,
By all ye leave or do,
The silent, sullen peoples
Shall weigh your Gods and you.

Take up the White Man's burden— Have done with childish days— The lightly proffered laurel, The easy, ungrudged praise. Comes now, to search your manhood Through all the thankless years, Cold, edged with dear-bought wisdom, The judgment of your peers!

6. ARMINIUS VAMBERY

A modified version of the white man's burden argument may be found in the works of contemporary explorers and world-travellers, of whom there were many. Phineas Fogg, hero of Jules Verne's *Around the World in Eighty Days* testifies not only to the opportunities which modern means of transport made available, but to the excitement and delight open to those who could take advantage of them.

Arminius Vambery was an anglicized Hungarian who travelled widely in Asia and published a great many accounts of his journeys. The preface of one of his less autobiographical works reflects a widespread contemporary point of view.

Western Influence in the East

In the regions where some decades ago the traveller's life was in constant danger, and where the struggle with the elements and with the natives made his progress necessarily slow and tedious, we now find a well-organised railway system, and in the place of the grunting camel the fiery steam-horse ploughs its way through endless vistas of sandy steppes. When, comfortably seated in our well-upholstered railway-carriage, gaze upon the Hyrkanian Steppe, upon the terrible deserts of Karakum and Kisilkum, we can scarcely realise the terrors, the sufferings, and the privations, to which travellers formerly were exposed. Truly, Tempora mutantur, nos et mutamur in illis. And great changes similar to those which have taken place in Central Asia may also be noticed in greater or less degree in other parts and regions of the Eastern world: in Siberia, West and North China, Mongolia, Manchuria, and Japan, which were in the first half of the nineteenth century scarcely known to us, and where the early martyrs of geographical research, such as Schlagintweit, Hayward, Wyburd, Conolly, Margary, and others, fell victims to barbarism, we now find that the supreme power of the Western world is gradually making itself felt. The walls of seclusion are ruthlessly pulled down, and the resistance caused by the favoured superstitions, prejudices, and the ignorance of the sleepy and apathetic man in the East, is slowly being overcome. If the English poet Matthew Arnold is right when he sang,

The East bowed down before the blast In patient, deep disdain; She let the legions thunder past, And plunged in thought again, our present-day Europe, in its restless, bustling activity will take good care not to let the East relapse again into its former indolence. We forcibly tear its eyes open; we push, jolt, toss, and shake it, and we compel it to exchange its worldworn, hereditary ideas and customs for our modern views of life; nay, we have even succeeded to some extent in convincing our Eastern neighbours that our civilisation, our faith, our customs, our philosophy, are the only means whereby the well-being, the progress, and the happiness, of the human race can be secured.

For well-nigh 300 years we have been carrying on this struggle with the Eastern world, and persist in our unsolicited interference, following in the wake of ancient Rome, which began the work with marked perseverance, but naturally never met with much success because of the inadequate means at its disposal. When we read the words of patriotic enthusiasm and inspiration with which Virgil addresses Caesar, we naturally begin to think that the Roman legions not only conquered the Asiatic world, but also exercised a civilising and beneficial influence over the whole East. This, however, was not the case. We may admire the splendour, the might, and the glory of Ancient Rome, we may allow that the glitter of its arms struck terror and alarm into the furthest corners of Asia; but in spite of all that, it would be difficult to admit that the civilising influence of Rome was ever more than an external varnish, a transitory glamour, Compared with the real earnest work done in our days by Western Powers, the efforts of Rome are as the flickering of an oil-lamp

Arminius Vambery, Western Culture in Eastern Lands (London, 1906), pp. 1-5.

in comparison with the radiance of the sun in its full glory. It may be said without exaggeration that never in the world's history has any one continent exercised such influence over another as has the Europe of our days over Asia: never were two such diametrically opposed elements engaged in so deadly a strife as is now to be seen in all parts of the Old World. This being so, it appears to me most important that we should realise what is the extent and the purpose of our civilising influence over Asia. We have to consider not only its historical growth and the means employed in its development, but also the results so far obtained, and the ultimate ends to be accomplished. And we are the more anxious to do so as our investigations into the remotest nooks and corners of the Old World have become fairly familiar ground to us all. We are in constant communication with those nations, we are familiar with their thoughts and their aspirations, we know what they think of our civilisation and the value they attach to the innovations which we are proposing to introduce into their lives. Our inquiries will in the first place make us acquainted with the means and the resources employed by the promoters of civilisation in the East. The advantages and disadvantages of our interference in the destiny of Eastern nations will stand out in bold relief, and the purely objective and unprejudiced estimate of the changes already effected may perchance have a beneficial influence upon future political relations all over the world. In the first place, then, we must ask ourselves the question: Have we a right thus to interfere in the concerns of the ancient world; and in the second place, What do the Asiatics think of it?

If we start with the assumption that

every man has a right to his own opinion and to the views which best correspond with his ideas of morality and material comfort, our pretended crusade in the name of civilisation must look like an unwarrantable interference. But the correctness of this assumption has so far been contradicted by historical events, for no community can remain in absolute isolation. Even China, the prototype of a seclusion extending over thousands of years, has before now migrated far into neighbouring lands. If Rome and Greece had remained within the narrow precincts of their native lands humanity would not have reached the present height of culture, and if Western nations had checked their passion for migration the aspect of things in Asia would now be even worse than it actually is. Of course the Asiatics themselves do not view the matter in this light. Many of them look upon our enforced reforms as hostile attacks upon their liberty, and as means to bring their people under our voke. But the better-informed amongst them, who know what the East now is and what it used to be, will hardly share this view. Humanity in Asia has never known culture and liberty in the sense in which we understand it, and has therefore never known true happiness, which is unavoidably dependent upon these two chief factors of mental and physical well-being.

During the much-extolled golden era of the history of Asia, tyranny and despotism were the ruling elements, justice a vain chimera, everything depended on the arbitrary will of the Sovereign, and a prolonged period of rest and peace was quite the exception. Asiatics, from motives of vanity or inborn laziness, may condone these abnormal conditions, but still it remains our duty to recognize the true state of affairs, and to take pity upon

our oppressed fellow-men. Without our help Asia will never rise above its low level, and even granted that the politics of European Powers are not purely unselfish, we must nevertheless, keeping the ultimate object in view, approve of the interference of Europe in the affairs of the East, and give the undertaking our hearty support.

7. AMERICAN ATTITUDES

The last third of the nineteenth century saw a steady increase in the material and potential political power of the United States. The country's expanding economy tempted her into overseas imperialism in the Pacific, in South America, and in Central America. The high point of this policy came when in 1898 the United States intervened in Spain's Cuban difficulties and shortly thereafter war broke out between the two countries. The war ended in a few months with the defeat of Spain, whose Caribbean and Philippine possessions were left in American hands.

Americans did not feel entirely easy in this matter, since the expansionist policy sponsored by men like Theodore Roosevelt clashed with the traditional anticolonialism of the Founding Fathers. This ambivalent American attitude is well illustrated by the following passages. The first reports an interview in which President McKinley explained his attitude toward the Philippines. The second is from the instructions which the President gave the American Peace Commissioners who went to Paris in 1898.

ATTITUDE TOWARD THE PHILIPPINES

I have been criticized a good deal about the Philippines, but I don't deserve it. The truth is, I didn't want the Philippines, and when they came to us, as a gift from the gods, I did not know what to do with them. When the Spanish war broke out, Dewey was at Hongkong, and I ordered him to go to Manila, and he had to; because, if defeated, he had no place to refit on that side of the globe, and if the Dons were victorious they would likely cross the Pacific and ravage our Oregon and California coasts. And so he had to destroy the Spanish fleet, and did it. But that was as far as I thought then. When next I realized that the Philippines had dropped into our lap, I confess that I did not know what to do with them. I sought counsel from all sides—Democrats as well as Republicans—but got little help. I thought first we would take only Manila; then Luzon; then other islands, perhaps all. I walked the floor of the White House night after night until midnight; and I am not ashamed to tell you, gentlemen, that I went down on my knees and prayed Almighty God for light and guidance more than one night.

And one night late it came to me this way—I don't know how it was, but it came: (1) That we could not give them back to Spain—that would be cowardly

From G. A. Malcolm and M. M. Kalaw, Philippine Government (Boston, 1932), p. 63.

and dishonorable; (2) that we could not turn them over to France or Germanythat would be bad business and discreditable: (3) that we could not leave them to themselves-they were unfit for selfgovernment-and they would soon have anarchy and misrule over there worse than Spain's was; and (4) that there was nothing left for us to do but to take them all, and to educate the Filipinos, and uplift and civilize and Christianize them. and, by God's grace, do the very best we could by them, as our fellowmen for whom Christ also died. And then I went to bed, and went to sleep, and slept soundly, and next morning I sent for the chief engineer of the War Department (our map-maker), and told him to put the Philippines on the map of the United States (pointing to a large map on the wall of his office); "and there they are, and there they will stay while I am president!"

INSTRUCTIONS TO PEACE COMMISSIONERS

Without any original thought of complete or even partial acquisition the presence and success of our arms at Manila imposes upon us obligations which we

cannot disregard. The march of events rules and overrules human action. Avowing unreservedly the purpose which has animated all our effort, and still solicitous to adhere to it, we cannot be unmindful that, without any desire or design on our part, the war has brought us new duties and responsibilities which we must meet and discharge as becomes a great nation on whose growth and career from the beginning the Ruler of Nations has plainly written the high command and pledge of civilization. Incidental to our tenure in the Philippines is the commercial opportunity to which American statesmanship cannot be indifferent. It is just to use every legitimate means for the enlargement of American trade; but we seek no advantages in the Orient which are not common to all. Asking only the open door for ourselves, we are ready to accord the open door to others. The commercial opportunity which is naturally and inevitably associated with this new opening depends less on large territorial possession than upon an adequate commercial basis and upon broad and equal privileges. . . . The United States cannot accept less than the cession in full right and sovereignty of the Island of Luzon.

From Foreign Relations of the United States, 1898 (Washington, Department of State), G. P. O., p. 907, 16 Sept. 1898.

V. War and Revolution

The growing friction between the powers eventually led to war—a war which was accepted not as a solution to their problems but as an excuse for not finding one. In any event, war had been threatening for so long that its coming seemed almost a relief. Though the British appear to have entered it only half-heartedly, even they soon succumbed to the general enthusiasm which caused each side to feel that it was fighting for justice and civilization against the powers of evil. The conflict drew on, sucking more countries into its vortex, consuming ever more of the world's energy, material, and blood. Those who could stand the strain longest came out on top; those who could not, collapsed not only militarily but economically and politically too (indeed, usually, first). All four eastern Empires—Germany, Austria, Russia, and Turkey—disintegrated, and in every one of them revolution went along with peace.

1. THE LOGIC OF ENTENTES

As Britain found herself thrust rather suddenly, and not very willingly, into a great European war that was going to develop into a conflict on a world scale, *Punch*, the humorous and influential English weekly magazine, produced its own comment on events.

To Serbia

You have won whatever of fame it brings
To have murdered a king and the heir of
kings,

And it well may be that your sovereign pride Chafes at a touch of its tender hide; But why should I follow your fighting line, For a matter that's no concern of mine?

To Austria

You may, if you like, elect to curb
The dark designs of the dubious Serb
And to close your Emperor's days in strife,
A tragic end to a tragic life,
By your bellicose taste for Balkan coups,
But why in the world should I stand to lose?

To Russia

No doubt the natural course for you Is to bid the Austrian bird "Go to!"

From Punch, 5 Aug. 1914.

He can't be suffered to spoil your dream Of a beautiful pan-Slavonic scheme:
But Britons can never be Slave, you see,
So what has your case to do with me?
But since another if you insist
Will be cutting in with his mailed fist
I shall be asked to a general scrap
All over the European map,
Dragged into somebody else's war
For that's what a double Entente is for.

Well, if I must, I shall have to fight For the love of a bounding Balkanite, But O what a tactless choice of time When the bathing season is at its prime, And how I should hate to lose my chance Of wallowing off the coast of France.

2. THE INTERNATIONALIST LEFT AND THE WAR

The great majority of Europeans, whatever their views on politics, class conflict, or international amity, reacted to the news like old war horses to the sound of a cavalry bugle. Socialists and their leaders, though they had long affirmed that workingmen had no country and threatened if mobilized to turn their guns first against their own officers and capitalist oppressors, were swept forward like their fellow countrymen in a great wave of patriotic fervor. My country right or wrong still sounded sweeter than the International though naturally no one suspected that his own country could be other than right. This letter from a Russian Socialist appeared in the London Times, on September 18, 1914.

Sir—May I be allowed to say a few words in connection with the excellent letter by my compatriot, Professor Vinogradov, which appeared in your paper today, September 14? Professor Vinogradov is absolutely right when he says that not only is it desirable that complete unity of feeling should exist in Russian political circles, but that this unity is already an accomplished fact.

The representatives of all political parties and of all nationalities in Russia are now at one with the Government, and this war with Germany and Austria, both guided by the Kaiser, has already become a national war for Russia.

Even we, the adherents of the parties of the Extreme Left, and hitherto ardent anti-militarists and pacifists, even we believe in the necessity of *this* war. *This* war is a war to protect justice and civilization. It will, we hope, be a decisive factor in our united *war against war*, and we

hope that after it, it will at last be possible to consider seriously the question of disarmament and universal peace. There can be no doubt that victory, and decisive victory at that (personally I await this in the immediate future), will be on the side of the Allied nations—England, France, Belgium, Serbia, and Russia.

The German peril, the curse which has hung over the whole world for so many decades, will be crushed, and crushed so that it will never again become a danger to the peace of the world. The peoples of the world desire peace.

To Russia this war will bring regeneration.

We are convinced that after this war there will no longer be any room for political reaction, and Russia will be associated with the existing group of cultured and civilized countries.

Yours truly, V. Bourtzeff

3. THE FOURTEEN POINTS

In an address to Congress delivered on January 8, 1918 President Wilson produced a statement of Allied war aims which has since become known as the "Fourteen Points." Britain, France, and the other powers in the Allied camp were not enthusiastic about all the points but were ready to regard them as a basis for discussion and negotiation. They also realized that the Americans were the dominant partner in the

From Documents of Russian History, 1914-1917 ed. F. A. Golder, tr. E. Aronsberg (New York: Appleton-Century-Crofts, Inc. 1927).

alliance and that they could not afford to anger Wilson by refusing to go along with his statement. The Germans, on the other hand, who were winning at the time, ignored the Fourteen Points completely. In the treaties of peace which they imposed on Rumania and on Russia during the spring of 1918 the only apparent principle we can find is that might makes right. By October, however, the Germans realized that defeat was upon them; and they very wisely decided that the offers which they had ignored when they were winning could be accepted as the basis of an honorable peace in the hour of defeat. By then the Allied interpretation of the points had changed somewhat. But this was not publicly known, and it became possible for the Germans in later years to claim that they had been tricked into signing the Armistice, when in fact the German military situation left no alternative between armistice and invasion. Below is a passage from Wilson's speech, containing the much-debated suggestions.

We entered this war because violations of right had occurred which touched us to the quick and made the life of our own people impossible unless they were corrected and the world secure once for all against their recurrence. What we demand in this war, therefore, is nothing peculiar to ourselves. It is that the world be made fit and safe to live in; and particularly that it be made safe for every peace-loving nation which, like our own, wishes to live its own life, determine its own institutions, be assured of justice and fair dealing by the other peoples of the world as against force and selfish aggression. All the peoples of the world are in effect partners in this interest, and for our own part we see very clearly that unless justice be done to others it will not be done to us. The programme of the world's peace, therefore, is our programme: and as we see it, is this:

I. Open covenants of peace, openly arrived at, after which there shall be no private international understandings of any kind, but diplomacy shall proceed always frankly and in the public view.

II. Absolute freedom of navigation upon the seas, outside territorial waters,

alike in peace and in war, except as the seas may be closed in whole or in part by international action for the enforcement of international covenants.

III. The removal, so far as possible, of all economic barriers and the establishment of an equality of trade conditions among all the nations consenting to the peace and associating themselves for its maintenance.

IV. Adequate guarantees given and taken that national armaments will be reduced to the lowest point consistent with domestic safety.

V. A free, open-minded, and absolutely impartial adjustment of all colonial claims, based upon a strict observance of the principle that in determining all such questions of sovereignty the interests of the populations concerned must have equal weight with the equitable claims of the government whose title is to be determined.

VI. The evacuation of all Russian territory and such a settlement of all questions affecting Russia as will secure the best and freest cooperation of the other nations of the world in obtaining for her an unhampered and unembarrassed op-

From Foreign Relations of the United States, 1918 (Washington, Department of State), Sup. 1, Vol. 1, pp. 13-17.

portunity for the independent determination of her own political development and national policy, and assure her of a sincere welcome into the society of free nations under institutions of her own choosing; and, more than a welcome, assistance also of every kind that she may need and may herself desire. The treatment accorded Russia by her sister nations in the months to come will be the acid test of their good will, of their comprehension of her needs as distinguished from their own interests, and of their intelligent and unselfish sympathy.

VII. Belgium, the whole world will agree, must be evacuated and restored, without any attempt to limit the sovereignty which she enjoys in common with all other free nations. No other single act will serve to restore confidence among the nations in the laws which they have themselves set and determined for the government of their relations with one another. Without this healing act, the whole structure and validity of international law is forever impaired.

VIII. All French territory should be freed and the invaded portions restored, and the wrong done to France by Prussia in 1871 in the matter of Alsace-Lorraine, which has unsettled the peace of the world for nearly fifty years, should be righted, in order that peace may once more be made secure in the interest of all.

IX. A readjustment of the frontiers of Italy should be effected along clearly recognizable lines of nationality.

X. The peoples of Austria-Hungary, whose place among the nations we wish to see safeguarded and assured, should be accorded the freest opportunity of autonomous development.

XI. Rumania, Serbia, and Montenegro should be evacuated; occupied territories restored; Serbia accorded free access to the sea; and the relations of the several Balkan states to one another determined by friendly counsel along historically established lines of allegiance and nationality; and international guarantees of the political and economic independence and territorial integrity of the several Balkan states should be entered into.

XII. The Turkish portions of the present Ottoman Empire should be assured a secure sovereignty, but the other nationalities which are now under Turkish rule should be assured an undoubted security of life and an absolutely unmolested opportunity of autonomous development, and the Dardanelles should be permanently opened as a free passage to the ships and commerce of all nations under international guarantees.

XIII. An independent Polish state should be erected which should include the territories inhabited by indisputably Polish populations, which should be assured a free and secure access to the sea, and whose political and economic independence and territorial integrity should be guaranteed by international covenant.

XIV. A general association of nations must be formed under specific covenants for the purpose of affording mutual guarantees of political independence and territorial integrity to great and small states alike.

We have spoken now, surely, in terms too concrete to admit of any further doubt or question. An evident principle runs through the whole programme I have outlined. It is the principle of justice to all peoples and nationalities, and their right to live on equal terms of liberty and safety with one another, whether they be strong or weak. Unless this principle be made its foundation, no part of the structure of international justice can stand. . . .

4. THE TREATY OF VERSAILLES

The Treaty of Versailles which was signed on June 28, 1919 between Germany and her victorious enemies is an extremely long and verbose document. The clauses cited below contain its most significant provisions.

Article 42 Germany is forbidden to maintain or construct any fortifications either on the left bank of the Rhine or on the right bank to the west of a line drawn 50 kilometres to the East of the Rhine.

Article 45 As compensation for the destruction of the coal mines in the north of France and as part payment towards the total reparation due from Germany for the damage resulting from the war, Germany cedes to France in full and absolute possession, with exclusive right of exploitation, unencumbered and free from all debts and charges of any kind, the coal mines situated in the Saar Basin . . .

Article 49 Germany renounces in favor of the League of Nations, in the capacity of trustee, the government of the territory defined above.

At the end of fifteen years from the coming into force of the present Treaty the inhabitants of the said territory shall be called upon to indicate the sovereignty under which they desire to be placed.

Alsace-Lorraine The High Contracting Parties, recognizing the moral obligation to redress the wrong done by Germany in 1871 both to the rights of France and to the wishes of the population of Alsace and Lorraine, which were separated from their country in spite of the solemn protest of their representatives at the Assembly of Bordeaux, agree upon the following. . . .

Article 51 The territories which were ceded to Germany in accordance with the Preliminaries of Peace signed at Versailles on February 26, 1871, and the Treaty of

Frankfort of May 10, 1871, are restored to French sovereignty as from the date of the Armistice of November 11, 1918.

The provisions of the Treaties establishing the delimitation of the frontiers before 1871 shall be restored.

Article 80 Germany acknowledges and will respect strictly the independence of Austria, within the frontiers which may be fixed in a Treaty between that State and the Principal Allied and Associated Powers; she agrees that this independence shall be inalienable, except with the consent of the Council of the League of Nations.

Article 81 Germany, in conformity with the action already taken by the Allied and Associated Powers, recognizes the complete independence of the Czecho-Slovak State which will include the autonomous territory of the Ruthenians to the south of the Carpathians. Germany hereby recognizes the frontiers of this State as determined by the Principal Allied and Associated Powers and the other interested States.

Article 87 Germany, in conformity with the action already taken by the Allied and Associated Powers, recognizes the complete independence of Poland . . .

Article 89 Poland undertakes to accord freedom of transit to persons, goods, vessels, carriages, wagons and mails in transit between East Prussia and the rest of Germany over Polish territory, including territorial waters, and to treat them at least as favorably as the persons, goods, vessels, carriages, etc., of Polish or of any

other more favored nationality, origin, importation, starting-point, or ownership, as regards facilities, restrictions, and all other matters. . . .

Article 102 The Principal Allied and Associated Powers undertake to establish the town of Danzig, together with the rest of the territory described in Article 100, as a Free City. It will be placed under the protection of the League of Nations.

Article 116 Germany acknowledges and agrees to respect as permanent and inalienable the independence of all the territories which were part of the former Russian Empire on August 1, 1914.

Germany accepts definitely the abrogation of the Brest-Litovsk Treaties and of all other treaties, conventions and agreements entered into by her with the Maximalist (Bolshevik) Government in Russia.

The Allied and Associated Powers formally reserve the rights of Russia to obtain from Germany restitution and reparation based on the principles of the present Treaty.

Article 119 Germany renounces in favor of the Principal Allied and Associated Powers all her rights and titles over her overseas possessions.

Article 159 The German military forces shall be demobilised and reduced as prescribed hereinafter.

Article 160 By a date which must not be later than March 31, 1920, the German Army must not comprise more than seven divisions of infantry and three divisions of cavalry.

After that date the total number of effectives in the Army of the States constituting Germany must not exceed 100,000 men, including officers and establishments of depots. The Army shall be devoted exclusively to the maintenance of

order within the territory and to the control of the frontiers.

The total effective strength of officers, including the personnel of staffs, whatever their composition, must not exceed four thousand . . .

Article 198 The armed forces of Germany must not include any military or naval air forces . . .

Article 231 The Allied and Associated Governments affirm and Germany accepts the responsibility of Germany and her allies for causing all the loss and damage to which the Allied and Associated Governments and their nationals have been subjected as a consequence of the war imposed upon them by the aggression of Germany and her allies.

Article 232 The Allied and Associated Governments recognize that the resources of Germany are not adequate, after taking into account permanent diminutions of such resources which will result from other provisions of the present Treaty, to make complete reparation for all such loss and damage.

The Allied and Associated Governments, however, require, and Germany undertakes, that she will make compensation for all damage done to the civilian population of the Allied and Associated Powers and to their property during the period of the belligerency of each as an Allied or Associated Power against Germany . . .

Article 233 The amount of the above damage for which compensation is to be made by Germany shall be determined by an Inter-Allied Commission . . . This Commission shall consider the claims and give to the German Government a just opportunity to be heard.

The findings of the Commission as to the amount of damage defined as above shall be concluded and notified to the German Government on or before May 1, 1921, as representing the extent of that Government's obligations. . . .

Article 234 The Reparation Commission shall after May 1, 1921, from time to time, consider the resources and capacity of Germany and, after giving her representatives a just opportunity to be heard, shall have discretion to extend the date, and to modify the form of payments, such as are to be provided in accordance with Article 233; but not to cancel any part, except with the specific authority of the several Governments represented upon the Commission.

Article 428 As a guarantee for the execution of the present Treaty by Germany, the German territory situated to the west of the Rhine, together with the bridgeheads, will be occupied by Allied and Associated troops for a period of fifteen years from the coming into force of the present Treaty.

Article 431 If before the expiration of the period of fifteen years Germany complies with all the undertakings resulting from the present Treaty, the occupying forces will be withdrawn immedi-

ately.

VI. Russia

Of all the great powers involved in the war, Russia was the least able to cope with the needs of a modern conflict in which production and supply count at least as much as martial valor. Though it was becoming industrialized, the country and its government were still a hundred years behind the West, politically as well as economically. And when the unwieldy machinery of Tsarist autocracy collapsed under the strains of three years of war, this evidence of failure was quick to bring the political revolution which had been threatening since 1905. During the spring and summer of 1917 power passed from one political group or personality to another, each under fire from more radical ones, each in turn succumbing to an appeal from further left. The final debate was held between the moderate Social-Democrats and the Bolsheviks. The former refused to go too far in the direction of a radical revolutionary program, favored a Constituent Assembly which would define the country's new regime and laws, and meantime proposed to continue the war on the side of the Allies. The Bolsheviks, at least after Lenin's appearance in Petersburg in April 1917, called for all power for the Soviets (councils); of Soldiers', Workers', and Peasants' Deputies, for distribution of the land, and for an immediate peace. Assured of the support of the Petrograd Soviet, the Bolsheviks seized power on November 7, 1917, organized a Soviet Republic, ended the war by the peace of Brest-Litovsk, and succeeded in maintaining their power through four years of bloody civil and foreign war.

1. TWO IMPOTENT GOVERNMENTS

From the beginning of hostilities, the Tsar's ministers had little influence against the will of the military authorities. Much of the chaos and corruption which had overtaken Russia by 1917 must be attributed to her attempt to wage a twentieth-century war with the administrative and political structure of an eighteenth-century country.

Meetings of the Council of Ministers, 1915

August 24, 1915

Scherbatov: The Council of Ministers knows that there were disturbances in Moscow which ended in bloodshed. . . .

There were even more serious disorders at Ivanovo-Voznesensk when it was necessary to fire on the crowd with the result that sixteen were killed and thirty wounded. There was a critical moment when it

From Documents of Russian History, 1914-1917 ed. F. A. Golder, tr. E. Aronsberg (New York: Appleton-Century-Crofts, Inc. 1927).

was uncertain what the garrison would

Shakhovskoi: I have information . . . that the workmen are quite aroused. Any kind of spark may start a fire. . . .

Goremykin. . . . I should like to ask the Minister of the Interior what measures he is taking to put an end to the lawlessness . . . going on everywhere. His principal function is to protect the State from disorder and danger.

Scherbatov: The Minister of the Interior is taking all the measures which his duty and present circumstances permit. I have more than once called your attention to the abnormal position of the Minister. Half of European Russia is out of his jurisdiction. Elsewhere in the rear the real government is in the hands of lieutenants who have despotic inclinations and little understanding. I have brought to your notice the fact that even in Petrograd, which gives the tone to the whole of Russia, the Minister of the Interior is a mere resident. He has only as much power as the war lords will grant him. . . . How can you expect me to fight the growing revolutionary movement when I am refused the support of the troops on the ground that they are unreliable, that one can not be certain that they will fire on the mob? You can not quiet the whole of Russia by the police alone, especially

now when the ranks of the police are being thinned out hourly, and the population is growing daily more excited by the speeches in the Duma, by newspaper stories, by continuous defeats, and rumors of disorders in the rear. The demonstrations and disorders come about from most unforeseen causes. At Moscow patriotic reasons were responsible. Newspapers gave out that the Dardanelles had been taken and that our troops had recaptured Kovno. One silver-tongued orator was arrested and trouble started. . . . I agree that something ought to be done. But how can you do anything when you have no support, when those in responsible places (ministers) can not get a hearing (from the Emperor) on questions on which the fate of the State may depend? . . . I have in my portfolio several telegrams from governors. They inform me that the flow of refugees, German colonists and Jews driven out by the military authorities is ever rising and that the local population is so aroused against the newcomers that they receive them with clubs. . . . The governors ask for instructions and help. What can the Minister of the Interior reply? . . . Among the workmen, as among the population in general, there are terrible reports of graft in connection with war orders. . . .

Formation and Program of Provisional Government, 1917

Citizens, the Provisional Executive Committee of the members of the Duma, with the aid and support of the garrison of the capital and its inhabitants, has triumphed over the dark forces of the Old Regime to such an extent as to enable it to organize a more stable executive power.

The cabinet will be guided in its actions by the following principles:

- 1. An immediate general amnesty for all political and religious offenses, including terrorist acts, military revolts, agrarian offenses, etc.
- 2. Freedom of speech and press; freedom to form labor unions and to strike.

These political liberties should be extended to the army in so far as war conditions permit.

- 3. The abolition of all social, religious and national restrictions.
- 4. Immediate preparation for the calling of a Constituent Assembly, elected by universal and secret vote, which shall determine the form of government and draw up the Constitution for the country.
- 5. In place of the police, to organize a national militia with elective officers, and subject to the local self-governing body.
- 6. Elections to be carried out on the basis of universal, direct, equal, and secret suffrage.
- 7. The troops that have taken part in the revolutionary movement shall not be disarmed or removed from Petrograd.

8. On duty and in war service, strict military discipline should be maintained, but when off duty, soldiers should have the same public rights as are enjoyed by other citizens.

The Provisional Government wishes to add that it has no intention of taking advantage of the existence of war conditions to delay the realization of the above-mentioned measures of reform.

> President of the Duma, M. Rodzianko

> President of the Council of Ministers, Prince Lvov

Ministers Miliukov, Nekrasov, Manuilov, Konovalov, Tereschenko, Vl. Lvov, Shingarev, Kerenski.

March 16, 1917.

2. THE ALL-RUSSIAN CONGRESS OF SOVIETS

During the summer of 1917 the Petrograd Soviet tended to act as if it were the representative or head of the other Soviets which had sprung up throughout the country. This was a position contested both by the moderate government to which it stood in opposition and by various other groups. The critics of the Soviet argued that Petrograd was not Russia and that the Petrograd Soviet which was entitled to speak for the soldiers and workers in that city had no right to speak for anyone else. To meet this criticism the Petrograd Soviet decided to call an All-Russian Congress of Soviets of Workers' and Soldiers' Deputies, to meet in their city in June. It was here (as we can see in the next four selections) that the moderate Socialists and the more extreme radicals clashed in an attempt to secure the support of the Congress—with Tseretselli speaking for the Mensheviks, Kerenski for the Social-Revolutionists, and Lenin for the extreme Left. After days of debate, the resolutions of the Mensheviks and Social-Revolutionists, who stood together, won a clear majority by a vote of 543 to 126.

Invitation to the Congress

To all Soviets of Workers' and Soldiers' Deputies and Army Committees:

The Executive Committee of the Petrograd Soviet . . . has resolved to call,

June 14, an All-Russian Congress of Soviets of Workers' and Soldiers' Deputies and army organizations at the front.

To this Congress, all the existing So-

From Documents of Russian History.

viets . . . and army organs are asked. Selections should be made according to the regulations laid down by the All-Russian Conference of Soviets of Workers' and Soldiers' Deputies:

Soviets numbering from
25.000 to 50.000 have 2 delegates
50.000 to 75.000 " 3 "
75.000 to 100.000 " 4 "
100.000 to 150.000 " 5 "
150.000 to 200.000 " 6 "
Over 200.000 " 8 "

Delegates from the front should represent armies and not regiments, etc. It would be best if the delegates were selected at the army congresses . . . Each army is entitled to no more than 8 delegates . . .

Soviets having less than 25.000 members should combine . . .

Sgd.: The Executive Committee of the Petrograd Soviet of Workers' and Soldiers' Deputies.

Clash between Moderates and Bolsheviks: June 17, 1917

TSERETSELLI'S SPEECH

In taking upon itself the fight for universal peace, the Russian revolution has also to take over the war, begun by other governments, the end of which does not depend on the efforts of the Russian revolution alone . . .

In order that it may succeed in its object, the Provisional Government must say clearly and emphatically . . . that it has broken with the old imperialist policy, and must propose to the Allies that the first question in order of importance is to re-examine on a new basis all agreements made until now . . . so that this general platform of war and peace may be given out, not only in the name of the Russian revolution, but in the name of all those who are allied with us. . . . We are moving in that direction. . . . We should do nothing which would break our ties with the Allies. . . . The worst thing that could happen to us would be a separate peace. It would be ruinous for the Russian revolution, ruinous for international democracy. . . . A separate peace is both undesirable and impossible.

Should we bring about a situation that would break relations with the Allies and necessitate a separate peace, the Russian revolution would be obliged, immediately afterwards, to take up arms on the side of the German coalition. Even if we brush aside the talk of a possible attack by Japan . . . picture to yourself the condition of the Russian revolution after the conclusion of a separate peace, while the rest of the world goes on fighting. Her economic and financial ties with the powers with which she is now united would be severed. . . . Under the circumstances. can there be any doubt that the German coalition, continuing with the war, would force the weaker side to give military support? . . . He who talks about a separate peace, talks about Utopia. . . .

We come to the question of taking the offensive, the actions of the Minister of War, Comrade Kerenski, and the whole Provisional Government, in their efforts to strengthen the front and the army. It is said that due to pressure from imperialist circles, the Provisional Government, and the Minister of War in particular, are taking steps to bring about immediate ac-

From Documents of Russian History.

tion at the front, in order thereby to put an end to the political campaign for universal peace, which this same Provisional Government is carrying on. . . . We believe that the measures taken by Comrade Kerenski tend to strengthen the cause of the revolution and prepare the way for the success of our object in the field of international relations and universal peace. It is clear to us that now, when our country is threatened from the outside, the Russian revolutionary army should be strong, able to take the offensive. . . . Comrades, this inactivity which has been going on at the front does not strengthen. but weakens and disorganizes our revolution and army. . . .

I should like to paint in a few strokes the picture of our internal situation. . . . The Russian revolution has taken over the burdensome inheritance of the last three years' war and the last three vears' reaction. The economic disorganization, the crushing financial difficulties, the food chaos which threatens to bring the country into a state of famine-all these are the inheritance of the old regime. We firmly believe that we can solve these problems, but we know that they can be solved only if the Russian democracy will make unheard-of sacrifices and self-denials. The most radical and extreme fiscal measures could not at the present moment liquidate altogether the financial crisis, and bring the finances of the country into a normal condition. A country that spends sixteen billion and has a net income of not more than half that amount cannot be saved by mere financial reforms, by fundamental reorganization. Only great self-sacrifice and mighty efforts can help at this moment. . . .

All classes of the population should be called upon to make these sacrifices and self-denials. . . . We are charged with not having done this so far in economic regulation, but laws alone will not benefit Russia. . . . Even that revolutionary organization [the Bolsheviks] which criticizes the acts of the Government and demands a speeding up, has nothing better to offer than declarations and principles. Time is necessary to put these into acts. . . .

As to the land question—we regard it as our duty at the present time to prepare the ground for a just solution of that problem by the Constituent Assembly. We believe that the question of the passing of the land into the hands of the laboring class can be, and should be, definitely settled by the Constituent Assembly. . . .

At the present moment, there is not a political party in Russia which would say: Hand the power over to us, resign, and we will take your place. Such a party does not exist in Russia (*Lenin*: "It does exist.") . . . The Bolsheviks say: When we have a majority, or when the majority comes over to our point of view, then the power should be seized. Comrade Lenin, you said that. At least the Bolsheviks, and you with them, say it in their official statements.

Gentlemen, until now there has not been a single party in Russia which has come out openly for getting for itself all power at once, although there have been such cries by irresponsible groups on the Right and the Left. . . . The Right says, let the Left run the Government, and we and the country will draw our conclusions; and the Left says, let the Right take hold, and we and the country will draw our conclusions. . . . Each side hopes that the other will make such a failure, that the country will turn to it for leadership.

But, gentlemen, this is not the time for that kind of a play. . . . In order to solve the problems of the country, we must unite our strength and must have a strong Government . . . strong enough to put an end to experiments dangerous for the fate of the revolution, . . . experiments that may lead to civil war. . . .

This, gentlemen, is our policy . . .

LENIN'S SPEECH

The first and fundamental question which we have to answer is: What are these Soviets which are meeting in this All-Russian Congress? What is this revolutionary democracy about which so much is said? To speak of revolutionary democracy before the All-Russian Congress of Soviets, and to keep silent about its formation, its class character, its role in the revolution, is a strange state of affairs. We had presented to us a program of a bourgeois parliamentary republic, a program of reform, which is accepted by all bourgeois governments, including our own; and at the same time we are told of a revolutionary democracy. To whom do they say this? To the Soviets. I ask you, is there any bourgeois, democratic, republican country in Europe where an institution similar to the Soviet exists? Of course, you will say no. It does not exist, and cannot exist, because it is either a bourgeois government, with these "plans" of reform which are presented to us, and which have been presented numerous times, and have remained on paper; or this institution—this new type of "government" which the revolution has created, and which has appeared before in history, at a time of great revolutionary enthusiasm, for example in France in 1792 and 1871, in Russia in 1905. The Soviet is an institution that does not exist in any bourgeois parliamentary government, and cannot exist alongside a bourgeois government. The Soviet is that new, more democratic type of government which we called, in our party resolutions, peasant-proletariat, democratic republic, and in which the whole authority belongs to the Soviet of Workers' and Soldiers' Deputies. It is vain to think that it is a theoretic question, vain to imagine that it can be passed over, vain to pretend that some other kind of institution can exist together with the Soviet. Yes, they exist together. But it gives rise to numerous misunderstandings, conflicts, and divisions. . . . One of the two: either the ordinary bourgeois government or the Soviet. A bourgeois government would make the Soviets unnecessary. They would either be dispersed by the generals, the counterrevolutionary generals who hold the army in hand, who pay no attention to our eloquent Minister of War, or they would die an inglorious death. There is no other alternative. We cannot stand still. We must either go forward or backward.

The Soviet is the form of government . . . which the revolution itself brought forth. Without it the revolution cannot conquer . . . the Soviets cannot go on as they are now. . . . We are told that the first Provisional Government was bad. At that time, when the Bolsheviks said: "Do not support, do not have any confidence in that Government," we were overwhelmed with charges of anarchism. Now everybody admits that the Government was bad. In what respect is this coalition government of almost-socialistic ministers better than its predecessor? Let us stop discussing programs, projects, and let's do something. . . . We are asked, is it possible to establish Socialism in Rus-

sia immediately, to reorganize the State from top to bottom? . . . Nowhere in the world in time of war can you go from pure capitalism to pure Socialism, but there should be something between, something new, unheard-of, because hundreds of millions are dying in the criminal war of the capitalists. It is not a question of reforms in the future—these are empty words-but of doing something which needs to be done now. If you wish to appeal to the "revolutionary" democracy, then differentiate between it and the "reform" democracy in a capitalist ministry. . . . That which is proposed is a transition to reform-democracy in a capitalistic government. It may be excellent, and looks well from the point of view of Western Europe. But just now a whole series of countries are on the brink of ruin, and those practical measures which are, seemingly, so complicated that it is necessary to work them out, as we were told by the previous speaker . . . can be put into force now. These measures are very clear. Tseretselli said that there is not a political party in Russia which would say that it is ready to take all the power into its hands. I say there is. Our party is ready at any minute to do that. (Applause and Laughter.) Laugh all you want to. . . . Our program in relation to the economic crisis is this-to demand the publication of all those unheard-of profits, reaching to 500% to 800%, which the capitalists make on war orders; to arrest 50 or 100 of the more important capitalists and, in this way, break all the threads of intrigue. Without such a step, all this talk of peace without annexation and indemnity is worthless. Our next step would be to announce to all the nations, separate from their Governments, that we regard all capitalists-French, English, all-as robbers.

Your own Izvestia has become confused. In place of peace without annexation and indemnity, it proposes the status quo. We believe that the Russian Republic should not oppress a single nation neither the Finns, nor the Ukrainians, with whom the Minister of War is now quarreling. . . . We cannot make a peace without annexation and indemnity until we are willing to give up our own annexations. It is really funny, this play! Every workman in Europe is laughing at it. He says: They are calling on the people to overthrow their bankers, while they, themselves, send their bankers into the Ministry. Arrest them; lay bare their schemes; find out their intrigues. But you will not do this, although you have the power. . . . You have lived through 1905 and 1917. You know that revolution is not made to order; that in other countries it was brought about through bloody uprisings, but in Russia there is no group or class that could oppose the power of the Soviets. Today or tomorrow, let us propose peace to all the peoples by breaking with all the capitalistic classes, and in a short time the peoples of France and Germany will agree to it, because their countries are perishing. . . .

If Russia were a revolutionary democracy, not merely in words, but in deeds, she would lead the revolutionary movement and not make peace with the capitalists; she would not talk so much of peace without annexation and indemnity, but would put an end to all forms of annexation in Russia itself, and would announce that she considers every annexation as robbery. If she were to do that, an imperialistic military offensive would not be necessary. . . .

You can write on paper what you please. But as long as the capitalists are in majority in the Government, it makes

no difference what you say, and how well you say it; the fact is that the war remains an imperialistic one. . . . It is easy to write, peace without annexations, but see what has happened in Albania, Greece, and Persia since the coalition government was formed. . . . The only way to end the war is by going on with the revolution. . . . If you were to take power into your own hands, if it were used against the Russian capitalists, then the laborers of other countries would believe you, and you could offer them peace. . . . The question is: Shall we advance or retreat? In revolutionary times, you cannot stand still. A military offensive now is a setback for the revolution; it means the continuation of the imperialistic butchery of millions. . . . The taking over of the power by the revolutionary proletariat, with the help of the poorest peasants, is the taking over of the revolutionary fight for peace . . . and gives assurance that power and victory will be given to the revolutionary workmen in Russia, and in the whole world.

KERENSKI'S SPEECH

Comrades:

You have been told of 1792 and 1905. How did 1792 end in France? It ended by the fall of the republic and the rise of a dictator. How did 1905 end? With the triumph of reaction. And now, in 1917, we are doing that which we could have done earlier. The problem of the Russian Socialist parties and the Russian democracy is to prevent such an end as was in France—to hold on to the revolutionary conquests already made; to see to it that our comrades who have been let out from prison do not return there; that Comrade Lenin, who has been abroad, may have

the opportunity to speak here again, and not be obliged to fly back to Switzerland. (Applause.) We must see to it that the historic mistakes do not repeat themselves; that we do not bring on a situation that would make possible the return of reaction, the victory of force over democracy. Certain methods of fighting have been indicated to us. We have been told that we should not fight with words. not talk of annexation, but should show by deeds that we are fighting against capitalism. What means are recommended for this fight? To arrest Russian capitalists. (Laughter.) Comrades, I am not a Social-Democrat. I am not a Marxist, but I have the highest respect for Marx, his teaching, and his disciples. But Marxism has never taught such childlike and primitive means. I dare say that it is likely that Citizen Lenin has forgotten what Marxism is. He cannot call himself a Socialist. because Socialism nowhere recommends the settling of questions of economic war. of the war of classes in their economic relations, the question of the economic reorganization of the State, by arresting people, as is done by Asiatic despots. . . . Every Marxist who knows his Socialism would say that capitalism is of an international character, that the arrest of a few capitalists in a certain State would not affect the iron law of the economic development of a givperiod. . . You [Bolsheviks] recommend childish prescriptions—"arrest, kill, destroy." What are you-Socialists or the police of the old regime? (Uproar. Lenin: "You should call him to order.")

This gathering of the flower of the Russian democracy understands its problems. Such prescriptions do not excite it, but among the masses such words will be taken seriously. We do not cater to the

mob; we are not demagogues. What we say now, we said ten years ago. We are warm defenders of the autonomy of Finland and the Ukraine. We say this: Members of the Provisional Government have not and do not desire to have absolute power, and until the meeting of the Constituent Assembly, they have no right to declare the independence of this or that part of Russian territory . . .

As to fraternization—why is it that while German officers fraternize in our trenches, they do not fraternize on the French front? Why is it that while our front is inactive, the German forces attack the English? . . . Why is it that this policy of fraternization falls in so well with the plan of the German General Staff on the Russian front? . . .

I can understand that there are people

who are naive enough to believe that an exchange of a piece of bread for a glass of vodka by a Russian soldier brings the kingdom of Socialism nearer, but we, who have borne the brunt of the old regime on our shoulders, cannot afford the luxury of such a naiveté . . .

You [Bolsheviks] recommend that we follow the road of the French revolution of 1792. You recommend the way of further disorganization of the country . . . When you, in alliance with reaction, shall destroy our power, then you will have a real dictator. It is our duty, the duty of the Russian democracy, to say: Don't repeat the historic mistakes. You are asked to follow the road that was once followed by France, and which will lead Russia to a new reaction, to a new shedding of democratic blood.

3. THE NOVEMBER REVOLUTION

Izvestia had been started in the early days of the revolution by a body calling itself the Committee of Petrograd Journalists. Soon it was taken over by the Petrograd Soviet and published by the Central Executive Committee of the Soviet. The number of November 8, 1917, excerpts from which are given below, was the last published by the Central Executive Committee. On the following day the paper had been taken over by the Bolsheviks and henceforward toed the party line. But in these, its last free reports, we can follow the swift unfolding of the November Revolution by which a handful of determined Bolsheviks grasped a power that the Kerenski government could no longer defend.

THE COUP

Kerenski remained at the office of the Staff from 2 until 7 A.M. . . . At 7 he set out for the front. . . . He is expected back any minute. . . . At 8.30 p.m. the Provisional Government at the Win-

ter Palace received an ultimatum signed by the Petrograd Soviet. Members of the government were given 20 minutes in which to surrender and, in case of refusal, they were threatened with having the guns of the Peter and Paul fortress and the cruiser Aurora turned on the Winter

All four excerpts on the November Revolution are from Documents of Russian History.

Palace. The Government refused to discuss matters and to accept the ultimatum. . . .

News reached us at 2 A.M. that the Winter Palace was taken, that the members of the Government were arrested . . . and locked up at the Peter and Paul fortress.

THE PETROGRAD SOVIET MEETS

The meeting opened at 2.35 P.M. with Trotski in the chair. He said: "In the name of the War-Revolutionary Committee, I announce that the Provisional Government no longer exists. (Applause.) Some of the Ministers are already under arrest. (Bravo.) Others soon will be. (Applause.) The revolutionary garrison, under the control of the War-Revolutionary Committee, has dismissed the Assembly of the Pre-Parliament. (Loud Applause. "Long live the War-Revolutionary Committee.") . . . The railway stations, post and telegraph offices, the Petrograd Telegraph Agency, and State Bank are occupied." . . .

Trotski continued by saying: "In our midst is Vladimir Ilyich Lenin, who, by force of circumstances, has not been able to be with us all the time. . . . Hail the return of Lenin!" The audience gave him a noisy ovation. . . .

LENIN'S SPEECH

Comrades, the workmen's and peasants' revolution, the need of which the Bolsheviks have emphasized many times, has come to pass. What is the significance of this revolution? Its significance is, in the first place, that we shall have a soviet government, without the participation of bourgeoisie of any kind. The oppressed

masses will of themselves form a government. The old state machinery will be smashed into bits and in its place will be created a new machinery of government by the soviet organizations. From now on there is a new page in the history of Russia, and the present, third Russian revolution, shall in its final result lead to the victory of Socialism.

One of our immediate tasks is to put an end to the war at once. But in order to end the war, which is closely bound up with the present capitalistic system, it is necessary to overthrow capitalism itself. In this work we shall have the aid of the world labor movement, which has already begun to develop in Italy, England, and Germany.

A just and immediate offer of peace by us to the international democracy will find everywhere a warm response among the international proletarian masses. In order to secure the confidence of the proletariat, it is necessary to publish at once all secret treaties.

In the interior of Russia a very large part of the peasantry has said: Enough playing with the capitalists; we will go with the workers. We shall secure the confidence of the peasants by one decree, which will wipe out the private property of the landowners. The peasants will understand that their only salvation is in union with the workers.

We will establish a real labor control over production.

We have now learned to work together in a friendly manner, as is evident from the revolution. We have the force of mass organization which has conquered all, and which will lead the proletariat to world revolution. We should now busy ourselves in Russia in building up a proletarian socialist state. Long live the world-wide socialistic revolution.

EDITORIAL COMMENT

Yesterday we said that the Bolshevik uprising is a mad adventure and today, when their attempt is crowned with success, we are of the same mind. We repeat: that which is before us is not a transfer of power to the Soviets, but a seizure of power by one party—the Bolsheviks. Yesterday we said that a successful attempt meant the breaking up of the greatest conquest of the revolution—the Constituent Assembly. Today we add that it means, also, the breaking up of the Congress of Soviets, and perhaps the whole Soviet organization. These are the facts: the Social-Revolutionists and the Social-Democrat Mensheviks have found it impossible under present circumstances to take part in the Congress. This is also the point of view of the men from the front. With the departure of these groups from the Congress, there are left . . . the Bolsheviks. They can call themselves what they please; the fact remains that the Bolsheviks alone took part in the uprising. All the other socialistic and democratic parties protest against it.

How the situation may develop, we do not know, but little good is to be expected. We are quite confident that the Bolsheviks cannot organize a state government. As yesterday, so today, we repeat that what is happening will react worst of all on the question of peace. . . . Today the Pre-Parliament was to vote a special resolution on the question of peace. But the Mariinski Palace was occupied by the Revolutionary Committee, and the Pre-Parliament did not meet.

4. PEACE

The Western Allies have often been blamed for the peace which they imposed upon their defeated enemies at Versailles, especially after President Wilson had laid down Fourteen Points upon which a just peace might be concluded. It is worth remembering that, for a good while after Wilson's speech of January, 1918 the Germans refused any serious attention to his suggestions and that, when they had a chance to impose peace upon their defeated enemies in the East, the resulting terms bore no trace of the Wilsonian principles to which Germany herself would appeal before long.

In the spring of 1918 the treaty of Bucarest turned Rumania into a German colony. The treaty of Brest-Litovsk imposed conditions disastrous to Russia: the Ukraine, Poland, Finland, and the Baltic states received their independence—to become, in effect, German satellites. Three Transcaucasian provinces were ceded to Turkey. Russia lost 26 per cent of her population, 27 per cent of her arable land, 26 per cent of her railroads, 33 per cent of her textile and consumer-goods industries, 73 per cent of her iron industries, 75 per cent of her coal fields, and, in addition, agreed to pay a large war indemnity. The documents below illustrate the Communist attempt to secure a peace "without annexations or indemnities," and their failure.

Brest-Litovsk

After securing power in November, 1917, the new Russian leaders set out to get the peace they had promised. An armistice was negotiated with Russia's enemies—Germany, Bulgaria, Austria-Hungary, and Turkey—and hostilities ceased on all fronts on December 2nd, while peace delegations met at Brest-Litovsk. Discussions, however, dragged on when the Central Powers put forward demands which the Soviet delegation felt contrary to the principles they had laid down. A Russian attempt to break the stalemate by withdrawing from the Conference merely led to a resumption of the German advance on a front practically deserted by Russian troops. As the Germans surged forward, the Soviet leaders realized that unless they concluded peace the Germans would soon be in Petersburg and they out of office. So negotiations were renewed and peace concluded on Germany's terms.

NOTE TO THE EMBASSIES AT PETROGRAD

Monsieur l'Ambassadeur.

I have the honour to announce that the Congress of Councils of Workmen's, Soldiers', and Peasants' Delegates of All the Russias instituted on 8 November a new Government of the Republic of all the Russias.

Having been appointed Commissary of Foreign Affairs in this Government, I beg to call to the attention of your Excellency the following words, which have been approved by the Congress of the Delegates of the Councils, and contain proposals for a truce and for a democratic peace without annexation and without indemnities, based on the principle of the independence of nations, and of their right to determine the nature of their own development themselves. I have the honour to suggest that you should consider this document in the light of an official proposal for an immediate truce upon all the fronts, and to take immediate steps to set on foot negotiations for peace. The Government, in the name of the Republic of All the Russias, is addressing the same proposal to all the nations and their Governments. Pray accept the assurance of the most perfect respect on the part of the Government of the Councils towards the people of France, which still keeps aloof from peace aspirations, as well as to all other nations who are drained of their blood and exhausted by the prolonged carnage.

(Signed) L. Trotsky.

Petrograd, Nov. 22.

BREST CONFERENCE SESSION OF FEBRUARY 9, 1918

Trotsky. We considered it necessary to sum up all our preceding work. The peace negotiations began with our declaration of Dec. 23 and the declaration of Dec. 25, by which the Quadruple Alliance replied to our declaration. These two declarations formulated the object of the negotiations as being based upon the principle of self-determination of peoples. During a short interval, which could be measured by hours, it appeared that this principle, accepted by both sides, would serve as a means for the solution of these national and territorial questions as aris-

From the (British) Daily Review of the Foreign Press, 26 November 1917.

ing out of the war. But after an exchange of views on Dec. 27, it became clear that the appeal to this principle was of a character calculated only to complicate all other questions. The points of view of one side, namely, our side, as applied by the other side were a direct negation of the very principle itself. Afterwards all the discussions took an entirely academic character, without any prospect of a practical settlement, because the opposite side was striving, with the aid of complicated logical maneuvers, to draw from the principle of self-determination what, in their opinion, was in accordance with the true situation as disclosed by the military maps.

The question concerning the occupied regions, which was the principal theme of all the discussions, was reduced, after a number of sessions, to the question of the evacuation of these regions by the troops in occupation. . . . So far as we understood it-and we honestly tried to understand it-the situation was as follows: Until the end of the war, so far as Germany was concerned and so far as Austria-Hungary was concerned, there could be no question of the evacuation of occupied territory on any front, owing to military considerations. Our Delegation later understood that the opposite side now had the intention of evacuating these occupied regions on the conclusion of a general peace, when the above-mentioned strategical considerations would have been put on one side. This conclusion, however, also appeared to be wrong. The German and Austro-Hungarian Delegations have refused categorically to make a declaration which could force them to withdraw their troops from the occupied regions, with the exception of the small belt of territory which they proposed to return to Russia. The situation only then

became clear. This clarity became, if possible, greater when General Hoffmann, in the name of both Delegations, proposed to us the frontier line which would in future separate Russia from its western neighbors, namely, from Germany and Austria-Hungary, because the separated regions were to be occupied by their troops for an indefinite period, unrestricted by any treaty.

We have already realized during the past discussions that if we were to trace the new frontier of Russia in accordance with the principle of self-determination, then we should have the best guarantee, under present conditions, against military aggression, because all the peoples on both sides of this frontier would be interested in maintaining it. The German conditions and the policy which dictates them, entirely exclude any such kind of guarantees for peaceful relations between Russia on the one side and Germany and Austria-Hungary on the other. The new frontier proposed by the other side is dictated by military and strategical considerations, and from this point of view must be estimated not only the separation from Russia of Poland and Lithuania, but even the separation of the Lettish countries. If such had been the desire of the peoples of those regions, then no danger would arise for the safety of the Russian Republic. Friendly relations with these States, which had freely formed for themselves an independent existence, would follow as a natural consequence of their origin and of their conditions. In such circumstances questions concerning the strategical character of the new frontiers would have for us no important significance. But these new frontiers which the opposite side propose appear to us in a very different light. Germany and Austria-Hungary, while maintaining their troops

the conclusion of peace, has hurriedly

recognized the independence of Ukrainia,

and, to wit, at the very moment when

Ukrainia entered the Russian Federation.

After this date events took place which should have had a decisive influence upon

these separate negotiations of the other

side with the Kiev Rada. The latter fell

under the blow of the Ukrainian Coun-

cil. The fate of the Rada, inviolable in

itself, was accelerated by the fact that the

Rada, in its struggle for authority, made

attempts, with the help of the Central

Powers, to draw the Ukrainian people

away from the Russian Federal Republic.

We officially informed the opposite side

that the Ukrainian Rada was deposed,

but, nevertheless, the negotiations with a

nonexistent Government have been con-

tinued. We proposed to the Austro-Hun-

garian Delegation, in a private conversation, it is true, but formally, nevertheless,

that they should send their representative

to Ukrainia with the object of seeing for

himself that the Ukrainian Rada no long-

er existed, and that the negotiations with

its Delegation could not have any practi-

cal value. We understood that, so far as

the Delegations of the Central Powers

needed confirmation of facts, they would

postpone the signature of the Peace Treaty until the return of their represent-

ative from Ukrainia. We have been in-

formed that the signature to the Peace Treaty could not be postponed any longer.

Whilst negotiating with the Government

in the occupied regions, are linking these regions to their States by railways and by other means, and for us the new frontier must thus be considered not as a frontier with Poland, Lithuania, and Courland, and so on, but as a frontier with Germany and Austria-Hungary. Both these States are seeking military expansion, as is clearly shown by their attitude toward the occupied regions. A new question arises for us, therefore, as to what these independent States mean for the Russian Republic in the future. The dependence of these peoples upon these two States will place very near to Russia the new frontier within their territories proposed by Germany and Austria-Hungary. What are really the military conceptions of the other side when they ask for such a frontier? For the purpose of examining this new question from the point of view of the leading military institutions of the Republic, I shall ask for the views of our military advisers. We have here to meet a fresh difficulty.

We have heard nothing of that part of the new frontier which is to run to the south from Brest-Litovsk. The opposite side was of the opinion that this part of the frontier had to be established in discussion with the Delegation of the Kiev Rada.1 We have decided that, irrespective of the unestablished political state of Ukrainia, there can be no question of a one-sided tracing of the frontier, based upon an agreement with the Rada alone; we declared that the consent of the Delegation of the Council of the People's Commissaries was also necessary Subsequently the political situation of Ukrainia was defined by its entrance into the Federal Russian Republic. The Delegation of the Central Powers, in spite of their declaration that they would examine the international position of the Ukraine after

of the Federal Russian Republic the Governments of the Central Empires not only, in spite of their former declaration, hurried to recognize the independence of the Ukrainian Republic on Feb. 1, at the very moment when it declared itself to be a part of the Russian Federation; but this is signing a treaty with a Government ¹ The Ukrainian National Assembly.

which, as we have categorically declared to the opposite side, does not exist any longer.

Such conduct is creating doubts if there is any sincerity of purpose on the side of the Central Powers for the establishment of peaceful relations with the Russian Federation. We are striving for peace now as in the beginning of the negotiations. The whole conduct of the opposite side, as far as this question is concerned, is creating the impression that the Central Powers were striving to [message defective] for the representatives of the Russian Republic. Only such a peace treaty will be binding for the Russian Federal Republic and its countries as will be signed by our Delegation.

SESSION OF 10 FEBRUARY, 1918

German Account

The W.T.B. wires give the following conclusion:

On February 10, the Sub-Committee mentioned above held two sittings under the chairmanship of the Austrian Sectional President, Dr. Gratz, when the respective military experts were the principal speakers. The Russian delegates attempted to demonstrate the strategical disadvantages to which Russia would be exposed by the proposed new frontier line, whilst the Germans denied this contention, adding that it was not a matter of the Russo-German frontier, but of the frontier between Russia and the new border States. Agreement, however, could not be reached on this point.

At a plenary sitting held on the same day M. Trotsky, replying to Baron von Kühlmann, denied any knowledge of an alleged order by the Russian Supreme Command urging Russian soldiers to incite German troops against their Generals and officers.

Dr. Gratz having reported that an agreement could not be reached in the sub-committee over which he had presided, Baron von Kühlmann asked M. Trotsky whether he had any communication to make which might contribute to a satisfactory solution.

M. Trotsky, replying, said his Delegation considered that the decisive hour had arrived. After a bitter attack on Imperialism, M. Trotsky declared that Russia would no longer participate in the war, as she was unwilling to shed the blood of her soldiers in the interests of one party against another. Russia, therefore, had decided to withdraw her army and people from the war. She had notified all peoples and their Governments of her decision, and had ordered the complete demobilization of all the Russian Armies now confronting the armies of Germany, Austria-Hungary, Bulgaria, and Turkey. His Government, however, refused to sanction the conditions of Germany and Austria-Hungary. Russia had abandoned the war, but she was obliged to forego the signing of a peace treaty.

Then follows the declaration of the ending of the state of war, and the demobilization order, which have already been published.

To this statement of M. Trotsky, Baron von Kühlmann rejoined that, if he analyzed the present position correctly, he found that the Quadruple Alliance was still at war with the Russian Government. Warlike operations were suspended for the time being by the armistice treaty, but on the lapse of this treaty these would

From the (British) Daily Review of the Foreign Press, 18 February 1918. The Deutscher Reichsanzeiger of 15 February 1918 has an account substantially identical with this.

automatically revive. If his memory did not deceive him, the real purpose of the armistice was the conclusion of peace. If, therefore, peace were not concluded, and the essential object of the armistice should thus vanish, Baron von Kühlmann concluded that warlike operations would revive again after the termination of the prescribed period. The fact that one of the two contracting parties had demobilized its armies would in nowise alter this, either in fact or in law. The existence of the customary international relations between States, and of legal and commercial relations, was the mark of a state of peace. He therefore requested M. Trotsky to state whether the Russian Government intended, in addition to making its declaration regarding the termination of the state of war, to say where the frontiers of Russia ran, as this would be a necessary requisite before the resumption of diplomatic, consular, legal, and commercial relations, and also to say whether the Government of People's Commissioners was willing to resume legal and commercial relations to precisely the same extent as would naturally result from the termination of the state of war.

These questions, he said, it was essential to determine in order to judge whether the Quadruple Alliance was still at war or not.

Baron von Kühlmann then proposed a sitting for the next day, at which the attitude of the Central Powers to the latest statement of the Russian Delegation might be made known.

To this proposal M. Trotsky replied that his Delegation had now exhausted all its power, and considered it necessary to return to Petrograd. All communications, he added, which the allied Delegations might make would be deliberated upon, by the Federal Russian Government, and a reply would be given in due course.

On being asked through what channel this exchange of views was to take place, M. Trotsky said that the Russian Delegation had had direct telegraphic communication with Petrograd from Brest-Litovsk. Furthermore, before the inauguration of the armistice negotiations, an understanding had been reached by wireless, and, moreover, there would be presently representatives of the four allied Powers in Petrograd who might communicate with their respective governments. Communication might, therefore, suggested M. Trotsky, be restored in this way.

The sitting then closed.

NEGOTIATIONS RENEWED

According to Russian wireless (Feb. 23) it is notified that, in reply to the proposal dated Feb. 19, 1918, of the Russian Government, Germany will renew peace negotiations with Russia, and will conclude peace upon the following conditions:

- 1. Germany and Russia to declare the state of war to end. Both nations believe that in the future they will live in peace and friendship.
- 2. Regions which are to the west of a line as indicated at Brest-Litovsk to the Russian Delegation, and which formerly belonged to the Russian State, are no more under the territorial protection of Russia. In the region of Dvinsk this line must be advanced to the eastern frontier of Courland. The former attachment of these regions to the Russian State must in no case involve for them an obligation toward Russia. Russia renounces every claim to intervene in the internal affairs

From the (British) Daily Review of the Foreign Press.

of those regions. Germany and Austria-Hungary have the intention to define the further fate of these regions in agreement with their populations. Germany is ready, after the completion of the Russian demobilization, to evacuate regions which are to the east of the above-named line so far as it is not stated otherwise in Clause 3.

- 3. Livonia and Esthonia must be immediately cleared of Russian troops and Red Guards, and will be occupied by German police until the date when the constitution of the respective countries will guarantee their social security and political order. All inhabitants who were arrested for political reasons must be released immediately.
- 4. Russia will conclude peace with the Ukrainian People's Republic. Ukraine and Finland will be immediately evacuated by Russian troops and Red Guards.
- 5. Russia will do all in its power to secure for Turkey an orderly return of its eastern Anatolian frontiers. Russia recognizes the annulation of the Turkish Capitulation.
- 6. Complete demobilization of the Russian Army, inclusive of detachments newly formed by the present Government, must be carried out immediately.
- 7. Russian warships in the Black Sea, Baltic Sea, and Arctic Ocean must immediately either be sent to Russian harbors and kept there till the conclusion of a general peace or be disarmed. Warships of the Entente which are in the sphere of the Russian authority must be regarded as Russian ships. Merchant navigation on the Black and Baltic Seas must be renewed as stated in the Armistice Treaty. The clearing away of mines to begin immediately. The blockade of the Arctic Ocean to remain in force till the conclusion of a general peace.

- Russo-German commercial treaty of 1904 comes into force, as stated in paragraph 11, clause 2, of the peace treaty with the Ukraine, with the exceptions as foreseen in paragraph 11, clause 3, of the Commercial Treaty concerning special privileges in the Arctic countries. Further, the whole of the first part of the final limits is reestablished. In addition, there must be a guarantee for the free, untariffed export of ores; the immediate commencement of negotiations for the conclusion of a new commercial treaty; the guarantee of the most favored-nation treatment at least until 1925, even in the case of the termination of the provisorium; and, finally, the sanctioning of clauses corresponding to paragraph 11 of the clauses 3, 4a, and 15 of the Peace Treaty with Ukraine.
- 9. The legal-political relations to be regulated in accordance with the decision of the first version of the Germano-Russian Convention. So far as action on that decision has not been taken, especially in respect to indemnities for civil damages, this must be in accordance with the German proposal, and there must be indemnification with expenses for war prisoners in accordance with the Russian proposal. Russia will permit and support as far as it can German commissioners for war prisoners, civil prisoners, and war refugees.
- 10. Russia promises to put an end to every propaganda and agitation either on the part of the Government or on the part of persons supported by the Government against the members of the Quadruple Alliance and their political and military institutions, even in localities occupied by the Central Powers.
- 11. The above-named conditions must be accepted within 48 hours. Russian plenipotentiaries must start immediately

for Brest-Litovsk and sign there within three days the Peace Treaty, which must be ratified within two weeks.

> Minister for Foreign Affairs, Von Kühlmann.

Berlin, Feb. 21, 1918.

THE DECLARATION OF THE PEACE DELEGATION

Russian Government wireless [Mar. 9] issues the following:

To all

To Paris, Vienna, Berlin, Sebastopol, Odessa, Kharkov, Nikolaiev, Tashkent, Arkhangelsk, Kazan, Irkutsk

The Russian Peace Delegation made the following Declaration before signing the Peace Treaty at the Session of the Conference at Brest-Litovsk on Mar. 3:

The Workmen's and Peasants' Government of the Russian Republic was forced, after the offensive of the German troops against Russia, when the latter had declared the war to be at an end and had commenced the demobilization of its armies, to accept an ultimatum presented by Germany on Feb. 24. We have been delegated to sign these conditions, which have been forced upon us by violence.

The negotiations which have been carried out so far at Brest-Litovsk between us, on the one part, and Germany and her allies, on the other, have shown strongly and clearly enough that the "peace by agreement," as it is termed by the German representatives, is really and definitely an annexationist and imperialistic peace. The Brest-Litovsk conditions at the moment are considerably worse than this. The peace which is being concluded here at Brest-Litovsk is not a peace based upon a free agreement of the peoples of Russia, Germany, Austria-Hun-

gary, and Turkey, but a peace dictated by force of arms. This is the peace which Russia, grinding its teeth, is compelled to accept. This is a peace which, whilst pretending to free Russian border provinces, really transforms them into German provinces and deprives them of the right of free self-determination, such as was recognized by the Workmen's and Peasants' Government of Revolutionary Russia, as due to them. This is a peace which, whilst pretending to reestablish order, gives armed support in these regions to exploiting classes against the working classes, and is helping again to put upon them the voke of oppression which was removed by the Russian Revolution. This is a peace which gives back the land to the landlords, and again drives the workers into the serfdom of the factory owners. This is a peace which for a long time to come imposes upon the workers of Russia in a still more aggravated form the old commercial treaty which was concluded in 1904 in the interests of German agrarians, and which is at the same time guaranteeing to German and Austro-Hungarian capitalists interest on the debts of the Tsarist Government. which have been repudiated by Revolutionary Russia. Finally, as if it was the purpose explicitly to emphasize the character of the German armed offensive, the German ultimatum is attempting to muzzle the Russian Revolution by forbidding all agitation directed against the Governments of the Quadruple Alliance and their military authorities. But even this does not suffice. Under the same pretense of reestablishing order, Germany is also occupying by arms regions in which the population is purely Russian and is establishing there a regime of military occupation in disregard of revolutionary institutions. For the Ukraine and Finland Germany is requesting the nonintervention of Revolutionary Russia, and at the same time is intervening actively with the object of supporting the counter-revolutionary forces against the workmen and peasants.

In the Caucasus, in direct contradiction to the conditions of the ultimatum of Feb. 21, as formulated by the German Government itself, Germany is breaking away for the benefit of Turkey regions of Ardahan, Kars, and Batum, which never have been taken by Turkish troops during this war, and with complete disregard of the real wishes of the populations of these regions. The most cynical and violent territorial seizures, the occupation of the most important strategical points, can have but one purpose—to prepare a new offensive against Russia and to defend capitalistic interests against the Workmen's and Peasants' Revolution. Such is the real object of the offensive undertaken by the German troops on Feb. 18 without the seven days' notice which was agreed upon in the armistice treaty concluded between Russia and the Central Powers. This advance was not stopped, in spite of the Declaration of the Council of the People's Commissioners that they accepted the German ultimatum of February 21. This advance was not stopped in spite of the fact that the conference of Brest-Litovsk was resumed and in spite of an official protest by the Russian Delegation. Through this, all the conditions of peace presented by Germany and by her allies are transformed into an ultimatum presented by them to Russia and supported in the interests of such a peace treaty, with the threat of immediate armed violence. Nevertheless, in the present situation Russia has no alternative choice. After having demobilized her ar-

mies, the Russian Revolution has by the same act given its fate into the hands of the German people. The Russian Delegation has already declared openly at Brest-Litovsk that no honest man can believe that the war against Russia can now be termed a defensive war. Germany has taken the offensive under the pretense of reestablishing order, but in reality with the purpose of strangling the Russian Workers' and Peasants' Revolution. For the benefit of world imperialism German militarism has succeeded at the present time in moving its troops against the masses of the workmen and peasants of the Russian Republic. The German proletariat has not as yet shown itself powerful enough to stop this offensive movement. We do not doubt for one moment that this triumph of the imperialist and the militarist over the international proletarian Revolution is only a temporary and passing one. Under the present conditions the Soviet Government of the Russian Republic, being left to its own forces, is unable to withstand the armed onrush of German imperialism, and is compelled, for the sake of saving Revolutionary Russia, to accept the conditions put before it. We, being empowered by our Government to sign the treaty of peace, are compelled, in spite of our protest, to negotiate under the absolutely exceptional conditions of continued hostilities against nonresisting Russia. We can not submit to any further shooting of Russian workmen and peasants who have refused to continue the war. We declare openly before the workmen, peasants and soldiers of Russia and Germany, and before the laboring and exploited masses of the whole world, that we are forced to accept the peace dictated by those who, at the moment, are the more powerful, and that

we are going to sign immediately the treaty presented to us as an ultimatum, but

that at the same time we refuse to enter into any discussion of these terms.

5. LENIN'S WRITINGS AND SPEECHES

The years after Brest-Litovsk were full of terrible strain and conflict and, though for a while the tide of revolution seemed to flow westward, there were few moments before 1921 or 1922 when the Bolsheviks could feel secure in their power. Nevertheless while fighting for life the Bolshevik leaders had to keep rethinking their political doctrine and to provide their followers in Russia and abroad with dogma and with practical advice. After Lenin's death in 1924 *The Communist International* published certain extracts from his speeches and writings which throw a useful light on the drift of his thought during these years.

THE NECESSITY TO SEVER CONNECTION WITH OPPORTUNIST-MENSHEVIKS*

It is not enough to know by heart Communist resolutions and to use revolutionary forms of speech at every opportunity. This is not enough, and we are decidedly against all Communists who know by heart this or that resolution. The pre-requisite of sincere Communism is—severance from opportunism. We shall talk freely and openly to all Communists who subscribe to this, and we shall be entitled to say to them boldly: "Do not commit foolish acts, be wise and clever." But such language will only be addressed to Communists who have severed all connection with opportunism, and this does not as yet apply to you. Therefore, I reiterate, I hope that the Congress will endorse the resolution of the Executive Committee. Comrade Lazzari said: "We are in a preparatory period." Nothing could be truer. You are in a preparatory period. The first phase of this period is—severance from the Mensheviks, similar to the severance between us and our Mensheviks in 1903. And it is due to the fact that the German Party has not broken off all connection with the Mensheviks, that the entire German working class is undergoing great hardship and suffering during the prolonged and wearisome post-war period in the history of the German revolution.

REVOLUTIONARY TACTICS OF THE COMMUNIST PARTY AFTER CAPTURING POWER**

After the first Socialist revolution of the proletariat, upon the overthrow of the bourgeoisie in a country, the proletariat remains for a time weaker than the bourgeoisie, simply by virtue of the latter's farreaching international connections, and also on account of the ceaseless and spontaneous re-birth of capitalism and the bourgeoisie, through the small producers of commodities in the country which has overthrown them. To overcome so potent

From The Communist International, Petrograd, May 1924.

** From Pamphlet, "Left Wing" Communism, Chap. 8.

^{*} From a Speech Delivered at the Third Congress of the Communist International, 28/11/21.

an enemy is possible only through the greatest effort and by dint of the obligatory, thorough, careful, attentive and skilful utilisation of every breach, however small, between the enemies; of every clash of interests between the bourgeoisie of all countries, between various groups and species of bourgeoisie within individual countries; of every possibility, however small, of gaining an ally, even though he be temporary, shaky, unstable, unreliable and conditional. Who has not grasped this has failed to grasp one iota of Marxism and of scientific modern Socialism in general. Whoever has failed to prove in practice, during a considerable period of time and in sufficiently varied political situations, his ability to apply this truth, has not yet learned to aid the revolutionary class in its struggle for the liberation of all toiling humanity from its exploiters. All this applies equally to the period before and after the conquest of political power by the proletariat.

THE TASKS OF THE REVOLUTIONARY CLASS*

History in general, the history of revolutions in particular, has always been richer, more varied and variform, more vital and "cunning" than is conceived of by the best parties, by the most conscious vanguards of the most advanced classes. This is natural, for the best vanguards express the consciousness, will, passions and fancies of but tens of thousands, whereas the revolution is effected at the moment of the exceptional uplift and exertion of all the human faculties—consciousness, will, passion, phantasy—of tens of millions, spurred on by the bitterest class

war. From this there follow two very important practical conclusions; first, the revolutionary class, for the realisation of its object, must be able to master *all* forms or aspects of social activity, without the slightest exception (completing, after the conquest of political power, sometimes with great risk and tremendous danger, what had been left undone before this conquest); secondly, that the revolutionary classes must be ready for the most rapid and unexpected substitution of one form or another.

REVOLUTIONARY TACTICS AND COMPROMISES**

Naive and quite inexperienced persons imagine that it is sufficient to recognise the permissibility of compromise in general, and all differences between opportunism on the one hand (with which we do and must wage uncompromising war) and revolutionary Marxism or Communism on the other will be obliterated. But for those people who do not yet know that all distinctions in nature and in society are unstable (and, to a certain extent, arbitrary), nothing will do but a long process of training, education, enlightenment, political and everyday experience. In practical questions of the policy appropriate to each separate or specific historic moment, it is important to be able to distinguish those in which are manifested the main species of inadmissible treacherous compromises, which embody opportunism detrimental to the revolutionary class, and to direct all possible efforts towards elucidating and fighting them. During the imperialist war, 1914-1918, between two groups of equally ruf-

^{*} From Pamphlet "Left Wing" Communism, Chap. 10.
** From Pamphlet "Left Wing" Communism, Chap. 8.

fianly and rapacious countries, such a main fundamental species of opportunism was social-chauvinism, that is, upholding "defence of Fatherland," which, in such a war, was really equivalent to a defence of the plundering interests of one's own bourgeoisie. Since the war, the defence of the robber "League of Nations," the defence of direct or indirect alliance with the bourgeoisie of one's country against the revolutionary proletariat and the "soviet" movement: the defence of the bourgeois democracy and bourgeois parliamentarism against "Soviet power," such are the chief manifestations of those inadmissible and treacherous compromises, which taken in all, have given rise to an opportunism fatal to the revolutionary proletariat and the cause.

PRINCIPLES OF REVOLUTIONARY TACTICS OF COMMUNIST PARTIES UNDER GIVEN CONDITIONS*

The main thing now is that the Communists of each country should, in full consciousness, study both the fundamental problems of the struggle with opportunism and "Left" doctrinairism, and specific peculiarities which this struggle inevitably assumes in each separate country, according to the idiosyncrasies of its politics, economics, culture, national composition (e.g., Ireland), its colonies, religious divisions, etc. Everywhere is felt an ever-widening and increasing dissatisfaction with the Second (Socialist) International, dissatisfaction due to its opportunism and its incapacity of creating a real leading centre, able to direct the international tactics of the revolutionary proletariat in the struggle for the world Soviet Republic. One must clearly realise that such a leading centre can, under no circumstances, be built after a single model, by a mechanical adjustment and equalisation of the tactical rules of the struggle. The national and State differences, now existing between peoples and countries, will continue to exist for a very long time yet, even after the realisation of the proletarian dictatorship on a world scale. Unity of international tactics in the Communist Labour movement evervwhere demands, not the elimination of variety, not the abolition of national peculiarities (this at the present moment is a foolish dream), but such application of the fundamental principles of Communism—Soviet power and the dictatorship of the proletariat—as will admit of the right modification of these principles, in their adaptation and application to national and national-State differences. The principal problem of the historical moment in which all advanced (and not only the advanced) countries now find themselves, lies here; that special national peculiarities must be studied, ascertained and grasped before concrete attempts are made in any country to solve the aspects of the single international problem, to overcome opportunism and Left doctrinairism within the working-class movement, to overthrow the bourgeoisie, and to institute a Soviet Republic and proletarian dictatorship.

THE FUNDAMENTAL CONDITIONS FOR THE VICTORY OF THE PROLETARIAN REVOLUTION**

The fundamental law of revolution confirmed by all revolutions, and particu-

^{*} From Pamphlet "Left Wing" Communism, Chap. 10.
** From Pamphlet "Left Wing" Communism, Chap. 9.

larly by all three Russian revolutions of the twentieth-century, is as follows: It is not sufficient for the revolution that the exploited and oppressed masses understand the impossibility of living in the old way and demand changes: for the revolution it is necessary that the exploiters should not be able to live and rule as of old. Only when the masses do not want the old regime, and when the rulers are unable to govern them as of old, then only can the revolution succeed. This truth may be expressed in other words. revolution is impossible without an allnational crisis, affecting both the exploited and the exploiters. It follows that for the revolution it is essential, first, that a majority of the workers (or at least a majority of the conscious, thinking, politically active workers) should fully understand the necessity for a revolution, and be ready to sacrifice their lives for it; second, that the ruling class be in a state of governmental crisis which attracts even the most backward masses into politics. It is a sign of every real revolution, this rapid tenfold, or even hundredfold increase in the number of representatives of the toiling and oppressed masses, heretofore apathetic, who are able to carry on a political fight which weakens the government and facilitates its overthrow by the revolutionaries.

PLIABLE REVOLUTIONARY TACTICS—NO RIGHT OR LEFT DOCTRINAIRISM*

That which has happened to Kautsky, Otto Bauer and other highly erudite Marxists, devoted to Socialism, and leaders of the Second International, could and ought to serve as a useful lesson.

They fully appreciated the necessity of pliable tactics, they learned and taught to others the Marxist dialectics-and much of what they have done in that respect will remain for ever a valuable acquisition to Socialist literature. But in the application of these dialectics they made a great mistake; they showed themselves in practice to be so undialectic, and so incapable of reckoning with the rapid changes of forms and the rapid filling of old forms with new contents, that their fate is not much more enviable than that of Hyndman, Guesde and Plekhanov. The main reason for their bankruptcy was that their eyes were "fastened" upon one fixed form of the growth of the working class movement and of socialism. They forgot all about its one-sidedness, and were afraid to perceive the sharp break which, by virtue of objective conditions, became unavoidable; so they continue to repeat the simple, at first glance, selfevident truth, once learned by rote: "Three are more than two." But politics resembles algebra more than arithmetic. and it is more like higher than lower mathematics. In reality all the old forms of the Socialist movement have been filled with new contents; there appears before the figures, consequently, a new sign, a "minus," and our wiseacres stubbornly continue to persuade themselves and others that "minus three" is more than "minus two!"

Communists must endeavour not to repeat the same mistake; or to speak more precisely the same mistake—committed the other way round by the Left Communists—must be corrected sooner and more quickly in order to get rid of it with less pain to the organism. Not only Right but Left doctrinairism is a mistake. Of course, the mistake of the latter in Com-

^{*} From Pamphlet "Left Wing" Communism, Chap. 10.

munism is at the present moment, a thousand times less dangerous and less significant than the mistake of Right doctrinairism (i.e., Social-Chauvinism and Kautskianism); but, after all, this is due to the fact that Left Communism is quite a young current, just coming into being. For this reason the disease under certain conditions can be easily cured, and it is necessary to begin its treatment with the utmost energy.

The old forms have burst; for the contents (antiproletarian and reactionary) obtained an inordinate development. We now have, from the standpoint of the development of international Communism, strong, powerful contents at work for Soviet power and the proletarian dictatorship, and these can and must manifest themselves in any form, new as well as old; the new spirit can and must regenerate, conquer and subjugate all forms, not only the new but the old, not for the purpose of reconciling the new with the old forms, but to enable us to forge all forms, new and old, into a weapon for the final decisive and unswerving victory of Communism.

The Communists must strain every effort to direct the movement of the working class, and the development of society generally, along the straightest and quickest way to the universal victory of Soviet Power and the proletarian dictatorship. This truth is incontestable. But it is enough to take one little step farther-a step it would seem in the same direction -and truth is transformed into error! It is enough to say, as do the German and British "Left" Communists, that we acknowledge only one straight road, that we do not admit manoeuvres, co-operation, compromises—and this will already be a mistake, which is capable of bringing, and, in fact, has brought and is bringing, the most serious harm to Communism. Right doctrinairism has foundered on the recognition of only the old forms, and has become totally bankrupt, not having perceived the new contents. Left doctrinairism unconditionally repudiates certain old forms, failing to see that the new content is breaking its way through all and every form, that it is our duty as Communists to master them all, to learn how to supplement with the maximum rapidity, one form by another, and to adapt our tactics to all such changes, caused not by our class nor by our endeavours.

World revolution has been given a powerful impetus by the horrors, atrocities and villainies of the world imperialist war, and by the hopelessness of the position created by it. This revolution is spreading more widely and deeply with such supreme rapidity, with such splendid richness of varying forms, with such an instructive, practical refutation of all doctrinairism, that there is every hope of a speedy and thorough recovery of the international Communist movement from the infantile disorder of "Left" Communism.

LEARN FROM THE EXPERIENCE OF THE RUSSIAN REVOLUTION*

At the Third Congress of 1921, we adopted a resolution concerning the organisatory upbuilding of the Communist Parties and concerning the method and the substance of their work. It was a good resolution. But the resolution is almost exclusively Russian; it was wholly derived from a study of Russian developments. That is the good side of the reso-

^{*} From Speech Delivered at Fourth Congress of the Communist International.

lution, but it is also the bad side. It is the bad side of the resolution because hardly any foreigner (I have read the resolution over again before expressing my conviction) is able to read it. In the first place, it is too long, for it contains fifty or more paragraphs. Foreigners are apt to find it impossible to read anything of this sort. In the next place, even if a foreigner should manage to read it through, it is too Russian. I do not mean because it was written in the Russian language, for there are excellent translations in the various tongues, but because it is permeated with the Russian spirit. Thirdly, if by a rare chance a foreigner could understand it, he could not possibly carry it out. That is the third defect.

I have talked matters over with some of the delegates, and I hope that in the later course of the Congress I shall find it possible (not in the Congress itself, for in that I am unfortunately not able to participate), to talk matters over in full detail with a large number of delegates from various lands. My impression is that we made a great mistake in the matter of this resolution, thereby blocking our own advance.

Let me repeat, it is an excellent resolution, I myself endorse every one of its fifty or more paragraphs; but we did not really know what we were about when we turned to foreigners with our Russian experience. Everything in the resolution has remained a dead letter. If we fail to understand why, we shall make no progress.

I think the most important thing for us all, Russians and foreigners alike, is that after five years of the Russian Revolution, we should set ourselves to school. Now for the first time we have the possibility of learning. I do not know how long this possibility will last. I do not know how long the capitalist powers will give us the opportunity of learning in peace and quietude; but we must utilise every moment in which we are free from war that we may learn, and learn from the bottom up.

The whole Party, and Russia at large, show by their hunger for culture that they are aware of this. The aspiration for culture proves that our most important task consists in this, to learn and to go on learning. But foreigners, too, must learn. though not in the sense in which we have to learn, namely, to read, to write, and to understand what is read. This is our lack. There is much dispute as to whether such things belong to proletarian culture or to bourgeois culture. I leave the question open. This much is certain, that our first task must be to learn reading and writing and to understand what is read. In foreign lands, this is no longer neces-

Foreigners need something different. They need some things higher. First of all, they have to learn how to understand all that we have written about the organisation and upbuilding of the Communist Parties, which they have subscribed to without reading and without understanding it. You foreign comrades must make this your first duty. This resolution must be carried into effect. These things cannot be done between one day and the next. That is absolutely impossible. The resolution is too Russian. It is a reflection of Russian experience. That is why it cannot be understood by foreigners, and why foreigners are not content to treat this resolution as a miraculous picture which they are to hang on the wall and pray to. That sort of attitude will not help us forward. You will have to make a portion of Russian experience your own.

How can it be done? I do not know. Perhaps the Fascists in Italy will do us a good turn by showing the Italians how. After all, they are not so highly cultured that the development of Black Hundreds in Italy has become impossible. This may have a good effect. We Russians must look for means of explaining to foreigners the elements of this reason. Otherwise it will be absolutely impossible for them to carry it out.

I am confident that in this sense (we

have to say, not only for the Russians, but for foreigners as well) that the most important thing for us all in the period now opening is to learn. We Russians have to learn in the general sense. You have to learn in the special sense that you may gain a genuine understanding of the organisation, structure, method and substance of revolutionary work. If you do this I am confident that the prospects for the world revolution are not merely favourable, but splendid.

A Time of Fear

. N	IUSSOL	INI A	ND II	ALIAN	FAS	CISM
-----	--------	-------	-------	-------	-----	------

II. NATIONAL SOCIALISM

III. APPEASEMENT

IV. THE SECOND WORLD WAR

V. ANOTHER POSTWAR WORLD

VI. SCIENCE AND SOCIAL CHANGE

VII. A SEA CHANGE IN THE CHURCHES

VIII. QUESTIONS FOR COMMUNISM

IX. THE REVOLT OF YOUTH

This last section which deals with our own time must of necessity be incomplete. Several writers have offered names which fit these recent years: "An Age of Anxiety," says Professor F. Le Van Baumer; "An Age of Longing," says Arthur Koestler; in 1917 Oswald Spengler published his widely read volumes on "The Decline of the West"; thirty years later George Orwell closed the span with his most successful and depressing novel, "1984."

The titles and the mood of such works are representative: the whole period is characterized by a marked loss of confidence. Politically this is very obvious among the supporters of democracy and limited liberalism who watch with growing fear a busy search for alternative patterns upon which the good society might be built. These alternative patterns—Fascist, Nazi, Communist, or other—all tend to be authoritarian, violent, and ruthless; and, since another characteristic of our time is its tremendous technological advance, these new regimes possess bigger and better means of imposing their will than the most absolute rulers of the past ever dreamed of in their most ambitious visions. They claim absolute power not only over the public activities of their subjects but also over their private lives and, finally and ideally, over their thoughts as well. Nor is there much reason to suppose that our technical ingenuity is unable to realize the most totalitarian ambitions.

But the new totalitarian systems do not limit their claims to a given area. Founded on exclusive interpretations of history, equipped with the vast potential of modern industry, each of them wants to order the world. Such elements as withstand or refuse to fit their pattern, be they classes, nations, or races, must be eliminated—which may mean exterminated. This tendency to discuss and transact national and international affairs in terms of irreconcilable and ultimate points of view has added a new and terrifying dimension to commonplace, everyday conflicts at every level. Ultimate philosophies equipped with ultimate weapons make the world a nervous place to live in and our time very much a time of fear.

I. Mussolini and Italian Fascism

The First World War left behind it a long trail of discredited governments, collapsed or collapsing economies, broken illusions of a better world—or at least a profitable victory—to justify the immense efforts of the preceding few years. Nowhere were these aftereffects more obvious than in Italy, the least favored power of the Allied camp. Embittered by a peace which failed to give her what she had hoped for, shaken by the revolutionary epidemic which had spread from Russia, by 1922 the country had drifted into the arms of a national-revolutionary dictatorship which promised the firm leadership, social reforms, internal order, and national self-assertion that most Italians seemed to want.

1. THE PROS AND THE CONTRAS

The new Fascist regime, with its ex-Socialist leader and its picturesque methods, such as doping political opponents with castor oil, fascinated the more sedate countries of the West and caused a good deal of discussion—abroad, for in Italy itself controversial discussions were very soon forbidden. The two selections that follow, both of which appeared in American publications of the twenties, present, one by Francesco Nitti the arguments of Mussolini's liberal opponents, the other by Antonio Cipicco the classic reasons for supporting the successful and efficient dictator.

Fascism: the Case for the Prosecution

Bolshevism and Fascism are the two menaces to the future prosperity of Europe. Both are similar phenomena in that they deny human liberty and involve the exercise of power on the part of an armed minority. Bolshevism sets about establishing the dictatorship of the proletariat—in other words, putting all resources in the hands of the workers and peasants. It attains this end by force. Fascism suppresses all political liberty and all free manifestations, saying that this is necessary to make Italy a great nation and to found an empire. Mussolini has made numerous speeches insulting the decaying

corpse of democracy and asserting that liberty is a prejudice of the past. He has announced that Fascism will found an Italian Empire. To found an empire would mean taking some piece of foreign territory—which in this case would be either a French or a British possession, since it would be out of the question to despoil Switzerland, Austria, or Yugoslavia, which lie along the Italian frontiers.

Italy lacks economic resources, and Italian finance is so wretched that public credit has been profoundly shaken. Italy lacks the prime necessities for war—coal,

From Francesco Nitti, "Probabilities of War in Europe," Atlantic Monthly, September 1928. By permission of the Atlantic Monthly Press.

steel, and oil. She also lacks food and cotton. In her present situation, she could not wage war without the support of Great Britain or the United States. Is it possible that these two countries would encourage such absurd, such grotesque, proposals?

Bolshevism has cut down Russia's productive capacity; and her foreign business, which the Government controls, has been utterly disastrous. The truth is that Russia is producing much less than she did before the war—in other words, much less than she did under the deplorable Tsarist regime. Economic production demands above all else order, liberty, and individual initiative—three things that no dictatorship can bring about.

Fascism has seriously weakened Italian production. In spite of appearances Italy has fallen into a state of the greatest economic disorder in the course of the last six years. Fascism has not bent its efforts to obtaining results, but to producing manifestations. All over the country there are celebrations, parades, and processions of Black Shirts. Wheat and rice production has declined; yet great festivals are held in honor of wheat and rice, and there is a special celebration in behalf of bread. Expressed in gold pounds, -in other words, without statistical manipulation,—the deficit of Italian business has risen from 643 million gold pounds in 1924 to 1259 million gold pounds in 1927. In short, it has almost doubled. Mr. MacLean, the American commercial attaché at Rome, has calculated that domestic business has dropped 40 per cent in the last two years. This is a terrible figure. Nevertheless, Mr. MacLean is a little too optimistic, for the real decline is nearly 50 per cent. The loans negotiated in America have been used to maintain the lira, though no one knows how

long this will last, and to stabilize it at its present level.

This extravagant stabilization, however, has ruined all industrial exporters. Italy now suffers more bankruptcies than any other country in Europe. In actual figures she has suffered twice as many as any other country, and, relatively to her industrial power, nine or ten times as many as any other country. Because of this absurd lira stabilization at a false level, undertaken not as a part of any economic programme, but merely as a piece of political bluff, the Italians are obliged to pay almost the same taxes as the French, whose country is at least three times as rich. In short, Italian taxes are heavier than those of any other country.

Since the Government bases itself on violence, it needs an even greater number of special militia to maintain it than Bolshevism does. These groups include militia to maintain general order, the voluntary Fascist militia, the railway militia, the post and telegraph militia, the harbor militia, the forest militia, and, most recently of all, the highway militia. About 200,000 people thus make their living off the Fascist Government, and it is like maintaining an army to support them. The industrialists and farmers have to pay for these militias. Besides this, all producers, both employers and employees, are grouped into corporations which involve still another enormous expense. There are fourteen ministries, but Mussolini scoffs at the rest of the world and occupies seven of them, comprising the office of Prime Minister, of Minister of the Interior, of Foreign Affairs, War, Marine, Aviation, and Corporations-in other words, Minister of Labor. Under these conditions he is able to involve the country in a war before anyone knows what is happening and before the people can manifest their desires in any way.

All free journals in Italy have been suppressed, and the press is suffering. The amount of paper used for the various daily journals has fallen off about one half or three fifths during the last two years. The ablest Italians are in exile, haying either been deported or retired from public life. Poverty is increasing, and the Government has refused to meet its obligations on the treasury and has forced them to be transformed into a consolidated debt. No criticism is allowed, even the most cordial. The press cannot discuss the economic crisis except to say that everything is going smoothly. Elections have disappeared. Even the Chamber of Deputies is going to be transformed into an assembly named by the Government. The

administrators of local government and even the representatives of the chambers of commerce are no longer elected. They are appointed by the Government.

The economic situation is bad, but the financial situation is worse. On the day when Fascism feels itself lost, will it not attempt to distract attention by some international adventure? Is not this what all dictatorships have done in the past?

Fascism and Bolshevism, although apparently direct opposites, act in the same manner. Several centuries before Jesus, Plato, the greatest of Greek philosophers, wrote that dictatorship always ended in war, saying that when the dictator felt himself lost he made war. There is no example in modern history of a dictatorship that has not ended in war, revolution, or both.

The Case for the Defence

In the last months of 1919 and the early ones of 1920, a good third of Italy was red. Over two thousand of the most flourishing communes were in the hands of the Communists. Their administration was characterized by violence and waste of public money. The government was incapable of protecting the public against the outrages of the reds, who imposed themselves more and more on the life of the people by means of assaults, strikes, blackmail, usurpation and occupation of factories and land. It was, therefore, necessary for those who still kept their belief in the nation, in order and in the sanctity of civil rights, to protect themselves by force of arms, i.e., by answering destructive violence with reconstructive violence.

At the beginning the number of these

brave defenders of the nation and of order was small. At the end of March, 1919, about forty spirited young men of the proletariat and middle classes gathered in Milan-in red Milan-around Mussolini, and founded the famous original new Fascismo. This rapidly found adherents, apostles, and willing fighters, from all classes of the nation, in every city and every village, especially in the populous industrial districts of northern and central Italy, where the tyranny was strongest of the Socialist Syndicates and of the Red Councils of workmen founded on the example of Moscow. There was scarcely a factory of a municipality of the rich industrial towns that did not fly a red or black flag, symbol of social war and destruction.

We then witnessed a whole series of

From A. Cippico, Italy, the Central Problem of the Mediterranean, (New Haven: Yale University Press, 1926). By permission of the Yale University Press.

just reprisals, which silently and systematically organized the defense of the nation. Here a Communist Cooperative, there a Socialist Chamber of Labor, in another place the offices and printing works of a Bolshevik newspaper, supported by rubles from Moscow, were attacked, besieged, and burnt. Workmen and peasants, who were inscribed in the red leagues and who lorded it over the country, were, rightly, put hors de combat by just measures of reprisal. The authors of these assaults were, in turn, attacked and stabbed, often treacherously, by means of ambuscades and mass attacks. War was declared. But it was not civil war in the real meaning of the word: it was the necessary and legitimate individual defense of the trampled-on rights of all the citizens, above all in defense of the vital interests of the country.

It thus comes about that in Romagna, Tuscany, Lombardy, and Piedmont, risings and encounters between armed bands, looting, and killing increase enormously. The struggle seems unequal—as the Chambers of Labor and the Red Syndicates, in addition to a vast organization and the authority which has accrued to them from the powerlessness of the liberal organs of the state against their criminal arrogance, and their systematic coercion and intimidation both of the working and middle classes, seem determined to undermine the state itself and make themselves masters of it.

The attacks and counterattacks became every day more frequent and violent. The Fascisti were determined to give no quarter. The mass of the workers, misled by their leaders and organizers, who had promised them shortly the earthly paradise of a communist revolution, rapidly realized the emptiness of such promises, and realized that their leaders were the false

and timid prophets of an Asiatic social religion, foreign to Italian civilization and temperament. The workers at last perceived that the Second and Third International were merely organs of disruption, incapable of reconstruction; that internationalism was a lie; that their own interests were identical with those of the nation, till then forgotten and combated.

Incidents of brutal violence occurred, such as the murder at a meeting of the Communal Council of a member of the red municipality of Bologna, Dr. Giordani, who had fought bravely in the Great War; such as the bomb thrown in the Diana Theatre at Milan, which killed at least forty harmless work-people; such as the man-hunts carried out by the reds of Empoli against sailors of the Royal Navy: like the sentence executed on the workmen Scimula and Sonzini, who, because they did not agree with their companions, were condemned by the latter to be thrown alive into the blast furnaces of the factory where they worked at Turin. Such incidents necessarily brought the Italian people, so essentially just and moral, to a rebellion against the tyranny of these brutal social-communist organizers.

In the end, the Fascisti got the upper hand in the bloody fight. They were by now an admirably organized and disciplined army composed of ex-soldiers, welleducated youths, peasants, and workmen, representatives of the best classes of the Italian people, who had seen through the communist propaganda, who had given everything to their country during the war, and who expected no recompense except the prosperity and moral greatness of their nation. They were men of thought and action who were determined to mould by their sacrifices a new Italy, no longer to be a museum of dead things, a vast and useless political and literary academy, nor a dreamy scientific Arcadia, dealing more in words than in deeds.

Italy, even in her periods of blindest anarchy, desired vaguely to be a state, led and governed by a firm hand, with an economic structure worthy of its capacity of industrial initiative and work. This aspiration, at present incarnated in Fascism, has become her will. In order to reach this goal over three thousand Fascisti, generous, disinterested youths, from all classes of the nation, have laid down their lives.

The Fascist program of national reconstruction was synthetized by Mussolini in June, 1921, when he proposed in Parliament to "define some historical and political positions." He then asked that the functions of the state should be limited to the creation of conditions suitable for individual activity, and of advantage to the consumer, in science, art, economic life, agriculture, industry, and commerce. The state must not confer privileges on one class to the detriment of others. It must resign monopolies: it must be neither banker, manufacturer, dealer, co-operative society, nor newspaper owner. It must not encourage unemployment by the palliative of "doles," nor enrich a favored few and impoverish the rest of the people by means of state contracts granted because of political protection or as gifts disguised under the name of cooperation. It is the state's business to do away with all that is superfluous and useless in the great bureaucratic machine. Only thus can true liberty-not license-and the equality of the citizens before the state be assured; only thus can the state be in condition to assure rapid justice and protection for life and property, and to safeguard the dignity and interests of its subjects in foreign countries.

In those years the prestige of Italy had dwindled miserably. There was no faith in the public finances. It will be opportune to compare some figures of today with those of yesterday. The consolidated war funds in October, 1922, had fallen to 81-08; later on in January, 1924, they were again at par. During 1920 there took place in Italy 1,881 industrial strikes and 189 agricultural strikes, which cost over 30,000,000 working days to the country. During 1923, the first year of the Fascist regime, industrial strikes were reduced to 200 and there was only one agricultural strike, involving the country in a loss of little more than 265,000 working days. In December, 1921, there were 541,000 unemployed; in October, 1924, they had fallen to 117,000, which number is today sensibly decreased.

In those troubled years almost all the industries dragged out a precarious existence. Today the activity of the then existing and since established industries has multiplied enormously; the workers work feverishly, forgetful of the unhealthy laziness of that time; they earn good wages; orders for goods are constantly increasing. In 1921 goods were exported to the value of 8,275,000,000 lire. For the first four months alone of this year exports have reached 5,350,000,000; for the corresponding period of 1923 the figures were 800,000,000. Importations of foreign goods amounted in 1921 to 17,266,000,-000; in 1924 to 19,387,000,000. In 1921 the railways carried 20,181,000 tons of goods; in 1924, 31,689,000. In 1921 the consumption of electric energy amounted to 4,300,000,000 kilowatts; in 1924 to 6,500,000,000.

2. THE DOCTRINES OF FASCISM

Benito Mussolini (1883–1945), the leader of Italian Fascism, was the son of a blacksmith and a schoolteacher in "Red" Emilia. Before 1914 he became one of the leaders of the radical wing of the Socialist party and editor of the party paper, Avanti. Expelled from the party for advocating intervention in the war, he founded his own newspaper to continue urging it, went to the front in 1915, and returned after being wounded. In Milan (1919) he founded the first fascio di combattimento (combat group) with only forty members. Three years later the "March on Rome" brought him the premiership, which he held until 1943.

Fascism arose in opposition to left-wing radicalism and expressed nationalist resentment at the poor deal Italy had got after the war. It proclaimed itself a movement of national rebirth and, lacking any clear doctrine, was free to appeal to all classes and political persuasions. However, after reaching power, the leaders felt the need of a theoretical doctrine, and this was outlined in an article contributed by Mussolini to the *Enciclopaedia Italiana* in 1932.

The Political and Social Doctrine of Fascism

When, in the now distant March of 1919, I summoned a meeting at Milan through the columns of the Popolo d'Italia of the surviving members of the Interventionist Party who had themselves been in action, and who had followed me since the creation of the Fascist Revolutionary Party (which took place in the January of 1915), I had no specific doctrinal attitude in mind. I had a living experience of one doctrine only—that of Socialism, from 1903-4 to the winter of 1914that is to say, about a decade: and from Socialism itself, even though I had taken part in the movement first as a member of the rank and file and then later as a leader, yet I had no experience of its doctrine in practice. My own doctrine, even in this period, had always been a doctrine of action. A unanimous, universally accepted theory of Socialism did not exist after 1905, when the revisionist movement began in Germany under the leadership of

Bernstein, while under pressure of the tendencies of the time, a Left Revolutionary movement also appeared, which though never getting further than talk in Italy, in Russian Socialistic circles laid the foundations of Bolshevism. Reformation, Revolution, Centralization-already the echoes of these terms are spentwhile in the great stream of Fascism are to be found ideas which began with Sorel, Péguy, with Lagardelle in the "Mouvement Socialiste," and with the Italian trade union movement which throughout the period of 1904-14 was sounding a new note in Italian Socialist circles (already weakened by the betraval of Giolitti) through Olivetti's Pagine Libre, Orano's La Lupa, and Enrico Leone's Divenire Sociale.

After the War, in 1919, Socialism was already dead as a doctrine: it existed only as hatred. There remained to it only one possibility of action, especially in Italy,

From Benito Mussolini, "The Political and Social Doctrine of Fascism," in *International Conciliation*, No. 306 (January 1935), pp. 5–17. Reprinted by permission of the Carnegie Endowment for International Peace.

reprisals against those who had desired the War and who must now be made to "expiate" its results. The Popolo d'Italia was then given the subtitle of "The newspaper of ex-servicemen and producers," and the word "producers" was already the expression of a mental attitude. Fascism was not the nursling of a doctrine worked out beforehand with detailed elaboration; it was born of the need for action and it was itself from the beginning practical rather than theoretical; it was not merely another political party but, even in the first two years, in opposition to all political parties as such, and itself a living movement. The name which I then gave to the organization fixed its character. And yet, if one were to re-read, in the now dusty columns of that date, the report of the meeting in which the Fasci Italiani di combattimento were constituted, one would there find no ordered expression of doctrine, but a series of aphoanticipations, and aspirations which, when refined by time from the original ore, were destined after some years to develop into an ordered series of doctrinal concepts, forming the Fascists' political doctrine—different from all others either of the past or the present day.

"If the bourgeoisie," I said then, "think that they will find lightning-conductors in us, they are the more deceived; we must start work at once. . . We want to accustom the working-class to real and effectual leadership, and also to convince them that it is no easy thing to direct an industry or a commercial enterprise successfully. . . . We shall combat every retrograde idea, technical or spiritual. . . . When the succession to the seat of government is open, we must not be unwilling to fight for it. We must make haste; when the present regime breaks down, we must be ready at once to take

its place. It is we who have the right to the succession, because it was we who forced the country into the War, and led her to victory. The present method of political representation cannot suffice, we must have a representation direct from the individuals concerned. It may be objected against this program that it is a return to the conception of the corporation, but that is no matter. . . . Therefore, I desire that this assembly shall accept the revendication of national tradesunionism from the economic point of view. . . ."

Now is it not a singular thing that even on this first day in the Piazza San Sepolcro that word "corporation" arose, which later, in the course of the Revolution, came to express one of the creations of social legislation at the very foundation of the regime?

The years which preceded the March to Rome were years of great difficulty, during which the necessity for action did not permit of research or any complete elaboration of doctrine. The battle had to be fought in the towns and villages. There was much discussion, but-what was more important and more sacred-men died. They knew how to die. Doctrine, beautifully defined and carefully elucidated, with headlines and paragraphs, might be lacking; but there was to take its place something more decisive-Faith. Even so, anyone who can recall the events of the time through the aid of books, articles, votes of congresses, and speeches of great and minor importance—anyone who knows how to research and weigh evidence-will find that the fundamentals of doctrine were cast during the years of conflict. It was precisely in those years that Fascist thought armed itself, was refined, and began the great task of organization. The problem of the relation be-

tween the individual citizen and the State; the allied problems of authority and liberty; political and social problems as well as those specifically national—a solution was being sought for all these while at the same time the struggle against Liberalism, Democracy, Socialism, and the Masonic bodies was being carried on, contemporaneously with the "punitive expedition." But, since there was inevitably some lack of system, the adversaries of Fascism have disingenuously denied that it had any capacity to produce a doctrine of its own, though that doctrine was growing and taking shape under their very eyes, even though tumultuously; first, as happens to all ideas in their beginnings, in the aspect of a violent and dogmatic negation, and then in the aspect of positive construction which has found its realization in the laws and institutions of the regime as enacted successively in the years 1926, 1927 and 1928.

Fascism is now a completely individual thing, not only as a regime, but as a doctrine. And this means that today Fascism, exercising its critical sense upon itself and upon others, has formed its own distinct and peculiar point of view, to which it can refer and upon which, therefore, it can act in the face of all problems, practical or intellectual, which confront the world.

And above all, Fascism, the more it considers and observes the future and the development of humanity quite apart from political considerations of the moment, believes neither in the possibility nor the utility of perpetual peace. It thus repudiates the doctrine of Pacifism—born of a renunciation of the struggle and an act of cowardice in the face of sacrifice. War alone brings up to its highest tension all human energy and puts the stamp of nobility upon the peoples who

have the courage to meet it. All other trials are substitutes, which never really put men into the position where they have to make the great decision—the alternative of life or death. Thus a doctrine which is founded upon this harmful postulate of peace is hostile to Fascism. And thus hostile to the spirit of Fascism, though accepted for what use they can be in dealing with particular political situations, are all the international leagues and societies which, as history will show, can be scattered to the winds when once strong national feeling is aroused by any motive-sentimental, ideal, or practical. This anti-pacifist spirit is carried by Fascism even into the life of the individual: the proud motto of the Squadrista, "Me ne frego" (I do not fear), written on the bandage of the wound, is an act of philosophy not only stoic, the summary of a doctrine not only political—it is the education to combat, the acceptance of the risks which combat implies, and a new way of life for Italy. Thus the Fascist accepts life and loves it, knowing nothing of and despising suicide: he rather conceives of life as duty and struggle and conquest, life which should be high and full, lived for oneself, but above all for others-those who are at hand and those who are far distant, contemporaries, and those who will come after.

This "demographic" policy of the regime is the result of the above premise. Thus the Fascist loves in actual fact his neighbor, but this "neighbor" is not merely a vague and undefined concept, this love for one's neighbor puts no obstacle in the way of necessary educational severity, and still less to differentiation of status and to physical distance. Fascism repudiates any universal embrace, and in order to live worthily in the community of civilized peoples watches its contempo-

raries with vigilant eyes, takes good note of their state of mind and, in the changing trend of their interests, does not allow itself to be deceived by temporary and fallacious appearances.

Such a conception of life makes Fascism the complete opposite of that doctrine, the base of the so-called scientific and Marxian Socialism, the materialist conception of history; according to which the history of human civilization can be explained simply through the conflict of interests among the various social groups and by the change and development in the means and instruments of production. That the changes in the economic field new discoveries of raw materials, new methods of working them, and the inventions of science—have their importance no one can deny; but that these factors are sufficient to explain the history of humanity excluding all others is an absurd delusion. Fascism, now and always, believes in holiness and in heroism; that is to say, in actions influenced by no economic motive, direct or indirect. And if the economic conception of history be denied, according to which theory men are no more than puppets, carried to and fro by the waves of chance, while the real directing forces are quite out of their control, it follows that the existence of an unchangeable and unchanging class war is also denied—the natural progeny of the economic conception of history. And above all Fascism denies that class war can be the preponderant force in the transformation of society. These two fundamental concepts of Socialism being thus refuted, nothing is left of it but the sentimental aspiration—as old as humanity itself-towards a social convention in which the sorrows and sufferings of the humblest shall be alleviated. But here again Fascism repudiates the conception of "economic" happiness, to be realized by Socialism and, as it were, at a given moment in economic evolution to assure to everyone the maximum of well-being. Fascism denies the materialist conception of happiness as a possibility, and abandons it to its inventors, the economists of the first half of the nineteenth century: that is to say, Fascism denies the validity of the equation, wellbeing = happiness, which would reduce men to the level of animals, caring for one thing only—to be fat and well-fed—and would thus degrade humanity to a purely physical existence.

After Socialism, Fascism combats the whole complex system of democratic ideology, and repudiates it, whether in its theoretical premises or in its practical application. Fascism denies that the majority, by the simple fact that it is a majority, can direct human society; it denies that numbers alone can govern by means of a periodical consultation, and it affirms the immutable, beneficial, and fruitful inequality of mankind, which can never be permanently leveled through the mere operation of a mechanical process such as universal suffrage. The democratic regime may be defined as from time to time giving the people the illusion of sovereignty, while the real effective sovereignty lies in the hands of other concealed and irresponsible forces. Democracy is a regime nominally without a king, but it is ruled by many kings-more absolute, tyrannical, and ruinous than one sole king, even though a tyrant. This explains why Fascism, having first in 1922 (for reasons of expediency) assumed an attitude tending towards republicanism, renounced this point of view before the March to Rome; being convinced that the question of political form is not today of prime importance, and after having studied the examples of monarchies and republics past and present reached the conclusion that monarchy or republicanism are not to be judged, as it were, by an absolute standard; but that they represent forms in which the evolution—political, historical, traditional, or psychological—of a particular country has expressed itself.

Fascism has taken up an attitude of complete opposition to the doctrines of Liberalism, both in the political field and the field of economics. There should be no undue exaggeration (simply with the object of immediate success in controversy) of the importance of Liberalism in the last century, nor should what was but one among many theories which appeared in that period be put forward as a religion for humanity for all time, present and to come. Liberalism only flourished for half a century. It was born in 1830 in reaction against the Holy Alliance, which had been formed with the object of diverting the destinies of Europe back to the period before 1789, and the highest point of its success was the year 1848, when even Pius IX was a Liberal. Immediately after that date it began to decay, for if the year 1848 was a year of light and hope, the following year, 1849, was a year of darkness and tragedy. The Republic of Rome was dealt a mortal blow by a sister republic-that of France-and in the same year Marx launched the gospel of the Socialist religion, the famous Communist Manifesto. In 1851 Napoleon III carried out his far from liberal coup d'état and reigned in France until 1870, when he was deposed by a popular movement as the consequence of a military defeat which must be counted as one of the most decisive in history. The victor was Bismarck, who knew nothing of the religion of liberty, or the prophets by which that faith was revealed. And it is symptomatic that such a highly civilized people as the Germans were completely ignorant of the religion of liberty during the whole of the nineteenth century. It was nothing but a parenthesis, represented by that body which has been called "The ridiculous Parliament of Frankfort," which lasted only for a short period. Germany attained her national unity quite outside the doctrines of Liberalism-a doctrine which seems entirely foreign to the German mind, a mind essentially monarchicwhile Liberalism is the logical and, indeed, historical forerunner of anarchy. The stages in the achievement of German unity are the three wars of '64, '66, and '70, which were guided by such "Liberals" as Von Moltke and Bismarck. As for Italian unity, its debt to Liberalism is completely inferior in contrast to that which it owes to the work of Mazzini and Garibaldi, who were not Liberals. Had it not been for the intervention of the anti-Liberal Bismarck at Sadowa and Sedan it is very probable that we should never have gained the province of Venice in '66, or been able to enter Rome in '70. From 1870 to 1914 a period began during which even the very high priests of the religion themselves had to recognize the gathering twilight of their faith-defeated as it was by the decadence of literature and atavism in practice—that is to say, Nationalism, Futurism, Fascism. The era of Liberalism, after having accumulated an infinity of Gordian knots, tried to untie them in the slaughter of the World War-and never has any religion demanded of its votaries such a monstrous sacrifice. Perhaps the Liberal Gods were athirst for Blood? But now, today, the Liberal faith must shut the doors of its deserted temples, deserted because the peoples of the world realize that its worship—agnostic in the field of economics and indifferent in the field of politics and morals—will lead, as it has already led, to certain ruin. In addition to this, let it be pointed out that all the political hopes of the present day are anti-Liberal, and it is therefore supremely ridiculous to try to classify this sole creed as outside the judgment of history, as though history were a hunting ground reserved for the professors of Liberalism alone—as though Liberalism were the final unalterable verdict of civilization.

But the Fascist negation of Socialism, Democracy, and Liberalism must not be taken to mean that Fascism desires to lead the world back to the state of affairs before 1789, the date which seems to be indicated as the opening year of the succeeding semi-Liberal century: we do not desire to turn back; Fascism has not chosen De Maistre for its high-priest. Absolute monarchy has been and can never return, any more than blind acceptance of ecclesiastical authority.

So, too, the privileges of the feudal system "have been," and the division of society into castes impenetrable from outside, and with no intercommunication among themselves: the Fascist conception of authority has nothing to do with such a polity. A party which entirely governs a nation is a fact entirely new to history, there are no possible references or parallels. Fascism uses in its construction whatever elements in the Liberal, Social, or Democratic doctrines still have a living value; it maintains what may be called the certainties which we owe to history, but it rejects all the rest—that is to say, the conception that there can be any doctrine of unquestioned efficacy for all times and all peoples. Given that the nineteenth century was the century of Socialism, Liberalism, and Democracy: political doctrines pass, but humanity remains; and it may rather be expected that this will be a century of Fascism. For if the nineteenth century was the century of individualism (Liberalism always signifying individualism) it may be expected that this will be the century of collectivism, and hence the century of the State. It is a perfectly logical deduction that a new doctrine can utilize all the still vital elements of previous doctrines.

No doctrine has ever been born completely new, completely defined and owing nothing to the past; no doctrine can boast a character of complete originality; it must always derive, if only historically, from the doctrines which have preceded it and develop into further doctrines which will follow. Thus the scientific Socialism of Marx is the heir of the Utopian Socialism of Fourier, of the Owens and of Saint-Simon; thus again the Liberalism of the eighteenth century is linked with all the advanced thought of the seventeenth century, and thus the doctrines of Democracy are the heirs of the Encyclopedists. Every doctrine tends to direct human activity towards a determined objective: but the action of men also reacts upon the doctrine, transforms it, adapts it to new needs, or supersedes it with something else. A doctrine then must be no mere exercise in words, but a living act: and thus the value of Fascism lies in the fact that it is veined with pragmatism, but at the same time has a will to exist and a will to power, a firm front in face of the reality of "violence."

The foundation of Fascism is the conception of the State, its character, its duty, and its aim. Fascism conceives of the State as an absolute, in comparison with which all individuals or groups are relative, only to be conceived of in their relation to the

State. The conception of the Liberal State is not that of a directing force, guiding the play and development, both material and spiritual, of a collective body, but merely a force limited to the function of recording results: on the other hand, the Fascist State is itself conscious, and has itself a will and a personality—thus it may be called the "ethic" State. In 1929, at the first five-yearly assembly of the Fascist regime, I said:

"For us Fascists, the State is not merely a guardian, preoccupied solely with the duty of assuring the personal safety of the citizens; nor is it an organization with purely material aims, such as to guarantee a certain level of well-being and peaceful conditions of life; for a mere council of administration would be sufficient to realize such objects. Nor is it a purely political creation, divorced from all contact with the complex material reality which makes up the life of the individual and the life of the people as a whole. The State, as conceived of and as created by Fascism, is a spiritual and moral fact in itself, since its political, juridical, and economic organization of the nation is a concrete thing: and such an organization must be in its origins and development a manifestation of the spirit. The State is the guarantor of security both internal and external, but it is also the custodian and transmitter of the spirit of the people, as it has grown up through the centuries in language, in customs, and in faith. And the State is not only a living reality of the present, it is also linked with the past and above all with the future, and thus transcending the brief limits of individual life, it represents the immanent spirit of the nation. The forms in which States express themselves may change, but the necessity for such forms is eternal. It is the State which educates its citizens in

civic virtue, gives them a consciousness of their mission and welds them into unity: harmonizing their various interests through justice, and transmitting to future generations the mental conquests of science, of art, of law and the solidarity of humanity. It leads men from primitive tribal life to that highest expression of human power which is Empire; it links up through the centuries the names of those of its members who have died for its existence and in obedience to its laws, it holds up the memory of the leaders who have increased its territory and the geniuses who have illumined it with glory as an example to be followed by future generations. When the conception of the State declines, and disunifying and centrifugal tendencies prevail, whether of individuals or of particular groups, the nations where such phenomena appear are in their decline."

From 1929 until today, evolution, both political and economic, has everywhere gone to prove the validity of these doctrinal premises. Of such gigantic importance is the State. It is the force which alone can provide a solution to the dramatic contradictions of capitalism, and that state of affairs which we call the crisis can only be dealt with by the State, as between other States. . . . Fascism desires the State to be a strong and organic body, at the same time reposing upon broad and popular support. The Fascist State has drawn into itself even the economic activities of the nation, and, through the corporative social and educational institutions created by it, its influence reaches every aspect of the national life and includes, framed in their respective organizations, all the political, economic and spiritual forces of the nation. A State which reposes upon the support of millions of individuals who recognize

its authority, are continually conscious of its power and are ready at once to serve it, is not the old tyrannical State of the medieval lord nor has it anything in common with the absolute governments either before or after 1789. The individual in the Fascist State is not annulled but rather multiplied, just in the same way that a soldier in a regiment is not diminished but rather increased by the number of his comrades. The Fascist State organizes the nation, but leaves a sufficient margin of liberty to the individual; the latter is deprived of all useless and possibly harmful freedom, but retains what is essential; the deciding power in this question cannot be the individual, but the State alone.

The Fascist State is not indifferent to the fact of religion in general, or to that particular and positive faith which is Italian Catholicism. The State professes no theology, but a morality, and in the Fascist State religion is considered as one of the deepest manifestations of the spirit of man; thus it is not only respected but defended and protected. The Fascist State has never tried to create its own God. as at one moment Robespierre and the wildest extremists of the Convention tried to do; nor does it vainly seek to obliterate religion from the hearts of men as does Bolshevism; Fascism respects the God of the ascetics, the saints and heroes, and equally, God, as He is perceived and worshipped by simple people.

The Fascist State is an embodied will to power and government; the Roman tradition is here an ideal of force in action. According to Fascism, government is not so much a thing to be expressed in territorial or military terms as in terms of morality and the spirit. It must be thought of as an empire—that is to say, a nation which directly or indirectly rules other nations, without the need for conquering

a single square yard of territory. For Fascism, the growth of empire, that is to say the expansion of the nation, is an essential manifestation of vitality, and its opposite a sign of decadence. Peoples which are rising, or rising again after a period of decadence, are always imperialist: any renunciation is a sign of decay and of death.

Fascism is the doctrine best adapted to represent the tendencies and the aspirations of a people, like the people of Italy, who are rising again after many centuries of abasement and foreign servitude. But empire demands discipline, the co-ordination of all forces and a deeply felt sense of duty and sacrifice: this fact explains many aspects of the practical working of the regime, the character of many forces in the State, and the necessarily severe measures which must be taken against those who would oppose this spontaneous and inevitable movement of Italy in the twentieth century, and would oppose it by recalling the outworn ideology of the nineteenth century—repudiated wheresoever there has been the courage to undertake great experiments of social and political transformation: for never before has the nation stood more in need of authority, of direction, and of order. If every age has its own characteristic doctrine, there are a thousand signs which point to Fascism as the characteristic doctrine of our time. For if a doctrine must be a living thing, this is proved by the fact that Fascism has created a living faith; and that this faith is very powerful in the minds of men, is demonstrated by those who have suffered and died for it.

Fascism has henceforth in the world the universality of all those doctrines which, in realizing themselves, have represented a stage in the history of the human spirit.

II. National Socialism

There is no logical necessity to connect Socialism and Internationalism. The traditional connection between the two reflects a feeling that the oppressed of this world have more in common with one another than with their masters, that common economic interests are more real than spurious bonds of nationality. This seemed reasonable enough in the relatively free late-nineteenth-century world, where men, money, and goods passed with little hindrance from one country to another—at any rate, west of the unenlightened territories of the Sultan and the Tsar. But with the beginning of the twentieth century one country after another began to use tariffs and regulations to control imports and immigration. National interests would henceforth be furthered by deliberate economic policies, and this economic nationalism seemed to league employers and workers of a given country together, profits for the former meaning also benefits for the latter, even if they came at the expense of fellow workers across the border.

Internationalist arguments grew less convincing in a world cut up by a multitude of economic and political barriers. The First World War exacerbated nationalistic and chauvinistic feelings, and its aftermath persuaded many who had hesitated until then that they must look after number one and the devil take the hindmost. This could well be done by reconciling the two most popular creeds of the time—Nationalism and Socialism. The idea of doing so was hardly new, and in the twenties much of Mussolini's appeal was based on it. But its fullest and most effective expression was to appear in the National-Socialist movement that conquered Germany in the thirties. The following passages are quoted from the excellent presentation of National Socialism, prepared by Raymond E. Murphy and published by the United States Department of State in 1943.

1. THE PROGRAM OF THE PARTY OF HITLER

The Twenty-Five Points

The National Socialist German Workers' Party at a great mass meeting on February 25th, 1920, in the Hofbrauhaus-Festsaal in Munich announced their Programme to the world.

In section 2 of the Constitution of Our Party this Programme is declared to be inalterable.

The Programme of the German Work-

ers' Party is limited as to period. The leaders have no intention, once the aims announced in it have been achieved, of setting up fresh ones, merely in order to increase the discontent of the masses artificially, and so ensure the continued existence of the Party.

1. We demand the union of Germans to form a Great Germany on the basis of

the right of the self-determination enjoyed by nations.

- 2. We demand equality of rights for the German People in its dealings with other nations, and abolition of the Peace Treaties of Versailles and St. Germain.
- 3. We demand land and territory (colonies) for the nourishment of our people and for settling our superfluous population.
- 4. None but members of the nation may be citizens of the State. None but those of German blood, whatever their creed, may be members of the nation. No Jew, therefore, may be a member of the nation.
- 5. Anyone who is not a citizen of the State may live in Germany only as a guest and must be regarded as being subject to foreign laws.
- 6. The right of voting on the State's government and legislation is to be enjoyed by the citizen of the State alone. We demand therefore that all official appointments, of whatever kind, whether in the Reich, in the country, or in the smaller localities, shall be granted to citizens of the State alone.

We oppose the corrupting custom of Parliament of filling posts merely with a view to party considerations, and without reference to character or capability.

- 7. We demand that the State shall make it its first duty to promote the industry and livelihood of citizens of the State. If it is not possible to nourish the entire population of the State, foreign nationals (non-citizens of the State) must be excluded from the Reich.
- 8. All non-German immigration must be prevented. We demand that all non-Germans, who entered Germany subsequent to August 2nd, 1914, shall be required forthwith to depart from the Reich.

- 9. All citizens of the State shall be equal as regards rights and duties.
- 10. It must be the first duty of each citizen of the State to work with his mind or with his body. The activities of the individual may not clash with the interests of the whole, but must proceed within the frame of the community and be for the general good.

We demand therefore:

- 11. Abolition of incomes unearned by work.
- 12. In view of the enormous sacrifice of life and property demanded of a nation by every war, personal enrichment due to a war must be regarded as a crime against the nation. We demand therefore ruthless confiscation of all war gains.
- 13. We demand nationalisation of all businesses which have been up to the present formed into companies (Trusts).
- 14. We demand that the profits from wholesale trade shall be shared out.
- 15. We demand extensive development of provision for old age.
- 16. We demand creation and maintenance of a healthy middle class, immediate communalisation of wholesale business premises, and their lease at a cheap rate to small traders, and that extreme consideration shall be shown to all small purveyors to the State, district authorities and smaller localities.
- 17. We demand land-reform suitable to our national requirements, passing of a law for confiscation without compensation of land for communal purposes; abolition of interest on land loans, and prevention of all speculation in land.
- 18. We demand ruthless prosecution of those whose activities are injurious to the common interest. Sordid criminals against the nation, usurers, profiteers, etc.

must be punished with death, whatever their creed or race.

- 19. We demand that the Roman Law, which serves the materialistic world order, shall be replaced by a legal system for all Germany.
- 20. With the aim of opening to every capable and industrious German the possibility of higher education and of thus obtaining advancement, the State must consider a thorough re-construction of our national system of education. The curriculum of all educational establishments must be brought into line with the requirements of practical life. Comprehension of the State idea (State sociology) must be the school objective, beginning with the first dawn of intelligence in the pupil. We demand development of the gifted children of poor parents, whatever their class or occupation, at the expense of the State.
- 21. The State must see to raising the standard of health in the nation by protecting mothers and infants, prohibiting child labour, increasing bodily efficiency by obligatory gymnastics and sports laid down by law, and by extensive support of clubs engaged in the bodily development of the young.
- 22. We demand abolition of a paid army and formation of a national army.
- 23. We demand legal warfare against conscious political lying and its dissemination in the Press. In order to facilitate creation of a German national Press we demand:
- (a) that all editors of newspapers and their assistants, employing the German language, must be members of the nation;
- (b) that special permission from the State shall be necessary before non-German newspapers may appear. These are not necessarily printed in the German language;

(c) that non-Germans shall be prohibited by law from participating financially in or influencing German newspapers, and that the penalty for contravention of the law shall be suppression of any such newspaper, and immediate deportation of the non-German concerned in it.

It must be forbidden to publish papers which do not conduce to the national welfare. We demand legal prosecution of all tendencies in art and literature of a kind likely to disintegrate our life as a nation, and the suppression of institutions which militate against the requirements abovementioned.

24. We demand liberty for all religious denominations in the State, so far as they are not a danger to it and do not militate against the moral feelings of the German race.

The Party, as such, stands for positive Christianity, but does not bind itself in the matter of creed to any particular confession. It combats the Jewish-materialist spirit within us and without us, and is convinced that our nation can only achieve permanent health from within on the principle: THE COMMON INTEREST BEFORE SELF.

25. That all the foregoing may be realized we demand the creation of a strong central power of the State. Unquestioned authority of the politically centralised Parliament over the entire Reich and its organisations; and formation of Chambers for classes and occupations for the purpose of carrying out the general laws promulgated by the Reich in the various States of the confederation.

The leaders of the Party swear to go straight forward—if necessary to sacrifice their lives—in securing fulfilment of the foregoing Points.

Munich, February 24th, 1920.

2. MEIN KAMPF

Adolf Hitler (1889–1945), the son of an Austrian customs official, was influenced by two currents in his youth: the pan-Germanism rife in his home town, and the anti-Semitism of Vienna. He served through the war in the German army and after 1918 as a minor political agent of the Reichswehr. In this capacity he got in touch with the German Workers' Party and quickly made himself its leader. In November 1923, after the failure of a Putsch, or uprising, that he and General Ludendorff had attempted in Munich, Hitler was sentenced to a term of imprisonment. During this time he wrote the first volume of Mein Kampf (My Struggle), which was completed by a second volume in 1927. After his accession to power in 1933, Mein Kampf served as the Nazi movement's bible. It was widely distributed, a copy being presented to every German bride. Unfortunately, if the book ever came to the attention of Western leaders, their policies showed little sign of it.

RULES OF ACTION

I wish, moreover, to state the following general premises:

If by foreign policy we understand the regulation of the relations of a people to the rest of the world, then the nature of this regulation will be determined by very definite facts. As National Socialists, we can further set forth the following principle with regard to the nature of the foreign policy of a folk-state:

It is the task of the foreign policy of a folk-state to secure the existence on this planet of the race which is encompassed by the state and at the same time to establish a healthy, viable, natural relation between the number and growth of the folk on the one hand and the size and quality of its soil and territory on the other hand.

In this connection only that condition may be regarded as a healthy relation which insures the nourishment of the people from its own soil and territory. Any other condition, even though it may endure for hundreds or even thousands of years, is none the less unhealthy and will lead sooner or later to the damaging, if not to the destruction, of the people in question.

We National Socialists must never at any time join in the distasteful hurrahpatriotism of the present-day bourgeois world. It would be particularly deadly to regard the last developments before the war as in any way binding upon our present course. Not a single obligation from the whole historical period of the nineteenth century can be followed up by us. In contrast to the representatives of that period we have again proclaimed ourselves the representatives of the supreme historical viewpoint of all foreign policy, namely: to bring the territory into harmony with the size of the population. Yes, we can only learn from the past that we must undertake the setting of aims for our political activity in two directions: Soil and territory as the goal of our foreign policy, and a new, philosophically firm and uniform foundation as the goal of our domestic political activity.

Our task, the mission of the National Socialist movement, however, is to lead our folk to such political insight that it will see its future goal fulfilled not in the intoxicating impression of a new Alexandrian campaign but rather in the industrious work of the German plow, which waits only to be given land by the sword.

If the National Socialist movement, in view of this greatest and most important task, frees itself of all illusions and lets reason prevail as its sole guide, then the catastrophe of the year 1918 can one day turn into an infinite blessing for the future of our folk. As a result of this collapse our people can achieve a complete reorientation of its foreign political activity, and, furthermore, inwardly strengthened by its new philosophy, it can arrive externally at a final stabilization of its foreign policy. It can then, at last, attain that which England has, which even Russia used to have, and which enabled France always to make uniform decisions which were in the last analysis best for her interests, namely: a political testament.

But the political testament of the German nation for its outwardly directed activity should and must always have the

following import:

Never tolerate the establishment of two continental powers in Europe. See an attack against Germany in every attempt to organize a second military power on the German borders, even if it is only in the form of the establishment of a state which is a potential military power, and see therein not only the right but also the duty to prevent the formation of such a state with all means, even to the use of force, or if it has already been established, to destroy it again. See to it that the strength of our folk has its foundations not in colonies but in the soil of the European homeland. Never regard the foundations

of the Reich as secure, if it is not able to give every off-shoot of our folk its own bit of soil and territory for centuries to come. Never forget that the most sacred right in the world is the right to the soil which a man wishes to till himself, and the most sacred sacrifice is the blood which he spills for this soil.

The basic racial elements are differently situated, not only territorially but also in individual cases within the same territory. Nordic men exist side by side with Eastern types; Easterners, with Dinarics; both of these types, with Westerners; and everywhere among them are mixed types. On the one hand this is a great disadvantage: The German folk lacks that sure instinct of the herd which has its roots in the unity of blood and, especially in moments when great danger threatens, preserves the nation from collapse, in as much as with such a folk all small internal distinctions will then immediately disappear and the common enemy will be faced with the closed front of the uniform herd. In the existence side by side of our most varied component racial elements, which have remained unmixed, lies the foundation of that which we designate with the word superindividualism. In peaceful times it may sometimes perform good services for us, but, considered all in all, it has deprived us of world supremacy. If the German folk, in its historical development, had possessed that herdlike unity which other peoples have enjoyed, the German Reich would today be mistress of the globe. World history would have taken another course, and no one can tell whether in this way that might not have been attained which so many deluded pacifists are hoping today to wheedle by moaning and whining: A peace supported not by the

palm branches of tearful pacifistic female mourners but founded by the victorious sword of a master race (Herrenvolk) which places the world in the service of a higher culture. . . .

PROPAGANDA

In this regard one proceeded from the very correct principle that the size of the lie always involves a certain factor of credibility, since the great mass of a people will be more spoiled in the innermost depths of its heart, rather than consciously and deliberately bad. Consequently, in view of the primitive simplicity of its mind it is more readily captivated by a big lie than by a small one, since it itself often uses small lies but would be, nevertheless, too ashamed to make use of big lies. Such an untruth will not even occur to it, and it will not even believe that others are capable of the enormous insolence of the most vile distortions. Why, even when enlightened, it will still vacillate and be in doubt about the matter and will nevertheless accept as true at least some cause or other. Consequently, even from the most impudent lie something will always stick.

To whom must propaganda appeal? To the scientific mind or to the less educated masses?

The task of propaganda does not lie in a scientific education of the individual but in pointing out to the masses definite facts, processes, necessities, etc., the significance of which in this way is first to be brought within the masses' range of vision.

The art lies exclusively therein, to do this in such an excellent way that a universal conviction arises of the reality of a fact, of the necessity of a process, of the correctness of something necessary, etc. Since it is not and cannot be necessary in itself, since its task, just as in the case of a placard, consists of bringing something before the attention of the crowd and not in the instruction of those who are scientifically trained or are seeking education and insight, its efficacy must always be oriented more to the emotions and only in a very restricted way to the so-called "intellect."

All propaganda has to appeal to the people and its intellectual level has to be set in accordance with the receptive capacities of the most-limited persons among those to whom it intends to address itself. The larger the mass of men to be reached, the lower its purely intellectual level will have to be set.

The more modest, then, its scientific ballast, and the more it exclusively takes account of the emotions of the masses, the more decisive will be its success. This, however, is the best proof of the accuracy or non-accuracy of propaganda and not the successful satisfaction of a few scholars or youthful esthetes.

The art of propaganda lies precisely therein, that, comprehending the great masses' world of emotions and imagination, it finds the way, in a psychologically correct form, to the attention and, further, to the hearts of the great masses.

The receptive capacity of the great masses is very restricted, its understanding small. On the other hand, however, its forgetfulness is great. On account of these facts all effective propaganda must restrict itself to very few points and impress these by slogans, until even the last person is able to bring to mind what is meant by such a word.

The task of propaganda is, for instance, not to evaluate diverse rights but to emphasize exclusively the single right of that which it is representing. It does not have to investigate objectively the truth, so far as this is favorable to the others, in order then to present it to the masses in strict honesty, but rather to serve its own side ceaselessly.

If one's own propaganda even once accords just the shimmer of right to the other side, then the basis is therewith laid for doubt regarding one's own cause. The masses are not able to distinguish where the error of the other side ends and the error of one's own side begins.

But all talent in presentation of propaganda will lead to no success if a fundamental principle is not always strictly followed. Propaganda has to restrict itself to a few matters and to repeat these eternally. Persistence is here, as with so many other things in the world, the first and most important presupposition for success.

Propaganda is, however, not designed to furnish jaded gentlemen currently with interesting diversions but rather to convince, and, indeed, to convince the masses. In view of their slowness of mind, they require always, however, a certain period before they are ready even to take cognizance of a matter, and only after a thousandfold repetition of the most simple concept will they finally retain it.

Any variation ought never to affect the content of that which the propaganda seeks to present, rather the same thing must always be said at the end. Thus the catchword must be elucidated from various sides, but the end of every consideration must always reiterate anew the catchword itself. Only in this way can and will the propaganda have a unified and concentrated effect.

In general the art of all truly great popular leaders at all times consists primarily in not scattering the attention of a people but rather in concentrating it always on one single opponent. The more unified this use of the fighting will of a people, the greater will be the magnetic attractive force of a movement and the more powerful the force of its push. It is a part of the genius of a great leader to make even quite different opponents appear as if they belonged only to one category, because the recognition of different enemies leads weak and unsure persons only too readily to begin doubting their own cause.

When the vacillating masses see themselves fighting against too many enemies, objectivity at once sets in and raises the question whether really all the others are wrong and only one's own people or one's own movement is right.

Therewith, however, appears already the first weakening of one's own force. Consequently, a number of intrinsically different opponents must always be comprehended together, so that in the view of the masses of one's own adherents the fight is only being carried on against one enemy alone. This strengthens the faith in one's own cause and increases the bitterness toward the aggressor against this cause.

In all cases in which there is a question of the fulfillment of apparently impossible demands or tasks, the entire attention of a people must be concentrated only on this one question, in such a way as if being or non-being actually depends on its solution. Only in this way will one make a people willing and capable of really great accomplishments and exertions.

This principle is also true for the individual man, if he wants to attain high goals. He also will be able to accomplish this only in steplike stages. He also will have to concentrate his entire exertions toward the attainment of a definitely restricted task until this one appears to be fulfilled, and the determination of a new segment can be undertaken. If he does not undertake to divide in separate stages the path to be mastered and does not seek to accomplish these one by one, systematically, by means of the greatest concentration of all energies, he will never be able to arrive at the final goal but rather will remain somewhere on the way, perhaps indeed somewhere off on a tangent. This slow approach to the goal is an art and always requires the use of all energies in order thus to accomplish the way step by step.

The most primary prerequisite, accordingly, which is necessary for the attack on a very difficult partial segment of the human path is this, that the leadership succeeds in presenting to the mass of the people precisely that partial goal, which is now to be attained, better, to be fought for, as the only goal worthy of attention, on whose attainment everything depends. The great mass of the people can never see the entire way before them, without tiring and doubting the task. It will to a certain extent keep the goal in mind; in general, however, it is only able to survey the path in small partial segments, just as the hiker, who likewise knows the destination of his journey but who proceeds better along the endless road if he divides it up for himself in segments and marches in each single one as if it were the desired goal itself. Only in this way does he get ahead without despairing.

3. ELEMENTS OF NAZI IDEOLOGY

As National-Socialist ideas of race, state, and leader-cult developed, they became more than mere inanities to be bandied about beer halls; they were now the law of the German state, a state bent on spreading them throughout the world. A number of learned works drew the legal and constitutional implications of Nazi doctrines. Of these, one of the best is Ernst Rudolf Huber's Constitutional Law of the Greater German Reich, published in 1939. The passages that follow are taken from the State Department's compilation on National Socialism, and the commentaries with which they are interspersed are those of the chief editor, Mr. Raymond E. Murphy, and his fellow editors.

THE VOLK

Ernst Rudolf Huber, in his basic work Verfassungsrecht des grossdeutschen Reiches (Constitutional Law of the Greater German Reich), published in 1939, states:

"The new constitution of the German Reich... is not a constitution in the formal sense such as was typical of the nineteenth century. The new Reich has no written constitutional declaration, but its constitution exists in the unwritten basic political order of the Reich. One

recognizes it in the spiritual powers which fill our people, in the real authority in which our political life is grounded, and in the basic laws regarding the structure of the state which have been proclaimed so far. The advantage of such an unwritten constitution over the formal constitution is that the basic principles do not become rigid but remain in a constant, living movement. Not dead institutions but living principles determine the nature of the new constitutional order."

In developing his thesis Huber points out that the National Socialist state rests on three basic concepts, the Volk or people, the Führer, and the movement or party. With reference to the first element, the Volk, he argues that the democracies develop their concept of the people from the wrong approach: They start with the concept of the state and its functions and consider the people as being made up of all the elements which fall within the borders or under the jurisdiction of the state. National Socialism, on the other hand, starts with the concept of the people, which forms a political unity, and builds the state upon this foundation.

"There is no people without an objective unity, but there is also none without a common consciousness of unity. A people is determined by a number of different factors: by racial derivation and by the character of its land, by language and other forms of life, by religion and history, but also by the common consciousness of its solidarity and by its common will to unity. For the concrete concept of a people, as represented by the various peoples of the earth, it is of decisive significance which of these various factors they regard as determinants for the na-

ture of the people. The new German Reich proceeds from the concept of the political people, determined by the natural characteristics and by the historical idea of a closed community. The political people is formed through the uniformity of its natural characteristics. Race is the natural basis of the people . . . As a political people the natural community becomes conscious of its solidarity and strives to form itself, to develop itself, to defend itself, to realize itself. 'Nationalism' is essentially this striving of a people which has become conscious of itself toward self-direction and self-realization, toward a deepening and renewing of its natural qualities.

"This consciousness of self, springing from the consciousness of a historical idea, awakens in a people its will to historical formation: the will to action. The political people is no passive, sluggish mass, no mere object for the efforts of the state at government or protective welfare work . . . The great misconception of the democracies is that they can see the active participation of the people only in the form of plebiscites according to the principle of majority. In a democracy the people does not act as a unit but as a complex of unrelated individuals who form themselves into parties . . . The new Reich is based on the principle that real action of a self-determining people is only possible according to the principle of leadership and following."

THE FÜHRER

The second pillar of the Nazi state is the Führer, the infallible leader, to whom his followers owe absolute obedience. The Führer principle envisages government of the state by a hierarchy of leaders, each of whom owes unconditional allegiance to his immediate superior and at the same time is the absolute leader in his own particular sphere of jurisdiction.

One of the best expositions of Nazi concept of the Führer principle is given by Huber in his Constitutional Law of the Greater German Reich:

"The Führer-Reich of the (German) people is founded on the recognition that the true will of the people cannot be disclosed through parliamentary votes and plebiscites but that the will of the people in its pure and uncorrupted form can only be expressed through the Führer. Thus a distinction must be drawn between the supposed will of the people in a parliamentary democracy, which merely reflects the conflict of the various social interests, and the true will of the people in the Führer-state, in which the collective will of the real political unit is manifested...

"The Führer is the bearer of the people's will: he is independent of all groups, associations, and interests, but he is bound by laws which are inherent in the nature of his people. In this twofold condition: independence of all factional interests but unconditional dependence on the people, is reflected the true nature of the Führer principle. Thus the Führer has nothing in common with the functionary, the agent, or the exponent who exercises a mandate delegated to him and who is bound to the will of those who appoint him. The Führer is no 'representative' of a particular group whose wishes he must carry out. He is no 'organ' of the state in the sense of a mere executive agent. He is rather himself the bearer of the collective will of the people. In his will the will of the people is realized. He transforms the mere feelings of the people into a conscious will . . . Thus it is possible for him, in the name of the true will of the people which he serves, to go against the subjective opinions and convictions of single individuals within the people if these are not in accord with the objective destiny of the people . . . He shapes the collective will of the people within himself and he embodies the political unity and entirety of the people in opposition to individual interests . . .

"But the Führer, even as the bearer of the people's will, is not arbitrary and free of all responsibility. His will is not the subjective, individual will of a single man, but the collective national will is embodied within him in all its objective, historical greatness . . . Such a collective will is not a fiction, as is the collective will of the democracies, but it is a political reality which finds its expression in the Führer. The people's collective will has its foundation in the political idea which is given to a people. It is present in the people, but the Führer raises it to consciousness and discloses it . . .

"In the Führer are manifested also the natural laws inherent in the people: It is he who makes them into a code governing all national activity. In disclosing these natural laws he sets up the great ends which are to be attained and draws up the plans for the utilization of all national powers in the achievement of the common goals. Through his planning and directing he gives the national life its true purpose and value. This directing and planning activity is especially manifested in the lawgiving power which lies in the Führer's hand. The great change in significance which the law has undergone is characterized therein that it no longer sets up the limits of social life, as in liberalistic times, but that it drafts the plans and the aims of the nation's actions . . .

"The Führer principle rests upon unlimited authority but not upon mere outward force. It has often been said, but it must constantly be repeated, that the Führer principle has nothing in common with arbitrary bureaucracy and represents no system of brutal force, but that it can only be maintained by mutual loyalty which must find its expression in a free relation. The Führer-order depends upon the responsibility of the following, just as it counts on the responsibility and loyalty of the Führer to his mission and to his following . . ."

The nature of the plebiscites which are held from time to time in a National Socialist state, Huber points out, cannot be understood from a democratic standpoint. Their purpose is not to give the people an opportunity to decide some issue but rather to express their unity behind a decision which the Führer, in his capacity as the bearer of the people's will, has already made:

"That the will of the people is embodied in the Führer does not exclude the possibility that the Führer can summon all members of the people to a plebiscite on a certain question. In this 'asking of the people' the Führer does not, of course, surrender his decisive power to the voters. The purpose of the plebiscite is not to let the people act in the Führer's place or to replace the Führer's decision with the result of the plebiscite. Its purpose is rather to give the whole people an opportunity to demonstrate and proclaim its support of an aim announced by the Führer. It is intended to solidify the unity and agreement between the objective people's will embodied in the Führer and the living, subjective conviction of the people

as it exists in the individual members . . . This approval of the Führer's decision is even more clear and effective if the plebiscite is concerned with an aim which has already been realized rather than with a mere intention."

Huber states that the Reichstag elections in the Third Reich have the same character as the plebiscites. The list of delegates is made up by the Führer and its approval by the people represents an expression of renewed and continued faith in him. The Reichstag no longer has any governing or lawgiving powers but acts merely as a sounding board for the Führer:

"It would be impossible for a law to be introduced and acted upon in the Reichstag which had not originated with the Führer or, at least, received his approval. The procedure is similar to that of the plebiscite: The lawgiving power does not rest in the Reichstag; it merely proclaims through its decision its agreement with the will of the Führer, who is the lawgiver of the German people."

Huber also shows how the position of the Führer developed from the Nazi Party movement:

"The office of the Führer developed out of the National Socialist movement. It was originally not a state office; this fact can never be disregarded if one is to understand the present legal and political position of the Führer. The office of the Führer first took root in the structure of the Reich when the Führer took over the powers of the Chancelor, and then when he assumed the position of the Chief of

State. But his primary significance is always as leader of the movement; he has absorbed within himself the two highest offices of the political leadership of the Reich and has created thereby the new office of 'Führer of the people and the Reich.' That is not a superficial grouping together of various offices, functions, and powers . . . It is not a union of offices but a unity of office. The Führer does not unite the old offices of Chancelor and President side by side within himself, but he fills a new, unified office.

"The Führer unites in himself all the sovereign authority of the Reich; all public authority in the state as well as in the movement is derived from the authority of the Führer. We must speak not of the state's authority but of the Führer's authority if we wish to designate the character of the political authority within the Reich correctly. The state does not hold political authority as an impersonal unit but receives it from the Führer as the executor of the national will. The authority of the Führer is complete and all-embracing; it unites in itself all the means of political direction; it extends into all fields of national life; it embraces the entire people, which is bound to the Führer in lovalty and obedience. The authority of the Führer is not limited by checks and controls, by special autonomous bodies or individual rights, but it is free and independent, all-inclusive and unlimited. It is not, however, self-seeking or arbitrary and its ties are within itself. It is derived from the people; that is, it is entrusted to the Führer by the people. It exists for the people and has its justification in the people: it is free of all outward ties because it is in its innermost nature firmly bound up with the fate, the welfare, the mission, and the honor of the people."

THE PARTY

The third pillar of the Nazi state, the link between Volk and Führer, is the Nazi Party. According to Nazi ideology, all authority within the nation is derived ultimately from the people, but it is the party through which the people expresses itself. In Rechtseinrichtungen und Rechtsaufgaben der Bewegung (Legal Organisation and Legal Functions of the Movement) published in 1939, Otto Gauweiler states:

"The will of the German people finds its expression in the party as the political organization of the people. It represents the political conception, the political conscience, and the political will. It is the expression and the organ of the people's creative will to life. It comprises a select part of the German people for 'only the best Germans should be party members' . . . The inner organization of the party must therefore bring the national life which is concentrated within itself to manifestation and development in all the fields of national endeavor in which the party is represented."

The party derives its legal basis from the law inherent in the living organism of the German Volk:

"The inner law of the NSDAP is none other than the inner law of the German people. The party arises from the people; it has formed an organization which crystallizes about itself the feelings of the people, which seemed buried, and the strength of the people, which seemed lost."

The Party has two great tasks-to in-

sure the continuity of national leadership and to preserve the unity of the Volk:

"The first main task of the party, which is in keeping with its organic nature, is to protect the National Socialist idea and to constantly renew it by drawing from the depths of the German soul, to keep it pure and clear, and to pass it on thus to coming generations: this is predominantly a matter of education of the people."

PROPERTY

In the Third Reich the holder of property is considered merely as a manager responsible to the Volk for the use of the property in the common interest. Huber sets forth the Nazi view in the following words:

"'Private property' as conceived under the liberalistic economic order was a reversal of the true concept of property. This 'private property' represented the right of the individual to manage and to speculate with inherited or acquired property as he pleased, without regard for the general interests . . . German socialism had to overcome this 'private', that is, unrestrained and irresponsible view of property. All property is common property. The owner is bound by the people and the Reich to the responsible management of his goods. His legal position is only justified when he satisfies this responsibility to the community."

III. Appeasement

To the challenge of the dictators, the Western powers opposed a policy of weakness and uncertainty which came to be known as "appeasement." The majority of the electorate in England and France were profoundly pacifist, unwilling to pay for the armaments which alone could have enabled them to restrain their ambitious neighbors and persuaded that a fair settlement, revising some of the arrangements of Versailles according to the principles of justice and national self-determination. could make for a lasting peace. This, at least in part, is why the Western powers did not go beyond protests when Hitler reoccupied the demilitarized zone of the Rhineland in 1936 and annexed Austria in 1938; and it helps to explain their extraordinary pusillanimity in the Czech crisis which followed shortly. Other factors also entered into it: the fear of Communism and of Russian ambitions which since 1918 had stood the Germans in good stead, which brought Hitler and Mussolini a certain amount of sympathy as the most active opponents of Bolshevism, and which made for the policy of nonintervention in Spain (meaning no intervention on the democratic side); the long-standing mess in French internal affairs; and the American withdrawal from effective international activity, which encouraged European statesmen to underrate the significance of American power and to regard international issues only in terms of European power. But the essence of the debate in the West is reflected in the speeches made in the British House of Commons during the period of the Munich crisis.

1. DEBATE OF 28 SEPTEMBER 1938

The development of the Munich crisis during the late summer of 1938 is outlined in the following account which the British Prime Minister, Neville Chamberlain, presented to the House of Commons. Germany demanded the Sudeten-German territories of Czechoslovakia, whose territorial integrity was guaranteed by France which, in turn, was the ally of Britain. Had war broken out over the Sudetenland, Germany would have had to fight the Czechs in their strongly fortified Bohemian positions, their French allies on the Rhine, and probably the British as well. This Hitler wanted to avoid by persuading Czechoslovakia's Western allies that the Sudetenland was not worth a war; and in his efforts he was unwittingly but mightily helped by the somewhat confused but sincere ideas held by Chamberlain and his friends as to the possibilities of a just settlement followed by a lasting peace.

The Prime Minister, Mr. Chamberlain: Shortly before the House adjourned at the end of July I remember that some

questions were addressed to me as to the possibility of summoning the House before the time arranged, and during the

From Parliamentary Debates, 5th Series, Vol. 339 (1938).

Recess, in certain eventualities. Those eventualities referred to possible developments in Spain. But the matter which has brought us together today is one which even at that time was already threatening but which, I think, we all hoped would find a peaceful solution before we met again. Unhappily those hopes have not been fulfilled. Today we are faced with a situation which has had no parallel since 1914.

To find the origins of the present controversy it would be necessary to go back to the constitution of the state of Czechoslovakia with its heterogeneous population. No doubt at the time when it was constituted it seemed to those then responsible that it was the best arrangement that could be made in the light of conditions as they then supposed them to exist. I cannot help reflecting that if Article 19 of the Covenant providing for the revision of the Treaties by agreement had been put into operation, as was contemplated by the framers of the Covenant, instead of waiting until passions became so exasperated that revision by agreement became impossible, we might have avoided the crisis. For that omission all Members of the League must bear their responsibility. I am not here to apportion blame among them.

The position that we had to face in July was that a deadlock had arisen in the negotiations which had been going on between the Czechoslovak Government and the Sudeten Germans and that fears were already entertained that if it were not readily broken the German Government might presently intervene in the dispute. For His Majesty's Government there were three alternative courses that we might have adopted. Either we could have threatened to go to war with Germany if she attacked Czechoslovakia, or we could

have stood aside and allowed matters to take their course, or, finally, we could attempt to find a peaceful settlement by way of mediation. The first of those courses we rejected. We had no treaty liabilities to Czechoslovakia. We always refused to accept any such obligation. Indeed, this country, which does not readily resort to war, would not have followed us if we had tried to lead it into war to prevent a minority from obtaining autonomy, or even from choosing to pass under some other Government.

The second alternative was also repugnant to us. However remote this territory may be, we knew, of course, that a spark once lighted there might give rise to a general conflagration, and we felt it our duty to do anything in our power to help the contending parties to find agreement. We addressed ourselves to the third course, the task of mediation. We knew that the task would be difficult, perhaps even perilous, but we felt that the object was good enough to justify the risk, and when Lord Runciman had expressed his willingness to undertake our mission, we were happy to think that we had secured a mediator whose long experience, and well-known qualities . . . gave us the best hope of success. That in the end Lord Runciman did not succeed was no fault of his . . .

On 21st September Lord Runciman addressed a letter to me reporting the results of his mission. . . . Perhaps I may conveniently mention some of the salient points of his story. On 7th June the Sudeten German party had put forward certain proposals . . . The Czechoslovak Government on their side had embodied their proposals in a draft Nationality Statute, a Language Bill, and an Administrative Reform Bill. By the middle of August it had become clear to Lord

Runciman that the gap between these two proposals was too wide to permit of negotiations between the parties on that basis. In his capacity as mediator, he was successful in preventing the Sudeten German party from closing the door upon further negotiations, and he was largely instrumental in inducing Dr. Benes to put forward new proposals on 21st August. which appear to have been regarded by the Sudeten party leaders as a suitable basis for the continuance of negotiations. The prospects of negotiations being carried through to a successful conclusion were, however, handicapped by the recurrence of incidents in Czechoslovakia. involving casualties both on the Czech and on the Sudeten German side.

On 1st and 2nd September Herr Henlein went to Berchtesgaden to consult with Herr Hitler about the situation. [Henlein returns "convinced of Herr Hitler's desire for a peaceful solution" but calling once more for the maximum programme from which he had started.] . . .

In the meantime, however, developments in Germany itself had been causing considerable anxiety to His Majesty's Government. On 28th July the Secretary of State for Foreign Affairs had written a personal letter to the German Minister of Foreign Affairs, Herr von Ribbentrop, expressing his regret at the latter's statement to Sir Neville Henderson, our Ambassador in Berlin, that the German Government must reserve its attitude towards Lord Runciman's mission and regard the matter as one of purely British concern. The Secretary of State had gone on to express the hope that the German Government would collaborate with His Majesty's Government in facilitating a peaceful solution of the Sudeten question and so opening the way to establishing relations between Great Britain and Germany on a basis of mutual confidence and cooperation.

But early in August we received reports of military preparations in Germany on an extensive scale. . . . These measures, which involved a widespread dislocation of civilian life, could not fail to be regarded abroad as equivalent to partial mobilisation, and they suggested that the German Government were determined to find a settlement of the Sudeten question by the autumn. In these circumstances H.M. Ambassador in Berlin was instructed, in the middle of August, to point out to the German Government that these abnormal measures could not fail to be interpreted abroad as a threatening gesture towards Czechoslovakia, that they must therefore increase the feeling of tension throughout Europe, and that they might compel the Czechoslovak Government to take precautionary measures on their side. The almost certain consequence would be to destroy all chance of successful mediation by Lord Runciman's mission and perhaps endanger the peace of every one of the great Powers of Europe. This, the Ambassador added, might also destroy the prospects of the resumption of Anglo-German conversations. In these circumstances it was hoped that the German Government might be able to modify their military measures in order to avoid these dangers.

To these representations Herr von Ribbentrop replied in a letter in which he refused to discuss the military measures referred to and expressed the opinion that the British efforts in Prague had only served to increase Czech intransigence. In face of this attitude H.M. Government, through the Chancellor of the Exchequer, who happened to be speaking at Lanark on 27th August, drew attention again to

some words which I had used on 24th March in this House. . . .

Where peace and war are concerned, legal obligations are not alone involved, and, if war broke out, it would be unlikely to be confined to those who have assumed such obligations. It would be quite impossible to say where it would end and what governments might become involved. The inexorable pressure of facts might well prove more powerful than formal pronouncements, and in that event it would be well within the bounds of probability that other countries, besides those which were parties to the original dispute, would almost immediately become involved. This is especially true in the case of two countries like Great Britain and France, with long associations of friendship, with interests closely interwoven, devoted to the same ideals of democratic liberty, and determined to uphold them." (Official Report, 24 March, 1938)

Towards the end of August further events occurred which marked the increasing seriousness of the situation. The French Government, in consequence of information which had reached them about the moving of several German divisions towards their frontier, took certain precautionary measures themselves, including the calling up of reserves to man the Maginot Line. On 28th August Sir Neville Henderson had been recalled to London for consultation and a special meeting of Ministers was held on 30th August to consider his report and the general situation. On the 31st he returned to Berlin and he gave Baron von Weizsäcker, the State Secretary at the Wilhelmstrasse, a strong personal warning regarding the probable attitude of H.M. Government in the event of German aggression against Czechoslovakia, particularly if France were compelled to intervene. On 1st September the Ambassador saw Herr von Ribbentrop and repeated to him, as a personal and most urgent message, the warning he had already given to the State Secretary on the previous day.

In addressing these personal warnings . . . and in making the reference to Czechoslovakia contained in the Chancellor of the Exchequer's speech on 27th August, H.M. Government desired to impress the seriousness of the situation upon the German Government without risking a further aggravation of the situation by any formal representations, which might have been interpreted by the German Government as a public rebuff, as had been the case (before) . . . H.M. Government also had to bear in mind the close approach of the Nazi Party Conference at Nuremberg, which was to open on 5th September and to last until the 12th. It was to be anticipated that the German Chancellor would feel himself compelled to make some public statement regarding the Sudeten question, and it therefore appeared necessary, in addition to warning the German Government . . . to make every effort in Prague to secure a resumption of negotiations between the Czechoslovak Government and the Sudeten representatives . . .

Accordingly, H.M. Minister at Prague saw Dr. Benes on 3rd September and emphasized to him that it was vital in the interests of Czechoslovakia to offer immediately and without reservation those concessions without which the Sudeten question could not be immediately settled. H.M. Government were not in a position

to say whether anything less than the full Carlsbad programme (Henlein's original demands) would suffice. They certainly felt that the Czechoslovak Government should go forthwith and unreservedly to the limit of concessions. . . . Dr. Benes responded to these representations, which were made in the best interests of Czechoslovakia, by putting forward proposals afterwards known as the Fourth Plan, which were communicated to the Sudeten German representatives on 6th September. In Lord Runciman's opinion this plan embodied almost all the requirements of the eight Carlsbad points and formed a very favourable basis for the resumption of negotiations. In forming this opinion he was guided partly by his own examination . . . and partly by the favourable reception that was accorded to it by the Sudeten negotiators. . . . the prospects of a satisfactory solution of the Sudeten question on the basis of autonomy within the Czechoslovak State appeared not unpromising . . . The publication of the Fourth Plan (September 7th) was, unfortunately, however, immediately followed by a serious incident . . . It would appear from the investigations of the British observer that the importance of this incident was very much exaggerated. The immediate result was a decision on the part of the Sudeten leaders not to resume negotiations until this incident had been liquidated. Immediately measures were taken by the Czechosolvak government to liquidate it, but further incidents took place on 11th September near Eger, and, in spite of Lord Runciman's efforts to bring both parties together, negotiations could not be resumed before Herr Hitler's speech winding up the Nuremberg Congress on 12th September. . . .

In his speech on 12th September Herr

Hitler laid great stress upon the defensive military measures taken on Germany's western frontier. In his references to Czechoslovakia he reminded the world that on 22nd February he had said that the Reich would no longer tolerate further oppression or persecution of the Sudeten Germans. They demanded the right of self determination, he said, and they were supported in their demand by the Reich. Therefore, for the first time this speech promised the support of the Reich to the Sudeten Germans if they could not obtain satisfaction for themselves, and for the first time it publicly raised the issue of self determination. He did not, however, close the door upon further negotiations in Prague, nor did he demand a plebiscite. As the speech was also accompanied by pacifying references to Germany's frontiers with Poland and France, its general effect was to leave the situation unchanged, with a slight diminution of tension.

The speech, however, and in particular Herr Hitler's reference to German support for the cause of the Sudeten Germans, had an immediate and unfortunate effect among those people. Demonstrations took place throughout the Sudetenland, resulting in an immediate extension of the incidents which had already begun on 11th September. Serious rioting occurred, accompanied by attacks upon Czech police and officials, and by 14th September . . . there had been 21 killed and 75 wounded, the majority of whom were Czechs. Martial law was immediately proclaimed in the affected districts. On the evening of 13th September Herr Henlein and other Sudeten leaders assembled at Eger and sent a telegram to the Czechoslovak Government, declaring that they could not be responsible for the consequences of martial law and the spe-

cial Czech emergency measures if they were not immediately withdrawn. Attempts by Lord Runciman's Mission to bring the Sudeten leaders into discussion with the Czechoslovak Government failed, and on 14th September Herr Henlein issued a proclamation stating that the Carlsbad points were no longer enough and that the situation called for self-determination. Thereupon, Herr Henlein fled to Germany . . . The House will recall that by the evening of 14th September a highly critical situation had developed in which there was immediate danger of the German troops now concentrated upon the frontier entering Czechoslovakia to prevent further incidents occurring in Sudetenland, and fighting between the Czech forces and the Sudeten Germans, although reliable reports indicated that order had been completely restored in those districts by 14th September. On the other hand, the Czechoslovak Government might have felt compelled to mobilise at once and so risk provoking a German invasion. In either event German invasion might have been expected to bring into operation French obligations to come to the assistance of Czechoslovakia, and so lead to a European war in which this country might well have been involved in support of France.

In those circumstances I decided that the time had come to put into operation a plan which I had had in my mind for a considerable period as a last resort. One of the principal difficulties in dealing with totalitarian Governments is the lack of any means of establishing contact with the personalities in whose hands lie the final decisions of the country. So I resolved to go to Germany myself to interview Herr Hitler and find out in personal conversation whether there was yet any hope of saving the peace. I knew very

well that in taking such an unprecedented course I was laying myself open to criticism on the ground that I was detracting from the dignity of a British Prime Minister, and to disappointment and perhaps even resentment, if I failed to bring back a satisfactory agreement. But I felt that in such a crisis, where the issues at stake were so vital for millions of human beings, such considerations could not be allowed to count.

Herr Hitler responded to my suggestion with cordiality, and on 15th September I made my first flight to Munich. Thence I travelled by train to Herr Hitler's mountain home at Berchtesgaden. I confess I was astonished at the warmth of the approval with which this adventure was everywhere received, but the relief which it brought for the moment was an indication of the gravity with which the situation had been viewed. At this first conversation . . . I very soon became aware that the position was much more acute and much more urgent than I had realised. . . . Herr Hitler made it plain that he had made up his mind that the Sudeten Germans must have the right of self-determination, and of returning, if they wished, to the Reich. If they could not achieve this by their own efforts, he said, he would assist them to do so, and he declared categorically that rather than wait he would be prepared to risk a world war. . . .

So strongly did I get the impression that the Chancellor was contemplating an immediate invasion of Czechoslovakia that I asked him why he had allowed me to travel all that way, since I was evidently wasting my time. On that he said that if I could give him there and then an assurance that the British Government accepted the principle of self-determination, he would be quite ready to discuss

ways and means of carrying it out; but, if, on the contrary, I told him that such a principle could not be considered by the British Government, then he agreed it was of no use to continue our conversations. I of course was not in a position to give there and then such an assurance, but I undertook to return at once to consult with my colleagues if he would refrain from active hostilities until I had had time to obtain a reply. That assurance he gave me . . . I have no doubt whatever now, looking back, that my visit alone prevented an invasion, for which everything was ready. It was clear to me that with the German troops in the positions they then occupied there was nothing that anybody could do to prevent that invasion unless the right of self-determination were granted to the Sudeten Germans, and that quickly. That was the sole hope of a peaceful solution.

I came back to London next day, and that evening the Cabinet met and it was attended by Lord Runciman who, at my request, had also travelled from Prague on the same day. Lord Runciman informed us that although, in his view, the responsibility for the final breach in the negotiations at Prague rested with the Sudeten extremists, nevertheless, in view of recent developments, the frontier districts between Czechoslovakia and Germany where the Sudeten population was in such an important majority, should be given the full right of self-determination at once. He considered the cession of territory to be inevitable and thought it should be done promptly. . . . Moreover, he considered that the integrity and security of Czechoslovakia could only be maintained if her policy, internal and external, was directed to enabling her to live at peace with all her neighbours. For this purpose, in his opinion, her policy should be entirely neutral, as in the case of Switzerland. This would involve assurances from Czechoslovakia that in no circumstances would she attack any of her neighbours, and it would also mean guarantees from the principal powers of Europe against aggression. . . .

Naturally, H.M. Government felt it necessary to consult the French Government before they replied to Herr Hitler, and, accordingly, M. Daladier and M. Bonnet were invited to fly to London for conversations with British Ministers on September. . . . During conversations the representatives of the two Governments were guided by a desire to find a solution which would not bring about a European War, and, therefore, a solution which would not automatically compel France to take action in accordance with her obligations. It was agreed that the only means of achieving this object was to accept the principle of selfdetermination, and, accordingly, the British and French Ministers in Prague were instructed to inform the Czech Government that the further maintenance within the boundaries of the Czechoslovak State of the districts mainly inhabited by Sudeten Germans could not continue any longer without imperilling the interests of Czechoslovakia herself and of European peace. The Czechoslovak Government were, therefore, urged to agree immediately to the direct transfer to the Reich of all areas with over 50% Sudeten inhabitants. An international body was to be set up to deal with questions like the adjustment of frontiers and the possible exchange of populations . . .

The Czechoslovak Government were informed that, to meet their natural desire for security for their future, H.M. Government would be prepared, as a contribution to the pacification of Europe,

to join in an international guarantee of the new boundaries of the Czechoslovak State against unprovoked aggression. Such a guarantee would safeguard the independence of Czechoslovakia by substituting a general guarantee against unprovoked aggression in place of the existing treaties with France and Soviet Russia, which involve reciprocal obligations of a military character. In urging this solution upon the Czechoslovak Government, the British and French Governments took account of the probability that the Czechoslovak Government would find it preferable to deal with the problem by the method of direct transfer rather than by means of a plebiscite, which would involve serious difficulties as regards other nationalities in Czechoslovakia.

In agreeing to guarantee the future boundaries of Czechoslovakia against unprovoked aggression, H.M. Government were accepting a completely new commitment as we were not previously bound by any obligations towards Czechoslovakia, other than those involved in the League of Nations.

The Czechoslovak Government replied on 20th September to these representations by suggesting that the Sudeten dispute should be submitted to arbitration under the terms of the German-Czechoslovak Arbitration Treaty of 1926. The British and French Ministers in Prague were, however, instructed to point out to the Czechoslovak Government that there was no hope of a peaceful solution on this basis, and, in the interests of Czechoslovakia and of European peace, the Czechoslovak Government was urged to accept the Anglo-French proposals immediately. This they did immediately and unconditionally on 21st September. H.M. Minister in Prague was instructed on 22nd September to inform Dr. Benes that H.M. Government were profoundly conscious of the immense sacrifices to which the Czechoslovak Government had agreed, and the great public spirit they had shown. These proposals had naturally been put forward in the hope of averting a general disaster and saving Czechoslovakia from invasion. The Czechoslovak Government's readiness to go to such extreme limits of concession had assured her of a measure of sympathy which nothing else could have aroused.

That Government resigned on 22nd September, but it was immediately succeeded by a Government of National Concentration under General Syrovy . . . We had hoped that the immediate problem of the Sudeten Germans would not be further complicated at this particular juncture by the pressing of the claims of the Hungarian and Polish minorities. These minorities have, however, consistently demanded similar treatment to that accorded to the Sudeten minority, and the acceptance of the Anglo-French proposals, involving the cession of the predominantly Sudeten German territories. has led to a similar demand for cession of the territory predominantly inhabited by Polish and Hungarian minorities being advanced by the Hungarian and Polish Governments. . . Troop movements have taken place in the direction of Teschen and considerable popular feeling has been aroused in Poland. The Hungarian Government has been encouraged by the visits of the Regent to Field Marshal Goering at Rominten on 20th September, and of the Prime Minister, Foreign Minister, and Chief of the General Staff to Berchtesgaden on 21st September. Mobilisation measures have been taken to double the strength of the Hungarian Army.

In view of these developments, the

task of finding a solution of the Sudeten German problem was still further complicated. However, on the 22nd, I went back to Germany to Godesberg on the Rhine . . . Once again I had a very warm welcome in the streets and villages through which I passed, demonstrating to me the desire of the German people for peace, and on the afternoon of my arrival I had my second meeting with the Chancellor. . . . (After some preliminary discussion) Herr Hitler said he could not accept the . . . proposals I had described to him, on the ground that they were too dilatory and offered too many opportunities for further evasion on the part of the Czechs. He insisted that a speedy solution was essential, on account of the oppression and terrorism to which the Sudeten Germans were being subjected, and he proceeded to give me the main outlines of the proposal which he subsequently embodied in a memorandumexcept that he did not in this conversation actually name any time limit.

Hon. Members will realise the perplexity in which I found myself, faced with this totally unexpected situation. I had been told at Berchtesgaden that if the principle of self-determination were accepted Herr Hitler would discuss with me the ways and means of carrying it out. He told me afterwards that he never for one moment supposed that I should be able to come back and say that the principle was accepted. I do not want Hon. Members to think that he was deliberately deceiving me—I do not think so for one moment-but, for me, I expected that when I got back to Godesberg I had only to discuss quietly with him the proposals that I had brought with me; and it was a profound shock to me when I was told at the beginning of the conversation that these proposals were not acceptable, and that they were to be replaced by other proposals of a kind which I had not contemplated at all.

I felt that I must have a little time to consider what I was to do. Consequently, I withdrew, my mind full of foreboding as to the success of my mission. [After this, the two statesmen exchanged some written communications, met for a last conversation during which Hitler handed Chamberlain a Memorandum containing his proposals and fixing a time limit for their acceptance, and Chamberlain declared that the manner and the language of the document was "more that of an ultimatum than that of a memorandum."] . . . I think I should add that before saying farewell to Herr Hitler I had a few words with him in private, which I do not think are without importance. In the first place, he repeated to me with great earnestness what he had said already at Berchtesgaden, namely, that this was the last of his territorial ambitions in Europe and that he had no wish to include in the Reich people of other races than Germans. In the second place he said, again very earnestly, that he wanted to be friends with England and that if only this Sudeten question could be got out of the way in peace he would gladly resume conversations. It is true he said, "there is one awkward question, The Colonies." [Hon. Members: "Spain" (Laughter) I really think that at a time like this these are not subjects for idle laughter. They are words which count in the long run and ought to be fully weighed. He said, "there is one awkward question, The Colonies, but that is not a matter for war," and, alluding to the mobilisation of the Czechoslovakian army, which had been announced to us in the middle of our conversations and had given rise to some disturbance, he said, about the colonies, "There will be no mobilisation about that."

I may now briefly recapitulate the contents of the Memorandum. He proposed immediate separation from Czechoslovakia on the areas shaded on the map (which went with the Memorandum). These areas included all areas in which Sudeten Germans constituted more than 50 per cent of the population, and some additional areas. These were to be completely evacuated by Czech soldiers and officials and occupied by German troops by 1st October. A plebiscite was to be held in November, and according to the results a definitive frontier was to be settled. . . . In addition, certain other areas, marked in green, were to be the subject of a plebiscite but these were to remain in occupation of Czech troops. . . . I returned to London on 24th September, and arrangements were made for the German Memorandum and map to be communicated directly to the Czech Government, who received them that evening. On Sunday, the 25th, we received from Mr. Masaryk, the Czech Minister here, the reply of the Czech Government, which stated that they considered Herr Hitler's demands in their present form to be absolutely and unconditionally unacceptable. This reply was communicated to the French Ministers. M. Daladier and M. Bonnet, who arrived that same evening and exchanged views with us on the situation. Conversations were resumed the next morning, when the French Ministers informed us that if Czechoslovakia were attacked France would fulfil her treaty obligations, and in reply we told them that if as a result of these obligations French forces became actively engaged in hostilities against Germany, we should feel obliged to support them.

Meanwhile, as a last effort to preserve peace, I sent Sir Horace Wilson to Berlin on the 26th, with a personal message to Herr Hitler to be delivered before the speech that Herr Hitler was to make in Berlin at 8 o'clock that night. The French Ministers entirely approved this initiative, and issued a communiqué to that effect at midday. Sir Horace Wilson took with him a letter from me . . . pointing out that the reception of the German Memorandum by the Czechoslovak Government and public opinion in the world generally had confirmed the expectations which I had expressed to him at Godesberg. I. therefore, made a further proposal with a view to rendering it possible to get a settlement by negotiation rather than by military force, namely, that there should be immediate discussions between German and Czechoslovak representatives in the presence of British representatives. Sir Horace Wilson arrived in Berlin on the afternoon of the 26th and he presented his letter to Herr Hitler, who listened to him, but expressed the view that he could not depart from the procedure of the Memorandum, as he felt conferences would lead to further intolerable procrastinations.

I should tell the House how deeply impressed on my mind by my conversations with Herr Hitler and by every speech he has made, is his rooted distrust and disbelief in the sincerity of the Czech Government. That has been one of the governing factors in all this difficult story of negotiation.

In the meantime, after reading Herr Hitler's speech in Berlin, in which he, as I say, expressed his disbelief in the intention of the Czech Government to carry out their promises, I issued a statement in which I offered, on behalf of the British Government, to guarantee that the

promises they had made to us and the French Government should be carried out. But yesterday morning Sir Horace Wilson resumed his conversations with Herr Hitler, and finding his views apparently still unchanged, he by my instructions repeated to him in precise terms what I said a few minutes ago was the upshot of our conversations with the French, namely, that if the Czechs reject the German Memorandum and Germany attacks Czechoslovakia, we had been informed by the French Government that they would fulfil their obligations to Czechoslovakia, and that should the forces of France in consequence become actively engaged in hostilities against Germany the British Government would feel obliged to support them.

. . . Now the story which I have told the House brings us up to last night. About 10.30 I received from Herr Hitler a reply to my letter sent by Sir Horace Wilson. . . . There is, for example, a definite statement that troops are not to move beyond the red line (on the map), that they are only to preserve order, that the plebiscite will be carried out by a free vote under no outside influence, and that Herr Hitler will abide by the result, and, finally, that he will join the international guarantee of the remainder of Czechoslovakia once the minorities questions are settled. Those are all reassuring statements as far as they go, and I have no hesitation in saying, after the personal contact I had established with Herr Hitler, that I believe he means what he says when he states that. But the reflection which was uppermost in my mind when I read his letter to me was that once more the differences and the obscurities had been narrowed down still further to a point where, really, it was inconceivable that they could not be settled by negotiations. So strongly did I feel this, that I felt impelled to send one more last letter—the last to the Chancellor. I sent him the following personal message:

After reading your letter I feel certain that you can get all essentials without war and without delay. I am ready to come to Berlin myself at once to discuss arrangements for transfer with you and representatives of Czech Government, together with representatives of France and Italy if you desire. I feel convinced that we could reach agreement in a week. However much you distrust the Prague Government's intentions, you cannot doubt the power of the British and French Governments to see that the promises are carried out fairly and fully and forthwith. As you know, I have stated publicly that we are prepared to undertake that they shall be so carried out. I cannot believe that you will take the responsibility of starting a world war which may end civilization, for the sake of a few days' delay in settling this longstanding problem.

At the same time I sent the following personal message to Signor Mussolini:

I have today addressed last appeal to Herr Hitler to abstain from force to settle Sudeten problem, which, I feel sure, can be settled by a short discussion and will give him the essential territory, population and protection for both Sudetens and Czechs during transfer. I have offered myself to go at once to Berlin to discuss arrangements with German and Czech representatives, and if the Chancellor desires, represen-

tatives also of Italy and France. Trust your Excellency will inform the German Chancellor that you are willing to be represented and ask him to agree to my proposal which will keep all our peoples out of war. I have already guaranteed that Czech promises shall be carried out and feel confident full agreement could be reached in a week.

In reply to my message to Signor Mussolini, I was informed that instructions had been sent by the Duce to the Italian Ambassador in Berlin to see Herr von Ribbentrop at once and to say that whilst Italy would fulfil completely her pledges to stand by Germany, yet, in view of the great importance of the request made by H.M. Government to Signor Mussolini, the latter hoped Herr Hitler would see his way to postpone action which the Chancellor had told Sir Horace Wilson was to be taken at 2 P.M. today for at least 24 hours so as to allow Signor Mussolini time to reexamine the situation and endeavor to find a peaceful settlement. In response, Herr Hitler has agreed to postpone mobilization for 24 hours.

Whatever view Hon. Members may

have had about Signor Mussolini in the past, I believe that everyone will welcome his gesture of being willing to work with us for peace in Europe. That is not all. I have something further to say to the House vet. I have now been informed by Herr Hitler that he invites me to meet him at Munich tomorrow morning. He has also invited Signor Mussolini and M. Daladier. Signor Mussolini has accepted and I have no doubt M. Daladier will also accept. I need not say what my answer will be. [Hon. Member: "Thank God for the Prime Minister!" We are all patriots, and there can be no Hon, Member of this House who did not feel his heart leap that the crisis has been once more postponed to give us once more an opportunity to try what reason and good will and discussion will do to settle a problem which is already within sight of settlement. Mr. Speaker, I cannot say any more. I am sure that the House will be ready to release me now to go and see what I can make of this last effort. Perhaps they may think it will be well, in view of this new development, that this debate shall stand adjourned for a few days, when perhaps we may meet in happier circumstances.

2. PEACE IN OUR TIME

So the statesmen met at Munich, and Czechoslovakia had to foot the bill. And from Munich Chamberlain returned to the cheers of a relieved and slightly ashamed London crowd, flourishing his private agreement with Hitler which, he claimed, promised "Peace in our time." This was the agreement as published by the London *Times* of October 1, 1938:

We, the German Führer and Chancellor and the British Prime Minister have had a further meeting today and are agreed in recognizing that the question of Anglo-German relations is of the first importance for the two countries and for Europe.

We regard the agreement signed last night and the Anglo-German Naval Agreement as symbolic of the desire of our two peoples never to go to war with one another again.

We are resolved that the method of consultation shall be the method adopted to deal with any other questions that may concern our two countries, and we are determined to continue our efforts to remove possible sources of differences and thus to contribute to assure the peace of Europe.

3. DEBATE OF 3 OCTOBER 1938

The Debate, which had been adjourned on September 28th (Wednesday), reopened the following Monday, October 3rd, with the resignation speech of Mr. Duff Cooper, who had been First Lord of the Admiralty in the Chamberlain Government.

Mr. Duff Cooper: The House will, I am sure, appreciate the peculiarly difficult circumstances in which I am speaking this afternoon. It is always a painful and delicate task for a Minister who has resigned to explain his reasons to the House of Commons, and my difficulties are increased this afternoon by the fact, of which I am well aware, that the majority of the House are most anxious to hear the Prime Minister and that I am standing between them and him. But I shall have, I am afraid, to ask for the patience of the House, because I have taken a very important, for me, and difficult decision, and I feel that I shall have to demand a certain amount of time in which to make plain to the House the reasons for which I have taken it.

At the last Cabinet meeting that I attended, last Friday evening, before I succeeded in finding my way to no. 10, Downing Street, I was caught up in a large crowd that were demonstrating their enthusiasm and were cheering, laughing and singing; and there is no greater feeling of loneliness than to be in a crowd of happy, cheerful people and to feel that there is no occasion for oneself for gaiety or for cheering. That there was every cause for relief I was deeply aware, as much as anybody in this country, but that

there was great cause for self-congratulation I was uncertain. Later, when I stood in the hall at Downing Street, again among enthusiastic throngs of friends and colleagues who were all as cheerful, happy, glad, and enthusiastic as the crowd in the street, and when I heard the Prime Minister from the window above, saving that he had returned, like Lord Beaconsfield, with "Peace with Honor," claiming that it was Peace for our time, once again I felt lonely and isolated; and when later, in the Cabinet room, all his other colleagues were able to present him with bouquets, it was an extremely painful and bitter moment that all that I could offer him was my resignation.

Before taking such a step as I have taken, on a question of international policy, a Minister must ask himself many questions, not the least important of which is this: Can my resignation at the present time do any material harm to H.M. Government; can it weaken our position; can it suggest to our critics that there is not a united front in Great Britain? Now I would not have flattered myself that my resignation was of great importance, and I did feel confident that so small a blow could easily be borne at the present time, when I think that the Prime Minister is more popular than he has ever

been at any period; but had I had any doubts with regard to that facet of the problem, they would have been set at rest, I must say, by the way in which my resignation was accepted, not, I think, with reluctance, but really with relief.

I have always been a student of foreign politics. I have served ten years in the Foreign Office, and I have studied the history of this and of other countries, and I have always believed that one of the most important principles in foreign policy and the conduct of foreign policy should be to make your policy plain to other countries, to let them know where you stand and what, in certain circumstances, you are prepared to do. I remember so well in 1914 meeting a friend, just after the declaration of war, who had come back from the British Embassy in Berlin, and asking him whether it was the case as I had seen it reported in the papers, that the Berlin crowd had behaved very badly and had smashed all the windows of the Embassy, and that the military had had to be called out in order to protect them. I remember my friend telling me that, in his opinion and in that of the majority of the staff, the Berlin crowds were not to blame, that the members of the British Embassy staff had great sympathy with the feelings of the populace, because, they said, "these people have never thought that there was a chance of our coming into the war." They were assured by their Government-and the Government themselves perhaps believed it—that Britain would remain neutral, and therefore it came to them as a shock when, having already been engaged with other enemies, as they were, they found that Great Britain had turned against

I thought then, and I have always felt, that in any other international crisis that should occur our first duty was to make it plain exactly where we stood and what we would do. I believe that the great defect in our foreign policy during recent months and recent weeks has been that we have failed to do so. During the last four weeks we have been drifting, day by day, nearer into war with Germany, and we have never said, until the last moment, and then in most uncertain terms, that we were prepared to fight. We knew that information to the opposite effect was being poured into the ears of the head of the State. He had been assured, reassured, and fortified in the opinion that in no case would Great Britain fight.

When Ministers met at the end of August on their return from a holiday there was an enormous accumulation of information from all parts of the world. the ordinary information from our Diplomatic representatives, also secret, and less reliable information from other sources. information from members of Parliament who had been travelling on the Continent and who had felt it their duty to write to their friends in the Cabinet and give them first-hand information which they had received from good sources. I myself had been travelling in Scandinavia and in the Baltic States, and with regard to all this information—Europe was very full of rumors at that time—it was quite extraordinary the unanimity with which it pointed to one conclusion and with which all sources suggested that there was one remedy. All information pointed to the fact that Germany was preparing for war at the end of September, and all recommendations agreed that the one way in which it could be prevented was by Great Britain making a firm stand and stating that she would be in that war, and would be upon the other side.

I had urged even earlier, after the rape of Austria, that Great Britain should make a firm declaration of what her foreign policy was, and then and later I was met with this, that the people of this country are not prepared to fight for Czechoslovakia. That is perfectly true, but I tried to represent another aspect of the situation, that it was not for Czechoslovakia that we should have to fight, that it was not for Czechoslovakia that we should have been fighting if we had gone to war last week. God knows how thankful we all are to have avoided it, but we also know that the people of this country were prepared for it-resolute, prepared, and grimly determined. It was not for Serbia that we fought in 1914. It was not even for Belgium, although it occasionally suited some people to say so. We were fighting then, as we should have been fighting last week, in order that one great Power should not be allowed, in disregard of treaty obligations, of the laws of nations and the decrees of morality to dominate by brutal force the Continent of Europe. For that principle we fought against Napoleon Buonaparte, and against Louis XIV of France and Philip II of Spain. For that principle we must ever be prepared to fight, for on the day when we are not prepared to fight for it we forfeit our Empire, our liberties, and our independence.

I besought my colleagues not to see this problem always in terms of Czecho-slovakia, not to review it always from the difficult strategic position of that small country, but rather to say to themselves, "A moment may come when, owing to the invasion of Czechoslovakia a European war will begin, and when that moment comes we must take part in that war, we cannot keep out of it, and there is no doubt upon which side we shall

fight. Let the world know that and it will give those who are prepared to disturb the peace reason to hold their hand." It is perfectly true that after the assault on Austria the Prime Minister made a speech in this House—an excellent speech with every word of which I was in complete agreement—and what he said then was repeated and supported by the Chancellor of the Exchequer at Lanark. It was, however, a guarded statement. It was a statement to the effect that if there were such a war it would be unwise for anybody to count upon the possibility of our staying out.

That is not the language which the dictators understand. Together with new methods and a new morality they have introduced also a new vocabulary into Europe. They have discarded the old diplomatic methods of correspondence. Is it not significant that during the whole of this crisis there has not been a German Ambassador in London and, so far as I am aware, the German Chargé d'Affaires has hardly visited the Foreign Office? They talk a new language, the language of the headlines of the tabloid Press, and such guarded diplomatic and reserved utterances as were made by the Prime Minister and the Chancellor of the Exchequer mean nothing to the mentality of Herr Hitler or Signor Mussolini. I had hoped that it might be possible to make a statement to Herr Hitler before he made his speech at Nuremberg. On all sides we were being urged to do so by people in this country, by Members in this House, by Leaders of the Opposition, by the Press, by the heads of foreign States, even by Germans who were supporters of the regime and did not wish to see it plunged into a war which might destroy it. But we were always told that on no account must we irritate Herr Hitler; it was particularly dangerous to irritate him before he made a public speech, because if he were so irritated he might say some terrible things from which afterwards there would be no retreat. It seems to me that Herr Hitler never makes a speech save under the influence of considerable irritation, and the addition of one more irritant would not, I should have thought, have made a great difference, whereas the communication of a solemn fact would have produced a sobering effect.

After the chance of Nuremberg was missed I had hoped that the Prime Minister at his first interview with Herr Hitler at Berchtesgaden would make the position plain, but he did not do so. Again, at Godesberg I had hoped that that statement would be made in unequivocal language. Again I was disappointed. Hitler had another speech to make in Berlin. Again an opportunity occurred of telling him exactly where we stood before he made that speech, but again the opportunity was missed, and it was only after the speech that he was informed. He was informed through the mouth of a distinguished English civil servant that in certain conditions we were prepared to fight. We know what the mentality, or something of the mentality, of that great dictator is. We know that a message delivered strictly according to instructions with at least three qualifying clauses was not likely to produce upon him on the morning after his great oration the effect that was desired. Honestly, I did not believe that he thought there was anything of importance in that message. It certainly produced no effect whatever upon him and we can hardly blame him. Then came the last appeal from the Prime Minister on Wednesday morning. For the first time from the beginning to the end of the four weeks of negotiations Herr Hitler was prepared to yield an inch, an ell perhaps, but to yield some measure to the representations of Great Britain. But I would remind the House that the message from the Prime Minister was not the first news that he had received that morning. At dawn he had learned of the mobilisation of the British Fleet. It is impossible to know what are the motives of man and we shall probably never be satisfied as to which of these two sources of inspiration moved him most when he agreed to go to Munich, but we do know that never before had he given in, and that then he did. I had been urging the mobilisation of the Fleet for many days. I had thought that this was the kind of language which would be easier for Herr Hitler to understand than the guarded language of diplomacy or the conditional clauses of the Civil Service. I had urged that something in that direction might be done at the end of August and before the Prime Minister went to Berchtesgaden. I had suggested that it should accompany the mission of Sir Horace Wilson, I remember the Prime Minister stating it was the one thing that would ruin that mission, and I said it was the one thing that would lead it to success.

That is the deep difference between the Prime Minister and myself throughout these days. The Prime Minister has believed in addressing Herr Hitler through the language of sweet reasonableness. I have believed that he was more open to the language of the mailed fist. I am glad so many people think that sweet reasonableness has prevailed, but what actually did it accomplish? The Prime Minister went to Berchtesgaden with many excellent and reasonable proposals and alternatives to put before the Führer, prepared to argue and negotiate, as anybody would have gone to such a meeting.

He was met by an ultimatum. So far as I am aware no suggestion of an alternative was ever put forward. Once the Prime Minister found himself in the atmosphere of Berchtesgaden and face to face with the personality of Hitler he knew perfectly well, being a good judge of men, that it would be a waste of time to put forward any alternative suggestion. So he returned to us with those proposals, wrapped up in a cloak called "Self-determination," and laid them before the Cabinet. They meant partition of a country, the cession of territory, they meant what, when it was suggested by a newspaper some weeks or days before, had been indignantly repudiated throughout the country. After long deliberation the Cabinet decided to accept that ultimatum, and I was one of those who agreed in that decision. I felt all the difficulty of it; but I foresaw also the danger of refusal. I saw that if we were obliged to go to war it would be hard to have it said against us that we were fighting against the principle of self-determination, and I hoped that if a postponement could be reached by this compromise there was a possibility that the final disaster might be permanently avoided. It was not a pleasant task to impose upon the Government of Czechoslovakia so grievous a hurt to their country, no pleasant or easy task for those upon whose support the Government of Czechoslovakia had relied to have to come to her and say "You have got to give up all for which you were prepared to fight"; but, still, she accepted those terms. The Government of Czechoslovakia, filled with deep misgiving, and with great regret, accepted the harsh terms that were proposed to her. That was all that we had got by sweet reasonableness at Berchtesgaden. Well, I did think that when a country had agreed to be partitioned, when a Government of

a country had agreed to split up the ancient Kingdom of Bohemia, which has existed behind its original frontier for more than 1000 years, that was the ultimate demand that would be made upon it, and that after everything which Herr Hitler had asked for in the first instance had been conceded he would be willing, and we should insist, that the method of transfer of those territories should be conducted in a normal, in a civilised, manner, as such transfers have always been conducted in the past.

The Prime Minister made a second visit to Germany, and at Godesberg he was received with flags, bands, trumpets, and all the panoply of Nazi parade; but he returned again with nothing but an ultimatum. Sweet reasonableness had won nothing except terms which a cruel and revengeful enemy would have dictated to a beaten foe after a long war. Crueller terms could hardly be devised than those of the Godesberg ultimatum. The moment I saw them I said to myself, "if these are accepted, it will be the end of all decency in the conduct of public affairs in the world." We had a long and anxious discussion in the Cabinet with regard to the acceptance or rejection of those terms. It was decided to reject them, and that information, also, was conveyed to the German government. Then we were face to face with an impossible position, and at the last moment-not quite the last moment, but what seemed the last moment-another effort was made, by the despatch of an emissary to Herr Hitler with suggestions for a last appeal. That emissary's effort was in vain and it was only, as the House knows, on that fateful Wednesday morning that the final change of policy was adopted. I believe that change of policy, as I have said, was due not to any argument that had been

addressed to Herr Hitler--it has never been suggested that it was-but due to the fact that for the first moment he realised, when the Fleet was mobilized, that what his advisers had been assuring him of for weeks, months, was untrue and that the British people were prepared to fight in a great cause.

So, last of all, he came to Munich and terms, of which the House is now aware, were devised at Munich, and those were the terms upon which this transfer of territory is to be carried out. The Prime Minister will shortly be explaining to the House the particulars in which the Munich terms differ from the Godesberg ultimatum. There are great and important differences, and it is a great triumph for the Prime Minister that he was able to acquire them. I spent the greater part of Friday trying to persuade myself that those terms were good enough for me. I tried to swallow them-I did not want to do what I have done-but they stuck in my throat, because it seemed to me that although the modifications which the Prime Minister obtained were important and of great value (the House will realise how great the value is when the Prime Minister has developed them) that still there remained the fact that that country was to be invaded, and I had thought that after accepting the humiliation of partition she should have been spared the ignominy and the horror of invasion. If anybody doubts that she is now suffering from the full horror of invasion they have only to read an article published in the Daily Telegraph of this morning which will convince them. After all, when Naboth had agreed to give up his vineyard he should have been allowed to pack up his goods in peace and depart, but the German Government, having got their man down, were not to be deprived of the pleasure of kicking him. Invasion remained; even the date of invasion remained unaltered. The date laid down by Herr Hitler was not to be changed. There are five stages, but those stages are almost as rapid as an army can move. Invasion and the date remained the same. Therefore, the works, fortifications, and guns of emplacements upon which that poor country had spent an enormous amount of its wealth were to be handed over intact. Just as the German was not to be deprived of the pleasure of kicking a man when he was down, so the army was not to be robbed of its loot. That was another term in the ultimatum which I found it impossible to accept. That was why I failed to bring myself to swallow the terms that were proposed—although I recognize the great service that the Prime Minister has performed in obtaining very material changes in them which will result in great benefit and a great lessening of the sufferings of the people of Czechoslovakia.

Then he brought home also from Munich something more than the terms to which we had agreed. At the last moment, at the farewell meeting, he signed with the Führer a joint declaration [Hon. Member: "Secret"]. I do not think there was anything secret about the declaration. The joint declaration has been published to the world. I saw no harm, no great harm, and no very obvious harm, in the terms of that declaration, but I would suggest that for the Prime Minister of England to sign, without consulting with his colleagues, and without, so far as I am aware, any reference to his allies, obviously without any communication with the Dominions and without the assistance of any expert diplomatic advisers, such a declaration with the Dictator of a great State, is not the way in which the foreign affairs of the British Empire should be conducted.

There is another aspect of this joint declaration. After all, what does it say? That Great Britain and Germany will not go to war in future and that everything will be settled by negotiation. Was it ever our intention to go to war? Was it ever not to settle things by communication and counsel? There is a danger. We must remember that this is not all that we are left with as the result of what has happened during the last few weeks. We are left, and we must all acknowledge it, with a loss of esteem on the part of countries that trusted us. We are left also with a tremendous commitment. For the first time in our history we have committed ourselves to defend a frontier in Central Europe.

Brigadier General Sir Henry Croft: It is what you have been asking for.

Mr. Cooper: We are left with the additional serious commitment that we are guaranteeing a frontier that we have at the same time destroyed. We have taken away the defences of Czechoslovakia in the same breath as we have guaranteed them, as though you were to deal a man a mortal blow and at the same time insure his life. I was in favor of giving this commitment. I felt that as we had taken so much away we must, in honor, give something in return, but realised what the commitment meant. It meant giving a commitment to defend a frontier in Central Europe, a difficult frontier to defend because it is surrounded on all sides by enemies. I realised that giving this commitment must mean for ourselves a tremendous quickening up of our rearmament schemes on an entirely new basis, a far broader basis upon which they must be carried out in future.

I had always been in favor of maintaining an army that could take a serious part in Continental war. I am afraid that I differed from the Prime Minister when I was at the War Office and he was at the Treasury, two years ago or more, on this point, but if we are now committed to defend a frontier in Central Europe, it is, in my opinion, absolutely imperative that we should maintain an army upon something like a Continental basis. It is no secret that the attitude maintained by this Government during recent weeks would have been far stiffer had our defences been far stronger. It has been said that we shall necessarily now increase both the speed at which they are reconditioned and the scale upon which they are reconditioned, but how are we to justify the extra burden laid upon the people of Great Britain if we are told at the same time that there is no fear of war with Germany and that, in the opinion of the Prime Minister, this settlement means peace in our time? That is one of the most profoundly disquieting aspects of the situation.

The Prime Minister has confidence in the good will and in the word of Herr Hitler, although when Herr Hitler broke the Treaty of Versailles he undertook to keep the Treaty of Locarno, and when he broke the Treaty of Locarno he undertook not to interfere further, or to have further territorial aims in Europe. When he entered Austria by force he authorized his henchmen to give an authoritative assurance that he would not interfere with Czechoslovakia. That was less than six months ago. Still, the Prime Minister believes that he can rely on the good faith of Hitler; he believes that Hitler is interested only in Germany, as the Prime Minister was assured. Well, there are Germans in other countries. There are Ger-

mans in Switzerland, in Denmark, and in Alsace; I think that one of the only countries in Europe in which there are no Germans is Spain. And yet there are rumors that Germany has taken an interest in that country. But the Prime Minister believes (and he has the advantage over us, or over most of us, that he has met the man) that he can come to a reasonable settlement of all outstanding questions between us. Herr Hitler said that he has got to have some settlement about colonies, but he said that this will never be a question of war. The Prime Minister attaches considerable importance to those words, but what do they mean? Do they mean that Herr Hitler will take "No" for an answer? He has never taken it vet. Or do they mean that he believes that he will get away with this, as he has got away with everything else without fighting, by well-timed bluff, bluster and blackmail? Otherwise it means very little.

The Prime Minister may be right. I can assure you, Mr. Speaker, with the deepest sincerity, that I hope and pray that he is right, but I cannot believe what he believes. I wish I could. Therefore I can be of no assistance to him in his Government. I should be only a hindrance, and it is much better that I should go. I remember when we were discussing the Godesberg ultimatum that I said that if I were a party to persuading, or even to suggesting to, the Czechoslovak Government that they should accept that ultimatum, I should never be able to hold up my head again. I have forfeited a great deal. I have given up an office that I love, work in which I was deeply interested and a staff of which any man might be proud. I have given up associations in that work with my colleagues with whom I had maintained for many years the most harmonious relations, not only as colleagues but as friends. I have given up the privilege of serving as lieutenant to a leader whom I still regard with the deepest admiration and affection. I have ruined, perhaps, my political career. But that is a little matter; I have retained something which is to me of great value —I can still walk about the world with my head erect.

The Prime Minister (Mr. Chamberlain): When the House met last Wednesday, we were all under the shadow of a great and imminent menace. War, in a form more stark and terrible than ever before, seemed to be staring us in the face. Before I sat down, a message had come which gave us new hope that peace might yet be saved, and today, only a few days after, we all meet in joy and thankfulness that the prayers of millions have been answered, and a cloud of anxiety has been lifted from our hearts. . . .

Ever since I assumed my present office my main purpose has been to work for the pacification of Europe, for the removal of those suspicions and those animosities which have so long poisoned the air. The path which leads to appeasement is long and bristles with obstacles. The question of Czechoslovakia is the latest and perhaps the most dangerous. Now that we have got past it, I feel that it may be possible to make further progress along the road to sanity.

My Right Hon. Friend has alluded in somewhat bitter terms to my conversation last Friday morning with Herr Hitler. I do not know why that conversation should give rise to suspicion, still less to criticism. I entered into no pact. I made no new commitments. There is no secret understanding. Our conversation was hostile to no other nation. The object of that conversation, for which I asked, was to try

to extend a little further the personal contact which I had established with Herr Hitler and which I believe to be essential in modern diplomacy. We had a friendly and entirely non-committal conversation, carried on, on my part, largely with a view to seeing whether there could be points in common between the head of a democratic Government and the ruler of a totalitarian State. We see the result in the declaration which has been published, in which my Right Hon. Friend finds so much ground for suspicion. What does it say?

There are three paragraphs. The first says that we agree "in recognising that the question of Anglo-German relations is of the first importance for the two countries and for Europe." Does anyone deny that? The second is an expression of opinion only. It says that: "We regard the agreement signed last night and the Anglo-German Naval Agreement as symbolic of the desire of the two peoples never to go to war with one another again." Once more I ask, does anyone doubt that that is the desire of the two peoples? What is the last paragraph? "We are resolved that the method of consultation shall be the method adopted to deal with any other questions that may concern our two countries, and we are determined to continue our efforts to remove possible sources of difference and thus to contribute to assure the peace of Europe." Who will stand up and condemn that sentence?

I believe there are many who will feel with me that such a declaration, signed by the German Chancellor and myself, is something more than a pious expression of opinion. In our relations with other countries everything depends upon there being sincerity and good will on both sides. I believe that there is sincerity and good will on both sides in this declara-

tion. That is why to me its significance goes far beyond its actual words. If there is one lesson which we should learn from the events of these last weeks it is this. that lasting peace is not to be obtained by sitting still and waiting for it to come. It requires active, positive efforts to achieve it. No doubt I shall have plenty of critics who will say that I am guilty of facile optimism, and that I should disbelieve every word that is uttered by rulers of other great states in Europe. I am too much of a realist to believe that we are going to achieve our paradise in a day. We have only laid the foundations of peace. The superstructure is not even begun.

For a long period now we have been engaged in this country in a great programme of rearmament, which is daily increasing in pace and in volume. Let no one think that because we have signed this agreement between these four Powers at Munich we can afford to relax our efforts in regard to that programme at this moment. Disarmament on the part of this country can never be unilateral again. We have tried that once, and we very nearly brought ourselves to disaster. If disarmament is to come it must come by steps, and it must come by the agreement and the active cooperation of other countries. Until we know that we have obtained that cooperation and until we have agreed upon the actual steps to be taken, we here must remain on guard. . . .

While we must renew our determination to fill up the deficiencies that yet remain in our armaments and in our defensive precautions, so that we may be ready to defend ourselves and make our diplomacy effective (Interruption) Yes, I am a realist—nevertheless, I say with an equal sense of reality that I do see fresh opportunities of approaching this subject of disarmament opening up before us,

and I believe that they are at least as hopeful today as they have been at any previous time. It is to such tasks (the winning back of confidence, the gradual removal of hostility between nations until

they feel that they can safely discard their weapons, one by one) that I would wish to devote what energy and time may be left to me before I hand over my office to younger men.

4. DEBATE OF 5 OCTOBER 1938

The Debate continued, and it was only two days later, on October 5th, that a somewhat unpopular Conservative backbencher was able to have his say.

Mr. Churchill: If I do not begin this afternoon by paying the usual, and indeed almost invariable, tributes to the Prime Minister for his handling of this crisis, it is certainly not from lack of any personal regard. We have always, over a great many years, had very pleasant relations, and I have deeply understood from personal experiences of my own in a similar crisis the stress and strain he has had to bear; but I am sure it is much better to say exactly what we think about public affairs, and this is certainly not the time when it is worth anyone's while to court political popularity. We had a shining example of firmness of character from the late First Lord of the Admiralty two days ago. He showed that firmness of character which is utterly unmoved by currents of opinion, however swift and violent they may be. My hon. Friend the Member for South West Hull . . . was quite right in reminding us that the Prime Minister has himself throughout his conduct of these matters shown a robust indifference to cheers or boos and to the alternations of criticism and applause. If that be so, such qualities and elevation of mind should make it possible for the most severe expressions of honest opinion to be interchanged in this House without rupturing personal relations, and for

all points of view to receive the fullest possible expression.

Having thus fortified myself by the example of others, I will proceed to emulate them. I will, therefore, begin by saying the most unpopular and most unwelcome thing. I will begin by saying what everybody would like to ignore or forget but which must nevertheless be stated, namely, that we have sustained a total and unmitigated defeat, and that France has suffered even more than we have.

Viscountess Astor: Nonsense!

Mr. Churchill: When the noble Lady cries "Nonsense," she could not have heard the Chancellor of the Exchequer admit in his illuminating and comprehensive speech just now that Herr Hitler had gained in this particular leap forward in substance all he set out to gain. The utmost my right hon. Friend, the Prime Minister, has been able to secure by all his immense exertions, by all the great efforts and mobilization which took place in this country, and by all the anguish and strain through which we have passed in this country, the utmost he has been able to gain [Hon. Members: "Is Peace"]. I thought I might be allowed to make that point in its due place, and I propose to deal with it. The utmost he has been able to gain for Czechoslovakia and in the matters which were in dispute has been that the German Dictator, instead of snatching his victuals from the table has been content to have them served to him course by course.

The Chancellor of the Exchequer said it was the first time Herr Hitler has been made to retract (I think that was the word) in any degree. We really must not waste time, after all this long Debate, upon the difference between the positions reached at Berchtesgaden, at Godesberg and at Munich. They can be very simply epitomized, if the House will permit me to vary the metaphor. One pound was demanded at the pistol's point. When it was given, two pounds were demanded at the pistol's point. Finally, the Dictator consented to take one pound, seventeen shillings and six pence, and the rest in promises of good will for the future.

Now I come to the point, which was mentioned to me just now from some quarters of the House, about the saving of peace. No one has been a more resolute and uncompromising struggler for peace than the Prime Minister. Everyone knows that. Never has there been such intense and undaunted determination to maintain and to secure peace. That is quite true. Nevertheless, I am not quite clear why there was so much danger of Great Britain or France being involved in a war with Germany at this juncture if, in fact, they were ready all along to sacrifice Czechoslovakia. The terms which the Prime Minister brought back with him (I quite agree, at the last moment; everything had got off the rails and nothing but his intervention could have saved the peace, but I am talking of the events of the summer) could easily have been agreed. I believe, through the ordinary diplomatic channels at any time during the summer. And I will say this, that I believe the Czechs, left to themselves, and told they were going to get no help from the western Powers, would have been able to make better terms than they have got—they could hardly have worse—after all this tremendous perturbation.

There never can be any absolute certainty that there will be a fight if one side is determined that it will give way completely. When one reads the Munich terms, when one sees what is happening in Czechoslovakia from hour to hour, when one is sure, I will not say of Parliamentary approval, but of Parliamentary acquiescence, when the Chancellor of the Exchequer makes a speech which at any rate tries to put in a very powerful and persuasive manner the fact that, after all, it was inevitable and indeed righteous: when we say all this, and every one on this side of the House, including many members of the Conservative Party who are supposed to be vigilant and careful guardians of the national interest, it is quite clear that nothing vitally affecting us was at stake, it seems to me that one must ask, What was all the trouble and fuss about?

The resolve was taken by the British and the French Governments. Let me say that it is very important to realise that it is by no means a question which the British Government only have had to decide. I very much admire the manner in which, in the House, all references of a recriminatory nature have been repressed, but it must be realised that this resolve did not emanate particularly from one or other of the Governments, but was a resolve for which both must share in common the responsibility. When this resolve was taken, and the course was followed (you may say it was wise or unwise, prudent of

short sighted), once it had been decided not to make the defence of Czechoslovakia a matter of war, then there was really no reason, if the matter had been handled during the summer in the ordinary way, to call into being all this formidable apparatus of crisis. I think that point should be considered. . . .

I have always held the view that the maintenance of peace depends upon the accumulation of deterrents against the aggressor, coupled with a sincere effort to redress grievances. Herr Hitler's victory. like so many of the famous struggles that have governed the fate of the world, was won upon the narrowest of margins. After the seizure of Austria in March, we faced this problem in our debates. I ventured to appeal to the Government to go a little further than the Prime Minister went, and to give a pledge that in conjunction with France and other powers they will guarantee the security of Czechoslovakia. while the Sudeten Deutsch question was being examined either by a League of Nations commission, or some other impartial body, and I still believe that if that course had been followed events would not have fallen into this disastrous state. I agree very much with . . . [Mr. Amery] when he said on that occasion (I cannot remember his actual words) "Do one thing or the other; either say you will disinterest yourself in the matter altogether. or take the step of giving a guarantee which will have the greatest chance of securing protection for that country."

France and Great Britain together, especially if they had maintained a close contact with Russia, which certainly was not done, would have been able in those days in the summer, when they had the prestige, to influence many of the smaller States of Europe, and I believe they could have determined the attitude of Poland.

Such a combination, prepared at the time when the German Dictator was not deeply and irrevocably committed to his new adventure, would, I believe, have given strength to all those forces in Germany which resisted this departure, this new design. . . .

All these forces, added to the other deterrents which combinations of powers great and small, ready to stand firm upon the front of law and for the ordered remedy of grievances, would have formed. might well have been effective. . . . Between submission and immediate' war there was this third alternative, which gave a hope not only of peace but of justice. It is quite true that such a policy in order to succeed demanded that Britain should declare straight out and a long time beforehand that she would, with others, join to defend Czechoslovakia against an unprovoked aggression. H.M. Government refused to give this guarantee when it would have saved the situation, yet in the end they gave it when it was too late, and now, for the future, they renew it when they have not the slightest power to make it good.

All is over. Silent, mournful, abandoned, broken, Czechoslovakia recedes into the darkness. She has suffered in every respect by her association with the Western democracies and with the League of Nations, of which she has always been an obedient servant. She has suffered in particular from her association with France, under whose guidance and policy she has been actuated for so long. The very measures taken by H.M. Government in the Anglo-French Agreement to give her the best chance possible. namely the 50% clean cut in certain districts instead of a plebiscite, have turned to her detriment, because there is to be a plebiscite too in wide areas, and those

other Powers who had claims have also come down upon the helpless victim. . . . No one has a right to say that the plebiscite which is to be taken in certain areas under Saar conditions, and the clean cut of the 50% areas—that those two operations together amount in the slightest degree to a verdict of self-determination. It is a fraud and a farce to invoke that name. We in this country, as in other Liberal and democratic countries, have a perfect right to exalt the principle of self-determination, but it comes ill out of the mouths of those in totalitarian States who deny even the smallest element of toleration to every section and creed within their bounds. But, however you put it, this particular block of land, this mass of human beings to be handed over, has never expressed the desire to go into the Nazi rule. I do not believe that even now—if their opinion could be asked, they would exercise such an option. . . .

I venture to think that in future the Czechoslovak State cannot be maintained as an independent entity. You will find that in a period of time which may be measured by years, but may be measured only by months, Czechoslovakia will be engulfed in the Nazi regime. Perhaps they may join it in despair or in revenge. At any rate, that story is over and told. But we cannot consider the abandonment and ruin of Czechoslovakia in the light only of what happened last month. It is the most grievous consequence which we have yet experienced of what we have done and of what we have left undone in the last five years: five years of futile good intention, five years of eager search for the line of least resistance, five years of uninterrupted retreat of British power, five years of neglect of our air defences. Those are the features that I stand here

to declare and which marked an improvident stewardship for which Great Britain and France have dearly to pay. We have been reduced in those five years from a position of security so overwhelming and so unchallengeable that we never cared to think about it. We have been reduced from a position where the very word "war" was considered one which would be used only by persons qualifying for a lunatic asylum. We have been reduced from a position of safety and power—power to do good, power to be generous to a beaten foe, power to make terms with Germany, power to give her proper redress for her grievances, power to stop her arming if we chose, power to take any step in strength or mercy or justice which we thought right—reduced in five years from a position safe and unchallenged, to where we stand now.

When I think of the fair hopes of a long peace which still lay before Europe at the beginning of 1933 when Herr Hitler first obtained power, and of all the opportunities of arresting the growth of the Nazi power which have been thrown away, when I think of the immense combinations and resources which have been neglected or squandered, I cannot believe that a parallel exists in the whole course of history. So far as this country is concerned the responsibility must rest with those who have the undisputed control of our political affairs. They neither prevented Germany from rearming, nor did they rearm ourselves in time. They quarrelled with Italy without saving Ethiopia. They exploited and discredited the vast institution of the League of Nations and they neglected to make alliances and combinations which might have repaired previous errors, and thus they left us in the hour of trial without adequate national defence or effective international security.

In my holiday I thought it was a chance to study the reign of King Ethelred the Unready. The House will remember that that was a period of great misfortune, in which, from a strong position, which we had gained under the descendants of King Alfred, we fell very swiftly into chaos. It was the period of the Danegeld and of foreign pressure. I must say that the rugged words of the Anglo-Saxon Chronicle, written 1000 years ago, seem to me apposite, at least as apposite as those quotations from Shakespeare with which we have been regaled . . . Here is what the Anglo-Saxon Chronicle said. and I think the words apply very much to our treatment of Germany and our relations with her:

All these calamities fell upon us because of evil counsel, because tribute was not offered to them at the right time nor yet were they resisted; but when they had done the most evil, then was peace made with them.

That is the wisdom of the past, for all wisdom is not new wisdom. . . .

We are in the presence of a disaster of the first magnitude which has befallen Great Britain and France. Do not let us blind ourselves to that. It must now be accepted that all the countries of Central and Eastern Europe will make the best terms they can with the triumphant Nazi Power. The system of alliances in Central Europe upon which France has relied for her safety has been swept away, and I can see no means by which it can be reconstituted. The road down the Danube Valley to the Black Sea, the resources of corn and oil, the road which leads as far as Turkey, has been opened. In fact, if not in form, it seems to me that all those countries of Middle Europe, all those Danubian countries, will, one after another, be drawn into this vast system of power politics (not only power military politics but power economic politics) radiating from Berlin, and I believe this can be achieved quite smoothly and swiftly and will not necessarily entail the firing of a single shot. [To prove his point, he then cites the success of the pro-German policy of Stoyadinovitch in Yugoslavia, and the dismay of the pro-Allied Opposition] . . .

Again, what happened in Warsaw? The British and French Ambassadors visited Colonel Beck, or sought to visit him, the Foreign Minister, in order to ask for some mitigation in the harsh measures being pursued against Czechoslovakia about Teschen. The door was shut in their faces. The French Ambassador was not even granted an audience, and the British Ambassador was given a most curt reply by a political director. The whole matter is described in the Polish Press as a political indiscretion committed by those two Powers, and we are today reading of the success of Colonel Beck's blow. I am not forgetting, I must say, that it is less than 20 years ago since British and French bayonets rescued Poland from the bondage of a century and a half. I think it is indeed a sorry episode in the history of that country, for whose freedom and rights so many of us have had warm and long sympathy.

Those illustrations are typical. You will see, day after day, week after week, the entire alienation of those regions. Many of those countries, in fear of the rise of the Nazi Power, have already got politicians, ministers, governments, who were pro-German, but there was always an enormous popular movement in Poland, Romania, Bulgaria and Yugoslavia, which looked to the Western democracies and

loathed the idea of having this arbitrary rule of the totalitarian system thrust upon them, and hoped that a stand would be made. All that has gone by the board. We are talking about countries which are a long way off and of which, as the Prime Minister might say, we know nothing. (Interruption) The noble Lady says that that very harmless allusion is . . .

Viscountess Astor: Rude.

Mr. Churchill: She must very recently have been receiving her finishing course in manners. What will be the position, I want to know, of France and England this year and the year afterwards? What will be the position of that Western front of which we are in full authority the guarantors? . . . Relieved from all anxiety in the East, and having secured resources which will greatly diminish, if not entirely remove, the deterrent of a naval blocade, the rulers of Nazi Germany will have a free choice open to them in what direction they will turn their eyes. If the Nazi Dictator should choose to look westward, as he may, bitterly will France and England regret the loss of that fine army of ancient Bohemia which was estimated last week to require not fewer than thirty German divisions for its destruction. . . . Many people, no doubt, honestly believe that they are only giving away the interests of Czechoslovakia, whereas I fear we shall find that we have deeply compromised, and perhaps fatally endangered, the safety and even the independence of Great Britain and France. This is not merely a question of giving up the German colonies, as I am sure we shall be asked to do. Nor is it a question only of losing influence in Europe. It goes far deeper than that. You have to consider the character of the Nazi movement and the

rule which it implies. The Prime Minister desires to see cordial relations between this country and Germany. There is no difficulty at all in having cordial relations with the German people. Our hearts go out to them. But they have no power. You must have diplomatic and correct relations, but there can never be friendship between the British democracy and the Nazi Power, that power which spurns Christian ethics, which cheers its onward course by a barbarous paganism, which vaunts the spirit of aggression and conquest, which derives strength and perverted pleasure from persecution, and uses, as we have seen, with pityless brutality, the threat of murderous force. That power cannot ever be the trusted friend of the British democracy.

What I find unendurable is the sense of our country falling into the power, into the orbit and influence of Nazi Germany, and of our existence becoming dependent upon their good will or pleasure. It is to prevent that, that I have tried my best to urge the maintenance of every bulwark of defence—first the timely creation of an Air Force superior to anything within striking distance of our shores; secondly, the gathering together of the collective strength of many nations; and thirdly, the making of alliances and military conventions, all within the Covenant, in order to gather together forces, at any rate to restrain the onward movement of this Power. It has all been in vain. Every position has been successively undermined and abandoned on specious and plausible excuses. We do not want to be led upon the high road to becoming a satellite of the German Nazi system of European domination. In a very few years, perhaps in a very few months, we shall be confronted with demands with which we shall no doubt be invited to comply.

Those demands may affect the surrender of territory or the surrender of liberty. I foresee and foretell that the policy of submission will carry with it restrictions upon the freedom of speech and debate in Parliament, on public platforms, and discussions in the Press, for it will be said (indeed, I hear it said sometimes now) that we cannot allow the Nazi system of dictatorship to be criticized by ordinary, common English politicians. Then, with a Press under control, in part direct but more potently indirect, with every organ of public opinion doped and chloroformed into acquiescence, we shall be conducted along further stages of our journey. . . .

I do not grudge our loyal, brave people, who were ready to do their duty no matter what the cost, who never flinched under the strain of last week—I do not grudge them the natural, spontaneous outburst of joy and relief when they learnt that the hard ordeal would no longer be required

of them at the moment; but they should know the truth. They should know that there has been gross neglect and deficiency in our defences; they should know that we have sustained a defeat without a war, the consequences of which will travel far with us along our road; they should know that we have passed an awful milestone in our history, when the whole equilibrium of Europe has been deranged, and that the terrible words have for the time being been pronounced against the Western democracies:

"Thou art weighed in the balance and found wanting."

And do not suppose that this is the end. This is only the beginning of the reckoning. This is only the first sip, the foretaste of a bitter cup which will be proffered to us year by year unless by a supreme recovery of moral health and martial vigor, we arise again and take our stand for freedom as in the olden times.

IV. The Second World War

Perhaps the most frightful peculiarity of the Second World War was the extent to which it developed methods of mass extermination. Both sides indulged in bombing designed to flatten large areas, and civilians became a target for enemy action to a greater degree and with more destructive results than ever since the Hunnish or Viking invasions. But while these patterns of destruction were new only in terms of their unusual scale and were common to both sides, Genocide was an innovation of the Germans alone. Genocide meant that people considered harmful to Germany and her new order were visited with mass destruction which remained uncompleted only because time or opportunity did not suffice to carry the project through. Little is known abroad about the extermination policies which decimated Jews, Slavs, gypsies, and others who might seriously displease the German masters. Many Germans today deny that such policies ever existed apart from isolated acts of sadism, and see in the West's present efforts to hush up discussion of the subject an admission that here are merely stories, invented by Germany's enemies out to discredit her, and indiscriminately used by Allied propaganda to encompass and hasten her defeat.

Yet well-attested evidence is not lacking, particularly in the vast files of the Allied War Crimes Tribunal, and the whole matter (as well as our inclination to deny or forget its existence) poses problems which are difficult but which are important to us all: the problem of responsibility—personal and collective; the question whether such a phenomenon might have developed elsewhere—"there, but for the grace of God, go I"; above all, perhaps, the problem of the reality and meaning of evil and of good, in a world where values tend increasingly to be relative, pragmatic, and ultimately amoral.

1. HARVEST OF HATE

Though Genocide may now be seen as a logical implication of their racial doctrines, the Germans were unprepared for the tremendous opportunities opened by their conquests of 1939–1943. This meant that much of their extermination policy had to be improvised ad hoc: special killer commandos, mass shootings, and clumsy mobile gas chambers preceded the final perfection achieved at Auschwitz and elsewhere toward the end of the war. But all this time their exterminatory genius never lagged. The campaign was carried forward on all fronts. And, while the SS performed the killings, bureaucrats in Berlin legislated to prevent birth and survival. All this is summarized, in gruesome detail, in Mr. Poliakov's remarkable study, Harvest of Hate.

Poliakov

EXTERMINATION POLICY

Shooting was not the only method the commandos used. On the shores of the Black Sea there were mass drownings; at Backtchissarai, that pearl of the Crimea which Pushkin sang about, the drowning of 1,029 Jews during the period July 1–15, 1942, was reported. There were cases of Jews being burned alive, especially at Minsk in White Russia. Finally in the spring of 1942, mobile gas chambers, designed and manufactured in Berlin and disguised as gas trucks, made their appearance all over Russia.

As we shall see, these death chambers were still very rudimentary machines which the homicide or "euthanasia" section of the Führer's chancellery had devised in Berlin. By a very simple arrangement, the exhaust gases of the Diesel motor, essentially carbon monoxide, were piped into the hermetically sealed interior of the truck instead of out into open air. Such trucks were put at the disposal of all commandos. We have a great number of documents, veritable manuals on the use of the trucks, describing their operation:

The gas is generally not used in the right way. To get things over with as soon as possible, the driver presses the accelerator to the floor. This kills the people by suffocation instead of making them gradually doze off. My directives have proved that, with the correct adjustment of the levers, death comes quicker and the prisoners sleep peacefully. There are no more of the contorted faces or defecations there used to be.

This was written by SS Lieutenant Becker on May 16, 1942; his job was to check on the functioning of the trucks. He added,

I had ordered the trucks of Group D to be camouflaged as houses on wheels by hanging a pair of shutters on each side, a sight that is frequently seen on our farms in the country. But these vehicles got to be so well known that not only the authorities but the civil population called them "death trucks" as soon as they appeared. In my opinion, these vehicles, even when camouflaged, cannot long be kept a secret.

The commando men stated during their trial that they disliked using these trucks. Besides, they gave mediocre results, at best fifty to sixty people per execution. Shooting continued to be the chief mode of execution during one period of the chaotic exterminations in Russia. Here is a clear and exact description of what they were like, by the witness Hermann Graebe:

I, the undersigned, Hermann Friedrich Graebe, make the following declaration under oath:

From September 1941 to January 1944 I was director and chief engineer of the Sdolbunow branch of the Josef Jung Construction Company of Solingen. In this capacity I had, among my other duties, to visit the firm's projects. Under the terms of a contract with the army construction services, the company was to build grain warehouses on

From Leon Poliakov, Harvest of Hate (Syracuse University Press, 1954). By permission of The American Jewish Committee.

the old Dubno airfield in the Ukraine.

On October 5, 1942, at the time of my visit to the construction offices in Dubno, my foreman, Hubert Moennikes, living at 21 Aus-Hamburg-Haarsenmühlenweg, burg, told me that some Dubno Jews had been shot near the building in three huge ditches about 30 metres long and 3 metres deep. The number of people killed daily was about 1,500. The 5,000 Jews who had lived in Dubno before the Pogrom were all marked for liquidation. Since the executions took place in the presence of my employee, he was painfully impressed by them.

Accompanied by Moennikes, I then went to the work area. I saw great mounds of earth about 30 metres long and 2 high. Several trucks were parked nearby. Armed Ukrainian militia were making people get out, under the surveillance of SS soldiers. The same militia men were responsible for guard duty and driving the trucks. The people in the trucks wore the regulation yellow pieces of cloth that identified them as Jews on the front and back of their clothing.

Moennikes and I went straight toward the ditches without being stopped. When we neared the mound, I heard a series of rifle shots close by. The people from the trucks—men, women and children—were forced to undress under the supervision of an SS soldier with a whip in his hand. They were obliged to put their effects in certain spots: shoes, clothing, and underwear separately. I saw a pile of shoes, about 800—1,000 pairs, great heaps of under-

wear and clothing. Without weeping or crying out, these people undressed and stood together in family groups, embracing each other and saying goodbye while waiting for a sign from the SS soldier, who stood on the edge of the ditch, a whip in his hand, too. During the fifteen minutes I stayed there, I did not hear a single complaint, or plea for mercy. I watched a family of about eight: a man and woman about fifty years old, surrounded by their children of about one, eight, and ten, and two big girls about twenty and twenty-four. An old lady, her hair completely white, held the baby in her arms, rocking it, and singing it a song. The infant was crying aloud with delight. The parents watched the groups with tears in their eyes. The father held the ten-year-old boy by the hand, speaking softly to him: the child struggled to hold back his tears. Then the father pointed a finger to the sky, and, stroking the child's head, seemed to be explaining something. At this moment, the SS near the ditch called something to his comrade. The latter counted off some twenty people and ordered them behind the mound. The family of which I have just spoken was in the group. I still remember the young girl, slender and dark, who, passing near me, pointed at herself, saying, "Twenty-three." I walked around the mound and faced a frightful common grave. Tightly packed corpses were heaped so close together that only the heads showed. Most were wounded in the head and the blood flowed over their shoulders. Some still moved. Others raised their hands and turned their heads to show that they were still alive. The ditch was two-thirds full. I estimate that it held a thousand bodies. I turned my eyes toward the man who had carried out the execution. He was an SS man; he was seated, legs swinging, on the narrow edge of the ditch; an automatic rifle rested on his knees and he was smoking a cigarette. The people, completely naked, climbed down a few steps cut in the clay wall and stopped at the spot indicated by the SS man. Facing the dead and wounded, they spoke softly to them. Then I heard a series of rifle shots. I looked in the ditch and saw their bodies contorting, their heads, already inert, sinking on the corpses beneath. The blood flowed from the nape of their necks. I was astonished not to be ordered away, but I noticed two or three uniformed postmen nearby. A new batch of victims approached the place. They climbed down into the ditch, lined up in front of the previous victims, and were shot.

On the way back, while rounding the mound, I saw another full truck which had just arrived. This truck contained only the sick and crippled. Women already naked were undressing an old woman with an emaciated body; her legs frightfully thin. She was held up by two people and seemed paralyzed. The naked people led her behind the mound. I left the place with Moennikes and went back to Dubno in a car.

The next morning, returning to the construction, I saw some thirty naked bodies lying thirty to fifty yards from the ditch. Some were still alive; they stared into space with a set look, seeming not to feel the coolness of the morning air; nor to see the workers standing around. A young girl of about twenty spoke to me, asking me to bring her clothes and to help her escape. At that moment we heard the sound of a car approaching at top speed; I saw that it was an SS detachment. I went back to my work. Ten minutes later rifle shots sounded from the ditch. The Iews who were still alive had been ordered to throw the bodies in the ditch; then they had to lie down themselves to receive a bullet in the back of the neck.

WHOSE RESPONSIBILITY?

A great deal of debate has surrounded the question of who was actually involved in these crimes, who was aware of what went on, who might be termed responsible for them to some degree. Another issue of more immediate concern during the war itself was the effect of these practices on the technicians, soldiers, and officials whom they involved. The following passages furnish a few brief glimpses into the consciences and concerns of these men. The first is an abstract from the diary of one who worked in a Polish death camp, a professional man, Dr. Kremer:

"1. IX. 1942. I wrote to Berlin for a leather belt and suspenders. During the afternoon I was present at the disinfec-

tion of a cell block with Cyclone B, to kill the lice.

2. IX. 1942. This morning at three

o'clock I attended a special action for the first time. Dante's hell seemed like a comedy in comparison. Not for nothing is Auschwitz called an extermination camp.

- 5. IX. 1942. I was present this afternoon at a special action applied to prisoners in the female camp (Moslems), the worst I have ever seen. Dr. Thilo was right this morning in telling me that we are in the anus mundi. Tonight, about eight, I was present at a special action on the Dutch. All the men are anxious to take part in these actions because of the special rations they get on such occasions, consisting of ½ of a liter of schnapps, 5 cigarettes, 100 grams of sausage and bread.
- 6–7. IX. 1942. Today, Sunday, an excellent lunch: tomato soup, half a chicken with potatoes and red cabbage, petits fours, a marvelous vanilla ice cream. After lunch I was introduced to . . . (illegible word). Left at eight in the evening for a special action, for the fourth time.
- 23. IX. 1942. Present last night at the sixth and seventh special actions. In the morning, Obergruppenführer Pohl arrived with his staff at the Waffen SS house. The sentinel at the door was the first to salute me. In the evening, at eight o'clock, dinner in the commanding officer's house, with General Pohl, a real banquet. We had apple pie, as much as we wanted, good coffee, excellent beer, and cakes.
- 7. X. 1942. Present at the ninth special action. Foreigners and women.
- 11. X. 1942. Today, Sunday, rabbit, a good leg, for lunch, with red cabbage and pudding, all for 1.25 RM.
- 12. X. 1942. Inoculation for typhus. Following this, feverish in the evening; still, went to a special action that night

(1,600 Dutch) Terrible scenes near the last bunker. The tenth special action."

Dr. Kremer's diary goes on in this way to the end of the year, alternating between noting the menus he particularly enjoyed and the carefully numbered special actions he attended, on which he commented with growing indifference.

If a few dozen Germans, some hundreds at the most, actually observed the last agony of the Jews in the gas chambers, those who witnessed their long Calvary were numbered in the hundreds of thousands. The SS formations stationed in the camps; the German workers, Army units, and officials at the numerous yards and factories where the Jewish slaves were used, whom they passed by daily; the railway men handling the innumerable transports of deportees all over Germany. which they saw coming back empty, if they were not loaded with the used clothing which was distributed to the needy by all the welfare offices in the country. This is a very incomplete list of those who can properly be called evewitnesses. As for the rest of the Germans, the press and radio of the Reich undertook to inform them more and more openly of what was going on. The time for vague and prophetic imprecations by Hitler had passed. The language now sharpens and it is the past tense that is employed. "The Jewish population of Poland has been neutralized and the same may be said right now for Hungary. By this action five million Iews have been eliminated in these two countries," a Danzig newspaper wrote in May 1944. And the next day Goebbels' Der Angriff published under the byline of Ley: "Judea must perish that mankind may be saved." The fate of the Jews was an example and a warning: "Whosoever imitates the Iew deserves the same end:

extermination, death," threatened Der Stürmer. The extermination policy thus became a matter of common knowledge and enough information filtered through a thousand channels for the location of the murder camps and the methods of execution to become notorious. A witness states that in the trains passing near Auschwitz (where, we will recall, four rail lines crossed) "the passengers stood up and leaned out the windows to see as much as they could." Another witness, none other than Rudolf Diels, the first director of the Prussian Gestapo in 1933-34, later police prefect of Cologne and administrator of the Hermann Goering Works during the war, stated that as far as he knew, the expression, "You will go up the chimney," had become proverbial in Germany toward the end of the war. Only those who did not wish to know might continue to pretend ignorance. During a dramatic session at one of the Nuremberg trials, a highly qualified witness, SS General Bach-Zelewsky, who was "head of the anti-partisan campaign" of the German armies during the war, insisted on clarifying the matter.

"For me it is a question. Though imprisoned for years, I see that people are still saving: Who knew? Nobody wants to be in the position of having known anything. I want to establish the truth here, regardless of whether it hurts or helps me. . . . Of all the German generals, I am perhaps the one who traveled most all over Europe during the war, since it was my job to manage the entire fight against the guerrillas. I talked to hundreds of generals and thousands of officers of all categories, and it is a fact that exterminations began on the first day of the war. This is the truth; anything else is a lie and a euphemism. . . . And anyone who traveled knew from the beginning that the Jews were being exterminated in a way that at first was not systematic. Later, when the Russian campaign began, the extermination of Judaism was an explicit part of the aim."

We have already quoted many personal accounts. Let us quote still another, the fact that it is not of SS provenance, and is uttered so casually, lends it a particular significance. It is dated October 23, 1941. Its author was a Wehrmacht officer, reporting his observations during a trip to the "Eastern zone of operations." Notice the similar construction of the two paragraphs quoted, both of which end on the same note of self-solicitude. The first paragraph concerns Russian prisoners of war:

"The columns of prisoners marching along the roads resemble a senseless flock of sheep. . . . Because of the physical exertion of the marches, the poor food and the bad conditions in the camps, the prisoners often collapse and have to be dragged along by their comrades or left where they are. The 6th Army ordered all stragglers shot. This was done on the road and even in the villages, with the unfortunate result that German employees returning home at night had to pass by the bodies of prisoners who were shot."

The second paragraph of the report concerns Jews: "In accordance with orders, the Jews are transferred. This is done in the following way: They receive an order to report the next night, in their best clothes and with all their jewels or valuables, at a designated assembly point. . . . They are then taken to a place already got ready for them, outside the particular locality. Under the pretext of fulfilling certain formalities, they are required to deposit all their clothing, jewels, and ornaments. They are then led off

the road and liquidated. The resulting situations are so agonizing that they cannot be described. The consequences this has for the German Commandos are inevitable. In general, the executions can be carried out only in an alcoholic stupor. According to what an SS officer who had been detailed for this duty told me, he had to endure (durchstehen) the most terrifying nightmares the next night." (NOKW 3147)

OTHER METHODS

Genocide by "Lowering the Fertility of the People"

Next to pure and simple homicide, this was the most direct method. Instead of physically suppressing the present generation, it was seen to it that there would be no future generations. The mass sterilization plans which have already been mentioned never got beyond the planning stage, but other large-scale measures did. The minutes of a meeting of experts charged with drawing up these plans list the following measures:

- Raising the marriage age to twenty-five (after completion of labor service or some such required service for a period of three or four years).
- Authorization of marriage only in cases where the economic position (of the people concerned) is assured.
- c) Requiring financial restitution to the public welfare funds in every case of illegitimate birth. If the mother is without funds, she will have to furnish her labor.
- d) If the same mother has burdened the public funds with several il-

legitimate children, her sterilization can be ordered.

- e) Deliberate lowering of the standard of living of large families (no monetary relief, no allocations for children, no premium during the nursing period, etc.).
- f) Official authorization for abortion at the mother's request (when desirable from the social point of view).

These measures were prepared by the experts of the Reich Ministry of the Interior and primarily had the Polish population in mind. They were introduced into the Government General by a decree of October 19, 1941. One year later, the Führer ordered their extension to all populations under the control of the "Ministry of the Occupied Territories of the East." Bormann sent the following instructions to Rosenberg:

July 23, 1942

My dear Party Comrade Rosenberg:

"The Führer wishes you to see to it that the following principles are applied and observed in the Occupied Territories of the East, and I am entrusting you with this task.

- 1) When girls and women in the Occupied Territories of the East have abortions, we can only be in favor of it; in any case, German jurists should not oppose. The Führer believes that we should authorize the development of a thriving trade in contraceptives. We are not interested in seeing the non-German population multiply.
- 2) The danger that the non-German population in the Eastern territories may increase more than before is very great. Their living conditions have improved considerably. For this very reason we

must take the necessary precautionary measures to prevent an expansion of the non-German population.

- 3) German medical relief must therefore not be set up for the non-German population in the Eastern territories in any way. Vaccination, for example, and other such health measures, are out of the question.
- 4) The population must in no way benefit from higher education. If we let ourselves be pushed into committing this error, we shall ourselves be cultivating the elements of a future resistance against us. According to the Führer, then, it will be enough for the non-German populations—even the so-called Ukrainians—to learn to read and write.
- 5) We must on no condition by any measure whatsoever cultivate any sort of feeling of superiority in the population! The contrary is necessary!"

In the recommendations in his memorandum for the practical execution of these measures, Wetzel gave proof of a fertile imagination.

"Every propaganda means, especially the press, radio, and movies, as well as pamphlets, booklets, and lectures, must be used to instill in the Russian population the idea that it is harmful to have several children. We must emphasize the expenses that children cause, the good things people could have had with the money spent on them. We could also hint at the dangerous effect of child-bearing on a woman's health. Paralleling such propaganda, large-scale campaign a should be launched in favor of contraceptive devices. A contraceptive industry must be established. Neither the circulation and sale of contraceptives nor abortions must be prosecuted. It will even be necessary to open special institutions for abortion, and to train midwives and nurses for this purpose. The population will practice abortion all the more willingly if these institutions are competently operated. The doctors must be able to help out without there being any question of this being a breach of their professional ethics. Voluntary sterilization must also be recommended by propaganda. Infant mortality must not be combatted. Mothers must be kept in ignorance of child care and of everything that has to do with children's diseases. We must try to reduce as much as possible the training and knowledge of Russian doctors in this field. Such institutions as day nurseries and children's homes must be abolished as far as it is possible."

THE KIDNAPPING OF CHILDREN

This method was generally applied after intervention by a "racial inspector." It was mostly the children of foreign workers who were affected. As future janissaries of the Third Reich, children of recognized Nordic descent were placed in nurseries for SS children, while a network of homes was provided for children and babies of foreigners who did not pass the "racial test." A few establishments of this kind were already functioning in 1944. An inspector's report sent to Himmler gives a few details on their functioning:

"During my visit, I noticed that all the babies in that home were undernourished. As the director of the home, SS Oberführer Langoth, told me, the home receives only a pint of milk and a piece and a half of sugar per day per baby. With these rations the babies are sure to die of malnutrition in a few months.

I asked SS Oberführer Langoth to inform Gauleiter Eigruber of this state of affairs, and to ask him to assure sufficient

supplies for these babies while waiting for your opinion on the subject. I consider the manner in which this business is now being managed to be impossible. There are only two solutions. Either we do not want these children alive, in which case we should not let them die slowly of hunger while they use up so much milk from the general supply; there are ways to achieve this without torture or pain. Or, on the other hand, we intend to bring up these children for later use as labor. In this case they must be nourished in such a way that it will be possible to make full use of them as workers."

Kidnappings of children from the occupied territories were particularly frequent during the time of the German retreat in the East. The Wehrmacht services were the principal perpetrators. A memorandum from the Political Section at headquarters in June 1944 envisaged the following huge operation under the characteristic code name of "Operation Hay" (Heuaktion):

"1. The Center Army group intends to assemble and send to the Reich 40,000 to 50,000 children between ten and fourteen from the territories now under its control. This measure is taken at the

suggestion of the 9th Army. It will have to be strongly backed up by propaganda and have as its slogan: Reich Aid to White Russian Children, Protection Against the Partisans. This operation has already been commenced in a five-kilometer zone. . . . The operation planned not only to reduce the direct growth of enemy strength, but also to impair its biological strength in the distant future. This point of view has been expressed by both the SS Reichführer and the Führer. Appropriate orders to this effect were consequently given in the Southern Sector at the time of last year's retreat.

"2. A similar action is now under way in the region controlled by the North Ukraine Army group (General Field Marshal Model). In the Galician sector, which enjoys special privileges from the political point of view, measures have been taken to collect 135,000 workers in labor battalions, while young men over seventeen will be incorporated into SS divisions and youngsters under seventeen will be placed in charge of the SS Aid. This operation, which was begun a few weeks ago, has led to no political unrest up to now."

2. SLAVES AS GUINEA PIGS

The treatment of human beings as objects was not confined to the prison camps alone. When manpower and material began to fall short, German industry learned to dip into the pool of human resources represented by the regime's slaves. In some cases this provided useful—and expendable—slave labor; in other instances, such as the one of which we get a brief glimpse below, they served as guinea pigs.

Nuernberg, November 14, 1947 (A.P.) A French witness testified today that the I.G. Farben combine purchased 150 women from the Oswiecim concen-

tration camp, after complaining about a price of 200 marks (then \$80.00) each, and killed all of them in experiments with a soporific drug.

From New York Herald Tribune, 15 November 1947.

The witness was Gregoire M. Afrine. He told the American military tribunal trying 23 Farben directors on war crimes charges that he was employed as an interpreter by the Russians after they overran the Oswiecim camp in January 1945 and found a number of letters there. Among the letters, he said, were some addressed from Farben's "Bayer" plant to the Nazi commandant of the camp.

These excerpts were offered in evidence:

- 1. In contemplation of experiments with a new soporific drug, we would appreciate your procuring for us a number of women.
- 2. We received your answer but consider

- the price of 200 marks a woman excessive. We propose to pay not more than 170 marks a head. If agreeable, we will take possession of the women. We need approximately 150.
- 3. We acknowledge your accord. Prepare for us 150 women in the best possible condition, and as soon as you advise us you are ready we will take charge of them.
- 4. Received the order of 150 women. Despite their emaciated condition, they were found satisfactory. We shall keep you posted on developments concerning the experiment.
- 5. The tests were made. All subjects died. We shall contact you shortly on the subject of a new load.

3. MICHEL FRANCOIS: AGAINST OBLIVION

The essay which follows is not included as a rehash of European suffering in the last German war but as a reminder that forgiveness and forgetfulness are not one and the same thing. Forgiveness is a positive and generous attitude which helps men, frequently clumsy, brutal, or thoughtless, to live together in a difficult world. Forgetting is an attempt to escape reality and responsibility, generally prompted by motives that are foolish or cowardly or both. When one insists on forgetting the past, there can be no historical perspective and hence no way of appreciating the problems and circumstances of the day in terms of their origins and background. Forgiveness brings peace; forgetfulness brings myths. The two do not, should not, go together.

Soon, eleven years will have passed since the death chambers went out of business. One feels almost ashamed to mention it, petty to spoil the satisfaction of a good conscience so quickly recovered. And I am not thinking, at this point, about the good conscience of the torturers, of their friends, of their immediate accomplices, of all their spiritual family; there is nothing more legitimate than to

see them wish for oblivion: have we not done our best these last few years to convince them that after all they were not so very wrong? But it is striking to observe in others—the non-accomplices, the surviving victims, the witnesses—a strange inhibition, a sort of fashion of "don't let's speak of it any more." And this behavior is not due to a wish to forgive: it shows the need to wipe out a

Adapted and translated by Eugen Weber from Michel François, "Contre l'Oubli," in the Catholic monthly Esprit (Paris, 1956). Reprinted by permission of the author and Esprit.

memory which, if allowed to survive, would affect us every moment of our lives. The blood of the martyrs can only be effective if the society which survives them allows it to be.

People will say that it is ecessary to forgive. And that is true, if only because we have no valid way of deciding the degree of guilt, or of complicity. We cannot fight against forgetfulness by protesting against the liberation of war criminals. But the very notion of forgiveness becomes ambiguous when, under the cover of a magnanimity which accepts the suffering and the death of others, we encourage and we practice the deliberate oblivion of Nazi crimes. Because, when we do this, we are trying to escape the bitter reproach of an act of treason that we are about to commit, of a denial which has already been committed. We hold our tranquility by paying this price: Could we live the way we live if we had made an honest effort to understand what was done to men by men from 1939 (and even from 1933) to 1945? The real scandal is that we are able, without giving it a thought, to speak and to write about other things. The image of the early martyrs dominated Christian thought during a number of centuries; the great plague of mid-14th century weighed, by the apocalyptic and macabre elements which it introduced, over the art and the thought of the late Middle Ages. But Nazism, which was both persecution and terrible plague, does not seem to have affected people, does not seem to have shocked people in any such way.

Perhaps we might be tempted to believe that we have a thinner skin than our ancestors, and that a sense of decency, an instinctive horror of cruelty prevents our mentioning the gassed or crushed babies, the mass shootings of

prisoners, the hangings, the innumerable horrors of the camps. There is no truth in that, and the very people who seem determined on spreading eternal silence over Nazi crimes, who hardly care to touch, let alone believe, the Iews of the Warsaw Ghetto, do not hesitate to furnish us with detailed descriptions of persecutions in China or Bulgaria, highpitched descriptions, with all the accompaniment of torn-out nails, burned flesh, raped women. Our decent respectable friend who covers his eyes when there is talk of Auschwitz, is hypnotized by the sight of blood, as soon as this blood has been shed by Communists. And certain good Christians who, for purely Christian reasons, preach that we should forgive and forget "because 10 years have passed," find it very easy to skip back over whole centuries and evoke with indignation the death of Christian martyrs and stigmatize their murderers. The readiness to forgive and forget varies according to the quality (and sometimes according to the color) of the killer and the killed.

As a cause and as a factor of this oblivion, anti-Communism has played a tremendous role. Among other things, there was an utilitarian reason why this should be so; one could not, without forgetting the past, think of mobilizing the Germans for the defense of Western Civilization. "The subject with which you deal and, more particularly, the photographs that you propose to publish, are of a nature likely to revive the feelings of hatred towards the German people and. consequently, to furnish arguments to those who oppose the policy which tends to give the Germans the possibility, through re-armament or any other means. to re-establish their influence in world af-

fairs," wrote in August, 1954, the Lord Chancellor of the United Kingdom to Lord Russell of Liverpool who was preparing to publish in his book, The Scourge of the Svastica, an account of German war crimes, based wholly on uncontested official evidence. Having refused to take part in the conspiracy of silence, Lord Russell had to resign from his post as legal counselor of the British Army. In all Western countries, the governments which were trying (sometimes in rather underhanded ways) to get German re-armament accepted, used all the means that served their purpose to make sure that war crimes should be forgotten. They did not always avoid making themselves ridiculous. On March 1, 1955, a court in Alexandria, Italy, acquitted two members of the local trade union who had used in a wall-newspaper, photographs from Lord Russell's book, and who had as a result been charged with a "crime against decency." And it is true that some of the prisoners shown in the photograph were naked. "It is the Court which has committed a crime against decency," the defense counsel remarked. "and also a crime against the memory of the victims." There have been other similar cases.

I was just thinking about the connection between the capacity to imagine and the will to forget, when I received a work entitled Martyrdom and Heroism of the Women of East Germany, published by the Federal German Ministry for Refugees and Deportees. It deals with the calvary of the German women of Silesia, raped or killed by the soldiers of the Soviet and the Polish armies in the spring of 1945. It is a calvary that I have no intention of denying or minimizing, even though it is well not to forget (as Mr.

Khrushchev pointed out in Moscow to Dr. Adenauer) that it was not the Soviet Union which invaded Germany, and that the road from the River Bug to the Volga, both going and coming, was marked by innumerable massacres and by indescribable sufferings for the Russian people. But in any case, even just one raped woman, whether she is German or whether she is Russian, is too much.

The Preface to the work in question was written by Monsignor Joseph Ferche, Auxiliary Bishop of Cologne, ex-Auxiliary of Breslau. This prelate, at least, means to make the most of other people's atrocities. "This book" he writes, "must fix for history the heroism of these women attacked by the Bolshevik hordes; it must become for Western Christendom a warning and a memorial." And further: "For Western men . . . these documents. with their pathetic truths, may seem unbelievable because they have not lived face to face with Bolshevism. Human imagination can hardly understand these facts; personal experience alone can give the necessary intelligence."

Does Monsignor Ferche really believe that, after five years of German domination in Europe, there can still be any horrors left that we cannot imagine? I begin to understand why "while we have not had the consolation of hearing the successor of the Galilean Simon Peter condemn clearly and definitely the crucifixion of so many Jews, brothers of our Lord," certain among the highest dignitaries of the Church have reacted much more promptly and spontaneously when after the war they had to denounce the rape of German women or the expulsion of Germans from the territories that went to Poland. The silence of 1940-1945 was certainly not the silence of accomplices; it was not even imposed by fear. It

was the silence of men who lacked precisely, as far as German crimes were concerned, the very imagination that Monsignor Ferche seems to think we lack.

And so it seems that a partial explanation of our present forgetfulness is a lack of sensitiveness to Nazi crimes due to over-sensitiveness to Communism. But the capacity to forget, the confused desire to forget, have other causes. The deportations and exterminations carried out by the Nazis have been a phenomenon of such dimensions that we could not begin to classify them within ready-made categories, or to simplify them so as to make them more accessible, more understandable, more conceivable. We cannot, for instance, consider such immense horrors as mere multiplications of individual murders or hardships, or as collections of arbitrary police acts or judicial errors. We are told that at Lidice or at Oradour the S.S. murderers got the wrong village; we are told that in a certain camp gas chambers were set up as a result of the individual initiative of the local S.S. leader; we shall never manage to sum up the totality of these acts within a familiar and therefore reassuring pattern. It has been tried. People have tried to rationalize the tragedy of deportation and extermination in some fashion that would allow for traditional explanation; they have tried with perseverance to invoke some kind of blindness, of intermittent folly, of intermittent madness. It is being explained that Germany is struggling against its peculiar demons, against its evil spirits; sometimes these evil spirits get the better of it in the struggle, and then there is Hitler, and then there are all the abominations that we have known. Now, in the first place, this business of evil spirits tends to class Hitlerism among other phenomena such as Prussian Militarism, German Nationalism, etc., and to do away with its undeniable originality. It also allows every sort of trick: the very people who, in order to get German rearmament accepted, were arguing that these familiar demons had been driven out for good, are now busily engaged in explaining their obvious revival by the delay that the enemies of E.D.C. have imposed on this aforementioned rearmament. Which produces a strange reversal of causes and effects! And lastly, the explanation of the Concentration Camps and the policy of genocide in terms of evil spirits or a passing fit of collective insanity is a lazy solution; and it tends, above all perhaps, to prevent our recognizing ourselves and our civilization (even though as seen in a distorting mirror) in the murderers of the S.S.

As a matter of fact the organization of oblivion had begun at the very moment when the crimes were carried out. Gradually, as the archives and memoirs give us access to the great and little secrets of the war, we discover the responsibilities which are still little known and which oblivion alone can maintain in a propitious shadow. The great trial of those who sinned by omission, the trial of those who failed to give assistance to people in peril of their lives, has never come up. We know now that in London, in Washington, in Moscow, even at the Holy See, it was no longer possible to ignore in 1942 the projects of mass extermination of the Iews. More was known sometimes in such places than among the future victims. What was done to save several million human beings, several million Jews? Nothing, or nearly nothing. The underground organizations were bombarding London with their supplications. "Here are the plans, organize some massive retaliation, bomb their communications,

destroy the camps of death." But the conscience of the allies was completely inhibited by the blackmail of the Nazis. Nothing was done because nothing should be done that would furnish material to enemy propaganda, create the impression that, as Hitler affirmed, this war was a war desired and ordered by the Jews. It was the supreme inanity. Again and again we find the same insensitivity to concrete horrors, the same will to take refuge in easy abstractions. If at that moment we had declared that we should fight quite simply to prevent the murder of six million Jews (and many more non-Iews), we should have given its real dimension to the war against Nazism—a more real dimension, in any case, a more authentic war-aim, than the phraseology of the Atlantic Charter. But, between gentlemen, it was impossible to fight for Jews!! Oblivion wipes out everything: no more crime, no more criminals, no more accomplices, no more indifferent onlookers. An easy conscience is well worth a little effort.

And yet the deportations, the exterminations, the massacres and the killings of the Second World War have become the object of serious studies. It may seem inhuman to probe and sear wounds that are still so fresh, according to the strict methods of historical research. This work is nevertheless necessary; and perhaps this kind of work alone may be able to oppose any kind of barrier to the invasion of wilful oblivion.

The direct testimonies on the life of the Concentration Camps, testimonies which appeared in great numbers in the immediate aftermath of war, have sometimes served as a pretext for those who wanted to bury such memories. This kind of literature did not always reach a very high standard, and some of the stories were not always true. People take advantage of it first to discredit certain men, then to group all the victims under a common disapproval, and lastly, to deny the very existence of the Concentration Camp world. Some want to diminish or abolish the guilt of the Germans, and, hence, of their accomplices in the occupied lands; others want to show that the miseries of the prisoners were mostly due to their own companions, and that everything was really much less terrible than people pretended. . . . What a gift for the craftsmen of oblivion!

Nor has it been so difficult to find, in the millions of published stories, errors, omissions, lapses of memory, and (why not?) some fables and lies. Because a story has mentioned gas chambers in a camp where apparently there were no gas chambers, it is suggested that gas chambers in general were perhaps nothing but the figment of an overheated imagination. And if there were no gas chambers, then it is all right. They have lied; we can sleep in peace.

The right-thinking man is so quickly reassured only because he is never really worried; naturally he will never think to ask himself what would remain of the History of Christianity if, taking advantage of the lies, the inventions, the omissions and the fables of which the Lives of the Martyrs are full, we decided to deny both the reality of the persecutions and the value of the evidence of the persecuted.

We should be grateful to the Commission for the History of Deportations for having quickly undertaken the scientific study of deportations, beginning with as large as possible a collection of documents checked in the most rigorous possible way. . . . There could be no more il-

luminating reading for those who continue to grasp the illusion according to which the immense majority of the German people ignored the existence of the camps. At a given moment the "integration" of the inmates of the camps into the German war industry, through a great number of enterprises and in every part of the German Reich, had grown to proportions which were far too large to remain hidden. The movement of forced labor produced a wealth of constant exchange and contact between the concentration camp world and the outside world. . . . To German industry the camps furnished an ideal labor force; "it could be endlessly renewed, it could be exterminated at will." From all this . . . "we get the impression of a frightful sort of tacit consent of a whole nation (doubtlessly powerless in its great majority) to the extermination of millions of beings who were put to work, in rags or in prison clothes: and all in order to enable the nation itself to be exterminated in uniform on all the battlefields of the 2nd World War, in the hypothetical hope of enlarging its dominion."

As the policies of the allied powers towards Germany have evolved, the principle of collective guilt has given place . . . to that of collective innocence or, at least, of the untroubled conscience of the nation; but the right-thinking man is not going to be completely at ease until we shall also have proclaimed the innocence of the elites, of the ruling class, and of the administration. It is not possible, it cannot be conceived, that such a great people, in which we can see ourselves reflected so clearly, should be criminalized. It is touching to see the arguments which are brought up to prove that the German administration could not know what was going on in the camps.

The naive and anodyne correspondence by which the offices in Berlin tried to regulate the rations and the hygiene of the camps is supposed to be a proof of this. If future historians are sufficiently uncritical to rely on the fictions and the formulas that the Germans used, our grandchildren are going to be presented with a queer version of the facts. . . . For instance, they will be intrigued to find in the official German correspondence frequent mention of "Häftlingszahnstationen" (dental stations for prisoners): and they will praise the sanitary arrangements of the camps without realizing that these are the offices of an organization whose purpose it was to remove the gold teeth of the murdered prisoners. Yet even the most credulous historian, the most inclined to believe in the innocence and the thoughtlessness of the German administration, might nevertheless experience some surprise if he came across a certain list of "Objects Found" in the railroad station of Radogoscz (Poland), which lists under the date of 28 May, 1942, 300 pants, brassieres and garters, 150 woolen rugs, 170 towels, 160 men's shirts, etc., etc. Even our well-intentioned friend might ask himself if the German official who drew up this list, the one who passed it on, the one who filed it (without counting all the others who might have known about it), really believed that the women of Poland, as careless as you like to imagine them, had lost 300 brassieres, etc., in one day alone in the railroad station of Radogoscz, tiny little hamlet that it is. Everything becomes much clearer when one knows that this station was used as a selection center of the victims destined for the gas chambers. . . . Yet, however many and valuable might be the studies, monographs and anthologies dealing with

the German crimes of the 2nd World War, we shall never be able to build up a documentation without gaps. Our knowledge of the subject must necessarily remain a partial one. There was, for instance, a camp in Poland where 600,000 persons were exterminated and on which we have only the evidence of one lonely survivor. Beyond this, even the concentration camp world, about which we know most, reflects after all only a part of the immense abjection. We shall never know the whole truth about the killings and the massacres which, from Crete to Letonia, from the Black Sea to the Pyrenees, accompanied the German occupation. When we have made allowances for certain operations explained as reprisals, and for the fear which turned military leaders into executioners, there still remains an infinite number of quite gratuitous hecatombs, which we might be able to list, but the circumstances of which could never be reconstituted. For these crimes, oblivion is almost inevitable. The human sacrifice has taken place without any ceremony, the martyrdom has lost its value as witness; it is just as if it had never been.

And so, to prevent oblivion, we shall have on our library shelves, statistics, evidence, historical interpretations: they are not enough. But perhaps, if only we could resist the insistent advances of oblivion. if only we could remember what has been done, we might make some use of these sufferings, of these martyrdoms, of these deaths. Through the evidence on our bookshelves, through the witnesses still living among us, the concentration camp world is to a certain extent, could be in a really constructive fashion, integrated in our reality and in our ways of feeling and thinking. It is because he was dead and came back to life that Lazarus lives in a world which cannot be the world of before his death. And, in the long run, Lazarus must affect also the world of those around him.

4. THE ATOM BOMB

It might be well to remember that, in many parts of the world, the American atomic attacks on Hiroshima and Nagasaki are also regarded as crimes akin to Genocide. Certainly, these attacks were not undertaken in a spirit of revenge or murderous principle, but rather as a matter of military convenience. Nevertheless their shadow has loomed large over the conscience of the West, and today there is no escaping the thought that the fate of these ports may be one that awaits our own cities and countries.

From: The United States Strategic Bombing Survey

In order to appreciate the effects of the atomic bombs on Hiroshima and Nagasaki one must realize something of the character and extent of medical institutions in the two cities. In addition, it is important for one to realize the magnitude of the destructive forces since they so completely surpass all previous concepts of destruction that one might have when thinking in terms of ordinary incendiary or high-explosive bombing.

STATUS OF MEDICAL CARE PRIOR TO BOMBING

Generally speaking, the Japanese are not accustomed to good medical care as one uses the term in light of practice in the Western world. Hospitals are usually available to only those who are able to pay and the average Japanese citizen has never been educated to the value and use of hospitals. Though the number of physicians per unit of population compares favorably with that in the United States, the average physician is poorly trained and the character of medicine which he practices is far below Western standards. Even the licensed physicians resort to unconventional and unscientific methods which have their origin in Far Eastern religion and superstition. In addition, the government licenses a group of "persons engaged in the traditional methods of treatment," such as acupuncture, massage, and moxa. There are also a large number of unlicensed cultists who treat persons by means of faith healing. Both the licensed and unlicensed cultists have fairly large followings, particularly in the rural population and the lower classes.

The average Japanese hospital is a small private hospital which consists of 10 to 50 beds. Actually, the term "beds" is used loosely in this respect since few of them have Western-style beds. The rooms in such hospitals are very much like rooms in Japanese homes with tatami floors and beds made by spreading bedding upon the floor. It is thus impossible to give an accurate bed capacity, this figure actually representing the number that can be crowded into the available space. On the other hand, the larger city institu-

tions and university hospitals are usually well equipped, of modern construction, and use Western beds throughout. Despite this fact, there are in every city large numbers of these small Japanesestyle hospitals. Too, a large percentage of the population never go to hospitals, but they are born, have their illnesses and babies, and die in their own homes. Most of the births in Japan are attended by midwives.

Hiroshima and Nagasaki did not differ from the usual medium-sized Japanese city. Hiroshima had two Army hospitals and an Army-Navy relief hospital in addition to the civilian institutions. The Red Cross Hospital and the Communications Hospital were modern structures and were the better institutions of the city. In addition there were many small Japanese hospitals scattered over the city. In the spring of 1945 a medical college was started in Hiroshima and the first class had matriculated. Though no school building was available they were being taught in one of the local hospitals at the time of the bombing. The supply of doctors and nurses seemed up to Japanese standards and it was thought that the city was well provided with medical care.

The situation in Nagasaki differed from Hiroshima in that it possessed one of the finest medical centers in Japan. The University Hospital was the pride of the city and was reputed to be second to none in Japan except the Imperial University Hospital in Tokyo. It was a large modern unit consisting of many buildings and contained about 500 beds. This number represented more than three-quarters of the hospital facilities in the city. The Medical College was located near the hos-

From "The Effects of Atomic Bombs on Health and Medical Services in Hiroshima and Nagasaki," in *The United States Strategic Bombing Survey* (Washington, 1948).

pital and had a large staff of well-trained teachers. There were in addition a tuberculosis sanatorium and many small private and industrial hospitals. Here too, the number of physicians and nurses seemed to be adequate in comparison to other Japanese cities.

Since most of the other large cities of Japan had been subjected to demolition and incendiary raids during late 1944 and 1945 it was natural for Nagasaki and Hiroshima to expect similar treatment. Hiroshima contained no large war industries and had been bombed on one previous occasion only. At that time a single B-29 had dropped several demolition bombs on a suburban district, but there was little damage done. Nagasaki had experienced demolition bombing on several occasions but these raids were directed at key industrial plants. On 1 August 1945, 6 bombs were dropped on the University Hospital hitting the operating room and laboratories and resulting in the death of 3 students and 30-40 other casualties. Many patients were then evacuated as an air-raid precaution. The fact that Hiroshima had been so completely spared of bombing apparently gave rise to some rumors that the city was being saved for some "fantastic" weapon. Several survivors relate having heard such rumors. There was, however, no real reason to suspect that any fate other than that experienced by other cities was in store for it. Accordingly, the officials proceeded with the creation of large firebreaks. This work was started in March 1945 and continued until the time of the atomic bombing. Thousands of homes were thus destroved and their occupants were required to leave the city. It was estimated by the Prefectural Health Officer that 150,000 people were evacuated from Hiroshima from March to August 1945, of whom probably 10,000 had returned. Similar preparations were being carried out in Nagasaki but they appear to have been on a somewhat smaller scale.

THE ATOMIC BOMBING

It was upon the previously described conditions that the atomic bombs were dropped on Hiroshima on 6 August and on Nagasaki three days later. In order to appreciate the conditions at the time of the blast and immediately thereafter it will be well to reconstruct the scene in Hiroshima as best it can be determined from talking with survivors.

The morning of 6 August 1945 began bright and clear. At about 0700 there was an air-raid alarm and a few planes appeared over the city. Many people within the city went to prepared air-raid shelters, but since alarms were heard almost every day the general population did not seem to have been greatly concerned. About 0800 an all-clear was sounded after the planes had disappeared. At this hour of the morning many people were preparing breakfast. This fact is probably important since there were fires in charcoal braziers in many of the homes at this time. Some of the laboring class were at work but most of the downtown business people had not gone to work. Consequently, a large percentage of the population was in their homes and relatively few were in the more strongly constructed business buildings.

After the all-clear sounded, persons began emerging from air-raid shelters and within the next few minutes the city began to resume its usual mode of life for that time of day. It is related by some survivors that they had watched planes fly over the city. At about 0815 there was a

blinding flash. Some described it as brighter than the sun, others likened it to a magnesium flash. Following the flash there was a blast of heat and wind. The large majority of people within 3,000 feet of ground zero were killed immediately. Within a radius of about 7,000 feet almost every Japanese house collapsed. Beyond this range and up to 15,000-20,000 feet many of them collapsed and others received serious structural damage. Persons in the open were burned on exposed surfaces, and within 3,000-5,000 feet many were burned to death while others received severe burns through their clothes. In many instances clothing burst into spontaneous flame and had to be beaten out. Thousands of people were pinned beneath collapsed buildings or injured by flying debris. Flying glass particularly produced many nonlethal injuries and the distances at which they occurred are discussed in the following chapter, but the foregoing presentation was necessary for one to appreciate the state of the population immediately after the bomb exploded.

Shortly after the blast fires began to spring up over the city. Those who were able made a mass exodus from the city into the outlying hills. There was no organized activity. The people appeared stunned by the catastrophe and rushed about as jungle animals suddenly released from a cage. Some few apparently attempted to help others from the wreckage, particularly members of their family or friends. Others assisted those who were unable to walk alone. However, many of the injured were left trapped beneath collapsed buildings as people fled by them in the streets. Pandemonium reigned as the uninjured and slightly injured fled the city in fearful panic. Teams which had been previously organized to render

first aid failed to form and function. Those closer to ground zero were largely demobilized due to injuries and death. However, there were physically intact teams on the outskirts of the city which did not function. Panic drove these people from the city just as it did the injured who could walk or be helped along. Much of the city's fire-fighting equipment was damaged beyond use so that soon the conflagrations were beyond control.

In Nagasaki a similar but slightly less catastrophic picture occurred. The blast was not centered over the main business section of the city but was up the valley about 2 miles. There were large industrial plants, hospitals, the medical school and partially built-up residential areas near the ground zero. The terrain in this area was uneven with large hills which shielded certain areas. Due to the shielding factor and the distance of the explosion from the center of the city, Nagasaki was less completely destroyed than Hiroshima and the panic was apparently less.

THE FATE OF MEDICAL FACILITIES

The fate of the hospitals in Hiroshima is particularly interesting in the light of this chaos and destruction. Many of the smaller hospitals and clinics were located in the center of the city and were of typical Japanese construction. For instance, the Shima Surgical Hospital was only 100 feet from ground zero. It was partly brick but largely wooden construction. The blast blew it flat and it is believed that all of the occupants were killed immediately. The remains of the building burned, and the spot is now a mass of flattened rubble. The Tada Hospital was partly reinforced concrete and partly wooden construction.

Located at 2,600 feet from ground zero it was completely demolished, and the only remnants were the concrete foundation and the gutted and broken concrete portions of the building. The exact fate of its occupants could not be definitely determined but it is believed that they were all killed by the blast and succeeding fire. Another building of medical nature which was located near the center of the blast was the Japan Red Cross Office Building. It was only 740 feet from ground zero and was almost completely demolished. The windows, window casements, and doors were blown out and even the concrete structure was broken by the downward thrust of the blast. The building was then gutted by fire and all occupants perished. The Hiroshima Army Hospitals No. 1 and No. 2 were located within 1,500-2,000 feet of ground zero. It is reported that 80 percent of the personnel and all of the patients (500 in No. 1 and 650 in No. 2) were killed. The ultimate fate of the surviving 20 percent of the personnel is not known, but on the basis of other experiences at this distance it is probable that a large percentage of them died of injuries or radiation effects. The hospital buildings collapsed and burned. The Red Cross Hospital, which was the city's largest and best hospital, was located 4,860 feet from ground zero. The basic structure of the building, which is reinforced concrete, remained virtually intact. However, steel window casements were blown out or twisted and torn on the side near the blast and the interior was seriously damaged by falling plaster, broken partitions, and falling ceilings. There were 90 percent casualties of the occupants of this building and the damage was so great that the hospital ceased operations for several weeks after the bombing. It did, however,

serve as a first-aid station and out-patient clinic in the interim. Practically all instruments and supplies in this hospital were completely destroyed or damaged bevond repair. The Hiroshima Communications Hospital was located at a similar distance from the ground zero, 4,900 feet. It, too, was of reinforced concrete construction. Though the concrete framework of the building remained intact it suffered even more severe damage than did the Red Cross Hospital. Steel window casements were blown out, partitions blown down, and all of the contents were damaged beyond repair. It was later reoccupied as were most of the buildings which were left standing. An example of a hospital located at greater distance from ground zero is the Army-Navy Relief Hospital. It was 10,400 feet from the ground zero and sustained considerable damage. The building was stucco and two floors in height. Though it did not collapse, it was seriously damaged. Most of the tile roof was broken and blown off, window frames were broken and blown out, and in a few places walls were crushed. The principal injuries to the occupants of this hospital were due to flying glass and other missiles. Many smaller hospitals and clinics were destroyed in a similar manner, depending upon their distance from the center of the blast. Since practically all of these buildings were of wooden construction they were either blown down and/or burned shortly thereafter. There was little evidence of their existence to one who came into the area later. It has been impossible to trace the fate of their occupants but it is felt that it coincided to some extent with the fate of other persons in Japanese-type homes at similar distances from ground zero. Actually the incidence of flash burns was probably lower, since few of them would have been outdoors, but the secondary injuries were probably higher. Inasmuch as they were already ill and many no doubt were helpless, the mortality rate surely exceeded that of the general population at comparable distances.

Thus it may be said of Hiroshima that essentially all of the civilian hospitals and 2 large Army hospitals were located within 5,000 feet of ground zero and were functionally completely destroyed. Those within 3,000 feet were totally destroyed and the mortality rate of the occupants was practically 100 percent. Two large hospitals of reinforced concrete construction were located 4,860 and 4,900 feet from the ground zero. The basic structures remained erect but there was such severe interior damage that neither was able to continue operation as a hospital. The casualty rate in these 2 hospitals was approximately 90 percent. Hospitals and clinics beyond 7,000-10,000 feet often remained standing but were badly damaged and there were many casualties due to flying glass and other missiles.

The destruction of hospitals in Nagasaki was even more outstanding than that in Hiroshima. Since the Nagasaki University Hospital contained over threequarters of the hospital beds in the city it represented the bulk of the city's hospital facilities. The center of the hospital grounds was only 2,400 feet from ground zero and from a functional standpoint the hospital was completely obliterated. Most of the buildings were of reinforced-concrete construction but a great deal of wood was used in interior construction and fittings. The basic structure of all these buildings remained essentially intact but there was severe damage otherwise. The blast effects were very severe and almost every building was gutted by fire. The mortality rate of occupants of

this hospital was at least 80 percent, twothirds being killed outright. The Nagasaki Medical College was located even closer to ground zero, being only 1,700 feet distant. A large portion of the buildings were of inflammable nature but a few small buildings were constructed of reinforced concrete. The wooden buildings were blown down and subsequently consumed by flames. The concrete structures remained erect but were completely gutted by fire. Of the 850 medical students present 600 were killed and 12 out of the 16 professors were also lost. The third- and fourth-year medical students escaped by virtue of the fact that they were elsewhere at the time of the bomb blast. Almost all of the other occupants of the buildings were killed outright. All medical equipment and supplies in the medical college buildings were completely destroyed by blast and fire. The Nagasaki Tuberculosis Sanatorium was located across the valley from the college and the hospital but was only 2,600 feet from ground zero. Since the buildings were all of wooden construction they were completely destroyed by blast and fire. It was reported that all of the patients and other occupants of the sanatorium were killed. Except the 2 hospitals mentioned above there were no others of any size located within Nagasaki, although there were many small private hospitals and clinics of typical Japanese construction, scattered throughout the city. The fate of these buildings and their occupants corresponded in general to that of buildings of similar construction at comparable distances from the bomb in Hiroshima. However, there was an additional factor of the hills shielding some structures in Nagasaki. In Hiroshima the effective zone was entirely flat and hills on the outskirts of the city were so distant that they did not interfere

with the effects of the bomb to any appreciable extent. On the other hand, in Nagasaki many structures that would otherwise have suffered much more severe damage were partially or completely protected from the bomb effects by hills.

In summary, it may be said of the hospital facilities in Nagasaki that over 80 percent of the hospital beds and the Medical College were located within 3,000 feet of ground zero and were completely destroyed. Reinforced-concrete buildings within this range remained standing but were completely gutted by fire; buildings of wooden construction were completely destroyed by fire and blast; the mortality rate of occupants of this group of buildings was about 75–80 percent.

RESTORATION OF HOSPITALS AFTER BOMBING

An amazing feature of the Atomic bombings to one going into the areas later was the poor recuperative powers of the population towards the restoration of all types of facilities. Though this was probably less so in the medical field than in others it was still alarmingly apparent. The panic of the people immediately after the bombing was so great that Hiroshima was literally deserted. It was apparently less true of Nagasaki and this was probably due to the fact that the city was less completely destroyed, but the same apathy was there. The colossal effects of the bombs and the surrender following shortly thereafter seemed to have completely stunned the people. The effects of the typhoons of September and early October may have contributed to this psychological reaction.

Since the most outstanding feature of the atomic bombs was the high rate of human casualties, it was natural that this was the greatest problem in the areas following the bombing. But even in this regard the progress was astoundingly slow and haphazard. Other evidences of restoration were almost completely absent. For instance, at the time the Medical Division visited Hiroshima, 3 months after the bombing, the first street car was beginning operation, people wandered aimlessly about the ruins, and only a few shacks had been built as evidence of reoccupation of the city. No system for collection of night soil or garbage had been instituted. Leaking water pipes were seen all over the city with no evidence of any attention. It was reported that following the bombing several days were required for disposal of the dead and they were simply piled into heaps and burned without attempts at identification or enumeration. Street cars were burned as a method of cremating the bodies within. All in all, there appeared to be no organization and no initiative.

The care of the wounded immediately after the bombing was essentially nil in Hiroshima. Beyond the sphere of family ties there seemed to be little concern for their fellow man. It is true that essentially all of the medical supplies were destroyed by the bombing and that there were no hospitals and little with which to work. For the first 3 days there was no organized medical care. At the end of this time the Prefectural Health Department was successful in getting a portion of the surviving physicians together and to begin ministering to the wounded who remained in the city. Up until this time all nursing and medical care had been on an individual basis. The more seriously injured were placed in the few remaining public buildings on the outskirts of the city. Many of them died but many seriously burned cases remained. Small stocks of medical supplies which had been stored in caves outside the city were brought out but were soon exhausted. With all medical supplies gone and practically none being brought in, the treatment of the injured seems to have consisted largely of offering a place of refuge. There is no doubt that many died who might have been saved by modern, competent medical care. As time elapsed many of the small hospitals and clinics were able to reopen and offer some help. Japanese medical authorities and other scientists visited the city in order to appraise the nature and extent of the damage but they did not contribute materially to the care of the sick and injured. Finally, medical teams consisting of medical students and physicians were sent into the area from the larger cities such as Tokyo, Osaka and Kyoto. They assisted materially in administering medical care but were handicapped by the overwhelming size of the task and the lack of supplies. The Red Cross Hospital was cleared of wreckage and finally reopened without any repair of the building. In many respects it was fortunate that such a large proportion of the injured fled to nearby towns and villages. Except for Kure which had been largely destroyed by incendiary bombing, the facilities in these areas were relatively intact.

Most of the fatalities due to flash burns and secondary injuries occurred within a few days after the bombing. The peak of deaths due to radiation effects was not reached until late August or the early part of September. Very few cases suffering from radiation died after 1 October and deaths due to other causes had practically ceased by this time. Thus during October the essential medical care was directed almost exclusively toward burn cases, most

of which were flash burns. A large number were still in hospitals but the vast majority of these patients could be treated as out-patients. By 1 November adequate hospital space was available but it was still of emergency nature and medical supplies were inadequate. Many of the burns remained unhealed. Inadequate medical care, poor nutrition, and secondary infection were important factors in this delayed healing.

The effects of the atomic bombing of Nagasaki were very similar to those in Hiroshima. Even though it followed the bombing of Hiroshima by 3 days, wartime secrecy, general confusion and the short lapse of time did not allow the population of Nagasaki any particular advantage from the previous experience. The psychological reaction of the people was essentially the same and the chaos in the city seems to have been almost as great. A very important difference between the two cities was that Nagasaki was not so completely destroyed. Further, the bomb blast was centered over a more industrial area and the character of the buildings resulted in less extensive fires. But from the medical standpoint the bombing was particularly catastrophic because the bulk of the city's hospital facilities were located within a radius of 3,000 feet of the center of the explosion. The destruction of the University Hospital and the Medical College was so great that the buildings left standing could not be reoccupied even for emergency medical care. Other hospitals and clinics, including the Tuberculosis Sanatorium, had burned to a heap of ashes. The only remaining facilities were small, private clinics and hospitals and many of them were seriously damaged. Essentially no organized medical care was carried out for several days after the bombing. The Shinkosen Hospital was established in an old school building for the care of bomb victims, but it was woefully inadequate. At one time it harbored over 500 victims. Fortunately, there was a large medical depot at Omura, 20 miles away. Such large stocks of supplies were on hand here that Nagasaki did not suffer in this respect as did Hiroshima. Another school building was converted into an infectious disease hospital.

At the time the Allied Military Government entered Nagasaki, about 1 October, the population was found to be apathetic and profoundly lethargic. Even at this time the collection of garbage and night soil had not been re-established, restoration of other public utilities was lacking, and the hospital facilities were inadequate. Through the initiative of the Military Government, a system of reporting infectious diseases was instituted, the collection of garbage and night soil was reestablished, and attempts were made to increase the supply of safe water. A survey of the remaining hospitals and clinics at this time by Captain Horne of American Military Government revealed such obvious inadequacies that the survey was not even completed. A perusal of the incomplete report reveals that there were many small private hospitals remaining, most of which were damaged and without satisfactory potential value even if they were repaired. In the face of the inadequacy of the Shinkosen Hospital, and the absence of other facilities in Nagasaki, bomb victims were transferred to the Omura Naval Hospital where the conditions were much better. The Shinkosen Hospital has now been evacuated and abandoned.

When Nagasaki was visited by the Medical Division, about three months after the bombing, conditions were still

very primitive. A visit to the Infectious Disease Hospital revealed that the school building in which it was located had been seriously damaged by bombing and no repairs had been made. The roof was partially destroyed, there were no window-panes, and the building was filthy. All the patients, both male and female, were in adjacent beds in the same ward. Members of their families were present and were going in and out at will. The hospital had a capacity of 35 beds and contained 21 patients; 18 cases of dysentery and 3 cases of typhoid fever, at the time of the visit. There were no isolation precautions in practice. The only medicine and supplies were those furnished by the Military Government. Because of these conditions the Military Government had taken over a Japanese Army Hospital of 103 beds and 12 bassinets and was converting it for use as a Japanese civilian hospital. It was expected to be available very shortly thereafter. The Omura General Hospital (formerly a Naval hospital) was in excellent condition and was being used for the care of atomic bomb victims. Thus, it may be seen that by 1 November some semblance of medical care and sanitary procedures had been re-established in Nagasaki but the facilities were still inadequate. The entire program had to be directed and forced by the Americans though they did not enter the area until nearly 2 months after the bombing.

The devastating effects of the atomic bombs upon medical facilities can be appreciated in the light of the foregoing presentation. Not only were the existing facilities almost completely destroyed but there was extreme apathy toward the restoration of hospitals and the care of the injured.

EFFECTS ON MEDICAL PERSONNEL

It was almost impossible to get any accurate information relative to the number of doctors, nurses and other medical personnel in the area prior to bombing, the number injured and killed, or even the number actually present at the time of the visit by the Medical Division. Data obtained from various sources showed extreme variation and were often unreliable. Naturally, the medical personnel in general met the same fate as others located at the same distances from the bomb. The number of casualties also probably bore a direct relationship to the fate of hospitals since medical personnel would be concentrated at those institutions and roughly in proportion to the size of the hospital or clinic.

The number of physicians in Hiroshima prior to the bombing has been variously estimated from 200 to 298. The former figure was supplied to the Medical Division by the Prefectural Health Officer and the latter figure was included in an address by the Prefectural Governor on 9 September 1945. The actual figures probably fall between these two extremes. Regardless of the total number it is known that the casualty rate among this group was very high. About 90 percent were casualties, and 60 of these physicians were killed. One month later only 30 physicians were able to perform their usual duties.

The Hiroshima Prefectural Medical College was started in the spring of 1945 and the first class had matriculated. As a result of the bombing the hospital was demolished and one member of the faculty was killed and another injured. The number of students killed and injured could not be determined.

Prior to the bombing there were 1,780 nurses in Hiroshima. Of these, 1,654 were killed or injured on 6 August. Consequently, the city suffered greatly because of the lack of nurses and many untrained volunteers had to be pressed into service in caring for the injured.

The experience in Nagasaki was very similar to that in Hiroshima. The exact number of physicians in the city prior to the bombing could not be determined but there were probably about 200-250 in 1944. This number may have decreased slightly in 1945 as a result of actual bombing and the effects of partial evacuation of the city in preparation for raids. Due to the different character of the two cities it would at first appear that the loss of medical personnel would have been proportionately less in Nagasaki. However, a factor which counterbalanced this fact to some extent was that the largest number and best of the medical personnel were concentrated in the medical school and the University Hospital, both of which were completely destroyed with a large percentage of their occupants. Actual investigation as of 1 November revealed that there were about 120 physicians in Nagasaki. So apparently the city did fare better than Hiroshima which had less than half that many physicians at about the same time.

The damage to the Nagasaki Medical College and University Hospital has already been described. Reports reveal that 600 of the 850 medical students were killed and some others may have died later. Of the survivors practically every one was injured and at least half had radiation sickness later. There were 16 of the 20 faculty members present at the time of the bombing and 12 of them were killed and the others injured.

The casualty rate among nurses in

Nagasaki could not be accurately determined. There were 683 nurses in the city on 1 November but it is not known how many of these had come in after the

bombing. The percentage of fatalities and injuries probably closely paralleled that of the physicians but no accurate figures are available to support this supposition. . . .

V. Another Postwar World

The feeling of hope which at least for a brief while survived the end of the First World War was not duplicated in the middle forties. At best, men felt, like Sieyès, that survival was an achievement. They were relieved that the struggle was over, but even this was generally tinged by a feeling that much more struggling still lay before them. To most people the war had brought destruction and defeat, and the poverty of vic-

tory was only a few degrees less than the poverty of defeat.

Very soon after the end of hostilities, the rivalry between Russia and the Atlantic powers led by the United States became the central theme of international affairs. Liberal democracy, which had not done too well in the struggle against the totalitarian democracy of Fascism, now had to face another totalitarian challenge in Communism. The years after 1947 saw the beginnings of "cold war" between the two doctrines, in which the ideal of a planned and regulated society challenged that of an individualistic one which was in practice simply less planned and regulated. It is difficult to say how much ideas counted in the contest-which still continues; at any rate, the West was forced into an "agonizing reappraisal" of all its values and assumptions which now had to face the arguments (and frequently the achievements) of powerful rivals. What was democracy? What was freedom; did such a thing really exist and could it be reconciled with order? What were the tendencies inherent in the present situation? And, on a more immediate plane, what policy could best cope with ally and enemy within the pattern of a cold-war world? These are the various issues discussed below.

1. THE DEMOCRATIC MYTH

In his time, Constantin Pobyedonostsev, Supreme Procurator of the Holy Synod, was the highest Russian lay official in charge of religious and educational affairs; he was also the most influential adviser of Tsar Alexander III and, for a time, of his successor, Nicholas II. This very powerful man, who dominated so much of Russian policy in the eighties and early nineties of the nineteenth century, was "a thorough despiser of human nature who had turned reaction into a system of philosophy," who saw representative institutions as "the greatest falsehood of our time" and advised that "fear of, not love of God, and fear of, and devotion to the Tsar, are to be cultivated as aids to government." His remarks on democracy, which follow in the translation of R. C. Long, have frequently been repeated against it.

The philosophy of the school of Rousseau has done much evil to humanity. This philosophy took possession of many minds; but at the same time it was all based on one false idea of human perfectibility, and on the assumption in every individual of capacity to comprehend and appreciate those principles of social organisation which it proclaimed.

The prevalent doctrine of the perfection of Democracy and of democratic government, stands on the same delusive foundation. This doctrine presupposes the capacity of the people to understand subtleties of political science which have a clear and substantial existence in the minds of its apostles only. Precision of knowledge is attainable only by the few minds which constitute the aristocracy of intellect; the mass, always and everywhere, is *vulgus*, and its conceptions of necessity are vulgar.

Democracy is the most complicated and the most burdensome system of government recorded in the history of humanity. For this reason it has never appeared save as a transitory manifestation, with few exceptions giving place before long to other systems. This is in no way surprising. The duty of the State is to act and to ordain: its dispositions are manifestations of a single will; without this government is inconceivable. But how can a multitude of men, or a popular assembly, act with a single will? The upholder of Democracy takes little trouble over the decision of this question, but evades it by means of those favourite phrases and formulas: - "The will of the people," "public opinion," "the supreme decision of the nation," "the voice of the people is the voice of God," and others of a like nature. All these phrases signify that a mul-

titude of men on a multitude of questions may form a common conclusion, and, conformably with their conclusion, arrive at a common decision. This may be possible sometimes, but only on the simplest questions. Where questions present the slightest complexity their decision by a numerous assembly is possible only through the medium of men capable of judging them in all their details, and of persuading the people to accept their judgment. In the number of complex questions may be counted all political questions requiring great concentration of the intellectual forces of the most capable and experienced statesmen; on such questions it would be absurd to rely upon unanimity of thought and will in a numerous assembly; the decision of the people only could be ruinous to the State. The enthusiasts of Democracy contend that the people may manifest its will in affairs of State: this is a shallow theory. In reality, we find that popular assemblies are capable only of accepting-through enthusiasm—the opinion expressed by individuals or by a small minority—the opinion, for instance, of the recognised leader of their party, of some local worker of repute, of some organised association, or the impersonal opinion of an influential journal. Thus the discussions which precede decisions become an absurd comedy played on a vast stage by a multitude of heads and voices; the greater the multitude the more unintelligible is the comedy, and the more the dénouement depends upon fortuitous and disorderly impulses.

To evade all these difficulties, the system of government by representation has been devised, a system first established and first justified by success, in England.

Thence, through the influence of fashion, it spread to other European countries, but proved successful only in the United States of America, and there by tradition and by right. Yet even in England, the land of their origin, representative institutions are in a critical epoch of their history. The very essence of the idea of representation has submitted already to modifications which have changed its primitive significance. In the beginning, the assemblies of electors, on a strictly limited franchise, sent to Parliament a certain number of persons whose duty it was to represent the opinions of the country, but who were not bound by any definite instructions from the mass of their constituents. It was assumed that these elected representatives were men who understood the real needs of their country, and who were capable of justly controlling the politics of the State. The problem was resolved simply and plainly: it was required to lessen, as far as possible, the difficulties of government by the people, by limiting in number the members of the assemblies summoned for the decision of questions of State. These men appeared in the capacity of free representatives of the people, and not as instruments of the opinions of factions; they were bound by no instructions. But in the course of time this system changed under the influence of that fatal delusion about the great value of public opinion, as enlightened by the periodical Press which gave to the people the capacity to participate directly in the decision of political questions. The idea of representation altogether lost its form, and reappeared as the idea of a mandate; or of specific commission. From this point of view each representative is accounted a representative of the dominant opinions of his constituency, or of the party under the banner of which his victory was

gained. Thus he is no longer a representative of the country or of the people, but a delegate bound by the instructions of his party. This change in the very essence of the idea of representation was the germ of the disease which has since devoured the whole system of representative government. With the disintegration of parties, elections have taken the character of personal struggle restricted by local interests and opinions, but independent of their primary purpose of subserving the advantage of the State. With the great increase of the numbers in Parliament, most of the members, apart from the interests of party strife, are characterised by indifference to public affairs; they neglect their duty of attendance at all sessions, and of direct participation in the consideration of business. Thus the work of legislation, and the direction of the gravest political affairs, become a play composed of formality, compromise, and fiction. The system of representation has falsified itself in practice.

These deplorable results are all the more manifest where the population of a country is of heterogeneous composition, comprising nationalities of many different races. The principle of nationality may be considered the touchstone which reveals the falseness and impracticability of parliamentary government. It is worthy of note that nationality first appeared as an active and irritant force in the government of the world when it came into contact with the new forms of Democracy. It is not easy to apprehend the nature of this new force, and the ends which it pursues; but it is unquestionable that it contains the source of a grave and complex struggle, impending in the history of humanity, and it is vain to predict to what issues this struggle will lead. Today we see the various races of composite States

animated by passionate feelings of intolerance to the political institution which unites them in a single body, and by an equally passionate aspiration to independent government with their generally fictitious culture. We see this not only among those races which have had a history and a separate political life and culture, but, to an equal extent, among races which have never known independence. Autocracy succeeded in evading or conciliating such demands and outbreaks, not alone by means of force, but by the equalisation of rights and relations under the unifying power. But Democracy has failed to settle these questions, and the instinct of nationality serves as a disintegrating

element. To the supreme Parliament each race sends representatives, not of common political interests, but of racial instincts, of racial exasperation, and of racial hatred, both to the dominant race, to the sister races, and to the political institution which unites them all. Such is the unharmonious consequence of parliamentary government in composite States, as Austria, in our day, so vividly illustrates. Providence has preserved our Russia, with its heterogeneous racial composition, from like misfortunes. It is terrible to think of our condition if destiny had sent us the fatal gift—an All-Russian Parliament! But that will never be.

2. CARL BECKER: A DISCUSSION OF MODERN DEMOCRACY

Carl Lotus Becker, of Cornell University, was the outstanding American historian of his generation. George Sabine has explained that "for him the test of a civilized society was the degree in which law and public authority rest on free discussion and voluntary consent," and that "he valued democracy because, with all its faults, it still offered the widest scope for intelligence and good will." His opinions, therefore, provide a useful contribution to the debate, appearing, as it were, for the Defense.

The problem of modern democracies as I have just defined it may be otherwise stated. Can the flagrant inequality of possessions and of opportunity now existing in democratic societies be corrected by the democratic method? If it cannot be so corrected the resulting discontent and confusion will be certain, sooner or later, to issue in some form of revolutionary or military dictatorship. This then is the dilemma which confronts democratic societies: to solve the economic problem by the democratic method, or to cease to be democratic societies.

It is obvious that the problem, intrin-

sically, is an economic one. At the present moment it takes the spectacular form of unemployment. For the past ten years, in the most prosperous democratic societies, from 10 to 20 per cent of the working population, for the most part willing but unable to find work, has been kept alive by public or private charity or by jobs created for that purpose by the government. Unemployment is no new thing, but never before in democratic societies has it reached the proportions of a major social catastrophe.

The catastrophe cannot be explained as an act of God, cannot be attributed to

Carl L. Becker, Modern Democracy (New Haven, 1941), pp. 67-100. By permission of the Yale University Press.

destructive natural forces beyond human control. The people are famished, but there is no famine. On the contrary, there is wealth in abundance, or should be. Given our natural resources, manpower, and technical equipment, there could be produced, in this country at least, sufficient wealth to provide all the people with the necessities of life and many of the desired comforts and luxuries besides. Yet in spite of widespread and insistent human need, the technical equipment is used only in part, the manpower is not fully employed. In a land of plenty, millions are destitute. Obviously the situation is one which arises not from lack of potential wealth, but from some defect in the method of producing and distributing wealth. That the defect is a serious one is indicated by a simple, ironic fact -the fact that in a world in which millions are destitute it is thought necessary, and under the prevailing system of production and distribution of wealth apparently is so, to limit the production of the necessities of life in order to keep people from starving.

The prevailing system for the production and distribution of wealth is variously denoted by the phrases capitalist system, competitive system, price system, system of free enterprise, system of laissez-faire. Its theoretical justification derives from the general assumption of the liberal-democratic ideology—the assumption that social welfare can best be achieved by reducing governmental interference with the freedom of the individual to a minimum. The assumption was never better stated than by John Stuart Mill in his famous essay On Liberty. Governmental interference with the activities of the individual, he maintained, is never justified except when manifestly necessary to prevent the activities of some individuals from injuring others. The principle is similarly, but more succinctly, formulated in the French Declaration of the Rights of Man: "Liberty is the right of everyone to do whatever does not injure others."

Applied to the economic realm, this principle was interpreted to mean the maximum freedom of the individual to choose his occupation or business, and to enter freely into contracts for the acquisition or disposal of private property and for the purchase or sale of personal services. It was assumed that the free play of individual initiative, stimulated by the acquisitive instinct, operating through the law of supply and demand and the resulting price system, would result in as equitable a distribution of wealth as the natural qualities and defects of men would permit. In this system the function of the government was reduced to defining and guaranteeing the rights of private property, enforcing the rules of contract, and preserving social order. Having defined the rules of the game, the government would see that they were enforced, but would not otherwise interfere with the players. Let the game go on and the best man win. Laissez-faire, laissez-passer!

Contrary to a wide-spread belief, *lais-sez-faire* was never more than a theory imperfectly applied. The happy, imagined time when government did not interfere in the freedom of the individual by meddling in business never in fact existed. The institution of private property is itself a most drastic regulation of business enterprise, the law of contract a fundamental interference with the liberty of the individual. But assuming private property and the law of contract as part of the system, there never was a time when government did not find it necessary, according to Mill's famous defini-

tion, to interfere with the activities of some individuals in order to prevent those activities from injuring others.

In England the trend toward laissezfaire was reversed before it was completed. A decade before 1846, when the doctrine was officially adopted by the repeal of the corn laws, the government had found it necessary to restrict free enterprise by passing the first Factory Act for the protection of women and children. And from that day to this, in England and in every industrialized country, including the United States, the governmental regulation of private property, of free competition and free contract, of the price of commodities and of labor, of the inheritance of property and of the disposal of income from it, has steadily increased. This extension of governmental regulation, this trend toward what is called social legislation, was brought about by the pressure of labor unions supported by the humane sentiment of the community, and underlying it is the assumption, avowed or unavowed, that the system of laissez-faire, so eminently successful in stimulating the production of wealth, is incapable, without governmental regulation, of bringing about an equitable or even a tolerable distribution of it. It is far too late to ask whether government should interfere in business enterprise. It always has interfered in business enterprise. The only relevant question is in what ways and to what extent it should so interfere.

Nevertheless, in spite of increasing governmental regulation, the theory of laissez-faire was never abandoned. The prevailing assumption was, and still is, in democratic societies, that governmental regulation should be kept to a minimum, however high the minimum might in the event prove to be. It was taken for granted

that the basic right and the assured foundation of the economic structure of society was private property in the means of production, free enterprise, and the competitive system. Social legislation was regarded as no more than a limited, if necessary, concession to adverse circumstances, a series of minor adjustments that would leave the system intact while enhancing its efficiency. In the optimistic decade before the Great War, social legislation came to be widely regarded, indeed, as in some sense an integral part of the system of free enterprise, a kind of insurance against the subversive doctrine of Socialism, a preordained and peaceful means of transforming that anomaly of progress and poverty which Henry George had so graphically described into that progress and prosperity which the prophets of democracy had so confidently predicted.

Since the Great War faith in social legislation as a means of validating the system of free enterprise has been much impaired. Surveying the history of a century of governmental regulation of business enterprise, it is obvious that while regulation has done much to correct minor evils it has as yet failed to solve the fundamental problem of an equitable distribution of wealth. On the contrary, the problem of the distribution of wealth is more serious and more insistent now than it was in the time of Henry George, so much so, indeed, that if the anomaly of progress and poverty is less glaring than it was, the only reason is that while the poverty is more patent the progress is less assured.

Inevitably, therefore, the question, long since raised, becomes every day more insistent: Can the problem of the production and distribution of wealth be solved, within the framework of the ex-

isting system of private property and free enterprise, by any amount of governmental regulation? In short, are the defects of the system of private property in the means of production incidental or inherent?

That the defects of the capitalist system are inherent is the contention of those ideologies known as Socialism and Communism. Socialism and Communism, taken in the generic sense of the words, are at least as old as Plato; but in their modern forms they derive from the doctrines formulated by Karl Marx in the middle of the last century.

Marxian Socialism, inspired by the failure of democratic institutions to effect an equitable distribution of wealth. was essentially a reinterpretation of the modern doctrine of progress, and as such it comprised a social theory and a philosophy of history. As a social theory it maintained that the social structure at any time is fundamentally determined by the methods of production and distribution of wealth, and that the prevailing institutions and ideas are those best adapted to maintain the interests of the class which, by ownership and control of the chief forms of wealth, dominates the social structure in its own interest. As a philosophy of history it maintained that social change or progress is the result, not of a conflict of ideas, but of economic forces, a conflict between the economic interests of the ruling and the dispossessed classes. Not by the persuasive force of ideas, but only by the impersonal pressure of economic conditions, could the ruling class ever be dispossessed, or the institutions and ideas through which its power operates ever be transformed.

Applying this theory to European history, Marx found that the liberal-demo-

cratic revolution was the result of the conflict between the economic interests of the landed aristocracy and the rising capitalist class. So far from reflecting the triumph of true over false ideas, it reflected the triumph of capital over land as the predominant factor in production; and the superstructure of liberal-democratic ideas and institutions, so far from having a universal validity, had merely the relative and temporary value of being suited to the functioning of the capitalist system and the interests of the ruling bourgeois class. The liberal-democratic revolution could not, therefore, be regarded as the final term of the historic process. On the contrary, the capitalist system once established, there necessarily developed within it a new conflict between the interests of the ruling bourgeois class and the dispossessed proletariat which would inevitably issue in another social revolution.

The coming social revolution was inevitable, according to Marx, because the capitalist system, like the landed aristocratic system before it, contained within it the defects that would transform itdefects inherent in the institution of private property and the competitive system. The ruthless competition for profits would necessarily result in an increasing concentration of wealth in the hands of those who proved most able in the ruthless competition for profits, thereby reducing the laborers and the defeated capitalists to the level of a bare subsistence; and when this process reached a certain stage the system would collapse for the simple reason that there would be no profit in producing commodities when the underlying proletarian population was no longer able to purchase them at a price that would yield a profit. When this stage was reached, the proletariat, made class-conscious by their misery, instructed in the dialectic of social change by their leaders, and united for the defense of their class interests, would by revolutionary action abolish private property in land and capital, and through a democratic government based upon a classless society, organize the production and distribution of wealth for the common good.

The Marxian doctrine provided a new and persuasive ideology for the oppressed working classes whose hopes were persistently defeated by liberal-democracy as a going concern. Its analysis of the capitalist system justified their grievances against their employers, while its philosophy of history promised them that all would be made right in the future, and assured them that in defending their class interests they could not fail since they were supported by the indefeasible forces that shaped the destiny of mankind.

Inspired by the Marxian faith, the industrial workers formed new political parties, for the most part called Socialist, and for the most part accepting the Marxian doctrine of the social revolution. But meantime, while waiting for the coming revolution, and as a preparation for it, the Socialist parties adopted a program of social legislation designed to benefit the masses at the expense of the classes. Attracted by this practical program, lower middle-class people, mostly timid folk who abhorred the idea of violence, voted in increasing numbers for Socialist candidates in the hope of benefiting from the legislation which the Socialist parties promised to support. One result of this trend in practical politics was that the Socialist parties derived their chief support from voters who were not Marxian socialists; another was that the leaders of the Socialist parties, in order to win and hold non-Marxian voters, found it necessary to soft-pedal the doctrine of imminent, catastrophic revolution. In the decade before the Great War the dominant Socialist parties had therefore virtually abandoned the Marxian conception of the revolution as a violent upheaval, and conceived of it as a slow and peaceful process in which the masses, by established political methods, would gain control of the government, and by normal legislative procedure within the existing democratic regime would abolish private property in land and capital and socialize the production and distribution of wealth.

During the Great War the influence of Socialism naturally declined, but the orthodox Marxian tradition, barely kept alive by minority groups within and without the dominant Socialist parties, was given a dramatic and world-wide significance by the Russian Revolution. As reinterpreted by Lenin and realized in the Soviet regime, neo-Marxianism took the name of Communism, and must be clearly distinguished from Socialism as understood by such prewar Socialists as Bernheim and Kautsky, and such present-day Socialists as Norman Thomas. Presentday Socialism and neo-Marxian Communism agree in one thing only—the necessity of abolishing private property in the means of production. In respect to the means for accomplishing this desired end they disagree radically. Socialism maintains that it can be accomplished by peaceful political methods within the framework of the existing democratic regime; Communism maintains that it can be accomplished only by violent revolutionary expropriation of the capitalist class, carried through for the masses by the dictatorship of a disciplined Communist party.

It was also an essential part of Communist theory that the establishment of Communism in one country would be the

prelude to an international Communist revolution. So far, the prediction has not been realized. Revolutions there have been, in Italy, in Germany, in many European countries. But these revolutions, stimulated in part by the fear of Communism rather than by devotion to it, have taken the name of Fascist; and until recently at all events Communism and Fascism have been commonly regarded, especially by the Communists and Fascists themselves, as being fundamentally opposed to each other.

In respect to political theory there are certain differences between Communism and Fascism. In theory Communism maintains that the dictatorship, a drastic technique essential to the revolution but ending with it, will be replaced by a democratic government of free and equal individuals, while Fascism rejects the democratic ideal altogether in favor of the permanent dictatorship. In theory Communism professes to be international, while Fascism frankly accepts the doctrine of racial superiority and national egoism. In theory Communism recognizes the value of reason and science, while Fascism is essentially anti-intellectual in its subordination of reason to will.

In theory, yes; but the Soviet regime in Russia has failed, even more conspicuously than existing democratic societies, to harmonize theory and practice. Although the revolution has long since ended, the classless society has not emerged. The dictatorship is now more firmly established, the prospect for a democratic government is now more remote, than in the time of Lenin. The Stalin regime is no less nationalist and no more international than the regime of Hitler, and its regimentation of opinion and scholarship no less effectively subordinates reason to the will of the dictator. The revolution

in Russia, as Trotsky said, has been betraved; but it has been betrayed less by men and circumstances than by a radical contradiction in Communist theory. The rational and humane values proclaimed in Communist theory are frankly divorced from the means by which they can be realized; they are regarded as ideal ends projected into the future, but incapable of being attained except by the temporary resort to antirational and inhumane means. So far at least the result of this radical contradiction between ends and means has been, and as I think must under any circumstances have been, that the ideal ends were defeated by the very means employed to attain them.

It is in this fundamental discord between ends and means that Communism and Fascism, as they actually function, are alike—alike in the methods they employ and in the assumptions by which the methods are justified. The Communist and the Fascist revolutions were carried through by the same political technique and the same resort to naked force. The personal power of Mussolini and Hitler is no more arbitrary, more complete, or more ruthlessly employed than that of Stalin. Both Communism and Fascism assume that the welfare of the community and the progress of mankind are in some mystical fashion identified with an abstract entity, called in the one case the dialectic of history and in the other the totalitarian state. Both assume that this abstract entity is realized in the person of an inspired leader to whom the truth has been revealed and the direction of affairs committed. Both assume that the individual, in comparison with the state or the dialectic process, has no significance except as an instrument to be used, with whatever degree of brutality may be necessary, for realizing ends which the

leader judges to be good. Both do in effect, whatever they may proclaim in theory, subordinate reason to will, identify right with naked force as an instrument of will, and accord value to the disinterested search for truth only in so far as the leader judges it to be temporarily useful for the attainment of immediate political ends.

Communism and Fascism claim to be theoretical formulations of a "new order" in the world. But as revealed in their works they are no more than the recurrence of old political forms, that is to say, the recurrence in practice of what is rariously known as tyranny, dictatorship, absolute monarchy; the recurrence in theory of what is known as divine right. As such they are alike, and alike at war with the fundamental values and assumptions which liberal-democracy, if it is to retain any significance, must preserve.

The infinitely complicated process which we call history continuously gives rise to what are called social problems, and at the same time generates those political and intellectual trends which indicate the direction which the solution of those problems is likely to take. The term "solution," used in this connection, is misleading. It connotes a certain perfection or finality, comparable to the solution of a mathematical or a chemical problem, which is never possible in social relations. "The function of history," as J. B. Bury once remarked, "is not to solve problems but to transform them." In our time the historical process has given rise to the problem of the distribution of wealth, a problem which assumes the double form of social conflict within the nations and of diplomatic and military conflict between them. It would be naive indeed to suppose that this problem, in either of its forms, will be "solved" with any notable degree of perfection or finality. It will be solved only in the sense of being transformed; and in looking for the direction which this transformation will take, we must consult, not merely our hopes or our preferences, but also the dominant political and intellectual trends which the history of our time discloses.

Those political and intellectual trends I have discussed and discriminated under the terms Liberal-Democracy, Socialism, Communism, and Fascism. The differences between them, both as ideological systems and as going concerns, are obvious and important; but underneath their differences we can note, in respect to what they propose to do and are doing to solve the problem of the distribution of wealth, an interesting and significant similarity. It is a similarity of direction: all these systems are carrying us, with or without our consent, toward an extension of governmental regulation of economic enterprise.

That this is the direction is evident. In all liberal-democratic countries, for the last hundred years, there has been a steadily increasing amount of such regulation of economic enterprise. Both Communism and Socialism propose to make the regulation complete by abolishing private property in the means of production, and the Communist regime in Russia has already accomplished this object. Fascism, no less than Communism, proposes to subordinate the individual to the state; and in the principal Fascist countries, although private property in land and capital has not been formally abolished, the national economy has been so far subjected to governmental direction that free economic enterprise has virtually disappeared. Like it or not, the complexities of a highly integrated technological civilization are carrying us in a certain direction, that is to say, away from freedom of the individual in economic enterprise and toward an extension of social control. This is therefore the direction which, in democratic as well as in other countries, the transformation of the problem of the distribution of wealth will surely take.

The question that chiefly concerns us is whether the necessary social regulation of economic enterprise can be effected by the democratic method, that is to say, without a corresponding social regimentation of opinion and political freedom. Can the possessors be sufficiently dispossessed and the dispossessed be sufficiently reinstated without resort to violence to revolution and the temporary or the permanent dictatorship. The Communists say no-sooner or later the revolution. The Fascists say no—the totalitarian state is the only solution. They may of course be right. It is futile to suppose that democracy must survive because it accords with the law of nature or some transcendent increasing purpose. Nor can we dismiss the rise of dictatorship in half the world as a temporary aberration brought to birth by the ingenuity of sinister or psychopathic individuals. Common men. when sufficiently distressed, instinctively turn to the inspired leader; and dictatorship in our time, as in past times, is the normal price extracted for the failure of democracy to bind common men by their hopes and fears. The survival of democrátic institutions thus depends, not upon the attractiveness or logical consistency of theories of government, but upon the possibility of effecting, by the pragmatic democratic method, a sufficient equalization of possessions and of opportunity to provide common men with what they will consent to regard as tolerable.

It may be said, it has often been said, that the most brilliant civilizations of the past have paid scant attention to the needs or desires of common men, that the oppression of common men was the price that had to be paid for those great and permanent achievements which we associate with the progress of mankind. It may be so, but it no longer matters. The very technology which gives peculiar form and pressure to the oppression of common men in our time has freed common men from the necessity of submitting to it. The time has gone by when common men could be persuaded to believe that destitution is in accord with God's will, or to rely upon the virtues of noblesse oblige to ease their necessities. Through education and the schools, through the press and the radio, common men are made aware of their rights, aware of the man-made frustration of their hopes, aware of their power to organize for the defense of their interests. Any civilization in our time, however brilliant or agreeable it may appear to its beneficiaries or to posterity, which fails to satisfy the desires of common men for decent living will be wrecked by the power of common men to destroy what seems to them no longer worth preserving. The ultimate task of democracy may be to establish a brilliant civilization; but its immediate task is the less exalted one of surviving in any form, and the condition of its survival is that it shall, even at the sacrifice of some of the freedoms and amenities of civilization as we have known it, provide for the essential material need of common men.

Considered as a problem in scientific engineering, providing for the material needs of common men presents no insuperable difficulties; the necessary resources, equipment, man power, and

knowledge are available. Given Plato's ruling class of philosopher-kings, and a docile population responding to suggestion as smoothly as molten iron yields to physical pressure, adequate wealth could be produced and equitably distributed. Unfortunately perhaps, there are no such philosopher-kings; fortunately, there are no such docile people. Government is much less a matter of knowing what is good to be done than of persuading average human beings, stubbornly rooted in conventional habits of thought and action, to do what fallible intelligence judges on incomplete data to be for the moment necessary or desirable. Democratic government is a matter of persuading them to do it voluntarily by registering their wishes in the form of ballots freely given. In democratic countries, therefore, the measures taken for effecting a more equitable distribution of wealth can never be based solely upon the best scientific knowledge available; they can be such only as the majority of citizens will voluntarily sanction and the minority voluntarily submit to.

It is as essential that the minority should voluntarily submit to the measures taken as it is that the majority should voluntarily approve them. Democratic goverment rests upon the principle that it is better to count heads than it is to break them. The principle is a good one, but unfortunately men will not, under certain conditions, so regard it. By and large the principle works well enough so long as the issues to be decided do not involve those interests which men will always fight for rather than surrender. By and large, democratic government, being government by discussion and majority vote, works best when there is nothing of profound importance to discuss, when the

rival party programs involve the superficial aspects rather than the fundamental structure of the social system, and when for that reason the minority can meet defeat at the polls in good temper since it need not regard the decision as either a fatal or a permanent surrender of its vital interests. When these happy conditions disappear democratic government is always in danger.

The danger has already proved fatal in many countries. It exists, although it may not prove fatal, even in those countries where the democratic tradition is most strongly intrenched. For in these countries too the insistent problem of the distribution of wealth is beginning to involve those fundamental class interests which do not readily lend themselves to friendly discussion and mutual concession. The flagrant inequality of possessions and of opportunity is creating an ever sharper differentiation between the beneficiaries of private property in the means of production and the masses whose present circumstances and future prospects depend less upon individual character and talent than upon the hazards of the business cycle. Accompanying this differentiation there has been and is going on a confused but persistent realignment of political parties; on the Right, conservative parties representing the beneficiaries of the system of free enterprise; on the Left, radical parties representing the poor and the dispossessed. As the divergence between Right and Left becomes sharper and more irreconcilable, moderate and conciliatory parties tend to disappear, and the rival party programs of the extreme groups, no longer confined to the superficial aspects of policy within the framework of the traditional system, are increasingly concerned

with the validity of the assumptions on which the system rests. Underlying the question of the equitable distribution of wealth is the more fundamental question of the validity of the institution of private property as a means of effecting it. The present power of the possessing classes rests upon the institution of private property; the present distress of the masses is somehow involved in it. If the present discords should be prolonged and intensified, the danger is that the masses will turn to revolution rather than submit to a system which fails to relieve them, that the classes will welcome forcible repression rather than surrender a system which guarantees their power.

The danger is not one to be lightly dismissed. It is certainly greater than many profess to think. But for all that we need not be browbeaten, by dogmatic assumptions, into believing that the discords in the capitalist system cannot under any circumstances be corrected by the democratic procedure. It is an article of Communist faith, which many advanced liberals seem to accept as a matter of course, that history offers no instance of a ruling aristocracy which has surrendered its power voluntarily, and that accordingly nothing short of violent revolutionary expropriation will induce the capitalist class to surrender the power which the institution of private property now confers upon it.

The premise is correct enough, but the conclusion is a non sequitur. True enough, no ruling class has ever surrendered its power voluntarily, but it does not follow that no ruling class has ever surrendered its power except under compulsion of naked force. The Roman Patricians did not surrender their power voluntarily, on demand; but they nevertheless

surrendered it, gradually, under pressure, without incurring the destruction of republican institutions. The English aristocracy did not surrender its power voluntarily; but since the eighteenth century it has, under pressure exerted through the democratic political procedure, conceded one strategic position after another. And indeed in all those countries where democratic institutions still persist, the capitalist classes have, during the last fifty years or more, conceded bit by bit much of the control over private property which they formerly possessed and once thought indispensable. There is no compelling reason to suppose that, in those countries where the democratic tradition is strongly intrenched, this process of increasing governmental regulation of economic enterprise should not continue, even to the point, if that should prove necessary, of a virtual if not a formal socialization of certain basic industries, without incurring the destruction of democratic institutions.

It is not a question of keeping what we have or scrapping it for some untried ideal social system. At best it is a question of sufficiently improving what we have to avoid the intolerable distress which if unrelieved ends in despair and the resort to violence. No infallible panacea for accomplishing this end is available. The desired end can be accomplished, if at all, only by the method of trial and error, by employing the best knowledge available, so far as it can be employed by the democratic political method, to effect those adjustments which will put idle money to work in productive enterprises and idle men to work at a living wage. What particular measures are best adapted to do this I am incompetent to say. It is for the experts to suggest the particular measures.

Since the experts disagree, the measures adopted, however carefully considered, will in the event no doubt be attended with unforeseen consequences calling for still further measures. That attempts to remedy the evil are not wholly successful is no reason for abandoning the task. Something must be done, and much must be attempted that a little may be gained. What is chiefly needed is time—time for experiment, for making mistakes and correcting them, time for the necessary adjustment in vested interests and the necessary psychological adaptation to new ideas, time for the slow crystallization of public opinion and for registering public opinion in legislative enactments by the cumbersome democratic technique.

It is true, of course, that there may not be time enough. There may not be time enough in any case. Technological advance has so accelerated the tempo and complicated the character of social change that present social ills can scarcely be properly diagnosed before they have been so far transformed that the proposed remedies are no longer adequate. But if time fails us, it will be less because of inherent defects in the capitalist system or the democratic procedure than because of the disastrous results of modern war in dislocating the national economy and in impairing the democratic morale. . . .

When we consider the problem of preserving democratic institutions broadly, from both the national and the international point of view, we seem to be helplessly caught in a vicious circle. We know that democratic institutions are threatened by social discords within the nations, and still more by war between them. We know that if we could avoid war it would be much easier to resolve our social discords, and that if we could resolve our social discords it would be much easier to avoid war. If we could do either of these things without the other, the future of democracy would be fairly secure; if we could do both of them it would be altogether so. Yet we know that social discords are a major cause of war, and that war is the one thing that will make it impossible, if anything does, to resolve our social discords. It is in such situations that reason succumbs to force, in such situations that dictators flourish and democracy declines.

It is possible that the crisis which confronts the modern world involves something more serious even than the collapse of democratic institutions. The contradictions in the capitalist system may be no more than symbols of a discord more profound—the discord between the physical power at our disposal and our capacity to make a good use of it. It is obvious at all events that the history of the last two centuries presents us with a disturbing paradox: whereas the application of reason to the mastery of the physical world has proceeded with unanticipated success and mounting optimism, the persistent effort to shape the world of human relations to humane and rational ends has been so far unavailing that we are oppressed with a sense of frustration and defeat.

Long ago it was said that man can more easily take a city than govern himself. Never was the saying more true than now. Never before has the intelligence of man placed so much material power at his disposal: never before has he employed the power at his disposal for the realization of purposes more diverse or more irreconcilable. The hand of man is subdued to what it works in, and the mind admires what the hand can ac-

complish. Modern man is therefore enamored of mechanical force. Fascinated by the esthetic precision and sheer power of the instruments he has devised, he will use them for doing whatever by their aid can be done, in the confident expectation that what can be done with such clean efficiency must be worth doing. Thus the machines we have invented tend to enslave us. Compelling us to use them on their own terms, and to adjust our conduct to their virtues and limitations, they somehow generate social forces which, being too complex and too intangible to be easily understood, shape our lives to ends we do not will but cannot avoid.

In times past certain civilizations, long established, brilliant and prosperous and seemingly secure against mischance, slowly decayed and either disappeared altogether or were transformed past recognition and forgotten. What has happened many times in the history of mankind may happen again. There are no barbarian hosts without the gates, but there are plenty of potential barbarians within them. It is then within the range of possibility that the flagrant discord between the mechanical power at man's disposal and his capacity to make good use of it is carrying the world into another period of widespread and chronic confusion in which democracy will everywhere succumb to dictatorship, reason to naked force, and naked force prove to be the prelude to another dark age of barbarism.

I do not say this will happen. I do not think it will. But it is futile to suppose that it cannot happen, futile to rely upon the saving grace of some transcendent increasing purpose (a law of nature or dialectic of history, or totalitarian state) to bring us in spite of ourselves to a predestined good end. For the solution of our difficulties the only available purposes are our own, the only available intelligence such as we can command. If then democracy survives, if civilization in any tolerable form survives, it will be because, in some favored parts of the world the human mind remains unshackled and, aided by time and fortunate circumstances, proves capable of subordinating the unprecedented material power at its command to the achievement of rational and humane ends. More obvious now even than in the seventeenth century is the truth of Pascal's famous dictum: "Thought makes the whole dignity of man; therefore, endeavor to think well, that is the only morality."

The chief virtue of democracy, and in the long run the sole reason for cherishing it, is that with all its defects it still provides the most favorable conditions for the maintenance of that dignity and the practice of that morality.

3. A NEW SOCIETY?

The Industrial Revolution we read about in textbooks was accomplished in societies with a restricted electorate, in which the masses with whose help and at whose expense industrial expansion first took place had little say. By the time workers had votes and effective unions, industrialization had been accomplished and they could concentrate on securing a greater share of the wealth it produced and, incidentally, on delaying changes in a familiar structure or cushioning their effects.

Today, however, a number of societies are trying to combine democracy and rapid industrialization, while others—already industrialized—try to reconcile centralization, long-range planning and large-scale control of production with the fairer modes of distribution achieved in generations of social struggle. In both cases, the parliamentary structures an earlier age devised appear increasingly awkward; and the free enterprise of liberal days, never altogether private, passes increasingly onto the public plane.

Such developments are criticized in some quarters as insufficient to cope with present needs, in others as steps toward a collectivism that must end by whittling away all individual freedom. George Lichtheim suggests that, while abandoning bourgeois capitalism, the mixed economies developed in West European societies are making not for socialism, but for something else, more suited to the classless society toward which we, like our Communist competitors, seem to be moving. The classless society, however, develops new classes of its own; the planned society must learn to keep the planners in their place; the ultimate question turns out to be, as always, Quis custodet ipsos custodes? Social tensions pull from one extreme, perilous for one kind of liberty, to another, ominous for other kinds of freedom. And the good society (or, at least, the better) turns out to be, as ever—and just as evasively as ever, not that which clings most closely to one particular ideal, but that which holds the fairest balance between two excesses.

The concept of industrial society is indeterminate as between the rival economic systems of capitalism and socialism, and for this reason tends to be looked upon with some suspicion by economists and politicians alike. Considering the frequent misuse of an allegedly neutral and "valuefree" sociology to underpin conclusions agreeable to the defenders of the status quo, this mistrust cannot be described as unjustified. Nonetheless, there is a sense in which an industrial society can be said to have a structure peculiar to it. There is no need to inquire whether societies should be regarded as "organic wholes," or indeed whether the economic "base" can be clearly differentiated from the "social superstructure." There are alternative ways of looking at such matters, but as long as all concerned are agreed that the

concepts of "growth" and "evolution" are applicable to the totality of the system, it does not matter much in what language we express the intuition that the "whole" has a specific mode of functioning. The difficulty lies rather in determining the particular historical stage which has been reached at a given moment as a result of some major political upheaval coinciding with a basic change in the underlying social texture. The impact of the two world wars on European society appears to mark a genuine "historical change," inasmuch as it hastened the collapse of the old pre-1914 social order, which, broadly speaking, rested upon a symbiosis of bourgeois and prebourgeois elements, with the latter generally in control of the state. The significance of this fact is open to various interpretations, depending on whether

Reprinted from George Lichtheim, The New Europe, Frederick A. Praeger (New York, 1963) pp. 182–198 passim.

one accepts the notion that bourgeois society is not a completely self-sustaining organism but requires political rule by a nonbourgeois stratum for the most part drawn from the ancient territorial nobility or the bureaucracy and its hangerson.

This problem is not peculiar to Europe. It has its counterpart in Latin America (though not in the United States). But for historical reasons it is of primary importance to West Europeans, because Western Europe is the only part of the world to have evolved a fully developed bourgeois-capitalist society on the ruins of a feudal past. For the same reason, it is the only Continent where authentic conservative, liberal, and socialist (or communist) parties genuinely confront one another. Elsewhere, one or the other of these elements is commonly missing. Thus the United States has not so far evolved a socialist labor movement (though Australia has done so, and Canada seems about to follow suit), while in some preindustrial countries, parties or movements bearing the socialist label are plainly no more than organizations of the political elite, quite unconcerned with the interests of the working class (which may not even be in existence). The extreme case—but one which by now is not at all uncommon—is that of a "socialist" movement in fact spearheading a capitalist form of economic development. One may hazard the guess that in a good many, if not all, backward countries, this particular form of delusion or self-delusion ("ideology" in the strict Marxist sense) is likely to have a fairly lengthy run. To the despairing question "How can we sell capitalism to the masses?" the obvious answer would appear to be, "By calling it socialism." Such stratagems need not be conscious; they are indeed more likely to

be successful if the exponents of the official creed are in good faith. But for obvious reasons they can work only in backward countries and with fairly unsophisticated electorates (if indeed there is any intention of consulting the voters at all). Where democracy and literacy have already had a trial run, most people are likely to see through such conscious or unconscious maneuvers whereby the political elites seek to mobilize support for industrialization policies that must initially demand heavy sacrifices, notably from the peasantry. A relatively backward country that introduces the apparatus of parliamentary democracy before industrialization is complete may actually find that while the ruling elite of army officers, politicians, and intellectuals is on the side of forced-draft modernization, the peasant voters will have none of it. In a situation of this kind, the elite then faces the awkward choice of scrapping either democracy or modernization. Turkey is a case in point. In such cases, if the ruling minority decides to press on with modernization against the will of the backward majority, it may find it necessary to seek a legitimation in "socialism." Its political doctrine will then be undemocratic and may come to bear some resemblance to either Fascism or Stalinism—as the case may be—though in point of fact it simply serves to speed industrialization, quite possibly laying the foundation of a subsequent development along fairly ordinary capitalist lines.

This particular problem clearly belongs to the typology of backwardness. In non-Soviet Europe it is of importance only in Turkey, Yugoslavia, Greece, and the Iberian peninsula. Western Europe proper—including Italy, which suffered its last relapse under Fascism—has moved out of the range of forced-draft mod-

926

ernization, and into an era of rapid selfsustained progress under conditions where industrialization begins to pay dividends. In a situation of this kind, the only real threat to political stability comes from mas unemployment (which hits the workers) and/or inflation (which affects primarily the salaried middle class). Political alignments consequently tend to shape themselves around the twin issues of full employment and monetary stability. In a fully industrialized society. "conservatism" signifies not defense of precapitalist interests (e.g., in agriculture), but rather the maintenance of middle-class values and standards such as home ownership, educational privileges, and various amenities associated with possession of individual property. "Liberalism" may come to stand for economic planning-a far cry from Cobdenite or Gladstonian orthodoxy. "Socialism" signifies concern for the status of lower-paid wage earners, while the historic goal of superseding "private ownership of the means of production" is tacitly abandoned, at any rate so long as the economy maintains full employment. The classical case is Scandinavia under Social-Democratic management, but Britain and the remainder of Western Europe show signs of following suit. Under circumstances of this sort, with growing wealth making for political quiescence, socialism loses its revolutionary edge, so that it is finally left to a minority of syndicalists and other enthusiasts to keep the pure flame of faith burning. It is, however, misleading to attribute this change in the political climate to embourgeoisement on the part of the workers or their leaders. The fact is that a society of this kind, though it may still be capitalist, cannot any longer be described as bourgeois.

The common ground occupied by so-

cial classes and political parties in contemporary Western Europe is the welfare state. This term is to be understood as signifying something beyond the enactment of legislation on public housing, unemployment compensation, progressive taxation, and other measures designed to equalize incomes and guarantee a minimum of social stability. Basically, it relates to the maintenance of full employment in a "mixed economy," which is still capitalist in the sense that the majority of investment decisions are made by private firms. Compared with the 1930's, when the unregulated market economy collapsed all over the Western world, the change is twofold: In the first place, the authorities now acknowledge their responsibility for maintaining something like full employment; secondly, the expansion of the public sector, plus governmental control over the central banks, enables them to adopt countercyclical measures, even if "business" (i.e., the private sector) lacks the necessary confidence to invest. A structure of this type is still basically a market economy, in that most decisions are decentralized and made by private individuals; but government intervention restricts the free play of the market in the interest of social stability and an adequate rate of growth. Income redistribution, through taxation and expansion of the social services, has the twofold object of ensuring economic growth and limiting inequalities. The rationale of this policy stems from the recognition that the traditional large disparities in income are no longer needed to provide the savings necessary for capital investment. This role is now increasingly shouldered by the state and by institutional saving of a kind not dependent on private wealth. The welfare state thus rests upon a mixed economy in which the public sector is large enough to set the pace for the kind of growth rate which society considers desirable.

The European boom of the 1950's and 1960's has been in part at least attributable to the adoption of this degree of conscious control over the economy; so, on the other hand, has the inflationary pressure which has now become the chief obstacle to balanced growth. The mixed economy sets targets which are difficult to reconcile: full employment, high investment, equitable income distribution, democratic decision-making, and price stability. The tug between public and private interests, and at a remove between rival political parties, turns upon the issue of achieving a proper balance. In principle, there is nothing in this picture that does not apply to the United States as well as to Western Europe. America led the world in the great depression of the 1930's and in the subsequent introduction of full employment and welfare measures (though it took the war to lift the economy out of its stagnation). Since 1946, the United States has been officially committed to the goal of maintaining a condition of more or less full employment. Yet for reasons having to do with the sociopolitical texturenotably the greater prestige of the business community as compared with Europe—the change-over to Keynesian, or welfare-state, economics has been halfhearted, while the West European governments have consciously adopted the mixed economy as the guideline of public policy. . . . Since mass unemployment is no longer politically tolerable, the governments concerned have more or less consistently adopted the necessary measures to ensure a rate of investment adequate to a state of (almost) full employment. Such measures . . . make for a level of public spending that precludes a return to low taxation; they also demand a constant effort at income redistribution so as to maintain purchasing power. . . .

Intellectually, the mixed economy is validated by the Keynesian orthodoxy in economics; politically, it corresponds to the pressures generated by a democracy with a strong organized labor movement. And since it is indeterminate as between capitalism and socialism, it can be operated by conservatives, liberals, and socialists alike. Stability is guaranteed as long as the parties respect the principle of balance between the public and private sectors of the economy, with the authorities reserving the right to lav down the general guidelines demanded by public opinion (or, what comes to the same, enforced by the mechanism of majority rule in a democracy). If labor is in power, the system acquires a "laboristic" bent which, however, does not alter its character sufficiently to make it possible for socialists to feel quite at home with it. Laborism is not socialism, though it tends in that direction. In itself it represents a compromise solution whereby society consents to leave the principal means of production—though not essential public utilities such as railways and power stations-in private hands, on the tacit understanding that the regulated market economy will conduce to a state of full, or almost full, employment. Governmental imposition of a growth rate adequate to this purpose follows from the discovery-now scarcely denied any longer by reputable economists—that the market economy by itself tends to stabilize below the full-employment lev-

It hardly needs emphasis that all this relates only to highly industrialized, and fully democratic, societies. Under prein-

dustrial conditions, state intervention has an altogether different function, though the difference is veiled by the current habit of describing as "socialist" both the welfare state in advanced and the authoritarian state in backward countries. In the latter, state control of the economy aims at speeding the process of industrialization, whereas in a fully developed welfare democracy of the Western type, the need for central control of the market economy arises from the maturity of an industrial society which has outgrown the liberal stage. There is indeed a common factor linking the two types, inasmuch as in both cases it is the failure of the market to sustain a high rate of growth that compels the intervention of the public authorities. In this rather general sense, the imposition of central planning in backward countries can be described as "socialist," though in the long run it may lead to the emergence of a "normal" capitalist market economy. But for theoretical purposes, the two cases must be rigorously distinguished, if only because antidemocratic movements feed on the confusion engendered by describing as "socialist" any and every form of state control, no matter what its political content. If Western democratic socialism is in question, it should be plain that industrial maturity is among its preconditions, just as it should be evident that "socialist" dictatorships are a concomitant of backwardness. The kind of socialism appropriate to industrial society is democratic, and conversely the mixed economy that responds to democratic pressures under conditions of industrial maturity has a socialist, or socializing bent: not . . . because the intellectual climate is hostile to private enterprise, but rather because the private sector is seen to play a subordinate part in mobilizing society's eco-

nomic resources and ensuring a sufficiency of aggregate demand. The fact that this particular problem arises under conditions of full industrial maturityi.e., after the phase of "primitive accumulation of capital" has been left behindnaturally alters the character of the debate between defenders and critics of the market economy. Controversy between liberals and socialists occurs not before but after liberal democracy has stabilized itself, and it concerns the problem of safeguarding individual and group freedoms within an increasingly planned and centralized economy. Terminology apart, this debate has little in common with the argument over dictatorial rule in backward countries, where "surplus value" has to be squeezed out of a reluctant peasantry for the purpose of financing industrial construction. "Socialization in a state of maturity," to employ Schumpeter's phrase, is a problem peculiar to cultures that have passed beyond this primitive stage. This is the ultimate reason why arguments between Eastern Communists and Western Socialists tend to be fruitless. Even where both sides employ Marxian language, they are not talking about the same thing. . . .

The tensions that emerge at this stage of social evolution are common to all mixed societies, whether governed by conservative, liberal, or laborist parties. Basically, they arise from the unsolved problem of establishing a social mechanism whereby conflicting sectional claims can be harmonized without damage to the public interest. By itself, the market economy cannot organize more than the material forces of society. Since these forces are not harmonious, they have to be arbitrated, and once the welfare state is in being, the role of arbiter falls to the government. The great economic inter-

ests are so many "solidarity blocs" pressing their sectional claims upon the authorities. Under nineteenth-century liberalism this problem solved itself automatically in favor of the business class, which was virtually in control of the market economy and could inflict crises of "confidence" and mass unemployment upon society whenever its claims were disregarded. Under welfare-state democracy, with capital and labor confronting each other as equals or near-equals, their sectional bargaining tends to promote constant inflationary pressures unless the government steps in. Inflation benefits the strongest sectors-monopolistic industry and the most powerful labor unions—at the expense of the weaker and more numerous members of society. Wage and price increases emerging from the inflationary spiral may even make consumer goods too expensive for the mass of buyers and thus precipitate the familiar cyclical depression due to insufficient demand. If the traditional disciplines of competition and unemployment are no longer adequate to restrain sectional conflicts in a fully democratized society, the public authorities have to step in and impose price and wage controls. Hence the extreme sensitiveness of labor movements to the issue of a wages policy, without which the system cannot be operated. In the long run it may indeed be to the advantage of trade unions and labor parties to take the initiative in formulating such a policy, which is anyhow in tune with the central tenets of socialism. But it is precisely at this point that socialist doctrine and laborist interest fail to harmonize. Nothing sounds more reasonable than to say that society must, in the last resort, decide how it wants to remunerate miners, nurses, policemen, etc.; but in practice, "society" boils down to the gov-

ernment of the day and/or the central planning authorities, however democratically controlled. By what criterionother than that of the market, which may no longer be effective—does one decide how much more a schoolteacher should be paid than a street cleaner? "Where should it all begin? The direct advance will be tentative and slow, and even if ideas of relative value were widely accepted by the public, their application in a free society would not be automatic." It is indeed precisely because Western industrial society is free and democratic that the operation of a planned economy raises problems quite unheard-of in lands where freedom is merely a name.

The inability to perceive these facts is among the marks of Soviet theorizing, which still operates with the concept of bourgeois-proletarian class conflict, as though nothing had happened since 1914. The obverse of this mistake is made by those interpreters of the "conventional wisdom"-with American academics well to the fore-who discuss the welfare state as though it merely signified (in the words of a recent survey already cited) "government responsibility for assuring to all citizens a standard of living at a 'health and decency level' and basic security against life's economic hazards." Although these aims have consistently figured in the literature of Fabianism and "collectivist liberalism" since before 1914, it does not follow that they adequately describe the present state of affairs in Western Europe. (They may designate the current aims and limitations of American liberalism, but that is a different matter.) In reality, socialwelfare legislation and income redistribution are aspects of a socialization process that circumscribes the operation of the market economy. The other half of this

process is constituted by the expansion of public ownership, and by the deliberate establishment of a balance between the public and private sectors. What underlies the whole movement is the persistent tension between social and market values, with the former gradually getting the upper hand. It is misleading to describe this by saving that "the proletariat at the base of the income pyramid and the idle rich at the peak have both disappeared, and people everywhere are acquiring middle-class habits and attitudes along with middle-class incomes." This is the language of political propaganda. The "idle rich" never mattered to anyone but sensational journalists, and the disappearance of the proletariat does not turn the working class into a middle class. (If it is in the "middle," who is at the bottom?) Least of all does it follow that industrial society retains a "bourgeois" complexion. There cannot be a bourgeoisie without a proletariat, and if the one is fading out, so is the other, and for the same reason: Modern industrial society does not require either for its operation. It is useless to pretend that one can have bourgeois society without classes, or a differently stratified society in which everyone belongs (a) to the middle class, (b) to no class at all. Yet American sociology seems largely devoted to the hopeless task of affirming both these contradictory propositions at once. It thus threatens to become the inverted mirror image of the Soviet theorizing it is trying to combat.

The reality is that contemporary industrial society is increasingly "postbourgeois," the nineteenth-century class structure tending to dissolve along with the institution of private entrepreneurship on which it pivoted. Hence the uncertainty that afflicts so much of current political

thinking. The "crisis of socialism" is also a "crisis of liberalism," not to mention the conservative defenders of preindustrial traditions, which indeed are now virtually identified with backward countries. In Western Europe proper, "conservatism"-whether on the British Tory model or the corresponding Christian-Democratic formations in Continental Europe—is in principle classless rather than aristocratic, and in practice a defensive organization of the old and new middle classes. Like other political movements it is torn between the conflicting claims of social and market values, though the dominant role of the business community within the middle class tends to weight the scales persistently in one direction. Conversely, the evolution of the traditional socialist movement since 1945 has proceded along the lines of transforming it into an alliance of organized labor and a section of the professional middle class, with the technical intelligentsia as its core. It is this transformation that distinguishes modern socialism from the pre-1945 variety and that causes political figures like Mr. Gaitskell or M. Mendès-France to present so strange an appearance against the background of clothcapped class consciousness typical of the traditional labor movement. . . .

It is beginning to look as though the mixed economy may become the fore-runner of something resembling a genuinely planned one, but it does not necessarily follow that democratic socialists will be any happier than liberals with some of the political consequences of this evolution. Leaving aside the Soviet orbit, which is perhaps too immature politically and economically to count for our purpose—many of its problems of growth seem due to lack of capital and similar marks of underdevelopment—it is still

possible to say that, despite the growth of central planning, democratic forms of public life have been preserved and even strengthened. It cannot be denied, however, that there has in recent years been a remarkable outcrop of technocratic tendencies—notably in such unlikely places as France. By technocracy is meant a tendency for authoritarian regulation of economic life, of a kind that is not, properly speaking, either liberal or socialist, and whose pivotal elements are neither employers nor industrial workers, but the planners themselves and their hangers-on, plus the managerial stratum as a whole. If this tendency should continue unchecked, state control may come to mean—temporarily anyhow—the rule of a new privileged stratum (not a "class," and certainly not a "new class," but rather a political elite with technical functions and a near-monopoly of specialized knowledge). This would be a curious gloss on some of the utopias we have been promised. The awkward thing is that such a state of affairs might even have to be regarded as "historically progressive" (whatever that may mean) while it lasts. So far, this is no more than a rather large cloud on the horizon. It will probably depend on the political maturity of democratic electorates whether the threat materializes.

VI. Science and Social Change

The peculiar characteristics of the world in which we live today are due above all else to mechanical inventions and scientific discoveries. The major problems we face: the possibility of atomic destruction, the relentless pressure of population growth, the advances of automation and cybernetics, with their combination of threat and promise for the livelihood and way of life of billions, stem from the discoveries and applications of science.

There can be no denying that we live in a revolution; that, since the 1930's and, even more, since 1950 mankind has known changes vaster and more profound than in any preceding millennium. The acceleration of change, an historical factor of the nineteenth century, has become a commonplace of the twentieth century.

Most people are aware of this, yet they persist in living and acting as if not much out of the way had happened or, at least, as if they had no effective part in it. Perhaps this is the only way they have of cushioning the shocks of change. They attempt, consciously or not, to keep their minds when all about them risk losing theirs, by applying the mind only to petty problems or to the new ones reduced to a familiar scale. Yet routine reactions to extraordinary problems contribute little to their solution. Ostriches, as a race, are in serious danger of extinction.

The first thing to be done about the problems that beset us is to face them, accept their existence and consider in what they consist and how they might be tackled.

1. THE PRESSURES OF SCIENCE

The discoveries of scientific research, like those of intellectual inquiry, have generally struck contemporaries as revolutionary influences subversive of the established order of things. The introduction of gunpowder or steam power, like the theories of class war or of a heliocentric universe, caused discomfort and trouble, disturbed vested interests and generally accepted philosophies. The man who suggests new techniques, like the one who brings up new ideas, can only perturb those who feel that things as they are are well enough. Society endures through conformity yet it lives on by change, adjusting its ways and its ideas only reluctantly.

In the essay which follows, a natural scientist interested in the interrelations of science and society considers whether the qualities which make the good scientist—disinterest, love of knowledge, relentless search for truth—may not be the very ones needed to solve or try to solve the problems which we face.

Science and Social Change

People today look upon science with ever deepening ambivalence. On the one hand it promises a material paradise, and on the other it threatens a nuclear inferno beyond Dante's wildest dreams. The scientists themselves have not been able to escape from this dilemma, even though some have struggled heroically to do so. In one breath they will agree that science is transforming our society and with the next they will attack the idea of technologically determined change as a form of communism. The fears and myths surrounding the relationship of science and social change have long obstructed a straightforward approach to the problem. C. P. Snow has recently tried to exorcise this specter:

One has to be ludicrously frightened of the shadow of Marx not to see earthy roots for the major transformations in scientific history. I am sometimes irritated that the West is so nervous of Marxist thought that we are unconsciously obfuscating ourselves.

The scientists are, of course, not averse to taking credit for the great blessings of science and its practical utilization in technology, but the discredit for the ever-menacing demons they may have unleashed is very bothersome. Many have tried to divest themselves of responsibility, and the most common rationale for this has been, "We discover, you employ." According to this view, the scientist only pursues truth, discovering new concepts, new forces, and new instruments. Other parts of society decide whether these shall be used for good or for ill. There is both truth and fiction in this hypothetical separation of powers.

A great lack of knowledge and sophistication is required to blame the scientists for the misuse of technical discoveries, and the same is no less true of a belief that scientists can intervene and guarantee a quick and sane solution to these problems.

On the other hand, sociologists such as R. K. Merton have shown the tremendous impact which culture has upon science and its practitioners. The interests of the culture indeed determine what kind of truths the scientist will pursue, and the naive vision of scientists working in their ivory towers, uncontaminated by social controversy around them, has been shattered. Merton described the situation in Social Theory and Social Structure:

The intensified division of labor has become a splendid device for escaping social responsibilities. As professions subdivide, each group of specialists finds it increasingly possible to pass the buck for the social consequences of their work on the assumption, it would seem. that in this complex transfer of responsibility there will be no hindmost for the devil to take. When appalled by the resulting social dislocations, each specialist, secure in the knowledge that he has performed his task to the best of his ability, can readily disclaim responsibility for them. And of course, no one group of specialists, the engineer any more than the others, alone initiates the consequences.

It is quite unrealistic to suppose that the scientists can avoid affecting public

"Science and Social Change," by Bruce Stewart, is reprinted with permission from the September 1961 issue of the *Bulletin of the Atomic Scientists*, Vol. xvii, no. 7, pp. 267–70, 286. Copyright 1961 by the Educational Foundation for Nuclear Science, Inc., 935 East 60th Street, Chicago, Illinois.

issues. Anything they say affects public issues. Anything they do *not* say affects these issues, for action is taken in default of their contribution. The effort to strip off their prestige as scientists when speaking about these matters, while commendable, is not likely to be entirely successful, nor should it be, for scientists often know more about some aspects of certain subjects than do laymen.

However, it is not the scientist's chief responsibility to give opinions on subjects where he has no special knowledge. Considered rationally, the main function of the scientist would be to bring to public problems those mental qualities and attitudes which have made him successful in science: critical analysis of old concepts, constant search for new and superior theories, insistence that all be based on evidence rather than generalized idealism and that they be accepted on the basis of predictive and analytic success, not on the strength of their tradition or the power of their special interests. Perhaps the scientist cannot originate social concepts but he can encourage the general expression of new ones and support the testing of those which show promise. This role is one which the scientists, social as well as natural, have avoided and which they have failed to assume.

How does one prove that such a failure has indeed occurred? First by the absence of widespread criticism of traditional ideas and the general non-circulation of radically different ones. This is the null hypothesis of the statistician. Simultaneously, there is an almost unchallenged currency of traditional beliefs, later to be illustrated. This unbalanced picture can scarcely be explained on any other grounds. Few surveys are available on the subject, but a 1937 sur-

vey by A. Kornhauser indicated that the engineers were more conservative than the big industrialists and only a little less so than the small businessmen. Probably the reactions of scientists are not greatly different from those of the general population, which has been shown to have a remarkable schizophrenia about its general principles and its specific practices. For example, an overwhelming majority favors freedom of speech, but most people are opposed to free expression for "radical groups." The more specific and operational the question of free expression of ideas that tend to threaten the status quo, the greater the resistance.

Why have scientists failed to perform the critical function of encouragement and rational support of new ideas? Probably the most important reason is that they shrink from the consequences. It is all very inspiring to speak of free inquiry, fearless search for truth, challenging old concepts and proposing new ones, but when this process threatens powerful interests and long cherished beliefs, then the scientific ideal shrivels under the hot glare of danger, passion, and antipathy. Scientists can suffer this prospect of alienation little better than can others. The attempt often follows to rationalize science into a position of harmony with the conservative faith. George Sarton whose perspective in science was very broad, took pains to demolish this harmony and to assert the revolutionary effect of science:

The resistance to scientific novelties was due to an intuitive, if unconscious, appreciation of their revolutionary nature. The slightest and most innocent scientific innovation is but a wedge which is bound to penetrate deeper and deeper, and

the advance of which will soon be impossible to resist. Conservative people are undoubtedly right in their distrust and hatred of science, for the scientific spirit is the very spirit of innovation and adventure into the unknown. And such is its aggressive strength that its revolutionary activity can neither be restrained nor restricted within its own field.

The scientists are aware, at least intuitively, of de Santillana's dictum: "Deviations from what is considered the essential orthodoxy have never, of course, escaped punishment since the beginning of history." Although we are thousands of years from the beginning of history, the situation has not changed very much; punishments are still things to be avoided and material rewards are perhaps even more to be sought. Threats by scientists to depart from orthodoxy are met with much agitated buzzing, so that the results are often very amusing. For example, in 1943 J. B. Conant wrote "Wanted: American Radicals" for Atlantic Monthly, an article which included an opinion by the author that all private property should revert to the state once every generation. One observer described the consequences as follows: "Conant was promptly set upon and badly stung by a majority of the various fellows, overseers, trustees, faculty members, and vintage graduates who uphold the Harvard tradition." Conant spoke no more about the need for American radicals and for property confiscation.

VESTED INTERESTS

On the ubiquitous subject of war and militarism, H. Brown and J. Real have recently commented in Community of *Fear* about the growing conservatism and special interests of many scientists:

Tens of thousands of scientists and technicians have devoted all of their professional lives to the invention and the construction of weapons. A majority of those who went to work after World War Two are convinced that weaponry is a way of life . . . Although these men are not generally openly political, they are in every sense the paramilitarycivilian soldiers. They have spent most of their adult lives in the direct or secondary employment of one or another of the services, and their sympathy for and concurrence with their uniformed colleagues are often marked and open. Should a showdown between the military and civilian sectors occur, this group could be relied upon to staunchly back the handlers of the weapons they have so devotedly evolved.

If this picture is accurate, many scientists threaten to become the modern merchants of death who were the cause of so much concern thirty years ago. In a similar way, the special interests of industry and government can exert a regimenting effect upon the scientists in their employ, and there may be the same reluctance to think or say anything which can be construed as biting the hand that feeds them. This feeling contributes to the support of feudalism, monarchy, or communism, but is scarcely consistent with scientific objectivity.

More money and fame for scientists is not necessarily an unmixed blessing, for there is inevitably some sense of quid pro quo, no matter how diffused it may be, and the scientist can betray his call-

ing to the extent that he gives hostages to fortune. Subsidies may easily become golden threads which tie down the exploring Gulliver to set ideas, set values, or set subjects of inquiry. As Ruskin observed, "Some slaves are bought with money and others with praise. It matters not what the purchase money is . . . The fact of slavery is in being driven to your work without thought at another's bidding." This is far from saying that discoveries which are sought by society cannot be good discoveries, but it would be more accurate to conclude that new concepts which are resisted or rejected by society are not necessarily bad concepts. The unquestioned tendency in scientific history to so regard many of them is invalid as well as dangerous. No one should know this better than today's scientists, yet far from being a new group of independent thinkers, the scientists show many signs of deepening the schizophrenia caused by the tug of war between scientific philosophy on the one hand and special interests and superspecialization on the other.

There are, of course, cases where modern scientists have publicly supported unorthodox social views, and perhaps among the most notable of these was Einstein's support of socialism. This has been either ignored or treated as an instance where a scientist was expressing faulty conclusions outside his specialty. The occurrence is very enlightening on several counts. First it illustrates what might be called the double standard of concept testing. For unorthodox beliefs such as socialism the degree of critical scepticism is high and there is a rigorous demand for supporting data. For the culturally accepted belief, in this case capitalism, criticism is not only unnecessary but unwelcome. Postulates are readily accepted without evidence. The occurrence also illustrates the difficulties which are to be experienced by involvement in social controversy. However, the reluctant scientist has one legitimate misgiving about his colleagues becoming the partisans of some organized doctrine (other than the accepted ones, of course). Alliance with any doctrine is unscientific and when it occurs, properly neutralizes much of the scientist's message. This leads to a still more important conclusion.

Poincaré observed that "in science it is necessary to be independent—utterly independent." But it is very difficult to be independent where there is great pressure to conform to dogmas such as capitalism, socialism, communism, democracy, and Americanism. These doctrines are not objectively derived concepts founded in causal dynamics but rather a compound of the purely descriptive, the idealistic, the mythological, and the opportunist. They may be well adapted for developing true believers and conducting propaganda campaigns, but they are poor instruments for analyzing, predicting, and ultimately controlling social change. There are several preconditions for the growth of scientific objectivity and successful control. We must sit down before many unpleasant facts which we have heretofore swept under the rug and learn how concepts may best be changed. In addition, social theory must be dusted free of its academic cobwebs, and as L. Hogben demanded, "get to grips with live contemporary issues if it ever hopes to enjoy the prestige of the natural sciences." Finally, we must distinguish sharply between our personal norms and our objective estimate of probable developments, for this is the first essential of any science.

ELEPHANTS, SLICED AND WHOLE

Modern social scientists have been captivated by the desire to imitate experimental physics, whereas the more important parallel with early astronomy has been slighted. The mass movements of society, which increasingly assume a broad pattern, are largely beyond experimental control, like the movements of celestial bodies, and vet microscopic laws can be detected. Moreover it is possible to test these laws in an empirical manner -by their ability to explain observed phenomena which have hitherto seemed unconnected or not satisfactorily accounted for, and by their ability to predict future events, new and unsuspected relationships, and to suggest productive lines of inquiry. If man is ever able to control the movements of celestial objects, it can only be as a result of comprehending their laws of motion. Likewise, if man is ever able to control the large scale changes in his society, this too can only become possible after a thorough understanding of these laws. Poincaré sardonically remarked that we cannot understand an elephant by restricting ourselves to thin slices of him seen under a microscope. This enormous organism called society can only be understood by a fearless study from all points of vantage, not the least important of which is microscopic analysis designed to detect dependable regularities. We have shrunk from the task of applying and systematically following up the consequences of radical new concepts.

The revolutionary impact of science is compelling us to conform to new circumstances of which we may have little appreciation. If we were rational creatures we would not wait to be dragged blindly into the future but would try to anticipate these tremendous changes by means of some new concepts. This new recognition does not, of course, exclude or minimize other dynamic processes besides science in man and in the environment. some of which have in fact given rise to Examples of these radical changes which will require new solutions are the maladiustments of automation, and the technology which triggered and is now impelling the rise of undeveloped countries: however it is more instructive to concentrate upon one which now occupies much of our time and thought: the changing role of war. Although man's traditional attitudes toward war and the methods and circumstances under which it is employed have been deeply implanted by the centuries, they are now being revolutionized by science. Thus far we have shown little capacity to anticipate the social consequences of these scientific changes and to bring our thinking into harmony with them.

The tragicomic efforts of the military, the superpatriots, and the civil defence advocates to preserve our old beliefs about preparedness and how to win wars may contribute to our amusement, to our expenditures, and perhaps even to the next war, but they can make no difference in the final result, though they may modify our path to that end. The campaign to move the population underground illustrates the power of conservative thinking. Yet if satellite bombs which will sear five states are soon to appear, we might make deeper holes to live in but we would not be likely to survive on a diet of rocks. We are not even close to any discovery which would free us from our dependence upon the land, which can be thoroughly poisoned or burned. New pathways must be broken, which in dangerous territory always involves frightening risk. In the event of war, says C. P. Snow, "We have a certainty of disaster. Between a risk and a certainty a sane man does not hesitate."

The dilemma of Nobel has been magnified as manifold as the power of the atom exceeds the power of dynamite. The costs of failure to bring our social thinking into harmony with the upheavals being caused by science are becoming more suicidal. Nevertheless there are powerful influences which stand in the way of any new exploration, as George Sarton so acutely described them:

Even now there are too many people, good citizens, pillars of society, who are afraid of science because they are afraid of truth: they will not face the facts of life. In order to cure a disease we must first understand it: the same is true of social diseases. In order to heal them we must first know them as well as possible. The Renaissance was an age of superstition, but so is our own, under the surface; science has made gigantic progress in certain fields, but in others, e.g. politics, national and international, we are still fooling ourselves.

Indeed we are, and furthermore we will not tolerate anyone pointing out instances of this self-deceit. These troublemakers are no longer burned, they are simply buried alive so deeply by the massmedia they can not be heard, and few people take any notice of them.

BURYING CRITICISM

The work of Fromm and Russell illustrates an effort to explore new concepts about war instead of being forcibly ab-

ducted into the future, which is now the case whether one agrees with them or not. The very mention of unilateral nuclear disarmament arouses strong negative feelings, but this reaction only illustrates the point at issue. Unilateral nuclear disarmament is by no means either logically indefensible or communistic, but the mass media are not free to treat this proposal as any more than a crackpot idea, for it promises only to diminish their profit and increase their troubles. Here again, the absence of any general criticism of established beliefs and dissemination of outrageous proposals, even when both are made available, proves the null hypothesis with regard to press freedom. It also provides a good example of what has already been called the double standard of concept testing. Finally, it cannot be over emphasized that any scientific analysis of nuclear disarmament and similar subjects of controversy must not allow an objective prognosis of probable developments to be influenced by what appears to be the most rational procedure.

The conclusion that science will ultimately proscribe war, however probable, gives no assurance about the next war. In fact a nuclear war would be a most compelling stimulus for the survivors to scrap all beliefs and to accept new ones which could effectively prevent its recurrence. H. G. Wells anticipated many modern developments of this kind and in a most remarkable book written, be it noted, in 1913, he predicted that atomic energy would be released in 1933. He foresaw the public battles over its control and utilization; he commented on the futile attempt to "put this explosive new wine into old bottles," and he despaired about "this profound, this fantastic divorce between the scientific and intellectual movement on the one hand, and the world of the lawyer politician on the other." He forecast that "By the spring of 1959 from nearly two hundred centers . . . roared the unquenchable crimson conflagrations of the atomic bombs . . ." Wells was just six years too early in his first prediction—the release of atomic energy. Will he be just six years too early in the last? It should be a matter of considerable interest to future historians to observe whether atomic war had to become inescapable before we were willing to inject the spirit of science into the world of the lawyer-politician-soldier.

The common picture of the scientist as a genius in his field and an illiterate outside it is a menace to the extent that it is true and to the extent that it blocks a more constructive attitude. The chief social function of scientists is to emphasize the applicability of scientific methods and attitudes to national and world

problems, particularly in the criticism of old concepts and in the proposal and testing of new ones. Opposition to this process is to be expected, but its productive benefits must be communicated in every possible way. Natural scientists may lack some relevant knowledge but the essentials are not difficult to gain. Moreover, it is surprising how little attention has been given to the interaction of science and society and to the exploration of new ideas and procedures. The main task is not to become steeped in more specialized social lore but to seek out and try new concepts. In this territory the scientist is no more a helpless neophyte than are the keepers of the established wisdom. The philosophy of his discipline (if he is indeed true to it) provides the most reliable means vet found to advance into the future-into that exciting room which nobody knows.

2. THE DEMOGRAPHIC PROBLEM

The population of Mexico numbered seventeen million in 1933 and thirty-four million in 1960. At the present rate of increase, the latter figure may be expected to double in twenty-seven years. In 2030, if the acceleration remains the same, there should be 272 million Mexicans; in 2075, over a billion of them.

Demographic projections are delusive things. Still, we are told to expect a world population of six billion by the year 2000. That was the figure given by UNO in 1959, a figure perhaps already out of date. It is generally thought that around the end of the century the population of the world will begin to double every twenty-seven years, like that of Mexico. Soon, Malthus's expectation of the population doubling every twenty-five years may come true. If we take this as the basis of some rather gruesome calculations, we may expect twelve billion in 2025, twenty-four billion in 2050, ninety-six billion in 2100, until, short of draining the seas, men will look back longingly to rush-hour conditions in the New York subway.

The article which follows was written by a member of an illustrious family of scientists and writers who has done a great deal to bring biological issues before the public. Julian Huxley was Director General of UNESCO in 1947–48.

Julian Huxley: World Population

The problem of population is the problem of our age. In the middle of the 20th century anyone who travels around the world, as I have recently done, cannot fail to be struck by the signs of growing pressure of population upon the resources of our planet. The traveler is impressed by the sheer numbers of people. as in China; by the crowding of the land. as in Java; by the desperate attempts to control population increase, as in Japan and India; and at the same time by the erosion, deforestation and destruction of wildlife almost everywhere. The experiences of travel merely highlight and illustrate a fact which for some time has been obtruding itself on the world's consciousness: that the increase of human numbers has initiated a new and critical phase in the history of our species.

This crisis was recognized by the holding of a Conference on World Population in Rome in 1954. Held under the aegis of the United Nations, the Conference was a milestone in history, for it was the first official international survey of the subject of human population as a whole. In 1949 the UN had convened a scientific conference on world resources at Lake Success. As Director General of UNESCO, invited to collaborate in this project, I had suggested that a survey of resources should be accompanied by a similar survey of the population which consumed the resources. I was told that there were technical, political and religious difficulties. Eventually these difficulties were smoothed over; censuses were taken; and a conference on population was duly held in 1954. During the five years it took to arrange for a look at

the problem the world population had increased by more than 130 million.

Let me begin by setting forth some of the facts-often surprising and sometimes alarming—which justify our calling the present a new and decisive phase in the history of mankind. The first fact is that the total world population has been increasing relentlessly, with only occasional minor setbacks, since before the dawn of history. The second fact is the enormous present size of the population-more than 2.5 billion. The third is the great annual increase: some 34 million people per year, nearly 4,000 per hour, more than one every second. The human race is adding to its numbers the equivalent of a good-sized town, more than 90,000 people, every day of the year. The fourth and most formidable fact is that the rate of increase itself is increasing. Population, as Thomas Malthus pointed out in 1798, tends to grow not arithmetically but geometrically—it increases by compound interest. Until well into the present century the compound rate of increase remained below 1 per cent per annum, but it has now reached 11/3 per cent per annum. What is more, this acceleration of increase shows no sign of slowing up, and it is safe to prophesy that it will continue to go up for at least several decades.

In short, the growth of human population on our planet has accelerated from a very slow beginning until it has now become an explosive process. Before the discovery of agriculture, about 6,000 B.C., the total world population was probably less than 20 million. It did not pass the 100 million mark until after the

The Scientific American, vol. 194, no. 3, March 1956, pp. 64-76. Reprinted with permission. Copyright @ 1956 by Scientific American, Inc. All rights reserved.

time of the Old Kingdom of Egypt, and did not reach 500 million until the latter part of the 17th century. By the mid-18th century it passed the billion mark, and in the 1920s it rose above two billion. That is to say, it doubled itself twice over in the period between 1650 and 1920. The first doubling took nearly two centuries, the second considerably less than one century. Now, at the present rate of acceleration, the population will have doubled itself again (from the 1920 figure) by the early 1980s—i.e., in the amazingly short space of 60 years.

Each major upward step in numbers followed some major discovery or invention-agriculture, the initiation of urban life and trade, the harnessing of non-human power, the technological revolution. During the present century the most decisive factor in increasing population has been of a different sort—the application of scientific medicine, or what we may call death control. In advanced countries death rates have been reduced from the traditional 35 or 40 per thousand to less than 10 per thousand. The average life span (life expectancy at birth) has been more than doubled in the Western world since the mid-19th century. It now stands at about 70 years in Europe and North America, and the process of lengthening life has begun to get under way in Asian countries: in India, for example, the life expectancy at birth has risen within three decades from 20 to 32 years.

BIRTH RATES VS. DEATH RATES

Population growth appears to pass through a series of stages. In the first stage both the birth rate and the death rate are high, and the population increases only slowly. In the second stage the death rate falls sharply but the birth rate stays high; the population therefore expands more or less explosively. In the third, the birth rate also falls sharply, so that the increase of population is slowed. Finally both the birth and the death rates stabilize at a low figure; thereafter the population will grow only slowly unless it is spurred by some new development, such as access to new food sources or a change in ideas and values.

In the Western world the reduction of the death rate came gradually, and its effect on population growth was buffered by factors which tended at the same time to reduce the birth rate—namely, a rising standard of living and industrialization, which made children no longer an economic asset.

Matters have been very different in the still underdeveloped countries of Asia. There death control has been introduced with startling speed. Ancient diseases have been brought under control or totally abolished in the space of a few decades or even a few years. Let me give one example. In England malaria took three centuries to disappear; in Ceylon it was virtually wiped out in less than half a decade, thanks to DDT and a well-organized campaign. As a result of this and other health measures, the death rate in Cevlon was reduced from 22 to 12 per thousand in seven years—a fall which took exactly 10 times as long in England. But the Ceylon birth rate has not even begun to drop, and so the population is growing at the rate of 2.7 per cent per annum-about twice the highest rate ever experienced in Britain. If this rate of growth continues, the population of Cevlon will be doubled in 30 years.

Almost all the underdeveloped countries are now in this stage of explosive

expansion. When we recall that rates of expansion of this order (2 to 3 per cent) are at work among more than half of the world's 2.5 billion inhabitants, we cannot but feel alarmed. If nothing is done to control this increase, mankind will drown in its own flood, or, if you prefer a different metaphor, man will turn into the cancer of the planet.

Malthus, a century and a hair ago, alarmed the world by pointing out that population increase was pressing more and more insistently on food supply, and if unchecked would result in widespread misery and even starvation. In recent times, even as late as the 1930s, it had become customary to pooh-pooh Malthusian fears. The opening up of new land, coupled with the introduction of better agricultural methods, had allowed food production to keep up with population increase and in some areas even to outdistance it. During the 19th century and the early part of the 20th food production increased in more than arithmetical progression, contrary to the Malthusian formula. We now realize, however, that this spurt in food production cannot be expected to continue indefinitely: there is an inevitable limit to the rate at which it can be increased. Although Malthus' particular formulation was incorrect, it remains true that there is a fundamental difference between the increase of population, which is based on geometrical or compound-interest growth mechanism, and the increase of food production, which is not.

There are still some optimists who proclaim that the situation will take care of itself, through industrialization and through the opening of new lands to cultivation, or that science will find a way out by improving food-production techniques, tapping the food resources of

the oceans, and so on. These arguments seem plausible until we begin to look at matters quantitatively. To accelerate food production so that it can keep pace with human reproduction will take skill, great amounts of capital and, above all, timetime to clear tropical forests, construct huge dams and irrigation projects, drain swamps, start large-scale industrialization, give training in scientific methods, modernize systems of land tenure and. most difficult of all, change traditional habits and attitudes among the bulk of the people. And quite simply there is not enough skill or capital or time available. Population is always catching up with and outstripping increases in production. The fact is that an annual increase of 34 million mouths to be fed needs more food than can possibly go on being added to production year after year. The growth of population has reached such dimensions and speed that it cannot help winning in a straight race against production. The position is made worse by the fact that the race isn't a straight one. Production starts far behind scratch: according to the latest estimates of the World Health Organization, at least two thirds of the world's people are undernourished. Production has to make good this huge deficiency as well as overtake the increase in human numbers.

A POPULATION POLICY

Is there then no remedy? Of course there is. The remedy is to stop thinking in terms of a race between population and food production and to begin thinking in terms of a balance. We need a population policy.

The most dangerous period lies in the next 30 or 40 years. If nothing is done

to bring down the rate of human increase during that time, mankind will find itself living in a world exposed to disastrous miseries and charged with frustrations more explosive than any we can now envision.

Even primitive societies practice some form of population control-by infanticide or abortion or sexual abstinence or crude contraceptives. Since the invention of effective birth control methods in the 19th century, they have been very generally practiced in all Western countries. Their spread to other cultures has been retarded by various inhibitions-religious, ideological, economic, political. It is worth noting that one retarding factor in the past has been the reluctance of colonial powers to encourage birth control in their colonies, often out of fear that they might be considered to be seeking to use population control as a weapon against an "inferior" race.

Today the underdeveloped countries are making their own decisions; what is needed is a new and more rational view of the population problem everywhere. We must give up the false belief that mere increase in the number of human beings is necessarily desirable, and the despairing conclusion that rapid increase and its evils are inevitable. We must reject the idea that the quantity of human beings is of value apart from the quality of their lives.

Overpopulation—or, if you prefer, high population density—affects a great many other needs of mankind besides bread. Beyond his material requirements, man needs space and beauty, recreation and enjoyment. Excessive population can erode all these things. The rapid population increase has already created cities so big that they are beginning to defeat their own ends, producing discomfort

and nervous strain and cutting off millions of people from any real contact or sense of unity with nature. Even in the less densely inhabited regions of the world open spaces are shrinking and the despoiling of nature is going on at an appalling rate. Wildlife is being exterminated: forests are being cut down, mountains gashed by hydroelectric projects. wildernesses plastered with mine shafts and tourist-camps, fields and meadows stripped away for roads and aerodromes. The pressure of population is also being translated into a flood of mass-produced goods which is washing over every corner of the globe, sapping native cultures and destroying traditional art and craftsmanship.

The space and the resources of our planet are limited. We must set aside some for our material needs and some for more ultimate satisfactions—the enjoyment of unspoiled nature and fine scenery, satisfying recreation, travel and the preservation of varieties of human culture and of monuments of past achievement and ancient grandeur. And in order to arrive at a wise and purposeful allocation of our living space we must have a population policy which will permit the greatest human fulfillment.

If science can be applied to increase the rate of food production and to satisfy our other needs, it can and should also be applied to reduce the rate of people production. And for that, as for all scientific advance, we need both basic research and practical application. Basic research is needed not only on methods of birth control but also on attitudes toward family limitation and on population trends in different sections of the world. Once we have agreed on the need for a scientific population policy, the necessary studies and measures to be applied

will surely follow. This does not mean that we should envisage a definite optimum population size for a given country or for the world as a whole. Indeed, to fix such a figure is probably impossible, and to use it as a definite target is certainly impracticable. For the time being our aim should be confined to reducing the over-rapid population growth which threatens to outstrip food supply. If we can do this, our descendants will be able to begin thinking of establishing a more or less stable level of population.

JAPAN AND INDIA

With these general observations as our guide, we can now get a clearer grasp of the population problems of individual countries. Since the end of World War II, we have seen a new phenomenon in the world's history. Two great and powerful nations, India and Japan, have officially adopted the policy of population control.

Japan I was unable to visit, but its demographic plight is so extreme and so illuminating that I shall take it first. Japan's 90 million people are crowded into an area only one and one-half times as large as the small British Isles. The country is so mountainous that it affords only one-seventh of an acre of cultivable land per head. And its population is increasing by more than 1 per cent per annum, so that within 10 years it will easily overshoot the 100-million mark.

The Japanese are not well nourished: the average daily calorie intake is only 2,000. About one-fifth of this meager food supply must be imported, despite the fact that the Japanese have developed the highest rice yield per acre in Asia. Since the war lost them their empire,

and the isolation of Communist China deprived them of their biggest market, the Japanese have been able to subsist only through aid given by the U.S. As a recent report on World Population and Resources by the Political and Economic Planning (P.E.P.) organization in Britain says: "Japan is undoubtedly the most overpopulated great country there has ever been."

Realizing that no expansion of its industry and trade could possibly take care of a major increase in its population, the Japanese Government has embarked on a firm policy of population control. In Japan infanticide was widely practiced until some 80 years ago. As its first move after the recent war the Government turned to an almost equally desperate measure: it legalized and indeed encouraged abortion. The number of induced abortions rose from a quarter of a million in 1949 to well over a million in 1953. As was to be expected, the effects on the health of Japanese women were deplorable-and the annual percentage rate of population increase was still above the prewar level.

With these stark facts in mind, the Japanese Ministry of Health's Institute of Population Problems in 1954 passed a strong resolution urging government encouragement of contraception. It proposed that birth-control facilities be provided as part of the health service, that medical schools pursue research and include family planning in the curriculum, that doctors called upon to induce an abortion should be required to provide the woman with information about birth control for the future and that national wage and taxation policies should be such as to avoid "encouraging large families."

Drastic though these recommendations are, they or something very like them

are necessary, and it is much to be hoped that they will be speedily and thoroughly implemented. If they are successfully put into practice, they will not only save Japan from disaster but will provide valuable lessons for other countries.

India's problem is rather different. It is an immense country—the best part of a subcontinent—with large resources waiting to be developed. Its present rate of population increase is just under 1½ per cent per annum—lower than that in the U.S. (which is 1.6 per cent, excluding immigration). Its immediate future is not quite as desperate as Japan's.

But India is still in the early expanding stage of the population cycle. Its death rate (now about 26 per thousand) has just begun to fall, and has a long way to go before it drops to that of advanced countries. Meanwhile its birth rate (about 40 per thousand according to the latest available figures) is well over double that in Western Europe, and shows no signs of dropping. If the death rate is cut to the extent that the Ministry of Health expects, and if the birth rate remains at its present level, within a few years India's annual increase of population will be some eight million equivalent to adding a new London each vear!

Moreover, India's population even now is not far from the borders of starvation; it must increase its food production drastically to achieve the barest minimum of decent living for its people. Their average daily diet is a mere 1,590 calories. At least two thirds of India's 380 million people are undernourished. Methods of cultivation and systems of land tenure are primitive and will need a painful and difficult process of improvement before they begin to satisfy modern requirements. Tradition, taboos, ignorance and

illiteracy are grave obstacles to progress. Comparatively little more land could fruitfully be brought into cultivation, and deforestation compels the people to burn cow manure as fuel, thus robbing the soil of fertilizer.

Above all, the mere size of the problem is formidable. Even at the present rather modest rate of increase, five million people are added each year.

INDIA'S MASSES

The size of India's human flood was forcibly brought home to me in 1954 when I visited the ill-fated Kumbh-Mela of that year. This religious festival is held at the junction of the two great rivers, the Jumna and the Ganges, at Allahabad. The assembled pilgrims acquire merit and salvation by bathing in the rivers' sacred waters. Every 12th year the festival is especially sacred, and the Kumbh-Mela of 1954 was uniquely important as being the first of these high points to occur after India's independence. One day of the festival is particularly auspicious and to bathe on that day is especially efficacious.

Pilgrims had converged from all over India—by train, by cart and by shanks' mare. On the day we arrived, two and a half million people were encamped on the flats by the river, and three days later, on the great day of the festival, the number had grown to four and a half million! I shall never forget the spectacle of this enormous human ant heap, with its local condensations of crowds converging onto the temporary pontoon bridges over the Jumna to reach the sacred bathing grounds. A crowd of this magnitude makes a frightening and elemental impression: it seems so impersonal and so

uncontrollable. This impression was all too tragically borne out three days later, when the crowd got out of hand and trampled 400 of its helpless individual members to death.

Calcutta was another manifestation of India's mere bulk. The overgrowth of cities has been a constant accompaniment of the growth of population: the hypertrophy of Calcutta has been exceptionally rapid and severe. In 1941 the population of greater Calcutta was under three million; today it is nearly five million. Its appalling slums are crowded to the rooftops, and at night the pavements are strewn with an overflow of people who have nowhere else to sleep and are forced to share the streets with the miserable roaming cattle. This was impressed upon me on the evening of my first day in the city by a scene I shall never forget. In one of the busiest streets a man and a cow approached a traffic island from opposite angles and composed themselves for the night on either side of the traffic policeman.

The Government of the new, independent India born in 1947 showed a refreshing courage in grasping the formidable nettle of overpopulation. Recognizing that superabundance of people was one of the major obstacles to Indian prosperity and Indian progress, they made the control of population one of the aims of their first Five-Year Plan. The Census Commissioner of India, in his report on the 1951 census, put the problem in quantitative terms. Efforts to keep pace with the growth of population by increasing food production were bound to fail, he said, when the population passed 450 million. If, however, India could "reduce the incidence of improvident maternity to about 5 per cent," an increase of 24 million tons per year

in agricultural productivity would be sufficient to feed the population and bring a "visible reduction of human suffering and promotion of human happiness."

INDIA'S EFFORTS

The Indian Health Ministry has made grants for research on new contraceptives, for certain population studies, for training workers in the field of family planning and material and child welfare, for educating public opinion, and for assisting the family-planning ventures of state governments and voluntary organizations.

It is heartening that a great country like India should make population control part of its national policy. But it must be confessed that the effects are as yet exceedingly small, and that to an outside observer the execution of the policy seems rather halfhearted.

Let me take an example. The one large-scale experiment initiated by the Government itself has been a pilot study of the so-called rhythm method of birth control, which is notoriously unreliable, owing to the great variation among individual women, and even in the same woman at different times, in the monthly period of infertility. I had the opportunity of visiting the chief center of the experiment in a village near Mysore, and of interviewing the capable and attractive woman in charge, a Negro social scientist from the U.S.

The results of the experiment were interesting. About three quarters of the married women in the village said they would like to learn some method of limiting their families. After their individual cycles were studied each woman was given a kind of rosary, with differently

colored beads for "safe days" and "baby days." With this guidance a number of the women managed to avoid pregnancy during the 10 months of the experiment. The social scientist in charge thought that about 20 per cent of Indian village families might learn to practice the rhythm method successfully. This was a maximum; in any widespread campaign the figure is much more likely to be 15 or 10 per cent. Thus the method would be quite inadequate to control population growth to any significant degree.

Methods used in Western countries are difficult to apply in India, partly because of the cost, partly because of the lack of privacy and hygienic facilities in the vast majority of Indian homes. In addition, there is the persistent influence of Gandhi. As he narrated in his autobiography, Gandhi indulged excessively in sexual pleasure after his marriage. As a result of his disgust at his own indulgence, and his dislike of anything he considered to be scientific materialism, he pronounced against all mechanical or chemical methods of birth control and solemnly recommended abstinence as the cure for India's population problem!

The ideal solution would be the discovery of what laymen (much to the annoyance and distress of the experts) persist in calling "the pill"—a cheap and harmless substance taken by mouth which would temporarily prevent conception, either by preventing ovulation or by rendering the egg unfertilizable. A number of promising substances are being investigated, including some extracts of plants used by primitive peoples. So far nothing safe and reliable has emerged. But our knowledge of reproductive physiology and of biochemistry has been so enormously increased in the last few

decades that I would be willing to bet that a solution can be found. A large-scale, concerted program of research is necessary, as it was for the atomic bomb. If we were willing to devote to the problem of controlling human reproduction a tenth of the money and scientific brain-power that we are devoting to the release of atomic energy, I would prophesy that we would have the answer within 10 years, certainly within a generation.

One of the facts that prompted the Indian Government to undertake the task of reducing population increase was the ghastly recurrence of famine in 1952, when a major tragedy was averted only by large-scale importations and gifts of wheat and other food-stuffs from other countries. Famine will continue to recur in India so long as population is not brought down into a reasonable balance with the production of food.

The Government has made heroic efforts to increase food production, and for the first time in modern history India has now a surplus of home-grown food—at the meager-diet level. But this has been made possible by two good seasons of abundant rain; when the climatic cycle brings the bad years around again, as it inevitably will, hunger once more will stalk the land. The long-term prospect is blacker: if population goes on increasing by five millions or more a year, food production cannot possibly continue catching up with the mouths to be fed.

The Government is also devoting more and more attention to industrializing the country, both by small-scale village industries and by large-scale projects. However, while industrialization is highly desirable, it is chimerical to suppose that it alone can cope with India's food and population problem.

INDONESIA

Indonesia, another country with an extraordinary population problem, contains the most densely populated large island in the world. Java has more than 50 million people on its 50,000 square miles—a density of population nearly twice that of highly industrialized Britain. Yet Java is almost entirely agricultural. Its cultivable land is very fertile, but there is less than two fifths of an acre per head. And much of the land is devoted to exportable products, so that rice has to be imported to feed the people, even at the insufficient level of about 2,000 calories per day.

Java's already overcrowded population is increasing at a compound interest rate of at least 1.5 per cent per year. A simple answer seems at hand: The excess should be transferred to the large nearby Indonesian islands of Sumatra and Borneo. which are far less thickly populated. But this facile suggestion has proved to be quite impracticable. With considerable difficulty the Indonesian authorities have persuaded some Iavanese to move to Sumatra, but many of these have not been able to stand the hardships of pioneering agriculture and have either returned to Java or settled into a depressed urban life on the Sumatra coast. The fact is the material resources and the skills needed to convert the dense equatorial forest of Sumatra and Borneo to agricultural production are not available. This is not to say that settlement should not be attempted. But resettlement of Java's population on the largest possible scale, plus other economic and political development, could not possibly cope with more than a part of Java's formidable annual surplus of people. Birth control also is necessary. Unfortunately there is

no sign yet that the Indonesian Government recognizes this necessity.

Bali, whose population density (over 500 per square mile) is about half that of Java, grows just about enough rice to feed itself. However, if its population continues to grow at the present high rate it will seriously outstrip food production in two or at the most three generations. Bali provides an extreme illustration of the erosion of a culture by world population pressure. The Balinese have a rich and vital cultural tradition. in which beauty is woven into everyday living. Every aspect of life is marked by some celebration or embellished with some form of decoration. Every Balinese participates in some form of creative activity—music, dance, drama, carving, painting or decoration. What is more, the tradition is not rigid, and the culture is a living and growing one, in which local and individual initiative are constantly introducing novelty and fresh variety. But the Balinese are afflicted with many preventable diseases; they are largely illiterate (though far from uncultured): their religion is now being undermined by the Christian missionaries who have at last been allowed to work in Bali: growing economic pressure forces them to take advantage of the flood of cheap massproduced goods from Western technology; their mounting population demands some adaptation to modern industrial life if living standards are to be raised or even maintained, and this in turn is imposing a Westernized system of compulsory education.

Most foreign residents prophesy that Bali's unique and vital culture is doomed, and will wither and die within 10 or 15 years. This may be overgloomy, but certainly it is in grave danger. We can only hope that the Indonesian Government

will realize the value of this rich product of the centuries, and that UNESCO will justify the C in its name—C for Culture—and do all in its power to help. No one wants to keep the Balinese in a state of ill health and ignorance. Yet instead of being pushed by the well-meaning but ill-considered efforts of overzealous missionaries and "scientific" experts to believe that their traditional culture is a symbol of backwardness, they could be encouraged to retain faith in the essential validity of their indigenous arts and ceremonials, and helped in the task of adapting them to modern standards. A traditional culture, like a wild species of animal or plant, is a living thing. If it is destroyed the world is the poorer.

THAILAND AND FIJI

The situation of Siam, or Thailand as it is now officially called, is in some ways not dissimilar to that of Bali. It is in the fortunate position of producing enough rice not only to feed its own people but also to export a considerable amount to less favored countries. Its people are well fed and look cheerful. Thailand is proud of its past, and especially of the fact that it alone of Southeast Asian countries has never lost its independence. There is a traditional culture in which the bulk of the people are content to find fulfillment. though there is not so much active participation or artistic creation as in Bali. At the same time, Thailand is crowded with organizations and agencies, international and national, which are giving advice and assistance on every possible subhealth. education, agriculture. democracy, scientific development, administration, industry, fish ponds and rural community life. As a result the traditional Siamese culture is being crushed or undercut.

Unless Thailand's birth rate falls along with the death rate, she will lose her proud distinction among Asian countries, and will become seriously over-populated well before the end of the century. Thailand needs better coordination of her departments of government with the motley collection of foreign agencies, and an over-all plan which would take account of population and traditional culture as well as food production and industry, science and education.

Fiji is another island, with another problem. Its population of about a third of a million is made up of two separate populations, which at present are about equal in number—the indigenous Fijians and the immigrants from India (together with a handful of Europeans, Chinese and others).

The history of the two populations is instructive. The native Fijian population numbered nearly 200,000 in 1850, had fallen to 150,000 when the islands were taken over by the British in 1874, and was steadily reduced by a succession of epidemics to a point well under 100,000 before health measures introduced by an alarmed administration reversed the decline. It is now around 140,000. Immigration from India started in 1879 and has continued to the present day. The Indian population outstripped the Fijian during World War II and has now passed 150,000. Since its rate of increase is well above that of the Fijians, Indians will in the space of two or three generations constitute a large majority unless present trends change.

The two groups are very different in physique, cultural background, interests and work habits. The Fijians have the finest physique I have ever seen: they make good soldiers and wonderful athletes. But their athletic and warlike propensities have induced no great keenness for Western education, and a definite dislike of regular agricultural work. Indians largely man Fiji's sugar plantation economy. They make excellent laborers and small farmers and traders, and have a notable thirst for education. They have even started secondary schools on their own initiative and at their own expense.

There is little intermarriage between the two groups, and indeed little liking. The Indians tend to regard the Fijians as barbaric, while the Fijians (who still take a sneaking pride in their warlike and cannibal past) find the Indians effeminate and affect to despise their laborious way of life. However, there are now signs of a rapprochement, and some of the younger Fijians are realizing that they must change their attitude toward work and education if the Fijian community is not to lapse into a sort of living fossil, cushioned by the protective measures of the Colonial Government. Once this new attitude is realized in practice, and the Fijians accept Western standards more wholeheartedly, their death rate is bound to fall and their numbers to jump. Since the Indian rate of increase shows no signs of falling, a demographic crisis looms ahead. Fiji will become overpopulated within the lifetime of its younger inhabitants, unless the Fijians and Indians alike are introduced to the necessity and desirability of family limitation. Unfortunately birth control is still taboo, or at least not publicly acceptable, in the British Colonial Office (and indeed in the governments of all other colonial powers). I can only hope that too much economic distress and social misery will not be required to force the action that present intelligent foresight could undertake—and could now undertake with much less difficulty than when the cohorts of the yet unborn have swelled the population to disastrous proportions.

AUSTRALIA

Australia is a storm center of demographic controversy. She is a continent of close on three million square miles with only nine million human inhabitants. Yet she is committed to a "white Australia" policy, and admits no Asians or Africans as immigrants, though she is on Asia's back doorstep. The three great swarming countries of Asia-India, China and Japan-have for decades been casting longing eyes on Australian space as a possible outlet for their surplus people: if the Axis powers had won the war, the Japanese undoubtedly would have established settlements in Australia on a large scale.

However, Australia's open spaces are, from the point of view of human occupation, largely a mirage. For an indefinite time its uninhabited areas will remain blanks on the world's map. Three quarters of Australia is desert or semidesert. At the present time only 2.5 per cent of Australia's land is cultivated. It is true that big irrigation schemes are being planned, and that the discovery that much poor land could be enriched by adding trace elements is heartening the farmers and wine growers and herders. But heavy additions of fertilizers would also be needed, and these, like irrigation schemes, are expensive.

Never is a big word, but it looks as if much of the land can never be brought into cultivation. I was driven down from Darwin to Alice Springs—a thousand miles of increasingly sparse bush and increasingly stony and barren soil, miserable and for the most part intractable to human effort. The best estimates put 7.5 per cent as the maximum area of Australia's surface which can be brought into cultivation, and to achieve even this will demand great effort and great expenditures of capital.

Australia is underpopulated in the double sense that it could support a larger population and that a larger population would benefit its economy. How much larger is a question. Some say 50 million people, but this seems an over-optimistic estimate. A total of 25 or at most 30 millions seems more reasonable. And this would absorb less than one year's increase of Asia's population, less than five years of that of India alone. Furthermore, Australia already is hard put to it to keep up living standards in the face of its present rate of population growth, which is one of the highest in the world (about 2.5 per cent per annum), thanks to its policy of encouraging and assisting immigration from Europe. Thus the idea of Australia becoming an outlet for the spillover of Asia is chimerical. The highest rate of human absorption possible without jeopardizing economic health could not take care of more than a small fraction of Asia's annual increase.

The white Australian policy remains as an affront to Asian sentiment. But this too has, in my opinion, strong arguments in its favor. Certainly it cannot and should not be justified on grounds of racial superiority or inferiority: there is no such thing. But it can be justified on cultural grounds. Cultural differences can create grave difficulties in national development. They often do so when cultural and racial differences are combined. A large minority group which clings to

its own standards and its own cultural and racial distinctiveness inevitably stands in the way of national unity and creates all sorts of frictions. And if the immigrant group multiplies faster than the rest of the population, the problem is aggravated, as we have seen in Fiji.

It should be put on record that there is little color prejudice in Australia. For its aborigines—the only nonwhite permanent inhabitants of the continent—the watchword now is assimilation: they are gradually to be incorporated into the country's social and economic life. Australia is also admitting a number of Asians as students or trainees, and giving them a very friendly welcome. What Australia seeks to guard against is the creation of permanent racial-cultural minorities.

RESOURCES

Such are some of the population problems of individual countries as I saw them in my tour of Asia and the Far East. The obverse of the population problem is the problem of resources, and I must say a word about the alarming differentials in consumption between different regions and nations. Even in food these are serious enough. The average daily diet in India (1.590 calories) is less than half that in countries such as the U.S. or Ireland. And between the more privileged classes of favored countries and the poorer ones of the underdeveloped countries the difference of course is much greater-nearly fourfold instead of twofold. When we come to other resources, the contrasts are still more startling. In the field of energy, the U.S. per capita consumption is double that of Britain and more than 20 times that of India. The U.S. consumes 80 times more iron

per capita than India and nearly two and one-half times more newsprint per capita than Britain. It uses about two thirds of all the world's production of oil.

As facts like these seep into the world's consciousness, they are bound to affect the world's conscience. Such inequalities appear intolerable. The privileged nations are beginning to experience a sense of shame. This guilty feeling finds a partial outlet in the various international schemes for technical and economic assistance to underdeveloped countries. But these schemes are not nearly bold or big enough. We need a world development plan on a scale at least 10 times as big as all existing schemes put together-a joint enterprise in which all nations would feel they were participating and working toward a common goal. To achieve even the roughest of justice for all peoples, the favored nations of the world will have not merely to cough up a fraction of their surpluses but voluntarily to sacrifice some of their high standard of living. For their part the underdeveloped countries, to qualify for membership in the international development club, must be willing not only to pledge themselves to hard and intelligent work but also to restrict their population growth.

As I have emphasized, the crux of the problem lies in establishing a satisfactory balance between the world's resources and the population which uses the resources. The Political and Economic Planning report to which I have referred surveys in some detail the prospects of the world's main resources for the next 25 years. It concludes that so far as energy, minerals and other inorganic raw materials are concerned, the total world requirements probably can be met during that period, and for energy the pros-

pect continues reasonably bright up to the end of the 20th century. But when it comes to food, a world deficiency "of appalling magnitude" already exists, and "supplying the necessary foodstuffs to feed the expected newcomers and also to bring about substantial and lasting improvement in the position of the many millions now underfed is likely to prove exceedingly difficult and increasingly precarious."

This forecast, it must be emphasized, applies to global consumption; when we take the position of individual countries into account, the situation appears even more serious. The trend is toward a widening of the already grotesque differences in consumption between the well-nourished and the undernourished regions of the world. For one thing, a rise in living standards in food-exporting countries is reducing the amount of food they have available for export; for example, Argentina is exporting less meat because its people are consuming more of its production.

Everything points to one conclusion. While every effort must be made to increase food production, to facilitate distribution, to conserve all conservable resources and to shame the "have" nations into a fairer sharing of the good things of the world with the "have-nots," this alone cannot prevent disaster. Birth control also is necessary, on a world scale and as soon as possible.

Though I may seem to have painted the picture in gloomy colors, I would like to end on a key of hope. Just as the portentous threat of atomic warfare has brought humanity to its senses and seems likely to lead to the abandonment of allout war as an instrument of national policy, so I would predict that the threat of overpopulation will prompt a reconsideration of values and lead eventually to a new value system for human living. But time presses. This year will add more than 34 million people to humanity's total, and certainly for two or three decades to come each successive year will add more. If nothing is done soon, world overpopulation will be a fact well before the end of the century, bringing with it an explosive cargo of misery and selfish

struggle, frustration and increasingly desperate problems.

It has taken just one decade from Hiroshima for the world to face up resolutely to the implications of atomic war. Can we hope that it will take no more than a decade from the 1954 World Population Conference in Rome for the world to face up equally resolutely to the implications of world overpopulation?

3. THE UNDERDEVELOPED WORLD: NEOCOLONIALISM?

The last fifteen years have been specially marked by the emergence of new states in Africa and Asia, born of the disintegration of European colonial enterprises, many of them lacking social or geographical coherence, all of them lacking a solid economic basis. These new states are not alone in their economic backwardness, although their "underdevelopment" is often a function of thoughtless overdevelopment in monoculture, with consequent soil exhaustion or overdependence on world market fluctuations; a function also, paradoxically, of overdevelopment in sanitation without parallel rises in food production and employment opportunities for the rising population. Older nations, like those of Latin America, are in the same position. All these countries are generally short on food and long on people. Their economies continue dependent on those of the industrial West, their independence is restricted largely to nuisance value, and their pretensions are often in proportion to the resentments which such a position creates.

The problems arising from this state of affairs have been attributed to colonialism and its aftermath. To the extent this is true, the explanation must be extended to the underdeveloped nations themselves and, especially, to their leaders whose vociferousness is matched, at times, only by their incapacity; to their rich whose fears seldom transcend their shortsighted selfishness; to their failure not only to secure the investment capital they need, but also to put what capital and resources they have to good use. Some of the issues involved in improving the situation (or, simply, in living with it) are discussed from a European point of view in the passage below.

Europe and Africa

The problem, such as it is, arises not so much from the legacy of colonialism as from the enduring unbalance between the industrialized core of the Western world and its agrarian hinterland. In this respect Latin America, which freed itself from foreign domination a century and a half ago, is not significantly better

Reprinted from George Lichtheim, *The New Europe*, Frederick A. Praeger (New York, 1963) pp. 166–174.

off than Africa and Asia. Recent international studies have laid stress on the permanence of a pattern with which the world has slowly become familiar: growing surpluses of food in the wealthy countries of North America and Western Europe, plus Australia-New Zealand, while shortages and malnutrition persist in much of the remainder, the so-called undeveloped or "underdeveloped." There seems every reason to believe that by 1970 the food surpluses of the industrial countries will have grown even larger. On the other hand, there also impend surpluses of tropical products, such as sugar and cocoa, which could ideally help the backward countries to obtain the food, fertilizers, and machinery they need but will not get if prices are depressed; hence the desire for stable world prices or guaranteed export markets. This need presses far more hardly upon the poor countries than upon the rich, which are now applying modern production techniques to farming with such good effect that their dwindling agricultural populations pour out a growing cornucopia of unsalable surpluses. In North America it is now accepted that the urban population cannot consume all the food that is grown, despite deliberate acreage shrinkage; Western—though not Eastern—Europe is likely to reach the same stage by 1970. At the same time, the market in these countries for tropical products (including quasi-luxuries like cocoa and coffee) does not grow fast enough to absorb the surpluses of the Latin American regions and the former colonial territories in Africa and Asia. Their own subsistence crops being inadequate, while their exports encounter inelastic markets, these countries face mounting difficulties at the very moment when their political elites have decided to break out of the circle

by investing heavily in ambitious industrialization schemes. Even if investments are switched from industry to farming, most of the countries in question are unlikely by 1970 to have emerged beyond the poverty line, i.e., beyond the point where they manage to grow just enough food in terms of energy (calories) to keep their populations from starving.

The orthodox liberal solution to this problem is familiar. "The way to feed Hong Kong or India is to buy their textiles. The way to feed Nigeria or Tanganvika is for Europeans to consume more coffee and chocolate. This can be doneby pulling down American and Common Market protective tariffs or excise taxes by opening the doors, at whatever temporary cost to American millworkers, European peasants, vested interests on either side of the Atlantic." Unfortunately this leaves unanswered the question what is to happen if American workers and European peasants prove obdurate. One of the aims of the Common Market is to reduce Europe's dependence on outside imports, though this has been balanced by granting special privileges to Europe's former African colonies. But such privileges go against the universalism of the liberal school. It is also uncertain how that school would react, were it suggested that Europeans and Americans could probably consume more sugar, coffee, cocoa, and other tropical foodstuffs, if their citizens in the mass really possessed that degree of "affluence" with which they are credited by liberal economists in their more expansive moments. The fact seems to be that Western "affluence" is not great enough to make a significant difference when it comes to purchasing the export crops of the poorer countries—except where political considerations have tipped the balance, as in the case of Eurafrica.

In the end it seems likely that the United States will have to do for Latin America what Western Europe is currently doing for its African hinterland: Pour in the necessary investment funds in the form of grants rather than loans, and at the same time supply a guaranteed market for export crops. Even so it is going to be a close-run thing. For Western Europe—already saddled with the necessity of having to drag Spain, Portugal, Greece, Turkey, and Northwest Africa into the modern world—the additional need to look after the interests of Black Africa south of the Sahara imposes a burden democratic electorates find hard to bear. but which nonetheless cannot be shirked. This may help to account for the fact that the national legislatures of the various European countries increasingly devote their time to strictly domestic matters.

BEYOND IMPERIALISM

It seems appropriate to conclude the discussion of this subject with some brief reflections on the well-worn theme of imperialism. Has the colonial chapter really been closed, or is there some truth in the assertion that Western relations with the backward, tropical, and subtropical countries have been no more than superficially revamped and are currently about to enter what is described as a "neocolonialist" stage of economic exploitation veiled by the formal trappings of independence? The charge, when directed against Britain and France, is the more plausible since it can be argued that something of the kind has indeed marked the relations between the United States and most Latin American countries over the past century. It can also be held that, quite irrespective of power relationships, the "normal" exchange of goods and services between developed and undeveloped areas inevitably works out to the detriment of the latter, unless a conscious effort is made to correct the imbalance.

The point at issue, however, is not whether Western capital investment in the past—with or without overt political control, i.e., "imperialism" in the strict sense of the term—has damaged and distorted the economies of backward areas, but whether this phase has now given way to a different kind of relationship. Socialists have traditionally denounced the capitalist-imperialist nexus, without denving that it was responsible for some degree of progress. The current controversy turns upon the question whether "planned" development—as instanced among others by the relations between the EEC * and the African states —represents something radically new or a continuation of the old "unequal relationship" at a higher level. European socialists—who have taken a prominent part in helping to liquidate the old colonial system-could in principle subscribe to all, or most, of the charges hurled against it by Leninists and/or radical nationalists and still maintain that it is absurd to talk of neocolonialism when considering the relationship of Asia or Africa to Europe under present conditions. They might also argue that it is perverse to saddle them with the sins of U.S. "private enterprise" in Latin America. The analogy would hold only if Afro-European relations were typified by what has been going on in the formerly Belgian Congo since 1960. But, in fact, the extraordinary doings of the Union Minière in Katanga represent a type of

^{*} The European Economic Community.

"monopoly-capitalist" activity that is rapidly going out of fashion. The notion that this kind of primitive skulduggery typifies the present order of things is really not worth controverting. Nor is it apparent that these antics form part of a global pattern that could with any plausibility be interpreted in Leninist terms, i.e., as an attempt on the part of "the monopolists and their governments" to secure physical possession of strategic raw materials.

This point leads to what is really the decisive consideration, namely the growing irrelevance of theoretical arguments derived from the pre-1914, or even the pre-1939, era. Every year that passes makes it plainer that shortage of colonial raw materials, and the need by hook or crook to seize control of them, simply does not describe the reality of presentindustrial capitalism, whether day planned or unplanned. The exact opposite is the case: Many of these raw materials are being superseded by industrial techniques making use of products available in the industrially developed countries themselves. The real danger facing the backward countries is that their exports will be squeezed out by the development of synthetics. Statistics relating to the consumption of raw materials in industrial countries since the early 1950's indicate that the use of crude materials (cotton, wool, rubber, jute, copper, etc.) has lagged far behind the consumption of synthetics and other processed materials (synthetic rubber, aluminum, plastic materials and fibers, etc.). In consequence of these developments, the flow of capital tends to be diverted from extractive industries (mining, plantations) towards manufacturing. On balance, this is clearly an advantage to the developing countries, though of course it does nothing to solve their surplus-labor problem. The new forms of foreign investment are directly linked to new techniques, and they also demand workers with modern skills, though fewer in number than did the old mining and plantation economy, which reached its peak on the eve of the 1914-18 war. Even if it be argued that this inflow of foreign capital results in a political partnership with the local bourgeoisie, the latter is at any rate becoming a genuine entrepreneurial class (i.e., in Communist parlance a "national" bourgeoisie) rather than a reactionary "comprador" class living off the crumbs of foreign exploitation. In fact, this is precisely what is happening; that it should be happening because Western industrial society has itself been revolutionized by new techniques is quite in accordance with Marxist principlesthough Soviet propagandists, for obvious reasons, have no interest in proclaiming the fact.

The Leninist model of a stagnant Western capitalism clutching at the life-line of colonial superprofits extrapolated certain features of an era that came to an end with the 1914-19 war, though even then the bulk of foreign investment did not go to the colonies but to developed countries in Europe or the Americas. Since then, the economic importance of the colonial hinterland has dwindled to such an extent that it has become a major political preoccupation of the rival blocs (East and West) to raise public funds for development purposes, largely in the hope (which may be frustrated) of securing political sympathies and averting a desperate outbreak on the part of chronically underfed and overpopulated countries. Such private investment as can be prevailed upon-not without difficulty-to venture forth into the hinter-

land typically yields a lower rate of profit than capital invested in Europe or North America. The few notable exceptions to this rule—principally oil—do not seriously alter the general picture. Oil investments indeed belong to the earlier phase, which is why they are always quoted by writers anxious to prove that the Leninist model is still operative. In terms of the real problems encountered by countries such as India or Brazil, they are of course quite marginal, and where -as in the Middle East and North Africa—they have genuine importance, the post-independence pattern makes it certain that they are going to be used for the purpose of financing industrialization—as is right and proper. By contrast, the fantastic games still played in Arabia and along the Persian Gulf by newly oil-rich sheikhs and princelings make good copy for journalists and propagandists, but their political significance is minute.

In our age, when the emergent countries are clamoring for capital investments which the developed industrial centers are reluctant to make available, it may seem odd that nationalists should go on quoting Lenin's theses on colonial exploitation as a feature of the "highest" stage of a supposedly overripe and moribund capitalism; but such intellectual lags are not unusual. Moreover, it can be held that the emergent countries are entitled to demand planned public investment in basic services and/or modern manufacturing industries rather than a continuation of the old wasteful system, which developed a few sectors of the economy while distorting or neglecting the remainder. This is a legitimate argument between the Western countries and the ruling elites of their former dependencies. It has nothing to do with the

weird notion that Africa is a stampingground for "monopolists" in search of profits denied to them at home. The real problem arises from the enormous claims levied upon the European countries by their less-developed partners, now understandably in a hurry to industrialize, and simultaneously faced with a population explosion.

In the case of Algeria, to take one notable example, it has been calculated that merely to hold living standards at their present level—in the face of a population growth curve that has doubled its numbers from 5 to 10 million since 1920 and promises to raise it to 15 million by 1980—the former metropolis would have to invest between \$5 billion and \$6 billion in Algerian industry-exclusive of oil production and pipeline construction—over the next twenty years. A plan to raise living standards by 2 per cent annually would require the investment of \$10 billion; raising standards by 4 per cent a year would call for some \$20 billion by 1980. Clearly such efforts are more likely to be made (if at all) by a semi-authoritarian regime in France than by a parliamentary democracy dependent on the voters. This may be among the reasons why all factions of Algerian nationalism greatly prefer the Gaullist regime to its predecessor.

If the Leninist formula of equating capital exports with colonialism is outmoded, the nationalist argument that without massive injection of public capital the vicious circle of poverty, overpopulation, and inadequate investment cannot be broken is well-founded. So is the insistence that such investments must in the main be guided to the key sectors of the economy, not left to short-range considerations of profitability. It is within these terms—familiar to European so-

cialists, and increasingly to intelligent conservatives and liberals as well—that the argument now tends to work itself out. It gains nothing from being presented in terms of stale controversies between Leninists and laissez-fairists. Now that the leading European countries have been shorn of their colonial possessions (without suffering the threatened disaster), while their former dependencies are experimenting with "mixed" public and private economies, it becomes possible to transcend the dispute over "im-

perialism as the highest stage of capitalism." Clearly, the colonial chapter is closed, while the maturation of Europe's industrial economy involves both an exceedingly fast rate of growth and a conscious departure from the state of affairs summed up in the phrase "anarchy of production." Whatever else imperialism may have been, it was plainly not the last stage in the development of the society that is now about to give itself a supranational political organization.

4. AUTOMATION

Machines have helped, hindered and confused men for a very long time, but never to the extent they do today. They are now an indispensable and inescapable part of our lives, with results sometimes ludicrous and sometimes downright disquieting. Not long ago the press carried stories about a farmer in Connecticut who received twenty thousand copies of *Time* Magazine, because the addressograph had got stuck at his name. More to the point would seem the story of a Ford Vice-President showing Walter Reuther round one of the company's newly automated plants: "How are you going to get these machines to pay you dues?" asked the company official. "And how are you going to get them to buy your cars?" replied the President of the Automobile Workers' Union.

The advance of new techniques has never been so striking or so public as in the American politics of the past decade, increasingly dependent on statistical prediction and the work of analytical computers. With every year, predictions extrapolated from public opinion samples and calculations based on a small fraction of electoral returns have become more important. In 1964, radio networks were able to announce the winner of the New Hampshire Republican primary eighteen minutes after the polls closed, the winner of the Oregon Republican primary four minutes after the polls closed, and the winner of the closely contested California Republican primary even before ballotting had finished. At this point one begins to wonder where prediction shades off into decision, with the element of speculation and doubt gradually eliminated from politics, economics, and eventually perhaps from thinking itself.

The impact of recent advances in automation and cybernetics has been felt even more strongly in industry and office work, where men are fast being replaced by machines. It is not yet clear whether this latest industrial revolution will in due course create new jobs in lieu of those which it abolishes. In any case, its social implications are immense for, whether to fill new jobs or the time left by their ab-

sence, men will require a kind and a level of education which most of them now lack and which our academic structure is hardly prepared to supply. One wonders whether advanced societies will have to learn to cope with boredom and its byproducts as they have in the past had to cope with want.

As usual, the implications of such developments are considered only by few and publicly discussed by even fewer. The first of these passages deals with certain concrete problems arising from technological progress, the second with some wider implications of the case at hand.

Alfred L. Malabre, Jr.: Automation Worry

"To call automation just another step in the advance of technology is the same thing as calling the H-bomb just another step in the advance of weaponry."

This is the view of a senior economist at the National Industrial Conference Board, a non-profit organization devoted to economic research. His remark typifies the view of a growing number of business analysts who are expressing grave concern over automation's potential impact on employment. These authorities fear automation will cause not just temporary, moderate unemployment, as displaced workers are retrained and put in new jobs, but permanent, massive unemployment, as automated devices wipe out jobs wholesale.

Such gloomy prophets, to be sure, represent a minority of the country's economists. But their concern points up a mounting controversy that could have dramatic impact on national policies in coming years.

The core of the argument is this: Can joblessness in the long run be reduced, or even held to present levels, simply by speeding economic growth, through such current measures as the recent tax cut and training programs for persons lacking skills? Or will the advance of automation be so swift and sweeping that the

sort of steps now being taken will prove pitifully inadequate a few years hence?

TRADITIONAL THEORY

Traditional economic theory, of course, holds that technological improvements, including automation, ultimately create jobs. In a sense, society has been automating since the wheel was invented, and there certainly has been an ever-increasing number of jobs.

The traditional view maintains that automation creates whole new industries, such as the computer business, and permits many existing industries eventually to employ many more workers at much higher pay. The reasoning is that by cutting costs automation enables companies to sell products more cheaply, and this in turn triggers so great a sales increase that more workers have to be hired, despite labor-saving devices.

The sales surge not only swells employment in the companies directly benefitting, the theory goes, but also in seemingly unrelated industries. A recent Philadelphia Federal Reserve Bank study provides an extreme example. Workers in companies prospering from automation, the study states, "are likely to eat more meals in restaurants, creat-

Reprinted from the Wall Street Journal, July 1, 1964, by permission of the publishers. Copyright the Wall Street Journal.

ing new jobs for waiters and waitresses."

Understandably, advocates of this optimistic view of automation are found mostly among conservative economists and members of top corporate management. But the list is far broader than that, as a recent statement by David J. McDonald, president of the United Steelworkers of America, indicates. "To oppose automation," according to the union leader, "is to oppose progress, and this I shall never do."

Those analysts, such as the economist at the National Industrial Conference Board, who liken automation to the H-bomb believe the traditional view of technological change simply cannot be applied to automation.

PESSIMISTIC PREDICTION

Automation is not merely another step in the advance of technology, they say, as the steam engine was a step forward from the windmill. They define automation distinctly—as the mechanization of decision-making and control functions, or machines operating machines. And they predict it will displace jobs at such a swiftly accelerating rate that in the end many millions of workers will be without jobs and without hope of ever obtaining jobs.

This will happen, warns the National Industrial Conference Board economist, "within this generation." And some of the gloomier analysts predict the day is even more imminent.

What makes the pessimists' argument difficult, of course, is the obvious fact that the massive joblessness they foresee simply hasn't taken place. Only 5.1% of the nation's labor force was unemployed at last report in May, after adjustment for seasonal factors. The jobless

rate, in fact, has been declining. Last November, it amounted to 5.9% of the work force and as recently as April, 5.4%.

The pessimists nonetheless maintain these unemployment statistics are not nearly so cheerful as they might appear. These authorities note that the economy is in the midst of what is probably the strongest business expansion in history, with industrial production running nearly 30% higher than at the upturn's start in early 1961. Yet, it is argued, the unemployment rate remains stubbornly above 5%, without prospect of moving appreciably lower as millions of unskilled teen-agers enter, or prepare to enter, the labor market.

Even Martin R. Gainsbrugh, the National Industrial Conference Board's chief economist who is not nearly as alarmed by automation as the above mentioned member of his staff, expresses concern. "The unemployment rate," Mr. Gainsbrugh says, "is probably as low as it's going to get, even if the economy continues to expand at the current healthy pace." Many economists feel further quickening of business activity will bring on inflation long before it brings down the jobless rate.

The pessimists also cite what appears to be a marked slowdown in the rate at which so-called white collar jobs are increasing. It is these jobs that will provide enough new employment in coming years to more than offset factory or farm losses from automation, many authorities have hoped. Yet, according to a recent report by this newspaper, last year's gain in white collar jobs amounted to only 0.9%, far less than the 2.8% average yearly rise during the 1950–60 decade.

"We may be witnessing the start of automation's invasion of the office," says

an analyst at New York City's Irving Trust Company. "It has already invaded the farm and the factory. Where do you go from the office?"

The whole debate over automation's possible consequences is complicated by the ease with which the two sides are able to bring forth statistics, often bearing on the same situation, to support their respective theories.

Take, for example, the matter of automation's impact on automobile industry employment in Detroit. Expounding the traditional view, a recent Government pamphlet notes that "the unemployment rate in Detroit—a city that has experienced about as much automation as any—dropped from 15% to 4% in three years, largely the result of increased demand for automobiles."

But, discussing the same topic before a Senate subcommittee on employment and manpower last year, United Auto Workers President Walter P. Reuther cited some very different statistics and drew some very different conclusions. Between 1947 and 1962, he noted, employment of production workers in the auto industry dropped 10.8%, even though vehicle output soared 70.8%.

Armed with these and similar statistics, Mr. Reuther told the Senators: "Only a moron could believe that in this kind of a revolution we can rely exclusively upon the blind forces of the marketplace" to prevent widespread unemployment.

OVERHAUL OF SOCIAL SYSTEM?

Particularly distressing to those who anticipate dire effects from automation is the fear that the nation's social system will require a drastic overhaul in the years just ahead, to cope with the anticipated unemployment.

"We are entering a period when it will be necessary to revise the deep-rooted belief that work and income should be tied together," claims the worried economist at the National Industrial Conference Board. "People will have to be permitted to live well, even if they can't find work. And that means drastic social changes."

Expressing similar concern, a Massachusetts Institute of Technology analyst warns that unless radical action is taken automation "will produce an unemployment situation in comparison with which the depression of the 1930's will seem a joke."

The sort of action these economists envisage is typified by a recent recommendation of a 32-member group of economists and liberal publicists, called the Ad Hoc Committee. The suggestion: Guarantee all Americans an "adequate" annual income, regardless of whether they work. This, the committee stated, would help break the economy's "incomethrough-jobs link" which provides "the only major mechanism for distributing effective demand (and therefore) acts as the main brake on the almost unlimited capacity" of a highly automated economy to expand.

The great majority of economists, to be sure, doubt that any such radical measures will be necessary, as automation comes into wider and wider use. However, most agree that the accelerating pace of technology requires very close scrutiny, by private business as well as by the Government. And, almost to a man, they urge that efforts to gather pertinent information be stepped up, so that if very difficult unemployment problems do arise from automation they can be tackled in the most effective manner possible.

The current lack of vital facts about

employment and unemployment is indicated by an example. The United States, unlike several other highly industrial nations, has no reliable information on job vacancies. Nor, despite some fledgling efforts in this direction, is there any prospect of obtaining such information any time soon. Such data, for one thing,

would help officials to know more precisely what sort of training jobless workers should be given.

It seems certain that, whatever else automation may hold for the future, it will be one of the major influences in this nation's economic planning.

Norbert Wiener: Cybernetics and Society

Norbert Wiener was one of the fathers of cybernetics and gave much thought to the effects of these new machines on the mankind which would use and misuse them. In the following extracts of his most interesting general work, *The Human Use of Human Beings*, he discusses the implications of the generalized use of automation techniques in offices and industry, with the resulting repercussion on labor and on society in general; and the danger that machines and machine-mindedness may seriously impinge on the already limited freedom and initiative of men.

I have spoken of the actuality and the imminence of this new possibility. What can we expect of its economic and social consequences? In the first place, we can expect an abrupt and final cessation of the demand for the type of factory labor performing purely repetitive tasks. In the long run, the deadly uninteresting nature of the repetitive task may make this a good thing and the source of leisure necessary for man's full cultural development. It may also produce cultural results as trivial and wasteful as the greater part of those so far obtained from the radio and the movies.

Be that as it may, the intermediate period of the introduction of the new means, especially if it comes in the fulminating manner to be expected from a new war, will lead to an immediate transitional period of disastrous confusion. We have a good deal of experience as to how the industrialists regard a new industrial potential. Their whole propaganda is to

the effect that it must not be considered as the business of the government but must be left open to whatever entrepreneurs wish to invest money in it. We also know that they have very few inhibitions when it comes to taking all the profit out of an industry that there is to be taken, and then letting the public pick up the pieces. This is the history of the lumber and mining industries, and is part of what we have called in another chapter the traditional American philosophy of progress.

Under these circumstances, industry will be flooded with the new tools to the extent that they appear to yield immediate profits, irrespective of what long-time damage they can do. We shall see a process parallel to the way in which the use of atomic energy for bombs has been allowed to compromise the very necessary potentialities of the long-time use of atomic power to replace our oil and coal supplies, which are within centuries, if

Reprinted from Norbert Wiener, The Human Use of Human Beings, Houghton Mifflin Company (Boston, 1955) pp. 161-162, 178-186.

not decades, of utter exhaustion. Note well that atomic bombs do not compete with power companies.

Let us remember that the automatic machine, whatever we think of any feelings it may have or may not have, is the precise economic equivalent of slave labor. Any labor which competes with slave labor must accept the economic conditions of slave labor. It is perfectly clear that this will produce an unemployment situation, in comparison with which the present recession and even the depression of the thirties will seem a pleasant joke. This depression will ruin many industries—possibly even the industries which have taken advantage of the new potentialities. However, there is nothing in the industrial tradition which forbids an industrialist to make a sure and quick profit, and to get out before the crash touches him personally.

Thus the new industrial revolution is a two-edged sword. It may be used for the benefit of humanity, but only if humanity survives long enough to enter a period in which such a benefit is possible. It may also be used to destroy humanity, and if it is not used intelligently it can go very far in that direction.

* * *

In the well-known Paris journal, *Le Monde*, for December 28, 1948, a certain Dominican friar, Père Dubarle, has written a very penetrating review of my book *Cybernetics*. I shall quote a suggestion of his which carries out some of the dire implications of the chess-playing machine grown up and encased in a suit of armor!

One of the most fascinating prospects thus opened is that of the rational conduct of human affairs, and in particular of those which interest communities and seem to present a certain statistical regularity, such as the human phenomena of the development of opinion. Can't one imagine a machine to collect this or that type of information, as for example information on production and the market; and then to determine as a function of the average psychology of human beings, and of the quantities which it is possible to measure in a determined instance, what the most probable development of the situation might be? Can't one even conceive a State apparatus covering all systems of political decisions, either under a regime of many states distributed over the earth, or under the apparently much more simple regime of a human government of this planet? At present nothing prevents our thinking of this. We may dream of the time when the machine à gouverner may come to supply—whether for good or evil—the present obvious inadequacy of the brain when the latter is concerned with the customary machinery of politics.

At all events, human realities do not admit a sharp and certain determination, as numerical data of computation do. They only admit the determination of their probable values. A machine to treat these processes, and the problems which they put, must therefore undertake the sort of probabilistic, rather than deterministic thought, such as is exhibited for example in modern computing machines. This makes its task more complicated, but does not render it impossible. The predic-

tion machine which determines the

efficacy of anti-aircraft fire is an example of this. Theoretically, time prediction is not impossible; neither is the determination of the most favorable decision, at least within certain limits. The possibility of playing machines such as the chessplaying machine is considered to establish this. For the human processes which constitute the object of government may be assimilated to games in the sense in which von Neumann has studied them mathematically. Even though these games have an incomplete set of rules, there are other games with a very large number of players, where the data are extremely complex. The machines à gouverner will define the State as the best-informed player at each particular level; and the State is the only supreme co-ordinator of all partial decisions. These are enormous privileges; if they are acquired scientifically, they will permit the State under all circumstances to beat every player of a human game other than itself by offering this dilemma: either immediate ruin, or planned cooperation. This will be the consequence of the game itself without outside violence. The lovers of the best of worlds have something indeed to dream of! Despite all this, and perhaps fortunately, the machine à gouverner is not ready for a very near tomorrow. For outside of the very serious problems which the volume of information to be collected and to be treated rapidly still put, the problems of the stability of prediction remain beyond what we can seriously dream of controlling. For human processes are assimilable to games with incompletely defined rules, and above all, with the rules themselves functions of the time. The variation of the rules depends both on the effective detail of the situations engendered by the game itself, and on the system of psychological reactions of the players in the face of the results obtained at each instant.

It may even be more rapid than these. A very good example of this seems to be given by what happened to the Gallup Poll in the 1948 election. All this not only tends to complicate the degree of the factors which influence prediction, but perhaps to make radically sterile the mechanical manipulation of human situations. As far as one can judge, only two conditions here can guarantee stabilization in the mathematical sense of the term. These are, on the one hand, a sufficient ignorance on the part of the mass of the players exploited by a skilled player, who moreover may plan a method of paralyzing the consciousness of the masses; or on the other, sufficient good-will to allow one, for the sake of the stability of the game, to refer his decisions to one or a few players of the game who have arbitrary privileges. This is a hard lesson of cold mathematics, but it throws a certain light on the adventure of our century: hesitation between an indefinite turbulence of human affairs and the rise of a prodigious Leviathan. In comparison with this, Hobbes' Leviathan was nothing but a pleasant joke. We are running the risk nowadays of a great World State, where deliberate and conscious primitive injustice may be the only possible condition for the statistical happiness of the masses: a world worse than hell for every clear mind. Perhaps it would not be a bad idea for the teams at present creating cybernetics to add to their cadre of technicians, who have come from all horizons of science, some serious anthropologists, and perhaps a philosopher who has some curiosity as to world matters.

The machine à gouverner of Père Dubarle is not frightening because of any danger that it may achieve autonomous control over humanity. It is far too crude and imperfect to exhibit a one-thousandth part of the purposive independent behavior of the human being. Its real danger, however, is the quite different one that such machines, though helpless by themselves, may be used by a human being or a block of human beings to increase their control over the rest of the human race or that political leaders may attempt to control their populations by means not of machines themselves but through political techniques as narrow and indifferent to human possibility as if they had, in fact, been conceived mechanically. The great weakness of the machine-the weakness that saves us so far from being dominated by it-is that it cannot yet take into account the vast range of probability that characterizes the human situation. The dominance of the machine presupposes a society in the last stages of increasing entropy, where probability is negligible and where the statistical differences among individuals are nil. Fortunately we have not yet reached such a state.

But even without the state machine

of Père Dubarle we are already developing new concepts of war, of economic conflict, and a propaganda on the basis of von Neumann's Theory of Games, which is itself a communicational theory, as the developments of the 1950s have already shown. This theory of games, as I have said in an earlier chapter, contributes to the theory of language, but there are in existence government agencies bent on applying it to military and quasi-military aggressive and defensive purposes.

The theory of games is, in its essence, based on an arrangement of players or coalitions of players each of whom is bent on developing a strategy for accomplishing its purposes, assuming that its antagonists, as well as itself, are each engaging in the best policy for victory. This great game is already being carried on mechanistically, and on a colossal scale. While the philosophy behind it is probably not acceptable to our present opponents, the Communists, there are strong signs that its possibilities are already being studied in Russia as well as here, and that the Russians, not content with accepting the theory as we have presented it, have conceivably refined it in certain important respects. In particular, much of the work, although not all, which we have done on the theory of games, is based on the assumption that both we and our opponents have unlimited capabilities and that the only restrictions within which we play depend on what we may call the cards dealt to us or the visible positions on the chess board. There is a considerable amount of evidence, rather in deed than in words. that the Russians have supplemented this attitude to the world game by considering the psychological limits of the players and especially their fatigability as part of the game itself. A sort of machine à gouverner is thus now essentially in operation on both sides of the world conflict, although it does not consist in either case of a single machine which makes policy, but rather of a mechanistic technique which is adapted to the exigencies of a machine-like group of men devoted to the formation of policy.

Père Dubarle has called the attention of the scientist to the growing military and political mechanization of the world as a great superhuman apparatus working on cybernetic principles. In order to avoid the manifold dangers of this, both external and internal, he is quite right in his emphasis on the need for the anthropologist and the philosopher. In other words, we must know as scientists what man's nature is and what his built-in purposes are, even when we must wield this knowledge as soldiers and as statesmen; and we must know why we wish to control him.

When I say that the machine's danger to society is not from the machine itself but from what man makes of it, I am really underlining the warning of Samuel Butler. In *Erewhon* he conceives machines otherwise unable to act, as conquering mankind by the use of men as the subordinate organs. Nevertheless, we must not take Butler's foresight too seriously, as in fact at his time neither he nor anyone around him could understand the true nature of the behavior of automata, and his statements are rather incisive figures of speech than scientific remarks.

Our papers have been making a great deal of American "know-how" ever since we had the misfortune to discover the atomic bomb. There is one quality more important than "know-how" and we cannot accuse the United States of any undue amount of it. This is "know-what" by which we determine not only how to accomplish our purposes, but what our purposes are to be. I can distinguish between the two by an example. Some years ago, a prominent American engineer bought an expensive player-piano. It became clear after a week or two that this purchase did not correspond to any particular interest in the music played by the piano but rather to an overwhelming interest in the piano mechanism. For this gentleman, the player-piano was not a means of producing music, but a means of giving some inventor the chance of showing how skillful he was at overcoming certain difficulties in the production of music. This is an estimable attitude in a second year high-school student. How estimable it is in one of those on whom the whole cultural future of the country depends, I leave to the reader.

In the myths and fairy tales that we read as children we learned a few of the simpler and more obvious truths of life, such as that when a djinnee is found in a bottle, it had better be left there; that the fisherman who craves a boon from heaven too many times on behalf of his wife will end up exactly where he started; that if you are given three wishes, you must be very careful what you wish for. These simple and obvious truths represent the childish equivalent of the tragic view of life which the Greeks and many modern Europeans possess, and which is somehow missing in this land of plenty.

The Greeks regarded the act of discovering fire with very split emotions. On the one hand, fire was for them as for us a great benefit to all humanity. On the other, the carrying down of fire from heaven to earth was a defiance of the Gods of Olympus, and could not but be punished by them as a piece of insolence

towards their prerogatives. Thus we see the great figure of Prometheus, the fire-bearer, the prototype of the scientist; a hero but a hero damned, chained on the Caucasus with vultures gnawing at his liver. We read the ringing lines of Aeschylus in which the bound god calls on the whole world under the sun to bear witness to what torments he suffers at the hands of the gods.

The sense of tragedy is that the world is not a pleasant little nest made for our protection, but a vast and largely hostile environment, in which we can achieve great things only by defying the gods; and that this defiance inevitably brings its own punishment. It is a dangerous world in which there is a condign punishment, not only for him who sins in conscious arrogance, but for him whose sole crime is ignorance of the gods and the world around him.

If a man with this tragic sense approaches, not fire, but another manifestation of original power, like the splitting of the atom, he will do so with fear and trembling. He will not leap in where angels fear to tread, unless he is prepared to accept the punishment of the fallen angels. Neither will he calmly transfer to the machine made in his own image the responsibility for his choice of good and evil, without continuing to accept a full responsibility for that choice.

I have said that the modern man, and especially the modern American, however much "know-how" he may have, has very little "know-what." He will accept the superior dexterity of the machinemade decisions without too much inquiry as to the motives and principles behind these. In doing so, he will put himself sooner or later in the position of the father in W. W. Jacobs' *The Monkey's Paw*, who has wished for a hundred

pounds, only to find at his door the agent of the company for which his son works, tendering him one hundred pounds as a consolation for his son's death at the factory. Or again, he may do it in the way of the Arab fisherman in the *One Thousand and One Nights*, when he broke the Seal of Solomon on the lid of the bottle which contained the angry djinnee.

Let us remember that there are gameplaying machines both of the Monkey's Paw type and of the type of the Bottled Djinnee. Any machine constructed for the purpose of making decisions, if it does not possess the power of learning, will be completely literal-minded. Woe to us if we let it decide our conduct, unless we have previously examined the laws of its action, and know fully that its conduct will be carried out on principles acceptable to us! On the other hand, the machine like the djinnee, which can learn and can make decisions on the basis of its learning, will in no way be obliged to make such decisions as we should have made, or will be acceptable to us. For the man who is not aware of this, to throw the problem of his responsibility on the machine, whether it can learn or not, is to cast his responsibility to the winds, and to find it coming back seated on the whirlwind.

I have spoken of machines, but not only of machines having brains of brass and thews of iron. When human atoms are knit into an organization in which they are used, not in their full right as responsible human beings, but as cogs and levers and rods, it matters little that their raw material is flesh and blood. What is used as an element in a machine, is in fact an element in the machine. Whether we entrust our decisions to machines of metal, or to those machines of flesh and blood which are bureaus and

vast laboratories and armies and corporations, we shall never receive the right answers to our questions unless we ask the right questions. The Monkey's Paw of skin and bone is quite as deadly as anything cast out of steel and iron. The djinnee which is a unifying figure of speech for a whole corporation is just as fearsome as if it were a glorified conjuring trick.

The hour is very late, and the choice of good and evil knocks at our door.

Margaret Mead: One Vote for This Age of Anxiety

When critics wish to repudiate the world in which we live today, one of their familiar ways of doing it is to castigate modern man because anxiety is his chief problem. This, they say, in W. H. Auden's phrase, is the age of anxiety. This is what we have arrived at with all our vaunted progress, our great technological advances, our great wealth-everyone goes about with a burden of anxiety so enormous that, in the end, our stomachs and our arteries and our skins express the tension under which we live. Americans who have lived in Europe come back to comment on our favorite farewell which, instead of the old goodbye (God be with you), is now "Take it easy," each American admonishing the other not to break down from the tension and strain of modern life.

Whenever an age is characterized by a phrase, it is presumably in contrast to other ages. If we are the age of anxiety, what were other ages? And here the critics and carpers do a very amusing thing. First, they give us lists of the opposites of anxiety: security, trust, self-confidence, self-direction. Then, without much further discussion, they let us assume that other ages, other periods of history, were somehow the ages of trust or confident direction.

The savage who, on his South Sea island, simply sat and let bread fruit fall into his lap, the simple peasant, at one with the fields he ploughed and the beasts he tended, the craftsman busy with his tools and lost in the fulfillment of the instinct of workmanship—these are the counter-images conjured up by descriptions of the strain under which men live today. But no one who lived in those days has returned to testify how paradisiacal they really were.

Certainly if we observe and question the savages or simple peasants in the world today, we find something quite different. The untouched savage in the middle of New Guinea isn't anxious; he is seriously and continually frightened—of black magic, of enemies with spears who may kill him or his wives and children at any moment, while they stoop to drink from a spring, or climb a palm tree for a coconut. He goes warily, day and night, taut and fearful.

As for the peasant populations of a great part of the world, they aren't so much anxious as hungry. They aren't anxious about whether they will get a salary raise, or which of the three colleges of their choice they will be admitted to, or whether to buy a Ford or Cadillac, or whether the kind of TV set they want is

Margaret Mead, "One Vote for This Age of Anxiety," in *The New York Times Magazine*, May 20, 1956. © 1956 by The New York Times Company. Reprinted by permission.

too expensive. They are hungry, cold, and in many parts of the world, they dread that local warfare, bandits, political coups may endanger their homes, their meager livelihoods and their lives. But surely they are not anxious.

For anxiety, as we have come to use it to describe our characteristic state of mind, can be contrasted with the active fear of hunger, loss, violence and death. Anxiety is the appropriate emotion when the immediate personal terror—of a volcano, an arrow, the sorcerer's spell, a stab in the back and other calamities all directed against one's self—disappears.

This is not to say that there isn't plenty to worry about in our world of today. The explosion of a bomb in the streets of a city whose name no one had ever heard of before may set in motion forces which end up by ruining one's carefully planned education in law school, half a world away. But there is still not the personal, immediate, active sense of impending disaster that the savage knows. There is rather the vague anxiety, the sense that the future is unmanageable.

The kind of world that produces anxiety is actually a world of relative safety. a world in which no one feels that he himself is facing sudden death. Possibly sudden death may strike a certain number of unidentified other people—but not him. The anxiety exists as an uneasy state of mind, in which one has a feeling that something unspecified and undeterminable may go wrong. If the world seems to be going well, this produces anxiety for good times may end. If the world is going badly—it may get worse. Anxiety tends to be without locus; the anxious person doesn't know whether to blame himself or other people. He isn't sure whether it is 1956 or the Administration or a change in climate or the atom bomb that is to blame for this undefined sense of unease.

It is clear that we have developed a society which depends on having the right amount of anxiety to make it work. Psychiatrists have been heard to say, "He didn't have enough anxiety to get well," indicating that, while we agree that too much anxiety is inimical to mental health, we have come to rely on anxiety to push and prod us into seeing a doctor about a symptom which may indicate cancer, into checking up on the old life insurance policy which may have out-of-date clauses in it, into having a conference with Billy's teacher even though his report card looks all right.

People who are anxious enough keep their car insurance up, have the brakes checked, don't take a second drink when they have to drive, are careful where they go and with whom they drive on holidays. People who are too anxious either refuse to go into cars at all—and so complicate the ordinary course of life—or drive so tensely and overcautiously that they help cause accidents. People who aren't anxious enough take chance after chance, which increases the terrible death toll on the roads.

On balance, our age of anxiety represents a large advance over savage and peasant cultures. Out of a productive system of technology drawing upon enormous resources, we have created a nation in which anxiety has replaced terror and despair, for all except the severely disturbed. The specter of hunger means something only to those Americans who can identify themselves with the millions of hungry people on other continents. The specter of terror may still be roused in some by a knock at the door in a few parts of the South, or in those who have just escaped from a totalitarian regime

or who have kin still behind the Curtains.

But in this twilight world which is neither at peace nor at war, and where there is insurance against certain immediate, downright personal disasters, for most Americans there remains only anxiety over what may happen, might happen, could happen.

This is the world out of which grows the hope, for the first time in history, of a society where there will be freedom from want and freedom from fear. Our very anxiety is born of our knowledge of what is now possible for each and for all. The number of people who consult psychiatrists today is not, as is sometimes felt, a symptom of increasing mental ill health, but rather the precursor of a world in which the hope of genuine mental health will be open to everyone, a world in which no individual feels that he need be hopelessly brokenhearted, a failure, a menace to others or a traitor to himself.

But, if, then, our anxieties are actually signs of hope, why is there such a voice of discontent abroad in the land? I think this comes perhaps because our anxiety exists without an accompanying recognition of the tragedy which will always be inherent in human life, however well we build our world. We may banish hunger, and fear of sorcery, violence or secret police; we may bring up children who have learned to trust life and who have the spontaneity and curiosity necessary to devise ways of making trips to the moon; we cannot—as we have tried to do—banish death itself.

Americans who stem from generations which left their old people behind and never closed their parents' eyelids in

death, and who have experienced the additional distance from death provided by two world wars fought far from our shores are today pushing away from them both a recognition of death and a recognition of the tremendous significance for the future-of the way we live our lives. Acceptance of the inevitability of death, which, when faced, can give dignity to life, and acceptance of our inescapable role in the modern world, might transmute our anxiety about making the right choices, taking the right precautions and the right risks, into the sterner stuff of responsibility, which ennobles the whole face rather than furrowing the forehead with the little anxious wrinkles of worry.

Worry in an empty context means that men die daily little deaths. But good anxiety—not about the things that were left undone long ago, that return to haunt and harry men's minds, but active, vivid anxiety about what must be done and that quickly—binds men to life with an intense concern.

There is still a world in which too many of the wrong things happen somewhere. But this is a world in which we now have the means to make a great many more of the right things happen everywhere. For Americans, the generalization which a Swedish social scientist made about our attitudes on race-relations is true in many other fields: anticipated change which we feel is right and necessary but difficult makes us unduly anxious and apprehensive, but such change, once consummated, brings a glow of relief. We are still a people who—in the literal sense—believe in making good.

VII. A Sea Change in the Churches

In 1970, baptized Christians numbered between 900 million and one billion souls. However, the number of practicing Christians is shrinking. In Europe, they account for 40 per cent of the rural population of Southern Italy and Spain, but only for 6 per cent in a city like Paris, and 4 per cent in English industrial towns. Yet, while religious practice retreats under the impact of industrial civilization and rival philosophies (like Marxism), the Christian churches have grown especially concerned with facing the possible failing this implies. Starting in 1943, the French innovation of Worker-Priests attempted to penetrate an industrial working-class largely indifferent or hostile to religion. Interrupted in 1953, the experiment continued in other guises so that —particularly in Southern Europe and Latin America—young priests are often found in the van of social work.

Such trends received the highest encouragement during the pontificate of John XXIII (1958–1963), a pope remarkable in his human warmth, generosity and faith in men, who opened the Catholic Church to the modern world. His encyclical *Mater et Magistra* (1961), dealing with economic and social questions, followed in the progressive wake of Leo XIII's *Rerum Novarum* (see above, p. 718). Two years after it, *Pacem in Terris* stated conditions for the achievement of peace and justice in the technical, scientific—and political—context of the midtwentieth century.

Pope John was a great believer in the unity of Christendom, in pursuit of which he called the second Vatican Council (1962–1965), attended by 2200 bishops from all over the world and designed in large part to open the way to the ecumenical union of all Christians. The Protestant and Orthodox churches had been moving in the same direction since the 1920's. The second part of this section comprises selections from the Report of the last ecumenical meeting, held in 1968, at Uppsala, Sweden, and attended by an official observer of the Roman Catholic Church. Pope John's successor, Paul VI, has supported the ecumenical initiatives of the Vatican Council, permitted the setting up of a joint inter-faith commission, and approved a report of this commission that affirms the unity of the ecumenical movement. When (and whether) the unity of Christendom will follow, it is difficult to predict.

972

Another orientation, and another attempt to adjust religious thought to contemporary attitudes, is reflected in the final selection, from the book of a prominent American theologian. Professor of the Philosophy of Religion at Union Theological Seminary, David E. Roberts (1911–1955) tried to reconcile the major philosophy of his day—existentialism—with the concerns of Christian thought.

John XXIII: Pacem in Terris (April 11, 1963)

- 11. Beginning our discussion of the rights of man, we see that every man has the right to life, to bodily integrity, and to the means which are necessary and suitable for the proper development of life. These are primarily food, clothing, shelter, rest, medical care, and finally the necessary social services. Therefore, a human being also has the right to security in cases of sickness, inability to work, widowhood, old age, unemployment, or in any other case in which he is deprived of the means of subsistence through no fault of his own.
- 12. By the natural law every human being has the right to respect for his person, to his good reputation, the right to freedom in searching for truth and in expressing and communicating his opinions, and in pursuit of art, within the limits laid down by the moral order and the common good; and he has the right to be informed truthfully about public events.
- 13. The natural law also gives man the right to share in the benefits of culture, and therefore the right to a basic education and to technical and professional training in keeping with the stage of educational development in the country to which he belongs. Every effort should be made to ensure that persons be enabled, on the basis of merit, to go on to higher studies, so that, as far as possible, they may occupy posts and take on re-

- sponsibilities in human society in accordance with their natural gifts and the skills they have acquired. . . .
- 39. Our age has three distinctive characteristics.
- 40. First of all, the working classes have gradually gained ground in economic and public affairs. They began by claiming their rights in the socio-economic sphere; they extended their action then to claims on the political level; and finally applied themselves to the acquisition of the benefits of a more refined culture. Today, therefore, workers all over the world refuse to be treated as if they were irrational objects without freedom, to be used at the arbitrary disposition of others. They insist that they be always regarded as men with a share in every sector of human society: in the social and economic sphere, in public life, and finally in the fields of learning and culture.
- 41. Secondly, it is obvious to everyone that women are now taking a part in public life. This is happening more rapidly perhaps in nations of Christian civilization, and, more slowly but widely, among peoples who have inherited other traditions or cultures. Since women are becoming ever more conscious of their human dignity, they will not tolerate being treated as mere material instruments, but demand rights befitting a human person both in domestic and in public life.

- 42. Finally, the modern world, as compared with the recent past, has taken on an entirely new appearance in the field of social and political life. For since all nations have either achieved or are on the way to achieving independence, there will soon no longer exist a world divided into nations that rule others and nations that are subject to others.
- 43. Men all over the world have today —or will soon have—the rank of citizens in independent nations. No one wants to feel subject to political powers located outside his own country or ethnic group. For in our day, those attitudes are fading, despite their prevalence for so many hundreds of years, whereby some classes of men accepted an inferior position, while others demanded for themselves a superior position on account of economic and social conditions, of sex, or of assigned rank within the political community.
- 44. On the contrary, the conviction that all men are equal by reason of their natural dignity has been generally accepted. Hence racial discrimination can in no way be justified, at least doctrinally or in theory. And this is of fundamental importance and significance for the formation of human society according to those principles which we have outlined above. For, if a man becomes conscious of his rights, he must become equally aware of his duties. Thus he who possesses certain rights has likewise the duty to claim those rights as marks of his dignity, while all others have the obligation to acknowledge those rights and respect them. . . .
- 109. . . . it is with deep sorrow that we note the enormous stocks of armaments that have been and still are being made in more economically developed countries, with a vast outlay of intellec-

- tual and economic resources. And so it happens that, while the people of these countries are loaded with heavy burdens, other countries as a result are deprived of the collaboration they need in order to make economic and social progress.
- 110. The production of arms is allegedly justified on the grounds that in present-day conditions peace cannot be preserved without an equal balance of armaments. And so, if one country increases its armaments, others feel the need to do the same; and if one country is equipped with nuclear weapons, other countries must produce their own, equally destructive.
- 111. Consequently, people live in constant fear lest the storm that every moment threatens should break upon them with dreadful violence. And with good reason, for the arms of war are ready at hand. Even though it is difficult to believe that anyone would deliberately take the responsibility for the appalling destruction and sorrow that war would bring in its train, it cannot be denied that the conflagration may be set off by some unexpected and obscure event. And one must bear in mind that, even though the monstrous power of modern weapons acts as a deterrent, it is to be feared that the mere continuance of nuclear tests, undertaken with war in mind, will prove a serious hazard for life on earth.
- 112. Justice, then, right reason and humanity urgently demand that the arms race should cease; that the stockpiles which exist in various countries should be reduced equally and simultaneously by the parties concerned; that nuclear weapons should be banned; and that a general agreement should eventually be reached about progressive disarmament and an effective method of control. . . .

PROGRESS OF ECONOMICALLY UNDERDEVELOPED COUNTRIES

121. Because all men are joined together by reason of their common origin, their redemption by Christ, and their supernatural destiny, and are called to form one Christian family, We appealed in the Encyclical *Mater et Magistra* to economically developed nations to come to the aid of those which were in the process of development. . . .

123. But it is never sufficiently repeated that the cooperation, to which reference has been made, should be effected with the greatest respect for the liberty of the countries being developed, for these must realize that they are primarily responsible, and that they are the principal artisans in the promotion of their own economic development and social progress.

124. It is inevitable that the powerful States, by reason of their greater potential and their power, should pave the way in the establishment of economic groups comprising not only themselves but also smaller and weaker States as well. It is nevertheless indispensable that in the interests of the common good they, as all others, should respect the rights of those smaller States to political freedom, to economic development and to the adequate protection, in the case of conflicts between nations, of that neutrality which is theirs according to the natural, as well as international, law. . . .

125. It is vitally important, therefore, that the wealthier states, in providing

varied forms of assistance to the poorer, should respect the moral values and ethnic characteristics peculiar to each, and also that they should avoid any intention of political domination. If this be done, it will help much toward shaping a community of all nations, wherein each one, aware of its rights and duties, will have regard for the prosperity of all. . . .

LITTLE BY LITTLE

161. There are some souls, particularly endowed with generosity, who, on finding situations where the requirements of justice are not satisfied or not satisfied in full, feel enkindled with the desire to change the state of things, as if they wished to have recourse to something like a revolution.

162. It must be borne in mind that to proceed gradually is the law of life in all its expressions, therefore in human institutions, too, it is not possible to renovate for the better except by working from within them, gradually. Pius XII proclaimed: Salvation and justice are not to be found in revolution, but in evolution through concord. Violence has always achieved only destruction, not construction, the kindling of passions, not their pacification, the accumulation of hate and ruin, not the reconciliation of the contending parties. And it has reduced men and parties to the difficult task of rebuilding, after sad experience, on the ruins of discord . . .

Norman Goodall: The Ecumenical Movement

. . . The most obvious and widely acknowledged feature of the Assembly

was its preoccupation—at times, almost, its obsession—with the revolutionary fer-

From the editorial by Norman Goodall in *The Uppsala Report*, 1968. Reprinted by permission of the World Council of Churches, Geneva, Switzerland.

ment of our time, with questions of social and international responsibility, of war and peace and economic justice, with the pressing, agonizing physical needs of men, with the plight of the underprivileged. the homeless and starving, and with the most radical contemporary rebellions against all "establishments," civil and religious. It was not only recognized that as it was often expressed—the world was writing the agenda for the meeting: the right of the world to do this was largely taken for granted and Uppsala tried to read the writing, understand it and respond to it in a willingness to accept the necessity for changes as tumultuous for the Church itself as for the rapidly changing world. The circumstances of the time made this the inevitable atmosphere of the Assembly. It was intensified by the need to deal specifically-and the longing to deal rightly—with such agonizing situations as those existing in Nigeria/Biafra, Vietnam or the Middle East, with the world-wide crisis in race relations and with the present mood of youth, unmistakably vocal in Uppsala. Well before Uppsala many of these concerns had become dominant in the life of the WCC * through the involvement of most of its Divisions in one or another feature of this contemporary ferment and signally in the World Conference on Church and Society held in Geneva in 1966 on the theme of "Christians in the Technical and Social Revolution of Our Time."

But at Uppsala the sense of crisis in world affairs and its shattering impact

upon Christian institutions and on what is generally assumed to be meant by "the Christian tradition" broke in again and again with the effect of a thunder-clap and lightning-flash. Even at other times the storm rumblings were seldom inaudible. The marks of these storms will be discerned in most of what follows in this volume.

Few, if any, who were present at Uppsala would have wished to be sheltered from this. This applies to participants of all ages, though there were times when the youth participants made it clear that they could not credit anyone over thirty with a sensitiveness to these things, nor could they believe that the Church had ever previously been awake to the state of the world around it and the kind of action called for by the compassion of Christ. This time, however, it was not a question of acknowledging or not acknowledging the ferment of the age. We were living in it and with it. We were it. This, at least, was recognized. Although I do not recall the dictum being quoted at any point in the Assembly, there would have been wide-spread acceptance of a word of Dag Hammarskjöld's (who was often remembered by us in his homeland): "In our era the road to holiness necessarily passes through the world of action." At any rate, there was the almost universal recognition that the Church belongs to the world of action. This is not only the place of its testing: it is the place where its beliefs must be fashioned and re-fashioned and where alone the truth to which it would testify can be met.

^{*} World Council of Churches.

W. A. Viccer't Hooft: The Mandate of the Ecumenical Movement

At the moment when a world assembly of the churches begins its work in this country and in this place my thoughts go naturally to the very first ecumenical assembly of the churches which I attended in 1925 as a very young participant, namely the Stockholm Conference on Life and Work. That conference had a close relation to Uppsala. For it was in the Archbishops' palace in this city that Archbishop Söderblom laid the foundations of this pioneer-meeting, an astounding achievement at a time when the churches had yet to be convinced that this plan without precedent was not just a castle in the air and at a time when there was no such thing as a staff of ecumenical workers. The closing meetings of the conference were held in the cathedral here and in the university. The young Dag Hammarskjöld, a son of the provincial governor and a friend of the Söderblom family, was one of the stewards and thus got his first introduction to the problem of management of an international assembly, not realizing that this would become his chief task in his years. . . .

At first sight it would seem that there is an enormous difference between Stockholm 1925 and Uppsala 1968. As a first attempt to bring together all the churches, Stockholm was more successful than most had dared to expect, but it was still far from being fully ecumenical. The American, British and European sections had sent large numbers of delegates, but of the Orthodox Churches only six had sent delegations and the fifth section, oddly designated as that of "other churches,"

and meant to include all of Africa, Asia and Latin America, had a very small group of delegates from only four countries. We have reason to be deeply grateful that in the relatively short period since 1925 the ecumenical movement has become more truly ecumenical and that this Assembly embraces a much larger part of Christendom. No less significant is that at the time of the Stockholm Conference the Roman Catholic Church stood quite outside the ecumenical movement and that today this great church is an active participant in the movement, which collaborates in many ways with our World Council and which will, through its official observers, undoubtedly make an important contribution to our discussions.

There are many other differences, but it is perhaps more important for us today to consider the points of analogy and similarity. The real significance of the 1925 meeting was that, after a very long period in which the churches had made no serious effort to understand the changing social and international realities and to help men to find illumination in the Gospel for their common life, they now made a common attempt to rediscover their task with regard to the world. What Söderblom had in mind is best illustrated by a sentence of his sermon at the closing service in Uppsala cathedral. He said that the divisions and silence of the churches impeded the work of the Saviour. . . .

We do not speak the same language as the fathers of 1925. The theological positions have shifted. But is it not true that we are still struggling with the same basic

From The Uppsala Report, 1968. Reprinted by permission of the World Council of Churches, Geneva, Switzerland.

theme? This assembly will largely be judged according to its capacity to speak a helpful word on the same question of the task of the Church in the world. . . .

HISTORY'S LESSONS

Stockholm had left the churches in the air, in so far as it had spoken strongly of the need for a Christian witness in society, but had said very little about the content of that witness and about the way in which it was to be given. It was largely taken for granted that the world knew quite well what the Christian ethic was and needed only to be exhorted to take it seriously. The churches did not vet realize that the very foundations of the Christian faith were being challenged. A few years later that challenge became unmistakably clear through the church conflicts in Germany. . . . it was therefore decided that the second world conference on Life and Work in Oxford in 1937 would concentrate on the issue of the Christian view of society, of the state and of international relations, in response to the various totalitarian challenges. But as the preparations proceeded it became clear that it would not be sufficient to talk about Christian principles. For we saw before our eyes that these principles would remain utterly irrelevant unless there existed a community which would embody these convictions and would make them manifest. But did such a community exist? Or had the churches become so largely a part of their surrounding societies that they could no longer speak the prophetic word to them? Thus Life and Work was forced to face the issue of the nature and task of the Church. The Oxford slogan: "Let the Church be the Church" was not an invention of panic-stricken ecclesiastics seeking

withdraw into the safety of their church institutions. It was a battle-cry calling the churches to a true obedience as the people who really know that their Lord has overcome the world and who now practise in the world that newness of life which must penetrate into all realms of human relations. . . . There were some who doubted the wisdom of placing the responsibility for the main stream of the ecumenical movement so squarely on the churches and who would have preferred to continue with a less formal and official structure. But the great majority believed that, if Christendom was to fulfil its calling, it should have the courage to enter into history and to enter into history implied the use of the given historical instruments, that is of the historical churches

We knew well that these churches would need a thorough renewal, if they were to become the conscience of society. Throughout the war . . . that theme of renewal was the basic motive of ecumenical thought. . . .

WHERE DO WE STAND TODAY?

It seems to me that the present ecumenical situation can only be described in the paradoxical statement that the ecumenical movement has entered into a period of reaping an astonishingly rich harvest, but that precisely at this moment the movement is more seriously called in question than ever before. And once again the basic issue is that of the relation between the Church and the world.

I need not develop why we can speak of the success of the ecumenical movement. We need only to think of this Assembly in comparison to earlier ecumenical world conferences. Who would have dared to believe in 1925 or even in 1948

that by 1968 we would have reached the point at which practically all Eastern Orthodox Churches would bring their much-needed contribution, at which Africa, Asia and Latin America would have such a distinctive word to speak, and in which through a great network of close fraternal relationships the Roman Catholic Church, after having elaborated its own position concerning the central ecumenical issues, would enrich and stimulate our discussions so greatly? We are near the point when Söderblom's dream will come true: that all churches of Christendom can speak out together on the great problems of mankind. . . . But at this very moment there are many inside and outside our churches, particularly among the younger generation, who have their deep doubts about the relevance of the ecumenical movement and turn away from it with a sense of disappointment. So our very success is ambiguous. . . .

For we hear it said that the ecumenical movement as it has developed over the last forty or fifty years is unable to help the churches to perform that mission which they should perform in the world of our time. That world requires radical renewal. But how can churches speak convincingly of radical renewal, if they are not radically renewed themselves? That world needs a thorough transformation of its traditional structures, but do not the churches exemplify that traditional structures resist such transformation? That world must become a worldwide responsible society, but are the churches themselves living as a responsible society in which full solidarity in service and mission is practised and in which all members, including all laymen and women, are able to bear their full share of responsibility for the common life?

Or again, this world needs effective unity. But is the relationship which the churches have in the ecumenical movement more than a pale reflection of the unity they should have? And is the progress toward full unity not so slow that it reveals rather a fear of unity than a great and passionate conviction about the essential oneness of the people of God? And must we therefore not admit that the ecumenical movement has had its time, and that we have now entered into the "postecumenical" age in which Christians will have to make their contribution and render their service to the world through other, less cumbersome channels? . . .

1. No horizontal advance without vertical orientation

I believe that, with regard to the great tension between the vertical interpretation of the Gospel as essentially concerned with God's saving action in the life of individuals, and the horizontal interpretation of it as mainly concerned with human relationships in the world, we must get out of that rather primitive oscillating movement of going from one extreme to the other, which is not worthy of a movement which by its nature seeks to embrace the truth of the Gospel in its fullness. A Christianity which has lost its vertical dimension has lost its salt and is not only insipid in itself, but useless for the world. But a Christianity which would use the vertical preoccupation as a means to escape from its responsibility for and in the common life of man is a denial of the incarnation, of God's love for the world manifested in Christ.

The whole secret of the Christian faith is that it is man-centered because it is God-centered. We cannot speak of Christ as the man for others without speaking of him as the man who came from God and who lived for God.

This is a very practical truth. For on it depends the relevance of the Christian witness in the world. Let me illustrate this by referring to one of the most important problems on our agenda.

We are all deeply concerned over the problem of international social justice with its different aspects of the increasing danger of famine conditions in large parts of the world, of the slow pace of development and of the growing tension between the affluent nations and those which live in conditions of poverty. We are profoundly disturbed by the fact that the attempts to deal with this most acute human problem are quite inadequate, so that, as Dr. Prebitsch has said, the decade of development has become the decade of frustration over development. It is not that we do not know what should be done. The experts . . . have worked out specific plans which would go a very long way in meeting the need. But these plans are not being carried out. Why not? Because they require that much larger amounts be made available for this purpose and that much closer collaboration be achieved between all the nations concerned. And the governments are at present not able to promise more aid and to enter into more far-reaching agreements because there is no sufficiently strong and clear public opinion which would back them up in such a course of action. For public opinion in the West is today rather tired of the issues of development. There seem to be so many urgent tasks in our immediate environment. And the arguments used to "sell" development seem to have lost their force. The economic argument that development is good for the growth of trade is not very convincing when the Western world is so obviously

able to make tremendous progress on the basis of its own inherent strength. The political argument that we cannot afford to let the tension between the rich and the poor parts of the world grow to the point of explosion carries little weight when a few great powers have the means to dominate the international political situation. And so we seem to be condemned to let the situation drift, and hand to our children a world in which there will be famine and despair and, as an inevitable result, even more violence than we have already known in our time.

What can the churches do about this? They can adopt resolutions and reports. But will that make much difference? The crisis is a crisis of motivation, of fundamental attitudes. The deep trouble lies underneath the political and economic level. The root of the matter is that, at a time when history requires that humanity should live as a coherent responsible society, men still refuse to accept responsibility for their fellow-beings.

Now we can, of course, seek to awaken a sense of solidarity with and sympathy for the needy. We do so with some success. And we must go on doing this. But that is not the radical operation which is needed. That does not lead to a changing of the structures of world-economy; that does not lead to a full acceptance of responsibility, so that the economically-weak in one part of the world are as a matter of course assisted by the economically-strong in other parts of the world, just as this happens in our modern welfare-states. No, what is needed is nothing less than a new conception of humanity.

New in relation to our present situation. Not new in an absolute sense. For as we look all over the place for the vision of humanity which we need, we are like the explorer who sought a new country and discovered his own country. For it is in our Holy Scriptures that the unity of mankind is proclaimed in the most definite manner.

The churches have not taken that proclamation seriously enough. They are largely responsible for the false impression that Christians are advocates of the Church and leave the advocacy of humanity to the philosophers, the humanists, the Marxists. But the fact is that the vision of the oneness of humanity is an original and essential part of the biblical revelation. Centuries before Alexander the Great's Oikoumene began to give Mediterranean man an idea of a wider human family, Israel had already recorded its insight that all men are made in the image of God. . . . Mankind is one, not in itself, not because of its own merits or qualities. Mankind is one as the object of God's love and saving action. Mankind is one because of its common calling. The vertical dimension of its unity determines the horizontal dimension.

So Christians have more reason than anyone else to be advocates of humanity. They are not humanitarians in the sentimental sense that it is nice to be nice to other people. They are not humanists in the aristocratic sense that learning and culture constitute a bond between the privileged few of all nations. They are on the side of *all* humanity because God is on that side and his Son died for it. . . .

4. Youth expects answers

We did not foresee that this Assembly would meet in a year which seems to belong to the category of years of general and world-wide social and cultural crisis such as 1848, 1918, or 1945. And this

time the crisis is above all a crisis in the relations between the generations.

It is difficult to understand a general crisis when we are in the midst of it. . . . There is first of all the obvious crisis in our system of education. . . . But that is only part of the story. For it has become very clear that behind that demand for reform of the educational system there is at a second deeper level a radical calling in question of the political and social regimes in all parts of the world. . . . However vague the aspirations of this new generation may be, whatever excessive, self-defeating or intolerable forms their protest may sometimes assume, the questions they raise are real questions. Youth rightly expects answers. And this brings us to the third level. Behind it all there lies the issue of the total orientation of our civilization. Youth performs its historical mission of confronting us brutally with the question of the meaning of our common life. Can man live meaningfully in a great society in which production and consumption have become automatic forces and in which the astounding possibilities of technology are not brought under the control of a clear common purpose, a purpose which has to do with man as a person rather than man as a producer and consumer?

When young people all over the world ask searching questions about the ultimate meaning of life the churches should prick up their ears. . . . If we have anything to say about the orientation of our life together, about the calling of men, about a truly responsible society, about the true priorities, this is the time to say it and to say it in such a clear, simple and direct way that youth also may prick up their ears. . . .

David Roberts: Existentialism in Religion

What is existentialism, and why should Christians pay any attention to it? There is no simple answer to this question because each of the writers whom we shall discuss gives his own account of what he is trying to do, and not all of these accounts are mutually compatible. Therefore we shall have to listen to what these thinkers actually have to say before we can even put forward an adequate definition of existentialism.

And one word of warning must be issued immediately. In recent years the word 'existentialism' has gained popular currency mainly through the works of Jean-Paul Sartre. People in Europe and America have seen his plays and read his novels and essays, and the idea has gotten abroad that existentialism means his particular brand of nihilism. Existentialism began, however, as a frankly Christian mode of thinking, and I shall hope to show that what is valid and illuminating in it can be held in perspective within the Christian faith. Yet I believe that these same emphases, when sundered from such faith, become particularly vivid expressions of the spiritual disintegration of our age.

Thus a study of existential philosophy brings into sharp focus the basic struggle between contemporary Christianity and so-called 'secularism.' The movement includes figures who represent both extremes, and many positions intermediate between them. Gabriel Marcel, the French Roman Catholic; Nicolai Berdyaev, the Russian Orthodox lay theologian; Martin Buber, the Jewish philosopher; and many Protestant thinkers have found in this sort of reflection a powerful

impetus driving them toward the affirmation and expression of religious faith. At the other extreme stand Martin Heidegger, the influential German philosopher who was unfortunately associated with the Nazis, and Sartre, who played a role in the French underground resistance. Both of these men are avowed atheists. and they are close together philosophically even though they stood at opposite poles politically during the war. Karl Jaspers provides a very interesting example of an intermediate position. He is not an atheist —on the contrary he is a deeply religious person; yet he holds aloof from his Protestant heritage and determinedly attacks the very center of Christian belief.

In all its forms, however, existentialism should be of compelling interest to the Christian thinker today. For it protests against those intellectual and social forces which are destroying freedom. It calls men away from stifling abstractions and automatic conformity. It drives us back to the most basic, inner problems: what it means to be a self, how we ought to use our freedom, how we can find and keep the courage to face death. And even more important, it bids each individual thinker wrestle with these problems until he has grown into personal authenticity, instead of simply taking his answers from someone else.

Yet in my opinion existentialism cannot serve as a self-sufficient philosophy. Its chief value is that of a corrective. By clearing away philosophical underbrush it brings us face to face with the urgency of ultimate questions. But it does not answer them. It may lead a man to the point where he sees the momentousness of a de-

From Existentialism and Religious Belief by David E. Roberts. Copyright © 1957 by Oxford University Press, Inc. Reprinted by permission.

cision for or against faith in God. But the over-all value of existentialism depends upon the outcome. Where it leads to Christian faith, it offers a promising basis for a concordat between philosophy and theology. Indeed, anyone who takes Biblical revelation seriously must approach philosophical problems in a fashion which incorporates certain existential elements whether he uses this term or not. Yet even where existentialism leads to atheistic conclusions, it is of great importance that we understand it, for it offers a particularly poignant exposition of the predicament of modern man. Here we see individuals facing tragedy without any hope of salvation. We see them standing in utter loneliness and staring at bleak emptiness. And as Christians we need to understand these atheists because, unlike more complacent modern thinkers, they are honest enough to voice that sense of despair which is so widespread in our world. They speak, in fact, for millions of our contemporaries for whom God is dead. They tear away the masks of optimism, self-confidence, and indifference. They help us to understand how the will-topower issues from hopelessness, how dictators can compel men to renounce their freedom for the sake of specious security, how emptiness lurks behind our amusements and our vices, and how men become enraged at a civilization which makes them cogs in a well-oiled economic and political machine.

Still, existentialism is difficult to define, even provisionally, because most of the writers I have mentioned are deliberately unsystematic. They are not in the slightest degree interested in purveying a set of findings like the answers to arithmetic problems which can be found at the back of the book. Rather are they inter-

ested in arousing the reader to a spiritual struggle. Hence the result of this kind of philosophy is what it does to you, not some answer which can be appropriated without going through the agony of figuring things out for yourself.

This is why these men so often produce plays, novels, journals, fugitive essays or meditations. For them, entering into the truth involves a profound kind of self-examination. The most significant thing, they feel, is a change in the manhis motives, feelings, and hopes—instead of an increase in his fund of knowledge. Such a method constitutes an explicit protest against traditional philosophizing by insisting that the personal commitments of a thinker be incorporated into his definition of truth. In fact, it accuses all objective philosophies of divorcing reason from life by trying to evade such human polarities as freedom-and-destiny, anxiety-and-courage, isolation-and-community, guilt-and-forgiveness, instead of recognizing that these polarities must remain perpetually at the center of vital thinking.

Ordinarily the student of philosophy assumes that his task is to master certain concepts and to get them straightened out rationally so that they will be free from inconsistency. He hopes thereby to arrive eventually at an explanation of nature, man, and God. But existentialism passionately protests that the truly great questions of life cannot really be answered by means of scientific information plus clear thinking. For example, I may learn and accept certain theories about immortality without moving one step toward fitness for eternal life. Or I may learn and accept arguments for the existence of God without making one step toward trusting Him in such a way as to incorporate His love in my own life.

The task which lies before us may seem, therefore, to be a contradictory one. We propose to survey and scrutinize existentialism, whereas a real grasp of it demands being on the inside rather than looking curiously at it from the outside. If the ghost of Kierkegaard were present, he would doubtless say that this book is a professor's project. Only the academic mind, he might say, could possibly be so stupid. And yet I cannot believe that this problem is totally insoluble. Is our danger very different from that of a teacher of literature? He can of course turn the study of Shakespeare or Dante into deadly pedantry, but need not. Admittedly, the problem of how to combine intense personal commitment with a critical detachment becomes most acute at the level of religious belief. But surely it is altogether possible to listen to another man's confession of faith (or unfaith) sympathetically, without feeling compelled to swallow it wholesale. And I, for one, can see no real contradiction in studying the general characteristics of existentialism, so long as it is remembered that acquiring information about it is very different from entering personally into the spiritual engagement which it exhibits. Therefore I shall make bold to suggest, in a preliminary way, a few of these general characteristics of existentialism.

First, it is a protest against all forms of rationalism which find it easy to assume that reality can be grasped primarily or exclusively by intellectual means. It is an emphatic denial of the assumption that construction of a logical system is the most adequate way to reach the truth.

In the second place, existentialism is a protest against all views which tend to regard man as if he were a thing, that is, only an assortment of functions and reactions. This means that in the sphere of philosophical theory existentialism stands against all patterns of human organization in which the mass mentality stifles the spontaneity and uniqueness of the individual person. Incidentally, this refusal to accept the dictates of mass-mindedness applies quite as much to the automatic conformities of a democratic, capitalistic society as it does to the obvious regimentation of a totalitarian ordering of life.

Thirdly, existentialism makes a drastic distinction between subjective and objective truth, and it gives priority to the former as against the latter. This word 'subjective' may be easily misunderstood. In ordinary speech when we say that someone has given a highly subjective interpretation, we imply that it is biased, prejudiced, and unreliable. When, however, existentialists speak of 'subjectivity' they have in mind something very different from this. They are not denying that through science, common sense, and logic men are able to arrive at genuinely objective truth. But they insist that in connection with ultimate matters it is impossible to lay aside the impassioned concerns of the human individual. They are calling our attention to the fact that in the search for ultimate truth the whole man, and not only his intellect or reason, is caught up and involved. His emotions and his will must be aroused and engaged so that he can live the truth he sees. The fundamental difference, then, is that between knowing about the truth in some theoretical detached way and being grasped by the truth in a decisively personal manner. While the objective standpoint gets as far as it possibly can from the feelings, hopes, or fears of the individual human being, the subjective point of view puts the individual with his commitments and passions in the very center of the picture. And only by the latter approach, say the existentialists, can a man be so grasped and changed inwardly as to deepen and clarify his relationship to reality, even as a thinker.

In the fourth place, existentialism regards man as fundamentally ambiguous. This is very closely linked to its predominant stress on freedom. It sees the human situation as filled with contradictions and tensions which cannot be resolved by means of exact or consistent thinking. These contradictions are not due simply to the present limitations of our knowledge, and they will not be overcome merely by obtaining further scientific information or philosophical explanation because they reflect the stubborn fact that man is split down the middle—at war with himself. He is free, yes; he is conscious of responsibility, of remorse, of guilt for what he has done. Yet his whole life is enmeshed within a natural and social order which profoundly and inevitably determines him, making him what in fact he is. He is finite; but he is capable of rising above the limits of any particular situation through his action or his imagination. His life is bounded in time and is moving forward toward death; yet he has a strange kinship with eternity because he can rise above the present and see its relation to the past and the future. From top to bottom, as it were, man is a contradictory creature. Viewed from the outside, he is but an episode in the vast process of nature. Viewed from the inside, each man is a universe in himself.

Hence there can be no simple answers to what man should do with his freedom. In one sense, he must himself create the answer by using his freedom to find out just what he wants to become. He will not avoid this dilemma by returning to the level of the animal who does not ask metaphysical and religious questions. Nor can he avoid it by accepting some ethical or religious system which purports to give him infallible guidance as to what he should do. For man himself has a hand in producing these systems, and does so for reasons which the system cannot altogether conceal. All of us try to run away from this predicament. Everything would be simple if we could become either like animals or like God. As an animal, or as God, man would be liberated from the agonizing torments of moral conflict and inner strife. But so long as we remain human we must enter into the mystery of what it means to be a finite self possessing freedom.

It is quite obvious that some at least of these characteristics of existentialism are as old as human thought. For example, the Bible constantly tells us that only through a conversion of the whole man can we enter into the truth. One might then inquire why existentialists should be permitted to claim a monopoly on something which has been affirmed by virtually ever Christian thinker. Yet writers like Pascal or Kierkegaard would gladly agree that there is no such thing as existentialism taken by itself. They would say that they were not trying to start something new, but were seeking to call men back to an inner realization of what Biblical revelation always has meant and always will mean. The crucial issue is not whether a philosophical outlook takes account of subjectivity, freedom, and inner conflict; every such outlook pays some attention to what these words stand for. The crucial issue is whether one regards these as central or peripheral. Many philosophers work them into a context which

denatures them. They are woven into a fabric of thought where all contradiction is finally smoothed out into intelligibility and harmony. The genuinely existential thinker, on the contrary, regards contradiction as not merely the Alpha but the Omega; thought must not only begin here but must return to the given ambiguity of the human situation, and do so continually. In the end, moreover, thought cannot get beyond it.

One further word of clarification is necessary before taking up our study of individual existentialists. All stirring firsthand experience may be termed 'existential' in a fairly broad sense; for example, falling in love, being seized by some group loyalty such as patriotism, or possessing any type of moral earnestness. But this usage is so vague that the word becomes almost completely meaningless. In this regard it is helpful to focus upon the fact that man alone can ask ultimate questions, let alone answer them. Also, of course, we can ask pertinent questions about the weight or worth of a particular experience like serving our country or making a certain decision. Yet beyond such particular meanings and values we may ask why there is a world at all, why man exists at all, and whether our lives are at bottom meaningful or meaningless. These questions can be raised in a speculative and detached way, but whenever we come to face them with passionate earnestness, fully aware of the solemn risks and tremendous opportunities involved in them, we are entering into an 'existential attitude' in the narrower and stricter sense.

Now such an attitude has its potential weaknesses as well as its strengths. One may carry the contrast between subjective and objective to such a point that value or science or logic is unwisely deprecated. In theology, the contrast can be drawn so sharply that faith and reason are driven unwholesomely asunder. Let us be clear that wherever existentialism undercuts the elements of rational structure which are indispensable to both metaphysics and Christian theology, it must be rejected. Properly employed, however, this mode of thinking rightly opens the way to a reformulation of philosophy and Christian doctrine which can render them vital and dramatic instead of rigid and sterile.

Another potential weakness can be detected at that point where the isolated individual becomes so preoccupied with his freedom, his struggle, his inner conflicts, that he is shut off from fruitful contacts with nature, society, and God. Here again existentialism is primarily valuable as an antidote, but poisonous as an exclusive diet. As an antidote, it issues a not unimpressive protest against those tyrannical and legalistic elements which may be found in every society and every institution. But unless it is able to carry the human being in the direction of a restored and purified conception of community, it becomes a destructive and not a truly prophetic voice. So far as Christianity is concerned, this means that the acid test of an existentialist is his attitude toward the Church; and on this score some but not all of them betray a grave weakness.

Finally, stress upon freedom can lead toward either faith in God or downright atheism. That is why the movement which we are to study is divided roughly into two camps. One group is trying to make an atheistic acceptance of freedom and despair serve as the only possible answer. The other group is finding that the implications of human responsibility lead

inescapably to a revival of religious faith. A deepened sense of human need and failure can lead toward readiness for faith in God. A keen recognition of our inability to heal ourselves through strenuous moral effort or through sustained theoretical knowledge can awaken us to the meaning of divine forgiveness. But on the other hand, the awareness of freedom may lead to the conviction that man must

make himself self-sufficient, self-authenticating. It may prompt us to feel that dependence on God is no more than a form of slavery. It may cause us to take our last stand on a Stoic courage which is able to stare at emptiness, tragedy, and death unafraid. Thus existentialism has produced both the most penetrating forms of Christian faith and the most nihilistic types of human self-assertion.

VIII. Questions for Communism

1948–1953 had been a time of terror and silence not only in Russia itself but in Russia's satellites, whose leading personalities—along with thousands of lesser men and women—were executed or imprisoned. Stalin's death in March 1953, the arrest of his Secret Police Chief, Beria, in July of that same year, marked the end of an era and the beginning of what was described as the Thaw. This was confirmed in February 1956 when the country's new master, Nikita Khrushchev (1954–64), addressing the Twentieth Congress of the Communist Party, denounced Stalin's tyranny and his errors—not least the late dictator's personality cult. Though secret, Khrushchev's report soon became known to a public which could not ignore the measures being taken to remedy some of the errors that were now being condemned.

The release of political prisoners by the thousand, the rehabilitation of Communist leaders murdered in Stalinist purges, the arrest of security police and the beginning purge of the party machine, set off a trail of questioning and criticism which soon rose to insurrectionary force. Industrial strikes (the greatest of them at Poznan, in Polish Silesia, in June 1956), meetings, debates, articles in the heretofore muzzled press, shook the hold of Stalinist bosses, first in Poland (Spring–Summer 1956), then in Hungary (Summer–Autumn 1956). In Poland, unrest was first calmed by timely concessions, then stifled. In Hungary, also occupied by fraternal Soviet troops, popular risings in October and a government which sought to assert its Socialist independence were to be crushed by Soviet tanks.

The last revolutions nevertheless left their mark. For a long time, the Polish and Hungarian regimes allowed their subjects greater freedom than that to be found in other Popular Democracies. Moscow's relatively liberal orientation did not change, nor did the relative latitude permitted to its satellites. The limits of liberalization appeared in the late 1960's, when criticism at home and assertions of independence abroad seemed to endanger the Party's total hold on the levers of power and Russia's total hold over its "allies." The crudest demonstration of this came in 1968, when the Czech people, united behind their own Communist leaders, tried to reform the Stalinist policies which had brought the once-prosperous economy to the brink of bankruptcy. After a few months of freedom, they were overrun by Russian troops and those of Poland, Hungary and East Germany. The Spring of Prague lay shattered. Socialism could only be defined by the strong. But the problems revealed in 1956 and 1968 could not be swept away so easily. The following selections indicate some of them.

1. POLAND

In the mid-1950's, the Soviet Empire in Eastern Europe went through difficult times. Its satellites, inspired by the example of Tito's Yugoslavia, showed an inclination to reassert their independence. The Stalinist masters of these subject countries sat uneasily in the seats of power, aware of a growing wave of criticism whose chief carriers were students and intellectuals who had hoped much from socialism and found little in the régimes under which they lived.

Wiktor Woroszylski: Materials for a Biography

The experience which, in 1953, led my friends (and not only those of my age) to a certain sentimental and intellectual state which short-sighted observers took for a kind of softening, were quite diverse. My personal experiences may not have been typical: the others had not left Poland. But what was characteristic was this atmosphere of bitterness, of despair and disquiet, characteristic not only of the writers, but also of a great many party militants. The attempt to connect this atmosphere to the somewhat later phenomenon of the thaw rests on a misunderstanding. I think, on the contrary, that the thaw was, among other things, set off by this atmosphere. However, what made it possible were the events of March-July 1953,* which put an end to a long period of falsification of the revolution, of violation of the Leninist principles, of the party's life, of the personality cult.

[A Polish writer] wrote one day that he resented as an insult the fact of mentioning a *thaw* which had not begun by the initiative of an artist. For myself, I feel no humiliation at having discovered the perspective of a solution to my doubts and my anxieties, perspectives which I lacked until then, thanks to the decisive action of the Communist Party of the Soviet Un-

ion and of our party. On the other hand it seems important to me that we should have entered into a new period more favorable to the peoples which are building socialism and to socialistic art, not as docile executors, not as observers of weather vanes, but as men totally committed and desiring to share in events, resolved to fight for a radical and logical elimination of all the anti-revolutionary and inhuman excrescences of the revolution.

I don't want to give the impression here that the period of my profound despair, which began at the end of autumn, 1952, ended with the liquidation of Beria. No: the more the revelations multiply concerning the errors, the degeneracies, and quite simply the crimes whose responsibility does not fall only on their direct executors but also on those who feared to oppose them, who acted thoughtlessly or blindly, the more these revelations multiplied, the more difficult it became to hold out against laments and distress. Several years before I had invested a bit of my heart in a poem on the pretended treason of Yugoslavia. How could I not feel duped and wronged when I found out that this too had been a provocation? It took some time before the satisfaction of knowing that one more ob-

Nowa Kultura, March 25, 1956, no. 13.

^{*} The insurrection of prisoners detained in the Sub-Arctic labor camp at Vorkuta; the brief workers' rising in East Berlin.

scure story was being clarified, that one more mistake was being repaired, got the better of my grief. And how could I not suffer on learning the enormity of the crime perpetrated on the very flesh of the Polish Communist Party [almost all of whose central committee had been massacred by the Russians]. All these painful affairs are revealed progressively. And, though we are much more hardened than we were a few years before, each one of these revelations unsettles us deeply. I do not think that this is bad. I think it is necessary and inevitable. Perhaps other despairs and other griefs await us before we conclude the revision of our conceptions on the history of the international revolutionary movement after the death of Lenin. It is difficult, but we shall see it through. It is better to see the period of profound despair draw out, for it will be more healthy and more fruitful than complete apathy under optimistic cheers and revolutionary slogans.

And even if our enthusiasm will never again be as unlimited and as pure as in our first youth, even if we are fated to keep forever a grain of bitterness and scepticism, what is there to do about it? We settle an account which it is impossible to avoid.

WE START FROM SCRATCH

But we have the means. Despite our bitterness, our scepticism, and our incalculable moral losses, we are rich. We become Communists once more, we become a party once more.

We were a party when we were making the Polish socialist revolution, when we rubbed against present reality, by our own initiative and our own responsibility.

We ceased to be one when we lost confidence in our own conscience, when we submitted ourselves to the pressure of a scholasticism which wrongly claimed to represent the party, when the supreme revolutionary virtue appeared to us to be the discipline and efficacy of executives. Nothing depended on us any more, and we had really stopped being useful. Our activity was no longer anything but a game of vain illusions.

Today we are once more useful and everything once more depends on us. Again we discover reality, we plunge into the revolution with deliberation, anger and love. We feel ourselves responsible for its ways, its purity, its truth. We are not obedient, we are vigilant. We act on our own initiative, under the pressure of our own need to act.

One of the chief subjects of criticism against the established System was the mounting awareness that the classless society was producing a new ruling class: the bureaucracy. The possibility of such an evolution had been considered by Leon Trotsky. In his book *The Revolution Betrayed*, written while in exile, Trotsky both envisaged and denied such a likelihood.

Leon Trotsky: From The Revolution Betrayed

The means of production belong to the State. The State "belongs," in a manner of speaking, to the bureaucracy. If these

relations, which are still quite recent, were to be stabilized, legalized, become normal, without the resistance or against the resistance, of the workers, they would end in the complete liquidation of the conquests of the proletarian revolution. But this hypothesis is still premature. The proletariat has not yet said its last word. The bureaucracy has not created a social basis for its domination, in the form of particular conditions of ownership. It is obliged to defend the property of the State, source of its power and of its revenues . . . bureaucracy has neither stocks nor shares. It is recruited, it is coopted, it is renewed, thanks to an administrative hierarchy, with no particular rights in matters of property. The civil servant cannot transmit his right of exploiting the State to his heirs. The privileges of the bureaucracy are abuses. It hides its revenues. It pretends that, as a social group, it does not exist.

Since the 1930's when these words were written, the privileges of bureaucracy, especially in countries where the whole state apparatus was nothing but one vast bureaucracy, had come to be affirmed. There was nothing shamefaced now about its power and very little even about its abuses. Inevitably, the inhabitants of Communist countries were among the first to note the rise of what Milovan Djilas has described as *The New Class*. By 1955 and 1956, the Stalinist members of the cultural establishment had gone over to the defensive before the barrage of criticism set off by Khrushchev's revelations at the Twentieth Congress of the Soviet Communist Party. A characteristic text of this period, the work of a Stalinist novelist, appeared in the Polish Student Weekly, *Po Prostu*. Its hero, a certain Dr. Faul, ends by justifying the position and the actions of Stalinists like himself to a couple of actors in a play called "Grenade," who had come to challenge him.

Kazimiers Brandys: Defense of Grenade

You demand that I make reparation. You hold me responsible for the evil perpetrated in the course of these past years. You have come to examine my files and my accounts in the name of the revolution. You have come on the day when the revolution accomplishes a new effort: that of knowing itself. This effort and this day make you wiser. . . . What did you know of the revolution when you created "Grenade"? You knew the tank with a red flag and the poster with its slogan "Leftward March." But, we have seen, this im-

age of the revolution is insufficient, the force of the revolution is infinitely greater. The forces of the revolution are so powerful that at certain moments the revolution itself cannot bear them. That is when the world believes that we are destroying ourselves, that we stifle and limit the revolution by submitting her to hierarchy and method. I do not justify the errors, I simply explain them. I do not exonerate myself, I demonstrate that the sacrifices which I asked of you were perhaps not unknown to me either. Am I responsible

for the evil that has been done? Yes. You must not believe, however, that you are not just as responsible. That which I passed on to you, you passed on to others. You passed on to others your own experi-

ences: the good and the evil which could not be separated as easily in the revolution as meat from the bone on the table of a bourgeois.

Within six weeks of its appearance, this apology of Stalinism in which revolutionary dialectic was used to justify the injustices of a particular moment would be answered in the pages of the same periodical.

Jan Josef Lipski: Who Is Dr. Faul?

Dr. Faul is an opportunist (it doesn't matter whether of the tragic or the cynical kind). But what is an opportunist? Is Dr. Faul an agent of the bourgeoisie? Evidently not. It is on this evidence that Brandys has built his attempt to absolve him (we cannot help it, only a spiritualist language is appropriate here). Nobody maintains that the doctor wanted to denationalize the factories. So who is he? A man who goes astray (or who sins)? And against whom does he "sin"? To whose advantage? Can such a process, which isn't at all individual, but takes place on a vast social scale, unfold outside any social interests? And, if this is so, in whose interest was Dr. Faul acting? "For" or "against" the working class? If it is "against" . . . then what was his aim? Does Dr. Faul also want to denationalize the factories?

I think I have asked enough questions left without an answer to feel myself constrained to formulate a hypothesis. This is it: the danger that we appear to have avoided, though God knows that we were not theoretically prepared for it, was the danger of seeing a part of our party apparatus and of the State become a new

class. Yes, precisely: a new class! This new class, if it had managed to crystallize and to constitute itself, would not have been the equivalent of the bourgeoisie. It would not have denationalized the factories and the land. It would have known how to annihilate the contents of our system while keeping its formal characteristics. It would have been capable of expropriating the working class without in the least having to restore the private property of the means of production. It would have known how to create privileges for itself, how to isolate itself from the rest of the nation by a wall of separating institutions typical of an elite, by alienating mores, a different kind of culture, of living quarters, of holidays, of love, the whole resting on a system of financial and political privileges that disown democracy.

It is not easy to unmask the men, the social group, who were moving in this direction. They used revolutionary slogans, and, better still, they were as hated by the bourgeoisie as by the true revolutionaries. We could therefore think that, if we had certain enemies in common with them, we would also have common ends.

Is all this simple fantasy? I do not think so. It is barely an attempt to explain what we today call the *Beriovchina* * without yet being able to provide a scientific definition of this social phenomenon. Before we can arrive at such a definition, we have to be satisfied with a partial definition.

The *Beriovchina* is the tendency of a group to separate itself from a society in which socialism has appeared. The aim of the *Beriovchina* was in fact to expropriate the workers. It tended to give birth to a new class.

Finally, the *Beriovchina*—and this is what makes our diagnostic more difficult—liquidated the bourgeoisie and was hated by it. There is not a single man so naive as to suppose that the liquidation of the *Beriovchina* would have been regretted by the bourgeoisie.

For years the working class has carried on a struggle on two fronts, in extremely difficult conditions and without the least theoretical support. The consequences were serious, and when the *Beriovchina* dealt a blow to the working class, at best this class parried the blow blindly as if it came from the bourgeoisie. But the worst is that often we took the blow and remained passive. We were then ready to consider the defensive reactions of the working class to the blows directed against it as an expression of weakness and mistrust.

It was not the first time in history that reason seemed to stand by the side of the working class, taken not as a vague hypothesis sprung from Hegelian philosophy, but as a concrete collectivity of men united by a common social and economic destiny. When on the contrary the *Beriovchina* dealt a blow to the bourgeoisie

. . . we were completely quiet.

Thus, without any theoretical understanding of the situation and deceived by the theoreticians of the hostile growing class, we found ourselves on the verge of catastrophe. If we avoided it, the merit must be partially attributed to those who intervened in time and especially to the class which has created the conditions for an exact solution of this problem.

Having noted this, we are inclined to a certain optimism: the structure of our regime evidently produces its own antitoxins, thanks to what one sometimes calls "the class instinct."

On these general foundations, how does the problem of Dr. Faul present itself?

This seems clear: Dr. Faul is the class enemy. He loves the proletarian revolution? Above all he loves his functions. What does he care about doctrine? He can change it every time the interests of his group demand it.

These functions are the key and the content of Dr. Faul's future hopes, because we must not deceive ourselves; we shall always see relapses in the future and they will take place according to a process which will always be similar to the one we have known.

The degree of Dr. Faul's self-consciousness matters little. In theory he is not certain to represent a group which tends to become a class. But the end of his activity is clear: this man profits from the privileges which he has created to his advantage in order to separate himself from the working class. Dr. Faul is the man who appropriates a part of the social revenue disproportionate to his labor; he is the man who fights against equalitarianism in order to defend his privileges,

^{*} The years of Beria, Stalin's last chief of secret police.

while at the same time hiding his privileged situation from public opinion; finally—and this is essential—he is the man who arrogates to himself the exclusive privileges of action and enters into a permanent conflict with the democratic bases of the regime.

The hopes of 1956 were soon disappointed. Waclaw Gomulka, the Communist leader imprisoned during the Stalinist terror, was released in the spring of 1956 and carried to the head of the Communist party and of the Polish government. His reappearance served as a pacifier and a promise of reform. What Poland got was less repression but no reform. Soviet troops withdrew from Poland, but the Soviet influence remained; and by 1957 the hopes of 1956 had to be abandoned. The following lines are taken from an issue of *Po Prostu* which never reached the newsstands. Printed but confiscated, it reflected a point of view widespread among the students and intellectuals of Russia's satellites.

Stefan Kurowski: Apathy, or the Search for a Purpose

Apathy, indifference and weariness this is how it has always been, perhaps with the exception of a few ardent days in the autumn of 1956. But today these phenomena appear on a new scale, affect new circles, influence even the most active, encompass all the aspects of social life, paralyze both the organizations of social production and the organizations of social morality. We are passing through a period of universal and profound devaluation of public speech. . . .

Apathy, indifference, discouragement, and tedium dominate the public spirit more and more; they appear literally everywhere, they become the basis of every situation and of every problem that we must resolve; we notice them on the faces of all those to whom we speak, and it is very likely that they appear on our faces as well, for apathy, discouragement and tedium are growing in ourselves. . . .

What can we conclude from this? If one wants to fight against indifference and apathy, against disenchantment, one must not fight with words, but with actions, basing oneself on facts, and on a concrete action. We need acts, we need facts, if we want to improve certain items in particular and the social condition of the people in general. Acts are the more necessary since no one, absolutely no one, believes any more today in words, in words alone.

2. HUNGARY

In Hungary, the role played by *Po Prostu* in Poland, as a speaker's corner open to discussion and criticism, fell to the Petöfi Circle of Communist Youth. Founded by young Communist intellectuals in 1955, the open debates the Circle sponsored beginning in March 1956 attracted thousands of listeners and scandalized the oldline Stalinists. On June 27, 1956 (while Polish workers were striking and rioting at

Po Prostu, September 7, 1957.

Poznan), the Petöfi public acclaimed the writer Tibor Déry for asserting that it was time to put an end to "this State of policemen and bureaucrats." On June 30, the resolution below expelled Déry from the Communist Party. His critics were right to do so, for the Petöfi Circle lit the fire of the revolt to come.

From: Resolution of the Central Committee of the Hungarian Workers' Party

Under the effect of the historic Twentieth Congress of the Communist Party of the Soviet Union and on the basis of the resolution of March 12–13 of the Central Committee of the Hungarian Workers' Party, the internal democracy of the party, the democratism of social and political life, and the socialist justice of our country, were becoming stronger. The party has obtained considerable initial results in the struggle against the remains of sectarianism and of the personality cult, and the Leninist principle of collective leadership makes itself increasingly felt in the work of the party.

Constructive criticism, healthy, creative discussion, and the motions of workers, peasants and intellectuals, all drive towards the construction of socialism.

We must welcome most particularly the fruitful discussion developed within our party organizations. In these discussions many sound and correct propositions see the day, all directed to increasing results and correcting errors.

However, this wholesome development is threatened at moments by demagogical interference, directed against the party and against the popular democracy. The organizations of the party, and the Communists, have on several occasions opposed such aspirations. But in certain cases, the members of our party have failed in their duty, chiefly because they believed that by taking up an energetic

position against incorrect views, they would give the impression of stifling criticism. Encouraged by the patience of the party, and of the Communists, elements hostile to the party have launched ever more vigorous attacks against the policy and direction of our party and against our system of popular democracy.

The Petöfi Circle of the Young Communist League is one of the centers of these attacks: In the beginning, its evening debates had a positive sense. But, lately, certain elements opposed to the policy of our party have tried to use them to a growing extent to spread their antiparty ideas and to mislead public opinion, particularly a section of the youth, as well as to recruit followers among hesitant elements.

Certain speakers in the last discussion of the Petöfi Circle have gone so far as to deny the leading role of the party and of the working class, and have propagated bourgeois, counter-revolutionary ideas. With other speakers, they have stressed unilaterally and in a demagogic manner, the errors committed in the course of the development of the party and of the popular democracy. Moreover, they have denied the revolutionary conquests of our party and of our working people, and have slandered the officials of the party and the State whose labor is one with the great triumphs of the Hungarian Popular Democracy. These speakers, relying on the extraordinary popularity of the Leninist ideas and of the Twentieth Congress, have spoken as if they took their stand on the Twentieth Congress and on Marxism-Leninism, in order to mask in this manner also, their anti-party and anti-popular democracy ideas. By this attitude they have deceived the honest workers, including among them Communists who did not realize at once that they were faced by a malevolent anti-party manifestation. . . .

The members and the organization of the party must keep a vigilant watch over the unity of the party and reinforce its discipline. Let them be aware that all those who want to break the unity of the party and introduce a shadow between the Central Committee and the members of the party, between the officials of the party and the State, and the people, are in the service of the enemy.

The Central Committee appeals to the members of our party and to the non-party workers, and asks them to intensify their revolutionary vigilance, for, under the impact of anti-party demagogic ideas, the danger of provocation of disorder is being born. The provocation of Poznan is directed at all Hungarian workers, at all honest patriots, and calls them to face the attempts to make trouble. . . .

Gyula Háy: The Problem of Truth

We reached the point where the essential problem-in my opinion . . . for the general assembly of today 1—is that of truth. The best Communist writersafter many difficulties, serious errors, and a violent spiritual struggle—have decided that never again, on any account, will they write lies. Let us say honestly that this was a fundamental cause of the struggles and humiliations of recent years. The true reason of our conflicts was that we had vowed to tell the truth and that certain influential personalities-not understanding the true role of literature in society and forgetting that the party also expects its members to tell the truth blamed us for it. We want to promise here that in the future we shall never be bound to those who, considering the lie as an indispensable political weapon,

want to impose it in literature as well.

I was fifteen years old when, staggered by the horrors of the First World War. I understood for the first time that the Rights of Man could only be applied with the aid of an infinitely wise philosophy, radiating an immense force. This philosophy is Marxism. During the forty years which followed, the Marxist philosophy became the foundation of all my thinking, the leading force of my life. But the recent years and the spiritual torments we have undergone have taught me that even an extremely wise philosophical foundation is not sufficient protection against the errors, the deviations, possibly the sins, of dishonesty. Even a Marxist must fight every day for truth, against himself and against others.

Irodalmi Ujsag, September 22, 1956.

¹ This refers to the meeting of the writers' association.

Manifesto of the Intellectuals (October 28, 1956)

The revolutionary committee of Hungarian intellectuals was set up on October 28 in the main building of Budapest University. The committee unites all intellectual organizations: writers, artists, scientists and students. The committee has immediately issued the following appeal to the population of the country:

Glory to those who, sword in hand, have fought against the crushing superiority of the enemy, and glory to the man in the street who has fought weaponless against the tanks and the machine guns! We thank those Soviet soldiers who have refused to use their weapons against the Hungarian people.

Hungarians! We can proudly face the iudgment of the world . . . in our country power at last belongs to the people. Our youth, our army, our police, the Workers' Councils, and the peasants have fought side by side. Together we shall now have the strength to organize our life in a spirit of independence, of liberty and of democracy. This is why we appeal to our heroic fighters, to the young workers and peasants, to the students, to the members of the Petöfi Circle and to those of the popular colleges, and ask them to enlist in the national guard and thus lend their aid to the army, the police and the Workers' Councils to safeguard the order and security of our country.

We hope that we shall obtain satisfaction of our claims, by peaceful means. . . . We refuse and we shall fight all attempt to restore Stalinism or to provoke a counter-revolution.

Hungarians! We may disagree on certain problems, but we all agree on our chief demands. This is the program that we intend to submit to the government:

- 1. Immediate settlement of our relations with the Soviet Union. Withdrawal of Soviet troops from Hungarian territory.
- Immediate cancellation of all commercial agreements concluded with foreign countries and detrimental to our national economy. The country must be informed of the nature of these commercial agreements, including those concerning the export of uranium and bauxite.
- 3. General elections with secret ballot. The candidates must be named by the people.
- 4. Factories and mines must really belong to the workers. The factories and the land must remain the property of the people and nothing must be returned to the capitalists or the big landowners. The factories must be managed by freely elected Workers' Councils. The government must protect the right of artisans and small shopkeepers to exercise their trade.
- 5. Abolition of the abuses of the old system: pensions and salaries that are too low must be raised according to the possibilities of our economy.
- The unions must truly defend the interests of the working class, and their leaders must be freely elected. The peasants will be able to set up their own unions.
- 7. The government must guarantee the freedom of agricultural production and help the small farmers and the voluntary cooperatives.

- The hateful system of compulsory [grain] deliveries must be abolished.
- The peasants, frustrated by enforced collectivization, must be restored to their rights and compensated.
- 9. The government must guarantee the full freedom of the press and freedom of assembly.
- The 23rd of October, day of our people's rising for its liberation, must be proclaimed a national holiday.

3. CZECHOSLOVAKIA

The October revolution was crushed by November. But it would be students and intellectuals who, once more, raised the banners of revolt—this time in Prague, in 1967 and 1968. After a few months of enthusiasm and hope, however, the country was invaded by "allies" bent on preventing it from taking its own road to Socialism.

On May 22, 1969, as the blanket of reaction stifled what remained of the liberties briefly won in 1968, a document was circulating from hand to hand among the citizens of Prague. It was the Manifesto endorsed by the Czechoslovak Cultural Front, a body of writers, architects, painters, journalists, musicians, and scientists. It seemed suitable that the intellectuals who had been responsible for the beginning of Prague's liberal revolution should provide the last, still, expression of its enduring hope.

Czechsolvak Cultural Front: Manifesto (May 22, 1969)

It is above all to ourselves that we set forth the basis on which our science, our arts, and our journalism are founded, and without which they cannot exist; it is to ourselves that we specify what it is that we want to defend. We are part of a civilized nation, to which we are all bound by our mother tongue, by our common work, by history. That is why we address ourselves to our fellow citizens to assure them that we share their alarm for the freedom, for the fate and the direction of socialism. The mission of culture consists in discovering and creating, in bringing profit and joy. We are ready to carry out this mission in whatever circum-

stances, favorable or unfavorable. Our experiences have taught us that culture is the blood of the nation and when the arteries are cut, the body dies.

Our first duty consists in serving truth, in seeking to discover freedom. Truth and freedom are for us inseparably bound. Freedom is not a gift or an endowment: it is not distributed, it is not granted. No epoch ever gives anybody anything free. It has always been necessary to wrest by struggle the freedom of creation, the independence of scientific research, the freedom of opinion. To overcome the obstacles created by the interests of power, such has always been, such is, such will

be, our mission. The greater the obstacles, the greater the moral demands of our position.

At the present moment, the fundamental cultural rights are limited. Culture is deprived of possibilities it had established a long time ago; culture is being turned away from its true objectives. We are witnessing the deformation of events past and present. It is without any shame that individuals who in the past have proven not their integrity but their spirit of compromise, who have shown not their capacities but their professional inadequacies, who have served not truth but the men in power, rise to the surface once more.

It is not only culture which is in danger. All human rights and all civil liberties are threatened as a result of the restriction of the freedom of expression. If the public administration is once more placed in the hands of those who, for years, have been incapable of solving the country's political and economic problems, we see no guarantee for the dignity and the security of the life of future generations.

We are told that science, culture, and the press belong to the State and that the State must be their master. But just as the land belongs to the farmers and the factories to the workers, the newspapers belong to the readers, the radio to the listeners, cinema and television to the public, science and art to all those who need them. Culture is not the property of the State, culture is the property of the people.

Today we are passing through a period of heavy trials. It is our brains, our courage, and our determination which are put to the test.

We want to come out of it with honor, in order to justify ourselves before our conscience, our fellow-citizens, and the unrelenting gaze of our children.

The interventions against culture multiply all the time; we shall oppose them to the fullest extent we can. Our unions, provided they are directed by legally elected representatives, will never again let themselves be forced to suppress the values which they must defend. None of us will betray his fellows or himself. Silence may be imposed upon us, but no one will ever be able to make us say what we do not think. We may be deprived of the freedom of expression, but none can deprive us of the freedom of thought, of a clear conscience and of dignity. Reason remains always the measure of the act, honor and integrity remain the measure of men. The Czechoslovak cultural world remains true to its beliefs and to all that it has discovered in truth and knowledge —to its tongue, to its national traditions, to its people. It will defend its mission, will develop cultural values according to its conscience, despite this difficult period.

IX. The Revolt of Youth

One of the great dreams of liberal reformers had been sited in the schools. Open the schools to the masses, and the world would become a better, wiser, more reasonable place. By 1970, with more people going to more schools than ever, the world seemed no better and the schools seemed worse. But though they no longer appear as instruments of salvation, schools have become essential training grounds for adult life, indispensable adjuncts of industrial civilization, inevitable preliminaries to position and profit.* Their degrees are impatiently sought by many who are indifferent to the education they dispense, their operation has become a matter of concern to all of society.

It is natural in the circumstances that the schools should come under fire from those who blame them for not adapting themselves to serve society's immediate needs, and those who feel that, adapting only too well, they serve as corrupting agents of a corrupt society; from those who demand more room, attention and facilities for themselves or their offspring, and those (often the same) who resent the increasing cost of educational systems that swallow an impressive part of the Gross National Product: 6.2 per cent in the United States, 5.7 per cent in Sweden and Holland, about 5 per cent in Russia and Britain, 4.3 per cent in France.

Greater and greater masses of young people, lured off the labor market into an artificially prolonged adolescence, are concentrated in teaching establishments whose relevance to their lives and needs they question with growing violence or dismay. They also question the authority of teachers whose prestige is sapped by competition from mass media more up to date on current affairs that seem of more immediate consequence to many, and also by uncertainty as to their own function. Unable to adapt to the swiftly changing world around them, or else so flexible that they lose all sense of a firm base, teachers as uncertain as their charges find it difficult to answer questions—and demands—that go far beyond the traditional offerings of the system.

Material dissatisfactions were sharpened and, so to speak, precipitated by ideological dissatisfaction with ambient society, with the

^{*} This is nothing new. In 1868, the head of an Oxford College complained that "the scholar's gown is too often to be found on youths who have no vocation for science or literature, and whom it was no kindness to have drawn away from their proper destination to active life. They have come here as a commercial speculation. High wages are given for learning Latin and Greek, and they are sent to enlist to earn the pay." Mark Pattison, Suggestions on Academical Organization (1868), p. 62.

values it proposed in theory and ignored in practice, at last even with the promises of revolutionary creeds which experience revealed to be as corruptible (and corrupt) as the imperfect universe of everyday. Built as training grounds for tomorrow's citizens, the schools became the nurseries of civil revolt, bastions of a new radicalism which expressed little more than the ideals that the parents had abandoned to their offspring.

It may have meant more than that, if one is to believe Charles Péguy, not long out of University himself at the time he wrote the following breathless lines:

The crises of teaching are not crises of teaching; they are crises of life; they designate and represent crises of life and are themselves crises of life; they are partial, conspicuous crises of life which announce crises of life in general; or, if you prefer, the crises of general life, the crises of social life, worsen, gather, culminate, in crises of teaching, which appear particular or partial, but which are actually total, because they represent the whole of social life; for it is in effect at that point that the eternal test awaits, so to speak, humanity as it changes; the rest of society can pass, faked or camouflaged, teaching does not pass; when a society cannot teach, it is because that society cannot teach itself; it is that it is ashamed, that it is afraid, to teach itself; for all mankind, in essence, to teach is to teach itself; a society that does not teach is a society that does not like itself; that does not respect itself; and that is precisely the case of modern society.*

The following selections reflect the new revolutionary temper of the late 1960's and its effects, in France where a student uprising in 1968 profoundly affected the course of national politics, in Germany where the radical students' anti-parliamentary opposition has made itself felt in the past few years, and in England.

1. THE STUDENT REVOLT AT NANTERRE

I teach at Nanterre where, in mid-November 1967, on the initiative of Sociology students and teaching assistants, a strike of the students of the Faculty of Letters and Social Sciences marked the first stage of events. There were two apparent causes for the outbreak of the

crisis: the saturation of the Faculty, designed for ten thousand students and which, in this its fourth year of existence, had just accepted twelve thousand; the confusion and disorganization of teaching and administrative personnel, as a result of the reform of university education,

Epistémon, Ces Idées qui ont ebranlé la France, Fayard, Paris, 1968, pp. 17-21. Translated by Eugen Weber. Reprinted by permission of Editions Fayard.

^{*} Cahiers de la Quinzaine, November 11, 1904, pp. xxiv-xxv.

known as the Fouchet reform, hastily imposed and accompanied by an insufficient

budget increase.

When the cadres feel uncertain of their objectives and their methods, the base loses confidence in them. When the masters of knowledge offer to those who come to take them as a model, the spectacle of their discouragement and of their ignorance (ignorance of regulations and curricula, as well as of the inclination and hopes of the students), the universe where the latter lived in security collapses. One belief sparked their coming to university: that the possession of knowledge brings to human beings true power and true nobility. This ideal notion changes into a burst balloon. Collective anxiety spreads, with its alternating escorts of rage and apathy. From that moment we date the break between the two attitudes-the radicals and the indifferents-which developed at Nanterre in exemplary fashion and much faster than in the rest of the French University. In any case each attitude reinforces the other by a mutual antagonism. The angry minority becomes more and more active, indeed "activist," in reaction to an ever more amorphous student mass. Amorphous towards learning as well as towards commitment.

A third last cause of the crisis: the campus. The domain of the University of Nanterre is a building site lost in the midst of cheap municipal housing blocks and shanty towns, difficult to reach, and whose surroundings have none of those cafés, those bookshops, those busy streets, those cinemas, those little bars where, in traditional university towns, the students seek a complement of life and their insertion in the social texture. No doubt Nanterre is such, but I do not think this cause played the major part too quickly

and too often attributed to it. I refer to two proofs. As long as the Faculty of Letters, which had just been built, remained underpopulated in terms of its capacity, and as long as the old program and the old curriculum functioned on familiar lines, there were no incidents, no tensions, no serious problems at Nanterre. The campus was experienced as unbearable only when the first two causes came into play. It then became a scapegoat: discontent was displaced from its principal object (the studies) onto the campus. It was also an aggravating factor: the campus, attendant cause of discontent, added to the principal causes, increased the discontent beyond the threshold of tolerance. My second proof is that in the Law Faculty, situated on the same campus and which is neither overcrowded with students nor affected by curricular changes, no agitation took place before the rising of May 1968.

Let us repeat that the first and deepest cause, in my opinion, has been the discrediting of knowledge. In the impossible situation created by the Fouchet reform and by the massive increase in the number of students, those who were supposed to know administered the proof that this knowledge gave them no power. What is the value of knowledge? What is a knowledge which does not even know how to communicate itself? Does knowledge exist? Vaguely, confusedly, the students began to face such questions. The hierarchy of experience and of competence, found itself implicitly contested. The students of Nanterre took five months, from November 1967 to March 1968, to draw explicitly, in the form of concrete actions, all the consequences of this contestation.

What eventually became the movement of March would extract its directing principles from this original experience. It would affirm, in effect:

1002

- that there is no difference in nature between the teacher and the taught;
- 2) that the "movement" does not have any particular political knowledge which would permit it to say in advance what it wants and what will happen.

And these two statements reflect very well, each in its fashion, the distressing discovery of the non-knowledge of those who were believed wise.

The first contradicts the traditional view which places teacher and taught on two opposed sides of a barrier. This view places the former on the side of knowledge: the latter, on the side of ignorance. It follows that the relation between them is hierarchized and follows a descending vertical line: the teacher addresses the ignorant, to whom he never hopes in any case to communicate anything more than a partial knowledge. May 1968 would see the generalization of the contestation of such a schematic view. Ever since, the equality of teacher and taught manifests itself in very concrete fashion, in commissions open to all that hold their meetings in the faculties in lieu of the old courses: all sit at the same table, they raise their hands if they wish to speak; their opinions have the same weight when a vote is taken. Teacher and taught are henceforth in the same boat, on the same side of the fence (and sometimes of the barricade): they are on the side of nonknowledge, both have to learn and to learn together. Knowledge—in the sense of total knowledge, which could, in any domain, be known by a single man-is

denounced as a hoax. Knowledge, like society, is to be made. This double objective arouses the enthusiasm, mobilizes the energy, of a youth in whom the idea of ingurgitating a mass of ready-made knowledge had finally killed both appetite and courage.

What is true for pedagogical practice is also true for political practice. To the contrary of the established parties, endowed with an organization and a doctrine, and pretending to know something in politics, the "movement" never ceases to affirm, not only its refusal of present society, but its refusal to organize itself and its refusal to theorize. By what society should the society they seek to destroy be replaced? The "movement" does not know and it contests the question. Let us first destroy, and the creative outburst will be set free which will invent a society quite different from those which could be imagined at the moment. The "movement" anticipates nothing, predicts nothing, establishes nothing. It decides its goals and its tactics from day to day. Does not every revolution follow an unforeseeable progression? Are not the results it produces always different from its proiects? Hence, spontaneism becomes a rule. or rather, spontaneity appears as the positive content of something which first states itself as a refusal: the refusal to consider that political action has room for rules, for laws, for predictions, for programs.

Knowledge, as one can see with professors, gives only a pale shadow of power. The practical efficacy that non-knowledge sets off is part of a superior order, that of an explosive force, that of revolutionary efficacity.

2. THE WALLS OF 1968

In May and June 1968, the walls of Paris flowered with a variety of inscriptions. Here are a few of them.

The dream is the reality.

God, I suspect you of being a left-wing intellectual.

Walls have ears. Your ears have walls.

Anarchy is I.

Millionaires of the world, unite! The wind is turning.

Freedom is the right to silence.

Did you know that there were Christians left?

Exaggeration is the beginning of invention.

The aggressor is not he who rebels but he who affirms.

May 1968. World revolution is the order of the day.

Pacifists of all countries, oppose all warlike enterprises by becoming citizens of the world.

All reformism is marked by the Utopianism of its strategy and the opportunism of its tactics.

Enough of churches.

When the finger points to the moon, the fool looks at the finger.

In the revolution there are two kinds of people: those who make it, those who profit from it.

Those who are afraid will be with us if we remain strong.

Conservatism is synonymous with corruption and ugliness.

I decree a state of permanent happiness.

To be free in 1968 is to take part.

The barricade closes the street but opens the way.

I have something to say but I don't know what.

For a democratic school in a classless society,

For a classless school in a democratic society.

A good master, we shall have one as soon as each is his own.

Take the trip every day of your life.*

Make love, not war.*

NOTHING.

Every teacher is a learner, Every learner is a teacher.

Invent new sexual perversions [can't think of any more].

We shall destroy from the outside, they will destroy it from the inside: International solidarity with the Afro-American people.

Amnesty: act by which sovereigns pardon the injustices they have committed.

Comrades, arm yourselves!

Alienation ends where yours begins.

^{*} In English

Permanent and cultural vibration.

Free yourselves of the Sorbonne [by burning it].

It is forbidden to forbid. Freedom begins by a prohibition: that of hurting the freedom of others.

No exams.

Kill the bureaucrats. Enough actions, let's have some words.

A single non-revolutionary weekend is infinitely more bloody than a month of permanent revolution.

Don't free me. I'll do it.

The mind travels farther than the heart but it doesn't go as far.

Long live the students of Warsaw.

In any case, no regrets!

You are hollow.

I have nothing to say.

The tears of Philistines are the nectar of the gods.

SISYPHUS!

We shall claim nothing.

We shall ask nothing.

We shall take.

We shall occupy.

Action must be not a reaction but a creation.

Motions kill emotion.

Enjoy yourself here and now.

The forest precedes man; the desert follows him.

Run, comrade, the old are behind you!

We are reassured. 2 + 2 are no longer 4.

Don't make a revolution in the image of your confused and hide-bound university.

If your heart is on the left, don't keep your wallet on the right.

Rags soaked in petrol + soap powder + earth + a fuse = Molotov cocktail.

Exam = servility, social promotion, hierarchic society.

Neither robot nor slave.

The emancipation of man will be total or will not be.

WE ARE ALL GERMAN JEWS.

Love each other.

Comrades, the legitimate revolution declares an amnesty for all the country's armed forces and requests these to place themselves in the service of the people.

Death to the tepid.

SEX. It's good, said Mao, but not too often.

Novelty is revolutionary. So is truth.

Art doesn't exist.

Art is you.

A cop sleeps in every one of us, he must be killed.

Those who lock their doors are cowards, therefore enemies.

TEN DAYS OF HAPPINESS AL-READY!

Open the window of your heart.

We want to hit hard.

Alcohol kills. Take LSD.

All reactionaries are paper tigers.

Here one thinks.

The enemy of movement is *scepticism*. Everything that has ever been done comes from *dynamism* which stems from *spontaneity*.

No to the revolution with a necktie!

Program = private property for the future.

Are you consumers or participants?

Long live rape and violence!

No.

Yes.

Speech is counter-revolutionary.

Student power.

Revolution is an INITIATIVE.

It isn't man, it's the world that has become abnormal.

I am a Marxist of the Groucho wing.

If you think for others, the others will think for you.

BE REALISTS—ASK FOR THE IM—POSSIBLE.

Respect is lost, don't go looking for it.

Comrades, do not neglect the cleanliness of these premises.

There is no revolutionary thought. There are only revolutionary acts.

Professors, you are as old as your culture; your modernism is only the modernization of the police.

Forget all you have learned. Begin by dreaming.

Alone we can do nothing.

Have ideas.

Worker: you are twenty-five years old but your Union stems from the past century. To change this, come to see us.

Prejudices are the underpinnings of civilization.

Make love and start again.

Live in the present.

Suppress the right to vote at retirement.

We lack vitamin C.

All power to the Workers' Councils.

All power to the free soviets.

Long live the living theater.

Permanent play-time.

The general will against the General's will.

Let us never forget the class struggle.

End of the university.

RAPE YOUR ALMA MATER.

What is a teacher, a god? One and the other are the image of the father and fulfill a function that is oppressive by definition.

IMAGINATION TAKES POWER.

Revolution, I love you.

Insolence is the new revolutionary weapon.

Let us fight against the affective fixation which paralyzes all our potentialities. Signed, Women's Committee in Process of Liberation

Neither master nor god, God is I.

Culture is an inversion of life.

Here stood 1 bourgeois university.

When the last sociologist has been strangled with a tripe of the last bureaucrat, shall we still have any problems?

To desire reality is good: to realize one's desires is better.

My desires are reality.

1006

Only truth is revolutionary.

I take my desires for reality, for I believe in reality.

Long live direct democracy!

Culture is like jam: the less one has, the more one spreads it.

Watch out, comrades, or we shall free our Profs. of their sense of guilt.

Nihilism must begin with oneself.

The more I make love,
The more I feel like making revolution.
The more I make revolution,
The more I feel like making love.

Comrades, five hours of sleep out of twenty-four are absolutely necessary. We rely on you for the revolution.

You too can fly.

Poetry is in the street.

The promise of enjoying myself tomorrow is no consolation for boredom today.

Shame is counter-revolutionary.

The revolution has begun.

Long live kids and hooligans.

LIFE IS SOMEWHERE ELSE.

3. FRITZ TEUFEL

A student of Berlin University in the mid-1960's, Fritz Teufel belongs to the German Socialist Students Union (SDS). A leading figure of its Marxist wing, he is also something of a bogeyman to the West German press, which sometimes plays on the sense of a name that in German means "devil." When, in June 1967, the SDS organized demonstrations against the official Berlin reception of the Shah of Iran, Teufel was among those arrested for breach of the peace. The text below is that of the statement which he made before the court that tried and finally acquitted him.

Prophylactic Notes for the Self-Indictment of the Accused

T. was born fifteen minutes before midnight on June 17th, 1943, in Ingelheim in the Rhineland. (Ten years later there occurred in East Germany a worker's uprising against Stalinist compulsion, set off by an increase of work norms in various branches of industry, which today is being unjustly praised or con-

demned in West or East Germany respectively as an anti-communist insurrection.)

Ingelheim was situated in the French occupation zone: there was nothing to eat there. In 1946 the T. family moved to Ludwigsburg in the U.S. occupation zone, where it was almost possible to find

From The New Revolutionaries: A Handbook of the International Radical Left, edited by Tariq Ali. Reprinted by permission of William Morrow and Company, Inc. Copyright © 1969 by Peter Owen, Ltd.

enough to eat for a family of eight. T.'s father, an economics graduate, was initially an employee of the rural district office, but, after the currency reform, he built up for himself a practice as tax consultant.

FIRST ANTI-AMERICAN ACTION

At the age of six, T. painted swastikas on houses occupied by Americans. His brothers had told him how Germany had twice fought against the whole world and nearly won, and would have done so if it had not been for the Americans. (Father T. was by no means a Nazi; but neither was he a Resistance fighter. He was a lawabiding citizen who sometimes railed against Church and State but always paid his taxes and Church contributions punctiliously.) At the time of his confirmation, T. was very religious and said his prayers every night. At the age of eighteen he read widely, including Tucholsky and Brecht. He was considered a bookworm. He wrote poetry. He abused his father because he did not vote for the Social Democrats-his father replying. "These Reds with their unions ruin the economy."

Up to the highest form but two, T. was a good scholar. Later on he felt school to be increasingly burdensome, boring and authoritarian—bad marks in Conduct and Co-operation; tried to do his school-leaving examination with as little work as possible—had to do it twice. In 1963 he received the testimonial of maturity. He was not eligible to defend his country because he was short-sighted; this suited him fine. (Many more rockets would probably have been stolen had T. been set to stand guard over them.)

When he had to enroll, T. was asked: "What is it you want to study? . . .

Journalism? Are you trying to pull my leg?" T. was not trying to pull the man's leg.

TO BERLIN

T. intended to go to Berlin, which not only had the advantage of being far from Ludwigsburg but was also, in his opinion, by far the most interesting place in Germany. (This is still the case.) T.'s father would have preferred to have had his son reading law at Tubingen University (near Ludwigsburg), but T.'s mother had always taken the part of her youngest son, who was thus for the summer term of 1963, admitted to the Free University of Berlin for studies in journalism, German language and theatrical knowledge. (These he had chosen according to his inclinations.)

When on the train to Berlin T. travelled across the German Democratic Republic for the first time, he stood at the window and waved. He thought: These poor brothers and sisters—still under Soviet occupation! The brothers and sisters waved back; T. felt himself justified. He went on studying cheerfully on the principle, whatever is fun, be praised!

The question which at that time occupied him chiefly, was this: How can one make people laugh? It took approximately two years before he noticed, or slowly began to notice, or had increasingly pushed under his nose, the fact that the question had to be put differently: Why have people so little to laugh about?

PROPERTY AND FREEDOM

At one time, during the vacation, T. worked as an unskilled labourer with the Siemens electrical concern. He was depressed by the thought that he had only

his social origin to thank for his good fortune in not having to do this sort of work for the whole of his life. He made the acquaintance of a Spanish student called Jesus, who was very badly off. It seemed to him a paradox that the Spaniards, who had fought against fascism, still have to suffer to this day under the Franco regime, whereas the Germans were liberated from Hitler without having done much about it themselves. T. began to take an interest in fascism. When attending the trials of the Nazis, he discovered that the accused were not so very different from their judges; or from other people, for that matter.

Studying was not unalloyed joy since, in order to pass certain examinations, he had suddenly to occupy himself with matters in which he had not the slightest interest (for instance, Gothic language). A lecture, to be given at the university by the writer Kuby, was arbitrarily banned simply on the basis of the domestic authority vested in the rector. T. began to read the leaflets lying about in the canteen. The best arguments were contained in the leaflets issued by the Left (SHB, SDS, Argument Club). T. began to take an interest in the political discussions at the university without, however, at that time becoming active himself. T. decided to fill a gap in his education and therefore took part in a SDS working party concerned with Marxism and the history of the working-class movement. This turned out to have been the decisive gap in his education. For six months T. read with hardly an interruption: Marx, Engels, Lenin, Trotsky, Rosa Luxemburg, Lukacs, Korsch, Reich, Marcuse, etc. Like lightning, theoretical knowledge struck into his innocent, fallow soil.

T. began to understand things which, previously, he had only vaguely divined:

for instance, that in bourgeois society, property and freedom are identical: that freedom exists either as a matter of form, as the free choice between different evils (like a student looking for a room) or, as a matter of content, as private property, which means privilege. As a student of journalism, T. had the opportunity of occupying himself, in his work for a seminar, with the ideology of newspaper publishers. On that occasion (about a year before the slogan "Expropriate Springer" became popular), he saw with particular clarity the connection between property and freedom as it affects the consciousness industry. In actual fact, freedom of the press is nothing but the freedom of publishers to defend, tooth and nail, and to expand the institution of private property, which, after all, they exemplifyand nobody knows this better than the publishers themselves. . . .

BASIC LAW AND REALITY

To be sure, the basic law of the German Federal Republic still embodies some socialist or social-democratic ideas, in so far as Article 14 (2) mentions that the use made of property ought to benefit the community. However, in the context of the Basic Law as applied in reality since 1949, this formulation is nothing but pure ideology in the sense of false consciousness. It suggests that private property and benefit to the community can be reconciled, or are even identical. But the use made of private property in the Federal Republic since 1949 has served not the community but private interests; it has cemented differences in wealth and education; it has furthered waste, through armaments and advertising, and also corruption and the fattening of the State and Party bureaucracy as well as the general hoodwinking of the people through the consciousness industry, and the exploitation and general frustration of all movements towards emancipation, both at home and abroad—where necessary, by brute force, as it manifests itself every day in Vietnam and as it manifested itself in Berlin on June 2nd. The death of Benno Ohnesorg was no tragic accident; on that day, a system established its essence.

THEFT

T. has a previous conviction for what the comedian Nestroy calls an experiment in achieving greater equality in the possession of wealth—the judiciary calls it larceny. T. did what, in a rationally organized society, probably anybody would be entitled to do, even on the present-day level of the development of productive forces: he took what he needed without paying for it. This happened in January 1967. It concerned half a pound of butter, two pairs of socks and a box of shoespray. T. freely admits it would have been better if he had expropriated the means of production of the newspaper publisher Springer.

COMMUNE K1

In March 1967 T. began to establish a "Commune," together with eight other people. The establishment of this Commune ("K1") was one of the results of a long discussion held both inside and outside the SDS. The dilemma shared by all participants in this discussion was the difficulty of bringing together theory and practice in a society in which the legacy of a thousand years of fascism, the perfected manipulation of consciousness, and the international level reached by

class struggle and exploitation, have caused the masses to accept domination in an apathetic way.

The participants in the discussion suffered from the contradiction between their socialist theories and their bourgeois existence. Socialist students, too, are products of bourgeois society and are dominated by "the furies of private interests" (Marx); they are orientated towards competition and career-making. It is necessary to change society in order to change oneself. Solidarity is a product of revolution but also its necessary precondition. The participants in the discussion agreed that an organization which intends to change society is doomed to suffer shipwreck if its own structure does nothing but reflect the structure of existing society (for this, there are many examples to be found in the history of European workers' movements). This means that an organization that wants to reorientate society in the direction of a structure that is anti-authoritarian, egalitarian and antiprivate, must organize itself upon an anti-authoritarian, egalitarian and anti-private basis. In order to achieve favorable conditions for collaboration, we wanted to solve in common all problems which can be solved in common (housing, reproduction). Within the Commune the division of labour was, as far as possible, to be abolished.

SEXUALITY

Even within the circle of our close friends, one encountered the strangest ideas, formed by philistine lasciviousness, regarding a collective sexuality practised by compulsion. In this connection it need only be said that the Commune sees it as a problem that, in this society, relationships between human beings very easily

take on the character of property relationships which impede or prevent collaboration—probably one of the most difficult problems of the Commune.

IN THE MATTER OF VIOLENCE

Perhaps it would be a Christian act to recommend to the Vietnamese that they should turn the other cheek. Very often, however, the other cheek is already burned as well. T. thinks that it is necessary to distinguish in principle between, on the one hand, violence serving oppression and, on the other, violence serving liberation. In view of the arsenal of weapons held by the police and military in the Federal Republic and in West Berlin, it would be madness and suicide if a minority were to try to counter that violence by violence of their own. The Commune K1 has never used violence nor advocated the use of violence. K1 hates violence. It is no accident that the same politicians and newspapers which applaud the genocide practised in Vietnam, talk of terror when, in Berlin, a tomato is squashed against the wall of the manipulated consciousness. T. confesses that he advocates that sort of "terror." But he thinks that to throw stones and dynamite in the fashion of Russian anarchists of the nineteenth century would be senseless manifestations of powerlessness. That we are not powerless is proved by the growing strength of the political students' movement. Every time we succeed in denouncing and ridiculing the ruling powers, we prove that we are not powerless.

"LEFT FASCISM"

What do academic Marxists, whose revolutionary impetus has dried out on

the altar of science, mean when they talk of "Left fascism"? It is known what fascism is-namely preventive counter-revolution. Bourgeois society pulls the emergency brake. In Germany, it was a passionate struggle for an irrational cause and correspondingly, therefore, one could give to the passionate struggle for a rational cause the name "Left fascism," if one chooses passion and not irrationality as the criterion for fascism. This is exactly what is done by academic Marxists who love the resigned quietude of their university chairs, and thus do nothing but supply a new variant to the bourgeois theory of totalitarianism. . . .

SHAH'S VISIT

Those who wished to avoid giving the impression that they agreed with the imperialist complicity with which Bonn and Washington supported all regimes in the Third World that are inimical to emancipation, who wished to avoid giving the impression that they approved of illiteracy, hunger, disease and exploitation in Persia, had no alternative but to demonstrate when the "greatest reformer of all times," the operetta gangster of Teheran, the Viceroy of the American oil companies in Persia, was received in Berlin with pomp and circumstance. Unfortunately, the Commune could not think of much that could be done apart from the demonstration paper bags which were, above all, to protect the Persian fellow students from the secret service of their country. Nevertheless, we took part in the demonstration against the Shah in order to see what would happen. After all, there had to be some occasion when somebody else besides the Commune produced the ideas.

One thing has become particularly

clear in connection with State visits: official politics assumes more and more the character of a circus; the politicians become interchangeable with ham actors. It is no accident that we talk of the political stage. (Some actors, of course, are quite cute; for instance Heinrich Lübke, the West German President. One could hardly believe that, once upon a time, he designed concentration camps; one could, at most, think of him as a former head waiter at the Führer's headquarters.) The population is being degraded to the status of a theatrical audience. T. thinks that the audience in a theatre has good cause to throw eggs and tomatoes if it does not like the play.

THE EVENING IN FRONT OF THE OPERA HOUSE

T. arrived some time after 7:30. He felt some misgivings when he saw the barricade through which the police were herding the demonstrators into a narrow gangway between a railing and a building-fence. In addition there was a gigantic police force. T. believed, however, that these preparations had been made to intimidate the demonstrators, but not in order to facilitate beating them up systematically, as was in fact done later. Clashes began at 7:45 when policemen, who had been placed on the building-site behind the fence, moved against the demonstrators who were sitting on the fence. Rubber rings flew over the fence on to the demonstrators-some fell on the street, since the gangway was so narrow. No stones were thrown. Some demonstrators threw things back. When the VIP appeared, eggs and tomatoes were thrown in front of the entrance to the opera house. Smoke-bombs were thrown on to the street, which were then thrown

back into the tightly-packed mass of demonstrators. T. can say with absolute certainty that he did not throw a single stone, still less did he incite others to do so; nor did he see any policeman or demonstrator throwing stones.

RELATIONS WITH THE POLICE

We have nothing against the police. On the contrary: in December 1966 we demonstrated in favor of the introduction of a thirty-five-hour week for the police. However, we do have misgivings when we see the police being misused for political purposes, or when the consciousness industry makes deliberate attempts to incite the police against students. T. believes that any normal policeman would vastly prefer kicking his superior officer's behind to beating up students. When one sees pictures of uniformed men using their truncheons to beat a woman who is lying in the street, it is understandable if stones are thrown, even if one does not approve.

However, one thing is certain: people who show themselves to be inhuman to such a degree cannot ever themselves have been treated as human beings. These were no free citizens of a democratic society, but rather bloodhounds trained to savagery, like the American elite troops in Vietnam.

TOMATOES, EGGS, SMOKE-BOMBS

T. declares his solidarity with all those who have thrown objects suitable for demonstration purposes (that means objects incapable of inflicting injury), such as eggs, tomatoes, and smoke-bombs. Even though he cannot prove having thrown, for instance, a tomato, he would like to encourage the Court to treat him

as it would those who have thrown tomatoes, eggs or smoke-bombs.

ARREST

Shortly after eight o'clock there occurred what has been referred to as "driving in the main wedge"-a task-force of policemen used their truncheons to beat a gap into the mass of the demonstrators. In order to see more clearly what was happening, T. advanced some way towards the scene of action. After the "driving of the wedge" had been achieved, the police began to drive the demonstrators like a herd of cattle towards Krumme Street. In order to escape a similar fate, those demonstrators who were standing in the vicinity of Sesenheimer Street sat down. T. was sitting near the events, approximately half-way between the building-fence and the railings, facing the direction of Krumme Street.

When, a little later, a second "wedge" was driven in the direction of Sesenheimer Street, he turned around to see what was going on, so that he was facing the demonstrators. The police then began to advance against the sitting demonstrators as well. T. tried to ignore the policemen and continued to turn his back on them. Suddenly he was pulled by the hair, and somebody said, "Move on, get up!" He did not get up and received blows from the truncheons, as well as kicks. He took no counter-action but confined himself to protecting his face with his arms, while attempting to put his spectacles away,

which, however, were broken nevertheless.

T. was carried away. When he was carried over the middle of the road, he heard a man in civilian clothes (this appears to have been CID officer Böhme) call out as he approached the group, "Why, that is Teufel"—followed by words to the effect that he was one of those who prepared a dynamite attack against Humphrey. While T. was still being carried across the road, he was beaten. He shouted loudly. The beating stopped.

T. was transported in a police car to Keith St. police station. He was accompanied by two policemen. One of them, who wore a white uniform jacket (T. later learned that this was Hessner), continued to beat him during the drive with both his fists and his truncheon, all the while demanding hysterically what sort of people they were who prepared dynamite attacks and threw stones—for each policeman, a thousand SDS swine should be done in, we should not imagine that the police did not know us, they had pictures of all of us. All this, and more besides, he shouted several times over. The other policeman (Mertin) sat there and pretended that the whole thing was none of his business. Once T, attempted to explain that he had not thrown stones: whereupon Hessner attacked him again and shouted that all of them had thrown stones.

T. was glad when the drive was over. In the writ of indictment it says: "Nothing of note happened during the drive to Keith St. police station."

4. TARIQ ALI

Born in Pakistan, Tariq Ali went to study in Oxford where he became President of the prestigious Oxford Union. He also became a revolutionary socialist and one of the leaders of the Vietnam solidarity campaign very active in England in the

mid-sixties. The essay below presents his view of the political context in which revolutionary activities are expected to develop in the foreseeable future.

The Age of Permanent Revolution

. . . It was assumed by most of the early Marxists that the Revolution would first take place in advanced capitalist countries such as Germany, France and England. This did not happen. The first proletarian revolution took place in a relatively backward country, Russia, and there it staved. Both Lenin and Trotsky had taken it for granted that the Revolution would have to spread throughout Europe if it were to be successful inside the Soviet Union itself, but the Revolution did not spread. The betravals by the reformists led to the defeat of the German and Central European revolutions of 1918-21 and thus succeeded in isolating the victorious Russian Revolution. The failure of these revolutions was largely responsible for the degeneration of the Russian Revolution. From that point onwards the policy of the Soviet Union became counter-revolutionary. The communist parties of Western Europe were transformed, after their leading cadres were either expelled or assassinated, from revolutionary parties into frontier guards for the Soviet Union. They became the instruments of Soviet foreign policy and the twists and turns of their "policies" resulted in the abandonment of all independent Marxist analyses. The Party line laid down by Stalin was transmitted to the various communist parties throughout the world, which in turn transmitted it to their respective followers.

At the end of the Second World War all pretence of internationalism was thrown to the winds by Stalin. He dealt directly with Churchill and Roosevelt to decide the fate of Europe in the classic fashion of a triumphant conqueror. Eastern Europe was Stalinized by the Red Army, with the exception of Czechoslovakia and Yugoslavia, where the indigenous communist parties had mass-support. In Western Europe the communist parties of France and Italy faithfully followed the Stalinist line: class-collaboration became the order of the day. Communists participated in coalitions with bourgeois governments. In France there was a National Government, including two communists, which voted war credits for France to continue the aggression against Vietnam. In Greece a successful revolution was betraved by the Stalinists. Stalin was keeping his side of the bargain with a scrupulousness that would have puzzled most of his left-wing victims. As a result of the failure of the two revolutionary movements in Europe after the First and Second World Wars the focus shifted to the colonial world.

Stalin had not believed that a socialist revolution was possible in China. . . .

The success of Mao's armies came as a shock to Stalin; right up to 1948 he had been persuading the Chinese communists to come to some sort of agreement with the nationalists and this the Chinese steadfastly, and to their credit, refused to

From The New Revolutionaries: A Handbook of the International Radical Left, edited by Tariq Ali. Reprinted by permission of William Morrow and Company, Inc. Copyright © 1969 by Peter Owen, Ltd.

do. In October 1949, exactly thirty-two years after the Bolshevik Revolution, Mao's peasant armies marched into Peking and proclaimed China a People's Republic. Since the largest country in the world was now under a communist government, the Soviet Union had no option but to help it. This was the logic of its own historic legacy and this is as true today as it was then: if a revolution succeeds, the Soviet Union will be obliged to aid it—or it will be compelled to justify its own existence as a socialist country in completely different terms. The success of the Chinese Revolution coupled with the Vietnamese victories in the northern half of Vietnam provided the same sense of elation to Asian communists as had the Russian Revolution to European socialists. Moreover, Asian communism was to prove itself more human, more humane and more willing to admit its mistakes than its counterpart in the Soviet Union. The Chinese Revolution established Mao Tse-tung as one of the leading experts on guerilla warfare, and while the excessive personality cult built around Mao today has alienated many revolutionaries, Mao's stature as one of the greatest revolutionary leaders of this century is beyond question.

In Latin America the record of Stalinism has been as bad as in Asia. . . . Latin America was to remain in the doldrums until the Cuban Revolution. It was this revolution which seemed to break all the laws of Leninism, since in the first instance it was not a socialist revolution. Castro's revolution was organized without a revolutionary party, without a massbase in the peasantry and, lest we forget, despite the Cuban Communist Party whose attitude to the Cuban guerillas was one of ill-concealed contempt. The evolution of the Castro revolution is well

known. Castro realized that it was impossible to be anti-imperialist and "neutral" at the same time; that if anti-imperialism was to be the basis of the Cuban Revolution then the Cubans had to ally themselves to the communist world and socialize the property relationships within Cuba. When the Cuban leaders rejected the bogus concept of "neutrality" and became part of the communist camp, they proclaimed at the same time the first communist state in the Western hemisphere.

Since then the Cuban Revolution has advanced and matured to an amazing extent—despite the economic blockade imposed by the United States and some of its satellites. As in China, illiteracy has been virtually stamped out; compulsory education is stringently implemented, and consequently the whole face of Cuba has been changed unalterably. . . .

The effect of the Cuban Revolution on the rest of Latin America cannot be overestimated. In every Latin American capital the writing on the wall can be seen by everyone: VIVA CUBA, VIVA CHE, VIVA FIDEL. During the riots of October 1968, the students and workers of Mexico carried Che's slogan: "Create Two, Three, Many Vietnams." The Castroist current has upset the status quo so zealously preserved and guarded by the Latin American communist parties. In these parties themselves the rank-and-file militants have after vicious arguments left the Party and joined the Castroites. The parliamentary road to "socialism" has been seen by many communist militants in Latin America to be simply a false substitute for real revolutionary work. Many socialists in Europe are not aware that "legalism," so far as the exploited countries are concerned, is simply not possible. The choice is not between "legal" work, during a transitional period, and

underground activities, but between underground work and annihilation. While it may be easy enough to hand out leaflets containing revolutionary propaganda outside factories in London, Paris or West Berlin, many militants have been killed for far less by the hired thugs of the oligarchies in Latin America. And it should also be understood that by "underground activities" one does not mean guerilla warfare alone, but organizing the urban militants within the cities as well. Both courses, however, imply that an armed struggle is inevitable for the seizure of power. There is no instance in history where a ruling class has handed over power voluntarily: and those who cite the Russian Revolution should not forget the civil war that followed it. . . .

Yet, while the underdeveloped countries of Europe are experiencing a nascent fascism, we are often told by social democrats that Scandinavia is a bright and shining model of social democracy. Sweden, in particular, is often cited as the example *par excellence*. . . .

Has Sweden proved that capitalism can do away with the problem of "private affluence and public squalor"? As Marxists we are not simply concerned with full employment. We are equally concerned with the question of alienation resulting from the capitalistic mode of property relationships, and in that regard there is nothing to suggest that Sweden is an exception. It would be wrong to maintain that Scandinavia, or the rest of Europe for that matter, will necessarily experience a high level of unemployment and that this will pave the way to a socialist revolution. Indeed there is evidence to suggest that the more affluent society becomes and the more leisure time that workers enjoy, the more does the process of alienation begin to take root. For Marxists, socialism is not

only a question of public ownership; we are as insistent on the question of control —workers' control on the shop-floor, students' control in the universities. This process is a necessary part of the withering away of the State, and the fact that no communist country has even begun to apply the "control" section of Marxism does not invalidate it as a concept. It merely causes one to view the development of "communist" societies with a certain amount of apprehension. Goran Therborn, a prominent Swedish New Leftist, accurately spelt out the corporate nature of Swedish social democracy thus:

The relations between the employers and the unions in Sweden are a function of the relations between the political dominance of the working class and the corporative hegemony of the bourgeoisie. This has meant that the employers have explicitly acknowledged the sectional justification for organized labour; indeed in a society like Sweden they had no alternative. In exchange the unions have willingly accepted bourgeois hegemony and recognized the needs of the "economy," that is the needs of Capital. In such a situation, the strategy of the employers since the middle 'thirties has been to press a kind of community of organized labour and organized capitalwith the implicit supremacy of the last. This strategy has met the demands of union leaders for formal respect and has resulted in a bilateral co-operation working ultimately in the interests of the owners and managers of the "economy." The famous productivitymindedness of the Swedish union leadership should be seen in this context.

But if Swedish social democracy has so far managed to avoid the basic problems of capitalism, the same cannot be said for its counterparts elsewhere. The socialdemocratic leaders of Western Europe are in a state of crisis. . . . The social democrats have, to paraphrase Marx's description of Thiers,* become "masters in small state roguery, virtuosos in periury and craftsmen in all the petty stratagems, cunning devices, and base perfidies of parliamentary party-warfare." It is their policies which are leading Europe to its second pre-fascist decade: and not only Europe but the United States as well. In his farewell address to the American people the then President Eisenhower expressed some curious views (no doubt the appropriate speech-writer was duly reprimanded by the FBI) in a somewhat uncannily prescient warning to Americans:

Until the latest of our world conflicts, the United States had no armaments industry. American makers of plowshares could, with time and as required, make swords as well. But we can no longer risk emergency improvisation of national defenses. We have been compelled to create a permanent armaments industry of vast proportions. Added to this, three and a half million men and women are directly engaged in the defense establishment. We annually spend on military security alone more than the net income of all United States corporations.

Now this conjunction of an immense military establishment and a large arms industry is new in the American experience. The total influence—economic, political, even spiritual—is felt in every city, every state house, every office of the federal government. We recognize the imperative need for this development. Yet we must not fail to comprehend its grave implications. Our toil, resources, and livelihood are all

involved; so is the very structure of our society.

In the councils of Government, we must guard against the acquisition of unwarranted influence, whether sought or unsought, by the military-industrial complex. The potential for the disastrous rise of misplaced power exists and will persist. We must never let the weight of this combination endanger our liberties or democratic processes. We should take nothing for granted. Only an alert and knowledgeable citizenry can compel the proper meshing of the huge industrial and military machinery of defense with our peaceful methods and goals, so that security and liberty may prosper together. †

Leaving aside the pseudo-liberal rhetoric, the warning given here by Eisenhower was a sound one and, as recent events have shown, the military-industrial complex has been exercising more and more influence upon the policies of subsequent United States presidents.

But while social democrats and their equivalents in the advanced capitalist countries are being confronted by a series of recurring crises, their counterparts in the underdeveloped countries are being forced, more and more, to show their real, repressive side. In India, "the world's largest democracy" (sic), a mass-movement is building up which, when it decides to unleash itself, will stun the world by its ferocity. The poverty and massstarvation that exist in India and Pakistan are no secret. Contrasted with China the "progress" achieved by the American satellites in Asia is virtually non-existent. In the Naxalbari region in West Bengal the peasant movement, led by Maoist

^{*} Thiers was the butcher who drowned the Paris Commune in blood.

[†] Quoted in The Nation (October 28, 1961), p. 278.

peasant militants, started occupying the land and burning the estates of the landlords. The movement—though supported by Peking—was denounced by the pro-Peking section of the Indian Communist Party. The growing resistance of the workers in Calcutta and other industrial centres was also discouraged by the "Left" Communist Party. In Kerala the "Left" communists form the government and are behaving in classic social-democratic fashion. The bureaucracies which run the Indian communist parties are coming under extreme pressure both from their own rank-and-file militants and from the masses in general. Unless they decide on a genuine revolutionary strategy and lead the masses, the pendulum will swing sharply to the Right—which is offering its usual panacea of religious chauvinism coupled with free enterprise.

In Pakistan the Ayub regime is everywhere unpopular. It has managed to antagonize large sections of the native bourgeoisie, the students, intellectuals and the growing urban proletariat. A major railway strike in early 1966 was largely successful, mainly because of the spontaneous pressure from the young workers. It was a total and complete strike and the most effective in the whole history of Indo-Pak trade-unionism. Although it was forcibly brought to an end after a few days, some of the major demands of the workers were accepted. The "Maoist" leaders of the trade union tried to get the strike called off on grounds that it was "backed by the CIA which was trying to destroy the Ayub regime" and was "preventing wheat supplies from reaching the peasantry." It was not surprising that these leaders were spat on by the militants on the one hand and imprisoned by the Avub regime on the other!

In other parts of Asia the struggle has

taken more concrete form. . . . The Vietnamese resistance has excited the imagination of peasants throughout South-East Asia. It has shown the world that, while the march of history can temporarily be frustrated by napalm bombs and B-52's, it cannot be halted. And the lessons which the Vietnamese are teaching American imperialism are also being assimilated and learned by the liberation movements throughout the world.

In Africa the Portuguese-controlled territories of Mozambique, Angola and Guinea are rapidly being taken over by native liberation movements. In Portuguese Guinea the guerrillas hail every new Vietnamese victory as their own. They have been visited by NLF cadres from Southern Vietnam and have been told by them how best to protect themselves against bomber raids and napalm bombs. Yet, while there has been an increasing degree of co-ordination on the part of the national liberation movements in the exploited world, there have been no similar trends in the advanced capitalist countries.

The division between imperialism and the exploited world has been much greater. The gaps in the standards of living, productive capacity, resources and capital investment continue to widen. While after 1917 the exploitation was more direct, insofar as the peasants and the workers of the colonies produced surplus value for Western capitalists, and while to a certain extent this is still the case, the emphasis now is on exploitation through trade by means of unequal exchange. As a result of this trade, considerable capital resources are transferred from under-developed to developed countries. Although most of the exploited countries are no longer colonies and have gained their "independence," this has not

really affected Western capitalism. Only in a few cases has the colonial revolution removed the opportunities for capital investment: China, Cuba, North Vietnam and North Korea. The rest are still part of the capitalist market. There has been a conscious attempt by the imperialists to free themselves from their chronic dependence upon raw materials, as is evidenced in the remarkable strides made in the production of synthetic materials. But the process is at best a partial one; key resources such as oil and iron-ore have still to be imported. Indeed dependence upon them has increased and even the United States counts on the import of oil * and iron-ore, for which Brazil and Venezuela are vital. Undoubtedly there has been a relative decline in imports from the exploited world, but there is no question of total independence at the moment. It should be noted in this regard. however, that the Soviet Union and the Northern European countries, in their trade relations with the exploited world, contribute towards maintaining the unequal exchange. The Soviet Union could easily pay more without harming its own economy. This would help break the imperialist trade-grip, but the ideology of "peaceful co-existence" acts as a barrier.

In its final phase monopoly capitalism is beginning to generate more and more capital. This is done at a rate which cannot be absorbed by the under-developed countries. The result is, therefore, a tremendous divergence of capital export towards other monopoly capitalist countries. Sixty per cent of American capital is now exported to Canada, Western Europe and Japan, and this increase in the flow of capital from one imperialist country to

others is a relatively new development The rationale behind this is also self-evident. As long as there are different wagelevels and as long as there are different levels of productivity the effect is virtually the same. Whether the United States invests in Latin America or Britain it pays much lower wages. The result is the same surplus profit. The average wage in Western Europe is 40 per cent of that in the United States; in Japan it is 20 per cent. This disparity has created a situation that is immensely attractive to capital investment. The so-called multinational corporations which are springing up are in fact controlled by the United States. But this perverted internationalism on the part of monopoly capitalism has completely by-passed the official organizations of the workers. There have been no corresponding moves to "internationalize" the trade unions. The trade unions are at least fifty years behind the development of monopoly capitalism. Efforts by some of the American unions for closer co-operation have been rebuffed on grounds of petty chauvinism by their European counterparts. During the French coal strike of 1963, when there was only one week's worth of coal reserves left. coal poured into France from Britain, Belgium and West Germany. The working class has at the moment no counter-strategy to pose against the international amalgamation of capital. Such a strategy is badly needed.

What is absolutely clear is that the revolutionary movement is in a period of upswing throughout the world. The war in Vietnam, the events of May 1968 in France and the invasion of Czechoslovakia symbolize this upswing. Vietnam is at

^{*} Editor's Note: Recent discoveries in Alaska are rapidly changing this situation, creating one where traditional oil producers view with anxiety North America's lessening need of their chief product and source of income.

the moment the battle-front against imperialism. France showed the extreme vulnerability of monopoly capitalism and the strength of the working class. Czechoslovakia has initiated the struggle for political revolutions in Eastern Europe and the Soviet Union itself. Trotsky's description of a Stalinist society is still valid:

The basis of bureaucratic rule is the poverty of society in objects of consumption, with the resulting struggle of each against all. When there are enough goods in a store, the purchasers can come whenever they want to. When there are few goods, the purchasers are compelled to stand in line. When the lines are very long, it is necessary to appoint a policeman to keep order. Such is the starting point of the power of the Soviet bureaucracy. It "knows" who is to get something and who is to wait.

A raising of the material and cultural level ought, at first glance, to lessen the necessity of privileges, narrow the sphere of application of "bourgeois law," and thereby undermine the standing ground of its defenders, the bureacracy. In reality the opposite thing has happened: the growth of the productive forces has been so far accompanied by an extreme development of all forms of inequality, privilege and advantage, and therewith of bureaucratism. That too is not accidental.*

Those of us who form the hard core of today's new revolutionaries are still Marxists, but we abhor Stalinism; we believe in Leninism but prefer the emphasis to be upon "democracy" rather than "centralism"; we are Guevarist but can appreciate and analyse the mistakes made by Che. We are puzzled by the tendency among many Left factions in the developed countries to devote as much time and energy to attacking each other as to attacking capitalism. The new revolutionaries fight against sectarian tendencies. And what is most important of all, we are not to be bought off by the State. WE mean business.

^{*} Leon Trotsky, The Revolution Betrayed.